HISTORY OF
ILLUSTRATION

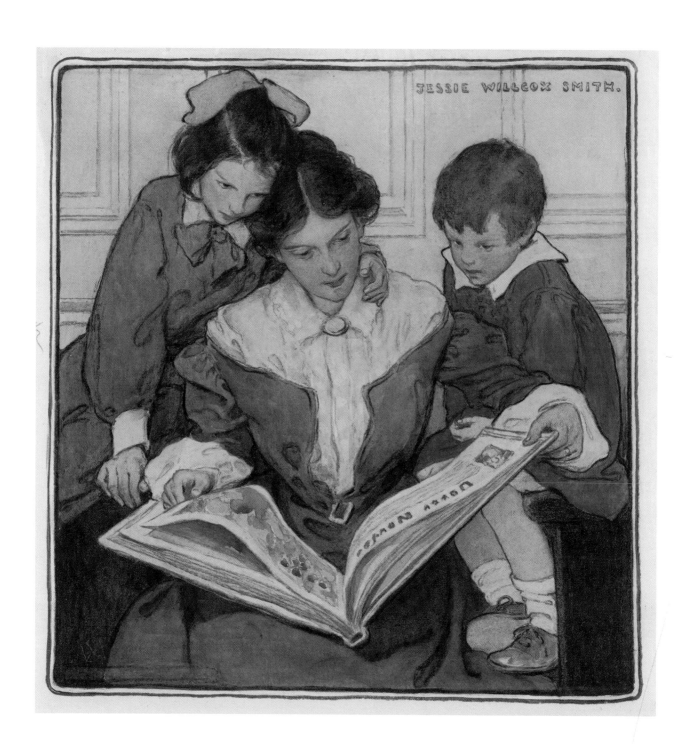

HISTORY OF
ILLUSTRATION

Susan Doyle

Editor

Rhode Island School of Design

Jaleen Grove

Associate Editor

Washington University

Whitney Sherman

Associate Editor

Maryland Institute College of Art

FAIRCHILD BOOKS

NEW YORK · LONDON · OXFORD · NEW DELHI · SYDNEY

FAIRCHILD BOOKS
Bloomsbury Publishing Inc
1385 Broadway, New York, NY 10018, USA
50 Bedford Square, London, WC1B 3DP, UK

BLOOMSBURY, FAIRCHILD BOOKS and the Fairchild Books logo are
trademarks of Bloomsbury Publishing Plc

First published in the United States of America 2018
This edition published 2019
Reprinted 2019

Library of Congress Cataloging-in-Publication Data
Names: Doyle, Susan, 1959– editor. | Grove, Jaleen (S. Jaleen), editor. |
Sherman, Whitney, editor.
Title: The history of illustration / Susan Doyle, Jaleen Grove, Whitney
Sherman.
Description: New York : Fairchild Books, 2018. | Includes bibliographical
references.
Identifiers: LCCN 2017001277| ISBN 9781501342110 (hardback) | ISBN
9781501342103 (paperback)
Subjects: LCSH: Graphic arts—History. | Art and society—History. | BISAC:
DESIGN / Graphic Arts / Illustration. | ART / History / General.
Classification: LCC NC998 .H46 2017 | DDC 740—dc23
LC record available at https://lccn.loc.gov/2017001277

ISBN: HB: 978-1-5013-4211-0
PB: 978-1-5013-4210-3
ePDF: 978-1-6289-2754-2

Typeset by Lachina
Printed and bound in the United States of America

To find out more about our authors and books visit www.fairchildbooks.com
and sign up for our newsletter.

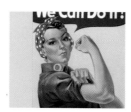

III.

The Advent of Mass Media

IV.

Diverging Paths in Twentieth Century American and European Illustration

V.

The Evolution of Illustration in an Electronic Age

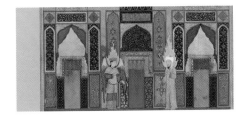

I. Illustrative Traditions from Around the World

II. Images as Knowledge, Ideas as Power

III. The Advent of Mass Media

IV. Diverging Paths in Twentieth Century American and European Illustration

V. The Evolution of Illustration in an Electronic Age

CHAPTER TWENTY NINE

Digital Forms

*by Nanette Hoogslag and Whitney
Sherman with contributions by
Brian M. Kane*

Preface

History of Illustration provides a global overview of illustration practices from before the development of written language to the digital age. As the first textbook on the topic, it fills significant gaps in the history of art and visual culture, and in the education of illustrators. Created by a team of educators, scholars, curators, and professional illustrators, each chapter has been written, edited, and reviewed by numerous experts. It is by no means encyclopedic in its presentation of works, artists, or even movements. Rather, *History of Illustration* is a survey that introduces the student to a variety of international illustration traditions, theories of the visual, and reference material that provide a foundation for further research and study.

Audience

The writing is aimed at undergraduate illustration students who have just begun taking classes in art or design history. It is also intended for art, design, and media students wishing to expand their understanding of visual culture studies. Definitions for specialist terms, print technologies, art movements, and so on are therefore given in the text and in a glossary. The book also addresses the globalized environment by juxtaposing culturally specific illustration practices never before considered together, and it introduces critical theories to provide analytic entry points for understanding a wide range of illustrations in new ways. Additional teaching resources such as sample exam questions are supplied online for busy instructors who may not be illustration specialists themselves. Practitioners, curators, and fans will also find value in this book's attention to the big issues of the field, brought to light through contextualized examples of illustration art.

Organization and Features

The Introduction grounds the purpose of the book and the study of historical illustration in more detail, and provides a concise, practical illustration research method that accounts for illustration's particular properties as a vehicle for communication. Editors of the textbook have successfully used this pedagogical method with second- through fourth-year students writing research papers.

Loosely organized by both chronology and subject specialization, the book is then divided into sections that group chapters by era or scope. Part One (Chapters 1–8) gathers together illustration traditions by geographic regions, exploring the origins of art in caves, on narrative objects, in manuscripts and early printing, as well as in more contemporary practices in regions of Japan, China, India, Latin America, and Africa. Part Two (Chapters 9–12) delves into the expansion of European print culture, and Part Three (Chapters 13–17) covers mainly the nineteenth century and the advent of automated mass media production in the United States and England. Parts Four (Chapters 18–23) and Five (Chapters

24–29) largely follow these topics into the twentieth and twenty-first centuries in the United States, delving into new genres of illustration characterized by successive waves of technological advances.

Within this informal chronology, various specialized chapters cover longer periods of time to keep the history of a given subgenre intact. These include chapters on fashion illustration (17), children's books (16 and 25), comics (23 and 26), and medical and scientific illustration (9, 10, and 28). This accommodates the needs of schools that have a particular subfield focus in their curriculum.

In addition to the chronologies of subjects and of general print history and artists, *Theme Boxes* in each chapter offer succinct presentations of printing technology, cultural phenomena, and critical theory relevant to illustration. The discussions of critical theory address conceptual content (such as semiotics, gender, race, nationalism, and so on) that supersede any particular era or art practice. So while Theme Boxes are necessarily situated within a given chapter, they are intended to provide ways of considering material in all chapters.

History of Illustration encourages further study and research. To this end, most chapters include a short list of *Further Reading* to provide more in-depth coverage of select topics within the chapter. Bibliographic entries are also provided, with further appendices available in the online resources. Together, these features comprise a comprehensive resource for the nascent field of Illustration Studies, not assembled anywhere before.

Approach and Learning Outcomes

Emphasis throughout the book is on the social, historical, technical, and theoretical contextualization of the 870 images presented within—so that students will come to regard illustrations and the study of illustration history as inherently interdisciplinary. This number represents but a tiny fraction of the illustration that exists in the world, selected as exemplars reflective of the illustrative *zeitgeist* of a certain time or place. Readers are encouraged to consider each illustration as an artifact through which to gain understanding of the object and its reciprocal relationship to culture.

To understand the meaning of an image, one must ask why it was created, for whom and by whom, and what purposes (anticipated or not) it served. Accordingly, references are made throughout to sociopolitical events, technological advances, aesthetic conventions, audience experiences, and the dynamics of studios, workshops, presentation sites, and publishing environments in which each example originated. This line of questioning is supported and informed by the short essays on critical theory and history of reproduction technologies given in the textbook's Theme Boxes.

While the textbook samples illustration from around the world, for practical reasons of scale and portability,

this textbook does not touch on *all* forms of illustration. Likewise, while writers from around the globe have been engaged, the book is North American in emphasis and does not lay claim to a truly global perspective. After reading the textbook, however, the student will be able to understand many of the major forms of visual and pictorial communication from five continents and many centuries, and be familiar with common approaches for contextualizing and analyzing illustration in terms of form, subject matter, and sociocultural factors.

Most of all, the student will gain a sense of belonging to a tradition and a field with ancient roots and inestimable social impact—one that aims to improve cultural life through expression of imagination and knowledge, through celebration of genre and tradition, or through challenging authority and complacency.

Instructor Resources

- An **Instructor's Guide** provides suggestions for planning the course, using the text in the classroom, supplemental assignments, and lecture notes.
- A **Test Bank** includes sample test questions (multiple choice, true or false, fill in the blank, and critical essays) for each chapter.
- **PowerPoint**® presentations include images from the book and provide a framework for lecture and discussion.

Instructor's Resources may be accessed by subscription at http://www.bloomsbury.com/us/academic/fairchild books/instructor-resources/.

Acknowledgments

There is a reason that this book never existed before: the history of illustration is inextricably linked to the history of humankind, and that is simply too vast for any one person to write. Because of the scope, and because it is important to keep the exploration open by including expertise from many different perspectives, it was decided that a team approach was necessary. Despite five years of hard work, this history of illustration is just a snapshot of a moving target: research is ongoing, and the theorization and historiography of the field are only nascent.

Yet the book is a milestone. Written, edited, and reviewed collaboratively by more than fifty volunteers from around the world, this book represents a community of communities that we named The History of Illustration Project (HIP). Made up of practitioners, collectors, curators, educators, and academic scholars in multiple disciplines, this meta-community did not exist beforehand because, although each contributor or group sometimes interacted with others, most have operated within discrete discourses and professional or social circles. It is one of the best achievements of *History of Illustration* that it has bridged many gaps and gathered together interdisciplinary experts in making, documenting, and critically analyzing illustration. In its gestation there was an awakening of sorts, as contributors became aware of the impressive scope and number of illustration historians and enthusiasts in the world. Out of the sometimes painful but always enlightening process have come new ideas, networks, and respect for the myriad ways of answering these questions: *What is illustration? What does this picture mean? How do we gauge its merit? Why does it exist? Why does it matter?*

We are grateful for Rebecca Barden, Priscilla McGeehon, and others at Bloomsbury, who did not discourage our audacious plan; the enormity of what has been accomplished by sheer goodwill and determination is impressive and unlikely to be repeated. Busy scholars sacrificed time away from more prestigious publishing to donate their expertise. Eminent historians and experts gritted their teeth and did not abandon us as we reviewed and edited their work through numerous drafts. We amassed nearly nine hundred images, staying within our modest budget through the generosity of our community, and without a doubt, it was everybody's willingness to pitch in—like an old-fashioned barn raising—that made this book possible. Perhaps most of all, we need to thank David Apatoff, who contributed not just an image or two, and his own illustration history knowledge and connections, but the legal expertise we needed to negotiate our publishing contract and to navigate the finer points of copyright matters.

There were no grants used in the making of this book. We express our gratitude, however, to patron of the graphic arts Yosef Wosk of Vancouver, British Columbia, for assistance with some travel and office expenses. We also wish to thank the institutions that employed the editors (who toiled evenings, weekends, and holidays between 2012 and 2017): The Rhode Island School of Design provided one year's sabbatical that enabled Susan Doyle to focus attention on the book and provided for research assistants Yu Pei and Cathy G. Johnson; Maryland Institute College of Art provided for Whitney Sherman's graduate research assistant Ashley Yazdani, while Sherman's position at MICA supported her role in making this book from 2012 to 2017. Through other employment, the Cahén Foundation indirectly supported Jaleen Grove's work from 2013 to 2016; while the D. B. Dowd Modern Graphic History Library at Washington University awarded her a postdoctoral position that enabled her work during the book's completion from 2016 to 2017. Both Rhode Island School of Design and the D. B. Dowd Modern Graphic History Library at Washington University supplied many images for this book as well.

Many people who did not ultimately write for us played absolutely pivotal parts in the earliest planning stages and deserve recognition. In 2012, the New York Society of Illustrators assisted Jaleen Grove and Whitney Sherman in launching the survey that began the entire process. Because of the survey, James Gurney initiated a conversation with a fateful group email "call to arms" that went out in January 2013, and Charley Parker started a WordPress site for initial discussion.

Our initial steering meeting was graciously hosted at The Norman Rockwell Museum by Laurie Norton Moffat, museum director; Stephanie Haboush Plunkett, deputy director and chief curator; and Joyce K. Schiller, director of the Rockwell Center for American Visual Studies. It was there that H. Nichols B. Clark, Sheena Calvert, Douglas B. Dowd, Susan Doyle, Kev Ferrara, Jaleen Grove, Mary Holahan, Robert T. Horvath, Barry Klugerman, Tom La Padula, Robert Lovejoy, Desdemona McCannon, Stewart McKissick, Stephanie Plunkett, Ann Posega, Roger Reed, Joyce K. Schiller, John Schoonover, Louise Schoonover Smith, and Carol and Murray Tinkelman hashed out the purpose and approach of the book, and twelve of them went on to help write it. Dowd, Professor of American Visual Studies at Washington University in St. Louis, took a leadership role at that important meeting by organizing our incipient discussions into actionable ideas on a blackboard. Rick Schneider generously volunteered for the web-portal companion effort to be developed with the Norman Rockwell Center—where it debuted at a second HIP meeting in 2014 (http://www.illustrationhistory.org/).

To our great regret, Schiller and both the Tinkelmans passed away before the completion of this book. The latter were vital to the project's development with their insightful and at times piquant challenges to us to do the field justice.

Many people also gave input other ways, including Ann Albritton, Bryan Gee, Adrian Holme, Angela Miller, Martha H. Kennedy, Jeff Menges, Jody Pratt, Guin Thompson, Jim Vadeboncoeur, Sun Yiqin, Pui Pui Yau, Shreyas R. Krishnan, and to Bryn Freeman for her work on the Timeline.

We give thanks also to comics consultants Brian Walker, Jim Steranko, Roger Stern, Rick Magyar, Klaus Janson, Tom Brevoort, Trina Robbins, and Brittany Tullis. Special thanks to Randy Duncan, Matthew J. Smith, and Paul Levitz for granting access to their unpublished manuscript, *The Power of Comics: History, Form and Culture,* 2nd edition, for Chapter 23.

A great many people graciously agreed to review what were sometimes woefully raw drafts. Peer review is very difficult to give and to take, but it absolutely ensured standards were maintained. We would like to acknowledge Rowland O. Abiodun, William Barker, Georgia Barnhill, Sheila Blair, Laura Brandon, James Brocklehurst, Alison Byrnes, Marie Stephanie Delamaire, Margaret Jackson, Paul Karasik, Judy Larson, Julia K. Murray, Adam Osgood, Elizabeth Parke, Emily Peters, Jane Allen Petrick, Daniel Powers, Chuck Pyle, Hannah Sigur, Carol Ventura, and the many anonymous market reviewers.

Several print and illustration art dealers, bloggers, and collectors came to our rescue with artwork, tearsheets, and unpublished knowledge, asking no remuneration. Collectors, bloggers, and dealers are essential to illustration history: it is they who archive and preserve original works, and ferret out often-forgotten ephemera. It is they who painstakingly and lovingly catalog it all, and who recall the tiniest anecdotal details that turn out to be significant. And it is they who share everything so generously, engaging broader audiences with their enthusiasm. In this category, we thank John Adcock, Elizabeth Marecki Alberding and Richard Kelly at The Kelly Collection of American Illustration Art, David Apatoff, David Mason Rare Books, Thomas Haller Buchanan, Doug Ellis, Grapefruit Moon, Chester Gryski, George Hagenauer, Heritage Auctions, Illustration House, Robert A. Levenson, Leif Peng, Wayne Morgan, Norman E. Platnick/Enchantment Ink, Jack Raglan, The Ronin Gallery, Shhboom Gallery, Fred Taraba, and Jason Vanderhill.

Special collections everywhere bent rules to locate materials, and staff at libraries and institutions went out of their way to support our work. They include Skye Lacerte and Andrea Degener at the D.B. Dowd Modern Graphic History Library; Leslie McGrath at the Osborne Collection of Early Children's Books, Toronto Public Library; Don McLeod at the Thomas Fisher Rare Book Library, University of Toronto; University of Guelph Library; Claudia Covert and Ariel Bordeaux at the Special Collections of Fleet Library at Rhode Island School of Design; Kathy Cowan, senior reference librarian, Maryland Institute College of Art; Daniel J. McKee, Division of Rare and Manuscript Collections, Cornell University Library; Japanese Studies librarian, Ryuta Komaki, Washington University at St. Louis Library; and Anne Kinney at University of Virginia. A special debt is owed to the Museum of the Rhode Island School of Design for their generosity in opening their collection to us, and to Emily Peters in particular for her guidance on European prints and contribution on block books; thanks also to Jan Howard, Britany Salsbury, and Sionan Guenther for their patience in research and documentation. Additionally, we acknowledge Harve Stein, whose highly detailed 1948 outline for a course on the history of illustration is housed both in the archives of the New York Society of Illustrators and the Rhode Island School of Design, where it has been referred to by three generations of teachers.

Artists and illustrators themselves, or their descendants, provided scans that otherwise would have been prohibitively expensive. There are too many to list here, but each is gratefully acknowledged in the captions.

Finally, we would like to acknowledge our families, who lived with the "Monster Book" almost as much as we did. Our loved ones supported us so we could deliver a book near and dear to our hearts and our passion.

The Publisher wishes to gratefully acknowledge and thank the editorial team involved in the publication of this book:

Acquisitions Editor: Amanda Breccia
Development Editor: Corey Kahn
Assistant Editor: Kiley Kudrna
Art Development Editor: Edie Weinberg
Cover Illustrator: Brian Rea
Production Manager: Claire Cooper

And to the editors for their contributions to the design and project management of this unique collaborative effort.

Introduction

Although illustration is ubiquitous globally, its history and analysis have lagged behind studies in media-specific disciplines in design, fine art, and craft. This book brings together multiple points of view to provide a sampling of illustration worldwide within a discussion of core issues and concepts in visual communication and visual culture relevant to illustration studies. It positions the act of illustrating at the center of visual meaning-making and highlights the cultural role and impact of illustrators.

What Is Illustration?

Simply put, illustration is visual communication through pictorial means. Etymologically, its Latin root, *lux,* means "to shine light upon"—to enable understanding. As artwork, illustration is often expressive, personally inspired, and beautifully crafted, but unlike art for art's sake, it is inherently in service of an idea and seeks to communicate *something particular,* usually to a specific audience. In other words, however delightful, accomplished, or arresting an art piece may be, it is illustration because of the *intent* to communicate a particular message or piece of information. And, while illustration often accompanies or refers to a written or spoken text, it may also operate independently. Because the illustrator must make visual what words can only generally indicate, illustration originates meaning, just as writing does.

Illustration, as will be shown, can be made through a huge range of traditional and digital means. It may be explicit, stylized, or naturalistic in its presentation of subject matter; or conversely, involve highly symbolic iconography or abstracted forms (see Figure 0.1). Illustrations may be printed or adopt three-dimensional or time-based forms chosen for their unique potential to enhance or transmit a specific idea. The "what" (subject) and "how" (medium) of an image are not the defining factors; rather, the "why" (purpose) determines whether a work of art is illustration or not.

The authors of this volume have been guided by a precept, informed by visual culture historian Alan Gowans (Canadian, 1923–2001) from his book *The Unchanging Arts* (1971), that illustrations can be considered to serve one or more of the following four purposes:

1. To document (create a visual record of a thing or person)
2. To narrate (to explain or entertain; storytelling)
3. To persuade (to establish, maintain, or discredit ideas)
4. To ornament (to enhance life or to concretize identity through decoration)

By these criteria, most works created before the advent of mass communication and curated in modern times as "fine art" qualify as illustration, which early chapters in this volume demonstrate. Christian or Buddhist devotional art, for example, served the purpose of communicating and explaining teachings important to

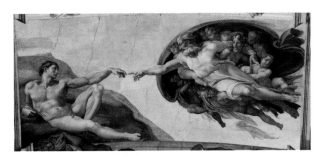

Figure 0.1
Michaelangelo di Lodovico Buonarroti Simoni (Italian, 1475–1564), *Creation of Adam, Sistine Chapel,* Vatican, 1511–1512. Fresco. Considered one of the greatest masterpieces of Western Renaissance art, this fresco was an innovative illustration of the central Christian narrative of the origin of man, rebirth, and redemption. Its scale and placement were intended to create awe not only of the subject matter, but also of the artfully crafted image itself.
Image courtesy Jörg Bittner Unna.

the faithful. A regal portrait recorded the likeness of a monarch and represented him or her in absentia, while propagandistically affirming power and status by virtue of its grandeur, auspicious placement, and symbolism.

When we recognize the illustrative properties pervasive in the visual and media arts, we must ask what, then, are the limits of what we discuss in the history of illustration? How does it differ from the history of art?

What Is Illustration History?

Since the blossoming of connoisseurship in the eighteenth century, discussions of "art" have excluded illustration because of its utilitarian purpose, association with commerce, and its mechanical reproduction—as opposed to unique creations of the fine-art world, which Gowans referred to as "precious objects for exhibition." As a result, objects we associate with illustration such as advertising, comics, and periodical illustration were mainly excluded from histories of art; and critical discourse about what constitutes illustration as a distinct field and consideration of its valuation and practice were stymied. Illustration suffered further loss of status when influential media and culture critics (some introduced in this book) questioned the value of mass communication media, popular culture, and advertising in general (*see Chapters 2, 14, and 19*). Along these lines, documentation, preservation, and interpretation of illustration have not been pursued with the same zeal as art made for exhibition—and formal archival holdings of books, advertising, and ephemera that was made for everyday use are comparatively lacking. It is the purpose of illustration history and illustration studies to redress these shortcomings.

Because so much of illustrated media was made for and about popular culture, study of the history of illustration is an excellent way to gain insight into past and current societies. Take, for example, the entertaining narrative images of the Gibson Girl by Charles Dana Gibson (American, 1867–1944; see Chapter 18) that comment on and satirize the upper classes while promulgating a narrow view of feminine beauty (Figure 0.2). In their own time, these images served as documentation, entertainment, persuasion, and even decoration—because the Gibson Girl's popular likeness was applied to wallpaper and other merchandise. For historians, they now

Figure 0.2
Charles Dana
Gibson, *A Widow
and her Friends*,
1900.
In a wry fiction
of the travails of
a beautiful young
widow, Gibson
lampoons her
late-mourning
interactions with
infatuated aristo-
cratic males
observed by envi-
ous competitors.
Courtesy of Special
Collections, Fleet
Library, Rhode Island
School of Design.

serve the additional purposes of providing a record of social values and standards of beauty, of historical costume, of the evolution of women's status, and of the dissemination of mores through mass communication.

Establishing a Research Method for Illustration

A rigorous history must situate illustrations in time and place as material objects and as visual communication. While many illustrations can be difficult to interpret through a contemporary lens, the study of images cannot be limited to classifying by style or by the depicted subject but must take into account the broader material culture of the day to reveal the semiotic nuances of *how* the illustration has signified over the years. The use of illustration as part of a publication or in the context of a certain publishing environment may be more telling than what the image looks like. Channels of distribution and accessibility (or limitations thereof) were pertinent then as now, and it is important to establish who profits by illustration, what producers' and consumers' motivations are, and what the social effects of illustrated media might be. Consideration of the formal qualities of illustration must take into account the cultural identity of the artist, his or her technique, creativity, and inspiration. This text-book introduces the student to these debates not to argue a definitive valuation of illustration as either good or bad, but rather to invite the student to contemplate the various taxonomies, critical apparatuses, and curatorial behaviors involved in the assessment of visual culture in general and of illustration in particular.

In analyzing the relationship of audiences to images, the student should delve into the effects of reproduction technologies and the exigencies of (mass) production, asking:

- By what means did viewers encounter the image?
- Who had access to such material?
- What power structures encouraged or curtailed illustrations of this nature or by this artist, and to what ends?

The following chart shows essential aspects historians and students should consider when studying illustration:

Context

In communication theory, a *message* (a feeling, concept, idea, or piece of information) has to be sent in a *code*. Words, gestures, musical notes, and pictures are all ways to encode, or signify a message. The person devising the message is therefore the *encoder,* and the party who receives the code is the *decoder*—because the receiving party has to figure out the meaning of the code on his or her own. Naturally, the code is more likely to be decoded according to the encoder's expectations if the encoder and decoder share a similar culture, social milieu, knowledge of world events, and local environment. But this isn't usually the case when the decoder is far removed by time from the original period and place, as historians usually are. Much research into the context—the historical moment and place(s) when the illustration was made and encountered—is necessary to decode messages.

Encoders

Many historians research the lives of illustrators, digging up informative facts that attempt to explain the resulting illustrations. But it's not just the illustrator who determines the code (its subject and formal attributes) or how it will circulate. The illustrator (unless self-directed) collaborates with or takes direction from a client or employer. If the illustrator has been given a headline to work with or a story to interpret, then that text also impacts what the illustrator may do. The text itself may suggest or disallow certain solutions. As a result, even if the author of a book is deceased, he or she is still contributing to the eventual code of the message. The thorough illustration historian will research every individual and institution that has influence over the production of the illustration.

Code

An illustration is a "code" because it uses recognizable visual conventions such as mimicry, composition, style, and other attributes to convey meaning. Even a highly "realistic" looking image is still considered a code because any picture—a two-dimensional representation—is not the real thing. We only accept it as realistic or true because we are so familiar with the code that we overlook that the picture is still only an artificial creation (see Figure 0.3). A large component of criticism about illustration is concerned with exposing the artifice and nature of the code and its propensity to convince and persuade.

All the aspects of codes may be sorted under three broad headings: *iconography* (subject matter and symbolism); *form* (the design or arrangement of shapes, colors, lines, and other structural components underlying the

Components of Illustration Media at a Glance

Context	Encoders			Code			Decoders	
Historical moment; place	Client; employer	Text; writer	Illustrator	Iconography	Form	Format	Intended audience/use	Other audiences/use

Chart by Jaleen Grove

iconography); and *format* (the media type the illustration is published in, such as a magazine or an animated GIF, as well as its delivery and distribution).

Decoders

It is fair to say that every illustration has or had an intended audience, but whether it reaches that audience in the desired way is unpredictable. Because illustration originates meaning of its own apart from text, it may complicate the comprehension of the spoken or written word as much as it illuminates it. No matter how careful and astute the illustrator, there is always a possibility that viewers will see something in it that was not intended. When the unintended reading is provocative (sexual, rude, political, or funny, for instance), it can subvert the aims of the illustrator or the client. The study of how audiences decode media messages is called *reception theory.*

While cultural critics may stereotype consumption of popular culture as uncritical, reception theorists have shown that the way individuals and groups consume media is anything but simple. The illustration historian must consider that viewers have agency in the way they construct meaning and selectively integrate illustrated objects into their life, which in turn influences cultural production. Clients, publishers, and illustrators who want their illustration to be popular—to engage their audience—are often motivated by fan letters, complaints, sales records, surveys, and fashion trends, so in a sense, decoders might be considered encoders as well.

While the "Components of Illustration Media at a Glance" chart implies there's a linear cause-and-effect progression in which historical context determines ultimate meaning via a maker, all parts are interconnected directly and influence each other. Encoders, codes and content, media format and technology, and decoders *in toto* add to the historical context. For the illustration historian, gathering basic information for each of the components of the preceding chart helps identify curious and interesting cause-and-effect linkages between components. It is these linkages, rather than the dry facts considered discretely, that will lead to engrossing research questions and topics.

Image, Text, and Format

The relationship of image to verbal text is a key element of coding, and a major area of study among illustration historians and theorists. Illustration may be inspired by a verbal text, accompany or expand on it, or even use textual elements as denotation or imagistic marks—but certainly the verbal text is not foundational to the creation of *all* illustrations; nor is it determinative of any given illustration. Illustration always asserts something of its own. That said, narrative forms are central to communicating ideas, and illustration is a primary vehicle for articulating and refining narratives. Accordingly, critical discussions frequently examine how the illustration's message and purpose are encoded in the work's forms and format in relation to its verbal text; and how visual and verbal components are interdependent in delivering meaning.

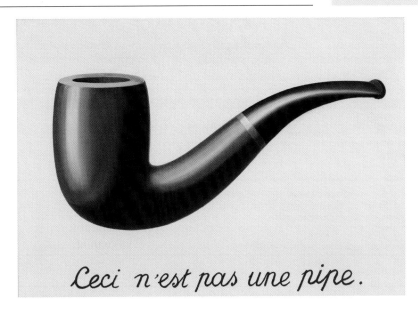

Figure 0.3
René Magritte, (Belgian, 1898–1967) *La Trahison des images* (*The Treachery of Images*), 1929. Oil on canvas, 23 5/8 x 31 7/8 cm.
The caption, "Ceci n'est pas une pipe," means "This is not a pipe." With this combination of text and image, Surrealist René Magritte underscores the obvious, declaring that despite its clear and apparently neutral presentation, the *depiction* of the pipe, like all images, is not the "real" thing.
© Artists Rights Society, New York.

Furthermore, the format may embody certain meanings in and of itself. This is what theorist Marshall McLuhan meant when he stated, "The medium is the message." For instance, an illustration first published as a large color plate in an early twentieth-century gift-book will convey a different sense and meaning when reproduced as a black-and-white miniature in a Postmodern 'zine.

In sum, the illustration historian should explain how the illustration (the code)—was determined by the illustrator (the encoder) within his or her particular historical and technological context, and was understood (decoded) in its own time—taking into account any layered meaning acquired through recontextualization. Central to all of this is acknowledgment that analysis of this kind is invariably inflected by human subjectivity as well as the quantity of information available—and therefore open to thought-provoking debate.

Further Reading

Gowans, Alan, *The Unchanging Arts: New Forms for the Traditional Functions of Art in Society* (Philadelphia: Lippincott, 1971).

Klanten, Robert, and Hendrik Hellige, "Illustration—An Attempt at an Up-to-Date Definition," in *Illusive: Contemporary Illustration and Its Context* (Berlin: Die Gestalten, 2005).

Male, Alan, *Illustration: A Theoretical and Contextual Perspective* (Worthing: AVA Publishing, 2007).

Miller, J. Hillis, *Illustration* (London: Reaktion Books, 1992).

Prehistory–100 CE

	PREHISTORY	**3000 BCE**
Religion, Ideas, and Culture		**Great Pyramid of Khufu** *ca. 2560 BCE* Egyptians develop elaborate tombs and rituals preparing for afterlife. **Moses** *ca. 1400 BCE* Prophet important in Judaism, Christianity, Islam, Bahá'í faiths is born.
Geopolitical Events and Conflicts		**Olmec civilization** *ca. 1200–400 BCE* Mesoamerica culture is first to erect pyramid-like structures in Americas (900 BCE).
Science and Inventions	**Agriculture Begins** *ca. 12,000 BCE* **Invention of Plow** *ca. 4500 BCE*	**Egyptian power** Territories of Nile Delta and valley to south dominated by Ancient Egypt through 30 dynasties (ca. 3100 BCE–363 BCE).
Art and Communication Media	**Parietal Art (cave art)** *ca. 40,000 BP* Earliest known communication made through images. **Pottery** *ca. 20,000 BP* Xianrendong Cave, China, cache of most ancient ceramic vessels found to date.	**Iron working** *ca. 1500 BCE* Early ironworking emerges in Anatolia, India, and parts of Africa (1500 BCE). Becomes central in Asia and Europe (ca. 800 BCE); used for steel weaponry and tools after 200 CE. **Writing** *ca. 3500 BCE* Writing evolves, likely from counting in the Mesopotamian region. **Hieroglyphs** *2686–2181 BCE* Egyptian picture/text visualizes ideas in standardized forms.

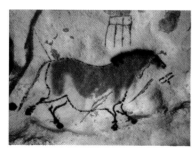

1.2 Chinese Horse, ca. 32,000–26,000 BP, Lascaux, France.

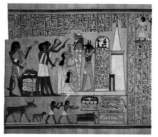

1.3 Opening of the mouth ceremony, ca. 1300 BCE, Thebes.

7.2 Cornice Fragment,
700-500 BCE, Chavin culture.

500 BCE

100 CE

The Buddha *ca. 500 BCE*
Siddhartha Guatama born.

Buddhist and Jain scripture *ca. 400 BCE*
In India, monks record sacred texts to preserve knowledge.

Plato *427–347 BCE*
Influential Greek philosopher.

Mogao and Yulin Grottoes *366 CE–1400*
492 caves of murals, sculptures, and movable Buddhist art are
created at strategic point along Silk Road.

First Buddhist Council *486 CE*
Buddhist canon is settled at Rajagaha.

Roman Empire *509 BCE–285 CE*
Romans establish independent republic (509 BCE), occupy
neighboring regions (265 BCE). Octavian named "Emperor"
(31 BCE).

Silk Road *200 BCE–ca. 1400s CE*
China and Europe trade routes linked first overland, then via sea.

Fall of Rome *285 CE*
Emperor Diocletian divides empire and moves capital to Byzantium
(Constantinople/Istanbul). Rome sacked by Visigoths (410 CE).

Christianity in Byzantine or Eastern Roman Empire
ca. 330–1453 CE when was it illegal
Byzantine emperors make Christianity legal, then official religion,
with the Eastern Church's capital in Constantinople (Istanbul).

Astrolabe *140 BCE*
Instrument used in early astronomy and maritime exploration.
Superseded by the sextant in the eighteenth century.

Ptolemy *ca. 100–170 CE*
Greek scientist writes treatises on astronomy and geography,
originating map projection of the world.

Zero *ca. 500 CE*
Mathematicians in India develop concept of zero, enabling
efficient numerical calculations; mathematician Fibonacci
brings it to Europe ca. 1200 CE.

Paper *100 BCE–105 CE*
First papermaking industry emerges in China [Han dynasty];
becomes pivotal in record-keeping and information sharing.

Story scrolls *before 100 BCE*
In India, drawings on scrolls illustrate sacred texts, and are
performed by itinerant storytellers.

Parchment and vellum *125 CE*
Substrate made of animal skin made thin and flat to accept ink
makes writing more efficient.

Codex *175 CE*
This folded book form is more easily indexed; gradually replaces
the scroll.

Illuminated manuscripts *450 CE*
Flat codex book allows for creation of elaborately painted pages.

1.4 *Tomb of the Diver,*
ca. 470 BCE, Paestum.

3.1 Ajanta Caves,
200 BCE–600 CE, India.

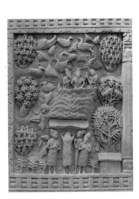

**3.7 The Miracle of Walking
on the Waters of Nairanjana
River, Great Stupa,**
100 BCE–0 CE, Sanchi.

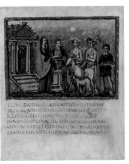

1.9 "Dido making a sacrifice,"
Vergilius Vaticanus ca. 400 CE.

**1.10 "Jacob Wrestling
the Angel,"** *Vienna
Genesis,* sixth century,
Syria region.

**5.3b Cave 25 of the Yulin
Caves,** ca. 810,
Gansu Province.

600 CE–1400

600 CE

900 CE

Religion, Ideas, and Culture

Islam *632 CE*
Prophet Muhammad founds Islam in Mecca. Islamic calendar begins (622 CE).

Christianity in England *597 CE*
St. Augustine arrives in Kent, becomes first Archbishop of Canterbury.

Charlemagne *800 CE*
Crowned Emperor of central Europe; aligns with Pope in Rome.

East–West Schism *1054*
Eastern Orthodox and Roman Catholic Church split.

University of Bologna *1088*
First university established.

Crusades *1095–1291*
Succession of wars waged by European Christians against Middle Eastern Muslims and against the Moors in Spain and Portugal.

Geopolitical Events and Conflicts

Teotihuacan civilization ends *ca. 600 CE*
Largest Pre-Columbian city destroyed by fire.

Abbasid Caliphate *750–1258 CE*
Muslim dynasty controls Near East and parts of North Africa.

Muslim scientific knowledge *ca. 900 CE*
Scholars preserve ancient knowledge on alchemy, astronomy, medicine, mathematics, botany, physics.

Science and Inventions

Narrative ceramic vessels created in Mesoamerica *600–800 CE*

Paper in Europe *900 CE*
Paper introduced to Europeans through contact with Islamic cultures.

Art and Communication Media

Printed books *ca. 868 CE*
Diamond Sutra (China) is world's oldest known printed book. Its fine quality suggests printing has been long established.

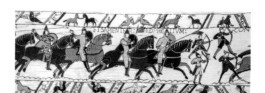

1.7 Battle Scene, *Bayeux Tapestry*, Scene 51 (detail), ca. 1077–1082.

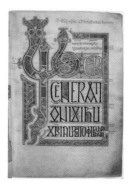

1.11 "Portrait of St. Matthew," *Lindisfarne Gospels*, ca. 720 CE, Eadfrith.

5.7 *Diamond Sutra* (*Jin'gang jing*), 868 CE. Mogao Caves, Dunhuang.

4.24 "A library in Basra," *Maqamat (Sessions) of al-Hariri*, 1237, Yahya ibn Mahmud al-Wasiti.

1200

Inquisition *1200–1600* ////
Church-established court to punish heresy and persecute dissidents.

Mongol Empire *1206–1405*
Founded by Genghis Khan, empire encompasses much of Asia, Middle East, and parts of Eastern Europe.

Plague *1334–1354* //// *what's the modern plague*
Transmitted by fleas, "Black Death" decimates Europe, recurs in significant bouts until the nineteenth century.

Hundred Years' War *1337–1453*
Series of wars between England and France over succession to the French crown.

Eyeglasses *ca. 1250*

Hourglass and Clock *ca. 1300*
Hourglasses become common in Europe, especially helpful with navigation at sea. Mechanical clocks invented about the same time.

Paper making in Europe *ca. 1260*
First ongoing paper making in Europe established in Fabriano, Italy.

Xylography (woodcut printing) in Europe *Late 14th c.*

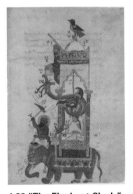

4.23 "The Elephant Clock," from *Compendium on the Theory and Practice of the Mechanical Arts,* 715 AH (1315 CE), al-Jazari.

1 14h Martyrdom of Isaiah (detail), Bible, ca. 1245, Paris.

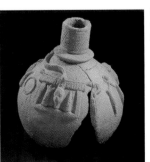

8.1 Ife ritual vessel, thirteenth century, Yoruba culture.

1400

Renaissance *1400–1600* //// /
European artists, scientists, and writers advance humanist ideas and creativity.

Fall of Constantinople to Ottoman Empire *1453*
Former Eastern Roman Empire capitulates to Ottoman rule.

Ottoman Empire invasions of Europe *1453–1683*
Conquests of modern-day Eastern Europe by Islamic combatants.

Colonial period begins *1492*
Christopher Columbus finds the "New World;" inaugurates European exploration, exploitation, Christian evangelization, and colonization of the Americas. Vasco da Gama navigates around Africa (1498), establishing ocean route to India.

Linear perspective *1435*
Leon Battista Alberti devises mathematical method for illusionistic depiction of three-dimensional space.

/// **Anatomy books** *1491*
Johannes de Ketham's *Fasciculus medicinae* is first printed guide to dissection and anatomy.

Block books *Late 15th c.*
European codices are printed from relief blocks combining text and illustrations on the same block.

Typographic printing *ca. 1450*
Gutenberg's moveable type enables mass reproduction of texts.

Engraving *ca. 1470*
Intaglio printing technique on metal plates enables fine detail.

2.2 *Biblia Pauperum*, ca. 1460s, South Netherlandish.

10.2 *a Fasciculo de medicina* 1494, Johannes de Ketham.

2.17 *St. Anthony Tormented by Demons,* ca. 1472, Martin Schongauer.

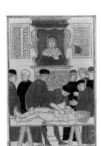

2.3 *The Golden Legend (Legenda aurea),* 1493, Wynkyn de Worde, English version by William Caxton.

7.8 "Venus Causes a Solar Eclipse," *Codex Borgia,* ca. 1500, Mayan culture.

1500–1700

1500 **1600**

Religion,
Ideas, and
Culture

Copyright for illustration *1500*
Jacopo de' Barbari's *View of Venice* granted protection under Venetian law.

Protestant Reformation *1517*
Dissent leads to establishment of Protestant Christianity.

Counter-Reformation *1545*
Expansion of Protestantism and sacking of Rome in 1527 prompt long-needed reforms of the Church.

Scientific Revolution *ca. 1550–1700*
Humanist emphasis on observation and verification allows scientific knowledge to advance rapidly.

Europeans leave Japan *1606–1624*
Anti-Christian edicts and persecution prompt exodus of Europeans.

Edo (or Tokugawa) Period *1639–1868*
Japan's isolationist policy creates politically stable environment; theater, poetry, and woodblock printing flourish.

East India Company *1600–1874*
Enterprise chartered by Queen Elizabeth I of England acts as agent of British imperialism in India.

30 Years' War *1618–1648*
Series of wars between Protestants and Catholics over religious beliefs causes widespread devastation and famine.

English civil wars *1642–1651*
England's government changes from monarchy to commonwealth.

Geopolitical
Events and
Conflicts

Circumnavigation of world *1522*
Ferdinand Magellan and crew circumnavigate the globe using the South American passage that now bears his name.

Viceroyalty of New Spain *1522*
Hernán Cortés establishes the Spanish colonial government seat at former Aztec capital Tenochtitlán (Mexico City).

Mughal Empire *1526–1857*
Muslim rulers control the Indian subcontinent and neighboring territories, bringing Persian arts with them.

Europe at War *ca. 1550–1714*
Numerous small and large boundary-shaping campaigns are waged.

Telescope *1610*
Galileo Galilei uses simple refractor telescope lenses in his astronomical studies and drawings.

Electricity *1600*
English scientist William Gilbert coins word *electricus* to describe charged properties of amber when rubbed.

Science
and
Inventions

Dürer's Treatises *1525–1528*
Treatise on Measurement and the *Four Books on Human Proportion* record Albrecht Dürer's theories on mathematics and form.

Modern medical illustration *1543*
Andreas Vesalius's *De humani corporis fabrica (The Fabric of the Human Body)* embraces human dissection in medical study.

Heliocentrism *1543*
Copernicus publishes thesis that the Earth revolves around the sun.

Interactive anatomy books *ca. 1600–1800*
"Flap-anatomy" books with movable layers representing organs encourage lay interest in the human body.

Chromoxylography *ca. 1600*
Polychrome woodblock prints appear in landmark Chinese book, *Ten Bamboo Studio Manual of Painting and Calligraphy.*

Pantograph *1603*
Mechanical tool to reduce or enlarge copies of drawings is invented by Christoph Scheiner.

Art and
Communication
Media

Broadsides *ca. 1500*
One-sided ephemeral prints share news, stories, songs.

Etching *ca. 1515*
Intaglio printing technique permits freehand drawing.

Pencil invented *ca. 1570*

5.16 "Plum And Camellia," *Ten Bamboo Studio Manual of Painting and Calligraphy,* 1633, Hu Zhengyan.

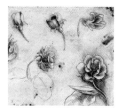

9.1 Botanical studies (detail), ca. 1505, Leonardo da Vinci.

10.6a, *De humani corporis fabrica (On the Fabric of the Human Body)* by Vesalius, 1543, Stefan van Calcar (attributed).

4.1 *Akhlaq-i Nasiri (The Nasirean Ethics),* ca. 1590–1595, Sajnu (attributed).

10.8 *Catoptri microcosmici (Mirrors of the Microcosm),* 1613, Lucas Kilian and Johann Remmelin.

12.3 "La Pendaison" ("The Hanging"), from the series *Les Misères et les malheurs de la guerre (Miseries and Misfortunes of War),* 1633, Jacques Callot.

1650

1700

Le Mercure galant *1672–1724*
French magazine is first to make fashion a regular feature.

Enlightenment *ca. 1650–1800*
European movement emphasizes humanism, reason, science, and progress over religion and superstition.

Encyclopedia (China) *1728*
Illustrated Synthesis of Books and Illustrations of Ancient and Modern Times has over 800,000 pages.

Hogarth's Act *1735*
Parliament passes Britain's first copyright act protecting visual art.

Great Turkish War *1683–1699*
Central and Eastern European nations unite to fight the Ottoman Empire, which concedes much territory.

Great Britain formed *1707*
England and Scotland united. Ireland added in 1800.

Binomial nomenclature *1737*
Carl Linnaeus creates first taxonomy of plants, *Systema naturae.*

Simple microscope *1668*
Dutch scientist Antonie van Leeuwenhoek develops advanced microscopy capable of 270X magnification.

Reflecting telescope *1672*
Isaac Newton's telescope uses mirror to reduce aberrations caused by lens-only designs.

Prussian blue *1704*
Prussian blue pigment chemically created in Germany is soon used in European cloth and paintings.

Steam engine *1698*
Thomas Savery develops steam engine applied industrially in mining. Contributes to the automation of trades and Industrial Revolution.

Color mezzotint *ca. 1740*
Intaglio color printing process.

Aquatint *ca. 1650*
Etching process, invented by Jan van de Velde IV, produces a tonal rather than linear effect.

Magic Lantern *ca. 1650*
Precursors to cinema, opaque projectors, and slide projectors, the magic lantern is used for trickery, amusement, education, and tracing copies of images.

Mezzotint *1680*
Intaglio printing method produces rich blacks and fine tonal gradations, ideal for reproducing the realism of oil painting in prints.

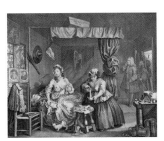

11.2 *A Harlot's Progress,* 1732, William Hogarth.

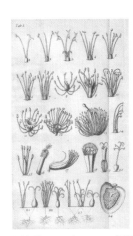

9.16 *Genera plantarum,* 1737, Georg Dionysius Ehret.

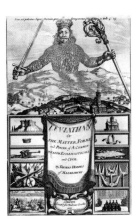

12.4 Frontispiece, *Leviathan,* 1651, Abraham Bosse.

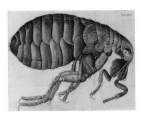

9.13 "Flea," *Micrographia,* 1665, Robert Hooke.

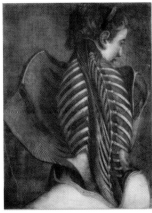

10.18 "Flayed angel," 1746, Jacques Fabien Gautier d'Agoty.

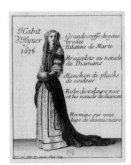

17.3 "Habit d'Hyver," *Le Mercure galant,* 1678.

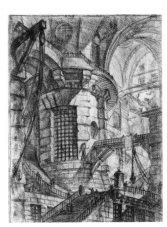

12.9 "Vaulted Building With Staircase," *Invenzione Capric di Carceri,* ca. 1748, Giovanni Battista Piranesi.

1750–1840

1750 **1800**

Religion, Ideas, and Culture

Encyclopedia (Europe) *ca. 1747-1780*
In France, Diderot and d'Alembert compile *Encyclopédie, ou dictionnaire raisonné des sciences, des arts et des métiers.*

Blue Stockings Society *1750–1790*
Gatherings of intellectually oriented Englishwomen, hailed as a precursor to feminism.

Industrial Revolution *ca. 1750–1850*
Invention of steam engine (1712) leads to mechanization of industries in England. People leave rural life for employment in factories in cities. Poverty and overcrowding ensue, middle class emerges.

Romanticism *ca. 1785–1845*
Complex period of philosophical thinking and artistic creation, emphasizing human emotional experience and spirituality. Often considered in opposition to the Enlightenment's emphasis on reason.

Science fiction *1818*
Frankenstein, or The Modern Prometheus, now considered a forerunner of science fiction, is written by Mary Shelley.

American Temperance Society *1826*
Established to agitate for elimination of alcohol.

Picture stories/Comic books *1827*
Rodolphe Töpffer creates "picture stories" for his students, later reprinted as first American comic book, *The Adventures of Obadiah Oldbuck* in 1842.

Geopolitical Events and Conflicts

American War of Independence *1775–1883*
Colonies in North America break with British rule.

French Revolution *1787–1799*
End of absolute monarchy; adoption of democratic rule underpinned by ideals of civic equality (among men) and freedom of religion.

Napoleonic Wars *1803–1815*
Pro-British coalitions fight against France and her allies, who are led by Napoléon Bonaparte.

Mexican War of Independence *1821*
War ends Spanish rule of New Spain.

Science and Inventions

Royal Botanical Expedition *1783*
Fifteen-year expedition studies and documents plant species of New Grenada.

Gas light *1805*
Cotton mill in Manchester, England, is first factory lit with gas.

Camera lucida or **"lucy"** *1807*
Optical aid allows artists to trace projections of three-dimensional scenes or objects onto paper, printing plate, or canvas at different scales. Remains in use into the twentieth century.

Printing press in India *1807*
Embraced by locals after Jesuits bring first press to Goa in 1556.

Pencil *1812*
Cabinet-maker William Monroe thought to have made America's first wood-encased pencils.

Prussian blue in Japanese prints *ca. 1820*
Prussian blue finds its way into Japan; used in woodblock prints.

Steam-Powered Rotary Press *1828*
French printer Claude Genoux puts curved printing plates onto rollers, enabling printing of four thousand sheets per hour.

Art and Communication Media

Opaque projector *ca. 1750*
This device that projects an opaque image remains in use until digital imaging begins.

Wood engraving *1785*
Thomas Bewick's innovation of carving into endgrain of boxwood rather than side grain allows for finer detail in relief printed imagery.

Relief etching *1794–1820*
Blake's experimental etching technique creates relief plates that he uses to self-publish hand-lettered and illustrated texts.

Lithography *1798*
Planographic printmaking process based on the mutual antipathy of oil and water, invented by Alois Senefelder.

12.6 "Papetterie," 1767, Diderot and d'Alembert.

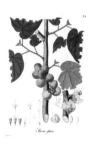

7.19 *Myrodia globosa*, ca. 1790, Antonio Barrionuevo.

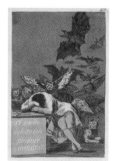

12.14 *Europe a Prophecy*, 1794, William Blake.

12.17 "The Sleep of Reason Produces Monsters," 1799, Francisco de Goya.

14.1 *History of British Birds*, 1797–1804, Thomas Bewick.

11.11 *The Plumb-pudding in Danger*, 1805, James Gillray.

6.18 "Under the well of the great wave off Kanagawa," ca. 1829–1833 *Thirty-six Views of Mount Fuji*, Hokusai.

22.2 *Frankenstein*, or, ***The Modern Prometheus*,** 1831, Theodor von Holst.

1830

Godey's Lady's Book *1830-1896*
Seminal long-running U.S. women's magazine.

Le Charivari *1832*
Influential illustrated French daily newspaper, often satirical. Copied in England as *Punch* in 1841.

The Penny Magazine *1832*
First periodical in England illustrated with wood engravings.

Brothers Dalziel *1839–1890*
Most prolific English wood engraving firm; produces blocks for *Illustrated London News, Punch,* and many artists.

Slavery Abolition Act *1833*
British Parliament makes slavery illegal in most of British Empire; India, Sri Lanka, and St. Helena added in 1843.

Revolver *1836*
Samuel Colt patents first rapid-firing handgun.

Electromagnetic technology *ca. 1832*
English scientist Michael Faraday advances knowledge in electromagnetism and electrochemistry.

Precursors to Animation *1832–1834*
Belgian Joseph Plateau invents phenakistoscope, William George Horner invents zoetrope. Both devices create illusion of movement.

Telegraph *1838*
First commercial electric telegraph system implemented in England.

Photography *1839*
Louis Daguerre (France) and Henry Fox Talbot (England) independently introduce methods of permanently fixing light projections.

1840

Illustrated London News (ILN) *1842*
High volume British newspaper prints over 7,500 wood engravings, creates demand for pictorial reportage.

L'Illustration *1843*
France's first major illustrated newspaper carries visual reportage of theater and current events.

Frederick Douglass *1845*
Narrative of the Life of Frederick Douglass, An American Slave is published, a seminal text in abolition movement.

The Communist Manifesto *1848*
Pamphlet by Karl Marx and Friedrich Engels criticizes economic structures that perpetuate inequality between classes.

Pre-Raphaelite Brotherhood *1848*
Anti-academic British artists influenced by critic John Ruskin revive medieval artisitic values.

Cholera *1846–1849*
Late 1840s pandemic in Europe, Asia, Central America, and North America.

Paint tubes *1840*
Painter John Goffe Rand invents portable containers for *plein air* use. Winsor & Newton quickly adopt the idea.

Computer programming *1843*
Ada Lovelace develops first program, which calculates numerical sequence using algorithm for machine pioneered by Charles Babbage.

Postage stamp *1849*
First postage stamp ("Penny Black") depicts Queen Victoria.

3-D imaging *1849*
Charles Wheatstone pioneers illusion of three-dimensional pictures with stereopticon cards (1838); Sir David Brewster improves it (1849). Mass production of stereoscopes and cards available from 1850.

3.28 The Jagganatha Rath Yatra Procession of 1822, Puri, Orissa, Anon.

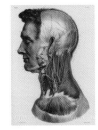

10.23 Nerves of the neck, in *Traité complet de l'anatomie de l'homme,* 1831–1854, Nicolas-Henri Jacob.

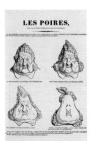

11.15 Les Poires, 1831, Honoré Daumier.

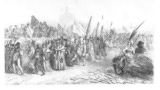

11.18 "Grand Review Passing before 'La Caricature,'" *L'Association mensuelle,* October 30, 1832, J. J. Grandville.

23.1 The Adventures of Obadiah Oldbuck, 1841, Rodolphe Töpffer.

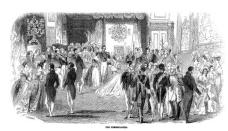

14.7 The Illustrated London News, 1843, John Gilbert.

14.3 The Pictorial History of Germany, During the Reign of Frederick the Great, 1845, Adolph von Menzel.

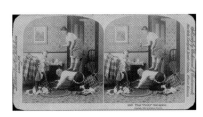

18.3 "That Pesky Rat Again," 1891, stereoscope photograph.

1850–1880

1850 ## 1860

Religion, Ideas, and Culture

Great Exhibition and Arts & Crafts Movement *1851*
International arts and industry showcase held at London's Crystal Palace fuels consumption, innovation, and professionalization of design.

Frank Leslie's Illustrated Newspaper *1855*
Heavily illustrated periodical dominates American news production, with competitor *Harper's Weekly* established in 1857.

The House of Worth *1858*
First couturier, Charles Frederick Worth, establishes business in Paris.

Theory of evolution *1859*
Charles Darwin's *On The Origin of Species* rejects Biblical history.

Cooper Union School of Design For Women *1859*
Free instruction to girls and women in illustration and wood engraving.

the Sixties *ca. 1857 - 1870*
British book illustration enters rich period called "the Sixties." Some work influenced by Pre-Raphaelites.

Dime Novels *1860*
Beadle's Dime Novels expands market for cheap, sensational adventure stories.

Japan Punch *1862*
Started by Charles Wirgman, English artist and cartoonist for the *Illustrated London News*; offers humorous and satirical images.

Alice's Adventures in Wonderland *1865*
Landmark fanstasy tale by Charles Dodgson (a.k.a. Lewis Carroll), rife with memorable characters, puzzles, and word-play.

Semiotics *1866*
Charles Sanders Peirce begins developing his theories of signs.

Académie Julian *1867–1968*
Paris atelier welcomes American artists who study academic drawing and painting, and later design and illustration, with French masters.

Geopolitical Events and Conflicts

Crimean War *1853–1856*
Alliance of France, Britain, Ottoman Empire, and Sardinia defeat Russian Empire in battle over territory in crumbling Ottoman Empire.

British Raj *1858*
British secure control of India after unsuccessful rebellion by Indian Army at Barrackpore in 1857 (the First War of Indian Independence).

American Civil War *1861–1865*
Conflict between northern and southern U.S. states ends slavery; the war is extensively covered in illustrated newspapers.

Meiji Era *1868–1912*
Americans open access to Japan, enabling cross-cultural influences such as Japonisme in European art.

Science and Inventions

Calculator *1851*
Commercially viable adding machines exhibited at the Great Exhibition, London.

Gray's Anatomy *1859*
Published in compact format to be carried to dissection theater by medical students.

Periodic Table of Elements *1869*
Invented by Russian chemist Dmitri Mendeleev.

Art and Communication Media

Chromolithography and Louis Prang & Co. *1856–1897*
Boston-based printing company manufactures first commercially produced greeting cards. Fuels appetite for color print.

Aniline dye *1856*
New synthetic dye (mauve) is patented, ushering in new pigments for paints and textiles.

Trans-Atlantic telegraph *1866*
Telegraph cables become reliable form of same-day Trans-Atlantic communication.

Typewriter *1867*
Pioneered in the U.S. by Christopher Latham Sholes and associates.

Halftone *1869*
First photomechanical reproduction of photograph breaks image into tiny dots (originally called a leggotype).

13.17 "An Aged Dame of Cornish Fame," 1851, John Brandard.

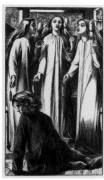

15.1 "The Maids of Elfen-mere," 1855, Dante Gabriel Rossetti.

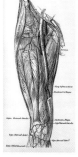

10.27 Gray's Anatomy Descriptive and Surgical, 1859, Henry Vandyke Carter.

15.3 "The Lady of Shalott," 1857, William Holman Hunt.

6.23 Amerika, 1860, Hiroshige II.

13.15 "Our Special," 1864, Winslow Homer.

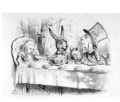

16.8 Alice's Adventures in Wonderland, 1865, John Tenniel.

1870

1880

Art Students League of New York *1875*
Student-run school offers individual classes taught by prestigious instructors. Provides art education to illustrators.

Livre d'artiste *1875*
Édouard Manet designs interpretive avant-garde images for Poe's "The Raven," establishing artist's books as a new direction for fine illustrated books.

Franco-Prussian War and **Paris Commune** *1870–1871*
German Empire consolidated, France loses Alsace-Lorraine region. Thousands of Communards, who supported the Paris Commune (short-lived Communist government) are executed.

Chromoxylography in Europe *1874*
Printer Edmund Evans publishes colorful children's books using wood blocks (1865); sets new standard for children's picture books.

Telephone *1876*
Invented by Scottish-born Alexander Graham Bell.

Phonograph *1877*
Invented by Thomas Edison.

Ben-Day tint *1879*
Benjamin Henry Day Jr. patents pre-made dot pattern screens to approximate mid-tones or add color tints in commercial printing.

Poster Movement *1881–1900*
Authorization to paste posters on Paris walls (1881) sparks rise of colorful posters.

Ladies' Home Journal *1883*
Highly illustrated, longest-running women's interest magazine is established.

Women's suffrage movement *ca. 1880–1950*
Women agitate for right to vote. Most European countries and U.S. gradually award suffrage to women after WW I.

Posada *1887*
Illustrator José Guadalupe Posada moves to Mexico City, produces 20,000 images over next 25 years.

Electric power *1882*
Pearl Street Station in New York City is built by Thomas Edison.

Safety bicycle *1885*
Bike with equally sized wheels allows women unprecedented freedom to roam.

Automobile and motorcycle *1885*
Karl Benz invents automobile using his internal combustion engine; Gottlieb Daimler invents the motorcycle.

Gillotage *1880*
Photoengraving process allows artists' line art to be photomechanically reproduced without being redrawn by engraver.

Mimeograph *1884*
A.B. Dick and Edison develop stencil-based forerunner of photocopiers.

Linotype *1886*
Ottmar Mergenthaler invents automated typesetting machine.

Motion picture camera *1888*
William K.L. Dickson develops motion-picture camera. Resulting short films are viewed in peep-show box by one person at a time.

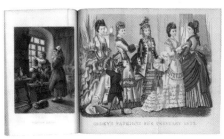

18.18 *Godey's Lady's Book,* 1873.

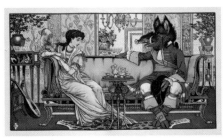

16.14 *Beauty and the Beast,* 1874, Walter Crane.

14.14 "Monet par Manet," 1880, Édouard Manet.

14.16 *Histoire des quatre fils Aymon,* 1883, Eugène Grasset.

18.12 "Calderwood Read it Aloud Slowly," *The Century,* 1884, Arthur Burdett Frost.

1890–1915

| 1890 | 1900 |

Religion, Ideas, and Culture

Golden Age of Illustration *late 19th to early 20th c.*
Illustrated print media burgeons with improved printing technology, delivery methods, and expanded audiences.

Art Nouveau *ca. 1890–1910*
International style of art, architecture, and applied art characterized by serpentine lines, figures of women, and floral motifs.

World's Columbian Exposition *1893*
Exposition in Chicago launches famous brands Cream of Wheat and Aunt Jemima; features world's first dedicated movie theater.

Kelmscott Press *1890–1896*
British Arts & Crafts book publishing by William Morris spawns the private press movement and modern graphic design.

Argosy *1896*
U.S. magazine publishes first all-fiction issue in format that later is dubbed "pulps" due to use of wood-pulp paper.

The Yellow Kid *1896*
Publication of first fully formed modern newspaper comic strip, *Hogan's Alley*, drawn by Richard Felton Outcault.

The Saturday Evening Post *1897–1969*
Widely circulated and influential magazine for American middle class, the *Post* is a prestigious venue for illustrators.

Pyle School of Art *1900–1905*
Howard Pyle founds illustration school in Wilmington, DE with hopes of establishing a vital form of American art.

New York Society of Illustrators *1901*
Illustrators establish a professional society to improve relations with clients and enhance visibility as a profession.

Gibson Girls *ca. 1902*
Charles Dana Gibson's popular cartoons of society belles land him $100,000 contract to produce 100 drawings for *Collier's* in 1902.

Bécassine *1905*
French comic strip *Bécassine* by Pinchon, Caumery, and Rivière features the medium's first female protagonist.

Maclean's *1905*
National Canadian magazine features news and fiction; initially uses many U.S. illustrators; supports mainly Canadian talent by 1940s.

La Follette's Weekly *1909*
Wisconsin-based monthly magazine of liberal politics, culture, and progressivism; later renamed *The Progressive*.

Psychoanalysis *1909*
Little Nemo in Slumberland, a 1905 comic strip by Winsor McCay, delves into the unconscious. Freud and Carl Jung lecture on psychoanalysis in the U.S. in 1909.

Geopolitical Events and Conflicts

Sino-Japanese War *1894–1895*
Japan's victory over China brings Korea independence and makes Taiwan a Japanese colony (returned after WW II).

Spanish American War *1898*
U.S. involvement in Cuba's struggle for independence is influenced by exaggerated news coverage called "yellow journalism."

South African (Boer) War *1899–1902*
The British gain control of South Africa.

Russo-Japanese War *1904–1905*
Russian expansion in East Asia ends in Russia's defeat and increased Japanese control over Korea and parts of Manchuria.

Air transportation *1900*
First zeppelin is flown. Wright brothers make first glider flight (1900) and first powered flight (1903).

Science and Inventions

Wilhelm Röntgen discovers X-ray *1895*

Kunstformen der Natur *1899*
Ernst Haeckel's painstaking illustrations of microscopic organisms enchant non-scientific audiences and influence Art Nouveau.

The Interpretation of Dreams *1899*
Sigmund Freud's book introduces the concept of the unconscious and its effect on thought and behavior.

Atlas der deskriptiven Anatomie des Menschen *1904*
German atlas by Johannes Sobotta considered masterpiece of macroscopic anatomy for its quality and detail.

Assembly line *ca. 1901*
High-speed industrial production workers repetitively perform one specialized small task in sequence. Soon used to manufacture cars.

Kodak Brownie Camera *1900*
Small, easy-to-use camera encourages masses to take informal snapshots. Illustrators photograph models to assist drawing.

Color photography *1903*
French Lumiére brothers invent color photography, commercially available in 1907.

Offset lithography on paper *ca. 1903*
Printers perfect high-speed lithographic printing, previously used on metal since 1875.

Art and Communication Media

Animation *1892*
Charles-Émile Reynaud's short *Pantomimes lumineuses* debuts in Paris.

Three-color-process printing *1892*
U.S. inventor Frederic Eugene Ives announces a three-color process for reproducing full-color illustrations using halftone screens.

Film projector *1895*
Auguste and Louis Lumière patent a projector that allows films to be shown to a group audience.

15.6 *Complete Works of Geoffrey Chaucer,* 1896, William Morris, Edward Burne-Jones, William Harcourt Hooper.

23.2 The Yellow Kid (detail), 1896, Richard Felton Outcault.

15.20 JOB cigarette papers, 1898, Alphonse Mucha.

18.14 "Her Day," *Life,* 1903, Charles Dana Gibson.

21.1 *Our Forces' Great Victory in the Battle of the Yellow Sea,* 1905, Kobayashi Kiyochika.

23.3 *Little Nemo in Slumberland, New York Herald,* (detail), December 20, 1908, Winsor McCay.

1910

Cubism *ca. 1910*
European artists eschew optical realism, explore simultaneity of viewpoints to express essential form.

Hollywood *1910*
D.W. Griffith films *In Old California,* the first Hollywood movie.

Krazy Kat *1913*
Idiosyncratic, surreal comic strip by African American cartoonist George Herriman begins.

Armory Show *1913*
Seminal exhibition held in New York City introduces the U.S. public to Cubism and other modern art trends.

American Institute of Graphic Arts *1914*
Professional industry group is established at the National Arts Club in New York City.

Mexican Revolution *1910–1920*
Overthrow of the government leads to drastic cultural and political change. The Constitution of Mexico is established in 1917.

Neon Lighting *1910*
Generated by charging inert gas trapped in a glass tube, this brightly glowing light is demonstrated at the Paris Motor Show.

Johns Hopkins University Medical Illustration Program *1911*
Max Brödel, "father of modern medical illustration," begins world's first formal medical illustration program.

1915

Semiotics *1916*
Ferdinand de Saussure's theories of signs published in France as *Course in General Linguistics.*

Bauhaus *1919–1933*
German school promotes integration of modern design into everyday life. After closure by Nazi Party, some instructors teach in the U.S.

Distance art lessons *1919*
Early art education by mail is offered by the Correspondence School of Illustrating, and Federal Schools of Commercial Designing.

Harlem Renaissance *ca. 1919–1935*
New York's Harlem neighborhood becomes important site of cultural, social, and artistic innovation and influence.

Prohibition *1916–1930*
Nationwide constitutional ban of alcohol in 1920 is repealed in 1933 after attempts to enforce the law repeatedly fail.

World War I *1914–1918*
Pan-European war is at this time the most deadly war ever fought.

Russian Revolution *1917*
Tsarist Russia is overthrown, marking the beginning of Communism.

Weimer Republic *1919–1933*
German democratic government formed post-WWI; its economic crises and internal factionalism create a fertile environment for Hitler's rise to power.

Radio *1918*
Developed by Tesla in the 1890s. In 1918, Edwin Howard Armstrong patents a radio circuit, key to making radio a common utility by 1922.

Transatlantic flight *1919*
John Alcock and Arthur Brown fly from Ireland to Newfoundland, the first non-stop transatlantic flight.

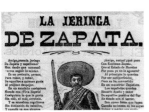

7.26 The Plague of Zapata (detail), ca. 1910, José Guadelupe Posada.

19.4 Saint Matorel (detail), 1910, Pablo Picasso.

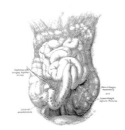

28.4 "Intestinal Obstruction Due to a Hole in the Mesentery of the Ascending Colon," 1914, Max Brödel.

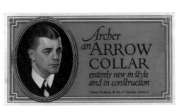

20.2 Streetcar card advertisement for Arrow Collars, ca. 1910-1925, J.C. Leyendecker.

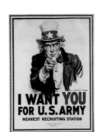

21.14 I Want You For U.S. Army, ca. 1917, James Montgomery Flagg.

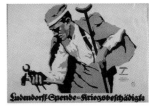

21.20 The Ludendorff Appeal for the War Disabled, 1917, Ludwig Hohlwein.

19.9 "Mouvement Dada," Dada #5, 1919, Francis Picabia.

1920–1950

1920

1930

Religion, Ideas, and Culture

American Birth Control League *1921*
Margaret Sanger advocates for access to contraception (then illegal).

Graphic Design *1922*
Term coined by W. A. Dwiggins, not widely used until the 1950s.

The New Yorker *1925*
Urbane periodical published using illustrated covers and cartoons to lance social and political pretensions.

Art Deco *1925*
Named for the *Exposition internationale des arts décoratifs et industriels modernes* in Paris, this art and architecture style uses flat, geometric shapes and patterns.

Stevens, Sundblom & Henry Studio *1925*
Chicago studio updates advertising brand mascots Aunt Jemima and Quaker Oats Man; later, iconic Coca-Cola Santa Claus.

Great Depression *1929–1939*
Crash of New York Stock Exchange triggers worldwide economic collapse.

Motion Picture Production Code (Hays Code) *1930*
Rules limiting portrayals of crime, sex and violence in film.

Syndicated licensing *1930–1940*
Licensed media circulation across multiple geographic areas; promotes shared sensibilities and mass recognition of cultural icons.

Gallup Poll *1931*
George Horace Gallup conducts first poll to quantify habits in newspaper readership. Statistical research thereafter drives advertising and marketing.

Charles E. Cooper Studios *1935*
Influential studio for photography and commercial art dominates advertising and ladies' magazine illustration in 1940s and '50s.

Caldecott medal *1937*
Awarded to an American children's book illustrator annually.

Golden Age of Comic Books *1938– ca. 1954*
Superman debuts in new format—the comic book.

Geopolitical Events and Conflicts

Irish Independence *1919–1949*
Irish War of Independence, 1919–1921; Irish Civil War, 1922–1923; Ireland becomes a republic, 1949.

Chinese Civil War *1927–1937; 1946–1950*
Communist Party of China gains control over Nationalists in two stages, interrupted by World War II.

Nazi Party *1933*
German National Socialist Party (Nazis) led by Adolf Hitler gains control of Germany.

The Great Purge *1936–1938*
Joseph Stalin carries out detentions and executions of 600,000–1,200,000 Russians suspected of opposition to Communist governance.

Science and Inventions

Penicillin *1928*
Alexander Fleming's discovery leads to the development of antibiotics.

Topographische Anatomie *1928*
A milestone in medical imagery by Eduard Pernkopf, this richly illustrated series remains problematic because of the author's association with the Nazi party.

Nuclear energy *1938*
Uranium atoms split with neutrons for first time.

Art and Communication Media

Isotype (International System of Typographic Picture Education) *1925*
Infographics and standardized public signage systems, developed by Otto and Marie Neurath.

Paperbacks *1935*
Penguin Books established in London; Pocket Books established in New York (1939). The small format eventually edges out pulps.

20.4 Cover of Woman's Home Companion, 1921, Neysa McMein.

28.20 *Das Leben des Menschen,* 1924, Fritz Kahn, Arthur Schmitson.

20.6 *Opportunity,* 1926, Aaron Douglas.

21.23 *Come Comrade, Join Us in the Collective Farm,* 1930, Vera Sergeyevna, Korableva.

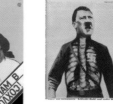

19.17 *"Adolf Der Übermensch: Schluckt Gold und redet Blech,"* 1932, John Heartfield.

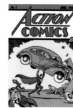

23.10 *Action Comics* #1, June 1938, Joe Shuster.

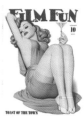

TB20.1 "Toast of the Town," cover of *Film Fun,* 1941, Enoch Bolles.

1940

1950

Captain America *1941*
Joe Simon's and Jack Kirby's superhero first appears in *Captain America Comics* #1 from Timely Comics, a predecessor of Marvel Comics.

Culture Critique *1944*
The Dialectic of Enlightenment by Marxist philosophers Theodor Adorno and Max Horkheimer condemns mass culture forms and their effects on creativity, culture, and consciousness.

The GI Bill *1944*
The Servicemen's Readjustment Act, created to fund education for veterans, allows many to study illustration.

Association of Medical Illustrators *1944*
Worldwide interdisciplinary network founded to further the use of visual media to advance life sciences, medicine, and health care.

Famous Artists School *1948*
Westport, Connecticut company offers sophisticated correspondence lessons in mainstream illustration.

Baby boom *1945–1955*
Population boom post WWII.

Postwar American economic growth *1950s*
Prosperity and standards of living increase in much of the U.S.; consumerism rises. Conservative social values prevail.

Peanuts *1950*
Iconic comic strip by Charles M. Schulz runs from 1950–2000.

Astro Boy *1951*
Japanese artist Osamu Tezuka creates *Astro Boy*, first modern manga.

Comics Code Authority (CCA) *1954*
Industry-sponsored censorship begins after government hearings contend mass media and comics injure children psychologically. *MAD* comics (1952) changes to a magazine (1954) to escape censorship.

Push Pin Studios *1954*
New York City firm heralds conceptual and postmodern illustration.

Brown vs. Board of Education *1954*
Legal ruling mandates desegregation of American schools.

Shrinking periodical market *1957*
As audiences move to television, longstanding American magazines begin to fail. *Collier's* ends in 1957; *The Saturday Evening Post* stops weekly publication in 1963.

World War II *1939–1945*
Near global conflict reconfigures power worldwide. Subsequently, United Nations is established.

Nuclear bomb attack *1945*
The atomic bomb is tested and then used by the U.S. against Japan, ending the war in Asia and the Pacific.

British Partition of India *1947*
The British Raj ends; modern state of Pakistan created.

Cold War *1946–1990*
The Soviet Union and the U.S. emerge from World War II as antagonistic superpowers competing for global control through increased arsenals and the implied threat of nuclear war.

Korean War *1950–1953*
North and South Korea permanently divide at the 38th parallel N.

Grant's *Atlas* *1943*
An Atlas of Anatomy, published in North America, organizes anatomy by regions, which is helpful with dissection.

Transistor *1947*
Makes electronic devices smaller and faster.

DNA double helix *1953*
The structure of human DNA is identified, laying the groundwork for molecular biology and genetics research.

Polio vaccine *1955*
Immunization against poliomyelitis begins; polio deaths plummet.

U.S. commercial television *1947*
Commercial broadcasts begin in urban centers of the U.S. Viewership grows from 6,000 in 1946 to 12,000,000 in 1951.

Bourges system *1952*
Jean Bourges introduces transparent tinted films for indicating color separations, simplifying spot color printing.

Photocopying *1959*
Xerox releases the first widely adopted photocopier; it replaces the mimeograph by the 1970s.

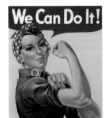

21.32 *We Can Do It,* ca. 1943. J. Howard Miller.

28.10 *An Atlas of Anatomy* by J. C. B. Grant, 1943, Dorothy Foster Chubb.

25.9 *Goodnight Moon,* 1947, Clement Hurd.

24.12 *New Television Antenna, The Saturday Evening Post,* November 5, 1949, Norman Rockwell.

24.20 *Travel Refreshed,* 1949, Haddon Sundblom.

23.16 *MAD #1,* E. C. Comics, 1952, Harvey Kurtzman.

24.21 "The Green Scarf," *Ladies Home Journal,* 1954, Joe DeMers.

1960–1990

1960

1970

Religion, Ideas, and Culture

Pop Art *1962*
Artists appropriate common commercial product designs, illustration, and media images in ironic gallery art.

Environmentalism *1962*
Book *Silent Spring* by Rachel Carson documents effects of pesticides and catalyzes environmental movement.

The medium is the message *1964*
Marshall McLuhan coins phrase, argues in several seminal books (1951-1970) that advertising, television, print, film, computers, and other media determine human thought and behavior.

Feminism *1963*
The Feminine Mystique, Betty Friedan's critique of American patriarchy in magazines, fuels Second Wave Feminism.

Alternative Press *1964*
Los Angeles Free Press is the first alternative newspaper promoting counterculture ideas and comix; followed by *The Berkeley Barb* and *The East Village Other* (1965).

General Strike, France *1968*
Peak of social and political protests in France; workers go on strike, universities are occupied, and civil war is feared.

New York Times Op-Ed page *1970*
New format art directed by J.C. Suares promotes conceptual illustration.

L.G.B.T.Q. rights *ca. 1970*
Activism increases after three-day riot sparked by 1969 police raid on Stonewall Inn. Two Minnesota men apply for same-sex marriage (unsuccessfully). American Psychiatric Association stops classifying homosexuality as mental disorder (1973).

Roe v. Wade *1973*
Landmark Supreme Court decision legalizes abortion in U.S.

Association of Illustrators *1973*
English body advocates for industry and practitioners' rights.

Dungeons and Dragons *1974*
Role-playing game conceptually models fantasy gaming.

Video games *1975*
Best-selling video game *Pong* introduced.

The Illustrators Workshop *1977*
Summer Workshop in Illustration offers noncredit instruction by founders Bernie Fuchs, Alan E. Cober, Fred Otnes, Mark English, Robert Heindel, and Bob Peak.

Geopolitical Events and Conflicts

Vietnam War *1962–1973*
U.S. drafts soldiers for Vietnam War; Americans sharply divided in support or protest.

Civil rights movement *1960s*
Great March on Washington for Jobs and Freedom (1963); Civil Rights Act outlaws discrimination (1964); Voting Rights Act (1965); Malcolm X (1965) and Martin Luther King Jr. (1967) assassinated; Black Panther Party operates (1966-1982).

Chinese Great Proletarian Cultural Revolution *1966–1976*
Mao Zedong restructures power and enforces Communist ideals.

Energy crisis *1973–1979*
Oil shortages cause sharp rise in oil prices, dampening economies of developed countries.

Magnetic resonance imaging (MRI) *1971*
Non-invasive technology renders graphics of inside of body.

Protein Data Bank *1971*
Online repository for experimentally derived data about structure of proteins and other biological molecules is established.

Science and Inventions

Contraceptive pill *1960*

LSD *1963*
Hallucinogenic drug influential in counterculture is discovered (1938); scientifically researched (1950s and '60s); available on the street (1963); made illegal (1968).

Networked email *1971*
Developers send messages between networked computers; not widely available until after 1990.

Federal Express (FedEx) *1971*
Courier company enables overnight delivery of art to clients.

3-D digital graphics *1972*
First developed by Edwin Catmull and Fred Parke; later used in film *Futureworld* (1976).

Mobile phone and commercial wireless telephone network established *1973*

Fax machine *1976*
Newly commercially available device transmits visual media (facsimiles) via phone lines.

Art and Communication Media

Vector graphics *1962*
First vector graphics made with digital drawing program *Sketchpad*.

Electron microscope *1965*
Invented ca. 1931, this high-resolution microscope becomes commercially available, profoundly impacting scientific research.

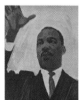

24.5 *Portrait of Martin Luther King,* 1965, Bernie Fuchs.

24.25 *Portrait of Dylan,* 1966, Milton Glaser.

26.10 "Whiteman," *Zap* **#1,** 1967, Robert Crumb.

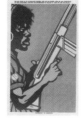

26.6 "Warning to America," *The Black Panther,* June 27, 1970, Emory Douglas.

26.19 *It Ain't Me Babe,* 1970, Trina Robbins.

27.8 "Straight to the Vein," *New York Times,* 1971, Brad Holland.

27.1 *Apocalypse Now,* 1979, Bob Peak.

1980

Graphic computer games *1980*
First graphic adventure computer game, *Mystery House*, designed by Roberta Williams of Sierra Online Systems, is launched.

RAW magazine *1980*
Punk magazine, featuring art, illustration, and alternative and European comics founded by Françoise Mouly and Art Spiegelman (graphic novel *Maus* debuts in the second issue).

American Illustration *1981*
Influential juried illustration annual founded to recognize more experimental illustration. *Print Regional Design Annual* published to show notable work created outside urban centers.

Akira *1988*
Katsuhiro Otomo's manga released in English in U.S. ignites American interest in manga.

Political correctness *ca. 1988*
Phrase coined to refer to reforms of language and policy aimed at greater inclusivity in the public sphere.

Fall of the Berlin Wall *1989*
End of Cold War and Communist control over Eastern Europe, symbolized by opening up of Berlin Wall (1961) separating East and West Germany. Wall dismantled by 1992.

HIV/AIDS *ca. 1980*
New virus disproportionately affects gay communities, IV drug users, and impoverished groups worldwide. Gay rights become openly debated.

The Incredible Machine *1985*
"Glassman" series of anatomical studies visualizing a transparent human for National Geographic books.

Apple Macintosh II *1984*
Mac comes with MacDraw and MacPaint programs; KoalaPad graphics tablet is first digital drawing tablet made for Apple II.

Adobe Illustrator and Adobe Photoshop *1986, 1988*
Commercially available programs support vector and raster image-making.

GIF *1987*
Graphics Interchange Format facilitates online images, then simple animation, using compressed file formats for slow modems.

Apple's HyperCard *1987*
Allows hyperlinking between pages within a document.

World Wide Web *1989*
HyperText Markup Language (HTML) follows in 1990.

1990

Stock art *ca. 1990*
Businesses take advantage of digital technology and the Internet to sell ready-made illustration at reduced fees, undercutting freelancers.

Maus wins Pulitzer *1992*
Pulitzer Prize bestows literary respectability on graphic novel format.

Pop Surrealism *1998*
Robert Williams coins art term "Lowbrow" (1979); "Pop Surrealism" is originated by Aldrich Contemporary Art Museum (Ridgefield, CT) in reference to California's Lowbrow scene.

Illustration Brut *1998*
Influx of images influenced by street fashion, independent music, and graffiti.

ICON *1999*
Bi-annual U.S. national Illustration Conference founded.

Persian Gulf War *1990–1991*
U.S. coalition with 34 nations engages in war against Iraq.

Yugoslav Wars *1991–2001*
Aggressions lead to genocide; dissolution of former Yugoslavia; creation of several independent nations.

Action on climate change *1994*
United Nations Framework Convention on Climate Change (UNFCCC) forms treaty between 197 countries to reduce greenhouse gas emissions. Kyoto Protocol (1997) confirms the UNFCC's mission and sets targets.

Cloning *1996*
Dolly the sheep cloned at University of Edinburgh. Spanish group clones an extinct ibex (2009).

Print on demand (PoD) *1990*
Paper documents scanned, edited, and printed on demand in economically viable, customized, short print runs on Xerox DocuTech.

Giclée *1991*
High-resolution digital inkjet reproduction, using archival inks and papers.

Flash (animation software) *1996*
Macromedia develops Flash animation software; becomes a common component of web and interactive media (2000).

eBooks *1999*
Simon & Schuster becomes first trade publisher to release e-book and printed titles simultaneously under new imprint, iBooks. Sony introduces eReaders (1998).

22.35 cover of Dragon Magazine #71, 1982, Clyde Caldwell.

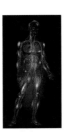

27.20 The Gift, 1984, Barbara Nessim.

28.25 "Circulatory System," The Incredible Machine, 1985, Kirk Moldoff.

23.31 Maus II: A Survivor's Tale, 1991, Art Spiegelman.

25.32 The Stinky Cheese Man and Other Fairly Stupid Tales, 1992, Lane Smith.

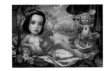

27.15, Snow White, 1997, Mark Ryden.

29.3 Modern Living, 1998–2001, Han Hoogerbrugge.

2000–2010

2000 ## 2005

Religion, Ideas, and Culture

Illustrators' Partnership of America *2000*
Founded by Brad Holland, Cynthia Turner, and others to promote illustrators' rights.

Same-sex marriage *2000*
Denmark legally recognizes same-sex unions (not marriage) (1989). Netherlands first to legalize same-sex marriage (2000).

Interactive graphic novel *2004*
Han Hoogerbrugge creates *Hotel*.

Varoom *2006*
Published in U.K., this international periodical and research project reports on contemporary illustration practice.

Recession *2008–2012*
Major economic collapse in U.S. with international ramifications leads to further division between rich and poor.

Crowdfunding *2009*
First instance of funding a project online occurs in 1997; crowdfunding becomes common when Kickstarter launches in 2009.

Geopolitical Events and Conflicts

9/11 *2001*
Al Qaeda terrorists fly passenger jets into NY World Trade Center and Pentagon, sparking abrupt change in U.S. policy and culture; Islamophobia deepens.

Iraq War *2003*
Unfounded suspicion that Iraq has weapons of mass destruction causes U.S. invasion; Saddam Hussein deposed.

Islamic State *2006*
Violent group proselytizing disputed interpretation of Islam recruits members for terrorist acts and war crimes.

Augmented Reality (A.R.) *2009*
Esquire magazine cover comes alive through A.R.

Sina Weibo *2009*
China's largest social media platform launched.

Science and Inventions

Human Genome Project *2003*
International project (launched 1990) finishes sequencing D.N.A. of *Homo sapiens*.

Art and Communication Media

iTunes 1.0 *2001*
Media player, library application, and online radio broadcaster developed by Apple; used to download, play, organize digital media.

ZBrush *2002*
Open-source 3-D modeling and painting software released in demo version by developer Pixologic Inc.

Social media *2004*
Facebook, launched to connect college students, soon used for general social networking and promotion of services. Twitter (2006) quickly evolves into important medium to circumvent regulated channels of broadcast communication and journalism.

29.5 *Obama Hope* memes, 2008–2016, various artists.

27.16 Cover of *New York Times Book Review*, 2001, Sara Fanelli.

TB29.1 *Gurney Journey,* July 25, 2007, James Gurney.

27.11 "The Politics of Fear," *The New Yorker,* 2008, Barry Blitt.

2010

2015

Illustration Research *ca. 2010*
U.K. illustrators form network, support academic illustration study. *Journal of Illustration* launches first academic journal (2013) with articles by illustrators and others writing on illustration. Academic conferences on illustration appear around the world.

***Charlie Hebdo* shooting** *2015*
Two gunmen affiliated with terrorist group Al Qaeda target cartoonists, editor, and staff of alternative French newspaper for publishing extreme graphic satire; twelve people die.

Brexit *2016*
U.K. votes to leave European Union, begins process in 2017.

Arab Spring *2010*
Uprisings in North Africa and Middle East overthrow authoritarian governments. Syria falls into civil war.

Occupy movement *2011*
Activists begin Occupy Wall Street protest in New York City park near stock exchange to bring attention to gap between the 1% wealthiest people and the other 99%. Activists stage similar protests globally.

Higgs boson *2012*
European Organization for Nuclear Research (CERN) announces discovery of elementary particle with mass, using Large Hadron Collider.

Stem cell research *ca. 2010*
Advances and setbacks of legal status of stem cell research funding occur (1990–2015), while research continues to make important, beneficial breakthroughs in regeneration of tissues.

iPad (iOS 3.2) *2010*
Apple iPad launches; was preceded by the less commercially viable Microsoft Tablet PC.

Instagram *2010*
Online mobile photo sharing, video-sharing, and social networking service, also used for promotion.

Snapchat *2011*
Digital application (originally "Picaboo") for sharing intentionally short-lived and self-deleting images launched.

Virtual reality (VR) *2014*
Sega VR consumer-level digital headsets immerse viewer in highly realistic three-dimensional space (1991); VR becomes mainstream (ca. 2014); Facebook, Google, Sony and others invest heavily in it.

29.14a *FORGE* no. 8, 2015, Maria Torres.

28.27 *Ultrastructure of the cell,* 2016, David Bolinsky.

29.8 *The Fantastic Flying Books of Mr. Lessmore,* 2012, Moonbot Studios.

TB51.1 On-location sketch, 2012, Victor Juhasz.

Timeline design by Whitney Sherman & Bryn Freeman

1

Image and Meaning, Prehistory–1500 CE
*Robert Brinkerhoff and
Margot McIlwain Nishimura*

What Is Illustration?

Surprisingly few people seem to know exactly how to define illustration. Perhaps this task is made difficult because so many visual art disciplines are identified by the artistic mediums associated with them (e.g., painting with paint, photography with photographs, printmaking with prints), whereas illustration is propelled by purpose—the intention to visually communicate ideas and information. Its formal and technical approaches are extremely varied and secondary to intent.

To illustrate is to signify and lend clarity to a subject by visual (usually pictorial) means. This can be accomplished in innumerable ways, addressing a wide variety of audiences. The etymology of this term makes perfect sense: the word *illustration* comes from the Latin root, *illustrare*, which means "to make bright or to illuminate." Across the great spectrum of illustrative genres—from the most didactic, data-packed info-graphic to the most expressively nuanced book cover—all illustrations aspire to communicate, to illuminate meaning. As embodied meanings, every illustration is a complex constellation of visual signs, serving to elucidate a subject in literal, metaphorical, and/or evocative terms.

The potency of any illustration is dependent on the **visual literacy** of its audience: the ability of a people to construct and derive meaning from visual information. Because the illustrator usually communicates to "the here and now," a keen awareness of visual signs in their contemporary context is vital (*see Chapter 2, Theme Box 7, "Saussure and Peirce: Semiotics"*). Whether quickly understood or more slowly decoded, an illustration's merit is judged by its ability to dynamically engage and convey significance to a specific audience. As we attempt to understand the purpose of illustrative art from any period, we must remain cognizant of the myriad forces that, at the time of its making, contributed to its significance and cultural relevance (*see Theme Box 1, "Giving Illustrators a Voice"*). This first chapter introduces the concept of illustration by looking at a selection of examples that predate the widespread use of printing for distribution of images.

Pictorial Narrative in Upper Paleolithic Art

Illustration has deep roots. Art from the **Upper Paleolithic** era (from approximately 50,000 to 10,000 BCE) demonstrates that pictorial communication came well before written language. Just about every book on the history of art begins with the earliest known pictorial narratives: Paleolithic art from ancient hideaways such as the Caves of Lascaux (ca. 17,300 BP) and Chauvet, France (ca. 32,000–26,000 BP); and Sulawesi, Indonesia (ca. 40,000 BP) display the work of remarkably facile hands and profoundly elegant economy of visual notation. These poetic images of animals, allusions to ritual, and manual, **anthropomorphic** (resembling human form) signatures help us map the legacy of the illustrator (Figure 1.1).

Most theories point to cave paintings as possessing some communicative purpose. This alone tells us that the impulse and practical need for apprehending the essence of a subject has been with us for millennia. The images on cave walls are alternatingly descriptive, metaphorical, and diagrammatic. They are figurative in both senses of the word: representing both forms observed from life and metaphors for abstract ideas. Some archaeologists assert that the images of large beasts—horses, deer, bison,

Figure 1.1
Cueva de las Manos, Río Pinturas, Patagonia Region, Santa Cruz Province, ca. 11,000 BP.
Created between 13,000 and 9,500 years ago, diminutive handprints boldly silhouetted by pigment may be read as emblems of self-empowerment through mark making—the nonverbal signatures of our ancestors. They foreshadow similar assertions of identity found in modern-day graffiti.

Photo by Thomas Schmitt, Getty Images.

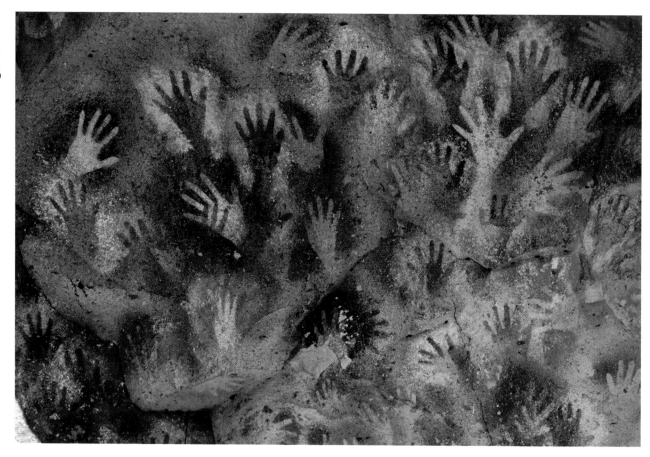

rhinoceros—are a means of capturing (at least in spirit) these elusive and prized creatures (Figure 1.2).

Curiously, while the prey depicted on the walls of caves is expressed with sensitive realism, the instruments of capture—weapons and human forms—are, in contrast, often markedly abstract. Perhaps the pronounced difference in these pictorial approaches is meaningful, suggesting that juxtaposition of the observational with the abstract is part of the "function" of the pictures. Abstract notation of an idea such as "capture" (an iconic spear or net), drawn in conspicuous contrast to the realistic representation of the prey, readily suggests two things in opposition to one another. The locations of these paintings, deep in caves, protected both art and art-maker from erosive elements and ancient interlopers, and they remain places where idea and image are interwoven in elegant pictorial narratives.

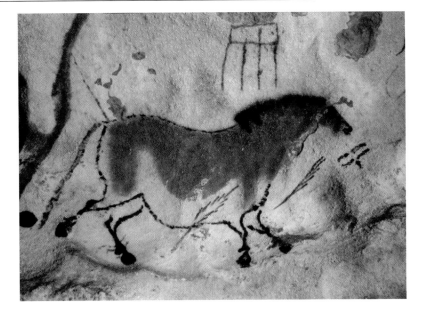

Figure 1.2
Chinese Horse, detail of mural from the Axial Gallery at Lascaux, France, Upper Paleolithic.
The variety of drawing strategies in this work implies that in addition to the subject of the image, the stylistic approaches may have been meaningful as well. The creators of these animated cave images are thought to have been of every age and gender.
Photo by Robert Harding, Getty Images.

Ritual in the Book of the Dead

The Egyptian Book of the Dead is not a book at all, but a group of papyrus scrolls produced during Egypt's **New Kingdom** period (1550–1077 BCE) and entombed with the dead as a practical and spiritual guide through the perilous "underworld" to rewards in the afterlife, which Egyptians envisioned as an actual place. Referred to by Egyptians as The Book of the Coming Forth by Day, the scrolls were by no means a singular text, but unique and individuated collections of written and illustrated incantations, which were placed in the tomb with the deceased. The texts were selected from a canon of approximately two hundred verses handed down from the **hieroglyphs** (pictographic script) inscribed on the walls of **Old Kingdom** Pyramid tombs (ca. 2686–2181 BCE). While the ancient pyramids were built exclusively for royalty, during the **Middle Kingdom** (ca. 2040–1786 BCE), funerary rites were democratized and spiritual beliefs changed so that ordinary citizens could expect to partake of the afterlife too. Consequently, inscriptions formerly made only on tomb walls appeared on coffins and were eventually written on papyrus scrolls in a portable format known as The Book of the Coming Forth by Day, but more commonly referred to as the Book of the Dead (Figure 1.3).

Books of the Dead were actually scrolls buried with the deceased; they included incantations meant to facilitate a successful journey to the afterlife. They remained prevalent as funerary texts in Egypt well into the **Late Period** (712–332 BCE). Over time, illustrations became more important to their potency, and some later scrolls even include poorly copied texts or unfinished sentences, suggesting the written word was eventually subordinated to the narrative information in the vignettes. Among the most profound and enduring documents of ancient funerary traditions, the Books of the Dead also comprehensively locate the roots of illustrated text many thousands of years in the past.

The earliest Books of the Dead appeared during the mid-fifteenth century BCE and were sparsely illustrated. Egyptians were polytheistic and did not view religious texts as singular divine conceptions, which freed them to craft each scroll to suit the spiritual aspirations of the specific deceased. Wealthy persons selected spells for inclusion

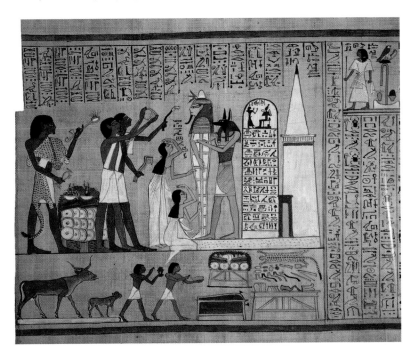

Figure 1.3
Book of the Dead of Hunefer, Thebes, ca.1300 BCE. Papyrus scroll.
In the top register, the deceased undergoes the "Opening of the Mouth" ritual. The register below left shows a mother cow and a calf, which will be sacrificed on the table with ritual implements. The images are more stylized than natural with heads shown in profile and figures in a flattened, three-quarter view, and simply outlined with soft infill color.
Photo by CM Dixon/Print Collector, Getty Images.

and engaged scribes to copy those incantations, while artisans were commissioned to illustrate the text with vignettes. Uniquely crafted scrolls were common among the upper and middle classes, while those of more modest means could purchase standard versions with blank spaces to enter the deceased's name and title. In time, specific chapters were illustrated with greater frequency and a repertoire of pictorial possibilities developed.

Typically, the customized illustrated scrolls depicted the individual deceased undergoing key funerary rites, including the "Opening of the Mouth" and the

Theme Box 1: Giving Illustrators a Voice
by D. B. Dowd

Illustrations come in many varieties and perform all sorts of communicative functions, from visualizing a scene in a narrative to showing how to change a flat tire to embellishing religious architecture in murals or stained glass. The historic overlap of illustration with literature, information, and especially with "art"—despite a lot of illustration not being exceptionally artlike—has complicated our understanding. Although illustration has been poorly defined for a host of reasons documented throughout this book, the intellectual history of the "high" or "fine" art object (art made primarily for aesthetic contemplation) has been particularly problematic.

The modern concept of the art object dates to the 1790s, when the German philosopher Immanuel Kant (German, 1724–1804) published The Critique of Pure Judgment (see Chapter 12, Theme Box 22, "Kant: Objective Aesthetic Judgment"). A section titled "The Analytic of the Beautiful" wrestles with problems in the cultivation of taste, insisting that to determine the aesthetic value of an object, it must be contemplated outside any other consideration. One point Kant argued was that determinations of beauty or aesthetic preferences for "x" over "y" have to be "disinterested." We recognize and value this precept even today as movie and food critics are expected to be independent, free of influence from film producers and restaurateurs. If the critic were paid off or prejudiced, or were friends with the reviewee, we would consider her corrupt and discard her opinions as worthless. Kant's persuasive philosophical argument for disinterested aesthetic experience came to define the terms for how modern art was made, as well as how audiences experienced it.

Consider museums designed to display modern art in the twentieth century. Such facilities tended to consist of large, white, clinical boxes to serve as neutral containers for artworks with no competing "visual noise," so that museum-goers could experience the work in isolation. Such display encouraged viewers to think of the object as autonomous: not dependent on or related to another source for its meaning. While art historians today sometimes dispute the purported autonomy of fine art objects, galleries and museums still maintain much of this atmosphere.

This approach presents a problem for illustration. Because illustrations are expected to convey information to a given audience, they are not autonomous. Illustration often appears in complicated contexts, in relation to other visual and textual elements that serve human communication. Illustration therefore always points to something else and does not belong in a "white box."

The fine art world has historically dismissed illustration on the basis of its lack of autonomy. In fact, when artistic opinion did find merit in an illustrator's work, it was usually suggested that the achievement had transcended illustration to become Art—the capital A denoting the supposed difference. Illustration was best, in other words, when it ceased to be itself. This lack of status was internalized by even virtuosic illustrators like N. C. Wyeth, who wrote in 1913, "I don't want to be rated as an illustrator trying to paint, but as a painter who has shaken the dust of the illustrator from his heels!" This prejudice against illustration only began to break up around 2001, when the Guggenheim—a New York museum for modern art that historically had a "white box" outlook—mounted a major exhibition of the work of Norman Rockwell. Serious study of the communicative and artistic importance of illustration has escalated since.

Yet powerful biases continue to bedevil the field and to cloud thinking about it. Illustrators and illustrations have been systematically left out of art history for being "kitsch" or "commercial." Related attacks come from intellectuals known as "critical theorists." Their critiques, grounded in Marxist thought, are characterized by deep distrust of capitalism and market economies. From such a perspective, work of basic commercial appeal such as magazine illustration can only suggest evidence of collusion with economic elites, or worse, naiveté.

Over many decades, some in the illustration field have reacted angrily to being left out of larger academic and cultural dialogues, whereas others have accepted the terms of exclusion. The lack of internally generated analysis of the field, however, has become untenable, because in ceding the debate to intellectuals outside of illustration, everyone was served poorly: high-culture experts remain largely ignorant of illustration and would-be advocates have had little practice in honing their ideas on par with contemporary art historical debates. For too long, illustrators have hidden behind market realities and fixated on professional expertise. Professional practice matters, but it won't tell us much about the importance of illustration in the cultural context.

Since illustrations are not autonomous art objects, we should avoid looking at them and reading them out of context. One approach is to adopt a Cultural Studies model (see Chapter 7, Theme Box 13, "Hall: Encoding, Decoding, Transcoding") in which case studies are examined to consider complex, layered contexts. For example, a Cream of Wheat advertisement ca. 1910 (Figure TB1.1) reveals important insights about a society: changing demographics, the use of word/

image relationships to convey coded messages about race, the editorial orientation of *The Saturday Evening Post*, the emerging phenomenon of advertising agencies, and the commissioning and production of a particular illustrated advertisement.

Illustrators may properly consider themselves visual practitioners who shed light on subjects and ideas as part of a larger cultural enterprise. That endeavor is capable of bearing more than one theoretical or interpretive approach. Illustration in all its guises can play a large part in the emerging debates about the study of culture in the twenty-first century—even as it represents an ancient human urge to communicate with others through symbolic picture-making. Contemporary practitioners of illustration, both emerging and seasoned, will be well served by exploring critical arguments and participating in discussions about the role and position of the field.

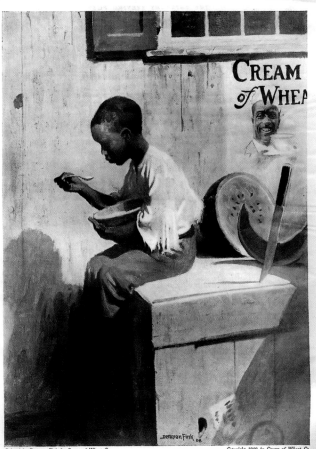

Painted by Denman Fink for Cream of Wheat Co. Copyright 1909 by Cream of Wheat Co.

"A CASE OF DESERTION."

Figure TB1.1
Denman Fink, "A Case of Desertion," Cream of Wheat advertisement, painted in 1908. Published in *The Saturday Evening Post*, July 13, 1918.
The readership of the *Post* was overwhelmingly white and generally culturally conservative. In that light, this troubling ad raises a great many questions. Three possible explications of the image and caption: one, "a case of desertion" refers to forsaking the stereotypical "slave treat" of watermelon for healthy Cream of Wheat; two, the same "desertion" makes reference to the Great Migration of Southern blacks to the North after 1900, actively resisted by Southern whites—that is, the poor black boy has been abandoned (presumably) by his father; and three, the image offers a nostalgic take on the old racial order then collapsing, in part through migration. Two things cannot be disputed: the tenderness of Fink's treatment of the boy and the disturbing implicit violence of the knife. Consideration of Fink's role in the creation of this troubling communication demands a contextual awareness of the larger forces in play. It makes no more sense to declare Fink an independent genius than it does to denounce him as an obviously malevolent racist, or a strictly unthinking tool of capitalist manipulators. The truth is more complicated and subtle.

D. B. Dowd Modern Graphic History Library.

"Weighing of the Heart." While Book of the Dead scrolls reflect much about the worldview and spirituality of the ancient Egyptians, they were ultimately personal items of extraordinary significance: part respectful sentiment and part reassurance that the departed would reach the afterlife.

Considering the fragility of papyri, Book of the Dead scrolls are exceptionally well preserved due to burial in Egypt's arid desert climate. One such example is the *Book of the Dead of Hunefer* (Figure 1.3) from Thebes (ca. 1300 BCE), which was buried with a royal scribe and steward to King Sety I. In this delicate **vignette** (borderless image), Hunefer undergoes the "Opening of the Mouth" ritual before being sealed in his tomb, a symbolic reanimation rite that empowered the deceased to breathe and eat in preparation for the journey to the afterlife. The rite was usually performed on a statue of the deceased or—in this case—on his mummified remains. Anubis, the jackal-headed god of the afterlife, presents Hunefer's mummy, while a white pyramidal tomb rises in the background. Hunefer's grieving wife and daughter are at his feet, while three priests perform the sacred rite.

Metaphor in the Tomb of the Diver

The Ancient Greek city of Paestum has been remarkably well preserved, with the remains of three beautiful temples (mid-sixth to mid-fifth century, BCE) arranged side by side on a tidy stretch of road less than 100 km south of Naples, Italy. A prized find from the archaeological region is the Tomb of the Diver (ca. 470 BCE), a compact group of limestone wall panels that once lined a rectangular grave about a mile from the temples. The tomb consists of four walls with **frescoes** (murals painted into moist plaster) depicting a **symposium** (a drinking party) with reclining male figures engaged in erotic foreplay and drinking games—a panoramic party for all eternity (Figure 1.4). The skeletal remains from the tomb tell us little, but the deceased is presumed to have been a young man due to the nature of objects found there: oil flasks commonly used in preparation for wrestling matches as well as part of a tortoiseshell lyre and drinking cups like those held by the symposium participants in the frescoes. While the scene depicted on the walls is engaging, it is not unlike many Greek **amphora** (a large two-handled storage jar) paintings of the day in its stylized depiction of activity common to everyday life. The most impressive and unusual piece

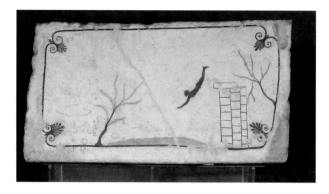

Figure 1.5
The Tomb of the Diver, Paestum, ca.470 BCE. Fresco.
The diving youth appears to be in complete control of his destiny, leaping from a tower of blocks, poetically entering death with triumphant gusto. He is promised a refreshing fate in the form of a cool stream of turquoise water rippling below and swelling gently to meet him.
Photo courtesy of Andrew Selkirk.

of the structure is its roof, the ceiling of which bears the lyrical image of a brown-skinned youth halfway between sky and stream (Figure 1.5). While it is an elegant image in its compositional clarity, still more impressive is its metaphorical potency.

As the center of optical attention, the nude diver could not appear more full of vigor and certainty, and yet the simplicity of the denotative narrative offers profound connotations: we behold in this image the moment of death, the decisive rite of passage from youthful vitality to the afterlife. The pictorial narrative is remarkably touching: the best of times among friends on earth, literally topped off with a fond but lonesome farewell.

Archetypes in the Villa of the Mysteries

While the Tomb of the Diver was created to be forever buried, the unintentional entombment of the ancient city of Pompeii occurred during the eruption of Mount Vesuvius in 79 CE. Excavations on the city, hidden for more than 1,500 years, began in earnest in the nineteenth century, and in 1909, a sprawling suburban residence was unearthed, revealing a painted hall of spectacular, well-preserved frescoes.

Probably built in the mid-first century BCE, the Villa of the Mysteries is named after the subject matter lining the

Figure 1.4
The Tomb of the Diver, Paestum, ca. 470 BCE. Fresco. Frescoed on the slab walls and ceiling of a tomb, this elaborate tableau shows the dead man eternally engaged in sport and romance at a drinking party, thus reassuring that death is as joyful as life.

Photo courtesy of Andrew Selkirk.

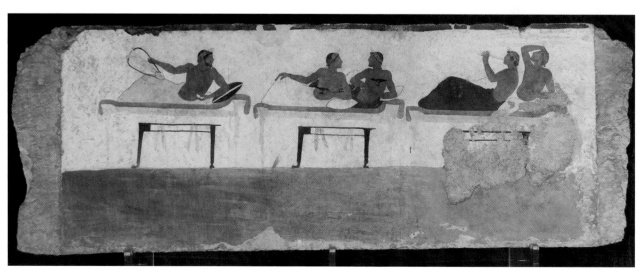

Painted Hall—a central room whose original use remains unclear. Its walls are completely covered by two-dozen figures in a compositional procession that is generally thought to chronicle a young woman's initiation into the cult of **Dionysian Mysteries** whose rites included intoxicants, dance, and music that enabled participants to experience an ecstatic "rebirth" (Figure 1.6). The scenes are painted in what is known as the **Second Style** (fresco painting style in first century Pompeii), which included extensive use of *trompe l'oeil*, a painting strategy that "fools the eye" through subtle illusions of depth by depicting objects in perspective and indicating distance by optical shifts in scale. The unfolding panorama of near life-sized figures is backed by a brilliant red wall, which recedes dramatically, creating an impression of depth beyond the confines of the room.

Successive images imply a ritual beating of a young woman and her eventual reappearance as a full-fledged member of the cult. The chief obstacle to interpretation of this narrative is that ancient rites such as these were known only to those who experienced them, and scarce documentation of details exist. While conjecture certainly plays into the interpretation of the Painted Hall's imagery, many agree the scenes depict familiar archetypes prevalent in ancient art and theater: the initiative rites of mystery cults, the presence of gods and demigods, objects of

reverence and sacrifice. Another important contextual consideration is that in 186 BCE, before the frescoes were painted, Roman authorities had declared practice of the rites of the Mysteries of Dionysus (Bacchanalia in Roman nomenclature) illegal. Since the Hall's possessor elected to commission this elaborately encoded visual metaphor anyhow, presumably these paintings were not mere decoration.

Propaganda in the Bayeux Tapestry

As civilizations have grown and prospered, political forces have quite often enlisted the talents of artists to embolden and promote ideologies. Enormous monuments proliferated in ancient Rome and set a precedent for heavily illustrated tributes served up in Europe's public sphere. But communication of this sort did not always happen through such monoliths: a potent historic narrative comes down to us in the relatively fragile form of the *Bayeux Tapestry*, which illustrates events surrounding the Battle of Hastings in 1066 CE (Figure 1.7).

Documenting a complicated bit of English history, the *Bayeux Tapestry*, which is technically an embroidery, is renowned for many reasons. Probably created between

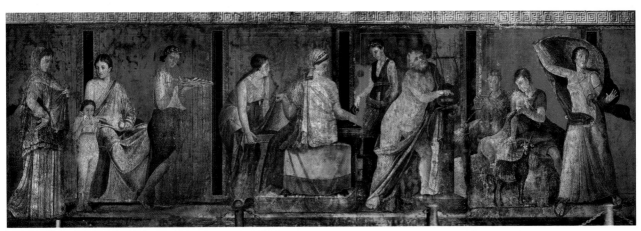

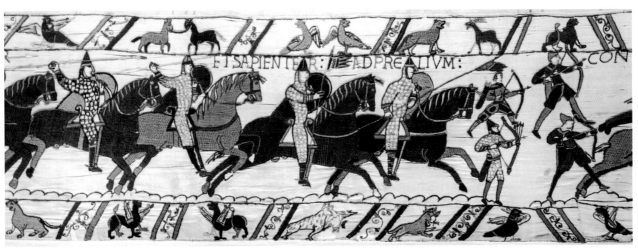

Figure 1.6
Sala di Grande Dipinto, Villa of the Mysteries, Pompeii, before 79 CE. Fresco, approx. 55.8 × 9.8'. Preserved in the ashes of Pompeii, the room-sized frescoes in the Villa of the Mysteries are masterfully wrought, with exquisite synthesis of architecture and figurative painting designed to envelop the room's occupants. The narrative begins on the north wall in which, from left to right, a young woman prepares for and transitions through an initiation rite that includes an encounter with Silenus, the drunken companion of Dionysus, and the wine-god Dionysus himself.

Photo by Wolfgang Rieger, distributed under a CC-PD-Mark license.

Figure 1.7
Battle Scene, *Bayeux Tapestry*, Scene 51 (extract), 1077–1082 CE.
This "tapestry" is actually an embroidered textile over 229 feet long, depicting the Battle of Hastings of 1066 CE, one of the most pivotal conflicts in English history, and events leading up to it. England's King Edward the Confessor died with no heir to succeed him. Harold, a chief advisor to the king, was also his brother-in-law and the most powerful nobleman in the land, and when Edward died, Harold wasted no time crowning himself as king. His coronation was not without complications, however, since he had vowed his support for William I, Duke of Normandy, in a bid for the kingdom on an earlier voyage to France. As medieval nobility were wont to do, Harold's own treacherous aspirations got the better of him, and a very ugly and important battle erupted. England was invaded, Harold was killed in battle, and William (later known as William the Conqueror) became king.

Photo by Myrabella, distributed under a CC0 1.0 license, Wikimedia Commons.

1077 and 1082, and perhaps inspired by the continuous epic frieze of Trajan's Column (Rome, 107–113 CE) as a visual statement of military might, the *Tapestry* is unparalleled in its accomplishments as a masterpiece of large-scale textile design and rambling pictorial narrative. Illustrated with woolen yarn, the entire work traverses about 230 feet of linen approximately 20 inches high, and consists of hundreds of **crewel**-embroidered (worsted wool for decorative stitching) figures, objects, and events in dozens of overlapping scenes. It is cinematic in effect, ingeniously compressing time and space and allowing parallel action to occur simultaneously in upper and lower **registers** (sections demarcated by borders). The meticulously detailed narrative, which is missing one or more final scenes, depicts almost the entire chain of events leading up to the Battle of Hastings, the chaos of

the battle itself, the death of Harold, and retreat of his companions. Latin captions identify the individual events, and this text renders the story comprehensible almost 1,000 years after the event.

Because it was created within fifteen years of the famous conflict, this remarkable historical document is also a paradigm of deftly played political **propaganda** (text and imagery designed to influence the public in support of certain endeavors or ideologies), as both the true story of a triumphant battle and a clever manipulation of fact, which gave an obligatory nod to the loser, celebrated the victor, and shaped the annals of history for centuries to come.

The timing of the Tapestry's completion is evidence enough for some medievalists to assert that the work may have been produced for dedication of the reconstructed

Theme Box 2: Plato: Allegory of the Cave
by Sheena Calvert

One of the key contributions of philosopher Plato (Greek, approx. 425–355 BCE) is the Theory of Forms. In this theory, Plato examines the conditions of reality and theorizes that there exists a set of idealized "forms," or archetypal examples of everything that exists in the real world (he does not explain where these archetypal forms exist, so the theory is abstract). These forms are perfect and unchanging, whereas the examples that exist in the world are imperfect copies or representations of these perfect (abstract) types. For example, there is an archetypal chair whose form never changes, but in the material world there are many chairs, all of which deviate from this model form. In short, we only perceive the world as a series of representations or copies of these perfect forms. Perception is therefore limited and partial.

To explain this one level further, in the "Allegory of the Cave" (an **allegory** is a type of metaphor, used to explain complex ideas) from *The Republic* (380 BCE), Plato relates a dialogue between the philosopher Socrates and Plato's brother, Glaucon. Socrates describes to Glaucon a group of prisoners who

have lived chained in a cave all of their lives, facing a blank wall. These people watch shadows projected onto the wall by things passing in front of a fire, which lies behind them. But they do not know that this is the source of the shadows because they are chained in such a way that they cannot turn around to see this movement. They begin to ascribe meaning to these shadows, and try to explain them through language to each other.

According to Socrates, the shadows are the closest the prisoners get to viewing reality. In fact, they believe that reality itself *is* the shadows. Then one of them is freed and sees that what they had come to understand as reality is in fact only shadows, since he has now seen the objects that make them. But his fellows' perceptions of what makes up reality have been so deeply shaped by their limited experience that they are resistant to accepting the newly discovered "truth" that their freed comrade describes.

The philosopher who contemplates such matters is like the prisoner who is freed from the cave, who comes to understand that the shadows on the wall do not make up reality at all. He can comprehend

the true form of reality rather than the mere shadows.

Plato wants to remind us that perception is *not* reality, and he suggests that images are untruthful representations of the world of concrete, unchanging absolutes (in Plato's theory, the Forms).

As a result of this allegory's influence, there exist long-held prejudices against pictures for providing false or limited truths. Religious traditions, by contrast, have put more emphasis on the truth of words in the form of holy scripture, and thus privileged verbal over visual communication—a bias called **logocentrism**. The reception of illustration (along with the other visual arts) has been affected by this ancient unease with the visual. In the history of images, critics have argued that images can lie, and that perception is unreliable because it is limited and contingent, heavily dependent on the subjective interpretation of the artist, illustrator, or viewer.

Further Reading
Plato, "The Allegory of the Cave," *The Republic*, Book VII.

Cathedral of Bayeux, and more specifically for its nefarious Bishop, Odo, a loyal member of William's court. Besides decorating the nave of the church, the work may also have been produced with portability in mind as a way to foster alliances by propagating a certain version of the victory as it traveled from one geographic center of power to another.

Dogma in the Last Judgment Tympanum

Begun in the mid-eleventh century, the **Romanesque** (prevailing architectural style in southern Europe from the ninth through twelfth centuries) Abbey of Ste. Foy in Conques was expanded to accommodate the increasing numbers of visitors on Christian pilgrimages in the early twelfth century. While the **relics** (holy remains or objects) of Ste. Foy were the main attraction for visitors, the spectacular portal over the primary (west) entrance of the church would have provided an experience of the sublime through the extraordinary carvings of its **tympanum**, the arched header above the entry doors (Figure 1.8). Within the semi-circle is a Last Judgment scene whose every aspect underscores the notion of duality upon one's arrival: there/here, journey/arrival, outside/inside, past/future, good/evil, heaven/hell, bliss/torture, salvation/damnation. The tympanum's placement above the dramatic threshold greatly enhanced the emotional impact of a crucial moment—arrival—serving as a condensed metaphor for the Last Judgment as pilgrims entered a sacred space in a state of delirious fatigue.

The tympanum provided explanatory verse, but only a select few could actually read the text. Everyone, however, could appreciate the message in the relief imagery. Its structure bears a resemblance to illuminated manuscripts of the day, and this effect was no doubt enhanced by the application of **polychrome** (many colors), traces of which are still visible on its figures. Christ is the central figure, and his position emphasizes the tipping point of judgment, as established in the axial division of space. The "saved" appear on his right in orderly formation, while the opposite side is teeming with the "damned."

The tympanum is also read from top to bottom. In the upper-most register, above Christ's head, two angels descend with artifacts of the Passion—a nail and a lance—while simultaneously supporting the cross. One tier down we see the sacred elect queued up on the left, led by Mary, Peter, and other venerated personae, including the Emperor Charlemagne, likely because Charlemagne was credited with the founding of the monastery. Just under Christ's feet, situated on the central axis, is Saint Michael, who once held scales (now missing) for the weighing of souls. The lowest register confirms the hierarchy in an **architectonic** (relating to architecture) arcade with saved souls on the left, while the right expresses the antithesis: mayhem, violence, and horror under a matching gabled roof, with one poor soul being shoved into the mouth of an enormous demon who gobbles up the damned and delivers them to the underworld.

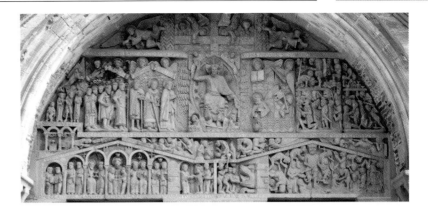

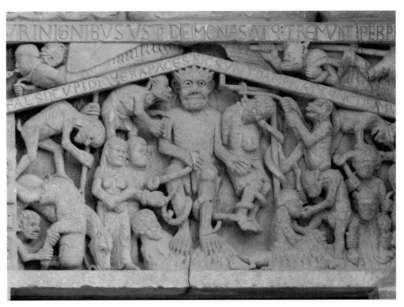

Figure 1.8
The Last Judgment, Abbey-Church of Ste. Foy, Conques, ca. 1100–1200 CE.
Designed to impress and welcome pilgrims, the tympanum's pictorial conventions, along with the dogma they communicated, would be echoed in illuminated manuscripts and later printed imagery. Writ large and in high relief, it endures as evidence of illustration's rich legacy. Each sinner is shown meeting a fate unique to his or her transgressions. The detail image shows Lust in the form of a bare-breasted adulteress, forever bound to her lover; a knight is toppled from his prideful position on a horse; and Greed, in the person of a man with moneybags around his neck, is hanged by demons. Christ's lowered left leg is weighed down by the dense chaos of hell and the souls of the damned in a subtly articulated statement about his role as both Savior and ultimate judgmental authority.

Illuminated Manuscripts

Essential to the study of modern forms of illustration and visual literacy is an understanding of the development of the first illustrated books in the western world, namely, illuminated manuscripts. What we know as the modern book, or **codex** (book format whose pages are individual sheets), makes its first appearance in classical literary references in the first century CE. The traditional format for recording the written word in the ancient world, the scroll (in papyrus or animal skin), was still preferred at this time and would be for at least three more centuries before the codex became the predominant portable medium for the circulation of text.

Many factors must have hastened this transition, but one of the most compelling is the establishment of the Biblical canon in the fourth and fifth centuries. Both in scholarly and ceremonial uses of the Bible, comparison of

events from one section to another and across the books of Old and New Testament had to be accommodated. The codex format was more convenient than scrolls for cross-referencing of texts. As for illustrations (or illuminations, as specialists also call them), very little evidence survives for scrolls. But what does survive of illustrated texts from this period suggests that the development of the illustrated book went hand in hand with the proliferation of biblical texts in the codex format.

By 400 CE, artists had been adapting, likely for some time, the stylistic, scenic, and technical traditions of monumental media, such as relief sculpture and mosaic, and especially wall painting to the scale and material peculiarities of the vellum page, adding a visual dimension to religious and secular texts alike. In examples that survive from Rome, such as the *Vatican Virgil*, the illustrations (also referred to as "illuminations") took the form of simply framed rectangular paintings with narrative scenes set within landscape or architectural settings (Figure 1.9).

In locations remote from the centers of antiquity, the earliest traditions of painting in manuscripts that survive also responded to local visual and decorative traditions, but these examples took the form of more abstract geometric and zoomorphic patterns, such as were found in the portable metalwork of Celtic, Saxon, and Germanic populations (see *The Lindisfarne Gospels*, Figures 1.11 and 1.12). In the monastery scriptoria of the vast European empire established in the eighth and

ninth century under Charlemagne and his successors, these two distinct visual traditions—intricate abstract patterns and classical naturalism—were combined to spectacular effect, especially in Bibles, Gospel Books, and other books used in the services of the Church, as well as in classical texts.

In the first couple centuries of the second millennium (1000–1200 CE), the basic page design associated with later medieval and Renaissance manuscripts developed from the Carolingian combination of Mediterranean and northern European visual traditions. As in earlier traditions, the degree of elaboration in both figural scenes and decorative motifs gives a clear indication of the relative importance of different sections of the text. In the thirteenth and fourteenth centuries, this hierarchical approach is distilled into familiar elements such as **historiated initials**, the letters at the beginning of important divisions within the text that contain figures or scenes; other decorated initials and patterned borders; and **marginalia**, the figural decoration in the periphery of the pages. This range of illumination was increasingly applied to both religious and secular texts, and the elements would ultimately be adopted with few modifications for the illustrated printed book of the Early Modern period (1450–1800).

The contexts for the production of illuminated manuscripts changed over this same period from almost exclusively monastic scriptoria through the twelfth century, with most production carried out by resident monks, to primarily secular workshops staffed by lay craftsmen in urban settings from the thirteenth century on. This transition corresponded with the rise of the universities in the European centers of Paris, Bologna, Oxford, and Cambridge, as well as to changing economic conditions and a growing educated and wealthy lay population.

The Craft of a Manuscript

The constants in this story of the illuminated manuscript's development over more than a thousand years can be found in materials and craft. There was a high degree of specialization in the medieval scriptoria beginning with the animal skin support, known as vellum or parchment, which was usually sourced from cattle and sheep in the north and goats in the south of Europe. The page design and text were prepared first by the scribe. Evidence survives of written clues being left by the scribe for the illuminator, but preparatory drawings were also used to guide the figural and decorative work.

If gold were to be used, it would be laid in first, either as gold leaf applied to a specially prepared surface or painted on in a powder form suspended in a medium. The application of colors from both mineral and vegetable pigments came next, and the final step would have been, for much of the middle ages, the addition of a fine black outline to tidy up the edges of the gold and paint. Most of the materials would have been found locally, except for certain mineral pigments; from the earliest period, the range of colors found in its manuscripts bore witness to a monastery's or urban workshop's contact, however indirect, with far-off lands. One source for a deep, ultramarine blue, for example, was lapis lazuli, a stone that was found in the middle ages only in Afghanistan.

Figure 1.9
"Dido Making a Sacrifice," *Vergilius Vaticanus*, Rome, ca. 400 CE. Colored pigments and gold on vellum. Vatican, Biblioteca Apostolica, Cod. Vat. L at 3225 fol. 33v.
The *Vatican Virgil* is one of the most richly illustrated manuscripts to survive from the earliest period of the form in western Europe. It was made some 400 years after Virgil composed the lines of his epic poem the *Aeneid* that are illustrated here with a simply framed narrative scene inspired by the conventions of Roman wall painting.
Photo: Art Images/Getty Images.

Common Formal Attributes of Manuscripts

Text and illustration styles were highly influenced by locale. The illumination of the *Vienna Genesis* (written in Greek) uses classical modeling and continuous narrative, both legacies of Roman wall painting to illustrate events from the Old Testament (Figure 1.10). No longer confined to the context of the wall, the artist forgoes conventional framing and a fully rendered background to allow the action to unfold against the purple-stained surface of the vellum page. Multiple scenes from the story of Jacob and the Angel (from the Book of Genesis 32:22–32) play out on a unified path that meanders, from left to right at top and then from right to left at bottom.

In *The Lindisfarne Gospels*, we have the rare case of knowing the name of the artist monk, Eadfrith, who illuminated this spectacular book in the second decade of the eighth century (Figures 1.11 and 1.12). The Gospels are four parallel accounts of the life of Christ that serve as the foundation for Christian worship; Eadfrith's monumental and highly skilled effort was in itself an act of devotion both to Christ and to Saint Cuthbert, the founding father of the monastery at Lindisfarne, on the far northeast coast of England. Whereas the *Vienna Genesis* relies on the conventions of visual narrative and Mediterranean classicism, meaning is conveyed here through the use of symbolic representation: the Old Testament ancestry of Christ in the opening page of the Book of Matthew is delineated using abstract designs derived from pagan metalwork traditions to convey Christian theology.

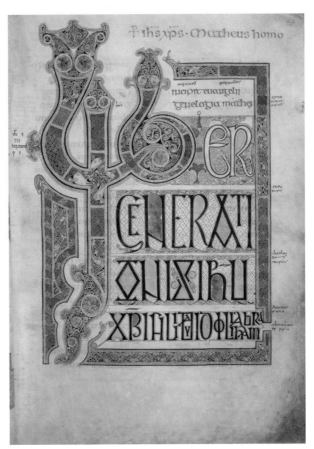

Figure 1.11
Eadfrith, "Incipit Page of St. Matthew's Gospel," *Lindisfarne Gospels*, Britain (Northumbria), ca. 720 CE. Ink, pigments on vellum, 13 1/2 × 9 3/4". The exquisite display text of the opening pages to the Gospel of Matthew comprises panels of intricate interlacing geometric and zoomorphic patterns that are copied with little modification from the portable metalwork of earlier, pagan populations in this area of the British Isles. Fully contained within the words of God, the abstract patterns now speak powerfully to the conversion of pagan England to Christianity.

British Library, London, Cotton Nero D. IV, fol. 27. Photo © British Library Board.

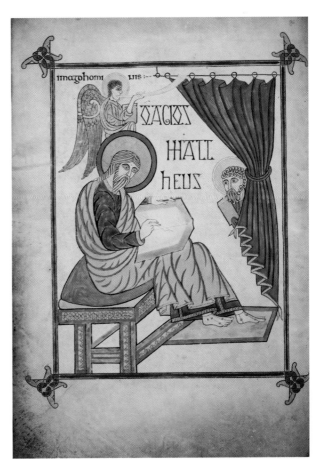

Figure 1.12
Eadfrith, "Portrait of St. Matthew," *Lindisfarne Gospels*, Britain (Northumbria), ca. 720 CE. Ink, pigments on vellum, 13 1/2 × 9 3/4". In this portrait of Matthew, a three-dimensional rendering of a classical scholar has been flattened due to the influence of the two-dimensional design aesthetic of the Northumbria region, as exemplified by the text-page example seen in Figure 1.11.

British Library, London, Cotton MS Nero D IV, fol. 25v. Photo © British Library Board.

Figure 1.10
"Jacob Wrestling the Angel" and related scenes, *The Vienna Genesis*, Syria-Antioch or Syria-Palestine region, sixth century. Silver ink and tempera pigments on dyed purple parchment, 12 1/2 × 9 1/4".
Jacob is shown four times, distinguished from other characters by his brown robes. His encounter with the angel (an embodiment of the divine, and for Christians a prefiguration of Christ) unfolds in two scenes in the middle of the lower register: to the right he wrestles the figure who, to the left, will bless him—indicating that Jacob was chosen by God to lead the Israelites. To the right of the encounter with the angel, we see Jacob leading his family over the ford of Jabbok, as described in Genesis, a journey emphasized by the clever use of a curving, arched bridge that leads the viewer's eye from background to foreground.

Vienna, Österreichische Nationalbibliothek, Cod. Theol. gr. 31, fol. 12r. Photo: Austrian National Library.

Historiated Initials

From the twelfth century on, the ubiquitous use of the historiated initial to indicate divisions and delineate hierarchies of importance within a text brought together letterforms, panel patterns, and narrative imagery in fully integrated page designs. In the Beatus Page from *The St. Albans Psalter*, David, enthroned in the letter *B*, is depicted as author and introduces the whole of the **psalter** text, a bound book that contained the "Book of Psalms" from the Old Testament (Figure 1.13). The marginal battle at the top offers a visual metaphor for the emphasis in the textual contents to come: that of the soul's quest for grace and the struggle of good versus evil.

The Shift to Urban and Secular Manuscript Production

By the early 1200s, the production of illuminated manuscripts in Western Europe had shifted almost entirely to the growing urban centers, driven in large part by the rise of the universities, but also by increasing centralization of commercial trade. Some major cities became known for the production of specific kinds of texts: Bologna for law books, since it had the preeminent school of law in Europe; and Paris, for its emphasis on theology, for single-volume, portable Bibles. A typical example of what is known as the Paris Bible illustrates the two-column format, compact script, and use of decorated and historiated initials that can be found in the thousands of Bibles made in and around Paris in the thirteenth century (Figure 1.14a, b).

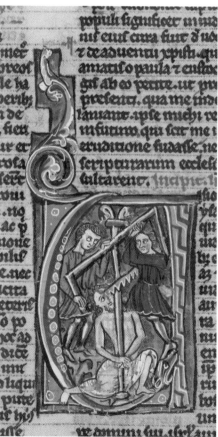

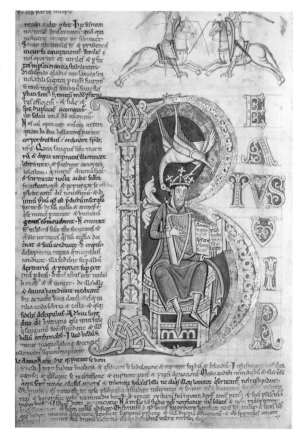

Figure 1.13 "Beatus Page," *St. Albans Psalter* (a.k.a. *The Psalter of Christina of Markyate*), St. Albans Abbey, England, ca. 1119–1145. Ink, tempera, gold on vellum, 10 $^7/_8$ × 7 $^1/_4$". Hildesheim, Dombibliothek HS St.God. 1, page 72. Historiated initials were a widely used convention for demarcating important passages and the general organization of manuscripts.

(Property of the Basilica of St. Godehard, Hildesheim).

Figure 1.14a, b
"Martyrdom of Isaiah in initial U" and detail, Bible, Paris, ca. 1245–1250. Ink, tempera, gold leaf on vellum, 6 $^1/_4$ × 8 $^3/_4$".
Of particular note in this typical Paris Bible is the scene introducing the text to the Book of Isaiah, which isolates a single defining moment in the life of the prophet (his martyrdom by having his head sawn asunder) to introduce the text attributed to him. This is not an incident related in the text, but rather a biographical note that emphasizes authority, much like the portrait of the Evangelist Matthew (Figure 1.12).

Photo: Morgan Library and Museum, MS M.269, fol. 245v.

Theme Box 3: Word and Image
by Jaleen Grove

While illustration can be defined in many different ways, one common definition is *a picture that accompanies the oral or written word*. Because the majority of illustrations are made for this purpose, when one is analyzing the nature and efficacy of an illustration, it is useful to consider the following basic ways that images go with words:

1. **Mirror the words as closely as possible.** Sometimes it is important that an illustration repeat exactly what the verbal text says without elaboration either for the benefit of illiterate people—especially when the subject is conveying important, incontrovertible information—or for technical specificity, as in instruction manuals, for example. Yet even the most simplified symbols (such as the male and female symbols for toilets) *always* add something extra to words. Emotional tone and cultural identity are inherent in the style and technique used, and offer clues about the audience addressed, as well as about the illustrator.

2. **Symbolize the message.** Sometimes a concept possible to explain verbally is very difficult to communicate visually, especially if the subject is nonconcrete or philosophical, or if the style of rendering is imprecise. Images are especially weak at telling the reader to *not* do something in one frame. Multiple cause-and-effect panels become necessary; and even then, showing a forbidden behavior tends to reinforce it—even if the next panel shows

a dire consequence. Illustrators have evolved customary symbols such as the red circle with diagonal bar to ban something, or the emotive marks in comic strips and manga that tell how the character feels.

3. **Expand upon a verbal description.** Besides what is inevitably added through detail and style, an illustrator can elaborate upon the basic scene set by the author. Imagination is the only limit. The illustrator can even combine several moments in time into one image by repeating a character in consecutive events. When readers add imagery by hand or by collage, the practice is called **extra-illustration**, or grangerization.

4. **Extend the concept.** While expanding upon a verbal description tries to flesh out the author's vision, extending the concept takes it one step further. In extending the concept, the illustrator relates things the author perhaps never intended, to enhance the story or message. A new character could show up in the illustrations yet is never mentioned in the story, for instance.

5. **Contradict the words.** Illustration performs a special role when it tells a different story than the spoken or written text. Used to great effect in humor, satire, horror, and the surreal, the contradiction of verbal versus visual messages demands more engagement with the reader, who must sleuth out meanings. This sort of illustrated text is therefore

more open to interpretation and benefits from an understanding of the origins and common uses of signs, in order to grasp ironic, subversive, or surreal recontextualizations.

6. **Become the words.** Pictographs, hieroglyphs, calligrams, decorated capitals, and typesetting in the shape of images are illustrations that are also words and letters. Even the design of typographic letterforms is partly illustration, in the choice of line weights, serifs, proportions of ascenders and descenders, and so on that give the letters personality. In many cultures, art and lettering or words and images are inseparable. Wordless books and other forms where letters and words are completely omitted also allow the pictures to entirely stand in for verbal communication.

The different ways that images challenge words to enhance and alter meaning are called **counterpoint**. Words convey one set of limited meanings by themselves; images convey another set. Put together, third, fourth, and more meanings arise. The analysis of word and image relationships is one of the core concerns of the field of Illustration Studies.

Further Reading
McCloud, Scott, *Understanding Comics* (NewYork: William Morrow Paperbacks, 1994)

Nikolajeva, Mari, and Carole Scott, *How Picturebooks Work* (New York: Garland Pub., 2001).

In secular manuscripts—historical chronicles and legendary romances, for example—simply framed, painted illustrations known as **miniatures** were typically employed across one or two columns of text to bring the action described in the text visually to life for the medieval and Renaissance reader. It was also the convention to depict historical and literary events in contemporary settings, with characters dressed in the costume of the day (Figure 1.15).

Just as the past was visualized in contemporary guise in later medieval manuscripts, so were remote lands often rendered in architecturally familiar motifs. In the case of *Sir John Mandeville's Travels* (Figure 1.16), the eastern Mediterranean cities of Jaffa in modern-day Israel (background) and Tyre in modern-day Lebanon (foreground) are imagined as typically western European walled cities with crenellated walls, circular turrets, and steeply gabled roofs. What sets the depiction of Jaffa

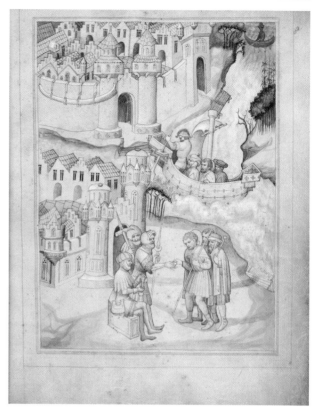

Figure 1.16
"Travelers Sail into Jaffa and Pay Duty at Tyre," *Sir John Mandeville's Travels*, Bohemia, ca.1410. Tinted ink and washes on green parchment, 8 7/8 × 7".
This manuscript presents the story of a fictional knight traveling through the Holy Land in **grisaille** (monochromatic) drawings, lightly overpainted on green parchment.
British Library, London, Add. MS 24189, fol. 8. Photo © British Library Board.

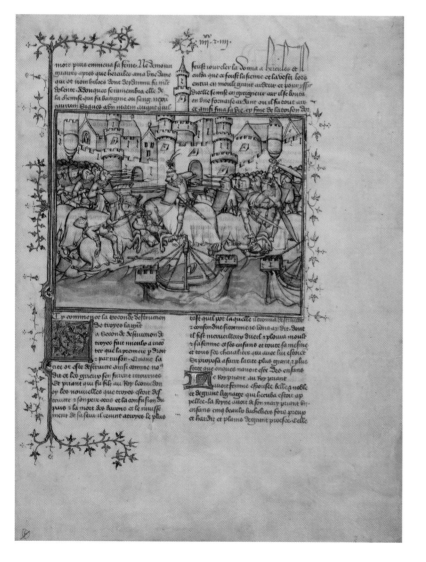

Figure 1.15
Anonymous First Master of Bible Historiale of Jean de Berry, "A Battle from the Trojan War," *Histoire ancienne jusqu'à César* (*Ancient History until the Reign of Caesar*), Paris, 1390–1400. Colored washes, gold leaf, and ink on parchment, 15 1/16 × 11 3/4".
This miniature shows the ancient battle between Trojans and Greeks with the combatants anachronistically dressed as medieval knights.
J. Paul Getty Museum, Los Angeles, MS. Ludwig XIII 3, leaf 3. Photo courtesy J. Paul Getty Museum.

apart, at least, is the large bone that hangs to the left of its entrance. Believed to be the rib of a giant, this was a well-known landmark for Christian pilgrims traveling to the Holy Land. Sir John Mandeville, like the turreted walls, was probably a fiction—the text of his *Travels*, a clever compilation by an armchair adventurer, most likely from northern France or Flanders. However, the naturalistic rendering of the two figural scenes and the unified landscape bring the itinerary to life and add to a sense of veracity. While the story was well known and translated into many languages, this particular manuscript had virtually no text except phrases illustrated within two of the twenty-eight full-page miniatures.

Often referred to as a medieval "bestseller," the **book of hours** was a popular and variable compendium of prayers for the lay population in which the structure of the text allowed the reader to mimic monastic ritual. Not all books of hours were illustrated, but in most that have survived to this day, miniatures signaled divisions within the texts, and scenes from the life of Christ, images of the Virgin Mary, and portraits of the saints predominated. These images were understood to function hand in hand with the text as a stimulus to prayer, and for the wealthiest class of patron—merchants, church officials, aristocrats, and royalty—there could be considerable personalization in text and image (Figure 1.17).

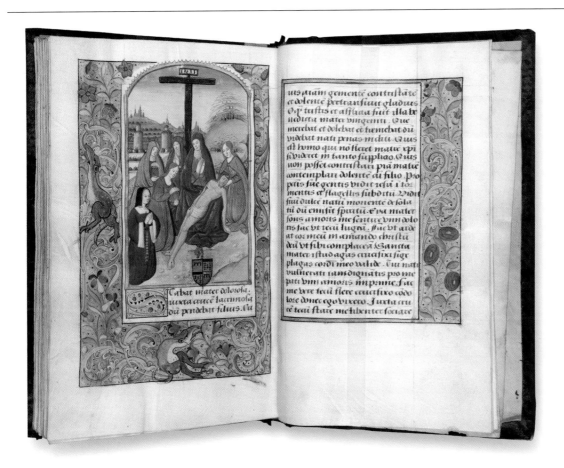

Figure 1.17
Master of the Missal of Amboise Le Veneur (attributed) (illuminations), and Jean Serpin (borders), "Deposition with Female Donor,"
Book of Hours (use of Rouen), France, ca. 1510. Ink, tempera, gold leaf on vellum, bound in purple velvet over wooden boards, 8 $^3/_8$ ×
5 $^5/_8$ × 1 $^1/_4$".
Elaborate manuscripts were a sign of status. In this typical late medieval illuminated book of hours, the artist has included two different
forms of personalization: a depiction of the owner—in the red robe to the left—and a heraldic shield identifying the family to which she
belonged. That the reader might imagine herself present at key moments in the life of Christ and experience emotions similar to those, in
this case, of Mary mourning the death of her son, was wholly in keeping with the movement toward a more affective and personal spirit-
uality in Europe in the later middle ages.

Photo courtesy of RISD Museum, Providence. Museum purchase in honor of Dr. Arnold-Peter Weiss; Helen M. Danforth Acquisition Fund, 2011.30.

Conclusion

Despite a breadth of subject and material form, the foregoing examples of early illustration share the goal of establishing meaning in a visual format. While our certainty about the identities of creators and their exact intent is sometimes limited, we garner clues to the images' communicative functions—beyond the obvious narrative—through considering attributes such as scale, whether the images were made for public versus private viewing, portability, and customization.

For instance, the Last Judgment tympanum at the Abbey of Ste. Foy is a vivid and idiosyncratic retelling of events that were associated in the middle ages with the end of time, a visual referent to Bible passages, with its magnificent scale, physicality, and symbolic positioning intended to inspire feelings of awe and fear in the viewer. The imposing, portable *Bayeux Tapestry* conversely operated as an impressive traveling "public relations" exhibit meant to inspire loyalty, while the Painted Hall of the Villa of the Mysteries, still of commanding scale,

obviously mandated private viewing by those already sympathetic to its message. The Tomb of the Diver was intended for the most private audience of all—a single deceased young man.

Small scale, customizable, and portable scrolls like the Egyptian Books of the Dead and the much later secular and devotional manuscripts point to the growing importance of the personal and proprietary illustrated communication. While these are still handcrafted items, and thus affordable to only some, we see the repetition of formal attributes and shared visual codes within populations.

The specificity with which all these images "spoke" within their own milieu, from the earliest cave paintings to the elegant *Book of Hours*, is forever lost to us as students of illustration history. This loss, however, underscores the importance of visual literacy in the artist–viewer exchange and cautions us to consider all images as highly contextual artifacts.

FURTHER READING

Anderson, John, "The Bayeux Tapestry: A 900-Year-Old Latin Cartoon," *Classical Journal*, vol. 81, no. 3, 1986.

Bernstein, David J., *The Mystery of the Bayeux Tapestry* (Chicago: University of Chicago, 1987).

Blanchard, Paul, *Southern Italy*, 11th ed. (London: Somerset, 2007).

Brown, Michelle P., *Understanding Illuminated Manuscripts: A Guide to Technical Terms* (Los Angeles: J. Paul Getty Museum, 1994).

Clemens, Raymond, and Timothy Graham, *Introduction to Manuscript Studies* (Ithaca, NY: Cornell University Press, 2007).

de Hamel, Christopher, *The History of Illuminated Manuscripts*, 2nd ed. (London: Phaidon Press, 1997).

Holloway, R. Ross, "The Tomb of the Diver," *American Journal of Archaeology*, vol. 110, no. 3, July 2006.

Lawson, Andrew J., *Painted Caves: Paleolithic Rock Art in Western Europe* (Oxford: Oxford University Press, 2012).

Lehmann, Karl, "Ignorance and Search in the Villa of the Mysteries," *Journal of Roman Studies*, vol. 52, 1962.

Lewis, Suzanne, *The Rhetoric of Power in the Bayeux Tapestry* (Cambridge: Cambridge University Press, 1999).

Noxon, Gerald, "The Bayeux Tapestry," *Cinema Journal*, vol. 7 (Winter, 1967–1968).

Petzold, Andreas, *Romanesque Art* (New York: Abrams, 1995).

Prina, Francesca, *The Story of Romanesque Architecture* (Munich, London, New York: Prestel, 2011).

Stubbs, H. W., *Pegasus: Classical Essays from the University of Exeter* (Exeter: University of Exeter, 1981).

Wieck, Roger S., *Painted Prayers. The Book of Hours in Medieval and Renaissance Art* (New York: George Braziller, 1997).

KEY TERMS

allegory	Middle Kingdom
amphora	miniature
anthropomorphic	New Kingdom
architectonic	Old Kingdom
book of hours	polychrome
codex	propaganda
counterpoint	psalter
crewel	register
Dionysian Mysteries	relics
extra-illustration	Romanesque
fresco	Second Style
grisaille	symposium
hieroglyph	*trompe l'oeil*
historiated initial	tympanum
Late Period	Upper Paleolithic
logocentrism	vignette
marginalia	visual literacy

Illustration in Early European Printed Matter, 1400–1660

Susan Doyle

Before printmaking was widely adopted in Europe in the fifteenth century, paintings, architectural relief, illuminated manuscripts, stained glass, and textiles often served illustrative functions by visualizing mythology, religious dogma, and history. Portraiture, while memorializing likeness, also served as a cultural marker, the display of which persuasively reinforced political and social hierarchies. At this point in history, an artist might attain a reputation for high-quality work, but the categories of "fine art" and "popular art" did not exist. Visual art, poetry, theater, and music were created with a purpose in mind. Artists and artisans responded to the requests and tastes of their patrons, reflecting *and shaping* the material culture of the day through their work.

The Church, monarchs, and nobility were the usual patrons, and most visual art, whether painted or sculpted to fit a designated space or to decorate a manuscript, was created on commission. Likewise, portraiture, tapestries, decorated furniture, and precious metalwares were the province of the rich; so with the exception of painted signs or artwork viewed in churches or cathedrals, the poorer classes had little access to images.

With the advent of printmaking, the situation changed dramatically. While some prints mirrored the functions of earlier art, new communicative forms emerged through the proliferation of printed images and illustrated texts. This output informed and shaped the interests of newly articulated social groups and was therefore integral to the rise of the Early Modern period (1450–1800). Furthermore, developments in printmaking and print culture during this period established traditions in illustration that affected the aesthetics of reproduced images until the advent of photomechanical reproduction at the end of the nineteenth century.

Printmaking: A Democratizing Cultural Phenomenon

Fifteenth-century Europe saw urban expansion in territories both north and south of the Alps as a powerful middle class of merchants, professionals, and artisans emerged in self-regulating urban centers. Society, however, remained stratified: the nobility maintained opulent dwellings and vied for patronage positions at the courts of monarchies or territorial princes, while the large, almost entirely illiterate peasantry worked on farms in rural areas. The Church directly and indirectly wielded significant influence on political as well as spiritual matters.

The advent of printing in the late fourteenth century and its spread in the fifteenth century facilitated the reproduction of texts and images in a vital combination that articulated concepts differently and more thoroughly than spoken word or written text alone could do. Printing had an immeasurable democratizing effect on culture by allowing ideas and information to circulate across time, space and social boundaries. Pictures provided access to texts for those who could not read and enhanced meaning for those who could. Reproduced images communicated technological, scientific, and geographical ideas and information more specifically than words, and whether displayed in public or viewed in private, provided visual referents that shared meaning among social groups.

Xylography: Woodcuts and Relief Printing Processes

Woodcut printing, or **xylography** proliferated for many centuries in Asia (*see Chapter 5*) before becoming the first type of printing in Europe. It is a **relief process** in which the artist creates a raised design by carving away the negative spaces between shapes and lines, leaving only

Theme Box 4: Xylography
by Susan Doyle

Xylography, or woodblock printing, is a relief printing method in which the image is created by removing areas that do not print, leaving only the final design raised above the supporting block of wood. To print, an artist rolls or brushes ink across the elevated surfaces. A sheet of paper (or cloth) is placed on top of the block and pressure is applied to the back of the paper by hand rubbing or with a mechanical press. This transfers the image to the paper.

To create the block, the artist first draws or transfers a drawing to the block's surface. The image must be drawn in reverse because the printing process creates a mirror image. Using a sharp blade and a variety of gouging tools, the block cutter carefully removes the wood in the negative spaces around the marks so that all the nonprinting areas are lower than those that form the image. Xylography is the technical name for both woodcut (Western) and woodblock (Asian) printing. The cutting tools, registration methods, and inks vary a bit between the two approaches, but the fundamental elements are the same.

that which will print (*see Theme Box 4, "Xylography"*). The earliest European woodblock prints were on fabric, but the process was quickly adapted to single sheet images, and then books when paper became regularly available from factories near Fabriano, Italy, in the fourteenth century.

Early block prints were cut with bold lines capable of withstanding repeated pressure in printing. Frequently, short, parallel lines indicated shadow or differentiated planes, but the medium did not lend itself to fine detail. Some prints were hand-colored after printing to enhance the image, as methods for printing multiple colors had not yet been developed.

Early prints were both secular and devotional. Playing cards are thought to date from the 1370s, although surviving images from such roughly used ephemera are rare. Devotional prints provided visual aids for the faithful, who memorized prayers and recited them in private, while looking at prints. These prints were sold by independent workshops, available at rural fairs, and sometimes sold outside churches. Monastic orders and other segregated religious communities also made or commissioned prints, which they both used and sold to lay congregants. The Birgittine convent at Marienwater in the Netherlands, for example, is one of five northern European convents known to have been involved in some aspect of the printing of devotional woodcuts. Distinctive for their decorative

borders, prints occasionally included nuns anachronistically placed within biblical scenes (Figure 2.1), thus aligning them with key religious moments. Some nuns are known to have annotated devotional prints with personal messages to be shared within their own community and sent to others outside the convent.

Early Printed Books: The Transition from Scribal Copying

Prior to the development of printing, the most frequently hand-copied books were pictureless manuscripts used in academic study or simple devotional texts. These were produced in workshops under the aegis of monasteries, and later, universities. Only the more exclusive manuscripts were illuminated (*see Chapter 1*). Narratives with instructive intent like fables or bestiaries were also commonly copied, and less frequently, popular tales were reproduced for entertainment.

Like printing, book production itself did not progress uniformly and was affected by local practices and aesthetics. Certainly, printed books did not simply replace manuscripts all at once. In some cases, hybrids were produced with printed text and handmade illustrations, or the inverse: calligraphy with small woodcut prints glued in, referred to as **chiroxylographic** books. Since artisans were typically affiliated with guilds based around technical skills, processes and design motifs were often shared by craftsman whose end products might bear little resemblance to each other. For instance, although woodcut prints were designed by those skilled in drawing, by about the 1480s,[1] the cutting of most blocks was subcontracted to artisans skilled in wood sculpting or intarsia, the craft of wood inlay.

Incunabula

Books printed before 1501 are referred to as **incunabula** from the Latin word meaning "to cradle." Incunabula are subdivided into two categories: typographic books, books printed with movable type; and **blockbooks**, those made by carving both images and text from a single block of wood.

Blockbooks flourished only briefly in the second half of the fifteenth century and were contemporaneous to typographical printing. After the image and text were carved in reverse, the block was inked with water-based inks, and transferred to paper laid on top of the block by vigorously rubbing the back of the sheet. Afterward, another craftsman might color the printed pictures by hand. Sheets could not be printed on two sides because the pressure of printing embossed the paper, making the backside too textured to print evenly. To make a codex (bound book), two facing pages were printed together in a spread and folded in half, leaving blank pages on the reverse facing each other. These pages were sometimes pasted together to eliminate empty pages between printed pages and ensure the visual flow of the book.

Of the more than thirty surviving blockbooks, the majority were religious in theme, including *Biblia*

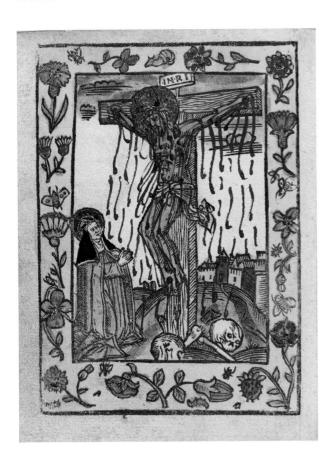

Figure 2.1
Anonymous, *The Crucifixion with St Bridget in Adoration*, 1495–1510. Woodcut on paper, hand colored, 4.37 × 3.1".
Hand-colored wood block prints were made and distributed by a few convents in the Low Countries around 1500. By placing St. Bridget, at the foot of the cross, the artist links the saint and her namesake convent to a central event of the Christian faith.
The British Museum, London.

[1] Landau and Parshall, *Renaissance Print*, p. 36.

Figure 2.2
South Netherlandish, *The Flight into Egypt with Jacob Fleeing Esau and David Fleeing Saul, Biblia Pauperum*, ca. 1460s. Woodcut printed in olive-brown ink and hand-colored in red, green, yellow, black, gray, and pink on laid paper, 10 5/8 × 7 3/4" (sheet).
This page from the blockbook *Biblia Pauperum* uses an architectural frame to divide up the various scenes from the the Bible to encourage the viewer to interpret Old Testament stories in the side panels, as symbolic precursors to the New Testament narrative in the central panel.
Helen M. Danforth Acquisition Fund, RISD Museum, Providence.

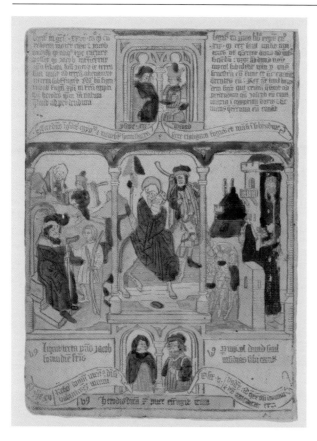

Figure 2.3
The Golden Legend (*Legenda aurea*), printed by Wynkyn de Worde, English version translated by William Caxton (English, ca. 1415–1492) from the French by Jean de Vignay, 1493. Woodcut. Hagiographies promoted the ven-eration of the saints who were specified through symbolic **attributes** (props that they hold or wear, or other physical evidence) rather than by likenesses.
Houghton Library, Harvard University, WKR 1.3.4.

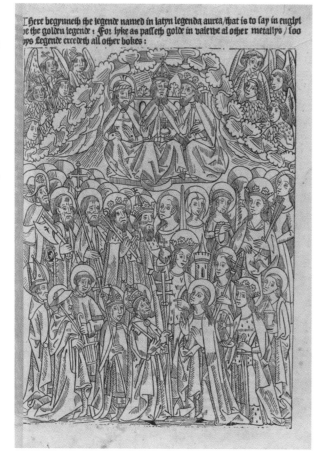

Pauperum, Latin for "Pauper's Bible" (Figure 2.2). This title is a misnomer because the book was not a Bible, nor was it made for the poor. Each of its forty full-page illustrations showed three narrative moments divided by an architectural frame, with Latin text. This **typological** format encouraged viewers to interpret Old Testament figures and stories as prefiguring the New Testament. The central subject is the New Testament, which is framed on either side by scenes from the Old Testament. Prophets depicted in the smaller inset illustrations above and below describe what takes place and issue prophecies in **banderoles** (scroll-like shapes), which are in effect an early form of the speech bubble later seen in cartoons. Readers of the book drew upon their knowledge of the Bible to create non-linear associations between the biblical images and stories, to aid them in a better understanding of the mysteries of the Divine.

Other popular incunabula were *Ars Moriendi* (*The Art of Dying*), which instructed Christians on how to improve chances for salvation by dying in a state of grace by denying sinful impulses, which were depicted as highly imaginative demons tempting humans on their deathbeds; and *The Apocalypse* with its terrifying predictions and compelling illustrations of the end of the world. With intermittent bouts of plague decimating European populations, it is understandable why images of death would hold such fascination for fifteenth-century artists and audiences.

Gutenberg and the Invention of Movable Type

In about 1450, Johannes Gutenberg (German, 1398–1468) revolutionized publishing through his method of printing with movable type in which individual cast metal letters could be assembled, disassembled, and reused to convey any text (*see Theme Box 5, "Gutenberg and Movable Type"*). Gutenberg's system facilitated the inclusion of relief images with text in a single impression using a mechanical press. His process relied on knowledge of metallurgy and casting techniques and was thus technically demanding and expensive to implement. Nonetheless, more efficient and flexible, typographic printing quickly outpaced contemporaneous blockbooks, which were slow, labor intensive, and ultimately rigid in their output.

One of the most copied medieval manuscripts was *Legenda aurea* (*The Golden Legend*), ca. 1260, by Jacobus de Voragine (Italian, ca. 1230–1298), a **hagiography**, or collection of idealized biographies of saints whose feast days marked the calendar year. *The Golden Legend* (Figure 2.3) evolved into a printed book popular throughout Europe that inspired Christians with its tales of saints' spiritual achievements and the heroism of their often gruesome martyrdoms.

As heroic figures, Christian saints were prayed to in times of particular need, and certain saints were (and still are) considered the "patron" of particular social groups:

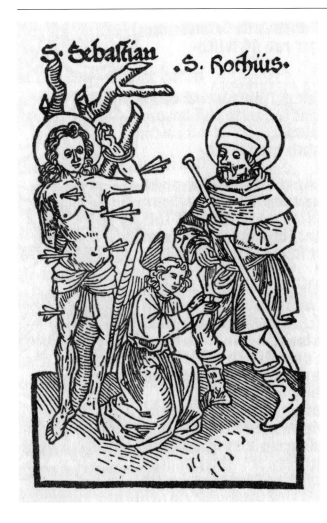

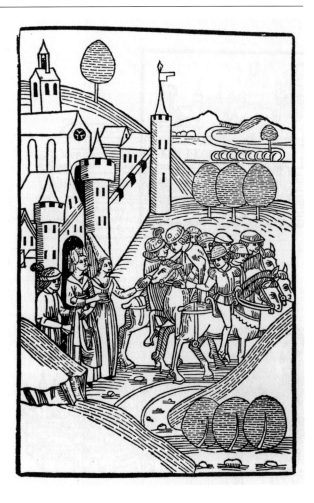

Figure 2.4
St. Sebastian and St. Roch with an Angel, *Buchlein der Ordnung (Pest Regiment) Book of Plague Regime*, ca. 1482, woodcut. From *The Illustrated Bartsch*.
Two popular saints were St. Sebastian and St. Roch, both associated with the plague and healing. St. Sebastian is typically shown shot through with arrows for refusing to renounce Christianity; St. Roch is depicted with a wound on his thigh.
Courtesy Abaris Books.

Figure 2.5
"The Departure of Jean de Mandeville," *Reysen und Wanderschafften durch das Gelobte Land (Travels and Wanderings Through the Holy Land)*, ca. 1481. Woodcut.
This anonymous German woodcut depicts the departure of Christian knight Sir John and his entourage, bound for exploration of the Holy Land. The image has the characteristic bold outline of early woodcut, with parallel line shading used to indicate form and shadow and to differentiate the repeated elliptical tree forms. Depth and architectural volume are indicated, but linear perspective is not utilized.
From *The Illustrated Bartsch*, Courtesy Abaris Books.

for instance, St. Roch, who cared for the sick during an epidemic in Rome, and St. Sebastian are appealed to in times of illness. Despite having lived nearly a millennium apart, these two saints are conveniently depicted together in an introductory print from a fifteenth century plague book (Figure 2.4).

Popular secular texts also transitioned from manuscript to early printed books, as in the case of *Sir John Mandeville's Travels* (ca. 1481) (Figure 2.5), a tale about a fictional knight traveling to the Holy Land (*see manuscript version in Chapter 1*). Translated into many languages within about fifty years, this text evidences the development of vernacular languages as well as the diffusion of narrative **iconography** (conventions of symbolic or figural representation) among various

communities. Illustrations in these early books encouraged literacy because poor readers could follow along by looking at the pictures. Even for the truly literate, images stimulated the imagination in ways that the text alone did not, thereby enhancing the overall experience.

The *Nuremberg Chronicle*

Printing encouraged a resurgence of interest in classical, scholastic, and humanist texts as well as the development of vernacular literature. The *Nuremberg Chronicle* is a book emblematic of the impulse to synthesize these many forms in a single tome. Written by Hartmann Schedel (German, 1440–1514), and published both in Latin as *Liber Chronicarum* and in German as *Die Schedelsche*

Theme Box 5: Gutenberg and Movable Type
by Susan Doyle

Johannes Gutenberg (German, d. 1468) was a craftsman and inventor credited with developing the modern system of printing with movable type. While movable type had existed in China hundreds of years earlier, the greater number of Chinese characters made movable typographic systems unwieldy in that language, so printers there often preferred to carve text alongside images as a single unit. Gutenberg's method, developed in the mid-fifteenth century, suited the small number of characters in the Roman alphabet. His method proliferated rapidly throughout Europe and was used industrially with only minor modifications until the twentieth century. **Letterpress**, as it is called, continues as an artisanal printing form today.

Gutenberg understood metallurgy and was able to devise a multistep process for duplicating durable letterforms in metal. To create even a single letter requires several steps: first, a master letter is carved in relief on the end of a short rod called a punch. The punch is pressed into a soft metal bar called a matrix, creating a void in the shape of the letter. The matrix fits into a larger mold that includes a standardized base. The mold is filled with molten metal that when cooled renders a single piece of type. All pieces of type are cast at slightly less than 1 inch in height (a measurement called **type-high**) with similarly ridged bases, so they can be accurately aligned and set into rows with others. The rows of type are then locked into place to create an entire page of text. Hundreds of letters are needed to print a single sheet, so printers amassed huge numbers of cast letters and stored them in shallow compartmentalized trays called "cases," with capitals in the upper case and miniscules in the lower case, hence the modern terminology "upper case" or "lower case." Type was and is stored in a very specific order so that the type-setter aligning the letters can quickly pick the type.

As the use of movable type became widespread, the casting processes created uniformity within fonts and helped standardize the aesthetics of the letterforms. For practical reasons, printers invested in only a limited number of fonts and sizes. Nonetheless, over time, the growth of the printing trade encouraged definition of many fonts, all influenced by regional aesthetic traditions.

Woodblock illustrations were cut from wooden blocks of the same height as the type so they could be locked into the printing **formes** (the base that included letterforms and woodblock illustrations) and printed simultaneously.

Gutenberg's Press and Ink

Gutenberg did not invent the printing press. Rather, he adapted a screw-operated press similar to what would have been used for pressing wine or olives. Gutenberg also devised a viscous oil-based ink that could be rolled evenly across the surfaces of printing formes. The oily ink remained moist and workable longer and transferred more easily to the printing paper than the water-based inks used in printing blockbooks. Despite being a laborious process, Gutenberg's system was much more efficient than any previous printing process, and is credited with catalyzing the expansion of print culture and the Renaissance in Early Modern Europe.

Weltchronik (Figures 2.6, 2.7, and 2.8), it combined unattributed extant writings with Schedel's own work in a practice that was not considered plagiarism in the fifteenth century. Schedel's history of the world followed St. Augustine's *Six Ages of the World* (ca. 400 CE) and included a variety of other topics ranging from the plague, omens, natural and supernatural phenomena, biographies, and genealogies.

Much of the *Nuremberg Chronicle* is dedicated to historic "portraits" that include depictions of classical gods and heroes, ancient and medieval rulers, philosophers, biblical figures, popes, and martyrs. Such portraits are at best placeholders that use text and symbolic attributes like halos, crowns, bishops' miters, quills, and staves to identify the subjects. To spare the expense of cutting additional blocks, many of the 652 separate woodblocks were used multiple times to represent different people or places, for a total of 1,804 images.

The *Nuremberg Chronicle*'s many biblical and worldly genealogies use a botanical-themed pictorial device whereby notable personages "sprout" from a highly stylized vine. "Genealogy of Charlemagne" (Figure 2.7) uses this format and is by no means complete, as it skips generations to succinctly link the eighth-century emperor Charlemagne to other important religious or political figures. Charlemagne has a crown and a halo along with a sword that communicate his combination of divine and temporal authority as the Holy Roman Emperor.

The illustrations in the *Nuremberg Chronicle* lent vitality to an otherwise impenetrable amount of textual information. They were designed by painters Michael Wolgemut (German, 1434–1519) and Wilhelm Pleydenwurff (German, 1460–1494), who drew the designs, commissioned or managed the transfer of designs onto the blocks, and oversaw the *formschneider*—the woodcutter-specialist responsible for actually incising

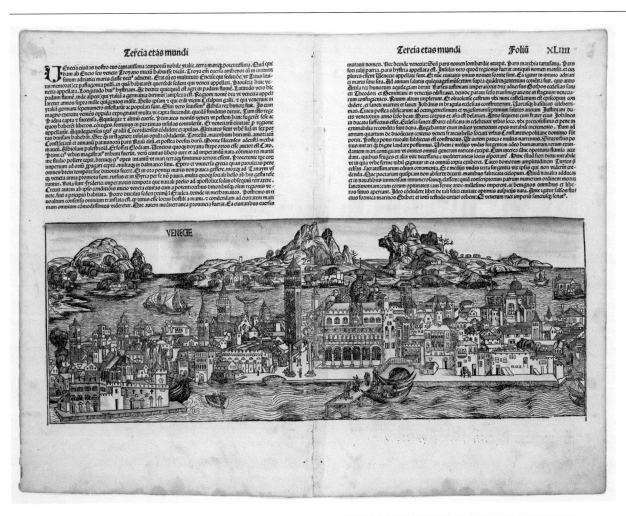

Figure 2.6
Wilhelm
Pleydenwurff
(German, ca.
1458–1494),
view of Venice,
from *Nuremburg
Chronicle*,
Nuremberg: Anton
Koberger, 1493.
Woodcut and
letterpress with
watercolor, 7 5/8 ×
21 1/16" (plate).
Among its
wide-ranging sub-
jects, geography,
including maps and
panoramic depic-
tions of important
cities, appeared
in the *Nuremberg
Chronicle*.

Museum Works of Art
Fund, RISD Museum,
Providence.

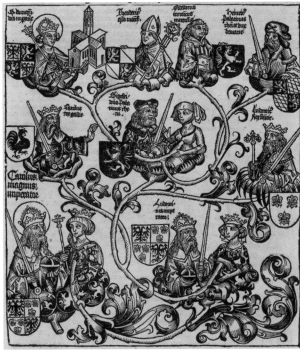

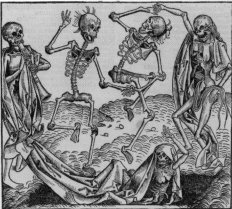

Figure 2.8
Wilhelm
Pleydenwurff
(German, ca.
1458–1494),
"Dance of Death,"
from *Nuremberg
Chronicle*,
Nuremberg: Anton
Koberger, 1493.
Woodcut and let-
terpress, 10 3/4 × 8
13/16" (plate).
Skeletons cavort
around a shrouded
corpse still bearing
moldering flesh in
"Dance of Death,"
an image that
underscores mor-
tality while seeming
to make light of it.

Museum Works of Art
Fund, RISD Museum,
Providence.

the blocks. The book was printed in black ink, and hand
coloring was done after purchase at the discretion of the
buyer, so surviving impressions vary.

Incunabula Illustration in Southern Europe

The printing press and movable type quickly made
their way south throughout Europe. Citizens of present-
day Italy did not adopt northern woodcut illustration
styles and initially printed predominantly unillustrated
classics intended for use by scholars. Devotional texts
and secular titles soon appeared, printed both in Latin
and Italian, and illustrated in accordance with local
tastes. *Aesop's Fables*, popular for its instructive qualities,
was interpreted by Francesco del Tuppo (Italian, ca.
1443–1498) in a 1485 version. Its illustrations were
created with uniform line work without much shading,
but achieve some spatial depth through the overlapping

Figure 2.7
Wilhelm Pleydenwurff (German, ca. 1458–1494), "Genealogy of
Charlemagnegne," from *Nuremberg Chronicle*, Nuremberg: Anton Koberger,
1493. Woodcut and letterpress, 14 13/16 × 8 13/16" (plate).
This image selectively traces the descendants of Charlemagne (ca. 742–814),
the first Holy Roman Emperor, to Saint Cunigunde (ca. 975–1040), the
Patroness of Luxembourg and wife of Holy Roman Emperor Saint Henry II
(ca. 975–1040). She appears in the upper left.

Museum Works of Art Fund, RISD Museum, Providence.

of figures. Its images were bordered by highly decorative frames that alternate between dark-on-light and light-on-dark figure-ground relationships (Figure 2.9).

Another Italian incunabula, *Hypnerotomachia Polipholi* (*Strife of Love in a [Poliphilo's] Dream*), was printed by Aldus Manutius (Italian, 1449–1515) in Venice, one of Europe's most important printing centers (Figure 2.10a, b). The text is attributed to Francesco Colonna (Italian, 1433–1527), a member of an unreformed monastic order; but other details of the book's creation, including the identity of the illustrator, have been questioned for centuries. The story revolves around the protagonist Poliphilo's search for his love Polia in a pagan world filled with classical architecture and pageantry. Noted for its rich and complex mixture of esoteric Latin vocabulary with emerging Italian vernacular syntax, the text also uses uncommon botanical and architectural terms, and was therefore challenging for even the well educated of the day to understand. With its innovative typography and page design, *Hypnerotomachia Polipholi* is widely regarded as a paragon of Renaissance book design. Its gracefully executed woodcut illustrations have refined, nearly uniform line weight with only occasional indications

of tone created through parallel lines, so illustrations are tonally balanced with the typography.

As the printing industry accelerated, illustrations were sometimes repurposed in new editions to save the time and cost of cutting new blocks. Relief printing methods were adapted to metal plates that were more durable than wood, and lent themselves to a system of modular reuse—particularly for decorative borders. Less frequently, illustrations were strategically designed in sections of interchangeable parts, and blocks were rented or loaned along with fonts, to make the production of books more profitable. The full range of incunabula publishing therefore brought together the skills of many: illustrators, block cutters, metallurgists (for casting movable type letterforms), papermakers, printers, illuminators, and because of the expense entailed in the entire operation, publishers, who had the necessary capital to underwrite large and time-consuming projects.

a

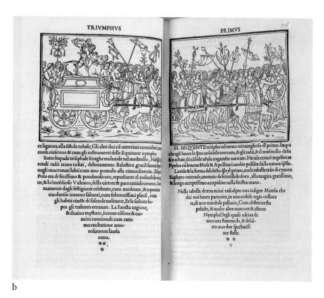

b

Figure 2.9
Anonymous artist, translated and editioned by Francesco del Tuppo, *Aesopus moralitus; Vita, Fabulae* (*The Moralized Aesop; Life, Fables*), fol. 4v, 1485. Woodcut, 11 1/4 × 8 1/4 × 7/8".
The narrative image depicts a wise servant accused of eating his master's figs who proves his innocence by vomiting. The design achieves rhythm through the diagonal repeat of the characters' legs and the tabletop, in counterpoint to the verticality of side columns and the center fold of the master's coat.
Courtesy of the Metropolitan Museum of Art, OASC.

Figure 2.10 a, b
Attributed to Benedetto Bordon (Italian, ca. 1450–1530); Francesco Colonna, author (Italian), *The Hercynian Forest*, and *Triumphus Primus* from *Hypnerotomachia Poliphili*, published in Venice by Aldus Manutius, 1499. Bound book with woodcut illustrations, 15 × 22 1/2 × 1 3/8".
Hypnerotomachia Polipholi presents the protagonist's search for love in a dreamlike land depicted in elegant woodcuts emphasizing beauty and classical form.
Museum Works of Art Fund, RISD Museum, Providence.

Artistic Publishing

The visual expression of woodcut illustrations saw a stylistic leap in the work of Albrecht Dürer (German, 1471–1528), who, after training with his goldsmith father, was apprenticed to Michael Wolgemut about the time he and his partner Wilhelm Pleydenwurff were producing the *Nuremberg Chronicle* illustrations. Dürer's journeyman work was focused on book illustration, a practice he continued throughout his career.

Because Dürer had learned the craft of woodcutting, he was able to create designs that pushed the limits of the woodcut medium. In his *Four Horsemen of the Apocalypse*, (Figure 2.11), Dürer abandoned the heavy outlines of his predecessors and modeled surfaces using curvilinear linework that *converges* to create edges. Through complex overlapping of forms, he created compositional movement as well as a sense of depth. The riders and the humans overrun by them have naturalistic anatomy and individuated visages and expressions. *The Apocalypse* brought Dürer international fame, which he bolstered with the inclusion of his monogram. While also a distinguished painter, Dürer continued to publish graphic series because they reached a wide audience and provided him financial independence outside the patronage system.

Hans Holbein (German, 1497–1543) is best known for his exquisite portraiture, but as with many artists of the day, his output was diverse and included designs for book illustration, stained glass, metal work, and even *trompe l'oeil* scenes for the exteriors of buildings that were popular in northern Europe. One of his most distinguished illustrative works is a cycle of forty-one diminutive images often referred to as "the Dance of Death" (Figure 2.12), which shows people of high and low status at the moment death comes to take them away. Often satirizing the powerful and self-important, Holbein's series underscores that unequal opportunities in life are meaningless in the face of death. The images were only "proofed" around the time of the death of their woodcutter Hans Lützelburger, but were later paired with Latin Bible quotations and French verse in the 1538 book *Les simulachres & historiees faces de la mort, autant elegamme[n]t pourtraictes, que artificiellement imaginées* (*Images and Illustrated Facets of Death, as Elegantly Depicted as They Are Artfully Conceived*).

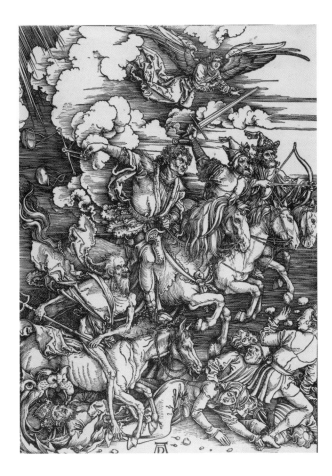

Figure 2.11
Albrecht Dürer, *Four Horsemen of the Apocalypse*, ca. 1497–1498. Woodcut, 15 3/8 × 11".
Dürer's series of woodcuts for "The Apocalypse" from the *Book of Revelation* achieved a groundbreaking synthesis of line and tone, with figures articulated by the interplay of tones and textures rather than simple outlines. Shown from left to right, the terrifying horsemen are Death, Famine, War, and Pestilence.

Courtesy of the Metropolitan Museum of Art, OASC.

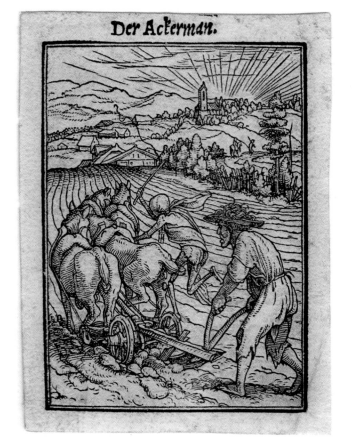

Figure 2.12
Hans Holbein, "The Plowman," from the "Dance of Death" series, ca. 1526. Hans Lützelburger, *formschneider*. Woodcut, 3 × 2.25".
Despite their diminutive size, Holbein's woodcuts expressively capture the environment and temperament of each subject as Death comes to steal them away. The phlegmatic plodding of the poor farmer contrasts the indignation and outright resistance of some of the more privileged citizens in other pictures.

British Museum.

Broadsides and Popular Printing

In the first quarter of the sixteenth century, Europe entered a stage of deep religious strife known as the Protestant Reformation, ignited in part by Martin Luther's *Ninety-Five Theses* (1517), a disputation of practices of the Church. The conflict brought along with it an explosion of printing that included thousands of pamphlets and **broadsides**—cheaply printed single-leaf prints designed to be posted or distributed in public.

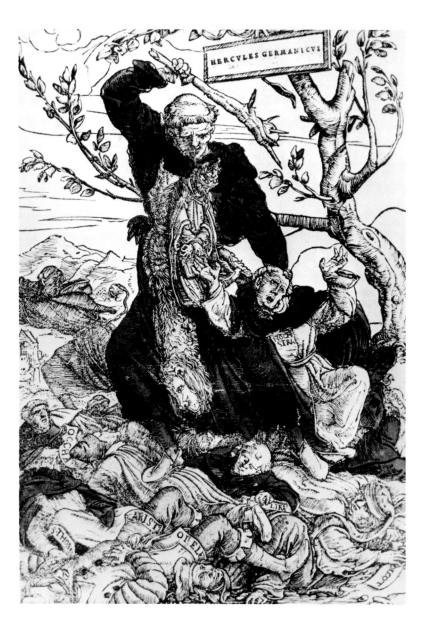

Figure 2.13
Hans Holbein, Martin Luther depicted as *Hercules Germanicus*, ca. 1522. Woodcut.
This propagandistic broadside depicts Martin Luther in his monk's habit, but with the spiked club and lion skin symbolic of the mythological hero Hercules. Neither a devotional image nor a collector's item, this "popular print" was designed as ephemeral communication.
Photo: DeAgostini/Getty Images.

Many broadsides included images because literacy rates were low.

Hercules Germanicus (*German Hercules*) is an illustrated broadside that is an excellent lesson in semiotics (*see Theme Box 7, "Saussure and Peirce: Semiotics"*). It shows Martin Luther in his monk's habit, but sporting the skin of a lion and wielding a spiked club—the traditional attributes of Hercules (Figure 2.13). The pope dangles from Luther's neck as he tramples over proponents of **scholasticism** (a system of theological teaching based on argumentation). He raises his club over the flailing figure of Jacob van Hoogstraten, a Dominican theologian associated with the Inquisition. The accompanying text compared Luther's struggles against the Church to Hercules battling the hydra. The illustration is noteworthy in that it marks a new illustrative strategy whereby contemporary news is comingled with classical symbolism in a propagandistic statement—evidence of the expansion and stratification of visual culture in early modern Europe.

Printed on inexpensive paper, broadsides and broadsheets (printed on two sides) detailed the latest news, sensational tales of crime and punishment, executions, witchcraft, and "true" stories designed to enforce social mores (Figure 2.14). Almanacs, which included calendars, some with astrological and astronomical information, were common. Broadsides detailing phenomena like comets, huge or otherwise unusual fish, or stories of human deformities included images to particularize information and provide some level of "verification," not unlike contemporary tabloids.

Broadsides were also used as propaganda. Conrad Corthoys's (German, ca. 1564–1620) equestrian portrait of Ferdinand II (Figure 2.15) shows the champion of the Counter-Reformation brandishing his baton as an angel looks on from the heavens and clouds part to reveal the sun on the right—signals of heaven's favor. Townspeople in the crowd behind Ferdinand are shown at a diminutive scale that communicates their relative insignificance.

Not published on a regular schedule like later newspapers, broadsides were nonetheless important in disseminating divergent commentary in continental Europe and Britain. By the seventeenth century, broadsides were especially popular in London's coffee houses, which operated as zones of free speech where men of many classes intermingled and discussed ideas in a sober setting (unlike the more rowdy pubs). Constraints were put on British publishing beginning with the Licensing Order of 1643, which required authors and publishers to register books or other potentially seditious printed matters at the Stationers Hall in the hopes of curtailing publications offensive to the government. Parliament regulated printing in England until 1679.

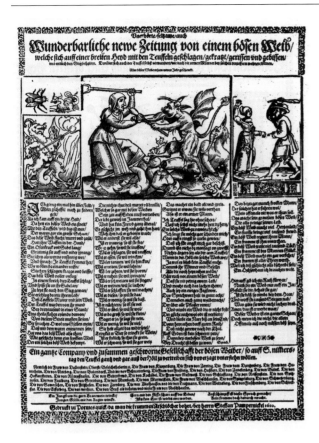

Figure 2.14
Stefan Pumpernickel, *News of a Naughty Woman Who Struggled with the Devil*, 1610. Woodcut.
This cautionary tale includes a subheading: "A New Year's present for all naughty women."

From *The Illustrated Bartsch*, Courtesy Abaris Books.

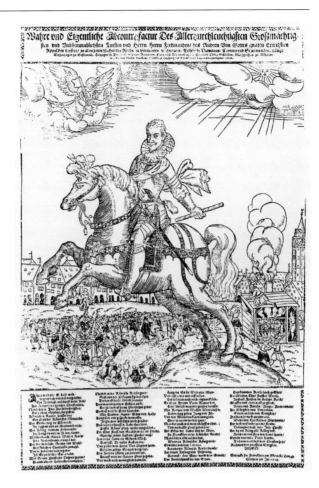

Figure 2.15
Conrad Corthoys, *Festivities on the Occasion of the Coronation of Emperor Ferdinand II*, 1619. Woodcut broadside, 21.25 × 14".
This print glorifies Ferdinand II by showing him on a fine steed, in the tradition of powerful Roman emperors of the past. Ferdinand was an ardent Catholic who forced many unwilling Protestants to accept Catholicism.

From *The Illustrated Bartsch*, Courtesy Abaris Books.

Intaglio Processes

Engraving in Northern Europe

Within decades of the proliferation of woodcut, engraving, which is the process of incising a design into the surface of a printing plate, also flourished in Europe. Engraving belongs to a larger category of printmaking called intaglio, in which the image exists in inked recesses (linear grooves, roughened texture, or dots) in a smooth plate (*see Theme Box 6, "Intaglio Printing"*). The image is transferred to paper by being passed through a high-pressure roller press, quite unlike that used in relief methods.

The earliest intaglio prints were created in Germany in the 1430s and are thought to have sprung from the goldsmiths' trade, a practice centered on incising decorative motifs on metal objects. Goldsmiths collected and recorded designs in model books, which expedited the reuse and transfer of designs within a

workshop. These intaglio prints were eventually printed as model sheets shared as a sort of stock imagery among studios.

The earliest intaglio prints were made by drypoint—scratching directly into a metal plate with a needle. However, drypoint marks degraded quickly and engravers soon devised a cutting tool called a burin that carved clean, durable lines from which roughly two hundred images could be printed before lines began to suffer.

Early engravings include religious, classical, and secular subjects, as well as decorative themes, many of which can be traced to manuscript illumination and relief decoration found in churches and furniture. Most early engravings were not signed, and the first engraver thought to do so is Master E. S., (German, active 1440–1467), who engraved his initials into several

Theme Box 6: Intaglio Printing
by Susan Doyle

Intaglio is a class of printmaking techniques that includes engraving, etching, drypoint, mezzotint, and aquatint. Intaglio images are made by creating recessed grooves (lines) or textures in the surface of a smooth metal plate and filling them with ink, which is then transferred by means of a press to damp paper. Regardless of how the plate matrix is created, to print an intaglio plate, the printer first forces viscous ink into the plate's recesses using a dauber or a stiff card. The printer then carefully removes all surface ink on the plate with a starched, open-weave cloth without disturbing the ink in the recessed marks. Damp paper is placed on top of the plate, and both are rolled through a press under great pressure. The softened paper is forced into the inky recesses, thus transferring the image to the paper.

Engraving
In use since the fifteenth century in Europe, **engravings** are incised directly on copper plates with a cutting tool called a **burin**. Burins typically have a square or rectilinear metal shaft cut at 45 degrees, honed to an extremely sharp point. The handle is bulbous and sits in the palm of the engraver's hand. As the engraver pushes the point against the metal plate, the burin forces a curl of copper to be removed, leaving behind a v-shaped furrow. The harder the engraver pushes, the deeper the burin cuts, and the wider and darker the line will appear when printed; so the artist must continually gauge the angle and pressure applied to achieve the appropriate density of line.

Because the burin completely and cleanly removes metal from the plate, engraved lines are crisp and very stable. Engraving plates can usually withstand hundreds of printings before the plate must be "refreshed," a process that entails re-incising lines that have become shallower—and thus print lighter—because of the compression caused by the extreme pressure of the roller press. In the nineteenth century, engravers began to work on harder steel plates, which were extremely durable in printing but more difficult to cut.

Etching
Etching is an intaglio process in which recessed printing lines or other marks are created through the corrosive action of acid. Usually made on copper or zinc plates, the surface of the etching plate is first coated with a waxy acid-resistant ground. The image is then drawn on the plate with a stylus or needle that cuts through the ground to reveal the copper underneath. The plate is submerged in acid, and wherever the stylus has removed the waxy ground, acid "bites" into the metal surface, creating a line or mark. The depth and darkness of the marks depend on how long the plate remains in the acid. The etcher may periodically remove the plate from the acid bath and selectively protect certain lines from further etching by coating them with a liquid resist. She may then return the plate to the bath to continue "biting" those lines that she wishes to be darker. This process may be repeated many times until the desired range of marks has been achieved.

Unlike the exacting technical precision required in engraving, etchings can be freely drawn and often have a loose, sketchy quality. The printing procedure of etchings is identical to that of engraving.

Drypoint
Drypoint is a simple intaglio process in which the artist simply scratches the plate with a pointed metal scribe. The harder the artist pushes, the deeper the line. However, unlike in engraving, which cleanly removes metal to form a v-shaped furrow, in drypoint the metal (usually copper) is simply displaced, forming a minute burr on one or both sides of the inscription. Both the line and the burr hold ink, which gives drypoints their characteristic "velvety" line quality. However, the amount of ink the burr will hold is relatively unpredictable and dependent on the angle at which the artist held the scribe at any particular point in the drawing process. Furthermore, the plates are extremely unstable because the burr flattens out under the pressure of the press. Drypoint plates therefore deteriorate rapidly, with images lightening almost as each print is made.

images. In addition to devotional images, Master E. S. created lively satiric alphabets (Figures 2.16a and b). His images exemplify the stylistic angularity of form characteristic of Northern European woodcuts, but with a more subtle tonal range made possible by the engraving process.

Since intaglio needed a different type of press, it could not be expediently combined with typographic printing and was less associated with book printing and mass communication until later in the sixteenth century when publishers were professionalized. Rather, early intaglio prints were frequently issued as pictures to be enjoyed by the growing audience of print collectors.

A generation after Master E. S., Martin Schongauer (German, ca. 1440–1491) created more technically refined engravings employing a wider variety of mark-making strategies than his predecessors. Schongauer's superb draftsmanship depicted figures volumetrically, using **chiaroscuro** (dramatic shading to describe three-dimensional forms) in compositions that benefitted from increasingly complex foreground/background relationships. In *St. Anthony Tormented by*

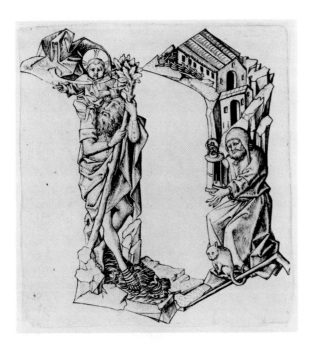

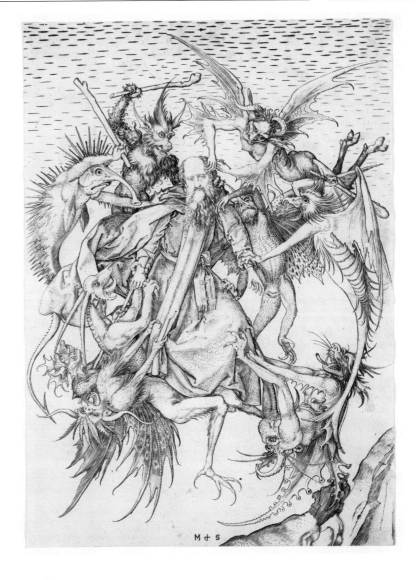

Figure 2.17
Martin Schongauer, *St. Anthony Tormented by Demons*, ca. 1470–1475. Engraving on laid paper, 12 ¼ × 8 ⅞" (plate).
Despite the fantastical nature of the subject matter. Schongauer's expert draftsmanship, with its subtle gray scale, convincingly expressed volumes using light and shadow.

Gift of Mrs. Gustav Radeke, RISD Museum, Providence.

Figure 2.16 a, b
Master E. S., Letter *n* and Letter *v*, ca. 1450–1467. Engraving, 5 ⅔ × 7" and
5 ⅔ × 5 ⅛", respectively.
The letter *n* on the left shows naughty fools cavorting in a scatological pileup while the letter *v* depicts St. Christopher with the Christ child on his shoulder on the left, and St. Joseph, with his lantern and fallen staff on the right.

From *The Illustrated Bartsch*, Courtesy Abaris Books.

Demons, Schoengauer's imaginative monsters appear dimensional and assault the saint with convincing dynamism (Figure 2.17).

A near contemporary and also a German artist, Israhel van Meckenem (ca. 1445–1503) is heralded for advancing the commercial aspects of engraving more than its artistic subtleties. A goldsmith by trade, van Meckenem often copied compositions and reworked plates of others, adding his own monogram. It is worth noting that copying was not uncommon in van Meckenem's day, and indeed, the apprentice system relied on students copying from their masters to ensure they could collaborate on studio work seamlessly.

While he was not stylistically innovative or a virtuoso engraver, van Meckenem nevertheless expanded the print marketplace by embracing everyday human interaction as subject matter. Because van Meckenem recognized that private collecting and viewing of prints did not require the decorous sensibility of more formal public presentation, his popular scenes encouraged middle-class audiences to look inward and at human foibles as a new category of illustration.

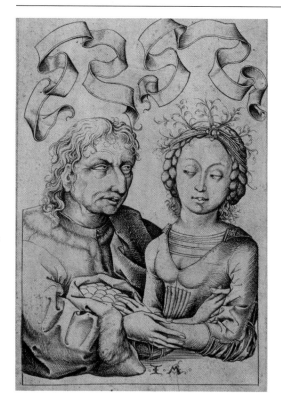

Figure 2.18
Israhel van
Meckenem, "The
Ill-Matched
Couple," n.d.
(Copy in reverse
after the *Master of
the Housebook*).
Engraving, 5.5 ×
3.74".
Van Meckenem
published popular
subjects that would
have been unsuit-
able for formal
or public display.
This copy of a
design by an earlier
printmaker shows a
wily beauty trading
her youth for an
older man's wealth,
symbolized by his
satchel of "eggs."

Kupferstichkabinett,
Staatliche Museen zu
Berlin.

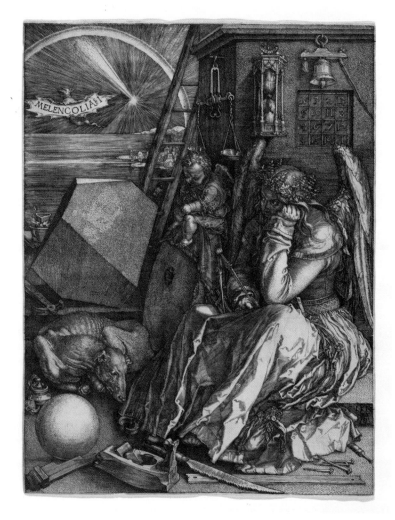

In "The Ill-Matched Couple" (Figure 2.18), van Meckenem shows a wealthy older man and a youthful beauty consummating a bargain in which physical desirability is traded for financial security, a theme that would endure in modern times. Van Meckenem sometimes included empty banderoles in prints—the equivalent of empty speech bubbles that invited the viewer to "fill in the blanks" as entertainment.

Albrecht Dürer, who made a fruitless attempt to visit the dying Schongauer, was influenced by Schongauer's naturalistic approach to figures and his groundbreaking exploration of the interdependence of figure-ground relationships. Given Dürer's goldsmith training, it is not surprising that he excelled at engraving as well as woodcut. His enigmatic *Melencolia I* (Figure 2.19) depicts a winged female figure as a personification of the melancholic artist temperament, caught in a reverie with a compass in her hand. She is surrounded by symbols representing both physical crafts and intellectual pursuits such as mathematics and geometry. These were subjects of key importance to Dürer, who later wrote theoretical treatises on measurement and human proportion. *Melencolia I* is one of three images completed in 1513–1514 that are referred to as Dürer's "master engravings." They exemplify Dürer's complex, disciplined approach to building up tone with the burin and would have been destined for discerning collectors appreciative of his sophisticated symbolism.

On the more popular end of the engraving spectrum, German artists Hans Sebald (German, 1500–1550) and his brother Bartel (German, 1502–1540) produced a plethora of classical and religious themed prints as well as images of contemporary life. Along with their associate George Pencz, the Beham brothers were dubbed the "Little Masters" because of the small scale of their engravings, which were collected in albums rather than intended as single-leaf prints suitable for display on a wall. Stylistically, the Behams' systematic mark-making approach of parallel lines, cross hatching, and intermittent dots is reminiscent of Dürer, and it allowed for clarity of detail at a remarkably small size (Figure 2.20).

Early Southern European Engravers

Southern European artists embraced engraving nearly as early as their northern counterparts, but given differences in the artistic and intellectual climates, they developed a particularly strong engagement with mythological themes and were stylistically influenced by classical aesthetics. Andrea Mantegna (Italian, ca. 1431–1506), a painter of renown in his own time, devoted significant effort to intaglio prints. Much of his work as a court painter was constrained in theme and location by his patron Ludovico Gonzaga of Mantua. Through printmaking, Mantegna was able to expand his repertoire and reputation, because his engravings were disseminated in present-day Italy and beyond.[2]

Mantegna's *Battle of the Sea Gods* (Figure 2.21) illustrates a skirmish between mythological half-beasts. He uses light contour outlines to define major forms, with a build-up diagonal shading (low on left, high on

Figure 2.19
Albrecht Dürer, *Melencolia I*, 1514. Engraving, 9 7/16 × 7 5/16".
Dürer was influenced by humanist theories as he visualized the nature of the artist in this intricately engraved image. He juxtaposes symbols of the intellectual as well as the mechanical arts in an enigmatic image that could only be decoded by an educated clientele.

Courtesy of the Metropolitan Museum of Art, OASC, Harris Brisbane Dick Fund, 1943.

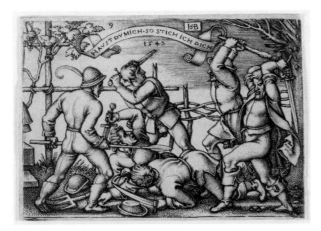

Figure 2.20
Hans Sebald Beham, *Peasants' Brawl, plate 9 from The Peasants' Feast or the Twelve Months*, 1547. Engraving, 2.25 × 2.9".
The Beham brothers took advantage of the expanding market for popular prints with work that sometimes embraced lowbrow themes. This is one of a series of prints describing peasant nuptials from a joyful procession to a bawdy aftermath.

Art Institute of Chicago.

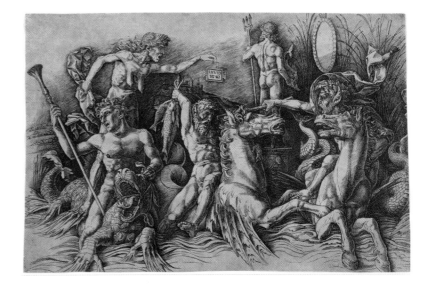

Figure 2.21
Andrea Mantegna, *Battle of the Sea Gods*, 1485–1488. Engraving (left half of a two-plate horizontal composition), 11 $^1/_4$ in. × 16 $^3/_4$".
In this mythological battle, Envy is personified as a crone astride a sea monster on the left. She stares into a suspended mirror; a plaque with *Invidia* (Latin for envy) dangles from her hand.

Google Art Project, National Gallery of Art, Washington, DC.

right) in a random, sketch-like toning style quite distinct from the more systematic approach of his northern contemporaries. Printed from two plates, Mantegna's frieze-like composition dramatically foreshortens the action, putting the viewer in the path of the stampeding beasts.

Mantegna, like Dürer, is referred to as a ***peintre-graveur*** (painter-engraver) by art historians, a term used to signify that they designed and engraved their own plates, as opposed to those who engraved images based on the designs of others. Marcantonio Raimondo (Italian, ca. 1480–1534) falls into the second category, having regularly collaborated with the Renaissance painter Raphael Sanzio (Italian, 1483–1520) to produce finished engravings from Raphael's sketches. Marcantonio's formulaic method for differentiating tonal values used straight, bowed, and angled parallel lines with occasional **stipple** (tiny dots or flecks) was widely adopted by other artists in Italy and beyond (Figure 2.22).

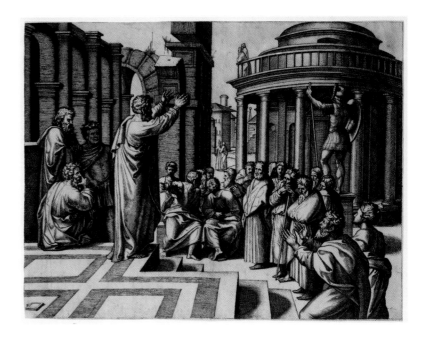

Figure 2.22
Marcantonio Raimondi after Raphael, *St. Paul Preaching at Athens*, ca. 1517–1520. Engraving, 10 $^7/_{16}$ × 13 $^{13}/_{16}$" (plate).
Marcantonio Raimondi's approach was influential in the formulation of reproductive engraving techniques later widely adopted throughout Europe.

Museum Works of Art Fund, RISD Museum, Providence.

The Reproductive Engraver and the Expansion of the Print Trade

In the sixteenth century, a market developed for engraved copies of extant art and architecture, and by the second half of the century, print publishers became professionalized in workshops that funded the reproduction of works of art as well as editions of original prints. A few publishing dynasties emerged that lasted through many generations, profiting from the reissue of plate editions and at times salvaging and republishing plates from other workshops. By the early seventeenth century, some engravings had already gone through three or more editions, with each subsequent publisher adding his name to the plate and erasing the previous one. One

such dealer, Antonio Lafreri, published large inventories of prints depicting antiquities, monuments, and maps of Rome called *Speculum Romanae Magnificentiae* (*Mirror of Roman Magnificence*). Reproductive prints of this nature were catalogued by topic, rather than by the printmakers' names, and clients selected images to be bound into custom collections. This marginalization of the engraver would have ramifications on the status of later artists.

The primary producer of reproductive engraving in the north was Hieronymous Cock (Flemish, 1518–1570) and his wife Volcxken Diericx (Flemish, active 1570–1600). Based in Antwerp, they published works based on Roman monuments and ruins, and on art by Italian and Northern European painters, as well as original prints designed after the inventions of artist peers.

Over the next decades and into the seventeenth century, artists devised evermore ingenious approaches to engraving with swelling curvilinear strokes, intricate systems of linear overlap, and the integration of tiny dots to modulate the grayscale with impressive control and luminosity (Figure 2.23b).

The image of Greek god Apollo by Hendrick Goltzius (Dutch, 1558–1617) achieves astonishing depth of field by careful placement and precise execution of undulating and swelling lines (Figure 2.23a). The figure's musculature, reflective of the Humanist interest in Classical sculpture, is hyperarticulated and resonates with the globular atmospheric formations that create a spiraling tunnel leading to the faint horse-drawn figure in the distance. Unlike a reproductive engraving, Goltzius's virtuosic marks are more than simply a means to convey the narrative and are intended to be dazzling in their own right. His artistic prowess underscores the enormous technical development of print from the simple woodcuts of the fifteenth century to the stylistic apogee of engraving in the middle of the seventeenth century.

While some artists focused on innovative marks, others concentrated on storytelling. In *The Sorceress*, a moody print by Jan van de Veldt (Dutch, ca. 1593–1641), dramatic darkness envelops a supernatural narrative in which a youthful witch tips her wand and sprinkles powder from a horn into her cauldron. Eerily underlit, she is surrounded by zoomorphic demons—one somersaulting as he deposits powder into her concoction via two pipes protruding from his bottom. Cards, dice, and tobacco around the fire are associated with earthly pleasures, while the skull, a popular symbol in **vanitas** (allegorical still-life) painting, reminds the viewer that human life is fleeting (Figure 2.24).

Rubens

Peter Paul Rubens (Flemish, 1577–1640), an internationally famous painter cum diplomat, hired and trained his own reproductive engravers to control the style and marketing of copies made after his paintings. Rubens's output was not limited to painting; he also designed book illustrations in addition to tapestries and large-scale decorations for important festivals.

Rubens's frontispiece for a lavish volume titled *Entry of Ferdinand, Infante of Spain, into Antwerp* (1642) (Figure 2.25) was created six years after the public event. The book commemorated the elaborate celebration of the arrival of the Spanish-born governor into the Netherlands in 1635 as an extension of Habsburg power in the late Holy Roman Empire. Many of the book's images depict the ornamented festival archways and stages that were built throughout the city—large faux-painted structures through which the courtly processions passed. The

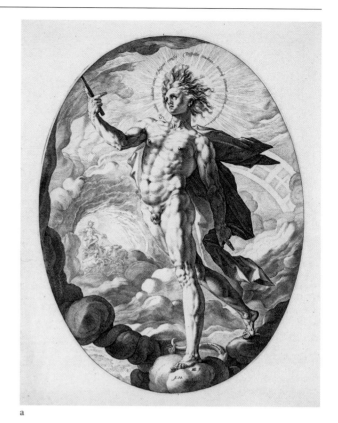

a

b

Figure 2.23a, b
Hendrick Goltzius, *Apollo*, 1588. Engraving, 13 ¹¹/₁₆ × 10 ½" (plate). Created at the height of engraving's stylistic innovation, Goltzius's virtuosic line introduces visual complexity to the toning strategy in the already complicated composition.

Gift of Professor and Mrs. A. David Kossoff, RISD Museum, Providence.

frontispiece asserts the authority of Ferdinand, brother of King Philip IV of Spain, whose portrait tops the image of the triumphal archway and who is shown handing Ferdinand a commander's baton below. The sun and moon are pulled by chariots toward the king in confirmation of his exalted status. Figural pillars uphold the architectural structure, alluding to peace and prosperity within Antwerp, with Mercury on the front right signifying the union of craft and invention, while the figure on the left stands ready to draw his sword as a symbol of military might.

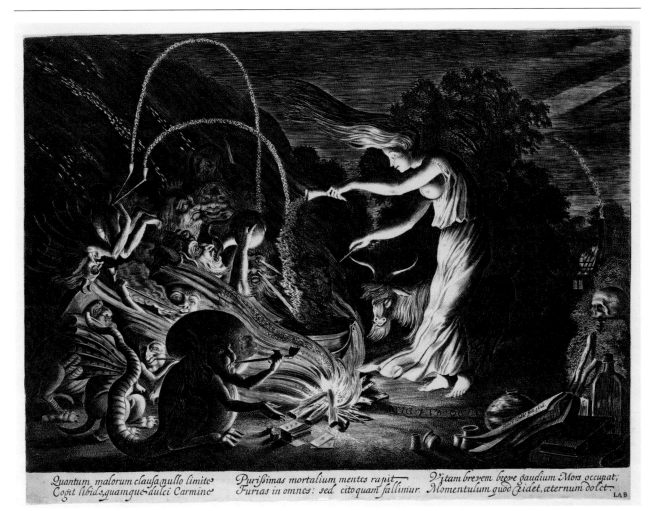

Quantum malorum clausa nullo limite· Puriſſimas mortalium mentes rapit. Vitam brevem breve gaudium Mors occupat;
Cogit libids,quamquc dulci Carmine· Furias in omnes: sed citoquam falliuir. Momentulum quod Cidet, æternum dolet.
LAB

Figure 2.24
Jan van de Velde II, *The Sorceress*, 1626. Engraving, 8 3/8 × 11 1/4" (plate). The overall darkness sets a tone of mystery in this fantasy image created in an era when superstition was still very much part of the culture. The verses condemn the effects of evil and proclaim the triumph of death over life.

Gift of Mrs. Murray S. Danforth, RISD Museum, Providence.

Etching and Further Developments in Printmaking

Because engraving was an arduous and in many ways confining process, artists sought alternative techniques that were faster and more creatively flexible. The most common of those techniques is etching, an intaglio process that uses acids to burn freehand drawings into metal printing plates (*see Theme Box 6, "Intaglio Printing"*). Experimental from around 1500, etching did not really take hold until the 1520s when the technique improved. Dürer was the first to date an etching, but his contemporary Daniel Hopfer (German, 1471–1536) is thought to have made earlier prints after adapting the process from his work as an armor decorator. Although he was not trained as a painter or draftsman, Hopfer created numerous designs for ornamental architectural panels, furniture, trophies, candelabras, daggers, and fountains, as well as narrative book illustrations, borders, and decorative alphabets. Not constrained by the burin, Hopfer's approach combined strong outlines with a sketch-like technique in which shading was achieved through crosshatch and parallel lines.

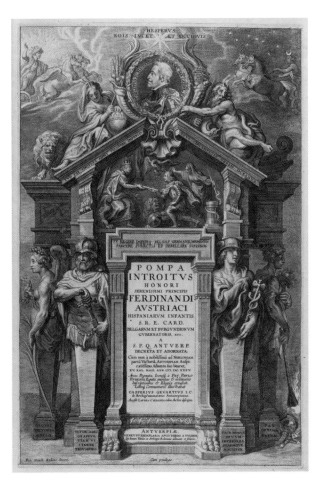

Figure 2.25
Peter Paul Rubens (designer), Theodor van Thulden (engraver) (Flemish, 1606–1669), Jean-Gaspard Gevaerts (author) (Flemish, 1593–1666), title page from *Pompa Introitus Honori Serenissimi Principis Ferdinandi*, Antwerp, 1642. Engraving. Designer of many frontispieces for luxury books, Rubens typically relied on classical motifs appreciated by the educated who would have understood their symbolism as well as the allusions to Roman grandeur.

Helen M. Danforth Acquisition Fund, RISD Museum, Providence.

Theme Box 7: Saussure and Peirce: Semiotics
by Sheena Calvert

Signs are things (such as pictures, words, evidence) that stand in for something else. **Semiotics** (or semiology), the study of signs and their meanings, attempts to categorize signs into a logical system. Semiotics is related to *structuralism*, the study of deeper, more hidden aspects of thought, communication, and society that underlie and determine language. In both structuralism and semiotics, there is an attempt to examine *how* meaning comes to be, not just what things mean.

Ferdinand de Saussure (France, 1857–1913), a linguist and one of the founders of semiotic theory, described semiotics very succinctly as "the study of the role of signs as part of social life." Charles Sanders Peirce (USA, 1839–1914), another important founder of semiotics, saw signs as consisting of three interrelated parts: a sign, an object, and an interpretant (the person encountering it and making sense of it). Semiotics is widely used to account for how signs may be encoded and decoded, and how meaning is established in visual, verbal, and other forms of communication.

According to Saussure, any sign can be broken down into a *signifier* and a *signified*. For example, an image of an arrow is a signifier, the direction in which the arrow is pointing is the signified, and taken together, the arrow becomes the sign. A photographic portrait is a signifier of a particular person, and the individual who appears in the photograph is the signified. The two together create a sign.

Peirce classified all signs into three main categories: icons, symbols, and indexes. *Icons* are signs that physically resemble what they stand for. In contrast, the many signs that bear no physical resemblance to what they represent are called *symbols*. Symbols are arbitrary, agreed upon by convention.

For example, the linguistic sign for the animal called a "dog" is the sequence of letters *d o g*. There is no causal relationship between these letters and the animal; we simply agree that in English these letters form a word, *dog*, which is a symbol for that animal. Similarly, we sometimes use a rose to indicate romantic love, but there is no natural connection between the symbol and the concept being signified. Peirce called his third type of sign an *index*. An index is natural and causal: smoke, for example, is an index of fire because it is produced by the fire. Footsteps in the sand are an index of human presence because they are evidence that a person has walked there.

The meaning of iconic and symbolic signs in particular are contingent on culture. Stylized images of a man and a woman frequently indicate gendered bathrooms, but as design theorists Ellen Lupton and J. Abbott Miller point out, the short style of dress deemed appropriate for most women in Europe and America would not be acceptable in some other parts of the world. Such signs assume and perpetuate what genders are considered "normal."

Some aspects of signs (such as a likeness of someone) are unambiguous and literal, pointing directly toward ideas or things in the world. These literal aspects are termed *denotative*. Ambiguous aspects of signs that are open to interpretation and that constitute extended and implied meanings are termed *connotative*. For instance, an image of Marilyn Monroe is not merely a photograph of a young woman; rather, it suggests Hollywood, tragedy, fragile beauty, and so on. Signs are often simple at the level of denotation while being highly complex at the level of connotation.

Illustrators' expertise lies in defining both denotation and connotation in nuanced ways to limit or shift meaning. Yet illustrators need to be aware that the images they produce will be subject to audience interpretation no matter how well one tries to control meaning because viewers are always reading and rereading signs from their own individual experiences and times. In short, the "science" of semiotics cannot account for how all meaning is delivered, since meaning is contingent, contextual, and personal, but it is a very useful tool for understanding how images work, predicting their effects, and analyzing their impact. Semiotics is the starting point for many scholars of the visual (*see Chapter 7, Theme Box 13, "Hall: Encoding, Decoding, Transcoding"; Chapter 9, Theme Box 17, "Berger: Ways of Seeing"; Chapter 22, Theme Box 44, "Barthes and the 'Death of the Author'"; and Chapter 27, Theme Box 50, "Derrida: Floating Signifiers"*).

Further Reading

Bang, Molly, *Picture This: How Pictures Work* (San Francisco: Chronicle Books, 2016).

Chandler, Daniel, *Semiotics: The Basics* (New York: Routledge, 2007).

de Saussure, Ferdinand, *Course in General Linguistics* (New York: Philosophical Library, 1959).

Peirce, C. S., *Charles S. Peirce: The Essential Writings*, Edward C. Moore, ed. with preface by Richard S. Robin (Amherst, NY: Prometheus Books, 1998).

Peirce, C. S., *Peirce on Signs: Writings on Semiotic*, James Hoopes, ed. (Chapel Hill: University of North Carolina Press, 1991)

Hopfer's *Morris Dancers* satirizes a group of men wildly dancing around a crone in a type of folk dance (Figure 2.26). She holds a jug in one hand and a skewer of seven sausages in the other, one for each dancer, implying that alcohol impairs the men's virility.[3] All the participants are shown with knobby, irregular features: oversized, flapping lips, and even a dangling goiter on the central female, thus aligning physical ugliness with crude behavior.

Hopfer's illustration for the *Acts of the Apostles* (1530) (Figure 2.27) employs an approach to narrative storytelling that can be compared with contemporary comic books. Here, rather than formal frames, Hopfer uses architectural elements within the pictures to separate the scenes of the narrative. He has paired the images with text using an innovative *trompe l'oeil* strategy in which text appears to be handwritten on small sheets of paper, placed on top of the images in a layered composition. This self-conscious approach calls attention to the creative process of representing the narrative, indicating it has taken place over time and reminding us of the physicality of the page itself.

Images, Protections, and Defining the Meaning of "Original"

Printed texts were copyrighted as early as 1486, and it was not long before printmakers and publishers sought protections against pirating of printed images (*see Chapter 29, Theme Box 56, "Copyright: An Abbreviated History"*). Protections were generally granted through municipal councils or the pope, and usually for a period of time just long enough for the publisher to recover expenses associated with printing. The earliest protection granted to an illustrated print was for the oversized six-block woodcut *Perspective View of Venice* (see Figure 2.28) created in 1500 by Jacopo de' Barbari (Italian [Venice], ca. 1460– ca. 1516).

[3]McPhee and Orenstein, *Infinite Jest, Caricature and Satire form Leonardo to Levine,* p. 27.

Citing the expense of the unprecedented scale of the block and paper, de' Barbari's publisher Anton Kolb, a Nuremberg native living in Venice, was granted a copyright of four years by the Venetian Senate. Without a central European legal authority, copyright protection was difficult to enforce, particularly since copying was a deeply engrained practice in studio training.

While appropriation from artist to artist had always been possible, the inherently reproductive nature of printmaking made copying print designs easier. The notion of "original" was further complicated by the fact that prints were themselves issued in multiples, and in many cases, the design from which the block or plate was made was not the "invention" of the printmaker but instead supplied by a collaborator or client.

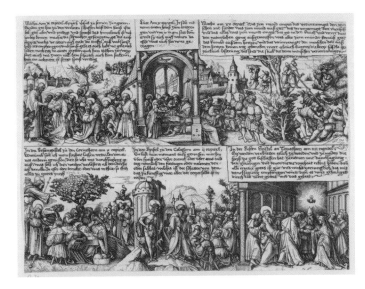

Figure 2.27
Daniel Hopfer, *Different Scenes*, from the *Gospels* and from *Acta Apostolorum* (*Acts of the Apostles*), ca. 1530. Etching, 11 ⁵/₈ × 15 ¹/₂"; second state of two.
In this innovative multiscene etching, text appears to exist on two physical layers: some on the same level as the pictures, the rest on irregularly shaped "paper fragments" floating over the illustration.
Courtesy of the Metropolitan Museum of Art, OASC.

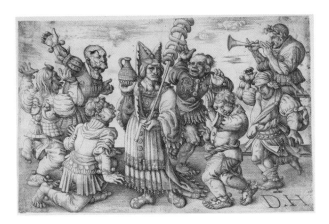

Figure 2.26
Daniel Hopfer, *Morris Dancers*, after Anonymous, Italian, late fifteenth–early sixteenth century. Etching, fourth state of four; 8 ³/₈ × 13 ¹/₈" (sheet).
The irregular and unappealing facial features of the rowdy dancers intensifies Hopfer's humorous social critique.
Courtesy of the Metropolitan Museum of Art, OASC, The Elisha Whittelsey Collection, The Elisha Whittelsey Fund, 1951.

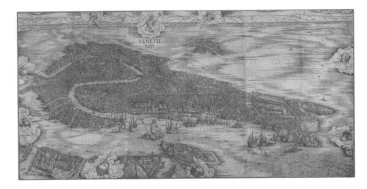

Figure 2.28
Jacopo de' Barbari, *View of Venice*, 1500. Woodcut from six blocks on six sheets of paper, 52 ¹/₄ × 109 ¹/₄".
This enormous print was the first stand-alone image to be a granted publishing "protection" issued by the Venetian senate. The work was valuable as a milestone not only in printing, but also as an important, well-researched civic record communicated visually.
Minneapolis Institute of Art, The John R. Van Derlip Fund 2010.88. Photo: Minneapolis Institute of Art.

A famous case that illustrates the complexity of early copyright issues involved Albrecht Dürer and Marcantonio Raimondi—the latter having made an engraved copy of "Joachim and St. Anne Meet at the Golden Gate" from Dürer's series *Life of the Virgin*. Despite prohibitions appearing in Dürer's frontispiece claiming protection under a privilege from Maximilian I, the Holy Roman Emperor (ca. 1504–1511), Marcantonio copied the work and brazenly included Dürer's famous "AD" monogram. Dürer consequently charged him with plagiarism in a visit to the Venetian Senate. Ironically, printing of the engraved copies continued after the hearing, because the Senate only prohibited the copying of Dürer's *monogram*, not the composition itself.

Conclusion

During the Early Modern Period, we see a significant shift in the range, creation, and accessibility of pictorial imagery across Europe through the general adoption of printmaking processes. Illustrative images that had previously been created by painters, illuminators, and sculptors and available to only the most elite members of society were now widely available through prints. Printed images (woodcut, engraved, and etched) were issued singly or in series, and were often paired with text in broadsides and books. Prints increased access to ideas and information for a population that was not fully literate, and images enhanced meaning even among the most learned populations. Through prints, common themes were explored (religion, human relationships, the supernatural, politics, and so on), and social order was both reinforced and challenged.

Illustrative prints would continue to be made in studios and workshops at an increasing volume over the next two centuries, with a division of the trade into tiers of output from the most exclusive engravings, series, and books to inexpensive ephemera for temporary public postings. Further distinctions were made between those who printed their own, or collaborated on original "inventions," as opposed to the booming trade in reproductive engraving. The aesthetic range of illustration was significantly tethered to printmaking processes from the fifteenth century until the advent of photomechanical reproduction in the late nineteenth century (*see Chapter 14*).

KEY TERMS

attributes	iconography
banderole	incunabula
blockbook	intaglio
broadside	letterpress
burin	*peintre-graveur*
chiaroscuro	relief process
chiroxylograph	scholasticism
drypoint	semiotics
engraving	stipple
etching	type high
forme	typology
formschneider	vanitas
hagiography	xylography

FURTHER READING

Colonna, Francesco, *Hypnerotomachia Poliphili: The Strife of Love in a Dream*. Translated by Jocelyn Godwin (New York: Thames & Hudson, 1999).

Grossinger, Christa, *Humour and Folly in Secular and Profane Prints of Northern Europe 1430–1540* (London: Harvey Miller Publishers, 2002).

Landau, David, and Peter Parshall, *The Renaissance Print 1470–1550* (New Haven and London: Yale University Press, 1994).

Lefbvre, Lucien, and Henri-Jean Martin, *The Coming of the Book, the Impact of Printing 1450–1800* (London and New York: Verso, 2010).

Monteyne, Joseph, *The Printed Image in Early Modern London: Urban Space, Visual Representation, and Social Exchange* (Aldershot, England; Burlington, VT: Ashgate, 2007).

Parshall, Peter (Ed.), *The Woodcut in Fifteenth-Century Europe* (Washington, DC: National Gallery of Art, 2009).

Shiner, Larry, *The Invention of Art, A Cultural History* (Chicago and New York: University of Chicago Press, 2001).

Wilson, Bronwen, *The World in Venice: Print, the City, and Early Modern Identity*, 2nd ed. (Toronto: University of Toronto Press, 2014).

A Pluralistic View of Indian Images: Second Century BCE–1990s

Binita Desai and Nina Sabnani

Even before the term *illustration* was defined, it existed as a practice for many centuries in India, as in other cultures. In Sanskrit (an ancient language that is a common etymological root for diverse languages across disparate social groups), a painting is termed *chitra* and illustration is called **chitra-nirupan**. *Nirupan* means treatment or explanation by example; therefore, *chitra-nirupan* suggests an explanation using a picture as an example. This description blurs the distinctions between the act of painting and the act of illustrating. The artist is a **chitrakar**, and the illustrator a **caksani**, an illuminator who explains using images or texts. A painter and illustrator of ancient India may be thought of as an "illustrartist" in the context of this chapter. This fused role reflects that the artists worked for a patron, where their work illustrated stories (Figures 3.1, 3.2) and ideas for a variety of applications: cave walls, temples, religious texts, poetry, courtly miniatures and documents, and colonial material culture. It was only with the introduction of the printing press and art schools that there were changes in the way "art" and "illustration" were defined, produced, and viewed in the popular imagination as separate endeavors.

To place illustration in a chronological order in India poses more problems because ancient forms have continued and coexist with new communication technologies. For instance, Bhil art (Figure 3.3), practiced today by the Bhil tribe of Madhya Pradesh, is made with paper and opaque paints, where they once created related images with mud on the walls of their houses as a form of ritual. Further, to define India in a geographic sense is complex: the borders have been porous across time, allowing for a confluence of cultures and ethnic diversity. The artists moved across regions seeking patronage, adapting and creating for new contexts, and working on two-dimensional and three-dimensional surfaces from stone reliefs to palm leaf manuscripts, birch bark, cloth, and paper.

In all ages, artists from the oral, literary, classical, and folk traditions were supported by patrons who valued the arts and considered them essential in their lives. Some

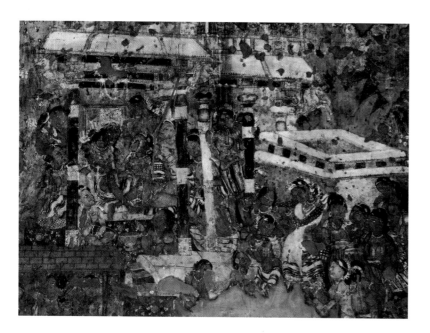

Figure 3.1
Mahajanaka Jataka, Ajanta Caves, Cave 1, between second century BCE and sixth century CE. Wall mural, mineral colors.
The *Mahajanaka Jataka* describes the future Buddha's birth as a prince named Mahajanaka. The mural, characterized by very fine line work, use of perspective, and rich expressions, depicts a scene from palace life with Mahajanaka on his throne, watching a dance performance arranged for his amusement.

Photo: Rajesh Kumar Singh, courtesy of the Archeological Survey of India.

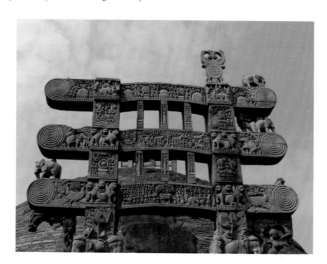

Figure 3.2
Eastern Torana (Gateway), Great Stupa, Sanchi, India, first century BCE.
The great stupa of Sanchi, considered a world heritage site by UNESCO, is the finest example of monumental architecture of the Shunga era (ca. 185–175 BCE).

Photo: Nina Sabnani.

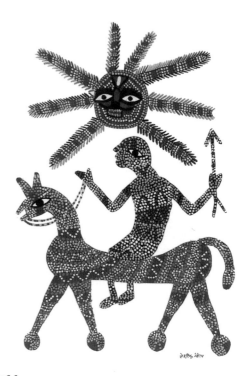

Figure 3.3
Sher Singh Bhil, Bhil painting, Madhya Pradesh, 2014.
Originally painted on walls, the Bhil now make portable folk art objects they can sell.

Photo: Nina Sabnani.

images were made for worship, others as visual narratives, and still others for sheer aesthetic pleasure. These artists illustrated surfaces of caves, their own bodies, the walls and floors of their homes and temples; some transient, others permanent. More than a mere donor, the patron was expected to be a connoisseur, a *rasik* who took pleasure in the arts and appreciated their form and content.

Connoisseurship contributed to a rich diversity of expression and to the co-evolution and interdependency of the arts, best illustrated by a dialogue between sage Markandaya (Figure 3.4) and King Vajra from the *Vishnu dharmottara-purāna*, a text from the sixth century CE. King Vajra, keen to learn the art of icon making of the deities he worships, asks the sage Markandaya to take him on as a student. The sage tells him that to understand the principles of image making, he must first acquire knowledge of painting. The king then proposes that he be trained in this art but is told he cannot grasp even the rudiments of painting unless he is an accomplished dancer. The king now wants to learn dancing, but the sage explains that proficiency in dance is impossible without a keen sense of rhythm or knowledge of instrumental music. The king requests that he be taught music and rhythm and learns that before he becomes proficient in instrumental music, a mastery of vocal music is necessary. Finally, the king goes through all these stages before the sage teaches him the art of iconography.

Voice and Image

What is an image, and how does it speak to us? In the Indian context, philosophy and religion pervade and formulate image and speech. The **Vedas** are the oldest texts from the oral tradition. More than storehouses of knowledge, they sought to represent a civilization by encoding the knowledge of the universe through verse and hymns. The *Vedas* inflected the tone and the tenor of the oral and introduced the *varna* (the Hindu caste system), the first encrypted narrative polytheism, and the anthropomorphic forms of Hindu gods. Agni, God of Fire who loved to drink the intoxicant *soma rasa* and one of the most important gods of the Vedic period (Figure 3.5), represents the sacrificial fire that is present and sanctifies all rituals. As a priest to the gods and as a god to all priests, he serves as a messenger between gods and humans.

The Vedic priests gave primacy to memory, and prohibited the written form of the *Vedas*. The *Vedas* were difficult for people to follow, but they were made accessible when told through the highly detailed spoken narratives known as the **Puranas**. Elaborate descriptions from the *Visnupurana* (stories dedicated to the worship of god Vishnu) and *Bhagavatpurana* (which revolve around Vishnu's incarnation as Krishna) spurred the imagination of the artists who visualized the divine forms for hundreds of years after their original conceptualization. For example, the popular

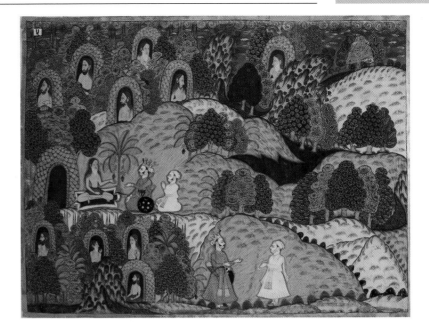

Figure 3.4
Anonymous, *Sage Markandaya's Ashram*, ca. 1780–1790. Watercolor on gold paper, 50 × 19″.
This eighteenth-century illustration of a sixth-century text shows a king's visit to the sage Markandaya, who explains the interdependence of the arts.
Image courtesy of His Highness Maharaja Gaj Singh of Jodhpur, Mehrangarh Museum Trust, Jodhpur, Rajasthan.

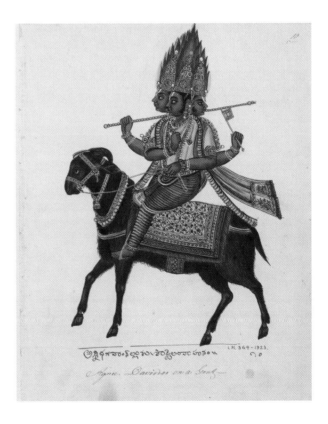

Figure 3.5
Anonymous, Trichinopoly, India, *The Vedic God Agni*, ca. 1825. Gouache on watermarked paper, 7 × 8 ⁵/₈″.
Agni rides upon a black goat, and his skin is the color of fire. He is four-armed and four-faced (one is not visible). In two hands, he holds a staff and a fire-fan. With the third, he holds the reins, and the fourth rests on his chest. Hindu deities are often portrayed with multiple heads and arms, as they reveal multiple aspects of the deity and emphasize the deity's immense power and ability to perform several acts at the same time.
Victoria and Albert Museum.

story of the gods and demons fighting over the elixir of immortality, *Samudra Manthan* (*The Churning of the Ocean of Milk*), has been painted time and again in every era (Figure 3.6).

Subsequently, the representations of the pantheon of gods that followed were created according to iconographic strictures. The **Chitrasutra** in the *Vishnudharmottara-purana* is a sort of rule book that references an ancient treatise, **Natya Shastra**, to define how gods, humans, animals, objects, and scenarios are to be represented. Not only does it suggest how the figures may be made and prescribe the sentiments, or **rasas**, the image must evoke, but it also specifies the discerning abilities a viewer must possess to truly appreciate the images: "The master (*acarya*) praises the lines; critics (*vicaksana*), the shading; women, the ornamentation; and common people, the richness of color. O Best of Men, keeping this in mind, effort should be made in such a way that there comes about captivation of the minds of people."[1]

Similar canons describing how the deities may be represented also exist in Buddhist and Jain scriptures. Images are not just representations of the visible; they are also conceptually symbolic. On the Eastern gate of the Great Stupa at Sanchi, there is a depiction in stone relief referring to the miracle of Buddha walking on the Nairanjana River (Figure 3.7). In a single frame, it portrays a moment in time with several scenes of the river in flood, playful ducks, four people in a boat looking for Buddha, and others watching from the banks. Buddha is represented by the empty space, and the viewer senses his immersive presence rather than seeing a depiction of him.

[1]Mukherji, *The Citrasutra of the Vishnudharmottara-Purana*, p. 163.

Story Scrolls

According to Buddhaghosa, a Buddhist scholar from the first century CE, Buddha admired the **Charana Chitta**, vertical story scrolls, which the stone reliefs on the gateways at Sanchi invoke (Figure 3.8). The Buddhists were familiar with the wandering minstrels or bards called **mankhas** who used picture boards to tell stories from the life of Buddha.

Storytellers from Orissa, Bengal, Andhra Pradesh, and Gujarat also used vertical-painted scroll illustrations to entertain and inform their audiences and as **mnemonic devices** (memory aids) for their performances. Known as *pattachitra*, or *Cheriya* or *Garoda* scrolls, their practice is still alive in parts of the country. Typically, these vertical scrolls have images arranged one below the other, divided by a frame; the storyteller unfurls the scroll to reveal one frame at a time as he narrates the story. Of these, the Bengal *pattachitras* are the most popular. There are several kinds of these **patas** (scrolls); among them, the ritualistic *jadu pats* (Figure 3.9) are believed to have magical properties. *Pattachitras* from Bengal continue to be made today, often in response to contemporary tragedies such as the destruction of the World Trade Center or the tsunami of 2004 (Figure 3.10).

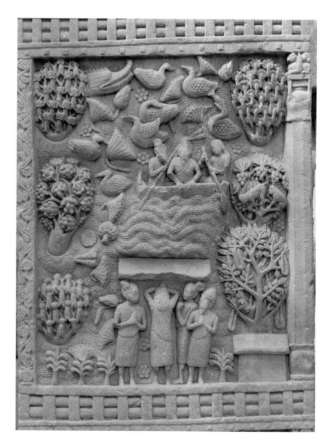

Figure 3.7
The Miracle of Walking on the Waters of Nairanjana River, narrative relief panel, Eastern Torana (Gateway), Great Stupa, Sanchi, India, First century BCE.
Illustrations on temples are portals for entering a spiritual space, leaving behind the world of the material and transforming one's life in some way.
Photo: Nina Sabnani.

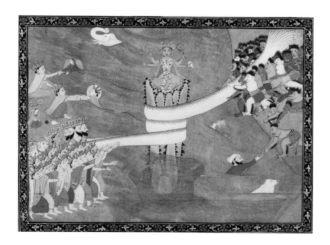

Figure 3.6
Anonymous, Garhwal, India, *Samudra Manthan* (*The Churning of the Ocean of Milk*), 1860. Opaque watercolor on paper, 12 9/16 × 17".
Lord Vishnu incarnate as a turtle, Kurma, offers his body as a base to churn the immortalizing nectar from the ocean of milk.
Victoria and Albert Museum.

Figure 3.8
Scroll-like reliefs on the Eastern Torana (Gateway), Great Stupa, Sanchi, India, first century BCE.
The carving is reminiscent of story scrolls that are thought to have preceded this temple's construction; they were used as portable shrines to bring Hindu and folk gods to people in far-flung places. There are no extant examples because they were likely made from perishable materials such as wood, cloth, or paper.
Photo: Nina Sabnani.

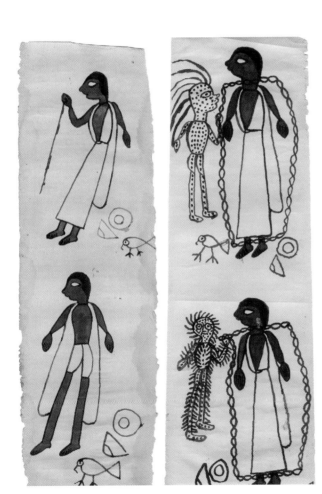

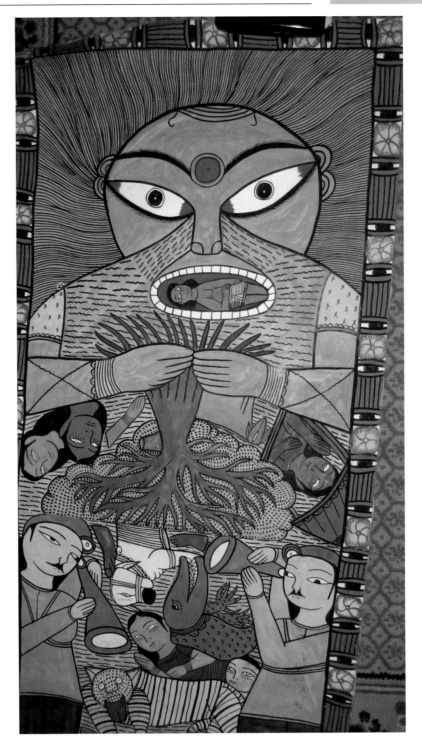

Figure 3.10
Anonymous, school of Dukhusyam Chitrakar, scroll (vertical), Bengal, after 2004. Gouache of organic pigments on paper.
This scroll's iconography is strongly influenced by paintings of flood disasters first started in 1978 by the school of Dukhusyam Chitrakar. Its composition conceives of the tsunami that struck Indonesia in 2004 as an all-consuming feminine figure in the tradition of Goddess Chand (Kali).
Photo: Roma Chatterjee.

Figure 3.9
Jadu *pats* or Mritu *pats*, 1990s. Vegetable color on paper, approximately 4 × 2 3/8" each.
Used in death rituals by the Santhal community, for a fee paid by the bereaved family. The *patua* (narrator priest) paints the pupils of the eyes of the deceased depicted in the scroll to ensure he or she would not wander blind in the other world.
Courtesy of Galerie Hervé Perdriolle, Paris.

For the horizontal Rajasthan fabric scroll called the *phad* (Figure 3.11), the itinerant storyteller commissions an artist to paint a cloth 15 to 35 feet in length and 5 feet in width. The scrolls are illustrated with epics of local deities and are performed for patrons who seek their blessings for themselves and their sick animals. The performance or storytelling is called *phad baanchana*, meaning "reading of the scroll image." The scroll is "read" first from the middle and then to the right and left. The performance takes place at night with a lamp bearer who illuminates different parts of the scroll and accompanies the *bhopa* (storyteller). Together, they walk the length of the scroll, narrating the folk legends with dance, music, and voice. The vocalization and movements of the performers add meaning to the images.

Puppets and Portable Shrines

Rajasthan also has traditions of storytelling using *kathputli* (wooden puppets) (Figure 3.12) and the *kaavad* (painted wooden shrine). The *kaavad* serves as a "portable pilgrimage" for its patrons. The storyteller unfolds the multiple panels (Figures 3.13, 3.14) while

reciting narratives of hardships or of community bonding, sacrifice, and devotion. Each single image represents an entire narrative, so the whole story comes alive through voice or speech. The images continue traditions established when oral knowledge began to be recorded in the written word. They explain not only the narrative, but through style, act as a signifier of regional identity too.

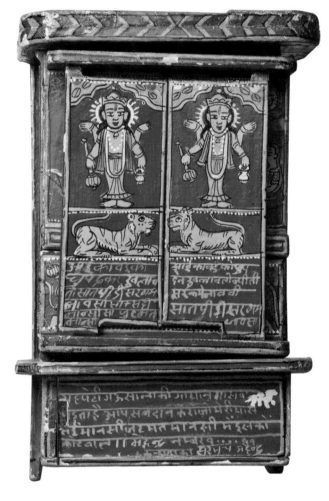

Figure 3.13
Kaavad story box from Rajasthan, 2007. Opaque colors on wood.
Colors are applied first and completed with a final black outline.
Photo: Nina Sabnani.

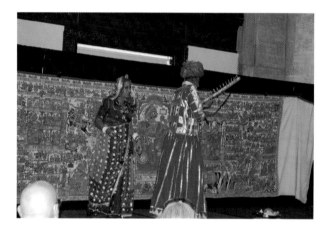

Figure 3.11
Phad (horizontal story scroll) performance, Rajasthan, 2007.
The performers wear red clothes because red is considered auspicious.
Photo: Kalyan Joshi.

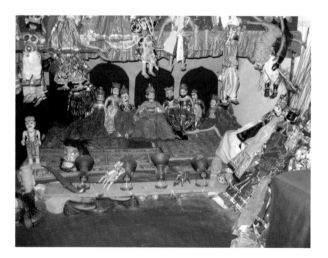

Figure 3.12
Kathputli, wooden string puppets from Rajasthan, 2007.
The puppeteer makes and manipulates wooden string puppets to entertain both young and old audiences with narratives of valor and romance, usually centered on kings and queens.
Photo: Nina Sabnani.

Figure 3.14
Storyteller Narsinhji reciting the *kaavad* for his patrons in a village in Rajasthan, 2007.
Storytellers use the same image to tell multiple stories, their words guiding the reader in interpreting the image.
Photo: Nina Sabnani.

Image and Text

In the ancient Hindu religion, important texts like the *Vedas* were passed down only orally because the Brahmins (the Hindu priestly caste) wanted to keep the knowledge among themselves. When the Brahmin order became oppressive, with its insistence on rituals, sacrifice, and a rigid caste system, in the sixth century BCE, a revolution occurred in the form of two emerging religions: Buddhism and Jainism, with both sects advocating a simple life of nonviolence and equality. A fifth-century BCE famine prompted concerns that oral knowledge could be lost, so Jain and Buddhist monks began to write and illustrate scriptures. Similar fears led senior Buddhist monks to account in writing for every word spoken by the Buddha. Eventually, the Hindu *Vaishnava* sect committed their literature to writing as well, primarily to spread the doctrine of devotion to the god Krishna.

Before the arrival and acceptance of paper, the sacred scriptures of the Jains and Buddhists were written on palm leaf, birch bark, and cloth; some of these practices continue to be used to this day (Figure 3.15). Buddhist manuscripts dating from the first century BCE have been found in the Bamian caves of present-day Afghanistan. Made on birch bark and stored in clay jars, these scrolls were not illustrated. Illustrated or illuminated palm leaf manuscripts known as *tadapatras* became popular in the Pala period, 700–1100 CE. A fine example of a palm-leaf manuscript illustrated in this period, the *Astasahasrika Prajnaparamita* (*The Perfection of Wisdom in Eight Thousand Verses*) (Figure 3.16), was completed at Nalanda, the monastery of the ancient seat of learning in Eastern India. The manuscript is protected by wooden covers and has few images. These images do not always illustrate the written texts; instead, the illustrations are of the life of the Buddha, and largely depict the events known as his miracles. The text has spaces for the images, which suggests the text preceded the image, and a colophon gives the place and year of execution, but the name of the "illustrartist" was never mentioned.

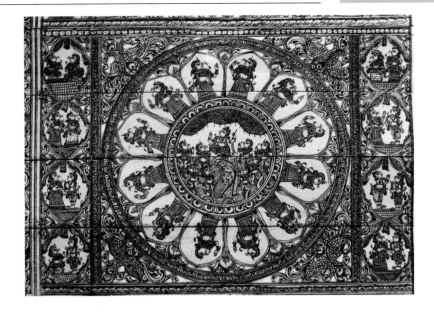

Figure 3.15
Raghunath Mandal, palm leaf manuscript from Orissa, 2014.
Images are etched in with a sharp tool, and then coal powder is pressed into the etched lines. Finally, the surface is wiped clean.
Photo: Nina Sabnani.

Pothis (palm leaf manuscripts) have been found in the Bihar, Orissa, Tamil Nadu, and Gujarat regions of India. Palm leaves could not be stitched together due to their brittle makeup, so holes were made in the middle of each leaf, through which a cord was passed that held the leaves in sequence. The pages were further protected by beautifully painted wooden covers.

Between the sixth and sixteenth centuries CE, rich examples of illuminated manuscripts on paper were often commissioned by patrons to earn *punya* (Hindu spiritual merit) and benefits for the next life. The manuscripts, some of which bear their patrons' names, were written and illuminated by the monks in monasteries and stored in their libraries.

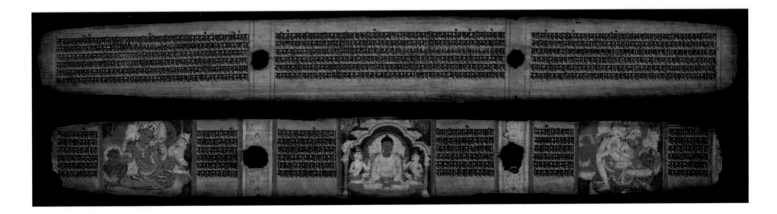

Figure 3.16
Anonymous, *Astasahasrika Prajnaparamita*, illustrated palm-leaf folio from a manuscript, probably Nalanda Monastery, Bihar, ca. 1112. Gouache and ink on palm leaf, 2 $^1/_2$ × 20 $^7/_8$".
According to the colophon, this manuscript was donated by a lay devotee, Udaya Sinha, in the thirty-sixth year of the reign of the Pala king Ramapala. The images of the deities follow strict iconographic rules, and the book itself was often an object of veneration: the wooden covers have been anointed with milk, oil, sandalwood paste, and vermillion.
Victoria and Albert Museum.

Jainism is an ancient Indian religion, and its adherents are known as Jains. The Jains revere and worship the *Kalpasutra* (*The Book of Sacred Percepts*) (Figure 3.17), which is recited during the monsoon season's *Paryusana* festival; and the *Kalakcharyakatha*, a narrative about an important monk, Kalka. The **Jaina style**, also known as Western Indian painting, has highly stylized figures, bright colors, and flat backgrounds—their most peculiar trait being the "protruding eye" (Figure 3.18).

The Content of Manuscripts

Not all manuscripts were religious in nature. There are beautiful examples of Sanskrit literature on romance such as *Laur Chanda* and *Chaurpanchashika* (*Fifty Verses Written by a Love Thief*), a delightful tale by Bilhan, an eleventh-century Kashmiri poet. One of the most popular versions of the tale is about the eponymous poet, who is put in prison because he dares to fall in love with the princess Champavati. He composes poems for his lover in his prison cell and on the day of his beheading reads them out as a last wish. The King, amazed by his devotion, pardons Bilhan and allows him to marry Champavati (Figure 3.19).

The "illustrartist" also interpreted other poems, such as Jaydeva's *Gitagovinda* (twelfth century CE) that celebrates the love and longing of the milkmaid Radha for the divine cowherd Krishna; and Bhanudatt's *Rasamanjari* (*Bouquet of Delights*), which focuses on *nayikas* (heroines), labeled according to their age, experience, status, or situation in love.

When the Indian subcontinent saw the invasion and occupation by Islamic rulers from the twelfth century CE onward, the art of the manuscript underwent further changes. In the fifteenth century, the introduction

Figure 3.17 Anonymous, Jain manuscript, *Kalpasutra, Birth of Mahavir*, late fourteenth century. Gouache on paper, 11 × 3 ⁵/₁₆". The illustrations of the deities in devotional books did not always relate to the texts because their function was primarily to invoke the sacred spirit.

Image ©L.D. Museum, Ahmedabad; ©N.C. Mehta Gallery, Ahmedabad.

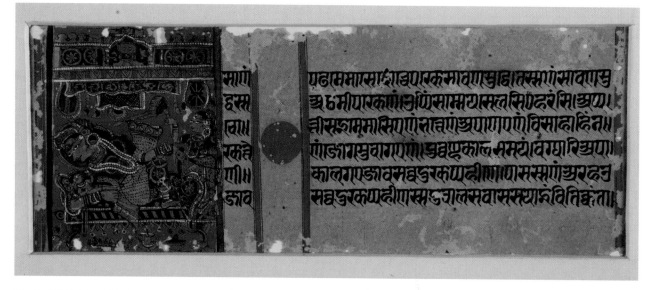

Figure 3.18 Anonymous, one of a pair of wooden covers for Jain manuscripts (*Patli*), early twelfth century. Opaque watercolor on wood, 2 ³/₁₆ × 12 ³/₄". The format is derived from the earliest Indian manuscripts, which were made of long, narrow palm leaves.

Courtesy Metropolitan Museum, OASC.

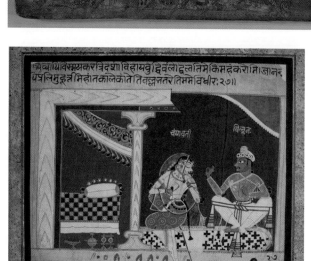

Figure 3.19
Anonymous, illustrated poem in *Chaurpanchashika* (*Fifty Verses Written by a Love Thief*), verse 27, sixteenth century. Opaque watercolor on paper, 6 ¹/₄ × 8 ¹/₂". The romantic text says, "And even now, knowing that death is drawing nearer every moment, my steady thought leaves the gods and with surprising force turns towards her, my beautiful and dearest beloved, what can I do?"

Lalbhai Dalpatbhai Museum, Ahmedabad.

of paper and Persian art through the ruling Muslim Sultanate had a strong impact on the content and style of illustration. An example of the **Ramayana** (an ancient epic that is considered sacred by Hindus) from Mewar in Rajasthan (Figure 3.20) from the seventeenth century reflects the deep influence in the depiction of architecture, composition, and gestures.

A unique treatise on the art of cooking, the *Nimmat Nama* (*Book of Delights*) from the fifteenth century is dedicated to recipes for food and drink, medicine, aphrodisiacs, perfumes, ways of hunting, and more (Figure 3.21).

Mughal Influence and Courtly Production

Four major courtly traditions emerged during the Mughal period, each with a distinctive style: the Deccani Sultans (South), the Mughal (Delhi), the Hindu Rajput from Rajasthan, and the Punjab Hills tradition. Deccan Art broadly denotes a manner of painting created from the sixteenth to the nineteenth centuries, in a region known as the Deccan in peninsular India under the Deccani Sultanate. Besides being geographically distinct, the Deccan also had its own art, culture, social, and religious ethos. The art of the Deccan courts was an eclectic amalgamation of elements and influences from Iran, Persia, Turkey, Europe, and China. Traditionally, figures are elongated with elegantly colored costumes, beautifully embroidered coats, and fine jewelry. Treatment of the landscape with high horizon lines represents a Persian influence, while detailed flora, arabesques, and gold leaf give the paintings a rich and luminous quality.

Although important creative stimulus for the noble arts had been provided by the development of manuscript illustration under the provincial Muslim sultans, the biggest influence came with the Mughal Empire, which originated in Persia and ruled northern India and nearby territories from the mid-sixteenth century to the mid-nineteenth century. Manuscripts in the Mughal tradition were richly bound and illustrated; they celebrated temporal themes, history, poetry, natural history, court life, and portraiture. The first Mughal emperor, Babur, and those that followed, drew artists from various parts of India and Persia into royal studios, thus founding a brilliant new style of painting that fused Persian and local Indian aesthetics. They also introduced the newest developments in Iranian book arts, such as fine calligraphy and sumptuously illuminated margins leafed in gold (*see Chapter 4* for further discussion of Islamic manuscripts).

One of the first major illustrated works in this style was the *Hamzanama* (*The Adventures of Amir Hamza*) (Figure 3.22), undertaken at the command of the powerful emperor Akbar (1556–1605). The enormous work took almost fifteen years to complete and required the expansion of the **tasvirkhana**, the court studio. Although illiterate himself, Akbar had scholars translate many books into Persian, including illustrated volumes of *Ramayana*

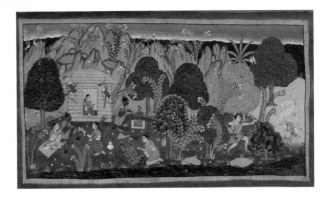

Figure 3.20 Anonymous, *Mewar Ramayana*, manuscript, Mewar, Rajasthan, 1649–1653. Opaque water color and ink on paper, 7 1/2 × 13 3/4". In this ancient, sacred story, the divine but exiled hero Rama, his wife Sita, and brother Laksmana take refuge in a mountain region.

British Library, London, © British Library Board, Add. MS 15296(1) ff. 71r. Commissioned by Rana Jagat Singh of Mewar in Rajasthan.

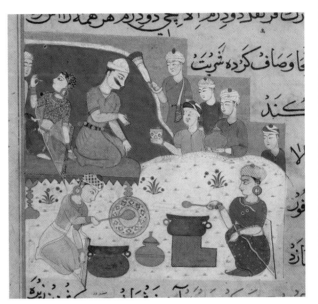

Figure 3.21 Anonymous, *The Ni'matnama-i Nasiral-Din Shah*, 1495–1505. Opaque watercolor. The illustration style amalgamates Persian and Indian influences in a manuscript on the noble art of fine cooking.

British Library, London, © The British Library Board, I.O. Islamic 149, fol. 76.

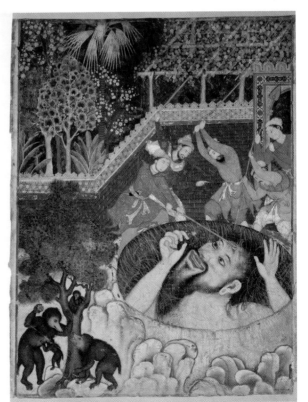

Figure 3.22 Anonymous, "Zumrud Shah Falls into a Pit and Is Beaten by Gardeners," in *Hamzanama*, 1562–1577. Opaque watercolor on prepared cotton backed with paper, 27 1/8 × 21.5 1/2" (painting). Hundreds of artists and calligraphers from different parts of India worked under the supervision of the Persian masters, who would draw the images and leave the artists to fill in the colors. Artists were allowed to draw only after they had adapted to the new Mughal style.

Victoria and Albert Museum.

and *Mahabharata*, another famous ancient epic history containing philosophical lessons. These volumes were replicated by hand and distributed among the courtiers.

No aspect of everyday life escaped the keen observation of the Mughal artist-illustrator: even though the primary attention of the composition was on the activities at the court, in the backgrounds and the *hashiyas* (margins) of the illustrations, we can see the life of common people—shepherds, village women, bookbinders, fishermen—in great detail.

Mughal interaction with Jesuit priests and European traders soon introduced elements of European visual culture. New genres emerged, including portraiture, symbolic maps, and botanical and scientific observational studies—along with the introduction of pale transparent watercolors instead of the traditional opaque paint. Artists became recognized and celebrated and were allowed to sign their work, as in Europe. When the Mughal Empire came to an end in 1857, many court artists left to join the various Rajput principalities or went to the Punjab Hills, while others joined the East India Company—the trading arm of the British Empire.

Colonialism and Objectification

Colonialism involved a diverse assemblage of the French, Dutch, Portuguese, and British interlopers. While each had different impacts, the focus here is on the Portuguese and the British. In 1498 CE, Portuguese explorer Vasco da Gama navigated around the coast of Africa and established an ocean route to India that was to become a lucrative trading passage between Europe and Asia. The Portuguese established colonies along the western coast of India, with Goa as their headquarters. In the spirit of the Renaissance with its new emphasis on scientific learning, physician and ethno-botanist Garcia da Orta (Portuguese, 1501–1568) took up the study of India's flora. His 1563 *Colóquios dos simples e drogas he cousas medicinais da Índia*, an expansive study on medicinal plants rich in ethno-medical details, is an early example of an illustrated book printed in India. Cristovao da Costa (Portugal, 1515–1594) is credited with further correcting and extending Orta's work in *Tractado des las drogas y de las Indias orientales con sus plantas*, in Spanish with illustrations based on Costa's own drawings. It was soon translated into French (Figure 3.23).

The classification of plants was extended to other aspects of life. The paintings in the *Codex Casanatense* are a visual categorization of various peoples and their knowledge, costumes and customs, festivals, Indian deities, modes of transport, trade, and agriculture as witnessed by the Portuguese in India (Figure 3.24). This fascination, curiosity, and documentation by scholars, navigators, merchants, and students of science led to a closer understanding of Indian life but also enabled control of the local population by the European interlopers.

The printing press arrived in India quite by accident in 1556 CE. Originally bound for Abyssinia (modern-day Ethiopia), the press was waylaid in Goa, where Jesuits adopted it to print Biblical and Catechistic literature needed for use in Christian proselytization. It took many more years, however, for the press to be accepted by Indian rulers, who were less interested in disseminating knowledge to the

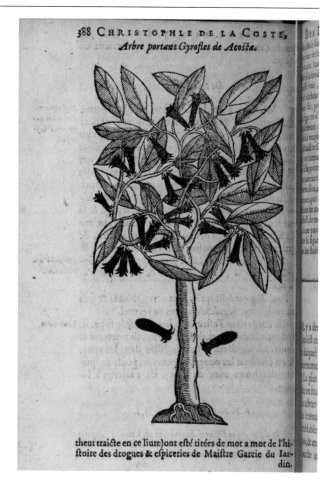

Figure 3.23
Cristovao da Costa, "Arbre portant Gyrofles de Acosta" (clove tree), *Histoire des drogues espiceries, et de certains medicamens simples, qui naissent és Indes, tant Orientales que Occidentales*" ("*The history of drugstuffs, and certain simple medicines, which originate in India, both Oriental and Occidental*"), 1602. Woodcut. Publisher: Iean Pillehotte, Lyon, France.
Costa's botanical illustrations of Indian flora were based on a 1563 work by Garcia da Orta.

Courtesy Archive.org and the John Carter Brown Library

Figure 3.24
Anonymous, *Codex Casanatense*, 1533–1546.
An illustration from an album of seventy-six watercolors depicts a noble Portuguese woman in India being carried on a litter with European gentlemen following on foot.
Biblioteca Casanatense.

masses than in commissioning visually rich and exclusive manuscripts. Some scholars also attribute the disinterest to the paucity of fonts available in the regional languages, while the royal courts or temple priests who controlled knowledge may have been suspicious of mass dissemination.

The East India Company

For the traditional Indian artist, the logic of making art and the reading of a painting goes beyond the **linear perspective** (the optical illusion of realistic spatial depth) that dominates European art. Instead, the Indian artist brings together his or her familial knowledge of the world, along with curiosity, understanding, and observation of it, combining the inner and the outer, often summoning the **sensorium** (the sensory and intellectual apparatus of the body), and emphasizing the tactile world. Indian art accommodates a multiplicity of perspectives and therefore is hermeneutic in intent, allowing for a plurality of layers, each painting being an invitation to a reading that is playful but not canonical. The arrival of Europeans and European visual culture affected these values of Indian art deeply.

The East India Company, a private business enterprise chartered by Queen Elizabeth I of England for trade with Asia, acted as the agent of British imperialism in India from 1600 until 1874. For the East India Company, Kolkata (Calcutta) provided a center of power as a model of administration and as a system of patronage. In this system, the Company created a market among its own British colonists and evolved a distinctive art practice embracing Western technology and local crafts in a range of hybridized forms—not all of them aesthetically coherent or authentic. Patrons commissioned local artists to depict everyday scenes of people and their activities. The amalgamation came to be known as **Company Painting** (Figure 3.25).

Company painting can be loosely divided into two strands: one in which artists portrayed subjects of local interest in their traditional style that were sold to travelers, soldiers, and company employees; and another in which artists adapted to meet the requirements of the new ruling class (Figure 3.26). Often individual patrons commissioned paintings on specific subjects, in which the artists not only adjusted their subject matter but also modified their traditional techniques to work in the watercolors preferred by Europeans (Figure 3.27). This new process altered the traditional color range, tempering the customary use of brilliant hues for somber colors reminiscent of European works, with attempts to represent perspective and shading in the European manner.

Many Indian artists adapted to life under the East India Company by assisting engineers as draftsmen. They helped with map making, architectural drawings, and perspective drawings, and they were trained in the use of pen-and-ink and wash techniques. Others created documentary images of local natural history, people, costumes, and crafts as a record of what the British found **picturesque** (quaint) and **sublime** (awe inspiring), in keeping with Romantic-era aesthetics (*see Chapter 12*). The adaptability and accuracy of the Indian "illustrartist" was recognized, albeit grudgingly, by Michael Symes, a British Major in His Majesty's 76th Regiment. He reported: "The representations of the costume of the country, I am persuaded, are as faithful as pencil can delineate: the native painters of India do not possess a genius for fiction, or works of fancy; they cannot invent or even embellish, and they are utterly

Figure 3.25
Anonymous, *Acrobats, Dombara*, Madras (Chennai), ca. 1785. Watercolor on English paper, 14 1/2 × 10 5/8". The Dombaras are classified as a Scheduled Caste, one of the official designations given to various groups of indigenous people in India.
Victoria and Albert Museum.

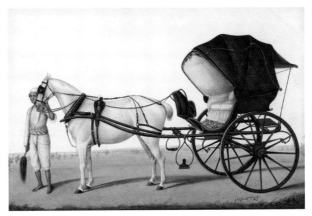

Figure 3.26
Shaykh Muhammad Amir Musawwir of Karraya, *A Groom with a Horse and Carriage*, Kolkata, India, 1845. Opaque watercolor on paper, 11 3/8 × 17 11/16". Not retaining much traditional style, this painting was likely commissioned by a European client.
Victoria and Albert Museum.

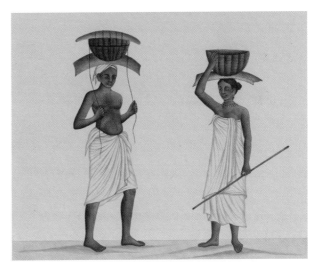

Figure 3.27
Anonymous, *Chavalacaren, A Basket Weaver and His Wife*, Coorg or the Malabar Coast, India, ca. 1830. Watercolor, 7.5 × 9".
A painting from a series of twelve depicting various castes and occupations, with implements related to specific trades.
Victoria and Albert Museum.

ignorant of perspective; but they draw figures and trace every line of a picture, with a laborious exactness peculiar to themselves"[2] (Figure 3.28).

Established in Calcutta in 1854, the Industrial School of Art taught alumni to observe and depict natural colors, textures, morphology, and external anatomy; and the technical processes of engraving, etching, woodcut, and lithography. Renamed in 1951 as the Government College of Art and Craft, it trained artists in the equally detail-oriented Mughal miniaturist manner that became invaluable in the accurate scientific illustrations of rare

flora and fauna key to investigation, identification, and classification in scientific repositories. What emerged were stunning and meticulously accurate illustrations done on English paper, most often using a wet-on-dry technique where several layers of thin, transparent pigment were applied over dry existing washes that made images seem luminous. Physicians, surgeons, naturalists, ethnologists, and others with a scientific interest in the natural world led groups of Indian artists to create such drawings (Figures 3.29, 3.30). Vital for trade and for the Company's profits, this work in the identification of plants was inevitably ideologically driven and exploitive.

[2]Symes, *An Account of an Embassy to the Kingdom of Ava*, p. xi.

Theme Box 8: Nationalism
by Jaleen Grove

Nations—geographical regions defined by borders, ruled by a central government, sharing an economic system, and ostensibly bound together by a singular representative cultural identity (albeit often contested)—began to emerge only in the late eighteenth century. Prior to this time, regions were governed by collectives, dynasties, states, and empires; their boundaries fluctuated; and their peoples may not have shared dialects, customs, or religions. Defining nations did not guarantee peace, however, and these underlying differences have often resulted in violent uprisings and separatist movements. In the face of such turmoil, a "nation" is, anthropologist Benedict Anderson (China, USA, UK, Indonesia, 1936–2015) argues, only an *imagined community*.

In an imagined community, members regard different factions as belonging to a collective whole, based on factors such as geographic location, language group, ethnicity, or political dictum. The imagined community is not an *imaginary* community—rather, the way people think of their nation guides their self-conception and their actions (such as whether to die for their country), making nationhood very real. Yet nations are ideological, and belonging is thus extended to some but not others. People or groups may not be treated equally when perceived by more dominant groups as being outside

the parameters set for the nation—regardless of how long they have lived in a particular region. Many nation-states have, for instance, denied rights of nomadic peoples, indigenous peoples, and slaves. Conversely, people who do not consider themselves part of a given nation may find themselves included by policy and by force, with a resulting loss of independence.

Despite discord, the identity of the nation and the story of how it came to be formed may be told in heroic, celebratory terms, and is often referred to as a *national narrative* (or, more critically, as a *national mythology*). In national narratives, prevailing inequalities and differences are typically unacknowledged or downplayed; the nation is therefore lauded as beneficial for all.

Anderson argues that the development of nations as imagined communities was partly due to **print capitalism**, or the production and circulation of books, newspapers, prints, and bureaucratic information. When Europeans began traveling worldwide to seek trade and then colonial opportunities, publishers capitalized on the interest in reliable knowledge and curiosity about distant lands, written in vernacular languages rather than Latin. European administrations in colonies grouped regions and peoples together for the purposes of economic and political control, and these groupings laid the groundwork for many modern nations. Maps,

schoolbooks, illustrations, and other printed texts have reinforced these groupings in ways that make them seem natural rather than designed or arbitrary, thus legitimizing the conceptualization of the nation itself. Although Anderson wrote specifically about colonized regions, print capitalism shapes and maintains national narratives and their power relations everywhere.

National narratives are constantly being challenged, negotiated, and redefined—or, conversely, entrenched—by competing social groups and interests. While many critics disparage nationalism as a tool of oppression, the postcolonial theorist Homi Bhabha has pointed out that nationalism has also been a rallying point for resistance against oppression. For Bhabha, a nation is just "a system of cultural signification," and as with any sign, such significations can be modified and redeployed through strategic intervention. Nationality can be the origin of new social movements and a politics of difference.

Further Reading
Anderson, Benedict, *Imagined Communities: Reflections on the Origin and Spread of Nationalism* (London, New York: Verso, 2006).

Bhabha, Homi K., *Nation and Narration* (London, New York: Psychology Press, 1990).

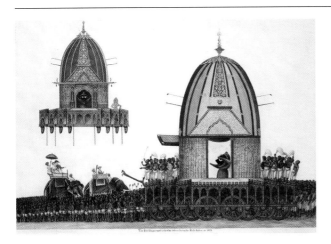

Figure 3.28
Anonymous, *The Jagganatha Rath Yatra Procession of 1822*, Puri, Orissa,
1820. Watercolor on paper, 18 5/16 × 26 9/16".
This painting shows the Jagannatharatha (chariot) during an annual festival.
The processionis observed by dignitaries on elephants: an Indian nobleman
on the first, and a British officer of the East India Company and his wife
(with howdah and umbrella) on the second. Puri, in Orissa, is considered one
of the seven great centers of Hindu pilgrimage.

Victoria and Albert Museum.

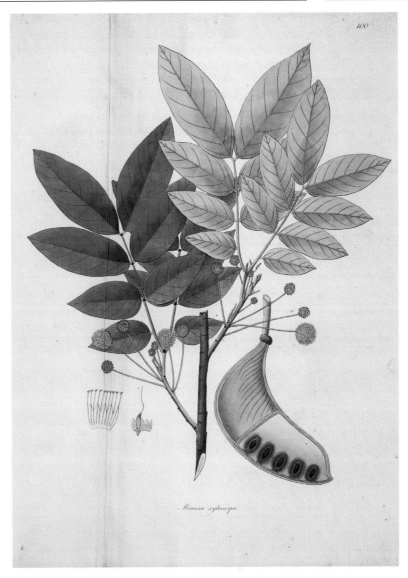

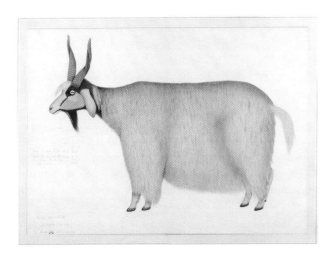

Figure 3.29
Zayn al-Din, *A Shawl Goat*, Calcutta, 1779. Watercolor, 21 × 29 1/2".
The British used illustration to document plants and animals they hoped
might provide new commercial opportunities, such as this shawl goat for fine
cloth. On the reverse of the painting, the seal of Elijah Impey is inscribed in
Persian.

Victoria and Albert Museum.

Figure 3.30
Anonymous artist, *Mimosa xylocarpa Roxb. synonym of Xyliaxylocarpa (Roxb.) Taub.*, plate 100,
*Plants of the coast of Coromandel: selected from drawings and descriptions presented to the Hon. Court
of Directors of the East India Company*, vol. 1, by William Roxburgh, 1795.
Watercolors commissioned by William Roxburgh for his "Flora Indica" collection and other doc-
umentary and scientific illustrations turned subjects into specimens decontextualized from their
origins and functions.

Courtesy Biodiversity Library.org and Missouri Botanical Garden, Peter H. Raven Library.

Further Impact of Printing in India

Printing technology arrived in Calcutta around 1777. It
is here that the first printing press was set up in 1807 by
an Indian, Babu Ram. Hindi and Sanskrit books were
made for Fort William College, an institution that aimed
at training British officials in Indian languages, and in
the process, fostered the development of several other
vernacular languages that aided business, administrative,
and political purposes.

The "Gutenberg revolution" in Bengal had similar
results, whereby missionaries in and around Calcutta
created type using the skills of traditional engravers. Print

became a standardized technology widely used to print
educational materials. Later, however, printing presses
once used by the British to control India began to be
used by Indians to fight the British masters, as ideas of
individualism and freedom spread.

Printing and advances in papers and pigments also
affected artistic production and consumption. Where
artists once made *pats* completely by hand, outlines
were now printed by lithography, with colors filled in
by less skilled workers and the final strokes applied by
the master artist. The first paper mill in Kolkata started
in 1809. The ready availability of cheap paper and

watercolors accelerated the emergence of the **Kalighat Style** of painting (Figure 3.31). Narratives told through scrolls were often turned into single illustrations to allow for large numbers, portability, and sale. Influenced by nineteenth-century temple terracotta art and Bengali bronze sculptures, Kalighat Style was characterized by bright colors, strong lines, simplified modeling of forms, and rhythmic compositions. The *pats* and paintings illustrated historical, religious, and mythological subjects; epics; and the breakdown of modern social values and institutions. Their popularity forced artists to employ mass reproduction technology to meet accelerating demands.

Battala Print

The British instituted the Vernacular Press Act in 1878 to keep anticolonial views from being expressed in print. The Repeal of the Press Act in 1881 under the regime of Lord Ripon resulted in the proliferation of printing presses in Battala, a locality in North Kolkata. Battala print artists created intaglio and relief images that appeared in newspapers, textbooks, fiction, and packaging labels. They were appealing to the semi-educated masses, and used decorative fonts in large sizes not otherwise available in the Bengali language. Characterized by cheap paper and poor printing, Battala subject matter often replicated that of Kalighat painting while bordering on crudeness in execution. Battala subjects included religious, diabolical, supernatural, superstitious, romantic, humorous, legendary, historical, biographical, and criminal stories; plays, farces, mysteries, and adventures; and even erotica (Figure 3.32).

Raja Ravi Varma

Woodcuts and metal engravings could not match the illusionistic tonal quality offered at the other end of the printing spectrum by artist and printer Raja Ravi Varma (Indian, 1848–1906) in the late nineteenth century. He was trained in the **Thanjavar Style** of the southern Indian state Tamil Nadu that used gold and precious stones to embellish and highlight clothes and ornaments. Ravi Varma was also trained in European oil painting techniques and set up his printing unit, the Fine Art and Lithographic Press, to create mass reproductions of his paintings using chromolithography (*see Chapter 13, Theme Box 28, "Chromolithography and Ben Day Tints"*). His hybridized paintings and **oleographs** (lithographic prints on canvas to mimic oil paintings) of mythological figures made in the European manner were influenced by theater and photography (Figure 3.33).

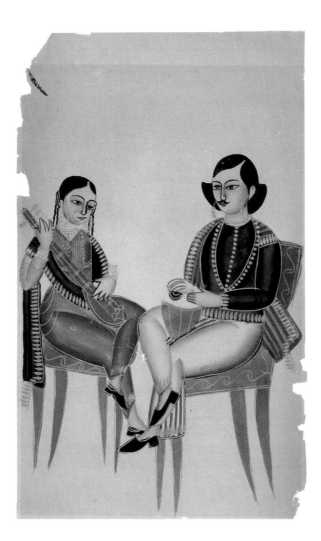

Figure 3.31
Anonymous, Kalighat style, *Nouveau Riche Bengali Couple Making Music*, nineteenth century, Kolkata. Watercolor over pencil drawing with accents of colloidal tin pigment.
This image of a Kolkata couple recalls the musical *gandharvas* figures seen on the walls of classical Indian temples and in the pages of Sanskrit literature. The lady's dress suggests she was one of the courtesans who left Lucknow when the court of the Nawab of Oudh moved to Kolkata, while the European chairs are another indication of the cosmopolitan nature of the city. The tin-pigment ornamentation, done with fine brushwork, served as a substitute for silver and added richness to the painting.
Amguedda Cymru—National Museum of Wales.

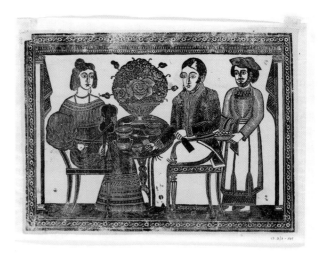

Figure 3.32
Shri Madhabchandra Daser Krita (Madhabchandra Das), Battala print, late nineteenth century. Woodcut.
A European *Memsahib* (lady) is playing the violin while the *Sahib* (gentleman) holds a liquor bottle and glass in his hands. The *Kitmatgar* (servant) stands in waiting.
Victoria and Albert Museum.

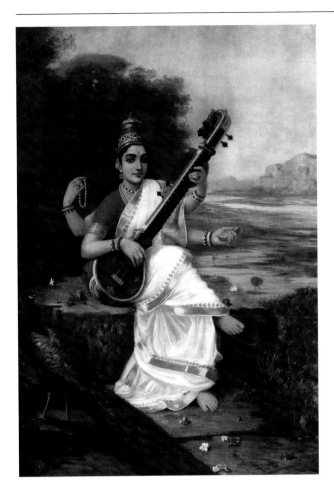

Figure 3.33
Raja Ravi Varma, *Goddess Saraswati, Goddess of Knowledge*, 1896. Oil on canvas, also produced as an oleograph.
Varma used advanced print technology to reproduce his oil paintings.
Image: Binita Desai.

Beyond Independence: Images for a New Identity

Between 1854 and 1887, the British established several art schools in which the fine and the commercial arts were separated, with the latter severed from the ancient illustrartist's role as a translator who mediated between multiple skills and adapted to changing contexts. An India that once produced three hundred variants of the *Ramayana* lost the ecology of diversity and plurality and collapsed into a mechanical mold.

After nearly a hundred years of struggle, India finally got its independence from British rule in 1947, followed by the annexation of Goa back from the Portuguese in 1961. In the euphoria of nation building, art schools now allowed Indians to pursue art as a profession that was no longer caste-based, but they continued to affirm and even widen the gap between illustration and art.

India was caught between two schools: one reflecting a need for older, more "classical" styles; and the other not quite effectively modern. This turned into a desperate effort to retain the traditional style and the modern hybrids within the emerging industrial economy.

Nationalists were critical: artist K. G. Subramanyan (born 1924) said the schools "were modeled on the lines of Victorian art schools out of contact with this country's

traditions. The effects of the old art traditions got swept away into the fields of functional and decorative arts and subsisted precariously."[3] India's visual culture became a mix of the iconically religious and the eclectically secular. Some art school graduates favored European-style modern commercial art, claiming Ravi Varma as their ancestor. Indeed, Varma's images influence calendar art, school textbooks, charts, advertising (especially film posters), and match box and textile labels (Figure 3.34a, b).

Modern Design Schools and Forms

The first Prime Minister, Jawarharlal Nehru (who served from 1947 to 1964), was a proponent of modernization. He enhanced Modernist design in India by inviting the American industrial designers Charles and Ray Eames to set up the National Institute of Design (NID) in Ahmedabad. The Government of India under the auspices of the Indian Institute of Technology Bombay also set up the Industrial Design Center (IDC) in 1969.

In accordance with Nehru's interest in industrialization, newly established design schools did not offer painting or sculpture, and applied arts' ancient ties with fine art were totally severed. Illustration became a part of Visual Communication in design schools and a part of the Applied

[3]Subramanyan, *Moving Focus: Essays on Indian Art* pp. 17–18.

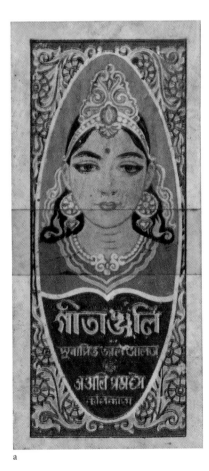
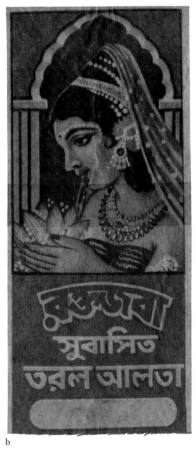

a b

Figure 3.34 a, b
Anonymous, labels for Raktajaba Subasita Aalta, late twentieth to twenty-first century.
This extract from *Hibiscus rosa sinensis* is a red-scented liquid used to decorate the feet of married Bengali women.
Images: Nina Sabnani.

Art department in the fine art schools. Furthermore, illustration came under the purview of service, catering to low-cost advertising and school textbooks with nominal, rudimentary, imitative work.

Greater creative opportunity, however, was to be found in illustrating ephemeral forms such as matchboxes, posters, comics, and children's books. A history of the popular imagination can be drawn from studying matchbox labels, textile labels, and cinema posters (Figures 3.34a, b and 3.35a, b, c, d).

Cinema posters borrowed from photography and from Ravi Varma's aesthetic. They served not just as advertisements but also as wall decorations in dhabas (roadside restaurants) and in auto-rickshaws, trucks, and buses, becoming an image on the move. As cultural icons, they dominated the cityscapes and continue to do so even in some cities today.

Graphic Satire, Comic Strips, and Comic Books

Beginning in the 1870s, comic magazines became a platform for anticolonial resistance modeled on the English *Punch* magazine, which had come to India with resident Europeans. Indian graphic satire emerged in many vernacular languages and gained momentum in the 1940s. Parodying social inequalities, politics, and the nation's vulnerabilities, it created a niche for subversive humor and thus provided a platform for talent.

Both influenced by and critical of *Punch*, R. K. Laxman (Indian, 1921–2015) was the creator and illustrator of the "common man," a character who silently witnessed in an everyday sense the making of democracy in utter bewilderment. This unassuming bald man with a scraggly moustache, wearing a traditional *dhoti* and a checked coat, greeted readers every morning in the newspaper *Times of India*.

Kesava Shankar Pillai (Indian, 1902–1989), a stalwart pre-independence cartoonist, started *Shankar's Weekly* in 1948, and later, the Children's Book Trust (CBT) for publishing children's content. In his political cartoons, Shankar parodied the politics of his day and offered a critique of democracy in a gentle but barbed way (Figure 3.36).

The *Chandamama* magazine initiated in 1947 by B. Nagi Reddy brought Indian content to young readers. This content included epics, myths, and folktales, to stimulate interest in their own cultural heritage—the most popular being *Vikram Betala*. Simultaneously, the first introduction of American pop culture, the American *Phantom*, appeared as comic strips in *The Illustrated Weekly of India*. The *Times of India* introduced the magazine *Indrajal Comics* in 1964, initiated by Anant Pai (Indian, 1929–2011), an educator and great contributor to comics in India. Half its pages were dedicated to syndicated comics like *Phantom*, *Mandrake*, and *Flash Gordon* (*see Chapter 23*), along with quizzes and puzzles to enhance general knowledge. Despite an emergence of comics in vernacular languages, after twenty-seven years of publishing, the *Indrajal* magazine collapsed due to declining readership.

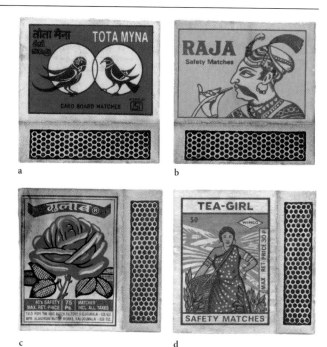

a b

c d

Figure 3.35a, b, c, d
Anonymous, match box labels, India, late twentieth to twenty-first century. Safety matches were first brought to India in the nineteenth century and thereafter were manufactured locally—particularly in Sivakasi, a town in the state of Tamil Nadu. Their boxes are covered with local themes and motifs, including royal portraits, mythological characters, movie stars, national heroes, lucky numbers, and images of modernity.

Images: Nina Sabnani.

Figure 3.36
Kesav Shankar Pillai, "Lord Willingdon's Dilemma," *Hindustan Times*, 1933. Amid struggles for independence, Gandhi sent British-appointed viceroy Willingdon a telegraph asking for an interview to explore a peaceful settlement on the issues of constitutional reforms. Willingdon's refusal to negotiate and the subsequent arrest of Gandhi bolstered the resolve of nonviolent protesters, who unified rather than giving up. They are shown here as throngs of Gandhis appearing behind a confused Willingdon.

Courtesy of the Sabarmati Ashram Preservation and Memorial Trust, Ahmedabad.

Undaunted, Anant Pai launched Amar Chitra Katha comics with India Book House in 1967. Through the comics, Uncle Pai (as he was called) introduced Indian children to their rich cultural heritage of myths and epics. This genre of comics still dominates the industry. The visual narratives of Amar Chitra Katha (Figure 3.37a, b, c) upheld Hindu sentiments, retelling and reconstructing popular folk tales, epics, and historical facts relating to legendary visionaries and freedom fighters. Several other comic book publishers also emerged between the 1960s

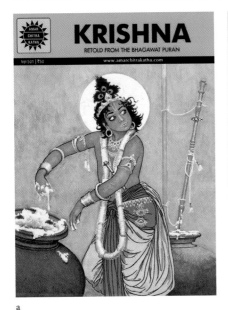

a

b

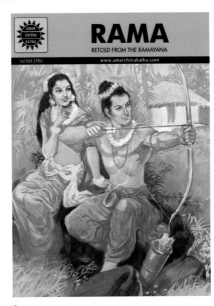

c

Figure 3.37a, b, c Comics, published by Amar Chitra Katha, 1969–1977. In the twentieth century, traditional stories found in earlier Indian illustrated art forms were adapted to comic books.

and the 1980s. *Raj Comics* presented superheroes, while *Champak* published stories of adventure; both *Diamond* and *Tinkle* focused on knowledge and entertainment along with other features targeted at schoolchildren.

Conclusion

The illustrated image in India originated in diverse forms created as invocation, as epiphany, as visual narrative, as cultural document, and as a tool for play and subversion. Central to the history of the illustrated image in India is the illustrartist, who both created the polyphony of Indian art and heuristically illustrated changes in the cultural milieu. Threatened by colonial administration and the advent of printing technologies, visual art in India became a hybrid—neither traditional nor modern in a European or American sense. This hybridization reflected a loss of authenticity. It became the responsibility of the nationalist movement to reinvent a contemporary practice that sustained the legacy of Indian art traditions. The illustrartist moved from a position of centrality and imaginative force in India in the traditional era, through a low point when swept up in foreign influences in the colonial period, back to a position of cultural primacy in the nationalist era.

FURTHER READING

Archer, Mildred, *Company Paintings* (London: Victoria and Albert Museum, India Series, 1992).

Dotz, Warren, *Light of India: A Conflagration of Indian Matchbox Art* (Berkeley, Toronto: Ten Speed Press, 2007).

Ghosh, D. P., *Medieval Indian Painting—Eastern School* (Delhi: Sundeep Prakashan, 1982).

Goswamy, B. N., *The Word Is Sacred Sacred Is the Word: The Indian Manuscript Tradition* (New Delhi: Niyogi Books, 2007).

Kesavan, Bellary Shamanna, *History of Printing and Publishing in India*, vol. 1 (New Delhi: National Book Trust, India, 1985).

Parimoo, Ratan, *Gujarati School and Jaina Manuscript Paintings* (Ahmedabad: Gujarat Museum Society Ahmedabad, 2010).

Sabnani, Nina, *Kaavad Tradition of Rajasthan: A Portable Pilgrimage* (Delhi: Niyogi Books, 2014).

Sharma, Mahesh, and Padma Kaimal (Eds.), *Indian Painting: Themes, Histories, Interpretations* (Ahmedabad: Mapin Publishing Pvt. Ltd., 2013).

KEY TERMS

caksani	oleograph
Charana Chitta	*pata*
chitrakar	*phad*
chitra-nirupan	picturesque
Chitrasutra	*pothis*
Company Painting	print capitalism
Deccan Art	*Puranas*
Jaina style	*Ramayana*
kaavad	*rasa*
Kalighat Style	*rasik*
kathputli	sensorium
linear perspective	sublime
Mahabharata	*tasvirkhana*
mankha	Thanjavar Style
mnemonic device	*Vedas*
Natya Shastra	

4

Illustrative Traditions in the Muslim Context, 1200–1900

İrvin Cemil Schick

There are more than 1.5 billion Muslims worldwide, making Islam the religion with the world's second largest number of adherents. Countries with significant Muslim populations stretch from the western shores of Africa to the southeastern shores of Asia. Throughout history and across a broad geographical area, Muslims have produced illustrations, and these illustrations therefore exhibit a great deal of variability. In this respect, the term *Islamic art* is somewhat reductive because it tends to obscure the huge diversity that exists across multiple societies that share a common faith but often not very much else. After all, it would make little sense to qualify all of European and American art as "Christian art" even if the artists who produced its greatest masterpieces were most often at least nominally Christian.

Given the breadth of the subject and the constraints imposed by the present volume, this chapter approaches the subject not chronologically nor geographically but thematically. In other words, rather than an exhaustive survey of the illustrations produced by Muslims across time and space, this chapter highlights and discusses some of the most salient aspects of those illustrations.

Islam and the Prohibition of Images

When one speaks of illustrations in the Muslim World, the first thought that pops into many a mind is bound to be the so-called Islamic prohibition of images. It is often stated that the Qur'an prohibits the pictorial representation of living things because Islam views such representations as tantamount to idolatry. Therefore, the argument goes, Muslims did not produce pictures, focusing their energies instead on calligraphy and abstract ornamentation. In fact, however, the Qur'an does nothing of the sort.

The Qur'an makes only passing reference to the subject of representation. On one occasion, the text refers to Abraham and reads as follows: "When he said to his father and to his people: 'What are these representations (*tamathil*) to which you are devoted?' They said: 'We found our fathers worshippers of them'" (Qur'an, *Anbiya* 21: 52–53). Here, it is very clear that the representations in question are idols, rather than pictures more generally. Elsewhere, believers are entreated to stay away from certain forbidden practices: "O you who believe! Intoxicants and games of chance and erected stones (*ansab*) and divining arrows are only an infamy of Satan's handiwork. Avoid it, so that you may succeed." (Qur'an, *Ma'ida* 5: 90). Once again, it is more than likely that the term *erected stones* refers to idols rather than sculptures in general, and least of all to pictures. Yet another verse refers to Solomon and the **jinns** (supernatural beings, one of the three categories of sentient beings along with humans and angels) at his service: ". . .and there were jinns that worked before him, by permission of his Lord, and if any of them deviated from Our command, We made him taste of the punishment of the blazing fire. They made for him what he willed, of sanctuaries and

Ruling States Referred to in Chapter 4

Regions specified in twenty-first-century nomenclature:

Byzantine Empire (Eastern Roman Empire): 330–1453 (with a brief interruption following the Fourth Crusade)
 Constantinople, now Istanbul, Turkey, was its center.

Abbasid Caliphate: 750–1258
 Near East and parts of North Africa

Artuqid Dynasty: early 1100s–mid-1230s
 Eastern Turkey, Northern Iraq, and Northern Syria.

Mamluk Sultanate: 1250–1517
 Egypt, Syria, and Western Arabia

Timurid Empire: 1370–1507
 Central Asia to Mesopotamia

Safavid Empire: 1501–1736
 Persia (modern-day Iran)

Mughal Empire: 1526–1857
 India and neighboring territories

Ottoman Empire: 1299–1922
 At its peak, it ruled Northwest Africa to Yemen, with its capital Istanbul.

Note: The Islamic calendar is lunar and begins with the Prophet Muhammad's journey from Mecca to Medina, called the Hijrah. In this chapter, most dates are given according to the Christian calendar. When the calendar is ambiguous, the date is marked CE (Common Era). Where works are dated according to the Islamic calendar, the date is marked AH (Anno Hegirae).

representations (*tamathil*) and basins like wells and cauldrons firmly anchored. . ." (Qur'an, *Saba* 34: 12–13). It is noteworthy that the representations in question were produced "by permission of his Lord," suggesting that, at least in Solomonic times, making representations was not necessarily illicit. This is just about the extent of the Qur'an's references to representations, whether they be pictures or statues. While idolatry was clearly forbidden, it would be very difficult to argue that the prohibition extends to all representations.

But the Qur'an is only one of the main textual sources upon which Islam is based, albeit the most important. Another source is the extensive corpus consisting of sayings and doings attributed to the Prophet Muhammad, known as **hadith**. These were collected and authenticated more than two centuries after the Prophet's death. A certain hostility to images can be discerned in the *hadith*s, though

once again the message is somewhat ambivalent. It is worth noting that in the nearby (predominantly Christian) area of Byzantium, debate over the appropriateness of representation and veneration of sacred likenesses was also taking place at the time. On the one hand, the Prophet is related to have said: "Angels do not enter a house in which there is a dog or there are pictures (*tasawir*)" (Bukhari, *Libas* 160, 167, 170, 171; Muslim, *Libas wa Ziynah* 121, 123, 125; Abu Dawud, *Libas* 132, 137, 138; Ibn Majah, *Libas* 100–102). The word *tasawir* (singular: *taswir*) is derived from a root that signifies to form, fashion, or create, and the subject of such action, *musawwir*, can mean either a painter or draftsman, or one who shapes or creates. The Prophet is related to have stated that "The people who will receive the harshest punishment from God will be the *musawwir*" (Bukhari, *Libas* 161; Muslim, *Libas wa Ziynah* 145–147). It is important to recall, in this context, that *al-Musawwir* is mentioned in the Qur'an as one of the attributes/names of God: "He is Allah, the Creator, the Maker out of naught, the Fashioner (*al-Musawwir*). . ." (Qur'an, *al-Hashr* 59: 24). In other verses, the related verb *sawara* is used to denote God's creative action, and the related noun *surat* to denote its result (Qur'an, *Al 'Imran* 3: 6; *al-Taghabun* 64: 3; *al-Infitar* 82: 6–8). Under these circumstances, a *musawwir* can be considered one who arrogates to himself or herself the creative act that properly belongs to God. If figurative representations are at all prohibited in Islam, then, they are so only to the extent that they attempt to imitate God's creation. It would be hard to argue that a mere picture or sculpture does so.

A *hadith* relates the story of a carpet or curtain that the Prophet's wife 'A'isha had hung at the door of her apartment (Bukhari, *Libas* 165, 166, 169; Muslim, *Libas wa Ziynah* 130–141; Abu Dawud, *Libas* 133, 135, 138; Ibn Majah, *Libas* 104). It bore figurative images, and in one version of the *hadith*, the Prophet is related to have complained: "Whenever I enter the room I see them and it brings to my mind worldly life" (Muslim, *Libas wa Ziynah* 130). The curtain was taken down, but most noteworthy is what actually ended up happening to it. According to several versions of the *hadith*, 'A'isha "made a pillow or two out of it" by cutting it up and stuffing it with date-palm fibers (Bukhari, *Libas* 165; Muslim, *Libas wa Ziynah* 129, 136–140; Abu Dawud, *Libas* 133, 138; Ibn Majah, *Libas* 104). She also related that she once saw the Prophet reclining against one of those pillows (Ibn Majah, *Libas* 104; Muslim, *Libas wa Ziynah* 142), suggesting that it was not the pictures themselves that he had found objectionable, but their prominent display, particularly in the room in which he prayed.

All this does not, of course, mean that there were no **iconophobic** (averse to and repudiating images, often because they are considered tantamount to idolatry) interpretations of the scriptures in the Muslim World, and one of the most uncompromising was due to the Shafi'i scholar al-Nawawi (1234–1278). (The Shafi'i are members of one of the four principal legal schools of the Sunni sect, one of the two major branches of Islam, the other branch being the Shi'i sect.) Nevertheless, Muslims produced pictures—both figurative and otherwise—in large numbers, and thus illustration in that part of the globe is certainly a legitimate object of study.

Technical Aspects and Patronage

Images can be found on countless objects produced in the Muslim World, from textiles to metalwork, from tiles to ivory- and mother-of-pearl-inlaid wood. The largest body of images, however, is without doubt on paper. Whether on single sheets, in albums composed of several such sheets, or most often in books, illustrations on paper constitute

Theme Box 9: The Taxonomy and Legitimation of the *Hadith*
by İrvin Cemil Schick

After the death of the Prophet Muhammad in the year 632, people often quoted him as having said or done something or another, and these narratives were called *hadith* (an account or report). However, they were for the most part based on hearsay, and one could not tell for sure whether or not they were truthful or accurate. During the ninth century, a number of scholars formulated rules by which to determine which of these sayings were authentic and which were not.

For example, they might require one or more uninterrupted chains of narrators going back to the Prophet, as well as evidence that successive narrators had actually met. Such a chain might be something like "A heard from B who heard from C who heard from D who heard from the Prophet's companion E who heard the Prophet say. . . ." Such *hadiths* were considered *sahih* (authentic) and accordingly were collected into a number of books that are second only to the Qur'an in

religious significance. Each collection is composed of a number of books (parts) organized according to topic, for example, *al-Libas* (clothing), *al-Hajj* (pilgrimage), and *al-Sawm* (fasting). A reference to a particular *hadith* indicates the compiler, the book, and the number of the *hadith* in that book. Thus, "Bukhari, *Libas* 160" means the 160th *hadith* in the book *al-Libas* in Muhammad b. Isma'il al-Bukhari's collection of the authentic sayings and doings of the Prophet.

a large corpus spanning historical, religious, literary, and everyday subjects from the Abbasid period onward.

Many of the sumptuous manuscripts discussed here were produced in workshops in such cities as Baghdad (in present-day Iraq), Herat (in present-day Afghanistan), Tabriz and Isfahan (in present-day Iran), and Istanbul (in present-day Turkey). Some of these workshops are themselves illustrated in the manuscripts, as in the late sixteenth-century copy of the book *Akhlaq-i Nasiri* (*The Nasirean Ethics*) commissioned by the great Mughal Emperor Akbar (Figure 4.1, in which we see a detailed picture of a book-making workshop).

The production of Islamic illustrated manuscripts involved a variety of technical processes including polishing paper, grinding pigments, hammering gold leaves and dissolving them to make gold ink, tinting paper, making and pouncing stencils, and many others. Since glossy paper was not available at the time, it was necessary to cover ordinary paper with sizing—a solution often containing rice starch and eggwhite—and polish it with a burnisher to facilitate the movement of the pen on its surface and to prevent the ink from spreading into the paper. High-end workshops generally included numerous artists who each specialized in some specific aspect of the miniatures. There were, for example, those who specialized in painting faces, vegetation, animals, textiles, architectural elements, and so on.

Figure 4.2 shows a page from a early seventeenth-century album made for the Mughal Emperor Jihangir, Akbar's son. Surrounding the central calligraphic panel by the great calligrapher Mir Ali al-Sultani (Timurid, ca. 1476–1544) are delicate illustrations attributed to Madhava (active 1582–ca. 1624) of six craftsmen engaged in various stages of book production. Counterclockwise from the upper right, we see a man polishing paper, a bookbinder applying a stamp to a cover and another trimming the edges of a bound book, a carpenter making a bookstand, a goldsmith melting gold for use in illumination, and a scribe writing. These images do not specifically illustrate any part of the text; rather, they constitute a self-referential statement on the part of the manuscript as a whole, describing how it came to exist.

The most important manuscripts were almost always produced in response to royal commissions, particularly up to the seventeenth century. While only some workshops were directly affiliated with the monarch's palace, the greatest artists were always prized and honored by the emperors. Indeed, artists were often an important part of war booty; for example, when the Ottoman Sultan Selim I conquered the city of Tabriz in 1514, he brought many of its artists back to Istanbul where they and their students produced masterpieces for the Ottoman court. Art-loving monarchs and members of royal households such as Prince Baysunghur (Timurid, 1399–1433) in Herat, Emperor Akbar (Mughal, 1542–1605) in Fatehpur Sikri, Shah Abbas I (Safavid, 1571–1629) in Isfahan, and Sultan Murad III (Ottoman, 1546–1595) in Istanbul patronized calligraphers and illustrators and often paid them high salaries to induce them to continue to serve their courts.

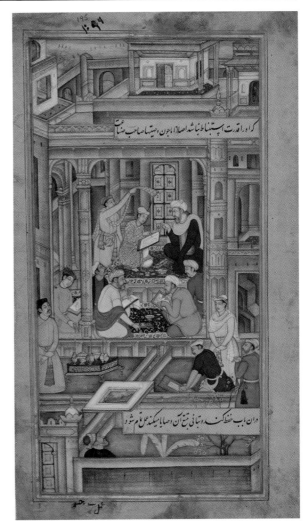

Figure 4.1
Sajnu (attributed), *Akhlaq-i Nasiri* (*The Nasirean Ethics*), manuscript, Mughal, possibly Lahore, ca. 1590–1595. Ink, gold, and pigment on paper, 8 ¹³⁄₁₆ × 5 ¹¹⁄₁₆".
A book production workshop depicting a master (center right) supervising a scribe, two painters preparing illustrations, and a man polishing paper, as well as various other attendants and details.

Aga Khan Museum.

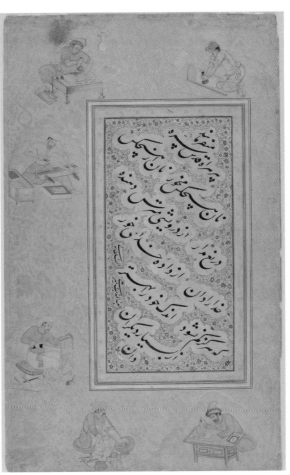

Figure 4.2
Mir Ali al-Sultani, illustrations attributed to Madhava. Mughal, early seventeenth century. Ink, gold, and pigments on paper, 16 ³⁄₄ × 10 ¹⁄₂".
A calligraphic panel surrounded on three sides by six figures engaged in various stages of book production. From an album (now dispersed) made for Emperor Jihangir.

Freer Gallery of Art, Smithsonian Institution, Washington, DC: Purchase—Charles Lang Freer Endowment, Fl954.116.

Naturalism versus Abstraction

Some contemporary Muslim art theorists tend to insist that Islamic art is not mimetic, but such a sweeping qualification could not possibly hold true across the board. In fact, a tension is present between naturalism and abstraction throughout Islamic art, as exemplified in Figures 4.3, 4.4, and 4.5, which all depict flowers and birds in varying degrees of abstraction. Figure 4.3 is a sixteenth-century Ottoman Turkish example of the so-called *saz* style, generally said to have been invented by Shah Quli, a Persian-born artist brought to the Ottoman court in 1514.

The image is a highly stylized representation of a peony and a bird with a profile hidden within the flower in the upper center. It is signed Veli Can (pronounced "Velly Jun") within the flower in the upper-left corner. Floral and foliate motifs (as well, in some cases, as birds, dragons, and other images) are very stylized in *saz* drawings, and flowers in particular are often represented schematically by their cross-sections. Such cross-section motifs are called **hatayi** ("Chinese"), because they are thought to have been imported by Timurid court artists from western China.

Figure 4.5, by contrast, is a Safavid Persian miniature signed by Muhammad Baqir and dated 1178 AH (1764–1765 CE). Heavily influenced by late seventeenth-century Isfahan painting, which itself bears the influence of European paintings and engravings, the hyper-realism of this image bears comparison with the best of eighteenth- or nineteenth-century European herbals and ornithological albums. In between these two examples is Figure 4.4, a mid-seventeenth-century Central Indian

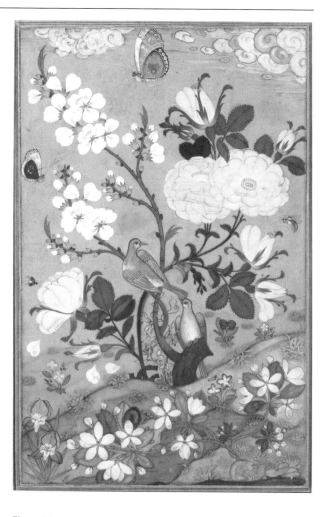

Figure 4.4
Anonymous, Deccan (Central India), ca. 1650. Pigments on paper, 8 × 5 ¹/₈". These relatively realistically painted flowers, birds, and butterflies in a fanciful setting bear European influences, both technical (spotting, shading) and representational (realism, three-dimensionality).

From the Collection of Prince and Princess Sadruddin Aga Khan.

Figure 4.3
Veli Can (signed), "Peony and a bird," Ottoman, ca. 1585. Ink and pigments on paper, 7 × 4 ¹/₂". This highly stylized representation is in the style known as *saz yolu*. Note the profile hidden within the flower in the upper center.

Turkish Republic, Ministry of Culture and Tourism, KUVAM, DOSIMM, Directorate of the Topkapı Palace Museum.

miniature in which somewhat naturalistic flowers, birds, and butterflies come together in a fanciful setting.

The range of stylization seen in these examples, from highly abstract to highly naturalistic, also applies to other kinds of images, notably religious illustrations. In them, the concern is that the holy cannot help but be burdened with the imperfections inherent in all physical forms, a serious problem for Islam, a religion that favors transcendence.

Representing the Unrepresentable

Although religious subjects were frequently taken up in the visual arts, it is noteworthy that the Qur'an itself was never illustrated. This may be due to the fact that Muslims believe it to be verbatim the Word of God Himself, and is therefore considered perfect and transcendent. Thus, one does not speak of a "translation" of the Qur'an but rather of its "meaning" (*ma'al*) in a different language. Similarly, perhaps, illustrations would be considered an unwarranted incursion into the Qur'an's absoluteness. Nevertheless, other religious works are often richly illustrated, notably biographies of the Prophet (*siyar*).

It is interesting to note that the depiction of the Prophet and his family in these illustrations spans a wide

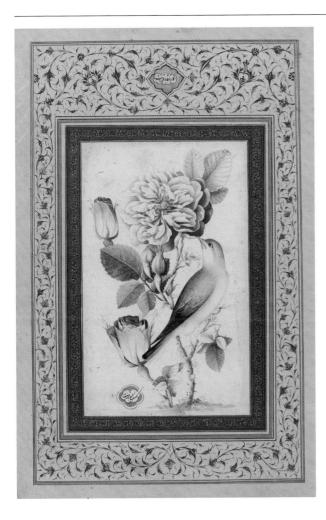

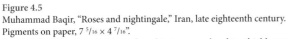

Figure 4.5
Muhammad Baqir, "Roses and nightingale," Iran, late eighteenth century.
Pigments on paper, 7 $^{5}/_{16}$ × 4 $^{7}/_{16}$".
In this Safavid Persian miniature, the subjects are rendered in a highly natu-
ralistic style.

Museum of Fine Arts, Houston, Texas, USA. Gift of Nasrin and Abolala Soudavar/
Bridgeman Images.

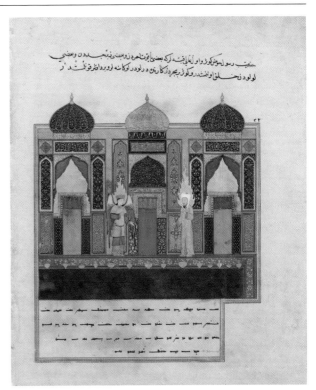

Figure 4.6
Anonymous, page from al-Sarai's *Nahj al-Faradis (The Paths of Paradise)*, Herat (present-day Afghanistan), ca. 1465. Ink, gold, and pigments on paper, 16 $^{7}/_{32}$ × 11 $^{3}/_{4}$". This Timurid miniature shows a realistically depicted Prophet Muhammad being greeted by the Archangel Gabriel at the Gates of Paradise.

The David Collection,
Photo: Pernille Kemp.

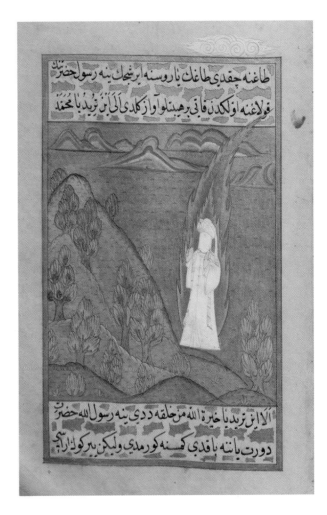

Figure 4.7
Workshop of Nakkaş Osman (Osman the Painter), "The Prophet Muhammad on Mount Hira, where he received the first Revelation," from the manuscript *Siyer-i Nebi (Life of the Prophet)* by Darir, Ottoman, dated 1003 AH (1595 CE) (with certain images somewhat later). Ink, gold, and pigments on paper, 15 $^{3}/_{8}$ × 11".
The figure and the landscape are abstracted in this image. Note the subtle patterning in the gold appliqué.

Turkish Republic, Ministry of Culture and Tourism, KUVAM, DOSIMM, Directorate of the Topkapı Palace Museum.

range, from the naturalistic to the highly abstract, as seen in Figures 4.6, 4.7, and 4.8.

In a page from al-Sarai's *Nahj al-Faradis* (*The Paths of Paradise*), a Timurid miniature produced in Herat (present-day Afghanistan) in the third quarter of the fifteenth century depicts the Prophet Muhammad being welcomed by the Archangel Gabriel at the gates of Heaven (Figure 4.6). Above the three gates is the inscription "There is no god but God, Muhammad is the Messenger of God, Ali is the Friend of God." Before the two figures is the heavenly river known as Kawthar and vessels of gold with which to drink from it. The flames rising from the Prophet and the Archangel are the Muslim equivalents of the Christian or Buddhist halo, and mark them as holy or otherwise central to the account. In other ways, however, the Prophet and the archangel are rendered quite naturalistically.

The later Sunni tradition largely frowned upon the figurative representation of the Prophet and his family. In Figure 4.7, an Ottoman illustration from a late sixteenth-century manuscript of *Siyer-i Nebi* (*Life of the Prophet*), the Prophet Muhammad is partly abstracted. His silhouette is recognizable, but his features are excluded, and his entire body is engulfed by a large flame, marking him not only as holy but also as unrepresentable.

Figure 4.8, an illustration from a compilation of Qur'anic chapters used in prayers, takes the process of abstraction a step further by representing the Prophet symbolically as a rose. The caption describes the rose as having "sprung forth from the Prophet Muhammad's perspiration." Similarly, it was common in the Ottoman tradition to symbolize God by a tulip, *laleh*, which in Arabic script is an anagram of the name *Allah* (God). Such concepts were also often represented calligraphically, an even further step in the abstraction process. In this image, the petals bear the inscription "There is no god but God, Muhammed is the Messenger of God," which is the Muslim Profession of Faith. The leaves contain the names of the four Rightly Guided Caliphs (the Prophet's first four successors according to Sunnis) and those of the Prophet's other companions.

Ornamentation versus Illustration

Some Islamic manuscripts were illustrated, that is, contained narrative images, but many more were merely ornamented. Such works are generally called illuminated manuscripts. Whereas in the West, an illuminated manuscript may contain images as well as decorations, in the Islamic context, **miniatures** (pictorial images) are considered distinct from illumination. Indeed, the Arabic term used for illumination, *tadhhib*, corresponds more closely to "gilding." Islamic manuscript ornamentation

spanned a broad range from abstract patterns to floral motifs and even landscapes.

Figures 4.9a and b are taken from a late eighteenth- or early nineteenth-century Ottoman manuscript of poetry, a transitional work that combines traditional elements with Western influences. Both images show section heads (*unwan*) from a collection of the poetry of Mir Süleyman Arif, copied by the calligrapher Seyyid Yahya Ihya Efendi.

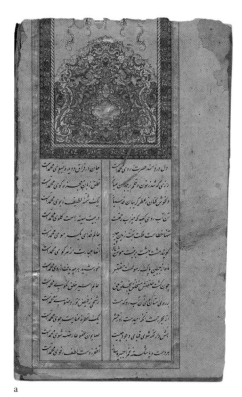

a

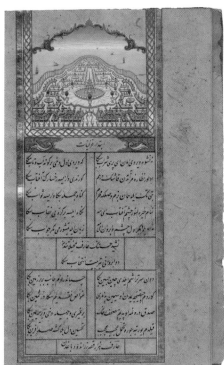

b

Figure 4.9a,b
Anonymous, section heads in a collection of poetry copied by the calligrapher Seyyid Yahya Ihya Efendi, Ottoman, late eighteenth or possibly early nineteenth century. Gold, ink, and pigments on paper, 7 $^7/_8$ × 4 $^3/_4$". These two section heads from a collection of poetry demonstrate two distinctly different approaches to illumination. Figure 4.9a is entirely decorative, and Figure 4.9b incorporates an illusion of three-dimensional space within an otherwise decorative pseudo-architectural motif.
Collection of Abdul Rahman al-Oweis, Sharjah, UAE.

Figure 4.8
Anonymous, "The Rose of the Prophet Muhammad," from the manuscript *Mecmua-i Süver-i Ed'iyye (Compilation of Prayer Chapters of the Qur'an).* Ottoman, second half of the nineteenth century. Ink, gold, and pigments on paper, 7 $^1/_2$ × 4 $^7/_8$". The Prophet, no longer taking human form, is symbolized by a rose. Around it are the names of his companions, notably the four Rightly Guided Caliphs.

Turkish Republic, Ministry of Culture and Tourism, KUVAM, DOSIMM, Directorate of the Topkapı Palace Museum.

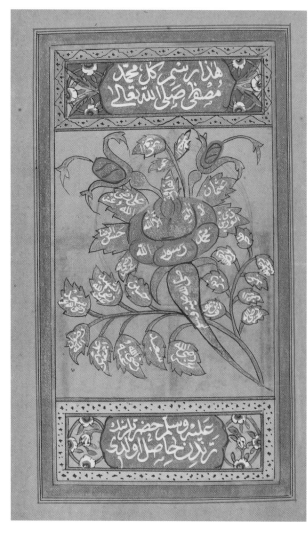

Figure 4.9a shows a section head composed of stylized foliate motifs that are also echoed in the individual poem headings. Created at a time when Ottoman decorative arts were increasingly coming under the influence of European art, the style seen here has been dubbed "Ottoman rococo" in recent scholarship. The colors used here are very unusual for Ottoman illumination. In the center is a gold shield on which a title might have been written. The designs, though leaf-like, are nonfigurative and do not provide an illustration of the text per se. However, the form of the section head illumination as a unit, with its dome-like crest and column-like edges, very much looks like that of a portal (*iwan*); thus, a parallel can be drawn between the section head through which one enters the text and the portal through which one enters a building.

Figure 4.9b, on the other hand, is quite realistic, a fascinating adaptation of a thoroughly European manicured garden into the traditional shape of an Islamic section head. The garden is shaped like a peninsula that juts out into a sea dotted with boats and sailing ships. Although this image is not related to the textual content of the manuscript, its illusionistic depiction of space bridges the gap between illustration and ornamentation, and is an example of the Western influences that affected Ottoman illumination starting in the eighteenth century.

Landscapes that do not serve as the background to a specific activity such as a battle, hunt, or journey but are themselves the subject of an illustration are somewhat rare, although certain cityscapes do occur with some regularity. In particular, Figure 4.10, from an early nineteenth-century Ottoman manuscript of the Moroccan mystic Muhammad al-Jazuli's *Dala'il al-Khayrat* (*Proofs of Good Deeds*) depicts the panoramas of Mecca and Medina that, although not directly related to the text, were traditionally included in this devotional work.

These miniatures are focused on the sacred sites in the context of the cities in which they are located, namely the Ka'ba in Mecca and the Prophet's mosque and tomb in Medina. While these panoramas do not directly illustrate any part of the text, they can certainly be considered an integral part of the narrative because the viewer's underlying appreciation for the symbolic importance of Mecca and Medina is a subtext that enriches the experience of the book.

Subject Matter in Illustrated Books

Landscapes as Compositional Elements

It is interesting to note that the distinction between a landscape or cityscape and a map was not as clear in the premodern era as it is today. Thus, we see extremely compelling illustrations in which cities appear in a bird's-eye view, but buildings are shown in elevation. For example, the image of the city of Istanbul—the capital of the Ottoman Empire, located in present-day Turkey—in Figure 4.11 is from a mid-sixteenth-century manuscript titled *Beyân-ı Menâzil-i Sefer-i Irakeyn* (*Description of the Stations of the Campaign to the Two Iraqs*) by the Ottoman scholar and artist Matrakçı Nasuh. This is one of over 130 illustrations that collectively describe with great precision the eastern campaign of Sultan Süleyman I, known to Europeans as Süleyman "the Magnificent" (Ottoman, 1494–1566).

In the figure, the three parts of the city and the bodies of water separating them are distinctly visible, as are some of the city's most important structures: the Basilica/Mosque of Hagia Sophia, the Topkapı Palace, the Hippodrome, the Tower of Galata, the Maiden's Tower, and the Mosque of Sultan Mehmed known as "the Conqueror." Showing both broad geography and detailed but flat iconography indicating city structures, this illustration might be considered both a map and a picture.

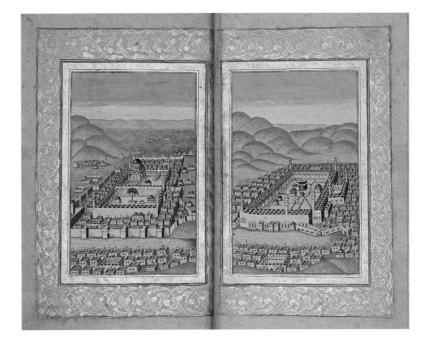

Figure 4.10
Anonymous, Mecca and Medina, from a manuscript of *Dala'il al-Khayrat (Proofs of Good Deeds)* by Muhammad al-Jazuli, Ottoman, 1170 AH (1756–1757 CE). Gold and pigments on paper, two pages, each page 5 ¹¹/₁₆ × 3 ¹/₂".
The holy cities Mecca and Medina are two of the three cities (along with Jerusalem) most central to the Muslim cosmology. *Dala'il al-Khayrat* was an extremely popular book in Turkey as well as Northwest Africa.

Collection of Kerem Kıyak, Istanbul, Turkey.

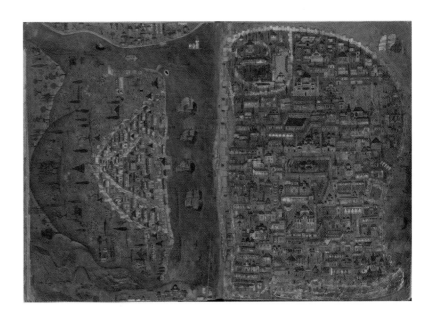

Figure 4.11
Matrakçı Nasuh, "Bird's-eye view of the city of Istanbul." From the manuscript *Beyân-ı Menâzil-i Sefer-i Irakeyn (Description of the Stations of the Campaign to the Two Iraqs)*, written and illustrated by Matrakçı Nasuh, Ottoman, dated 944 AH (1537 CE). Pigments on paper, two pages, each page 9 × 12 ¹³/₃₂".
In this view of Istanbul as it stood in the early sixteenth century, the city appears in a bird's-eye view, but buildings are shown in elevation.

Courtesy of Istanbul University Library, Istanbul.

Landscapes often provided the background for a variety of images, an important group of which are religious scenes. The most richly illustrated religious text ever produced in the Muslim World is the manuscript of *Siyer-i Nebi* (*Life of the Prophet*) (see also Figure 4.7). It was commissioned by the Ottoman Sultan Murad III, a passionate patron of the arts of the book, and completed under his successor, Sultan Mehmed III. The *Siyer-i Nebi* was six volumes long (one of which is now dispersed) and included 814 illustrations. Figure 4.12 shows a miniature from this manuscript, depicting the Prophet Muhammad (with veiled face) and his companions traveling to Mecca, accompanied by the four archangels.

Another episode in the Prophet's life, and one of the most important miracles attributed to him, was his night journey from Mecca to Jerusalem and miraculous ascension (*Miraj*) thence to the heavens. This episode, which is described in the Qur'an as well as the *hadith*s, was the subject of some of the most spectacular illustrations produced in the Muslim World. Figure 4.13, from a mid-sixteenth-century manuscript of Nizami's *Khamsa* (*Pentalogy*)—one of the masterpieces of Persian lyrical poetry—depicts the Prophet's ascension, riding the horse Buraq (lightning), with angels surrounding him. With tiny details carefully represented through graphic shapes that themselves have internal modulations of color, the entire image is contained within a sumptuous tone-on-tone border made up of silhouetted plant and animal forms.

Legitimating the Ruling Monarch

Another group of illustrations that typically have landscapes in the background are battle scenes. Whether they depict historical battles or current events, one must not lose sight of the political role such images played in legitimating the ruling monarch and/or his ancestors. Figure 4.14 shows two facing pages from Arifi's *Süleymanname* (*The Book of Süleyman*, the final two syllables here and in the works that follow pronounced "nah-MÉ"), a mid-sixteenth-century work written to honor the then-reigning Sultan Süleyman "the Magnificent." It depicts the Battle of Mohács, fought between the Ottoman Empire and the Kingdom of Hungary in 1526.

At the center of the right-hand page, mounted on a black horse, is the sultan, overseeing the great victory that led to the Ottomans' annexation of much of Eastern Europe. The Ottoman army is shown on the right-hand page as neatly advancing under the leadership of Sultan Süleyman, while the Hungarian army is depicted on the left-hand page as moving in every direction, suggesting disarray. Dead bodies litter

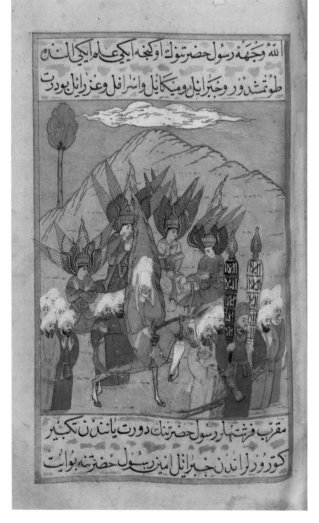

Figure 4.12
Attributed to Nakkaş Hasan (Hasan the Painter), "The Prophet Muhammad traveling to Mecca, accompanied by his companions and the four archangels." From the manuscript *Siyer-i Nebi* (*Life of the Prophet*) by Darir, Ottoman, dated 1003 AH (1595 CE), certain images somewhat later. Ink, gold, and pigments on paper, 14 3/4 × 10 13/16". The carefully controlled palette balances the subtle burnished hues of the arch-like landscape and graphic panels, in contrast to the vibrant hues of the clothing and wings of the angels. All the figures, except the Prophet, have sensitively rendered features, although forms in general are not modeled through tone or differentiated by the illusion of light and shadow.

Turkish Republic, Ministry of Culture and Tourism, KUVAM, DOSIMM, Directorate of the Topkapı Palace Museum.

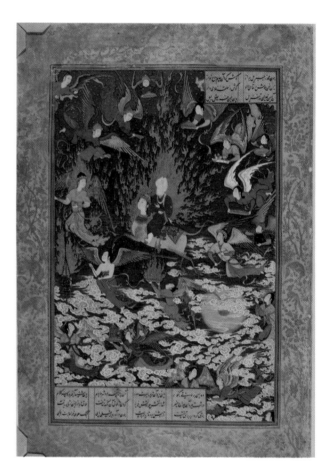

Figure 4.13
Attributed to painter Sultan Muhammad, "The Prophet Muhammad's miraculous journey from Mecca to Jerusalem and thence to the heavens" (*Miraj*). From a manuscript of the *Khamsa* (*Pentalogy*) of Nizami, Safavid, 1539–1543 CE. Gold, ink, and pigments on paper, 11 5/16 × 7 11/32".
Note the Chinese-style clouds and flames; indeed, the faces of some of the characters appear influenced by Central and East Asian sources.

British Library, London, © The British Library Board Or. 2265, f. 195a.

the banks of the river in the foreground. Similar images may be found in other illustrated histories such as the *Hünername* (*The Book of Accomplishments* [*of the Ottoman Dynasty*]).

The legitimation of the ruling dynasty was also achieved through depictions of imperial magnificence. Ottoman works known as *Surname* (*Book of Festivals*) were richly illustrated and showed the sultan presiding over parades and entertainment. Figure 4.15 is an example from the eighteenth century, illustrated by the Ottoman artist Levni.

This image shows the Ottoman Sultan Ahmed III and his entourage watching the festivities organized in 1720 to celebrate the circumcision of his four sons. The double-page miniature depicts firework displays on the Golden Horn, the estuary that joins the Bosphorus before the imperial palace in Istanbul. This is one of 137 large miniatures depicting the various activities performed during the fifteen-day festival.

Likewise, palace scenes in which the monarch is shown among his courtiers and servants indicate the self-image that he wished to project, both in his own time and for posterity. Figure 4.16, a late sixteenth-century Mughal miniature attributed to Farrukh Beg, shows the Emperor Babur (the founder of the Mughal Empire) receiving a courtier, entering the hall from the left, while musicians perform in the foreground.

This image illustrates Babur's memoirs, known as *Baburnama* (*The Book of Babur*), but was actually produced after his death during the reign of his grandson Akbar. The absolute rulers of the premodern period drew their legitimacy largely from their distinguished lineage, and thus often commissioned illustrated histories of their ancestors.

Indeed, sometimes these histories were partly or even mostly mythological. Thus, the *Shahnama* (*Book of Kings*) by the Persian poet Ferdowsi retells the history of Persia over some 50,000 verses, starting with the creation of the world! As in the case of King Arthur in the British "Knights of the Round Table" legends, a good part of the *Shahnama* is fictitious, but this is of little consequence to its importance for the self-definition of (Greater) Persia. It is one of the best-known illustrated books to come out of the Muslim World and the inspiration behind many highly refined manuscripts that are preserved in various collections. The most sophisticated version, sometimes referred to as "the *Shahnama* of Shah Tahmasp" or "the Houghton *Shahnama*," is a masterpiece illustrated with 258 miniatures, unfortunately now dispersed as a result of a former owner's effort to commercialize it. Not only have a sizeable number of miniatures disappeared into private collections never to be seen again, but we have lost the opportunity to see the pages in context and thus to understand the flow of the narrative, the connection between text and image, and the relationship between the images.

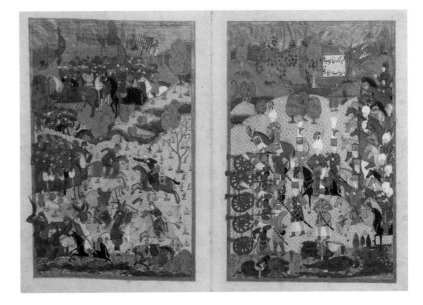

Figure 4.14
Anonymous (member of the Palace Workshop), "The Battle of Mohács (1526) between the Ottoman Empire and the Kingdom of Hungary." From the *Süleymanname* (*The Book of Süleyman*) of Arifi, Ottoman, 1558. Ink, gold, and pigments on paper, two pages, each page 14 $^{7}/_{16}$ × 10".
The continuity between the two pages is ensured not only by the porosity of the left-hand boundary of the right-hand page (note the cannons sticking out of the frame) but also by the landscape, notably the river that flows from one page to the next.
Turkish Republic, Ministry of Culture and Tourism, KUVAM, DOSIMM, Directorate of the Topkapı Palace Museum.

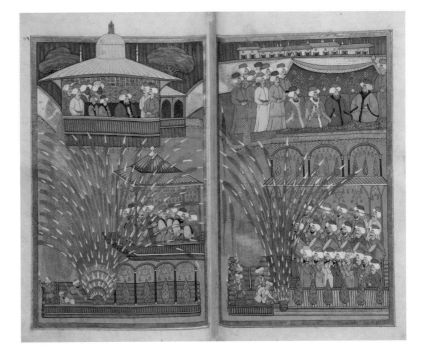

Figure 4.15
Levni, "The Ottoman Sultan Ahmed III and his retinue watching fireworks during the festivities celebrating the circumcision of his sons." From the *Surname* (*Book of Festivities*) of Vehbi, Ottoman, ca. 1730. Gold and pigments on paper, two pages, each page 15 × 9 $^{5}/_{8}$".
This image shows fireworks launched from rafts floating on the water, while musicians accompany the display.
Turkish Republic, Ministry of Culture and Tourism, KUVAM, DOSIMM, Directorate of the Topkapı Palace Museum.

Figure 4.16
Attributed to Farrukh Beg, "The Mughal emperor Babur receiving a courtier." From a manuscript of the *Baburnama* (*The Book of Babur*). Mughal, ca. 1589 CE. Gold and pigments on paper, 10 ¼ × 6". The floors, walls, and dome are richly decorated, and the vegetation sensitively rendered in this biography of Babur commissioned by his grandson Akbar.

Arthur M. Sackler Gallery, Smithsonian Institution, Washington, DC: Purchase—Smithsonian Unrestricted Trust Funds, Smithsonian Collections Acquisition Program, and Dr. Arthur M. Sackler, S1986.230

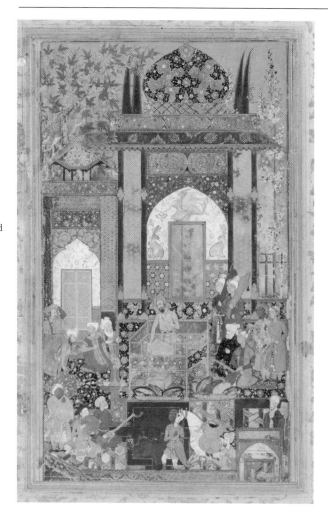

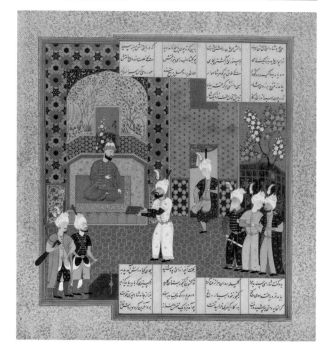

Figure 4.17
Attributed to Aqa Mirak, "The scholar Burzuy presents King Nushirvan with a copy of the book of fables *Kalila wa Dimna*." From the *Shahnama* (*Book of Kings*) of Shah Tahmasp, Safavid, ca. 1535. Ink, gold, and pigments on paper, 10 ⅞ × 10 ⅛".
The architectural details and particularly their tile decorations are exceptionally detailed in this example.

Museum of Islamic Art, Doha, MIA MS.7.2006, Photo: Marc Pelletreau.

Figure 4.18
Hüseyin el-Musavvir (Hüseyin the Painter), *Kitab-ı Silsilenâme* (*Book of Genealogy*). Ottoman, dated 1094 AH (1682 CE). Ink, gold, and pigments on paper, two pages, each page 11 × 7".
These are the first and last illustrated pages from an Ottoman book of genealogy, showing Adam and Eve on the left page, and the reigning sultan Mehmed IV and his immediate predecessors on the right page. The work was signed with a seal by the painter.

Republic of Turkey, General Directorate of Foundations, 1872, ff. 9b and 21a.

Figure 4.17 shows one of the miniatures from the magnificent *Shahnama* of Shah Tahmasp: it depicts a scholar offering a copy of the book of fables *Kalila wa Dimna* to the monarch, testifying to the importance given to books at many Islamic courts.

Books of portraits like the sixteenth-century *Kıyâfetü'l-insâniye fi Şemâ'ili'l-Osmâniye (Human Physiognomy on the Appearance of the Ottomans)*, illustrated by Nakkaş Osman, and Lokman's *Zübdetü't-Tevârih (The Essence of Histories)*, as well as schematic genealogies were other interesting tools that served in the legitimation of ruling dynasties. Figure 4.18 shows two pages—the first and the last—from a late-seventeenth-century Ottoman *Silsilenâme (Book of Genealogy)*, the work of Hüseyin el-Musavvir (Hüseyin the Painter). The page on the left begins with Adam and Eve, and the page on the right ends with the reigning Sultan Mehmed IV and his two immediate predecessors.

The twenty-two intervening pages provide a genealogy, part historical, part mythical, that links the Ottoman dynasty back to Adam going through the various prophets and ancient kings, thus establishing the nobility of the Ottoman sultan and his fitness to rule. It is interesting that Adam is shown holding a book, presumably testifying to the fact that the Holy Scripture pre-existed humanity. Next to the sultans are their respective dates of enthronement and the durations of their reigns, as well as the names of their sons.

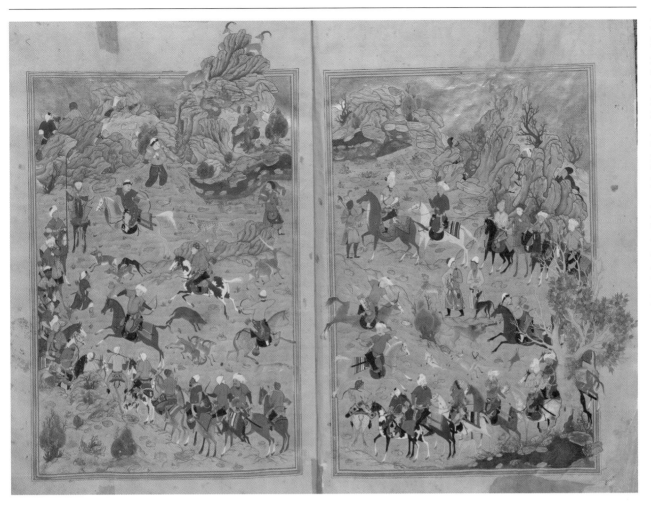

Figure 4.19
Anonymous, "Hunting scene," from a manuscript of *Hasht Bihisht* (*The Eight Paradises*) by Amir Khusrau Dihlevi, Timurid, dated 902 AH (1496–1497 CE). Gold and pigments on paper, two pages, each page 15 × 10 ¼". Produced in Herat, a major cultural center under the Timurid Dynasty, this hunting scene shows the horsemen and hounds as well as quarries in a richly detailed landscape. The movements of the animals in particular are rendered with great skill.

Turkish Republic, Ministry of Culture and Tourism, KUVAM, DOSIMM, Directorate of the Topkapı Palace Museum.

Animals as Subjects

Sultan Mehmed IV, during whose reign this *Book of Genealogy* was produced, was known as "The Hunter," and hunting was of course an important form of leisure for the ruling class, in addition to being a source of sustenance for everyone.

The double-page illustration in Figure 4.19 is from a late-fifteenth-century manuscript of *Hasht Bihisht* (*The Eight Paradises*) by the Indian poet Amir Khusrau Dihlevi (1253–1325).

The right-hand miniature shows the protagonist under a parasol, an attribute of royalty that underscores the courtly nature of hunting. Hunting scenes such as these are not only of artistic significance, but also provide important information as to the local fauna, hunting techniques, hounds and falconry, and horsemanship.

Images of animals also abound in such works as Fariduddin Attar's *Mantiq al-Tayr* (*Conference of the Birds*), a mystical allegory; the twenty-second of the *Rasa'il* (*Epistles*) of the Ikhwan al-Safa (Brethren of Purity); al-Jahiz's *Kitab al-Hayawan* (*The Book of Animals*), a manual of zoology; and al-Qazwini's *'Aja'ib al-Makhluqat* (*The Wonders of Creation*). Another, *Kalila wa Dimna* (a.k.a. the *Fables of Bidpay*), is the Arabic and Persian version of a collection of fables that originated in India. Figure 4.20 shows a miniature from a mid-fourteenth-century (likely Syrian) manuscript of *Kalila wa Dimna* that illustrates the tale in which Ferouz the hare took the king of the elephants to the Spring of the Moon in order to convince the elephants not to drink there. The **anthropomorphic** expressions of the animals make this illustration appear surprisingly modern.

Knowledge Illustrated

While *Kalila wa Dimna* was a book of fables, *Kitab al-Hayawan* represented a scientific approach to animals, at least within the parameters of its age. Taken from a manuscript of *Kitab al-Hayawan* produced in Syria in the

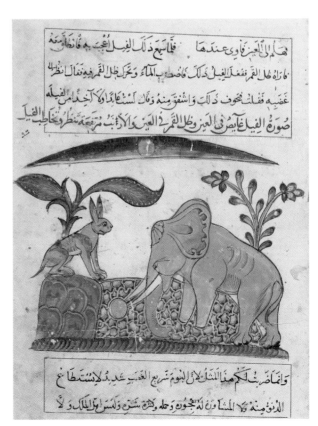

Figure 4.20
Anonymous, "The hare and the king of the elephants at the Spring of the Moon" from *Kalila wa Dimna*, probably Mamluk Syria, dated 755 AH (1354 CE). Pigments on paper, 6 ¾ × 9 ¹⁹/₃₂". Here, and elsewhere in this manuscript, the animals are given anthropomorphic expressions to accompany their human-like thoughts and behavior.

Bodleian Library, University of Oxford, MS. Pococke 400, f. 99a.

mid-fourteenth century, Figure 4.21 illustrates an ostrich sitting on her eggs. Unlike the examples discussed earlier, which originated in Central Asia, India, Persia, or Turkey, these last two miniatures were produced in Arabic-speaking lands and are of relatively early dates. They are refreshingly simple, sometimes whimsical, and quite direct.

Works on such subjects as astronomy, medicine, and engineering constitute some of the masterpieces of the early Islamic arts of the book. Figure 4.22 shows the double frontispiece of the Arabic translation of the ancient Greek physician and pharmacologist Pedanios Dioscorides' pharmacopoeia, *Peri hules iatrikes* (a.k.a. *De Materia Medica*), produced in Northern Iraq or Syria in the early thirteenth century. It depicts Dioscorides lecturing before his students, and is in a way a metaphor for the book itself, which contains Dioscorides' teachings. Although this ancient Greek pharmacologist and his students are represented in Muslim garb, complete with turbans, the style of the illustrations—notably the

representation of drapes and the gold background—is unmistakably Byzantine, evidence of the acculturation between Christians and Muslims in the Middle Ages.

The manuscript of *al-Jami bayn al-'ilm wa'l-'amal al-nafi fi sina'at al-hiyal* (*Compendium on the Theory and Practice of the Mechanical Arts*) by al-Jazari provides another example of scientific illustrations during this period (Figure 4.23).

An inventor and engineer who lived in Eastern Anatolia during the Artuqid era, al-Jazari is credited with having invented a variety of mechanisms such as the camshaft and the crank-slider. This image depicts a mechanical clock and is one of some one hundred ingenious devices (automata, pumps, clocks, and so on) described by the author. Represented in great detail in this illustration from an early fourteenth-century manuscript, the elaborate mechanism of this clock included automata in the forms of three humans, two birds, and a dragon, and sound makers such as a gong, a whistle, and a drumstick. It should come as no surprise that a twelfth-century Muslim scientist would be acquainted with such high technology, for medieval Arabs were the heirs of Ancient Greek civilization, to which they added, and which they transmitted to Europe, thus contributing to the Renaissance.

Figure 4.21
Anonymous, "A brooding ostrich" from the zoological handbook *Kitab al-Hayawan* (*The Book of Animals*) by al-Jahiz, probably Mamluk Syria, mid-fourteenth century. Pigments on paper, 4 1/2 × 7 7/16". The stylized plants on either side elegantly frame the picture and echo the shape of the eggs.
© Veneranda Biblioteca Ambrosiana–Milano/ De Agostini Picture Library.

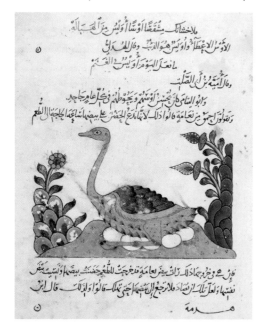

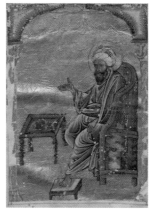

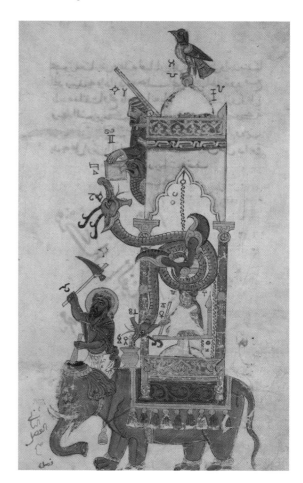

Figure 4.22
Anonymous, "Pedanios Dioscorides lecturing before his students" in the frontispiece of *Kitab al-Hashaish* (*The Book of Herbs*) by Dioscorides, Northern Iraq or Syria, dated 626 AH (1229 CE). Gold and pigments on paper, two pages, each page 12 × 7/16".
This image is self-referential, in that it represents the author of the book in the process of teaching, just as his book teaches its readers.
Turkish Republic, Ministry of Culture and Tourism, KUVAM, DOSIMM, Directorate of the Topkapı Palace Museum.

Figure 4.23
Anonymous, "The elephant clock, a water-clock designed by al-Jazari" from a manuscript of *al-Jami bayn al-'ilm wa'l-'amal al-nafi fi sina'at al-hiyal* (*Compendium on the Theory and Practice of the Mechanical Arts*) by al-Jazari. Probably Mamluk Syria, dated 715 AH (1315 CE). Pigments on paper, 12 × 8 5/8".
The elaborate mechanism of this clock represents in great detail a few of the many technologies known to Muslim scientists.
Courtesy Metropolitan Museum of Art, OASC.

Figure 4.24 shows a miniature from an early thirteenth-century manuscript of al-Hariri's *Maqamat (Sessions)*, a very important Arabic collection of stories that was illustrated numerous times. Created by the painter Yahya ibn Mahmud al-Wasiti, it testifies to the value accorded to scholarship at the time, by showing the fictitious characters Abu Zayd and al-Harith depicted at a library in Basra (present-day Iraq). Note such historically correct details as the scholars crouching on the floor (rather than sitting at tables) and the books placed horizontally in niches (rather than vertically on shelves). Books in libraries in Muslim lands were, in fact, stored horizontally in small stacks as shown here, rather than vertically and side by side as we do today. Horizontal storage is actually much healthier for the books' spines!

Islamic manuscript illustrations are not only beautiful to look at but also extremely informative about the daily life of the time in which they were created. For example, the late-fifteenth-century miniature attributed to the great Persian artist Behzad (Figure 4.25) is a **genre scene** (that is, an image of everyday life) that represents the construction of the Fort of Kharnaq, and it provides invaluable hints as to how such buildings were built at the time. We see stone-cutters at work on the left of the miniature, while men are mixing mortar in the foreground, and others carry the mortar up to the stone layers on top of the wall.

Likewise, images accompanying fiction were often quite realistic in their details, as we see in the early sixteenth-century Persian miniature from Nizami's *Khamsa* (Figure 4.26). One of the five books comprising the *Khamsa* is that of Leyla and Majnun, a story

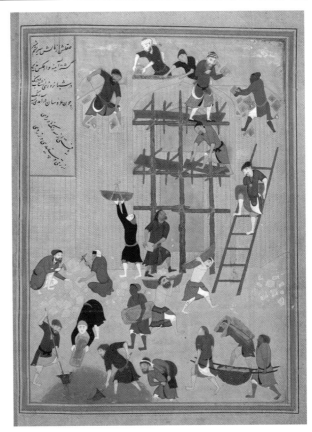

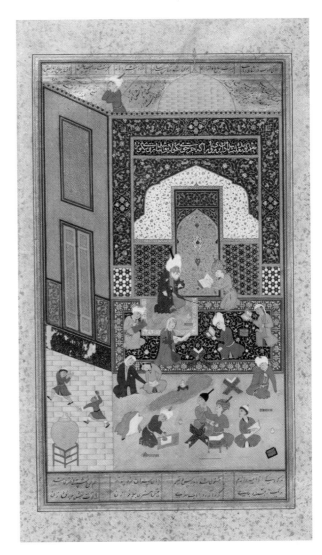

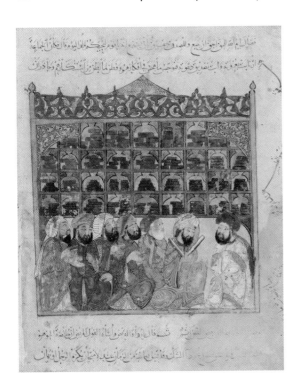

Figure 4.24
Copied and illustrated by Yahya ibn Mahmud al-Wasiti, "A library in Basra" from a manuscript of the *Maqamat (Sessions)* of al-Hariri, possibly Baghdad, 1237. Ink and pigments on paper, 14 $^{9}/_{16}$ × 11".
Depicting a library in Basra, this image testifies to the value accorded to scholarship at the time.
© BnF, Dist. RMN-GrandPalais/Art Resource, NY.

that originated in Arabia, which was elaborated and popularized by Nizami in Persian and then rewritten by many others in Persian, Turkish, Urdu, and other versions. The eponymous heroine and hero are to the Muslim World what Romeo and Juliet are to the West, and their story has been told and retold by countless poets and writers in numerous different languages. The lovesick Majnun is shown on the roof, crying out the name of his beloved while in the building below pupils are writing, reading, and drawing. We see inkwells, sand-sprinklers (used like blotting paper to absorb extra ink), bookstands, and other paraphernalia. One person in the foreground is shown polishing paper.

Other important sources of factual information are the costume albums that describe the attire of different ethnic and social groups. (It was common in premodern societies for individuals belonging to different ethnic, religious, and vocational groups to wear different attire.) The diversity that could be observed in so-called **oriental** (a now discredited way of referencing Asian cultures) societies was a source of great fascination for travelers, and catalogues of costumes provided them with a visual record.

The *Album of Sultan Ahmed I*, an apparently commercially produced Ottoman manuscript from the early seventeenth century, contains genre scenes as well as many examples of attire (Figure 4.27). This page shows various palace officials as well as a "palace dwarf," a page boy, and a keeper of wild animals. While such albums provide valuable information about individual costumes, they are also important in that they can be said to represent a cross-section of society, and thus tell us a great deal about social organization.

A Broadening of the Illustration Market

Although earlier masterpieces of illustration owed their existence to royal or imperial patronage, the open market increasingly played an important role in the production of art from the seventeenth century onward. A number of factors contributed to this development, notably the gradual rise of nonroyal elites and the proliferation of foreign (especially European) travelers with an appetite for interesting manuscripts. Inevitably, the changing economics of book production affected the contents of the books and their illustrations. The new elites who patronized the artists wished to see themselves in the works they purchased, so notables and their mansions began to replace emperors and their palaces as subjects. Foreigners were also interested in the exotic and the picturesque, much like modern tourists, and often sought costume albums, erotic works, or other local fare.

"A couple in amorous embrace" (Figure 4.28) is one of twenty erotic miniatures in a late-eighteenth-century manuscript that found its way to the West, along with many other such works. Interestingly, the room depicted in this miniature is thoroughly Western: the mantle clock, mirror, chair, and tables are all of European origin. The lovers' attire, on the other hand, is very much in keeping with Ottoman fashion of the time.

Just as books were taken to Europe from the Muslim World, European books and images were imported into Islamic societies, and they too inevitably influenced local book production. This said, it is very important not to

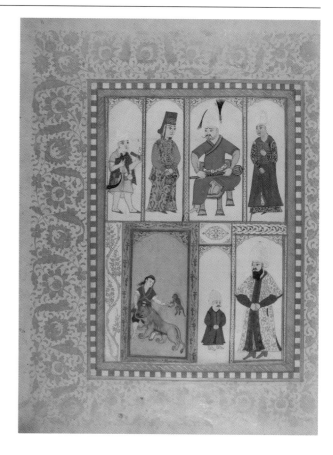

Figure 4.27
Anonymous, page from the *Album of Sultan Ahmed I*. Ottoman, 1603–1618. Gold and pigments on paper, 18 ⁹/₁₆ × 13 ¹⁵/₃₂".
This page from a costume album depicts a "palace dwarf," a page boy, and a keeper of wild animals, among others.
Turkish Republic, Ministry of Culture and Tourism, KUVAM, DOSIMM, Directorate of the Topkapı Palace Museum.

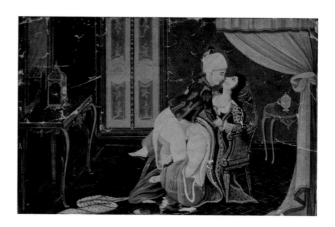

Figure 4.28
Anonymous, "A couple in amorous embrace," from a translation of *Ruju' al-shaykh ila sibah fi al-quwwati 'ala al-bah* (*Return of the Old Man to Youth through the Power of Sex*) attributed to Ibn Kemal Pasha. Ottoman, text dated 1209 AH (1794). Ink, gold, and pigment on paper, 13 × 8".
While the erotic illustrations in this late-eighteenth-century manuscript appear to be contemporaneous with the text, they are not integral to it.
Formerly in the collection of Edwin Binney, III, current location unknown.

divide the history of illustration in the Muslim World into two phases—one early and "authentic," the other late and "corrupted"—as both Western orientalists and Eastern conservatives are wont to do. In fact, to use a cliché, the only thing that is permanent is change. There were external influences in earlier periods, such as Byzantine and Chinese, and external influences in later periods, such as French and Italian. However, none of these

Theme Box 10: Orientalism
by İrvin Cemil Schick

Edward W. Said (1935–2003) was a Palestinian-American scholar, literary and music critic, and activist best known for his book *Orientalism* (1978), as well as for several other works critical of the representation of Islam and the Middle East in Western literature, popular culture, and the media. Although others had expressed similar criticism before him, what distinguished Said's work from his predecessors' was his methodological approach as well as the seamlessness between his intellectual production and his militant political advocacy. Both these dimensions have earned him a great deal of admiration as well as severe criticism. Nonetheless, he ranks among the most influential thinkers of the late twentieth century and is the leading inspiration for what has come to be known as post-colonial theory.

An important influence on Said's work was the French philosopher Michel Foucault (1926–1984) (*see Chapter 10, Theme Box 18, "Discourse and Power"*), who investigated the relationship between knowledge and power, not in the conventional sense that "one who has knowledge gains power," but rather in the sense that power begets knowledge in a form that serves to reproduce itself. Thus, Said argued that orientalism as a wide-ranging scholarly and artistic discipline that covered everything from religion

through literature and numismatics to anthropology was an outgrowth of European power during the age of high colonialism, and that as such it had a vested interest in the production of a certain kind of knowledge that would extend and perpetuate its rule over the rest of the world. For example, stressing the "timelessness" and "fixity" of the East suggested that Western colonialism was driven not by self-interest but by the altruistic desire to civilize and enlighten.

Said was not concerned with "correcting" Western perceptions of the East but with challenging the very foundations of the knowledge produced in the West about the East, and indeed of such fundamental concepts as "East" and "West." His emphasis was not so much that Westerners have misunderstood the East or deliberately misrepresented it, but that "the Orient" itself was a fiction, a conceptual fabrication created by the West in the process of self-construction and as one of the intellectual underpinnings of colonialism. Indeed, he demonstrated in *Culture and Imperialism* (1993) that colonialism was a leitmotif underlying much of Western culture during the late eighteenth, nineteenth, and early twentieth centuries, and that the literary classics of this period could not be fully understood and appreciated without giving the omnipresence of imperialism its due.

While Said did not delve deeply into the visual arts, his critique of orientalism was taken up by art historians, notably by Linda Nochlin whose pioneering essay "The Imaginary Orient" (1983) explored the ways in which paintings featuring such topics as scenes of harems, Turkish baths, and slave markets contributed to the construction of a worldview that resonated with Western imperialist ambitions as well as patriarchal and racialist discourses.

As always, one should take care not to oversimplify the issue. It is not that orientalist painting, or literature, or scholarship, were mere "imperialist propaganda." Rather, they were reflective of a certain mindset that resonated with and reproduced the spirit of the times, itself largely shaped by colonialism. Said's work was not perfect, nor did it exhaust the problems at hand, but it did open new possibilities and horizons for a critical perspective that has proven to be extremely fertile.

Further Reading
Said, Edward W., *Orientalism* (New York: Vintage, 1979).

Nochlin, Linda, "The Imaginary Orient," *The Politics of Vision: Essays on Nineteenth Century Art and Society* (New York: Harper & Row, 1989).

influences resulted in mere imitation. Rather, there were complex processes of acculturation in which influences were assimilated, altered, and sometimes subverted, always resulting in something new, something that had never been done before.

The Advent of Lithographic Printing

Whether produced for a patron or for the market, books were relatively expensive until the nineteenth century, and illustrated ones even more so. As a result, illustrated books were the exclusive domain of the elite until the popularization of printing, particularly the advent of

lithography, which provided a cheap and relatively easy way of mass-producing illustrated books. Invented in 1798 by Alois Senefelder (German, 1771–1834), lithography entered the Muslim World within only a few decades and gained immediate popularity because, as a planographic process, it facilitated the writing of calligraphic Arabic scripts directly onto the printing surface (*see Chapter 11, Theme Box 20, "Lithography"*). Thus, books produced lithographically looked similar to manuscripts and were more aesthetically pleasing than those produced through movable type. By the mid-nineteenth century, illustrated books were being printed in large numbers across the Muslim World. The

large majority of lithographed illustrated books published in Turkey, Iran, and elsewhere during this period were popular works such as folk tales. Figure 4.29 is taken from a Persian book, an anonymous illustrated translation of *The Thousand and One Nights*. In contrast to the graceful lines of calligraphy, much of the illustration uses straight lines and short parallel lines to create tone—an approach more in keeping with the aesthetics of woodcut than the tonal potential of lithography.

Conclusion

Figurative images were far from absent from the Muslim World, although the transcendence of certain subjects necessitated a degree of abstraction. From the highly stylized to the highly naturalistic, all kinds of illustrations adorn Islamic manuscripts. Some served political purposes; others religious; still others literary, scientific, or scholarly. Together, they constitute a corpus produced over more than a millennium that richly deserves to be studied for its unique visual language and sophisticated artistic techniques as well as for the information it communicates on history, culture, religion, and daily life.

KEY TERMS	
anthropomorphism	*jinn*
genre scene	miniatures
hadith	oriental
hatayi	*siyar*
iconophobia	

Figure 4.29
Mirza Reza Tabrizi, illustration from a lithographed edition of *Alf leila va leila* (*The Thousand and One Nights*), Qajar, printed in Tehran, 1272 AH (1855). Printer's ink on paper, 6 $^{11}/_{16}$ × 6 $^{23}/_{32}$".
In this image illustrating the tale of the 843rd night, Khalifah opens the chest he has just purchased and finds in it the lovely maiden Qut al-Qulub.

Private collection.

Chinese Illustration, 100 CE–1900

Sonja Kelley and
Frances Wood

5

China has a rich tradition of illustration, especially images that were created to explain an idea through recounting an event or story. This chapter presents a selection of those images along with some that are more explicitly expository, organized chronologically and also by form and thematic category. The earliest examples include funerary inscriptions surviving from over 2,000 years ago, followed by devotional wall paintings and pictures made on portable media such as silk and paper scrolls. However, the majority of the chapter deals with illustrations made and disseminated through woodblock printing, a significant art form in China. It should be noted that themes originating in one medium often reappear later in another—in what can be seen as evidence of cultural continuity.

Narrative versus Mimetic Images

"Narrative" in this chapter refers to explication through storytelling—an important mode through which cultural ideals were communicated in Imperial China. Narrative illustration excludes simple **mimesis** (faithful copying from observation) and pictorial interpretations made solely as self-expression and without specific communicative intent.[1] Rather, narrative illustration illuminates oral or written stories or ideas. It can sometimes be difficult to tell the difference because narrative images can be visually similar to mimetic ones. A seemingly generic landscape, portrait, or genre scene, for example, may symbolically refer to an allegory or other culturally important narrative appreciated for its edifying content. The intended audience would know the tale in advance and therefore recognize not only the subject, but also its culturally embedded symbolism.

Relief Illustrations and Wall Paintings

Early surviving illustrations generally take the form of low-relief depictions of deities and scenes of hunting or feasting found on the walls of tombs or the sides of shrines and sarcophagi dating from the Han dynasty (206 BCE–220 CE). Reflecting both religious beliefs and popular lore, the images were intended for the spirit of the deceased and thus were not meant to be seen by others after the tomb was sealed. A well-known example is the Wu Family shrines that were carved in the mid-second century CE in the Shandong province of China. The shrines subsequently were buried from the third to the eleventh century by a flooding of the Yellow River; we know they were at least partially uncovered in about the eleventh century because rubbings of the images and stones (original and recarved copies) began to circulate then.

The shrines were freestanding structures with peaked roofs composed of stone slabs carved in narrative

[1]See Murray, "What is 'Chinese Narrative Illustration'?" pp. 602–615. http://www.jstor.org/stable/3051315.

registers. The images represent historic and mythological stories important to Chinese culture; most of the images promote Confucian ideals that emphasize high personal and governmental moral standards and **filial piety** (obedience and service to one's progenitors). A detail from the east wall of Chamber 1 predominantly shows silhouettes with occasional sparse inline detail (Figure 5.1). Costumes and relative scale indicate rank, with important figures depicted larger than humbler ones. Since the stories were well known, not much information beyond that provided in the **cartouches** (inset rectangles with writing) was needed to clarify what was being shown. One image runs into the next, creating an unbroken, fairly balanced design for each register. Amid the many processions and scenes of food preparation in the relief in Figure 5.1, we see the character Laizi (middle register of this detail) offering a large, round container of food to his parents. The legend claims that well into his seventies, Laizi played like a child in front of his elderly parents so that they would not feel old. One of the clues to his identity is the staff in his hand with the bird above it that represents a memento given by Han emperors to men of old age. Inscribed in simple relief, the images have some fine incisions to indicate facial and clothing details.

Since the discovery of the Wu Shrine site in 1786, the *in situ* slabs of the shrine have been fully uncovered and studied along with those that were separated from the site long ago. Some stones that were thought to have been part of the original shrine are now known to be copies, and missing stones have been recovered. The importance of the imagery is attested to by the fact that the images were copied and distributed as rubbings for centuries after the original shrines were "lost." Indeed, many of the stories proliferated through other forms of Chinese illustration and narrative text.

Devotional Buddhist Cave Paintings

Among the important extant devotional images in China are the extensive wall paintings found in Buddhist rock-cut temple complexes—man-made caves carved from cliff faces. The most extensive and best-known group of such

wall paintings are the Mogao and Yulin **Grottoes**, caves dug out of the mountain cliffs near Dunhuang, in the Gansu province in western China (created in the fourth to eleventh centuries CE). The 492 decorated caves at Mogao are covered with over 40,000 square meters of murals that were produced over the course of approximately 800 years. Together, these murals are a record of stylistic developments in religious painting over a very long span of time. The pre-Tang murals are of particular importance because they were produced during a period from which there are very few surviving examples of two-dimensional pictorial art, religious or secular. In addition to the murals, a significant cache of scrolls and other relics was found in the caves, including a copy of the *Diamond Sutra* printed in 868 CE—the world's oldest known printed book, discussed later (Figure 5.7).

The site was at a desert oasis, a crossroads along the famed Silk Road connecting Asia and the Mediterranean that became a hub where peoples of different nationalities and religions mixed. According to traditional accounts, Buddhist monks first began work on the Mogao Caves in 366 CE. The caves became an important site for Buddhist travelers to practice their faith and for donors to gain spiritual merit by funding the expansion and decoration of the caves.

With the arrival of Buddhism in China from India, hundreds of unfamiliar parables that framed the ideology of the new religion flooded into the culture. Inspiring the scenes depicted in the caves and other devotional imagery, these narratives were important subject matter for a religion in which inscribing images of the Buddha served a devotional purpose. In addition to iconic images of various Buddhas in static poses (sometimes multiplied countless times), the murals also include many anecdotes from the life story of Shakyamuni Buddha (the historical Buddha), along with representations of other key Buddhist tales involving supernatural beings such as **bodhisattvas** (enlightened beings who remain on earth rather than ascending to heaven) and **apsaras** (celestial maidens akin to angels), and a host of other characters.

A wide variety of compositional strategies is employed throughout the caves. For instance, the top register of the west wall of Cave 146 (Figure 5.2) relays a complex story from the *Xianyu Sutra (Sutra of Wise and Foolish)* and is an example of an illustration in which multiple narrative "moments" are shown all at once through separate vignettes arranged in a single compositional space. The main characters are shown larger: the heretic Raudraksa is on the right; the believer

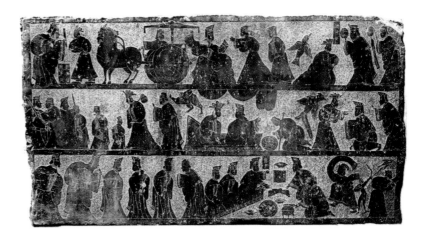

Figure 5.1
Anonymous, *Wu Family Shrines*, rubbing from original relief carvings, Shandong province, Eastern Han dynasty ca. 151 CE. 25 ¹¹/₃₂ × 48 ⁷/₈".
In this detail from the east wall of Chamber 1, the registers of silhouetted figures create a pleasing balance of dark and light while communicating a series of separate narratives.

Walters Art Museum.

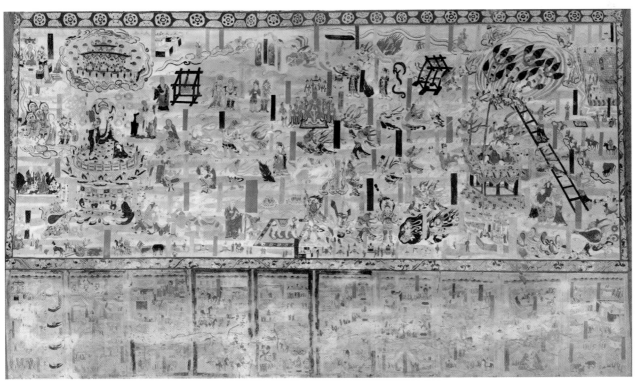

Figure 5.2
Anonymous, "The Magic Competition," in *Xianyu Sutra (Sutra of Wise and Foolish)*, Cave 146, Mogao Caves, Dunhuang, Gansu Province, ca. 920 (Five Dynasties). Wall painting, vegetable and mineral pigments.
A contest of magic takes place between Buddhists and heretics to settle a dispute over whether a Buddhist monastery should be built. Thirty-one narrative vignettes depict individual contests while the king (in the center) presides over the proceedings. The bottom register shows ten related images in an orderly layout, using the same color palette, now faded.

Dunhuang Research Academy.

Sariputra is on the left. Supernaturally charged skirmishes are randomly placed around them, while a king positioned at the center presides over the competition. The composition is densely packed and expressed in a limited palette, with wavy strains of pale turquoise creating a subtly striated tonal background. Secondary scenes are interspersed between the larger vignettes with text in rectilinear cartouches throughout.

The lower register includes ten additional scenes from the *Sutra of Wise and Foolish* within an orderly configuration, now faded.

A more unified composition, Cave 25 of the Yulin Caves (Figure 5.3a, b) evidences a very different pictorial approach than in the *Xianyu Sutra* of the Mogao Caves. The subject is the Maitreya Buddha, or the future Buddha, still currently a bodhisattva awaiting the moment when the (prior) Buddha's teaching will be entirely corrupted on earth and he (Maitreya) will descend to earth to bring new hope. This painting is an iconic depiction of a deity, not a narrative, and it serves as both a didactic tool and an aid for visualization during meditation. It was produced during the Tang dynasty, a period when China was economically strong and culturally influential, and represents a high point in the artistic tradition.

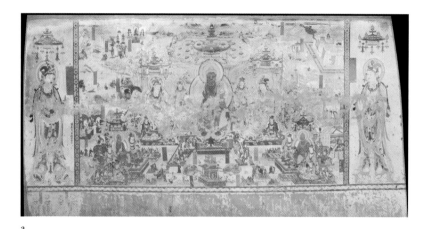

a

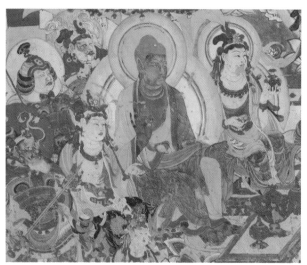

b

Figure 5.3a, b Cave 25 of the Yulin Caves (north wall, left side), Gansu Province, Tang dynasty, ca. 810. Wall painting, vegetable and mineral pigments. The central composition shows Maitreya's *ketumati* paradise (a). A detail of the lower left section depicts the Buddha with bodhisattvas and heavenly kings (b). Dunhuang Research Academy.

Painted Scrolls

Found stored in one of the Dunhuang caves were numerous scrolls on silk and paper, highly perishable materials that survived because of the dry climate and the protection provided by the caves. Also found was a silk banner painting that echoes the roof-shape of an enclosure (Figure 5.4). In Buddhist practice, such vertical banners were typically hung up or carried in processions so that the faithful could see them during special ceremonies. Because of their fragile backing material of silk or hemp, such scrolls could not have been used for permanent display. The vertically formatted scroll presents episodes in the life of the Buddha in a chronology "read" one section at a time, from top to bottom.

Scroll paintings have endured as a major art form in China until the present day, and both vertical and horizontal formats are common. Horizontal scrolls (called handscrolls) can be quite long and are meant to be unrolled in sections to reveal images and text over time, at the viewer's pace. One scroll can consist of one long image that tells a single narrative or, as in the case of *The Admonitions of the Court Instructress*, a series of individual vignettes in support of a unified theme (Figure 5.5). This painting was an oblique comment on the excesses of an empress, told through the guise of more general instruction to the imperial harem. The text by Zhang Hua (Chinese, 232–300 CE) strategically refers back to the *Biographies of Exemplary Women* (*Lienü zhuan*) (Figure 5.14), a text written approximately 300 years earlier by Liu Xiang (Chinese, 79–8 BCE) that used biographical narratives to educate women with regard to moral matters in alignment with Confucian virtues. Confucianism, as previously mentioned, was an important and ancient set of guiding principles that emphasized cultivation of personal and governmental morality along with filial loyalty and female virtue—the latter generally manifested through self-sacrifice.

The images of *The Admonitions of the Court Instructress* are attributed to Gu Kaizhi (Chinese, ca. 344–406 CE), but the version in Figure 5.5 may actually have been made in the sixth or seventh century. Copying scrolls was common practice in the dynastic courts and was done by professional painters under the patronage of the emperors. In the absence of a developed method for tonal color printing, scroll paintings were hand copied by anonymous artists. Establishing whether an image was the first of its kind (that is, the "original composition") or a copy of an existing scroll is often difficult. For instance, the linear style and spare use of color in the scroll in Figure 5.5 is typical of an earlier fourth-century painting style, but its seals and textual inscriptions suggest a later creation date.

The *Admonitions* scroll was held in the imperial collection and thus would have been seen only by a very restricted audience. It would not have been placed on permanent display and was likely brought out only very occasionally, if at all.

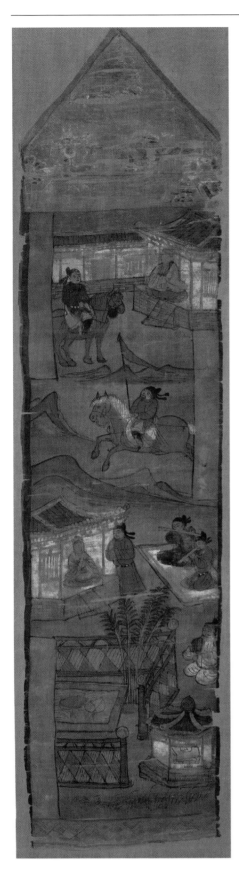

Scroll painting flourished in imperial courts from the Tang dynasty onward with skilled representation of all sorts of figurative imagery, including humans, animals, landscape, and architecture, as well as portraits and historical accounts. Even apparently objective images contained subtle editorial messages using pictorial scale to suggest the relative importance of figures, and commentary was communicated through details such as facial expression and body positions.

The handscroll illustration from *Eighteen Songs of a Nomad Flute* (Figure 5.6) was made in the fifteenth century after a twelfth-century scroll, but record of a tenth-century version also exists. The plot line unfolds in a series of eighteen numbered scenes paired with verses that tell the legend of Cai Yan (Lady Wenji, ca. 170–220 CE), a Chinese noblewoman captured in 195 CE by marauding Xiongnu tribes, nomadic people living to

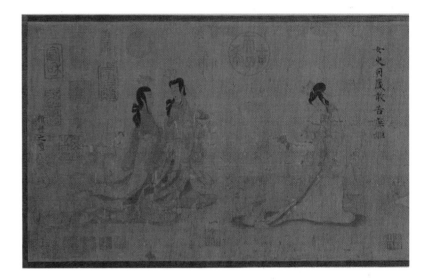

Figure 5.5
Anonymous, *The Admonitions of the Court Instructress* (detail), likely a sixth- to seventh-century copy of an earlier work. Handscroll, ink and color on silk, 9 $^9/_{16}$ × 135 $^3/_8$".
The *Admonitions* scroll implicitly criticizes the excesses of an empress through images and text that offer general instructions on the appropriate behavior of court women. Here, in the last scene, the instructress writes down her lessons for the two palace women approaching from the left.
British Museum. 1903,0408,0.1.

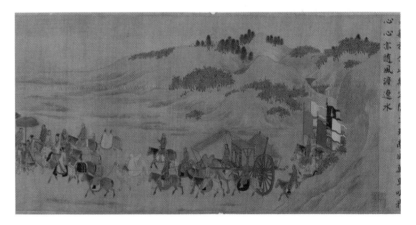

Figure 5.6
Anonymous, *Eighteen Songs of a Nomad Flute: The Story of Lady Wenji*, handscroll, fifteenth century, after a Song dynasty (960–1279 CE) painting. Ink, color, and gold on silk, 11 $^1/_4$" × 39' 3".
The entourage returning to China carries Lady Wenji, who is enclosed in the carriage. The soft coloring of the barren landscape sets off the brightly colored banners and red-wheeled carriage.
Courtesy of the Metropolitan Museum.

Figure 5.4
Anonymous, *Scenes from the Life of the Buddha*, found in Cave 17 of the Mogao Caves, Dunhuang, Gansu Province, Tang Dynasty. Ink and color on silk, 30 $^1/_2$ × 70 $^1/_2$".
This silk banner painting shows three scenes from the life of the Buddha. Reading from top to bottom, we see Buddha's father, King Suddhodana, instructing a messenger to look for his son, Shakyamuni Buddha, which the messenger does in the middle stratum; finally he returns to report that he cannot find the Buddha.
British Museum 1919. 0101. 0.92.

the north of China. Compelled to marry their chieftain, she bears him two children whom she nurtures despite her forced marriage and the tribe's arduous nomadic lifestyle. After twelve years, an official Chinese envoy arrives with her ransom, and she is duty-bound to leave her children and to return to her former cultured life. Her story was told as a suite of lyric verses, the "Eighteen Songs" referred to in the title. In them, Cai Yan laments the loss of her children and is lonely after returning to her home. The most famous version by eighth-century poet Liu Shang de-emphasizes her heartbreak at leaving her children and gives the tale a happier ending marked by a warm return to her first family.

The twelfth-century scroll (on which this is modeled) followed Liu Shang's version, which affirmed the moral necessity of choosing homeland over even one's own children. The scroll was commissioned by Song Emperor Gaozong (Chinese, 1107–1187 CE) and was written in a calligraphic style associated with him. The scroll is thought to have been commissioned as pictorial propaganda motivated by the recent capture of Gaozong's mother, who was returned through a peace treaty negotiated with the Jurchens—another tribe to the north, who established the rival Jin dynasty.

Text and Illustration

The combination of illustration and text has a long history in China, and the inclusion of calligraphy in images would not have been considered an intrusion. Quite the contrary, calligraphy was (and is) a cherished

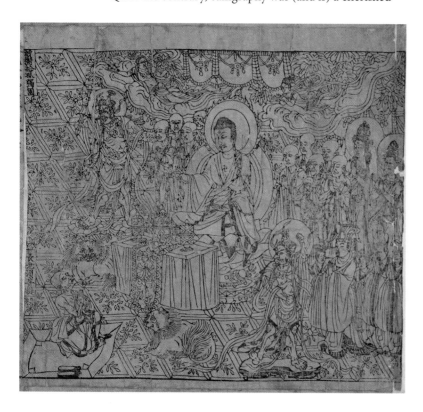

Figure 5.7
Anonymous, frontispiece, *Diamond Sutra* (*Jin'gang jing*), 868 CE. Discovered at the Mogao Caves near Dunhuang, Gansu province. Woodblock print on paper.
This finely cut woodblock print is confident and complex, likely the product of a mature industry whose date of origin is still unknown.
British Library, London, ©British Library Board, Or.8212/P.

art form, with cultivation of a beautiful personal style of calligraphy considered a worthy achievement.

Members of the elite were expected to excel at calligraphy and write poetry in addition to devoting significant time to imperial service—all evidence of striving for the highest level of personal development in accordance with Confucian ideals. Later, painting became another art form embraced by the cultural elite. By the Song Dynasty (960–1279 CE), amateur scholar-artists, referred to as **literati** painters, created paintings that tended to be more self-expressive and less concerned with verisimilitude than those made by professional court painters. Illustrative, narrative, or didactic paintings were thereafter characterized by being aimed at a less cultured audience—even though elite patrons continued to commission narrative images.

The Earliest Illustrated Books and Printed Images

While fragile Chinese paintings on silk and paper were never intended to be hung in permanent displays and were only seen by a privileged audience, from the Tang dynasty (618–906 CE) onward, access to illustration for the general population depended largely on woodblock printed versions. The earliest materials from which "books" were made in China were bamboo and wood. Text was inscribed on thin slips of bamboo (in the south) and wood (in the north), and the slips were joined together with string and rolled up for storage—a format that persisted even after the invention of paper. The narrowness of the materials precluded the use of illustration, however. Illustrated manuscripts were instead drawn and written on silk; a few ancient fragments are extant, having remarkably survived in waterlogged tombs in southern China.

The invention of paper is traditionally dated to 105 CE, based on a famous report to the emperor by the report's producer, eunuch Cai Lun, who referred to paper made from bark, hemp, cloth rags, and fishing nets. Explorations in the northwest, however, have unearthed paper fragments made from hemp dating as far back as the Western Han dynasty (206 BCE–9 CE).

The significance of the invention of paper was enormous in a culture that venerated writing, for it enabled the mass production and circulation of significant texts. The first copies may have occurred in the form of rubbings on paper taken from inscriptions carved into stone **stelae** (standing slabs), such as the imperially sanctioned stone carvings of the Confucian Classics made in 175–180 CE. Because of the delicate nature of paper, little of it has survived in China from before the ninth century. However, extant materials show that from that time on, although manuscript illustration continued, printing on paper came to dominate book production.

The world's first securely dated printed "book" is an illustrated copy of Kumarajiva's translation of the *Diamond Sutra* (*Jin'gang jing*) made in 868 CE (Figure 5.7). It was discovered at the Mogao Buddhist cave-temple complex near Dunhuang in Gansu province. A block-printed paper scroll about 17 feet long, it consists of seven sheets of paper pasted together, with the first printed with a finely executed depiction

of the Buddha preaching the **sutra**, or sermon. It is a stunning frontispiece, crowded with figures surrounding the Buddha and bodhisattvas shown with jeweled headdresses. They, along with fierce guardian figures, have heads surrounded by halos. Shaven-headed monks are flanked by richly dressed donor figures, and flying apsaras or angel-like beings soar above among the trees of the garden in which the sermon takes place. A jeweled canopy hangs above the whole scene, and the Buddha sits behind a table covered with silk and embroidered cloths adorned with a set of silver altarpieces. The little old monk, Subhuti, who posed the questions that prompted the Buddha's speech, sits on a meditation mat with his cloth shoes placed neatly beside him, watched by two small cat-like lions, guardians of the Buddhist faith.

The *Diamond Sutra* is materially different from paintings on the cave walls because of the linear constraints of the print medium, yet it is nonetheless clearly aligned with the cave paintings in the complex in which it was found. Its dense, all-at-once composition echoes the cave art's compositional strategies, and relates to the theme of Maitreya's progress found in the Yulin Cave 25 mural shown in Figure 5.3, albeit somewhat distantly.

Slightly earlier examples of printing have been found in East Asia, such as the Japanese Empress Shotoku's little *dharanis* (prayers to be chanted) of 764 CE, and a copy of the same text found in the Bulguk-sa pagoda in Korea, constructed in 751 CE. However, neither one of these examples includes illustrations; nor do they approach the fine work of the *Diamond Sutra*. The fact that all of these early examples of woodblock printing are Buddhist in content demonstrates the significance of that faith in promoting mass production. Buddhists believed that the repetition of the words of the Buddha, by recitation or copying, and the duplication of the Buddha's image, were all ways to achieve merit and perhaps escape the cycle of rebirth. Woodblock printing of text or image was an ideal method of repetition: the printed colophon to the *Diamond Sutra* states that a certain Wang Jie had the printing done for "universal distribution" on behalf of his parents.

Among the items discovered at Dunhuang were dozens of painted or printed prayer sheets and stitch-bound booklets from the tenth century, presumably produced for sale to pilgrims as devotional images for private prayer. Figure 5.8 shows an illustrated booklet of *juan* (chapter or volume) 25 of the *Lotus Sutra* found in Cave 17 at Dunhuang. It describes how all people in trouble, whether attacked by bandits, threatened by fire, or anticipating childbirth, can call for help from the Bodhisattva Avalokitesvara, whose name, in Chinese translation, means "the one who hears the cries of the world." Its immense popularity meant that it was copied and carried as a protective talisman; this little booklet was possibly homemade. The hand coloring accents the halos and sets off the figure of the believer in the various compositions.

Illustration and the Growing Book Trade

During the Song dynasty (960–1279) China underwent a commercial revolution as government control of markets lessened, allowing freer movement and sale of all sorts of items. Distribution of illustrated religious texts continued, but books of a secular nature were also published in great number. They included technical manuals, didactic "self-improvement" texts designed to cultivate moral codes, and fiction for entertainment.

China's major cities had clusters of bookshops in "book quarters." Centers of paper and print production developed, where families of printers operated for generations from the Song to the Qing dynasties (1644–1911), and where certain sectors became known for high- or low-quality publishing. The distribution of books was very well organized, with books traveling by river and canal and on the backs of itinerant peddlers all over the country.

Illustration expanded with the development of the printing trade. In general, illustrations from the ninth century onward were essentially diagrammatic and consisted

Figure 5.8a, b
Anonymous, manuscript pages from a devotional booklet, discovered at the Mogao Caves near Dunhuang, Gansu province, ca. tenth century. Ink and hand coloring on paper, 7 × 4".
This booklet contains an illustrated version of Chapter 25 of the *Lotus Sutra*, which recounts the ways that the Bodhisattva Avalokitesvara (Guanyin in Chinese) comes to the aid of believers. Such works were created for private prayer or in some cases carried as talismans against all manner of ill fortune.
British Library, London, ©The British Library Board Or. 8210/S. 6983.

of simple line drawings rather than tonal treatments—a style of drawing that would prevail even after the seventeenth century, when the advent of multiblock color printing made more painterly printed illustrations possible.

Where a good calligrapher was required to produce text, a good draftsman was necessary to produce a fine picture. It is likely that the process of cutting a block for illustration would have required a little more time to achieve a more nuanced effect than the almost mechanical way in which text was cut. Therefore, books including illustrations would have been more expensive to produce than those just containing text.

Religious Texts

Between the tenth and thirteenth centuries, several editions of the Buddhist canon (*Tripitaka*) were printed, and these, like the earlier *Diamond Sutra*, often had frontispieces depicting Buddhas and bodhisattvas.

One printing of the *Tripitaka* was begun in Jiangsu province in 1231 and its name, the *Qisha Tripitaka*, refers to the island where the work was begun in a temple during the Song dynasty (Figure 5.9). After a series of disasters, including a fire and the overthrow of the Song dynasty by the invading Mongols in 1279, the printing was finally completed in 1322. Most of the *juan* are presented in a **concertina** format (a zig-zag folded binding) that was seen in earlier manuscripts found at Dunhuang and that came to be restricted in use to Buddhist works. These examples have fine pictorial frontispieces covering four leaves.

The placement of illustrations upon the page or within a book varied. A format seen in tenth-century manuscripts from Dunhuang, known as *shangtu xiawen* or "picture above, text below," was probably very helpful for those of limited literacy who could follow the general story through the pictures. Fine illustrated works of the Song often had full-page illustrations, where in some superior cases the original drawings and calligraphy were probably produced by different hands and combined on the block.

Not all religious texts were elaborate or finely crafted. The little booklet in Figure 5.10 contains the text of an apocryphal sutra, printed in a cheap, popular edition during the Ming dynasty (1368–1644) in the characteristic "picture above, text below" format. The illustration on the right shows a butcher committing a crime in the eyes of Buddhist believers in taking the life of what is probably a pig. On the left, a pious couple is shown burning incense and reading the Buddhist sutras. Printed on yellow bamboo paper, this booklet was probably produced in the Fujian province, a center of popular printing during the Ming dynasty.

Secular Texts: Technical and Practical Topics

From the Song Dynasty onward, officials commissioned nonreligious compendia such as the *Taiping yulan* (*Imperial Readings of the Taiping Era*), an encyclopedic compilation in 1,000 juan of classic works on government, statecraft, and political philosophy taken from poetry and intended for the use of government officials. In addition to the poems, they also included rubbings of famous stone inscriptions and book extracts designed to elevate the already well-educated bureaucrats. There were also the more strictly literary works of prose and

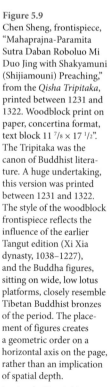

Figure 5.9
Chen Sheng, frontispiece, "Mahaprajna-Paramita Sutra Daban Roboluo Mi Duo Jing with Shakyamuni (Shijiamouni) Preaching," from the *Qisha Tripitaka*, printed between 1231 and 1322. Woodblock print on paper, concertina format, text block 11 ⁷/₈ × 17 ¹/₂". The Tripitaka was the canon of Buddhist literature. A huge undertaking, this version was printed between 1231 and 1322. The style of the woodblock frontispiece reflects the influence of the earlier Tangut edition (Xi Xia dynasty, 1038–1227), and the Buddha figures, sitting on wide, low lotus platforms, closely resemble Tibetan Buddhist bronzes of the period. The placement of figures creates a geometric order on a horizontal axis on the page, rather than an implication of spatial depth.

Los Angeles County Museum of Art, Far Eastern Art Council Fund (M.73.97.1).

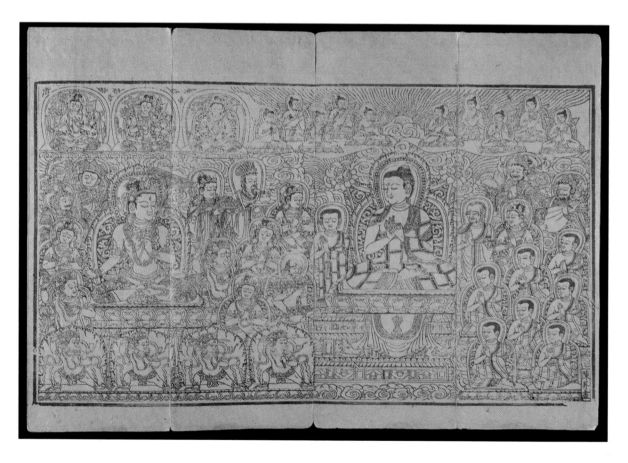

poetry, medical and agricultural books, and those on tea or wine—all produced in the center of official printing at Hangzhou. Only some would have been illustrated.

Song Yingxing's *Tiangong kai wu* (*The Exploitation of the Works of Nature*) (Figure 5.11), was a major technical manual produced in 1637. With full-page illustrations throughout, it described the conversion of natural materials such as clay, minerals, and bamboo into ceramic bowls, bells, and paper. The text was historical as well as technical, and the illustrations appeared in series showing the processes by which the transformations were effected. Largely self-explanatory, the illustrations were still accompanied by brief textual descriptions.

Popular Works

Only a small sampling survives of the popular printing from Fujian province—a center for such works produced during the Song dynasty. That such a small sample exists is hardly surprising, since those books were produced for immediate consumption, not bound for elite collections. Books about methods of divination and fortune-telling, family encyclopedias, school texts, reading primers, and a variety of illustrated medical works, as well as popular guidebooks to scenic areas, "self-improvement" reading, and throwaway fiction were all illustrated. Literary accounts note that the town of Masha in northern Fujian was notorious for piracy, famously reprinting abridgements of works without permission but with slightly altered titles or attributing the names of famous authors to spurious works.

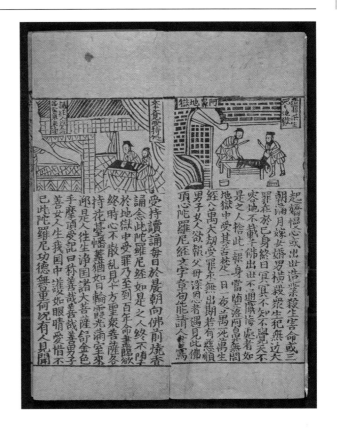

Figure 5.10
Anonymous, *Fo ding xin da tuoluoni jing* (*Sutra of Great Dharani of the Usnisa-citta*), Ming dynasty (1368–1644). Woodblock print on paper, concertina format, text block. 6 ¹/₃ × 23 ¹/₄".
This is an illustrated book of Buddhist chants or *dharani* showing scenes of sin on the right and piety on the left.

British Library, London, ©British Library Or. 80.d.21.

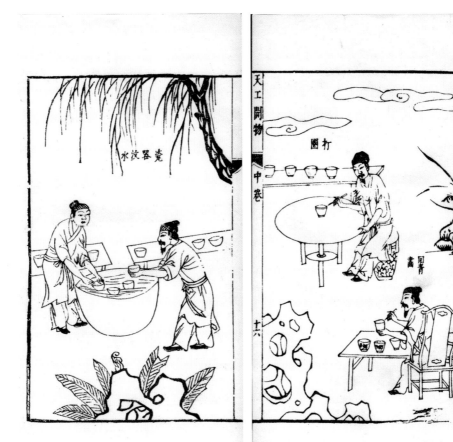

Figure 5.11a, b
Song Yingxing, figures 68 and 69, *Tiangong kai wu* (*Exploitation of the Works of Nature*), p. 202 and 203, 1637. Woodblock print on paper, text block 8 ¹⁵/₃₂ × 5 ¹/₂".
In this technical manual, rather than separating the artisanal process into discrete drawings, the illustrator shows the activities over time through the repetition of the craftsman who is identifiable by his distinctive facial hair.

Max Planck Institute of the History of Science.

a

b

Theme Box 11: Gramsci: Hegemony
by Jaleen Grove

Developed by the Communist thinker Antonio Gramsci (Italian, 1891–1937), the concept of **hegemony** addresses the normative status quo and worldview of a society, held in place by the everyday functions of dominant social groups, institutions, and business. This perpetuation of everyday functions is made possible by the conscious and unconscious consent of everyone who benefits by it (and even of those who don't particularly benefit) through profit, protection, or psychological reassurance. It is enforced by police, laws, religion, social customs, schooling, and cultural production, including art and media images—the effect of which Gramsci called the "manufacturing of consent."

Gramsci sought to explain why Communism—economic and cultural equality of social classes—was not popular even though it promised great advantages for most people. Gramsci concluded that people prefer to tolerate a large measure of unfairness, oppression, and poverty so long as most of their basic needs are met, because above all, people value stability. Furthermore, even if it needs improvement, the social order is presented in media and the arts as so natural and normal that it is impossible or even immoral to tamper with it. Individuals do not recognize any right or need to radically change it; nor would they know what to replace it with. Hegemony therefore not only oppresses but also obscures imagination and the ability to think of alternatives.

Visual culture—the aspects of a culture that are seen, such as art, fashion, design, performance, display, or illustration, and the practices, attitudes, and ways of looking and understanding that they engender—is key to the maintenance of hegemonic social norms. Gramsci noted that words are imbued with connotations that govern what meaning is communicated and that these meanings usually force our thoughts and beliefs to conform to hegemonic norms. Insofar as images and other aspects of visual culture comprise a visual language as equally nuanced and suggestive as words, they too uphold conventions as Gramsci felt words do.

For instance, in the art of many cultures, deities and rulers are depicted at the top and in the center of the page, while less powerful people are depicted at the bottom and sides. This placement reinforces the idea that anything associated with height is superior, and anything to the side—near the margins, in European books—is literally "marginal," unimportant. It takes a conscious effort to place the main character in a crowd scene in anything other than a central position. An illustrator might refuse to do anything else, since breaking with audience expectation could hamper the effective visual communication of the illustration. Thus, the status quo is upheld. Hegemony, then, is useful insofar as it keeps traditions intact and communication clear.

Paradoxically, the existence of hegemonic customs enables disruption of them too, for it is by contrast with a set of accepted rules that opposition defines itself. An illustrator who wishes to make a counter-hegemonic statement may take a well-known symbol and subvert it through juxtaposition, caricature, or parody. The new message would be comprehensible to those who recognize the normal usage. Such subversion has sometimes resulted in the death of the illustrator, as was Gramsci's fate as a writer in prison under Italian Fascism for his beliefs.

Further Reading
Gramsci, Antonio, *The Prison Notebooks of Antonio Gramsci* (New York: International Publishers, 1995).

One of four Buddhist holy mountains in China, Putuoshan is dedicated to the cult of the Bodhisattva Avalokitesvara, believed to guard against calamities like fire or shipwreck or attacks by wild beasts, robbers, or assassins. Depicting a favorite destination for pilgrims, the crudely printed guidebooks (Figure 5.12) shows the various routes around and up the mountain to the many temples and shrines. Produced in the late seventeenth century and likely acquired near Putuoshan by a surgeon working for the British East India Company in about 1700, the booklet's images lack detail and would have been almost useless without the text.

Elite and Popular Illustrated Narratives in Ming Printed Books

The survival of later Ming imprints is naturally greater than their Song and Yuan antecedents, and recent scholarship has revealed many illustrated works of the period, particularly from the Jianyang area of northern Fujian province. The fact that surviving examples can be also found in libraries throughout China and Japan testifies to the commercial networks transporting Jianyang imprints all over the country and abroad.

Figure 5.12
Anonymous, *Putuoshan Guidebook*, seventeenth century. Woodblock print on paper.
This inexpensive ephemera sold at a pilgrimage site has a poorly illustrated map showing the location of popular destination Putuoshan, an eastern mountain on the Zhoushan archipelago off the coast of Zhejiang province.
British Library, London, ©British Library 15269.d.6.

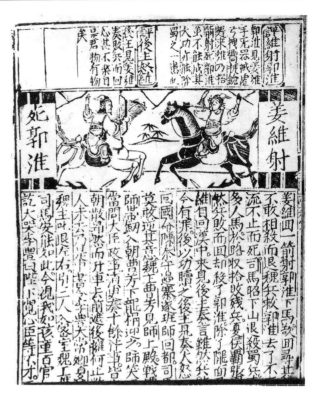

Figure 5.13
Anonymous, *Sanguo zhizhuan* (*The Romance of the Three Kingdoms*), 1592. Woodblock print on paper, text block 8 $^{27}/_{32}$ × 5 $^{5}/_{64}$".
Still using the time-honored "picture above, text below" format, this narrow depiction shows horsemen attacking each other. The man on the left, who holds a bow, has shot the soldier on the right with an arrow.
British Library, London, ©British Library 15333.e.1.

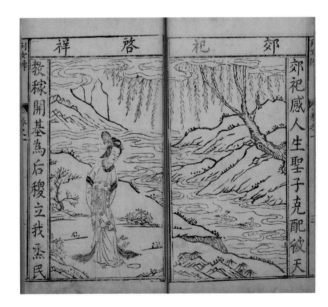

Figure 5.14
Anonymous, "Jiang Yuan, Mother of Qi (Houji)," in *Xinjian zengbu quan xiang pinglin gu jin lienü zhuan ba juan* (*Newly Engraved, Fully Illustrated and Annotated Ancient and Contemporary Traditions of Exemplary Women in Eight Scrolls*), Ming Dynasty edition, but thought to be a later reprinting. Woodcut.
This tale has mythic overtones: the illustration depicts Jiang Yuan as she steps in the footprint of a giant, which will cause the virgin birth of her son Qi. She regards his conception as inauspicious and tries several times to abandon him as a baby. (His name Qi means "The Abandoned"; he was later called Houji.) He is saved each time through remarkable events that convince his mother to accept and nurture him. Her teachings enable him to become skilled in agriculture, and he later alleviates widespread starvation as the Minister of Agriculture.
Image courtesy of Anne Kinney and the University of Virginia Library.

Reprints of popular texts such as the late fourteenth-century *Sanguo zhizhuan* (*Romance of the Three Kingdoms*), which described the exploits of warring generals and rulers of a period of division in Chinese history (128–280 CE), were widely produced. A 1592 edition printed by Yu Xiangdou (Figure 5.13) has narrow strips of illustration near the head of the page, with slender horses and figures drawn in a spiky manner. Later editions from different printers in the same area use the same "picture above, text below" format but show a marked difference in drawing style, with plump figures crammed into the narrow strip of illustration.

Texts for Self-Improvement

Although Confucian ideas had influenced government and society in China since antiquity, they were codified into the "Five Classics" (a sixth having been lost) and attributed to the revered Confucius (551–479 BCE) by the late Han dynasty (206 BCE–220 CE). Later, they became the base texts for the imperial exams that would allow entry into government service; thus, all boys from well-to-do families would be educated from an early age in the Classics. Confucian ideas were also fundamental to the family, and female virtue was celebrated in tales of women who sacrificed themselves for the sake of their families.

The *Lienü zhuan* (*Ancient Record of Female Exemplars*) is a collection of "biographical" tales of feminine virtue and the earliest (extant) text written specifically for the moral education of women (Figure 5.14). Written by Liu Xiang (79–8 BCE), the text was modified many times and appeared in many formats, including as an illustrated book. Divided into eight categories such as "matronly models," the "benevolent and wise," and the "principled

and righteous," the anthology also includes sections on wicked women, "accomplished speakers," and uncategorized female exemplars. In addition to filial piety and maternal beneficence, the stories emphasized chastity (through suicide or self-mutilation if necessary). It remained influential for two centuries. Finely produced editions of the *Lienü zhuan*, like the Confucian Classics, would have been expensive and probably destined for families associated with the official class of government bureaucrats, but cheaper editions were also available.

"Self-improvement" works could range from primitive to fine editions. The *Dijian tushuo* (*The Emperor's Mirror, illustrated and discussed*) in its first iteration was a finely produced album of hand-painted images and text, created in 1573 for the Wanli Emperor of the Ming, who had ascended the throne in 1572 at the age of nine. The young emperor's advisors supervised the anthology's production, which was designed to educate him in the responsibilities of just rule by illustrating the stories of emperors of the past, both good and bad. The handmade version was quickly followed later that year by a woodblock-printed book beautifully produced with very fine double-spread illustrations of eighty-one "Honorable Patterns of the Sagely and Wise" and thirty-seven examples of "Destructive Tracks of the Uninhibited and Stupid" (Figure 5.15). This official publication was shared among government officials, leading to commercial derivatives appearing in the same year. Versions of *The Emperor's Mirror* continued to be published throughout the Ming and Qing dynasties. With its depictions of life within the palace walls, it appealed to general audiences, and it also served as an abridged and simplified Chinese history presented in an appealing format. These popular editions reinforced the Confucian notion of the "good" emperor, favored by heaven and assisted by wise ministers whose primary duty was to advise him loyally and unconditionally.

Copying and Republication

Unauthorized copying was rife in the Chinese printing industry. Certain texts were much in demand, such as model essays of the type used to pass the imperial civil service exams. Pirated editions of books were often available, although usually published with a slightly amended title. Illustrated editions frequently included purloined images from previously printed editions, even when the source of the original illustrations was quite well known. Moreover, books were often reprinted with their original prefaces still intact, thus indicating an earlier publication date.

Distinguishing early and late printings is often difficult, but the study of the condition of the blocks often makes this task easier. Repeatedly pressing the blocks against paper gradually results in cracks in the wood and fuzziness along the edges of lines—faults that are then transferred to the printed image. Wear and damage to blocks affected cheaper imprints particularly but was not unknown in more expensive publications as well.

Color Printing

In Chinese printing, with the exception of the occasional use of red for notes or punctuation, there are only a few isolated examples of color printing. Color rarely made its way into book illustration and was more commonly used for painterly productions bound as albums to be admired at home, or as larger colored prints made as inexpensive alternatives to original paintings.

The most notable book is Hu Zhengyan's *Ten Bamboo Studio Manual of Painting and Calligraphy* (Figure 5.16), which predominantly depicts flowers, birds, fruits, and landscapes, paired with poetry on the facing pages. These prints reveal the complexity of color printing through which states, reprintings, applications of seals, and wear and tear on blocks can be seen.

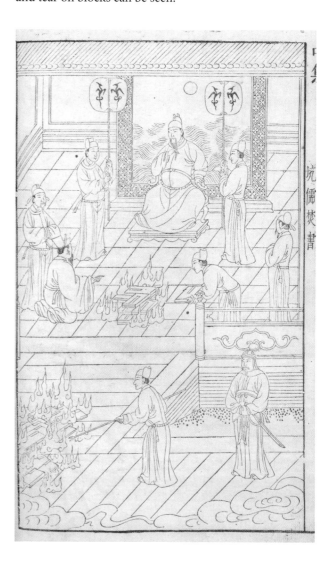

Figure 5.15
Anonymous, "Burning of the Books," in *Dijian tushuo* (*The Emperor's Mirror, illustrated and discussed*), 1604. Woodcut.
Printed versions of the original handmade album given to the young emperor were quickly circulated. They gave the general population a look into palace life while providing an overview of Chinese history. The First Emperor of China (259–210 BCE), who is best known today for the 8,000 Terracotta Army statues found in his luxurious necropolis, was branded an evil anti-Confucian by the historians of the Han dynasty. On this page, he is shown presiding over the "burning of the books." Interestingly, the books being consigned to the flames are clearly thread-bound volumes of the type common during the Ming dynasty, whereas "books" in the First Emperor's time were actually written on narrow strips of bamboo or wood.
British Library, London, ©British Library Or. 74.d.45.

Figure 5.16
Hu Zhengyan, "Plum and Camellia," *Shi zhu zhai shu hua pu* (*Ten Bamboo Studio Manual of Painting and Calligraphy*), p. 89, 1633. Colored woodblock print on paper.
This 1633 edition, organized by Hu Zhengyan, was the original version of this painting manual and is one of the earliest known examples of color woodblock printing using multiple blocks.
Cambridge University Library Fh.910.83-98.

Another example was the popular painting manual *Jiezi yuan hua zhuan* or the *Mustard Seed Garden Painting Manual* (ca. 1669–1701), a didactic production that contains printed examples of finished paintings, which generally required up to four colors. The manual also contains monochrome illustrations intended to instruct would-be painters, including figures shown in various poses, different birds, and plum blossoms shown in all their stages of growth (of great symbolic importance in Chinese art and culture). Once mastered, these models might be included in a larger landscape painting.

To print a color image, separate blocks are necessary for each color, and they are printed in a specific sequence. The *Ten Bamboo Studio Manual* uses the **douban**, or "assembled block," method, in which each block is irregularly shaped and only large enough to cover the area needed for its assigned color. Blocks were sometimes given fine gradations of pigment to mimic watercolor washes, the successive impressions of which gradually developed delicate, painterly effects. Editions can be distinguished by the usual cracks of aging, and by the sophistication of their coloring.

Continuity and Change: Experiments in Movable Type and Lithography

The Qing dynasty (1644–1911) saw the greatest changes in book production in China, largely through the adoption of new technology—some of it from Europe. Ming emperors had used the *Wuyingdian* (Hall of Martial Valour) in the Forbidden City in Beijing as a meeting hall, but Manchu Qing rulers decided to use it as the center for imperial book production. In addition to basic editorial

work, collating, and manuscript copying, various printing experiments were also undertaken there.

While movable type made from clay had been used as early as the mid-eleventh century, it was cumbersome for creating the approximately 44,000 different characters in the Chinese script. Experiments in producing both wooden and metal movable type, however, led to their use in many large-scale Imperial printing projects in the Qing. Commissioned by the Kangxi Emperor, a massive illustrated Imperial encyclopedia of over 800,000 pages was compiled. Completed in 1728, the more than 60 full sets of this Qing printing experiment, entitled *Qinding gujin tushu jicheng* (*Illustrated Synthesis of Books and Illustrations of Ancient and Modern Times*) (Figure 5.17), required the casting of over 250,000 pieces of bronze type and included hundreds of full-page woodblock illustrations. Later Imperial printing projects returned to using woodblocks and wooden type because both were much cheaper than bronze type. Wooden type was used to produce 134 titles from the Imperial manuscript library between 1774 and 1794.

While European missionaries had introduced copperplate engraving to China in the seventeenth century, it was the Western printing technology of **lithography** (*see Chapter 11, Theme Box 21, "Lithography"*) that was to become widespread in port cities by the end of the nineteenth century. The lithographic process allowed fine lines and tonal shading, but the potential for shading did not seem to be immediately exploited by Chinese artists, who continued in a more linear approach. Since the greatest woodblock artists and block cutters in the Ming had

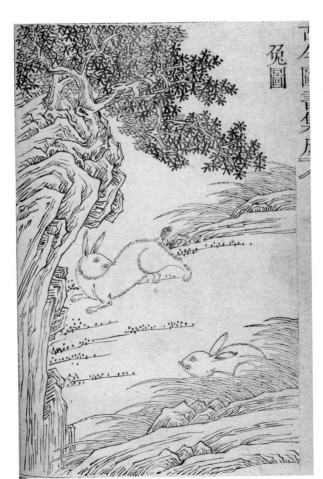

Figure 5.17
Anonymous, illustration of two rabbits from *Qinding gujin tushu jicheng* (*Illustrated Synthesis of Books and Illustrations of Ancient and Modern Times*), 1728. Woodcut.
The *Qinding gujin tushu jicheng* was an encyclopedia made up of extracts from earlier books, organized by subject. Some sections were illustrated with explanatory images. This depiction of two rabbits accompanies texts describing their mating practices.
British Library, London, ©British Library, Oriental and India Office Collections, 15023.b.1.

already achieved fine-line work, the new technology did not initially greatly alter the style of illustration but did enhance the speed of the process.

One of the greatest Western-style printing houses in Shanghai was the Dianshi Zhai (Hall of Lithography), which between 1884 and 1898 published the *Dianshizhai huabao* (*Dianshizhai Pictorial*), an illustrated journal issued every ten days. This paper brought news to Shanghai—from international train accidents to local events like depictions of hair-pulling fights in brothels, or the birth of two-headed sheep and other sensationalized phenomena. Adopting the far more expedient lithographic printing process from Europe, pictorial journals like the *Dianshizhai Pictorial* also adapted the use of Western-style perspective in depicting space and architecture.

Wu Youru (d. 1893), one of the most prolific *Dianshizhai Pictorial* illustrators, started the competing illustrated journal *Feiyingge huabao* (*Feiyingge Pictorial*) in 1890 (Figure 5.18). After three years, however, he shifted the periodical's focus away from captioned news and embraced traditional Chinese stories, poems, and illustrated themes that allowed for an imaginative approach more aligned with book publishing than with news reporting.

The Dianshizhai press also published dictionaries, textbooks, and novels, with illustrated covers becoming a more important feature of popular fiction. Their inexpensive illustrated editions of classics like *Hongloumeng* (*Dream of the Red Chamber*) and the *Sanguo zhizhuan* (*Romance of the Three Kingdoms*) fulfilled popular demand just as the Jianyang printers had done 400 years earlier—but through lithography rather than woodcuts. Lithography, however, was not immediately adopted beyond the city of Shanghai because other regional centers of printing continued to utilize traditional Chinese woodblock printing for quite some time.

Conclusion

From the Confucian and mythological themes inscribed in the Wu Liang Shrine to the hundreds of Mogao and Yulin caves decorated with Buddhist devotional paintings, evidence of an early and strong engagement with illustration exists in Chinese visual culture. While the demand for the reproduction of religious texts and images by Buddhist believers encouraged the early development of printing, the technology came to serve a wide variety of audiences. With the expansion of printing in the Song (960–1279), Yuan (1279–1368), and Ming (1368–1644) dynasties, Confucian ideals continued to be expressed through illustrated narratives; while an expanded range of illustrated works included compendia, treatises on knowledge and practical processes, "self-improvement texts," and popular works of fiction.

Despite the embrace of the more efficient process of lithography by the Shanghai pictorials and the introduction of European–style linear perspective by the late nineteenth century, woodblock printing remained the dominant form of image-and-text reproduction. This perpetuated traditional styles using strong linear outlines rather than the tonal capabilities of lithographic printing to indicate light and shadow.

FURTHER READING

Murray, Julia K., *Mirror of Morality: Chinese Narrative Illustration and Confucian Ideology* (Honolulu: University of Hawai'i Press, 2007).

Wood, Frances, *Chinese Illustration* (London: British Library, 1985).

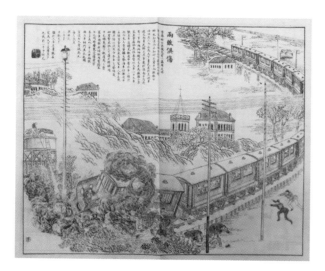

Figure 5.18
Wu Youru, "Trainwreck in America," in *Feiyingge huabao* (*Feiyingge Pictorial*) no. 4, October 1890. Lithograph.
Note the mix of drawing styles, combining more traditional line work harkening back to Chinese woodcuts with incidences of the tonal and spatial approach more typical of European publications.
Collection of D. B. Dowd.

KEY TERMS	
apsaras	*juan*
bodhisattvas	literati
cartouche	lithography
concertina	mimesis
douban	stelae
filial piety	sutra
grotto	visual culture
hegemony	

6

Prints and Books in Japan's Floating World, 1600–1900

Daphne Lange Rosenzweig

with contributions by Susan Doyle

During the Edo Period (1615–1867), Japan's leadership was divided between the emperors officiating ceremonially from Kyoto, and the shoguns, who were hereditary military leaders of the Tokugawa clan ruling politically from Edo (modern-day Tokyo). The word *Edo* identifies both the place and the cultural period.

Edo social hierarchy placed even wealthy merchants in the lowest class, below warriors, farmers, and artisans. Effectively excluded from politics and subject to strict governmental policies regarding social behavior, affluent merchants spent much of their time going to the theater or indulging in other pleasures in the government-controlled entertainment quarters in Edo and other major cities. The leisure world inhabited by these patrons was known as the *ukiyo*, or "Floating World"—a reference to its transitory pleasures, a slight twist on the original Buddhist term referring to the evanescence of life.

Images of this seductive world became known as **ukiyo-e** (the *e* translated as "painting" or "print"). Woodblock prints and illustrated books proliferated in Edo, with designs inspired by the theater and its actors and beauties, and by landscapes and nature (Figure 6.1).

Created by skilled, competitive, and imaginative illustrators, the still-memorable *ukiyo-e* images have influenced many aspects of illustration in Asia, Europe, and North America.

The *Ukiyo-e* Print Production Industry

The expanding and increasingly literate Edo urban merchant class became avid patrons of *ukiyo-e*. Numerous competitive publishing establishments in the cities of Osaka, Kyoto, and above all, Edo, mass-produced prints and illustrated texts. *Ukiyo-e* designers, block carvers, and printers were well trained through a workshop-apprenticeship system.

Early Edo prints were printed only in black ink on paper. Afterward, pigments were hand-applied to some prints to enhance the images. By the 1740s, one or two colors were printed by cutting a block for each color (Figure 6.2). It wasn't until ca. 1765 that *ukiyo-e* were printed in several colors, and referred to as **nishiki-e**, meaning "brocade" because of their sumptuous appearance—a practice that continued into the Meiji era (1868–1912) after Japan was opened to the West.

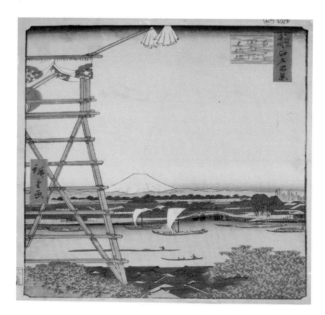

Figure 6.1
Ando Hiroshige, "The Ekoin Monastery at Ryogoku and the Moto-Yanagibashi Bridge" from the series *One Hundred Views of Edo*, ca. 1857. Woodblock print, ink and color on paper, 14 × 9 9/16".
Apart from their appealing appearance, Japanese prints often have numerous subtexts: this seemingly placid landscape incorporates a Jodo Sect Buddhist temple built by order of the Shogun following a 1657 conflagration that reportedly killed over 108,000 people. The new temple provided a burial site for those victims without relatives; the purpose was to carry out the correct death rituals on their behalf. The symbolic importance of this temple would have been appreciated by temple visitors and print viewers.

Private collection.

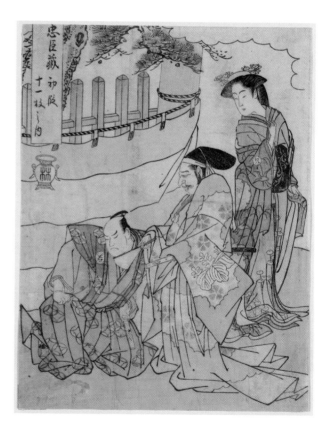

Figure 6.2
Katsukawa Shunshō (Japanese, 1726–1793), "Shodan" (first scene) from *Chūshingura jūichimai no uchi* (*Eleven Scenes of Chushingura*), ca. 1785. Woodblock print, ink and color on paper, 9 13/64 × 7 13/64".
Early *ukiyo-e* were printed in limited palettes with subdued color. This image depicts a stage adaptation of the classic tale of the *Chushingura*, popularly known as *Forty-seven Ronin* (see also Figure 6.6).

Library of Congress.

Print Production

Print production was a four-step process, with publishers managing, and often housing, teams of workers engaged in both print and illustrated book production. Artists were hired to create illustrations based on an assigned topic, turning their sketches over to the publisher, whose block cutter might modify the design before carving the cherry-wood blocks (one for every color and special effect, such as an embossed texture or gradient). The blocks would then be sent to the printer. The artist whom we credit for the print (Hokusai, Hiroshige, Shunsho, and so on) typically had little or nothing to do with the production of the print apart from submission of a basic illustration, although a few famed artists might suggest a particular color palette. The publisher controlled the process and could reject or alter the design, and government censors had to approve the design to make sure it presented no seditious or otherwise objectionable content before the final publication of the prints. This step was particularly important because prints were distributed among patrons whose social and political behaviors the government wished to control.

Once cleared by the censor, the edition was produced and then promoted in the publisher's storefront and bookstores and by street vendors. Prints were sold singly or in sets and might be used promotionally or sold as souvenirs of a particular event or play performance, or of a place. Ultimately, each print might bear the artist's name, the publisher's logo, perhaps the engraver's identification, the censor's seal, possibly a date of publication, a title, identification of the subject, and other information (Figure 6.3).

Ukiyo-e prints were not issued and numbered in finite editions and could be reprinted intermittently based on market demand, until the blocks wore down. It is often only through careful study of nuanced differences in line and color quality and paper texture that original and later impressions can be distinguished.

As the popularity of a design waned, the publisher might resell the blocks to another publisher, who could have the block lines sharpened. Parts of the block could be altered or repaired by cutting out a section and wedging in a replacement piece of wood to be carved. This was common practice for the outlines of noses and delicate hairlines that tended to deteriorate first. Blocks were also recut to replace the publisher's logo or to replace an actor's name in a certain role with the name of his successor in that role. Each illustration is therefore much more than its fundamental design; it represents the legacy of the cultural and economic needs, the skills, and the decisions involved in bringing the illustration to market.

Artists' Names and Schools

Most print artists were male and from obscure backgrounds. They apprenticed for years to emulate their master's style and might ultimately be awarded permission to assume part of his name and the right to consider themselves part of a certain "school." For example, the artists Utagawa Kuniyoshi (Japanese, 1797–1861), Utagawa Kunisada (Japanese, 1786–1865), Utagawa Kuniyasa (Japanese, 1773–1810), and other "Utagawa Kunis. . ." were the students of an early master of the dominant nineteenth-century Utagawa School that also included Utagawa (or Ando) Hiroshige, better known as just "Hiroshige." Artists often used several names in their lifetimes. Katsushika Hokusai (Japanese, 1760–1849) used over fifty names during his long career, "Hokusai" being just one of his *go* (pseudonyms).

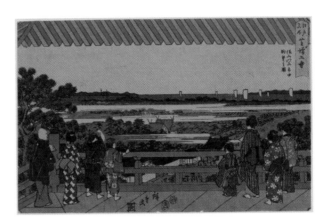

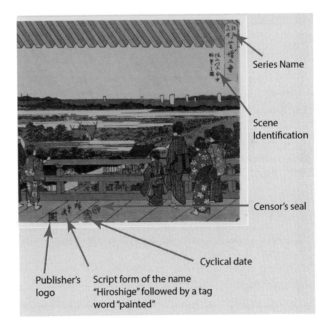

Series Name

Scene Identification

Censor's seal

Cyclical date

Publisher's logo

Script form of the name "Hiroshige" followed by a tag word "painted"

Figure 6.3
Utagawa Hiroshige (1797–1858), "Zōjō-ji Temple in Shiba (Shiba Zōjō-ji): Panoramic View of the City from the Top of the Sanmon Gate" ("Sanmon ue yori shichū chōbō no zu"), from the series *Famous Places in Edo* (*Edo meisho*), 1854. Woodblock print, ink and color on paper, 8 7/16 × 13 3/8". Print artists often worked in series based on a theme. Hiroshige, particularly, is known for his landscape series designed from drawings made on journeys throughout Japan. In this image, the distant landscape is framed by groups of figures on the left and right. The diagonals along the top and bottom indicate a roof and wooden platform. The scene identification is located at the top right.

Museum of Fine Arts, Boston. Denman Waldo Ross Collection. Photograph © 2017 Museum of Fine Arts, Boston.

Theme Box 12: Bourdieu: Cultural Capital and the Field of Cultural Production
by Jaleen Grove

How does art function in society? French sociologist Pierre Bourdieu (1930–2002) posited that art is a means for individuals to compete for *distinction*—prestige—as consumers and creators of visual presentation. Bourdieu called the art world a **field of cultural production**, meaning a professional milieu, but also a battleground where artists, dealers, curators, critics, collectors, and writers on art compete for acclaim and power. While Bourdieu mainly wrote about fine art and elite and intellectual society, his concepts may also be applied to how subcultures and fandoms negotiate what and who is "cool."

In the field of cultural production, "currency" is not simply a matter of money, but a combination of symbolic values, specialized knowledge, taste, and feeling of belonging that together Bourdieu calls **cultural capital**. Although wealth is always associated with and motivates the field, speaking of money is disavowed in favor of speaking of taste, quality, and passion. An artist with cultural capital may not be rich, but he or she has a good reputation as a creator and tastemaker, talks knowledgeably about the kind of creative field he or she is in, and knows how to behave in special cultural settings such as galleries, studios, and parties.

The field of cultural production is constantly in flux as various "agents" vie for dominance by policing aesthetics and the terms by which they are understood and viewed—for example, allowing one's work to appear in only certain venues or products to enhance fashionable association with a particular social group. Bourdieu describes how new generations trying to break into an established field may resort to rebellion rather than following the accepted path of those who came before. If successful, they upset hierarchies of value, which can result in a rapid valuation of a new style and devaluation of the old. This happened when abstract art became more fashionable than nineteenth-century academicism; in illustration, a similar shift happened when "conceptual" illustrators such as Seymour Chwast and Robert Weaver gained prominence over older narrative realist illustrators like Norman Rockwell in the 1950s and 1960s.

While the field of cultural production tends to maintain categories of "high" art (restricted to a knowledgeable in-crowd) and "low" art (accessible to all), actual objects and styles within those categories can swap positions. What is considered low or high is therefore a matter of who made it, for what purpose, where it is seen, and what is said about it. For instance, when Andy Warhol began exhibiting massproduced illustrations and graphic designs in art galleries, he turned these "low" items into "high" art (this art movement was called Pop Art because of the popular nature of the everyday things it appropriated; *see Chapter 26, "Countercultures"*). This did not elevate illustration and design; rather, only the actual individual Warhol art objects were elevated. Like any art that "quotes," the new artwork may be subtly changed to spark and signal that it is no longer ordinary: perhaps it is given brighter colors, a different scale, a new frame, an unusual orientation, or is paired with something else. Semiotic nuances of form and content like this matter greatly, as they reference other cultural phenomena that are similarly morphing, bringing new distinctive alliances and identities into play. On the other hand, some everyday objects—**readymades**—brought into the gallery are not altered at all: it is only the context of the gallery, the fact they were selected by the artist, and what is said about them by curators and critics that transform them into art objects and a means of generating cultural capital (Dada artist Marcel Duchamp originated the readymade in 1917 when he entered an actual urinal into an art exhibition).

Illustrators may be thought of as cultural capital experts who must competitively identify, predict, react to, and adjust the output of a field of cultural production. Whether they succeed, however, depends also on other agents in the field—art directors, publishers, clients, consumers, and fans.

Further Reading

Bourdieu, Pierre, *Distinction: A Social Critique of the Judgement of Taste* (Boston: Harvard University Press, 1984).

Bourdieu, Pierre, *The Field of Cultural Production* (New York: Columbia University Press, 1993).

Major Themes in "Floating World" Prints

Ukiyo-e artists found inspiration for their works within the rich literary narratives of Japan and China as well as the material displays and social mores of contemporary life within the floating world. The most typical subjects of *ukiyo-e* print production were classic literary or romantic tales, actors and theatrical scenes, female beauties, landscapes, and birds and flowers (nature).

Literary Themes

Traditional literary themes included extended and rousing tales of treachery, heroism, and loyalty illustrated in *musha-e*, or "warrior" prints, which were also enacted in popular kabuki theater productions. For instance, the *108 Heroes of the Suikoden* (water marshes) was an adaptation of a collection of Chinese tales about an honorable gang of rebel bandits who inhabit marshy lowlands and combat corrupt ruling forces to bring justice to the poor. Their legendary exploits inspired dynamic compositions, such as Utagawa Kuniyoshi's (Japanese, 1798–1861) print depicting *Rôri hakuchô chôjun* as a ferocious warrior advancing in attack, undeterred by a water gate defense barrier (Figure 6.4).

Illustrators of *musha-e* (warrior prints) and *senso-e* (war prints) (*see Chapter 21*) were constrained by the necessity of differentiating the hero's outstanding moral qualities and bravery from that of his opposition. Heroes had highly expressive countenances and were shown in control or in the process of wresting control from a villain. Their upper bodies might be exposed with taut abdominal muscles or tattoos (Figure 6.4). The antagonist was often portrayed as darker-skinned, emotionally distressed, and exhibiting poor posture. Hirsute men might represent honorable, even admirable characters—although possibly lower class individuals.

Another narrative adaptation from the Chinese was *Sanguo Yanyi*, or "Romance of the Three Kingdoms," a fourteenth-century novel by Luo Guanzhong (Chinese, ca. 1330–1400) that chronicled the power struggles of dynastic succession in China from 220 CE to ca. 265 CE. "Liu Xuande visits Zhuge Liang in a snowstorm" by Tsukioka Yoshitoshi (Japanese, 1839–1892) is a triptych print based on the novel (Figure 6.5). The narrative sequence moves from right to left, with each panel designed to succeed as an independent composition as well as part of the triptych. Its selective color palette shows the wintery landscape in desaturated hues, with stronger colors reserved for the figures and cartouches.

The Forty-seven Rōnin

Kanadehon Chûshingura (also known as *Forty-seven Ronin*) inspired many *ukiyo-e* prints based on the original literature, as well as prints related to theatrical productions of the tale. The narrative centers on a band of **ronin** (masterless samurai) who are honor bound to revenge the death of their lord by attacking his nemesis, a conniving government official. By doing so, the *ronins* will themselves be obligated to commit

ritual suicide. Based on actual events that occurred 1701–1703, the narrative is still popular in contemporary Japan. Katsukawa Shunshô's (Japanese, 1726–1793) print (Figure 6.2) shows the opening moments of the play in which a regional lord breaches court protocol, thereby shaming himself and necessitating his own suicide—thus setting in motion the *Ronin* revenge plot.

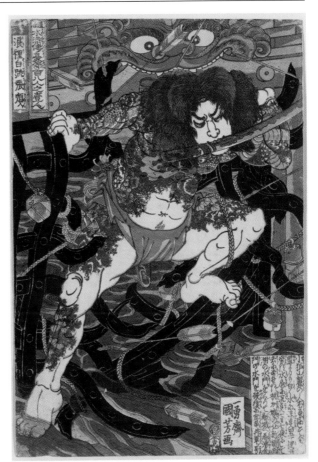

Figure 6.4
Utagawa Kuniyoshi, the warrior *Rôri hakuchô chôjun*, from *108 Heroes of the Suikoden* (originally *Shuihu Zhuan* in Chinese), ca. 1826–1830. Woodblock print on paper, 14 9/32 × 9 3/4".
A knife clenched in his teeth, the tattooed warrior advances through the rushing river, having just broken through a metal gate. The strong diagonal of the central figure creates a dynamic compositional thrust.
Library of Congress.

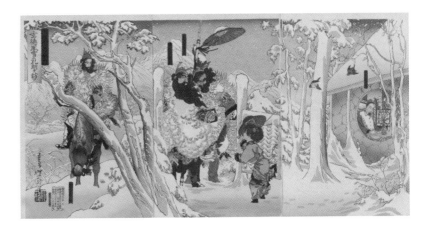

Figure 6.5
Tsukioka Yoshitoshi, "Liu Xuande (Liu Pei; J., Gentoku) visits Zhuge Liang (Liang Chu-ko; J., Komei) in a snowstorm," from *Illustrated Chronicle of the Three Kingdoms*, 1883. Polychrome woodblock print, 14 13/16 × 29 1/3" (sheet).
RISD Museum, Providence. Gift of Paula and Leonard Granoff.

A later *ukiyo-e* by Utagawa Kuniyasu (Japanese, 1794–1832) illustrates Act 11 of a stage presentation of *Chushingura*, in which the three kabuki actors in stylized make-up act out the climactic attack on the villain's villa (Figure 6.6).

Tale of Genji

The *Tale of Genji*, considered the world's first psychological novel, was written in the eleventh century by Murasaki Shikibu, a Japanese noblewoman and lady-in-waiting in the Heian imperial court (794–1185 CE), located in modern day Kyoto. Its fifty-four chapters provide a fictional exposé of court life through the chronicles and love affairs of the protagonist Genji, son of an emperor. Published in 1857, Utagawa Kunisada's (Japanese, 1823–1880) print is an exemplar of the delicate line work, patterning of textiles, controlled gradients, and carefully registered spot colors for which *ukiyo-e* are known (Figure 6.7). The title in the upper right is followed by a design device signifying which of the fifty-four chapters is being illustrated.

Yakusha-e: Prints of Actors

There are several types of drama in Japan, including **Nô**, the classical masked theater favored by the upper classes; **bunraku**, the puppet theater; and the **kabuki** theater, which was performed in government-licensed theater districts and more accessible to the average viewer. Kabuki narratives typically revolved around tragedies, death, forbidden love, and betrayal, with the actors' face paint indicating their persona (hero, villain, and so on).

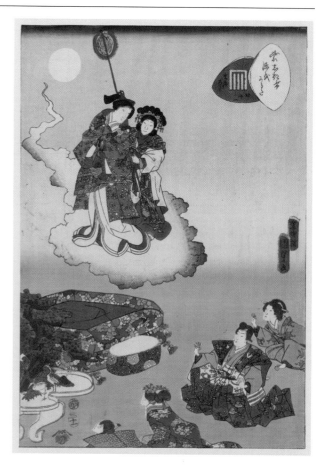

Figure 6.7
Utagawa Kunisada, "Maboroshi" ("Illusion"), chapter 41 of the *Tale of Genji*, 1857. Polychrome woodblock, approximately 12 3/4 × 9".
Woven into a fictionalization of the Heian imperial court, *The Tale of Genji* included episodes of magic, like this wizard and his attendant flying on a cloud.
Courtesy of Library of Congress.

Fans collected **yakusha-e**, depictions of their favorite actors, which often showed them full-figure in dramatic poses, enacting particular roles. Subcategories of theater prints included actors shown behind-the-scenes putting on their make-up, wigs, and costumes (Figure 6.10); wide-view stage pictures (**shibai-e**); and "big heads" close-up portraits (**okubi-e**). During performances, an actor paused in moments of high drama in one of many stock poses called a **mie**, the significance of which was understood by the audience (Figures 6.8, 6.9).

Beyond stylized likenesses, actors' identities were signified in prints through use of a **mon** (a crest) that appeared as a decorative element on their costume. *Mon* were passed down through acting family lines as one generation of actors superseded the other (Figure 6.11).

As the actors' fame grew, some prints showed them in roles they had never played, in what was referred to as **mitate-e**, which translates as "comparison" or "analogy." *Mitate-e* might also refer to other subjects too, as an invitation for a cultured audience to interpret the layered meaning implied by ironic transpositions of contemporary characters, costumes or props, or

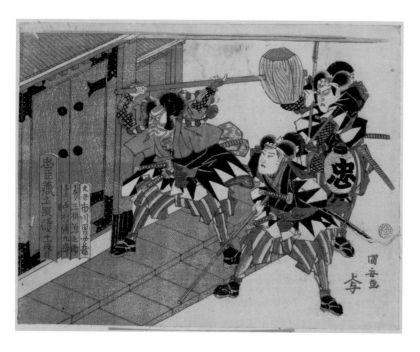

Figure 6.6
Utagawa Kuniyasu, "Jūichidanme," Act 11 of the *Chushingura (Forty-seven Rōnin)*, ca. 1815–1818. Polychrome woodblock, approximately 7 1/2 × 10 1/4".
Wearing the black and white overgarments characteristic of the *ronin*, actors are shown attacking the entrance to the mansion of the villain Moronaô in the climactic scene of the *Forty-seven Rōnin*.
Library of Congress.

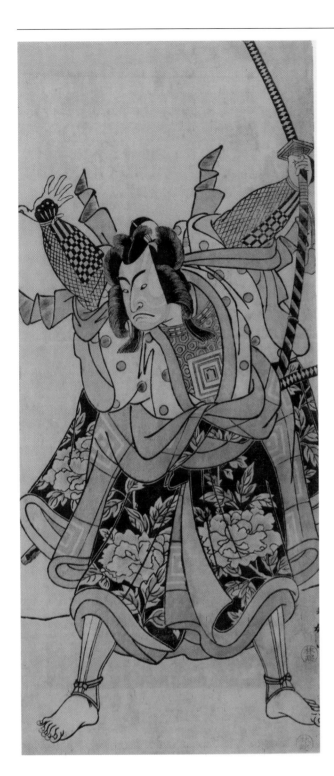

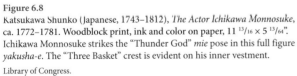

Figure 6.8
Katsukawa Shunko (Japanese, 1743–1812), *The Actor Ichikawa Monnosuke*, ca. 1772–1781. Woodblock print, ink and color on paper, 11 13/16 × 5 13/64". Ichikawa Monnosuke strikes the "Thunder God" *mie* pose in this full figure *yakusha-e*. The "Three Basket" crest is evident on his inner vestment.
Library of Congress.

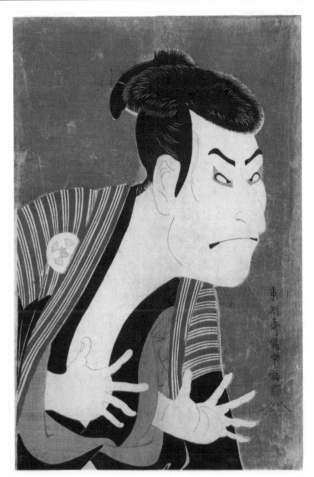

Figure 6.9
Tôshûsai Sharaku, *Kabuki actor Ōtani Onili III as Yakko Edobei* in the play *Koi nyōbō some-wake tazuna* (*The Colored Reins of a Loving Wife*), 1794. Woodblock print, ink and color with white mica on paper, 15 × 9 7/8". Tôshûsai Sharaku depicts the actor with contorted hands and eyes crossed—an effect of the grimacing *mie* that indicated his dastardly intentions.

Courtesy of Metropolitan Museum of Art.

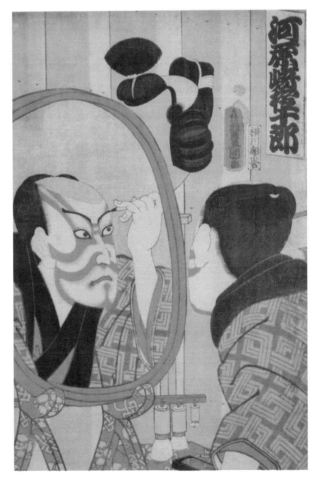

Figure 6.10
Toyokuni III (Kunisada) (Japanese, 1786–1864), *Actor Kawarazaki Gonjuro in the Dressing Room*, 1861. Woodblock print, ink and color on paper, 10 × 15". A kabuki actor sits before a mirror in his dressing room; his wig is shown above the mirror. This print is **oban** size (roughly 10 × 15"), a popular *ukiyo-e* format.

Courtesy of Ronin Gallery.

anachronistic literary allusions. As is the case of many types of illustration, decoding the meaning of these curious images centuries after their circulation is difficult if not impossible.

Though in its early years kabuki had been staged with females and then young boys as performers, later government regulations forbade both in kabuki, and

allowed only male actors to play female roles, referred to as ***onnagata***. A print by Tôshûsai (Japanese, active 1794–1795) (Figure 6.11) depicts the actor Sanokawa Ichimatsu III playing a woman. Despite his costume and affected female posture, it is clear from the personalized facial features that this is a specific actor as opposed to an idealized beauty. Like all *onnagata,* he wears the required head cloth that hides his shaved head. In *ukiyo-e,* these head cloths were indicated by blue, brown, or purple patches of color.

Bijin-ga: Prints of Beauties

The concept of ideal beauty pertained to both genders and was part of the visual vocabulary of Japan from the eighth century onward in both secular and religious presentations. *Ukiyo-e* continued the idealization of beauty with ***bijin-ga*** (prints of beautiful women), which most often depicted inhabitants of the Green

Houses, licensed "pleasure quarters" (brothels) in the entertainment print districts of various cities. The most famous district was that of Yoshiwara, in the city of Edo. Less commonly, *bijin-ga* might also show well-dressed upper-class women, legendary beauties of the past, or even more rarely, women of the merchant class.

The women living in the Green Houses were highly stratified. They ranged from accomplished, educated beauties who could limit their clientele, to girls without discernable cultural achievements or those considered less attractive, who were widely sexually available to visitors. In *ukiyo-e*, larger scale and prominence within a composition were pictorial conventions that indicated higher social rank or importance (Figure 6.12).

In contrast to modern usage, "geisha" did not originally refer to all women from the Green Houses; rather, it indicated "persons of accomplishment," both men and women of talent, chiefly singer-entertainers.

In addition to wilting, swaying posture, feminine desirability was communicated through other stock characteristics that included the exposed neck (an erogenous zone), tiny hands and feet, long three-quarter view faces with a simplified, straight nose, elevated eyebrows, and tiny "bee-stung" lips (Figure 6.13). Beauties were shown in the pursuit of appropriate feminine activities and in gracious poses that underscored their delicacy. Seasonal themes were commonly used as a pretext for creating *bijin-ga* (beauties) series (Figure 6.14).

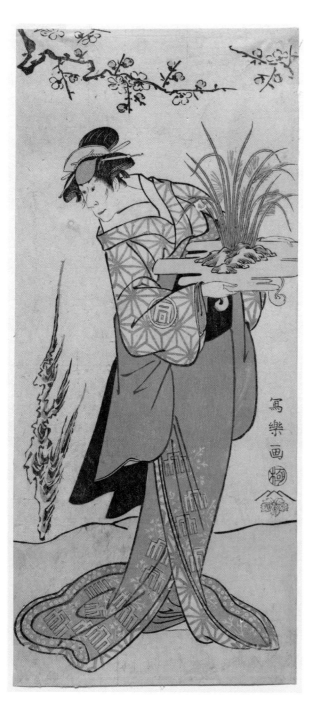

Figure 6.11
Tôshûsai Sharaku, "Actor Sanokawa Ichimatsu III as Ihohata" in the play *Uruôtôshi Meika no Homare*, 1794. Woodblock print, ink and color on paper, 12 ¹/₂ × 5 ⁵/₈". Museum of Fine Arts, Boston, William S. and John T. Spaulding Collection. Sanokawa Ichimatsu adopts the wilting female pose with a tilted head, exposed neck, and demure downward gaze. The actor's *mon* is clearly visible on his sleeve.

Photograph © 2017 Museum of Fine Arts, Boston.

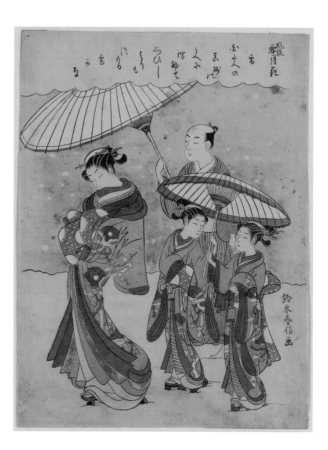

Figure 6.12
Suzuki Harunobu (Japanese, ca. 1725–1770), *Yuki* (*Snow*), ca. 1767–1769. Woodblock print, ink and color on paper, 11 ¹/₄ × 8 ¹/₂".
Bijin-ga often depicted "parading" courtesans, usually with attendants who, according to *ukiyo-e* pictorial conventions, are depicted on a smaller scale, signifying their lower status.
Library of Congress.

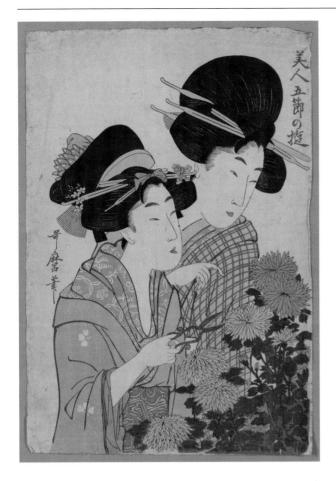

Figure 6.13
Kitagawa Utamaro (Japanese, 1753–1806), "Chōyō" ("September"), from *Beauties Having Fun During the Five Festivals*. Woodblock print, ink and color on paper, 9 × 7" (approximate).
Kitagawa Utamaro is one of the most acclaimed designers of *bijin-ga*, who influenced Impressionist and Post-Impressionist artists such as Mary Cassatt.
Library of Congress.

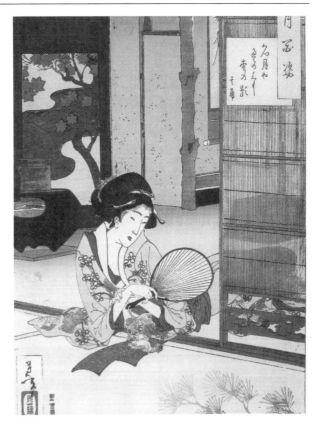

Figure 6.14
Tsukioka Yoshitoshi (Japanese, 1839–1892), "Meigetsu ya tatami no ue ni matsu no kage" ("Full Moon on the Tatami Mats, Shadows of the Pine Branches"), #5 from his series, *100 Aspects of the Moon*, 1885. Woodblock print, ink and color on paper, 13 × 9".
Set in a teahouse brothel, a beauty reclines next to a maple leaf screen holding a fan. Tea equipment used in the ceremonial service of geishas is shown in the back left. This richly colored *ukiyo-e* suggests the autumnal season, symbolizing the onset of decline for the beauty.
Private collection.

Shunga: Spring Pictures

Another figural *ukiyo-e* is the **shunga** (spring picture), erotic designs produced by many printmakers including famed artists such as Kitagawa Utamaro (Japanese, 1750–1806), Moronobu (Japanese, d. 1694), and Hokusai. Their *shunga* designs are considered among their finest work, although their names seldom appeared on such prints because government regulations kept many *shunga* from public view. Book reproductions of *shunga* were forbidden until very recently in Japan, but in Europe and America recent publications and major museum exhibitions have now explored the genre.

Shunga illustrated females from the Green Houses and theatrical district teahouses. In typical *shunga* lovemaking scenes, a maid or two might be on hand, and the protagonists were partially clothed, with robes opened strategically to reveal the focus of activity. As might be expected, the usual format of *shunga* is horizontal (Figure 6.15).

Less explicit versions of suggestive prints showing but a glimpse of intimate areas of the body were known as **abuna-e**. These "teasers" were legal and openly published, whereas prints with overt sexual content were usually sold, quite literally, under the counter in print shops.

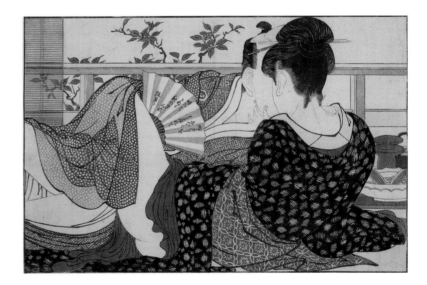

Figure 6.15
Kitagawa Utamaro, *Utamakura* (*Poem of the Pillow*), 1788. Color woodblock-printed album leaf, 10 × 14 ½".
Lovers recline in this tastefully erotic print with only minimal nudity. Note the poem on the fan, which is translated "Its beak caught firmly in the clamshell, the snipe cannot fly away on an autumn evening."[1]
British Museum.

[1]British Museum, *Shunga, sex and pleasure in Japanese art*, https://youtu.be/T9eNggxOu-o

Fukeiga (or *Sansui-e*): The Rise of Landscape Prints

Merchants and bankers often were wealthier than the samurai who were officially socially superior to them. The Tokugawa shoguns and their government watched for signs of unrest caused by societal inequalities, fearing sedition by those with wealth but without real power, as well as insurrection by the poor. In the late eighteenth and early nineteenth centuries, the government imposed sumptuary laws (reforms) to curb conspicuous consumption. Such laws restricted merchants' house elevations, their wives' clothing, and even the sort of art works they patronized. "Big head" prints of actors and women, erotica, and other pictures deemed morally offensive were banned, as well as prints that were extravagantly produced. Consequently, in the early nineteenth century, *ukiyo-e* artists turned to other subject matter such as landscape and bird-and-flower prints less prone to government censure, although still requiring the censor's seal of approval.

While landscape painting had existed previously in Japanese art, those images tended to be abstracted and symbolic, more timeless than based on reality. Landscapes had also been depicted in the backgrounds of *ukiyo-e* prints with some regularity, but rarely as the primary subject matter of prints. Now they emerged as a significant genre.

Another reason landscapes flourished as a subject in this period was that many ordinary people began traveling around Japan, a practice forbidden earlier in the Edo Period by the restrictive Tokugawa government, which had also prohibited commoners from traveling abroad. As governmental restrictions eased, and a system of roads was completed, journeys to pilgrimage sites increased dramatically (Figure 6.16).

Travelers, often on foot, stopped at the many stations along the main roads. Hiroshige completed such a journey in 1832. It inspired his innovative series *53 Stations of the Tōkaidō Road* (Great Eastern Highway; Figure 6.17), and the later *69 Stations of the Kisokaidō Road* (the interior mountainous route between the two cities of Edo and Kyoto).

Picnicking in parks also became a popular activity. This fed the public's appreciation for images of specific vistas with an illusion of depth and scale; and numerous topographical guidebooks, *meisho-ki* (records of famous places), maps, travel fiction, and prints depicting religious or scenic sites were published. In a tradition dating back at least to the ninth century, when some of the earliest Japanese woodblock prints were produced, travelers collected mementos of shrines they had visited. Often these were simple black-and-white prints of shrine figures or architectural features together with the shrine name that would be stamped by the shrine office to authenticate them as mementos of the pilgrims' visits.

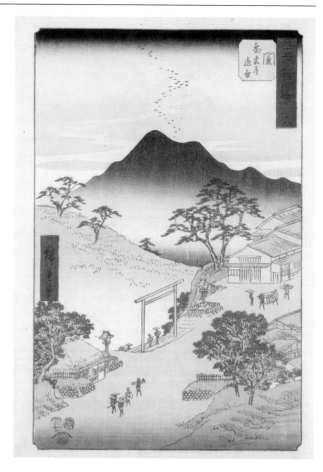

Figure 6.16
Utagawa Hiroshige, "The Junction of the Pilgrim's Road [to Ise], Seki," from the series *Pictures of the Famous Places of the 53 Stations of the Tōkaidō*, 1855. Polychrome wood block print, 13 $^1/_2$ × 8 $^{13}/_{16}$" (plate).
With the building of interior roads and shoreline passages, travel became more common within Japan, making pilgrimages more feasible and popular. Even the remote Ise Shrine, the subject of this print, is said to have received over a million pilgrims in the year 1830. Note: Hiroshige is designated as both Utagawa Hiroshige and Ando Hiroshige.
RISD Museum, Providence. Gift of Marshall H. Gould.

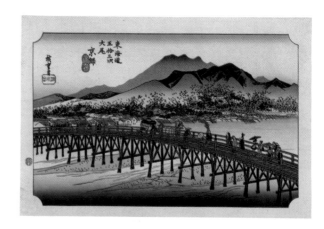

Figure 6.17
Ando Hiroshige, "Keishi," from *53 Stations of the Tōkaidō Road.* (1833–1836, printed later). Woodblock print in ink and color on paper, 8 $^{15}/_{16}$ × 13 $^{13}/_{16}$".
Kyoto was at one end of the Tōkaidō Road, Edo at the other. In this image, pedestrians and porters are walking across the Sanjo Ohashi, a bridge spanning a river near Kyoto. Hiroshige depicts the architecture of the bridge from an imaginary vantage point, a "bird's eye view."
Library of Congress.

Hokusai and Hiroshige were two of the most prolific and imaginative nineteenth-century print illustrators/designers. Both embraced this "new" approach to landscape, adapting the already mature *ukiyo-e* woodblock techniques to create thousands of images. Some **sansui-e** (views) were ambiguously cropped and might employ a variety of perspectives, including a bird's eye view or tilted or peep-hole framing (Figure 6.18).

Fukeiga (pictures of landscapes) depicted particular places and at times incorporated one-point perspective and horizon lines introduced from European book illustrations. It is worth noting that perspectival viewpoints (called *uki-e*) were neither new nor exclusive to landscape and cityscape prints, and were used as early as the eighteenth century to depict built environments such as the full-stage scenes of kabuki. However, systematic, mathematical one-point perspective was an innovation. An example is Hiroshige's "Suruga-cho" from his *One Hundred Famous Views of Edo*, which uses such Western-style perspective to capture two enormous buildings flanking both sides of the street as a symmetrical pathway leading the eye to an ethereally floating Mount Fuji (Figure 6.19).

Ukiyo-e landscapes do not suggest volumetric form through chiaroscuro, the traditional European device of light and shadow. Although there may be a depiction of a moon or candle in *ukiyo-e*, neither casts a shadow (Figure 6.14). Atmospheric effects such as rain and snow primarily marked seasons, but rather than emulating nature, they functioned compositionally as pleasing shapes and textures that enlivened the landscape.

Kacho-e: Birds and Flowers

A fourth major category of classic *ukiyo-e* from both the Edo and succeeding Meiji (1615–1912) periods is **kacho-e** or kacho-ga (traditionally referred to as "bird and flower" prints). This category encompasses images of living but nonhuman beings, including real species (tigers, monkeys, or fish) and invented ones (such as dragons). Auspicious occasions, good fortune, and the cylindrical (sixty-year) cycle were alluded to through the symbolic depiction of natural objects. Other favorite subjects were the twelve months and four seasons. Spring, for instance, implied rejuvenation heralded by plum or cherry blossoms with their pink or white efflorescence signifying energy and renewal, while leafy trees and lotus signified the maturity and abundance of summer. The sweet melancholy of autumn might be symbolized by chrysanthemums, weeping willow, silver reeds, or maple leaves; while nearing the end of one's career or the reality of life's approaching end was suggested by snow or bare pines.

Flowers were often pictorially exploited for emotive purposes, whether illustrated in their fulsomeness, or alternatively, as battered or

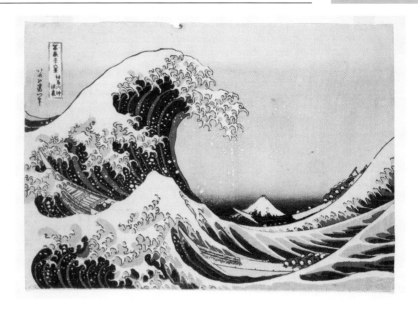

Figure 6.18
Katsushika Hokusai, "Under the well of the great wave off Kanagawa" ("Kanagawa oki nami ura"), from the series *Thirty-six Views of Mount Fuji*, ca. 1829–1833. Polychrome wood block print, 10 1/$_4$ × 14 11/$_{16}$" (image).
This famous composition is widely referenced in popular culture worldwide today.
RISD Museum, Providence. Gift of Mrs. Gustav Radeke.

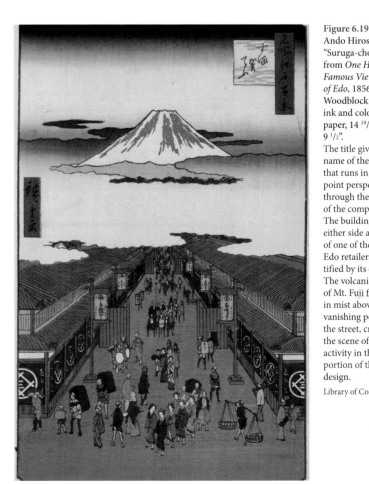

Figure 6.19
Ando Hiroshige, "Suruga-cho," from *One Hundred Famous Views of Edo*, 1856. Woodblock print, ink and color on paper, 14 19/$_{64}$ × 9 1/$_2$".
The title gives the name of the street that runs in one-point perspective through the center of the composition. The buildings on either side are those of one of the largest Edo retailers, identified by its crest. The volcanic cone of Mt. Fuji floats in mist above the vanishing point of the street, crowning the scene of urban activity in the lower portion of the design.
Library of Congress.

fading—emblematic of the declining years of life. The pomegranate symbolized fertility because it is seed-rich, while mandarin ducks, which mate for life, were symbols of marital happiness (Figure 6.20). Produced for a variety of clients and usually in sets of images, *kacho-ga* sometimes included lyrical poetry along with the illustrations (Figure 6.21).

Surimono Prints

Edo Period poetry clubs in Japan, especially those in Kyoto, privately commissioned many notable prints. Before the New Year, clubs would choose two or three members' poems to promote and then hire a print artist to visually depict the mood and content of those poems in the form of **surimono** (literally "printed things")—limited-edition woodcuts. Produced by accomplished artists using the finest materials, *surimono* often included special effects such as applied metallics and **gauffrage** (embossing) and represent the highest order of printmaking.

Figure 6.20
Utagawa Hiroshige, *Mandarin Ducks in Icy Pond* (*Ochiba ni kôrimizu no oshidori*), 1830s. Polychrome wood block print, 14 ⁵/₈ × 5 ¹/₈" (image). The haiku poem translates: *For mandarin ducks, thin ice is a wedding cup, for a thousand years.*[1]
RISD Museum, Providence. Gift of Mrs. John D. Rockefeller, Jr.

[1] Translation by Alfred H. Marks in *Hiroshige: Birds and Flowers*, by Cynthia Bogel, (New York: George Brazillier Publishing, 1988)

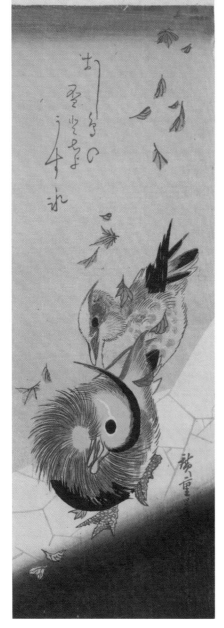

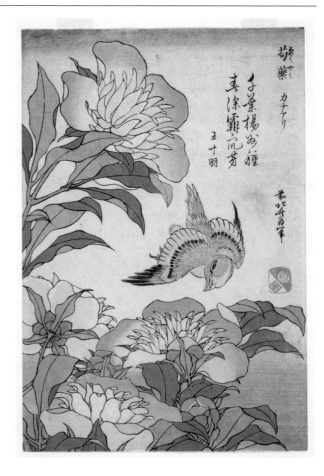

Figure 6.21
Katsushika Hokusai, *Canary and Herbaceous Peony* (*Shakuyaku kanaari*), ca. 1834. Polychrome wood block print, 9 ¹³/₁₆ × 6 ¹³/₁₆" (image).
The calligraphy is elegantly balanced with the illustration of the bird and flowers in this Hokusai print.
RISD Museum, Providence. Gift of Mrs. John D. Rockefeller, Jr.

Ferreting out the symbolic content of *surimono* can be challenging because the meaning was often tied to a culturally layered sort of punning that relied on "pivot words" to create double entendres, or referred back to forgotten events, arcane symbolism, classic literature, and settings that no longer exist. The images themselves were often enigmatic puzzles to be interpreted by the erudite members of these uniquely egalitarian clubs in which artisans, poets, merchants, and samurai could submit poetry using pseudonyms to hide their identities, and thus mitigate class distinctions. The clubs underwrote the luxury printing and sometimes invited "guests" to submit poems—usually accomplished poets, who would not pay to be part of the publication. Images were highly variable and might include *ukiyo-e* themes (beauties, actors, and so on), as well as hidden calendar references, because nongovernment calendar publications were forbidden (Figure 6.22).

Later Nineteenth-Century *Ukiyo-e*

Japan's isolationist ("Closed Door") policy during the Edo Period left it technologically and scientifically behind the West. While Chinese and Dutch foreigners had been residents in discrete regulated areas of southern Japan,

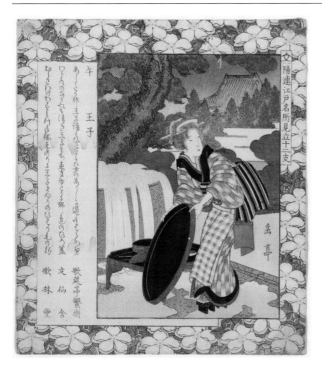

Figure 6.22
Yajima Gogaku, *Uma ōji* (*Year of the Horse: Ōji.*) approx. 1818–1830.
Woodblock print, ink, color, and embellishment on paper, 8 ⁵/₁₆ × 7 ⁷/₁₆".
One of a group of similarly bordered prints, this *surimono* enigmatically
mentions a horse—likely in the context of the zodiac sign—and a famous
shrine near Edo that is also known for its spring.
Library of Congress.

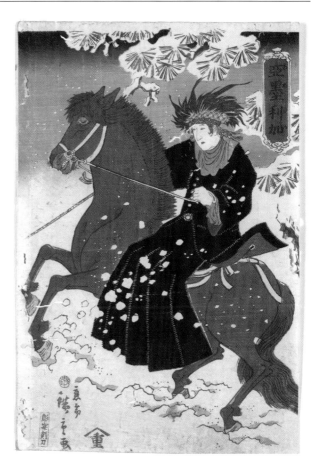

Figure 6.23
Hiroshige II, *Amerika*, 1860. Woodblock print, ink and color on paper,
13 ²⁹/₃₂ × 9 ¹/₂".
From a series of imaginatively depicted foreign women, an American rides a
horse sidesaddle and wears a tobacco leaf headdress denoting her nationality.
Library of Congress.

it was the arrival of American Commodore Perry's
naval expeditions of 1853–1854 and Japan's subsequent
submission to coercive treaties that forced its borders
open. Thereafter, Japan experienced an extraordinary
transformation. **Yokohama-e** (or Yokohama prints) of
the early 1860s reflect this period of transition, often
depicting foreign visitors (Figure 6.23) or celebrating
advances in transportation and urban development. With
the introduction of newly available pigments, Yokohama
prints are often more chromatic than their "Floating
World" antecedents.

The last Edo period shogun, Tokugawa Yoshinobu
(1837–1913), was deposed in 1867, and in 1868 the
young emperor and his court moved from Kyoto to
Edo, which was renamed Tokyo, or "Eastern capital."
The samurai class was abolished, and the term *Meiji*
("Enlightenment") was selected as the imperial reign
name. "Meiji Restoration" (1868–1912) was adopted
to refer to the restoration of power to the emperor, as
opposed to the shoguns. The Meiji government invited in
foreign advisors from diverse technology, manufacturing,
and educational fields who became instrumental in the
rapid transformation of Japan into a modern society. As
Westerners poured into Japan, the government sponsored
showrooms of Japanese products at numerous world's
fairs, and art dealers opened shops selling Japanese art
in European and American cities. This cross-fertilization
spurred the **Japonisme** movement in which European
and American artists and designers adapted Japanese
aesthetics in their own cultural expression. *Ukiyo-e*

pictorial traditions such as flat, uncluttered backgrounds,
inclusion of textile designs, and alternative perspectival
systems greatly influenced certain Impressionists, the
Arts and Crafts Movement, and Art Nouveau (*see Chapter
15*), and later avant-garde art.

Within Japan itself, Meiji era *ukiyo-e* woodblock
printmakers soon had competition from photography
studios and lithographic printers as well as the
proliferation of imagery in illustrated newspaper
publications. Nonetheless, remnants of traditional
ukiyo-e style and subject matter continued. The Sino-
Japanese War (1894–1895) and the Russo-Japanese War
(1904–1905) created demand for battle scenes among
the Japanese population (*see Chapter 21*), and many
newspapers and the government hired print illustrators
to sketch directly on battlefields, or to create interpretive
images from on-site accounts. It is during this period
of modernization and war that the government became
actively involved in print patronage because it wished
to convey its reform measures and military exploits.
Private print production of the Edo period was largely
transformed into government patronage, and for the
first time in Japanese history, the emperor and empress

were not only illustrated but also shown in European-style dress and exhibiting European customs as signs of modernity (Figure 6.24).

As in contemporaneous Victorian art, Meiji Era illustrations were often loaded with detail. Polychrome woodblock images depicted urban spaces with people in European garb or enjoying modern transportation. Most were created in very large editions using aniline dyes that bled through the cheap paper, making them inferior to those created at the zenith of *ukiyo-e*. The woodblock tradition continued into the twentieth century in the **Shin Hanga** ("New Woodblock" [print] School), but it was soon supplanted by faster and cheaper forms of printing.

The Illustrated Book Market in the Edo Period

The Edo book trade was closely related to *ukiyo-e* printing, but book illustration per se can also be said to have evolved from a tradition of sequential narratives found in hand-painted scrolls (*emaki*) dating back to about the sixth century. These scrolls were long, horizontal formats that were unrolled to reveal the narrative, which was typically communicated through text and images. Scrolls printed from wood blocks existed from the eighth century onward using techniques introduced from China. The earliest printed forms were devotional, but secular narratives soon followed, including *monogatari* (romantic tales), *setsuwa* (myths, folk tales, legends), histories of shrines and temples, and biographies of celebrated people.

Early Book Publishing in the Edo Period

When the Tokugawa shogunate moved the political capitol to Edo, the long-standing imperial city Kyoto was left with a concentration of cultural resources formally associated with the imperial court, which included artists

and calligraphers, and collections of historic texts and art created under the former Ashikaga shoguns (1336–1573).

In the vicinity of Kyoto, Honami Kōetsu (Japanese, 1558–1637), an artist, connoisseur, and calligrapher, teamed up with wealthy, literary-minded Suminokura Sōan (Japanese, 1571–1632) to establish a private press at Saga, on the outskirts of Kyoto. Their fine-quality codex formatted books (**Saga-bon**) were printed in small editions, using movable type during its brief moment of popularity from about 1600 to 1640. Thereafter, woodblock printing displaced movable type until the end of the Edo period, when Western methods were adopted.

Of the fewer than twenty *Saga-bon* titles, only four seem to have been illustrated. One of the most well-known works of the press is the *Ise Monogatori* (*Tales of Ise*), a collection of poems that recount the romantic episodes in the life of the central character Nariha, illustrated with many black-and-white illustrations. The *Saga-bon Ise Monogatori* proved so popular that it was reprinted seven times by 1610 (Figure 6.25).

With the increased literacy of the Tokugawa period, book production expanded, and with it came a demand for illustrations. As the audience for books broadened from scholarly patrons to those who were only partially literate, the image-and-text relationship evolved from one in which images were in a subordinate role or closely following the text to one in which images became more interpretive and central to communication. Artist Hishikawa Moronobu (Japanese, d. 1694) is a pivotal figure in the history of Japanese books, and is estimated to have illustrated over

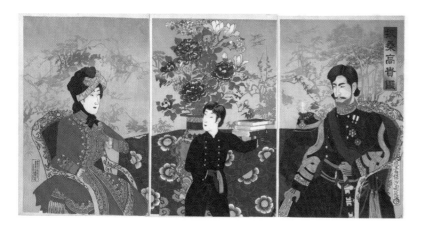

Figure 6.24
Toyohara Chikanobu (Japanese, 1879–1925), *A Mirror of Japan's Nobility: The Emperor Meiji, The Empress, and Prince Haru*, August 8, 1887. Triptych of ink and aniline dye polychrome woodblock prints, 14 ³/₄ × 29 ⁵/₈".
Depicting the Meiji emperor and his family in Western dress, the triptych seeks to project the imperial family at ease with European and American cultural customs.
Gift of Lincoln Kirstein, 1959, Metropolitan Museum of Art.

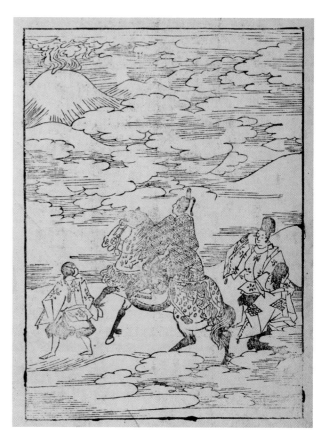

Figure 6.25
Anonymous, *Ise Monogatori*, 1608. Woodblock, 9 ⁷/₈ × 7 ¹/₄" (covers).
In this spatially ambiguous image, Mount Fuji, an iconic symbol of Japan, pokes through the clouds.
University of Cambridge Library.

150 titles between 1672 and 1694. As a highly versatile painter and designer of woodcut imagery, he created diverse subjects including classic tales, themes of *ukiyo-e* daily life, and erotica (Figure 6.26).

The Flourishing of Books in Edo

Many distinguished *ukiyo-e* painters and printmakers became involved in book illustration not only as source of income, but as a way to enhance their reputations. Themes popular in single-sheet *ukiyo-e* prints (kabuki theater and performers, courtesans and activities in the teahouses, and so on) were also popular in books, and publishers who printed both books and single sheets also issued book images as stand-alone prints. Many *ukiyo-e* artists had originally apprenticed to craftsmen in other fields, and so also provided designs for combs, lacquer objects, mirrors, and other commercial items. Their model drawings were often gathered into convenient books to serve as guides for artisanal workshops.

While Kyoto and Osaka remained important cultural centers, Edo became the largest city and book market in Japan by about 1770. As a center of publishing, there were over six hundred lending libraries in the city of Edo by the early nineteenth century, with a market evolved to satisfy specific target audiences: men, women and children, the highly literate, the barely literate, art workshops, and other patrons.

Popular Reading Genres: *Gesaku*

Popular reading in its myriad forms was referred to as **gesaku** (playful compositions), a slightly derisive term when applied by those with higher literary aspirations. Popular book genres included **hanashibon**, compilations of humorous short stories, and **kokkei-bon**, comic

novels. An example of the latter is *Tōkaidōchū Hizakurige* (*Shank's Mare*), a rambling tale of two bumbling fellows walking the Tōkaidō road—the same one Hiroshige made famous through his series *53 Stations of the Tōkaidō Road* (Figure 6.27; see also Figure 6.17).

Kibyoshi and *Aobon*

Kibyoshi (yellow covers) and **aobon** (blue covers) were books of popular fiction named for the color of their covers. *Aobon* were generally geared toward younger audiences or those of lower literacy capabilities, while *kibyoshi* were typically satirical novels set in contemporary Japan, usually for adult audiences. Categorization of these books is irregular not only because of the similarity of narrative content, but because some "blue books" faded as they aged, so the word

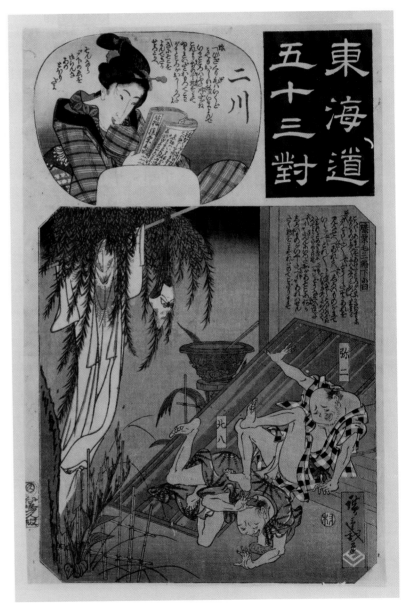

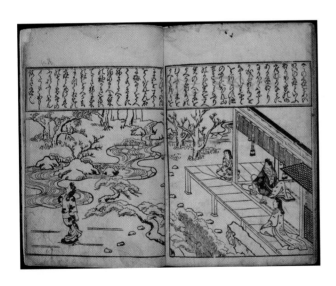

Figure 6.26
Hishikawa Moronobu, (*Hishikawa*) *Tsukiyama no zu niwa zukushi* (*An Account of Landscape Gardening*), 1691. Woodblock printed book, ink on paper, 10 ¹/₂ × 7 ¹³/₆₄" (page).
Moronobu's skillfully modulated line work contrasts the organic masses of the trees and rocks with the regular and precise articulation of the architectural elements.

Museum of Fine Arts, Boston.

Figure 6.27
Ando Hiroshige, *Tōkaidōchū Hizakurige, Footing It Along the Tōkaidō Road* (or *Shank's Mare*), ca. 1845–1846. Woodblock print, ink and color on paper, 14 ¹/₂ × 9 ⁵/₈".
The main image of this print shows the two characters, Yaji and Kita, in a misadventure typical of stories in this comic novel. Having been frightened by a kimono hung to dry in the wind, they realize their error and fall to the ground laughing. The woman in the fan-shaped image is shown avidly reading a soft-covered book similar in format to *Shank's Mare*.

Walters Art Museum, Baltimore.

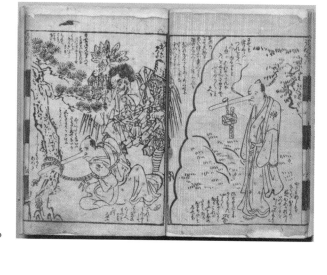

Gokan

Gokan (joined volumes) were multivolume, illustrated, serial fiction, usually issued in sets. *Gokan* were fairly inexpensive despite their often full-color covers and plentiful black-and-white interior illustrations. Individual volumes were not hard cover by today's terms, but were sometimes enclosed in a cover-envelope called a *fukuro*. Their stories sometimes referred to plays currently being performed in kabuki theaters (Figure 6.29), which shows three covers from a set of *gokan* based on the real-life events of beloved kabuki actor Sawamura Tanosuke III.

Gafu, Kyokabon, and Manga

Gafu were printed picture books that translated paintings by masters into woodblock images to be used as models for artists, a tradition adapted from the Chinese, the most famous being the *Kaishien gaden* (*Mustard-Seed Garden Manual*), ca. 1748, (*see Chapter 5*). *Gafu* illustrations were block-printed to simulate painting in color, and examples come in monochrome and polychrome. Sometimes special effects such as a lacquer finish or embossing (gauffrage) might be added. *Gafu* were often published in multivolume formats organized thematically, whereas others were random collections. However, since many *gafu* have been dispersed from their original formats, we have lost the opportunity to see the images in the progression that the artist and publisher intended (Figure 6.30).

Kyokabon were illustrated collections of poetry, which like *surimono*, were put out by private clubs that wrote *kyoka* (playful verse). Often, these were in albums rather than bound formats.

Many artists of stature created imagery for books, with perhaps the most famous being Katsushika Hokusai, best known as an innovative and prolific landscape artist. His

kibyoshi can also mean "yellowed" rather than yellow. *Kibyoshi* were short in length and often printed in a two- or three-volume format. They frequently made reference to contemporary social situations, celebrities (kabuki, poets, writers), and even politics, and are now considered a precursor to modern-day manga (*see Chapter 23*).

Commercial printers continued to use woodblocks rather than movable type because the setting and resetting of the large number of characters in the Japanese written language was more time consuming than the carving of blocks, which could be used, repaired, and copied over and over. Woodblock designs were not constrained to the rectilinear grid layouts required in typographic printings, and *kibyoshi* therefore made use of a variety of integrative text and image designs (Figure 6.28). The prints were hand-rubbed with a **baren** (a bamboo pad used to transfer the ink from the woodblock to the paper) that allowed for subtle tonal variations within shapes or in line work.

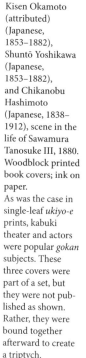

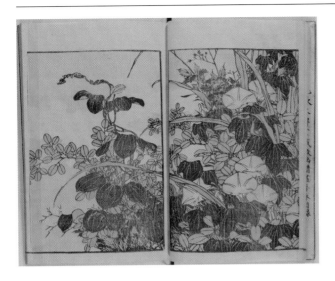

Figure 6.30
Hokusai Gafu, vol. 2, 1849. Woodblock print on paper, 9 $^{11}/_{64}$ × 6 $^{5}/_{16}$".
Bound *gafu* volumes served as painting manuals and were often thematically organized. Double-page spreads can be slightly misaligned because the left-hand page was printed on a separate block from the right-hand page. Each leaf contained two pages that were folded back-to-back and sewn at the center spine.

Freer Gallery of Art, Smithsonian Institution, Washington, DC. Purchase, The Gerhard Pulverer Collection—Charles Lang Freer Endowment, Friends of the Freer and Sackler Galleries and the Harold P. Stem Memorial Fund, in appreciation of Jeffrey P. Cunard and his exemplary service to the Galleries as chair of the Board of Trustees (2003–2007).

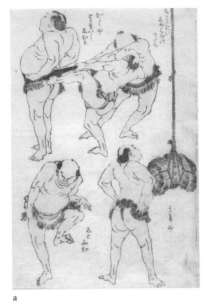
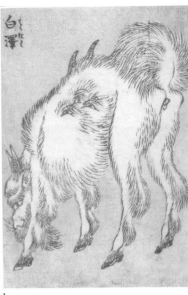

a b

Figure 6.31a, b
Katsushika Hokusai, *Hokusai Manga*, c. 1815. Woodblock printed books, 9 × 6 $^{1}/_{4}$".
Hokusai's hundreds of images served as drawing models for his students. "Sumo Wrestler Training Activities" (a) is one page of a double-spread; White Baku: the "Eater of Bad Dreams" (b) magically sports many eyes and extra horns.

Private collection.

manga (curious or whimsical drawings) series is made up of hundreds of spontaneous sketches collected and composed into pages that were then carved into wood blocks, printed, and bound into books. Hokusai's manga images explore a variety of themes, such as scenes from everyday life, plant and animal studies, and landscapes, as well as fantasy (Figure 6.31a, b). The first volume of *Hokusai Manga* was published in 1814, followed by eleven more published over the course of his lifetime. Capitalizing on the popularity of the series, Hokusai's publishers issued three more volumes after his death. They provide visual records not only of Hokusai's experiences, but of Edo Japan itself.

Kuchi-e

During the Meiji era (1868–1912), mass-produced illustrated frontispieces for romance novels called **kuchi-e** were popular. Intended for female audiences, *kuchi-e* were occasionally inserted into literary magazines, with some printed as lithographs after the advent of Western printing methods in Japan.

During wartime, soldiers became the new male ideal and displaced actors as heroes in popular prints. Grieving widows (Figure 6.32) were the subjects of many popular illustrated novels.

Conclusion

During the isolationist Edo era and into the Meiji Restoration of Japan, literally thousands of *ukiyo-e*, inexpensive single-leaf prints or sets of prints, were produced by hundreds of Japanese illustrators trained through an apprentice system in a highly developed commercial publishing environment. The primary

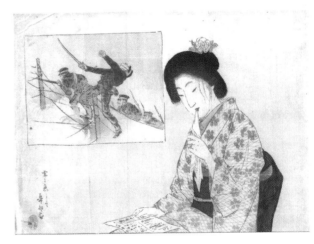

Figure 6.32
Anonymous, *Woman Mourning Her Husband Lost in Battle*, late Meiji Period. Woodblock print, ink and color on paper. The combination of the traditionally dressed Japanese woman and the man in a European style of uniform becomes common in this period—a sign of European and American influences in newly accessible Japan.

Private collection.

audience for *ukiyo-e* was a politically disenfranchised merchant class who favored images of the beauty and artifice of their cultural refuge, referred to as the "Floating World."

Book publishing of the period included genres ranging from classic tales to unsophisticated popular reading. Sharing many of the artistic qualities of *ukiyo-e* prints, Edo period book publishers steadfastly used woodblock printing techniques that allowed a dynamic relationship between image and text. With the termination of Japan's isolationist policies, new forms of printing infiltrated from the West, and woodblock printing declined. *Ukiyo-e* prints with their flattened presentation of forms and space, elegant line work, and selective palettes are acknowledged as the apogee of polychrome woodblock printing, and were a major influence in late-nineteenth-century European and American art.

KEY TERMS

abuna-e	*manga*
aobon	*mie*
baren	*mitate-e*
bijin-ga	*mon*
bunraku	*monogatari*
cultural capital	*nishiki-e*
emaki	*nō*
field of cultural	*oban*
production	*okubi-e*
fukeiga	*onnagata*
gafu	**readymade**
gauffrage	*ronin*
gesaku	*Saga-bon*
go	*sansui-e*
gokan	*setsuwa*
hanashibon	*shibai-e*
Japonisme	**Shin Hanga**
kabuki	*shunga*
kacho-e or *kacho-ga*	*surimono*
kibyoshi	*ukiyo-e*
kokkei-bon	*yakusha-e*
kuchi-e	*Yokohama-e*
kyokabon	

FURTHER READING

Guth, Christine M. E., Alicia Volk, Emiko Yamanishi, et al., *Japan and Paris: Impressionism, Postimpressionism and the Modern Era* (Honolulu: Honolulu Academy of the Arts, 2004).

Marks, Andeas, *Japanese Woodblock Prints: Artists, Publishers and Masterworks, 1680–1900* (North Clarendon, VT: Tuttle Publishing, 2010).

Morse, Anne Nishimura, ed., *Drama and Desire: Japanese Paintings from the Floating World, 1690–1850* (Boston: Museum of Fine Arts, 2007).

Reigle, Amy Newland, ed., *The Commercial and Cultural Climate of Japanese Printmaking* (Amsterdam: Hotei Publishing, 2004).

Salter, Rebecca, *Japanese Woodblock Printing* (Honolulu: University of Hawaii Press, 2002).

Appendix: *Ukiyo-e* Web Resources

www.artelino.com
Ukiyo-e articles and signatures

www.barenforum.org
Technical information on woodblock print process

www.chikanobu.com
Reproductions of series images by this artist

www.hanga.com/sizes.cfm
Sizes and format information

www.hiroshige.org.uk
Comprehensive illustrated list of Hiroshige series

www.hiroshigeii.net
Catalogue raisonné of Utagawa Hiroshige II prints

www.intermonet.com/japan/
Analysis of Monet's interpretations of Japanese aesthetics

www.japansociety.org.uk/329631/japonisme-cortazzi/
Juxtaposition of Japanese woodblock prints and European art, including Hiroshige and Manet

www.kabuki21.com
Comprehensive list of kabuki plays and actors

koikoikoi.com.2009/11/old-japan-in-stereoview/
Many stereo view photographs illustrating aspects of late nineteenth-century Japan

www.kunisada.de
Approximately 4,500 illustrated prints, by series

www.kuniyoshiproject.com
Chushingura prints

www.myjapanesehanga.com
Alphabetized illustrated print resource

osakaprints.com

www.yale.edu/ynhti/curriculum/units/1982/4/82.04.03.x.html
The Yale New Haven Teachers Institute's detailed study guide discussing the influences of *Ukiyo-e* on late nineteenth- and early twentieth-century French art)

www.yoshitoshi.net
Catalogue raisonné of the work of Tsukioka Yoshitoshi

7

Illustration in Latin America, Pre-Columbian Era–1950

Maya Stanfield-Mazzi

with contributions by R.W. Lovejoy

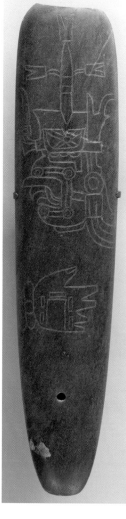

Figure 7.1
Olmec Culture, *Jade Celt with Carving of the Maize Deity*, Mexico, 800–300 BCE. Greenstone, 14 3/8 × 3 1/8".
The maize deity appears in profile with a heavily lidded eye and a maize plant sprouting from his head. His mouth is shown surrounded by four round jade beads, and the mouth itself seems to sprout maize shoots.
Metropolitan Museum of Art.

Since very ancient times, peoples of the region known today as Latin America created illustrations to communicate ideas about the world around them. Their illustrations showed ways of conceptualizing the universe in time and space, explained religious concepts, and told sacred stories. These pictures expressed ways of thinking about sovereignty, from the divine nature of kings to the forms of democracy aspired to after the region gained independence from European powers. Often in Latin America, illustration was the primary mode for expressing ideas, since it was used by societies without writing. On the other hand, sometimes illustration coexisted with writing in ways unique to the region. This chapter is arranged chronologically and considers illustrations from a variety of mediums, all of which respond to the concerns listed here.

The Pre-Columbian Era

Native peoples of the Americas arrived in the Western Hemisphere thousands of years ago. As in other world regions, the earliest surviving illustrations are cave paintings that relate to the hunter-gatherer lifestyle that predated settled societies.

As ancient peoples settled and began to practice agriculture, societies developed religious beliefs that were expressed through illustration. The Olmec civilization of ancient Mexico, located in the tropical lands bordering the Gulf of Mexico, developed a unique religious ideology. Farmers produced enough maize (corn) so that certain individuals were able to increase their status by trading their stores for other valuables. Central to the Olmec religion were water and maize deities, and artifacts were sculpted that referred to these supernatural beings. Greenstone **celts**, so named because they are shaped to evoke the form of axe heads, represented ears of green corn and were exchanged as valuables.

Often these celts were sculpted or incised with images of the maize deity himself. One shows a laboriously incised image of the maize deity's head in profile (Figure 7.1). Appearing mainly as a human head with ear ornaments and headdress, the divinity has a wide-lipped, open mouth, and a maize plant sprouts from his head. Not all celts were incised, but many show similar maize-related imagery.

A separate religious tradition that emerged in the Peruvian Andes, centered at the site of Chavín de Huántar, featured religious specialists who claimed to be able to commune with formidable supernatural creatures, including felines and raptorial birds.

The second temple built at Chavín had multiple overhanging stone cornices with low relief carvings (Figure 7.2). They show creatures with mixed human and animal features, perhaps representing the beings the priests were able to transform into with the assistance of hallucinogens. Chavín developed into an important pilgrimage site, and presumably images such as that on the cornice helped visitors visualize the mental processes experienced by the religious specialists.

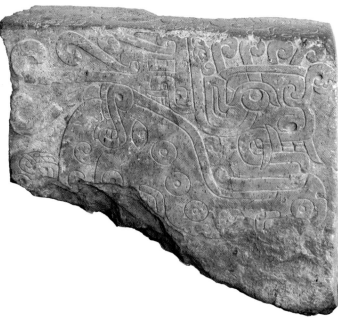

Figure 7.2
Chavín culture, *Cornice Fragment with Supernatural Creature*, Chavín de Huantar, Peru, 700–500 BCE. Stone, approx. 27 1/2 × 27 1/2 × 5 9/10".
The figure carved on the underside of this cornice, which would have been visible to viewers walking along the outside of the temple, shows a creature with human and animal characteristics. The profile face is somewhat human, except for the large fangs and wide grimacing mouth. The figure's body has spots and seems to take the form of a snake, and has other toothy mouths attached to it.
Museo Nacional de Chavín, Photograph by Maya Stanfield-Mazzi.

A civilization that developed in Peru's southern coastal valleys created elaborate cloth imagery that also shows humans with animal characteristics but is thought to have had a different meaning due to its funerary context (Figures 7.3a, b). The mummies of the Paracas people, found interred on the desert peninsula of the same name, were shrouded in multiple layers of camelid-fiber textiles with **embroidery** (decorations sewn using colorful thread). Each textile piece features a repeating motif of a human with animal or plant characteristics. Comparing motifs across textiles, scholars now think they represent the sequential process of the dead's transformation into revered and life-giving ancestors. Figures that represent more advanced ancestors, as opposed to the recently deceased, appear with the characteristics of predatory animals and are feeding on the bodies of the recent dead. While many Andean civilizations are thought to have honored deceased ancestors, Paracas embroideries illustrate a unique and complex ideology of the afterlife.

The Moche society of coastal northern Peru (1–750 CE) also developed a complex religious ideology, which held that human sacrifice was necessary to maintain the balance of the natural world. A principal narrative culminated in the Sacrifice Ceremony, shown in its detailed form as a fineline painting wrapping around the chamber of a ceramic vessel (Figure 7.4).

This image is arranged in two registers that suggest the upper and lower platforms of a pyramid-temple. On the lower level, we see a vacant litter followed by two elaborately dressed figures that reach into, and likely draw blood from, the necks of two nude, bound prisoners. On the upper level, a procession of bedecked figures moving from right to left converges on a large

a

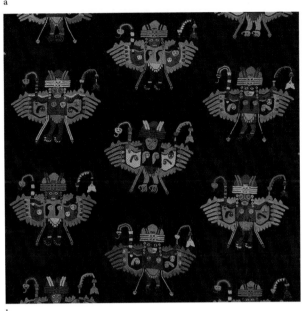

b

Figure 7.3a, b
Paracas culture, *Embroidered Man's Mantle with Bird-Human Figures*, Paracas, Peru, 50–100 CE. Camelid fiber, 39 3/4 × 96 3/16".
This large mantle was wrapped around a mummy in the Paracas cemetery known as the Necropolis, likely accompanied by a matching skirt. Embroidered onto a dark blue ground cloth are figures of humans with outstretched bird wings, arrayed in staggered columns. A border of similar figures, embroidered with a yellow background, was added to the edges of the cloth. The mantle's figures display an upright stance and human clothing and adornments. But their outstretched wings and bird-like feet suggest their transformation into predatory ancestors, as do the small, disembodied heads on their wings and chests, symbolizing their life-taking and life-giving potential.

Museum of Fine Arts, Boston. Denman Waldo Ross Collection.

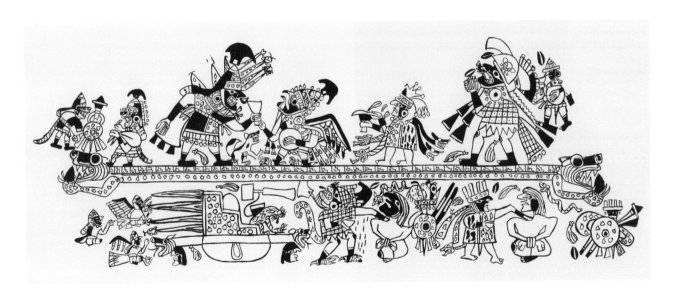

Figure 7.4
Moche culture, *Sacrifice Ceremony*, Rollout drawing of painted scene on stirrup spout bottle, Peru, ca. 300–600 CE. Ceramic with pre-fire slip.
In the lower register of this complex scene representing a post-battle ritual ceremony, two bound prisoners are bled, their bundles of weapons placed to their sides. A litter at the lower left was probably the conveyance for the main figure at the top left, the "Warrior Priest" who receives a sacred goblet.
Drawing by Donna McClelland. PH.PC.001, Christopher B. Donnan and Donna McClelland Moche Archive, Image Collections and Fieldwork Archives, Dumbarton Oaks, Trustees for Harvard University, Washington, DC.

personage wearing a crescent-shaped headdress. This figure appears to accept a goblet, which scholars assume contains the blood of the slain prisoners meant as a ritual offering to the gods. Smaller floating figures depict other participants and plants thought to have had ritual significance. Archaeologists have found that Moche elites were buried in regalia similar to that depicted on these figures, who may have acted in life as representatives of the gods, in charge of maintaining worldly order. Other, simpler Moche works focus on small aspects of important narratives and to educated viewers would have cued the stories in their entirety (Figure 7.5).

Created in three dimensions as a ceramic vessel, the piece in Figure 7.5 shows a puma attacking the neck of a prisoner whose hands are bound. It is a three-dimensional depiction of the lower-central scene of the Sacrifice Ceremony (Figure 7.4), where a warrior with feline qualities (including a spotted tail) bleeds a prisoner. The sleek naturalism of the piece may have appealed to all viewers, whether or not they understood the entire narrative.

While Moche art is our main source for understanding that culture's stories, other Pre-Columbian civilizations had stand-alone writing systems that were used to document mythology and history. In addition, the myths of some people were written in alphabetic writing shortly after Europeans arrived in the Americas. The Maya civilization of ancient Central America developed a complex system of **hieroglyphs** with a phonetic basis. While most of the surviving glyphic texts refer to historical events, others documented myths such as the story of the Hero Twins, which after the Spanish Conquest was converted to alphabetic writing and is known as the *Popol Vuh*. Ceramic vessels made during

the height of Maya civilization (ca. 600–800 CE), which include hieroglyphic texts along their rims, also illustrate scenes from the *Popol Vuh*, thus demonstrating that its stories were being told centuries before the account was written in its surviving form (Figure 7.6).

The example in this figure shows a key stage in the narrative and is reproduced as a detail of a **rollout photograph**, a method for capturing all of the original cylindrical vessel in a two-dimensional format. The story centers on the exploits of two divine youths known as the Hero Twins, Hunahpu and Xbalanque. Their father was defeated by death gods in the dank underworld known as Xibalba, and the Twins return to avenge his death. This scene shows the arrival of one of the twins in Xibalba, who appears in profile as an idealized Maya youth. His conveyance is the snout of an open-mouthed serpent with a white X on its eye, its upper jaw extending vertically like a platform. Other open-mouthed serpents, their tendriled heads shown in profile, appear around the scene to underscore its otherworldly qualities. To the left appears one of the owls the death gods used as messengers to call the Twins to Xibalba, shown with its head sliced off. The black background suggests the underworld setting, as do the twisted white cords, since Xibalba was a tangled, knotty place. The death gods, rendered as old men with blank eyes, gesture menacingly to the twin. Ultimately, the Hero Twins outsmart the death gods, resurrect their father, and become the sun and moon. The hieroglyphs in the scene, arranged on white panels, may have simply named the creator and owner of the vessel while the pictures describe a rich episode in the great Maya epic.

The Maya may have written and illustrated stories such as the *Popol Vuh* on fig bark paper or deer hide, but few Maya manuscripts survive. Other cultures of Mexico such as the Mixtec (ca. 1300–1520 CE) also had traditions of works on paper painted with mineral and vegetable pigments. Several manuscripts that survive were made in central Mexico in the decades before the Spanish Conquest. Much of the focus of these books

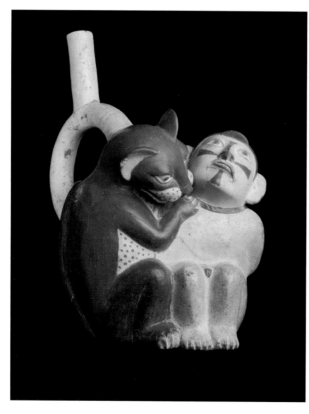

Figure 7.5
Moche culture, *Bottle with Puma Attacking Prisoner*, Peru, 400–600 CE. Ceramic with pre-fire slip, 10 ⁵/₈ × 8 ¹/₄ × 7 ¹/₂". This "stirrup-spout" vessel, the main form for Moche works of art, is sculpted in the shape of a puma about to sink his teeth into the neck of a human prisoner. The man's hands are bound behind his back, and he looks upward with an anguished expression. The puma may represent a Moche warrior, like the one at bottom center in the *Sacrifice Ceremony* in Figure 7.4.

© President and Fellows of Harvard College, Peabody Museum of Archaeology and Ethnology, PM# 16-62-30/F727.

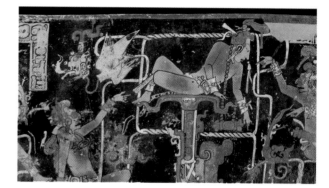

Figure 7.6
Maya culture, *A Hero Twin's Descent into Xibalba*, Motul de San José area, El Petén, Guatemala, 600–800 CE. Rollout photograph of ceramic vase with pre-fire slip, 8 ⁷/₈ × 4 ³/₄".
This scene shows the beginning of the central narrative of the *Popol Vuh*, in which the Hero Twins descend to the underworld to defeat the death gods and avenge the death of their father. Here, the first twin, Xbalanque, arrives, nearly nude but wearing a jaguar tail that cues his name since *balan* means "jaguar" in the K'iche language.

Museum of Fine Arts Boston, rollout photo by Justin Kerr. Gift of Landon T. Clay.

was calendrical and astronomical, and they provided priests with the means to link the mundane world with the wider cosmos. A series of pages in the Central Mexican manuscript known as the *Codex Borgia* illustrate astronomical events of the year 1496, correlating them with the various calendars in use at the time (Figure 7.7).

This page refers to a solar eclipse, which may correspond to one that occurred on August 8, 1496. A spiked yellow disk at upper center represents the sun, which is attacked by an avatar of the planet Venus. The avatar plunges a knife into the sun, causing blood to gush out. The disk is located over the torso of a splayed and black-painted human figure, which is the embodiment of the shared darkening of the earth and sun during the eclipse. Smaller disks on this being's wrists and knees are also attacked by Venus figures, since the planet Venus appeared in the sky during the eclipse and was thus believed to have caused the event. In the lower section, various cosmic deities interact in reference to other astronomical events. Symbols enclosed in red squares along the outer edges mark the day signs of the calendrical period in which the eclipse occurred.

Shortly after this manuscript was painted, a series of man-made but equally world-changing events occurred due to the arrival of Europeans in the Americas. Known most simply as the Spanish Conquest, the arrival of Europeans in Latin America caused major depopulation and the destruction of traditional ways of life. It also led to a new world view with altered approaches to image making, including new forms of illustration.

The Colonial Era

Although referred to as the Spanish Conquest, the defeat of the great civilizations of the Americas, especially the Aztec and Inca empires, was due in large part to the participation of native people who allied with the Spaniards. Native people also participated in the remaking of society after colonization, developing many culturally mixed, or hybrid, art forms (*see Theme Box 13, "Hall: Encoding, Decoding, Transcoding"*). Illustrations communicated responses to the evolving colonial situation and expressed ideas related to the new Catholic faith, brought by the Spanish.

Manuscripts and Maps

The Mexican manuscript tradition remained strong throughout the sixteenth century. While many traditional manuscript genres survived, others were adapted to satisfy Spanish eyes. A type of historical manuscript characterized as the event-based history was adapted to tell the events of the Conquest of Mexico in 1521 (Figure 7.8). This scene from the *Codex Azcatitlan*, whose earlier sections recount events in the history of the Aztec Empire, depicts the Spanish army, using a mix of European and Aztec conventions.

The figures appear primarily in profile, and a standardized mode of representing Spanish soldiers in armor is employed. But some of the key actors in the

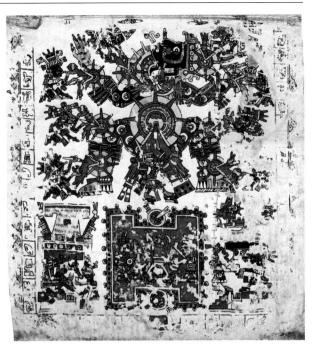

Figure 7.7
Mixtec culture, "Venus Causes a Solar Eclipse," *Codex Borgia*, Puebla-Tlaxcala Valley, Mexico, ca. 1500 CE. Pigment on animal hide, 10 ¹⁄₂ × 10 ¹⁄₂" (sheet).
This scene depicts a solar eclipse that occurred in 1496 and attributes its cause to the planet Venus. The sun is shown as a series of yellow spiked disks (the largest at top center), which is attacked with knives by manifestations of Venus, shown as black- and gray-painted men.
Photograph ©Susan Milbrath.

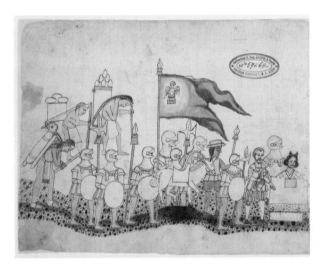

Figure 7.8
Anonymous, "Spanish Conquistadors and Their Native Supporters," *Codex Azcatitlan*, Mexico, ca. 1550–1600 CE. Ink and watercolor on paper, 9 ¹⁄₂ × 11" (sheet).
The painter carefully depicted the details of the Spanish conquistadors' armor, following the Aztec practice of using elements of dress to identify figures. Cortés's translator Malintzin, at right, wears a wide *huipil* (the long tunic worn by Mesoamerican women) and the tufted hairstyle popular among Aztec women.
Bibliothèque Nationale de France. Photograph courtesy of Art Resource.

event are rendered in portrait-like detail, especially Hernán Cortés, with blonde hair and beard at right. He is accompanied by his indigenous translator Malintzin (known also as La Malinche), wearing the hairstyle and garments typical of elite Mexican women. Other native support for the expedition is evident in the Mexican porters, who carry a variety of foodstuffs, including a turkey. The second figure behind Cortés is the dark-skinned Juan Garrido, an African-Spanish conquistador. The figures walk along a ground covered in evenly dispersed black rocks, evoking the volcanic landscape surrounding the Aztec capital of Tenochtitlán, later to become Mexico City. The

undulating ground and the use of overlapping, both meant to indicate spatial relationships, are European introductions. But the placement of two native porters above the figures at left, with no reduction in size even though they are located further away from the viewer, follows Aztec tradition and gives those figures importance in the narrative.

As Spain took control of much of Central and South America, establishing the Viceroyalties of New Spain and Peru, the monarchy wished to catalogue the new territories to fully understand their potential. In 1579 King Philip II asked the leaders of each viceroyalty to supply reports on the communities now under the empire's control. Unlike in most other regions where the request was made, the reports made in Mexico often included maps painted by native artists, presumably trained in the local manuscript painting craft. A beautifully painted map on European paper presents the community of Guaxtepec, "place of the *huaxin* plants" (Figure 7.9).

The native way of marking the community's name is located at center, where a feathery *huaxin* plant emerges from a stylized mountain, the glyph for "town." Yet above this symbol is a new introduction that also marks the community center, a Christian church in a European architectural style. Small churches with bells are also used to indicate surrounding communities, which are further qualified by legends in alphabetic writing. In this map, Mexican and European illustrative modes coexist. Rivers and springs are shown with conventional water patterns and tipped with green and red "beads" symbolizing vitality and preciousness, similar to those on the depiction of the maize god incised on the celt in Figure 7.1. A coiled snake next to one of the springs at upper left must be a pictograph for the feature, but it was also identified in cursive writing by the Spanish scribe Hernán García Ruiz, as was the spring further to the left. Naturalistic, European-style trees line the riverbanks, and topographical mountains are painted in a manner very different from the stylized mountain of the place name.

A similar documentary project was undertaken by a Franciscan friar in Mexico, as part of the large-scale Spanish missionary effort to eradicate native Mexican religion and replace it with the Christian faith. Known today as the *Florentine Codex*, after its repository in Italy, Fray Bernardino de Sahagún, with indigenous informants and artists, created the first encyclopedia of the Americas (Figure 7.10).

Written as twelve books (now gathered in three volumes), the encyclopedia gives information about the belief systems, culture, and natural world of the

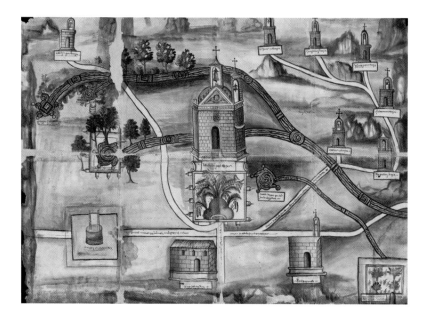

Figure 7.9
Anonymous, *Map of Guaxtepec*, Mexico, 1580. Ink and watercolor on paper, 24 × 33 ¹/₂".
The town of Guaxtepec is shown with a Renaissance-style church whose front courtyard encloses the native glyph naming the town. Christian churches mark the surrounding hamlets, connected by roads. A ranch with a horse corral appears at lower left, and natural features such as springs, rivers, and mountains are also shown.
Nettie Lee Benson Latin American Collection, University of Texas Libraries, The University of Texas at Austin.

Figure 7.10
Fray Bernardino de Sahagún and others, "Mexican Eagles," *Florentine Codex*, vol. 3, page 410, Mexico, 1577. Ink and watercolor on paper, 8 ¹/₃ × 12 ¹/₄".
On this page from the eleventh book, three framed pictures running parallel to the Nahuatl text show the hunting and nesting habits of Mexican falcons, and how the falcons were trained by humans wearing bird masks.
Biblioteca Medicea Laurenziana, Florence. Photograph courtesy of Art Resource.

Aztecs. The eleventh book on "earthly things" is an early natural history, enumerating the flora and fauna, minerals, and colors of the Aztec world. The twelfth book is a history of the Spanish Conquest. Handwritten pages present parallel columns of Nahuatl and Spanish text, interspersed with 2,468 color painted illustrations created by Nahua students at the College of Santa Cruz in Tlatelolco. Apart from still serving as an essential information source on ancient life in Mexico, these paintings show how indigenous artists assimilated European pictorial modes while retaining elements from Mexican painting traditions. A scene from the tenth book on vices and virtues (Figure 7.11) illustrates a good doctor or wise man. Set within a Renaissance structure, two men in native dress face each other, the left figure drinking liquid from a cup. The doctor, at right, is shown giving good advice by the bead-tipped scrolls that emerge from his mouth, **speech scrolls** being an Aztec convention to suggest sound or dialogue.

In South America, there had not been a tradition of recording information in writing; rather, in the Inca empire, information was codified in knotted cords known as *quipus*. Nevertheless, after the Conquest, the indigenous Peruvian Felipe Guaman Poma de Ayala (Peruvian, ca. 1535–after 1616) learned to read and write in Spanish and created a massive hand-illustrated book following the example of European histories illustrated with woodcut prints. Nearly as comprehensive as the *Florentine Codex*, the *Nueva corónica y buen gobierno* (*New Chronicle and Good Government*) first features a history of the Andes prior to the Spanish Conquest. It then presents a sweeping survey of life in the colonial Andes, intended in large part as a critique of Spanish government (Figure 7.12).

Guaman Poma's full-page illustrations, interspersed between pages of handwritten text, expressively convey the injustices of colonial rule. He hoped his *Chronicle* would be read by the king in Spain, the only person he felt could right the wrongs done to his people. While it is doubtful that a Spanish king ever read it, the manuscript did make its way to Europe and is now a trove of information on Andean life and history.

Christian Influences in Narrative and Informational Images

The Spanish conquistadors arrived with banners bearing the images of the Catholic faith (Figure 7.8), and soon religious brothers assumed the task of converting native peoples to Christianity. In the following centuries, the great majority of illustrations were intended to convey the stories of the Bible, events in the lives of saints, and central features of Catholic dogma. Artists worked in highly realistic, dramatic styles, creating paintings and sculptures meant to incite viewers to experience, for instance, the suffering of Christ on the cross. Many locally made statues began to attract devotees and were attributed with working miracles, thus creating newly

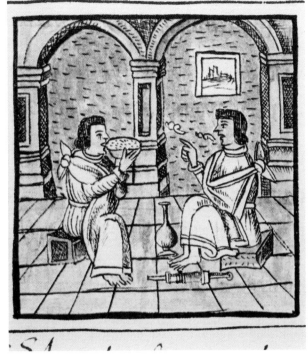

Figure 7.11
Fray Bernardino de Sahagún and others, "The Good Doctor," *Florentine Codex*, vol. 3, page 54, Mexico, 1577. Ink and watercolor on paper, full page 8 1/3 × 12 1/4". In this scene, the painter employed Renaissance one-point perspective, indicated by the converging lines of the tiles on the floor, but the figures are in the profile seated poses commonly seen in Aztec manuscripts.

Biblioteca Medicea Laurenziana, Florence. Photograph courtesy of Art Resource.

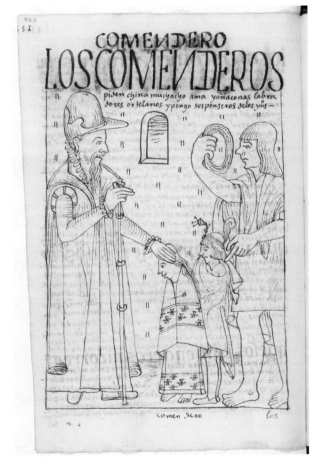

Figure 7.12
Felipe Guaman Poma de Ayala, "A Spanish *Encomendero* Demands Many Native Servants," *Nueva corónica y buen gobierno* (*New Chronicle and Good Government*), page 551 [565], Peru, ca. 1615. Ink on paper, 8 × 5 1/2". In this full-page illustration from the chapter on *encomenderos*, or Spanish land grantees, a richly dressed *encomendero* at left claims two servants from a native overseer holding a coiled rope. Guaman Poma depicted the servants as children in noble dress, thus suggesting the unfairness of colonial rule.

Royal Library of Copenhagen.

Latin American Christian histories (Figure 7.13). As oil painting developed along with sculpture to illustrate the tenets of Christianity, painters developed the **ex-voto** painting form, intended to narrate the stories of these miracles. One large painting from the Cathedral of Cusco illustrates the founding miracle of the cult to a statue in the Cathedral known as Christ of the Earthquakes. It was believed that after a major earthquake struck in 1650, aftershocks continued to destroy the city until the statue was taken out in procession. The painting illustrates this event, showing the city falling to ruins while in the main plaza a throng of people gathers around a statue of Christ Crucified.

Curiously, the painting's inscription tells a slightly different story, in which a painting of the Virgin Mary brought to the city by the Spaniard Alonso Cortés de Monroy (portrayed at lower right) was brought onto the Cathedral steps to assist. That miraculous intercession is indicated by the heavenly scene at upper left, where Mary pleads with Christ and God the Father to help the city. This painting thus presents two alternate miracle narratives, but the visual narrative of Christ of the Earthquakes' assistance was the one that came to be commonly believed. Like the *Map of Guaxtepec* (Figure 7.9), this work manifests a colonial desire to document and claim the new territories of Spanish America, in this case by placing Spain's coat of arms triumphantly on the horizon. At the same time, the painting illustrates the importance of Christianity in the colonial territory.

Other paintings from colonial Latin America further illustrate societies' engagements with the new religion. A series of paintings also from Cusco, the former Inca capital, displays the participation of Inca descendants in the feast of Corpus Christi—the Catholic festival dedicated to the body of Christ (Figure 7.14). The works are associated with Basilio de Santa Cruz Pumacallao (Peruvian, 1635–1710), a leading artist of the indigenous painting movement known as the Cusco School.

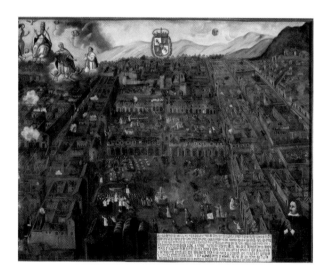

Figure 7.13
Anonymous, *Cusco during the Earthquake of 1650 with Donor Alonso Cortés de Monroy*, Cusco, Peru, ca. 1670. Cathedral of Cusco, Peru. Oil on canvas, 131 ¹/₂ × 182".
This painting faithfully renders the city of Cusco during the earthquake of 1650, while setting the event in a Christian cosmic frame. The city's three main plazas appear down the center of the scene, and people take refuge in them, escaping from crumbling buildings.
Photograph ©Raul Montero.

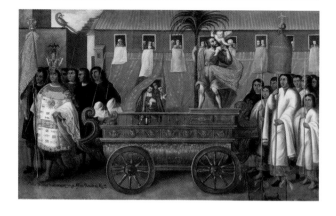

Figure 7.14
Circle of Basilio de Santa Cruz Pumacallao, *The Parish of Saint Christopher*, Cusco, Peru, ca. 1675–1680. Museo de Arte Religioso, Palacio Arzobispal, Cusco, Peru. Oil on canvas, 49 ¹/₂ × 86 ¹/₂".
The statue of Saint Christopher, shown in red and green robes and holding the Christ Child, is depicted astride a fancy wooden processional cart for the festival of Corpus Christi. Carts such as this were nonexistent in Cusco, but painters had seen them in prints imported from Spain and so added this imaginary aspect to their depictions of the Cusco festival.
Photograph ©Raul Montero.

Intended to celebrate the triumph of Christianity over other religions, in Cusco the pageantry developed in ways that allowed Inca descendants to display aspects of their heritage. In this work, members of the Parish of Saint Christopher, a neighborhood of Cusco in which many Inca descendants were forced to resettle, parade their titular statue of the saint to the city's cathedral. At left is portrayed the royal standard bearer Don Carlos Huayna Capac Inca, in full Inca attire with colonial flourishes such as lace sleeves. The artist was careful to render this man accurately, including showing him missing an eye. A large parrot perches on a building directly above Don Carlos, serving to highlight his status. This series of paintings shows the city's inhabitants celebrating the festival in a wholehearted manner, bright cloths hanging from their balconies for the occasion.

In Mexico, Catholicism developed in its own unique ways, especially around the painted image of the Virgin Mary known as the Virgin of Guadalupe (Figure 7.15). The original image is believed to have appeared miraculously on the cloak of a native Mexican (Nahua) man named Juan Diego in 1531. The fame of the image spread, as did the narrative of the miracle, and in 1895 Guadalupe was named patroness of Mexico and the Americas. In this work created nearly two centuries after the appearance, the painter Manuel Arellano (Mexican, ca. 1662–1722) replicated the archetype and surrounded it with flowers and four scenes depicting the events leading to the central miracle. At upper left, Juan Diego, accompanied by angels, perceives a vision of Mary at the rural site of Tepeyac near Mexico City, asking him to build a shrine in her honor. At upper right, Juan Diego returns to the Virgin Mary to explain he has not found support for the construction, and she asks him to try again. He returns a third time (seen at lower left), and the Virgin miraculously provides him with a pile of roses to take to the archbishop. At lower right is the central miracle, in which Juan Diego spills the roses from his cloak, and the image of Mary is miraculously revealed on it, to the astonishment of the church officials. An

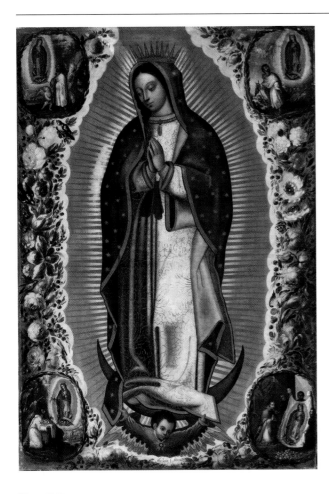

Figure 7.15
Manuel Arellano, *Virgin of Guadalupe*, Mexico, 1691. Oil on canvas, 71 7/16 × 48 9/16".
This large-scale painting features a copy of the original image known as the Virgin of Guadalupe in the middle, and tells the story of its appearance in four smaller scenes. The main characters in the narrative are the Virgin Mary, who appears virtually the same in every scene, and the native Mexican man Juan Diego, on whose cloak the image of Mary is believed to have appeared. The same rendition of the Virgin of Guadalupe would circulate for centuries in devotional paintings and prints.
Los Angeles County Museum of Art.

inscription above Arellano's signature says this replica was "touched to the original," meaning it was closely based on the original painting and was thus more holy.

Illustrative Taxonomies

As societal observers noted disturbing changes in the social hierarchies that had prevailed since the Conquest, the Spanish crown instituted many staunch reforms in its colonies during the eighteenth century. In Mexico, painters were commissioned to address the issue of racial mixing, a theme that they developed into the unique genre known as **casta painting**, which depicts Mexico's different racial "castes" (Figure 7.16).

Generally created as a series of fourteen to sixteen canvases, the works depict couples of varied racial backgrounds with their children. Labels assign racialized terms to each parent and their offspring. In this work, a Spanish (white) man is shown with an Afro-Mexican (black) woman, and their child is labeled as a *mulatto*. Created by Mexico's most skilled painters, these lush paintings showcase the cultural variety of Mexico, including evidence of class, such as rich textiles, tobacco (here the child helps his father light a cigarette), and

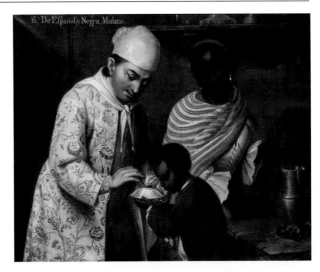

Figure 7.16
José de Alcíbar (attributed), *From Spaniard and Black, Mulatto*, Mexico, ca. 1760. Oil on canvas, 30 5/8 × 38 3/4".
This painting, labeled as number six in a *casta* series, shows a Spanish man and a black woman with their child, named as a *mulatto*. The richness of Mexico is suggested by the local luxuries of tobacco and chocolate, as well as the fineness of the imported clothing the family wears.
Denver Art Museum Collection: Gift of the Collection of Frederick and Jan Mayer, 2014.217. Photo courtesy of the Denver Art Museum.

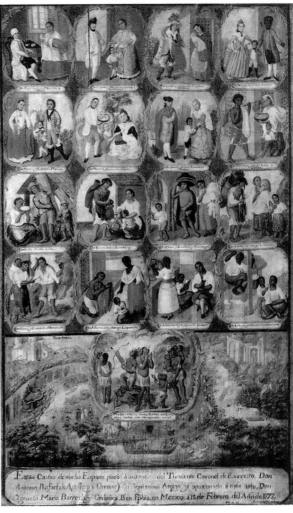

Figure 7.17
Ignacio María Barreda y Ordoñes, *The Castas of New Spain*, Mexico, 1777. Oil on canvas, 30.3 × 19.3".
This painting displays the *casta* system in a grid format, each scene featuring a couple with their mixed-race child surrounded by a rococo-style frame. A verdant park in Mexico City appears in the lower section of the painting, behind a stereotypical rendering of Mexico's nomadic Indians.
Real Academia Española, Madrid. Wikimedia.

chocolate (being prepared as a hot beverage by the mother at right). By the mid eighteenth century, paintings displayed the *casta* series on a single canvas (Figure 7.17).

The initial scene at top left usually features a Spaniard and an Indian with their child, and is followed by two successive intermixtures. Another series of three begins with the pairing of a Spaniard and a black

Theme Box 13: Hall: Encoding, Decoding, Transcoding
by Jaleen Grove

What is representation? Media theorist Stuart Hall (Jamaican, British, 1932–2014), a founding member of the Centre for Contemporary Cultural Studies at the University of Birmingham known as the **Birmingham School**, explains that to represent something is to give it meaning—that nothing exists in a way we can comprehend without our first representing it to ourselves in our minds, and then verifying it by sharing it with others. These personal and shared representations depend on semiotic (*see Chapter 2, Theme Box 7, "Saussure and Peirce: Semiotics"*) social norms he calls "cultural codes," which are embedded in language and discourse that we absorb from birth. Words, images, gestures, and other signs work, he says, primarily by what they *connote*—that is, what associations they conjure up subliminally, symbolically, and emotionally.

Hall is interested in how **tropes**—habitual ways of representing ideas, values, and things—*signify*: how they produce certain politicized, value-laden meanings (ideologies); how they are perpetuated; and whose interests they serve. As a Jamaican, Hall was particularly interested in how people of African descent are represented in the visual cultures of European countries and their colonies. An example is how nineteenth-century cartoons by E. W. Kemble perpetuated concepts of African Americans as inferior (*see Chapter 18, Theme Box 38, "E. W. Kemble: The Comic Black Mask"*).

Hall insists that we must "interrogate" and "open up" such images to "make them uninhabitable," in order to intervene in how they affect behavior. Representation must be kept "open" so that new and differing meanings can enter into how they signify. This is not, however, simply a task of just debunking stereotypes or substituting more positive pictures for ones we think are wrong. The more important task, Hall suggests, is to tackle the way problematic meaning is produced and reinforced in and by large-scale media circulation in print, film, television, or Internet, which drown out diverse meaning-making.

Hall argues that images can be "opened" because there is no ultimate "true" image of anything, and no "false" one either—the objects we call pictures have no intrinsic meaning except what is assigned to them. Further, meaning is not fixed and is always contingent and dependent on time, place, person, usage, and other contexts. The acceptability or offensiveness of an image—its meaning(s)—is an effect of the social and media "work" going on to stabilize the representation according to whatever powers benefit by that meaning.

For example, the angle you are shown people *encodes* your relationship to them: the illustrator or photographer controls whether you look up to them, look down on them, or encounter them close up as an intrusive examiner. Just as these depicted persons are thus given an identity, so too are you in relation to them. The creator who produces this way of looking does so according to a viewpoint defined by his or her own prejudices, which underpin notions of "taste" and assumptions of who is supposed to consume this gaze: a client, a target audience, or a vague "everyone"—that some scholars argue is a code for an implicit normative figure such as a white, heterosexual middle-class male (*see Chapter 26, Theme Box 48, "Judith Butler: Gender and Queer Studies"*).

We can disrupt this "work" by delving into how meaning is made. In Saussure's structuralist semiotics (*see Chapter 2, Theme Box 7*), meaning is established by differentiation: we know things not just by what they are, but what they are not. Hall argues that there is a tendency in language and thought to sort things into sharply contrasting pairs—binaries—such as high and low, black and white, male and female, citizen and foreigner. This is the foundation of cultural identity, but Hall maintains that it also accentuates difference and, importantly, encourages one of the paired items to be considered lesser than the other, creating a hierarchy. Much of the work of cultural codes, language, and media operates on behalf of dominant social forces (class privilege, for example) to reinforce differences

man or woman (seen here at top right) and proceeds to show further racial mixing. Later scenes (such as that at lower left), in which both parents are racially mixed, often show violent interactions between the parents and suggest that racial mixing leads to familial discord. Many of these works were imported to Spain, whereas others are thought to have decorated the homes of elite colonists, whose anxieties about racial mixing would be soothed by viewing the painted microcosms rationalizing the process.

Casta paintings have been connected to European Enlightenment thinking and new desires to codify the world. A series of expeditions sponsored by the Spanish crown near the end of the eighteenth century were intended to classify the natural world of the Americas. One of the most long-lasting and prolific expeditions was that led by the naturalist José Celestino Mutis (Spanish, 1732–1808) in the Kingdom of New Granada, corresponding to modern-day Ecuador, Colombia, and Venezuela. The fifteen-year expedition produced more than 6,000 illustrations, created primarily by artists hailing from the devotional art workshops of Quito, the capital of Ecuador. The artists, once trained in the style of European botanical drawing, used local pigments to create meticulous illustrations of plants (Figure 7.18).

The paintings show plants in idealized states, both in fruit and in flower simultaneously, and include

in order to maintain identity and the often unequal power between entities by "closing" meaning: making representations that are simplified, exaggerated, and fixed, known as **stereotypes**, that connote particular sets of associations. The effect of this is to make something appear natural and "true"—such was the case in the nineteenth century when phrenologists and their handbooks showed that men with Classical Greek features and high foreheads were more intelligent and moral than other people (*see Chapter 11, Theme Box 20, "Phrenology"*).

Media producers, employed by the dominant powers that be, are especially in collusion with the dominant cultural order when they **encode** messages according to what Hall calls the "professional code"—that, by using a persuasive appearance of objectivity and neutrality and what we might think of as "good design" and technical polish, illustrators and other creators imbue visual communication with legitimacy, authority, and a seeming rightness.

But because meaning is unfixed, how viewers **decode** the message varies. Those who understand the cultural codes may accept the intended message as-is; this Hall calls the **preferred meaning**. Viewers may also accept only part of the message and reshape it according to their own circumstances and needs; this is called a **negotiated**

meaning. Or viewers may deliberately or instinctively reject the usual meaning and substitute a different one—this is an **oppositional meaning**. If viewers seize the message and twist it to subvert it through parody or satire, or to deconstruct its workings, or to expose the hybrids, in-between states, and complexities that binaries and stereotypes obscure, or to redeploy it in a context never envisioned or desired by the originator, Hall calls this **transcoding**. Transcoding opens up tropes to expose their inner workings and break their potency to reproduce society's status quo.

Further Reading

Hall, Stuart, "Encoding / Decoding," In S. Hall, D. Hobson, A. Lowe, and P. Willis (Eds.), *Culture, Media, Language: Working Papers in Cultural Studies, 1972–79* (London: Hutchinson, 1980): 128–138.

Hall, Stuart, *Representation and the Media* [video], directed and produced by Sut Jhally (Media Education Foundation, 1997).

Hall, Stuart, "The Spectacle of the Other," In *Representation: Cultural Representations and Signifying Practices* (London; Thousand Oaks, CA: Sage, in association with the Open University, 1997): 223–290.

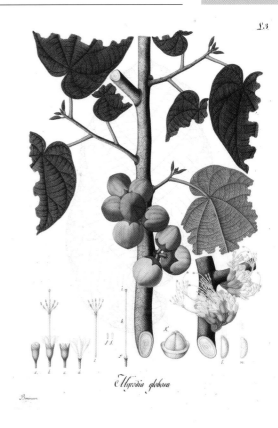

Figure 7.18

Antonio Barrionuevo, *Myrodia globosa*, Colombia, late eighteenth century. Tempera on paper, 21 1/2 × 15".

Artists on the Mutis expedition sought to render every aspect of a plant on a single page, including its stalk and leaves, flowers and fruit. While these works appear highly naturalistic, their creation involved a great deal of artistic license.

Real Jardín Botánico, Madrid, Archivo Real del Jardín Botánico de Madrid, III, 2169.

anatomical dissections of fruits and seeds at bottom. While the artists followed European precedents, they also developed a unique style. Plants are shown flattened on the picture plane and arranged symmetrically or in highly controlled compositions, such as this one that shows leaves eaten away in order to achieve an aesthetic arrangement of the plant on the paper. While *casta* paintings show people contextualized in natural or domestic settings, the plants are shown isolated in white space and betray the imperial desire to know and control nature in the vast territories of Spanish America. Ironically, Mutis's expedition was halted by the wars of independence that would bring an end to the Spanish empire in the Americas.

The Modern Era

Independence as a Theme

In the first half of the nineteenth century, most of the Latin American regions under Spanish or Portuguese control gained independence. Illustrations of these decades focused on celebrating the efforts of independence leaders and consolidating ideas about nationhood. In these illustrations artists copied the compositions of traditional devotional images,

replacing familiar religious figures with political symbols. *The Triumph of American Independence* from Peru shows an allegorical image of Independence as a celestial woman riding a horse-drawn chariot, placed compositionally where the Virgin Mary would typically have been located (Figure 7.19).

The horses represent the nations established by the time the work was painted: Mexico, Guatemala, Argentina (named as Buenos Aires), Peru, and Chile. Independence bears a staff topped with a Phrygian cap, a symbol of independence borrowed from the French Revolution, and she is crowned by the figures of Prudence and Hope. Cherubim symbolizing Moderation and Justice drive the horses, while others representing national ideals such as the arts and learning flutter above. In a format similar to the ex-voto paintings, explanatory text accompanies the image in a panel at the bottom.

Spain's retreat from the Americas caused an opening of the new nations to other artistic influences, namely French academicism. Art academies were founded in many Latin American countries after independence, and many budding artists were able to travel to Europe to hone their skills. Upon their return, they often used these skills to represent their home countries in unique ways. The Academy of San Carlos in Mexico City was founded in 1785, before independence, and flourished through the nineteenth century, training artists in the academic style. Many created large-scale paintings representing the history of Mexico in works that helped formulate a national identity that looked to its own past rather than that of Greece and Rome. Leandro Izaguirre (Mexican, 1867–1941), who returned from Europe to later teach at the Academy, depicted a semi-legendary episode of the Conquest in which the Aztec ruler Cuauhtémoc was tortured to reveal the location of hidden Aztec treasure (Figure 7.20).

Cuauhtémoc, at center, is shown with idealized Amerindian physiognomy and proportions, tied to a seat bearing Maya-inspired carvings. He gazes directly at Cortés though his feet are placed over a fire, accepting the torture and defying the conqueror's wishes. Paintings such as this were meant to ennoble the native descendants of modern Mexico, recovering their legacy from the shame of the colonial era and using it to build the new nation.

Documenting the New World

As Latin America was opened to European visitors after independence, further travelers documented the region's natural and cultural richness. The German Alexander von Humboldt traveled throughout Latin America in the early nineteenth century, and his popular illustrated volume *Atlas pittoresque: Vues des cordillères et monuments des peuples indigènes de l'Amérique* (*Picturesque Atlas: Views of the Mountain Ranges and Monuments of American Indigenous Peoples*), illustrated with lithographs, began a European craze for picturesque imagery describing the New World. Travelers such as the French artist Jean-Baptiste Debret, who published his work as *Voyage pittoresque et historique au Brésil* (*Picturesque and Historical Voyage to Brazil*), documented the clothing and customs of native groups and Afro-descendants in Brazil (Figure 7.21).

This engraving depicts Afro-Brazilian women from northeast Brazil, wearing thick necklaces and off-the-shoulder flounced dresses, bringing young children to church for baptism. They are greeted by a cleric wearing a similarly trimmed white surplice and also appearing to be of African descent. Such illustrations show, in an objectifying manner, the melding of African and European cultures.

After the precedent set by European artists, Latin American illustrators adopted the documentary spirit and began to create illustrations of the cultures they belonged to. Known as ***costumbrismo***, this illustrative mode was widespread during the mid-nineteenth century. The watercolorist Pancho Fierro (Peruvian, 1810–1879), of African, indigenous, and Spanish descent, made a living

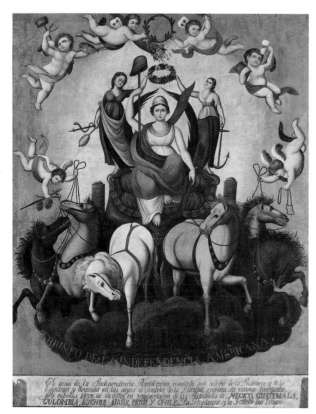

Figure 7.19
Anonymous, *The Triumph of American Independence*, Cusco, Peru, ca. 1821–1825. Oil on canvas.
An allegorical image of independence rides a chariot pulled by horses representing five new Latin American nations, named in the inscription below. Other allegorical figures represent new national ideals, including Prudence and Hope, and refer to the ongoing process of nation-building.
Collection of Ramón Mujica Pinilla. Photograph ©Daniel Giannoni.

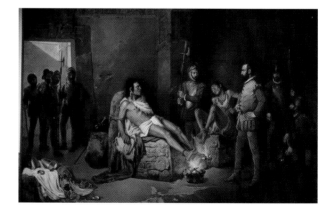

Figure 7.20
Leandro Izaguirre, *The Torture of Cuauhtémoc*, Mexico, 1893. Oil on canvas, 116 × 178 ³/₄".
In this heroic painting of the torture of the Aztec ruler Cuauhtémoc, the bound ruler stares defiantly at Hernán Cortés, standing at right. His courage is highlighted by the anguished expression of his companion, who flinches away from the fire.
Museo Nacional de Arte, Mexico City. Reproduction authorized by the Instituto Nacional de Bellas Artes y Literatura, 2015.

in Lima selling his loose-leaf *costumbrista* paintings of local society and the clothing and activities of local types (Figure 7.22).

Like the artists of the Mutis expedition (Figure 7.18), Fierro often isolated his figures in white space and thus presented them as specimens for examination. Fierro's works were often humorous and satirical though, offering an insider's social critique.

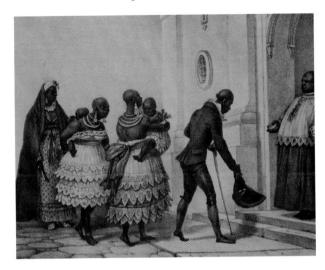

Figure 7.21
Jean-Baptiste Debret, "Negresses Going to Church for Their Baptism," *Voyage pittoresque et historique au Brésil* (*Picturesque and Historical Voyage to Brazil*), 1839. Engraving, ink on paper.
As depicted by the French traveler Debret, finely dressed African women and men in Brazil bring children to church for baptism. Although many of these people were likely enslaved, Debret showed them not in that aspect but as respectful churchgoers.
University of Florida Libraries.

The Advent of Reproductive Technologies

While Fierro was limited to creating unique works in watercolor, other illustrators began to use reproductive technologies such as photography in the nineteenth century. Printmaking, which had existed in major cities during the colonial era, also became a popular form for illustration. The prolific printmaker José Guadalupe Posada (Mexican, 1851–1913) worked in Mexico City for twenty-five years and contributed illustrations to over fifty newspapers and pamphlets with a prodigious output estimated at over 20,000 images.

In 1887, Posada moved to Mexico City where he found work producing images for popular prints on every subject from traditional religious imagery to designs for sensational crime broadsides. His *Terrible y verdadera noticia* (*Terrible and True News*, ca. 1890–1913) (Figure 7.23) uses sharp lines to depict a horrible double murder, with text that explains the details of the event and recounts that ultimately the perpetrator, Norberta Reyes, was killed by wild dogs. The vast majority of such crime broadsheets focused on violent murders or executions, while other types of crimes, particularly those committed by the upper classes, were rarely the subjects of popular prints.

Posada is most widely known today for his images of ***calaveras*** (skulls), a theme in Mexican art since Aztec times that became an integral part of Mexican annual Day of the Dead celebrations. *Calaveras* prints were, as with Hans Holbein the Younger's earlier *Dance of Death* prints (*Chapter 2*), a reminder that all classes, high and low, ultimately met the same fate (Figure 7.24).

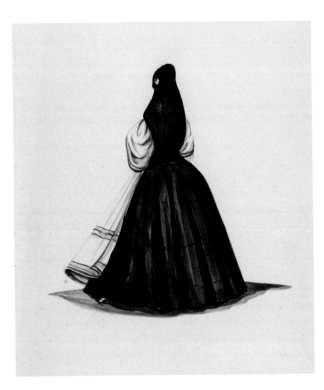

Figure 7.22
Francisco (Pancho) Fierro, *Tapada*, Lima, ca. 1850. Watercolor on paper, 10 × 7 ²/₃".
Here, Fierro depicts a Limenian *tapada*, an upper-class woman who appeared in the street covered in multiple layers of clothing that nevertheless created a highly feminine silhouette. *Tapadas* wore black veils that they grasped with their hands to expose only one eye.
Wikimedia.

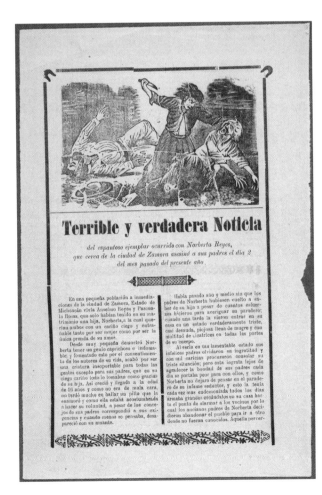

Figure 7.23
José Guadalupe Posada, *Terrible y verdadera noticia* (*Terrible and True News*), Mexico, ca. 1890–1913. Relief print with text in letterpress, ink on paper, 12 × 8". Destined for a popular audience, this sensationalized image of a double murder shows an enraged daughter about to stab her mother, while her wounded father lies to the left.

Library of Congress.

The Calavera *of a Soldier from Oaxaca* (1903) memorializes the 1864 Mexican resistance to the French invasion at Oaxaca, where 3,500 Mexican soldiers defeated a French force more than twice their number. The print includes authentic visual details, such as the characteristic Oaxaca region hat, but is at the same time general enough to be reproduced again for a number of *corridos*, or **broadsheets** that combined the lyrics of narrative folk songs with illustration.

A visual journalist, Posada's graphic output included politically oriented *corridos* reproduced as lithographs and relief prints that were distributed to the populace. However, when revolution came to Mexico in 1910, Posada's graphic commentary was limited. Posada had become fascinated with the use of photography as an artistic tool. His image of revolutionary leader Emiliano Zapata follows the photograph closely with little of the imaginative verve found in his earlier prints (Figure 7.25). Posada's portrait of Zapata includes the distinctive cross cartridge belts and patriotic sash that would become symbols of the revolutionary figure.

Although his political work is best known, Posada also illustrated devotional prints—still popular after independence despite the diminished political and economic power of the Church. Latin American societies

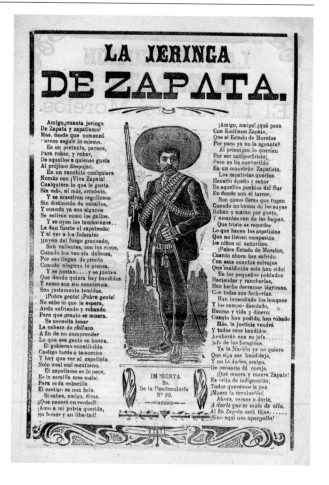

Figure 7.25
José Guadalupe Posada, *La Jeringa de Zapata* (*The Plague of Zapata*), Mexico, early twentieth century. Relief etching, ink on paper, 11 × 7 ¹/₂". Posada's image belies the photographic source of Zapata's likeness, with its stiffer approach to the tonal development of the portrait. While the image features the distinctive cross cartridge belts and patriotic sash that aggrandize the reputation of the revolutionary figure, ambivalence about the methodology of the revolution's leaders is implied in the title.
Getty Research Institute.

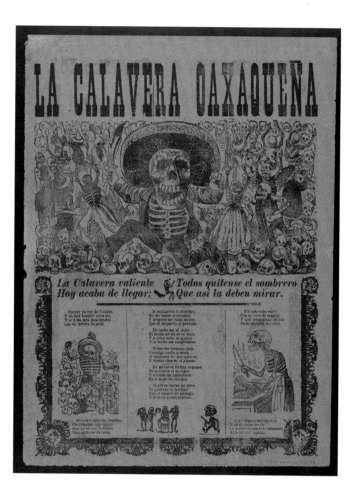

Figure 7.24
José Guadalupe Posada, Calavera *of a Soldier from Oaxaca*, Mexico, 1903. Relief etching, ink on paper, 13 ¹/₃ × 8 ¹/₃".
This *corrido*, an illustrated song issued as a broadsheet, celebrates the 1864 Mexican resistance to the French invasion at Oaxaca, its bold central skeleton wearing a Oaxaca-style hat.
Library of Congress.

remained Catholic, and home-based devotion became more important.

Retablos

More permanent religious paintings, executed on cheap tin panels and known as *retablos*, were produced for home altars. The ex-voto tradition, introduced in the colonial era in the form of large-scale oil paintings (Figures 7.13 and 7.15), was carried over into *retablos* (Figure 7.26).

Usually created in thanks for a divine favor, these paintings were kept in homes or donated to churches to serve as permanent records of miracles performed. They usually follow a standard compositional format that is consistent with that of the Cusco ex-voto (Figure 7.13). At right appears an image of a devotee (seen here as a black-clad woman kneeling in prayer) or a scene narrating the miracle performed. At upper left appears an image of the divine being, in this case an image of Christ Crucified known as the Lord of Mercy. In the lower section of the ex-voto, written text narrates the details of the miracle and gives thanks. Since colonial times and to the present, ex-voto illustrations have been important ways in which Catholics communicate with the divine.

Figure 7.26
Ex-voto to the Lord of Mercy, Mexico, 1866. Oil on tin, 5 × 7".
In this ex-voto, a woman named Lugarda Villalobos gives thanks to Christ for curing her from a fever. The inscriptions in these works usually give rich historical particulars, naming the event's participants and providing the date.
The University Art Gallery, New Mexico State University #1966.5.89.

Revolutionary Ideals in Prints and Murals

The repressive Porfirio Díaz regime ended with the Mexican Revolution, which began in 1910 and led to many political reforms in Mexico. The muralists known as *Los Tres Grandes* (The Three Great Ones)—Diego Rivera (Mexican, 1886–1957), José Clemente Orozco (Mexican, 1883–1949), and David Alfaro Siqueiros (Mexican, 1896–1974), who were trained in the ideals of modern art in Europe—were commissioned to depict the tenets of the revolution in government buildings (Figure 7.27).

One of Diego Rivera's murals for the Ministry of Public Education, commissioned by the minister of education José Vasconcelos, expresses the principles of revolutionary Mexico. It also shows how Rivera's training in European styles such as Cubism (*Chapter 19*) was applied to Mexican subject matter. In the image, set within a Mexican desert landscape, we see at left a peasant (in a striped *serape*) and an urban worker (in overalls) embracing. As opposed to European socialism, which focused on liberating the urban worker, Mexican revolutionary ideals stressed the union of both urban and rural workers. At right, past a Cubist-inspired village on a hill, appear aesthetically pleasing groups of peasant men and women. While Izaguirre before him had ennobled an Aztec leader (Figure 7.20), Rivera sought to ennoble the Mexican commoner. His murals were aligned with education and health reforms meant to raise up all Mexicans. Rivera quoted both European and Mexican sources, such as sixteenth-century manuscript illustrations, in his unique painting style.

Orozco and Siqueiros tended to be more critical of the ideals of the revolution, especially in later years when the muralists' art was used as propaganda for a government unable to carry out the revolution's goals. Orozco's murals for the ground floor of the National Preparatory School, which were painted over earlier works considered unfit, used Christian symbolism to decry the failures of the revolution (Figure 7.28). His expressive scenes present the revolution's sacrifices as

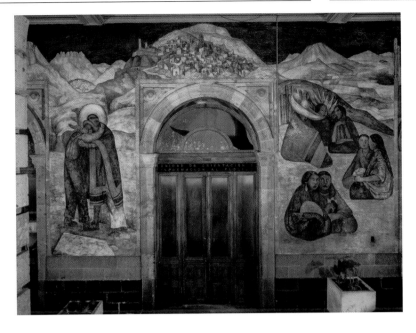

Figure 7.27
Diego Rivera, *The Embrace and Peasants*, Ministry of Education (Court of Labor), Mexico City, 1923. Fresco.
In this work, Rivera extolls the ideals of the Mexican Revolution, especially with the embrace of an urban worker and peasant at left. While parts of the mural show the influence of European Cubism, *The Embrace* was inspired by a fresco by the Italian Renaissance painter Giotto di Bondone, showing the embrace of the Virgin Mary's parents.
Photo by Bob Schalkwijk with permission of Instituto de Bellas Artes, Mexico; © 2016 Banco de México Diego Rivera Frida Kahlo Museums Trust, Mexico, D.F. / Artists Rights Society (ARS), New York.

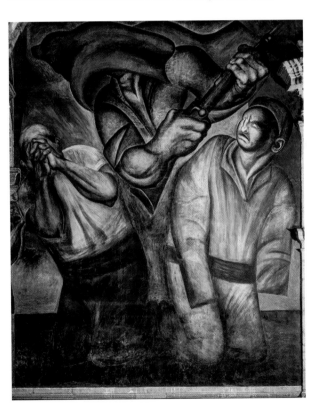

Figure 7.28
José Clemente Orozco, *The Revolutionary Trinity*, National Preparatory School, Mexico City, 1926–1927. Fresco.
In Orozco's *The Revolutionary Trinity*, we see not the eternal Catholic Trinity but the breaking apart of the stable worker-and-peasant pair that Rivera had offered. The pair is kneeling and pushed apart by an armed revolutionary, whose red head wrapping obscures his eyes, suggesting his blindness.
Photograph © Bob Schalkwijk. © 2016 Artists Rights Society (ARS), New York / SOMAAP, Mexico City.

a tragedy akin to Christ's crucifixion, and point more historically to Mexico's continuing struggle to achieve racial equality.

Printmaking also became an important illustrative art form used to promote revolutionary ideals. In 1937, Leopoldo Méndez (Mexican, 1902–1969), Luis Arenal (Mexican, 1908 or 1909–1985), and Pablo O'Higgins (Mexican, 1904–1983) founded the *Taller*

de Gráfica Popular (The People's Graphic Workshop). There they taught printmaking and advocated for reforms in Mexico while expressing more international concerns, such as opposition to fascism. Their work was founded on the legacy of Posada and intended to reach popular audiences. The *Taller* created multiple portfolios of lithographs and woodcuts criticizing social inequality and celebrating those who worked against it. In one illustration, Méndez also decried the loss of the revolution's ideals to greed, presenting newspaper carriers as fallen martyrs (Figure 7.29).

One of the workshop's few female members, Mariana Yampolsky (Mexican, born in United States, 1925–2002), contributed linocuts to the *Taller's Estampas de la Revolución Mexicana* (*Prints of the Mexican Revolution*).

In *Emiliano's Youth*, Yampolsky depicted a young Emiliano Zapata, standing at right against a black background, observing the inequality that would later cause him to take up arms for the revolution (Figure 7.30). Although better known as an insightful photographer of Mexican culture, Yampolsky became an important editor of educational texts, helping issue millions of illustrated books in support of Mexico's education reforms.

The *Taller* also produced portfolios celebrating aspects of Mexican culture. Departing from the social realist approach, Méndez illustrated Juan de la Cabada's *Incidentes melódicos del mundo irracional* (*Melodic Incidents of the Irrational World*), a compilation of tales and songs from Maya folklore (Figure 7.31). His prints adopt the illogical and dreamlike qualities of Surrealism but employ a distinctly Mexican vocabulary, with figures that refer back

to Pre-Columbian art. The rattlesnake in *The Serpent* refers to the mythical feathered serpent of Aztec mythology and uses the creature's gaping mouth as the platform for human activity, as seen in Maya ceramics (Figure 7.6).

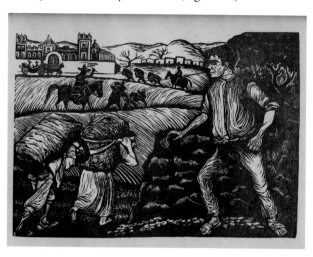

Figure 7.30
Mariana Yampolsky. "Emiliano's Youth: Objective Lesson," in portfolio *Estampas de la Revolución Mexicana* (*Prints of the Mexican Revolution*), 1947. Linocut, ink on paper, 8 ¼ × 11 ¾".
This scene illustrates a legendary event of Zapata's youth, when he observed peasants forced to work land that was not theirs and resolved to return those lands to the people. Similar to Méndez's print, this piece juxtaposes those fighting for reform and those driven by greed. The land's owners ride in a carriage in the background, in front of their palatial home.

D.R. © Fundación Cultural Mariana Yampolsky, A. C.; Artis—Naples, The Baker Museum. 2007.3.0871. The Bryna Prensky Collection, gift of Michael F. and Tonya L. Aranda.

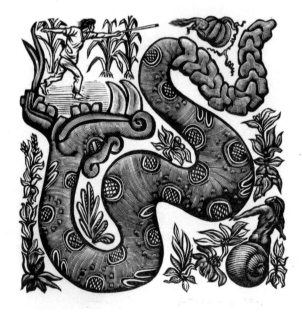

Figure 7.29
Leopoldo Méndez, "Newsboys," in portfolio *25 Prints of Leopoldo Méndez*, 1943. Wood engraving, ink on paper, 9 ⅝ × 7 ¹¹/₁₆" (sheet).
This illustration shows a mass of fallen newsboys covered with a newspaper bearing a headline that refers to a manifesto on the minimum wage. A large hand holding coins reaches up in front of Mexico's national palace, and text at the top reads "$200,000," and "Get rich in the raffle of the revolution."

RISD Museum of Art. © 2016 Artists Rights Society (ARS), New York / SOMAAP, Mexico City.

Figure 7.31
Leopoldo Méndez, "The Serpent," plate 1, *Incidentes melódicos del mundo irracional* (*Melodic Incidents of the Irrational World*), 1948. Linocut, ink on paper, 6 × 6".
Although not largely featured in the tale this scene illustrates, this print is dominated by the mythical serpent of Mexican lore. The markings on its body look like Maya glyphs, and feather shapes indicate its supernatural qualities. Smaller figures relate to the story of a snail woman and her hungry squirrel husband, legs and tail peeking out of a pumpkin, who is chased by an angry farmer.

University of Florida Libraries. © 2016 Artists Rights Society (ARS), New York / SOMAAP, Mexico City.

Conclusion

While expressed in a wide variety of styles and modalities, Latin American illustrations of the past explored societal ideas about the nature of the world and humans' place in it. Artists used illustration to depict supernatural realms and show how the mundane was touched by those other worlds. They also responded to the demands of kings and empires, whether characterizing the nature of power or helping convey information to rulers. More recent works responded to personal, often spiritual concerns, and expressed political ideals and critiques. Politically driven illustrations were especially influential in times of political upheaval, such as the independence era and during political reforms of the early twentieth century. Latin American illustrations vividly and uniquely reflect the concerns of their eras in testament to the important changes experienced by the region.

KEY TERMS	
Birmingham School	**hieroglyph**
broadsheet	**negotiated meaning**
calavera	**oppositional meaning**
casta **painting**	**preferred meaning**
celt	*retablo*
corrido	**rollout drawing or**
costumbrismo	**photograph**
decode	**speech scroll**
embroidery	**stereotype**
encode	**transcoding**
ex-voto	**trope**

FURTHER READING

Ades, Dawn, *Art in Latin America: The Modern Era, 1820–1980* (New Haven: Yale University Press, 1989).

Adorno, Rolena, *Guaman Poma Writing and Resistance in Colonial Peru* (Austin: University of Texas Press/Institute of Latin American Studies, 2000).

Bleichmar, Daniela, *Visible Empire: Botanical Expeditions and Visual Culture in the Hispanic Enlightenment* (Chicago; London: University of Chicago Press, 2012).

Boone, Elizabeth Hill, *Stories in Red and Black: Pictorial Histories of the Aztecs and Mixtecs* (Austin: University of Texas Press, 2000).

Craven, David, *Art and Revolution in Latin America, 1910–1990* (New Haven: Yale University Press, 2002).

Frank, Patrick, *Posada's Broadsheets: Mexican Popular Imagery, 1890–1910* (Albuquerque: University of New Mexico Press, 1998).

Katzew, Ilona, Casta *Painting: Images of Race in Eighteenth-Century Mexico* (New Haven: Yale University Press, 2004).

Mujica Pinilla, Ramón, "Identidades alegóricas: Lecturas iconográficas del barroco al neoclásico," in *El barroco peruano*, vol. 2 (Lima: Banco de Crédito, 2003): 250–336.

Zarur, Elizabeth Netto Calil, and Charles M. Lovell, *Art and Faith in Mexico: The Nineteenth-Century* Retablo *Tradition* (Albuquerque: University of New Mexico Press, 2001).

8

Illustration in the African Context, Prehistory–Early 2000s

Bolaji Campbell

With more than three thousand different ethnic and linguistic groups, Africa is a vast and diverse continent with rich artistic and cultural traditions that are equally as varied. A survey of illustrative forms from such myriad populations within a single chapter is impossible, and would no doubt lead to oversimplification and sweeping generalizations. To strive for a more nuanced understanding of the evolution of illustrative practices in the sub-Saharan context, we instead focus almost exclusively on the illustrative traditions of the Yoruba—one of the most prolific art-producing groups in Africa. Numbering about thirty-five million and predominantly concentrated in southwestern Nigeria, the Yoruba are perhaps one of the most critically analyzed cultural groups on the continent. Beginning with the West African subregion, Yoruba are also found in the Republic of Benin, Togo, Ghana, Ivory Coast, and Sierra Leone, where they have settled among the Creole populations since the abolition of the transatlantic slave trade. They also constitute a sizeable presence in the African diaspora, particularly in Cuba and Brazil. Their artistic traditions, which go back to at least 800 CE, cover the entire gamut of the plastic arts, including terracotta, stone, ivory, wooden and metal sculptures, decorated gourds, painting, and textiles, to mention but a few. In spite of their cultural importance, however, very few extant examples of works in perishable media have survived the humidity of the West African subregion.

The Nature of Representation for the Yoruba

Whether drawn, painted, or photographed, artistic images on two-dimensional surfaces are regarded as *àwòrán* in the Yoruba language, while their three-dimensional counterparts are regarded as *ère*—figurative images in the round. The word *àwòrán* when fully rendered as *àwòrántí* means "that which we see, apprehend, or engage with in order to remember something," and should not be confused with another related but different Yoruba word, *iran*—a spectacle, fantasy, and/or wonder. Fused together, the two words—*awo-ìran*—would be used to describe a "person watching" or simply "we saw" a spectacle, depending on the modulations of the tones. Both *ère* and *àwòrán* are capable of evoking cognitive as well as emotional reactions in the viewer. *Ère* and *àwòrán* have their own peculiar aesthetics and religio-mythical function, especially in a predominantly oral, nonliterate culture such as that of the Yoruba, where the visual dynamically illuminates the verbal. Let's begin with images on ancient terracotta pottery from Ile Ife, the holy city of the Yoruba, where, according to Yoruba ontological belief, humanity was first created before spreading centrifugally to other parts of the universe.

Ritual Pottery

The ancient city of Ife produced globular pottery fascinating for its illustrative content. Approximately dating to the thirteenth century is a ritual vessel used in the worship and veneration of the inner spiritual head, *orí inú* (Figure 8.1). It is adorned with eight robust figurative images. The most distinctive depicts a partially raised altar-shrine with three heads: two are abstracted, and a centralized one is naturalistic. Conceptually, the abstract heads embody a visualization of the soul as a site of personality, and are often regarded as symbolizing spiritual *orí inú* (the inner head). Above the altar is a snake, which symbolizes the power of transformation and embodies *ilè*, the spirit of the primordial ancestors who reside underneath the earth. Other objects in close proximity to the altar-shrine include another vessel with human legs, a pair of animal horns referencing the power of the inner spiritual head, two identical fish joined by a rope, a knife, a ring, and a drum. These ritual paraphernalia were probably used in the worship of the ancestors and the inner spiritual head. Buried in the ground, with an opening at the bottom, the ritual vessel would have served as a conduit through which food and beverages could be offered in devotion to the spirits of the departed ancestors.

Calabash Decoration

Lagenaria siceraria, commonly referred to as *igbá* in Yoruba, and calabash or gourd in English, is a creeping vegetable that can be hollowed out as a receptacle or container for storage of food and beverages. But *igbá* has a sacred context in many African cultures as well. Conceptually, the cosmos is visualized by the Yoruba as a spherically shaped *igbá* with two tightly fitting hemispheres. The upper half represents *ode òrun*, the otherworldly realm and domain of primordial and deified

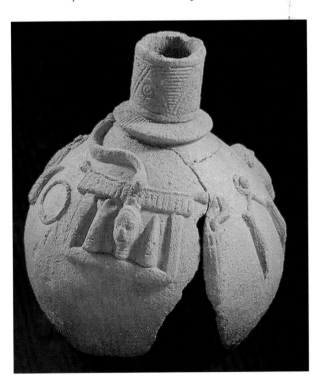

Figure 8.1
Ife, Yoruba culture, Ife, ritual vessel, approximately thirteenth century. Terracotta. On this vessel for venerating the "inner head" or soul, a slithering snake representing the power of ancestral spirit and transformation wraps around the topmost part of the vessel and dangles its head over a naturalistic human head in the middle.

University Art Museum, Obafemi Awolowo University, Ile Ife, Nigeria.

ancestors, including a pantheon of divinities known as *òrìsà*; whereas the second half represents *ilé ayé*, the material tangible world occupied by ordinary mortals and the unseen presence of otherworldly forces. Among the Yoruba, *igbá* is used as a sacred vessel in the installation rites of high-ranking chiefs and divine rulers known as *oba*.

Farmers have cultivated *igbá* since at least 11,000 BCE in Iwo Eleru, the oldest Yoruba settlement in the region. When harvested and left to dry, *igbá* hardens and assumes an attractive dark yellowish color, but can be carved, incised, or decorated when malleable and soft. Patterns, in addition to figurative images of animals such as elephants, birds, and lions; and instruments of royal authority and power like the crowns, thrones, and scepters typically appear on *igbá*.

Inscriptions may refer to texts containing proverbs and wise sayings dating from the beginning of the colonial era, such as "*àtidádé kìnínún, kìí séhìn Elédùmarè*," meaning literally that the Lion cannot be enthroned without the sanction of the Almighty, but more idiomatically suggesting that a King cannot be installed without the support and sanction of the creator, Almighty God. In one nineteenth-century *igbá* (Figure 8.2), the tight interconnectedness of peoples, an ideal that governs Yoruba social and cultural institutions, is referenced in the image of the interlocking knots on the *igbá*. On a more philosophical level, it invokes the ideal of cooperation—*ifowósowópò*, during the installation rites for rulers and high-ranking chiefs, when the candidates are presented vessels inscribed with such metaphoric illustrations. The image-design then functions as a visual reminder symbolizing the bond of collaboration between the people and their rulers.

Ritual Objects and Images of Divination: *Ìróké Ifá and Opón Ifá*

Used by ritual specialists and diviners among the Yoruba, *Opón Ifá*, or divination boards, provide the critical means of unraveling problems of human existence. Through divination rituals, the diviner is able to understand spiritual forces that might be influencing the lives of their clients.

The divination board functions as a microcosm of Yoruba universe. Boards are characteristically carved in a circular or rectangular shape with a slightly raised border decorated with figurative images of animals, plants, and humans engaged in various activities. On all divination boards, Èsù, the Yoruba deity of communications, policeman and messenger of the gods, and through whom all ritual sacrifices must be presented, is represented as a face set amidst a range of decorative patterns around the board's rim (Figure 8.3). In the course of a divination session, Èsù must be positioned facing the diviner. Powdery dust (*iyèròsùn*) is sprinkled on the surfaces of the board; design configurations in abstract patterns that emerge in the dust in the course of the ritual are known as *odù ifá*. The diviner interprets these patterns as representing pertinent verses or divination chapters from the vast corpus of Ifa literature, as a means of resolving the client's problem. Once an oral tradition, *Ifá* literature has taken on a written dimension since the colonial era.

Created in wood or ivory, the *ìróké* (diviners' scepter) is a symbol of authority used in the course of divination

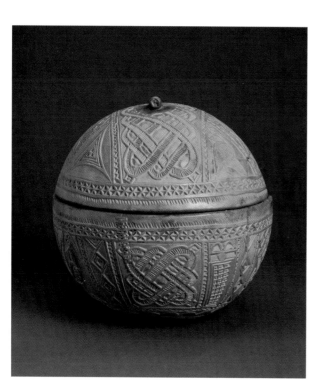

Figure 8.2
Oyo-Yoruba Peoples, *Igba Iwa*, nineteenth century. Incised calabash. The interlocking knots on this ritual *igbá* symbolize the tight interconnectedness of peoples. Such objects continue to be used as souvenirs for marriages and other secular ceremonies.

Museum Fünf Kontinente, Munich, Germany. Photo: Marietta Weidner.

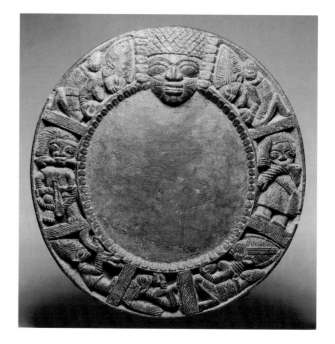

Figure 8.3
Dáda Arówòògún, *Opón Ifá* (divination tray), Osi-Ilorin, Ekiti Region, first half of twentieth century. Wood, 18 ¼" (diameter).
Èsù, the Yoruba deity of communications, is represented as a face amidst a range of decorative patterns around the divination tray's rim.
New Orleans Museum of Art. The New Orleans Museum of Art: Gift of H. Russell Albright, M.D., 90.389.

to tap the divination board (Figure 8.4a, b). It also functions as a site of creative expression for the artist. The malleability of ivory and wood provides immeasurable possibilities for illustrating visual metaphors in service of the diviners and ritual specialists, who occupy influential positions in Yoruba society.

One of the most common representations found on *ìróké* is that of *ìkúnlè abiyamo*: a woman kneeling in the throes of childbirth (a posture adopted by Yoruba women in labor), symbolizing total submission and surrender to the will of the Almighty creator, Olódùmarè—a recognition of human vulnerability in the organization of the universe. The kneeling woman equally alludes to the sacred act of selection of one's destiny, which can only be received in a kneeling position.

According to Yoruba ontological belief, every individual weighs the options available at the moment of selection with cautious optimism and humility. When the divination board is struck with the *ìróké* and Ifá is saluted during the ritual, the inner spiritual head of the client is both invoked and provoked; this action serves as a performative reminder of the choices made during the process of the selection of destiny, effectively reconstituting the selected destiny.

Narratives in Bas-Relief: Edo-Bini Plaques

The present dynasty in Benin can be traced back to the thirteenth or fourteenth century when Òrànmíyàn, a prince of Ifè, arrived at the invitation of some Benin nobles who, during a period of intense political instability, had asked Ogene (also known as Oòni, the divine ruler at Ifè) to send an emissary to teach them the principles of political organization and statecraft. Òrànmíyàn and his entourage of political advisers, ritual specialists, and artists transformed the sociocultural fabric of Edo-Bini society with the establishment of dynastic institutions. Court artists thereafter worked exclusively for the royal households producing prestigious items in metal, terracotta, wood, and ivory, constituting an elaborate panoply of cultural production in support of the prestige of monarchical institutions.

The world-famous narrative bronze plaques from the court of Benin (Figure 8.5) document war, territorial expansion, and trade with Europeans. According to oral accounts, the makers were descendants of Ife artists who once settled in the Igun Quarters in the ancient city of Benin. These bronze **bas-reliefs** (low relief panels) were created using a **lost-wax process**—a method of casting in which the original wax model drips out (is lost) as the final metal replaces it in the mold.

The narrative plaques functioned as historical and archival resources, and as decorative devices on the interior walls and pillars in the royal household. Their design celebrates social hierarchy with the most important individual, the ruler, portrayed as the largest figure in the composition, centrally positioned and most elaborately decorated. European mercenaries who

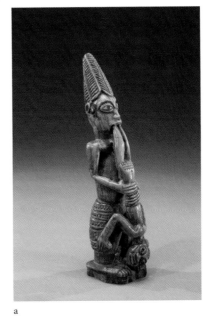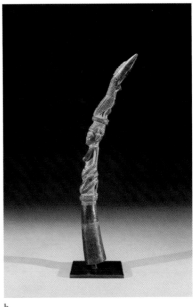

a b

Figure 8.4a, b
(a) Yoruba Peoples, ìróké, *Standing Owo Figure Devouring Inverted Figure*, Nigeria, n.d. Ivory.
The New Orleans Museum of Art; Gift of the Françoise Billion Richardson Charitable Trust, 2015.38.68.

(b) Yoruba culture, ìróké Ifa, Owo Region, Nigeria, n.d. Ivory.
The *ìróké*, or diviners' scepter, is a symbol of authority used to tap the divination board in the course of the divination ritual.
The New Orleans Museum of Art: Gift of the Françoise Billion Richardson Charitable Trust, 2015.38.58.

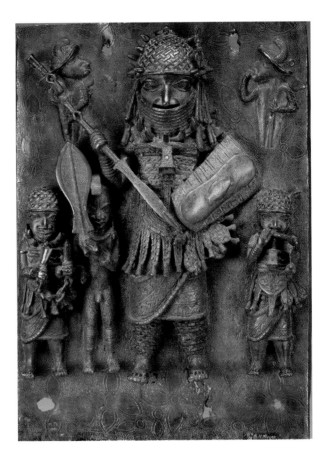

Figure 8.5
Yoruba Peoples, plaque, Edo-Bini, Nigeria, sixteenth to seventeenth century. Bronze, 18 1/2 × 13 7/16 × 3 1/4".
Displayed on the interior walls and pillars in the royal household, narrative plaques functioned as historical and archival resources, as well as decoration.
National Museum of African Art, Smithsonian Institution, Washington, DC.

fought alongside Edo-Bini warriors are also depicted on some of the plaques, but in a less robust manner than the indigenes of Bini, indicating their lesser social status. Other thematic subjects include recreational activities, religious rituals, courtly attire, and ceremonial dress, which create extensive documentation of the social and religious activities in the Kingdom. Legend has it that the plaques were sometimes examined by succeeding generations in order to better understand how to dress for specific social and ritual events.

Door Panels: *Ilèkùn Abógundé*

Another category of narrative imagery common among the Yoruba in the eighteenth and nineteenth centuries appeared in the form of carved wooden door panels known as *ilèkùn Abógundé*—meaning, doors carved in the Abógundé style. These doors are typically hung at the entrances to both public and domestic spaces including royal courts, communal shrines, and homes of Yoruba nobility. The origin of decorated doors can be traced back to old Oyo, a Yoruba kingdom that flourished in the savannah region from about the fourteenth century until the early decades of the nineteenth century. Typically made with a vertical orientation, the doors celebrate historic events documented in different registers, sometimes divided into two distinct panels. Each section is further subdivided into squares or rectangular units, with distinct figurative borders. The units are carefully carved with narrative scenes of cultural and historic significance like the visit of the British Colonial District Officer, Captain Ambrose, to Ikere Ekiti in 1895, seen on the door panel carved by Olówè of Ìsè (Figure 8.6). Doors were often aesthetically enhanced with pigments such as yellow ochre, camwood red, white clay, charcoal, and soot, and occasionally green and laundry blue (used domestically for washing and sold commercially in Nigeria since the colonial era).

While some panels celebrated heroic accomplishments of distinguished warriors, deified ancestors, or Yoruba divinities known as *òrìsà*, others integrated proverbial sayings. Animal imagery (Figure 8.7) was metaphoric: the snake symbolizes the power of transformation and embodies *ilè*, the spirit of the primordial ancestors who reside underneath the earth, as in the aforementioned ritual pottery celebrating *orí inú* (Figure 8.1). The chameleon represents change, adaptability, impregnability, and the ability to neutralize aggression from enemies; and the tortoise is a metaphor for longevity and protection.

One of the most prevalent subjects illustrated on Abógundé doors was the rapid change witnessed in Yoruba society in the latter part of the nineteenth century. Resulting social crises precipitated the ultimate fall of Oyo-Katunga—the citadel of the great Oyo-Yoruba Kingdom (ca. 1400–1896). Civil wars then engulfed the Yoruba landscape, leading to mass migration of peoples across the region. The British, with their interest in penetrating the interior, ultimately put a stop to the wars in 1886, with all factions compelled to sign an

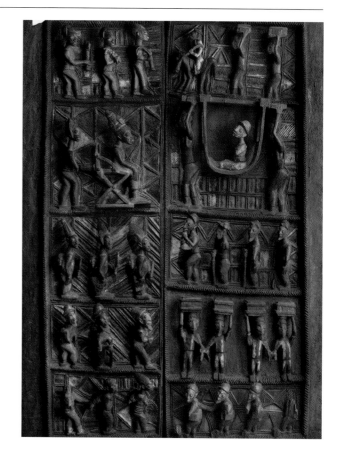

Figure 8.6
Olówè Ìsè, *The reception of Captain Ambrose by Ògògà, King of Ikere Ekiti*, palace door, late nineteenth century. Wood, pigments, 90 ½ × 32". Created for the royal palace at Ikere in Nigeria, these doors were first exhibited in England in 1928.

British Museum.

Figure 8.7
Yoruba Peoples, Osugbo Society Lodge door panel, Yoruba, Ijebu Region, Nigeria, late nineteenth century. Wood and pigments. Created by an unidentified artist, this door is carved with snake, equestrian, and mudfish iconography.

The New Orleans Museum of Art, Museum purchase, Robert P. Gordy Fund, 89.283.

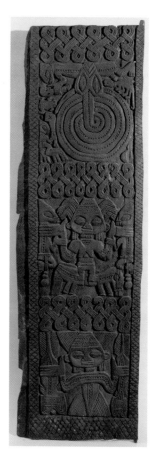

Anglo-Yoruba peace agreement. In large measure, it was this agreement that led to the establishment of British colonialism in Nigeria. Consequential effects of these wars included psychosocial anxieties, mass migration, family disruptions, social dislocations, kidnapping, and slave raiding. Beginning in the early 1890s, the traditional rulers' prestige and power were further compromised by the British policy of Indirect Rule, whereby the African rulers became mere stooges of colonial authority. By 1914, both the Northern and Southern Protectorates of Nigeria were amalgamated into a single entity.

The violence and social transformations were graphically illustrated on the evocative wooden door panels created by Dàda Arówòògún (a.k.a. Aréógún) of Osí-Ilorin (Nigerian, 1880–1954), Bámgbóyè of Odò Owá (Nigerian, 1893–1978), and Olówè of Ìsè Èkìtì (Nigerian, 1875–1938), who were among the prominent Yoruba artists active in the latter part of the nineteenth and early twentieth centuries. The artists witnessed many of these violent events and radical transformations of their communities, which they recorded and commented on in some of their art.

Commissioned by the traditional rulers and chiefs, the door panels were created, among other reasons, to register their disaffections and reactions to the presence of the colonial authorities. Sometimes the colonial officials are lampooned in a grotesquely satirical manner, with exaggerated features in their characteristic pith helmets and elongated noses. In certain instances, their accomplices, the African servants who were often non-Yoruba, are not spared the biting humor either. Colonial officials are sometimes portrayed either riding a bicycle or being carried on a litter on the shoulders of their African servants—their human mules. At other times, the British colonizers are depicted seated across from traditional rulers whose status and power were increasingly being redefined as a result of colonial takeover.

A typical example is a late nineteenth-century carved door panel by Dàda Arówòògún (Figure 8.8) that would have been installed at the palace of a Yoruba ruler. The entire door is divided into four horizontally oriented registers with abstract decorative elements between. Seated on a folding chair in the middle of the first register is the figure of a merchant, who appears to be involved in a commercial transaction, the sale of the three chained figures in the composition. The victim being handed over to the merchant has both hands tied in addition to a noose around his neck, with a bodyguard or another slave raider in the background.

In the second register, the colonial official is the primary focus of attention, depicted on a bicycle with tobacco pipe in his mouth. The officer is flanked by four figures, two in front and two behind. A man holds a chained female on the left, while the two figures on the right are probably engaged in sexual intercourse, with the woman holding the man's genitalia in her hand. The third panel depicts Jagunjagun—a Yoruba warrior-hero who is a consistent motif in Yoruba art of the nineteenth and early twentieth centuries. Jagunjagun's horse is being fed by two attendants standing right on top of one another.

The last register is of a woman, with a figure to her left who holds a scepter of authority in his hand. The scepter identifies him as a diviner. This is a devotional scene, honoring Ifá, the *òrìsà* in charge of divination. Here, a man holds up the hand of the naked woman, who is kneeling with a sacrificial offering of a chicken. The woman is simultaneously being fed from a gourd by the diviner. Another female companion kneels with an offering bowl in her hand. Finally, next to the principal female figure is a frightened little boy who is clinging on to the trousers of the male figure.

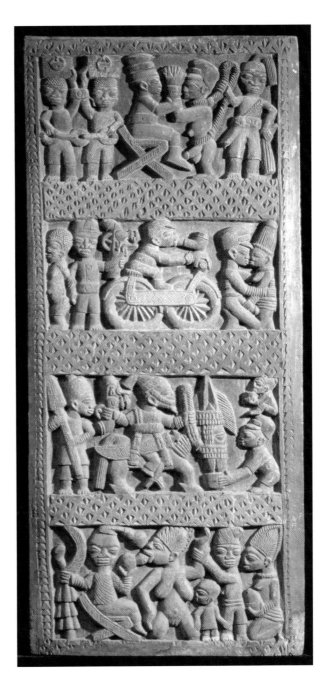

Figure 8.8
Dàda Arówòògún (Aréógún), door panel, late nineteenth century. Wood and pigments. Divided into four registers, the door's highly charged imagery presents images of slavery, power, and divination.

Private Collection. Photo© Heini Schneebeli, Bridgeman Images.

Theme Box 14: Mapping Africa
by Richard A. Lobban, Jr.

The history of printed maps is as long as the history of prints, with hand-drawn maps certainly dating from millennia earlier. The history of global cartography parallels advances in arts, science, chronometry, exploration, navigation, printmaking, and colonialism, as the themes in a selective group of maps of Africa will illustrate.

Claudius Ptolemaeus (ca. 85–165 CE) or Ptolemy—a Roman cartographer residing in Alexandria—first systematized maps with scaled measures of latitude fixed by solar and seasonal fluctuation, and by longitude that is arbitrarily fixed. His *Geographia* (in thirteen scrolls) influenced later Western mapping for centuries to come.

Libyae Inte-rioris Pars; *Tavula III Affri* (*Libya, Interior portion, Table 3, Affri*) by Lugini (Figure TB14.1) follows Ptolemy's inaccurate style. Showing from 47° to 64° east of the Canary Islands, it includes no scales but

has climate zones that "explained cultures," according to his contemporaries. Coastal sites can be reckoned: Berenice (Benghazi) is at *longitude 47°*, *latitude 31°*, and a lake, presumably Siwa Oasis, has the coordinates of longitude 51° and latitude 30°. Toponyms (place names) along the Nile sometimes correlate with modern places; for example, Syene (Aswan) is located at longitude 62° and latitude 24°. Other interior tracks and mountain ranges are very approximate, determined more by rumor and travelers' reports than by proper scientific observation. South of 23° latitude, Roman knowledge trailed off, as at the time, it was forgotten that the African continent was circumnavigable.

Maps of this era were made as much as collector's items for the wealthy as for actual travelers and were printed in only black ink until the end of the nineteenth century.

Color was applied by hand, usually with watercolor washes if at all.

German map maker Sebastien Munster (1489–1552) depicts Africa as circumnavigable, but the proportions of the continent and other information are incorrect (Figure TB14.2)—for instance, the Senega Flu is confused with the Niger. No longitudes or latitude are given; no scales included. The map still uses Latin terminology, but the extensive German narrative text indicates that the transition away from Latin to vernacular European languages in cartography and other print media is underway.

Thomas Jefferys (British ca. 1695–1771) along with a royal geographer to King George III produced an English-language hand-painted polychrome map of the African continent (Figure TB14.3). It gives a sketch of some precolonial interior boundaries of Africa with names like "Negroland" (translated from the

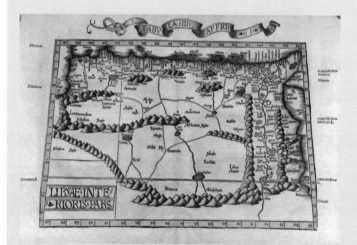

Figure TB14.1
Lugini, *Libyae Inte-rioris Pars; Tavula III Affri*, woodcut, handpainted polychrome, 1535.
This Latin-inscribed map by the Italian Lugini covers northeast Africa from the Sinai to Cyrenaica.
Courtesy of Dr. Richard A. Lobban, Jr.

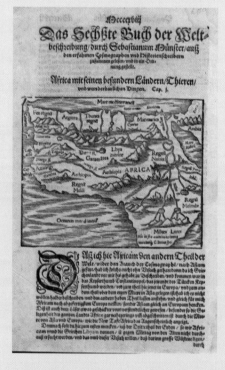

Figure TB14.2
Africa, Sebastien Münster, sixteenth century, German woodcut, 1550.
Courtesy of Dr. Richard A. Lobban, Jr.

Arabic *Bilad as-Sudan* or Land of the Blacks); "Nubia," the name applied to the modern Sudan; the Greek reference to Ethiopia ("burnt-faced people"); and the Biledul Gerid—the recurrent name for the interior of north Africa. Tripoli, Tunis, and Algiers are noted, as well as a small tip of Brazil just above the cartouche of Africa, complete with a crocodile, a slave trade castle, and a ship presumably filled with African slaves. The islands of the Indian Ocean are also noted in some detail. There is no scale, but the Meridian of London passes through the (Upper) Guinea coast because, in the eighteenth century, the placement of the Prime Meridian varied arbitrarily by the nationality of the cartographer.

A fourth map, also English language, shows northern Tunisia of Near Africa, along with the "Sea of Africa" and Numidia (eastern Algeria), the islands of Sicily and Malta, Lotophagitis Island (the "lotus eaters" of Djerba) from Homer's *Odyssey*, and many Latin place names (Figure TB14.4). It provides a scale in Roman miles of 5,000 feet for students of Roman North African history, while the longitudes and latitudes still roughly correlate with Ptolemaic reckoning. The strategic island of Malta is found on the right side of this map.

While precision increases in these four maps, cartographic transitions and toponyms are slow to change, perpetuating inaccuracies in some cases. Maps made on hearsay and guesswork were gradually replaced with correct information as African interiors were explored; and as colonial conquest by European armies needed ever more precise information for military campaigns, and later, for imposing political and administrative boundaries. Maps of Africa show states emerging and disappearing. This process continued into the colonial era and on into the post-colonial times as still other new states emerged in their wake.

Maps and elements such as nomenclature, boundaries, historical claims, and various mythology are always political. Since Scipo Africanus conquered the remnants of the Punic empire in 146 BCE, the name of Africa has stuck for the continent. Although many old European names coined in reference to economic resources in the West African coast such as grain, pepper, slaves, and shrimp are now obsolete (Ivory Coast is an exception), European economic interests in Africa have not disappeared—they have only shifted to oil, gas, uranium, and so on.

Further Reading
Akerman, James R. Jr., and Robert W. Karrow (Eds.), *Maps: Finding Our Place in the World* (Chicago: University of Chicago Press, 2007).

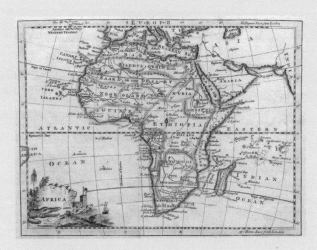

Figure TB14.3
A New Geographical and Historical Grammar, Thomas Jefferys, London, 1766. Engraving.
Woodcuts were replaced by copperplates and later by lithography to achieve greater production for a larger commercial market.
Courtesy of Dr. Richard A. Lobban, Jr.

Figure TB14.4
A Map of Africa, Propria, and Numidia, by an unknown English cartographer. Vol. X, page 366, 1779.
Courtesy of Dr. Richard A. Lobban, Jr.

Theme Box 15: Cultural Appropriation
by Jaleen Grove and Kev Ferrara

Cultural appropriation can be defined as the adoption, adaptation, and financial exploitation of the art, religion, dress, customs, and other intellectual or cultural property of one society or social group by another of a different heritage, without permission and without sharing the accrued profits, credit, or prestige with the originators. Unlike copyright infringement, which refers to the theft of a specific unique design, appropriation includes the quoting of or the misapplication of a generally recognizable mode of creative expression. An example is European modernists' borrowing of African, Oceanic, and other art forms they considered "primitive" (see Chapter 19).

The concept of cultural appropriation arises from advocacy movements for indigenous peoples' rights in the Americas, Africa, Oceania, and other territories colonized by European empires where there is a history of exploitation and eradication of culture. It can also apply to borrowing between other social groups, such as the global fashion industry taking from inner-city youth subcultures.

Appropriation is particularly problematic when a disadvantaged community's survival is threatened by cultural loss and poverty. Activists believe that creators deserve to keep control over their arts in order to raise themselves economically and thus protect themselves culturally. The originating group may also wish to control the use of their cultural expression in order to maintain cultural integrity, especially when the art is strongly constitutive of their identity and may be held sacred by them. A borrowed costume, motif, hand signal, or dance move might give a package, poster, or mural some visual interest in one's own culture but may in fact desecrate or cheapen someone else's. Appropriation can also be costly: in 2015, fashion design company Kokon To Zai (KTZ) had to recall a sweater based without permission on a ritualistic design made by Inuit shaman Qingailisaq in the 1920s.

Cultural appropriation is sometimes contrasted with **cultural hybridity**, the nonexploitive mixture of cultural expressions that typically occurs when creative people share in various influences in the course of everyday life and training. The meeting of cultures often produces such an exchange, where it can be very difficult to determine the lines between synthesis, adoption, tribute, and theft. A major factor in deciding whether a given case is appropriation is whether the adopter is more powerful than the originator in terms of social, political, and economic might, and gains more by the transaction than the originator.

Contemporary artists and activists from marginalized communities may also engage in strategies of **re-appropriation**, to claim back and subvert exploitive narratives about their cultures through intentional copyright infringement, parody, and deconstruction.

Further Reading
Okeke-Agulu, Chika, *Postcolonial Modernism: Art and Decolonization in Twentieth-Century Nigeria* (Durham, NC: Duke University Press, 2015).

Ziff, Bruce H. and Pratima V. Rao (Eds.), *Borrowed Power: Essays On Cultural Appropriation* (New Brunswick, NJ: Rutgers University Press, 1997).

Neo-Traditional Wood Carving in the Twentieth Century

Between 1947 and 1954, in an attempt at winning new converts to the Christian faith, the Society of African Missions in Nigeria (SMA Fathers) organized a series of workshops in Oye-Ekiti with the mission of creating devotional objects for the Catholic Church. The artists were allowed to base their interpretation of biblical narratives on the Yoruba artistic conventions, thus Africanizing the Christian subject matter. Accomplished artists such as George Bamidele (Nigerian, 1910–1995), son of Dàda Arówòògún, together with apprentices like Lamidi Fakeye (Nigerian, 1920–2009) and local weavers, potters, masons, bead artists, and woodcarvers, were brought together in the workshops. They created a range of decorative objects, including altar furniture, baptism fonts, stations of the cross, and ritual vestments for the priests. In the example *The Annunciation* (Figure 8.9), a wooden bas-relief panel illustrating one of a series of Bible stories made by Lamidi Fakeye, Mary and the angel are presented within the domestic setting of the kitchen dressed in traditional Yoruba clothing. Declared a "living legend" by UNESCO in 2006, Lamidi Fakeye had a long and distinguished career as an artist and examples of his neo-traditional sculptures are found in several private and public collections. In 1973, Fakeye was commissioned to carve doors illustrating vignettes of Yoruba life for the African Lounge of the prestigious John F. Kennedy Center for the Performing Arts in Washington, DC.

The Modern Era: Easel Painting, Newspaper Cartoons, and Illustrations

Aina Onabolu (Nigerian, 1882–1963) is credited with pioneering the European manner of easel painting in Nigeria in the early decades of the twentieth century. A modestly successful self-taught portrait painter working among the colonial elites of Lagos, in 1920 Onabolu sought formal art training in Britain and France to legitimize his professional practice. Despite apparent inaccuracies in terms of draftsmanship, his sophisticated portaits were rendered with close attention to detail with a compelling naturalism that is clearly without any precedent in the annals of Nigerian art—especially in a two-dimensional format. While Onabolu's efforts distantly echo the idealized naturalism of ancient Ife terracotta and metal sculptures, his portraits of elegantly dressed Yoruba elites can arguably be understood as visual expression of opposition to the colonial attitude of racial superiority and arrogance, in their deliberate appropriation of the Victorian dress code of the era.

Newspapers

Western-style periodicals such as the Sierra Leonean *Gazette* (published sporadically until 1822), and the Gold Coast and Liberian *Gazettes* (established in 1822 and 1826) were published in the West African regions before the English-Yoruba daily newspaper *Ìwé Ìròhìn* began its circulation between 1859 and 1867. Regarded as Nigeria's first Western-style print periodical, *Ìwé Ìròhìn* was established by English missionary Reverend Henry Townsend, (British, 1815–1886), and was primarily a newsletter without much illustrative content. Generations later, the *West African Pilot*—a newspaper established in 1937 by Dr. Nnamdi Azikiwe (Nigerian, 1904–1996), who later became the first president of an independent Nigeria—was in the vanguard for nationalistic agitation and became a platform to promote anticolonial propaganda following World War II.

Akinola Lasekan (Nigerian, 1916–1974), working within the same era as Onabolu, embraced the possibilities for revealing colonialist atrocities in the two-dimensional cartoons in the pages of the *West African Pilot*. Lasekan's cartoons critiqued and lampooned British colonial authority as the epitome of naked and brutal aggression, the personification of greed and exploitation of the natural resources of Africa. In a typical example (Figure 8.10), a British official is portrayed as overbearing as he sits on the back of both the traditional ruler and the commoner, totally oblivious to the discomfort caused by his weight. The three are depicted in a seemingly desolate landscape, a popular motif for the downtrodden and the underprivileged masses in the colonial theater of brutality and exploitation.

Apart from his cartoons and illustrations on the pages of the daily newspapers, Lasekan was also an accomplished history painter in the European tradition. Lasekan commemorates the historic Kiriji wars that had

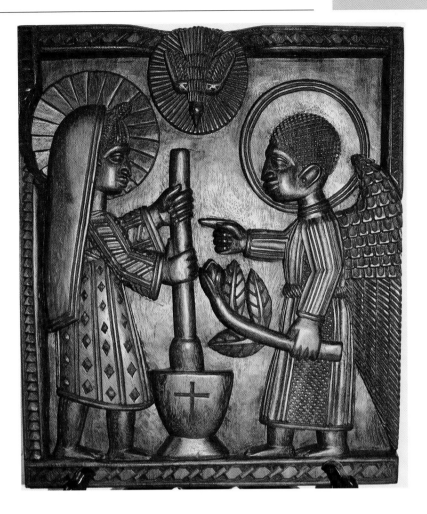

Figure 8.9
Lamidi Fakeye, *The Annunciation*, 2007. Carved wooden panel.
Fakeye reinterprets a biblical narrative in a neo-traditional Yoruba aesthetic. Mary is portrayed as an ordinary Yoruba woman, pounding yam in a mortar in preparation for the evening meal.
Courtesy of Dr. Nicholas Bridger.

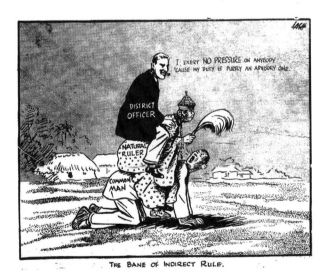

Figure 8.10
Akinola Lasekan, "Bane of Indirect Rule," published in the *West African Pilot*, November 11, 1950.
Oblivious to the discomfort caused by his weight, a British official sits on the traditional local ruler, who is in turn mounted on a commoner.
Courtesy of Yomi Ola, from his *Satires of Power in Yoruba Art* (2013).

heralded British colonialism in Yoruba land (Figure 8.11). His attention is focused here on the movement of soldiers, drummers, and war captives across the picture frame. Set within a thickly forested landscape, the attention of the viewer is directed toward the dominant figure of the military commander on horseback, who seems to be leading his troupe across the rugged terrain. The narrative is reminiscent of the numerous European paintings and

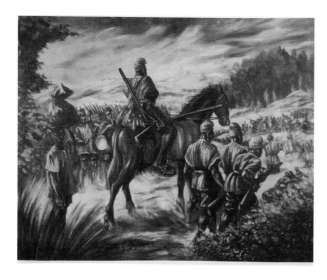

Figure 8.11
Akinola Lasekan, *Ogedengbe of Ilesa in the Kiriji War*, ca. 1960s. Oil on board. The motif of the mounted military leader is reminiscent of European paintings and is a visual reminder of the theme of the horse rider in Yoruba wooden sculpture.

Courtesy of Lasekan family estate.

sculptures that glorify mounted military leaders, but the same motif of the horse rider (see Figure 8.7) serves as a visual reminder of the thematic preoccupation of Yoruba wooden sculpture, appropriated here on a different format with new materials by a celebrated modern artist.

Signwriting and Roadside Illustrations

If Onabolu's and Lasekan's art adopted the modes of the colonial elites of their generation, a new category of art that was in the service of the masses soon emerged in the lower strata of Nigerian society. Termed **Roadside Art**, it developed in the major urban centers of Lagos, Ibadan, Enugu, Port Harcourt, and Abeokuta in southern Nigeria following World War II. Roadside Art was commercially oriented and created by youths whose education never went beyond elementary school. These aggressive and innovative entrepreneurs created art and signage on commission to advertise local businesses, such as barbering and hairdressing salons, bicycle repair shops, food vendors and canteens, beer parlors, English football and pool betting houses, herbalists and traditional healers, and diviners' services. Typically, the signage is naturalistically rendered, with human figures engaged in the pertinent activity, often complemented with brightly colored, strategically positioned texts. The same advertisements are also found on the backs of commuter buses and transport vehicles (sometimes referred to as "mammy wagons") crisscrossing the country (Figure 8.12). Popular sayings, including biblical quotations and local proverbs, are often boldly emblazoned on these vehicles. Some of them include *Safe Journeys*, *No Condition is*

Figure 8.12
Anonymous, image of a lion on a "mammy wagon," in or before 2009. Often a metaphor for royal authority and power, this imposing lion is painted on the back of a commercial vehicle

Photo ©Seth Lazar, 2009.

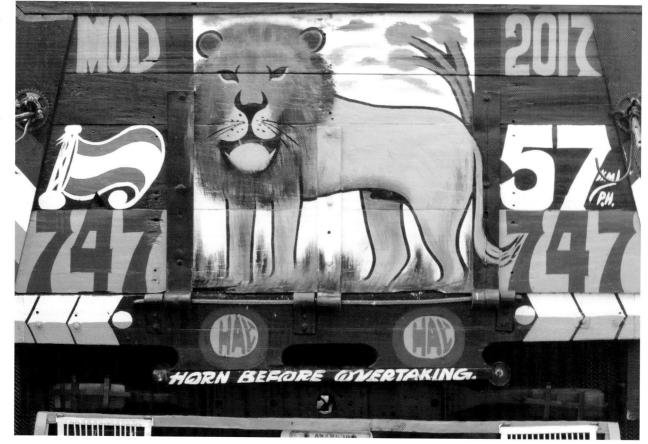

Permanent, God's Case, No Appeal, Givers Never Lack, and *Slanderers cannot alter one's destiny* (*Ìbàjé ènìà kò dá'sé olúwa dúró*), among others.

Murals

Long before the appearance of the contemporary genre of Roadside Art, women periodically gathered throughout Yorubaland to decorate the facades and interior walls of Orìsà shrines, as part of their devotional activities. In some respects, these painted murals are not radically different from the ancient cave paintings found throughout Africa—such as images from the Tassili Plateau in southern Algeria (8000–600 BCE) (Figure 8.13) and San rock paintings from Namibia (28000 BCE) (Figure 8.14). In the absence of documentation, historians can only assume from their privileged placement that cave paintings documented important matters, aspirations, or rituals of the daily existence of the people who created them. Similarly, Yoruba shrine murals record the hopes and prayers of their makers and share remarkable graphic similarity to their **parietal**, or permanently affixed, wall painting antecedents.

Contemporary murals usually include animal images such as cows, goats, dogs, pigeons, crocodiles, and fish, usually collected together in vertical panels; they may also incorporate abstract ideographic symbols and Latin characters in veneration of the *orisa*. Within certain contexts, the painted murals are representations of the spiritual characters and attributes of the *orisa*, which were revealed to the devotees through divinations. On a typical shrine illustration, the figures and animals are painted flat, without any illusion of three-dimensionality.

One example of an Olúorogbo painting shows a densely packed decorative design in red and white pigments over a black background (Figure 8.15). The pigments are derived from different colored soils, animal by-products, and vegetable matter such as charcoal. Images painted on the murals are sometimes suffused with dots in red and white pigments made from laterite (iron-rich soil) and pounded eggshells. Rendered as a sacrifice to the spirit of the *orisa*, these paintings symbolically constitute new "clothing," and are periodically changed to reflect the peculiar temperaments and character of the deity.

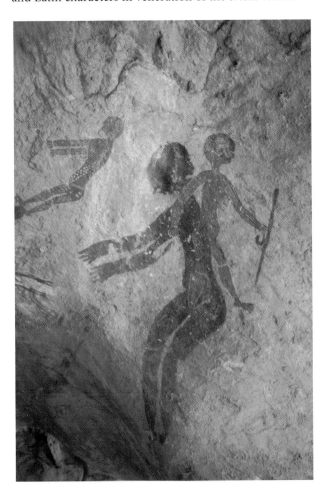

Figure 8.13
Mother and child scene, Tassili N'Ajer, southern Algeria, Pastoralist Period 7000–4000 BCE. Rock painting.

Image: Ian Griffiths, Robert Harding, Getty Images.

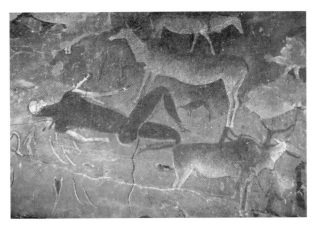

Figure 8.14
San Peoples, *Therianthrope and Eland*, Drakensberg Mountains, Eastern Cape, South Africa. Polychrome. These paintings from distant areas of Africa explore universal themes such as "Mother and child" and the interaction of humans and animals in graphically simplified silhouettes.

Photo:© Kevin Schafer / Alamy.

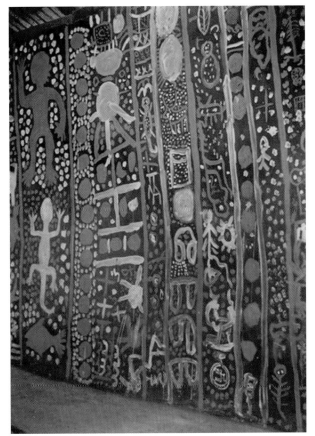

Figure 8.15
Olúorogbo Shrine Painting, Ile Ife, Nigeria, 1986. Essentially prayers rendered visually, this mural's graphic symbols and images represent the requests, aspirations, and hopes of the devotees. Some of them are spiritually charged with incantations and suffused with bodily fluids, thereby making them especially potent and therapeutic.

Photo: Bolaji Campbell.

Theme Box 16: Textiles in Sub-Saharan Africa
by Winifred Lambrecht

Because of North Africa's early associations with Eurasian cultures, it has become common in the scholarly literature to make a distinction between areas lying north of the Sahara and those lying south. Although the vast desert gives the appearance of a dividing line, it was in effect a vibrant trading zone with caravans crossing the Sahara for religious or commercial purposes. Overland routes thus connected West and Central Africa to the Middle East for the exchange of commodities such as salt, gold, slaves, and textiles. On the East African coast, communities were linked across the Indian Ocean with Asia, India, and China among others; so, despite its apparent geographic isolation, Africa was always part of a long-standing trade network.

Textiles were exchanged globally and appreciated for their aesthetics cross-culturally but were also used locally as a means of communication. They are portable, two-dimensional formats as opposed to other indigenous artwork that is often three-dimensional or site-specific (as in rock painting, architectural design, sculpture, masks, and body decoration). Semantically charged textiles in the African setting have long been associated with ethnic identity, wisdom, and political and spiritual messages.

Evidence of the confluence of cultures is apparent in a fifth-century Egyptian tapestry (Figure TB16.1), which brings together a Roman-style arcade with prancing horsemen, Christian angels in the roundels, and baskets of fruit reminiscent of Syrian wall paintings. Coptic Christians in northeastern Africa continued the Egyptian practice of burying the dead in large shrouds, which protected the textiles over the centuries.

Production of textiles provides evidence of the historic movements of people and goods and the spread of influences and designs across cultural lines. Ninth-century textile fragments have been found in Nigeria in the Igbo region, where weaving is still a thriving art form. Silk, which originated in China during the fourth or third millennium BCE, was found on an Egyptian mummy dating to about 1070 BCE in the Valley of the Kings near modern-day Luxor. Its gradual spread to the Mediterranean world through merchants plying the Silk Road during the later half of the first millennium BCE probably brought it to East Africa through trade with Indian or Arabian merchants during the first half of the first millennium CE. Silk was also collected from the wild or unraveled from imported fabrics and reused as threads in the production of fine textiles.

In addition to silk, African textiles are also made from bark, hemp,

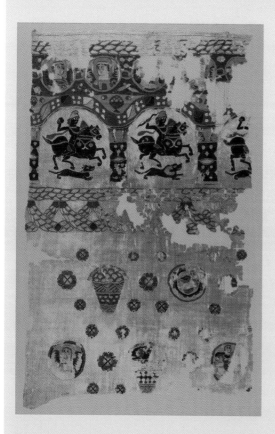

Figure TB16.1
Fragment from a Coptic hanging, Egypt, fifth century. Tapestry weave of linen and wool, 40 ¹⁵/₁₆ × 24 ¹³/₁₆".
Visual traditions of Roman and Syrian art as well as Christian symbolism are literally woven together in this tapestry.
Courtesy of the Metropolitan Museum of Art.

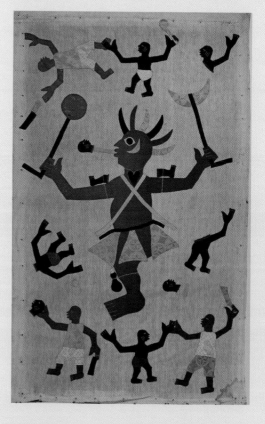

Figure TB16.2
Fon appliqué banner celebrating King Glèlè of Dahomey, Dahomey Kingdom (now the Republic of Benin), nineteenth century. Cloth, 69 × 42".
The use of red in this battle scene signifies those who are aligned with the Dahomey and King Glèlè, the androgynous one-legged creator god of the Fon—shown at center.
British Museum.

raffia, and wool. Linen (made from a bast fiber) was common in Egypt early on and was woven until recently in parts of Nigeria, but is generally not widely used today. Cotton was the most widely used fiber to produce textiles in Africa for centuries. The origins and history of the domestication of cotton are not well known, but it seems to have been independently cultivated in Africa.

Regional Textile Traditions

Fon

Some of the most literal textiles produced in West Africa are the Fon appliqué cloths from Benin, previously the Dahomey Kingdom, which flourished in the eighteenth and nineteenth centuries. Originally designed as part of royal paraphernalia that included royal pavilion banners and umbrellas as metaphors for royal leadership, these appliques started appearing in greater numbers during the late eighteenth and nineteenth centuries due to the increase of available imported fabrics. Fon appliqués are pictographs most often alluding to a king's royal name and the achievements of his reign. Attributes are sometimes represented allegorically with animals reputed for their strength, cunning, or wisdom.

One banner depicts King Glèlè as the androgynous one-legged creator god of the Fon, with the moon in one hand and the sun in the other (Figure TB16.2). His fellow Dahomey (depicted with red flesh) dominate in a battle scene, having dismembered several opponents whose heads and limbs are scattered about the design.

Textile artists usually chose black and white backgrounds to which they applied cut-out figures made from cloth of various colors. In the past, these appliqué works were restricted to the courts and to sacred contexts. With colonial expansion and the subsequent loss of power by indigenous courts, artists continue to produce representational appliqué hangings, now catering to a wider public and the tourist trade. No longer restricted to royal motifs, these popular versions embrace a much broader range of symbols from narrative subjects to nature and animals.

Adinkra and Kente Cloths

Adinkra cloths are fabrics printed by the Asante (also Ashante) people of Ghana. Originally worn only by Asante Kings as toga-like wraps, their use later expanded to the general population, who reserved their wear for ceremonial events. *Adinkra* were also associated with funerals and usually printed in black, on brownish or black fabrics.

The cloths are printed with a selection of symbols that refer to the qualities of the wearer—or the deceased in the case of a funeral. Symbols are arranged in a grid-like format (Figure TB16.3). The inclusion

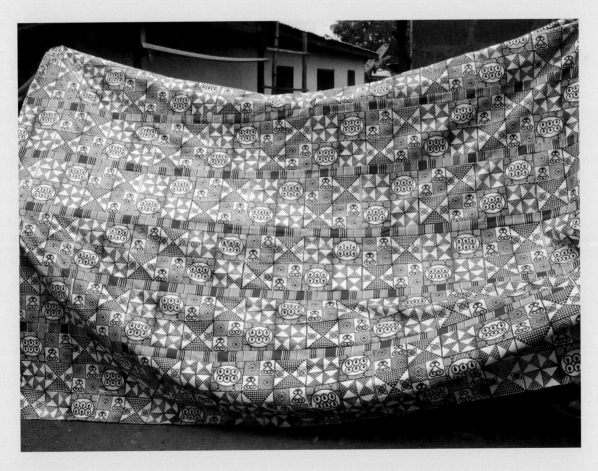

Figure TB16.3
Adinkra cloth, Ghana, 2009.
This cloth was made by combining strips of *adinkra* cloth printed in black and white with colorful woven strips of *kente*. The symbols on this cloth refer to elegance, prosperity, and wisdom.
Photo courtesy of Professor Carol Ventura.

Theme Box 16: Textiles in Sub-Saharan Africa
by Winifred Lambrecht (continued)

of more numerous and finer symbols makes the cloth more prestigious and communicates the higher status of its wearer. The Asante value speech enlivened with folktales, proverbs, and other culturally rich turns of phrase, and hundreds of *adinkra* symbols refer to proverbs or may be inspired by organic and celestial forms or abstract geometry—all bear metaphoric significance. Placing symbols next to one another requires the viewer to consider the relationship implied. Therefore, *adinkra* symbols are not simple illustrations; nor are they fixed ideograms in the sense that they have a one-to-one correspondence between the visual and the verbal. Rather, the sum total of the cloth requires interpretation.

Traditional cloths were printed with stamps carved out of calabash gourd, but contemporary cloths are also silkscreened. While the oldest symbols tend to reference proverbs, *adinkra* continues to be adapted in contemporary use, and some newer symbols even integrate elements of Roman letterforms in a visual code that constitutes a unique form of verbal/visual literacy.

Kente cloth is made of narrow-strip weavings that are sewn together to make larger cloths. These are worn wrapped around the body, traditionally in ceremonial contexts by men as a full body wrap (similar to a toga); and by woman as either a lower body wrapper or with two cloths, worn top and bottom. Originally found among the Ewe and Asante people of Ghana and Togo, *kente* is now recognized globally for its bold geometric designs and has been fashionable in West Africa since Kwame Nkrumah, an independence leader and President of Ghana from 1960 to 1966, wore the cloth during diplomatic functions.

The popularity of this cloth in other contexts perhaps diminishes its importance as a means of communication within the Akan community where it is widely understood. Like *adinkra*, *kente* cloth is not a one-to-one symbol-word referent but rather represents a shared verbal-visual connection. *Kente* cloth designs correlate to "names" that might refer to significant objects, nature, proverbs, or even historic figures as exemplars of ideas—all of which allow for nuanced and shifting interpretations. It is worth noting that the production of *kente* cloth was—and still is to a great extent—the domain of men who weave on narrow strip looms. Indeed, gender specificity was a hallmark of sub-Saharan African art until a century or so ago. Furthermore, no creative process was isolated from other forms of visual or performance art or from belief systems.

Literacy campaigns and the adoption of common languages (mostly English, French, and Portuguese) are the norm in much of sub-Saharan Africa today. As traditional expressions expand beyond their original context in modern communications, connections between word and image are made evident, and a new dimension is added to "literacy." But by merging the written word with an image in new, commonly shared forms, specific, local cultural meanings have become diluted: while a broader audience can read a text, its ideograms, the symbolism of colors used, and other graphic elements are accessible only to those who still possess traditional knowledge of their original cultural meaning.

Kanga
For the past fifty years or so, the most ubiquitous textile traditions found in many parts of sub-Saharan Africa are the *pagne* and the *kanga*. The *pagne* is a 2-by-6-meter piece of cotton cloth that can be fashioned into a number of items of clothing or used untailored as a wrap-around by both men and women; it is extremely popular in most of tropical Africa.

The *kanga* is a traditional type of dress originally from the East African coast (specifically from the Swahili), an area of intensive cultural exchanges with traders plying the Indian Ocean for more than two millennia. Initially block printed in Africa using existing textile patterns, by the late nineteenth century, *kangas* were machine produced in India and Europe (primarily in Holland and England). In both cases, designs by non-African artists manifest attributes of local and international cultural influences, such as symbols and iconography found in Indonesian batik, Persian rugs, and European wallpaper and tapestries.

Although both often express messages of a political or social nature, *pagnes* are distinct in origin, design, and size from kangas. Typically, a *kanga* features a large border and a central motif (plant, animal, fruit, or other object) under which a saying is written—usually in a capsule (Figure TB16.4). Written messages started appearing on *kangas* in the late 1800s, initially in Arabic script. The Roman alphabet was used when Swahili became the preferred language, later followed by English or French.

Many textiles were (and still are) used extensively as political and social tools. Formerly with portraits of independence leaders, more recently some appear with political candidates during voting campaigns or to highlight the anniversary of a political party or a visit by a dignitary. Cloths might also urge people to seek health services, follow traditional edicts, and impart wisdom and cultural information through proverbs. Some of the factory-made versions might reference popular culture like television programs, music, or current events, whereas others classified as "commemorative cloths" (also known in Ghana) are

designed and worn for important cultural or political events.[1] Because of their specificity (both chronological and geographical), they can be used to trace the political movements and the history of nations and regions, through visual imagery and traditional sayings. *Kangas* and commemorative cloths form a record

[1]Kreamer, *Inscribing Meaning: Writing and Graphic Systems in African Art*, p. 137.

of political, social, and cultural trends (Figure TB16.5).

In summation, it is evident that no African art form can be isolated from either its long-standing global connections or its matrix; no item of textile or style of dress can be commoditized and stand on its own. Like most aesthetic expressions in sub-Saharan Africa, textiles are elements in a complex and negotiated set of social, gendered,

economic, political, and/or spiritual relationships, with individualized levels of meaning and creative interpretation.

Further Reading

Kreamer, Christine Mullen, et al., *Inscribing Meaning: Writing and Graphic Systems in African Art* (Washington, DC: Smithsonian, National Museum of African Art, 2007).

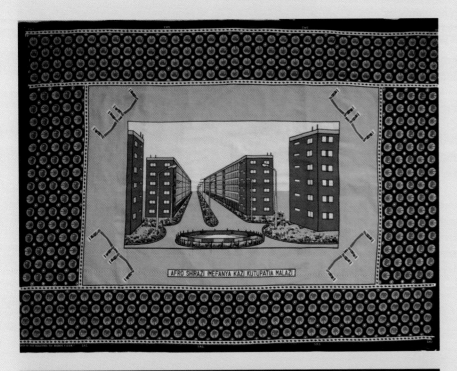

Figure TB16.4
Anonymous, *kanga*, Kenya, 1980s. Printed cotton, 39 × 51". This *kanga* refers to the Afro Shirazi political party from Zanzibar, who essentially took control of the land in 1964. The saying translates to "Afro Shirazi is working to provide us with housing," which refers to the shortage of housing in Zanzibar in the 1970s.

Private collection. Photo courtesy of Professor Winifred Lambrecht.

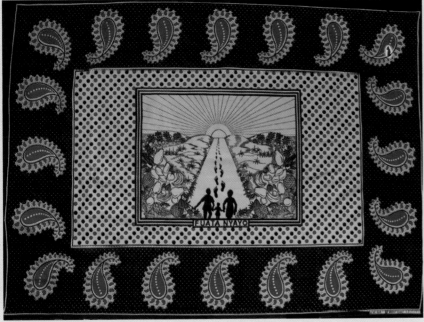

Figure TB16.5
Anonymous, *kanga*, Kenya, 1980s. Printed cotton, 39 × 53". The central image of this *kanga* shows a family walking toward the sun, which could symbolize the life of an individual in which the footsteps represent the different stages of life. The translation is "Follow the footsteps," without specifying whose footsteps—it may refer to the traditions of ancestors.

Private collection. Photo courtesy of Professor Winifred Lambrecht.

Yoruba Textiles: *Àdìre Eléko*

The Yoruba *Àdìre Eléko* cloth is an indigo-dyed fabric with designs produced by a variety of resist-dye techniques. Traditionally, women produce it through an enduring cultural tradition handed down from one generation of family members to the next.

Typical *Àdìre* textiles are characterized by grid-like but polyrhythmic patterns in which units of the grid may not necessarily repeat the same motif but share a design affinity that is aesthetically pleasing (Figure 8.16). Many *Àdìre Eléko* motifs are zoomorphic and include avian creatures along with botanical forms like petals, leaves, trees, and cocoa pods. They may integrate utilitarian objects like combs, cutlery, and hoes, along with abstract representations of cosmic bodies such as the sun, moon, and stars. Decorative patterns like dots and concentric circular motifs and lines are often included—carefully organized in various directions to intensify aesthetic interest. Some of these patterns are painted directly on the fabrics, whereas others are made with stencils using linoleum, zinc, or tin plates.

One of the more famous examples of *Àdìre Eléko* is the *Ìbàdán Dùn* motif, inspired by the distinctive Greco-Roman columns erected at the four entrances of Mapo Hall in the city of Ibadan, the first metropolitan Yoruba city of the modern era. Mapo Hall functioned as the administrative headquarters of colonial authority in Ibadan. Strategically located on top of the hill with a compelling view of the ancient city, the columns became a metaphor for the centrality, prestige, and power associated with the sprawling city of Ibadan at the height of colonial engagement. In one design (Figure 8.17), the columns alternate with abstracted spoons, the symbol of femininity, power, elegance, and nurture, referring generally to the role of women as nurturers and providers for their families—but also to Erelú, the most important titled female member in the Ògbóni society, the Yoruba council of elders.

Figure 8.17
Anonymous, Yoruba people, *Àdìre Eléko, Ìbàdán Dún* motif, Nigeria, n.d. Stencil-patterned cotton, indigo dye, 75 $^1/_2$ × 69 $^1/_2$" (overall). Set within an overall design (top), one motif (bottom) shows the Greco-Roman pillars of Mapo Hall, the city's administrative headquarters, interspersed with double-ended spoons, a symbol of femininity, power, and nurture among the Yoruba. The Greco-Roman pillars reinforce the notion of the political sophistication of the city of Ibadan, remarkable for its socioeconomic activities and financial success.
Mead Art Museum, Amherst College, MA. Museum Purchase. Bridgeman Images.

Àdìre Eléko's creative vocabulary may also integrate Roman letters into the decorative motifs. While textual communication may not have been the original intention of the illiterate women who created such motifs, *Àdìre Eléko* artists occasionally solicited the help of their children in arranging their decorative patterns; and since the children might have received some degree of Western education, they may have been aware of what a word meant.

At other times, the texts were actually supplied by their patrons to be integrated into the decorative patterns and motifs, and designs were sometimes inspired by imagery from foreign sources (Figure 8.18). This complex illustrated cloth's central medallion derives from a design commemorating the twenty-fifth jubilee of King George V and Queen Mary of Britain in 1935. The densely packed field, however, includes animals, humans, plant forms, and dots in a seemingly random narrative placement that nonetheless achieves compositional balance. Repeated several times on the edges of the fabric

Figure 8.16
Anonymous, Yoruba Peoples, *Àdìre Eléko*, cloth with Olókun, Goddess of the Sea motif, Nigeria, ca. 1973. Cotton, 71 × 77".
Àdìre Eléko designs employ a grid but do not necessarily repeat the same motifs in a strict pattern. Motifs include zoomorphic and botanical forms, and may integrate utilitarian objects.
Samuel P. Harn Museum of Art, University of Florida, Gainsville.

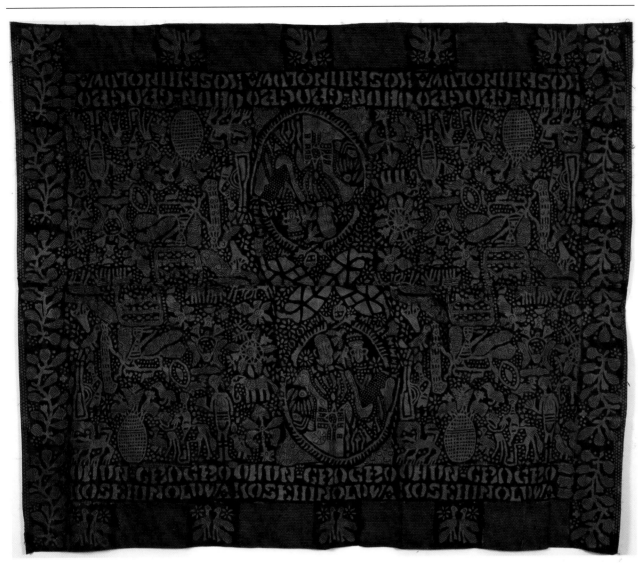

Figure 8.18
Anonymous, Yoruba people, *Oloba, Àdìre Eléko*, wrapper, Nigeria, twentieth century. Stencil-patterned cotton and indigo dye, 68 1/2 × 84". The central element is based on a medallion commemorating the Silver Jubilee of King George V and Queen Mary in 1935, with textual and floral patterns on the borders. "Nothing is hidden from the Almighty" (*Ohun Gbogbo kò sèhìn Olúwa*) is repeated horizontally as a design motif on the top and bottom parts of the fabric.

Mead Art Museum, Amherst College, Massachusetts. Museum Purchase. Bridgeman Images.

are textual patterns: "*Ohun Gbogbo kò sèhìn Olúwa*"—"Nothing is hidden from the Almighty"—a Yoruba dictum for human vulnerability and an acknowledgment of the power of the creator.

Conclusion

What typifies illustrative art in an African context may not necessarily align with the narrow confines of European, American, or Asian perspectives, which in the modern era tend to center on ephemeral traditions of printed media. Instead, we have highlighted the gamut of the visual arts: terracotta, calabash decorations, wooden and metal bas-reliefs, parietal cave imagery, and shrine murals, which have functioned as concretized illustrative communication prior to and after the introduction of European artistic conventions. We also investigated textiles as an important and popular visual medium throughout Africa that encodes cultural, sociopolitical, and religious meaning.

FURTHER READING

Abiodun, Rowland, *Yoruba Art and Language: Seeking the African in African Art* (New York: Cambridge University Press, 2014).

Campbell, Bolaji, *Painting for the Gods: Art and Aesthetics of Yoruba Religious Murals* (Trenton, NJ: African World Press, 2008).

Kreamer, Christine Mullen, et al., *Inscribing Meaning: Writing and Graphic Systems in African Art* (Washington, DC: Smithsonian, National Museum of African Art, 2007).

Okediji, Moyo, *African Renaissance: Old Forms New Images in Yoruba Art* (Boulder, CO: University Press of Colorado, 2002).

Ola, Yomi, *Satires of Power in Yoruba Visual Culture* (Durham, NC: Carolina Academic Press, 2013).

Oloidi, Ola, "Art and Nationalism in Colonial Nigeria," In *Seven Stories about Modern Art in Africa*, edited by Clementine Deliss (London: Whitechapel, 1995): 192–194.

KEY TERMS

bas-relief
cultural appropriation
cultural hybridity
lost-wax process

parietal
re-appropriation
Roadside Art

Observation and Representation: Natural Science Illustration, 1450–1900

*Shelley Wall and
David M. Mazierski*

This chapter introduces key figures in the evolution of illustration within the domain of natural science in Europe and European colonies, from the fifteenth to the end of the nineteenth century. Early Modern (1450–1800) precursors to science as we now know it were branches of investigation termed "natural philosophy," which corresponds roughly to the physical sciences, and "natural history," or the study of biological phenomena. Natural history emerged as a distinct discipline in the mid-sixteenth century, and its hallmark was close, direct observation of the natural world as the basis for detailed description. Renaissance (1400–1600) thinkers rediscovered classical Greek and Latin texts and tested these writings against the evidence of their own senses. At the same time, Renaissance visual artists refined linear perspective as a mode of representing the world "naturalistically," as it appears to the human eye. The emergence of observational, experiential science and of naturalistic conventions in visual representation coincided with Johannes Gutenberg's (German, 1398–1468) introduction of moveable type and the printing press to Europe (*see Chapter 2*). Together, this emphasis on sensory evidence, these artistic technologies of naturalistic representation, and this new means of reproducing and disseminating knowledge revolutionized both science and illustration.

Leonardo da Vinci and Albrecht Dürer

Plant, animal, and human anatomical studies created by Leonardo da Vinci (Italian, 1452–1519) and Albrecht Dürer (German, 1471–1528) exemplify the Renaissance interest in careful study of the natural world. While knowledge of anatomy, especially externally visible anatomy, was already considered necessary for artists, da Vinci pushed these studies to the extreme, ultimately carrying out his own dissections of human bodies and documenting his findings and speculations in his notebooks. In addition to human anatomy, da Vinci also observed and documented nonhuman phenomena, including biological subjects such as animal anatomy, the growth patterns of plants (Figure 9.1), and the mechanics of bird flight. In spite of his prodigious accomplishments, da Vinci's work stands outside the direct lineage of scientific illustration because his work in this domain was not published in his lifetime; it lived in his notebooks alone and therefore did not participate in the dissemination and exchange that are essential to the progress of both science and its visual records.

Albrecht Dürer, like da Vinci, brought a "scientific" eye to bear on the natural world (*see Chapter 2*). His *Four Books on Human Proportion*, published shortly after his death in 1528, quantify and analyze the variety of human body types in an effort to erect a rational framework for the representation of the human form, in the same way that the science of linear perspective provided a framework for the representation of three-dimensional space. Dürer also executed meticulous studies of plant and animal life; these studies, unlike those of da Vinci, were circulated during his lifetime. His *Hare* (1502) and *The Large Piece of Turf* (1503) are well-known examples of his naturalistic studies, demonstrating the close attention to details of form, color, texture, and the animal's stance that would come to be essential in natural science illustration. These qualities in Dürer's plant and animal studies were widely imitated (Figure 9.2).

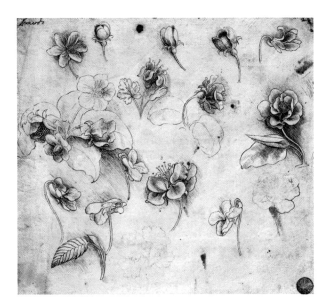

Figure 9.1
Leonardo da Vinci, botanical studies, ca. 1505. Pen and ink.
Da Vinci captured the subtleties of flower and leaf morphology in these closely observed studies.
Getty Images.

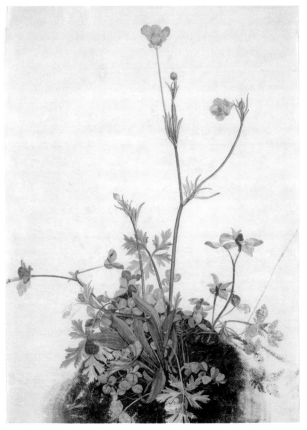

Figure 9.2
School of Albrecht Dürer (German, 1471–1528), *Buttercups, Red Clover, and Plantain*, 1526. Watercolor and gouache on vellum, 11 ¹¹/₁₆ × 8 ⁹/₁₆".
Dürer's style of close examination from nature was widely emulated.
RISD Museum, Providence. Gift of Mrs. Brockholst Smith in memory of her mother, Jane W. Bradley.

Rhinoceros (1515) (Figure 9.3) is perhaps Dürer's best-known animal illustration. It was *not* drawn from life, but rather was composed on the basis of someone else's sketch and a written report. Dürer himself never saw a rhinoceros, and his image includes an erroneous supplementary horn on the shoulder. The image was produced as a woodcut print and circulated widely—copied as a serious representation of the animal for hundreds of years afterward. Ironically, of all Dürer's images of nature, many of them exquisitely accurate, it is this rhinoceros that entered the canon of natural history.

Questioning Authority

Other publications were explicitly intended to catalog bodies of knowledge about the natural world. A common theme in both anatomical and natural-science illustration in the Renaissance is the transition from reliance on received authority to insistence on the evidence of the senses. We see this shift in key printed botanical, anatomical, and zoological texts: *Herbarum vivae eicones* (*Living Portraits of Plants*) (1530), *De historia stirpium commentarii insignes* (*Notable Commentaries on the History of Plants*) (1542), *De humani corporis fabrica* (*On the Fabric of the Human Body*) (1543), and *Historiae animalium* (*Histories of the Animals*) (1551–1558), as explained here.

The Beginnings of Scientific Botany

Because of their long history of medicinal use, plants are among the earliest organisms to be systematically illustrated. Botany was, in effect, a branch of medical study rather than a distinct discipline until the sixteenth century: illustrated herbals, in manuscript and later in printed form, were meant to serve as guides to the identification of plants known for their healing properties. Classical herbals were copied and recopied by hand over the course

of centuries, resulting in images so stylized that in most cases any likeness to the actual plant was lost. Early printed herbals, such as the *Ortus Sanitatis* (*The Garden of Health*) (ca. 1500), followed in this tradition, with illustrations based not on direct observation but on the replication of earlier work (Figure 9.4).

This tradition changed in 1530 with the publication of the first part of *Herbarum vivae eicones* (*Living Portraits of Plants*), illustrated by Hans Weiditz (German, 1495–1537), a student of Albrecht Dürer, and written by theologian, physician, and botanist Otto Brunfels (German, 1488–1534). Whereas the text was derived in large part from classical authorities, the 260 illustrations contributed something new: they were, as the title suggests, drawn from life. Weiditz represented individual specimens, including flaws such as broken stems and wilting leaves. It is because of the radical innovation of these illustrations that the book continues to be regarded as a key moment in the history of botanical science (Figure 9.5).

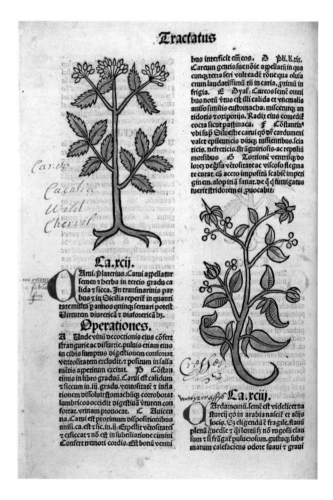

Figure 9.4
Jacob Meydenbach (publisher), "Chervil" and "Cardamom," *Ortus sanitatis*, 1491. Woodcut with hand-coloring, approximately 11 ¹/₂" (folio).[1]
Early printed books at first replicated the stylization and inaccuracies of older hand-copied manuscripts.

Courtesy of the Wellcome Library, London.

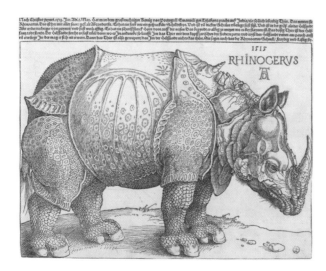

Figure 9.3
Albrecht Dürer, *Rhinoceros*, 1515. Woodcut, 8 ³/₈ × 11 ⁵/₈" (image).
Dürer's drafting skill resulted in a persuasive image in spite of its many inaccuracies, convincingly portraying the solid volume of the massive body and the rugged texture of the beast's "armor."
Courtesy of the National Gallery of Art, Washington DC.

[1]It is customary that only the height of the sheet (folio) is provided when describing images that exist in bound volumes. The reason is that it is impossible to ascertain the exact width of the sheet without destroying the binding.

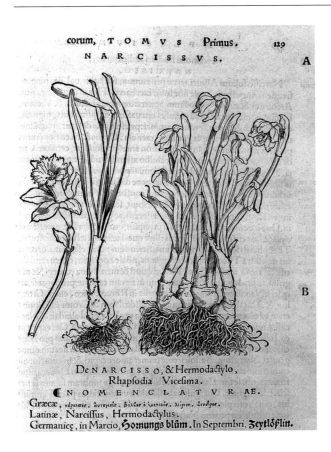

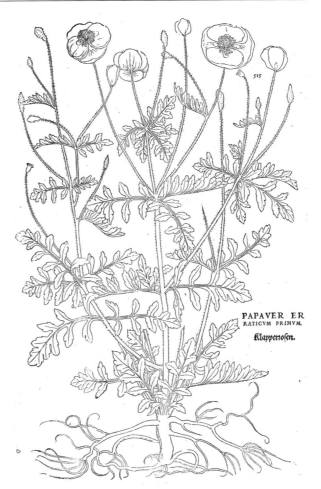

Figure 9.6
Albrecht Meyer,
"Poppy," *De
Historia Stirpium*
by Leonhart Fuchs,
1542. Woodcut;
and woodcut with
hand-coloring,
approximately 14 1/4
× 9 7/16".
The simple but
expressive linework
also allowed for
the book to be
hand-tinted after
publication, which
was done in many
extant copies.
Courtesy of the
Wellcome Library,
London.

Figure 9.5
Hans Weiditz, "Narcissus," *Herbarum vivae eicones* (*Living Portraits of Plants*), 1530. Woodcut, 12 5/16 × 8 7/16".
Weiditz included images of the same plant at different stages of flowering.
Courtesy of the Wellcome Library, London.

Leonhart Fuchs (German, 1501–1566) and his illustrator Albrecht Meyer (German, fl. 1540s) built on the legacy established by Brunfels and Weiditz. *De historia stirpium commentarii insignes* (*Notable Commentaries on the History of Plants*) (1542) is significant in the history of botanical science in that it begins to attempt a systematic organization of the information it compiles, although a regular system for naming and classifying plants did not yet exist. It is notable in the history of botanical illustration for several innovations. The book contains over 500 illustrations: these are full-page, in contrast to the illustrations in Brunfels's book, which were integrated with the text; this arrangement accords the images greater weight and authority, on par with the verbal description. The illustrations more consistently include details of plant structure and life cycle—for example, in including images of roots, fruit, and flowers (Figure 9.6). The woodcuts are executed in delicate linework, without shading. Fuchs states in his dedication that this is a deliberate strategy to avoid errors introduced by the "artifice" of painters. While this statement seems to eschew some of the newly developed elements of "naturalistic" depiction, such as tonal rendering, the delicacy and attention to detail of the images are such that they provide a vivid picture of the characteristics of specific, recognizable plants. Botanical science evolved rapidly during this period, and so did the visual language used to describe it.

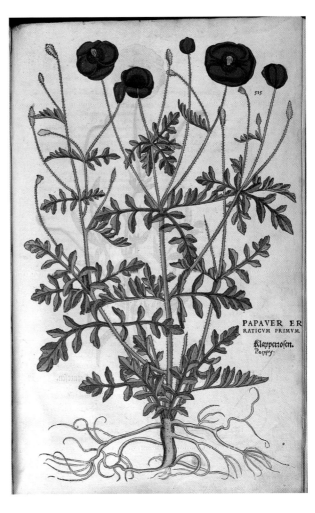

Observation, Representation, and Human Anatomy

Just as the collaborations between Brunfels/Weiditz and Fuchs/Meyer brought new insight to bear on classical knowledge of plants, so the work of the anatomist Andreas Vesalius (Flemish, 1514–1564) and his illustrators expanded knowledge of, and representational practices in, human anatomy with the publication of *De humani corporis fabrica* (*On the Fabric of the Human Body*) in 1543. The *Fabrica* sparked a revolution in the study and teaching of human anatomy through its insistence on direct observation. Before Vesalius, would-be doctors studied the writings of the physician Claudius Galen (Greek, ca. 129–216 CE), who had described the human body based on dissection of nonhuman animals such as dogs, pigs, and apes. Vesalius took the radical step of performing his own dissections of human bodies, and in doing so exposed errors in Galen that had been perpetuated for more than a millennium. These dissections were depicted in equally revolutionary woodcut illustrations (Figure 9.7). The influence of Vesalius's teaching and images in the history of human anatomical illustration is formidable (*see Chapter 10*).

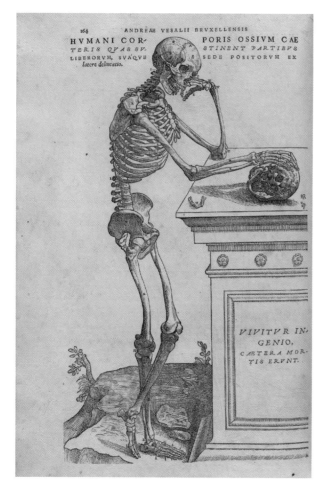

Figure 9.7
Jan Stefan van Calcar (attributed), a skeleton contemplating a skull in a *memento mori* tableau, *De humani corporis fabrica*, 1543. Woodcut, approximately 15 ⁵/₈" (folio).
It appears that Vesalius, in addition to creating some of the simple illustrations in this book himself, worked very closely with other illustrators, including Jan Stephan van Calcar (Flemish, ca. 1499–1546), a student of the painter Titian.
Courtesy of the National Library of Medicine.

The Birth of Modern Zoology and Veterinary Medicine

The first modern pictorial text in zoology—the study of animals—also appeared at this time and became one of the major influential books in natural science. It was the work of physician and scholar Conrad Gessner (Swiss, 1516–1565), who set out to create an encyclopedic, illustrated book to bring together all known information about the animal kingdom from Biblical, classical, medieval, and contemporary sources. His *Historiae animalium* (*Histories of the Animals*) appeared in four volumes (1551–1558), with a fifth volume published posthumously in 1587 (Figure 9.8a, b). In addition to using existing pictorial and textual material, Gessner had a wide network of correspondents who sent him notes, sketches, and specimens. Gessner himself created some of the illustrations and also worked with a host of artists; Lucas Schan (German, fl. 1550s) is one of the few whose names we know. For the last decade of his life, Gessner worked at compiling and illustrating a similarly comprehensive study of the plant world. The annotated drawings for his planned *Historia plantarum* (with many of his own illustrations) were not published until almost 200 years after his death.

The rapid and intensive development of natural science, anatomical study, and descriptive naturalistic illustration in the Renaissance created fertile ground for the appearance of more specialized works, such as *Dell'anatomia et dell'infirmita del cavallo* (*On the Anatomy and Diseases of the Horse*) (1598) by Carlo Ruini (Italian, 1530–1598), the first great book of veterinary medicine. Ruini's work was based on dissections and appears to be influenced by the work of Vesalius. Figure 9.9, for example, evokes the Vesalian "muscle-men" in their Italian landscape; other images depict, as in the *Fabrica*, isolated organs and organ systems. It is thought that Ruini may have done the drawings himself. Alternatively, rumors circulated that the illustrations were by "an artist from the workshop of Titian"—a suggestion that would reinforce the parallels to the *Fabrica*, with its illustrations by Titian's student van Calcar.

An Inventory of the World

Natural history by the late sixteenth century was becoming less exclusively associated with medicine and more closely connected with an "encyclopedic" impulse. With the growing interest in natural history and the explosion of new species becoming known in Europe through voyages of discovery and the increase in global trade came a parallel passion for collecting. Plants, for example, were collected in the form of "herbaria"—specimens pressed and preserved between sheets of paper or vellum. In living form, plants were collected in newly established botanical gardens, both at universities and on private estates. Scholars and wealthy collectors also amassed **cabinets of curiosities**—collections of natural specimens and artifacts, which were the precursors of museums. The extensive collection of physician Ulisse Aldrovandi (Italian, 1522–1605) is a prime example; after his death, it was maintained by the Senate of Bologna, and in 1617 opened as the first public science museum.

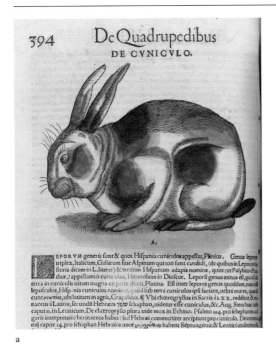

a

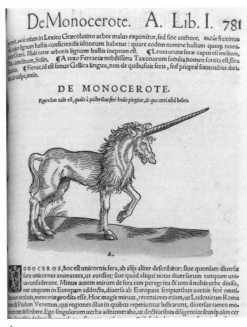

b

Figure 9.8a, b
Conrad Gessner, *Historiae Animalium*, 1551–1558. Woodcut, approximately 15 3/4 × 11 13/16". Reflecting the eclectic nature of Gessner's sources, the images themselves vary in verisimilitude. Along with living species such as rabbits and porcupines (and a copy of Dürer's *Rhinoceros*), the *Historiae* also includes mythical animals such as the unicorn.

Courtesy of the National Library of Medicine.

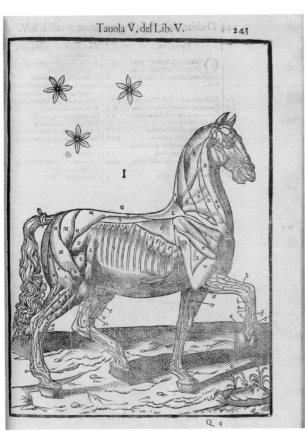

Figure 9.9
Carlo Ruini, *Dell'anatomia et dell'infirmita del cavallo*, superficial musculature of the horse, 1598. Woodcut, 13 3/8" (folio).
Ruini's book was published, translated, and plagiarized widely in the decades following its first appearance.

Courtesy of the National Library of Medicine.

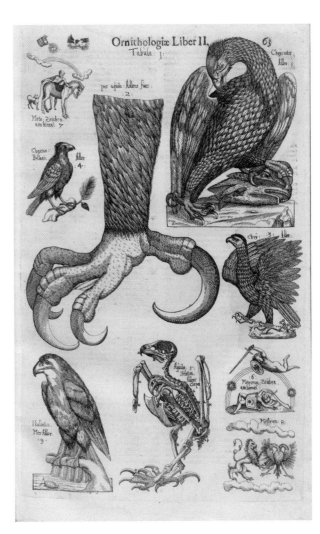

Figure 9.10
Anonymous, eagle, *Ornithologiae* (*Ornithology*), volume 2 by Ulisse Aldrovandi, 1610–1613. Woodcut, 16 5/32" (folio). This plate contains not only the kind of information we now regard as the purview of biology, such as skeletal anatomy and anatomical details, but also emblems that relate to the creature's symbolism and cultural associations.

Courtesy of ETH-Bibliothek Zürich, Alte und Seltene Drucke.

Illustrated catalogues of such collections form an important chapter in seventeenth-century scientific illustration. They document, organize, and, in the case of ephemeral specimens, preserve a lasting record. Like Gessner, Aldrovandi set out to create an encyclopedic record of his collection through textual observations, heavily illustrated with woodcuts based on drawings by an array of artists. Although the full set of records was not completed until after his death, three volumes on ornithology were published during his lifetime, marking a significant contribution to bird classification and illustration (Figure 9.10). Later published works described insects and invertebrates, fish, quadrupeds, snakes and dragons, and "monsters."

Aldrovandi's student, Volcher Coiter (Dutch, 1534–1576), pioneered the study of comparative osteology (the study of bones) (Figure 9.11).

In the domain of botany, the *florilegium* (flower book) became a significant genre. Where botany was once the preserve of pharmacy, even plants lacking identified medicinal value were valued for their beauty, and therefore collected and cultivated. *Florilegia* were visual catalogues of flowering plants illustrated with great accuracy and a strong aesthetic sense—often showcasing plants from a single collector's garden. The first such record of flowers in a single garden is the *Hortus Eystettensis* (*The Garden at Eichstätt*) (1613), which documents over a thousand plants from the garden of the Prince Bishop of Eichstätt. *Hortus Eystettensis* was produced by botanist and apothecary Basil Besler (German, 1561–1629), who oversaw both the garden itself and the work of the artists and engravers who produced the images. This was one of the first botanical works to

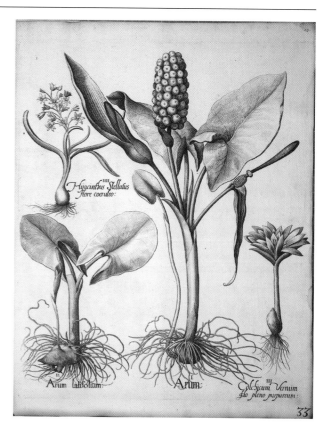

Figure 9.12
Anonymous, cuckoo-pint, arum, spring meadow saffron, and hyacinth, *Hortus Eystettensis* by Basil Besler, 1613. Copperplate engraving, approximately 22 $^{7}/_{16}$ × 18 $^{7}/_{64}$".
These fine engravings were designed to be hand-colored; a number of workshops in Nüremberg specialized in such illumination.
The Biodiversity Heritage Library. Digitized by Missouri Botanical Garden, Peter H. Raven Library.

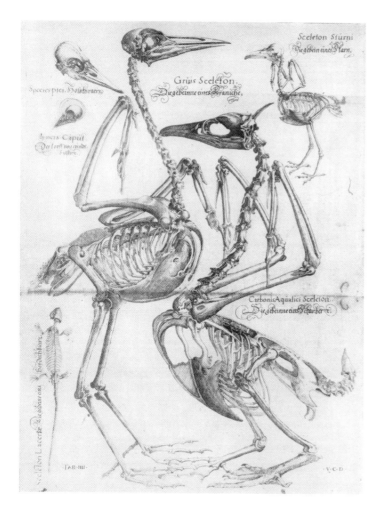

Figure 9.11
Volcher Coiter, comparative osteology of birds, *De avium sceletis et praecipuis musculis* (*On the Principal Muscles and Skeletons of Birds*), appended to *Lectiones Gabrielis Fallopii* (*Lectures of Gabriele Falloppio*), 1575. Copperplate engraving, approximately 19 × 24" (folio).
Coiter published detailed and delicate engravings of his own illustrations to demonstrate comparisons among vertebrates.
The Biodiversity Heritage Library. Digitized by Missouri Botanical Garden, Peter H. Raven Library.

be illustrated with copperplate engravings rather than woodcuts (Figure 9.12). Sebastian Schedel (German, 1570–1628) is the only artist whose name is known.

Observation Changes Scale: The Revolution in Optical Technologies

The *Scientific Revolution* is the term used to describe the period from the mid-sixteenth to the late seventeenth centuries, when the sciences in Europe took a transformative leap. In this chapter, we consider that revolution's impact on representational practices in the biological sciences, but for context, it is important to note other contemporary scientific developments. In the physical sciences, a landmark text of the scientific revolution was *De revolutionibus orbium coelestium* (*On the Revolutions of the Heavenly Spheres*) by Nicolaus Copernicus (Polish, 1473–1543), which placed the sun at the center of planetary orbits, overturning the Ptolemaic geocentric view. *De revolutionibus* was published in the same year as Vesalius's *Fabrica*, and, like Vesalius, Copernicus repudiated classical authority. Galileo Galilei (Italian, 1564–1642) championed the ideas of Copernicus, furthering the science of observational astronomy in anticipation of the classical

mechanics of Isaac Newton (English, 1642–1727). Newton's publication of *Philosophiae naturalis principia mathematica* (*Mathematical Principles of Natural Philosophy*) in 1687 inaugurated the discipline of modern physics. Francis Bacon (English, 1561–1626), another towering figure in the scientific revolution, developed the scientific method of methodical observation and experimentation—the cornerstone of modern scientific investigation.

Against the background of this ferment of ideas, an optical technology was developed that added an entirely new dimension to the visual language of natural science: the microscope. The earliest microscopes used for scientific exploration date back to the early 1600s. Two types were used: devices with a single small lens, or designs built into a cylinder that used two lenses—one for magnification, another for focus. Both types suffered in various degrees from optical deficiencies related to the shapes of the lenses and the type of glass used to make them. Despite their faults, these tools enabled early **microscopists** (those who used microscopes for scientific study), to see structures and organisms invisible to the naked eye. The observations of these vanguard scientists, such as Robert Hooke (English, 1635–1703), stimulated other scientific research as well as public interest. Hooke is credited with first using the word *cell* to describe the walled-in spaces he observed in a thin slice of cork, which we now recognize as plant cell walls. (Despite Hooke's breakthrough, the idea that all living creatures are made up of cells and that they are the basic unit of life—the "cell theory"—was not formulated until 1838.) Hooke's *Micrographia* (1665) contained large, fold-out copperplate illustrations of a louse, a flea, and the head of a fly, among other miniature subjects (Figure 9.13). While *Micrographia* is famous for its sensational biological illustrations, it also contains observations on astronomy, gravity, light, and other phenomena.

Hooke is remembered for his dramatic enlargements of relatively common subjects, but Antonie van Leeuwenhoek (Dutch, 1632–1723) pursued microscopy as a vehicle for his study of subjects too small for the naked eye to see; his curiosity and wide-ranging observations have earned him the title "father of microbiology." Over his lifetime, Leeuwenhoek built hundreds of miniature but powerful single-lens microscopes, which he used to observe spermatozoa (Figure 9.14), blood, pond water, mold, and muscle fibers. Leeuwenhoek's research is known from the hundreds of letters he sent to the Royal Society of London (the UK's scientific academy) for publication, and from the letters that he himself collected and published.

Jan Swammerdam (Dutch, 1637–1680) used microscopes to dissect and study many species of insects; he published his research in *Historia Insectorum Generalis* (*The Natural History of Insects*) in 1669, including the first detailed illustrations of insect internal anatomy and descriptions of the complex metamorphosis of many insects. Later, Swammerdam turned his attention to the anatomy and life cycle of the frog, and observed cleavage of the fertilized egg (Figure 9.15).

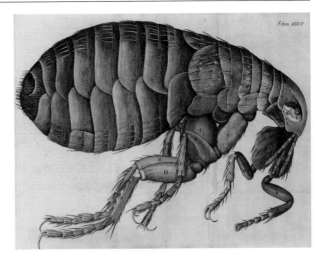

Figure 9.13
Robert Hooke, flea, *Micrographia*, 1665. Copperplate engraving, 7 3/8 × 11 1/4".
While the text was produced using letterpress, Hooke's use of intaglio rather than wood-cut resulted in the enhanced detail of his illustrations.
Courtesy of the National Library of Wales.

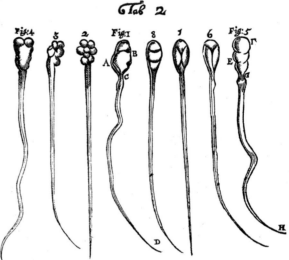

Figure 9.14
Anonymous, spermatozoa of rabbits and dogs, *Philosophical Transactions* of the Royal Society of London by Antonie van Leeuwenhoek, 1677. Woodcut.
Recognizing his shortcomings as an artist, van Leeuwenhoek hired local draftsmen in Delft to illustrate his discoveries.
Courtesy of the Wellcome Library, London.

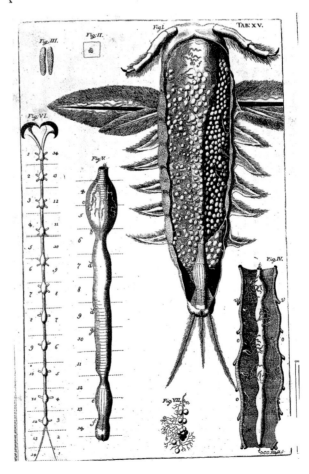

Figure 9.15
Jan Swammerdam, dissection of the worm of the day-fly, *The Book of Nature; or, The History of Insects*, 1758. Copperplate engraving, 15 3/4 × 9 5/8" (folio).
Swammerdam developed techniques for injecting colored wax into the vessels of anatomical specimens to make them easier to study.
Courtesy of the Wellcome Library, London.

New Systems of Classification and New Standards in Illustration

One of the challenges faced by early modern scholars seeking to catalogue the natural world was the lack of a common **taxonomy**, or system of classification. It was not until the eighteenth century that Carl Linnaeus (Swedish, 1707–1778), physician and botanist, codified and consistently applied the system of naming that we use to this day—that is, **binomial nomenclature**, or the identification of an organism by its genus and species (e.g., *Homo sapiens*). While Linnaeus extended his taxonomic system to the animal, mineral, and vegetable kingdoms, his passion for organization originated with his interest in botany. Just as Linneaus set a new standard in scientific taxonomy, so one of his collaborators, the artist Georg Dionysius Ehret (German, 1708–1770), set a new standard for detail, accuracy, and beauty in botanical illustration.

Georg Dionysius Ehret was a gardener, who learned from his father both his practice of drawing from observation and his knowledge of plants. After a modest career as a botanical painter, he met George Clifford (Dutch, 1685–1760), a wealthy banker, director of the Dutch East India Company, and botanical enthusiast. Clifford had an extensive botanical garden on his estate, which he had engaged Carl Linnaeus to oversee. In 1737, Linnaeus published a description of the rare plants in Clifford's garden—the *Hortus Cliffortianus*—for which Ehret supplied twenty illustrations, many including detailed dissections of the sexual parts of the plant, a key diagnostic feature for Linnaeus. In the same year, Linnaeus published *Systema Naturae*, which featured a table by Ehret illustrating the twenty-four classes of plants (Figure 9.16). Ehret went on to a long and successful career as a botanical illustrator and teacher, and became one of the most influential botanical artists of the eighteenth century (Figure 9.17).

Linnaeus's contemporary and scientific rival, Georges-Louis Leclerc, Comte de Buffon (French, 1707–1788), advanced a proto-evolutionist view of natural history in the massive, extensively illustrated, and influential *Histoire Naturelle*, thirty-six volumes of which were published in his lifetime (Figure 9.18a, b, c). Two

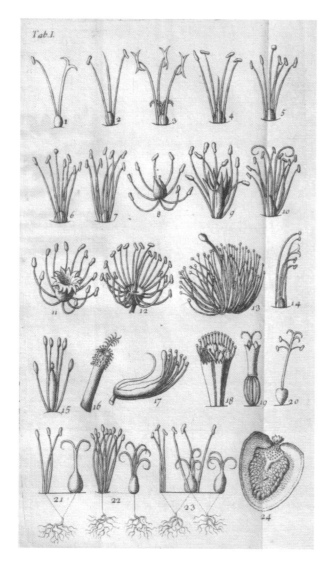

Figure 9.16
Georg Dionysius Ehret, frontispiece, *Genera Plantarum* by Carl Linnaeus, 1743. Engraving. 7 9/10" (octavo).
This illustration depicts Linnaeus's proposed twenty-four classes of plants identified by the number and arrangement of stamens.
The Biodiversity Heritage Library. Digitized by Missouri Botanical Garden, Peter H. Raven Library.

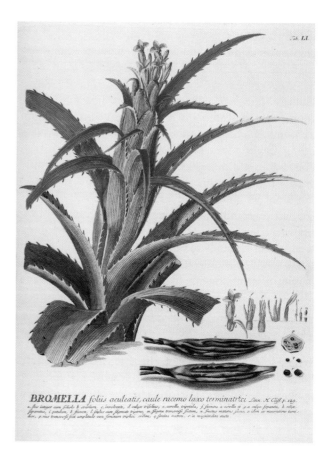

Figure 9.17
Georg Dionysius Ehret, bromeliad, *Plantae Selectae*, 1750–1773. Engraving with hand-coloring, 20 5/8 × 14 1/8" (folio).
The physician Christoph Jacob Trew (German, 1695–1769), who published these engravings based on original watercolors, was one of Ehret's most significant patrons.
The Biodiversity Heritage Library. Digitized by Missouri Botanical Garden, Peter H. Raven Library.

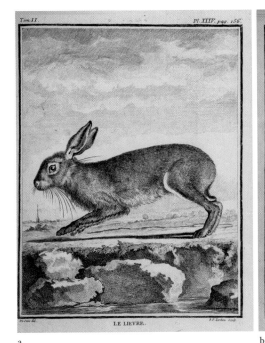

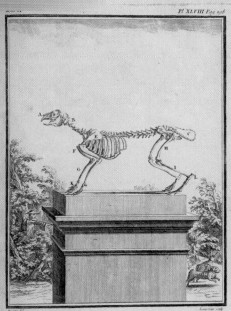

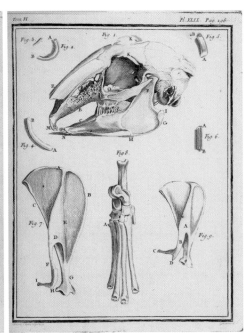

a b c

Figure 9.18a, b, c
Jacques de Sève and others, hare: habitus, skeleton, and skeletal details,
Histoire Naturelle (*Natural History*), volume 6, by Georges-Louis Leclerc,
Comte de Buffon, 1756, Copperplate engraving.
Typical of plates in the volumes on quadrupeds, the skeleton is posed on a
plinth; in the background, a hunter takes aim at two fleeing hares.

The Biodiversity Heritage Library. Digitized by University of Ottawa Library.

artists who between them produced most of the work's
illustrations were Jacques de Sève (French, fl. 1742–1788),
about whom little is known, and François-Nicolas
Martinet (French, ca. 1731–1800), who, in addition to
contributing hundreds of engravings to Buffon's work,
also illustrated numerous other works on ornithology.

Another important work of animal anatomy from
this period is *The Anatomy of the Horse* (1766) by George
Stubbs (English, 1724–1806). During his lifetime, Stubbs
was best known for his paintings of animals, in particular
noteworthy racing and breeding horses. However, his
lasting legacy is *The Anatomy of the Horse*, which he
created in its entirety, from dissection to drawing to
etching (Figure 9.19).

Illustrating New Environments

European audiences were fascinated with images of exotic
species reported and collected in the course of European
exploration and colonial expansion into other continents.
An early significant illustrator of entomological and
botanical subjects, both European and South American,
was Maria Sibylla Merian (German, 1647–1717). Her
first published books were botanical studies intended
as pattern-books for embroidery, collected in *Neues
Blumenbuch* (*A New Book of Flowers*) (1680). However,
Merian was fascinated by insects from a young age, and
her observations and illustrations of insects in their
various life stages were published in 1679, 1683, and
(posthumously) 1717 in the three-part *Raupenbuch*,

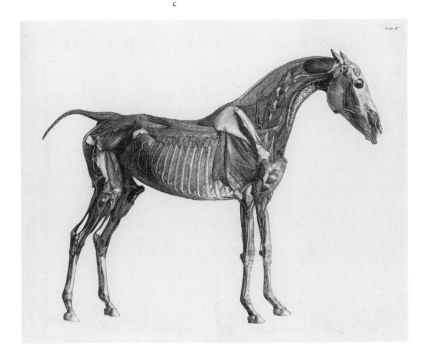

Figure 9.19
George Stubbs, écorché horse, deep dissection, side view, *Anatomy of the Horse*, 1766. Copperplate
etching, 14 $^7/_8$ × 18 $^7/_8$".
Far surpassing the detail and accuracy of Carlo Ruini's *Dell'anatomia et dell'infirmita del cavallo*
(1598), Stubbs's work became the standard reference for veterinarians and artists until the twentieth
century.

Courtesy of the Wellcome Library, London.

including 150 plates of illustrations. Her culminating
work was *Metamorphosis insectorum Surinamensium*
(*The Transformation of the Insects of Surinam*) (1705),
the result of an expedition undertaken with one of her
daughters to Surinam, a Dutch colony in South America.
As in the *Raupenbuch*, Merian did not simply depict
specimens in isolation, but gave a more comprehensive,
contextualized picture of the living creatures by

Theme Box 17: Berger: Ways of Seeing
by Sheena Calvert

John Berger (1926–2017) was a writer and critic who, in his seminal 1972 TV series *Ways of Seeing* and book of the same name, introduced several foundational concepts in the fields of art, photography, visual communication, and visual culture.

Beginning by pointing out that that *seeing* comes before words and language, Berger emphasizes that *how* we see constitutes *what* we see, where the how—or way—is based on our particular cultural experience more than it is based on the anatomy and physics of vision. Our perception of what we see is affected by beliefs, and therefore the knowledge we communicate, derived from perception, is not always objectively formed. For Berger, knowledge, images, and words are in a dynamic relationship that constantly evolves in response to the surrounding social environment.

Berger, who sought to demystify art by showing its social functions, has been especially influential in the criticism of visual culture. In *Ways of Seeing*, he points out how portrayals of the female nude have changed (and not changed) over time in the history of painting and advertising, showing how women have become objectified. Men survey women, while women watch themselves being surveyed—a concept feminist film theorist Laura Mulvey also develops (*see Chapter 16, Theme Box 35, "Women in Illustration,"* and *Chapter 26, Theme Box 48, "Judith Butler: Gender and Queer Studies"*). Berger identifies several advertising tropes applied to women, such as serene mother, busy secretary, perfect hostess, or sexual object, which cast them as passive subjects under the control of men. Berger argues that we need to be much more critical of such imagery, since it influences our perceptions of ourselves and the world. He suggests that advertising's promise that the purchasing of products will engender happiness, satisfaction, and the envy of peers promotes false desires and needless consumption (*see Chapter 15, Theme Box 33, "Marx: Modes of Production"*).

Berger points out that reproducing artwork detaches the art from its original context. Just as reproduction enables the Mona Lisa to be seen in a vast number of contexts that Da Vinci could never have imagined, any illustration can now be expected to exist outside of the studio in which it was made. Once detached, it becomes merely a "species of information" that, through a process of montage, editing, or recontextualization, enters into new discourses and new uses that the maker would never have envisaged, becoming part of a new set of possibilities (*see Chapter 27, Theme Box 50, "Derrida: Deconstruction and Floating Signifiers"*).

Berger further argues that reproductions of artwork retroactively alter the meaning of the original artworks by transforming them into seeming prototypes for reproductions, as if they were made *in order* to be reproduced. Photography, Berger asserts, allows this reproduction and wide dissemination to take place, making photography the main art form of the twentieth century (succeeding oil painting). Berger's point takes on new significance as reproduction and dissemination have become vastly accelerated due to digital technologies and the availability and immediacy of sharing platforms such as Instagram (*see Chapter 29*).

In "Why We Look at Animals" (from *About Looking*, 1980), Berger examines our relationship to animals through an ethical lens. Where the difference between animals and humans has long been attributed to humans' possession of complex symbolic language, for Berger, our dependence on and use of language does not place us in a superior position to animals. Rather, it creates an "abyss" of understanding that we cannot bridge. He states: "[Animals] are the objects of our ever-extending knowledge," by which he means that we oppress sentient life for our own purposes through the amassing of what we consider knowledge. Where we once feared animals that dominated the natural world, we may domesticate them or place them in zoos as specimens, fundamentally altering our relationship to them through technology and social organization, to our detriment. Looking at animals in a zoo, cage-by-cage, is like seeing paintings in a gallery: they become relegated to the level of just images that we take in but do not contemplate deeply. Ultimately, the relationship to the conscious creature and a sense of awe toward it is lost, since animals thus become "unknown" to us—recontextualized, as images in reproduction are. Berger's essay challenges image-makers to reconsider the presentation and representation of animals, to close the gap between them and humans, and to end their objectification (*see also Chapter 28, Theme Box 54, "Haraway: Crossing Boundaries"*).

Further Reading

Berger, John, *About Looking* (London: Vintage International, 1992).

Berger, John, *Ways of Seeing* (London: Penguin Books, 1977).

*Quoted material attributable to subject

depicting them in different life stages and situated on their presumed food-plants (Figure 9.20). The final book, executed in hand-colored engravings based on Merian's paintings, was intended for both specialist and nonspecialist audiences.

Other illustrators in the New World followed Merian in representing animals and plants together in ecological scenes, such as Mark Catesby (English, 1683–1749), and William Bartram (American, 1739–1823). Mark Catesby produced the earliest illustrated work on the flora and fauna of what is now North America, *A Natural History of Carolina, Florida and the Bahama Islands* (1729–1747), based on his observations during a four-year sojourn. His practice of depicting animals within their environment (Figure 9.21) would later influence John James Audubon in his *Birds of America*. William Bartram, a botanist and plant collector, documented his exploration of what is now the American South in paintings, drawings, and writing. His *Travels through North & South Carolina, Georgia and Florida* (1791) promoted a view of nature as a web of interdependencies, an idea captured in his illustrations (Figure 9.22).

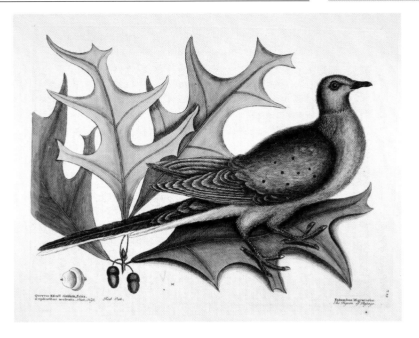

Figure 9.21
Mark Catesby, "Pigeon of Passage," passenger pigeon and red oak, *The Natural History of Carolina, Florida and the Bahama Islands*, 1754. Engraving with hand-coloring.
Catesby was one of the first people to recognize the risk of extinction from human depredation on animal habitat; the last passenger pigeon died in captivity in 1914.

The Biodiversity Heritage Library. Digitized by Missouri Botanical Garden, Peter H. Raven Library.

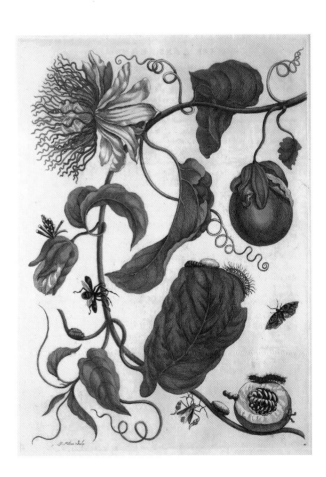

Figure 9.20
Maria Sibylla Merian, *Metamorphosis insectorum Surinamensium*, 1705. Engraving with hand coloring, approximately 21 $^9/_{32}$ × 13 $^{19}/_{32}$".
Insects in various stages of metamorphosis are shown on the stem and leaves of the passion flower.

The Biodiversity Heritage Library. Digitized by Smithsonian Libraries.

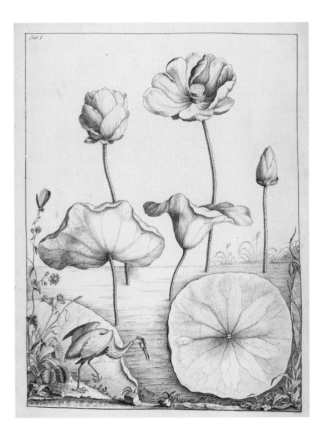

Figure 9.22
William Bartram, *Nelumbo lutea Willd*, American Lotus or Water Chinquapin; *Dionaea muscipula* J. Ellis (Droseraceae), Venus Flytrap; *Ardea herodias Linnaeus*, Great Blue Heron, 1767. Pen and ink on paper, 15 $^{21}/_{32}$ × 11 $^{13}/_{16}$".
Bartram represented the relationships among these plants and animals conceptually, rather than naturalistically.

Courtesy of the Natural History Museum, London.

In the late eighteenth and early nineteenth centuries, it became common practice for naturalists and illustrators to accompany voyages of exploration to observe, document, and collect specimens. One such illustrator was Ferdinand Lucas Bauer (Austrian, 1760–1826), who was already a well-known botanical artist in 1801 when he was appointed Natural History Draughtsman on an English expedition to survey the Australian coastline and study its plants and animals. During his Australian expedition, Bauer made thousands of sketches of both animals and plants (Figure 9.23). On his return to England, he painted, engraved, and hand-colored fifteen plates for the publication *Illustrationes Flora Novae Hollandiae* (1813).

Ferdinand Bauer's older brother, Franz Andreas Bauer (Austrian, 1758–1840), was also a botanical artist of great significance. Unlike the well-traveled Ferdinand, Franz spent most of his career in one place, as the first paid Botanical Illustrator by Appointment at the Botanic Gardens at Kew, in England, from 1790 until his death in 1840. Although many of his illustrations remained unpublished in his lifetime, an important feature of Franz Bauer's work was his depiction of microscopic details of plant structure (Figure 9.24). Both of the Bauers were accomplished in not only the art but also the science of botany; Franz Bauer was elected a member of the Royal Society in 1821.

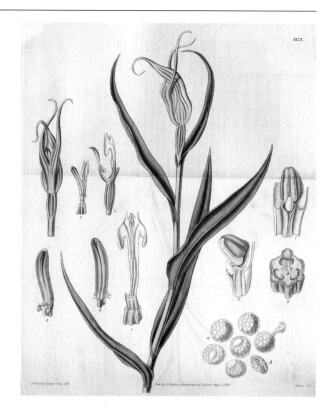

Figure 9.24
Franz Andreas Bauer, *Pterostylis Banksii, Curtis's Botanical Magazine*, 1832. Engraving with hand-coloring, 9 3/4 × 7 7/8".
Note the detailed depiction of pollen grains in the lower-right corner, at 570 times magnification.

The Biodiversity Heritage Library. Digitized by Missouri Botanical Garden, Peter H. Raven Library.

Nineteenth-Century Natural Science

In the first half of the nineteenth century, large, public natural history museums began to be established across Europe, successors to the great private collections of wealthy individuals as hubs of natural science research. As more naturalists entered the field, specializations emerged (for example, botany, geology, zoology)—and eventually further subspecializations, such as ornithology, ichthyology, and entomology. The development of faster and more economical printing technologies aided in the spread of new research, in which illustrations played a major role. It also helped feed the growing public appetite for information and images of natural history. The work of Charles Darwin (English, 1809–1882), proposing the theory of evolution, initiated a paradigm shift that would transform the view of the natural world in Western scientific and intellectual communities.

Also during this century, biology emerged as a discipline simultaneously aligned and in tension with the older, classificatory and observational natural history; the word *biology* came into use to describe the search to characterize the fundamental laws that govern living organisms, and experimentation came to play a larger role in the life sciences. Against this background, out of the vast body of scientific illustrations created for researchers and the broader public in this period, we will identify a few key figures.

John James Audubon (American, 1785–1851) produced one of the most significant illustrated bird

Figure 9.23
Ferdinand Lucas Bauer, *Phascolartus cinereus* (koala), ca. 1811. Watercolor on paper.
Bauer based this study on direct observation begun on the H.M.S. *Investigator* voyage to Australia (1801–1803) and on collected specimens. Bauer had previously produced illustrations for the *Flora Graeca* (1806–1840), a survey of Mediterranean plants acknowledged as one of the most magnificent botanical publications ever produced.
Courtesy of the Natural History Museum, London.

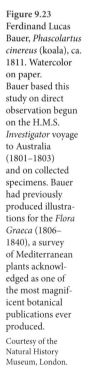
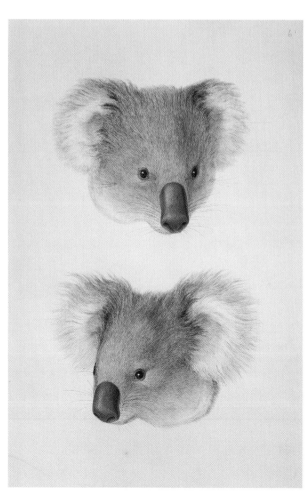

books of the nineteenth century. His engraved, hand-colored publication of *The Birds of America* (1827–1838) holds the record as one of the largest books ever produced; at 39.5 inches by 26.5 inches, the page format is known as the **double elephant**. A later edition of *The Birds of America* reproduced the plates in a smaller format (the **royal octavo**, a standard page size measuring approximately 6 1/4 × 10"), using lithography (*see Chapter 11, Theme Box 21, "Lithography"*), to provide a more affordable version of the publication (Figure 9.25).

John Gould (English, 1804–1881), the leading British ornithologist of his time, produced over forty lavishly illustrated volumes on birds, working with numerous artists. Foremost among these was his wife Elizabeth (née Coxen) Gould (English, 1804–1841). In addition to working on her husband's publications, she also contributed fifty plates to Charles Darwin's *The Zoology of the Voyage of the H.M.S. Beagle* (1838–1843) (Figure 9.26).

Gould learned her lithography skills from another of Gould's illustrators, Edward Lear (English, 1812–1888). While Lear is best known today for his children's books and nonsense verse (such as "The Owl and the Pussycat," *see Chapter 16*), he was a highly accomplished natural history illustrator. In addition to creating illustrations for other researchers, he also published a self-initiated monograph under his own name—*Illustrations of the Family of Psittacidae, or Parrots*, which appeared in installments between 1830 and 1832. Lear's approach to bird illustration was innovative on several counts: he worked from living models whenever possible (while other bird artists relied largely on freshly killed or stuffed specimens), and he made his own lithographs. The *Psittacidae* was the first book devoted entirely to a single species; it was published in large folio size, with the birds represented life-sized (Figure 9.27).

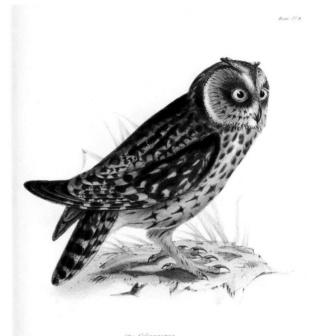

Figure 9.26
Elizabeth Gould, *Otus galapagoensis* (short-eared owl), *The Zoology of the Voyage of the H.M.S. Beagle*, 1838–1843. Lithograph. Gould created over 650 lithographic plates before her death at the age of thirty-seven.

The Biodiversity Heritage Library. Digitized by Smithsonian Libraries.

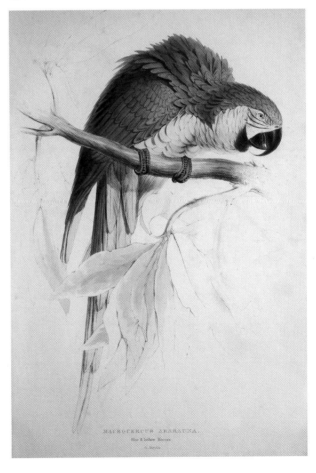

Figure 9.27
Edward Lear, *Macrocercus ararauna* (blue and yellow macaw), *Illustrations of the Family of Psittacidae, or Parrots*, 1830–1832. Lithograph with hand-coloring, 21 11/32 × 14 3/8" (folio).
In contrast to engraving, lithography allows the depiction of soft, subtle textures ideal for representing plumage.

The Biodiversity Heritage Library. Digitized by Smithsonian Libraries.

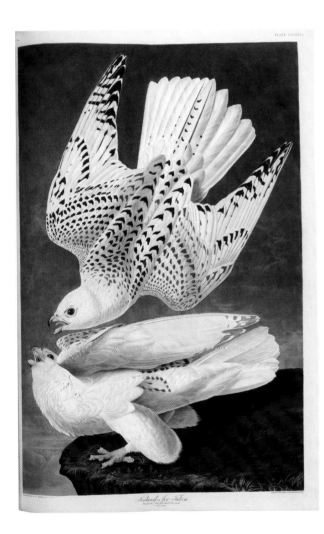

Figure 9.25
John James Audubon, gyrfalcon, from *Birds of America*, Royal Octavo edition, 1840–1844. Lithograph with hand-coloring, 10 1/2 × 6 1/2".
Audubon's paintings were based on direct observation in nature as well as his studies of specimens he killed and mounted in lifelike poses.

The Biodiversity Heritage Library. Digitized by Smithsonian Libraries.

A very well-known illustrator whose work in natural history remains underappreciated is Beatrix Potter (English, 1866–1943), creator of the Peter Rabbit children's books (*see Chapter 16*). From early childhood, she made detailed studies of the world around her, including plants, animals, insects, and fossils, and later conducted dissections and microscopic investigations, recording what she observed. Her area of most intense investigation was mycology—the study of fungi (Figure 9.28). By the late nineteenth century, natural science was increasingly a professional pursuit, and as both an amateur scientist and a woman, Potter faced barriers to the dissemination of her research.

Nineteenth-Century Microscopy

Optical and mechanical improvements to the microscope, and better methods for preparing specimens for viewing, resulted in more accurate devices that are essentially the models for all modern optical microscopes. However,

the development of cameras and film that could record images through the microscope's focusing tube were not perfected until the middle of the twentieth century, and therefore, illustration still played an important role in the dissemination of new discoveries. Notable microscopic discoveries, described by illustrations based on careful observation, include the neuron as the basic functional unit of the central nervous system in 1894 by Santiago Ramón y Cajal (Spanish, 1852–1934). Ramón y Cajal, a pioneering neuroscientist and co-winner of the Nobel Prize in Physiology or Medicine in 1906, had early ambitions to become an artist but was persuaded to enter medicine by his father. Nonetheless, his artistic skills shine through in his delicate, complex renditions of detailed tissue architecture as glimpsed through the microscope (Figure 9.29).

One of the most extraordinarily productive scientists and illustrators of the late nineteenth and early twentieth centuries was Ernst Haeckel (German, 1834–1919). Haeckel's earliest scientific research was on the topic of radiolarians, single-cell marine organisms that secrete a unique inner skeleton. His painstakingly accurate figures, drawn from microscopic observation, are still the benchmark by which radiolarians are studied today. His further research into the morphological similarities between simple invertebrates such as radiolarians, sponges, and jellyfish and their parallel stages of embryological development convinced him that the theory of evolution proposed by Charles Darwin in *On the Origin of Species* (1859) was correct, and he became one of Darwin's most vocal advocates. Haeckel's greatest contribution to scientific illustration was *Kunstformen der Natur* (*Art Forms in Nature*), published between 1899 and 1904. The lithographs by Adolph Giltsch (German, 1852–1911) were created from Haeckel's research drawings as well as new compositions, which emphasized Haeckel's fascination with symmetry and form (Figure 9.30a, b).

Figure 9.28
Beatrix Potter, Wax Cap (*Hygrophorus puniceus* or *Hygrocybe coccinea*), collected at Smailholm Tower, October 7, 1894. Watercolor and body color heightened with white. Although her scientific illustrations and research were not well known during her lifetime, Potter's deep knowledge and appreciation of the natural world inform every aspect of her work, including her whimsical portrayal of animals and plants in her children's books.
Courtesy of the Armitt Trust.

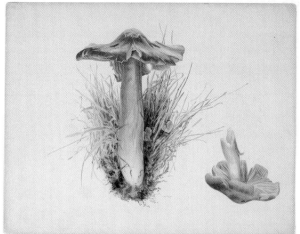

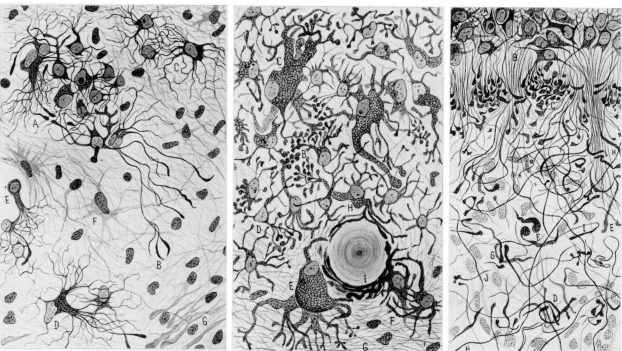

Figure 9.29
Santiago Ramón y Cajal, brain cells, *Libro en honor de D.S. Ramón y Cajal* (*Book in Honor of D.S. Ramón y Cajal*), pages 338, 340, 342, 1922. Pen and ink. Ramón y Cajal's visual notes demonstrate the crucial role of illustrations as scientific data.
The Biodiversity Heritage Library. Digitized by University of Toronto.

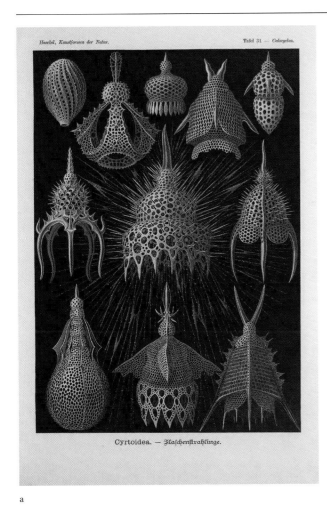

a

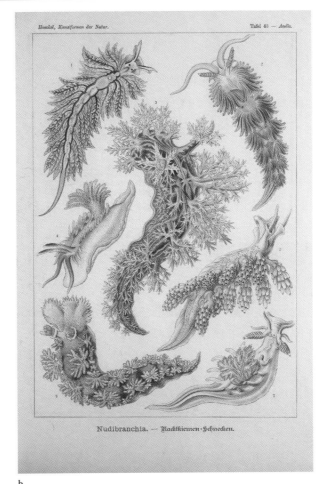

b

Figure 9.30a, b Ernst Haeckel, radiolarians (a) and nudibranchs (b), *Kunstformen der Natur* (*Art Forms in Nature*), 1899–1904. Lithographs. *Art Forms in Nature* brought Haeckel's technical and specialized illustrative work to a nonscientific audience, and in particular influenced artists and architects of the Art Nouveau movement (*see Chapter 15*).

The Biodiversity Heritage Library. Digitized by Smithsonian Libraries.

Conclusion

Natural science illustration, which has long played a central role in exploring and understanding the living world, remains a rich and vital field in our own time as a vehicle for both scientific research and the dissemination of knowledge.

The Renaissance initiated a surge of interest in the observation, description, and classification of the living world, creating visual records that played a key role in the origins of modern science. The scientific revolution of the sixteenth and seventeenth centuries introduced new ways of conceptualizing the natural world, and new technologies for observing it at scales beyond the human. At the same time, scholars and wealthy collectors began to assemble specimens from far beyond the borders of Europe. This form of collecting drove the need for comprehensive, detailed systems of classification, which were complemented by—and sometimes achieved through—sophisticated systems of accurate visual depiction. Over the course of the past five centuries, scientific disciplines such as botany, zoology, and microbiology have emerged as distinct fields of study with their own sets of visual conventions. Throughout this period, scientists have worked closely with illustrators—and have in some cases created their own skilled illustrations—to record, communicate, and extend their research. In fact, illustration has actively shaped the course of natural science. The process of visually depicting natural phenomena—observing and delineating slight differences in the shape of birds' beaks, the branching of neurons, or the microscopic details of plant morphology, for example—can reveal patterns that lead to new insights, thereby contributing to scientific discovery.

FURTHER READING

Ford, Brian J., "Scientific Illustration in the Eighteenth Century," In *The Cambridge History of Science*, vol. 4, edited by Roy Porter (Cambridge: Cambridge University Press, 2003): 561–583.

Guild of Natural Science Illustrators, www.gnsi.org.

Jardine, Nicholas, James A. Secord, and Emma C. Spary (Eds.), *Cultures of Natural History* (Cambridge: Cambridge University Press, 1996).

Kusukawa, Sachiko, *Picturing the Book of Nature: Image, Text, and Argument in Sixteenth-Century Human Anatomy and Medical Botany* (Chicago: University of Chicago Press, 2012).

Lambourne, Maureen, *The Art of Bird Illustration* (London: Quantum Publishing Inc., 2005).

Saunders, Gill, *Picturing Plants: An Analytical History of Botanical Illustration*, 2nd ed. (Chicago: KWS Publishers, 2009).

KEY TERMS	
binomial nomenclature	microscopist
cabinet of curiosity	royal octavo
double elephant	taxonomy
florilegium	

10

Visualizing Bodies: Anatomical and Medical Illustration from the Renaissance to the Nineteenth Century, 1420–1860

Shelley Wall

The body, with its complex forms and intricate spatial relationships, can be most readily understood through images, as this chapter shows in tracing the long Western tradition of anatomical representation. The evolution of anatomical illustration from the Renaissance to the late nineteenth century reflects advances in anatomical and medical knowledge, shifting cultural and philosophical conceptions of the body, expanding audiences for anatomical imagery, changes in representational practices, and advancements in the technologies of image reproduction.

In medieval Europe, a tradition of medical study and practice persisted that was more than a thousand years old, based largely on the writings of classical Greek and Roman authors, primarily Claudius Galen (Greek, ca. 129–216 CE). Structure (anatomy) was not thought to be as important as function in the diagnosis and treatment of disease, and therefore anatomical images in manuscript form were probably not intended to present a "realistic" picture of the body, but rather to act as schemata of anatomical principles, or as mnemonic devices (Figure 10.1). These images, copied and recopied by scribes over generations, would inevitably alter with successive iterations.

By the fourteenth century, public dissections were becoming a part of medical curricula in European universities, while fifteenth-century printing practices made it possible to reproduce and disseminate images that would remain identical across multiple copies, in contrast to the manuscript tradition. The first illustrated anatomical book to appear in print, the *Fasciculus medicinae* (1491) compiled by the anatomist Johannes de Ketham (German, late fifteenth century), contains anatomical diagrams as well as an image of the contemporary protocol for dissection, in which the professor or "lector" above read aloud from an authoritative classical text while a barber

or "sector" performed the dissection and the assistant known as the "ostensor" pointed to the anatomical structures (Figure 10.2a). The purpose of such ritualized performances was to demonstrate traditional Galenic anatomy; accordingly, the anatomical illustrations included in the *Fasciculus medicinae* do not present a record of observed structures, but perpetuate stylized, symbolic representations of the body (Figures 10.2b, c).

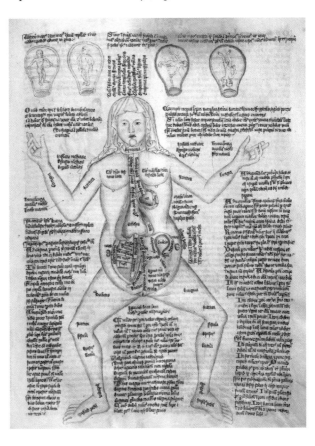

Figure 10.1
Anonymous, anatomy of a pregnant woman labeled with ailments, ca. 1420–1430. *Wellcome Apocalypse*, Manuscript, 15 ³/₄" (folio).[1]
The images at the top of the page depict positions of the fetus in the uterus. The "frog-like" position of the body was a common convention at this time.
Courtesy of the Wellcome Library, London.

[1]It is customary that only the height of the sheet (folio) is provided when describing images that exist in bound volumes. The reason is that it is impossible to ascertain the exact width of the sheet without destroying the binding.

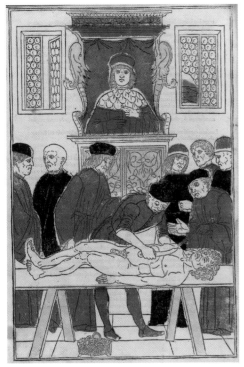
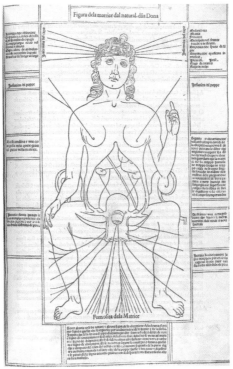
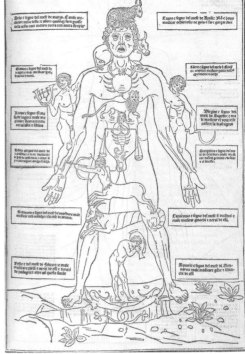

Figure 10.2a, b, c
Anonymous, *Fasciculo de medicina*, 1494. Woodcut, approximately 12 ⁷/₁₆" (folio).
This Italian translation of *Fasciculus de medicina* (1491) contained additional and more sophisticated woodcuts than the Latin publication. In (a), an instructor (top, center) declaims aloud from a traditional anatomical text while an assistant performs the dissection. This copy has been printed from four blocks in black, red, green, and yellow with hand additions in brown and beige. The female body (b) is depicted in the squatting position typical of medieval anatomy, with emphasis placed on the reproductive organs. In (c), the microcosm of the human body is seen as a mirror of the macrocosm, with regions of the body associated with signs of the zodiac.
Courtesy of the Metropolitan Museum of Art (a), and the National Library of Medicine (b and c).

The 1517 *Feldbuch der Wundartzney* (*Fieldbook of Wound-doctoring*), written by surgeon Hans von Gersdorff (German, ca. 1455–1529) and illustrated by Johann Ulrich Wechtlin (German, fl. 1517, also known as The Master of the Crossed Pilgrim's Staves), describes surgical procedures based on medieval practices. The "woundman" (Figure 10.3) is a recurrent image in anatomical treatises of this period and provides a "reference chart" of all the types of wounds that might be sustained in battle. Similar charts of "vein men" and "disease men" exist, in which the body is represented as a kind of map.

These two early printed anatomy books reflect a theme that persists throughout the history of anatomical representation. The male body is assumed to be the "universal" body that serves to illustrate the sum of anatomical knowledge, with the exception of pregnancy and childbirth. Female bodies are represented primarily in the form of images known as **gravidae**, meaning pregnant figures. This imbalance reflects a longstanding view of the female as a lesser, derived version of the male human form, whose signal difference is reproductive function.

Isagogae breues (1522), a publication by physician and anatomist Jacopo Berengario da Carpi (Italian, ca. 1460–1530), presents the first printed anatomical illustrations that record observed dissections. Berengario supplements his discussion of the anatomical texts of medieval anatomist Mondino dei Luzzi (Italian, d. 1326) with information gleaned from his own dissections. The illustrations present dramatic **écorché** figures—that is, flayed human figures demonstrating their own musculature as if they were alive (Figure 10.4). This "living cadaver" is a tradition that will persist in anatomical illustration for centuries. This convention may have arisen from several traditions,

including allegorical representations of the "dance of death," a widespread medieval genre in which skeletons or decayed corpses come to claim the living across all walks of life (*see Chapter 2*). It may have been a strategy to mitigate the horrors of a dissected corpse, or, conversely, by making the corpse participate in its own display, it may reinforce the notion of dissection as a punishment, since many of the bodies available for dissection were those of executed criminals. In later works, it sometimes serves the didactic purpose of demonstrating muscle action.

Anatomist Johannes Dryander (German, 1500–1560) produced the first illustrated book of neuroanatomy in 1536; an expanded volume with additional plates showing the thorax, heart, and lungs was issued the following year. The blocks were cut by artist Georg Thomas (German, fl. 1536), working from Dryander's own sketches. These volumes depict the results of actual dissections, although Dryander attempts to reconcile his observations with Galen's teachings (Figure 10.5).

Vesalius and Renaissance Anatomy

Berengario's and Dryander's books anticipate the major publication of anatomist Andreas Vesalius (Flemish, 1514–1564; *see Chapter 9*), whose work marks a watershed in anatomical study and representation

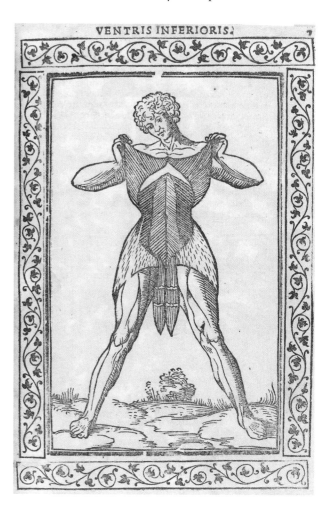

Figure 10.4
Ugo da Carpi (attributed), muscles of the lower abdomen, in *Isagogae breues* by Berengario da Carpi, 1522 (1523 edition). Woodcut, 8 1/4" (folio).
The "living cadaver," standing in a landscape and participating in the display of its anatomy, is a persistent and arresting tradition in anatomical illustration.
Courtesy of the National Library of Medicine.

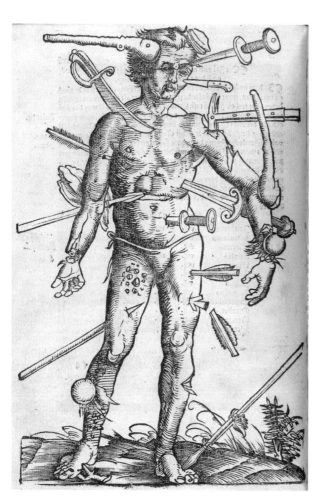

Figure 10.3
Johann Ulrich Wechtlin, "Woundman," in *Feldbuch der Wundartzney* (*Fieldbook of Wound-doctoring*) by Hans von Gersdorff, 1517 (1528 edition). Woodcut, 11" (folio).
Despite its "naturalistic" depiction of the body, including realistic proportions, lifelike stance, shading to indicate form, and context within a landscape, this is clearly a conceptual representation.
Courtesy of the National Library of Medicine.

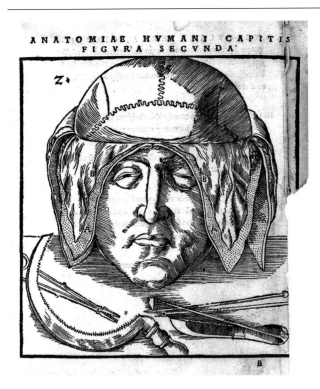

Figure 10.5
Georg Thomas, a dissection of the scalp, in *Anatomia capitis humani* by Johannes Dryander, 1536. Woodcut, 7 ¹/₂" (folio).
In addition to depicting anatomy, the images convey instructions for the process of dissection, including appropriate instruments.
Courtesy of the Wellcome Library, London.

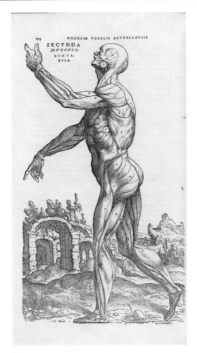
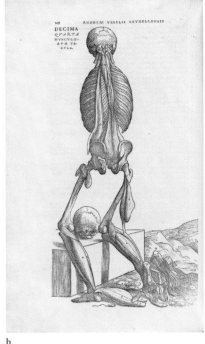

a b

Figure 10.6a, b
Jan Stefan van Calcar (attributed), the second (a) and the last (b) in the "muscle-man" series, *De humani corporis fabrica*, by Andreas Vesalius, 1543. Woodcut, 16 ¹⁵/₁₆" (folio).
Among the most striking illustrations in the *Fabrica* are the "muscle-men," a series of fourteen écorchés depicting a sequential dissection. Unlike earlier écorchés, these figures are rendered with exceptional detail and subtlety.
Courtesy of the National Library of Medicine.

and establishes him as the founder of modern human anatomy. Vesalius's work can be situated in the context of the move in Renaissance science toward direct observation, rather than reliance on classical authorities, since he performed his own dissections (in contrast to common practice at the time) and compared his findings against existing textual traditions. The illustrations Vesalius created and commissioned to record his observations codified conventions that would define anatomical illustration for centuries to come.

Vesalius's groundbreaking publication, *De humani corporis fabrica* (*On the Fabric of the Human Body*) (1543), is considered the most influential medical publication of the sixteenth century. This beautifully designed book, which integrates more than two hundred fine woodblock prints within the descriptive text, inaugurates the age of modern medical illustration (Figures 10.6a, b). The ornate title page celebrates the innovation in Vesalius's research and teaching (Figure 10.7). It depicts a crowded anatomy theater with Vesalius at the center, performing the dissection himself, and thus presents a calculated pictorial response to the *Fasciculus medicinae*, in which the professor teaches at a distance from the body.

In 1543, Vesalius also published the *Epitome*, an affordable, twelve-page synopsis of the *Fabrica* intended for students. This work contains two pages of illustrations designed to be cut out and pasted together to form a flap-anatomy—a layered paper figure that could be interactively "dissected." These so-called fugitive sheets, often representing a male and female (Adam and Eve) pair, were a popular genre throughout the sixteenth and seventeenth centuries. *Mirrors of the Microcosm* by Lucas Kilian (German, 1579–1637), with anatomist Johann Remmelin

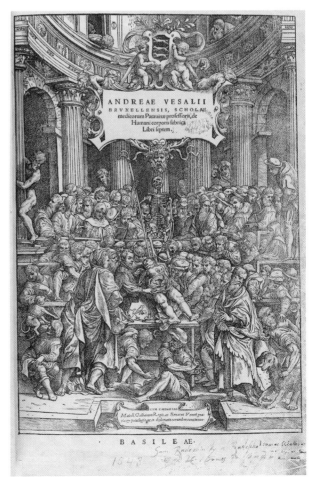

Figure 10.7
Jan Stefan van Calcar (attributed), title-page of *De humani corporis fabrica*, by Andreas Vesalius, 1543. Woodcut, 16 ¹⁵/₁₆" (folio).
This crowded and richly symbolic scene depicting a public dissection makes a powerful visual statement about Vesalius's innovations. Not only is he shown as both instructor and dissector, but other figures in the scene, such as a student holding a closed book and pointing to the dissection, speak to the shift in anatomical study from textual authority to direct observation.
Courtesy of the National Library of Medicine.

(German, 1583–1632) (Figure 10.8) is a testament to the lay public's interest in the mysteries of the human body.

Many of the plates of the *Fabrica* were rerendered as copperplate engravings and republished—through many editions—by Juan Valverde de Amusco (Spanish, ca. 1525–1587) as *Historia de la composición del cuerpo humano* (1556) (Figure 10.9). Valverde acknowledged his debt to Vesalius; Vesalius regarded Valverde as a plagiarist. Part of the success of Valverde's derivative work may lie in its format: it had a shorter, more succinct text, in Spanish (and later other vernaculars) rather than Latin, and it was in a smaller and therefore more affordable format.

A contemporary of Vesalius, anatomist Charles Estienne (French, ca. 1504–1564), published a heavily illustrated book of anatomy in 1545, *De dissectione partium corporis humani libri tres* (*Three Volumes About Dissecting Parts of the Human Body*). While it appeared after the *Fabrica*, it in fact represents pre-Vesalian learning; the work was completed in 1539, but publication was delayed by a dispute between Estienne and his collaborator, surgeon and artist Étienne de la Rivière (French, d. 1569). It is notable in part for the strangeness of its illustrations. In many plates, the actual anatomical information takes up a very small proportion of the image, as a result of the mannered figures placed within elaborate settings (Figure 10.10a). It has been suggested that the woodblocks were repurposed from existing ones because, in many instances, the sections of woodblock that depict anatomical features appear to have been mortised into pre-existing blocks; and that the gynecological plates were modeled after the series of erotic engravings from *Loves of the Gods* (1527) by Giovanni Jacopo Caraglio. (Italian, d. 1565) (Figure 10.10b).

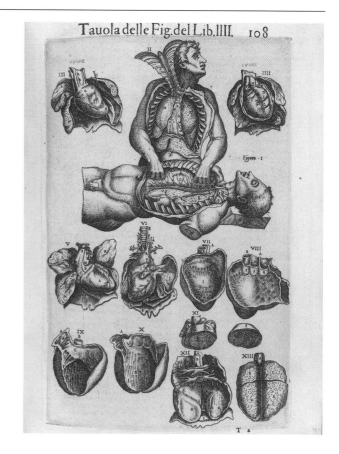

Figure 10.9
Gaspar Becerra (attributed), *Historia de la composición del cuerpo humano* by Juan Valverde de Amusco, 1556. Copperplate engraving, 12 ³/₁₆" (folio). The artist working for anatomist Valverde de Amusco was probably Gaspar Becerra (Spanish, 1520–1570), who created fifteen new images that were composites of images from Vesalius, including this depiction of one dissected corpse dissecting another.

Courtesy of the National Library of Medicine.

Figure 10.8
Lucas Kilian and Johann Remmelin, "First vision," in *Catoptrum microcosmicum* (*Mirror of the Microcosm*), 1619. Engraving with etched components, cut and assembled, 19 ⁷/₈" (folio). "First vision" is one of a trio of broadside flap-anatomies created by Remmelin and Kilian, together consisting of over one hundred organ layers.
Courtesy of the Hay Library, Brown University.

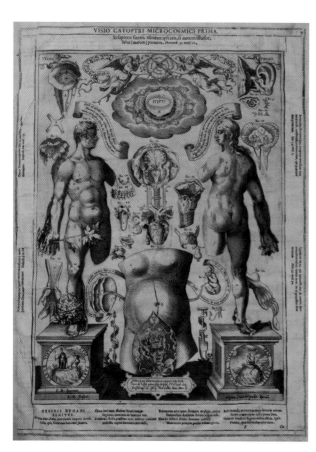

Baroque Anatomy

A generation later, other significant collections of anatomical illustrations were published under the names of anatomist Giulio Cesare Casseri (Italian, ca. 1552–1616) and anatomist and surgeon Adriaan van de Spiegel (Flemish, 1578–1625). Casseri's magnum opus on human anatomy remained unpublished at his death. It contained many copperplate engravings made under his supervision, based on illustrations by Odoardo Fialetti (Italian, 1573–1638), a student of painter Tintoretto (Italian, 1519–1594). Spiegel, too, left an unpublished—and unillustrated—manuscript at his death. Physician Daniel Bucretius (German, d. 1631) acquired Casseri's copperplates from his heirs, commissioned another twenty plates by the same artist, and brought out both works as a two-volume text: *Tabulae anatomicae* (*Anatomical Tables*) (1626) and *De humani corporis fabrica libri decem* (*Ten Books on the Fabric of the Human Body*) (1627). Spiegel's son-in-law likewise combined copperplates commissioned by Casseri with text by Spiegel and published *De formato foetu* (*The Formed Fetus*) (1626). While some of the illustrations depict discrete portions of anatomy, dissected and observed in isolation, others carry on the convention of animated cadavers with even greater drama than before (Figures 10.11a, b).

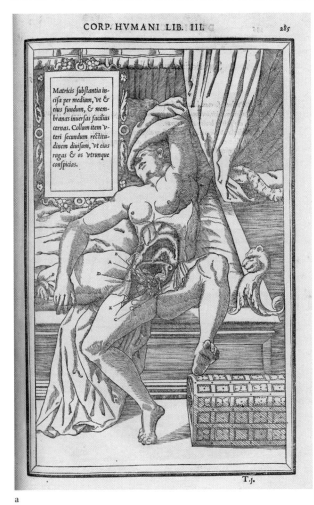

a

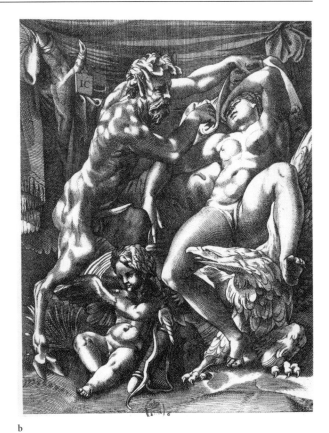

b

Figure 10.10a, b
(a) Charles Estienne, female reproductive organs, *De dissectione partium corporis humani libri tres*, 1545. Woodcut, 14 ¹/₄ × 9" (folio).
(b) Giovanni Jacopo Caraglio, *Loves of the Gods*, 1527. Engraving.
It has been suggested that some of Estienne's anatomical plates were based on images from the erotic series by Caraglio.

(a) Courtesy of the National Library of Medicine, (b) Thomas Fisher Rare Book Library.

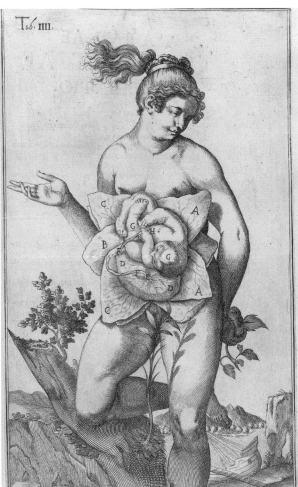

a

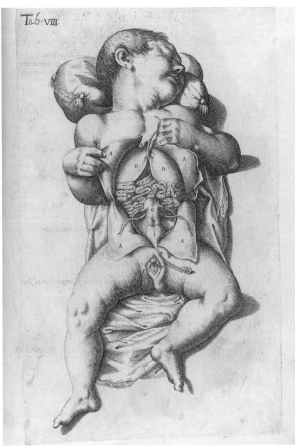

b

Figure 10.11a, b
Odoardo Fialetti (1573–1638), the gravid uterus (a) and fetal anatomy (b), in *De formato foetu* by Spiegel and Casseri, 1626. Copperplate engraving, 16 ¹/₂" (folio). Copperplate engravings permit a delicacy and level of detail unattainable in even the finest woodcuts—for example, the intricacies of the woman's elaborate hairstyle. Both mother and fetus appear to be very much alive. With one hand, the "gravida" demonstrates the layers of her womb; in the other, she clutches an apple behind her back, suggesting her identification with Eve.

Courtesy of the National Library of Medicine.

Anatomical Realism

The next major illustrated anatomical text to appear was *Anatomia humani corporis* (1685), by anatomist Govard Bidloo (Dutch, 1649–1713) and illustrator Gérard de Lairesse (Dutch, 1641–1711). In keeping with the values of Enlightenment empiricism, Bidloo and de Lairesse re-imagined anatomical representation with a stark realism not seen in previous work. De Lairesse was a successful painter in his own right and an accomplished draftsman. Some of his illustrations for Bidloo reference earlier traditions with their suggestions of **memento mori** (symbols of the ephemerality of life that remind one to focus on spirituality rather than material comforts)—for example, a skeleton holding an hourglass and standing beside a sarcophagus (Figure 10.12a). However, many of the images depict not an animated figure in a landscape, or even a diagrammatic representation of anatomy, but the realities of the anatomy theater (Figures 10.12b, c).

Bidloo, an accomplished microscopist, had corresponded with Antonie van Leeuwenhoek (Dutch, 1632–1723), famed for his innovations in microscopy (*see Chapter 9*). In addition to gross anatomy, *Anatomia humani corporis* also includes illustrations of details of fine tissue architecture.

A Publishing Controversy

Bildoo's *Anatomia humani corporis* was published in Dutch translation as *Ontleding des menschelyken lichaams* (1690), but it was not a financial success. Eventually, under circumstances that remain the subject of debate, three hundred copies of the printed, illustrated plates came into the hands of William Cowper (English, 1666–1709), an anatomist, surgeon, and author of *Myotomia reformata* (1694), a treatise on the muscles. Cowper commissioned additional illustrations from artist Henry Cook (English, 1642–1700), including two full-body écorchés; and along with some new and insightful text and the purchased plates from Bidloo's atlas, he published the amalgamation as *The Anatomy of Humane Bodies* (1698). He even reused the original frontispiece from *Anatomia humani corporis*, pasting his title and name over those of Bidloo. Since no international copyright agreements existed between England and the Netherlands at that time, Bidloo could do little more than fire off an angry pamphlet. A heated exchange raged around the publication for some time. While this plagiarism controversy has clouded Cowper's reputation, he was an accomplished anatomist, scientist, and member of **The Royal Society** (a group who met regularly in London to discuss and promote science), and his text for and additions to *The Anatomy of Humane Bodies* reflect the ferment of experimentation and discovery of the time (Figure 10.13).

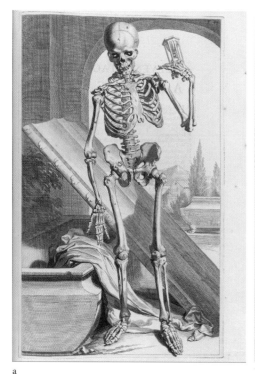
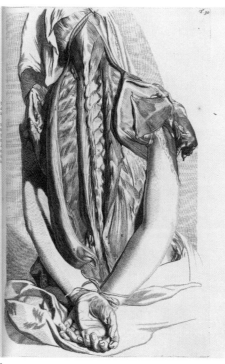
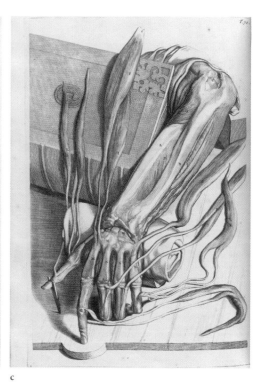

a b c

Figure 10.12a, b, c
Gérard de Lairesse, skeleton (a), muscles of the back (b), and muscles of the forearm (c), in *Anatomia humani corporis* by Govard Bidloo, 1685. Copperplate engraving, 20 ⁷/₈" (folio).
These images portray the realities of the dissection table. In (c), the meticulously propped-up specimen demonstrates the art of the anatomist: the delicacy, craft, and compositional skill involved in an excellent dissection.
Courtesy of the National Library of Medicine.

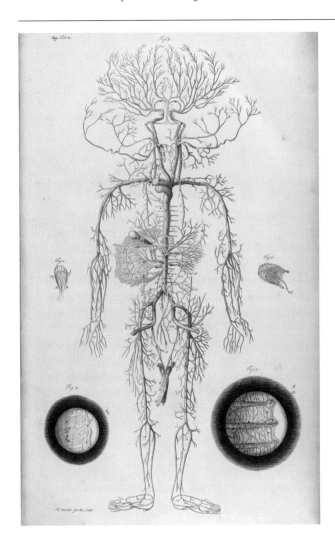

Figure 10.13
William Cowper, fetal arterial system in *The Anatomy of Humane Bodies*, 1698. Copperplate engraving, 22 13/16" (folio).
One of the new illustrations Cowper commissioned (or perhaps created himself) depicts fetal circulation prepared from a specimen injected with wax before dissection to preserve the pattern of the vessels. This plate also includes insets showing microscopic anatomy.
Courtesy of the National Library of Medicine.

A Measured Ideal

William Cheselden (English, 1688–1752), anatomist and surgeon, was a pupil of William Cowper in London in the early years of the eighteenth century and later became one of the leading instructors of anatomy in London. His two primary publications, created with artists/engravers Gerard van der Gucht (English, 1696–1776) and Jacob Schijnvoet (Dutch, 1685–1733), offer an interesting contrast in the audiences for and relative financial success of different kinds of anatomical books. *Anatomy of the Humane Body* (1713) was a compact and affordable textbook for students. A great commercial success, it went through numerous British and American editions during the eighteenth century. In contrast, Cheselden also published *Osteographia, or the Anatomy of the Bones* (1733), hoping to make the most accurate and beautiful atlas of the bones ever created. In it, human bones are depicted life-sized and also within the context of the skeleton (Figure 10.14). To introduce an element of comparative osteology, animal skeletons appear in full-page plates and also

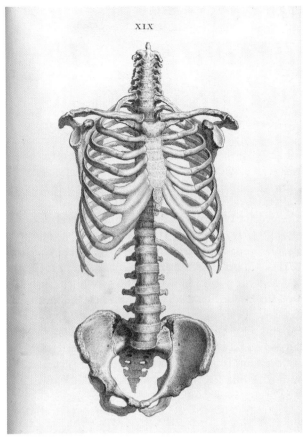

Figure 10.14
Gerard van der Gucht or Jacob Schijnvoet, spine, ribcage, and pelvis, in *Osteographia* by William Cheselden, 1733. Copperplate engraving, approximately 20 7/8" (folio).
Note the lovely use of atmospheric perspective to send the sacrum/coccyx and dorsal aspect of the ribs into the background.
Courtesy of the National Library of Medicine.

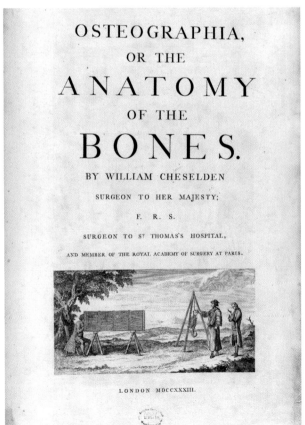

Figure 10.15
Gerard van der Gucht or Jacob Schijnvoet, title page, *Osteographia* by William Cheselden, 1733. Copperplate engraving, approximately 20 7/8" (folio).
The use of the camera obscura, a device that projected images onto the drawing surface to ensure accurate proportions, was a key feature in Cheselden's enterprise.
Courtesy of the National Library of Medicine.

serve as decorative and playful chapter-heads. Although Cheselden accomplished his goals of accuracy and beauty, this large-format, high-quality publication was not a financial success.

A **camera obscura**, a device for projecting traceable images, was used in developing the drawings. The book's title page depicts the device in use (Figure 10.15), and

Cheselden's preface notes how much time this saves. Importantly, his use of this technology also speaks to an interest in recording the specimens' proportions with the utmost accuracy, and his foregrounding of this technology signals to readers that what they are getting is objectively recorded "fact."

The measured ideal in anatomical illustration reached its zenith in the work of anatomist Bernhard Siegfried Albinus (German 1697–1770) and his artist and engraver Jan Wandelaar (Dutch, 1690–1759). The anatomical figures illustrated in *Tabulae sceleti et musculorum corporis humani* (*Tables of the Skeleton and Muscles of the Human Body*) (1747), on which Albinus and Wandelaar worked together closely for twenty years, are intended to represent an absolute ideal in human anatomy as a composite of many bodies. To this end, Albinus selected as a foundation a male skeleton that possessed what he assessed to be perfect proportions; he then had Wandelaar view the specimen through an elaborate system of paired grids composed of string, in order to obtain accurate measurements. If the skeleton was perceived to have any imperfections or deviations from the ideal, these were corrected in the drawing. The muscles were then added to the skeleton, based on a synthesis of measurements taken from multiple specimens. The final publication contains complete standing figures as well as details of the bones and muscles (Figure 10.16). The full-figure plates have elaborate backgrounds consisting of natural landscapes, architectural details, sculpture, and even a rhinoceros (Figure 10.17). These backgrounds were added at Wandelaar's suggestion, to balance out the tonal values and provide a sense of depth. The resulting copperplates possess a Neoclassical elegance and dignity; they also demonstrate the way in which an anatomical image can be not only descriptive but also prescriptive—that is, reinforcing the picture of a normative, ideal body against which other bodies may be measured.

The Color of Flesh

Jacques Fabien Gautier d'Agoty (French, 1711–1785) is notable in the history of anatomical illustration on a number of counts. Trained as a printmaker, he was an artist who worked with anatomists as well as doing dissections himself. As such, he asserted authorship on the resulting illustrations, thus reversing the usual hierarchy. He introduced color printing to anatomical illustration, and his images, while not the clearest explication of anatomy, are striking for his aesthetic and compositional choices. He trained under the printmaker Jacob Christoph Le Blon (French, 1670–1741), who developed a technique for three-color **mezzotint** printing—a laborious intaglio process that can print subtle tonal ranges (*see Theme Box 18*). Gautier d'Agoty later added a fourth pass with black ink to the process. Working with surgeons/anatomists Jacques-Francois-Marie Duverney (French, 1661–1748) and Antoine Mertrud (French, d. 1767), he issued multiple publications. His most well-known image is the so-called "flayed angel" (Figure 10.18), which appeared in *Myologie complète* (1746).

a

b

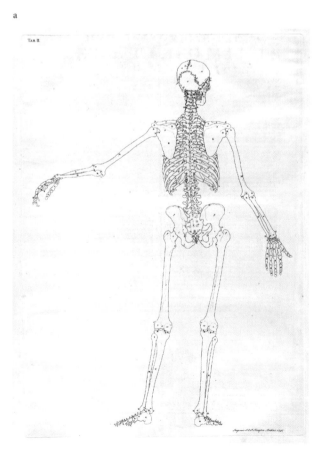
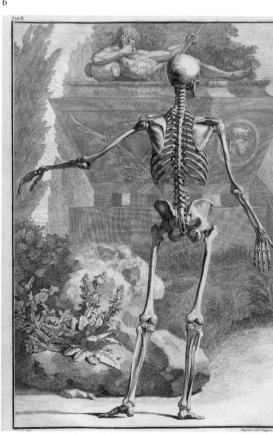

Figure 10.16
Jan Wandelaar, posterior view of skeleton, *Tabulae sceleti et musculorum corporis humani* by Bernhard Siegfried Albinus, 1747. Copperplate engraving, 28 ¹¹/₃₂" (folio).
Albinus's atlas is notable for its use of labeled outline drawings (a) as a key to structures in the fully rendered illustrations (b), so that the latter could remain uncluttered by text.
Courtesy of the National Library of Medicine.

Theme Box 18: Mezzotint
by Susan Doyle

Mezzotint is a laborious intaglio process (*see Chapter 2, Theme Box 6, "Intaglio Printing"*). First, the plate is blackened by systematically roughening the entire surface with a serrated tool called a "rocker." The image is created by selectively burnishing away the texture made by the rocker so that areas of the plate hold variable amounts of ink and print different tones of gray. Highlights are created by burnishing away *all* texture, thus creating a perfectly smooth, mirror-like area that holds no ink at all. Mezzotints are less common than other intaglio prints not only because the process is very time consuming, but because the plate is relatively delicate and renders far fewer prints than an engraving, etching, or aquatint. Mezzotints are, however, capable of deep blacks and nuanced shades of gray.

Figure 10.17
Jan Wandelaar, the fourth order of muscles, front view, *Tabulae sceleti et musculorum corporis humani* by Bernhard Siegfried Albinus, 1747. Copperplate engraving, 28 $^{11}/_{32}$" (folio).
Indian rhino Clara (1739–1758) was something of a celebrity in Europe at the time; it has been suggested that her inclusion in two plates of the *Tabulae* functioned as a cross-promotional endeavor, to advertise her European tour and add whimsy and contrast to the anatomical image.
Courtesy of the National Library of Medicine.

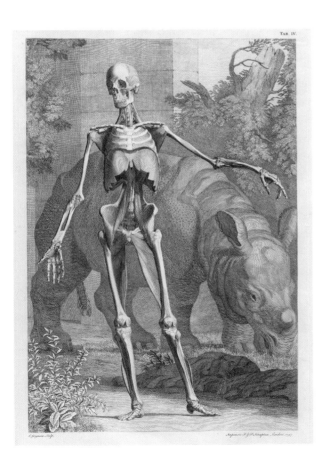

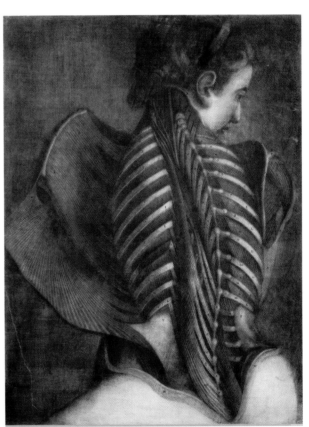

Figure 10.18
Jacques Fabien Gautier d'Agoty, "Flayed angel" (back muscles, deep dissection), in *Myologie complètte*, 1746. Color mezzotint.
The stark contrast between the idiosyncratic, eroticized aesthetic of this image and the dispassionate, Neoclassical poise of Albinus's images published one year later speaks to the wide range of representational idioms in anatomical illustration in this period.
Courtesy of the Wellcome Library, London.

The Great Eighteenth-Century Obstetrical Atlases

By the second half of the eighteenth century, childbirth, which had always been a domestic event presided over by female midwives, was becoming medicalized as learned "man-midwives" took over the domain of childbirth from traditional midwives and invested it with scientific prestige. The publication of anatomical atlases devoted exclusively to the pregnant uterus coincides with this transition; the two most significant were *A Sett* [sic] *of Anatomical Tables, with Explanations, and an Abridgement of the Practice of Midwifery* (1754) by William Smellie (Scottish, 1697–1763), and *The Anatomy of the Human Gravid Uterus Exhibited in Figures* (1774) by William Hunter (Scottish,

1718–1783). The artist Jan van Rymsdyk (Dutch, fl. 1750–1788) was the illustrator for both works, as well as for other books on anatomy and obstetrics.

We have seen examples of anatomized female bodies thus far, from a stylized schema, to a semi-erotic scene, to an animated cadaver with the layers of her womb opening like a flower. These eighteenth-century obstetrical atlases present a different kind of image entirely. Smellie was an advocate of the use of forceps, a relatively new technology, and his instrumental view of childbirth is reflected in the illustrations, which concentrate on the fetus's position in the uterus, delivery presentation, and delivery strategies in the case of difficult births (Figure 10.19a). Many of the illustrations are in cross-section, for a clear representation of the relationship of the fetus to the maternal anatomy. Some employ diagrammatic strategies to convey conceptual information relative to the actual scene depicted, such as, for example, the alternative positions of the uterus indicated with a series of lines (Figure 10.19b). The images are printed life-sized. In spite of its large format, however, Smellie's is a practical work, and the illustrations convey information not just about anatomy, but also about action.

Hunter's atlas, on the other hand, is pure anatomy. Taking his cue from the realism of Bidloo's atlas, he pushes the unvarnished recording of observed reality to a brutal extreme, and directs his illustrator van Rymsdyk to depict every accident of form in the specimen at hand. Even though the pregnant uterus is the focus of the work, the plates include details implying the grim context of dissection, including the severed legs and the ragged edges of cut flesh (Figure 10.20). Hunter comments on his ethos of uncompromising objectivity in the preface to the book, in effect providing his readers with a guarantee of the absolute facticity (and by implication, scientific accuracy) of the illustrations.

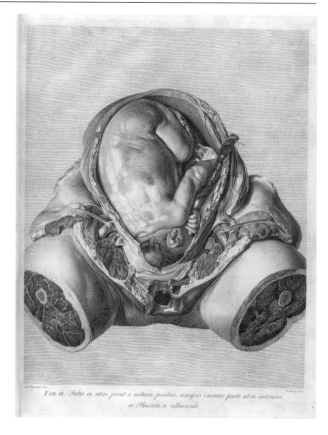

Figure 10.20

Jan van Rymsdyk, fetus in utero, in *Anatomy of the Human Gravid Uterus* by William Hunter, 1774. Engraving and etching, 26 $^{25}/_{32}$" (folio).
Hunter's book was published in 1774 but was begun as early as 1750. The images are reproduced life-sized, but unlike Smellie's practical anatomical tables, Hunter intended his atlas from the beginning as a high-end luxury item for collectors.

Courtesy of the National Library of Medicine.

Figure 10.19a, b
Jan van Rymsdyk, delivery of the fetus using forceps (a), and fetus during labor (b), in *A Sett of Anatomical Tables* by William Smellie, 1754. Engraving and etching.
In Smellie's work, the images are reproduced life-sized and intended for practical use. They depict not just anatomy, but also the changes to the body during birth, and show possible actions by medical attendants. Note the use of schematic lines to indicate alternative positions of the uterus.

Courtesy of the National Library of Medicine.

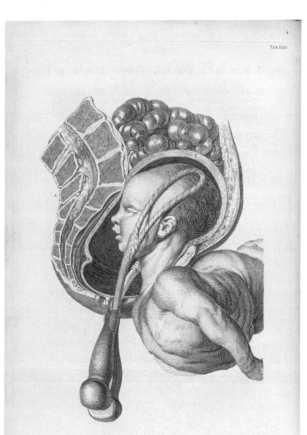

a

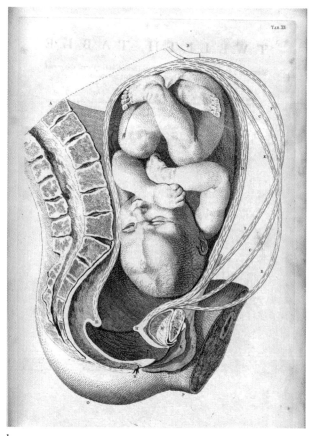

b

Theme Box 19: Foucault: Discourse and Power
by Sheena Calvert and Jaleen Grove

The philosopher Michel Foucault (French, 1926–1984) theorizes that knowledge and the institutions that create knowledge inherently make and perpetuate *power relations*, which are the habits and rules of how a person or thing is defined and subsequently treated. Power relations give some people and institutions more rights, freedom, and authority than others. These relations also constitute and modify *the modern subject*: a unique, individual person who is at the same time a type of person, because he or she is socialized by the culture he or she grew up in.

This socialization occurs through **discourse** (texts, images, speech, customs; anything that represents a set of ideas). For instance, law, medicine, art criticism, or scientific illustration each use a discipline-specific set of discourses to establish principles and practices. The way subject matter is represented through systems of signification (such as anatomy books that exclusively use the male body, with labels in Latin, and body parts assigned an order of importance) iterates and reiterates social hierarchies and patterns of thought (that males are the norm and more important than females or the intersexed, that Latin is the correct and best language of science, that the mechanics of the body take precedence over the psychological, and so on).

In books such as *Madness and Civilization* (1961), *The Order of Things* (1966), *The Archaeology of Knowledge* (1969), and *The History of Sexuality* (1976), Foucault argues that modern society has actively created harmful social categories and reinforced them through texts, images, and social practices (discourses). To reveal and dismantle such categories, Foucault is particularly interested in undertaking a detailed "archeology" of knowledge: rigorous, historically supported critiques of the discourses surrounding institutions such as prisons and

mental institutions, thereby exposing the assumptions that underlie them.

In one example, he argues that during the medieval period of history, the mentally ill were accepted and had a place in everyday life. In the late seventeenth and early eighteenth centuries, however, prisons and mental asylums detained and disciplined such people, defining them as unacceptable. The expert and popular visual and written discourses used to define "madness" and what we "know" about it perpetuate these policies, and affect our societal acceptance of them. Think, for example, of the frequently church-like forms of architecture used in the building of eighteenth-century asylums. Such visual codes aligned the asylum and how it was run with religion, constructing the inmates' identities as sinners.

Foucault argues that history writing itself is not neutral; history books actively participate in the construction of fictions that pass for knowledge and truth by giving an appearance of credibility. In fact, historical, scientific, philosophical, and other kinds of "knowledge" are a result of power and various mechanisms of social control (such as who is permitted to become an author), supported by our frequently unconscious acceptance of how things and relationships are traditionally represented. Foucault enables dissent by asking questions about who and what we consider to be normal, and what the most important subjects are.

One of Foucault's most well-known (and most visual) theories of how power works is found in his book *Discipline and Punish* (1975), regarding a prison designed by the philosopher Jeremy Bentham in the late eighteenth century. Called a **panopticon**—the all-seeing eye—it arranged prison cells in a circle around a central tower from which guards could see into every cell at all times. Whether there was

a guard in the tower or not, the inmates would self-regulate their behavior based on the ever-present potential for them to be surveilled; they were thus *disciplined* by a regime of power inclined to observe and normalize subjects. Modern theories of surveillance within contemporary digital society and even the constant public exposure of the private through social media can be likened to a panopticon.

In *The Order of Things*, Foucault proposes that the organization of information substantially shapes our understanding of the world by reinforcing certain dominant views— thereby leading us away from truth. For example, scientific and natural history depictions and descriptions (such as taxonomic classification, bestiaries, zoos, museum dioramas, reference books) tend to reinforce our separation from nature by posing plants, animals, and landforms as objects of contemplation rather than things we are connected with.

In depicting knowledge, illustrators create what is taken to be real and true. But concepts of reality and truth, Foucault would argue, are indebted to power and have the potential to determine what we think of as true or false, right or wrong, normal or deviant.

Further Reading
Foucault, Michel, *Discipline and Punish: The Birth of the Prison* (New York: Vintage, 1995 [1975]).

Foucault, Michel, *The History of Sexuality: An Introduction* (New York: Vintage, 1990).

Foucault, Michel, *The Order of Things: An Archaeology of the Human Sciences* (New York: Vintage, 1994).

*Quoted material attributable to subject

The Real versus the Ideal

In the examples discussed in this chapter, we see two distinct approaches to anatomical representation running in parallel. One is epitomized in the work of Albinus, who defined and synthesized human anatomy in images that presented both the typical (measurements averaged from many specimens) and the ideal (all irregularities smoothed away). The other, embodied in the atlases of Bidloo and Hunter, grounds itself in the faithful representation of exactly what is observed. Both approaches make their own claims to a certain kind of anatomical truth.

An anatomist who brought the ideals of Albinus to bear on the representation of female anatomy was Samuel Thomas von Soemmerring (German, 1755–1830). In 1796 he published, as an individual folio, the *Tabula sceleti feminini*, claiming (erroneously) that it was the first representation of a specifically female skeleton. Like Albinus, he sought out a specimen that represented "ideal" proportions, working with the skeleton of a twenty-year-old woman and referencing classical statuary (such as the Venus de Medici) and other fine art. The result executed by Christian Koeck (German, 1758–1818), a skeleton standing in graceful contrapposto (Figure 10.21), demonstrates the extent to which cultural values (for example, of beauty)

can be embedded in even the most "objectively" measured anatomical illustration.

Brothers John Bell (Scottish, 1763–1820) and Charles Bell (Scottish, 1774–1842) were surgeons, anatomists, and illustrators whose work is located firmly in the tradition of anatomical realism. Charles is known primarily for his work in neuroanatomy: Bell's palsy is named after him. John, a highly regarded surgeon, taught anatomy with an emphasis on its surgical application. In 1794, John Bell published *Engravings, Explaining the Anatomy of the Bones, Muscles, and Joints* to accompany a text he had issued the previous year. Not only did he create all the drawings, but he also etched and engraved the majority of them.

In the preface to this work, Bell articulates his rationale for creating his own anatomical illustrations—to eradicate what he perceived to be a historical tension between the artist and the anatomist. The artist, asserted Bell, works from imagination and aesthetic impulse to the detriment of the anatomist's desire for accurate representation. In acting as both anatomist and illustrator, Bell claimed to represent anatomical specimens exactly as they appear on the dissecting table (Figure 10.22). His approach anticipates that taken in *Grant's Atlas* in the twentieth century (*see Chapter 28*), in which textbook illustrations resemble what students will see

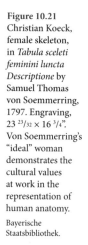

Figure 10.21
Christian Koeck, female skeleton, in *Tabula sceleti feminini Iuncta Descriptione* by Samuel Thomas von Soemmerring, 1797. Engraving, 23 23/32 × 16 3/4". Von Soemmerring's "ideal" woman demonstrates the cultural values at work in the representation of human anatomy.
Bayerische Staatsbibliothek.

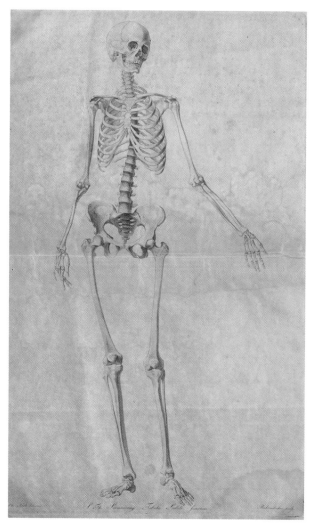

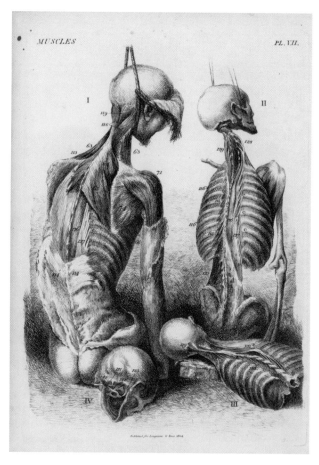

Figure 10.22
John Bell, muscles and bones of the back, in *Engravings of the Bones, Muscles, and Joints, Illustrating the First Volume of the Anatomy of the Human Body*, 1804. Engraving and etching, 11" (folio).
While he may have aided students by representing the realities of dissection, Bell has been criticized for what some perceive to be the unnecessarily macabre quality of his illustrations.
Courtesy of the Wellcome Library, London.

when performing the dissection themselves. Charles Bell illustrated John Bell's next book, on the heart and arteries, and authored and illustrated a further two volumes, on the nervous and lymphatic systems.

Images of Surgery

Before the development of surgical anesthesia in the 1840s, and of antiseptic and aseptic surgical technique in the 1860s and 1870s, surgeries were restricted to procedures that could be performed rapidly and did not involve extensive cutting into body cavities. Common procedures included amputations, lithotomy (removal of bladder stones), cataract surgery, hernia repair, and even plastic surgery to repair noses or cleft lips.

Between 1831 and 1854, a magnificent eight-volume atlas of anatomy and surgery was published in France: the *Traité complet de l'anatomie de l'homme comprenant la médecine opératoire* (*Atlas of Human Anatomy and Surgery*) by anatomist and physician Jean-Baptiste Marc Bourgery (French, 1797–1849) and artist Nicolas-Henri Jacob (French, 1782–1871). Its 3,750 figures depict descriptive and surgical anatomy, embryology, and microscopic anatomy. Jacob, a student of Neoclassical painter Jacques-Louis David (French, 1748–1825), was an early adopter of the new technique of lithography, which allowed for a much softer and more nuanced tonal range than earlier printing methods (*see Chapter 11, Theme Box 21, "Lithography"*).

One notable student collaborator was Charlotte Hublier (French, fl. 1817), a woman in an almost all-male field who later married Jacob. Early editions were available in black-and-white or with hand-stenciled color. Later, a second edition was printed using chromolithography, a system of printing where many colors are overprinted, each rendered on a separate lithography stone (*see Chapter 13, Theme Box 29, "Chromolithography and Ben-Day Tints"*).

The *Traité* is solidly in the tradition of idealizing anatomy. Bourgery explains in the introduction to the first volume that "to allow for easy comparisons of all parts of our work, we had to create an ideal type of the most beautiful form and the most perfect development of the species, a type based on which all figures would be represented in the same way. To this end, we agreed to describe a man of Caucasian race, five foot tall, 33 years old, and endowed with the most fortunate proportions" (Figure 10.23).

Some aspects of the *Traité*'s illustrative strategies map easily onto approaches to medical illustration in our own time. For example, Bourgery notes the importance and the innovation of depicting surgical procedures from the surgeon's point of view so that the illustrations will most effectively teach the reader how to perform the procedure. He also comments on the importance of showing patient position, lighting, the position of assistants, and the instruments used—again, procedural information that remains a staple of surgical illustration to this day (Figure 10.24). Other aspects of the atlas are thankfully alien to contemporary practice—for example, Bourgery notes that it is necessary to show

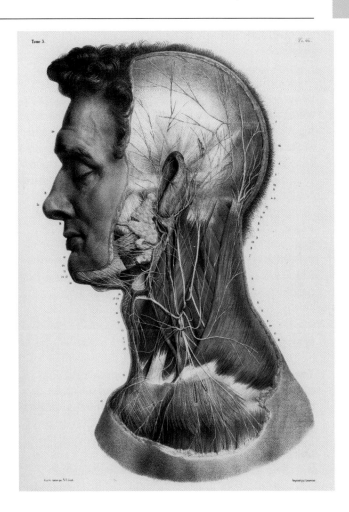

Figure 10.23
Nicolas-Henri Jacob, nerves of the neck, in *Traité complet de l'anatomie de l'homme* by Jean-Baptiste Marc Bourgery, 1831–1854. Lithograph.
In this plate, we see not only the "ideal man" described by Bourgery, but also the subtle tonal variations possible in lithography.
Courtesy of the Thomas Fisher Rare Book Library.

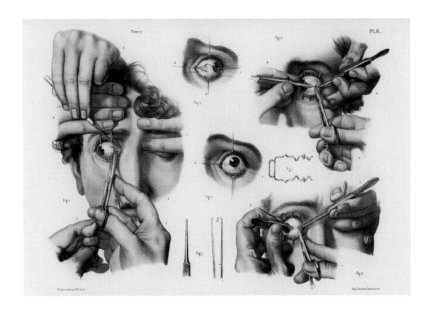

Figure 10.24
Nicolas-Henri Jacob, surgery for strabismus, in *Traité complet de l'anatomie de l'homme* by Jean-Baptiste Marc Bourgery, 1831–1854. Lithograph.
Bourgery and Jacob's surgical illustrations convey procedural information such as patient position and instruments used, visualized from the surgeon's point of view.
Courtesy of the Thomas Fisher Rare Book Library.

the means of "restricting the patient's movements" in an era before anesthesia.

Another beautiful and noteworthy surgical atlas of the mid-nineteenth century was *Surgical Anatomy* (1851) by surgeon and illustrator Joseph Maclise (Irish, ca. 1815–1880), who had previously produced an extensive series of hand-colored lithographs for *The Anatomy of the Arteries of the Human Body, With Its Applications to Pathology and Operative Surgery* (1844) by his former teacher, anatomist Richard Quain (Irish, 1816–1898). Maclise's illustrations contain details that suggest the context of death and dissection—for example, the cords that hold limbs and tissues in place—visual elements that reinforce the fact that the anatomy is portrayed from direct observation of dissections performed by the surgeon-illustrator himself. At the same time, many of the human figures are poised, beautiful, and unblemished by decay (Figure 10.25).

Images of Pathology

Pathology is the study of disease. Anatomical pathology is the correlation of living patients' symptoms with anatomical findings post-mortem—a medical field that was established as a discipline in the early nineteenth century. Robert Carswell (Scottish, 1793–1857), a pathologist and skilled artist, created an impressive body of approximately two thousand watercolor paintings documenting the outcome of various diseases, including the first visual description of the ravages of multiple sclerosis on

the central nervous system. Between 1833 and 1838, Carswell published *Pathological Anatomy: Illustrations of the Elementary Forms of Disease*. Caswell made the lithographic plates himself and also oversaw the hand-coloring of prints (chromolithography was not patented until 1837). This atlas of diseased tissue is strangely beautiful, due to the subtleties of and variations in hue and texture, which are all minutely observed (Figure 10.26).

Gray's *Anatomy*

The most significant anatomy book of the nineteenth century was Henry Gray's (English, 1827–1861) *Anatomy Descriptive and Surgical* (1859), known as the "anatomical bible" for students required to name anatomical parts. This volume (entitled in later editions *Gray's Anatomy*) was a text-heavy work containing detailed black-and-white wood engravings of discrete areas of anatomy, integrated directly within the descriptions. A move toward plain, practical, almost diagrammatic visual description, it represents a departure from approaches to depicting human anatomy in preceding centuries, such as the full-body, art-inspired aesthetic of Albinus's *Tabulae* and the brutal realism found in the works of William Hunter. While forgoing the advances in etching and lithography in favor of simple wood engraving (Figure 10.27), Gray also abandoned the massive folios of many previous

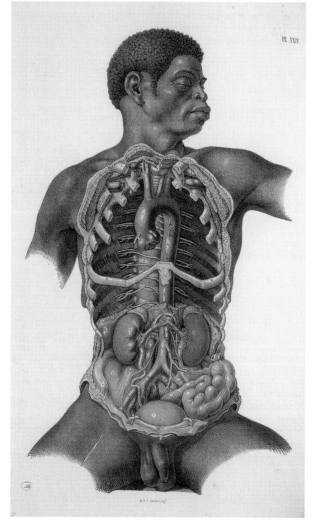

Figure 10.25
Joseph Maclise, dissection of thorax and abdomen, in *Surgical Anatomy*, 1851. Lithograph. By colorizing only the focal elements in this composition, Maclise clarifies the visual hierarchy within the complex context of the body.

Courtesy of the Thomas Fisher Rare Book Library.

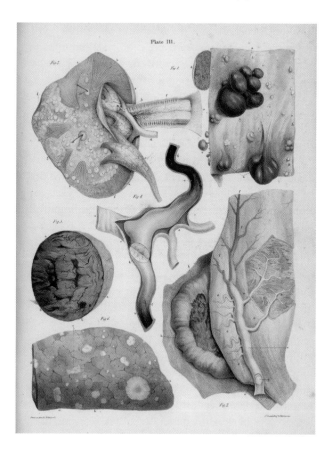

Figure 10.26
Robert Carswell (draftsman) and A. Ducoté (lithographer), neoplasms of the peritoneum, the stomach, the kidney, the portal vein, and the lung, Plate III in *Pathological Anatomy*, 1838. Hand-colored lithograph, 15 3/8" (folio). Before the microscope became pathologists' instrument of choice, the color, texture, and form of organs and tissues at autopsy were the most important diagnostic criteria in the assessment of disease. Lithography provided a perfect vehicle for conveying this kind of visual information.

Courtesy of the Wellcome Library, London.

anatomical treatises to create a design compact enough for medical students to carry to the dissection theater. For these reasons, this focused body of work was as revolutionary in its day as Vesalius's *De humani corporis fabrica* was in the Renaissance. Gray's artist was Henry Vandyke Carter (English, 1831–1897), whom he met when they were medical students at St. George's Hospital in London. They worked together on the *Anatomy* between 1856 and 1857; Carter drew all of the 363 figures, including some that he rendered in reverse directly on the wood blocks for the engravers.

The book was a great success, but Gray died of smallpox as the third edition was being planned in 1861, so the focus and visual content of subsequent editions were in the hands of other editors. The first North American edition was published in 1859, with asynchronous British and American versions published until 1990, when the last U.S. edition appeared. In 2009, the publishers of *Gray's Anatomy* celebrated the one-hundred-fiftieth anniversary of its publication with a substantially revised fortieth edition containing new full-color illustrations and photographs throughout its 1,576 pages. While bearing little resemblance to the original book, the reputation, thoroughness, and accuracy of *Gray's Anatomy* ensure that it will be the anatomical reference of record for years to come.

Conclusion

Over the course of its history, Western anatomical illustration has evolved in tandem with changes in medical practice—for example, from battlefield surgery (medieval "wound men"), to the medicalization of childbirth (eighteenth-century obstetrical atlases), to the proliferation of medical specializations (such as anatomical pathology). It has also responded to expanding or changing audiences, serving anatomists, students, practitioners, researchers, collectors, and the lay public.

Approaches to depicting the human form have varied along a spectrum between the ideal and the actual, between the conceptual synthesis of the representative "type" and the assiduous observational drawing of the individual specimen. The choice of approach has been influenced by many factors, including the intellectual climate (e.g., Renaissance humanism, Enlightenment empiricism), prevailing artistic languages (e.g., Neoclassicism), the motives of the individual creator, and the needs of the audience. Anatomical illustrations not only reflect changing conceptions of the body but also *construct* conceptions of the body by producing images of normative bodies and reinforcing cultural notions of sexual difference. Anatomical illustration has also evolved in response to changes in technology—both the technologies of observation, which have permitted ever more detailed analyses of the human body, and the technologies of image creation and reproduction.

FURTHER READING

Barnett, Richard, *The Sick Rose or Disease and the Art of Medical Illustration* (London: Thames & Hudson, 2014).

Cazort, Mimi, "The Theatre of the Body," In *The Ingenious Machine of Nature: Four Centuries of Art and Anatomy* (Ottawa: National Gallery of Canada, 1996): 11–42.

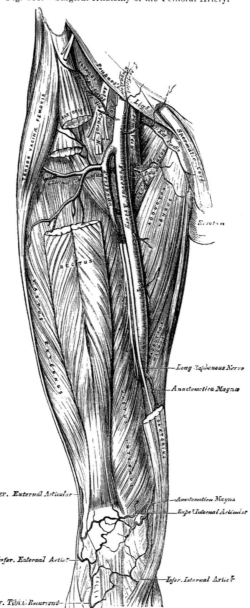

Fig. 211.—Surgical Anatomy of the Femoral Artery.

Long Saphenous Nerve
Anastomotica Magna
Super. External Articular
Anastomotica Magna
Supe. Internal Articular
Infer. External Artic.
Infer. Internal Artic.
Anter. Tibial Recurrent

Figure 10.27
Henry Vandyke Carter, surgical anatomy of the femoral artery, in *Anatomy Descriptive and Surgical* by Henry Gray, 1859. Wood engraving, 10.25" (folio).
Note the prominent labeling, in contrast to earlier unlabeled or discretely labeled images; these illustrations are clearly intended as teaching tools.
Bernard Becker Medical Library, Washington University School of Medicine.

KEY TERMS

camera obscura	memento mori
discourse	mezzotint
écorché	panopticon
gravidae	The Royal Society

Kemp, Martin, "Style and Non-Style in Anatomical Illustration: From Renaissance Humanism to Henry Gray." *Journal of Anatomy*, vol. 216, 2010: 192–208.

Roberts, K. B., and Tomlinson, J. D. W., *The Fabric of the Body: European Traditions of Anatomical Illustration* (Oxford: Oxford University Press, 1992).

Sappol, Michael, *Dream Anatomy* (Bethesda, MD: U.S. Department of Health and Human Services, National Institutes of Health, National Library of Medicine, 2006).

11

Dangerous Pictures: Social Commentary in Europe, 1720–1860

R.W. Lovejoy

Eighteenth-century European culture was rich in satire. It emerged in the literary work of Voltaire, Jonathan Swift, and Henry Fielding, and took visual form in caricature and graphic social commentaries that exposed and ridiculed the political clashes, cultural trends, and social attitudes of the day in ways not permitted in official histories and records. Eighteenth- and nineteenth-century caricaturists were openly critical of their kings, royal families, and political leaders in general, but their primary concern was not revolution. These were working artists whose principal purpose was visualizing public opinion in order to sell their prints to a largely upper-class clientele. Caricature of this period spoke to an urban audience and so displays an insider's knowledge of the city, its society, and its politics.

The term **satire** has its roots in ancient Rome. It derives from the Latin *satura* meaning "a mixture" or "a melody." The Latin grammarian Diomedes (late fourth century CE) associates satire with the *lex satura* (a legal proposition composed of a number of smaller issues), thus comparing the method of the humorist with that of the lawyer. Just as a lawyer must persuade the members of the jury, so too a satirist employs a range of methods including ridicule, vernacular, exaggeration, and irony to censure human folly and sway the public.

Caricature in Britain

In the 1730s, portrait painter and publisher Arthur Pond (English, ca. 1701–1758) popularized the art of caricature in England with his collections of etchings based on drawings by Annibale Carracci (Italian, 1560–1609). The term **caricature** distinguished humorous or satirical prints (political and nonpolitical) from noncomedic prints and has its origins in the Renaissance *caricatura*, exaggerated or charged images, typically a comic human portrait. Caricature often functions as a "fun house mirror" of portraiture, exaggerating the features of the subject for satirical effect. Whereas the portrait painter attempts to render the likeness of the subject naturalistically or, as in the case of official portrait paintings, idealize the subject as a military hero, visionary statesman, or virtuous lady, political caricatures offer a polemical representation of public figures, usually with subversive intent in the guise of humor.

Although painter and printmaker William Hogarth (English, 1697–1764) has often been associated with the development of caricature in Britain, the artist was highly critical of this art form. To him, caricatures, while amusing, did not attain the higher comic truth that was the aim of great art and literature. In 1743, Hogarth published *Characters and Caricaturas* (Figure 11.1), which contrasted his own approach to comedy based on observation of human character with the artificial distortions of caricature. The print parodies the caricatures of Italian masters by contrasting them with several heads located in the bottom panel that have been taken from the work of the esteemed Renaissance painter Raphael (Italian, 1483–1520). In the upper two-thirds of the image, Hogarth draws

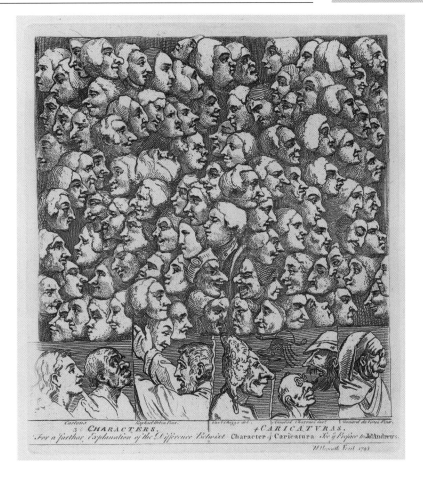

Figure 11.1
William Hogarth, *Characters and Caricaturas*, 1743. Engraving.
This print, which demonstrates character design, served as the receipt for customers' downpayments on the purchase of *Marriage a la Mode*, a sequential narrative told in a series of prints that communicated moral lessons taught through the portrayal of individuals' actions (Figure 11.2).
Courtesy of the Fleet Library at Rhode Island School of Design, Special Collections, Providence, Rhode Island.

an assemblage of heads in profile as visual evidence of a range of expressions that avoids the **grotesque** (fantastic or absurd distortion).

At a time when connoisseurs considered Italy and France the centers of art, Hogarth was fiercely determined to elevate English art, not through mastery of European traditions, but by creating a distinctively English expression grounded in contemporary life. Trained as a silversmith rather than as an academic artist, Hogarth had taught himself to observe and record London society. He transitioned from engraving to painting and earned a good reputation as a portrait painter, but it was his work as a printmaker that proved more lucrative and influential.

In *A Harlot's Progress* (1732), Hogarth arranged his narrative in a series of six scenes, each a separate painting later reproduced through engraving. Hogarth sought to elevate his engraved series to the height of the great literary satirists through dramatic composition, layering of details, and vivid visual characterizations. *A Harlot's Progress* also tapped into the popular market for narratives that revolved around the rise and fall of a woman who surrenders her innocence and virtue for illicit romance or gain.

Hogarth constructed his visual narratives like theatrical plays, his characters akin to actors inhabiting stage sets loaded with props that visually reveal the

circumstances of their lives. In the third plate of *A Harlot's Progress*, the protagonist, Moll, lives in a poor apartment (Figure 11.2). Hogarth shows that Moll has fallen in with lawbreakers through objects in the room, such as the highwayman's wig box above her bed

and the portraits of criminals by her window. She has become a prostitute and taken to robbing her clients, indicated by her satisfied dangling of a stolen pocket watch at the very moment a magistrate enters her Drury Lane room.

The Harlot's Progress was a great success. Its popularity was further enhanced by Hogarth's reference to unnamed but easily identified living persons—although the artist would neither confirm nor deny the figures' identities. The unfortunate aftereffect of this success was the sale of pirated editions of Hogarth's prints through cheap copies engraved three to a plate.

Dismayed at the pirating of his work, Hogarth, with the assistance of influential friends, pushed for an Act of Parliament that protected the copyright of engravers (British authors had already received protection in 1709 under the Statute of Anne). On June 25, 1735, the law known afterward as Hogarth's Act granted original engravings some protection against pirates and plagiarists.

By the 1740s, fashionable London had become a popular subject for satirical artists. Hogarth's enduring series *Marriage a la Mode* (1743–1745), which the artist described as "A Variety of Modern Occurrences in High Life," critiqued the dissolute lives of the upper class, enriched by insights he obtained as a portrait painter.

This theme is most perfectly realized in the second plate, "Early in the Morning" (Figure 11.3), in which the newlywed couple remain aloof in the large, opulent apartment. The husband has returned from a night of carousing confirmed by the extraction of a woman's cap from his pocket by the couple's dog; and the broken sword at his feet—a symbol of spent sexual energy. His wife attempts to engage his attention, having indulged in equally scandalous entertainments in their home: a chair has been toppled as someone dashed out, while a violin lies on the floor along with playing cards, indicating that she has been gambling and making music late through the night with somebody. In the foreground, a servant gestures in disgust, unpaid bills in his hand, while another in the background yawns, perhaps not fully recovered from a night of attending to his mistress.

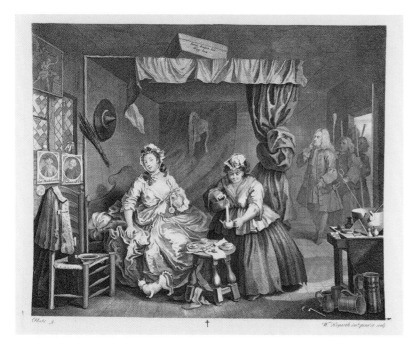

Figure 11.2
William Hogarth, *A Harlot's Progress* (Plate 3), 1732. Engraving, 11 ³/₄ × 14 ²/₃" (image). Hogarth both drew and engraved this series, and took the highly unusual step of publishing it through his own shop rather than through a third-party print seller–publisher, as was more typical in the era. This gave the artist complete control over the quality of his reproductions and also allowed him to keep the share of profits that would have been paid to the print sellers.
Wikipedia

Further Development of British Caricature

Although Hogarth denounced caricature as frivolous, later English visual satirists James Gillray (1756–1815), Thomas Rowlandson (1756–1827), George Cruikshank (1792–1878), and others embraced it, uniting comic distortions and rich characterizations of society.

In the decades that followed Hogarth, there was a rise in the production of satirical prints, credited in part to the activities of highborn George Townshend (Scottish, 1724–1807), a military officer later elected to the House of Commons. Townshend drew caricatures for private amusement, a hobby common to gentlemen of his class; however, Townshend forwarded his images, with their rudimentary likenesses and other political allusions to Darly & Edwards—publishers of visual satire. The publication of such imagery was considered potentially libelous and a violation of class decorum, so in order to disguise his identity, Townshend's images were credited to "Leonardo da Vinci."

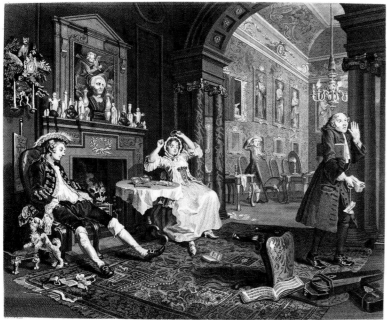

Figure 11.3
William Hogarth, "Early in the Morning," *Marriage a la Mode* (Plate 2), 1745. Engraving , 14 × 17 ¹/₂" (image).
Marriages of convenience were common among the upper class but in decline in the eighteenth century. Hogarth satirizes the dangers of such matches in this series. Visual signifiers like the various gaudy and exotic objects in the couple's home reflect not just bad taste but moral corrosion as well.
Courtesy of Wellcome Library, London.

Theme Box 20: Phrenology
by Jaleen Grove

Phrenology (Latin, "study of the mind"), a forerunner of psychology and physical anthropology, is the practice of measuring the idiosyncrasies of the skull and facial features in combination with the "four temperaments" (blood, phlegm, yellow bile, black bile—associated with moods) to determine someone's personality, intelligence, and moral capacity (Figure TB20.1). Because physical looks were thought to be indicative of specific traits, phrenology was important to writers and artists who wished to portray stock characters and personalities that the public would know at a glance. Many visual stereotypes owe a debt to phrenology—for instance, that a large, high forehead indicates high intelligence.

Phrenology began as a serious scientific study around the year 1800 by Franz Josef Gall (German, 1758–1828) and Johann Gaspar Spurzheim (German, 1776–1832). Although phrenology purportedly showed what a person had been born like, it also insisted that any individual could willfully develop better qualities. The practice was of interest to sociologists wishing to identify, understand, and reform criminals. It also interested the emerging lower middle classes ca. 1830, who wished to scientifically prove their fitness for education and social advancement; but even Queen Victoria had her children examined. Some phrenologists performed analyses as entertaining public spectacles. Although most scientists and doctors considered it a pseudoscience by the 1880s, ordinary people believed

in phrenology well into the twentieth century: by 1900 two copies of George Combe's phrenology bestseller *The Constitution of Man* (1828) had sold for every one of Darwin's *On the Origin of Species* (1859). Clients "had their heads examined" to determine what career to pursue, to qualify for employment, to choose a marriage partner, and to gain insight into themselves and others.

Major flaws in phrenology were that it drew upon customary European visual art codes for good and evil character (or wise, or humble, and so on), and privileged the "beautiful" features of noble Caucasians over those of other races. These codes had descended from Classical times and were disseminated in Johann Kaspar Lavater's (Swiss, 1741–1801) *Physiognomische Fragmente* (1775–1778), which illustrated "types" of people identified by their "typical" physical features (Figure TB20.2). Thus, in phrenology, the Greek god Apollo as sculpted by ancient Romans or Queen Victoria's head were held as ideals. One phrenological book claimed the Irish had bumps indicating great "combativeness," which explained their supposed propensity for brawling, while women were considered less intelligent than men since their brains were smaller.

Within the preservation of stock types, however, phrenology encouraged attention to the particulars of individuals, and provided more options for illustrating characters than did the limited range of the art academies' standard types. Given that a

telltale protrusion on the skull was supposed to be read in the context of the subject's temperament, and that diligent effort to enhance one's faculties was thought to change personality for the better, more nuanced and complicated depictions of character became possible. The art theorist Sir Charles Bell (British, 1774–1842), in his book *The Anatomy of Expression in Painting* (issued in 1806 but revised and widely consulted in 1834) argued that expression of a good personality could render even undesirable features attractive. As the nineteenth century unfolded, Bell's treatise joined with phrenology's impulse to celebrate individualism, allowing illustrators to observe actual people keenly and to combine realistic traits with idealized tropes to create unique variations of accepted character types. Social commentator Charles Dana Gibson is an exemplar of this approach (*see Chapter 18*).

Further Reading

Codell, Julie, "Expression over Beauty: Facial Expression, Body Language, and Circumstantiality in the Paintings of the Pre-Raphaelite Brotherhood," *Victorian Studies*, vol. 29, no. 2, 1986: 255–290.

Cowling, Mary, *The Artist as Anthropologist: The Representation of Type and Character in Victorian Art* (Cambridge: Cambridge University Press, 1989).

Gould, Stephen Jay, *The Mismeasure of Man* (New York: Norton, 1981).

Figure TB20.1 Illustrations contrasting the physical attributes of a minister to those of a murderer. *How to Read Character: A New Illustrated Handbook of Phrenology and Physiognomy for Students and Examiners; With a Descriptive Chart.* Fowler & Wells Co., 1895.

Olin Library, Washington University in St. Louis.

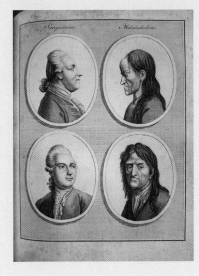

Figure TB20.2 Johann Kaspar Lavater, "Sanguine, Melancholy," *Physiognomische Fragmente*, Vol. 4, 1778, facing p. 352.

Olin Library, Washington University in St. Louis.

Townshend's prints relocated his private commentary to the public sphere and also provided a glimpse into the realm of government—a world that was otherwise closed to the public because newspapers were banned from publishing the proceedings of Parliament until the later eighteenth century. Townshend's political caricatures therefore marked a turning point in British satirical art. Furthermore, while earlier political images had been largely symbolic and relied heavily on explanatory text, Townshend's caricatures were clear visual statements requiring less notation. His drawings were simple, as in *The Recruiting Serjeant* [sic] *or Britannia's Happy Prospect* (Figure 11.4), in which a parade of politicians follows Whig party leader Henry Fox (whose head resembles that of a fox) past a clearly identified statue of the Duke of Cumberland—a failed military commander.

Most working artists were from the middle and lower classes (like Hogarth), but British caricature could not have enjoyed the degree of freedom it did without the patronage and participation of the genteel classes who could afford the higher-priced hand-colored editions. Some enjoyed producing caricatures themselves. By the early 1760s, Matthew Darly (fl. 1740s) encouraged contributions from the upper classes and advertised collections of political caricatures "Drawn and Etched by some of the most eminent Parties interested herein." The fees paid for these drawings were low, as many contributors were delighted enough to find their work in print. In 1762, Darly's wife, caricaturist Mary Darly (fl. 1756–1777), published a short instruction book for such amateur contributors. In keeping with the tenets of the Hogarth Act, these original drawings were archived and catalogued, the artists discreetly credited in the records as "a Gentleman," "a Lady," or "an Artist."

The involvement of high society not only afforded a measure of protection but also set a chief characteristic of British political art—that of providing an insider's view of politics—and fostered the use of parodies based on classical allusions. Although they illustrated their own ideas, artists like Rowlandson, Gillray, and Cruikshank also interpreted concepts submitted by amateur contributors—relying on those amateurs' intimate knowledge of the targeted milieu. As writer William M. Thackeray noted in the *Quarterly Review*, "You could not have society represented by men [to] whom it was not familiar." In 1771, the doors to Parliament were effectively opened when newspapers were granted legal permission to publish accounts on parliamentary debates. Thereafter, the faces and manners of politicians became known to the citizenry and enriched political caricature.

James Sayers (English, 1748–1823) was one of the first caricaturists to develop a consistent and quickly recognizable visual shorthand for his portraits of political figures. A former attorney of independent means, Sayers took advantage of the freedom of the press to sit in on House of Commons sessions, which lent his parliamentary satires a journalistic quality. The fierce political rivalry between Prime Minister William Pitt and opposition leader Charles James Fox shaped British politics in the late eighteenth century and was the subject of numerous caricatures. Fox's overweight and slovenly appearance and Pitt's thin physique and supercilious demeanor offered artists a perfect comic juxtaposition. As a supporter of Pitt, Sayers joined the Prime Minister's inner circle, and even Fox later admitted that Sayers's caricatures had motivated the opposition more than "the debates in Parliament or the works of the press."

Sayers's etching *Cicero in Catilinam* (Figure 11.5) depicts Pitt addressing the House of Commons. The title compares Pitt, who had risen to prime minister at the age of twenty-four, with the ancient Roman statesman who had saved the Roman Republic from an overthrow plot by rival Catilina. Pitt stands as firm as a column while his political rivals, Charles James Fox (son of Whig leader Henry Fox, Figure 11.4) and Frederick Lord North, refuse to engage the speaker. North writes with a quill, only his bushy eyebrows showing above the sheet of paper, while Fox slouches nervously on the side, biting his nails, his hat remaining on his head.

Caricature and Caricature Shops

British caricature was executed by etching or engraving, which required that illustrations were hand drawn and lettered in reverse on copper plates (*see Chapter 2, Theme Box 6, "Intaglio Printing"*). Caricatures and social satire prints could be bought either in black and white or hand colored—a task usually performed by low-paid female assistants. Subscribers could also rent portfolios. At two shillings, the cost of a hand-colored etching was beyond the means of most people, and even the lower-priced black-and-white intaglio print was costly for the lower-class citizen. Nevertheless, people of all classes, genders, and races had access to single-leaf prints through the windows of print shops and on the walls of coffee houses, barbershops, and taverns—important venues where

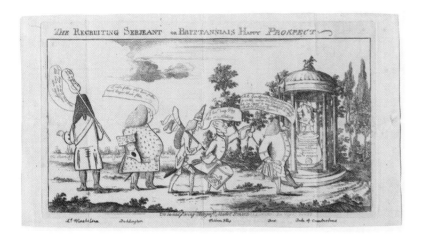

Figure 11.4
George Townshend, *The Recruiting Serjeant* [sic] *or Britannia's Happy Prospect*, 1757. Engraving, 8 × 14" (plate).
George Townshend caricatured his fellow politicians. Here, Townshend shows political leader Henry Fox conscripting several reluctant politicians who are marched past a statue of Duke of Cumberland, whose pedestal proclaims that England will be forever triumphant. In fact, Cumberland's command, in which Townshend served, was defeated during the Seven Years War (1754–1763). Townshend blamed Fox and Cumberland for the misconduct of the war.
Courtesy of The Lewis Walpole Library, Yale University.

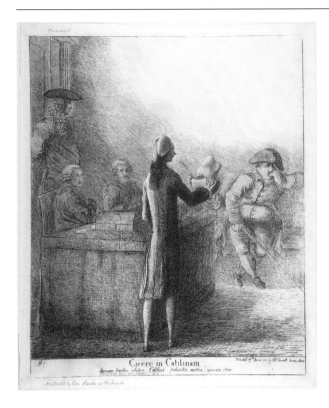

Figure 11.5
James Sayers, *Cicero in Catilinam*, 1787. Engraving, 13 7/16 × 11 1/4" (plate).
Sayers lightly caricatured the politicians, capturing their likenesses in a grounded naturalism and expressive lighting. The young Prime Minister is cast in dramatic light created through a thicket of etched lines atop aquatint, a tonal intaglio technique.

Harris Brisbane Dick Fund, 1917, Metropolitan Museum of Art, OASC.

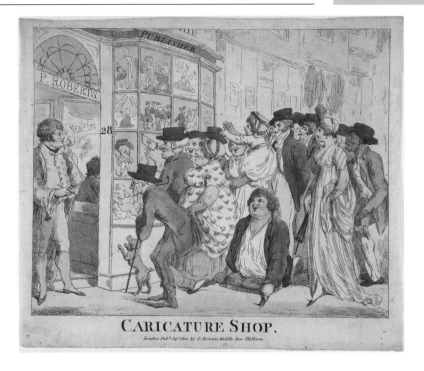

Figure 11.6
Caricature Shop of Piercy Roberts, 28 Middle Row, Holborn, published by Piercy Roberts (British, active 1794–1828), 1801. Hand-colored etching, 10 7/16 × 12 3/8" (sheet).
Prints such as these also functioned as advertisements for the print seller. With the shop name prominently displayed on the doorframe, the crowd of people standing in line not only express the popularity of the proprietor's prints, but position the medium as a social equalizer. The unlikely crowd of admiriers depicted includes old and young, a well-dressed woman, a black man, and a paraplegic.

The Elisha Whittlesey Collection, The Elisha Whittlesey Fund, 1953, Metropolitan Museum of Modern Art.

prints and political newspapers were regularly available to attract customers (Figures 11.6 and 11.7). These establishments in turn were centers of public discourse on the issues of the day.

Caricature prints of the period suggest that it was a common occurrence for crowds to gather in the streets while looking at prints illustrating the latest politics or scandals. A visitor could also pay a small fee to see an exhibition of caricatures on display inside the larger print shops, while distribution networks moved political and topical prints from London to customers throughout Britain, Europe, and America. Europeans visiting England marveled at the liberties enjoyed by British political cartoonists, who freely mocked political subjects in print shops within walking distance of the royal palace. People of means, including officials and royals who were the subject of satires, purchased these caricatures.

Dozens of print sellers established themselves in London during the second half of the eighteenth century. The Darlys' chief rival was the Humphrey family's print shop, which would become the principal publisher of James Gillray. In Gillray's *Very Slippy-Weather* (Figure 11.7), a crowd looks in the windows of Mrs. Humphrey's print shop—an image that promotes not only the shop but also a wide selection of Gillray's work depicted in the window. The image also provides evidence of the social-leveling effect of caricature. In the foreground, an old gentleman has slipped, gold coins falling from his pocket, his wig and hat dislocated. This

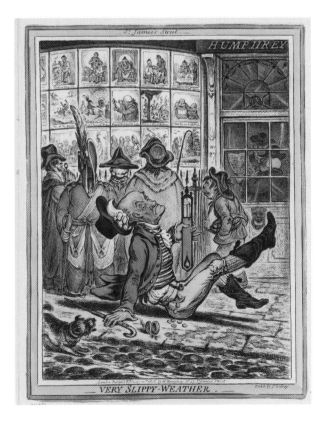

Figure 11.7
James Gillray, *Very Slippy-Weather*, published by H. Humphrey, 1808. Hand-colored etching and engraving, 10 1/4 × 8 1/16" (plate).
Gillray's image of Hannah Humphrey's shop window shows a patrician having slipped on the ground—unnoticed by the crowd whose rapt attention is on a window full of Gillray's own work.

Prints & Photographs Division, Library of Congress.

bit of unfortunate slapstick is ignored by all the figures in the street, who remain enraptured by the caricatures in the window, while through the shop's door a customer inspects a print.

The Political Caricatures of Gillray and Cruikshank

Graphic shorthand for the various public figures depended on well-known codes of dress and physical characterizations (*see Theme Box 20, "Phrenology"*). One of the most effective political prints was Gillray's portrait of the Prince of Wales, later to rule as George IV. Titled *A Voluptuary under the Horrors of Digestion* (Figure 11.8), the **parody** (comic, exaggerated imitation) encapsulates the Prince's self-indulgence but is etched in a soft-looking line-and-stipple technique normally used for idealized patrician portraiture. The Prince's pose references the young noble from Plate 2 of Hogarth's *Marriage a la Mode* (Figure 11.3) after his night of gambling and debauchery. The room is filled with brandy and port, unpaid bills, and gambling debts.

The mid-1790s were a period of great political turmoil in Britain, as Pitt's administration saw major defeats of Britain and its allies in the French Revolutionary Wars (1792–1802). Within Britain, the passage of the Treason and Sedition or Convention Acts (1795) limited the press and public's freedom to criticize the government. Political opposition both within Parliament and from radical groups throughout Britain sought to overturn the acts. During this same period, satire opposing British government policies flourished. One contemporary observer claimed that Gillray published one caricature supporting Pitt for every ten that savagely attacked Pitt's administration.

Gillray's *Presages of the Millennium* (Figure 11.9) displays the caricaturist's imaginative powers at their most vicious. The image satirizes the prophecies contained in Richard Brothers's *A Revealed Knowledge* (1795), which claimed that the French Revolution of 1789 signaled the coming of the apocalypse, at which time the King and those who opposed the revolution would be judged and cast into darkness. Gillray placed Prime Minister Pitt in the role of Death, spreading famine and destruction in his wake. The Prince of Wales, rendered as a small demonic creature, hangs onto Pitt's skeletal form and kisses the Prime Minister's backside while their powerful white Hanoverian horse charges forward over the "swinish multitude." Pitt's political adversaries are startled by horse and rider, and grasp documents alluding to the opposition party's proposal to seek peace with France.

Another frequent subject of political caricature was the French leader Napoleon Bonaparte, whose rise in France, expansionist ambitions, and long war with England made him a focus of European political interest. Isaac Cruikshank (English, 1764–1811) created the first caricature of Napoleon: *Buonaparte at Rome giving Audience in State* (Figure 11.10) represents Napoleon's victory over Rome as an assault on and insulting of the Roman church and its leaders. This depiction evolved into a lasting stereotype: later caricaturists added to Cruikshank's prototype, resulting in an aggressive Napoleon diminished in height (although in reality he was of average height), perpetually dressed in military coat belted with a sash, often with a sabre in his hand, and distinctive bicorn hat.

Gillray's *The Plumb-pudding in Danger or State Epicures taking un Petit Souper* (Figure 11.11) takes advantage of the physical contrasts between Prime Minister Pitt and Napoleon as they divide the world according to their respective spheres of influence.

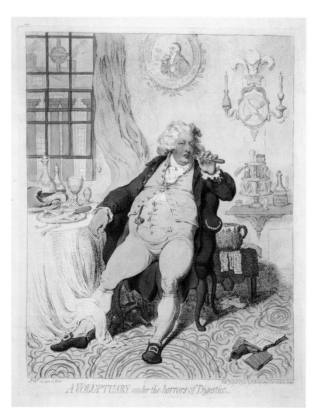

Figure 11.8
James Gillray, *A Voluptuary under the Horrors of Digestion*, published by H. Humphrey, 1792. Hand-colored stipple engraving, 14 1/4 × 11 3/8" (sheet). Gillray's portrait of royal overindulgence and self-satisfaction further compromised the poor reputation of the prince, who at the time of publication was once more in debt despite grants from the government to support his expenses. Gillray contrasts the superficial elegance of the Prince's dress with his coarse manners: picking his teeth with his fork while looking dismissively at the viewer.

Prints & Photographs Division, Library of Congress.

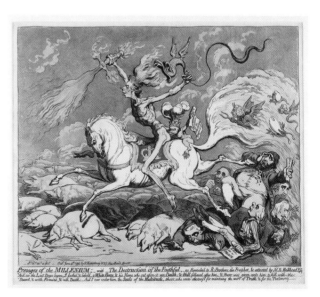

Figure 11.9
James Gillray, *Presages of the Millennium*, published by H. Humphrey, 1795. Hand-colored etching, engraving, and aquatint, 11 5/8 × 14 1/8" (plate). British caricaturists would often parody the compositions of others to augment their own satirical themes. In this example, Gillray appears to have been inspired by Benjamin West's drawing *Death on a Pale Horse* (1783) and John Hamilton Mortimer's etching of the same theme (1784). The Hanoverian horse was a reference to the British king and his royal family who, like the horse, were of German stock. The Hanover dynasty's reign in Britian would end with the death of Queen Victoria (granddaughter of King George III) in 1901.

British Museum London, BMC 8655.

Napoleon aggressively rises from his seat to slice away Europe while Pitt, alluding to Britain's naval power, takes a large piece of the ocean. Beneath Pitt's knife is the West Indies (British colonies in the Caribbean), a source of long dispute between the two countries.

In the autumn of 1812, Napoleon invaded Russia, an unwise strategy because the harsh winter would result in the death of many of his soldiers and force his Grand Army to retreat. George Cruikshank (English, 1792–1878), the son of Isaac, seized on the absurdity of Napoleon's dispatches, in which the French leader declared that he had always intended to withdraw (Figure 11.12). His "Little Boney" barely manages to keep his head and iconic hat above the snowfall. Within two years of this debacle, a coalition of nations united against Napoleon and exiled the French leader to the island of Elba.

Social Satires

Nearly half of the satirical prints produced between 1720 and 1830 focused on nonpolitical subjects, including scandals, erotica, fashion, and the pleasures and frustrations of everyday living. Social satires centered on human foibles, which gave the prints a wider appeal than political prints with their inherent bias. Less topical, social satires also enjoyed a longer shelf life.

Thomas Rowlandson's *The Bassoon—with a French Horn Accompaniment* (Figure 11.13) humorously focuses on a sleeping couple locked in an embrace, their noses the prominent focal point of the image. The plain cottage with sheets used for window curtains and a bed too small for the man (whose feet hang over the edge) indicates their commoner status. The "Bassoon" and "French Horn" of the title refer to the couple's snoring duet.

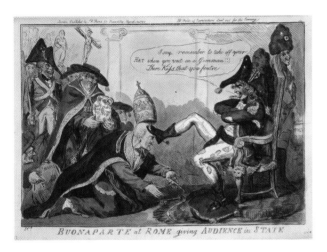

Figure 11.10
Isaac Cruikshank, *Buonaparte at Rome giving Audience in State*, published by S.W. Fores, 1797. Hand-colored etching, 11 1/$_3$ × 15 1/$_4$" (sheet).
Isaac Cruikshank's early caricature of Napoleon was later developed by his son George Cruikshank and caricaturists like James Gillray into the popular image of the French leader as egotistical and aggressive.

Prints & Photographs Division, Library of Congress.

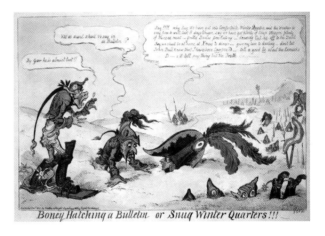

Figure 11.12
George Cruikshank, *Boney Hatching a Bulletin or Snug Winter Quarters!!!*, published by Walker & Knight, 1812. Hand-colored etching, 9 1/$_4$ × 13 1/$_3$" (sheet).
This print shows the fully developed emblematic caricature of the French leader easily identified by his hawk-like nose, oversized uniform, and plumed hat, which emphasizes his supposedly short stature. His army is depicted here nearly buried by the Russian winter with only the tips of their bayonets and bonnets' *rouges* poking above the snow.

Prints & Photographs Division, Library of Congress.

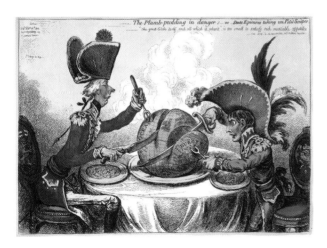

Figure 11.11
James Gillray, *The Plumb-pudding in Danger or State Epicures taking un Petit Souper*, published by H. Humphrey, 1805. Hand-colored etching, 10 1/$_4$ × 14 1/$_4$" (plate).
Gillray's caricature shows British Prime Minster Pitt and the French leader greedily dividing up the world. They both wear military uniforms, although in reality Napoleon by this time no longer wore a uniform and Pitt had no military background except commanding a small volunteer regiment.

Prints & Photographs Division, Library of Congress.

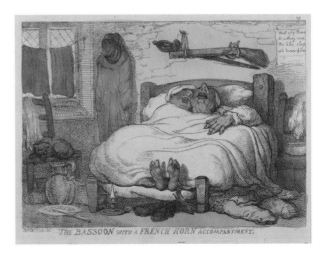

Figure 11.13
Thomas Rowlandson, *The Bassoon—with a French Horn Accompaniment*, published by W. McCleary, 1811, 1821. Hand-colored etching, 9 7/$_8$ × 13 3/$_4$" (plate).
Rowlandson was adept at communicating the humor of daily life, as in this hand-colored print of an affectionate snoring couple lying in bed in the afternoon (the time is indicated by the verses on the wall, which quote the "Noon Sonnet" from James Hook's song cycle *Hours of Love*). Details such as the plates, candle, water jug, the cat and mouse, and clothing both laid out on the floor and hung on hooks suggest the lifestyle of the subjects.

Prints & Photographs Division, Library of Congress.

Over the man's side of the bed hang crossed weapons: a sabre and a blunderbuss. The latter signifies the volume of his snores—the word *blunderbuss* comes from the Dutch *donderbus*, or "thunder gun," because of its loud report when fired.

Rowlandson's fondness for **comic juxtaposition**, the deliberate pairing of opposites, is also apparent in his etching *Doctor Convex and Lady Concave* (Figure 11.14). The subject is a confrontation between a grand lady and medical man. The doctor's protruding belly and grotesque smiling features find their complement in the thin, bent body and face of the lady. In addition to the difference between portly and thin bodies, Rowlandson also implies contrast of social status (he is a doctor, while she is a lady) and attitude (he is confident and complacent; she seems annoyed and determined). The noble lady aggressively argues her point, her body leaning toward the doctor, whose corpulent form and smug manner block her advance.

In 1796, James Gillray and his publisher were arrested for blasphemy over the publication of *Wise Men's Offering*, a political satire that took religious art as its inspiration. The case never came to trial, but the arrest alone indicated government attempts to suppress political caricature through means other than political censorship. In some cases, rather than noisily sue for libel, British royals, nobles, and members of Parliament quietly purchased the rights to prints from the artists. Gillray himself was offered a government pension from the Pitt administration and subsequently published caricatures that focused on Pitt's political enemies. George IV, the former Prince Regent and a favorite target of caricaturists, had attempted to prosecute satirists into submission. When this failed, bribery was used instead. Between 1819 and 1822, the king spent £2,600 in bribes to satirists and publishers, often purchasing the plates and securing the promise that no further attacks on the King would be published. In 1820, George Cruikshank accepted £100 "not to caricature his Majesty" and arranged with the royal house for additional monies to limit satires on the royal government in the future.

James Gillray's death in 1815 marked the end of the most acerbic phase of British satirical art. By 1820, the age of the caricatures as single-leaf etchings had come to a close. Social satire and book illustrations would become the mainstay of British illustrative art while political imagery would continue in a milder, more respectable form during Queen Victoria's reign (1837–1901).

Political Caricatures in France

French censorship laws long attempted to eradicate defamatory political art. From 1586 to 1734, under French law an engraver could not own a press; and beginning in 1685, printmakers were required to secure authorization from the government prior to publishing anything. State censorship laws were eased during the French Revolution (1789–1799), but when Napoleon came to power in 1799, he closed all but thirteen of Paris's

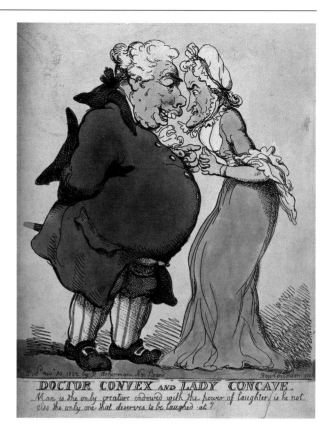

Figure 11.14

Thomas Rowlandson, *Doctor Convex and Lady Concave*, no. 101, published by Rudolph Ackerman, 1802. Hand-colored etching, 11 ³/₄ × 9" (sheet). Here, body types suggest the give and take of an argument. The doctor's body and that of the lady's fit together like puzzle pieces, his convex form analogous to her concave body. The doctor's left foot steps on the lady's pink dress, and a finger on his left hand points toward the two upraised thumbs of her clasped hands. These hand gestures may signify a sexual relationship between the lady and the physician, as does the position of his sword.

Courtesy of Wellcome Library, London.

seventy-three daily political newspapers and enacted laws censoring anything "contrary to good morals or against the principles of government."

Beginning in 1815, British caricatures were allowed distribution in France, although the several regimes that followed Napoleon's reign still restricted the French press. Censorship laws were finally repealed in August 1830 under King Louis-Philippe, only to be replaced in November 1830 by laws that outlawed illustrative attacks on the king and legislature. These new laws were in response to the work of French caricaturists who, inspired by British political prints, criticized the monarch and his administration with inventive and devastating images.

In this brief window of freedom of the press in France following the Revolution of 1830, Charles Philipon (French, 1800–1861) published *La Caricature*, a weekly illustrated political newspaper featuring four pages of text and two full-page caricatures in each issue. Philipon had taken part in the revolt that had led to the installment of Louis-Philippe, the "citizen-king," whose liberal constitutional monarchy replaced the repressive regime of Charles X. On the prospectus of *La Caricature*, Philipon declared a new age of political imagery that would demonstrate the power of caricature in political dialogue with the state.

Theme Box 21: Lithography
by Susan Doyle

Invented in 1798 by Alois Senefelder (German, 1771–1834), lithography (from the Greek *lithos*, for stone) is a planographic printing process, meaning it uses a flat-surfaced matrix, as opposed to relief or intaglio printing that both rely on surfaces with raised, lowered, or physically textured parts to define the ink-holding areas.

Lithography works because oil and water do not mix. Senefelder discovered that by drawing on a smooth, porous limestone with a greasy crayon, he could replicate the drawing by wetting the stone and rolling oil-based ink over the drawing area. The greasy drawing attracted more oily ink, and the aqueous area (nonprinting) repelled it. The print was made by placing a sheet of paper on top of the stone and rubbing the back side of the paper. Not subjected to wear due to great amounts of pressure like relief blocks and intaglio plates, large numbers of lithographs could be pulled from one stone.

Lithographic techniques expanded to include washes created by liquid **tusche** (greasy suspension of carbon pigment) and the use of specially coated papers that allowed artists to draw on portable sheets that were later transferred to the printing stone. Colored images, called chromolithographs or "chromos," were accomplished by registering multiple stones, each holding only the part of the image to be printed in a specific ink color (*see Chapter 13, Theme Box 29, "Chromolithography and Ben-Day Tints"*).

As in relief printing, steam-powered presses, adaptations to the printing rollers, and the use of zinc plates in place of stones greatly increased the output of commercial lithography throughout the nineteenth and twentieth centuries. After 1903, **offset lithography** (where the plate transfers ink to a rubber roller that subsequently transfers the ink to the paper) began to replace stone and zinc-plate lithography, but fine art printmakers continue to print from stones and plates by hand.

La Caricature was printed using **lithography**, a process invented in 1798 that allowed the artist to draw directly on a stone from which the prints were pulled, thereby eliminating the need for an intermediary engraver while preserving the artist's drawing style (*see Theme Box 21*). Moreover, lithographic prints were capable of reproducing tones drawn with a crayon or an inky liquid that were unlike those of either intaglio or relief printing, and that could be printed on the same piece of cheap paper as the letterpress text (although it required a separate pass through a different press), thus inaugurating the illustrated newspaper.

Philipon owned the largest lithographic publishing firm in Paris, and in addition to *La Caricature*, in 1832 he inaugurated *Le Charivari*, a daily paper featuring humorous illustrations of contemporary life and political subjects. Philipon was himself a caricaturist and often suggested design ideas to his artists. He published a barrage of editorials and caricatures critical of the monarchy, and in 1831, he was placed on trial for libel. During his defense, Philipon demonstrated how the shape of a pear bore resemblance to the king and could be transformed into a caricature portrait. This courtroom drawing, titled "Les poires" ("The Pears"), was a double entendre: *la poire* was contemporary slang for "simpleton." Redrawn by Honoré Daumier (French, 1808–1879) and reproduced in *La Caricature* (Figure 11.15), the pear became the ubiquitous symbol of the monarch and his government—scrawled on the walls of the city and picked up by other publications.

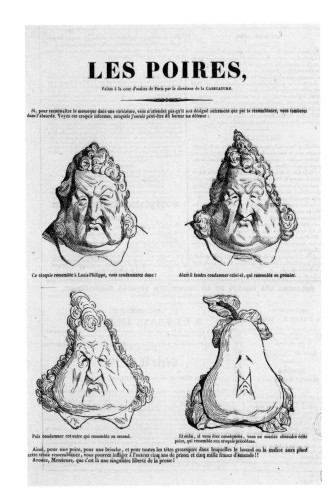

Figure 11.15 Honoré Daumier (after Charles Philipon), "Les poires," *La Caricature*, November 24, 1831. Lithograph and letterpress. "Les poires" ("The Pears") is considered the first four-panel cartoon published in a periodical. On trial for publishing images insulting to King Louis-Philippe, Philipon argued that the court had no control over the "liberty of the crayon," so he drew this sequence and asked if the resemblance between the King and the pear meant that artists could no longer draw the fruit. While the exercise did not help his case, the iconic "Les poires," which was also French slang for "simpleton," became a derogatory icon among political caricaturists for Louis–Philippe's July Monarchy.

© Photo Josse/Scala, Florence.

Between 1830 and 1834, there were widespread government assaults on the press with over five hundred prosecutions in Paris. The print runs of political journals were confiscated and the publishers fined for imagery criticizing or mocking the government. Philipon was prosecuted six times, sentenced to a year in jail, and fined over four thousand francs. Unlike sedition laws in Britain, in France, text was not censored to the degree that images were, so some journals published clever descriptions of the banned images, even arranging their typography in the shape of a pear (Figure 11.16).

Philipon published many of the leading caricaturists in France and is best remembered for his work with Daumier, who was also tried for his depiction of Louis Philippe as the grotesque colossus Gargantua—a character from a well-known sixteenth-century French fable (Figure 11.17). To rebuke the excessive taxation that supported the King's lavish salary, Daumier drew the King sitting on a privy throne (toilet) devouring bags of coins taken from the poor. Ministers seize the resources of the people to feed the appetite of the King, who excretes rewards to his fat officials. For this image, Daumier and Philipon were sentenced to six months in jail.

To raise funds for their legal defense, Philipon published a monthly series of larger lithographs called *L'Association mensuelle* (*The Monthly Association*). J. J. Grandville's (the pseudonym of Jean Ignace Isidore Gérard, French, 1803–1847) contribution (Figure 11.18) depicts a parade of magistrates, police detectives, and other officials of the *juste–milieu* (middle of the road), a label for Louis-Philippe's government, which sought to walk the middle path between Republicans and

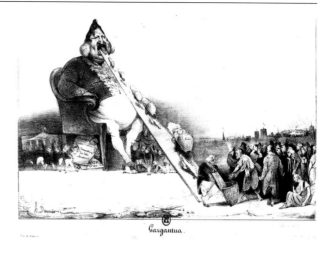

Figure 11.17
Honore Daumier, *Louis-Philippe as Gargantua Devouring France*, 1831. Lithograph, 8 ¹/₂ × 12" (plate).
Before Philipon could publish this powerful indictment of the French king, authorities seized the artwork. The print was briefly sold separately in a Parisian caricature shop until authorities located and destroyed the remaining proofs and the lithographic stone upon which it had been drawn.
Wikiart, Bibliothèque nationale de France.

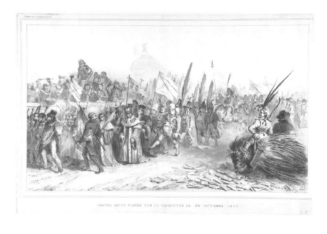

Figure 11.18
J. J. Grandville, *Grand Review Passing before "La Caricature," L'Association mensuelle*, Octobert 30, 1832. Lithograph, 11 ⁹/₁₆ × 20 ³/₁₆" (plate).
Grandville's print ridicules a parade of political subjects passing with clownish pomp before the allegory of Caricature sporting a jester's outfit and riding a porcupine.
Bequest of Edwin De T. Bechtel, 1957, Metropolitan Museum of Art, OASC.

Monarchists. They march past a jester riding a porcupine representing *La Caricature*. Dressed in black with his back to the jester is the Minister of the Interior, the head of the government censors, who approved all political prints before publication from 1835 until 1881.

As prosecution of political prints increased, Philipon's four-page daily paper *Le Charivari* shifted focus to social caricatures and cartoons that satirized the hypocrisies and follies of French life but avoided direct attacks on political figures. Daumier, for instance, drew many caricatures of fictional comic conman Robert Macaire—a spin-off of a popular stage character. In his initial *Le Charivari* appearances, Macaire was an overt reference to greedy politicians, but after the new censorship laws of 1835, he evolved into a bourgeois cheat reappearing as a banker, quack doctor, sleazy lawyer, huckster businessman—in short, a symbol of the duplicity of the age.

Figure 11.16
Cover of *Le Charivari*, February 27, 1834.
Editors circumvented censorship laws in many ways, including writing descriptions of banned cartoons and, as in the example here, formatting their text into the shape of a pear, the symbol of government tyranny.
Courtesy of D.B. Dowd Modern Graphic History Library, Washington University in St. Louis.

Grandville also embraced anthropomorphism, a visual narrative device that can be traced to Aesop's fables (ca. 620–560 BCE) in which human behaviors or intentions are attributed to nonhuman entities. His *Les métamorphoses du jour* (beginning 1828) illustrated the transformations, customs, and manners within nineteenth-century France through naturalistic renderings of fully attired animals. The title refers to Ovid's (Roman, 8 CE) *Metamorphoses.*

Grandville's illustration from the collection *Misère, Hypocrisie, Convoitise* (*Misery, Hypocrisy, Covetousness*) (Figure 11.19) shows a French citizen (characterized as a mouse) lying on his deathbed. As the reader moves from left to right, Grandville represents the many hands that stand to profit from this death—from a family cat pretending to wipe tears from his eyes to three scavenger birds dressed in uniforms indicating their roles as members of the state and clergy.

Social Commentary in the Advent of High-Speed Printing

The efficacy of wood engravings that could be printed simultaneously with type by steam-powered presses that were commercially viable after 1814 precipitated the mass production of illustrated newspapers such as *The Penny Magazine*, *Punch*, and *The Illustrated London News* (*see Chapter 14*).

While satire and caricature had been powerful weapons against political corruption in the eighteenth century, by the second decade of the nineteenth century, members of the newly enfranchised middle class favored more naturalistic imagery and a more genteel approach to humor. New comic journalists sought to create publications incorporating witty narratives tempered by good humor. Britain's periodical *Punch* proved both respectable and commercially successful with its gentler form of political and social commentary. Founding members of the "Punch Circle," Mark Lemon (English, 1809–1870), Henry Mayhew (English, 1812–1887), and Douglas Jerrold (English, 1803–1857), modeled the weekly *Punch* on Philipon's *Le Charivari* and emphasized social satire more than political illustration. In 1841, editor Mark Lemon's opening editorial for the initial issue of *Punch* promised neutrality in political matters, assuring the reader that it would "be interspersed with trifles . . . which will never be sought for at the expense of others, beyond the evanescent smile of a harmless satire" (*Punch*, July 17, 1841).

This claim to "harmless satire" did not necessarily mean an end to all political caricatures, as evidenced by many images dealing with working class and nationalist reform movements. "Young Ireland in Business for Himself" (Figure 11.20) is a political cartoon attacking the radical nationalist movement referred to as "Young Ireland," part of the Irish nationalists' call for independence. It was led by William Smith O'Brien, shown seated behind the counter of a gun shop surrounded by a veritable arsenal. O'Brien is depicted as a gruesome monkey-like creature with a crumpled hat, smiling as he greets an already well-armed customer. English (and then American) political cartoons typically caricatured Irish people with simian features. *Punch*'s more volatile graphic satire also included many anti-Catholic cartoons, which resulted in the resignation of Catholic illustrator Richard "Dickie" Doyle (English, 1824–1883) from the periodical (*see Chapter 16*).

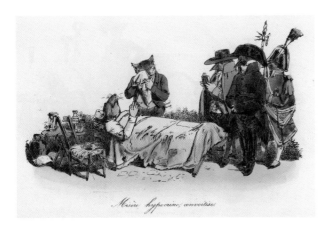

Figure 11.19
J. J. Grandville, "Misère, Hypocrisie, Convoitise" ("Misery, Hypocrisy, Covetousness"), *Les métamorphoses du jour*, plate 26, 1869. Hand-colored lithograph, 10 ¼ × 6 ¹¹/₁₆" (plate).
Grandville's series orignally appeared in album form in 1829. In later editions, some of Grandville's lithographs satirizing the church and state were censored. In this lithograph, Grandville shows how the church, the nobilty, and the state (represented as three crows) wait to seize the property of a powerless dying citizen.
Gift of Lincoln Kirstein, 1970, Metropolitan Museum of Art, OASC.

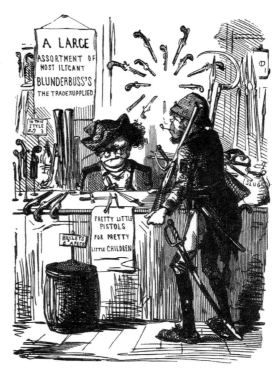

YOUNG IRELAND IN BUSINESS FOR HIMSELF.

Figure 11.20
John Leech, "Young Ireland in Business for Himself," *Punch*, August 22, 1846. The blunderbusses for sale were a scattershot type of weapon, perpetuating British fears of the Irish as innately violent. The sign in front of his counter reads "Pretty Little Pistols for Pretty Little Children," demeaning the Irish as infantile while chillingly suggesting the generational perpetuation of violence underwritten by ulterior motives.

Punch's weekly primary political image took the form of a double-page illustration referred to as the **large cut**. The topic of the large cut was decided at a weekly dinner meeting in which publishers and invited staff would suggest ideas and *Punch*'s political artists would advise on whether a given concept had suitable visual potential.

Punch artist John Leech (English, 1817–1864) preferred illustrating social satires, but did not entirely abandon politics. "Shadow and Substance" (Figure 11.21) was published in 1843 with a subtitle of "Cartoon No. 1," nomenclature Leech continued in subsequent images in the series. "Shadow and Substance" portrayed a group of paupers visiting the "free day" at Westminster Hall Exhibition to view an art competition of "cartoons" (large sketches) for proposed decorations for the Parliament Buildings. Leech contrasts the dignitaries and fashionable upper class whose portraits are on display with the poor and maimed who gape at them. Jerrold's accompanying text lampooned the priorities of Parliament: "The Poor ask for Bread and the Philanthropy of the State accords – an Exhibition" (*Punch*, July 15, 1843). Following Leech's series, the term *cartoon* found new life as a general term used for comic images.

Punch's large cut was often drawn by John Tenniel (English, 1820–1914), who joined the staff in 1850. Tenniel's highly influential political illustrations were typically naturalistic and closer to Hogarth's theatrical characters than Gillray's expressive caricatures. His bold, heavy line gave weight and volume to the figures, and he often reduced the number of personalities in his political cartoons to two or three inhabiting a shallow, stage-like space.

Tenniel's simplified compositions typify an emerging uniformity in late-nineteenth-century political imagery.

Examples are found in the large cuts published by *Punch* and its rivals on the outbreak of the Prussian War in 1870. Tenniel's cartoon titled "Six of One and Half-a-Dozen of the Other" (Figure 11.22) shows John Bull, the symbol of Britain, seated at the center, dominating the cartoon. He acts as arbiter between Paris, represented by a caricature of Napoleon III on the left, and Berlin's King Wilhelm. John Bull balances their arguments on his scales to determine which has more weight. Concurrently, William Boucher's *Judy* cartoon had the same title and a similar composition. It too features three figures: John Bull with scales at the center with Napoleon III and King Wilhelm at either side (Figure 11.23). These images both hearken back to an earlier design featuring John Bull: "The

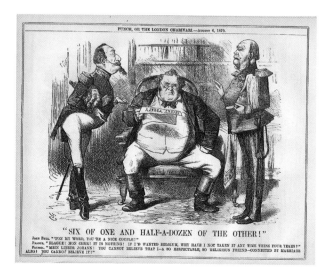

Figure 11.22
John Tenniel, "Six of One and Half-a-Dozen of the Other!" *Punch*, August 6, 1870.
John Bull, the personification of Great Britain, contends with the leaders of France and Germany.
From the author's collection.

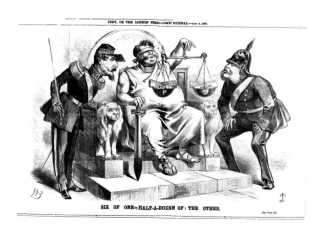

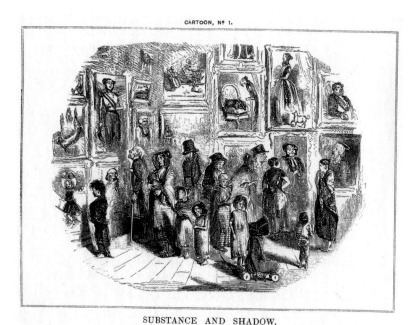

Figure 11.21
John Leech, "Cartoon No. 1: Substance and Shadow," *Punch*, July 15, 1843.
Leech's cartoon was based on a suggestion by *Punch* writer Douglas Jerrold. It criticizes a government whose priorities are revealed in this unseemly "exhibition" of wealthy personages in the guise of philanthropic art.
Philip V. Allingham, The Victorian Web. Courtesy of the Irving K. Barber Learning Centre, University of British Columbia, Vancouver.

Figure 11.23
William Boucher, "Six of One–Half-a-Dozen of the Other," *Judy*, August 3, 1870.
Long-running nineteenth-century comic weeklies were collected in hardbound annual and biannual editions. Boucher's two-page illustration from the 1870 volume displays a remarkable similarity to John Tenniel's political cartoon of the same year.
From the author's collection.

Bone of Contention" (1867) by John Proctor (English, 1836–1898) (Figure 11.24). Although such balanced, frontal arrangements had become predictable by the 1870s, graphic innovation and imaginative cartooning were still much in evidence, particularly in the smaller, less prestigious social satire featured in British comic periodicals.

The respectability and good-humored approach cultivated by *Punch* signified a change in political cartooning. After forty-three years as *Punch*'s primary political cartoonist (and illustrator of *Alice's Adventures in Wonderland*—see Chapter 16), Tenniel was knighted by the Queen in 1893. This was the first time a cartoonist had received such an honor, and notably, it was bestowed by a ruler who was the subject of much visual commentary—albeit generally depicted by *Punch* in a positive light (Figure 11.25). Tenniel's knighthood honored not only his work at *Punch* but by extension validated visual satire as a vehicle for disseminating popular opinion in political discourse—a form once despised and feared by kings and politicians.

Conclusion

Satire and caricature have long been effective in communicating controversial political and social critiques by expressing them through humor. Eighteenth- and early-nineteenth-century British artists were infrequently subjected to soft forms of censorship such as market manipulation, bribery, and threat of legal action, enjoying far more freedom of the press than their French counterparts Charles Philipon and Honoré Daumier, who were heavily fined or jailed by the government. Certainly, Tenniel and all satirical artists who came after him benefitted from the foundation laid by courageous illustrators and publishers like Gillray, Cruikshank, Daumier, and Philipon, who paved the way for this strain of powerful and often controversial visual expression.

THE BONE OF CONTENTION.

John Bull, in the background, to his Dog, STEADY, OLD BOY, STEADY! LET 'EM WORRY EACH OTHER AS LONG AS THEY LIKE. IT DON'T MATTER A STRAW WHICH WINS.

Figure 11.24
John Proctor, "The Bone of Contention," *Judy*, September 25, 1867.
While the texture and line quality of the printed illustrations can be in many ways attributed to the wood-engraving process, the similarity in concept and compositional approach is likely driven by market considerations in which dominant publications set standards that influence others.

From the author's collection.

KEY TERMS	
caricature and *caricatura*	**offset lithography**
comic juxtaposition	**parody**
grotesque	**phrenology**
large cut	**satire**
lithography	**tusche**

MR. PUNCH'S FANCY BALL.

Figure 11.25
John Leech, "Mr. Punch's Fancy Ball," *Punch*, 1847.
John Leech's cartoon shows Queen Victoria escorted by a bewigged Mr. Punch, the mascot of the periodical, to a costume party attended by politicians, soldiers, and nobles. *Punch* staff members are musicians (editor Mark Lemon is the conductor, Douglas Jerrold beats the drum, W. M. Thackeray plays the flute, with artists John Leech and Richard Doyle on clarinet). Leech's cartoon suggests a complicated relationship in which the *Punch* staff performs for the amusement of the Queen and other dignitaries, while those powerful political and noble figures dance to *Punch*'s tune.

From the author's collection.

FURTHER READING

Altick, Richard D., *Punch: The Lively Youth of a British Institution, 1841–1851* (Columbus: Ohio State University Press, 1997).

Bindman, David, *Hogarth and His Times: Serious Comedy* (Berkeley: University of California Press, 1997).

Curtis, Perry L., *Apes and Angels: The Irishman in Victorian Caricature* (London and Washington, DC: Smithsonian Institution Press, 1997).

Donald, Diana, *The Age of Caricature: Satirical Prints in the Reign of George III* (New Haven and London: Yale University Press, 1996).

Godfrey, Richard, *James Gillray: The Art of Caricature* (London: Tate Gallery Publishing, Ltd., 2001).

Goldstein, Robert Justin, *Censorship of Political Caricature in Nineteenth Century France* (London: Kent State University Press, 1989).

McFee, Constance C., and Nadine M. Orenstein, *Infinite Jest: Caricature and Satire from Leonardo to Levine* (New York: The Metropolitan Museum of Art, 2011).

12

From Reason to Romanticism in European Print, 1619–1820

Hope Saska

with contributions by Susan Doyle

In the Baroque and Romantic eras, art patronage in Europe increasingly shifted away from domination by the Catholic church and absolutist monarchies to a system driven by the tastes of private, elite patronage. National art academies were formed to institutionalize artistic training. As these academies grew more authoritative, some artists sought to distinguish themselves as independent of the academic system.

The printing trades boomed during this period. Prints became an important means by which artists, writers, philosophers, scientists, and politically minded men and women shared knowledge and created communities. Ideas and images were disseminated via books, pamphlets, and single-sheet engravings. Engraving reproductive images was an important trade, and engravers were encouraged to assert themselves, seeking status in the artistic community as artists in their own right, rather than just as the "translators" of works by more famous artists. During the Romantic era, in particular, artists became known for their original prints, experimenting with techniques, themes, and compositional devices.

Callot: A Technical and Conceptual Innovator

While etching techniques evolved and were soon more generally adopted, it was Jacques Callot (French, 1592–1635) who used the process to pioneer new avenues of illustrative content. Born of noble parents in the independent duchy of Lorraine (now a part of France), Callot grew up tangentially associated with courtly life. After he was apprenticed to a goldsmith, his impressive printmaking skills led to patronage at the Florentine Medici court, where most of his official work would qualify by contemporary standards as that of public relations: the creation of visual records of court fêtes, spectacles, and other Renaissance pageantry.

Callot introduced technical improvements to etching processes that enabled him to control the density of his line with more precision, from thin, faint lines to very heavy, dark marks. His use of a new stop-out varnish allowed printing plates to be immersed in acid multiple times without causing the **foul biting** (accidental pitting of the plate; see Figure 2.27) that plagued his predecessors. He also deployed a curved-ended etching tool called an **échoppe** that created a swelling line reminiscent of engraving, thus bringing engraving's more labor-intensive but "tried and true" visual aesthetic to the freer process of etching. *The Stag Hunt* (Figure 12.1) shows both the variable line of Callot's new stylus as well as the more nuanced grayscale made possible by multiple rounds of etching.

Leaving the Medici court in 1621, Callot returned to Nancy and for the rest of his career published series of etchings. He is especially well known for his illustrations of character types: peasants, nobles, gypsies, beggars, as well as theatrical performers from the **commedia dell'arte** (improvised itinerant theater groups using stock characters) and the Gobbi—hunchbacked entertainers associated with the Florentine court. The frontispiece for his series of fifty etchings, *Varie Figurae Gobbi* (1622) (Figure 12.2) is presumably based on sketches Callot made while employed at the Medici Court in Florence.

Callot's most important works are his two series titled *The Miseries and Misfortunes of War*—comprising a small set of six prints in 1632 and a larger series of eighteen prints in 1633 (Figure 12.3). In both, Callot

Figure 12.1
Jacques Callot, *La Chasse* (*The Stag Hunt*), 1619. Etching, 7 5/8 × 18 1/16" (plate).
Callot captures an aristocratic entertainment in great detail. Distinct spatial zones are established by the frame of foreground trees, through which our gaze passes to spy a distant shore faintly indicated with the thinnest lines.
Gift of an anonymous friend, RISD Museum, Providence.

Figure 12.2
Jacques Callot, frontispiece, *Varie Figurae Gobbi*, 1622. Etching, 2 5/16 × 3 3/8" (plate).
Callot captures the ribald humor of the entertainers with swelling lines created with an échoppe in simulation of engraving. Such entertainments and prints of this sort were enjoyed as farcical social inversion whereby normal protocols of polite behavior were abandoned.
Gift of an anonymous friend, RISD Museum, Providence.

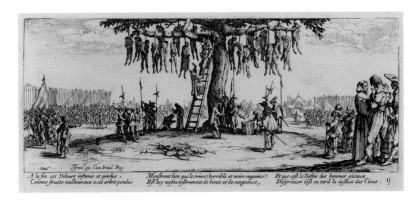

Figure 12.3
Jacques Callot, "La Pendaison" ("The Hanging"), from series *Les Misères et les malheurs de la guerre* (*The Miseries and Misfortunes of War*), 1633. Etching, 3 3/8 × 7 3/8" (plate).
A priest climbs a ladder and gives last rights to a prisoner in a mass execution. Callot's theatrical perspective imposes a clinical distance between the viewer and the horror of the scene illustrated.
RISD Museum, Providence.

depicted the devastation of the French countryside during the Thirty Years War, a religious and political conflict that involved many major European powers. In an elongated horizontal format, Callot depicts the activities of mercenary soldiers from recruitment and battle to lawless pillaging and other destructive exploits—leading to the the torture and execution of wrong-doers. The eighteen-print series ends with a revolt of angry peasants, followed by rewards for the honorable. Callot's work is credited with influencing Francisco de Goya's (Spanish, 1746–1828) series *Los Desastres de la Guerra* almost two hundred years later (see discussion later in this chapter) and foreshadowing modern pictorial journalism (*see Chapter 27, Theme Box 51, "Illustrator as Witness"*). His singular dedication to the creation of original illustrative prints to the exclusion of painting or any other visual medium distinguishes him among the artists of his day.

Expansion of the Print Marketplace

The print market in general expanded in the 1630s, and Paris became an important publishing center of a truly international trade. Intaglio prints were available in large numbers and at extremely variable quality levels, unlike contemporaneous woodcuts, which had become associated with lower-end printing like broadsheets, inexpensive books, and other ephemera (*see Chapter 13*). Single-sheet etchings were within the means of much of the population, while large or elaborate engravings still remained the province of exclusive collectors.

With the professionalization of engraving and improvements in etching, it became more practical to include intaglio images in finer books, but they had to be printed on high-quality paper and on a different press than the letterpress text. Pages were later combined in binding, which added expense to the already risky publishing business.

An artist of extraordinary range in this era was printmaker/publisher Abraham Bosse (French, 1604–1676), who collaborated with Jacques Callot from 1628 to 1630 and published a treatise on etching and engraving in 1645, much of it indebted to Callot's innovations. Bosse is credited with about 1,500 single-leaf prints and, like Callot, he identified social types in his prints and hinted at tensions among social classes and between genders in his narrative images. Bosse also created illustrations for over 120 books, including the frontispiece for *Leviathan* (1651), in which author Thomas Hobbes (English, 1588–1679) contends that men ought to freely contract to the rule of a sovereign in order to maintain peace (Figure 12.4). Bosse interprets Hobbes's "body politic" as a literal human figure whose torso is a composite of a multitude of men, but with the large head of a king. The left side of the page presents symbols of temporal power, and the right side shows ecclesiastical elements; likewise, the landscape is bifurcated between a rolling countryside and an orderly town.

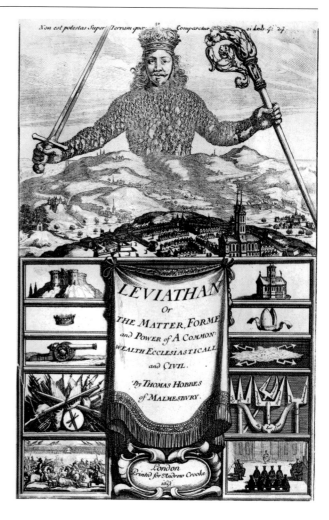

Figure 12.4

Abraham Bosse, frontispiece, *Leviathan* by Thomas Hobbes, 1651. Etching. Bosse's image depicts a sovereign as a composite of his subjects with temporal authority balanced with that of the Christian Church.

Holmes Collection, Rare Book & Special Collections Division, Library of Congress.

Illustration and Engraved Portraits

Besides capturing a likeness, portrait paintings signified status and were commissioned by the wealthy or powerful to commemorate a significant moment in the sitter's life, such as marriage or elevation in title. Although printed portraits could not aspire to the grand display of large canvases, as multiples, they circulated more broadly and assumed other purposes. For instance, inexpensive broadside portraits confirmed the social status of the famous and the infamous (see Figure 2.15, a broadside that announced Ferdinand II's ascendency to the throne).

Renowned for engraved portraiture, artist Robert Nanteuil (French, 1623–1678) completed approximately 300 portraits over his career, including twelve of his patron King Louis XIV (French, 1638–1715, ruled 1643 through 1715). Nanteuil depicted his subjects with exceptionally lifelike countenances and detailed clothing. The subjects were usually encircled in a *trompe l'oeil* (optical illusion of three-dimensionality) framing device with spare text alluding to the status of the sitter (Figure 12.5). Most of his portraits were of the socially elite, and indeed, Nanteuil's fine engravings conferred high status—significant in an era when the nobility were witnessing the alarming acquisition of land by wealthy merchants aspiring to gentleman status.

Figure 12.5
Robert Nanteuil, *Henri de la Tour d'Auvergne, Viscount of Turenne and Marshal of France* (*The Great Turenne*), 1665. Engraving, 19 ¹¹/₁₆ × 16 ³/₄" (plate).
The acccomplished portrait engraver Nanteuil was known for his lifelike images. Note the exceptional specifity of the likeness and costume.

Bequest of Isaac C. Bates, RISD Museum, Providence.

Enlightenment and the Distribution of Knowledge

The Enlightenment is an intellectual movement that developed over the course of the seventeenth and eighteenth centuries, one that valued empirical knowledge, celebrated innovations in the trades and technologies, and welcomed a more democratic social order. Many Enlightenment thinkers admired the morality and philosophies of classical Greece and Rome, while advocating for modernization of prevalent social structures, away from the church and absolutist monarchy.

In art, Enlightenment values were expressed through the artistic style of **Neoclassicism**, in part fueled by the discoveries in 1738 and 1748, respectively, of the ancient Roman cities Herculaneum and Pompeii, which had been covered with ash in the 79 CE eruption of Vesuvius. In emulation of classical artistic styles, Neoclassical artists adopted restrained color palettes and simplified their compositions, depicting their subjects with precise brushstrokes and clear outlines. Art critics celebrated the genre of **history painting**, which in the Neoclassicist's hands communicated moralizing lessons with stoic restraint in grand, narrative pictures of heroic classical and biblical personages enacting noble deeds and sentiments through established aesthetic rules and symbolism. In part a reaction against the fanciful and ornamental styles embraced by the Baroque era, and especially by Rococo artists such as Jean-Antoine Watteau (French, 1684–1721) and François Boucher (French, 1703–1770), the Neoclassical style flourished during the second half of the eighteenth century, becoming the fullest expression of Enlightenment ideals in art.

Diderot and D'Alembert

Exemplifying the forward-looking aspects of the Enlightenment is one of the most extensive print projects of the period, the *Encyclopédie, ou dictionnaire raisonné des sciences, des arts et des métiers* (*Encyclopedia of the Sciences, Arts, and Trades*), edited by Denis Diderot (French, 1713–1784) and Jean le Rond d'Alembert (French 1717–1783). The *Encyclopédie* pairs essays written by specialists with detailed engravings in a series of twenty-eight volumes, including eleven volumes of illustrated plates. In its very title, Diderot and D'Alembert announce that the encyclopedia is a work of order and logic, authored "by a society of men of letters" ("*par une société de Gens des Lettres*"). Over the course of the encyclopedia's history (1751–1772), its production was impacted by skyrocketing costs and by scandal, including charges of plagiarized, heretical, and subversive content.

Compiled by Diderot and D'Alembert, until the latter's resignation in 1757, the *Encyclopédie* was collectively written by a network of Enlightenment thinkers who covered nearly every facet of knowledge in essays touching on philosophy, science, chemistry, history, literature, art, and the modern trades. While the authors visited many of the factories and sites of industry addressed in the volumes, essays were also copied or paraphrased from existing sources. For example, the article on papermaking was based on the l'Anglée paper factory, located in Montargis, France (Figure 12.6). The factory is shown to be orderly, clean, and rationally laid out along a system of canals that convey an essential water supply to workshops and machine rooms within. The illustration presents the factory as a modern marvel, a point underscored by the boat passengers who gesture toward the large edifice with admiration and enthusiasm.

The plates used to illustrate the encyclopedia entries are a combination of engravings initially commissioned for a project initiated by the French Royal Academy of Science

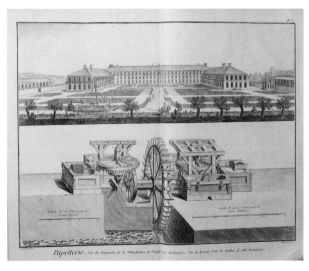

Figure 12.6
"Papetterie" ("Paper Factory"), *Recueil de planches, sur les sciences, les arts liberaux, et les arts méchaniques, avec leur explication*, fourth edition, 1767.
This engraving presents a view of the l'Anglée factory at top, an illustration of a water wheel used to power mills inside the building at bottom. The engraving treats the entire factory like a machine with the water wheel depicted as one of the essential gears.

MIT Libraries/ Creative Commons.

along with new copperplate engravings expressly made for the encyclopedia. While the engravings are uniformly clear and rational, there are important differences in the stylistic approaches used. Compare, for example, the view of the paper factory with a view of the interior of a studio for copperplate engraving (Figure 12.7). The copperplate studio is depicted with a greater freedom of line, and the studio is a hive of activity as the assistants and artists prepare, engrave, and finish the plates. Each man goes about his work with careful competence, and the range of ages shown indicates the workers' progression from apprentice to master.

Piranesi and the Antique

Of the many artists who embraced Neoclassicism, Giovanni Battista Piranesi (Italian, 1720–1778) was among the most prolific, producing numerous prints inspired by ancient Rome. Piranesi studied engineering, architecture, and stage design with the aim of becoming an architect. He became a printmaker and created dramatic and richly etched views of Rome that juxtaposed ancient marvels with the modern city (Figure 12.8). Piranesi's view of the Basilica of Constantine (ca. 306–315 CE) was issued in the volume *Vedute di Roma*, an edition created over a thirty-year span of his career. The etching shows the coffered arches of the Basilica of Constantine crumbling and overgrown with vegetation yet still majestic and imposing. Piranesi deftly alternates between the rich velvety lines in the shadows and lightly etched lines in patches of sunlight. His training as a set designer is evident in his stage-like setting in which wealthy travelers on a **Grand Tour** are positioned alongside

impoverished Romans and laborers for whom the ruins provide shelter or an open space through which animals may be herded.

Yet Piranesi's most fanciful inventions were reserved for a series of etchings depicting imaginary prisons titled *Carceri d'invenzione* (1761–1778) that blend elements of classical architecture with fantastical engineering devices, winches, wheels, and gears often broken and in pieces (Figure 12.9). The immediate

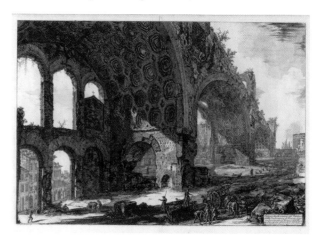

Figure 12.8
Giovanni Battista Piranesi, "View of the Remains of the Dining Room of the Golden House of Nero commonly called the Temple of Peace (the Basilica of Maxentius and Constantine)," *Vedute di Roma*, ca. 1748–1778. Etching, 19 $^1/_4$ × 28" (plate).
Notice how Piranesi dramatizes the ruins, creating a heavy diagonal from the arcade. Modern Rome may be viewed through the arches with a row of apartment buildings that have none of the gravitas of their ancient predecessors.
Yale University Art Galleries.

Figure 12.7
"Gravure en taille-douce" ("Intaglio printmaking"), *Encyclopédie, ou dictionnaire raisonné des sciences, des arts et des métiers*, Volume 5, by Denis Diderot and Jean le Rond d'Alembert, 1767. Engraving.
Below the image of the busy studio, the engraver neatly illustrates the essential tools of the trade with a careful row of burins and burnishers. Note that the points are shown demonstrating the types of mark each tool makes.
Courtesy of the ARTFL Encyclopédie Project, University of Chicago.

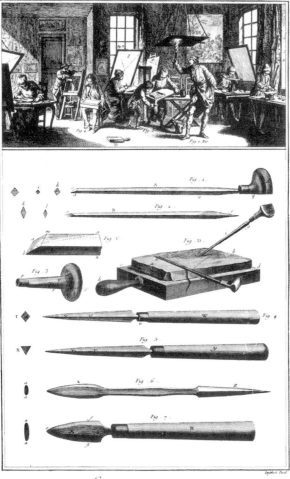

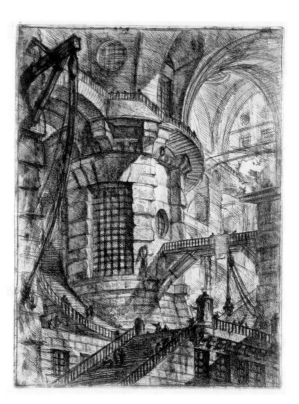

Figure 12.9
Giovanni Battista Piranesi, "Vaulted Building with a Staircase," from series *Carceri d'invenzione*, ca. 1745–1750. Etching, 21 $^5/_{16}$ × 16 $^5/_{16}$" (plate).
In this image there are impossible staircases that lead nowhere and heavy pulleys dripping with broken ropes, all set within an imposing architectural space that is designed to strike the viewer with fear and awe.
Jesse Metcalf Fund, RISD Museum, Providence.

Theme Box 22: Kant: Objective Aesthetic Judgment
by Sheena Calvert

After the advent of movable type and the mass production of printed books in the fifteenth century, the European intellectual classes gradually embraced logic, reason, and the scientific method to distinguish ancient superstitious and traditional ideas from verifiable information. One of the most influential philosophers of the period we call the Enlightenment, Immanuel Kant (German, 1724–1804), brought this sort of scientific mindset to aesthetics, the study of beauty and the definition of art. His ideas dominated the reception of painting, sculpture, and other visual media throughout the nineteenth and twentieth centuries, with a significant negative impact on illustration.

In his text "The Critique of Judgment," Kant asked: How can one reliably identify a superior work of art? In his attempt to solve the problem of personal bias affecting perception, Kant distinguishes between two kinds of truths. *A-priori* truths come before experience and are determined by reason alone, and are thus independent of all experience and unaffected by it. Mathematical propositions such as linear perspective, for example, are a-priori—valid as "pre-given" parts of a system of rational thought that Kant considers to be untainted by subjective opinion. For Kant, a-priori truths are, therefore, universal (common to all), and as such are the standards by which we can make reliable judgments about what counts as good or bad art.

In contrast, *a-posteriori* truths, such as aesthetic impressions by individuals, are particular (individual and singular). The reason is that they are grounded in direct experience: we encounter an artwork that stirs our emotions, and our understanding of it and our assessment of its beauty are formed directly from that unique encounter. Our impression must therefore—Kant reasons—be considered contingent, uncertain, and unreliable—perhaps merely a biased opinion rather than a true evaluation of quality.

Kant wants to remove subjective impression as much as possible, and to instead identify "judgments of taste" based on a universal (shared) standard of beauty. These judgments are "disinterested"—meaning that the viewer regards the art dispassionately, aloofly, without being moved by it. The qualified viewer (Kant assumes this to be a refined European gentleman) is the most capable arbiter—someone who channels a common sense appreciation that the object possesses beauty according to the universal human traits he has identified. This then becomes *the* standard of beauty that we can all agree to because it is rooted in reasoned judgment, not in experience.

Impact of Kantian Thought

Many thinkers question Kant's theories of "disinterested" aesthetic judgment, because they are very Eurocentric, and cannot account for the different aesthetic standards and principles of other cultures (for example, **wabi-sabi**, the Japanese theory of aesthetics that embraces imperfection and celebrates broken and transient forms of aesthetic expression that are alien to the European tradition). Nor can Kantian judgment account for a wide range of different aesthetics encountered in visual culture after Kant's lifetime and in contemporary media today, such as daguerrotypes or animated film.

To his credit, Kant attempted to identify systems by which we, as human beings, could make sense of the way we experience beauty and artworks, in the pursuit of improving noble standards of fairness, goodness, and wisdom. But such systematization is quite restrictive, especially for creative practitioners. In a system, nothing can deviate; all must be accounted for, and anomalies are simply rejected. The form of the system constitutes a totality: the strictest interpretation of High Modernism, for instance, rejects anything that doesn't stylistically fit a preconceived design according to rationalized aesthetic principles. In the effort to reinforce similarity within such a system, the unique, particular, sentimental, and concrete in a given object are discouraged.

Additionally, as D. B. Dowd argues in *Chapter 1, Theme Box 1, "Giving Illustrators a Voice,"* by the time the modernist avant-garde art matured in the twentieth century (*Chapter 19*), the ideal of disinterested contemplation privileged the appreciation of the artwork's form, and held art-for-art's-sake—the self-referential production of art for the joy or curiosity of it, or to experiment in form with no further purpose or content in mind—to be the most important of all artistic values. This meant that illustration, which is not purely self-referential given its purpose to tell stories, document important people and events, persuade the viewer to some action or belief, or add meaning to objects through decoration—was assigned a lower status in the art world and intellectual circles.

As restrictive and contentious as we might find Kant's ideas today, something of his quest lives on in **neuroaesthetics**, the scientific study of aesthetic reception in the brain, which has resulted in evidence that there may in fact be reactions to visual stimuli that are hard-wired. Bilateral symmetry, for instance, attracts the eye and is arguably universally pleasing. There may, after all, be physical evidence for universal agreement about what constitutes good and bad aesthetics, but Kant's theories still present a challenge to creative practices that stand outside the norms and conventions of "absolute" aesthetic values.

Further Reading
Kant, Immanuel, *Critique of Judgment* (Oxford and New York: Oxford University Press, 2007).

Koren, Leonard, *Wabi-sabi: For Artists, Designers, Poets & Philosophers* (Port Reyes, CA: Imperfect Publishing, 2008).

Lauring, Jon O., *An Introduction to Neuroaesthetics: The Neuroscientific Approach to Aesthetic Experience, Artistic Creativity and Arts Appreciation* (Copenhagen: Museum Tusculanum Press, 2015).

emotional impact of these imagined spaces is enhanced by heavy etched lines that are broken and ragged and have the appearance of being quickly drawn. Of all Piranesi's works, these etchings most clearly point to the emotive Romantic print productions that begin to displace Neoclassicism at the end of the eighteenth century and in the first half of the nineteenth.

Printmaking in the Romantic Era

Romanticism (peaking 1790–1850) was an international movement that took many stylistic and conceptual forms. Overarching themes associated with it include the powerlessness of the individual when faced with overwhelming and unpredictable forces of nature and history, the struggle of the romantic hero to assert himself and express his individuality, and a belief that the artist, as a "**genius**," possessed special insight and could reveal something fundamental and hidden about the world by using his imaginative powers. In this formulation, emotion is privileged over reason as a more authentic reaction to the surrounding world. William Blake and Francisco de Goya exemplify this era in their creation of deeply personal and symbolic artworks that describe the massive changes that occurred within their local and global environments.

William Blake

William Blake (English, 1757–1827) was active as a poet, printmaker, and painter from the early 1770s until his death in 1827. Deeply inspired by the classical tradition, Blake desired to emulate ancient and Renaissance artists and eschewed the artistic style promoted by the Royal Academy of Art as a corrupted version of the Classical tradition. In his own life and work, Blake cast himself as an individualist, and admired artists such as Henry Fuseli, James Barry, and John Hamilton Mortimer, who similarly embraced the artistic styles of Greek and Roman antiquity while promoting the role of imagination in the creation of works of art.

The image known as *Albion Rose* (Figure 12.10, also called *Albion's Dance* and *Glad Day*) provides an example of Blake's idiosyncratic and appealing style, and demonstrates his repeated engagement with important themes. A color-printed etching with additions of ink and watercolor made by the artist, *Albion Rose* depicts Albion, the personification of Britain, standing on a high peak with outstretched arms. Although the facial features convey little emotion, the expansion of the figure's limbs and the full exposure of his torso express an ecstatic posture. In an engraving made after 1800, Blake revisited the composition and inscribed the plate with notes that date the conception of the image to 1780 and provide the work its name: "Albion Rose from where he labour'd at the Mill

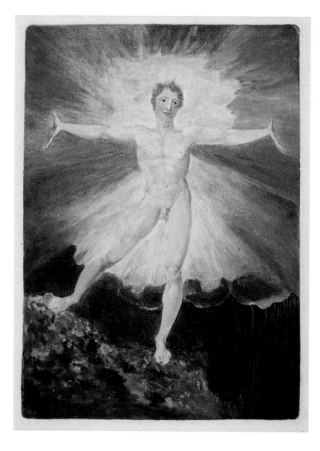

Figure 12.10
William Blake, "Albion Rose," *A Large Book of Designs*, Copy A, plate 1, 1794–1796. Color etching and engraving with hand-coloring, 10 $^{7}/_{10}$ × 7 $^{4}/_{5}$" (sheet). The figure's classical proportions and outstretched limbs echo those of Leonardo da Vinci's Vitruvian Man (1490), a diagram of the divine balance of the universe expressed in ideal bodily proportions, indicating Blake's familiarity with Renaissance works.
The British Museum, 1856,0209.417.

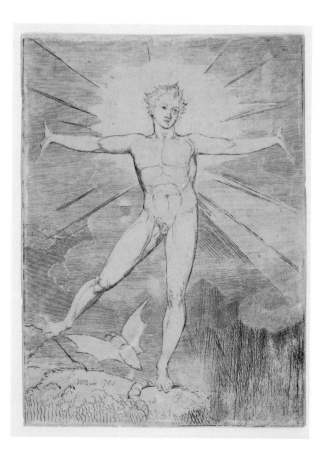

Figure 12.11
William Blake, *Albion Rose*, ca. 1804. Engraving, etching, and drypoint, 10 × 7 $^{1}/_{2}$" (plate).
Blake's inscription indicates that the figure was intended to illustrate a glorious transition from a state of slavery to an emblem of freedom.
The British Museum, 1894,0612.27.

with Slaves / Giving himself for the Nations he danc'd the dance of Eternal Death" (Figure 12.11). Working primarily in London, most notably in the South London parish of Lambeth, Blake was connected to the political and cultural center of England and was keenly aware of disparities in class and social injustices, a theme of many of his works.

Blake's formal artistic education was wholly conventional, indicating his aspiration to secure employment in a skilled trade. At the age of ten, he enrolled in Henry Pars's drawing school, where he learned the fundamentals of drawing by meticulously copying reproductions of master works. Through an apprenticeship under engraver James Basire (English, 1730–1802), who illustrated the publications of the Royal Society and the Society of Antiquaries, Blake acquired not only the fundamentals of copperplate engraving, but also a deep knowledge of English history—especially the Gothic era—which helped formulate his personal mythology. At the age of twenty-one, Blake worked as an engraver for a number of publishers in London, and in 1799, he enrolled in the Royal Academy of Art, embarking on a course of study that included painting as well as engraving.

An ambitious artist, Blake believed that he could use his artworks to interrupt staid traditions and provide a new trajectory for the arts in England. His development of **relief etching** (a process he claimed that his deceased brother, Robert, had revealed to him in a dream) served Blake's artistic aims by affording him greater freedom of creation because he could create his image directly on the plate rather than excising it from a stop-out ground, as in most forms of intaglio (*see Chapter 2, Theme Box 6, "Intaglio Printing"*). Using relief etching, Blake produced about twenty illustrated texts, including *Songs of Innocence and Experience* (1789–1794)—perhaps his most widely known work. As in many of his projects, Blake composed both the poetry and the images, conceiving of his image and text as one unit. In *The Tyger* (Figure 12.12a, b), the artist's hand is evident in the distinctive script printed above the fearsome tiger as well as in the addition of watercolors, possibly by Catherine Blake, his wife and partner in print production.

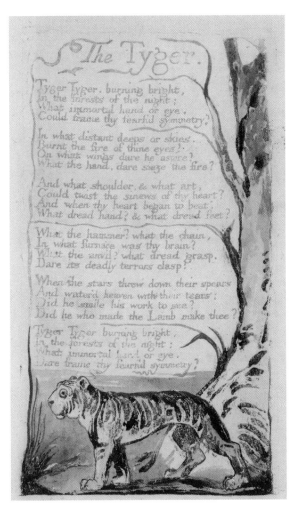

a

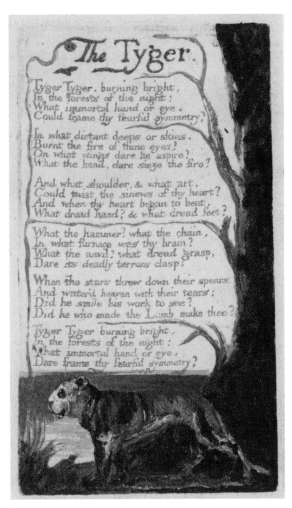

b

Figure 12.12a, b
(a) William Blake, "The Tyger," *Songs of Innocence and of Experience. . .*, Copy B, plate 35, 1794. Color relief etching with hand-coloring, approximately 4 $^1/_3$ × 2 $^3/_4$" (plate).

British Museum, 1932,1210.22.

(b) "The Tyger," *Songs of Innocence and of Experience. . .*, Bentley Copy F, plate 42, 1794. Color relief etching with watercolor, 4 $^3/_8$ × 2 $^1/_2$" (plate). Blake referred to his relief etching process as "illuminated printing" and likened it to ancient and medieval illuminated manuscripts. A comparison of two impressions of the same plate demonstrates the range of variation Blake could achieve with this technique.

The Yale Center for British Art, Paul Mellon Collection, B1978.43.1573.

Blake's *America a Prophecy* (1793) and *Europe a Prophecy* (1793) were published in the years following the American and French revolutions and were often bound together. Along with *The Song of Los* (1795), they form a group called the *Continental Prophecies* in which Blake creates a cast of mythic characters to explain the inevitability of political revolution in response to despotic rule. America is presented as the first revolution that sets off a fiery reaction across the continent (Figure 12.13). The frontispiece for *Europe a Prophecy* (Figure 12.14) demonstrates a similar interest in filling the plate with dramatic and apocalyptic imagery.

Even while Blake created his prophetic illuminated books, he continued to seek work as a reproductive engraver. In 1795, Blake received his most significant commercial commission from Richard Edwards for illustrations to Edward Young's poems collected in *The Complaint and the Consolation, or Night Thoughts* (1797). In all, Blake produced 537 watercolor designs from which he engraved 43 illustrations. As demonstrated by a preparatory drawing, Blake's illustrations were created around boxes of type set into the page (Figure 12.15a, b).

Although the 1790s and early 1800s were a productive and somewhat profitable period for Blake as an illustrator and reproductive engraver, he had difficulty finding a wide market for his relief etchings; outside the handful of **bibliophiles** (book lovers) who collected artist's books, Blake's productions had limited appeal. The artists who owned copies of his works tended to belong to his circle of acquaintances, friends, and those with whom he hoped to curry favor. In the last decade of his life, Blake benefited from the patronage of a young painter, John Linnell (English, 1792–1882), who rediscovered Blake

and commissioned several projects, including illustrations for *The Book of Job*, a story of redemption that Blake had begun to explore some twenty years earlier (Figure 12.16).

The engravings for the *Book of Job* were the last complete work that Blake produced. His immediate artistic legacy can be found in the visionary approaches cultivated by later artists, such as the Pre-Raphaelites, who championed Blake's desire to emulate pre-Renaissance precedents (*see Chapter 15*). Among his contemporaries, however, Blake was primarily remembered as an eccentric.

Francisco De Goya

In his lifetime, Francisco José de Goya y Lucientes (Spanish, 1746–1828) was a celebrated painter who worked in the royal courts and accomplished many commissions, primarily portraits, for the Spanish aristocracy and other social elites. As a court artist, Goya created works suitable for display on palace walls, but it is his powerful etchings and engravings that have had the most lasting impact on the trajectory of illustration. Like Blake, Goya followed a fairly typical path in artistic training, starting with study in the studio of painter José Luzán Martinez (Spanish, 1710–1785), where he learned techniques of drawing and composition by copying engravings. Despite having been twice rejected by the Royal Academy of San Fernando, Goya tenaciously pursued a career in history painting in the hopes that

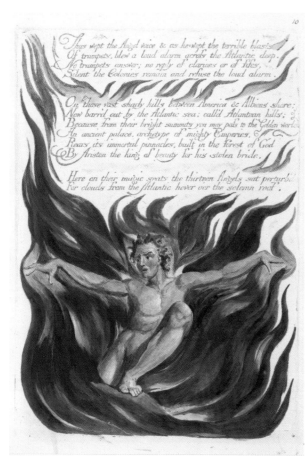

Figure 12.13 William Blake, "Thus wept the Angel Voice. . .," *America a Prophecy*, plate 12, Bentley Copy M, 1793. Color relief etching with hand-coloring, 9 ¼ × 6 ¾" (plate). In this, the twelfth plate of *America*, Blake presents a conflagration as the colonies are summoned to revolution. Blake fuses his poetry and his imagery to such an extent that the flames that engulf the figure threaten to engulf his text: tongues of fire separate the stanzas, and the flames lick the borders of his composition.

Yale Center for British Art, Paul Mellon Collection, B1992.8.2(12).

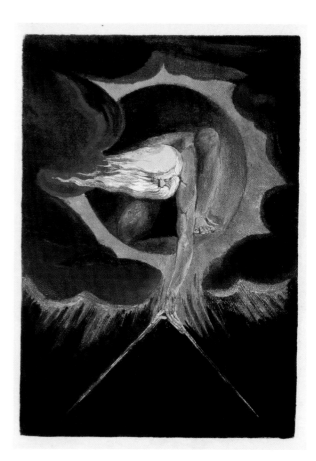

Figure 12.14
William Blake, frontispiece, *Europe a Prophecy*, Copy B, 1794. Color relief and white-line etching hand-coloring, 9 ¼ × 6 ⅝".
In this plate, Urizen, a god-like figure who represents the old order threatened by revolution, bends to measure the darkness. Heavenly light surrounds him, although he is entirely preoccupied by his task.
By permission of University of Glasgow Library, Special Collections.

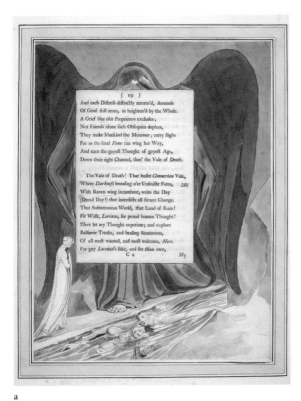

a

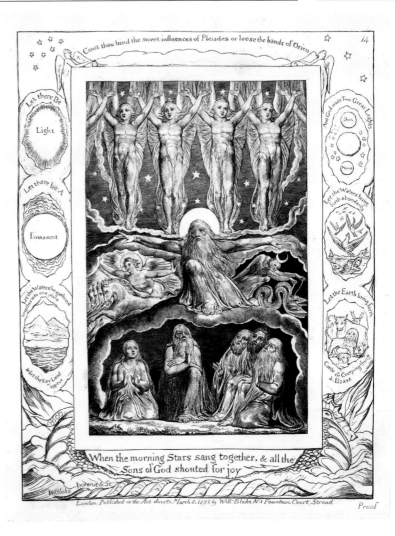

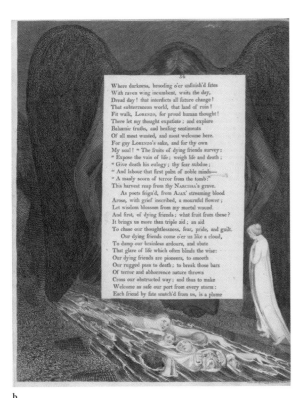

b

Figure 12.15a, b
(a) William Blake, "And each Distress distinctly mourn'd', in *The Complaint and Consolation, or Night Thoughts* by Edward Young, study for *Night III*, page 19, by Edward Young, 1795–1797. Pen and gray ink, with wash and watercolor (with printed text mounted on drawing), 16 ¹/₂ × 12 ⁴/₅".

British Museum, 1929,0713.48;

(b) "The vale of death! that hush'd cimmerian vale," in *The Complaint and the Consolation, or Night Thoughts*, page 54, by Edward Young, 1797. Etching and line engraving, hand-colored, 15 ¹/₂ × 12 ³/₄" (plate).
In *Night Thoughts*, the text box takes the place of the figure of Death as described in the poem and integrates Young's poetic language with Blake's visual interpretation.

Yale Center for British Art, Paul Mellon Collection, B1992.8.10(26).

Figure 12.16
William Blake, "When the Morning Stars Sang Together, and all the Sons of God Shouted for Joy," *Illustrations of The Book of Job*, plate 14, published by John Linnell the elder, 1825. Engraving, 17 ¹/₂ × 12 ⁵/₈".
The engraved version of *The Book of Job* incorporates rich designs and biblical texts in the margins and points to Blake's illuminated engravings wherein image and text are integrated. Blake's mastery of engraving is also on display here: the velvety tones of the night sky provide contrast for the figures highlighted against the darkness. The arrangement of figures into horizontal tiers signals a transition from earthly to celestial space, with Job and his family below and God and angelic beings above.

Gift of Mrs. Jane W. Bradley in memory of Charles Bradley, RISD Museum, Providence.

it would serve his artistic ambitions and leave him well positioned to pursue contacts in the court.

Striking a balance between meeting the expectations of his patrons and pursuing his own creative interests, Goya embraced etching as a way to diversify his artistic output. He made etchings of paintings by Diego Velàzquez (Spanish, 1599–1660) in the royal collection, which publicized the works to a broader and more international audience, and promoted him as the heir to the academic tradition in Spanish painting.

Elected to the Royal Academy in 1786, Goya worked on important painting projects such as frescoes of religious subjects for the Nuestra Señora del Pilar church, and earned a reputation for highly skilled portraits. He expanded his circle of wealthy patrons, the most important being Charles IV and Maria Luisa, who ascended to the Spanish throne in 1789. Goya was subsequently named Court Painter, granting him access to the privileged circles at court with the expectation that his works would celebrate the rulers and decorate their royal residences.

Theme Box 23: Color, Affect, and Synesthesia
by Sheena Calvert and Jaleen Grove

Physicist Isaac Newton (English, 1643–1727) developed the first color wheel in 1666, reminding us that color theory has a long history, and that color and science have always been closely aligned. Emphasizing the physical aspects of color in his theory of optics, Newton states: "Shine white light through a glass prism and the emerging rays of light will spread out in a rainbow of colors." The physics of color as light are the basis of the additive color that we use in digital technologies, such as computer screens.

In contrast to Newton, the Romantic polymath Johann Wolfgang Goethe (German, 1749–1832) claimed that color is experienced beyond the properties specified in scientific analysis. The term used for things that register not so much in rational thought as they do in unconscious bodily sensations, intuition, feeling, and the unexplainable is **affect**. Goethe describes color in terms of the affective properties of dampness and weakness when he says, "Yellow is a light which has been dampened by darkness. Blue is a darkness weakened by the light." Goethe's approach to color is one in which the affective qualities of color are not dominated by physics or science. We might say that his writings in *Theory of Colours* (1810) operate somewhere between a science and a poetics of color; and while he was not always correct about the technical aspects of color, he brought it into focus for us as an individual experience that inspires awe in the viewer. Temperature, hue, value, and intensity can each radically alter our experience of color. Our relationship with color is not just made of ethereal rays and glows, but the stickiness of pigments on our brushes and cheeks, the staining of dyes in our clothes, the seeping of blood.

Goethe's approach is echoed in the work of later color theorists such as the philosopher Ludwig Wittgenstein (Austrian, 1859–1951), who, in his book *Remarks on Colour* (1950), queried "What is red?"—a primary question about how words can, or cannot, stand in for the experience of color itself. In short, he examines the relationship between color and language as a system of representation.

Some people's brains mingle senses that are normally separated—a phenomenon known as **synesthesia**, "union of the senses." In their mind's eye, they may see specific colors (and/or experience tastes, textures, smells, and other sensory data) when they think of or hear about concepts such as numbers, days of the week, or other abstract concepts. The associations pop into their minds automatically. What color or smell goes with what concept is particular to the individual, but is consistent: for Jane Doe, the month of March will always be green, for example. The senses themselves may also be inter-mingled, where (perhaps) the taste of strawberries sounds like bells.

Beginning in the late eighteenth century, synesthesia became a key interest of painters and poets (like Goethe) who were part of the German Romantic movement and who were concerned with art's potential to stimulate and overwhelm the senses. In 1849, Romantic composer Richard Wagner (German, 1813–1883) theorized and devel-oped the **gesamtkunstwerk** (total work of art), an immersive theatrical experience that combined music, visuals, word, dance, and theater into one closely knit extravaganza that he regarded as the art form of the future.

Of particular interest to artists was the relationship between color and music, which by 1900 became foundational in the development of abstract painting and of musical light shows, or **visual music**. These, in turn, evolved into animated films and cinematic special effects by the likes of Oskar Fischinger (German, American, 1900–1967) and Norman McLaren (Scottish, Canadian, 1914–1987). Painter Wassily Kandinsky (Russian, 1866–1944) conducted many experiments in painting music, and in his book *Concerning the Spiritual in Art* (1912), he argued that color had a spiritual dimension as well: "Blue is the typical heavenly color. The ultimate feeling it creates is one of rest. When it sinks almost to black, it echoes a grief that is hardly human," he wrote.

In the age of digital media that Newton's physics made possible, visual music and combinations of light, word, image and sound dominate television, film, advertising, nightclubs, and other media environments; while the immersive and integrative aims of the gesamt-kunstwerk characterize the experi-ence of twenty-first century virtual reality gaming.

Further Reading

Van Campen, Cretien, *The Hidden Sense: Synesthesia in Art and Science* (Cambridge, MA: MIT Press, 2010).

Cytowic, Richard E., David M. Eagleman, and Dmitri Nabokov, *Wednesday Is Indigo Blue: Discovering the Brain of Synesthesia* (Cambridge, MA: MIT Press, 2011).

Goethe, Johann Wolfgang, *Theory of Colours* (Cambridge, MA: MIT Press, 1970).

Vergo, Peter, *The Music of Painting: Music, Modernism, and the Visual Arts from the Romantics to John Cage* (London; New York: Phaidon Press, 2010).

Wittgenstein, Ludwig, *Remarks on Colour* (New York: Wiley-Blackwell, 1991).

Adversity and Invention: Goya's Artistic Vocabulary

Late into the year of 1792 and early in 1793, Goya suffered an illness that resulted in his total loss of hearing. The difficult recovery and ensuing deafness plunged the artist into depression. While Goya's personal world foundered, the French Revolution was becoming ever more violent, threatening the balance of power in Europe. On January 21, 1793, Louis XVI, a cousin of the Spanish King Charles IV, was put to death by guillotine. As a result, Spain declared war on France. It is at this time that Goya began to explore fantastic and otherworldly subjects, in small cabinet paintings done in oil on tin-plate, claiming that such themes helped to distract him from his illness and offered him some relief from troubles.

Los Caprichos

The cabinet paintings and drawings that filled Goya's notebooks during this epoch assert a new direction in his artistic vocabulary and foretell his first major series of etchings, *Los Caprichos* (*Caprices*), which were offered for sale at a local bookshop in 1799. If Goya's assertions are to be believed, the etchings were not enthusiastically received. Most scholars agree that Goya understated the number of impressions that sold (twenty, according to his claims), but it is also true that the works did not have broad appeal. The etching titled "El sueño de la razon produce monstrous" ("The Sleep of Reason Produces Monsters") (Figure 12.17) was perhaps intended to be the title page for the series of eighty sheets that were sold as a suite.

The etchings in *Los Caprichos* demonstrate Goya's experimental approach and ultimate mastery of a combination of intaglio techniques, chiefly etching and **aquatint**, a method of achieving subtle shades of gray, with the plate then selectively burnished to create highlights (*see Theme Box 24, "Aquatint," later in this chapter*).

In referring to his series as *caprichos*, or caprices, Goya was consciously linking himself to the artistic tradition of creating inventive, fanciful, and sometimes playful images that gave the artist's imagination free rein. He may also have been motivated by the imagery and technical inventiveness of caricatures and satirical prints coming out of England in the late 1700s (*Chapter 11*).

From the moment of their publication, the meanings of *Los Caprichos* have been the subject of extensive speculation, primarily because of the incongruous relationship between image and caption. "Hasta la muerte" ("Until Death") (Figure 12.18), for example, mocks the attempt of a crone to appear youthful and attractive by adorning herself with a ridiculous mass of ribbons. The vain attempts of aging women to regain their youthful appeal was a favorite theme of English caricaturists, especially James Gillray and Thomas Rowlandson.

That contemporary viewers recognized Goya's debt to the satirical print tradition is indicated by the numerous contemporaneous commentaries that attempted to make sense of these images. It must be noted that Goya planted the seeds for this interpretation in his advertisement for the series, which claimed that the artist did not mean to satirize any particular individual. Goya's protestation echoes a similar disclaimer by William Hogarth, whose disavowal of caricature only encouraged his viewers to more assiduously seek resemblance. Yet despite the appearance of satire, it is unclear whether Goya himself viewed these works as such.

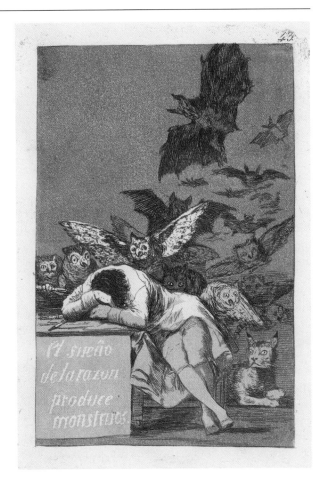

Figure 12.17
Francisco de Goya, "El sueño de la razon produce monstruos" ("The Sleep of Reason Produces Monsters"), from series *Los Caprichos*, Plate 43, 1799. Etching, aquatint, drypoint, and burin, approximately 8 ⅓ × 6" (plate).
In this now-iconic image of the tormented artist, a male figure sits at a desk in a somewhat awkward sideways pose. Goya's depiction of the artist's inner world is a troubled one: without the governance of rational thought, the imagination runs rampant. Thus, while the dreams may represent freedom, the visions themselves are a little dangerous and potentially subversive. Their precise meaning is indeterminate, compelling the viewer to complete the artist's thought.
Courtesy of The Metropolitan Museum of Art, OASC.

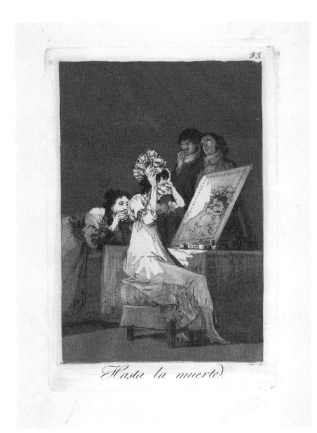

Figure 12.18
Francisco de Goya, "Hasta la muerte" ("Until Death"), *Los Caprichos*, plate 55, 1799. Etching and Aquatint, 8 ⅜ × 5 ¹⁵/₁₆" (plate). Although she sits in front of a mirror, the crone's eyes are closed, making her blind to her appearance as well as to the reactions of the young men and woman who watch her and laugh.
Courtesy of The Metropolitan Museum of Art, 18.64 (55).

Los Desastres de la Guerra

Art historians who study the work of Goya frequently caution against viewing his graphic works as historical evidence. The series *Los Desastres de la Guerra* (*The Disasters of War*), which was etched in the years following the 1808–1813 French invasion and occupation of Spain and the subsequent famine in Madrid (1811–1812), represents Goya's response to the atrocities of war and starvation, although it cannot be taken as a journalistic effort. Goya did not sell etchings from this series in his lifetime; they remained in the family after Goya's death and were sold to the Royal Academy of San Fernando in 1862. Moreover, although artist's proofs of the works exist, the bulk of extant prints were pulled in 1863 and thus do not necessarily reflect the artist's intention because he was not there to supervise the publication. Goya's decision not to publish these prints during his lifetime has been interpreted as both an indication of the personal nature of such images and as the artist's recognition that the subject matter was controversial.

"No se puede mirar" ("One Can't Look") (Figure 12.19) depicts a violent attack on a group of middle-class citizens. The composition centers on a cluster of men and women who are kneeling or falling to their knees in poses of extreme grief, fear, and supplication. They are hiding their eyes, or their eyes are closed, bracing themselves against the onslaught of bullets or attacks from the bayonets that menace from the right side of the page. Goya heightens the sense of immediacy using elements of theater: the scene is illuminated as if by a spotlight that bathes the central figures while casting strong shadows. He gives the impression the print was created quickly in a fury of mark making, but examination reveals layers of tone that could only have been crafted through careful and sequential processes.

Los Disparates

Goya's final print series was issued from etchings made in the last decade of his life. Known as *Los Disparates*, the etched plates were inherited by his son and were completed before the artist left Spain for Bordeaux,

France, in 1824, in a sort of self-imposed exile. The etchings' subjects have been attributed to Spanish folk-sayings and were originally published with the title *Los Proverbios* (*The Proverbs*), but inscriptions on drawings and sketches indicate that Goya thought of the images as representing *disparates*, or follies. Exactly what Goya intended to say again remains unclear, and likely intentionally so. Throughout his *Proverbios*, Goya explores the theme of flight, often associated with witchcraft and sorcery. The etching "Where There's a Will, There's a Way" (Figure 12.20) depicts a group of figures wearing makeshift wings against a dark sky.

The works esteemed today as Goya's most avant-garde were never displayed publicly. Taciturn and plagued with illness, he did not engender a large following of students in his lifetime as would have been typical for a great master, and at the time of his death, he was primarily known for his portraits and tapestry designs. Yet, after the publication of his etched series in the 1860s, avant-garde artists such as Realist Gustave Courbet (French, 1819–1877) and Impressionist Edouard Manet (French, 1832–1883) (*Chapters 14, 19*) were deeply inspired by his direct and imaginative imagery. Goya's images of war provided a visual vocabulary for later artists who faced atrocity: Pablo Picasso (Spanish, 1881–1973) paid homage to Goya's *The Third of May, 1808* in his painting *Guernica*; and Expressionist Otto Dix (*see Chapter 21*) referenced Goya's *Desastres de la Guerra* in *Der Krieg* (*War*), his 1924 indictment of the horrors of World War I.

Conclusion

For some artists of this period, the rigorous study and exploration of print media were used to expand the thematic boundaries of publication, whereas for others their experimentation with print processes was tied to a desire to push the expressive boundaries of art itself as Europe moved from the Neoclassical to the Romantic period. Callot's improvements in technique and materials allowed for expanded tonality and detail in a full range of artistic subjects from entertainment to critical historical

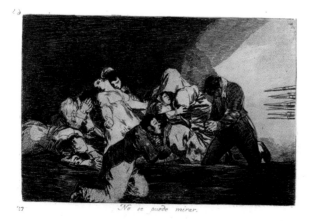

Figure 12.19
Francisco de Goya, "No se puede mirar" ("One Can't Look"), from series *The Disasters of War*, 1810–1820. Etching, drypoint, and lavis, 5 ⁵/₈ × 8 ⁵/₁₆" (plate). Goya conveys the realities of war by focusing not on individual heroism but rather senseless acts of violence and the terror felt by the victims. The cropping of the composition and the spare details transform the viewer of the print into a witness, forced to experience the emotional weight of the drama while remaining powerless to identify (and thus take action against) the perpetrators of the crime.
Gift of Mrs. Gustav Radeke, RISD Museum, Providence.

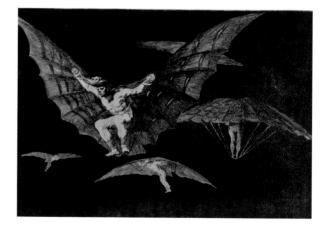

Figure 12.20
Francisco de Goya, "Where There's a Will, There's a Way," from series *The Proverbs*, ca. 1820. Etching, aquatint, and drypoint, 9 ⁵/₈ × 13 ⁷/₈" (plate). The winged figures recall the owls and bats that plague the sleeping author in "The Sleep of Reason" (Figure 12.17). Goya creates a densely black sky as a backdrop for the nightmarish figures that fly into the void. Here, the make-shift wings also recall the myth of Icarus.
RISD Museum, Providence.

Theme Box 24: Aquatint
by Hope Saska

Aquatint is a form of intaglio (*see Chapter 2, Theme Box 6, "Intaglio Printing"*) in which the entire plate is covered with a fine powdered resin ground rather than a solid semi-liquid coating. The resin, when heated, adheres to the copper plate in a granular formation so that, when etched, the acid bites around the grains, creating tiny recesses in the plate surface to hold ink. By selectively applying resists (on top of the aquatint resin) to prevent the acid from reaching parts of the surface of the plate, the artist controls the tonal range to create the shadows and highlights of the composition. The dark tones are the result of the plate having been exposed to the acid bath the longest, creating a deeply bitten and uniform texture. When the range of tones is largely established, the plate will be coated in a standard solid ground, and the artist draws the linear marks freely with a scribe. Those lines are then etched to the depth desired. Finally, after all grounds are removed, a burnisher is used to further modulate texture on the plate by smoothing the tonal textures. Where the plate is highly burnished, it does not hold ink, leaving it bright white when printed. Artists such as Goya frequently engraved directly into the plate as well, after multiple etching or aquatint procedures.

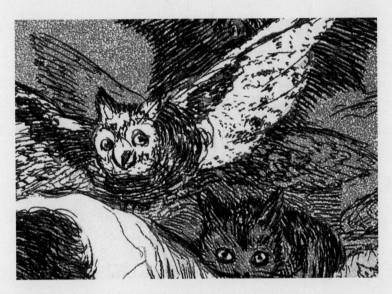

Figure TB24.1
Francisco de Goya, *The Sleep of Reason Produces Monsters* (detail view), Plate 43 of *Los Caprichos*, 1799. Etching, aquatint, drypoint, and burin.
Courtesy of The Metropolitan Museum of Art.

commentary. Diderot and D'Alembert are exemplars of the Enlightenment pursuit and codification of knowledge. They mobilized print to promote democratic notions of shared knowledge across social classes, while the work of Bosse and Nantueil shows how cataloging productions could be directed toward reinforcing the stratification of society.

In Piranesi, we find an artist who combines a scholarly interest in historical subject matter with a desire to experiment with materials and compositions. In his works, he moves with facility between traditional, albeit somewhat theatrical representations of architecture, to their reinterpretation along purely imaginative and narrative lines of invention. Finally, Blake and Goya assert the artist's role in representing not the rational, but the individual and the imaginary. Not acting as chroniclers of their age yet expressing it all the same, the artists sought to record the antiheroic and the fantastic by expressing the complex, fraught nature of history. Both would impact future generations of artists with their mastery of formal technique in the expression of an emotive visual language. Blake's invention of relief etching and Goya's exploration of the tonal qualities of etching enabled each to forge a highly idiosyncratic vocabulary that melded knowledge of artistic tradition with personal vision.

FURTHER READING

Bechtel, Edwin, *Jacques Callot* (New York: George Braziller, 1955).

Bindman, David, *Hogarth and His Times: Serious Comedy* (Berkeley: University of California Press, 1998).

Damon, S. Foster, *A Blake Dictionary: The Ideas and Symbols of William Blake* (Hanover, NH: Dartmouth College Press, 2013).

Erdman, David V., *Blake Prophet Against Empire* (Princeton, NJ: Princeton University Press, 1977).

Goldstein, Carl, *Print Culture in Early Modern France: Abraham Bosse and the Purposes of Print* (New York: Cambridge University Press, 2012).

Rosand, David, *Graphic Evolutions: The Print Series of Francisco Goya* (New York: Columbia University Press, 1989).

Tomlinson, Janis, *Francisco Goya y Lucientes: 1746–1828* (London: Phaidon Press, 1994).

Tomlinson, Janis A., Stephanie Stepanek, and Frederick Ilchman, *Goya: Order and Disorder* (Boston: MFA Publications, Museum of Fine Arts, 2014).

Wolfe, Reva, *Goya and the Satirical Print in England and on the Continent, 1730–1850* (Boston: Godine, 1991).

KEY TERMS

affect	history painting
aquatint	Neoclassicism
bibliophile	neuroaesthetics
commedia dell'arte	relief etching
échoppe	Romanticism
foul biting	synesthesia
genius	visual music
gesamtkunstwerk	wabi-sabi
Grand Tour	

13

Illustration on British and North American Printed Ephemera, 1800–1910

Graham Hudson

As the artisan and middle classes grew in both Britain and America through the nineteenth century, a corresponding increase also occurred in the production of goods and services. Mid-century brought London's Great Exhibition of 1851 and the New York Exhibition of the Industry of All Nations in 1853, with other international trade fairs soon to follow. Each came with illustrated catalogs, flyers, and other ephemera, thus familiarizing man, woman, and child with the goods of enterprise and creating an urge to purchase. Further encouragement came from the department stores with their tempting displays of goods both practical and artistic. In the printing industry, advancing technology speeded production, and the printed image now burgeoned into full color. Culturally, there was for a time a coalescence of art and commerce when works of fine art were adapted to the purposes of advertising, but this would be but a brief dalliance. All these and other social and industrial changes were to leave their record in the printed ephemera of the times.

Literature of the Streets

As cities increased in size, the middle classes moved into the greener suburbs, leaving the old urban centers to manual workers who were now crowding into the factories and sweat shops, and for the latter the benefits were few. In London as late as 1863, many thousands were still too poor to buy good books, and many of them could not even read. "And yet," a journalist of the time reported, "these people have a literature, such as it is, which affords them no slight gratification." What he was referring to was a street literature of penny **ballad sheets** and sensational broadsides reporting on crimes and other notorious events. With similar social conditions prevailing across the Atlantic, the same quality of literature was circulating in America also.

The printing of American ephemera was to be strongly influenced by British practice until the 1860s. Thus, for example, in both appearance and content, the ballads purchased in Boston in 1813 by the Worcester, Massachusetts publisher Isaiah Thomas (1749–1831) are little different from those then being printed in Britain. In fact, many thousands of British-printed ballad sheets were imported into America. Songs were printed without music, and in both countries, to know the tune, the purchaser had to listen to the ballad seller, who sang what he or she sold, fitting the words to whichever popular air best suited the current song.

The illustrations on ballad sheets were not specially commissioned but chosen virtually at random from whatever old and often battered cuts the printer had at hand. For instance, the **cut** (short for woodcut) illustrating the ballad sheet in Figure 13.1 is a competent enough piece of work but bears no relationship to any of the three songs. In the words of the ballad below it, the girl's lover "welcome[s] the lass wi' the bonny blue e'en" and *his* feelings are returned, but the man in the cut is clearly *forcing* his attentions on the girl, and she equally is repulsed by him. Neither does it suit "When

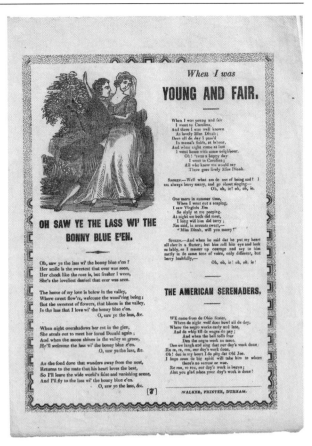

Figure 13.1
Ballad sheet, Durham, UK, ca. 1850. Woodcut, 10 × 7 ¹/₂". Typically, the stock woodcut did not illustrate the ballads, as in this example in which the aggression and repulsion depicted are at odds with the mutual affections expressed in the lyrics of "Oh saw ye the Lass."

I was young and fair," which is a jolly minstrel ditty; nor "The American Serenaders," which is blatantly a plantation song. The inclusion of the latter two ballads is additionally interesting in showing how American culture was influencing the British at this time.

In 1833, the nonprofit Society for the Diffusion of Useful Knowledge introduced the *Penny Magazine*, with its eight pages of well-illustrated articles on wildlife, geography, history, and general knowledge directed primarily at the uneducated masses. Among those aspiring to better things and readers to whom a penny was of no consequence, the magazine achieved excellent sales; but for its intended market, it proved of little interest. The tastes of the poor and uneducated (for whom newspapers and commercially published magazines were too expensive) were better met by the broadside. The content here, however, was largely limited to the sensational—monstrous births, robberies, trials, executions, and so on. Mostly, they were published as one-offs, but occasionally, as with long murder trials, they came out in series, each new printing carrying fresh revelations. Broadsides were peddled by the **flying stationer** with his cry of (typically) "'Ere yer 'ave it, ladies *and* gentlemen, just parinted and publish'd—a full, true, and partick-ler account of the dr-r-edful ghost which hap-peared last night in the Hedgware Road . . .", after which he would read a few choice lines to get the audience eager to buy, sell his wares, and then scurry off to sell again elsewhere. The best sellers were execution broadsides, which, printed well *before* the hanging, went on sale immediately after the condemned man had dropped.

Theme Box 25: Further Improvements in Printing
by Brian M. Kane and Graham Hudson

Iron Presses
In the first few years of the nineteenth century, inventor and politician Charles, Third Earl of Stanhope (1753–1816), revolutionized printing by creating the Stanhope Press. This new press, which consisted of a massive cast-iron frame formed in one piece, mechanized the print industry by separating out the spindle and the bar and adding a series of compound levers to augment the power of the screw, thus enabling a larger sheet of paper to be impressed than was previously possible on wooden presses. Stanhope never patented the designs for his press but instead made them as widely available as possible. This act of generosity made it possible for newspapers to purchase presses at a substantially lower cost. Printing at up to 250 pages per hour, this new press now made it possible for publishers to increase their circulation considerably.

Other iron presses followed, all utilizing some form of mechanical advantage. Among them was the Colombian of 1813 (introduced into Britain in 1817), invented by Philadelphian George Clymer, and Richard Cope's Albion Press of 1820 in London. There were several others, the most celebrated American press being Samuel Rust's Washington, patented in 1821. Its iron frame could be dismantled into smaller parts for transportation—a major selling point in times of westward expansion.

Jobbing Presses
On the jobbing-platen press, developed in England and the United States by several people independently between 1820 and 1850, the action was continuous. The forme (iron frame holding the type, and illustrations) and platen (pressure plate) came together to make the print and then swung apart, allowing the pressman to remove the printed sheet and insert the next blank before the forme and platen came together again. Inking rollers passed over the type during the moments while the forme and platen were separated. Such presses were particularly adapted to the needs of the jobbing printer, affording the pressman accurate control of **registration** (ensuring multiple impressions onto the same print land correctly placed), thereby enabling work in several different colors to be printed. The name most closely associated with the jobbing platen is that of New Yorker George Gordon (1810–1878) whose first patent was granted in 1851. Around 1858, Gordon introduced the Franklin jobber, which was shown in 1862 at the London International Exhibition and subsequently manufactured in Britain. The earliest jobbing platens were treadle-operated; the later ones were powered by steam and later, electricity.

Automated Presses
In 1810, Walter Koenig, a German printer living in London, obtained a patent for the first steam-powered printing press that could print up to 400 pages per hour. In 1814, John Walter II, son of *London Times* founder and the paper's editor, commissioned Koenig to construct two double-cylinder steam-powered presses that could print up to 1,100 pages per hour. In 1815, William Cowper wrapped curved stereotype plates (*see Theme Box 26*) around rollers on a steam-powered press. This rotary printing press could print

Thomas Coombs was executed in 1824 (Figure 13.2). The reason for the blank spaces either side of the single hanged man in the woodcut is to accommodate imagery appropriate to a multiple execution. The printing block would have a squared hole cut through it, allowing for the insertion of up to four more cuts similar to the one used here. Coombs was executed on Pennenden Heath in Kent, UK, and one wonders if any of the crowd noticed that the execution depicted is actually set outside Newgate Jail in London.

Bearing in mind the nature of their market, the amount of text that ballads and broadsides typically contain is surprising. The Coombs broadside runs to over 900 words. One suspects that it was not only the poor who purchased such literature but also those higher up the social ladder, because ladies in carriages are certainly known to have stopped their horses to purchase the more sensational ballads.

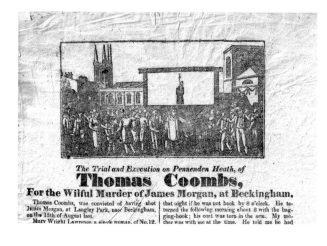

Figure 13.2
Charles Piggot, execution broadside, London, UK, 1824. Woodcut, 14 1/4 × 9 1/2".
The woodcut has a slot sufficient for the insertion of up to five little hanging-man cuts but here shows only one figure.

up to 1,200 sheets on both sides, or 2,400 pages per hour. Then in 1828, Claude Genoux (French, 1811–1874) perfected stereotypes (*see Theme Box 26*) for rotary printing by creating a papier-mâché mold, called a flong, instead of the less precise plaster molds, thus making it possible to print 4,000 sheets on both sides per hour.

Innovations in Paper, Papermaking, and Binding

Italian printer Aldus Manutius the Elder (ca. 1449–1515) invented the pocket-sized octavo book format so that gentlemen of leisure could easily carry them. A standard sheet of paper was folded three times to create eight pages, or "leaves," hence the name **octavo** (oct = eight). The pages were printed on both sides, creating a sixteen-page **signature**, or set of nested pages to be sewn together with other signatures to form a book. The octavo format has remained the standard in publishing and was adopted by the inventors of the first illustrated newspapers. The final page size is dependent on the original sheet

size. During Thomas Bewick's time, the standard size for most books was either a "foolscap" octavo (6 ¾ × 4 ¼") or a "crown" octavo (7 ½ × 5"). Other format sizes are "quarto" (folded twice, four leaves per side, eight pages per sheet) and "folio" (each sheet is folded only once to create two leaves, or four pages).

Before 1800, papermaking was a slow and laborious task. From 1804 to 1806, Henry and Sealy Fourdrinier invented a papermaking machine that could make continuous rolls of paper. The Fourdrinier machine used a **slurry** of fibrous wood pulp and vegetable matter to be formed, pressed, and dried into a continuous bolt of paper. Recycling was nothing new in the early manufacturing of paper: in addition to old newspapers and letters, many mills collected rags, old sails, worn-out sacks, and rope that could be shredded and repurposed into new paper. For the next fifty years, new advancements in steam-powered paper processing occurred annually on both sides of the Atlantic. By the time the first issue of the *Illustrated London News* went to press in 1842, there were

an estimated 700 paper mills in England and almost 200 in the United States. As the nineteenth century progressed, paper used in everyday print changed from high rag content (based on linen and cotton) to high pulp content (based on softwood pulp). Unfortunately, wood-pulp paper contains much acid, which causes the paper to yellow and disintegrate, putting much nineteenth- and twentieth-century printed matter in jeopardy while more antique paper is still robust.

Further Reading

Jury, David, *Graphic Design Before Graphic Designers: The Printer as Designer and Craftsman: 1700–1914* (London: Thames & Hudson, 2012).

Rummonds, Richard-Gabriel, *Nineteenth-Century Printing Practices and the Iron Handpress* (New Castle, DE: Oak Knoll Press, 2004).

Steinberg, S. H., and Beatrice Warde, *Five Hundred Years of Printing* (New York: Criterion Books, 1959).

A Double Playbill

Playbills had two functions. Sold to the queuing audience, they served as theater programs but were also pasted up on vacant walls around the venue to work as posters for the show. In both cases, the playbills' textual witticisms and detailed scene descriptions meant that they too were an everyday part of street literature. Those who hawked playbills earned no more than a scant income, for the really poor might purchase only a single bill between three or four of them. The price was a penny for the more common single-column bill, but a double bill (Figure 13.3) would have cost double. Folding down the center (and the fact that the house lights stayed on) facilitated reading during performance. Some printers specialized in the work, among them the Ledger Job Printing Office of Philadelphia and E. J. Bath of London. Both firms had extensive ranges of **stereotyped** wood engravings (*see Theme Box 26, "Mass Production Plates and Printing Forms"*), illustrating the

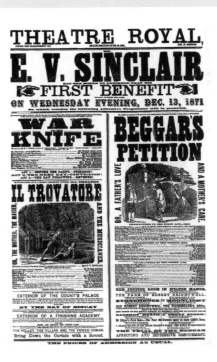

Figure 13.3 Playbill, Birmingham, UK, 1871. Letterpress, 19 ¾ × 15". Posted in the streets around the theater, the textual witticisms, imagery, and scene descriptions in playbills such as this were themselves a contribution to street literature. The illustrations also afford us clues as to how these melodramas were originally staged.

Theme Box 26: Mass Production of Plates and Printing Formes
by Graham Hudson and Brian M. Kane

Stereotypes and Electrotypes

Also known as glytotypes, stereotypes and electrotypes were processes enabling facsimiles of type formes, wood engravings, and line and halftone process engravings to be made. They had two advantages: first, printing from a "stereo" or "electro" avoided damage to the original, enabling it to be replicated again if necessary. Second, copying entire formes of type meant that a job could be printed simultaneously on more than one press.

Stereotyping entailed making a mold of the original typesetting and engravings, from which a printing plate was cast and then mounted on to a block to make it **type-high**. The process was introduced in the 1820s, plaster of Paris being superseded by papier mâché in the 1830s.

Electrotyping was invented in 1839. Here, the mold was made in a shallow brass pan called a case that was partially filled with liquified beeswax. A thin coating of black lead was applied over the top of the beeswax to give it a metallic surface. The wood engraving or letterpress plate was then pressed down under great pressure into the case, producing a perfect mold of the original. The mold was given another coating of black lead and connected to the positive pole of a battery by means of a cable. The case was then submerged into a water-filled tank containing a solution of copper sulphate, along with a sheet of copper that was connected to the negative pole of the battery. The resulting galvanic discharge caused particles from the copper sheet to migrate and form a thin film of copper on the black lead. Within an hour, the copper film on the mold accumulated to about the thickness of a heavy sheet of paper. After the fragile copper impression was removed from the beeswax mold, the back of it was covered with tin foil, which was heated until it melted and coated the surface. After the mold cooled, melted type-metal was poured into the back of the mold, thus making the resulting plate strong enough to withstand the multiple impressions of the presses. The intermediate step utilizing the tin foil was necessary, since copper and type-metal will not adhere to one another, but both will affix to tin. The resulting plate was a precise copy, and identical electrotypes of the same page could easily be made from the original block for use on multiple printing presses running at the same time.

Stock Cuts

Stereotypes or electrotypes of general-purpose imagery such as cattle, bald eagles, flags, masonic emblems, train engines, and so forth were called **stock cuts** (*cut* became a generic term for any illustration or the plate used to print it). Most jobbing letterpress printers would stock a selection of cuts for customers to choose from, the advantage being that an element of illustration could be included in a job without additional cost for origination.

Siderography

Invented by the Philadelphian Jacob Perkins (1766–1849), siderography is a method of duplicating engraved steel printing plates. Perkins introduced the system into Britain in 1819 and subsequently opened a factory there for the engraving and printing of private banknotes, stock certificates, and other high-quality documents where protection from forgery is essential. An intricate engraving is first made in steel, which is then case-hardened. The hardened plate is then passed back and forth beneath a soft-steel roller (also called a cylinder die), the successive passes thereby creating a relief image of the design on the softer roller surface. Following this, the roller is case-hardened and then used to create duplicates of the original engraved plate. It is these duplicate plates that are used for printing, the original and the roller being retained for further use if necessary. Firms specializing in siderography would keep a stock of vignettes, emblems, commonly used wording, and other imagery that might be used to meet future customers' needs where applicable.

Reducing/Enlarging Machines

Apparatus for reducing or enlarging lithographic images was introduced in the latter part of the nineteenth century, enabling the printing of both monochrome and chromolithographic imagery with extremely fine detail. The image was drawn on stone in the usual way and then printed onto an India-rubber sheet held in tension in an adjustable metal frame. The tension was then evenly released all around, allowing the rubber to contract and thereby reduce the image to the desired size. The image was then transferred from the rubber to the stone from which the job would actually be printed. A similar but reverse procedure was used for enlarging.

Further Reading

Wilson, Frederick John Farlow, and Grey, Douglas, *A Practical Treatise upon the Modern Printing Machinery and Letterpress Printing* (London; New York: Cassell & Co., 1888).

most popular dramas. Such images are invaluable to the theater historian because they can contain evidence of the scenery of actual productions. In Figure 13.3, the staircase on the left in the engraving for "Il Trovatore" (left bottom) appears stout enough for the actors actually to use it, but the perspective of the receding wall in the background is wrong, suggesting that it was painted on a backcloth. Similar points could be made about the illustration for "The Beggar's Petition" (right top), which is also noticeably cruder in execution and likely to be by a different hand. The "Il Trovatore" cut is signed "McCall," but this signature is more likely to indicate the wood-engraving firm than the individual engraver. The majority of playbills were printed *without* illustrations, however, because the words describing the action and successive scenes were the main concern of those thinking of seeing the play.

Art for Commerce

The increase in manufactured goods also brought changes in the design of printed matter. Manufacturers and shopkeepers now sought to promote their businesses by including pictures of their factories and shops in the design of their headings, or showing the goods produced or sold, in which case the billhead also served as a sort of sample catalog.

It was in the years following the Great Exhibition (1851) that the full-scale illustrated catalog came into wide production. It is very likely that Smith & Byram, proprietors of the Waterman Kitchen Store (Figure 13.4), produced their own catalog accurately depicting the goods they could supply. Their billhead, however, is illustrated with a printer's stock cuts and is thus generic rather than specific, indicating that the firm could supply a wide *range* of hardware though not necessarily the identical things depicted. Even so, these cuts do have the look of particular items (note the patent ice chest and oil lamp and birdcage next to it), suggesting they were copied from larger engravings.

The heading employed by Simpson, Fawcett of Leeds, UK (Figure 13.5) also has a catalog function, but here the product images are specific rather than generic. We can tell this from their being captioned with their model names—Hammock Woodenette and Royal Mail Cart. "Hammock" derives from the way in which the wooden cot was supported by the single large C spring, while "Royal" implies an unlikely link with the British royal family. The baby cart is rather formally illustrated, showing its appearance and how it is constructed. Contrast this with the mail cart, where the ease with which it can be drawn along is shown by the boy running between the shafts. Incorporated in this heading is a view of the firm's factory, the ultra-fine detail showing that this and the other images were engraved on lithographic stone at larger scale and then mechanically reduced with a **reducing/enlarging machine**, which used stretchable rubber to transfer the image (*see Theme Box 26*).

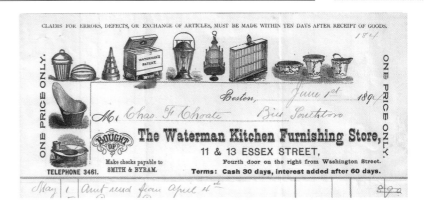

Figure 13.4
Anonymous, Billhead for Smith & Byram, 1890s. Letterpress, 7 × 8 ¹/₂".
Printed from stock cuts chosen from a type-founder's catalog, the wood-engraved hardware pictured on this billhead represents the *range* of goods that the firm could supply rather than specific items.

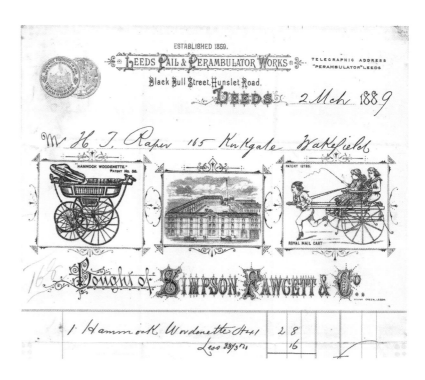

Figure 13.5
Julian Green, billhead for Simpson, Fawcett & Co., Leeds, UK, ca. 1880. Lithograph, 8 ¹/₈" (width).
The inclusion of the model names "Hammock Woodenette" and "Royal Mail Cart" shows that these were specific items, the central image picturing the factory from which they could be ordered. The medal at upper left indicates that the firm showed its wares at the 1875 Yorkshire Exhibition of Arts & Manufactures.

Stationery for the Tourist

The introduction of the Penny Post in Britain in 1840 and the reduction of postal rates in America in 1851 encouraged people to write more letters at the same time that the expanding railroad systems of both countries encouraged travel. The result was the growth of tourism. The new tourists had plenty to write home about, and when they did, it was largely on sheets of illustrated writing paper headed with views of castles, exhibition buildings, local landscapes, and other subjects. The majority of images were steel engravings, in some cases with color

added from wood blocks or by hand coloring. The smaller illustrations often found a secondary use decorating the lids of trinket boxes and other items, or were reprinted in booklets of views or simply as small souvenir cards—the latter the precursors of the picture postcard.

Among the many attractions of Tunbridge Wells, Kent, UK, is the Toad Rock. The two sizes of writing paper depicting the Rock in Figure 13.6 show the fidelity with which a Victorian trade engraver could translate from one scale to another, as was necessary when a popular subject needed adaptation to the smaller format. Different operatives would be involved: one tradesman sketching the chosen scenes and the other pretty well confined to the workshop engraving the printing plates. As the latter might never actually *see* the subjects he was engraving, errors could creep in. Here, the neck of the Rock is far too narrow, and the large flat rock on which two men are standing is wholly imaginary, as the visitor can see today. The scattered groups in each engraving constitute **staffage**—incidental figures chiefly included to populate and give scale to a landscape. Here, their formal attire represents the dress that even "holiday-makers" (vacationers) adopted in the period.

In contrast, "A case of real distress" shown in Figure 13.7 is a comic writing paper, one of a series featuring seaside incidents. This too is a steel engraving, though with stronger line work and bolder mark making than employed in "Toad Rock" (and in both cases the treatment chosen is well suited to the subject). Here, the two girls are the focus of the illustration.

Immersed in reading, they have remained unaware of the creeping tide, and one girl frantically signals to their father approaching in a rescue boat. A significant difference between this illustration and those of "Toad Rock" (Figure 13.6) is that here only one creative hand was involved, the artist being his own engraver. Although this image is unsigned, the style of drawing suggests the artist was Thomas Onwyn (fl. 1830–1850).

Plain postcards were introduced in Britain in 1870 and in America in 1872 as a cheaper alternative to the more formal letter and envelope. In the 1890s, it became permissible for a small picture to be included on the writing side, the first such American cards being published in 1893 to celebrate the World's Columbian Exposition held in Chicago. The true picture postcard with a picture covering all of one side, with writing and address confined to the back, was introduced in Britain in 1902 and in the United States and Canada at about the same time.

British commercial artist Tom Browne's (1870–1910) cartoons appeared in *Punch*, *The Tatler*, and other periodicals. In one example of his bold cartoon style, the postcard in Figure 13.8 reflects the social order around the turn of the twentieth century, where the street urchins and well-heeled children gathered at the sweet shop window represent society's extremes briefly brought together by their common love of chocolate. In 1908, Browne went on to originate the striding, monocled figure advertising Johnnie Walker Whisky, still in use today.

Multiplying the Image

The earlier discussion of "Toad Rock" showed how an image could be duplicated by simple copying. Another example would be the blocks cut by Alexander Anderson

Figure 13.6
Newman & Co., decorated writing paper, ca. 1850. Etching with steel engraving, 7 ³/₈" (width, large sheet).
The two sizes of vignette on these illustrated writing papers show the fidelity with which an engraver could copy from one scale to another. Completed at the etching state (that is, without additional hand engraving), the delicate treatment appears well suited to this landscape subject.

Figure 13.7
Thomas Onwyn (attributed), comic writing paper, Newman & Co, ca. 1850. Steel engraving, 4 ¹/₂" (width).
Completed at the etching state, the drawing shows a bolder treatment than Figure 13.6. Normally, these girls would be wearing crinolines, but in the more relaxed setting of the seaside, they have chosen to go without them.

(1775–1870) for an American edition of engraver-illustrator Thomas Bewick's (English, 1753–1828) *A General History of Quadrupeds* (1790), in which Anderson copied the illustrations line-by-line from Bewick's originals. Engravers might also modify existing images when needed, as with the London wood-engraving firm J. & R. M. Wood, which in the 1860s produced many printers' stock cuts copied from American originals, mostly with changes in costume and detail to suit the British market.

Another method of duplication applicable to intaglio printing was **siderography** by which steel-engraved plates could be exactly replicated (*see Theme Box 26*). Those who issued banknotes, stock-share certificates, and similar material sought safety from forgery in finely engraved imagery and lettering. Many such designs would be applicable to a variety of clients' needs, so security printers stored these images as **cylinder dies** (cylindrical masters from which duplicate plates could be made) pending future use. Thus, the same patch of fancy lettering or vignette illustration, the latter perhaps transformed in various ways, could appear on the papers of different firms.

The woman with sickle and sheaf (personifying Agriculture) shown in each of the three vignettes from American private banknotes in Figure 13.9a, b, c) probably originated as an engraving without a background. The client for the first of the three (Figure 13.9a) was the Bank of Milford, Delaware, and it was this client that would have chosen to have field, church, and cottage added to its plate. The same woman appears again in the second vignette (Figure 13.9b), engraved for the Union Bank of

Kinderhook, New York, this time joined by another lady, whose pose suggests they are conversing. The same two women make a further appearance on the third vignette (Figure 13.9c), taken from a note issued by the Bank of the Republic, Washington, DC, but with the standing figure now presented as an idealized indigenous American.

Those who worked in the engraving studio of a security printer tended to specialize in particular areas such as lettering, vignettes, or portraits of well-known people—the

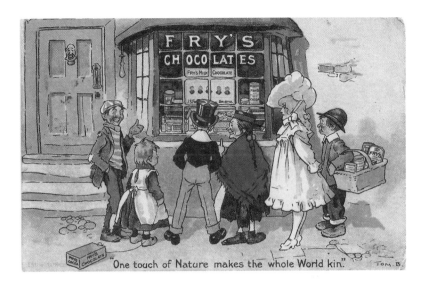

Figure 13.8
Tom Browne, "One touch of Nature makes the whole World kin," advertising picture postcard, J. S. Fry & Sons Ltd, ca. 1910. Chromolithograph, 3 $^1/_2$ × 5 $^1/_2$".
The world here is exemplified by street urchins and the better off—the polarity of the social order—brought together by a common love of chocolate.

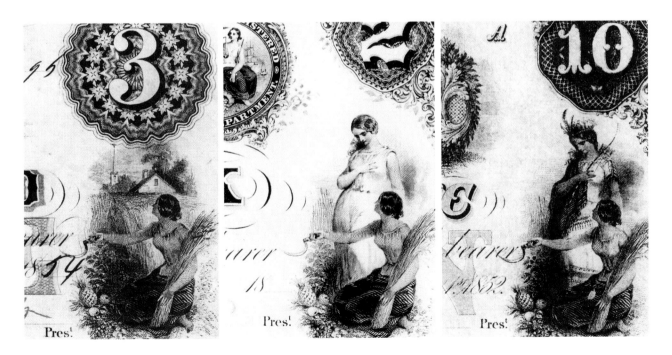

Figure 13.9a, b, c
Banknotes (detail), 1850s. Siderographic steel engravings. Adapted from the late Richard G. Doty's "Surviving images, forgotten peoples: Native Americans, women, and African Americans on United States obsolete banknotes," in Virginia Hewitt (ed.), *The Banker's Art: Studies in Paper Money* (British Museum Press, 1995): pp. 127, 129.
The same woman (emblematic of agriculture) is shown in vignettes taken from three different private banknotes. It is possible that the pineapple lying by the sitting woman's knee was introduced through its associations with hospitality in American culture. If so, then it is a touch of artistic licence, since pineapple cultivation demanded a far warmer situation than would be found in this open field.
By permission of British Museum Company.

Theme Box 27: Benjamin: Aura, Mass Reproduction, and Translation
by Sheena Calvert

Walter Benjamin (German, 1892–1940) was a philosopher, cultural critic, and political thinker who amassed and studied collections of ephemera. His classic essay "The Work of Art in the Age of Its Technological Reproducibility" (1935–1939) responds to the burgeoning of new mass reproduction in the late nineteenth and early twentieth centuries, by considering how an original work of art (or, by extension, an illustration) loses its authenticity and value when it is reproduced.

Since the technology of reproduction affects the structure and therefore the reception of an image, Benjamin suggests that photo-based print technology (such as halftone and rotogravure) diminishes the **aura** of the original work of art. The aura is the traditional physical and spiritual impact of the artwork's specialness, what Benjamin describes as "its presence in time and space, its unique existence at the place where it happens to be." We only experience this feeling in person, as an "apparition of a distance" from the art object. A photo-mechanically produced bookplate might replicate a painting, but the plate (arguably) cannot capture the original painting's essence or authentic identity, this distance—its aura.

The relevance of Benjamin's thesis to illustration is in its reminder that while most illustration is intended to be reproduced (rather than existing as artwork in a gallery setting), we need to be mindful of the effects of reproduction and other imaging technologies on our experience of the work. We become spectators who no longer have the personal relationship to images that we once had—while images become politicized, because the media they appear in (such as newspapers) determine through context, caption, and format how we are supposed to understand them.

This detachment from direct relationships and replacement with dictated ones is, for Benjamin, one of the defining characteristics of twentieth-century life, where modernity, capitalism, and our experience of artworks are intimately and dangerously entwined. We can see the extension of his ideas in the contemporary world, through our engagement with Google images and Instagram, which discourage experiences in person in favor of heavily mediated images of them (see Chapter 24, Theme Box 46, "McLuhan: Media Theory").

Benjamin wants to suggest that this diminishment of the "true" meaning of a work of art is an inevitable outcome of capitalism. As a Marxist, he was interested in exposing the ways in which capitalist production of imagery alienates us from authentic experience, a theme that the Situationists of the 1960s (Guy Debord, Raoul Vaneigem, and other Marxist intellectuals interested in avant-garde art) later explored in relation to visuality in texts such as Debord's "The Society of the Spectacle" (1962).

Yet Benjamin's purpose was not to mourn the loss of aura, but to argue that reproducibility, by shattering tradition, may also cathartically herald a "renewal of humanity." Specifically, he proposed that film, if controlled by individuals rather than capitalists, would bring about the liberation of society from oppressive class systems. The reason was that film's command of attention and special forms of showing (in slow motion, or viscerally, or subliminally, for example) had the potential to change perception and reveal truth on a mass scale.

How do we experience the unique, physical original objects of illustration and craft versus screen-based, digital, ephemeral, and intangible forms? Design theorist and historian Johanna Drucker extends Benjamin's theories into the twenty-first century, interrogating the ontological status (meaning, the "being" in the world, the presence or "realness") of digital images, and their relationships to the code they are made of and to the material world they represent. For Drucker, the assumed exactness of mathematical code should not be equated with capturing the "truth" of the thing the code renders, since what images represent cannot ever be limited to code, which she proposes is essentially a totalitarian language of information, not meaning.

Another important critical framework Benjamin provides for illustration practice is that of translation. The imperfect, contingent nature of translation is something illustrators encounter when moving from text to image, or from medium to medium, and back again. To translate means never to assume that the product of translation will be point-for-point the same as the source. As in translating a language, something is always lost—but something is frequently gained, too. Embracing this movement, then, may be creatively productive. Moreover, such a process resists the totalizing forces of aesthetic systems such as Kant's theory of a "correct" aesthetic of beauty perceptible only by the disinterested judgment of a qualified individual (see Chapter 1, Theme Box 1, "Giving Illustrators a Voice," and Chapter 12, Theme Box 22, "Kant: Objective Aesthetic Judgment"). Illustrators may therefore be seen as cross-cultural translators in Benjamin's sense—searching out new forms of meaning in the cultural landscape as they travel from text to image and back again, from the world "out there," to its expression in the image; and from the interior world of the individual imagination to public presentation. This gives illustration a special role, one in which translation is an inexact but very human process.

Further Reading
Benjamin, Walter, The Work of Art in the Age of Its Mechanical Reproducibility and Other Writings on Media, edited by Michael W. Jennings et al., translated by Edmund Jephcott et al. (Cambridge, MA: Belknap Press of Harvard University Press, 2008).

Debord, Guy, Society of the Spectacle (Exeter: Rebel Press, 1987).

Drucker, Johanna, "Digital Ontologies: The Ideality of Form in/and Code Storage: Or: Can Graphesis Challenge Mathesis?" Leonardo, vol. 34, no. 2, 2001: 141–145.

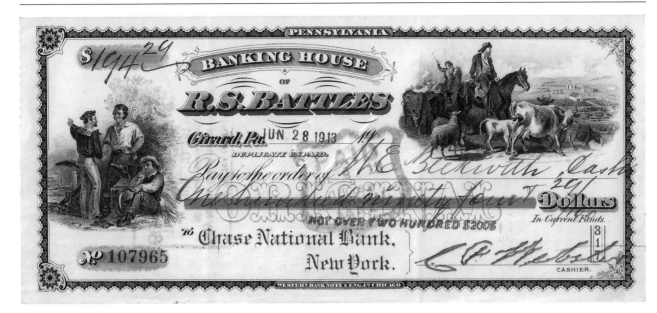

Figure 13.10
Anonymous, check
drawn on the pri-
vate bank of R. S.
Battles of Girard,
Pennsylvania,
Western Bank
Note & Engraving
Co., ca. 1875. Steel
engraving with
siderographs, 3 7/8
× 8 3/4".
The design
includes vignettes
emblematic of
trade, manufacture,
agriculture, and the
meat industry. The
rubber stamp indi-
cates continuing
use into the twenti-
eth century.

latter calling for the greatest skill since a poor likeness would
be easily noticed. In the preparation of the R. S. Battles bank
check in Figure 13.10, the design would have originated
largely as a paste-up utilizing proofs from Western Bank
Note's stock of imagery, the chosen letterings and vignettes
being impressed into a steel printing plate from the
respective dies following approval by the banking house.

The two vignettes are emblematic of the
foundations of American commerce. On the left, a
sailor speaks to a blacksmith, symbol of iron and steel,
the sailor's pointing hand showing that he speaks of
distant voyages; beside them the farmer rests from his
labors, sickle in hand, while behind them a sailing ship
comes into port. On the right-hand vignette, a group of
cowboys representing the meat industry bring in a herd
of cattle and sheep, while below them are the stockyards
and a distant departing train.

Ephemera in Color

Hand Coloring

It was during the nineteenth century that cheap and
visually convincing color printing became commercially
viable and that full-color pictures and other imagery,
previously enjoyed only by the privileged, could now be
appreciated by virtually everyone. The most direct means
of producing a color illustration was hand coloring. The
sophisticated colored prints of Currier & Ives, for instance,
were enhanced by a production line of around twelve young
women following a specimen print set up before them.
The girls worked under the supervision of a lady "finisher,"
whose job it was to retouch any prints found wanting.

Vinegar valentines were the opposite of the more
familiar sentimental type and often carried a hint of
malice. One such valentine, shown in Figure 13.11, is an
example of the cheapest colored work, almost certainly
produced by a team of five girls working in sweat-shop
conditions, each in turn adding her allotted color to print
after print. This one, though, appears more comic than
malicious, and would almost certainly have been sent

by one girl to another—hardly by a young man to his
beloved! Ancestor to the modern bicycle, the velocipede
was basically the earlier foot-propelled hobbyhorse now
fitted with simple pedals, which became a craze in Paris
following its appearance at the Paris Exhibition of 1867,
and was soon taken up in America and Britain also. The
Scientific American reported how velocipedes had been
introduced into gymnasiums for ladies "who use the dress
commonly used by them in callisthenic exercise." That
dress was based on the Bloomer Costume advocated by
Mrs. Amelia Bloomer, and thus differed from the more
racy gear sported by the girl on the valentine.

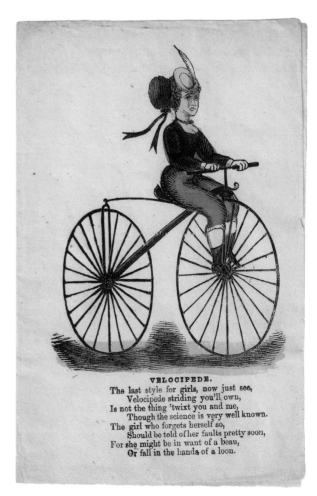

Figure 13.11
Anonymous, comic
valentine, UK,
ca. 1875. Wood
engraving with
hand coloring, 8 1/2
× 5 1/2".
The girl riding the
velocipede is attired
in a manner that
would have been
considered even
racier than the
Bloomer costume
of the period. This
image appears to
be based on an
engraving pub-
lished in the French
periodical *Le
Velocipède Illustré*.

Theme Box 28: George Baxter, Chromoxylography, Photoxylography
by Graham Hudson

The first means of color printing on a commercial scale was patented by the Londoner George Baxter in 1835. A detailed linear drawing was first printed in neutral color from an aquatint- or mezzotint-etched plate (see Chapter 2, Theme Box 6, "Intaglio Printing"; Chapter 10, Theme Box 18, "Mezzotint"; Chapter 12, Theme Box 24, "Aquatint"), and then a series of colors was overprinted from engraved wood blocks. The process entailed between eight and ten impressions and sometimes many more. There is no record of the Baxter process having been used in America though it is thought that Moons & Crosby of Boston may have been Baxter licensees.

As early as 1843, three of Baxter's ex-apprentices, Gregory, Collins, and Reynolds, began printing the base image itself as a fine-line wood engraving, thus evading Baxter's patent, which covered only the intaglio stage. Their process is known as chromoxylography. With both this and Baxter's method, the separation of an artist's original into its constituent colors was similar to that of chromolithography (Theme Box 29, "Chromolithography and Ben-Day Tints").

Credited to Timothy Cole (American, 1852–1931) in the 1870s, photoxylography involved painting the woodblock with a light-sensitive material and then exposing a photo negative onto it to create a tonal positive on the block. The reproductive engraver then engraved the design following the photo image as a guide, which saved time and was more accurate than redrawing the design by hand.

Color Printing

Effective color printing started with the Londoner George Baxter (English, 1804–1867), whose **Baxter process**, a combination of intaglio and letterpress, was patented in 1835 (*see Theme Box 28, "George Baxter, Chromoxylography, Photoxylography"*). Besides a range of small decorative prints, Baxter also produced a number of book illustrations and work such as music covers and needle-box labels, the images being printed separately from the book or ephemera and subsequently pasted in place. In 1849, Baxter's patent was renewed for a further five years but conditional on his licensing the process to other printers, the committee concerned observing that such color prints would be conducive to the moral improvement and good conduct of the working classes.

Foremost among Baxter's licensees was Abraham Le Blond (English, 1819–1894). In an uncut example of one of his sets of ten needle-box labels (Figure 13.12a), all but two of the labels relate to Queen Victoria. These include the Duke of Wellington, Commander-in-Chief of the British Army until his death in 1852; Victoria on horseback; the Crystal Palace of 1851; Victoria's coronation procession en route to Westminster Abbey; Osborne House, the Queen's residence on the Isle of Wight; Balmoral Castle, the royal residence in Scotland; and the Royal Yacht entering Portsmouth Harbor. The odd ones out are those third and fourth down on the right, the first showing a view of Brothers Water in the English Lake District and the other a Venetian scene. Neither of these has connections with Victoria, and it is thought Le Blond included them simply to make up the number necessary for the set.

The label at top right shows the Queen and Prince Albert riding at Balmoral. A larger version of it (Figure 13.12b) is not a label but a miniature print in its own right, one of a set of three that would have been individually mounted on either embossed or gold-lined card suitable for framing. The boy riding ahead is the Prince of Wales, the future Edward VII, while the girl riding behind is the Queen's first child, Princess Victoria, here very much in the background—royal princesses were of minor importance once a male heir had been assured.

As early as 1843, three of Baxter's ex-apprentices found they could evade his patent by dispensing with the intaglio stage and printing entirely from wood blocks. Known as **chromoxylography**, this form of color printing was speedier than the Baxter process and in due course supplanted it (*see Theme Box 29*). Prominent among British chromoxylographers were Leighton Brothers, Benjamin Fawcett, and Edmund Evans, the latter proving especially innovative in publishing children's books (*see Chapter 16*).

American printers made only limited use of chromoxylography, one exception being the production of clipper-ship sailing cards. In addition to advertising a ship's speed or other virtues, these cards also promoted a sense of urgency: phrases such as "will be promptly despatched" or "now rapidly loading" encouraging shippers to make haste lest they miss the boat. Sailing cards were first produced around 1852 and mostly promoted the voyage to California from New York or Boston via Cape Horn.

Donald McKay's *The Great Republic*, launched in Boston in 1853, began as the largest merchant ship in

a

b

Figure 13.12a, b
Le Blond, needle-packet labels, UK, 1850s. Baxter-process prints, 5 ¹/₂ × 4"
(a); 3 ¹/₂ × 4 ³/₈" (b).
This collection, mostly illustrating aspects of the reign of Queen Victoria,
comprises ten labels printed together from one set of blocks (a). After cutting, each label would be pasted on to a separate packet. A larger image (b)
is a print in its own right, intended to be sold on an individual card mount.
The picture repeats a scene shown on one of the labels: the young Prince
of Wales riding with Prince Albert and the Queen while, very much in the
background, Princess Victoria follows behind.

the world but was considerably modified after major
fire damage prior to her maiden voyage. A sailing card
(Figure 13.13) printed by George Nesbitt (1809–1869) of
New York shows the ship rigged as a four-masted barque,
with graphics aptly echoing the patriotism implicit in
her name: the Stars and Stripes and the Cap of Liberty;
oak leaves for strength, and laurel for honor. The words
"Clipper of August, 1858" and "Pier 27 E.R." give an
approximate idea of her expected sailing date and location
on the East River. The claimed "91 days!!" to California is
probably a typographic error because the ship is known to
have made the trip in *92* days in 1856.

The color-printing process par excellence from the
later nineteenth century to well into the twentieth was
chromolithography (color lithography), which was
capable of achieving richer color than chromoxylography
(*see Theme Box 29*). The process began to proliferate in
the 1870s when its technology was well established and
steam-powered printing machines began to be widely
adopted. It was during this period too that American
commerce embraced the colorful trade card as an
advertising medium.

Figure 13.13
George Nesbitt, sailing card, New York, 1858. Chromoxylograph.
Clipper ship sailing card of *The Great Republic*, the design decorated with iconography
of the Union. Text indicates the ship was loading for a voyage around Cape Horn to San
Francisco.
New York Historical Society.

Theme Box 29: Chromolithography and Ben-Day Tints
by Graham Hudson

Color printing by chromolithography was developed in Europe by Godefroy Engelmann, in Britain by Charles Hullmandel, and introduced into America in 1842 by the immigrant William Sharp. To make a chromolithograph, an artist's original was traced as an intricate "keyline" mapping the boundaries between each discernibly different color area. This was then transferred as a nonprinting image on to each of the stones required, and a team of specialist artists then ink-stippled the areas of the stone corresponding to the color each had been allotted. The color stones were then successively overprinted, the microscopic stippling of the colors blending optically to create the illusion of gradients and more colors, just as halftone color separations of the twentieth century did later (*see Chapter 18, Theme Box 37, "Halftone and Rotogravure"*). Sixteen colors might be used even for commercial work, and for fine-art reproductions the number could be considerably more. While early chromos used just a few colors overlapped to create a larger range of hues, very elaborate color methods using many stones were common by the second half of the nineteenth century. The most accomplished chromolithographs, such as those produced by Louis Prang, mimicked color photographs convincingly—before color photography had been invented.

In the 1880s, the laborious process of hand stippling was largely superseded by manufactured tints. Using them, the engraver could transfer a large variety of dot and other textures on to the printing surface, following the illustrator's directions. In 1878, Benjamin Day patented the process in America, and the moniker **ben-day** was given to any applied tonal pattern thereafter.

Further Reading
Marzio, Peter C., *The Democratic Art: Pictures for a 19th-Century America: Chromolithography, 1840–1900* (Boston: D. R. Godine; Fort Worth: Amon Carter Museum of Western Art, 1979).

Figure TB29.1
Louis Prang & Company, "Four Children for Calendar," ca. 1861–1897. Chromolithograph. This ten-color print was designed for a calendar issued between 1861 and 1897. Each of the individual stones would have been drawn by hand and printed in one of the mixed ink colors indicated in the side color bar.

Louis Prang & Company Collection, Boston Public Library.

Compared with the majority of advertising trade cards, one promoting Bixby's Mucilage (a common type of glue in the period) is relatively muted (Figure 13.14a, b), but even so has been printed in no fewer than six colors. The figures are well drawn and the composition well considered: note how the red of the table cloth draws one's eye to the center of action. Our attention held, we then see the bottles scattered in the foreground, and from them, we move to the caption. But as with the majority of illustrations on ephemera, neither the illustrator who designed the card in watercolors nor the chromo artist who translated the design into a printable image is credited.

One chromolithographic artist whose name *is* recorded is the painter Winslow Homer (American, 1836–1910), though he was a virtually unknown freelancer when he drew "Our Special" (Figure 13.15)—"Special Artist" being the term for a visual reporter. The publisher was Louis Prang (American, born Prussia, 1824–1909), who at the height of his career, was producing around five million high-quality greetings cards per year. This little card, however, is an example of Prang's earlier and less ambitious work dating from 1864.

During the American Civil War, Homer had camped with McClellan's army on the Potomac, producing sketches for translation into wood engravings by *Harper's Weekly* (*see Chapter 14*), and on this experience, he later drew two sets of picture cards for Louis Prang. With the collective title "Camp Life," these cards recorded not the conflict of the battlefield, but the soldier's everyday life—saying good-bye to his girl, having his hair cut, and so on. The cards were issued in both black-and-white and color versions and were available either loose for pasting into scrap albums (a popular pastime of the period), or printed on one long strip that was bound **concertina** format—a "zig-zag" format with multiple folds.

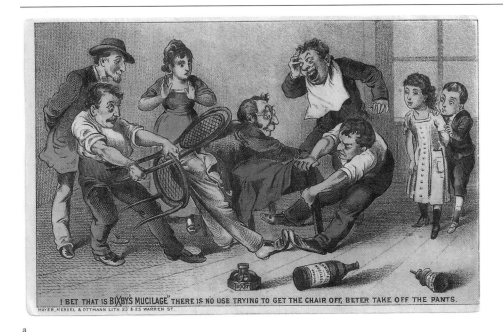

a

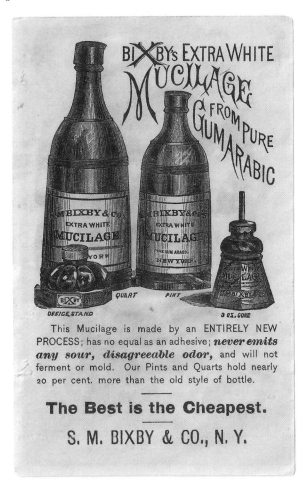

b

Figure 13.14a, b
Anonymous, trade card front (a) and back (b), Mayer, Merkel & Hoffman, New York, ca. 1890. Chromolithograph, 3 1/8 × 4 7/8".
The chromo artist's drawing (a) is so fine that it would have been drawn on stone at a larger size and then brought to scale on a reducing/enlarging machine. Advertising copy is relegated to the back of the card (b), where a monochrome drawing presents a more objective view of the product.

Figure 13.15
Winslow Homer, "Our Special," from the picture card series *Camp Life*, L. Prang & Co., Boston, 1864. Chromolithograph, 4 1/4 × 2 1/2".
This card depicts Homer working as a war artist, 1861–1862. The visual content is contained largely in the black delineation, with the colors serving largely to enhance the image. This enabled the series to be published in both monochrome and color versions.

Courtesy of the American Antiquarian Society.

Homer had learned the lithographer's trade in the 1850s when apprenticed to the Boston lithographer John H. Bufford (1810–1870) and thus was able to draw well on the lithographic stone himself rather than having his drawings copied to the stone by one of Prang's artisans.

He would have made his drawings on relatively small stones, with the separate images subsequently transferred onto a single large stone for machine printing. Five colors were used, including red, which is barely apparent in "Our Special" but was essential for the red caps and pantaloons of Zouave regiments (those adopting a quasi-Moorish uniform) shown on several other cards. The artist depicted is, of course, Winslow Homer himself.

Owing to the limitations of letterpress printing, advertising in mass-circulation magazines was limited to black and white. For those wishing to employ full color, the answer was to use a separately printed inset, tipped into the magazine during binding. Popular around 1890 to 1910, these insets were far more common in Britain

than America. The Pears' Soap inset in Figure 13.16 is not only a fine piece of chromolithography but also an example of the brief interface between advertising and fine art occurring at this time.

In 1877, Pears' commissioned the London-based sculptor Giovanni Focardi (Italian, English, ca. 1843–1903) to create a marble figure group for display on the company's stand at the Paris Exposition Universelle, to suggest a cultural link between trade and fine art. Titled "You Dirty Boy," Focardi's subject was an old lady washing her protesting grandson with Pears' Soap. The marble was unfinished at the time of the show's opening in May 1878, so Focardi's original plaster maquette had to be exhibited instead. The group attracted considerable attention, and smaller versions reproduced in terracotta, plaster, or metal were to grace many a shop counter for years to come. The same two characters are shown on the inset in Figure 13.16, but here monochrome sculpture is translated into the colorful world of advertising illustration. While the identity of the printer Alf Cooke is known, the name of the illustrator is not recorded. A Mrs. Elizabeth Langley and her grandson are said to have acted as models for the group.

Music in the Home

The development of the upright or parlor piano in the early-nineteenth century encouraged a growing interest in music, and for middle-class young women, the ability to play became an asset in the marriage market. Sheet music was available to all who could afford it, but in those pre-sound-recording days, music had largely to be purchased unheard. Thus, attractive sheet music covers had strong sales potential.

"An Aged Dame of Cornish Fame" (Figure 13.17) is a parlor ballad celebrating Mary Callinack, an octogenarian who in 1851 tramped nearly 300 miles from Penzance to the Crystal Palace in London to visit the Great Exhibition. The trip took her five weeks. Mary saw the exhibition several times and on one occasion, now a celebrity in her own right, was noticed in the crowd and introduced to the Queen, as depicted here.

The image is a monochrome lithograph, the main figures drawn on the stone by John Brandard (English, 1812–1863) with subordinate figures and background put in by an assistant. Also depicted are the well-established elm trees enclosed within the Great Hall of the Crystal Palace, with, in the distance, the 27-foot Crystal Fountain that formed the central feature of the building. The drawing is largely executed in crayon with a few accents in ink to achieve the full range of tones. Brandard was the most celebrated cover artist of his day, specializing in ballet and opera subjects and parlor songs such as this, which were among the repertoire of professional singers entertaining at private functions.

Among the earliest of the British music-hall celebrities was the singer-songwriter "Handsome Harry" Clifton, whose portrait is shown on the cover of the "Dark Girl Dressed in Blue" (Figure 13.18). The artist is Alfred Concanen (British, 1833–1886), leading illustrator of the comic song, who started his career on the *Illustrated Sporting & Dramatic News* and went freelance in 1858.

Figure 13.16
Anonymous, advertisement inset printed by Alf Cooke, Pears' Soap, ca. 1877. Chromolithograph, 8 ⁷/₈ × 5 ⁵/₈".
This illustration is based on a figure group commissioned by Pears' from the sculptor Giovanni Focardi in 1877. The Mrs. Langtry quoted in the image was Lily Langtry, a parlor singer and, later, popular actress.

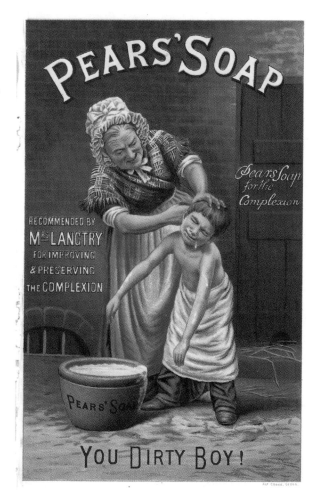

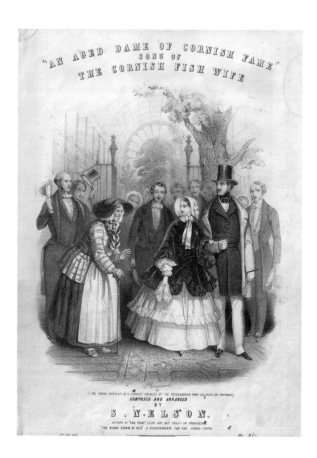

Figure 13.17
John Brandard, "An Aged Dame of Cornish Fame," sheet music cover, 1851. Lithograph, 13 ¹/₄ × 9 ³/₄" (trim).
The picture illustrates the moment when Queen Victoria, visiting the Crystal Palace with Prince Albert, met the octogenarian Mary Callinack, who had walked nearly 300 miles from Cornwall to visit the Great Exhibition.

He and Brandard were among the few cover artists whose names were promoted on music sellers' lists. Here, Concanen depicts Clifton as a well-to-do farmer come to London to see the International Exhibition of 1862. Ignoring the sequence of events described in the song, Concanen chooses instead to illustrate the overall plot. Thus, we see the dark girl catching the farmer's eye and behind them the Exhibition building to which they will both subsequently travel by omnibus. On the left is the "peeler"—London policeman of the period—who near the *end* of the song will arrest the farmer for passing the forged £5 note that the girl cons him into changing. Thus, Concanen's cover illustrates a passage of time, while Brandard's captures a given moment. Note also the graffiti chalked on the pavement—"Harper's Soap Powder" and "Boot Trees"—an advertising nuisance of the time perpetrated by those desperate for work. The cover is a chromolithograph executed in crayon and ink, the major elements drawn by Concanen but much of the work on the color stones probably done by an assistant.

The Influence of Fine Art

The increasing production of goods and services in the nineteenth century was complemented by a growth in advertising. Socially, there was a marked gulf between society, that is, the moneyed and leisured classes, and trade, those who made their way through manufacture and selling; but there was no similarly clearcut separation between trade and art. Thus, to some artists, advertising seemed to offer new opportunities: W. P. Frith wrote in 1899 that he could "name a dozen artists who, I feel sure, would be glad to make appropriate designs, by which all kinds of commodities could be advertised."

In 1871, London's Olympic Theater commissioned the painter Frederick Walker (English, 1840–1875) to design the poster for Wilkie Collins's dramatization of his novel *The Woman in White* (Figure 13.19). Walker's concept was not to show a scene from the play, as was usual on the illustrated playbills of the time (Figure 13.3), but to *suggest* an overall sense of mystery—a woman in flowing white stepping out through a door and glancing back at the viewer, finger to lips.

Although the poster would be large, it was agreed that it be produced as a wood engraving, with the work assigned to the engraver William Hooper (English, 1834–1912). Contacting Hooper, Walker wrote: "The figure ought not to be less than 4 ft. 6, or 5 ft. in height; and to my way of thinking a vigorous *wood-cut* [i.e., engraving] would be the thing, on a sheet of pear wood the size of a door. Will you help me with your counsel or graver, or might I say chisel [?]." Walker then subsequently observed: "I am bent on doing all I can with this first attempt at what I consider *might develop into a most important branch of art*" (Walker's emphasis). After Walker had produced a full-size drawing in chalk and charcoal, he wrote further: "I have got it on to the big paper, but not on to the blocks. These I have had fastened together by a carpenter, and I don't quite know whether you'd say they fit close enough;" and added "I have [now] got more purpose and 'go' in the figure and it strikes me we shall make a good thing of it." And so they did. Wilkie Collins was delighted with the result, as was the Pre-Raphaelite painter Sir John Millais

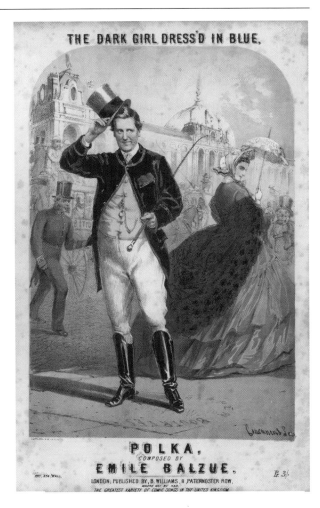

Figure 13.18
Alfred Concanen, "Dark Girl Dressed in Blue," sheet music cover, 1862. Chromolithograph, 13 3/4 × 9 3/4" (trim). Cover featuring British music-hall singer-songwriter Harry Clifton. Three different stages in Harry's encounter with the eponymous Dark Girl are represented in this one scene: the girl catching his eye, the International Exhibition building to which they will subsequently travel by omnibus, and the policeman who will later arrest Harry for passing a counterfeit note.

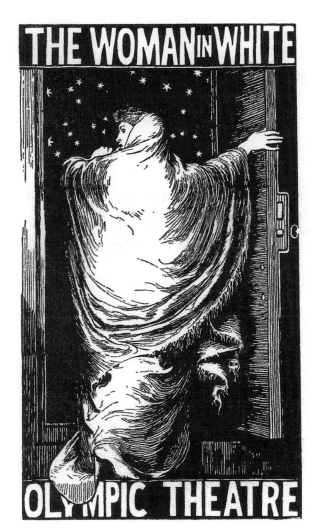

Figure 13.19
Frederick Walker (illustrator), William Hooper (engraver), small wood-engraved version of life-size woodcut poster for *The Woman in White* by Wilkie Collins, 7 1/4 × 4 1/8", 1871. Here Walker seeks to evoke a general mood of mystery rather than illustrating a particular scene, as would have been usual at the time. Designed by one of the better known fine artists and illustrators of the period, this poster was an early exemplar of the use of art in advertising.

(English, 1829–1896), who described the poster as: "a splendidly designed figure, serving to decorate the hoarding [billboard]" and "exactly [serving] its purpose as an advertisement." Walker's full-size drawing for the poster was exhibited at London's Grosvenor Gallery in 1872.

In 1886, the **vanitas** painting *A Child's World* by Sir John Millais was exhibited to much acclaim at the Grosvenor Gallery. The painting showed the artist's grandson blowing bubbles and looking wistfully upward at a single large bubble floating above—the bubble representing life's brevity and thus the *vanity* of all worldly things. The picture was purchased by Pears', who, disregarding Millais's implicit moral, changed the title to "Bubbles" and adapted it to the needs of soap advertising. This they did with the addition of a bar of soap at the boy's foot and "Pears' Soap" dominating the bubble above the child's head; and to stress the status of the advertisement as "art," when produced as a poster, the whole was printed within a gilt frame.

The novelist Marie Corelli (English, 1855–1924) was highly critical of what she saw as a perversion of art, as was the painter W. P. Frith (English, 1818–1909) (whose *New Frock* had been similarly appropriated by Sunlight Soap under the slogan "So Clean"). But Millais himself was apparently undismayed, mollified by the quality of the chromolithography. "Bubbles" was subsequently reproduced in both postcard and magazine-inset form (Figure 13.20), and with Millais's *Cherry Ripe* (1879) as a companion print, was issued free with *Pears' Annual* in 1897.

In 1889, discussing the whole question of the use of art in advertising, the editor of the *Magazine of Art* wrote that when it was carried out with taste, he was on the side of commerce: "Before long it will be thought no more derogatory, even to a Royal Academician, to design or paint a work for a man of business, than it is to-day to sell one for money, whether to an aristocratic 'patron' . . . or a manufacturer of knives or pickles." Yet the editor was to be proved wrong, for the selling of goods and services would soon come to demand a brasher approach than the established fine artist would tolerate, and this commercial need was subsequently to be met by more commercially minded artists working in the **bullpens** (art departments) of advertising agencies and commercial art studios.

Conclusion

The nineteenth century witnessed many changes in the design and production of printed ephemera. Ballads and broadsides gave way to penny newspapers and cheaply printed music. Process reproduction supplanted wood engraving, and by the end of the century, the four-color process was overtaking chromolithography in the reproduction of illustrators' artwork. But in its essence, ephemeral printing itself had not changed because it continued to reflect the passing show of everyday life, as it always will.

FURTHER READING

Applebaum, Stanley, *Advertising Woodcuts from the Nineteenth-century Stage* (New York: Dover, 1977).

Dempsey, Mike (Ed.), *Bubbles: Early Advertising Art of A. & F. Pears' Ltd* (London: Fontana, 1978).

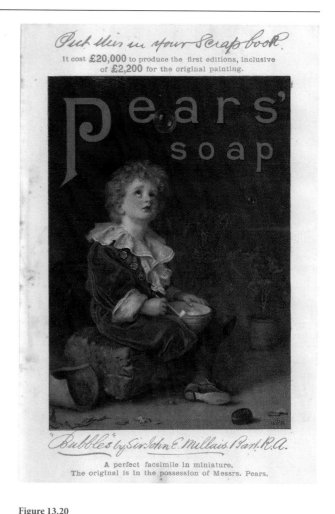

Figure 13.20
John Everett Millais, *A Child's World*, used in a magazine inset, Pears' Soap, ca. 1888. Chromolithograph, 8 ³/₄ × 5 ³/₄".
Millais's vanitas painting was demoted by Pears' to serve as a soap advertisement under its new title, "Bubbles."

KEY TERMS

aura	octavo
ballad sheet	reducing/enlarging
Baxter process	machine
ben-day tint	registration
bullpen	siderography
chromolithography	signature
chromoxylography	slurry
concertina	staffage
cut	stereotype (printing)
cylinder die	stock cut
electrotype	type-high
flying stationer	vanitas

Peters, Harry T., *Currier & Ives, Printmakers to the American People* (New York: Doubleday, Doran, 1942).

Rickards, Maurice, *The Encyclopedia of Ephemera, a Guide to the Fragmentary Documents of Everyday Life for the Collector, Curator and Historian*, edited by Michael Twyman et al. (London/New Castle: British Library/Oak Knoll, 2000).

Staff, Frank, *The Picture Postcard and Its Origins*, 2nd ed. (London: Lutterworth, 1979).

14

Illustration in Graphic Journalism and Magazine Fiction in Europe and North America, 1830–1900

Brian M. Kane and Page Knox

Graphic journalism is the art of reporting the news through images, and as with many other forms of illustration, it requires strategic storytelling. In the premier edition of the French weekly newspaper *L'Illustration* on March 4, 1843, the editor Jean-Baptiste Paulin (French, 1793–1859), promised readers that, through advances in technology, *L'Illustration* would not simply print the news in prose, but "strike the eyes with seductive forms of art." *L'Illustration* and other nineteenth-century newspapers strove to cover all the news of politics, entertainment, industry, wars, and fashion, and to do so with as many illustrations as possible.

The ensuing plethora of imagery was made possible in part by Thomas Bewick's (British, 1753–1828) innovative **wood engraving** process (*see Theme Box 30, "Wood Engraving as an Assembly Line Process"*), which was capable of far more detail than earlier woodcuts (Figure 14.1). Wood engraving impacted nineteenth-century book, newspaper, and periodical illustration tremendously because, for publishers, using them presented a practical advantage: they could be printed simultaneously with letterpress text on fast steam-powered rotary presses. Intaglio images, by contrast, required slow hand inking of the plates, with text and art printed separately on different presses (*see Chapter 2, Theme Box 6, "Intaglio Printing"*).

Nineteenth-century newspapers and periodicals established standards for how news has been visually reported for over 170 years; they have, by extension, influenced even contemporary television and internet journalism. **Graphic journalists** of the era illustrated events from around the world as the first embedded reporters in war zones, some suffering imprisonment or death while covering stories. Due to a lack of formal educational art training in early-nineteenth-century primary classrooms, these illustrated periodicals were often the first art primers for many great fine artists, such as Vincent van Gogh (Dutch, 1853–1890) and John Singer Sargent (American, 1856–1925), who learned their craft by copying images from them. The first sequential art comics also appeared in their pages, and we can trace the inspiration for creations as disparate as Japanese manga and contemporary humor publications in the vein of *MAD* magazine back to nineteenth-century news publications as well (*see Chapter 23*).

This chapter explores the world of nineteenth-century graphic journalism and highlights just a few of the creative illustrators and innovators who not only helped define visual reportage for their time, but also substantially codified the language of pictorial communication for generations to come.

Figure 14.1
Thomas Bewick, *The History of British Birds*, vol. 1, 1797–1804. Wood engraving.
Using jeweler's tools and end-grain boxwood, Bewick was able to create highly detailed engraved illustrations never before attempted on wood. Although cross-sections of the hard wood resulted in smaller blocks, the size of the images corresponded to standard page sizes of the time. Bewick's book was a significant example of independent ornithological study.
Courtesy of the Lownes Collection, Hay Library, Brown University.

Painters as Illustrators in Europe

Many artists, some of whom are remembered primarily as painters, created illustrations throughout their entire careers and significantly influenced the aesthetics of European illustration. For instance, academic painter Adolph Friedrich Jean-Louis Ernest Meissonier (French, 1815–1891) helped elevate illustration by more closely aligning it with the tenets of academic art, emphasizing logical, clearly delineated images and exemplary drawing skills. Meissonier was president of the Institut de France and of the Société Nationale des Beaux-Arts; a member of the Académie des Beaux-Arts (*see Chapter 12*); and was appointed Chevalier (Knight) to the Légion d'honneur—receiving their highest honor, the Grand Croix (Grand Cross). A prolific illustrator as well, Meissonier encouraged art students attending *ateliers* to work for newspaper and periodical publishers so they could earn a living while studying.

Meissonier's illustrations for *Paul et Virginie* (Figure 14.2) influenced Erdmann von Menzel's (German, 1815–1905) five hundred wood-engraved illustrations for the pictorial history *Frederick the Great* (1845) (Figure 14.3). Renowned among European painters and illustrators, Menzel was the only artist to ever receive the Kingdom of Prussia's highest honor, the Order of the Black Eagle. He in turn inspired illustrations by Pre-Raphaelite artists for the famed edition of *Poems* by Alfred Tennyson (1857), published by Moxon (*see Chapter 15*).

Paris was the center of the art world during the nineteenth century. While Meissonier certainly supported illustration by both producing it and encouraging students to work for publishers, it was Jean-Léon Gérôme (French, 1824–1904) who probably had the most impact on illustrators. His body of work

Figure 14.2
Ernest Meissonier, "*Vue de la baie du tombea*," in *Paul et Virginie* by J. H. Bernardin de Saint-Pierre, p. 407, 1838.
Paul et Virginie and its companion, *La Chaumière Indienne* (1838–1839), were significant books printed outside England that used wood engraving, to which Meissonier's highly detailed illustrations were perfectly suited. Both books also included illustrations by other notable painters, such as Paul Huet (French, 1803–1869).
Hathi Trust.

Figure 14.3
Adolph von Menzel, illustration in *The Pictorial History of Germany, During the Reign of Frederick the Great* by Franz Kugler, 1845, p. 436.
Highly decorated as a painter, Menzel set new standards for realism and detail in the mid-nineteenth-century publishing with his illustrations.
Courtesy of Brian M. Kane.

includes history painting, genre scenes, portraits, and landscapes, which achieved a high degree of international popularity through reproductions made by gallery owner and printmaker Adolphe Goupil (French, 1806–1893). Gérôme maintained a seat in the Académie des Beaux-Arts from 1865 to 1904, and operated his own atelier where his American pupils included George Bridgman (1865–1943) (*see Chapter 18, Theme Box 39, "Education"*), Thomas Moran (1837–1926), Thomas Eakins (1844–1916), Mary Cassatt (1844–1926), Kenyon Cox (1856–1919), Simon Harmon Vedder (1866–1937), and Julian Alden Weir (1852–1919)—all successful artists in their own milieus. Possibly the

most recognizable painting from Gérôme's oeuvre is *Pollice Verso* (*Thumbs Reversed*, 1872) (Figure 14.4), a lush dramatic scene in which a gladiator looks to the raucous crowd for permission to kill his fallen foe. Gérôme skillfully places the viewer in the arena with the gladiator in order to heighten the sense of danger in this iconic visual that has influenced artists, illustrators, and filmmakers for over 140 years.

Pen-and-ink illustration, which emerged toward the end of the century, in particular was influenced by Mariano Fortuny (Mariano José María Bernardo Fortuny y Marsal, Spanish, 1838–1874) (Figure 14.5). Prior to Fortuny, pen-and-ink drawings were generally executed only as sketches for paintings or prints and employed long, strong pen lines in a technique that had remained mostly unchanged since the Renaissance. As an academic painter who studied Velazquez and Goya, Fortuny used shorter, broken lines to integrate figures into their environment in much the same way a painter softens edges—relying on the interplay of light and shadow to imply solidity, and to integrate forms into the environment.

Fortuny attended the Academia de Bellas Artes de Barcelona and was inspired by Gavarni's lithographs of everyday life (see "The *Flâneur*," later in this chapter). Awarded the Prix de Rome, at nineteen Fortuny was sent with the Spanish Army to Africa to document the war with Morocco, where he sketched the dead and dying on the battlefield. After the war, Fortuny moved to Paris and entered the atelier of Gérôme. It was not until 1873, however, that the first of Fortuny's wood-engraved illustrations of his Moroccan travels appeared in the Madrid newspaper *Illustracion* and brought him acclaim.

Fortuny's academic paintings were popular, but his lasting contribution was his innovative pen-and-ink

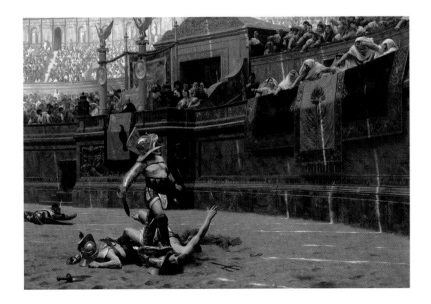

Figure 14.4
Jean-Léon Gérôme, *Pollice Verso*, 1872. Oil on canvas, 38 × 58 3/4".
The French Academy was a tremendous international influence on both fine art and illustration, and one of its most notable proponents was Gérôme. Hailed as the inspiration for Ridley Scott's contemporary film *Gladiator* (2000), *Pollice Verso* is possibly Gérôme's most recognizable painting. It continues to engage viewers' imaginations with its drama, lifelike forms, and extraordinary detail.
Courtesy of Phoenix Art Museum.

Figure 14.5
Mariano Fortuny,
illustration in *The
Art Journal*, vol. 1,
1875, p. 238.
Fortuny was one of
the first artists to
focus on pen-and-
ink technique as an
art form rather that
just as a sketching
medium for future
paintings. Because
white shows
through even the
darkest areas (hat,
coat, and the shad-
ows), the figure
does not flatten
out. This effect
is referred to as
"sparkling blacks,"
a technique later
adopted by Daniel
Vierge.

Courtesy of Brian M.
Kane.

illustration style, noted for its "sparkling blacks," a quality achieved through the interplay of strong, fragmented lines with white space, which heavily influenced first generation pen-and-ink illustrators such as Daniel Vierge (see "Vierge, Gillot, and "Modern Illustration" later in this chapter), Martín Rico (Spanish, 1833–1908), Antonio Salvador Casanova y Estorach (Spanish, 1847–1896), and Alphonse de Neuville (French, 1835–1885).

The Illustrated Newspaper Takes Form in England and France

Illustration was an important and respected aspect of culture during the 1800s, which proliferated through influential illustrated newspapers in Britain and on the Continent. The *Penny Magazine* (1832–1845) (*see Chapter 11*) was the first periodical to use wood-engraved illustrations, the magazine format avoiding a **Stamp Tax** imposed on newspapers. Its publisher, Charles Knight (British, 1791–1873), had an ambition to educate the working and middle classes about great works of art by printing images of masterpieces along with scenes from current news stories. The *Penny Magazine* sold extremely well, reaching a circulation of over 200,000 copies per issue by the end of the first year. Knight was a keen businessman, and worked with other publishers in Germany, France, Italy, South America, and the United States to exchange plates and the stories that went with them. Two of the *Penny Magazine*'s "progeny" that shared its plates were *Le Magasin Pittoresque* (1833–1912) in Paris and *Das Pfennig-Magazin für Verbreitung gemeinnütziger Kenntnisse* (1833–1842) in Leipzig.

In England, publisher Herbert Ingram (English, 1811–1860) noticed that whenever newspapers included illustrations, their sales increased. Ingram had hoped to profit from this insight by making a newspaper capitalizing on sensational news reports similar to those in the lurid penny bloods (*see Chapter 22*). Hiring

Mark Lemon (British, 1809–1870) of the weekly satire magazine *Punch* as a consultant, and Frederick William Naylor "Alphabet" Bayley (Irish, 1808–1852) as editor, the *Illustrated London News* (*ILN*) appeared on May 14, 1842, and set the tone for news reporting that has carried through to the present day.

The premiere issue of *ILN* contained a story of a disastrous fire in Hamburg, Germany, that had occurred nine days earlier. Considering that it took five days for German news to reach London, showing the event on the front page of the *Illustrated London News* four days later was not considered "old" news. Copying a print depicting Hamburg from the British Museum, an artist redrew the city and added flames, smoke, and spectators. The edition also included articles about the Royal Academy Exhibition, a steamboat explosion in America, a war in Afghanistan, Paris fashions, and eight illustrations of Queen Victoria's first *bal masque* at Buckingham Palace, an event most people could only dream of attending. Though many of the early illustrations were crude, quality improved and, by the end of 1842, *ILN* had printed over 7,500 original illustrations. Notable artists worked for the *ILN*, including George Cruikshank (English, 1792–1878), John Leech (English, 1817–1864) (Figure 14.6), John Gilbert (English, 1817–1897) and Bewick's favorite pupil, William Harvey (English, 1796–1866).

While *ILN*'s chief engraver was Henry Richard Vizetelly (British, 1820–1894), Bewick's apprentice and *Punch* co-founder Ebenezer Landells (British, 1808–1860) was occasionally contracted for larger projects. The first edition of *ILN* sold 26,000 copies, but rose to 66,000 copies by year's end due in part to a subscription incentive featuring *The Colosseum Print of London*, a 4 × 3' panoramic print of London.

The most prolific engraving firm in London was that of the Dalziel Brothers, credited with producing more than 50,000 images in thirty years. The firm began

Figure 14.6
John Leech, "First Day of the Season," in the *Illustrated London News*, November 22, 1856.
Leech portrays the advent of the foxhunt, an elite diversion. Known for his humor and satire in caricatures appearing regularly in the magazine *Punch* (*see Chapter 11*), Leech also illustrated fiction, comic reinventions of history, ballads, and grammar books.
D. B. Dowd Modern Graphic History Library, Washington University in St. Louis.

Theme Box 30: Wood Engraving as an Assembly-Line Process
by Brian M. Kane

Like woodcuts, wood engraving is a relief printing process (*see Chapter 2, Theme Box 4, "Xylography"*), in which the nonprinting areas of the surface are removed with sharp tools. Thomas Bewick's late eighteenth-century innovation was to use end-grain cross-sections of hard Turkish boxwood, which could be carved in great detail using fine jeweler's tools.

The boxwood tree's small girth, however, meant that at first, a 5 × 5" block was the largest possible surface on which an artist could engrave. Charles Wells's invention of the "bolted block" method in 1842 made it possible for up to sixty separate boxwood blocks to be bolted together to form one huge image. The process remained the standard for printing large black-and-white illustrations for most of the century. Because rotary presses could print up to 1,200 sheets per hour, and it was impossible for wood blocks to withstand so much pounding of the press, systems of creating metal plate duplicates of individual wood blocks or of entire laid out pages, called stereotypes and later electrotypes, were devised (*see Chapter 13, Theme Box 26, "Mass Production of Plates and Printing Forms"*). These made it possible to print the same job on multiple presses simultaneously while freeing up the movable type to be immediately used on a new job. Stereos and electros, as they were nicknamed, could also be saved in case a reprint was needed—or sold to other publishers.

Assembly-Line Process
Due to the success of the pictorial news, the rise in demand for illustrations and the lack of artists and engravers skilled in an artistic or "pictorial" approach became secondary to meeting deadlines. During the 1850s–1860s, wood engravers became tradesmen, and the cutting of illustration blocks became formulaic in the name of efficiency. The engraving process was streamlined into an assembly-line process referred to as the "facsimile" approach, in which apprentices learned a specialty: those who engraved the sky and trees were called "pruners"; "tailors" engraved drapery and clothing, while "mechanics" handled buildings and machinery. The advanced engravers who "cut" people's flesh were termed "butchers." Specialization made it unlikely that one engraver would become proficient in all types of engraving.

Since tools were simple and inexpensive, the work could be done anywhere with freelancers of both genders, called outworkers, operating from their homes. After the image was drawn on the wood, the master engraver would make his preliminary cuts, separate the blocks, and distribute them to each specialist according to his or her skill.

All the apprentices were taught a "house" style so that when all the blocks were reassembled, the finished image looked as if only one engraver had completed the work. This mechanical, slavish, facsimile copying of the image line-for-line became the standard for the industry. No matter who made the initial drawings, the vast majority of printed illustrations looked as if the same artist created them.

The evolution from pictorial approach to facsimile approach took several years and went largely unnoticed by the public. It was accomplished engraver William James Linton's (English, 1812–1897) conviction that the facsimile approach diminished the role of the engraver to that of an automaton, a replaceable cog. Linton railed against the large engraving workshops run by Joseph Swain (1820–1909), Edmund Evans (1826–1905), and the Dalziel Brothers. He advocated for the dignity and creativity of illustrators and designers through reform of industrial practices. Linton's beliefs were shared by designer William Morris (English, 1834–1896) and others involved with the Arts and Crafts movement (*see Chapter 15*).

Further Reading
Beegan, Gerry, "The Mechanization of the Image: Facsimile, Photography, and Fragmentation in Nineteenth-Century Wood Engraving," *Journal of Design History*, vol. 8, no. 4, 1995: 257–274.

Jobling, Paul, *Graphic Design: Reproduction and Representation since 1800* (Manchester; New York: Manchester University Press; Distributed exclusively in the USA and Canada by St. Martin's Press, 1996).

Jury, David, *Graphic Design before Graphic Designers: The Printer as Designer and Craftsman: 1700–1914* (London: Thames & Hudson, 2012).

in 1839 with Edward Dalziel (English, 1817–1905) and his brother George (English, 1815–1902) supplying engravings to *ILN*, and to Landells for use in *Punch*. Younger siblings John (English, 1822–1869), Thomas (English, 1823–1906), and Margaret (English, 1819–1894) soon joined the firm as demand for wood engravings increased. In addition to working for the illustrated press, the Dalziel Brothers engraved images for periodicals, for their own publishing ventures, and for an impressive group of artists.

With the introduction of the telegraph in the 1840s, **literary news illustrators**, who drew imagined pictures from verbal reports, like the one who drew the Hamburg fire for the first issue of *ILN*, became increasingly more important. Of these, John Gilbert was one of the most prolific, and is said to have personally made thousands of drawings for *ILN*. The morning clippings of stories from text-only national and foreign newspapers that had visual potential were sent to Gilbert at the Dalziel Brothers' engraving offices along with wood blocks. It was Gilbert's job to read the articles and create interesting illustrations. By evening, the engraved blocks were returned to the paper ready to be made into plates (Figure 14.7).

The world depicted in the illustrated press was therefore not an *objective* world, but one in which graphic journalists synthesized imagery from available sources or completely fabricated illustrations. The readers' visual experience was based on the textual reports, influenced by what the editor and illustrator chose to emphasize, incorporate, or eliminate. The final image was an *interpretation*: often a symbolic, culturally biased, and sometimes politically motivated depiction; and the product of an assembly-line process as well (*see Theme Box 30*). Nineteenth-century graphic journalists were, in effect, the first concept artists, who made visual a world that the illustrated press's readers thought they lived in—one that many viewers today still believe existed as it was depicted.

As sales increased, additional graphic journalists were hired and dispatched to witness and illustrate the newsworthy. By the mid-nineteenth century, **correspondents** were being sent to other countries to cover events, politics, and wars. These correspondents would send original drawings back to the newspapers, where they would be transferred to wood blocks for engraving. The ability to take in everything in an instant and remember it

well enough to draw it in exacting detail was of paramount importance to graphic journalists. In 1847, Horace Lecoq de Boisbaudran (French, 1802–1897), professor at the school of the Légion d'honneur, published *L'Éducation de la mémoire pittoresque* (published in English as *The Training of Memory in Art and the Education of the Artist, 1847*), which was adopted by many international artists by the mid-1860s, and influenced later graphic journalists such as Americans John Sloan, George Benjamin Luks, and Everett Shinn, who were members of the Ashcan School (see later in this chapter).

L'Illustration, France's first major illustrated newspaper, led by Jean-Baptiste Paulin (French, 1793–1859), premiered a year after *ILN* and adopted the same format. Paulin's promise to show readers scenes of faraway lands with images of anything new, strange, or grand extended to the Crimean War (1853–1856), in which soldier/artist Jean Baptiste Henri Durand-Brager (French, 1814–1879) sent images back from the front lines to *L'Illustration*, which were then shared with *ILN* (Figure 14.8).

L'Illustration faced its first French competition on April 18, 1857, with the publication of *Le Monde Illustré*. This coincided with the return of Paris-trained newspaper draftsman Edmond Morin (French, 1824–1882) from England, where he had contributed to *ILN* and helped

Figure 14.7
John Gilbert (illustrator) and Frederick James Smyth (engraver, active 1841–1867), "The Presentation," in the *Illustrated London News*, vol. III, no. 62, July 8, 1843. Wood engraving.
Graphic journalism gave readers unprecedented visual access to people, places, and events that, due to their social and economic standings, they could never see for themselves. This image of Queen Victoria and Prince Albert was one of a series of illustrations related to Her Majesty's birthday celebration, drawn by John Gilbert in The Presence Chamber of St. James Palace.
University Libraries Thompson Special Collections, The Ohio State University.

Figure 14.8
Jules Worms, "Jean-Baptiste Henri Durand-Brager in Crimea," in *L'Illustration*, February 9, 1856. Wood engraving.
Durand-Brager (pictured here) became one of a new breed of graphic journalists who was not only a soldier, but also an embedded reporter sending back news items and illustrations from the front lines of the war.
Courtesy of Brian M. Kane.

found the art magazine *Pen and Pencil*. Morin, in addition to working for *Le Monde Illustré*, was also a landscape and portrait painter who showed his work at the Salon, and contributed to *Magasin Pittoresque*, *L'Illustration*, and *La Vie Parisienne* (Figure 14.9).

The engraver's technique profoundly impacted the way illustrations looked when printed. *Le Monde Illustré*'s chief engraver Octave Édouard Jean Jahyer (French, b. 1826) customized his engraving approach to complement the individualized style of the artist, rather than employing the more typical assembly-line "facsimile approach" of most engravers of the illustrated press (*see Theme Box 30*). Jahyer and his apprentices' "pictorial approach" imparted a more organic feel to *Le Monde Illustré*'s images, and Jahyer was soon in demand for engraving illustrations for well-known artists like Gustave Doré (French, 1832–1883), Édouard Riou (French, 1833–1900), and occasionally, Paul Gavarni (nom de plume of Sulpice Guillaume Chevalier, French, 1804–1866). His technique, which can be considered a return to the artistic ideology of Thomas Bewick, had a lasting effect on the working practices of future engravers.

The *Flâneur*

Paul Gavarni, one of the most influential illustrators of the mid-nineteenth century, was a mordant but witty observer of life. Like Honoré Daumier, Gavarni was one of the leading illustrators of *Le Charivari* (*see Chapter 11*), but he also created art for *L'Illustration* and dozens of other magazines. Gavarni's was a biting approach with a penetrating insight into the human condition that made his storytelling all the more powerful (Figure 14.10). Gavarni has been referred to as a bohemian and a ***flâneur*** (a man of leisure), constantly on the prowl for inspiration. Gavarni's deeper convictions were evident in his two-volume work *Le Diable à Paris* (*The Devil in Paris*) (1844, 1846), which showed the waifs, paupers, and unemployed in what may be the first illustrated books by a major artist that exposed Parisian social injustice.

Another prominent illustrator of the 1800s was Gustave Doré—a child prodigy who began illustrating professionally at the age of fifteen for *La Silhouette*, whose co-founder, Charles Philipon (the publisher of satirical magazines—*see Chapter 11*), also gave him a place to live. Doré was a pictorial satirist rather than strictly a caricaturist; he contributed thousands of illustrations to *Journal pour Rire*, *Musée Franco-Anglais*, and later *Le Monde Illustré*. But to some degree, Doré's continued popularity may be the enduring nature of the non-satirical texts he selected to illustrate: The Bible,

Figure 14.9
Edmond Morin (illustrator) and Henry Linton (engraver), "After the battle of Inkerman. Fellowship of the two armies," in *L'Illustration*, December 2, 1854. Wood engraving.
This image depicts the bond between the French and British Armies following the Battle of Inkerman and their defeat of the Imperial Russian Army during the Crimean War.
Courtesy of Brian M. Kane.

Figure 14.10
Paul Gavarni, "Mr. Mayor, the truth can sometimes not be true . . . no joke," in *L'Illustration*, May 6, 1852.
Gavarni and Daumier (*Chapter 11*) were two of the leading humorists/satirists working during the early years of the French illustrated press. Their commentaries on society and politics were often acerbic but revealing.
Courtesy of Brian M. Kane.

William Shakespeare's plays, Poe's *The Raven*, Dante's *Divine Comedy*, and many others that are still in print.

Doré's unique and ambitious *London, a Pilgrimage* with journalist Blanchard Jerrold (English, 1826–1884) documented life in late-nineteenth-century London. Many of Doré's images tended toward extremes, contrasting lighter fare like boat races and the Derby with gloomy images of squalor, depicting the homeless under bridges and overcrowded ghettos of the urban poor (Figure 14.11). The nearly four-year project included 180 engravings and was met with mixed reviews by those who thought the dire circumstances depicted were overstated.

The *Illustrated London News*'s first major English competitor, the *Graphic*, was founded by engraving studio owner William Luson (W. L.) Thomas (English, 1830–1900) and editor Henry Sutherland Edwards (English, 1828–1906) in 1869. Edwards hired the core of his literary staff away from the *Illustrated Times*, and selected illustrators trained at the Royal Academy. With the outbreak of the Franco-Prussian War in 1870, the *Graphic* secured a publishing stronghold by sending graphic journalists to cover all aspects of the conflict—producing some of the highest quality newspaper illustrations of the late-nineteenth century. This forced *ILN* to do the same in order to remain competitive.

Vierge, Gillot, and "Modern Illustration"

In his lifetime, Daniel Urrabieta y Vierge (Spanish, French, 1851–1904) was referred to as "The Father of Modern Illustration." A graduate of the Royal Academy of San Fernando, Madrid, Vierge moved to Paris to become a painter. When his atelier closed due to the Franco-Prussian War, he became a graphic journalist at *Le Monde Illustré*; eventually becoming one of the most notable illustrators of his generation. Like Morin before him, Vierge helped train the newspaper's wood engravers to interpret his illustrations artistically, rather than through the formulaic facsimile method (Figure 14.12).

Vierge was attempting to photo-mechanically reproduce his pen-and-ink illustrations when he met Charles Gillot (French, 1853–1903), who was trying to establish a business in the print trade. Gillot and Vierge perfected a photoengraving process called **gillotage** that created a metal printing plate in a fraction of the time and at lower cost than wood engraving (*see Theme Box 32, "Gillotage"*). The first Vierge/Gillot reproduction of a pen-and-ink illustration appeared in *Le Monde Illustré* on August 7, 1875. Unlike previous photoengraving attempts,

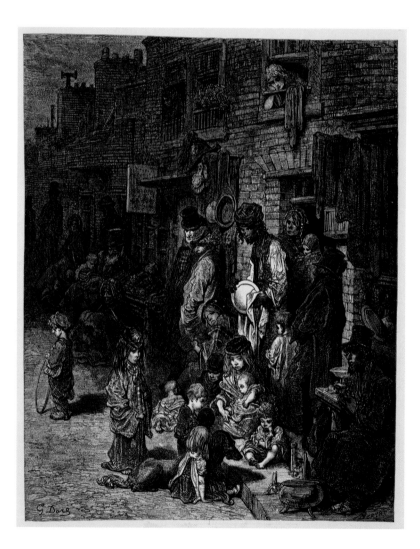

Figure 14.11
Gustave Doré, "Wentworth Street, Whitechapel," in *London, a Pilgrimage* by Blanchard Jerrold, 1872.
Jerrold and Doré went on location for an extended exploration of the city of London. Doré's dramatic use of chiaroscuro is particularly effective in conveying the gloom of this poor neighborhood.
Toronto Public Library.

Figure 14.12
Daniel Vierge, "Gwynplaine," in *L'Homme Qui Rit* by Victor Hugo, 1875, p. 68. Vierge's image for Victor Hugo's novel is an example of the enduring creative influence of nineteenth-century illustration: his disfigured orphan, Gwynplaine, was emulated in the 1928 silent film adaptation of Hugo's novel, which in turn visually inspired the design of the notorious comic-book villain, the Joker, still vital in contemporary graphic novels, television, and film.
Courtesy of Brian M. Kane.

gillotage preserved the finest lines; and as a scalable photo-transfer method, it also reduced restrictions on the size of the original drawings. Consequently, pen-and-ink drawing became more highly valued as an art form, rather than being perceived as merely an intermediary step.

In 1876, Gillot opened the first French workshop of photoengraving on Rue Madame in Paris, and was joined by Eugène-Samuel Grasset (Swiss, 1845–1917), who became well known for his poster art (*see Chapter 15*). That same year, Gillot published *Bosnie et Herzégovine: Souvenirs de voyage pendant l'insurrection* (*Bosnia and Herzegovina: Memories of Travel During the Uprising*) by Charles Yriarte, the first book entirely produced using the gillotage process and containing fifteen illustrations by Vierge (Figure 14.13).

In 1879, Gillot published his own weekly Parisian arts newspaper, *La Vie Moderne*. The front page of the first issue featured an illustration by Vierge, and the second featured one by Pierre-Auguste Renoir (French, 1841–1919). Soon other artists, both Academic and Impressionist, began contributing to *La Vie Moderne*, including Gérôme, Jules Worms (French, 1832–1924), Claude Monet (French,

1840–1926), and Édouard Manet (French, 1832–1883) (Figure 14.14).

In 1882, while collaborating on a new edition of *Pablo de Segovia* (by Francisco de Quevedo, Spanish, 1580–1645), Vierge suffered a stroke and was paralyzed on his right side. The volume was published with only three-fourths of the illustrations, but became an international sensation. Vierge made a miraculous recovery and within two years had taught himself how to draw with his left hand. He returned to *Le Monde Illustré* and went on to complete the remaining twenty illustrations for *Pablo de Segovia*'s second edition, which was published in 1892 in English (Figure 14.15). *Pablo de Segovia* was a turning point not only in publishing, but in illustration as well, influencing the works of American illustrators Howard Pyle (1853–1911) and Joseph Pennell (1857–1926), and architect Frank Lloyd Wright

Figure 14.14
Édouard Manet, "Monet par Manet," in *La Vie Moderne*, June 12, 1880. Gillotage.
La Vie Moderne was a weekly arts newspaper that included illustrations for book reviews, gallery reviews, and sketches from everyday life. This drawing of Impressionist painter Claude Monet by Édouard Manet reproduced by gillotage retains all the texture and immediacy of the brush and ink that Manet used, sharply differing in style from wood engraving.
Courtesy of Brian M. Kane.

Jeunes filles au marché d'Agram. — Un karaüla.
Pont sur la Unna, d'après l'aquarelle de S. A. le prince de Joinville, frontière des confins militaires et de la Turquie. (Frontispice.)

Figure 14.13
Daniel Vierge (illustrator) and Charles Gillot (engraver), frontispiece, *Bosnie et Herzégovine: Souvenirs de voyage pendant l'insurrection*, 1876. Gillotage. This was the first book printed using gillotage, an experimental photoengraving process that created a metal plate directly from original art. This process eliminated costly wood engraving with its intermediary translation of the art by an engraver, instead reproducing pen-and-ink artwork more or less as originally drawn by the artist.
Courtesy of Brian M. Kane.

Figure 14.15
Daniel Vierge (illustrator) and Charles Gillot (engraver), illustration in *Pablo de Segovia* by Francisco de Quevedo, 1892. Gillotage. Vierge's technique and design sense create light-infused images filled with movement, atmosphere, textures, and interesting characters such as the double-amputee beggar, and the boy on the wall shooting seeds through a straw.
Courtesy of Brian M. Kane.

Theme Box 31: Prejudice Against Illustration
by Brian M. Kane

Elitist prejudice against illustration accelerated with English poet and critic Charles Lamb (1775–1834). After writer Samuel Rogers's illustrated edition of poems *Pleasures of Memory* appeared in 1833 (Figure TB31.1), Lamb wrote an editorial vehemently opposing the inclusion of illustrations because he believed they made the book decadent, ostentatious, and abhorrent to the "true reader." In a conciliatory letter to Rogers, Lamb acknowledged that he had a prejudice against illustration, feeling that the "sister arts," or the "feminine arts," should never be intertwined with the "manly art" of writing. Furthermore, he thought that literary works, such as Shakespeare's *Romeo and Juliet*, should never be acted out or illustrated because the visuals corrupted the imagination and tied Juliet's appearance to just one conception.

Had the illustrations in *The Pleasures of Memory* been inferior, Lamb's negativity might have been deserved, but the illustrators in question, English painters J. M. W. Turner (1775–1851) and Thomas Stothard (1755–1834), were members of the elite Royal Academy in London. Though Turner contributed illustrations to several books, he is mainly known today for his paintings, which were a seminal influence on Impressionists such as Claude Monet. What may have motivated Lamb was that Rogers, a minor poet, was wealthy enough to hire illustrators for his books, thereby making inferior work more salable; while Lamb, who was raised poor and worked for a living, did not have that option.

In 1844, the *Quarterly Review* posthumously published an article by former editor John Murray (English, 1778–1843), titled "Illustrated Books." The article championed the work of Turner and Stothard, but found fault with the majority of the artists of the time and their facility to properly illustrate the text. The critique is understandable considering that the increasing demand for illustrations quickly outgrew the talent pool of skilled artists and engravers, making way for the less accomplished to enter the field. However, it must be noted that since payment for illustrations added to the cost of producing a book, their inclusion impacted an author's earnings even though they guaranteed increased sales. Murray protested that the pictorial arts, which were once included in books as visual aids, "now bid to supersede much of descriptive writing," and that the text had become subordinate to "their so-called illustrations." Rather than call on authors to rise to the challenge by creating works better than the art that accompanied their texts, Murray chastised illustrated books as a "partial return to baby literature—to a second childhood of learning," thus beginning the "juvenile" pejorative that continues to stigmatize illustration.

During the nineteenth century, text and image also evolved into a hierarchical, gendered relationship in which the "superior" verbal arts were considered masculine, powerful, intelligent; whereas the pictorial arts, referred to as the "lesser arts," were aligned with the feminine attributes of mimicry and attractiveness. In his essay, Murray commented on the popular compendiums of stories and articles called **annuals**, also known as gift books because they were intended to be given as presents

Figure TB31.2
Frontispiece for *The Juvenile Forget-Me-Not: A Christmas and New-Year's Gift or Birth-Day Present*, by Mrs. S. C. Hall, published by London: Ackermann, 1835.

Special Collections, Olin Library, Washington University in St. Louis.

Figure TB31.1
J. M. W. Turner, "A Tempest. Voyage of Columbus," in *Pleasures of Memory* by Samuel Rogers, 1833 (from 1834 edition).
Courtesy of Brian M. Kane.

during holidays (not to be confused with lavish color gift books of fairy and folktales; *see Chapter 16*). The great many annuals marketed to women and girls were also written and illustrated by women; with sales driven by a growing, prosperous middle class rife with young, literate brides-to-be, publishers pumped out such titles as *The Juvenile Forget Me Not* (Figure TB31.2), *The Juvenile Keepsake*, and the *Juvenile Scrap-Book*, all, unfortunately, making use of the youth-oriented adjective. Murray revealed his own gynophobia when he contended that the annuals were nothing but "nonsense," and that he was "[happy] they are nearly extinct" because so much money was "wasted on their production." Murray, however, was wrong: annuals continued to be popular well into the 1920s, particularly for children.

A year after Murray's article, poet William Wordsworth (English, 1770–1850) published his sonnet "Illustrated Books and Newspapers," bemoaning the written word's fall from grace to become the servant of the mindless public's increased "taste" for illustration. He reiterated Murray's "juvenile" pejorative, and claimed that the popularity of illustrations was a degenerative return to a time when cavemen painted on walls. Wordsworth then sought to further debase illustration by associating it with a "lower stage," which exposed his fear of feminine subversion on the "masculine" art of writing. For Wordsworth, the combination of verbal and visual in the same book, or worse, on the same page, personified an unnatural relationship between the sexes. The fact that illustrated books sold better and were more popular than text-only books was a direct affront to an author's masculinity, power base, station in society, and income.

Since the publication and popularity of illustrated books could not be stopped, they were something to be feared and denigrated. Therefore, the pejoratives such as "superficial," "frivolous," "juvenile," and "mere" began in part not because they were truly deserved, but because they reflected shifts in gender relations and in the marketplace that threatened traditional masculine prerogatives. Other factors, such as the widespread belief that "Art" should be separate from commerce and focus on explorations of form or particular subject matter (the capital *A* was commonly used to mark this intent), continued to impact illustration's status as the nineteenth-century explosion in printed matter continued.

Further Reading

Bogart, Michele H., *Artists, Advertising, and the Borders of Art* (Chicago: University of Chicago Press, 1995).

Kooistra, Lorraine Janzen, *The Artist as Critic: Bitextuality in Fin-De-Siecle Illustrated Books*. The Nineteenth Century Series (New York: Scolar Press, 1995).

Kooistra, Lorraine Janzen, "Poetry and Illustration," *A Companion to Victorian Poetry*. Blackwell Companions to Literature and Culture (Hoboken, NJ: Wiley-Blackwell, 2007).

Murray, John, "Illustrated Books," *Quarterly Review*, vol. 74, 1844: 167–199.

(1867–1959). In 1889, Vierge won the Grand Prix in Fine Art at the Exposition Universelle and was made a Chevalier in the Légion d'honneur at the insistence of Meissonier.

A year after the first edition of *Pablo de Segovia*, Gillot used gillotage to publish the first photoengraved book in color, *Histoire des quatre fils Aymon* (*History of the Four Sons of Aymon*, 1883) (Figure 14.16), fully illustrated by Grasset. Soon many wood engravers who apprenticed during the boom years of the 1850s–1860s were forced out of work as more new economical photoengraving processes were invented. The drop in the cost of print production resulted in a flood of new publications. As the demand for artists exceeded the supply, many publications turned to less skilled students and amateurs to meet their needs.

Rebuffing all mechanized reproduction, Auguste-Louis Lepère (French, 1849–1918) left *Le Monde Illustré* to create his own weekly newspaper, *L'Image* (1896–1897), which touted the aesthetic superiority of wood-engraved art that was designed, drawn, and cut by a single artist

Figure 14.16
Eugène Grasset (illustrator) and Charles Gillot (engraver), title page, *Histoire des quatre fils Aymon* (*History of the Four Sons of Aymon, Very Noble and Very Valiant Knights*), 1883. Color gillotage. It took Grasset more than two years to complete over two hundred individualized page designs for this volume—the first photoengraved book in full color.
Courtesy of Brian M. Kane.

Theme Box 32: Gillotage
by Brian M. Kane

Paniconography is a plate-making technique first developed in about 1850 by Firmin Gillot (French, 1819–1872) that resulted in a relief zinc plate created by etching away nonprinting areas with acid. Paniconography took less time to make than a wood engraving and could similarly be mounted type-high to print at the same time as letterpress. Gillot's process took up where William Blake's (*Chapter 12*) eighteenth-century early relief-etching experiments left off. The process solved some of the under-cutting problems Blake found insurmountable, in which the acid "bit" sideways as well as down into metal plates, thus resulting in weak and ragged lines.

Gillot's son Charles (1853–1903), together with Daniel Vierge, is credited with refining the paniconography technique for black-and-white image-to-plate printing by developing gillotage in 1872. The gillotage process was a way to photome-chanically transfer line art to the zinc plate, thereby creating an exact copy of the original line art on the plate in a coating that was a linear block-out that prohibited the acid from "biting" the drawing marks. After an initial light etch established the design on the plate, the image was surface rolled using ink and powdered rosin, and heated so that the inky material sagged a little over the edge of the line, thus protecting the side planes of the raised lines. The plate was

re-etched, rerolled, and heated, and then re-etched, and so on, until there was acceptable definition between the top relief level and the recessed areas where the acid had eaten away the negative spaces that were not going to print. There were no tonal gillotages, since halftones were not perfected until the 1880s (*see Chapter 18, Theme Box 37, "Halftone and Rotogravure"*).

Further Reading
Béguin, André, "Gillotype," A technical dictionary of printmaking, http://www.polymetaal.nl/beguin/mapg/gillotype.htm

(Figure 14.17). Though it lasted only twelve issues, *L'Image* showcased art from some of the most prominent illustrators of its day, including Lepère, Vierge, Toulouse-Lautrec, Pissarro, Grasset, Latour, Mucha, and several others (*see Chapter 15*).

The Emergence of Illustration in North American Print Media in the Mid-Nineteenth Century

In America, as in Europe, by 1830 technological advances resulted in the rapid expansion of the printing industry. Population had more than tripled since the first census in 1790, and improvements in literacy created a burgeoning reading public with a desire for self-improvement. An explosion of printed imagery could be found not only in books devoted to fiction and history along with newspapers covering current events, but also in magazines, which served to bridge the two. During the antebellum years, American entrepreneurs looked to British publishing models such as the *Illustrated London News*.

America's most widely read illustrated periodical was *Harper's Monthly*; initially launched by the printing company Harper & Brothers as a means to publicize and stimulate book sales (*see also Chapter 18*). Founded in 1817 as J. & J. Harper by two American brothers, James (1795–1869) and John Harper (1797–1875), the firm was joined by their siblings Joseph Wesley (1801–1870) in 1823, and Fletcher (1807–1877) in 1825, and rechristened Harper & Brothers. Though profitable, it was not until youngest brother Fletcher was brought on as editor that

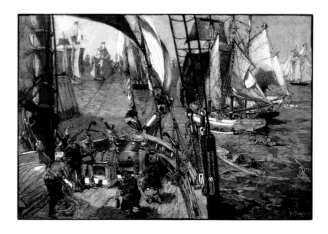

Figure 14.17
Auguste Lepère, "Our Ports, Dunkerque—Departure of Icelandic fishing vessels," in *Le Monde Illustré*, April 12, 1884.
As a major contributor to *Le Monde Illustré* as both an engraver for other artists and as a creator of his own images, Lepère founded the Société des Graveurs sur bois (Society of Wood Engravers) in 1897.
Courtesy of Brian M. Kane.

the company expanded to encompass a wider range of ventures, with the firm recognized by mid-century as the world's largest printing and publishing firm. Founded in 1850 as a literary periodical and conceived as a "feeder" to the publishing house, *Harper's Monthly*'s popularity as a family magazine was propelled by its serialization of well-known British novels, accompanied by illustrations.

Motivated by the success of *Harper's Monthly*, Fletcher Harper published the first issue of *Harper's Weekly* in 1857. It was a complement to its more literary predecessor with a larger 11× 16" size and sixteen-page

format. As in Europe, both Harper & Brothers' periodicals took advantage of new techniques emerging in the woodblock printing process that allowed them to produce large, complex images on tight publication deadlines (*see Theme Box 30*).

In its early years, *Harper's Weekly* took a moderate editorial stance on slavery and the turbulent issues of its day, but by 1861, with the outbreak of the Civil War, its political imagery supported Lincoln, the preservation of the Union, and the Republican Party. Illustrations by *Harper's* two most prominent artists, Winslow Homer (American, 1836–1910; *see Chapter 13*) and Thomas Nast (German naturalized American, 1840–1902) provided Americans with extensive coverage of the political, military, and social aspects of the conflict.

Some images depicted specific locations and battle scenes and spoke to the progress of the Union Army in its engagement with the Confederates (Figure 14.18a). Others, such as the mélange of genre vignettes in his illustration celebrating Emancipation by Thomas Nast, put a more human face on the reasons behind the strife (Figure 14.18b).

Recognized as one of the nation's most prominent painters of the nineteenth century, Homer began his career as freelance illustrator, working primarily for *Harper's Weekly* from 1857 to 1875. Sketching at the Union front for months as a **special artist**, or simply "special" (*see Figure 13.15 in Chapter 13*) on assignment for the *Weekly*, Homer captured the essence of warfare in his illustrations. As seen in *Sharpshooter*, Homer's action-packed reportage images of the Civil War did not merely complement the text, but came to define the way many Americans understood the conflict (Figure 14.19). Homer's ability to simplify and abstract a larger idea made his illustrations both readable and aesthetically pleasing (Figure 14.20).

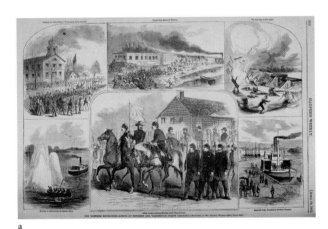

a

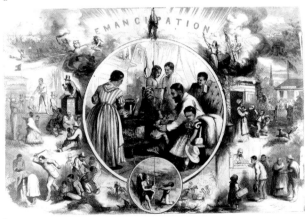

b

Figure 14.18a, b
Angelo Wiser, "Illustrations of the Civil War in eastern North Carolina," in *Harper's Weekly*, April 19, 1862, p. 252; Thomas Nast, "The Emancipation of the Negroes, January, 1863—The Past and the Future," in *Harper's Weekly*, January 24, 1863.
Both illustrations represent not only the sophisticated imagery being produced for *Harper's Weekly*, but also the important ways in which these images provided visual symbols and stories, and propaganda and politics, to the American (Union) citizens who desired to understand the tactical and societal aspects of the national conflict.
Courtesy of Columbia University Library.

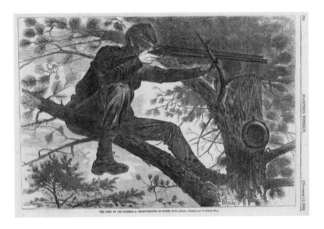

Figure 14.19
Winslow Homer, "The Army of the Potomac—A Sharp-Shooter on Picket Duty," in *Harper's Weekly*, November 15, 1862.
Homer's image of the sharpshooter depicted the advanced telescopic sights recently developed for rifles that improved accuracy and range. The image boosted readers' confidence that the war would be short and decisive based on this new type of soldier and his deadly aim.
Boston Public Library.

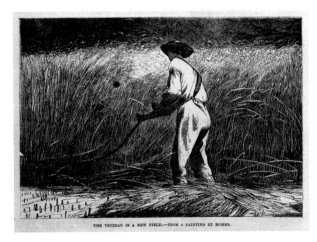

Figure 14.20
Winslow Homer, "Veteran in a New Field," in *Frank Leslie's Illustrated Newspaper*, July 13, 1867.
Homer's iconic depiction of a veteran returning to the normalcy of farming made Biblical references to the end of the war. The image was also regarded as an emblem of the bloodiest conflict in the nation's history, with the soldier/farmer seen as the reaper of death.
Courtesy of Columbia University Library.

Homer's work documented topical events and trends, and he was also commissioned to illustrate specific passages for popular literature. His illustrations were often of topics he explored in his oil paintings such as his iconic *Snap the Whip*, which captured American youth at play and reflected the changing attitudes of the era toward childhood and the nostalgia for pre-war simplicity (Figure 14.21).

Homer also provided descriptive images of the lives of post–Civil War women and their rapidly changing customs, fashions, and values, portraying female "types" that ranged from hardworking farm girls to sociable urban matrons (*see Chapter 11, Theme Box 20, "Phrenology"*). His depictions of recreation and coastal resorts captured the new manners and mores of the period that revealed the prevailing genteel tastes, interests, and diversions of the urban middle class. By transforming this wide variety of imagery into oil paintings and watercolors, Homer was able to increase his audience to include both the general public and elite patrons, using the power of illustration to expand his reputation (Figure 14.22).

Harper's Weekly developed a substantial art department to facilitate the rapid production of woodblocks for printing graphic reportage and, quite notably, the political cartoons of Thomas Nast—arguably the most influential American illustrator in the mid-nineteenth century. Nast's work not only substantially increased *Harper's Weekly's* circulation and prestige, but also had a significant impact on public opinion and political events: both Lincoln and Grant credited his work with supporting the Union troops and ultimately ending the Civil War. Nast created or helped standardize many characters and symbols that remain with us today, including the Republican elephant and Democratic donkey, Uncle Sam, Santa Claus, the Tammany Tiger, and Columbia, the female personification of the United States (Figure 14.23).

Nast attacked the corruption of the political boss William Marcy Tweed, who controlled New York politics through the infamous Democratic political organization Tammany Hall. In one memorable caricature, the Tammany Tiger (Figure 14.24) devours Lady Liberty in the Roman Coliseum, while Tweed as Roman emperor, surrounded by his elected cronies, looks on with approval.

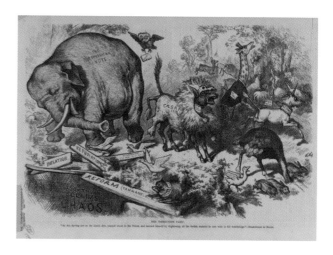

Figure 14.23
Thomas Nast, "The Third Term Panic, An ass, having put on the Lion's skin roamed about in the forest, and amused himself by frightening all the foolish Animals he met with in his wanderings," in *Harper's Weekly*, November 7, 1874. This image alluded to trumped-up rhetoric condemning Ulysses S. Grant's potential run for a third term. It is the first of Nast's images that linked the Democratic and Republican parties to the symbols of donkey and elephant.
Courtesy of Columbia University Library.

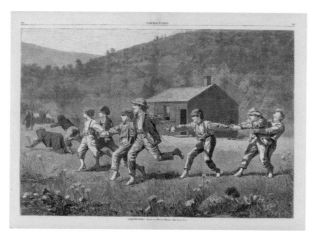

Figure 14.21
Winslow Homer, *Snap the Whip*, oil painting reproduced in *Harper's Weekly*, September 20, 1873. Demonstrating the new post–Civil War importance attached to the innocence of play, Homer's image of young adolescents outside of a country schoolhouse also speaks to the competitive nature of boyhood.
Courtesy of Columbia University Library.

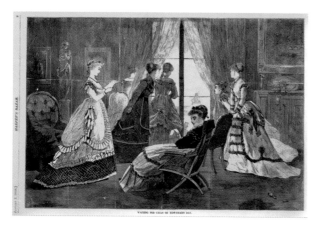

Figure 14.22
Winslow Homer, "Waiting for Calls on New-Year's Day," in *Harper's Bazaar*, January 2, 1869, p. 9.
The Civil War led to substantial changes in the lives of women, providing Homer with numerous "types" that he portrayed throughout the decade after the conflict. Here, Homer captures urban women's fashions and social mores as they await their suitors.
Courtesy of Columbia University Library.

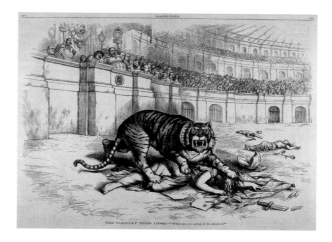

Figure 14.24
Thomas Nast, "The Tammany Tiger Loose—'What are you going to do about it?'" in *Harper's Weekly*, November 11, 1871.
Nast, whose own work included history painting, often referred to Neoclassical paintings and European architecture in making points about American politics and culture.
Courtesy of Columbia University Library.

Effective in swaying public opinion, Nast's relentless illustrations are often credited with the downfall of Tweed, who lost the election in 1871 (Figure 14.25). During the late nineteenth century, Nast continued to create images that were often associated with radical, reformist views that soon fell out of favor with the publishers of Harper & Brothers, whose emphasis shifted toward aesthetic, genteel illustrations in both the *Weekly* and the *Monthly*.

Illustrators for Harper & Brothers such as Edwin Austin Abbey (American, 1852–1911) (Figure 14.26) and Charles S. Reinhart (American, 1844–1896) embodied the new engagement with culture and urbanity, responding to readers' engagement with events such as the 1876 Centennial and their desire to put the violence and animosity associated with the war years and thus Nast's images behind them. Nast continued to provide cartoon illustrations for *Harper's Weekly* until his untimely death from yellow fever, contracted in Ecuador while serving as the United States' Consul General as an appointee of President Theodore Roosevelt.

Frank Leslie's Illustrated Newspaper

The only major competitor to Harper & Brothers' magazines was *Frank Leslie's Illustrated*. Founded in 1855, the publication set the standard for American graphic journalism and in fact introduced the oversized, sixteen-page format that was later adopted by *Harper's Weekly*. Although decidedly less refined, *Frank Leslie's Illustrated* provided illustrations and reports on topics ranging from war and politics to fine art and travel. Having trained as an

illustrator and later appointed superintendent of engraving at the *Illustrated London News*, Frank Leslie (born Henry Carter, British naturalized American, 1821–1880) came to America in 1848, and is credited with introducing the use of "overlaying," a system of regulating light and shade effects in the printing of wood engravings that *Harper's* also adopted. By 1860, Leslie had become one of the most prominent of the new magazine publishers in America due to the popularity of his publication's pictorial "eye-witness" accounts. *Frank Leslie's Illustrated* covered sensational topics as well as the seamier events of urban life, with illustrations depicting scenes and victims of notorious crimes, cheap amusements, and violent sporting competitions (Figure 14.27).

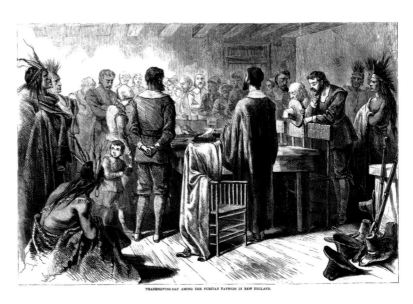

Figure 14.26
Edwin Austin Abbey, "Thanksgiving-Day Among the Puritan Fathers in New England," in *Harper's Weekly*, December 3, 1870, p. 781.
Abbey's illustration of the First Thanksgiving speaks to *Harper's* intention to engage its readers with more genteel topics, such as the Colonial Revival, reflecting the preference of less overtly confrontational imagery.
Courtesy of the Fleet Library at Rhode Island School of Design, Special Collections, Providence, Rhode Island.

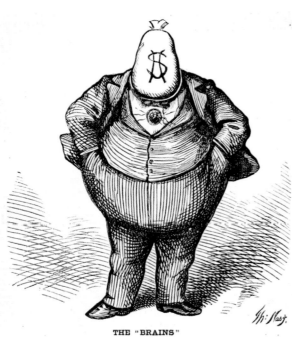

THE "BRAINS"
THAT ACHIEVED THE TAMMANY VICTORY AT THE ROCHESTER DEMOCRATIC CONVENTION.

Figure 14.25
Thomas Nast, "The 'Brains' That achieved the Tammany victory at the Rochester Democratic Convention," in *Harper's Weekly*, October 21, 1871. Nast uses the dollar sign as a face on the moneybag head. Tweed's corpulent body with his oversized jeweled shirt-stud was recognizable even without features.
Courtesy of Columbia University Library.

Figure 14.27
Anonymous, "The dog pit at Kit Burns' during a fight," in *Frank Leslie's Illustrated Newspaper*, December 8, 1866, p. 181.
Dogfights would have been considered low-class entertainment, as is indicated by the appearance of the perpetrators and the crowd.
Courtesy of American Social History Project.

Soon after the onset of the Civil War, *Frank Leslie's Illustrated* became a vigorous supporter of the Union. The conflict gave the publication heightened stature and importance, as its more graphic images served as barometers of public opinion regarding the events of the war and Reconstruction (Figure 14.28). As readers began to prefer more "cultural" topics by the mid-1870s, however, *Frank Leslie's Illustrated's* circulation declined while the more genteel monthly magazines with abundant illustrations rose in popularity (*see Chapter 18*).

Graphic Journalism at the End of the Nineteenth Century

In the 1880s, wood-engraved art began to be systematically replaced by photography and **halftone**, a system for reproducing tonal images by breaking up the image into a series of dots (*see Chapter 18, Theme Box 37, "Halftone and Rotogravure"*). In 1886, conservative figures for book production were 4,676 in the United States; 5,210 in Great Britain; and 16,253 in Germany. There were an estimated 15,000 magazines in the United States, and another rapid acceleration was underway in the proliferation of newspaper titles. By 1900, New York City had fifteen daily newspapers; and even territories that were not yet states, such as Oklahoma, saw the production of nine dailies and almost a hundred weekly newspapers.

Photographs soon became the dominant image form, and by the early twentieth century, photojournalism accounted for much imagery in the newspapers—with the exception of scenes depicting movement too rapid to be captured by the still slow exposure times of most film. In an effort to stay competitive, some illustrators turned to realistic gouache or black-and-white watercolor wash paintings that looked like photographs and could be easily reproduced using the same halftone screens. The softer wash paintings were quick to make but did not have the impact of their high-contrast black-and-white predecessors.

By comparison, others realized the potential of the new technology and the needs of the altered business environment: circulation battles were won in part by having illustrators with the ability to refine a story to its visual essence with speed and individualized draftsmanship. A new style therefore emerged, typified by swift strokes capturing moments in time, subtleties of character, and the unique hand of the artist (Figure 14.29). World-class celebrity sketch artists emerged from San Francisco (Henry Raleigh, American, 1880–1944), Chicago (Frederick Richardson, American, 1862–1937), Boston (Harry Grant Dart, American, 1869–1938), Sydney (Norman Lindsay, Australian, 1879–1969), and London (Phil May, English, 1864–1903), to name a few.

The largest cities, especially New York and Philadelphia, were the hottest centers of activity in the United States. An extraordinary pool of talent coalesced around the *Philadelphia Press* in the mid-1890s, which included William Glackens (American, 1870–1938), John

Figure 14.28
"North Carolina–'The Ku-Klux Klan'—Plan of the contemplated murder of John Campbell, on August 10th, 1871, in Moore Country," in *Frank Leslie's Illustrated Newspaper*, October 7, 1871, p. 60.
Graphically presenting the terror of the Klan, this illustration of an attempted execution is indicative of *Leslie's* willingness to include images of violence and oppression in the aftermath of the Civil War.
Courtesy of American Social History Project.

Figure 14.29
Phil May, illustration in *East London* by Walter Besant, 1901.
Like many others who became prominent in the 1890s, English illustrator and caricaturist Phil May became a celebrity by developing a recognizable autographic style to humorously portray all levels of society.
Providence Public Library.

Sloan (American, 1871–1951), George Benjamin Luks (American, 1867–1933), Everett Shinn (American, 1876–1953), May Wilson Preston (American, 1873–1949), Charles D. Mitchell (American, 1885–1940), and Frederic Rodrigo Gruger (American, 1871–1953). Many of these illustrators were simultaneously studying painting with Robert Henri (1865–1929) at night (*see Chapter 18, Theme Box 39, "Education"*).

The most radical of these artists—politically and artistically—later exhibited canvases in the breakthrough show The Eight (1908) and in the International Exhibition of Modern Art better known

as The Armory Show (1913). They are remembered primarily as painters known as the **Ashcan School** for their gritty, realist depictions of urban working-class life. Yet dozens of others flourished within the constraints of magazine publishing and illustration after their newspaper years were over. Frederic Rodrigo Gruger, for example, produced thousands of drawings for the *Saturday Evening Post* (Figure 14.30), and was selected to write the definitive essay on illustration for the *Encyclopedia Brittanica* in 1929. His prominence among the Philadelphia artists has led many to consider them collectively as the **School of Gruger**.

One would expect photography and halftones to have immediately decimated the ranks of illustrators, just as the wood engravers had been put out of work by new photo processes. But the demand for illustrative art only increased, as monthly magazines featuring fiction flourished, and newspapers themselves began to feature editorial text, sports, and cartoons, as well as weekend magazines—sometimes called the **roto section** after the new high-speed rotogravure printing presses (*see Chapter 18, Theme Box 37, "Halftone and Rotogravure"*)—replete with serialized stories, poems, and puzzles. Fed by technological developments that continued to free artists to work in new ways and splintering into subgenres such as comics, reportage, and posters, illustration at the end of the nineteenth century widened its modes of expression beyond its traditionally literal, academic visual vocabulary. Top illustrators had great control over their material, with the ability to choose the passages to illustrate in assigned texts and develop page layouts, while as "special artist" journalists they enjoyed a free hand in exploring their subjects.

Conclusion

Placed in a historical context, illustrated newspapers and magazines demonstrated society and its spectacle in vivid detail, conveyed in low-cost, mass-produced, widely distributed, disposable print commodities that interpreted the world through the eyes of graphic artists rather than camera lenses. The cultural and aesthetic impact of the illustrated press cannot be overemphasized. Though unintentional, illustrated newspapers and magazines were the first art primers for underprivileged art students, and a major source for the proliferation of artists' images in the latter half of the nineteenth century. The practices of utilizing foreign correspondents and sharing the fruits of their labor between publications were established in this period, and iconography created by nineteenth-century graphic journalists remains influential today.

FURTHER READING

de la Motte, Dean, and Przyblyski, Jeannene M. (Eds.), *Making the News: Modernity & the Mass Press in Nineteenth-Century France* (Amherst: University of Massachusetts Press, 1999).

Figure 14.30
Frederic R. Gruger, illustration for "Cousin Egbert Intervenes," by Harry Leon Wilson, *The Saturday Evening Post*, June 24, 1916, p. 3. Carbon pencil and watercolor, 9 ³/₄ × 13".
Gruger used a cheap, industrial sort of paper-board favored by newspapers. When it caught on with other illustrators, an art manufacturer soon distributed a similar sort under the moniker "Gruger Board," proof of his influence.
Courtesy of Illustration House.

KEY TERMS

annuals	literary news illustrators
Ashcan School	roto section
correspondent	School of Gruger
flâneur	special artist
gillotage	Stamp Tax
graphic journalist	wood engraving
halftone	

De Shazo, Edith, *Everett Shinn, 1876–1953, A Figure in His Time.* (New York: Clarkson N. Potter, Inc., 1974).

Harper's New Monthly Magazine, vol. LXXV, July, 1887.

Hogarth, Paul, *The Artist as Reporter* (London: Studio Vista, 1967).

Hungerford, Constance C., *Ernest Meissonier: Master in His Genre* (Cambridge: Cambridge University Press, 1999).

Jackson, Mason, *The Pictorial Press Its Origin and Progress* (London: Hurst and Blackett, 1885).

Pennell, Joseph, *The Graphic Arts* (Chicago: University of Chicago Press, 1921).

_____ *Modern Illustration* (London: George Bell & Sons, 1895).

Zurier, Rebecca. *Picturing the City: Urban Vision and the Ashcan School* (Berkeley: University of California Press, 2006).

15

Beautifying Books and Popularizing Posters in Europe and America, 1855–1910

Susan Ashbrook and Alison Syme

With the mechanization of the printing industry, the spread of literacy, and the invention of artificial light, the availability of printed materials grew enormously during the nineteenth century. In response to a growing demand for pictures, artists provided illustrations for books and new pictorial periodicals. Some designed illustrations as a lucrative sideline to their more prestigious careers as painters; for others, illustrating was their only profession, one through which considerable fame might be achieved.

This chapter explores aspects of the new profession of illustration during the Victorian period, with particular emphasis on Britain. Beginning with the Pre-Raphaelite artists during **the Sixties** (about 1855–1875), we see a reconfiguration of the relationship between the artist/illustrator and the skilled professional wood engravers who translated drawings into relief images that could be printed with text. The challenges of that relationship (*see Chapter 14, Theme Box 30, "Wood Engraving"*) encouraged a new attention to books as potential objects of art, leading to the founding of several small-scale **private presses** in the last years of the century. For many of these presses, illuminated manuscripts and fifteenth-century printed books provided visual models, and a strong medievalizing tendency in their designs ties them to earlier impulses in the art of the Pre-Raphaelites. At the same time, this new awareness led in a different direction with the Aesthetic movement, toward sparer, Japanese-inspired or eclectic works of book design and illustration, the meaning and morality of which were hotly contested. Toward the end of the century, artists experimented with new industrial printing processes, resulting in eye-catching styles suitable for advertising in the form of the poster. Increasing communications between Europe and North America, and commercial demand from an ever-expanding mass audience, meant that artists associated with the Art Nouveau and Poster Movements stimulated and responded to artistic innovations in an international milieu.

The Pre-Raphaelite Illustrators and Arthurian Themes

The years between 1855 and 1870, referred to as the Sixties, are seen as a highpoint in Victorian wood-engraved illustration. Images produced by the Pre-Raphaelites were especially influential. The **Pre-Raphaelite Brotherhood** was formed in 1848 by a small group of young artists, including Dante Gabriel Rossetti (English, 1828–1882), John Everett Millais (English, 1829–1896), and William Holman Hunt (English, 1827–1910), who were profoundly influenced by the ideas of critic and theorist John Ruskin (English, 1819–1900). Rejecting what they saw as tired **academic** tradition based on classically influenced sixteenth-century models (*see Chapter 12*), they embraced a simpler and, in their view, more sincere style, inspired by close observation of nature, and by late medieval paintings and illuminated manuscripts. They favored themes from scripture and English literature, legends of King Arthur, Shakespeare, and Romantic poetry in particular. Often they inscribed the frames of their paintings with poetic texts to enhance the sometimes veiled meaning of the depicted action. Images of women

dominate Pre-Raphaelite art: chaste, desirable, fallen, dutiful, or mysterious, they reflected and shaped the ideals of femininity that many social and economic changes were challenging.

The Pre-Raphaelites' literary tastes primed them to illustrate the books of poetry that were popular publications of the day. They eschewed the lightly printed, decorative, or atmospheric "vignette" style typical of the previous generation of illustrators in favor of a style reminiscent of woodcuts from the first century of printing, but also informed by the syntax of early photography. Their images typically focus on one or several large central figures posed to express a dramatic defining moment of the narrative in a flattened and compressed pictorial space. In their illustrations, as in their paintings, symbolic elements enrich the meaning of the action.

Rossetti, the Dalziel Brothers, and "The Maids of Elfen-mere"

The Pre-Raphaelites made new claims for the illustrator's role, asserting that their designs were equal to the texts they were interpreting. This demand is demonstrated by a famous dispute between Rossetti and the engravers, the celebrated Dalziel Brothers (*see Chapter 14*), over his first and perhaps finest illustration, "The Maids of Elfen-mere," for William Allingham's *The Music Master* (1855) (Figure 15.1). Rossetti was highly dissatisfied with the engraving of his design, charging the Dalziels with making his drawing unrecognizable. They in turn protested that the artist was

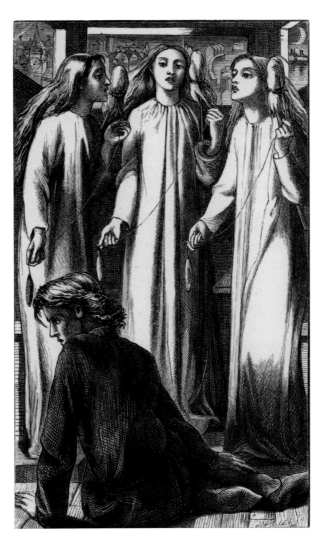

Figure 15.1
Dante Gabriel Rossetti, "The Maids of Elfen-mere," in *The Music Master* by William Allingham, published by Routledge, 1855. Wood engraving, 4 7/8 × 3". Rossetti's compressed scene captures the other-wordliness of the mysterious maidens "Spinning to a pulsing cadence, / Singing songs of Elfin-Mere," and the psychological torment of the young man who, "Listening to their gentle singing, / Felt his heart go from him, clinging."

Thomas Fisher Rare Book Library, University of Toronto.

"altogether unacquainted with the necessary requirements in making a drawing for the engraver's purposes," his pencil, chalk, and ink wash drawing "producing a very nice effect but being quite unsuitable for translation into black and white." But because Rossetti drew his design directly onto the woodblock (standard practice until photographic methods of transfer were introduced early in the next decade), we have no original drawing against which to judge either claim.

Despite Rossetti's dissatisfaction, "The Maids of Elfenmere" became one of the most influential illustrations of the period. William Allingham's (Irish, English, 1824–1889) poem is a melancholy fairytale of mystery and frustrated love, a favorite Pre-Raphaelite theme. Rossetti masterfully telescopes the narrative into a single scene and makes the setting at once real and imaginary. The nightly nocturnal apparition of three white-clad maids singing as they spin enchants a pastor's son, who, obsessed, tries to trick them, with tragic results. The simple rhythm of the trio, standing erect like Gothic jamb statues, evokes Allingham's verbal repetition. Seated at their feet but seemingly in a different realm, the silhouetted figure of the despondent young man twists away from the vision. Behind the maidens' heads lies the view where the story plays out: the tiny walled town with its fateful clock tower, and the moonlit water where the maids meet their mysterious end.

The Moxon Tennyson and Stylistic Disunity

The best-known publication to showcase Pre-Raphaelite illustrations was Tennyson's *Poems*, published in 1857 by Edward Moxon (English, 1801–1858). Directed at a principally female market, the "Moxon Tennyson" (as it is frequently called) is an example of a new kind of publication, the illustrated **gift book**, offered as an object of display for middle-class Victorian parlors. Alfred, Lord Tennyson (English, 1809–1892), poet laureate of Britain since 1850, was at the height of his popularity, and Moxon ambitiously commissioned fifty-four illustrations from eight artists, including Rossetti, Millais, and Hunt. Because of a diversity of artistic styles, the book lacks visual unity and was at first a commercial failure, but the Pre-Raphaelite contributions are considered to be among the finest illustrations of the Sixties.

The prevalence of female subjects in Tennyson's early poems made them particularly attractive to the Pre-Raphaelites. Millais's illustration for "Mariana" (Figure 15.2) reprises a subject he had explored earlier in a large, richly colored and detailed painting of 1851. Tennyson's poem tells of a woman, abandoned by her lover, isolated in "a lonely moated grange." Millais shows Mariana collapsed in despair before the window through which she has been gazing in futile hope of her beloved's arrival. The disjunction of scale between the figure and her cramped chamber communicates her physical and psychological imprisonment and enhances an archaic quality that is reminiscent of images from early printing.

An important subgroup of poems in the collection was inspired by the legend of King Arthur, which Tennyson had done much to popularize. During the early Victorian period, the chivalric epic of the Knights of the Round Table had been claimed as a symbol of national pride and idealized manliness. For the Pre-Raphaelites, however,

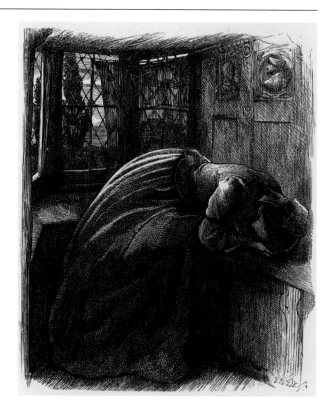

Figure 15.2
John Everett Millais, "Mariana," in *Poems* by Alfred Tennyson, published by Edward Moxon, 1857. Wood engraving, 3 $^5/_8$ × 3 $^1/_8$".
Mariana's pose instantly communicates the hopeless despair expressed in Tennyson's repeated refrain: "She only said, 'My life is dreary, / He cometh not,' she said; / She said, 'I am aweary, aweary, / I would that I were dead!'"
Thomas Fisher Rare Book Library, University of Toronto.

the legend's appeal lay in the poetic settings and poignant love stories of Arthur, his knights, and fair ladies. Hunt and Rossetti both supplied illustrations for "The Lady of Shalott," another tale of female confinement and unfulfilled longing. The poem's tragic narrative unfolds when the Lady unleashes a mysterious curse that has confined her alone on the island of Shalott, restricting her experience of the outside world to its reflection in a mirror. Hunt chose the catastrophic moment when the Lady, yielding to temptation, springs up from her loom to gaze directly upon handsome Lancelot riding past below (Figure 15.3). As the mirror shatters, her figure is ensnared by yarn unraveling from her tapestry, her passionate awakening revealed by her wildly animated proto–Art Nouveau hair. The image of the crucified Christ hanging to the right of the mirror (not mentioned in Tennyson's poem) imparts a moralizing message of abandonment of duty, a recurrent theme in Hunt's art and one that he explored later in a painting of the same subject.

Rossetti interprets the final scene of the ballad in a hermetic and claustrophobic illustration. The Lady has abandoned her prison and cast herself adrift in a boat (Figure 15.4). By the time it washes up along the wharves of Camelot, she has succumbed to death. Lancelot, unaware of his part in this tragedy, stoops to gaze down at the peaceful corpse, musing that "she has a lovely face." Onlookers crowd behind Lancelot to gawk, their heads boldly cropped by the image's upper border. Beneath the walkway we catch a glimpse of swans floating in the river, an emblem of the Lady's soul now set free.

Rossetti's densely worked surface and angular composition are at odds with Hunt's sinuous line and fluidly posed figure. His Lady does not even look like the same woman: her pale, delicate face and tamed tresses, modeled on Rossetti's wife, the artist Lizzie Siddall, contrast with the sultry features and sensuous pose of Hunt's figure. Nevertheless, both illustrations imply a message that unleashed female sexual desire leads to tragedy.

Tennyson, who believed that "an illustrator ought never to add anything to what he finds in the text," disliked Hunt's and Rossetti's illustrations, complaining that their visual interpretations did not truly reflect his poems. Rossetti, with the support of Ruskin, asserted the independence of the illustrator when he wrote of seeking subjects where one could "allegorize . . . the subject of the poem without killing . . . a distinct idea of the poet's."

Ruskin and Rossetti staked out a new role for the illustrator. The Pre-Raphaelite artists, while steeped in literature, offered in their illustrations a new interpretative model of verbal-visual interaction that challenged the exclusive authority of the author and validated the autonomy of the reader's imagination. This shift had far-reaching implications for a rise in status for artistically ambitious illustration within the hierarchy of the visual arts.

Dürer's Legacy: Frederick Sandys

Although Frederick Sandys (English, 1829–1904) was not a member of the Pre-Raphaelite Brotherhood, his illustrations share their style and preferences in subject matter. Rossetti was a particular influence, especially his psychologically charged female characters. Sandys' illustration work appeared almost exclusively in magazines and, more than other artists in his circle, he embraced the technical constraints of drawing for translation into wood engraving. His symbol-laden compositions reflect his admiration for Dürer, widely esteemed in Pre-Raphaelite circles. "Until Her Death" (Figure 15.5), for a poem published in the religious monthly *Good Words* in 1862, is one of a number of Sandys' images to explore the theme of death. A young woman in sixteenth-century costume rests chin on hand in a pose borrowed from Dürer's magisterial *Melencolia I* engraving of 1514 (*see Chapter 2*) to meditate before a skeleton. Wearing a nun's wimple, the skeleton invites her to choose between chastity, in the form of a nun's habit, or marriage and motherhood, symbolized by a bridal veil draping over a crib bearing a beribboned baby's rattle. The hourglass he brandishes makes clear that whichever path she chooses, death will be the inevitable outcome. Behind the strongly defined figures lies a detailed landscape of water meadows that Sandys drew directly from observation, in accordance with the Pre-Raphaelite ideology of truth to nature.

The illustrators of the Sixties were much admired by the artists of the 1890s. But by the last two decades of the century, reproductive facsimile wood engraving of the kind practiced by the Dalziels had been made obsolete by photo-mechanical "process" that reproduced artists' designs cheaply and accurately (*see Chapter 13, Theme Box 26, "Mass Production Plates and Printing Forms"; and Chapter 18, Theme Box 37, "Halftone and Rotogravure"*). This technical advance fundamentally changed illustration, as will be shown later in this chapter.

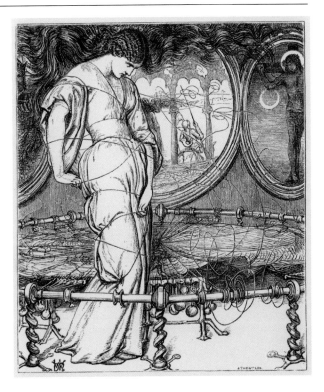

Figure 15.3
William Holman Hunt, "The Lady of Shalott," in *Poems* by Alfred Tennyson, published by Edward Moxon, 1857. Wood engraving, 3 ⁵/₈ × 3 ¹/₄".
The suppressed sexuality of Hunt's sultry maiden owes more to Baroque goddesses than to the fifteenth-century models generally preferred by the Pre-Raphaelite artists at this date. A moralizing note is provided by the image of the crucified Christ.
Thomas Fisher Rare Book Library, University of Toronto.

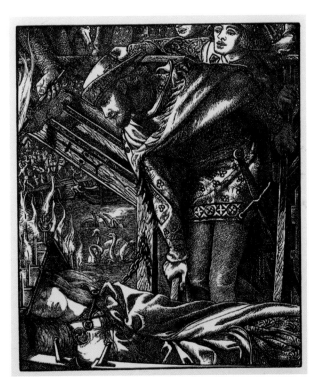

Figure 15.4
Dante Gabriel Rossetti, "The Lady of Shalott," in *Poems* by Alfred Tennyson, published by Edward Moxon, 1857. Wood engraving, 3 ⁵/₈ × 3 ¹/₈".
Rossetti's dense composition contrasts stylistically with Hunt's for the same poem. Criticism of the Moxon Tennyson's stylistic diversity encouraged more attention to artistic unity in later publications.
Thomas Fisher Rare Book Library, University of Toronto.

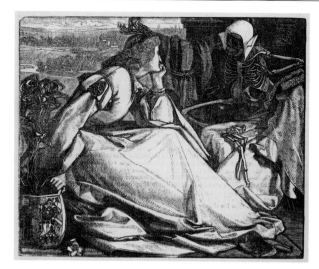

Figure 15.5
Frederick Sandys, illustration for "Until Her Death," *Good Words*, October 1862. Wood engraving, 4 ¹/₈ × 5 ¹/₈".
The influence of Dürer and Rossetti is apparent in much of Sandys' work. Unlike Rossetti, Sandys embraced the technical constraints of drawing for reproduction.

Robarts Library, University of Toronto.

The Arts and Crafts Book and "The Revival of Wood Engraving"

Although Britain in the Victorian age was at the forefront of the industrial manufacture of consumer goods, many tastemakers argued that the design of most products was woefully inferior. To educate the public, architect and theorist Owen Jones (Welsh, English, 1809–1874) and Prince Albert, Queen Victoria's consort, led the charge to found in 1852 a national museum of decorative arts, the South Kensington Museum, later renamed the Victoria and Albert Museum. Growing out of this design reform initiative, in conjunction with Ruskin's ethos of handwork's redemptive power, the **Arts and Crafts Movement** began to advocate for a return to traditional handcrafts and the elevation of the decorative arts to a status equal to that of painting and sculpture in the 1880s. This movement remained influential well into the twentieth century in illustration, design, and architecture.

Printing was a natural target of design reform. Despite the high quality of much Sixties illustration and the fashion for gift books, design theorists felt that commercial printing had generally fallen to a low standard, with little attention paid to unified design of page layout, typography, and binding. The Moxon Tennyson with its mix of different styles of illustration is an example. Some advocated the return to traditional methods of printing and book production. In the 1890s numerous small private presses sprang up, typically independently owned, employing proprietary typefaces and a variety of decorative styles, layouts, and bindings, printing by hand small editions of five hundred copies or fewer.

Central to private press ideology was a desire to counter the deterioration of page design that was blamed on "process" printing. Wood engraving was revived as an autograph technique, returning to printing's historical origins. According to design reformists, the type-compatible relief process promoted harmonious page design because letterpress and ornaments were printed at the same time. Moreover, to avoid the kind of dispute that Rossetti had

with the Dalziels, the artist and engraver could be one and the same, although in practice that was often not the case.

William Morris, Edward Burne-Jones, and the Kelmscott Press

William Morris (English, 1834–1896), designer, poet, and socialist campaigner, is a key figure in late nineteenth-century printing. A passionate follower of Ruskin, he believed that art is an expression of joy in labor and that a return to the spirit of craftsmanship could reform society. His highly successful design firm, Morris & Co., produced textiles, wallpaper, furnishings, and stained glass, putting Ruskin's philosophy into practice and influencing taste in Britain and beyond. Because he was a book connoisseur and collector, printing was a natural area for Morris to turn his attention. In the last decade of his life, he undertook his final project, the Kelmscott Press (1891–1898), with the aim of printing books that were "visible works of art."

Morris's principal inspiration was the first century of printing (*see Chapter 2*). Dissatisfied with available fonts, he designed three typefaces, numerous ornamental initials, and heavy foliate borders. Kelmscott books, distinctive in their richness, were printed with hand presses on special handmade paper. Central to Morris's aesthetic was his insistence that in book design the storytelling function should never eclipse the harmony of the page.

Morris did not consider illustrations essential to "the ideal book," and many Kelmscott books did not include them; but for those that did, most were designed by his friend and colleague, the painter Edward Burne-Jones (English, 1833–1898). Burne-Jones had been deeply moved forty years earlier by Rossetti's "Maids of Elfen-mere" (Figure 15.1). Morris and he agreed that illustrations should be simple and severe, to harmonize with the typeset text. Forms should be outlined and filled in with a minimum of shading, never cross-hatched. The artist should understand the dictates of the reproductive medium and treat his relationship with the engraver as a partnership. Morris railed against the thoughtlessness of artists who supplied scribbly drawings that would take an engraver countless hours to faithfully translate on to a block.

Burne-Jones's deliberately archaizing style is evident in the double-page spread from *Troilus and Criseyde* (Figure 15.6), two of the artist's eighty-seven illustrations from Kelmscott's magnum opus, *The Complete Works of Geoffrey Chaucer*, completed shortly before Morris's death in 1896. Slender, simply draped figures occupy shallow, box-like interiors. The severity of figures and settings is offset against Morris's opulently twining borders. Burne-Jones avoids scenes of action, and his figures are barely individualized. Nothing detracts from the volume's magisterial solemnity, described by Burne-Jones as "a pocket cathedral."

The Eragny Press and Color Wood Engraving

The Kelmscott Press inspired many imitators of its signature ornamental style, but its more lasting contribution lay in the new attention it brought to the artistic book as a unified design statement. An example is the Eragny Press (1895–1914) of Lucien Pissarro (French, 1863–1944), son of

Theme Box 33: Marx: Modes of Production
by Sheena Calvert

In his key text, *The Communist Manifesto* (1848), political theorist Karl Marx (German, English, 1818–1883) addresses *modes of production*—the ways in which a society organizes itself in terms of economic activity. The larger part of Marx's political theories rest on a simple observation that has profound consequences: capitalism creates a society that is unequal, where some people profit while others do not. Marx sought to expose the negative effects of capitalism and the industrialization of labor and production to ultimately erase inequity between classes and return power to workers.

In Marx's lifetime, the English Industrial Revolution (approximately 1750–1840) and advanced capitalism had caused a drastic transformation of traditional trades and quality craftsmanship into dehumanizing factory work, at the same time as populations moved from rural lands to cities. For workers, this resulted in impoverishment, social ills, loss of traditional ways of life, and diminishment of rights and dignity.

Critical of capitalism being driven by the market and concerned only with the production of commodities that could be sold for a profit, Marx theorized that consumer products become the dominant aspect of social relationships. At the same time, human beings and their relations become objects in the process of both manufacturing and trading those products; Marxists call this objectification *reification*. Marx argued that reification resulted in workers' psychological detachment from the products of their labor, and loss of purpose in life, a phenomenon he termed **alienation**. He identified alienation as being particularly corrosive in its effects on society.

Marxist political theory supports and informs many of the ideas of a wide range of critical thinkers whose work is reflected in other Theme Boxes within this book, such as Adorno, Benjamin, Barthes, McLuhan, Berger, and others. Each looks at the effects of mass media and capitalism on cultural production and on the minds and material realities of human beings, reassessing the relation between modes of production and social structures as it concerns artistic production. These theorists also pose questions about the roles that art, literature, music, and so on might play in reforming capitalism. Marxism influenced the Arts and Crafts Movement (present chapter), many avant-garde artists (*Chapter 19*), and the social activist illustrators of the 1960s and after (*Chapter 26*). Artists in the latter half of the nineteenth century adopted a range of positions with respect to capitalism, some critical, some celebratory. Within the Arts and Crafts Movement, Walter Crane created illustrations championing workers' rights, and William Morris advocated a return to non-alienated, highly skilled labor, producing works like the Kelmscott *Chaucer* on hand presses. Artists associated with the Poster Movement, on the other hand, produced eye-catching advertisements that promoted commodities and consumer culture.

Further Reading
Singer, Peter, *Marx: A Very Short Introduction* (Oxford: Oxford University Press, 2001).

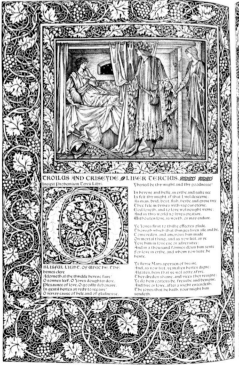
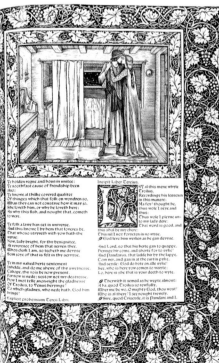

Figure 15.6
Edward Burne-Jones, "Troilus and Criseyde" (illustrations); William Morris (borders and typography); William Harcourt Hooper (engraver), in *The Complete Works of Geoffrey Chaucer*, published by Kelmscott Press, 1896. Wood engraving, 16 3/4 × 11 1/2" (leaf), The *Chaucer* was the most magnificent of all the Kelmscott books. The opulent borders and initials of the chapter openings are balanced by the typography and Burne-Jones's simple and severe wood-engraved illustrations.

Beinecke Rare Book and Manuscript Library, Yale University.

French Impressionist painter Camille Pissarro (1830–1903), whose little press was one of the few to make full use of color printing. Pissarro, who was an admirer of the color illustrations of Walter Crane, Randolph Caldecott, and Kate Greenaway (*see Chapter 16*), had moved to London in 1890 in expectation of a more sympathetic climate for his printing ambitions. With the partnership of his wife Esther, the press produced charming little books in tiny editions, mostly of French or English poetry, ornamented with delicate foliate borders (often colored), and bound in prettily patterned board covers. Many of Pissarro's illustrations echo his father's rural Impressionist scenes, but the unusually sumptuous opening page of Gérard de Nerval's (French, 1808–1855) *Histoire de la reine du matin* (1909) reflects his love of Persian and Indian miniatures and Japanese color woodblock prints in the colorful play of pattern (Figure 15.7). The trellis of the border through which roses twine is continued behind the figures in the

inset illustration, compressing the space and recalling some of Morris's wallpapers. Technically, the printing is a tour de force, combining five color woodblocks, including gold, each printed separately. The delightful initials consist of delicately colored historiated roundels entwined by a capital letter printed with gold leaf. The tiny scene contained by the letter *N* locates the turbaned queen of the tale in a pastoral landscape that is more reminiscent of northern France or England than the exotic Arabia of the story (Figure 15.8).

The Eragny Press is part of a late nineteenth-century flowering of artistic book design. Other British private presses of the time with distinctive wood-engraved illustrations include Charles Ricketts's Vale Press (1896–1903) and C. R. Ashbee's Essex House Press (1898–1910).

Illustration and Social Reform: Walter Crane

Walter Crane (English, 1845–1915), best known for his color "toy books" (*see Chapter 16*), became a socialist, like Morris, and an activist and theorist in the Arts and Crafts Movement. During the 1890s, he used his talent for illustration to produce political cartoons promoting workers' rights and social justice. These were published as a group in *Cartoons for the Cause, 1886–1896*. "A Garland for May Day" was originally published in a special 1895 May Day issue of a socialist weekly, and was also sold as a separate image for framing (Figure 15.9). Subtitled "Dedicated to the Workers by Walter Crane," it features an allegorical female figure wearing a winged Phrygian cap (a traditional emblem of freedom) and holding up a large garland. Politically progressive slogans wind around the garland and unfurl onto the grassy ground below her bare feet. Her gift of nature's beauty to downtrodden workers reflects the vision shared by Ruskin, Morris, and Crane of a Utopian society in harmony with nature.

Figure 15.7
Lucien Pissarro, title and first page, *Histoire de la reine du matin* by Gérard de Nerval, published for La Société les cent bibliophiles by Eragny Press, 1909. Color wood engraving, 8 ³/₄ × 5 ²/₃".
The Eragny Press was the sole British private press to work in full color. This sumptuous page was made by combining five color blocks printed separately in blue, pink, dark green, and gold leaf. The gold leaf was especially tricky to print because it tended to stick to the damp paper in the wrong places.
Private collection.

Figure 15.8
Lucien Pissarro, initial letter, *Histoire de la reine du matin* by Gérard de Nerval, published for La Société les cent bibliophiles by Eragny Press, 1909. Color wood engraving.
This book has twelve historiated initials, each containing a miniature scene. Pissarro's decorations play on the delicate romanticism of Nerval's tale.
Private collection.

Morris's Influence in America

The British Arts and Crafts Movement inspired similar endeavors in America, and this is especially evident in the book arts. Boston in particular, a center of publishing, had close ties with the British movement, and the Kelmscott style took strong hold there. The most magnificent American Kelmscott-inspired production is the grand *Altar Book* (1896) of Boston's Merrymount Press created for the Episcopal Church in New England, designed by Daniel Berkeley Updike, with decorations and typography by Bertram Goodhue and illustrations by British artist Robert Anning Bell (1863–1933) (Figure 15.10). Bell complemented Goodhue's heavy, emblematic borders with a sober outline style that clearly follows Burne-Jones's archaizing manner, appropriate for the volume's solemn liturgical purpose.

Although many deplored the archaism of the Kelmscott style, the heightened appreciation for high-quality, unified design that the Arts and Crafts Movement brought to books had long-lasting beneficial effects on artistic and commercial printing far beyond Britain.

Aestheticism

Many of the qualities associated with the Arts and Crafts book were equally important to the Aesthetic Movement in England. Initially inspired by the ideas of Ruskin and the Pre-Raphaelites, and developing alongside Morris's design firm in the 1860s, the first phase of **Aestheticism** emphasized social regeneration through elegant design and quality craftsmanship. The movement attained the height of its popularity between 1875 and 1885, the period in which the fashionable Grosvenor Gallery in London opened and showed works by Crane, Burne-Jones, and the painter James McNeill Whistler (American, 1834–1903); and the ideal of the "House Beautiful" was popularized by the writers Walter Pater (English, 1839–1894) and Oscar Wilde (Irish, English, 1854–1900). In this phase, Aesthetic style in interior design, fashion, book illustration, and painting became increasingly eclectic (notably through the influence of **Japonisme**, inspired by Japanese arts), and the movement, despite its socialist underpinnings, became associated with the idea of **art for art's sake** (meaning, without practical or moral purpose; *see Chapter 19*) and the privileged sphere of a cultural elite. By the 1890s, Aestheticism had become linked with artifice, perversity, and decadence, especially when one of its most vocal proponents, Wilde, was tried for "gross indecency," or homosexual acts, which at that time were illegal in Britain.

Ricketts, Wilde, and the Riddles of *The Sphinx*

The illustrations of Crane and Greenaway (*see Chapter 16*) exemplify the socialism and simplicity Aestheticism could enshrine. Charles Ricketts's "decorations" for the 1894 publication of Wilde's poem *The Sphinx*, on the other hand, embody the sensuousness, elitism, and

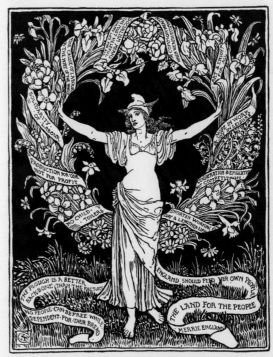

Figure 15.9
Walter Crane, "A Garland for May Day 1895," *The Clarion*, reprinted in *Cartoons for the Cause: Designs and Verses for the Socialist and Labour Movement 1886–1896*, 1896. 12 × 8 ¹/₂".
Crane and Morris were both socialists, working toward an ideal of social equality and harmony. Crane's optimism is expressed in this idealized and decorative image published both in a socialist weekly, *The Clarion*, and separately for framing.
Beinecke Rare Book and Manuscript Library, Yale University.

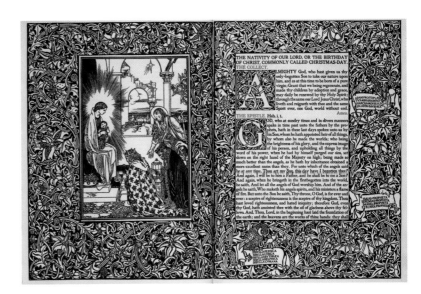

Figure 15.10
Robert Anning Bell, "Christmas" (illustrator); Bertram Grosvenor Goodhue (decorative borders and type); Daniel Berkeley Updike (designer), *The Altar Book*, published by The Merrymount Press, printed by The DeVinne Press, 1896. Wood engraving, 11 × 15" (page size).
The influence of the Kelmscott Press was widespread in Britain and overseas, especially in the United States. This Bible echoes the great Kelmscott *Chaucer*.
Trinity College Library, University of Toronto.

stylistic variety of late Aestheticism (Figure 15.11). With a print run of 200, *The Sphinx* was a luxury object, printed on handmade paper and bound in gold-stamped vellum. Ricketts's elegantly sparse scheme, which included initials as well as ten illustrations, does not dominate the 174-line poem, but rather tries to create a visual counterpoint to the text. The poem consists of a speaker questioning a sphinx—a mythical creature part lion, part woman—who has appeared in his room. The questions trace through history, first asking what the sphinx has seen and then becoming increasingly erotic and ornate in their imagery, demanding answers about ancient passions and phantasmatic couplings. Facing the page on which the speaker asks "Who were your lovers?"—and imagines a variety of animal and human partners meeting her on the reedy banks of the Nile—is an illustration in which the sphinx hovers above the river while nature-defying vegetation exhibiting phallic or feathery plumes, or knotty, whip-like tendrils conjures up a world of restless energies and monstrous growth. Ricketts's minimally framed illustrations suggest their Celtic, Japanese, and Greek sources even as they are fused into a unified decorative whole.

The Boldness of Beardsley

The short career of Aubrey Beardsley (English, 1872–1898) encapsulates Aestheticism's trajectory from neo-medieval roots to *fin-de-siècle* decadence and suggests its impact on unambiguously commercial and mass-marketed arts. Inspired as a young artist by the dreamy medievalism of Morris and Burne-Jones, Beardsley eventually became renowned for

his increasingly modern and sexually transgressive, photomechanically reproduced drawings. His illustrations for an edition of Sir Thomas Malory's *Morte d'Arthur*, his first major commission, are visibly indebted to Kelmscott books yet seem to mock their utopian pretensions through grotesque details like the border's breast-and-orifice-riddled pears and branches that evoke flagellation (Figure 15.12). Technically, the illustrations defied Kelmscott's craft principles, as Beardsley's drawings were printed using the **line block process**, which combined photography and etching to create a relief print. Unlike the intricate modeling possible with wood engraving, line blocks produce thicker lines and flat, unmodulated blacks and whites, the starkness of which can create optical oscillations—the horizontal band of white near the top, for example, can be read as a wall or river. Beardsley exploited the technique's formal possibilities, developing an original style that drew on an extensive array of visual sources while bringing art to the masses.

The striking illustrations for Wilde's play *Salome* show Beardsley's mastery of black and white as well as the impact of Japanese woodblock prints on his work. In one, the figure of Salome creates an audacious inky **arabesque** against the page (Figure 15.13). Her pose and the blank background are common in Japanese prints of courtesans (*see Chapter 6*), and the cultural eclecticism of the illustration is heightened by the fusion of Eastern and Western attire and what seemed to Victorian audiences to be mixed racial features. Beardsley regularly created figures of ambiguous sexual or ethnic identity to challenge contemporary assumptions. With his powerful illustrations that demand the reader's attention and frequently have little or no relation to the narratives they accompany, he also challenged, as had Rossetti and others before him, the traditional view that illustration should be subordinate to text.

The Yellow Book and Other Reading for the New Woman

The Yellow Book, an innovative periodical for which Beardsley briefly served as art editor, put text and image on a more equal footing by presenting the artworks in its pages (and in its table of contents) as independent features rather than as supplementary illustrations (Figure 15.14). The name *Yellow Book* suggests both risqué French novels and British railway fiction, which were bound in yellow, and thus alludes to the elite and the popular at once. Although the journal included works from a range of viewpoints, it became associated with the figure of the feminist **New Woman**, who advocated for legal and sexual equality; and with Wilde, who carried a yellow-covered book into his trial. Both challenged the Victorians' conservative sexual politics, as did Beardsley's drawings. His design for the back cover was considered indecent, not for what it actually depicted but for what it implied. Behind the screen provided by the table of contents, revelers at a masked ball cast suggestive glances, creating a sense of voyeurism and sexual license. So provocative were Beardsley's images that he was fired after Wilde's trial, considered too scandalous for the good of the publication.

Figure 15.11
Charles Ricketts, interior illustration in *The Sphinx* by Oscar Wilde, published by Elkin Matthews and John Lane, 1894. Ricketts's illustration scheme for Wilde's mysterious poem exhibits late Aestheticism's stylistic eclecticism and artificiality. Medieval, Greek, and Japanese sources inform the highly contrived scenes.

Rare Books and Special Collections, McGill University Library.

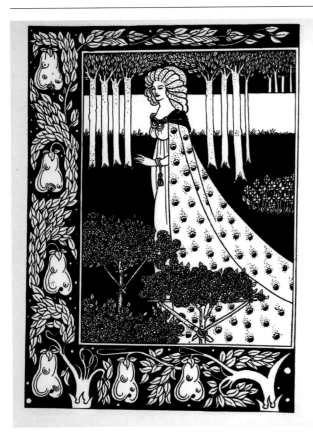

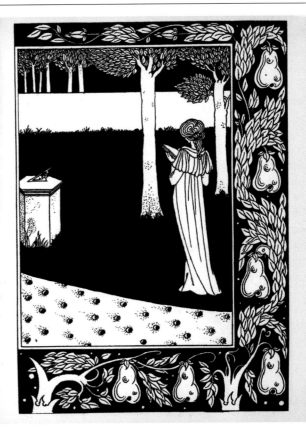

Figure 15.12
Aubrey Beardsley, illustration depicting La Beale Isoud at Joyous Guard, in *The Birth, Life, and Acts of King Arthur . . . and in the End Le Morte d'Arthur . . .* by Thomas Malory, published by J. M. Dent and Co., 1893–1894. Beardsley imitated the style of the Kelmscott Press for this edition but subverted its ideals by including lewd details and pushing the Morris-like, foliate borders to a decadent extreme.

Thomas Fisher Rare Book Library, University of Toronto.

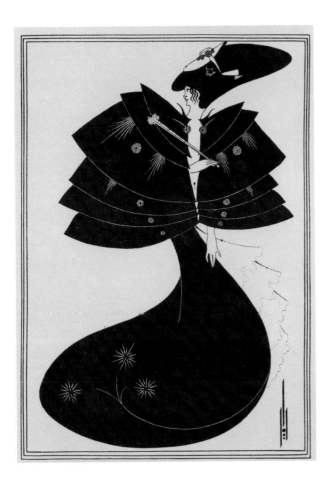

Figure 15.13
Aubrey Beardsley, "The Black Cape," in *Salome* by Oscar Wilde, 1894. Line block print, 9 × 6 ¹/₂".
The influence of Japanese prints is evident in this arresting image of Salome, an illustration that does not subordinate itself to the text. The stylization of the sinuous figure extends to Beardsley's signature—the abstract (though sexually symbolic) emblem visible at the bottom right.

Special Collections, Olin Library, Washington University in St. Louis.

Figure 15.14
Aubrey Beardsley, back cover, *The Yellow Book: An Illustrated Quarterly*, vol. 4 (January 1895). Beardsley's back cover design was used for the first five issues of *The Yellow Book*. The "screen" provided by the table of contents, where text and image ("Literature" and "Art") are accorded equal status, allows the viewer a suggestive glimpse of a decadent masked ball.

Thomas Fisher Rare Book Library, University of Toronto.

Although he later made much more sexually explicit illustrations, some of which were banned in England, Beardsley's striking graphics and erotically evocative images are his most important legacy; both qualities would become essential to modern advertising. It is appropriate, then, that Beardsley took his art beyond the world of the book or the periodical and onto the streets in the form of the poster, a medium whose utility and aesthetic potential he admired. His poster for a book called *The Spinster's Scrip* (Figure 15.15) exhibits his characteristic bold use of black and white and plays with the flatness of the page in the text-boxes-turned-shop-stall at left. Despite the book's title, the two fashionable women inspecting each other seem anything but chaste old maids: through the bared breasts and splayed haunches of the sphinx-like figure on the left and the intensity of the exchanged look, the image accrues sexual connotations. The two modern women defy proprieties and stake a claim for independence here, seemingly without doing any such thing. As we shall see, women feature prominently in many other posters of the period, which engage with changing gender roles in a variety of ways.

The Poster Movement

The illustrated, rather than simply typographic, poster (*affiche illustrée* in French) came into its own in nineteenth-century Paris. Early examples typically advertised books, but by the *fin de siècle* (end of the century), they promoted all sorts of commodities, from chocolate to bicycles to celebrities. After the requirement for official authorization to post bills (an older word for poster) was eliminated in 1881, the next two decades saw a veritable poster craze. Pasted on walls, hoardings, scaffolding, advertising columns, and kiosks, they were visible throughout in the modern metropolis (Figure 15.16), vying for attention with bold colors and designs, and frequently with eroticized imagery. Journalists estimated that millions were hung every year in Paris during this period, and many people welcomed the transformation of the city into a gallery free to all. Others perceived this inundation as a threat to the existing social order: the pleasures pictured often transgressed the rules of propriety; posters addressed everyone, regardless of class or age; and the businesses they promoted were often those of self-made entrepreneurs rather than the establishment.

Posters and Parisian Nightlife: Chéret and Toulouse-Lautrec

Jules Chéret (French, 1836–1932), a master lithographer who designed well over a thousand posters in his lifetime, revolutionized the *affiche illustrée*. He began printing color posters in the 1860s and by the 1890s had developed a distinctive and successful formula: rejecting realistic settings and small vignettes in favor of simplified design, his works

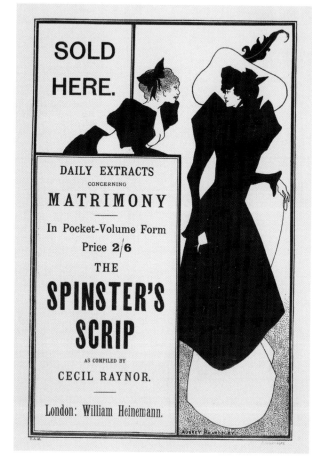

Figure 15.15
Aubrey Beardsley, poster for *The Spinster's Scrip*, 1894. Line-block and letterpress, 14 ¼ × 9 ⅓". Beardsley uses posters within a poster to build the architecture of his image: typographical ads become a street-side book-stall, the setting for a suggestive exchange between two independent, modern women.
Victoria and Albert Museum.

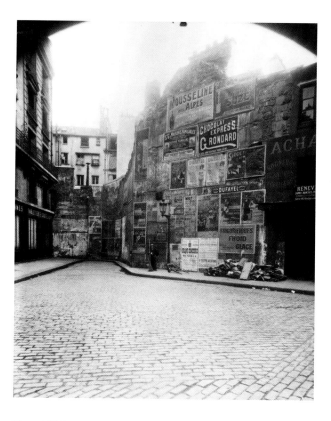

Figure 15.16
Eugène Atget, photograph of rue Brise-Miche, Paris, France, 1898. Albumin print, 7 × 8 ¾".
Illustrated posters (*affiches illustrées*) were pasted on hoardings and walls throughout Paris in the later nineteenth century, turning the street into an art gallery or a visual assault, depending on one's point of view.
George Eastman House/Getty Images.

feature swirls of primary colors; big, bold lettering; and a large-scale principal—and often scantily clad—female figure in motion. His seductive and sporting women were so recognizable that they became known as *chérettes*; bursting with *joie de vivre*, they embodied the excitement of modern life in Paris. Half of Chéret's output was dedicated to popular entertainments and nightclubs in particular, the rise of which contributed substantially to his success.

Chéret produced posters in various formats and sizes up to nearly 2 ½ meters tall; the larger of these were printed in parts and assembled on the wall. He used multiple lithographic stones to create rainbow color schemes and deployed a range of techniques including stippling, hatching, and washes to achieve subtle effects. While many contemporary commentators found his palette violent, they acknowledged that his work captured the spirit of the times. His acclaim was such that the American dancer Loïe Fuller (1862–1928), who manipulated long swathes of fabric lit by colored electric lights in her metamorphic dances, commissioned Chéret to advertise her debut at the Folies Bergère music hall (Figure 15.17). This resulted in some of his most striking works, which suggest the iridescent, swirling magic of her performances, even if her near nudity is wholly fictive.

Although the poster is inherently ephemeral, subject to the weather and replacement by competing advertisements, collectors increasingly sought out and preserved examples of this modern medium. Journal articles and books about the poster began to appear in the 1880s, and exhibitions were mounted in Paris and London. Chéret was recognized as having elevated posters to the status of high art, and by the 1890s collectors could buy them from businesses and even in special editions rather than having to salvage them from the streets. The poster's new status, visibility, and connection with modernity induced a number of "fine" artists to try their hands at it.

The Post-Impressionist painter Henri de Toulouse-Lautrec (French, 1864–1901) had an instant success with his first poster depicting Louise Weber, popularly known as *La Goulue* (the glutton), and her partner *Valentin le désossé* (Valentin the boneless) dancing at the Moulin Rouge (Figure 15.18). With its lack of modeling and flat blocks of color inspired by Japanese prints and contemporary shadow plays, the nearly 2-meter-high poster is eye-catching, and its immediacy is reinforced by its positioning of the viewer as one of the silhouetted crowd circling the dance. La Goulue is the main focus and most detailed feature; everything else is simplified in terms of color or shape, almost to the point of abstraction in the circular yellow lamps at the left, which nevertheless convey the light and heat of the spectacle. The dancer is in the middle of a high kick, her skirts raised to reveal underclothes (which she didn't always wear). The titillating quality of the performance is heightened by the position of Valentin's right hand, which optically appears to be pushing her raised leg even higher, while his left raises a phallic thumb. The repetition of the words *Moulin Rouge* at the top and below, with the promise "*tous les soirs*" (every night), suggests that these

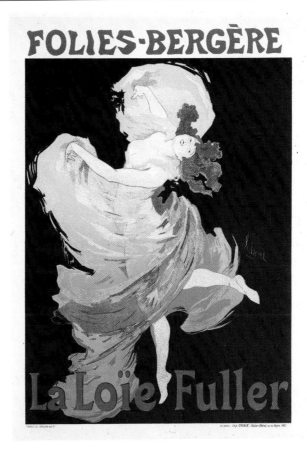

Figure 15.17
Jules Chéret, *La Loïe Fuller*, 1893. Color lithograph, 48 ³/₄ × 35 ¹/₂". Chéret's brightly colored posters often used female figures to advertise popular entertainments. Commissioned by Loïe Fuller, he produced several that try to capture the effect of Fuller's modern, metamorphic dances lit by colored electric light.
De Agostini Picture Library/Getty Images.

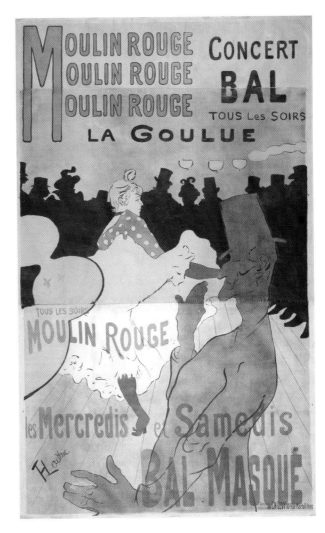

Figure 15.18
Henri de Toulouse-Lautrec, *Moulin Rouge—La Goulue*, 1891. Brush and spatter lithograph, 76 ¹/₄ × 47". Toulouse-Lautrec's nearly 2-meter-high poster of the dancer *La Goulue* uses modernist formal language and sexual innuendo to attract the viewer to the Moulin Rouge cabaret.
Courtesy Metropolitan Museum of Art.

sexualized pleasures will be offered again and again to the voyeuristic crowd.

Unlike Chéret's often generic figures, Toulouse-Lautrec's are portraits of recognizable individuals; in addition to the celebrity performer, certain silhouettes in the crowd are identifiable as those of the artist's friends. This greater realism is equally evident in Toulouse-Lautrec's choice of scenes: rather than Chéret's luminous fantasies, he offers gritty, crude, and sometimes melancholy visions of modern life that influenced designers across Europe and America.

Posters also held a central place in the oeuvre of the Swiss-born Eugène Samuel Grasset (1845–1917), who worked in nearly every decorative art from textiles to metalwork. The poster for his solo show at the 1894 Salon des Cent, a commercial art exhibition (Figure 15.19), depicts a redhead reminiscent of figures by the early Renaissance painter Botticelli examining a flower. The poster exhibits his characteristic style, a kind of "modern

archaism" with references to Japanese prints, Renaissance art, and the Pre-Raphaelites. Using thick black lines like the leading in stained glass, he separated distinct areas of unmodulated color to very decorative effect. Compared to Chéret's posters, Grasset's display more muted palettes, demure and static figures, and perceptible links to past arts; they have a simple grandeur and legibility that brought him the critical acclaim usually reserved for painters.

Mucha and the Art Nouveau Poster

Grasset's work helped launch a linear, ornamental style that swept across Europe: **Art Nouveau** (new art). The name derives from the *Maison de l'Art Nouveau*, a commercial gallery opened in Paris by Siegfried Bing in 1895 to display and sell modern art. The term *Art Nouveau* is generally used to refer to work produced between 1890 and 1910 that rejects academicism and responds to the modern age. Sinuous, tendrilly, plant-like forms and an aesthetic mixture of **Rococo** (sensuous painting of the eighteenth century associated with aristocratic decadence), Japanese prints, Celtic ornament, and Arts and Crafts are typical across the media in which Art Nouveau works were produced, from architecture to book illustration.

One of the most recognizable Art Nouveau artists was the Czech Alphonse Mucha (1860–1939), famous for his Byzantine opulence and rapturous women with madly coiling hair. His poster for Job cigarette papers (Figure 15.20) has a mosaic frame in regal purple and gold, out of which leans a woman who blissfully (and, for the period, brazenly) enjoys a cigarette. Its smoke unfurls above her like a scarf, an accessory for her voluptuously bared flesh, while her hair swoops upward in a great wave to cascade in spiraling, almost animate tendrils that float in the dreamlike atmosphere. Art Nouveau posters are known for their integration of text and image; here, the mosaic *O* functions like a halo for this woman in a state of almost religious ecstasy. The green decoration against the flat purple ground, which at first appears an abstract linear design, in fact spells out *JOB*. Mucha's poster style was so successful that he also produced numerous *panneaux décoratifs* (decorative panels) of women: poster-style images without text or product advertisement for home decoration.

Will Bradley and the Poster Movement in America

While Art Nouveau was a pan-European phenomenon, the new style also reached North America and influenced the American **Poster Movement** of the 1890s. Inspired by the craze in Europe, American publishers experimented with posters to try to increase the sales of their magazines, first in association with special holiday numbers and later with regular issues. Publishers like Harper and Brothers invited Grasset and other Europeans (excluding Chéret, who was generally considered too risqué for a more prim American audience) to design posters, but home-grown artists soon rose to prominence in the United States and received international recognition as well. The

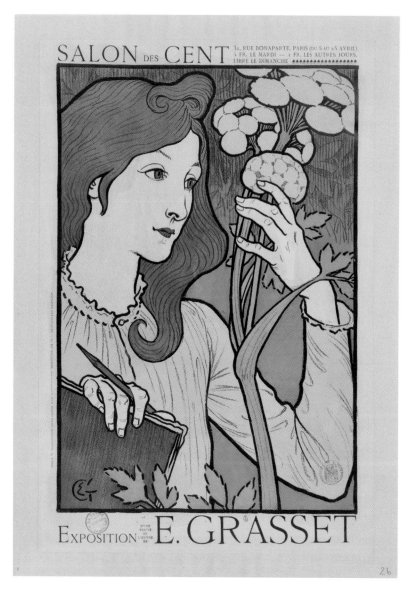

Figure 15.19
Eugène Samuel Grasset, poster for Salon des Cent exhibition, 1894. Color lithograph, 25 1/4 × 19 3/4". Grasset's elegant, decorative posters highlight their continuity with and respect for the past by referencing earlier art forms like stained glass, and artists like the Italian Renaissance painter Botticelli.
Bibliothèque de l'INHA, Collections Jacques Doucet © INHA, Dist. RMIN-Grand Palais/Art Resource, New York.

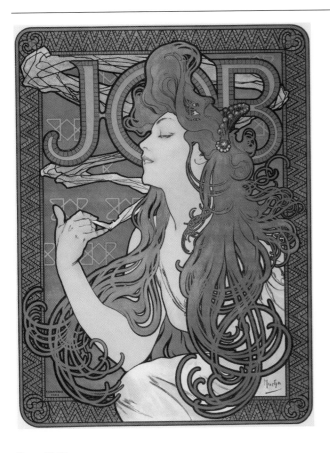

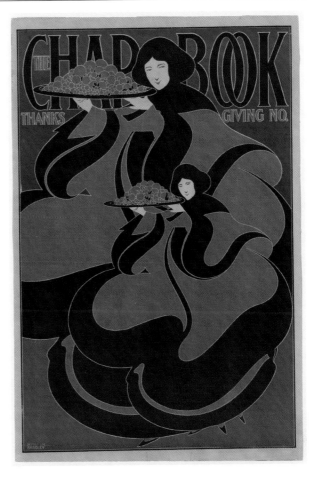

Figure 15.21
Will Bradley, poster advertising *The Chap-Book, Thanksgiving No.*, 1895. Color lithograph, 19 ²/₃ × 13 ¹/₄".
Bradley, a key figure in the American poster movement of the 1890s, used bold, occasionally almost abstract patterns and flat planes of color that suggest the influence of Aubrey Beardsley and Japanese prints.
Library of Congress, Washington, DC.

Figure 15.20
Alphonse Mucha, poster advertising Job cigarette papers, 1896. Color lithograph, 20 ¹/₄ × 11 ³/₄".
Mucha's Art Nouveau posters are often very ornate and depict sensual women in luxurious surrounds. Here, the name of the company is worked into the background against which a woman provocatively enjoys her cigarette.
Worcester Art Museum, Worcester, Massachusetts. Gift of Dr. Lawrence M. Epstein and Ms. Jeanne Griffin, 2007.174.

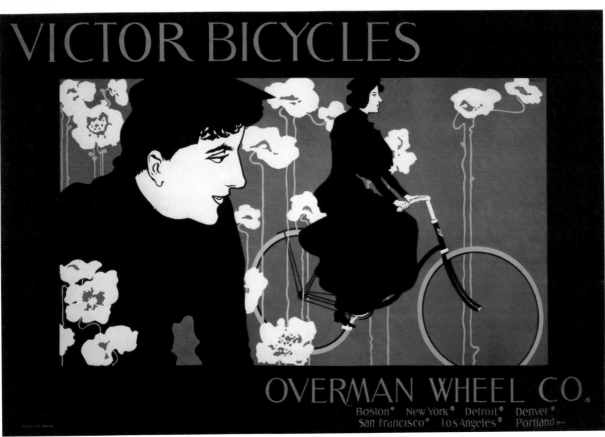

Figure 15.22
Will Bradley, poster advertising *Victor Bicycles*, ca. 1895. Color lithograph, 27 × 40 ²/₃".
Bradley's poster employs a restricted palette, striking silhouettes, and decorative abstraction to suggest the pastoral charms and potential romance of a modern bicycle ride.
Library of Congress, Washington, DC.

inventiveness of American posters has been ascribed to the fact that many of the artists were young and had no commitment to academic traditions. As in Europe, the poster came to be seen as having artistic value and was celebrated in American journals and exhibitions.

Will Bradley (American, 1868–1962), a largely self-taught illustrator who learned printing techniques on the job, is the most notable of the American Art Nouveau designers; his work was displayed at the opening of Bing's Paris gallery in 1895. After having produced covers for a number of periodicals, Bradley was commissioned in 1894 to design seven posters for *The Chap-Book*, a small literary magazine publishing the work of European as well as North American authors. The cover for the 1895 Thanksgiving number (Figure 15.21) reveals his debt to Beardsley and Japanese prints in its rhythmic, flowing line and bold, flat planes of color, but also shows a distinctive decorative conception that verges on abstraction. The stylized figures, repeated at different scales, suggest an infinitely extendable pattern. Naturalism is sacrificed for the sake of luxurious visual effect.

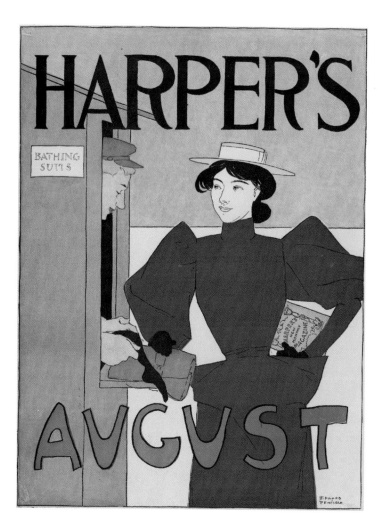

Figure 15.23
Edward Penfield, poster advertising *Harper's Magazine*, August 1894. Color lithograph, 16 ³/₄ × 12 ²/₃". Penfield's posters for *Harper's* employ a clean style suited to one of his recurrent figures: the confident American girl at leisure, always carrying a copy of the magazine.
Courtesy Metropolitan Museum of Art, Leonard A. Lauder Collection of American Posters. Gift of Leonard A. Lauder, 1984.

A poster for Victor Bicycles from the following year (Figure 15.22) uses a similarly restricted palette, silhouettes, and varying degrees of naturalism to create a poetic impression. The appearance in the 1890s of "safety" bicycles with same-sized wheels, pneumatic tires, and increasingly lightweight frames led to a massive surge in the number of cyclists riding both for transportation and pleasure. Bicycles offered women new and not uncontroversial mobility, and allowed city dwellers to temporarily escape the congestion and pressures of urban life through outings to the countryside. Bradley's poster depicts two cyclists out in nature, framed by white poppies on an unmodulated field of blue. In the absence of any ground plane, the flowers read as both clouds against an otherwise spotless sky and water lilies in an unruffled pool. The riders glide effortlessly through this imaginary landscape, and the idyllic quality of their pastoral excursion is heightened by the suggestion of romance as the short-haired male cyclist at left glances admiringly at the female cyclist on the right.

Some moralists thought cycling dangerous both because it could lead to unchaperoned encounters and because it supposedly made women more mannish. The similarity in the rendering of the male and female figures here suggests a potential parity between the sexes. The text in the poster, like the cyclists, moves from left to right, suggesting progress, as does Bradley's showcasing of the female rider.

Women, as we have seen, were a central feature of *fin-de-siècle* posters in both Europe and America. Often their figures are merely vehicles for male consumption and pleasure in a nineteenth-century version of "sex sells," but in a period in which women were more visible in the public sphere, commercial artists increasingly depicted and addressed female consumers. Bicycle ads were suited to appeal to the modern woman and to visualize new freedoms, while posters for other products also captured the new mobility and independence of women.

Penfield, Reed, and American Girls

Edward Penfield (American, 1866–1925), the artistic director at Harper and Brothers, depicted fashionable, self-assured, and charming "American girls" popularized by Charles Dana Gibson and others (*see Chapter 18*). Most of Penfield's posters for the monthly installments of *Harper's Magazine* feature well-dressed women reading, or at least carrying, the latest issue in a variety of places. The August 1894 poster (Figure 15.23) exhibits his typical flat planes of breezy color, assured contour drawing, and minimal background, which focus attention on the figures and text. A confident young woman in stylish modern garb, arms akimbo, looks on with mild amusement at an abashed young man who seems to fondle the stocking of a lady's bathing costume.

One of the few renowned female poster artists of the period, Ethel Reed (American, 1874–1912) was a New Woman who lived unconventionally and independently; "I am my own property," she wrote to one possessive lover. Her work uses strong color and simplified forms inspired by Beardsley and Japanese prints, and consists

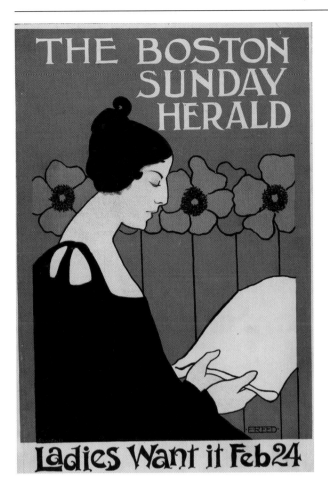

Figure 15.24
Ethel Reed, *The Boston Sunday Herald—Ladies Want It*, 1895. Color lithograph, 17 1/4 × 11 3/4".
Reed was a New Woman and one of the few female poster artists of the period. Her work exhibits flat planes of color and decorative motifs, and frequently acknowledges female desire.

Library of Congress, Washington, DC.

primarily of posters and book illustrations, although she also contributed artworks to *The Yellow Book* and other periodicals. Like her male counterparts, she frequently pictured women in her work, but unlike them, she foregrounded women's own desires. Her poster for an edition of *The Boston Sunday Herald* (Figure 15.24), for example, depicts a woman with eyes closed, *not* reading the paper in her hands. The powerful allure of her daydream is suggested by the row of poppies at the level of her head (Reed smoked opium), and its erotic nature by the saucy tagline "Ladies Want It." The escape from constraint evoked by the image is echoed in the artist's signature: enclosed by lines, the letters seem to spell out "FREED."

KEY TERMS

academic
Aestheticism
affiche illustrée
alienation
arabesque
art for art's sake
Art Nouveau
Arts and Crafts
 Movement
fin de siècle

gift book
Japonisme
line block process
New Woman
Poster Movement
Pre-Raphaelite
 Brotherhood
private press
Rococo
the Sixties

Conclusion

In the later nineteenth century, illustrations saturated the visual field inside and outside the home. Artists and professional illustrators designed images for popular, mass-printed books and periodicals as well as the luxurious editions of private presses. They created posters, the most ephemeral-seeming form of advertisement, yet one which almost immediately garnered avid collectors. They revived older techniques like wood engraving and embraced newer ones, including the line block process and color lithography. Stylistic trends crossed national boundaries. Some designers were motivated by reform; others were more commercially pragmatic. But all of this flourishing of illustration responded to and stimulated new forms of consumer demand, whether for gift books, products, or racy nightlife.

FURTHER READING

Casteras, Susan P., *Pocket Cathedrals: Pre-Raphaelite Book Illustration* (New Haven: Yale Center for British Art, 1991).

Howard, Jeremy, *Art Nouveau: International and National Styles in Europe* (Manchester: Manchester University Press, 1996).

Iskin, Ruth, *The Poster: Art, Advertising, Design, and Collecting, 1860s–1900s* (Hanover, NH: Dartmouth College Press, 2014).

Reid, Forrest, *Illustrators of the Eighteen Sixties* (London: Faber and Gwyer, 1928; Reprint, New York: Dover, 1975).

Taylor, John Russell, *The Art Nouveau Book in Britain* (Edinburgh: P. Harris, 1980).

16

British Fantasy and Children's Book Illustration, 1650–1920

Alice A. Carter

In the mid-seventeenth century, new ideas concerning education inspired Jan Amos Comenius's *Orbis Sensualium Pictus* (*The World of Sensible Things Depicted*, 1658)—a small volume with a large impact, now generally considered the first picture book specifically designed for children. The popular text was soon translated to the vernacular from its original Latin and High Dutch for use in primary schools throughout Europe, America, and Asia. Teachers noted that pairing illustrations with words accelerated learning, and in 1693, philosopher John Locke (English, 1632–1704) endorsed their observations by proposing that picture books encouraged childhood literacy. The longevity of Comenius's innovation proved the point: his little book remained a classroom standard for close to two centuries. The success of *Orbis Sensualium Pictus* inspired other productions for children that this chapter will survey.

Figure 16.1
Anonymous, "They were both very ragged, and *Tommy* had two shoes but *Margery* had but one," in *The History of Little Goody Two-Shoes*, 1765, p. 15. Woodcut. This crude wood-cut is typical of the illustrations prevalent in eighteenth-century picture books.
© British Library Board, General Reference Collection C.180.a.3.

The Eighteenth and Nineteenth Centuries

By the end of the eighteenth century, instructional texts and inexpensive chapbooks were widely distributed. Their dominant purpose was to expel original sin through cautionary tales encouraging virtuous behavior. The expense of paper, printing, and distribution put the majority of children's publications in the hands of inferior craftsmen who often incorporated repurposed and irrelevant wood engravings into the text.

John Newbery (English, 1713–1767) (commemorated annually by the awarding of the Newbery Medal for children's literature) was among the most prolific publishers of eighteenth-century children's books. Two of Newbery's best-known juvenile offerings, *A Little Pretty Pocket-Book Intended for the Instruction and Amusement of Little Master Tommy and Pretty Miss Polly* (ca. 1744) and *The History of Little Goody Two-shoes* (1765), featured carefully reproduced frontispiece engravings relevant to the text. In contrast, the interior pages presented stiff, symbolic woodcuts that typified the genre (Figure 16.1). Quality engraved or etched illustrations required an artist's drawings, a craftsman's expertise, and a printer's time, whereas woodcuts could be assembled and printed along with the type on a single press.

Newbery's prolific output is often taken as proof that his children's books were profitable despite the inconsistent quality of the pictures. In fact, Newbery's success was not built on the juvenile market but on adult titles and his main enterprise, the sale of patent medicines.

Folk Tales and Fairy Tales

Coexisting with eighteenth-century books published for the education and improvement of children were traditional folk tales marketed as family entertainment. These tales derive from oral sources popularized as bawdy amusement in the court of Louis XIV (French, 1638–1715). French author Charles Perrault (1628–1703) is credited for collecting and transcribing these narratives in (*Stories* or) *Tales of Times Past With Morals* (1697), which was illustrated with a frontispiece and seven **headpiece** engravings (decorative elements near the top of the page). Since text consumed more than two hundred pages, it is probable that the largely unadorned book was intended for

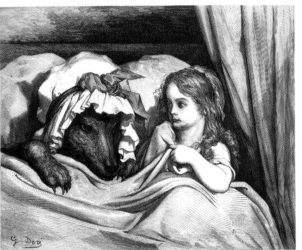

Figure 16.2
Gustave Doré, "Little Red Riding Hood, in *Les Contes de Perrault*, 1867. Steel plate engraving. Doré, who is best known for his illustrations for the Bible and Dante's *Divine Comedy*, makes no concessions for the sensibilities of children in this disturbing interpre-tation of Little Red Riding Hood's last moments.
Osborne Collection of Early Children's Books, Toronto Public Library.

all ages. Moreover, many of the tales contained suggestive themes and double entendres more readily understood by adults than children. For example, in Perrault's *Little Red Riding Hood*, the wolf tells the child to strip and join him in bed. The innocent obliges and is gobbled up. The moral? Well-bred young ladies should never talk to strangers—much less hop into bed with them. Almost two hundred years later, French illustrator Gustave Doré (1832–1883) captured the alarming quality of Perrault's story with Little Red regarding the wolf with disastrously belated suspicion (Figure 16.2).

As Perrault's tales were disseminated, they were altered to suit an increasingly literate and diverse audience. In the early nineteenth century when Jacob (German, 1785–1863) and Wilhelm Grimm (German, 1786–1859) began collecting German folk tales, more wholesome interpretations coexisted with the original versions. The Grimm brothers' "Little Red Cap" does not undress or climb into bed with the wolf.

By 1823, when Grimms' *German Popular Stories* was translated into English, fairy tales had gained traction as childhood entertainment. Since prevailing Romantic ideology suggested that imagination should be stimulated, not suppressed (*see Chapter 12*), the book's translator Edgar Taylor declared the volume suitable and beneficial for children. The "age of reason," Taylor lamented, had replaced imagination with philosophy. Fairy tales, as long as they endorsed moral education, were offered up as an antidote.

George Cruikshank

Although the success of *Orbis Sensualium Pictus* demonstrated that picture books encouraged literacy, more than a century passed before advances in printing technology enabled the profitability of high-quality illustrated books. Fortunately, the 1823 publication of *German Popular Stories*, the first to be abundantly illustrated, coincided with these advances, and fell into the hands of George Cruikshank (English, 1792–1878), a skilled artist and printmaker. During his lifetime, Cruikshank created a massive output of illustrations that not only set a precedent for pairing pictures with folk tales, but also included political caricatures, illustrations for pamphlets and displays, and etchings for Charles Dickens's *Sketches by Boz*, *The Mudfog Papers*, and *Oliver Twist* (Figure 16.3) (*see also Chapters 11 and 14*).

Nevertheless, it was the drawings he produced for the Grimm brothers' tales that won the praise of the Victorian art critic John Ruskin (*see Chapter 15*). Ruskin proclaimed Cruikshank's illustrations equal to the work of Rembrandt, and novelist William Makepeace Thackeray (British, 1811–1863) declared that from "Michael Angelo onwards, there was no better hand to illustrate these timeless tales." Indeed, Cruikshank's ability to capture motion created scenes of unprecedented vitality (Figure 16.4), which contrasted sharply with the more formal **set pieces** (formal synoptic illustrations) of his contemporaries. Equally impressive was his handling of human characters—heroes and villains alike, which appeared as unique, sentient, and appealing individuals.

While the content of Cruikshank's work sprang from artistic imagination, the lively quality of his line also depended on his skill as a craftsman. Throughout most of the nineteenth century, preparing a picture for publication continued to be a two-step process: the creation of the original drawing by the illustrator

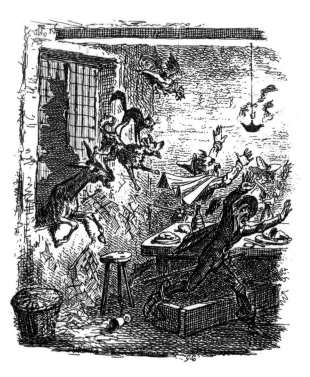

Figure 16.4
George Cruikshank, "Bremen Town Musicians," *German Popular Stories*, Jacob and Wilhelm Grimm, 1823. Etching.
This illustration demonstrates the artist's skill in capturing his animal protagonists with anatomical accuracy in mid-flight—without the benefit of a camera to stop motion.
Osborne Collection of Early Children's Books, Toronto Public Library.

followed by its transference to a printing matrix (such as a woodblock, metal plate, or stone) by an engraver. The most popular nineteenth-century method of reproduction was wood engraving (*see Chapter 14, Theme Box 30, "Wood Engraving as an Assembly-Line Process"*), which yielded more detail than a woodcut while sustaining the older method's chief benefit—the ability to print illustrations and text simultaneously. But while a wood engraver could (and sometimes did) improve a drawing, more often the sense of energy and freedom of the artist's original conception was lost in the process of incising the unwieldy blocks. Cruikshank circumvented this problem by etching the Grimms' illustrations on copper plates—an expensive proposition requiring a special press (*see Chapter 2, Theme Box 6, "Intaglio Printing"*).

Cruikshank's wide-ranging output as illustrator, engraver, and printer necessitated a punishing schedule. Eventually, the workload and a proclivity toward alcoholism affected his strength and produced an epiphany. In 1847, Cruikshank published *The Bottle*, a series of prints advocating temperance. The success of the edition not only prompted a sequel but also improved the artist's health because following the publication of the folio, Cruikshank renounced alcohol and became a proselytizing teetotaler. While Cruikshank's temperance campaign enhanced his status as an exemplar, there were those who questioned its effect on his books. When he published a four-volume *Fairy Library* bending classic stories into temperance treatises, Dickens called

Figure 16.3
George Cruikshank, "Oliver Asking for More," *Oliver Twist; or The Parrish Boy's Progress.* Charles Dickens, 1838. Etching.
After Dickens's death, Cruikshank claimed to have originated several plot lines and characters for *Oliver Twist*. Although this assertion has been discounted, there is no doubt that the artist's illustrations have become iconic—shaping all subsequent visual treatments of the novel.
Special Collections, Olin Library, Washington University in St. Louis.

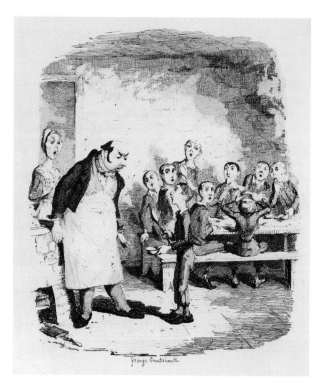

them "Frauds on the Fairies." By 1853, fairy tales were revered childhood classics, and although the quality of his artwork was undiminished, Cruikshank's depiction of a giant who "drunk himself stupid" was seen as near sacrilege (Figure 16.5).

A worthy successor to Cruikshank was Richard (Dickie) Doyle (English, 1824–1883), who became one of the nation's most celebrated illustrators of fairy tales. His pictures for an 1846 edition of the Brothers Grimm stories demonstrate the flair and humor that distinguishes his best work (Figure 16.6).

John Tenniel

George Cruikshank was at the height of his fame when twenty-eight-year-old John Tenniel (English, 1820–1914) completed one hundred illustrations for an edition of *Aesop's Fables*. The artist's portrayals of anthropomorphized animals had a lively, gestural quality that showed Cruikshank's constructive influence (Figure 16.7).

In 1850, Tenniel's *Aesop's Fables* caught the eye of the editors of *Punch*. When Dickie Doyle resigned over the magazine's anti-Catholic views, Tenniel replaced him. Tenniel kept his political opinions to himself, and

Figure 16.6
Richard "Dickie" Doyle, "The Dragon and His Grandmother," in *The Fairy Ring: A Collection of Tales and Traditions*, The Grimm Brothers, 1857. Wood engraving.
Doyle was also a staff artist with *Punch*, England's liberal humor and satirical magazine.
© British Library Board, General Reference Collection 1507/467.

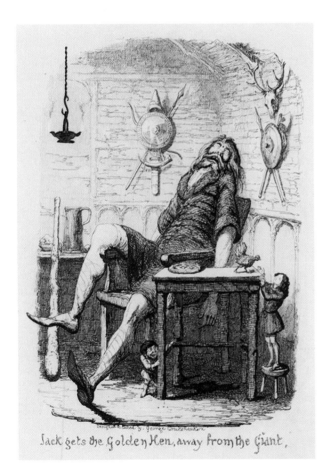

Jack gets the Golden Hen, away from the Giant.

Figure 16.5
George Cruikshank, "Jack gets the Golden Hen away from the Giant," in "Jack and the Beanstalk," *George Cruikshank's Fairy Library*, 1853–1854. Etching.
In Cruikshank's version of this classic story, the giant is portrayed as succumbing to a drunken stupor.
Courtesy of the Fleet Library, at Rhode Island School of Design, Special Collections, Providence, Rhode Island.

Figure 16.7
John Tenniel, "The Lion and the Mouse," *Aesop's Fables: A New Version, Chiefly from Original Sources*, 1848. Wood engraving.
Hours of sketching at the London Zoo contributed to the success of Tenniel's illustrations for *Aesop's Fables*. The drawings impressed both the editors of *Punch*, who offered Tenniel a staff position, and Charles Dodgson (Lewis Carroll) who was looking for an artist to illustrate a work in progress: *Alice's Adventures in Wonderland*.
Osborne Collection of Early Children's Books, Toronto Public Library.

subordinated his sentiments to those of the publisher. His discretion yielded a half-century with *Punch*, and resulted in a knighthood for his moderating influence on political discourse (*see Chapter 11*). While Tenniel's title added to his status, the drawings that inspired the honor are largely forgotten. What is remembered is a commission that has endured the caprice of time and politics: his drawings for Charles Dodgson's (known as Lewis Carroll, English, 1832–1898) manuscript that would become *Alice's Adventures in Wonderland* (1865). Dodgson was a domineering, meticulous client, but despite his meddling, Tenniel produced forty-two remarkable illustrations that capture the originality and fantasy of the author's story (Figure 16.8).

Beginning with a small drawing of a flustered rabbit and ending with the collapse of Alice's dream in a whirl of cards, Tenniel created a convincing alternate universe in which humans, animals, architecture, and landscapes were rendered with a persuasive realism that linked the fantastic and the commonplace. Even so, the printed *Alice* illustrations fluctuated in artistry from flowing and descriptive (Figure 16.9a) to static and quaint (Figure 16.9b). The discrepancy is best explained by the artist's working methods. Unlike Cruikshank, Tenniel never learned the art of engraving. He transferred his designs to the block by reversing them on tracing paper and adding details with a hard 6-H pencil that resisted smearing. The resulting drawings were so delicate that a friend remarked that they looked like the wind could blow them away. This presented a challenge for the engravers whose "facsimiles"—the engraved block copies—often lacked the spontaneity of the original drawings.

a

Figure 16.8
John Tenniel, "Mad Hatter's Tea Party," *Alice's Adventures in Wonderland*, Lewis Carroll, 1865. Wood engraving.
In a letter to Charles Dodgson, Tenniel described this illustration as "The Hatter asking the riddle." A keen observer of human interaction, Tenniel differentiated the personalities of each character by showing their individual, idiosyncratic reactions to the query.
Courtesy of David Mason Books.

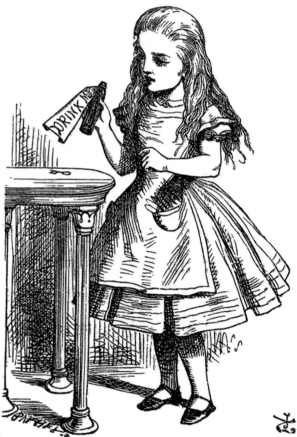

b

Figure 16.9a, b
John Tenniel, interior illustrations for *Alice's Adventures in Wonderland* by Lewis Carroll, 1865. Wood engraving.
A common consequence of incising a drawing on wood was a loss of spontaneity, which affected the consistency of engraved illustrations. Figure 16.9a (Alice watching the rabbit run away) retains an expressive, gestural quality, while Figure 16.9b (Alice takes the Drink Me bottle) appears static and formal.
Courtesy of David Mason Books.

London's most celebrated wood engravers, the firm of the Dalziel Brothers (*see Chapter 14*), incised Tenniel's drawings on blocks, which were then electrotyped for durability. Even so, when *Alice's Adventures in Wonderland* was published in 1865, Tenniel was so disappointed with the printing that he persuaded Dodgson to re-issue the book at great expense. The author's capitulation did not entirely appease the artist, and when Dodgson asked Tenniel to illustrate his sequel, *Through the Looking-Glass and What Alice Found There*, Tenniel at first refused but eventually completed fifty magnificent illustrations (Figure 16.10).

Tenniel never suspected that the *Alice* books would be his most significant accomplishment, and later wrote, "It is a curious fact that with *Through the Looking-Glass* the faculty of making drawings for book illustration departed from me, and, notwithstanding all sorts of tempting inducements, I have done nothing in that direction since."

Edward Lear

Tenniel's somewhat dismissive attitude toward children's literature was not unique. His contemporary Edward Lear (English, 1812–1888) also regarded the genre as a diversion from a more serious career. Lear had been a sickly child who found consolation in literature and art; birds and animals were his favorite subjects. By the age of eighteen, Lear was employed as a draftsman at the London Zoological Gardens where he produced a stunning folio of lithographs of exotic parrots (*see Chapter 9*). These beautifully wrought ornithological illustrations attracted the patronage of Edward Stanley, the thirteenth Earl of Derby. Lear spent the next five years drawing the birds and animals in his benefactor's menagerie. Although reserved in the company of his employer, he befriended the Stanley grandchildren, who were delighted with the limericks he wrote and illustrated to amuse them.

At the time, Lear did not see any potential in these rhymes, as his ambitions were taking him elsewhere. When he completed his work for Lord Stanley, he began painting topographical watercolors (Figure 16.11). Although not entirely profitable, his work was respected, and in 1846, Queen Victoria hired him as her drawing tutor. While shyly negotiating protocol at Buckingham Palace, Lear finally decided to publish the limericks and sketches created for the Stanley grandchildren. Unsure of how this whimsy would affect his reputation, he issued his *Book of Nonsense* under the pseudonym Derry down Derry (Figure 16.12).

When the book was published, sales were steady enough to encourage Lear to reveal his identity and to issue a second printing. In 1861, in an effort to increase both quality and profits, Lear brought *A Book of Nonsense* to the Dalziel brothers. The resulting combination of high-quality wood engravings, an experienced publisher, and a reasonable retail price produced a best seller. Lear, who had sold the copyright for £120, soon regretted the decision when customer demand justified nineteen more editions.

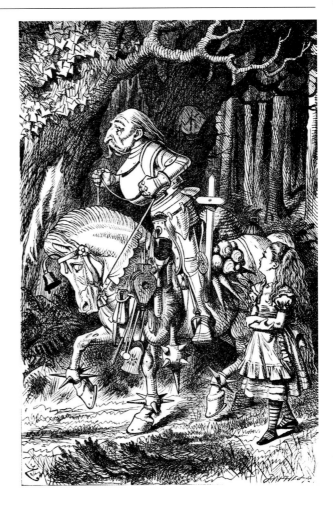

Figure 16.10
John Tenniel, "The White Knight," frontispiece for *Through the Looking-Glass and What Alice Found There* by Lewis Carroll, 1871. Wood engraving.
Initially reluctant to continue his collaboration with the exacting Dodgson (Lewis Carroll), Tenniel ultimately tackled the commission with care. A resemblance between the White Knight and Tenniel himself is often noted, but it is unclear whether the illustration was meant to be a self-portrait.
Courtesy of the Fleet Library, at Rhode Island School of Design, Special Collections, Providence, Rhode Island.

Figure 16.11
Edward Lear, "Lago di Fucino," *Illustrated Excursions in Italy*, 1846.
Edward Lear's detailed watercolors engraved and published in this book attracted the attention of Queen Victoria, who then hired the artist for private drawing lessons.
Image by Dreweatts & Bloomsbury.

Theme Box 34: Jenkins: Media Convergence
by Jaleen Grove and Wayne Morgan

In recent decades, large entertainment industry corporations have begun developing a range of formerly separate products as one coordinated marketing effort. Where films, comic books, toys, trading cards, TV shows, merchandise, and gaming used to be made independently from each other, now they may be developed as a unified strategy so that the public is saturated with the same stories and characters no matter what medium they look at. Often, the different media outlets and platforms are actually owned by the same parent corporation. One medium (movies, for instance) may now be embedded in another (Internet) and viewed through yet another (cell phone). Such production also involves the licensing of characters to advertisers, blurring cultural expression with commercial interests. The preceding examples are aspects of **media convergence**, a topic written about by media and popular culture theorist Henry Jenkins.

Licensing and **transmedia storytelling** (the production of interrelated narratives across several media platforms at once) have their origins in the advertising artist, cartoonist, and children's book writer and illustrator Palmer Cox (Canadian, American 1840–1924). In 1883, he invented the Brownies, elfin characters derived from Scottish folk tales, who went on fabulous adventures in Cox's highly detailed and humorous drawings, narrated by rhyming verses that he penned himself. The Brownies initially appeared in the children's magazine St. Nicholas (which had both American and European editions), just at the time that children's education was undergoing a change toward being more creative and play-oriented. Starting in 1887, thirteen collections of the Brownie graphic narratives were issued as books; about a million of these were sold.

Cox became the first person to license rights, where his own literary and artistic product (Brownies) was later used to promote another product (soap). The cover of Harper's Young People of November 13, 1883, featured Cox's drawing of the Brownies doing laundry, hauling bars of the newly introduced Ivory soap—the first of over forty ads that soap company Procter & Gamble commissioned from him. Cox sold further rights to other advertisers, doll and toy makers, a chocolate company, and various businesses that put them on over fifty categories of merchandise as diverse as dishes, rubber boots, stove polish, jewelry, and biscuits (Figure TB34.1).

In 1893, Cox was also the first author to turn his creation into a musical play that toured U.S. and Canadian venues for years. The program promoted Brownie books, dolls, gum, and sheet music. Cox toured with the show, giving interviews and ensuring publicity, cultivating his persona as "the Brownie man." Cox was selective in defending his copyright, however, and over one hundred unauthorized Brownie products have been documented. Most infamous of all, the photography company Kodak used Cox's Brownies without permission to market its early handheld amateur's camera, dubbed the Kodak Brownie.

Cox's pioneering of licensing was a lucrative model for following illustrators such as comics artist Rose O'Neill (American, 1874–1944), who created the Kewpies (see Theme Box 35, "Women in Illustration"), and Richard Felton Outcault (American, 1863–1928), who created Buster

Figure 16.12
Edward Lear, cover, *A Book of Nonsense*, 1862. Wood engraving.
This illustration accompanied the book's first limerick: "There was an Old Derry down Derry, who loved to see little folks merry; So he made them a book, and with laughter they shook at the fun of that Derry down Derry!"

The comical, reductive style of *A Book of Nonsense* was unique. Unlike his competitors' drawings, Lear's drawings were not created to stand alone—they were conceived as half of a larger whole, where absurd limericks created a perfect foil for preposterous illustrations.

Lear invented words such as *scroobious* and *borascible* that only made sense in the context of his book. Likewise, his characters had such unusual physiognomies that their credibility depended on the accompanying verses. Although many of the characters in *A Book of Nonsense* were violently dispatched—choked, smashed, drowned, and in one sad case doomed by despair—Lear's work carried no moral message save the notion that the irrationality of life is best confronted with humor.

Lear incorporated this philosophy in his personal and professional life, and in 1871 reclaimed his nonsense franchise by publishing *Nonsense Songs, Stories, Botany, and Alphabets*. The new book featured stories, limericks, and the now-iconic poem "The Owl and the Pussy Cat" (Figure 16.13).

In 1886, with his health in final decline, Lear's children's books entered the canon of English literature

Brown after losing control over his earlier character Mickey Dugan, a.k.a. the Yellow Kid (*see Chapter 23*). By this time, a highly commodified culture industry aiming at children as a discrete market had evolved.

Individual illustrators today who wish to establish a brand and maintain control over it must compete with the corporations. Jenkins and others criticize the concentration of cultural production among a few large corporations because they feel that such monopoly and fierce copyright protection reduce cultural diversity and creativity by crowding out smaller (and therefore less profitable)

experimental forms, lower-budget productions by newcomers, and works that reflect the interests of smaller (that is, less profitable) minority groups. Furthermore, many salaried creative workers employed by large corporations do not have control over their art. The domination of mass marketing to child consumers using the same characters they bond with in stories also raises concerns.

Nevertheless, in what he calls **participatory culture**, Henry Jenkins has suggested that network media and social media provide ways for consumer groups to form and exert pressure on hegemonic

media companies, to negotiate the terms and content offered to them, and to define content as producers themselves. It remains to be seen, however, whether popular intervention into mass media will be co-opted and censored, whether independent content providers will be fairly compensated, and whether those without the technology or agency to participate will be included.

Further Reading

Jenkins, Henry, *Convergence Culture: Where Old and New Media Collide* (New York: New York University Press, 2006).

Morgan, Wayne, and Sharilyn Ingram, "If Palmer Cox Wuz t'See Yer, He'd Git Yer Copyrighted in a Minute: The Origins of Licensing," (paper presented at the 14th Conference on Historical Analysis and Research in Marketing, University of Leicester, June 2009): 50–60.

Figure TB34.1
Author-illustrator Palmer Cox was the first to retain control over his creations, the Brownies, and license their use in merchandise, advertising, and theater.

Collection of Wayne Morgan.

when the *Pall Mall Gazette* released John Ruskin's list of the "Best Hundred Authors" with Lear in the top spot. Although Ruskin's commendation came too late to benefit Lear directly, it validated the next generation of children's book illustrators. When contemporaries Walter Crane, Randolph Caldecott, and Catherine "Kate" Greenaway turned their attention to the genre, it was with the knowledge that the nation's most respected art critic endorsed the field.

Walter Crane

At the age of fourteen, Walter Crane (English, 1845–1915) was apprenticed to William James Linton (English, 1812–1897), a skilled engraver whose commitment to the integration of design, materials, and production influenced the artist's subsequent work. When his indenture was fulfilled, Crane found employment with Edmund Evans (English, 1826–1905), another distinguished engraver and a pioneer in color printing. Evans maintained a lucrative business producing **yellow-backs**, also known as "railway novels." These sensational works with distinct yellow

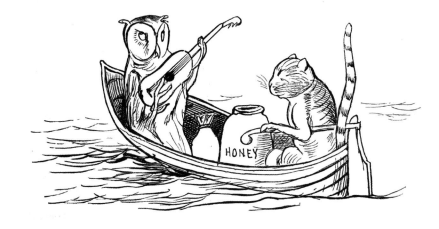

Figure 16.13
Edward Lear, "The Owl and the Pussycat," *Nonsense Songs, Stories, Botany, and Alphabets*, 1871. Wood engraving.
This poem was originally written for the amusement of Janet Symonds, the daughter of Lear's friends, John Addington Symonds and his wife, Catherine.
Osborne Collection of Early Children's Books, Toronto Public Library.

covers were sold in train stations, since lighted cars and smooth tracks provided an ideal reading space for an increasingly mobile and literate population. Not suited to the adult themes of the yellow backs, Crane's skills were ideal for Evans's new venture—a line of children's six-penny toy-books. Among Crane's first assignments were illustrations for *The History of Cock Robin and Jenny Wren*, *Dame Trot and Her Comical Cat*, and *The House That Jack Built*. While these titles engaged the artist's lively imagination, the pictures he produced were not readily distinguishable from the work of other artists entering the field of affordable children's books.

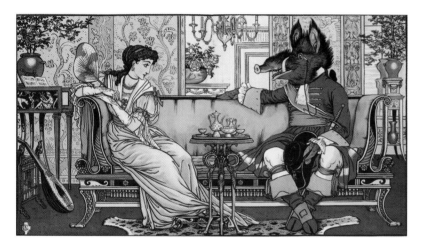

Figure 16.14
Walter Crane, double-page spread for *Beauty and the Beast*, 1874–1875. Xylograph.
Crane was among the first illustrators to effectively pace his children's books by combining single-page illustrations with the drama of the double-page spread.
Osborne Collection of Early Children's Books, Toronto Public Library.

Figure 16.15
Walter Crane, centerfold illustration for *The Sleeping Beauty in the Wood*, 1876. Xylograph.
Crane, who was an active member of the Arts and Crafts movement, often worked out his designs for decorative friezes, fabrics, tile, and furniture on the pages of his picture books.
Osborne Collection of Early Children's Books, Toronto Public Library.

Crane's breakthrough came several years later, inspired by the graceful black outlines, flat colors, and elongated formats of *ukiyo-e* wood-block prints, newly available with the resumption of trade between Japan and the West (*see Chapter 6*). Crane, an adherent of the Arts and Crafts movement, synthesized the Japanese aesthetic with elements of the medievalism popular among the Pre-Raphaelites (*see Chapter 15*) (Figures 16.14 and 16.15). In all, Crane illustrated more than forty children's books. His striking imagery for classic favorites including *Aesop's Fables* and *Household Stories from the Collection of the Brothers Grimm* helped establish the precedents for excellence in juvenile publishing.

In addition to his illustrations, Crane exhibited paintings and produced decorative works in tile, pottery, and stained glass. He was also a respected teacher and academic, writing influential books such as *Line and Form* and *Of the Decorative Illustration of Books Old and New*. Still, as contemporary critics noted and as history has confirmed, his children's books were his masterpieces and his legacy.

Randolph Caldecott

The collaboration between Walter Crane and Edmund Evans verified the profitability of picture books, which led to opportunities for other artists. So, in 1877 when Crane turned his attention to new ventures, Evans commissioned freelance illustrator and former bank clerk Randolph Caldecott (English, 1846–1886) to illustrate an edition of *The House that Jack Built*—the same title that had initiated Crane's career more than a decade earlier (Figures 16.16a, b).

Although Caldecott drew his first children's book on wood, his black-and-white drawings were soon applied to the block photographically—an innovation that not only produced an exact copy of his linear work, but also left the original drawing intact for reference. Although color blocks were still engraved by hand, the photographic application of the line drawings meant they could be reduced or enlarged, and no longer had to conform to the dimensions of the block. Drawing quality improved because artists could work in a size convenient to their natural inclination.

By the end of the year, Caldecott and Evans completed a second book, *The Diverting Story of John Gilpin* (Figure 16.17). Both were released in time for the 1878 Christmas holidays and sold more than 60,000 copies in just six months.

Caldecott continued to produce children's books each December for the next eight years. His editions were designed in a progressive style combining spontaneous sketches with color illustrations outlined in brown rather than black. The reductive quality of the line was important to Caldecott, who once said that he studied "the art of leaving out as a science . . . the fewer lines, the less errors committed." Although economical with his drawing, Caldecott was liberal with

This is the House that Jack built,
And there is the loft where the Malt was spilt.

a

b

Figure 16.16 a,b
a. Walter Crane, *The House that Jack Built*, 1865. Xylograph.

Houghton Library, Harvard University, Type 8304.70.12.

b. Randolph Caldecott, "This is the Cock that crowed in the morn," *The House that Jack Built*, 1878. Xylograph. Walter Crane and Randolph Caldecott both began their careers as picture-book illustrators with interpretations of this popular nursery rhyme. Crane's was an "Indestructible Edition on Strong Cloth" to withstand rough handling by children.

Image: Wikipedia.

Figure 16.17
Randolph Caldecott, *The Diverting Tale of John Gilpin*, 1878. Xylograph. Caldecott had an abiding interest in animals and often added them to his illustrations to promote the sense of motion and lively humor that distinguished his work.

Osborne Collection of Early Children's Books, Toronto Public Library.

his interpretations, augmenting stories with pictures that contributed additional narrative to the text. For example, his version of the Queen of Hearts bears no resemblance to the imperious shrew in *Alice's Adventures in Wonderland* (Figure 16.18).

Throughout his short but productive life, Caldecott was plagued by illness, and he often fled England in winter to recuperate. In 1886, on a trip to the United States, he became gravely ill and died in St. Augustine, Florida, at the age of thirty-nine. The Caldecott medal, an annual award from the Association for Library Service to Children (a division of the American Library Association) to the artist of the best American picture book, is named in his honor (*see Chapter 25, Theme Box 47, "Diversifying Recognition within Picture Book Illustration"*).

Kate Greenaway

Catherine "Kate" Greenaway (English, 1846–1901) and Randolph Caldecott came to prominence at the same time. While Caldecott's health restricted his opportunities, Greenaway's obstacle was her gender. In England, professional publishing was considered a masculine enterprise, and early on in Greenaway's

career, a male painter complained that her work was effeminizing the art of the children's book. Nonetheless, the popular appeal of her illustrations soon yielded continuing commissions, enviable profits, and eventually, critical endorsement.

Greenaway attended the South Kensington School (which promoted the progressive Arts and Crafts movement) and then Heatherley's, the first British art school to admit women to life-drawing classes. By the age of twenty-one, she was attending London's Slade School while working independently to develop her signature work: watercolors of children dressed in clothing she designed and fitted on models. Although her costumes bore a nostalgic resemblance to the fashions of the **Regency** era (1811–1820), they owed as much to her invention as to authenticity.

When Greenaway finished her education in 1871, her drawings found a modest market in greeting cards—anonymous work credited to the manufacturer, not the illustrator (Figure 16.19). Greenaway's life changed in 1878, when she brought a portfolio of her artwork and poems to Edmund Evans. Fascinated by the sentimentality of her wistful characters and the charm of her accompanying verses, he published the work despite Greenaway's obscurity.

Borrowing a line from one of Greenaway's poems as a title, Evans printed 20,000 copies of *Under the Window*, which sold out before he could print the next run of 50,000 (Figure 16.20).

Greenaway continued her collaboration with Edmund Evans for the next nineteen years, producing illustrations for stories, poems, classic fairy tales, and nursery rhymes such as *Mother Goose; or the Old Nursery Rhymes* (1881), *A Apple Pie: An Old Fashioned Alphabet Book* (1886), and *The Pied Piper of Hamelin* (1888).

Figure 16.18
Randolph Caldecott, frontispiece for *The Queen of Hearts*, 1881. Xylograph.
The nasty Queen of Hearts apparently enjoys baking from her cookbooks, a scene added by Caldecott that has no direct link to the text.
Osborne Collection of Early Children's Books, Toronto Public Library.

Figure 16.19
Kate Greenaway, "To wish you a merry Christmas," greeting card issued by Marcus Ward & Company, ca. 1880.
This publisher produced Greenaway's designs from 1867 onward.
Osborne Collection of Early Children's Books, Toronto Public Library.

At a time when industrialization was altering the social and cultural landscape, Greenaway's idealized vision of a rural childhood complemented a prevailing nostalgia for a simpler past (Figure 16.21). Victorians revered childhood innocence, despite the fact that child labor played an essential role in Britain's economic success. The contrast between rhetoric and reality eventually awakened the national conscience, and Greenaway's popularity coincided with reforms aimed at ending exploitation of children. After years of debate over these reforms, the public welcomed Greenaway's drawings of a utopian childhood, and her celebrity engendered a host of imitators at home and abroad. Much to her annoyance, some were said to have "out-Kate-Greenawayed" Kate Greenaway.

The Twentieth Century

Greenaway died in 1901 at the age of fifty-five, just missing the next advance in the art of the children's book: the common use of **photo-trichromatic printing**, a technique of photographing an original painting through special filters to separate the primary colors (red, yellow, and blue) from the black lines. This process allowed the engraver to control quality by enhancing miniscule details on the matrices, adjusting tones with precision, and accurately matching color to the original artwork—a highly skilled, slow, and costly operation. The resulting volumes were spectacular. Between the covers of these lavishly illustrated, vividly colored children's books, nineteenth-century Romanticism would survive the onslaught of twentieth-century pragmatism and Social Realism (*see Chapter 20*) for another decade—entertaining new audiences with old stories.

Beatrix Potter

Born in London, Beatrix Potter (English, 1866–1943) was the only daughter in a wealthy family. Educated at home and encouraged in amateur artistic pursuits considered appropriate for her gender, as an adult she lived with her parents and earned a modest income drawing greeting-card designs and scientific illustrations (*see Chapter 9*). In 1901, at the age of thirty-five, Potter wrote and illustrated *The Tale of Peter Rabbit*—a tiny volume developed from a series of illustrated letters composed for the child of a friend (Figure 16.22).

Having been rejected by several commercial publishers, Potter decided to finance, print, and distribute the book privately. Her first edition of 250 copies, unassumingly enclosed in a paper cover, featured a color frontispiece and forty-two black-and-white drawings. The book's popularity resulted in a contract from publisher Frederick Warne for the three-color process edition (printed by Edmund Evans) that secured Potter's fame.

Although Beatrix Potter had no formal art education, long hours of observational drawing and a thorough knowledge of animal anatomy informed the endearing characters that populated the twenty-three books of her series. Potter admired the work of Randolph Caldecott and Edward Lear, and in that vein favored genial,

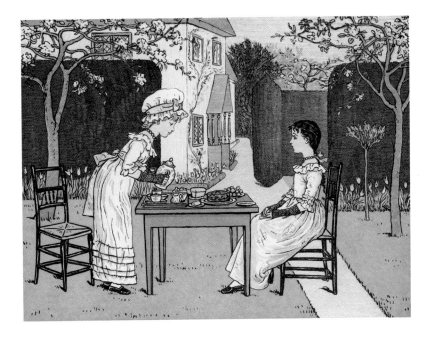

Figure 16.20
Kate Greenaway, interior illustration for *Under the Window: Pictures and Rhymes for Children*, 1879. Xylograph.
This illustration is typical of Greenaway's work, which featured idealized children in quaint costumes and rural settings that provided a welcome respite from the realities of childhood in industrialized Britain.
Osborne Collection of Early Children's Books, Toronto Public Library.

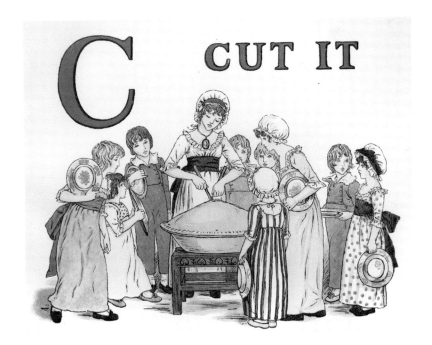

Figure 16.21
Kate Greenaway, "C Cut it," in *A Apple Pie*, 1886. Xylograph.
In this nostalgically faithful rendition of a seventeenth-century alphabet book, there is no page for the letter *I* since in the 1600s, the letters *J* and *I* were not differentiated.
Osborne Collection of Early Children's Books, Toronto Public Library.

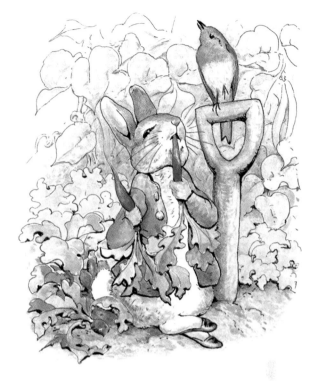

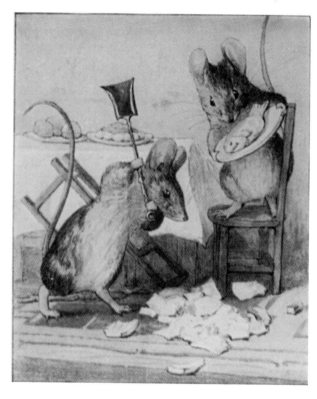

expressive watercolors designed to charm younger readers (Figure 16.23). The world she created is one of temperate landscapes, rounded volumetric forms, and soft color—a gentle domain where appealing animals maintained their own society, coexisting with humans in much the same way that children coexist with adults.

Beatrix Potter's modestly produced children's books survived the two world wars and remain in publication to the present day. "The Tale of Peter Rabbit" has sold more than 45 million copies, and the 1903 patent that Potter secured for Peter Rabbit merchandise provided her with a steady income throughout her life.

Gift Book Illustrators

Ostensibly created as holiday presents for wealthy children, in fact, gift books were status symbols often purchased as collector's items, displayed in glass cases, and only handled on special occasions. Children's gift books peaked in popularity between the turn of the century and World War I, but adult equivalents were marketed in London as early as 1867, when the Doré gallery opened on Bond Street. Classic works illustrated with Gustave Doré's large-format wood engravings, such as *Dante's Inferno* (1861), *Don Quixote* (1862), and the *Bible* (1866), were coveted additions to private libraries.

Arthur Rackham

Arthur Rackham (English, 1867–1939) was a notable gift book artist whose subtly toned artwork profited from accuracy of the photo-trichromatic printing process. From an inauspicious beginning as an insurance clerk with an interest in art, Rackham gained skill through practice and keen observation, and landed a position as a staff artist on a local newspaper at twenty-five. Four years later, he set out on his own, garnering commissions of increasing importance, including an assignment to illustrate *The Fairy Tales of the Brothers Grimm* in 1900 (Figure 16.24). Rackham completed one hundred black-and-white illustrations for the project, re-invigorating the familiar stories with sophisticated imagery that recalled their earlier grotesque, Northern European characterizations. It was this stylistic direction that distinguished Rackham from his competitors and appealed to both children and adults—important in a market about to expand its audience and profitability.

The popularity of *The Fairy Tales of the Brothers Grimm* boosted Rackham's reputation, but it was his 1905 edition of *Rip Van Winkle* that earned him a place among Britain's leading illustrators of luxury gift books (Figure 16.25). Because this book featured fifty-one color illustrations, publisher William Heinemann devised a marketing plan to underwrite the expense of its color printing in which Rackham's original watercolors were exhibited and offered for sale at London's Leicester Galleries prior to the book's release. When the book was brought out, consumers were offered two options: deluxe, signed copies or affordable trade editions. The scheme worked so well that it became standard procedure for publishers competing in the lucrative gift book market.

When the copyright on Tenniel's *Alice's Adventures in Wonderland* expired in 1907, Rackham's gift book adaptation was the best-selling of seven rival versions. Although well aware of the popularity of Tenniel's original illustrations, Rackham was unprepared for the criticism that followed. The *London Times* called his work "forced and derivative," noting a lack of imagination in his interpretation. Because Rackham and Tenniel illustrated some of the same scenes, comparisons were easily made. Tenniel's benign designs closely followed the narrative, while Rackham's more interpretive illustrations expanded the text's fantastic elements and were considered unnerving (Figure 16.26a, b.)

Figure 16.24
Arthur Rackham, "'Stupid goose!,' cried the Witch. 'The opening is big enough. . .'" in "Hansel and Gretel," *The Fairy Tales of the Brothers Grimm*, 1900.
In this illustration, Rackham restores the original menacing quality to Hansel and Gretel by choosing to portray the frightening moment when the witch leads the innocent girl to the oven.

Courtesy of the Children's Literature Collection, Providence Athenæum.

Figure 16.25
Arthur Rackham, "A company of odd-looking persons playing at ninepins," *Rip Van Winkle*, 1905.
In this complex composition, Rackham shows the individuality and humanity of each of his characters through expressive, exaggerated gesture.

Image: ebooks at University of Adelaide Library.

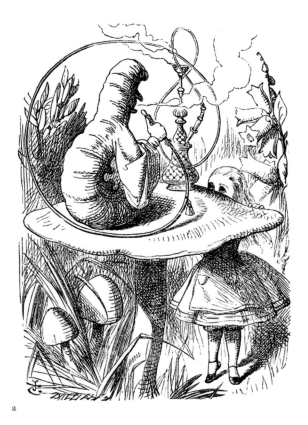

a

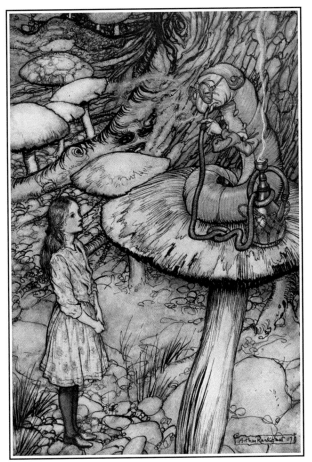

b

Figure 16.26a,b
John Tenniel (a) and Arthur Rackham (b), interior illustrations, *Alice's Adventures in Wonderland* by Lewis Carroll, 1865 and 1907.
In Tenniel's version of Alice meeting the Caterpillar, the potentially frightening face of the caterpillar is hidden. Rackham's illustration, which some readers found objectionable, is set in a landscape of twisted bark and bulbous fungus, with an older Alice directly confronting the countenance of a grotesque larva.

Courtesy of David Mason Books.

Although the controversy over the Alice illustrations caused Rackham to refuse an offer to illustrate *Through the Looking-Glass*, it did not hinder a productive career. Taken in total, Rackham's illustrations demonstrate superb draftsmanship, haunting color, and natural environments as seemingly alive as the creatures that inhabit them (Figure 16.27).

Edmund Dulac and Kay Nielsen

Edmund Dulac (French, British, 1882–1953) was fifteen years younger than Arthur Rackham, but his swift rise to prominence made him a major competitor. Trained in Paris but inspired by the work of British artists such as designer William Morris and Walter Crane (*see Chapter 15*), Dulac anglicized his name from Edmond to Edmund and set out for London. Within a few weeks, he was hired to create sixty watercolors for the collected works of the Brontë sisters. Although the Brontë illustrations were critically praised, it was competition between publishers that gave Dulac entrée into the children's book market: when Rackham signed with William Heinemann for *Alice's Adventures in Wonderland*, rival publisher Hodder and Stoughton commissioned Dulac to illustrate *Stories from the Arabian Nights* (1907).

Dulac's use of compressed perspective, flat color, and exotic characters mimicked the Japanese prints and Persian miniatures popular at the time. This Asian influence, as in "Princess Badoura" (Figure 16.28), distinguished Dulac's elegant heroes and unusual scenery from Arthur Rackham's gnarled landscapes and Nordic characters. Reviews of *Arabian Nights* were flattering, and the exhibition of Dulac's original watercolors at the Leicester Galleries sold out. By the age of thirty, he had illustrated six editions of classic tales including *The Rubaiyat of Omar Khayyam* (1910) (Figure 16.29) and *The Sleeping Beauty and Other Fairy Tales* (1911). When Edmund Dulac became a naturalized British citizen in 1912, his popularity matched Rackham's.

That same year, Danish artist Kay (rhymes with "pie") Rasmus Nielsen (1886–1957) mounted a solo exhibition that brought him to London from Paris, where he had been studying art for almost a decade. The show yielded a prestigious children's book commission with a contractual arrangement that replicated the successful formula customary for deluxe children's books with his first offering, *In Powder and Crinoline* (1913), issued concurrently with a holiday exhibition of twenty-four originals at the Leicester Galleries. Robust sales prompted a second commission, *East of the Sun and West of the Moon: Old Tales from the North*—an assignment that united design influences from the artist's Northern European childhood with his fascination for Asian aesthetics.

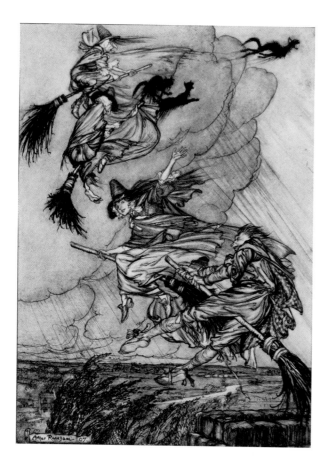

Figure 16.27
Arthur Rackham, "Hey! up the chimney lass! Hey after you!" frontispiece, *The Ingoldsby Legends*, 1907.
For affluent Edwardian families, Christmas was not complete without Rackham's latest lavish gift books, classics such as *The Ingoldsby Legends* (1907), *Fairy Tales from the Brothers Grimm*, (1909), and *Aesop's Fables* (1912).
Providence Public Library.

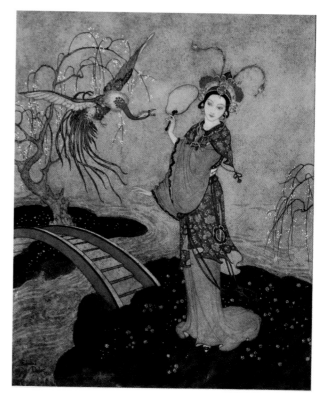

Figure 16.28
Edmund Dulac, "Princess Badoura," *Stories from the Arabian Nights*, 1907. Dulac's illustrations for this book show the influence of Japanese prints and Persian miniatures with their juxtaposition of minute detail with large areas of flat color.
Osborne Collection of Early Children's Books, Toronto Public Library.

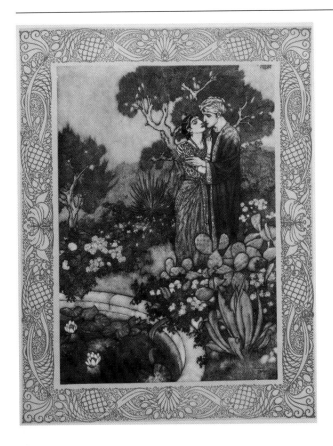

Figure 16.29
Edmund Dulac, interior illustration for Quatrain XLIV, *The Rubaiyat of Omar Khayyam*, 1909.
This painting was one of twenty color illustrations Dulac produced for a sumptuous gift book translation of the poems of Persian scientist and writer Omar Khayyam.

Courtesy of the Fleet Library, at Rhode Island School of Design, Special Collections, Providence, RI.

East of the Sun and West of the Moon was printed in November 1914 with a preface asserting that Nielsen's amalgamation of the real with the supernatural would appeal to all ages (Figure 16.30). The book was a phenomenon, with stunning illustrations featuring stylized characters set against theatrical backgrounds enhanced by the addition of black as a fourth color in the trichromatic printing process. Two sensational achievements in successive years should have marked the beginning of a long record of distinction for Nielsen, but political events intervened.

The Impact of World War I on Gift Book Publishing

Britain's entry into World War I in August 1914 plunged the nation into crisis. Optimistic reports predicting that fighting would cease by Christmas were dashed by the magnitude of the conflict. Widespread privations crippled the publishing industry, and luxury books proved untenable as well as unwarranted in a time of national emergency. The age of the deluxe children's book ended with the 1914 holiday season.

Too old to enlist, Arthur Rackham joined the Hampstead Volunteers. Even so, he completed a new children's book each year through 1920. Although the quality of his work was undiminished, the war

necessitated modestly produced editions. When combat ended in 1918, Britain was slow to recover, and although Rackham secured commissions from publishers in the United States, the market for luxury children's books never recovered on either continent. Nevertheless, the artist rebounded, sustaining a fulfilling career in the changed economy. Rackham died on September 6, 1939, a few weeks after completing illustrations for Kenneth Grahame's *The Wind in the Willows*, a commission he had ironically declined thirty years before.

By 1914, Edmund Dulac was an established celebrity with book contracts guaranteed for the next three years. When these contracts were canceled due to wartime hardships, Dulac worked without compensation illustrating books benefiting the war effort (Figure 16.31). After the armistice, a hastily published volume of Hawthorne's *Tanglewood Tales* kept Dulac solvent but could not restore the high-end market for children's books.

Kay Nielsen found employment as a theatrical costume and set designer in postwar Denmark. Hodder

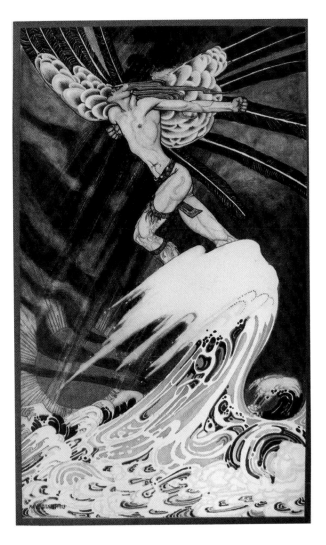

Figure 16.30
Kay Nielsen, "The North Wind Goes Over the Sea," *East of the Sun and West of the Moon: Old Tales from the North*, 1914.
Nielsen's heroic personification of the North Wind demonstrates his powerful, decorative style.

Courtesy of the Fleet Library, at Rhode Island School of Design, Special Collections, Providence, RI.

Theme Box 35: Women in Illustration
by Pernille Holm

The modern women's movement dates back to the eighteenth century when philosophers argued for the equality of all human beings. Writer Mary Wollstonecraft (English, 1759–1797) challenged the idea that women, as a group, are by nature inferior to men and argued that if they were less capable, it would be due to poor education and fewer opportunities.

The women's movement in the nineteenth century, called *first-wave feminism*, focused primarily on suffrage, the right to vote, which was won in most European countries and

the United States in the early twentieth century. Illustrator Rose O'Neill (American, 1874–1944) promoted suffrage with her popular "Kewpie" characters (Figure TB35.1).

O'Neill, along with Kate Greenaway, Maud Humphrey Bogart (American, 1868–1940), Mabel Lucie Attwell (English, 1879–1964), Jessie Willcox Smith (American, 1863–1935), Beatrix Potter (English, 1866–1943), and many other women illustrators for and of children enjoyed fame and prominence during the Golden Age of Illustration ca. 1900. In comparison to their fine-art colleagues, they

were held in high esteem and also fared well financially. Why? First, new ideas and ideals of childhood were emerging, and images were being redefined, popularized, and commercialized in print media during this era. Additionally, writer and art historian Anne Higonnet suggests that their success was possible because they primarily focused on suitably feminine subjects of maternity and childhood (Figure TB35.2). Effectively, they were rewarded because their work did not threaten conventional gender norms (even though their personal lives were very often unconventional). In contrast, women who did not specialize in children's materials were less likely to become famous, and until recently, their histories were not researched or preserved as much.

After a lull in feminist politics and writings, the debate about women's issues picked up again after World War II when female war-effort workers were dismissed and encouraged to confine themselves to traditional homemaker roles. Simone de Beauvoir's famous book *The Second Sex* (1953) and Betty Friedan's *The Feminine Mystique* (1963) spurred *second-wave feminism*, in which scholars and political activists in the

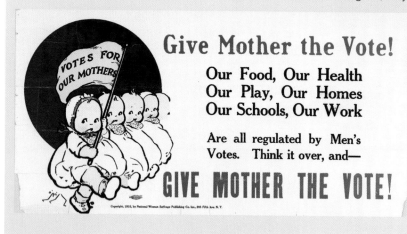

Figure TB35.1
Rose O'Neill, "Give Mother the Vote!" 1915. Chromolithograph.
Political Collection, Missouri History Museum, St. Louis, N20256.

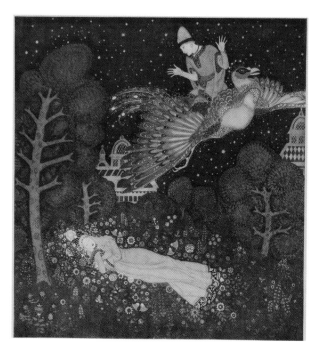

Figure 16.31
Edmund Dulac, "There he found the princess asleep and saw that her face was the face he had seen in the portrait," in "The Fire Bird," *Edmund Dulac's Fairy-Book: Fairy Tales of the Allied Nations*, 1916.
This book and *Edmund Dulac's Picture Book for the French Red Cross* both raised substantial charitable funds for the war effort.
Courtesy of the Fleet Library, at Rhode Island School of Design, Special Collections, Providence, RI.

and Stoughton later published Nielsen's *Hans Anderson's Fairy Tales* (1924) and *Hansel and Gretel* (1925) with only modest sales, so Nielsen soon returned to Copenhagen where he continued his theatrical work. In 1939, an invitation to stage a production in Hollywood lured him to California, where he stayed on to work at the Walt Disney Studios, applying his unique vision to the "Night on Bald Mountain" sequence featured in Walt Disney's 1940 animated film, *Fantasia*.

Conclusion

Between 1823, when George Cruikshank's first successful children's book was published, and the Armistice of 1918, societal upheavals altered the cultural landscape and influenced all forms of art. The children's book market burgeoned and became stratified with offerings ranging from lavish gift books to the six-penny toy-books available at commuter bookstands. While World War I

1960s and '70s challenged inequality between the sexes in the workplace and examined the ideological values and structures that produced and maintained the divide between the sexes. Feminist and queer theory was born out of this era (*see Chapter 26, Theme Box 48, "Judith Butler: Gender and Queer Studies"*).

In a famous 1971 essay, art historian Linda Nochlin asked, "Why have there been no great women artists?" She argued that the answer did not lie in the lack of individual talent but in factors such as a discriminatory educational system that did not afford women the same opportunities as men, prejudiced social institutions that awarded men only, and inhibiting cultural and social values that saw ambition and single-mindedness as unfeminine and frivolous self-indulgence.

Others, including comics historian Trina Robbins, have argued that ideology and gendered biases have excluded women creators from the canon. Robbins's research has brought to light "forgotten" female cartoonists such as Nell Brinkley (1886–1944) and Dalia "Dale" Messick (1906–2005), whose strips featured assertive heroines.

Further Reading

de Beauvoir, Simone, *The Second Sex* (1953), translated by Constance Borde and Sheila Malovany-Chevalier (London: Cape, 2009).

Carter, Alice, *The Red Rose Girls: An Uncommon Story of Art and Love* (New York: Harry N. Abrams, 2000).

Friedan, Betty, *The Feminine Mystique* (New York: W.W. Norton and Co., 1963).

Higonnet, Anne, *Pictures of Innocence: The History and Crisis of Ideal Childhood* (New York: Thames and Hudson, 1998).

Nochlin, Linda, "Why Have There Been No Great Women Artists?" In *Woman in Sexist Society: Studies in Power and Powerlessness*, edited by Vivian Gornick and Barbara Moran (New York: Basic, 1971).

Robbins, Trina, *Pretty In Ink: North American Women Cartoonists 1896–2013* (Seattle, WA: Fantagraphics, 2013).

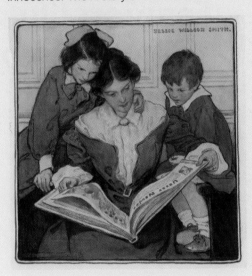

Figure TB35.2 Jessie Willcox Smith, *The Picture Book*, design for cover of *Collier's*, June 30, 1906, ca. 1906. Watercolor and charcoal, varnished, 19 $^{15}/_{16}$ × 19 $^{11}/_{16}$".

Gift of Mrs. Gustav Radeke and Isaac C. Bates. RISD Museum, Providence.

brought an end to the market for high-end gift books, the appeal of the iconic images created by the illustrators who flourished in London during the nineteenth and early twentieth centuries continued. Illustrations by Cruikshank, Tenniel, Lear, Crane, Caldecott, Greenaway, Potter, Rackham, Dulac, and Nielsen inspired the imagination of generations of youngsters and set the standard for future children's book illustration—a testament to the enduring relevance of their creativity and impeccable craft.

FURTHER READING

Blackburn, Henry, *Randolph Caldecott, A Personal Memoir of His Early Career* (London: Sampson, Low, Marston, Searle & Rivington, 1886).

Hudson, Derek, *Arthur Rackham: His Life and Work* (New York: Scribner, 1960).

Spielman, M. H., and G. S. Layard, *Kate Greenaway*, 2nd ed. (London; Bracken Books, 1987).

Thackeray, William Makepeace, *An Essay on the Genius of George Cruikshank Reprinted Verbatim from the Westminster Review* (London: George Redway, 1884).

Wakeling, Edward, *Lewis Carroll: Man and His Circle* (London: I. B. Tauris & Co. Ltd., 2015).

KEY TERMS

headpiece	Regency
media convergence	set piece
participatory culture	transmedia storytelling
photo-trichromatic printing	yellow-back

17

Six Centuries of Fashion Illustration, 1540–Early 2000s

Pamela Parmal

From the Renaissance to the present day, what we wear has reflected personality, status, profession, and identity. Print media has been instrumental in documenting, enforcing, and inspiring fashion. This chapter describes the evolution of fashion illustration in Europe over a 500-year period.

Costume Illustration, 1540–1800

Most writers on the history of Western dress date the birth of fashion to the Renaissance. Expanding wealth among the social classes caused by a growing economy and global trade, coupled with the new philosophical emphasis on the individual, provided the proper environment for fashion to flourish. The new global reality also brought about the European urge to classify, document, and eventually dominate the expanding world around them. This urge found many expressions during this Early Modern Period and included the mapping of the globe, the study of anatomy by Andreas Vesalius (Italian, 1514–1564), the taxonomy of Carl Linnaeus (Swedish, 1707–1778) (*see Chapters 9 and 10*), and the publication of illustrations documenting the dress of the period.

As wealth expanded during the sixteenth century, sartorial boundaries began to blur as people of the lower classes began wearing the clothing of their "betters," which they commissioned or acquired on the second-hand market. A 1543 Venetian proclamation outlined this problem as it related to women and particularly prostitutes who appeared in public "much bejeweled and well-dressed, that very often noble ladies and women citizens, because there is no difference in their attire from that of the above-said women, are confused with them, not only by

foreigners, but by the inhabitants of Venice, who are unable to tell the good from the bad."[1]

The practice of one class adopting the dress of another caused social unrest and was seen by many as a threat to the status quo. As a result, **sumptuary laws** regulating how people could dress were passed. To create a sense of order, books illustrating the appropriate dress of different social classes and different cultures became popular. While costume historians and others have sometimes viewed these images as fashion plates, their role served the opposite function: instead of introducing new styles, the plates helped to document traditional dress in order to maintain class divisions. Even so, the illustrations probably did find their way into the hands of dressmakers, tailors, and their clients, serving as inspiration for the design of a new style of garment or for an individual aiming to "ape his betters."

As Venice experienced growing economic success and became one of Europe's leading centers of trade, it welcomed people from throughout Europe, the Ottoman Empire, and beyond. Books on costume were especially popular in Venice, which by the end of the fifteenth century had also become an important center for publishing. At least eight costume books, one-third of all published, were done so in the city prior to the early seventeenth century. Two of the most popular books were Ferrando Bertelli's (Italian, about 1525–1580) *Omnium fere gentium nostrae aetatis habitus* (*Clothing of Almost All Nations of Our Time*) of 1563; and Cesare Vecellio's (Italian, 1521–1601) *Habiti antichi e moderni di diverse parti del mondo* (*Of Costumes, Ancient and Modern, of Different Parts of the World*), 1590 and 1598 (Figure 17.1a, b). Each of the books contained a series of woodcut or engraved illustrations, some of which were hand colored.

[1] Quoted in Wilson, "Reproducing the Contours of Venetian Identity," 259.

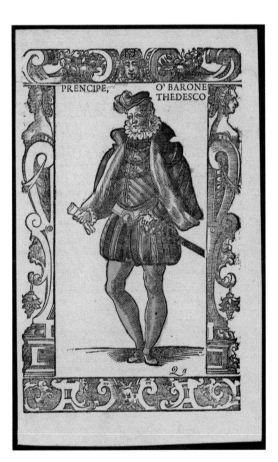

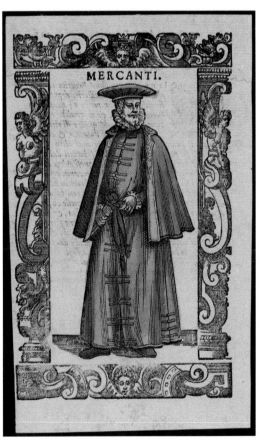

Figure 17.1a, b
Cesare Vecellio, "Prencipe, O 'Barone Thedesco'" and "Mercanti," illustrations in *Gli habiti antichi et moderni di diversi parti del mondo*, 1590. Woodcut with hand-applied color on cream laid paper, 6 15/16 × 4 3/16" (each). Artists like Cesare Vecellio and members of the Bertelli family profited from their encounters with foreign traders from North Africa, the Ottoman Empire, Poland, Bavaria, and Silesia who traveled to Venice. Their illustrations are credible depictions of the range of dress found in northern Italy during the sixteenth century.

Photograph © Museum of Fine Arts, Boston. Gift of L. Aaron Lebowich, 50.2567; 50.2579.

a

b

While the majority of the plates document existing styles of dress in an attempt to maintain social order, Vecellio, a savvy publisher, was not unaware of the power of the plates to influence the consumer. In his 1590 publication, he introduced readers to M. Bartholomeo Bontempele at the sign of the Chalice, a silk **mercer** who claimed among his clients the Venetian nobility, Princes of Italy, and even the Seraglio of the Grand Turk. Vecellio goes on to mention the fine silks and cloths of gold available in Bontempele's shop. His book contains the first known use of costume plates for marketing purposes.

While the fashion for costume books waned during the seventeenth century and into the eighteenth, notable artists including Jean de Saint Igny (French, about 1600–1649), Abraham Bosse (French, 1604–1676), Jacques Callot (French, ca. 1592–1635) (*see Chapter 12*), and Wenceslaus Hollar (Czech, 1607–1677) continued to create prints chronicling the fashions of their day (Figure 17.2). The plates these artists made are not that different in purpose from the costume books of the sixteenth century. Each shows the costume of a man or woman of a specific social class.

Le Mercure galant

While Saint Igny, Callot, and Hollar created plates for sale to collectors in the spirit of the costume books, the seventeenth century also saw the introduction of the first modern magazine to include fashion coverage: *Le Mercure galant* (published 1672–1678; retitled *Le Nouveau Mercure galant* in 1677; revived in the early eighteenth century as *Mercure de France*) (Figure 17.3). *Le Mercure galant* included news and war reports, as well as poems, riddles, gossip, songs, readers' correspondence, and fashion coverage. While the latter was irregular, the magazine's publisher, Jean Donneau de Visé (French, 1638–1710), recognized the power of the press to spread the latest fashions, and he made sure to note the newest trends in fabric and trims and where they could be purchased in Paris.

The plates were designed by Jean Berain (French, 1638–1711), who was the court-appointed designer of the King's cabinet. The plates were engraved by Jean Le Pautre (French, 1618–1682), who, like Berain, designed ornaments for furniture, architecture, and the stage. Berain was a clever choice by de Visé because his position at court allowed him to live and work at Versailles; the designer would have been very familiar with the clothing worn by the most fashionable court in Europe, that of Louis XIV. The king and his finance minister Jean-Baptiste Colbert sought to establish the French court as the center of fashionable dress while, at the same time, promoting the growth of luxury trades such as silk and wool weaving, lace making, and the knitting of silk stockings on newly introduced knitting frames.

Figure 17.2
Jean de Saint Igny (illustrator) and Abraham Bosse (engraver), Plate 9 from *La Noblesse Française à L'Église*, ca. 1630. Etching and engraving on white laid paper, 5 7/8 × 3 3/4". Abraham Bosse, a noted French printmaker and engraver of the seventeenth century, was the son of a tailor. His work pays close attention to the details of dress. This image illustrates a widow in an elaborate overdress. The hood was probably shaped using whalebone. Photograph © Museum of Fine Arts, Boston. The Elizabeth Day McCormick Collection, 44.879.

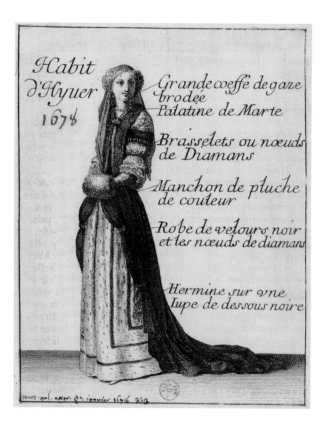

Figure 17.3
"Habit d'Hyver," *Le Nouveau Mercure galant* (*Extraordinaire*), 1678. *Le nouveau Mercure galant* enjoyed the royal patronage of Louis XIV's son Louis, the Dauphin of France. On May 15, 1678, a supplementary issue—*Extraordinaire*—included the first series of fashion plates. Each plate, such as this woman wearing winter dress, included detailed descriptions of the textiles and trims used to make the garments.
Bibliotheque Nationale NB-B-169908.

French Costume Plates of the Late Seventeenth and Early Eighteenth Centuries

During the reign of Louis XIV, a fashion for collecting engraved costume plates developed in Paris. Illustrations of the dress of the various social classes, foreign cultures, and tradesman were reminiscent of those of the earlier sixteenth century. They proved to be a lucrative commodity for the print shops located on and near the Rue St. Jacques in the Latin Quarter, where proximity to the Sorbonne encouraged the establishment of the printing and book selling trades during the fifteenth century. French engravers including Jean Le Pautre, the Bonnart family, Dieu de St. Jean (French, d. 1694), and Nicolas Arnoult (French, d. 1722) created thousands of plates, many of which were hand colored. The most popular appear to have been those that depicted members of the French court, some of whom were named in the captions, while others were simply referred to as a "*Homme de Qualité*" or "*Dame de Qualité*" (Figure 17.4). Unlike the plates in *Le Mercure galant*, these single-plate engravings had simple captions such as a "young girl in winter dress" or "a woman of quality in undress for the bath." They did not go into detail regarding the materials out of which the clothing was made.

The early part of the eighteenth century saw the continuation of similar trends in fashion illustration, with artists periodically issuing a series of plates depicting the dress of the time. Perhaps the most famous artist to do so is Antoine Watteau (French, 1684–1721), who between 1709 and 1710 designed and engraved a series of plates titled *Figures de modes* (Fashionable Figures) (Figure 17.5).

Perhaps the most famous series of costume engravings, now known as the *Monument du costume*, was designed by Sigmund Freudenberger (Swiss, 1745–1801) and engraved by Jean-Michel Moreau le Jeune (French, 1741–1814). Nicolas Edmé Restif de la Bretonne (French, 1734–1806) in his introduction to the 1789 edition specifically mentions that the plates were drawn from real life and depicted the dress, furnishings, and

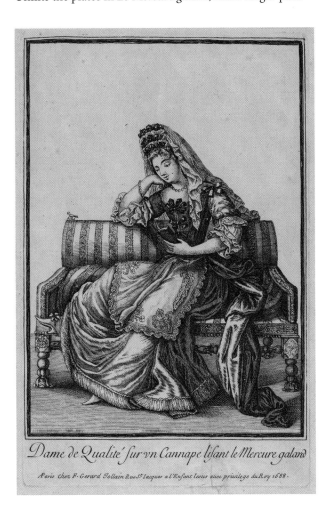

Figure 17.4
Francois-Gerard Jollain (engraver), "Dame de Qualité sur un Cannape lisant le *Mercure galand*," 1675–1700. Engraving and etching on laid paper, 12 ³/₈ × 8 ¹/₄".
Single-sheet engravings, such as this depicting a fashionable woman reading the *Mercure galand*, were popular collectibles during the late seventeenth century. As with the costume plates of the sixteenth century, the French publishers produced images of the nobility, merchants, tradesmen and women, and lower classes.
Museum of Fine Arts, Boston, The Elizabeth Day McCormick Collection, TFA. Inv.120.73.

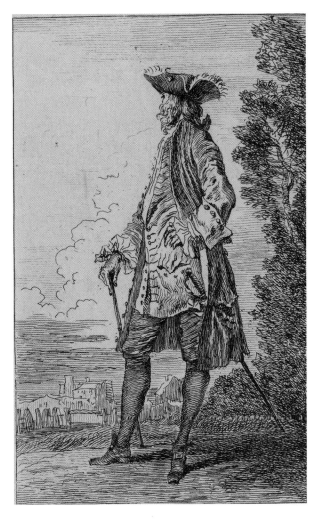

Figure 17.5
Antoine Watteau, Plate 6, *Figures de Modes*, 1709–1710. Etching and engraving on laid paper, 4 ¹/₂ × 2 ³/₄".
Watteau's *Figures de modes* included seven plates, four illustrating the fashionable dress of men and three of women. During the eighteenth century, men followed fashion as assiduously as women. To dress fashionably was a sign of wealth and position.
Photograph © Museum of Fine Arts, Boston. Gift of Mrs. Lydia Evans Tunnard in memory of W. G. Russell Allen, 63.2891.

settings of the time for the purpose of documenting them for future generations. The plates pay as much attention to fashionable men as they do to fashionable women (Figure 17.6).

The Fashion Plate

Dress of the later part of the eighteenth century was characterized by a simplification in fabric and in ornamentation that made fashionable dress more accessible to a wider range of social classes. This shift resulted in changes in consumer behavior, and more and more of French households' dollars were devoted to acquiring the latest cap or bonnet. According to Louis Sebastien Mercier (French, 1740–1814) in his *Tableau de Paris* (1781–1789), "The expense of fashion today exceeds that of the table and that of a horse and carriage." During this period of excess, the fashion merchants flourished, especially the **marchande des modes** (milliner), whose role was to create the latest in headwear and dress trims. The most famous *marchande des modes* was Rose Bertin (French, 1747–1813), who worked closely with Marie Antoinette to keep the queen at the top of the fashion pyramid. As in the past, the latest fashions were on display at court, and access was

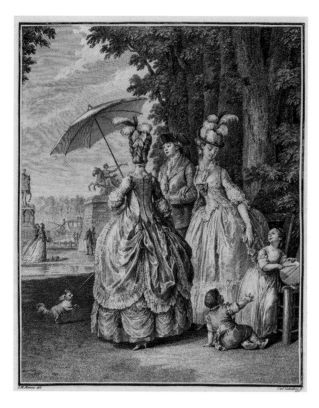

Figure 17.6
Jean-Michel Moreau le Jeune (illustrator) and Carl Guttenberg (engraver), after Sigmund Freudenberger (illustrator), "Le Rendez-vous pour Marly" ("The Appointment at Marly"), *Monument du costume physique et moral de la fin du dix-huitième siècle*, 1775; published by Société typographique (Neuvied sur le Rhin), 1789. Etching and engraving on laid paper, 10 ⁵/₈ × 8 ¹/₂". Freudenberger's monumental survey of French culture and dress was originally titled *Suites d'estampes pour servir à l'histoire des mœurs et du costume des Français dans le XVIIIᵉ siècle* (*Series of Prints to serve as the History of the Culture and Costume of the French during the 18th century*).
Photograph © Museum of Fine Arts, Boston. Bequest of William A. Sargent, MFA 37.2410.

key to remaining up-to-date with the latest styles. Fashion periodicals broke down aristocratic exclusivity when they reported on (and thus popularized) Marie Antoinette's latest dress or bonnet. The period was finally ripe for the fashion press to flourish.

Despite the focus on fashion in France and its claim to be the fashion capital of Europe, the first periodical with regular fashion coverage was introduced in England in 1770 and was directed mainly at women. *The Lady's Magazine or Entertaining Companion for the Fair Sex* remained in publication until 1837 and, like *Le Mercure galant*, it included local and foreign news, letters to the editor, literary contributions, and semi-regular fashion coverage and plates. Three German publications, also directed at women, followed in the early 1780s: *Magazin für Frauenzimmer* (*Magazine for Women*), *Neues Magazin für Frauenzimmer* (*News Magazine for Women*), and *Damen-Journal* (*Lady's Journal*).

Unlike the English and German publications, which were primarily literary, several new French magazines of the late eighteenth century were the first devoted solely to fashion (Figure 17.7). The first was *Cabinet des modes* (*The Cabinet of Fashion*) (1785), the sole purpose of which was to introduce new styles of dress. Each edition, which appeared every two weeks in its first year and every ten days in subsequent years, contained two or three plates, text describing the fashions depicted, and, for the first time, advertisements. The last edition appeared just before the Revolution started in 1789. The plates from the *Cabinet des modes* were copied in Liège, Belgium, and in multiple cities in Germany.

Gallerie des modes et costumes

The most luxurious series of French plates issued during the period was the *Gallerie des modes et costumes* (*Gallery of Fashion and Dress*) published by Jules Esnauts and Michel Rapilly of the rue St. Jacques. The first folio appeared early in 1778 and included six plates with each depicting four fashionable headdresses; full figures in fashionable dress appeared in the seventh folio. New folios were issued about every two weeks until the late 1780s, when fewer plates were published (the last appeared in 1787). In total, 436 plates carry designs by French artists Pierre-Thomas Leclerc (about 1740–after 1799), Claude-Louis Desrais (1746–1816), François-Louis-Joseph Watteau (1758–1823), and Augustin de Saint-Aubin (1736–1807). Like the plates of the late seventeenth century, some of the *Gallerie des modes* (Figure 17.8a, b) featured images of those whose notoriety augmented the prints' appeal: members of the French court and actors and dancers in their costumes. The plates were widely disseminated throughout Europe and, like de Visé's *Le Mercure galant*, a few featured the names of the *marchande des modes* responsible for a specific look.

Fashion Caricatures

As obsession with fashion spread, a concurrent popularity for prints satirizing the more extreme tastes arose. Caricatures lampooning the exaggerated hairstyles of the late eighteenth century and the scanty garments of the

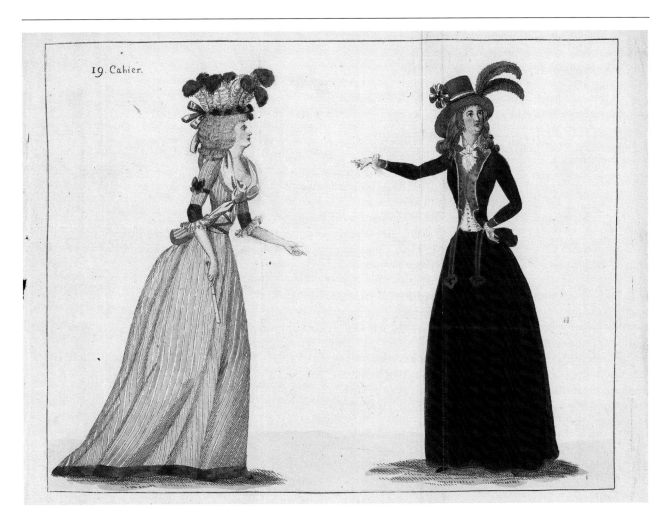

Figure 17.7
Plate 1–2, *Journal de la mode et du gout*, vol. 19, August 25, 1790. Etching with hand-applied color, 7 ⁷/₈ × 10".

The *Journal de la mode et du gout ou Amusement du salon et de la toilette* (*The Journal of Fashion and Taste or Amusements of the Salon and of the Toilette*) was one of the few journals to be published during the French Revolution in the years 1790 to 1793, its predecessor *Cabinet des Modes* having been discontinued before the conflict.

Photograph © Museum of Fine Arts, Boston. The Elizabeth Day McCormick Collection, 44.2030.

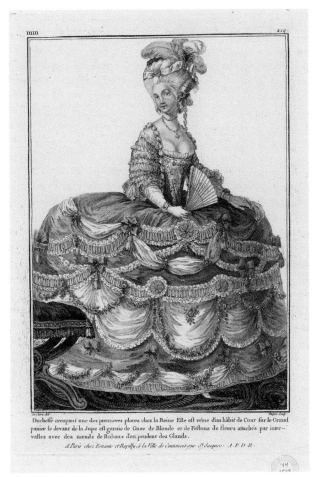

a

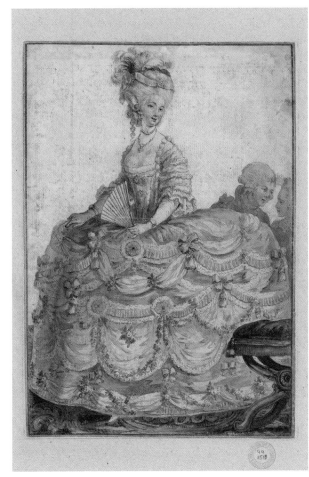

b

Figure 17.8a, b
Pierre-Thomas LeClerc (designer) (French, about 1740–after 1799), preparatory sketch, 1781. Ink and watercolor on laid paper, 16 ¹/₂ × 11 ¹/₄"; Nicolas Dupin (engraver) (French, eighteenth century), Plate 36e; *Gallerie de modes et costumes Français*, 1781. Hand-colored engraving on laid paper, 15 ¹/₄ × 10".

The rare survival of an original sketch for a plate from Esnaut and Rapilly's *Gallerie de modes et costumes Français* proves the latitude given to the engraver, who chose not to include the couple lurking in the background; and the colorist, who chose to use green for the dress and pink for the trim, the exact opposite of LeClerc's sketch.

Photograph © Museum of Fine Arts, Boston. The Elizabeth Day McCormick Collection, 44.1517, 44.1518.

early nineteenth were created by artists in France and England, including Jean-Baptiste Huet (French, 1745–1811), James Gillray (English, 1757–1815) and George Cruikshank (English, 1792–1878) (Figure 17.9).

After the French Revolution subsided and a new government, The Directory, was put in place in 1795, a fashionable subculture arose among the young French people of Paris. They took on extreme habits in dress and social customs imitating the aristocrats of the **Ancien Régime** (the former ruling elite). The men were referred to as *Incroyables* (the Incredibles); and the women, *Merveilleuses* (The Marvelous). Hundreds of balls such as the *bals des victimes* were held, in which aristocrats who survived the Revolution danced in black mourning costume. Two of the most noted French caricaturists, Carle Vernet (French, 1758–1836) and his son Horace (French, 1789–1863), amused many with their post-Revolutionary depictions of the extravagant looks of the *Merveilleuses* and the *Incroyables* (Figure 17.10a, b). Men sported tight breeches, long hair, and exaggerated collars and neck cloths, while women favored chemise dresses of light fabric with very low necklines, inspired by Classical Greek garb. The display of cleavage during the post-Revolutionary period also became a favorite subject with the caricaturists.

Nineteenth-Century Fashion Plate

The changes to the fashion system that originated during the late eighteenth century firmly took hold in the beginning of the nineteenth century. Fashion was increasingly feminine focused, international, and characterized by rapid change in the cut of dress and trims. New fashion publications were introduced at a rapid pace, encouraged by the improved literacy among women and by cheaper methods of reproduction such as lithography. In England, Rudolph Ackermann's *The Repository of the Arts* was published between 1809 and 1828; and *La Belle Assemblée or Bell's Court and Fashionable Magazine* was available from 1806 to 1868. These magazines made it to the United States, where by 1830 *Godey's Lady's Book*, a native publication, appeared and remained in print under a variety of titles until 1898 (*see Chapter 18*). In France, the most successful magazine was the *Journal des dames et des modes*, which first appeared in 1797 and outlasted all other magazines that entered the market prior to 1800, remaining continuously in print until 1839. The magazine appeared every five days, with each issue containing eight unsigned plates. Evidence suggests that among the French artists involved in producing the images were Carle Vernet (1758–1863) and his son Horace (1789–1863), Philibert-Louis Debucourt (1755–1832) (Figure 17.11), Louis Marie Lanté (b. 1789), and by the late 1820s, Paul Gavarni (1804–1866) (discussed later). The plates from the 1800s through 1820 are in a small format and usually include one figure, and at times a hint of landscape in the background or a piece

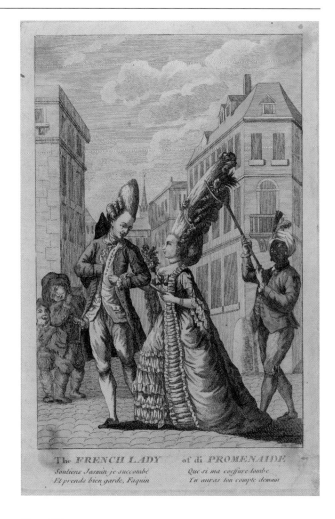

Figure 17.9
The French Lady of De Promenaide, 1775–1790. Etching with hand-applied color, 12 × 8".
Caricatures lampooning the extraordinarily high hairstyles and headdresses of the late eighteenth century abounded. This plate pokes fun at the French, who started the fashion and wore the most extreme hairstyles and head-dresses of the late eighteenth century.
Photograph © Museum of Fine Arts, Boston. The Elizabeth Day McCormick Collection, 44.2280.

of furniture is visible. The figure is often elongated to emphasize the new long lines of the Empire style. This exaggeration of specific aspects of the fashionable silhouette became a common feature of fashion plates of the nineteenth century. The clothing was also meticulously rendered so that a dressmaker or home sewer could copy the entire garment or a detail such as a sleeve, neckline, or trim.

Writer and art critic Charles Baudelaire (French, 1821–1867) studied plates from this era when he wrote his essay "Le Peintre de la vie moderne" ("The Painter of Modern Life") (1863). He felt that the illustrations revealed not only how people wanted to look and dress, but indicated the proper deportment and social pursuits of their day. To Baudelaire, the fashion plate with its enviable and suggestively attainable ideal was more than just one of fashion's most successful marketing tools—it was also an insightful historic document that expressed the quintessential beauty of its day.

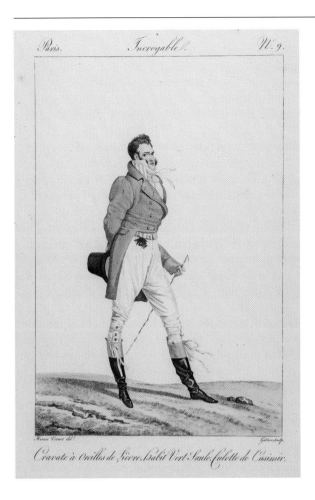

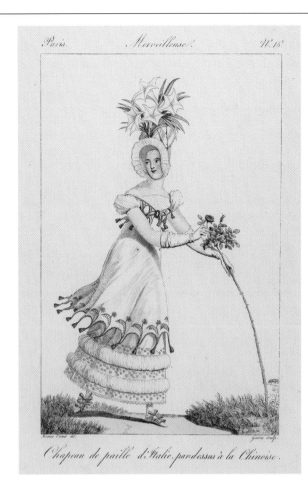

Figure 17.10a, b
Emile-Jean-Horace Vernet, Plate 9 and Plate 16, *Incroyables et merveilleuses*, 1811. Etching with hand-applied color, 14 ³/₄ × 9 ³/₄" (each). A fashionable subculture in post–Revolutionary Paris was influenced by aristocratic culture. The men were nicknamed *Incroyables* (the Incredibles) and women called *Merveilleuses* (The Marvelous).

Photograph © Museum of Fine Arts, Boston. The Elizabeth Day McCormick Collection, 44.3199, 44.3206.

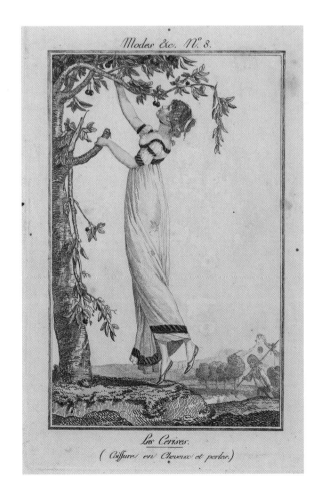

Figure 17.11
Philibert-Louis Debucourt, Plate 8, *Modes et manières du jour*, 1810. Etching with hand-applied color, 10 ⁵/₈ × 7 ⁵/₁₆". The fashion plates of the first decade of the nineteenth century usually featured just one figure, often in a charming pose.

Photograph © Museum of Fine Arts, Boston. The Elizabeth Day McCormick Collection, 44.3127.

By the second quarter of the nineteenth century, fashion plates began to feature two figures, one of which was portrayed from the back or from the side so that the costume could be seen from more angles, and thus, more accurately copied. At times, women would be accompanied by children or men, although men were seen less frequently in the plates as the century progressed. Women became more closely associated with fashion while men eschewed it and adopted the more democratic dark suit. The setting for the plates also became restricted to the home or a garden—the proper milieu for women—while men concerned themselves with business and political affairs of the outside world.

The subject matter of the illustrations and their moral overtones made them an acceptable artistic medium for female artists, and some of the most successful illustrators of the mid-nineteenth century were women. Daughters of the French Colin family—Héloïse (1819–1873), Anaïs (1822–1899), and Laure (1827–1878), as well as Anaïs's daughter Isabelle (1850–1907)—were among the most sought-after fashion plate illustrators of their day. Because women were not allowed to attend the art academies, the Colin girls were probably trained at home by their father, a painter and

lithographer. The Colin sisters' work appeared in the most fashionable French magazines and was sold by the French publishers to magazines throughout Europe, England, and even the United States (Figure 17.12).

Expansion in the Mid-century

The profusion of fashion plates published during the mid-nineteenth century meant that they were more widely available across the social classes, making the hand-colored fashion plate a ubiquitous part of life. While formulaic, the plates held great currency not only with women and dressmakers, but also with painters, poets, and writers of the age. It is during this period, in fact, that fashion became worthy of serious consideration by writers in addition to Baudelaire, such as Honoré de Balzac (French, 1799–1850), Èmile Zola (French, 1840–1902), and the poet Stéphane Mallarmé (French, 1842–1898).

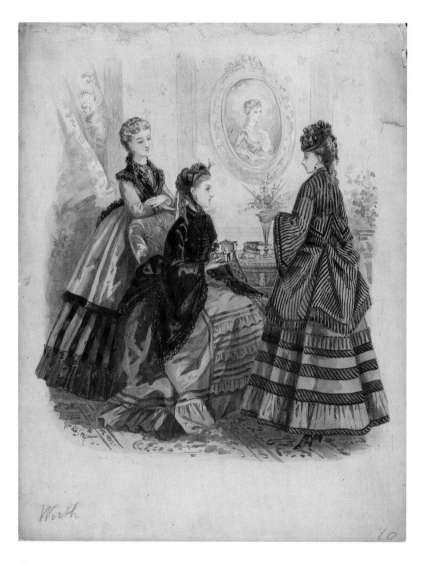

Figure 17.12
Héloïse Colin, preparatory drawing for a fashion plate, ca. 1875. Watercolor and graphite on board; 12 × 9 ¹/₂".
Héloïse Colin and two of her sisters continued in their careers as illustrators after marriage, finding a balance between work and home. All three married artists.
Photograph © Museum of Fine Arts, Boston. The Elizabeth Day McCormick Collection, TFA.Inv.487.

One of the most well-respected illustrators of the day was Hippolyte Guillaume Sulpice Chevalier, who took the penname Paul Gavarni. Baudelaire considered Gavarni and Honoré Daumier (French, 1808–1879) to be the "painters of modern life" (*see Chapter 14*). Gavarni illustrated fashion for several magazines—including *La Mode* (to which Balzac also contributed), the *Journal des dames*, and the *Petit courrier des dames*—delineating the idealized beauty of the period and infusing his work with a sense of humor (Figure 17.13). Eventually, the French magazine *Le Charivari* convinced him to submit drawings, and he became one of its most popular caricaturists (*see Chapter 14*). Gavarni went on to create several suites of drawings capturing modern Parisian culture such as *Les Lorettes*, *Les Actrices*, *Paris le soir*, and *Le Carnaval à Paris*. He also became a popular book illustrator and illustrated many of Balzac's novels.

The painters of the mid-nineteenth century also paid close attention to fashion. The influence of the fashion plate can be seen on the work of Edouard Manet (French, 1832–1883), Claude Monet (French, 1840–1926), and even Paul Cézanne (French, 1839–1906), who as a young man is known to have copied at least two plates. These artists' depictions of daily life closely mirror the attitudes and settings seen in the plates. Other artists, such as Pierre-Auguste Renoir (French, 1841–1919) and Jacques Tissot (French, 1836–1902), depicted fashionable women and placed emphasis on the particularities of contemporary dress (Figure 17.14). Renoir's use of the title *La Parisienne* for one of his paintings was not by chance: the idea of the *Parisienne* as the most fashionable figure in the world arose during the nineteenth century. Writer Octave Uzanne (French, 1851–1931) in his book, *The Modern Parisienne*, claimed that while Parisian women were not always the most beautiful, they had something better than perfect beauty: perfect art.

The Couture

By the 1860s, a new leader in fashion—the couturier— emerged, lead by the Englishman Charles Frederick Worth (1825–1895), who opened his own business and eventually designed for the French court of Emperor Napoleon III (French, 1808–1873) and Empress Eugenie (Spanish, 1826–1920). Worth and his fellow couturiers dictated fashion by introducing new designs from which the client could choose, unlike traditional French dressmakers who collaborated with their clients on the style of the finished garment. Worth's facility with the English language made him particularly popular with American clients. His popularity with foreign customers was augmented by the fact that he also served as an important advisor to women who were not familiar with French etiquette, helping them navigate the sophisticated European social environment. Worth's success inspired several other designers to start couture houses, including the French designers Jeanne Paquin (1869–1936), Emile Pingat (1820–1901), and Jacques Doucet (1853–1929). By the early twentieth century, couture houses launched new

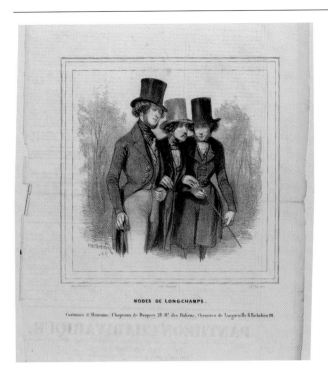

Figure 17.13
Paul Gavarni, "Modes de Longchamps," 1839. Lithograph, 14 ¹/₂ × 10 ³/₄". Paul Gavarni, better known for his caricatures, created fashion plates early in his career. The figures in his plates often react to each other in a manner not found in other plates of the era; at times, the interaction hints at seduction or intrigue.

Photograph © Museum of Fine Arts, Boston. Gift of Miss Amy Pleadwell, 51.215.

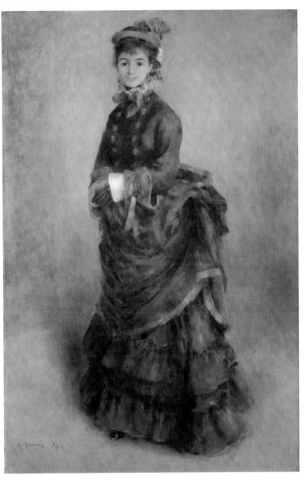

Figure 17.14
Pierre-Auguste Renoir, *La Parisienne*, 1874. Oil on canvas, 64 ¹/₄ × 42 ²/₃". Renoir's painting of the actress Henriette Henriot hung in the first Impressionist exhibition in 1874. By using the title *La Parisienne*, Renoir signaled his intent to paint not a portrait but an illustration of the fashionable Parisian woman of her day. The bright blue dress, probably colored with newly introduced synthetic dye, dominates the canvas with its ruffles, swags, and softly draped bustle.

National Museum Wales, The Davies Sister Collection, NMW A 2495.

Figure 17.15
House of Lucien Lelong (French, 1914–1948), design sketch, Winter 1925. Gouache on paper with silk swatches attached, 10 × 7 ¹/₂". During the first half of the twentieth century, illustrators created hand-colored sketches of all the designs in a couture house's seasonal collection. Saleswomen used these designs and often sent them to preferred clients. The sketches included swatches to show clients the fabrics out of which the dress could be made.

Photograph © Museum of Fine Arts, Boston. Gift of Jean S. and Frederic A. Sharf, 2013.2054.

collections twice a year, with as many as two hundred to three hundred designs in each. The **couture** developed into one of the biggest industries in France by the early twentieth century.

Fashion illustrators found work in the couture houses. Evidence shows that from the mid-nineteenth century, some artists actually sold designs that served as inspiration to Paris dressmakers and early couture houses.[2] Later, the couture houses hired illustrators who, at times, worked directly with the couturier and sketched the new designs as the maestro draped them on a live model. They also drew illustrations of each design in the finished collection that could be sent to clients (Figure 17.15).

The interest in and growing access to fashionable dress resulted in the introduction of more than 150 fashion periodicals during the nineteenth century in countries throughout Europe, the United States and South America—all of which included fashion plates. The French, however, continued to dominate the fashion world, and French illustrations were distributed to foreign publishers who would reproduce them in their periodicals. It was not until the later part of the nineteenth century, when advances in printing technology and photography made the inclusion of photographs in magazines possible, that the fashion plate lost its popularity and fashion illustrators found new ways to exercise their talents.

[2]See Tetart-Vittu, "The French-English Go-Between," 40–45, and Coleman, *The Opulent Era*, 64–65.

Theme Box 36: The Camera
by Monica Bravo

In January 1839, Louis Daguerre (1787–1851) presented to a joint meeting of the French Academies of Fine Arts and Sciences news of his recent invention: a means of photo-chemically fixing an image projected through a camera onto a light-sensitive surface. Across the Channel, the Englishman polymath William Henry Fox Talbot (1800–1877) was astonished to learn that another inventor had independently found the means to achieve what he himself had discovered. Ultimately, although Daguerre is sometimes credited as first inventor, only Talbot's process—which was quite distinct from Daguerre's—would serve as the conceptual basis for what we think of as photography today. Daguerre's photographs, known as **daguerreotypes**, are one-off images: the negative and positive are combined in a single, mirror-like metal plate. Talbot's process, by contrast, which he called calotypy (etymologically, "beautiful image"), produced a waxed-paper negative in the camera. Talbot realized he could reverse the image—thereby creating a positive more closely corresponding to the subject—simply by reprinting the negative on another prepared sheet of paper. By using a negative (in the same way that engravers and etchers use a **matrix**), one could produce multiple positive photographs.

Although the popularity of photography was profound through-out the mid-nineteenth century, particularly in its application to portraiture, photography hardly competed with illustration until the 1880s when the **halftone**, which converted the photograph to a series of tiny dots that could be printed alongside letterpress (see Chapter 18, Theme Box 37, "Halftone and Rotogravure"), began to be used in book and periodical production.

Because of their apparent simili-tude, halftones acquired some of the unique attributes of photographs: the belief that they are true, that they are equivalent to "the thing itself," that they are somehow more "real" than other kinds of images. The belief in photographic truth rests in part on what the nineteenth-century American philosopher Charles Sanders Peirce (1839–1914) called **indexicality**. Peirce developed a logical model for differentiating signs according to their denotative qual-ities (see Chapter 2, Theme Box 7, "Saussure and Peirce: Semiotics"). An *icon* is related to its object by likeness; Peirce gives a painting as an example. An *index* is related to its object by a causal relationship; the most famous example is of a weathervane, whose position is controlled directly by the wind. The final category is the *symbol* or sign proper, one whose relationship to its object is arbitrary: the relationship of the word *tree* to the tree-thing is solely conventional, for instance. A photograph, as Peirce noted, has elements of all three categories. A photographic portrait will look very much like the sitter (iconicity), and the image is impressed by

the action of light on a photo-sensitive plate (indexicality), but that image—a two-dimensional formal composition—and its relationship to its object are ultimately a matter of convention (symbolic). Nevertheless, photography's indexical quality—and hence its difference from paint-ing or illustration—has long been used as a means of privileging its veracity above other kinds of visual representation.

A photograph need not be truly iconic or indexical, however. Prior to inventing calotypy, Talbot made some of the first **photograms**, in which an image is produced by laying objects directly on photo-sensitive paper, without using a camera. While a photogram of a leaf may indeed be iconic, one of an apple will appear only as a round form with little resemblance to its object. In the 1880s, the French physiologist Étienne-Jules Marey (1830–1904) developed a process he called **chronophotography**, in which multiple moments in time (such as the phases of a bird's flight pattern) are captured on the same photographic plate—something that cannot be observed by the naked eye.

Surely the philosopher Walter Benjamin (1892–1940), writing in the Weimar Republic, had Marey's oeuvre in mind when he praised photography's ability to capture the world's "optical unconscious." Benjamin believed that photography and its attendant photo-mechanical ink-based processes ushered in an

Editorial Fashion Illustration

The end of the nineteenth century was a period of transition in how magazines handled fashion illustration. While newspapers, magazines, and trade manuals continued to reproduce illustrations, and the couture houses and the emerging ready-to-wear industry used them, the fashion plate was no longer seen as a symbol of modern life. With its immediacy

and reproductive quality, the photograph had taken its place, as new technological developments such as halftone printing and rotary presses allowed for the reproduction of photos directly onto the pages of the magazines (see Chapter 18, Theme Box 37, "Halftone and Rotogravure"). One positive result of these changes was to free illustrators from the need to make an exact record of the clothing, in favor of more interpretive renditions of fashionable dress.

era of "mechanical reproduction" or "technological reproducibility." In the context of his belief in Marxist revolution, he welcomed photography's democratizing capability: the ability to make art accessible to the masses, and to strip art of its *aura*, the sense of distance or remoteness evoked by great artworks (*see Chapter 13, Theme Box 27, "Benjamin: Aura, Mass Reproduction, and Translation"*).

For much of its history, photography has not been perceived as a fine art in itself. It is a medium deployed in various contexts, from the courtroom to advertising to journalism. Indeed, American photo historian John Tagg (b. 1949) asserts that "photography as such has no identity"; it is a practice whose function and meaning varies within different networks of power. The American writer Susan Sontag (1933–2004), by contrast, focused on photography's power as a whole. She was critical of the medium's ubiquity, and the ethical problems raised by the unfettered access it can provide. For her, the camera is a recording device that often bears witness to the pain and suffering of others, without intervening.

The assumption of photographic indexicality has prompted many viewers to ignore photographs' constructedness, despite the fact that one can sandwich negatives, crop compositions, and use primitive tools within the darkroom to alter a representation, or even deploy it

propagandistically. In an essay later published in *Mythologies* (1957), the French literary critic Roland Barthes (1915–1980) reveals how a photograph of a young black soldier on the cover of *Paris Match* magazine signifies the ideology of a unified postcolonial French nationalism (*see Chapter 22, Theme Box 44, "Barthes: Mythologies and Death of the Author"*). In a later book, however, *Camera Lucida* (1980), Barthes's tone is far more elegiac. He analyzes a number of amateur and fine art photographs together in a quest to uncover photography's essence, and memorably discusses but does not show an image of his mother as a child—which he refers to as the Winter Garden Photograph—because he knows the deeply personal photograph of his dead mother cannot affect the reader/viewer as it does him.

The debate over photography's indexicality—whether photographs represent reality or not, and the relative significance of that trait—raged among photography historians (between Rosalind Krauss and Joel Snyder, for example) for much of the 1990s and early 2000s. The invention of digital photography in the mid-1970s and its increasing popularity have brought this debate to the mainstream. In digital photography, an image is produced by what we might refer to as a deposit of digital code, rather than one of chemicals or ink, and as such may be produced entirely in a computer

rather than in a camera. Yet digital technology has only highlighted the possibilities for manipulation that have always characterized photographic practice.

Further Reading
Barthes, Roland, *Camera Lucida*, translated by Richard Howard (New York: Hill and Wang, 1981).

Barthes, Roland, *Mythologies*, translated by Annette Lavers (New York: Hill and Wang, 1972).

Benjamin, Walter, "A Short History of Photography" (1931), in *Classic Essays on Photography*, edited by Alan Trachtenberg, translated by P. Patton (New Haven: Leete's Island Books, 1980).

Elkins, James (Ed.), *Photography Theory* (New York, London: Routledge, 2007).

Sontag, Susan, *On Photography* (New York: Farrar, Straus and Giroux, 1977).

Sontag, Susan, *Regarding the Pain of Others* (New York: Farrar, Straus and Giroux, 2003).

Tagg, John, *The Burden of Representation* (London: Macmillan, 1988).

Talbot, William Henry Fox, *The Pencil of Nature 1844–46* (New York: Da Capo Press, 1969).

The early twentieth century, an intensely creative period, witnessed the emergence of artistic movements such as abstraction, cubism, and futurism (*see Chapter 19*), as well as the breaking down of the boundaries between art, design, and craft that had started with the Arts and Crafts movement (*see Chapter 15*). With this artistic fervor, the luxury fashion plate developed into a new art form unlike anything seen in the previous century. The age of editorial fashion illustration had begun.

Paul Poiret and the Development of the Art Deco Fashion Plate

The couturier Paul Poiret (French, 1879–1944) and the illustrator Paul Iribe (French, 1883–1935) are credited with the creation of the modern fashion plate. In 1908, Poiret invited Iribe to publish a series of ten illustrations of dresses from his *Directoire* collection. Poiret felt that Iribe's simple lines and broad, flat use of color would suit his clothing inspired by the Neoclassical styles of the

early nineteenth century. The plates were published in the book *Les Robes de Paul Poiret racontées par Paul Iribe* (*The Dresses of Paul Poiret as Recounted by Paul Iribe*) (Figure 17.16).

Iribe printed the plates using the **pochoir** technique in which colors were brushed onto paper through metal stencils. Invented by Jean Saudé (French, fl. 1900–1930), *pochoir* imitated the look of Japanese woodblock printing and became standard for many deluxe fashion periodicals of the early twentieth century such as *La Gazette du bon ton*, *Le Journal des dames et des modes*, and *Modes et manières d'aujourd'hui*. Iribe's figures are not depicted in exact reproductions of Poiret's garments, but rather are the illustrator's interpretation of the clothing and the independent women of means who wore them.

Poiret distributed the book free to his best clients, and in 1911, he hired illustrator Georges Lepape (French, 1887–1971) to create *Les Choses de Paul Poiret vues par Georges Lepape* (*The Work of Paul Poiret as seen by Georges Lepape*). Lepape's illustrations of Poiret's designs, this time inspired by the exotic East as presented in the Ballet Russes, are even more stylized than those of Iribe. He further elongated the figures and made even greater use of flat color. The work of Lepape and Iribe anticipated the Art Deco style that came into prominence during the 1920s (*see Chapter 20*). This style was also seen in the work of another illustrator/designer who benefited from the patronage of Poiret—Erté (b. Romain de Tirtoff,

in Russia; French, 1892–1990), who worked with Poiret from 1913 to 1914 as a fashion designer. Soon after he left Poiret, *Harper's Bazaar* hired Erté to illustrate a magazine cover—the first of more than two hundred for *Harper's Bazaar* published between 1915 and 1936.

Poiret also played a role in the development of the deluxe French periodicals of the early twentieth century in collaboration with Lucien Vogel (French, 1886–1954). Together, the two men conceptualized what is perhaps the most famous magazine of its genre, the *Gazette du bon ton*. The first issue appeared in 1912 and the last in 1925, with publication suspended during the war years, from 1915 to 1919. Vogel, who acted as publisher, became the magazine's impresario, bringing together the most talented writers, artists, and designers of his day. He gave artists such as George Lepape, Georges Barbier (French, 1882–1932) (Figures 17.17 and 17.18), Bernard Boutet de Monvel (French, 1881–1949), André-Edouard Marty (French, 1882–1974), and, on a few occasions, Léon Bakst (Russian, 1886–1924) complete artistic freedom to interpret the work of the renowned couture houses of Paul Poiret, Mme. Louise Chéruit (French, 1866–1955), Georges Doeuillet (French, 1865–1929), Jeanne Lanvin (French, 1867–1946), Jacques Doucet (French, 1853–1929), Redfern & Sons, and the House of Worth. Each edition of the *Gazette* contained ten *pochoir* plates and several uncolored plates depicting fashionable interiors. Even the advertisements featured similar high-quality prints.

Fashion Magazines and Illustration in the Twentieth Century

Luxury magazines of the twentieth century such as *Gazette du bon ton* were expensive and intended for an elite audience. In contrast, the mass-market-fashion magazines *Vogue* and *Harper's Bazaar* in the United States and *Les Modes* and *Femina* in France covered the social scene as well as contemporary clothing trends and beauty. *Vogue* featured the work of American illustrators such as Charles Dana Gibson (1867–1944); and later, Helen Dryden (1887–1972), who created covers and line illustrations for the magazine between 1909 and 1922. In 1921, Condé Nast (American, 1873–1942), the publisher of *Vogue*, bought controlling interest in the *Gazette de bon ton* and began to feature the work of French illustrators on the covers of *Vogue*, while continuing to use American illustrators' line drawings inside. Condé Nast was a good patron to illustrators, but the magazine's goal of featuring detailed reproductions of the current fashions was often at odds with the artistic inspiration of the French *Gazette* artists. This became especially apparent during the interwar years as the fashion shifted from the short boxy dresses of the 1920s to dresses draped on the bias that clung to the body, which were not as well suited to the flat, linear style of illustration.

Vogue finally found a new voice in the work of Carl Oscar August Erickson, known as Eric (American, 1891–1958), and Count René Bouët-Willaumez (French, 1900–1979). Both men provided more accurate renditions

Figure 17.16
Paul Iribe, Plate X, *Les Robes de Paul Poiret racontées par Paul Iribe*, 1908. Relief etchings on laid paper with hand-applied color (*pochoir*), 13 × 12". In creating the plates for Poiret's book, Iribe included examples of his own furniture dating from the early nineteenth century to provide the proper setting for the dresses, which were inspired by the clothing of the same period.
Photograph © Museum of Fine Arts, Boston. Museum purchase with funds donated by Mrs. Roberta Logie, 1998.2.

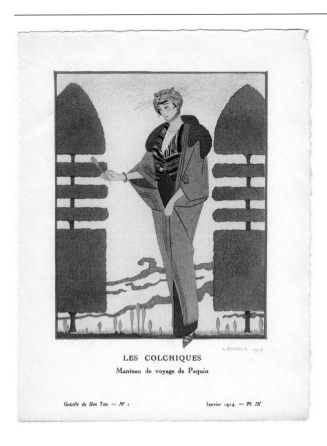

Figure 17.17
Georges Barbier, "Les Colchiques" ("The Crocuses"), plate IX, *Gazette du bon ton*, Winter 1913–1914. Photomechanical lithograph with hand-applied color (*pochoir*), 10 × 7 ¹/₂".
Barbier's sketch of a full-length mantle designed by Jeanne Paquin playfully mirrors the crocus flower of early spring with the mantle's shape and color. The plate is typical of the luxurious *pochoir*-printed illustrations featured in the *Gazette du bon ton*.

Photograph © Museum of Fine Arts, Boston, 2004.18.9.

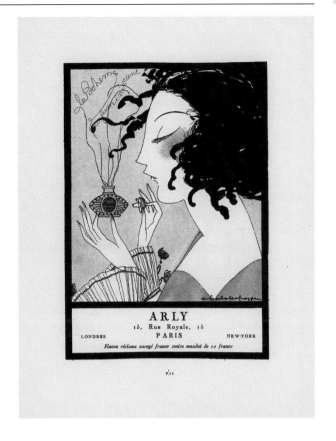

Figure 17.18
Georges Barbier, advertisement for the perfume Arly, *Gazette du bon ton*, February 1921. Color lithograph, 10 × 7 ¹/₂".
The style of illustration used in the *Gazette du bon ton*'s advertisements was the same as that of the fashion illustrations, which gave the periodical a consistent look.

Photograph © Museum of Fine Arts, Boston, 2004.37.14.

of the current fashions with a sure, deft hand, their illustrations emphasizing the line of the garment rather than flat plains of color (Figure 17.19). At the same time, photography became the more dominant medium for fashion coverage, and *Vogue* printed its first photo cover on July 1, 1932. The photo by Edward Steichen (American, 1879–1973) shows a young woman in a red swimsuit sitting against a deep blue background, holding a beach ball over her head—an image often heralded as the beginning of the end of fashion illustration in magazines.

During the 1930s, more color images were introduced into magazines. Eric and René Bouët-Willaumez continued to contribute to American *Vogue*, as did the artists Christian Berard (French, 1902–1949), whose illustrations were inspired by Surrealism; Marcel Vertés (Hungarian, 1895–1961), whose acerbic brush caricatured the fashionable world of the day; and Edouard Benito (Spanish, 1891–1981), whose bold use of color made him a popular illustrator. After World War II, a new group of artists came to prominence including Tom Keogh (American, 1922–1980), René

Figure 17.19
René Bouët-Willaumez, illustration in *Vogue*, 1932. Willaumez and Eric were well known for their ability to capture the fashionable, relaxed look of aristocratic *hauteur* popular during the 1930s—a look that is clearly seen in the casual poses of the three women in Schiaparelli suits pictured in this illustration.

Illustration by Rene Bouet-Willaumez/Condé Nast via Getty Images.

Gruau (Italian, 1909–2004), and René Bouché (Czech, 1905–1963) (Figure 17.20). The refinement and elegance found in all three designers' works epitomized the fashionable woman of the postwar era. Gruau in particular is closely associated with the postwar period, mainly due to his collaboration with designer Christian Dior, with whom he worked closely to popularize the postwar "New Look" with feminine full skirts and fitted waists.

Unfortunately, by the end of the 1950s, fewer and fewer illustrations found their way into the fashion magazines and, by the 1960s, both *Vogue* and *Harper's Bazaar* ceased using illustration in their editorial spreads, relying completely on photography instead.

Despite the American magazines' declining interest in illustration, it could still be found in newspapers, advertisements, sewing patterns, and manuals. Some European magazines continued to feature designs by René Gruau, Tod Draz (American 1917–2002), and younger artists like Antonio Lopez (Puerto Rican-American, 1943–1987) on their pages. Although the glamour years of fashion illustration were almost at end, one publication in which it lived on was *Women's Wear Daily*. First published in 1910 by Edmund Fairchild, *WWD* became the popular source for information on New York's Seventh Avenue, a center of the clothing trades. When Fairchild's grandson John took over as publisher in 1960, the newspaper shifted focus toward personalities involved in fashion. *WWD* resisted the trend to exclude illustration and continued to employ artists. Among the most important and influential of those illustrators was Kenneth Paul Block (American, 1924–2009), who was widely admired for his ability to capture the essence, grace, and casual ease of his sitters. According to John Fairchild, to have your portrait by Block appear in *Women's Wear Daily* was an honor coveted by society women (Figure 17.21). With Fairchild's focus on society, Block was important in repositioning *WWD* as a more popular newspaper, in order to compete with magazines like *Vanity Fair*, which had long included society news.

Kenneth Paul Block became the lead designer at *WWD* and subsequently influenced a host of young artists who worked in the newspaper's studio at some point in their career, including Antonio Lopez, Steven Stipelman (American, born in 1944), and Steven Meisel (American, born in 1954). In 1972, Fairchild founded *W Magazine*, which continued to keep the studio busy until 1992, when they finally closed. While Meisel went on to fame as a fashion photographer and Stipelman went to teach at the Fashion Institute of Technology in New York, Antonio Lopez eventually moved to Paris, where he integrated with the world of the couture, befriending Karl Lagerfeld (German, born in 1933) and Yves Saint Laurent (French Algerian, 1936–2008)—both successful designers of the era. Antonio's more youthful illustration appeared in British *Vogue* and the *New York Times* (Figure 17.22).

Figure 17.20
René Bouché, advertising image for Saks Fifth Avenue New York, *Vogue* (US), February 1952. Watercolor and gouache on paper, 25 ²/₃ × 20".
During the postwar period, fashion illustration remained popular with the international press. French and English *Vogue* continued to feature editorial illustration of the Paris designs, as did American newspapers.
Courtesy of Gray MCA.

Figure 17.21
Kenneth Paul Block, portrait of Gloria Guinness, 1962. Charcoal on paper, 24 ¹/₂ × 16 ¹/₂".
Gloria Guinness was a contributing editor to *Harper's Bazaar* from 1963 to 1971 and was included in the International Best Dressed List from 1959 to 1963. In 1964, she was named to the List's hall of fame. Block traveled to Palm Beach in 1962 to capture the social scene and depicted Guinness seated and smoking at Gemini, her home in Palm Beach.
Photograph © Museum of Fine Arts, Boston, 2009.1205.

The Revival of Fashion Illustration

While work was limited by the late twentieth century, fashion illustration did not die, and a renaissance occurred during the 1980s. Publications such as the Italian magazine *Vanity* featured covers by the likes of Antonio Lopez or François Berthoud (Swiss, b. 1961); while American magazines *Interview* (founded by ex-fashion illustrator Andy Warhol) and *Rolling Stone* reserved their covers for illustrations of celebrities. *Details*, an American monthly, included illustrated fashion editorials and a back page created by Ruben Toledo (American, born in Cuba, 1961) (Figure 17.23). It was probably the advertising campaigns of several high-end department stores, however, that made illustration fashionable again. Jean Philippe Delhomme's (French, b. 1959) illustrations for retailer Barneys 1993–1996 campaign, which featured the artist's cartoon-like figures painted in gouache and pithy captions by fashion writer Glenn O'Brien, caught the popular imagination. Ruben Alterio's (Argentinian, b. 1949) campaign for Neiman Marcus (1997), and Ruben Toledo's campaigns for Nordstrom (2000–2010) were noteworthy for their fresh approaches (Figure 17.24).

As the illustrators' focus was no longer on the accurate rendition of the garment, but on interpreting the clothing and the person who might wear it, a wide range of unique artistic styles developed in the late twentieth century and early twenty-first. Artists worked in a wide range of traditional media such as pen, ink, watercolor, and acrylic, while others adopted techniques such as collage, stencil, silk screen, and digital media. The most accomplished illustrators of the late twentieth century include David Downton (English, b. 1959), whose work is primarily created in watercolors and is inspired by prior illustrators such as Eric and René Gruau. Matts Gustafson (Swedish, b. 1951) works in watercolor, and Bil Donovan (American, b. 1953) with gouache and various wash techniques

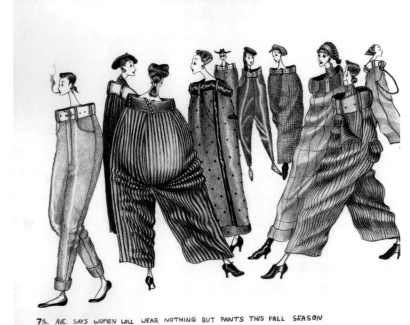

7th. AVE. SAYS WOMEN WILL WEAR NOTHING BUT PANTS THIS FALL SEASON

Figure 17.23
Ruben Toledo, "Seventh Avenue says women will wear nothing but pants this season," in *Details*, 1988. Graphite and pencil on paper.
Every month, underground fashion magazine *Details* featured Toledo's work on the back page. His illustrations often satirized the fashion industry. This one questions fashion magazines' penchant for marketing a single piece of merchandise.
Courtesy of Ruben Toledo.

Figure 17.22
Antonio Lopez, "Red Legs," *Harpers Bazaar Red Story*, 1967. Pastel, felt tip, and charcoal on paper, 24 × 18".
Antonio's fashion illustration typified the fashion icon of the 1970s and 1980s. His illustrations celebrated the more overt sexuality of the era and were influenced by Pop Art and other art movements of the postwar era.
Courtesy of Gray MCA.

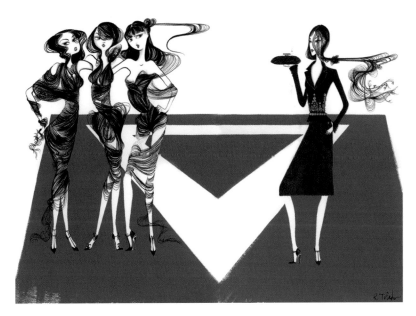

Figure 17.24
Ruben Toledo, Nordstrom advertisement for Chanel Couture, Fall 2005. Watercolor, sumi ink, graphite.
Toledo illustrated campaigns for Nordstrom department stores throughout the first decade of the twenty-first century. He was chosen for his chic, playful illustrations, which the department store felt would stand out in publications and appeal to a younger clientele.
Copyright of Ruben Toledo.

(Figure 17.25), to create impressionistic illustrations—while Piet Paris (Dutch, b. 1962) employs stencils to lay down flat areas of color with a roller in a method echoing *pochoir* prints of the early twentieth century. François Berthoud (Swiss, b. 1961), known for his eloquent, monochromatic linocuts, has more recently integrated mixed media such as enamel drip and digital formats.

Fashion Illustration in the Twenty-First Century

Fashion illustration in the twenty-first century remains popular and has found new audiences especially in the world of the couture, where artistic expression has always been paramount. The fashion houses invite the illustrators to reinterpret the designer's work through their own personal lens. The Italian houses of Prada, Krizia,

and Romeo Gigli have patronized François Berthoud for creating advertisements and documenting collections; while Karl Lagerfeld has commissioned Ross Kirton (British, b. 1971) to illustrate Chanel designs since 2003 using large-scale acrylic renderings of erotic figures based on photos of live models. Pierre-Louis Mascia (French, b. 1968) creates riveting collages by manipulating silhouettes, typography, and textures in Photoshop to reinterpret the work of Yohji Yamamoto (Japanese, b. 1943).

While fashion houses and specialized magazines have provided an outlet for fashion illustration, the Internet and digital platforms have enabled artists to reach whole new audiences. Several artists have started their own blogs, such as *Fifi Lapin: What Shall I Wear Today*—a chic rabbit avatar for an incognito blogger who self-describes as "an international it-bunny and furry fashionista"; and *Markers and Microns: A Style Blog by Jenny Walton* (American, b. 1990), where the artist presents her current work. Some artists turn to social media like Instagram and Pinterest to share their work, lives, and inspiration. Blair Breitenstein (American, b. 1991) posts her illustrations of fashionable women, which she characterizes as "Big lips, big hair, big lashes," along with some favorite photos; while Katie Rodgers (American, b. 1985) posts images of her drawings and photos chronicling her process and travels (Figure 17.26).

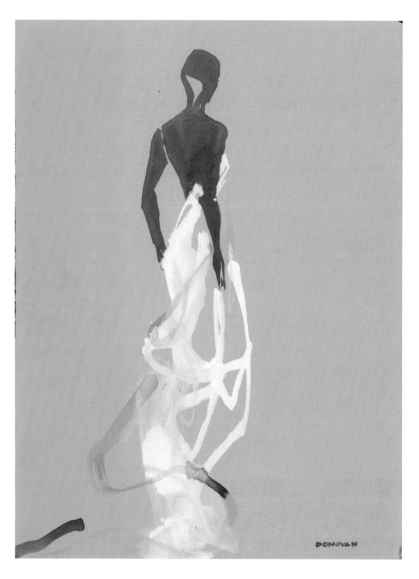

Figure 17.25
Bil Donovan, illustration of design by Rosie Assoulin, New York Fashion Week, *New York Magazine*, 2015. Ink and gouache on paper, 15 × 11 ¹/²".
Donovan's drawing, like other contemporary illustrators' works, is impressionistic. This drawing invokes the essence of a fashionable, elegant woman rather than providing a detailed illustration of the garment.
Courtesy of Bil Donovan Archive.

Figure 17.26
Katie Rodgers, "Strawberry Dancer," Instagram post, 2016.
Rodgers created the website *Paper Fashion* in 2009 as a way to showcase her watercolors. The site, along with other social media outlets, allows her to share her work and life with others. Along the way, the site also generates interest in companies like Valentino, Cartier, and Kate Spade, and magazines such as *Elle* and *Glamour*, which have since featured her illustrations.
Image courtesy of the artist.

Conclusion

From the late sixteenth century to the middle of the nineteenth century, fashion and costume illustration primarily served the purpose of documenting contemporary dress. A few prescient publishers such as Cesare Vecellio and Jean Donneau de Visé understood that the plates had potential for use in marketing new styles and advertising the wares of specific merchants. From the eighteenth century, the hand-colored fashion plate became the most common form of fashion illustration for almost one hundred years, influencing not only dressmakers and designers, but artists and writers as well. Its popularity coincided with the spread of fashion throughout the social classes made possible by the increasing affordability of textiles and other manufacturing advances of the Industrial Revolution. The advent of faster printing processes inaugurated a shift toward periodicals that included fashion coverage.

After the advent of photography, fashion illustration of the twentieth and early twenty-first century developed into a new expressive art form with artists reinterpreting clothing through their own unique styles, influenced by the *zeitgeist* of the day. Early twentieth century artists like Iribe and LePage carried forward influences from Japanese printmaking while ushering in Art Deco. Contemporary artists like Downton and Berthoud capture the essence of a garment with a line or a wash of color; while others explore hybrid or digital technologies to create illustrations in which the structure of the clothing is secondary to capturing the spirit of the garment and its wearer. While fashion designers and illustrators today work in many different styles, their work continues to reflect and reinterpret contemporary culture. It provides us with a look at ourselves, our values, and our dreams.

FURTHER READING

Coleman, Elizabeth Ann, *The Opulent Era: Fashion of Worth, Pingat and Doucet* (New York: The Brooklyn Museum and Thames and Hudson, 1989).

Groom, Gloria et al., *Impressionism, Fashion, and Modernity* (New Haven: Yale University Press, 2012).

Iskin, Ruth E., *Modern Women and Parisian Consumer Culture in Impressionist Painting* (New York: Cambridge University Press, 2007).

Koda, Harold, and Andrew Bolton, *Poiret* (New York and New Haven: Metropolitan Museum of Art and Yale University Press, 2007).

Mulcahy, Susan, *Drawing Fashion: The Art of Kenneth Paul Block* (New York: Pointed Leaf Press, 2007).

Simon, Marie, *Fashion in Art: The Second Empire and Impression* (London: Zwemmer, 1995).

Tetart-Vittu, Françoise, "The French-English Go-Between: '*Le Modèle de Paris*' or the Beginning of the Designer 1820–1880," in *Costume*, no. 26 (1992): 40–45.

Wilson, Bronwen, "Reproducing the Contours of Venetian Identity in Sixteenth-Century Costume Books," In *Studies in Iconography*, vol. 25 (Kalamazoo, MI: Board of Trustees of Western Michigan University through its Medieval Institute Publications and Trustees of Princeton University, 2004): 259.

KEY TERMS

Ancien Régime	*marchande des modes*
chronophotography	matrix
couture	mercer
daguerreotype	photogram
halftone	*pochoir*
indexicality	sumptuary laws

Part IV

Diverging Paths in Twentieth
Century American and
European Illustration

American Narratives:
Periodical Illustration,
1840–1930

Mary F. Holahan

*with contributions by Alice A. Carter, Jaleen
Grove, Page Knox, and Joyce K. Schiller*

"The illustration mania is upon our people," declared a critic in *Cosmopolitan Art Journal* in 1857. His remark reflected the burgeoning popularity of illustration in American books, magazines, and newspapers made possible by the advances in mass printing technology that accelerated in the 1840s.

In the American context, popular illustration was overwhelmingly characterized by an affinity for realism in narrative depictions, or, **narrative realism**. This, of course, raises the question of what we mean by the broad term *realism*, which we will qualify as an approach to illustration that included individualized and naturalistically depicted characters, explicit settings modeled through light and shadow, with convincing life-like details. While "illustration mania" encompassed a plethora of artistic approaches, as a whole it strove for an impression of truth and authenticity. One *Munsey's Magazine* commentator in 1895 claimed, "winning and keeping the heart of the [American] people . . . requires the keenest perception of detail and the most facile handling of human nature and its surroundings." The same author praised "fidelity of detail" and an illustrator who "puts air, color, movement, into everything he draws, and succeeds in impressing one with the sense of the life of the scene."

For a near-century from 1840 to 1930, human interactions were at the core of visual storytelling. Illustrators made stories "real" by bringing characters to life through evocative expressions and gestures, complemented by believable depictions of clearly defined historical times and places. Such versions of "reality" seemed familiar and plausible—and sought to represent universal human experience to broad segments of the American reading public. But because narrative realism was thus completely fabricated, such images reinforced shared cultural assumptions and conventions of taste, paradoxically making them also *unreal*. Narrative realism's claims to truth can therefore be questioned.

Concepts of what the American West was were very much influenced by illustrators attempting, but not always succeeding, to capture the "real" West. For example, in the mid-nineteenth century, as cities in the East continued to become more densely urban, settlers flocked to territories in the West, attracted by availability of land and opportunities. They further displaced already marginalized indigenous populations severely affected by foreign disease, genocide, and cultural oppression. These events, however, were often omitted from illustrations while settlers were heroized. Often, the native peoples were stereotypically depicted as either romantic "noble savages" or, conversely, as lazy or alcoholics.

For example, in 1843, Felix Octavius Carr Darley (American, 1822–1888), a staff illustrator for *Graham's Magazine* in his native Philadelphia, published *Scenes in Indian Life: A Series of Original Designs Etched on Stone* (Figure 18.1). Darley had not visited the West; his ennobling image of two Native American men spear fishing and others from his *Scenes* were largely based on documentary works by the peripatetic painter George Catlin (American, 1796–1872), whose resulting "Indian

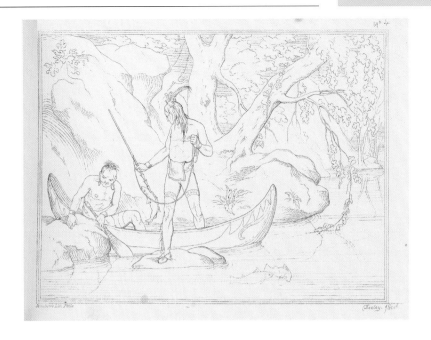

Figure 18.1
F. O. C. Darley, *Scenes in Indian Life: A Series of Original Designs Etched on Stone*, Philadelphia: J. R. Colon, 1843. Lithograph.
Darley's image of two Native American men spear fishing was based on second-hand information. Despite its Eurocentric bias, one 1843 critic admired the *Scenes* as "historically truthful."
Albert and Shirley Small Special Collections Library, University of Virginia.

Gallery" of canvases had been published in twelve volumes and exhibited in a traveling show. Despite inaccuracies, Catlin's portraits and scenes won praise for their realism and became a common reference for later illustrators like Darley.

Mass Media: Shaping and Reflecting Culture

The publishing industry expanded after the Civil War (1861–1865). With the aid of the telegraph (introduced in the 1840s), news was transmitted to publishers and, after 1865, printed on fast presses that were web-fed, meaning paper came in spools rather than sheets. Publications were sold at city newsstands and distributed via rail and postal service, and by 1900, rural free delivery was bringing mail-order publications well outside urban areas. The expanded networks together comprised **mass media**: a system of information-sharing accessible to the majority of the population.

The expanded readership and lower publishing costs meant that books were no longer simply for the rich, although still a luxury for most families. *Harper's Monthly* and other sophisticated periodicals remained expensive, but public libraries in major cities and social libraries and book clubs in rural areas provided them to poorer people. Public education meant 90 percent of the American adult white population was literate by 1870. As an abundance of magazines emerged, competitors focused on the quality of their illustrations, often reproducing examples of American painting important to an emerging national cultural identity.

Many illustrations could be understood independent of text, which benefited America's cultural "melting pot," an amalgamation of traditions and ethnicities inherited from the many immigrant and social groups who lived in the United States. For instance, Winslow Homer's (*see Chapter 14*) "The Christmas Tree" broadened the appeal of a German holiday tradition (Figure 18.2).

Such mass media images, however, favored the tastes and worldview of an overwhelmingly Caucasian, Anglophone audience aspiring to middle- or upper-class life. By the 1890s, companies began to pay large sums to place advertisements in the backs of magazines to reach these upwardly mobile audiences. Advertising revenues allowed magazines to be sold more cheaply than the cost of production—which meant even more people could afford them, and in turn even more were printed. Illustrators, whose images for fiction, nonfiction, and advertising were indispensable to making the magazines competitive, rose to prominence. Some became celebrities.

Visual Storytelling: Convergence of Taste and Technology

Americans' preference for seemingly true-to-life depiction was further informed by photography (*see Chapter 17, Theme Box 36, "The Camera"*). Within a few years of the 1839 invention of the daguerreotype, an early system of photography, new studios in American cities invited the public to see displays of celebrity photographs, prompting a demand for personal portraits as keepsakes. By the late 1880s, amateur photography was increasingly common, and many households had a **stereoscope**, a goggle-like viewing device that enhanced photographs by creating an illusion of three-dimensional space. Stereoscope cards (some of which were hand-tinted) often featured newly accessible Western landscapes, the construction of landmarks such as the Brooklyn Bridge, and stories told through a sequence of staged scenes derived from conventions of theater (Figure 18.3).

Mimesis in narrative illustration was also aligned with academic painting traditions taught at the New York Art Students League, regional American art schools, and European academies. Illustrators, by default, engaged in mimetic depiction, imitating life without overt stylistic deviation from the everyday appearance of figures, costume, and settings in conformity to academic precepts.

Until the 1880s, wood engraving, which was necessarily limited in expression, was still the primary method of image reproduction. In 1881, the American inventor Frederic E. Ives (1856–1937) improved the halftone process so that **continuous tone** (gradated) images such as photographs, illustrations in wash or pastel, and paintings could be photomechanically reproduced, preserving the tonal gradations and

Figure 18.2
Winslow Homer, "The Christmas-Tree," *Harper's Weekly*, December 25, 1858. Homer's images familiarized the American public with the German tradition of the Christmas tree.

Print Department Collection, Boston Public Library.

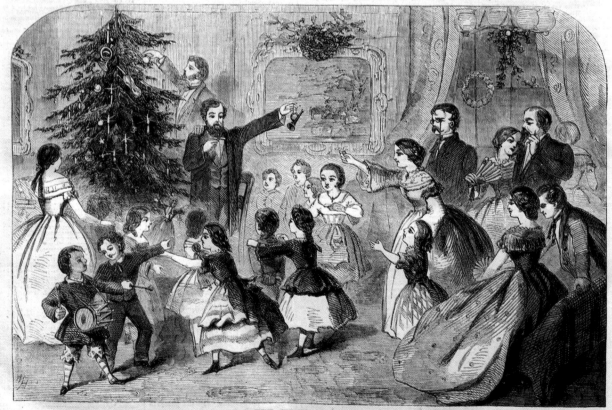

THE CHRISTMAS-TREE.

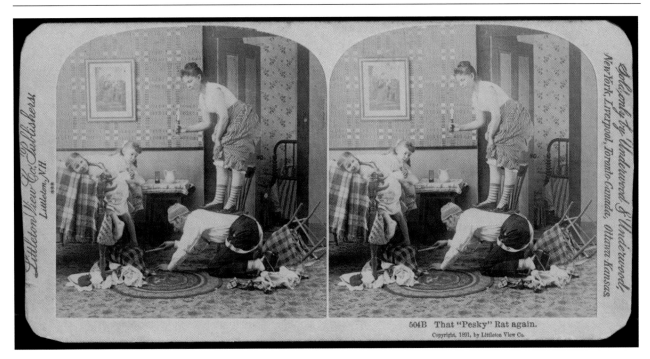

Figure 18.3
"That Pesky Rat Again," 1891. Stereoscope photograph. Most stereoscope cards were quite mundane photographs of places and minor events. This theatrical image clearly gives a comical twist to a nettlesome everyday problem: rats.

Boston Public Library.

textures of the original artwork (*see Theme Box 37, "Halftone and Rotogravure"*). By the 1890s, color illustrations were also available through a multiplate halftone process. Initially, this was an expensive procedure, but after the turn of the twentieth century, many magazines adopted full-color process for covers, featuring interior illustration reproduced with only two or three colors.

Leading Illustrated Magazines, 1865–1900

Harper & Brothers Publishing

In its magazines, Harper & Brothers presented a mix of fashion, serialized novels, articles on travel and adventure, scientific discoveries, history, and biography, all enhanced by illustrations. An early adopter of innovations in wood-engraved printing, *Harper's Monthly* was the most popular magazine of its type immediately following the Civil War.

Illustration was a critical selling feature of periodicals, and contributed to an author's success because new novels such as Wilkie Collins' mystery "The Woman in White," illustrated by John McLenan (American, 1827–1865), made their first appearance as serials. If the series sold well, the story would then be published in book form (Figure 18.4).

First appearing in *Harper's Weekly* in the early 1880s, Frederic Remington's (American, 1861–1909) images of the frontier were immediately popular with readers. In 1887, he was commissioned to produce

"I TURNED ON THE INSTANT, WITH MY FINGERS TIGHTENING ROUND THE HANDLE OF MY STICK."

Figure 18.4
John McLenan, "I turned on the instant, with my fingers tightening round the handle of my stick," in "The Woman in White" by Wilkie Collins, *Harper's Weekly*, November 26, 1859. Wood engraving. "The Woman in White" was serialized in *Harper's Weekly* from November 26, 1859, to September 8, 1860, and published simultaneously in *All the Year Round*, founded and owned by Charles Dickens in the United Kingdom.

Courtesy of the Fleet Library at Rhode Island School of Design, Special Collections, Providence, Rhode Island.

Theme Box 37: Halftone and Rotogravure
by Mary F. Holahan and Jaleen Grove

In 1869, William Leggo (Canadian, 1830–1915) filed a patent for the **leggotype**—the first photo-mechanical printing process. Leggo had discovered that if he exposed a negative through glass etched with a grid of lines, then the result was not a photograph made of continuous-tone gradients but rather a series of microscopic black dots that he dubbed "granular photography." If the exposure was made on a zinc plate coated with photosensitive gel, then the dotted image could be etched to make a relief block that could be printed with letterpress, just as wood engravings were (Figure TB37.1). Although the leggotype was used for several years for the *Canadian Illustrated News* beginning in 1869 and then for the *New York Daily Graphic* in 1873, it was not a lasting success due to the publisher's financial hardships.

Meanwhile, others were simultaneously inventing and developing similar technology in the United States and Europe. Between 1881 and 1885, inventor Frederic E. Ives substantially improved the process for producing the various densities of tiny dots to be etched into metal plates. Mimicking the tonal gradations of original illustration art and photographs, this new kind of matrix became known as the halftone. It did not require a human to engrave the image (although engravers touched up halftone blocks to bring out sharpness), thereby reducing costs and increasing fidelity to the artist's original image. Halftones subsequently supplanted wood engravings in about a decade's time, caused an exponential increase in production, and resulted in a loss of the handicraft and clarity of wood engraving—matters of grave concern to critics of modern visual culture such as William Morris and Walter Benjamin (*see Chapter 15,* and *Chapter 13, Theme Box 27, "Benjamin: Aura, Mass Reproduction, and Translation"*).

Rotogravure

Photoengraving technologies such as the gillotage (*Chapter 14, Theme Box 32, "Gillotage"*) quickly combined halftones to create relief printing blocks for use with letterpress. But after 1890, photoengraving could also produce cylindrical plates for use on automated presses. Instead of relief printing, these cylinders followed the intaglio method (*Chapter 2, Theme Box 6, "Intaglio Printing"*) and placed the ink into the recesses rather than the raised parts of the plate. Rotogravure yielded dense, velvety blacks, brilliant color, and fine detail, unlike the murky, fuzzy relief line-block halftones. Newspapers, books, and magazines soon adopted rotogravure for all large-run, high-quality color and black-and-white work, using the technology well after the perfection of offset lithography. It is still used in the twenty-first century.

Further Reading

Desbiolles, Yves Chevrefils, "La reproduction de l'image au Canada de 1848 à 1902," *Nouvelles de l'estampe,* no. 97, March 1988: 18–28.

Figure TB37.1
William Leggo, "H. R. H. Prince Arthur from a Photograph by [William] Notman," *Canadian Illustrated News,* October 30, 1869. Leggotype.
This is the first photomechanically reproduced photograph.
Library and Archives Canada, c048503.

eighty-three illustrations for Theodore Roosevelt's book *Ranch Life and the Hunting Trail* (Figure 18.5), which was serialized in *The Century* the following year, cementing Remington's long-term association with the West and with Roosevelt, who became President of the United States, 1901–1909.

Promoted extensively in *Harper's Weekly* as the "Soldier Artist," Remington supplied numerous images of battles between Plains Indians and the U.S. Cavalry, with whom he traveled. His illustrations of Native Americans, cowboys, and life on the plains (the later ones beautifully painted in oils) brought a new sophistication to the archetypes of the West that had been first introduced on the covers of dime novels in the 1860s (*see Chapter 22*).

Scribner's Monthly

Founded by Charles Scribner in 1870 to compete with *Harper's Monthly*, *Scribner's Monthly* was initially intended to be a vehicle for Christian thought. Known for its distinctive illustrations, *Scribner's Monthly* was also a pioneer in its official recognition of its illustrators, listing for the first time in 1877 the names of artists and engravers in each volume's index. The magazine also promoted them in exhibition reviews and illustrated series, serving as a virtual art gallery for this new generation of visual artists.

Alexander Drake (American, 1843–1916) managed *Scribner's Monthly*'s art department, working with renowned engraver Timothy Cole (American, 1852–1931), who used **photoxylography**, a photomechanical means of exposing the artist's image onto an engraving woodblock so that a reproductive engraver could use it as a guide. Better able capture the artist's techniques (*see Chapter 13, Theme Box 28, "George Baxter, Chromoxylography, Photoxylography"*), this "new school" of engraving dramatically changed the nature of the image on the printed page and encouraged *Scribner's Monthly* to increase coverage of art. Such technological innovations during the 1870s allowed illustrators greater latitude in creating original work because the new method could approximate the tonal qualities of various media.

In the spirit of the Aesthetic movement begun in England (*see Chapter 15*) that was popularized in America through the Philadelphia Centennial Exposition of 1876, illustrators placed new emphasis on the consideration of page design. Some turned out creative layouts with cropping and overlapping of page elements, as in Robert Blum's (American, 1857–1903) city scenes for *Scribner's Monthly* (Figure 18.6).

Scribner's Monthly included work by many of the nation's emerging illustrators, many of whom in the 1860s and '70s were women (*see Theme Box 39, "Education"*). Mary Hallock Foote (American, 1847–1938) documented the many mining boomtowns and rural areas that

Figure 18.5
Frederic Remington, "Roping in a Horse-Corral," in "Ranch Life in the Far West: The Home Ranch," by Theodore Roosevelt, *The Century*, March 1888, p. 65.
President Roosevelt was a supporter of illustrators of outdoor life, such as Remington, Charles Livingston Bull (American, 1874–1932), and Daniel Beard (American, 1850–1941), a founder of the Boy Scouts of America.
Courtesy of Cornell University Library, Making of America Digital Collection.

Figure 18.6
Robert Blum, "Tin-Shop in Greene Street," in "Basement Grocery in Houston Street," *Scribner's Monthly*, November 1879, p. 1.
Technological advances in the 1870s encouraged illustrators to experiment with page layout. This page design creates the impression that the two illustrations are on overlapping papers.
Courtesy of Cornell University Library, Making of America Digital Collection.

Theme Box 38: E.W. Kemble: The Comic Black Mask
by Francis Martin, Jr.

Throughout much of the history of the United States, there have been artists, like Edward Windsor Kemble (American, 1861–1933), whose images depicted blacks as worthless, irresponsible, and foolish. In keeping with common stereotypes of the nineteenth century (*see Chapter 11, Theme Box 20, "Phrenology"*), Kemble displays a radically limited conception of his subjects' humanity, and his caricatures amount to a complex body of symbols that reinforce conceptions of white supremacy by typecasting blacks within highly recognizable, denigrating roles: the grotesque buffoon, the obsequious servant, and the comic entertainer.

In Kemble's lifetime, America was witnessing profound change; civil unrest, economic inflation, political upheaval, social realignment, and shifting demography and technology captured the imaginations of most Americans. The aftermath of the Civil War, which had promised equality for African Americans, in fact left race relations in continuing conflict, even as some blacks began to achieve more middle-class circumstances (to the consternation of many whites). A strong mass media and a new school of professional illustrators appeared during this period in which almost all ethnic groups were subject to attack due to the clashes of the United States' multicultural social makeup. Kemble made considerable contributions as a political and social cartoonist and as a children's illustrator; but in this age of increasing illustrator specialization, he found his niche in rustic humor and "comic" images of African Americans. Yet Kemble often complained: "I had no more desire to specialize in that subject (black caricatures) than I had in the Chinaman or the Malay pirate."

Depicted in the illustrated press by the white illustrator for an essentially white audience, the black caricature introduced a style of "comic-grotesque" that was new to American art that was soon adopted internationally. While Kemble's black caricatures avoid the more obvious exaggerations found in Thomas Worth's (American, 1834–1917) *Darktown Comics* (drawn for print publishers Currier & Ives), such as big mouths, large feet and hands, and sloping foreheads (meant to indicate limited intelligence), Kemble does present blacks behaving ridiculously and ineptly.

Additionally, like the popular fiction and art of the day, Kemble's black representation was in accord with the standard appellations and titles considered whimsical or funny by whites, who did not view such terms as *Sambo*, *Coon*, *Blackberry*, and *Pickaninny* as racist or unacceptable. Kemble himself casually remarked, "My coons caught the public fancy."

Realizing the market potential of Kemble's "comicalities," the New York–based R. H. Russell and Sons published a series of six year-end gift books, or "picture albums," based on them. With the text and captions probably provided by an anonymous editor, *Kemble's Coons* appeared in 1896, the same year as the most famous and most controversial "coon song" titled "All Coons Look Alike to Me," written by the renowned black vaudevillian, Ernest Hogan (1865–1909). Kemble followed with *The Blackberries and Their Adventures* (1897), *Comical Coons* and *A Coon Alphabet* (1898), *Kemble's Sketch Book* (1899), and *Kemble's Pickaninnies* (1901).

During Kemble's heyday, when illustrated journals were the most popular form of mass communication in the United States, his audience appreciated these African American caricatures with the kind of devotion that many had for the illustrations of Norman Rockwell (American, 1894–1978) or the cartoons of Gary Larson (American, b. 1950) or Robert Crumb (American, b. 1943) in the later twentieth century.

Today it is difficult to interpret these stereotypes and caricatures the way they were understood in the past. Within the context of their crude humor, Kemble's images were not demagogic or atypical of what could be found in slightly more refined forms in the genteel journals of the period and in novels like *Huckleberry Finn* (writer Mark Twain selected Kemble to illustrate the first edition). The prevailing sense of the period valued these images merely as a form of entertainment. But where bourgeois white audiences saw humor in Kemble's comic portrayals of African Americans, black audiences, who saw underneath the comic mask to the derisive insult, did not. Rather, Kemble's books, cartoons, and comic strips were clever textbooks of racial prejudice.

Their stock characters reflected and amplified his audience's perceptions of black people not as individuals, but as stereotyped members of a subordinate group, because, like all caricaturists, Kemble depended on recognition of the familiar to help classify and categorize experience. His Uncles and Aunties, preachers and deacons, Rastuses, Sambos, and ol' Mammies are convenient abstractions—comic blacks that had become the most familiar and persistent stereotypes of the African American pervading hegemonic American culture and graphic arts. The rhetoric of this imagery assumed that blacks were contented as slaves and wretched as freemen, and explained their love of fun and irresponsibility as the result of a child-like dependency on white Americans. Although sometimes seen as a high point, even the boisterous comic action, robust humor, and farcical misadventures of Kemble's syndicated comic strip *The Chocolate Drops* (produced for newspaper magnate Hearst in the 1910s) are in fact emblematic of a low point for race relations (Figure TB38.1).

By creating and reinforcing a well-crystallized set of beliefs about black America, Kemble's black caricature provided escapism—a kind of "defense mechanism"—from black reality, helping white society avoid embracing and

accepting the existence of African American reality or the possibility of African American equality. For African Americans, this was a continual and bitter reminder of their lack of status.

Illustrators like Kemble had enormous influence when their comic-strip characters became as well known to the public as the leading citizens (the cartoon page was the only part of the news that many immigrants could "read"). Racist images had significant lasting effects because they entered the national consciousness and never left. In the 1960s and 1970s, the comic black popped up again in Robert Crumb's work (see Chapter 26), which seems to exploit as much as it satirizes the packaging of black stereotypes as a saleable commodity.

In general, artists interested in addressing the identity behind racial masks and the problems that such masks cause have been a notable few; relying on circumscribed conceptions of physiognomy and societal roles, they too have often made the question "What is the black American?" merely rhetorical. Society itself still lacks the mechanism for answering a much more pressing question: "*Who* are these black men and women?" American illustrators have only recently begun to redirect the question in terms of individuality—and, unlike Kemble's "black comicalities"—to address a black person in terms other than a codified visual object (see Chapter 7, Theme Box 13, "Hall: Encoding, Decoding, Transcoding").

Further Reading

Cobb, Jasmine Nichole, *Picture Freedom: Remaking Black Visuality in the Early Nineteenth Century* (New York: New York University Press, 2015).

Hall, Stuart, "The Spectacle of the Other," In *Representation: Cultural Representations and Signifying Practices* (London; Thousand Oaks, California: Sage, in association with the Open University, 1997): 225–279.

Henderson, Carol E., *America and the Black Body: Identity Politics in Print and Visual Culture* (Madison, NJ: Fairleigh Dickinson University Press, 2009).

Kern-Foxworth, Marilyn, *Aunt Jemima, Uncle Ben, and Rastus: Blacks in Advertising, Yesterday, Today, and Tomorrow* (Westport, CT: Greenwood Press, 1994).

Martin, Francis Jr., "To Ignore Is to Deny: E. W. Kemble's Racial Caricature as Popular Art," *Journal of Popular Culture*, vol. 40, no. 4, August 2007: 655–682.

Nuruddin, Yusuf, "Racial Stereotypes," *The Jim Crow Encyclopedia*, edited by Nikki L. M. Brown and Barry M. Stentiford (Westport, CT: Greenwood Press, 2008): 650–659.

Petrick, Jane Allen, *Hidden in Plain Sight: The Other People in Norman Rockwell's America* (Miami, FL: Informed Decisions Publishing, 2013).

Figure TB38.1
Edward. W. Kemble, *The Chocolate Drops*, 1911.
Courtesy of John Adcock.

she lived in throughout the West and Mexico as she accompanied her husband, a mining engineer, to job postings in California, Colorado, and Idaho (Figure 18.7).

Scribner's Monthly Becomes The Century

By 1880, *Scribner's Monthly* claimed a circulation of 125,000 readers and stood as a formidable competitor to *Harper's Monthly*. At that moment, the descendants of Charles Scribner disassociated themselves from the publication, and *Scribner's Monthly* officially became *The Century Illustrated Monthly Magazine* in November 1881. While visual imagery remained a vital aspect of the magazine, it expanded to include political and economic issues, and between 1884 and 1888, *The Century* ran an extremely popular, extensively illustrated series on the Civil War. Rufus Zogbaum's (American, 1849–1925) "General Howard Striving to Rally His Troops" illustrates the one-armed General Oliver O. Howard as he struggles to maintain order in the face of chaos, while still patriotically bearing the Union flag (Figure 18.8).

The Peak of Realism in American Illustration

During the 1880s, *The Century's* investment in illustration paid off with an unprecedented rise in readership to a circulation of 250,000. In response, *Harper's Monthly* began to increase its commitment to its art department. A "non-compete" clause had initially prevented Scribner's and Sons from introducing a new periodical, but by 1887, the company initiated another illustrated monthly, *Scribner's Magazine*. Intensified competition engendered what many consider the origins of a **Golden Age** of illustration in American print media—an overall improvement in the quality and creativity of illustrations, aided by the widespread adoption of photomechanical

printing and underwriting by advertisers. At the end of the nineteenth century, *Harper's*, *The Century*, and *Scribner's* publications and even those of smaller publishers included the work of first-rate illustrators and thousands of competent ones.

Newer competitors included the *Saturday Evening Post*, *Collier's Weekly*, and *Munsey's*, general-interest arrivals that charged from five to ten cents—as much as thirty cents less than their older rivals. These magazines appealed to a broader middle-class audience and provided a wide array of investigative journalism, human-interest stories, fiction, and self-improvement articles—some accompanied by photography, which was often less expensive than illustration. Advertisements, often full-page and illustrated, made these magazines longer and larger. Whereas older magazines segregated ads in a back section, new magazines dispersed them throughout, forcing the reader to encounter them between features.

Many illustrators worked for multiple publications, receiving only abstracts of stories while equally hard-pressed authors simultaneously rushed to finish the texts. The list of fiction and nonfiction subjects that might be assigned to an illustrator in these decades was exceedingly broad.

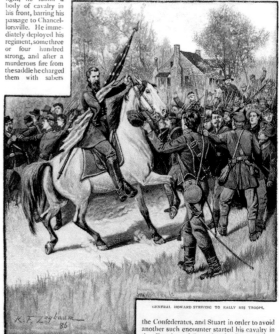

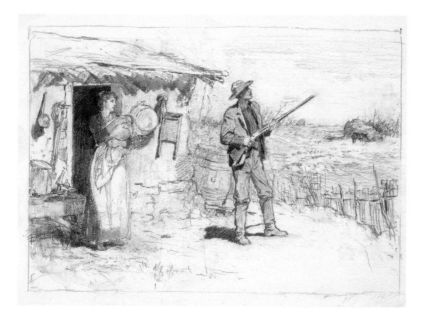

Figure 18.7
Mary Hallock Foote, "The Coming of Winter," in "Pictures of the Far West, Her Story," *The Century*, December 1888. Graphite and ink on paper, 5 5/16 × 7 3/4".
As an author and illustrator, Mary Hallock Foote often presented a domestic side of the West, revealing the struggles and accomplishments of women settlers.
Delaware Art Museum, Acquisition Fund, 1991.

Figure 18.8
Rufus Fairchild Zogbaum, "General Howard Striving to Rally His Troops," in "The Successes and Failures of Chancellorsville," *The Century*, September 1886, p. 754.
Part of a series of illustrated accounts that sought to humanize Civil War battles, this image shows Union troops caught off guard by Confederate fire—their mounted general stoically rallying them as he carries a Union flag despite a partially amputated arm.
Courtesy of Cornell University Library, Making of America Digital Collection.

Howard Pyle and the Brandywine School of Illustrators

Of all the accomplished illustrators popular in these magazines, the most influential was illustrator and teacher Howard Pyle (American, 1853–1911) (*see Theme Box 39, "Education"*). In addition to more than three thousand illustrations for books and major magazines, Pyle also wrote and illustrated four books retelling the stories of King Arthur and his knights, with ninety-two scenes of major characters and events and with numerous head- and tailpieces and decorated capitals.

Pyle taught that a visual story is often best told not at the most dramatic apex of the action, but by an image that allows the viewer to fill in the longer narrative, imagining moments before and after the episode. In a scene of civil disturbance from a disputed Arkansas gubernatorial election, Pyle focuses on the moment preceding the violence instead of the critical moment when one faction forcibly took over the state capital building, and were fired upon (Figure 18.9).

As working illustrators, Pyle's students developed a wide range of styles, as a comparison of visual approaches to illustrating pirate narratives by Robert Louis Stevenson shows. Elenore Plaisted Abbott's (American, 1875–1935) treatment of *Treasure Island* (Figure 18.10), while intensely emotive, is rather like a flat, painted backdrop that focuses on shapes and patterns rendered with outlines and broad areas of color rather than on an illusion of spatial depth. In contrast, N. C. Wyeth's (American, 1882–1945) illustration for *Kidnapped* (Figure 18.11) shows fully modeled figures that cast shadows against the background walls and ceiling of a dramatically lit space.

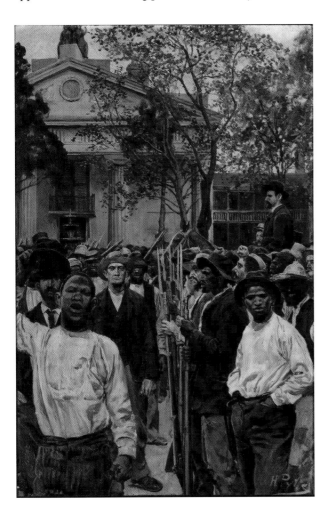

Figure 18.9
Howard Pyle, "The Brooks Forces Evacuating the State House at Little Rock," in "A History of the Last Quarter Century" by E. Benjamin Andrews, *Scribner's Magazine*, May 1895. Oil on illustration board, 18 × 11 ⁷/₈".
While the text reads "(i)ndiscriminate shooting ensued, with sanguinary results," Pyle suspensefully shows the protesters before the fateful moment, leaving viewers to imagine the climax and enticing them to read the story to satisfy curiosity.
Delaware Art Museum, Museum Purchase, 1915.

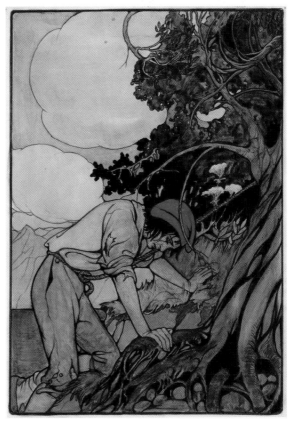

Figure 18.10
Elenore Plaisted Abbott, "Now and Again I Stumbled," in *Treasure Island* by Robert Louis Stevenson, published by G.W. Jacobs, 1911. Watercolor and gouache on paper, 11 ¹/₂ × 9".
The bright red cap draws the viewer to Jim's face, who with eyes closed, "shaken . . . and . . . haunted," struggles under the "murderous glances" of the pirate Long John Silver, out of sight at the end of the rope.
Delaware Art Museum. Gift of Frank Schoonover, 1950.

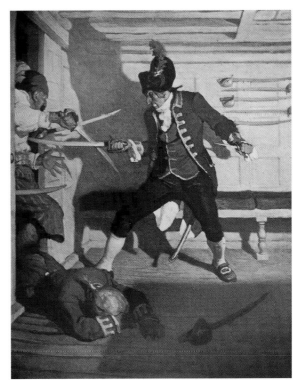

Figure 18.11
N. C. Wyeth, "The Siege of the Roundhouse," in *Kidnapped* by Robert Louis Stevenson, published by Charles Scribner's Sons, 1913.
Like Abbott, Wyeth adds intense orange-red at focal points within the composition. Depth of space is emphasized as one character lunges forward while hands, swords, and a dead body are thrust toward the viewer.
D. B. Dowd Modern Graphic Library, Washington University in St. Louis.

Theme Box 39: Education
by Jaleen Grove, Roger Reed, and Mary F. Holahan, with contributions by Brian M. Kane

In the mid-nineteenth to early twentieth centuries, in Canada and the United States, one became an illustrator through drawing lessons in grade school and then on the job if from a working-class family, or through an art school and then on the job if from a wealthier background. Artists often continued training into their mid-twenties. Whether one was formally trained or not, most expertise was developed through professional practice. In the twentieth century, this sort of apprenticeship became known as the "studio system"; Haddon Sundblom's various Chicago studios (began as Stevens, Sundblom & Henry in 1925) and Charles E. Cooper Studios are examples of this (see Chapter 24). Techniques and styles were passed from one generation to the next through young and old illustrators working closely together (Figure TB39.1).

A nineteenth-century or early twentieth-century boy of modest means typically began as an office boy in an engraving house or at a newspaper as early as twelve years of age (though more likely fifteen or so). He would perform mundane tasks while having the opportunity to watch the art staff draw, engrave wood blocks, design, set type, or hand-letter **showcards** (advertising signs displayed in shop windows). If he showed aptitude, he would be given critiques on his own drawings, and eventually, would be given small jobs such as **tailpieces** (decorative black-and-white embellishments printed at the end of a book chapter) or caricature. The apprentice would often supplement his on-the-job training with night classes in drawing at a nearby art school or **Art Students League**, or from correspondence courses such as Art Instruction, Inc., began offering in 1914. When he became good enough, he would find a place as an illustrator or "lettering man" in the **bullpen**, the studio area of a firm.

A girl from a modest background would most likely find admittance into the workplace only if she had an older male relative already working there, or if the firm employed females as cheap labor for certain less-skilled tasks, since they were customarily paid much less than men. In the mid-nineteenth century, for instance, Currier & Ives employed hundreds of girls and women to hand-color lithographs in assembly-line fashion. Schools such as the National Academy of Design in the 1830s and the New York School of Design for Women in the 1850s, however, nurtured significant numbers of working female artists, who found paying work providing content and production for the burgeoning magazine business. The Cooper Union School of Design for Women, opening in 1859, then trained hundreds in engraving, illustration, and design to a professional standard (see the later section).

A young person with some family wealth would likely finish high school while taking private instruction from a local artist. Many girls received instruction from nuns or art teachers in boarding schools. Graduates would then enter an art school and complete up to four years of training, often completing freelance and self-directed work at the same time. Their schooling would follow the customary program of the European academies, which taught students figure drawing in segregated classes (where women did not work from fully nude models); Classical idealization and symbols; customs of depicting emotions, narrative, and character; and the moral and technical standards of salon painting. Some schools also offered classes in illustration.

Due to his privileged training and social connections, a wealthier male had a greater ability to have a fine-art career or to be taken on by prestigious advertising or publishing houses, or to successfully freelance with big-name clients. But there are notable exceptions in which men of humble backgrounds rose through talent and perseverance: Albert Dorne (1904–1965), president of the Famous Artists School purveyor of correspondence courses (see Chapter 24) and one of the best-known American illustrators, had quit school at twelve to support his mother and siblings with assorted non-art jobs while teaching himself to draw and letter.

By contrast, a wealthy female was less likely to find work in a bullpen, unless it was one staffed mainly by women or was devoted to fashion or catalogue illustration. She did, however, have much more opportunity to break into women's and children's magazines and books, and could readily find a place in the numerous Arts and Crafts societies that promoted handicraft production for the home. Women were plentiful in art schools, but proportionately fewer became famous freelance illustrators compared to their male peers. Although art school advertisements assured women they would suffer no discrimination based on gender in the field of illustration, testimony exists of women being passed over because the art editor thought they were useful only for illustrating "a woman's point of view" and the majority of women did not transcend executing feminine subjects and low-paying categories of work. Examples of women working their way up to greatness from abject poverty as men like Dorne did are close to nil; the most successful women came from "respectable" backgrounds.

Many aspiring illustrators would visit Paris if they could, often taking further instruction at **Académie Julian**, a traditional atelier where eminent salon artists such as William-Adolphe Bouguereau (1825–1905) taught. Although the Académie emphasized Classical figurative drawing and painting, after 1900 students could also take classes in design and illustration. The Académie's many women students, for whom it was more difficult to achieve notable fine-art careers, particularly excelled in the frequent competitions for awards in these graphic arts.

Some American Art Schools and Teachers Before 1940

Art schools that trained illustrators gave a solid grounding in perspective, anatomy, lettering, chiaroscuro, color theory, composition, and hundreds of hours of drawing from plaster casts and live models. Some

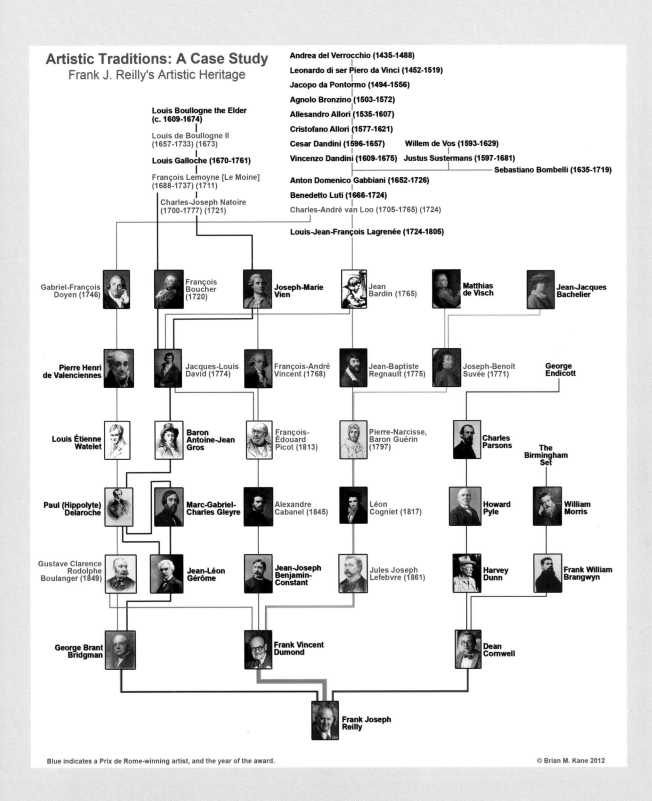

Artistic Traditions: A Case Study
Frank J. Reilly's Artistic Heritage

Andrea del Verrocchio (1435-1488)

Leonardo di ser Piero da Vinci (1452-1519)

Jacopo da Pontormo (1494-1556)

Agnolo Bronzino (1503-1572)

Allesandro Allori (1535-1607)

Cristofano Allori (1577-1621)

Cesar Dandini (1596-1657) Willem de Vos (1593-1629)

Vincenzo Dandini (1609-1675) Justus Sustermans (1597-1681)

Sebastiano Bombelli (1635-1719)

Anton Domenico Gabbiani (1652-1726)

Benedetto Luti (1666-1724)

Charles-André van Loo (1705-1765) (1724)

Louis Boullogne the Elder (c. 1609-1674)

Louis de Boullogne II (1657-1733) (1673)

Louis Galloche (1670-1761)

François Lemoyne [Le Moine] (1688-1737) (1711)

Charles-Joseph Natoire (1700-1777) (1721)

Louis-Jean-François Lagrenée (1724-1805)

Gabriel-François Doyen (1746)

François Boucher (1720)

Joseph-Marie Vien

Jean Bardin (1765)

Matthias de Visch

Jean-Jacques Bachelier

Pierre Henri de Valenciennes

Jacques-Louis David (1774)

François-André Vincent (1768)

Jean-Baptiste Regnault (1775)

Joseph-Benoît Suvée (1771)

George Endicott

Louis Étienne Watelet

Baron Antoine-Jean Gros

François-Édouard Picot (1813)

Pierre-Narcisse, Baron Guérin (1797)

Charles Parsons

The Birmingham Set

Paul (Hippolyte) Delaroche

Marc-Gabriel-Charles Gleyre

Alexandre Cabanel (1845)

Léon Cogniet (1817)

Howard Pyle

William Morris

Gustave Clarence Rodolphe Boulanger (1849)

Jean-Léon Gérôme

Jean-Joseph Benjamin-Constant

Jules Joseph Lefebvre (1861)

Harvey Dunn

Frank William Brangwyn

George Brant Bridgman

Frank Vincent Dumond

Dean Cornwell

Frank Joseph Reilly

Blue indicates a Prix de Rome-winning artist, and the year of the award.

© Brian M. Kane 2012

Figure TB39.1
Every illustrator inherits a tradition from previous generations, whether it be formally through training or informally through exposure to visual culture. This "family tree" charts the influences on Reilly's technique, which includes a system he developed for arranging color on a palette. Reilly's approach was a confluence of the Munsell color system and the color theory ideals taught by the French Academy, which in turn was based on Southern Renaissance precedents that looked back to ancient Greek and Roman art. Reilly, a well-respected illustrator and popular teacher, taught at the Art Students League in New York for twenty-eight years and founded the Frank J. Reilly School of Art. Among his most noted students were James Bama, Peter Max, Clark Hullings, Fred Fixler, and Basil Gogos.

Chart by Brian M. Kane.

Theme Box 39: Education (*continued*)
by Jaleen Grove, Roger Reed, and Mary F. Holahan, with contributions by Brian M. Kane

schools specifically taught illustration, which was understood to be the art of how to select and interpret passages from a text. Every member of the top echelon of American commercial illustrators was extremely technically proficient, and even their routine work was remarkably skillful. But technical expertise alone was not sufficient: illustrators took such "craft" for granted and instead spoke of picture ideas and problem solving as more significant markers of excellence when they critiqued their own work.

Cooper Union School of Design for Women

In the United States, opportunity for working-class women to train in wood engraving and commercial art increased with the establishment of Cooper Union School of Design for Women in 1859. Tuition was free, and admission was highly competitive. Those who succeeded received rigorous instruction in drawing, composition, and wood engraving for four years; the engraving work was done on actual commissions secured by the school. Upon graduation, women could join a small engraving house mostly staffed by women and were paid similarly to men. Graduates also accepted freelance engraving and illustration commissions, painted watercolors, and embellished place-setting cards for banquets, which brought status as respected artists, since at this time beautiful artisanal and commercial arts were valued nearly as much as gallery art. Cooper Union training allowed women to be financially independent, even in some cases after marriage and motherhood.

The Art Students League of New York

In 1875, New York art students established their own collectively run school with classes in drawing, painting, sculpture, and illustration (it is still operating) (Figure TB39.2). They hired the most eminent artists they could to teach them and emulated the manner of the Paris *atelier*, in which a master

guides a studio of journeymen and apprentice artists in his manner of work. Students paid tuition by the class and self-directed their attendance and progress. Degrees and grades were not given, but prizes and scholarships were awarded by outside juries. Many illustrators took advantage of the flexible schedule, which accommodated those who held jobs.

Among teachers most influential with illustrators were Impressionist painter Frank Vincent DuMond (1865–1951); the legendary Howard Pyle (1853–1911) (see the following section); Robert Henri (see the following section); Joseph Pennell (1857–1926), whose instruction books on pen-and-ink drawing were considered the best; Frank J. Reilly (1906–1967), who developed a regimented method of teaching color; John Sloan (1871–1951), who encouraged self-expression; and George Bridgman (1865–1943), who trained thousands of illustrators in anatomical figure drawing derived

from his own education under the French academicians such as Jean-Léon Gérôme (1824–1904)—lessons that Bridgman also published as books, which are still consulted today.

Prominent illustrators who attended the Art Students League of New York include Wanda Gàg, Charles Dana Gibson, William Glackens, Arthur William Brown, Peter Max, Frederic Remington, Norman Rockwell, Maurice Sendak, Ben Shahn, and countless others. Art Students Leagues also operated in Chicago; Washington, DC; Philadelphia; and Toronto.

Howard Pyle and the Brandywine School

In 1894, Howard Pyle inaugurated a program in illustration (with large female enrollment) at Drexel Institute of Art, Science and Industry (now Drexel University) in Philadelphia, which was renamed in 1896 as its School of Illustration. In 1898, Pyle established a summer school at Chadds Ford, Pennsylvania, allowing

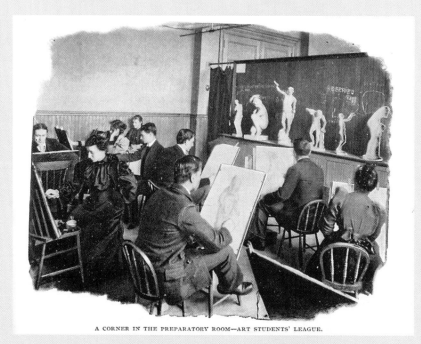

A CORNER IN THE PREPARATORY ROOM—ART STUDENTS' LEAGUE.

Figure TB39.2
Men and women draw from Classical plaster statues at the New York Art Students League. Published in "A Turning Point in the Arts" by Charles de Kay, *The Cosmopolitan*, July 1893, p. 271.
D. B. Dowd Modern Graphic History Library at Washington University in St. Louis.

him to give intensive instruction to select students. In 1900, he resigned from Drexel and founded his own school (recruiting mainly men) in nearby Wilmington, Delaware, which he operated until 1905. Pyle's rigorous curriculum stressed naturalistic accuracy and emotional resonance, and many of his more than 165 students (one-third female in total) went on to create some of the most memorable work of the early twentieth century. Collectively, these courses became known as the **Brandywine School** because of the school's location in the Brandywine Valley, which cuts through Delaware and Pennsylvania. Pyle also taught at the Art Students League in New York.

Pyle's best-known students include Stanley Massey Arthurs (1877–1950), Anna Whelan Betts (1875–1952), Arthur Ernst Becher (1877–1960), Harvey Dunn (1884–1952), Elizabeth Shippen Green (1871–1954), Thornton Oakley (1881–1953), Maxfield Parrish (1870–1966), Frank Earle Schoonover (1877–1972), Jessie Willcox Smith (1863–1935), Ellen Bernard Thompson (1876–1936), Sarah Stilwell Weber (1878–1939), Katharine Richardson Wireman (1878–1966), and N. C. Wyeth (1882–1945).

Robert Henri

The painter Robert Henri (pronounced "Hen-rye"; American, 1865–1929) played a complicated role in illustration's evolution. Henri repudiated his Impressionist roots to become a proponent of **Realism**, an art movement originating in Paris. Associated with socialist views, Realists documented the lives of the poorest classes without idealizing them as quaint, nostalgic, innocent, or picturesque, as was the norm among Academicians. Because Henri was an extremely influential teacher, his exhortations to fine-art students to capture the spirit of a scene in a few quick strokes of the brush found a very receptive audience among newspaper illustrators

in the 1890s. Their job entailed distilling a newsworthy event down to its essence in a concise number of ink lines in time to be photo-engraved for the morning edition.

Having indirectly validated illustration, Henri came to indirectly condemn it, by insisting on a distinction between personal and commercial goals. He flatly stated, "Art is certainly not a pursuit for anyone who wants to make money," and "Your only hope of satisfying others is in satisfying yourself. I speak of a great satisfaction, not a commercial satisfaction."

Henri turned his inner coterie of followers away from illustration toward art for art's sake, and molded them into The Eight, a group that not only exhibited controversial work but also evolved into the primary American avant-garde art movement prior to World War I. They later came to be derisively known as the **Ashcan School** for their embrace of Realist subjects that were considered vulgar, such as the tenements of the poorest people, street kids, and boxing matches—the same subjects that they treated in their illustrations and cartoons as journalists. Despite being documentary in an illustrative manner, however, the paintings were to be hung on walls, not mass-reproduced—making them "art" and not "illustration" in some people's eyes. This fine line between art and illustration was fiercely debated throughout the twentieth century.

American artists who came under the influence of Henri and who also made illustration according to their consciences include Rockwell Kent (1882–1971), Art Young (1866–1943), Reginald Marsh (1898–1954), George Bellows (1882–1925), and John Sloan (1871–1951).

Harvey Dunn

Another popular and charismatic teacher in the 1910s was Harvey Dunn (American, 1884–1952), who had been a student of Howard Pyle. Dunn advised, "Paint a little

less of the facts, and a little more of the spirit. Look a little at the model and a lot inside. Paint more with feeling than with thought." Contrary to critics of illustration such as Robert Henri, who felt that working for clients compromised artistic integrity, Dunn believed that the artist could find honest expression within the strictures of the mass market. Indeed, he seemed to believe that the illustrator could find elements worth developing in even the meanest of manuscripts or from the densest of art directors: "Once when I had a little job, the editor said, 'Mr. Dunn, don't spend too much time on these things, we're not paying you for a lot of work, and they're not worth it.' And I replied, 'Mr. Editor, you may be paying me for these, but I'm really working for this fellow Dunn, and he's got to be pleased.'" In this regard, Dunn's and Henri's points of view were remarkably similar. Prominent American Dunn students include John Clymer (1907–1989), Dean Cornwell (1892–1960) (himself another influential teacher), Amos Sewell (1901–1983), Saul Tepper (1899–1987), and Harold von Schmidt (1893–1982).

Correspondence Courses

Beginning in 1914, the Minneapolis firm Art Instruction, Inc., began offering courses in cartooning, design, and illustration through the mail. Several other companies throughout the twentieth century did as well, including the Famous Artists School that began in 1949 (*Chapter 24*). The courses gave practical career advice from established illustrators as well as detailed and useful how-to lessons. Students completed lessons by following the instructions and then mailing in the result for marking by the instructors, who would send the work back with critiques and the next module of the course. Before the days of television and when poorer families could not afford books or art school lessons, mail-order courses were a godsend

Theme Box 39: Education (*continued*)
by Jaleen Grove, Roger Reed, and Mary F. Holahan, with contributions by Brian M. Kane

for artistic youth, especially those in small towns that lacked art galleries, libraries, a graphics industry, or artists. One celebrity who began with correspondence courses is Charles M. Schulz (1922–2000), creator of the comic strip *Peanuts*; but by far most graduates would have gone on to regular jobs in printing shops and advertising agencies.

Further Reading

Bartholomew, Charles L., and Joseph Almars (Eds.), *Modern Illustrating Including Cartooning*, Divisions 1–12 (Minneapolis: Art Instruction, Inc, 1948).

Carter, Karen L., "'Earning a Living' in the International Graphic Arts: The

Académie Julian and the Teaching of Poster Design and Illustration, 1890–1914," In *Foreign Artists and Communities in Modern Paris, 1870–1914: Strangers in Paradise*, edited by Karen L. Carter and Susan Waller (Burlington, VT: Ashgate, 2015): 53–65.

Heller, Steven, "Draw Me Schools of Commercial Art," *Design Observer*, December 3, 2008, http://designobserver.com/feature/draw-me-schools-of-commercial-art/7687/.

Masten, April F., *Art Work: Women Artists and Democracy in Mid-Nineteenth-Century New*

York (Philadelphia: University of Pennsylvania Press, 2008).

May, Jill P., and Robert E. May, *Howard Pyle: Imagining an American School of Art* (Urbana: University of Illinois Press, 2011).

Reed, Walt, Roger Reed (ed.), and Lynn Verschoor, *Harvey Dunn: Illustrator and Painter of the Pioneer West* (Santa Cruz, CA: Flesk Publications, 2010).

Zurier, Rebecca, *Picturing the City: Urban Vision and the Ashcan School* (Berkeley: University of California Press, 2006).

Illustrators' Perspectives: A Range of Human Interest Subjects

Illustrations in popular magazines helped viewers envision all kinds of topics from current events and history to "slice of life" fiction, which, while entertaining, might also tackle serious social issues. Some common themes are described in the following sections.

Race and Class

Arthur Burdett Frost (American, 1851–1928) is perhaps best known for his vivacious pen-and-ink line drawings for *Uncle Remus* stories, collections of folktales in southern dialect written by Joel Chandler Harris (American, 1848–1908). However, Frost also created countless illustrations of small-town life, politics, and pastimes from hunting to baseball. His volumetric tonal work often relied on exaggerations of physiognomy and expression, which in his images of African Americans often communicated racist sensibilities.

Frost's 1884 illustration for "Free Joe and the Rest of the World" is a hybrid of the two strands of his work, drawn with an expressive line, but with more or less naturalistic forms (Figure 18.12). This work presents a sympathetic portrait of the dire conditions of freedmen after the Civil War, but the text ultimately panders to racist notions of the former slaves as simple, superstitious, and in an untenable situation that undermines optimism for equality between races.

"CALDERWOOD READ IT ALOUD SLOWLY."

Figure 18.12
Arthur Burdett Frost, "Calderwood Read It Aloud Slowly," in "Free Joe and the Rest of the World," by Joel Chandler Harris, *The Century*, November 1884, p. 119.

Free Joe, the formerly enslaved man, at left, who has arrived to visit his still-enslaved wife, is fearful and wary as an imperious white man reviews the "pass" that would allow Joe to move about freely. Joe's wife, stolidly standing by in the doorway, plays no role in the decision that will affect her life. The vignette reinforces Joe's conviction that "though he was free he was more helpless than any slave"—a controversial sentiment that reveals nineteenth-century readers' mixed feelings about the end of slavery.

D. B. Dowd Modern Graphic History Library at Washington University in St. Louis.

Class differences were another pervasive preoccupation in magazine fiction. Plots and characters often reflected aspirations to rise above the lower or middle classes, an ambition sometimes fraught with moral quandaries. Anna Whelan Betts (American, 1873–1959) illustrated a short story for *McClure's* in which the poor protagonist attempts to profit by secretly showing off his employer's opulent offices during his absence (Figure 18.13). Although fictional, the story reflects stereotypes of the day through the exaggerated immigrant dialect of the protagonist and his simplistic understanding of class divisions.

The New Woman

By the end of the century, women's presence in the public sphere increased exponentially as more young women joined the workforce, and more privileged women began enrolling in colleges and choosing professions before or instead of marriage. Many were interested in suffrage, community service, physical fitness, or bicycle riding—which allowed them unprecedented unescorted liberty and mobility. This independent type was dubbed the New Woman—a staple of popular fiction and cartoons, and the subject of concerned social critique (*see Chapter 15*).

Charles Dana Gibson (American, 1867–1944), who specialized in social satire in the vein of Gavarni (*see Chapter 14*), created the visual archetype of the New Woman that came to be known as the **Gibson Girl** in the early 1890s (Figure 18.14). Defined by voluminous upswept hair, an hourglass figure, fashionable clothes and lifestyle, and an elegant, aloof bearing, the patriotic Gibson Girl presented an ideal of American beauty that quickly proliferated beyond print into fashion and material

Figure 18.13
Anna Whelan Betts, "He had Insisted on Dusting Their Shoes," in "Ben Zoni's Matinee" by Joseph Blethen, *McClure's Magazine*, May 1904. Charcoal and pastel on illustration board, 23 9/16 × 14 9/16."
The secrecy of the action shown is implied by the compressed composition as much as the figures' postures.
Delaware Art Museum, Gift of Stafford Good, 1939.

Figure 18.14
Charles Dana Gibson, "Her Day," cover of *Life*, July 1903.
In the guise of the long-established allegory of the nation known as Columbia, the Gibson Girl wears the **Phrygian cap** (a red hat that historically symbolized liberty) to personify America on "her" birthday, July 4th.
Library of the General Society of Mechanics and Tradesmen.

Figure 18.15
Allen Tupper True, "'The less you count, the longer you'll live,' said Shields," in *The Orphan* by Clarence E. Mulford, published by The Outing Publishing Company, 1908. Oil on canvas, 30 × 20".
In the evocative light of a dramatic Western landscape, viewers are positioned in the foreground shadows behind a group of outlaws, watching the potentially deadly encounter with a sheriff, luminescent on his white steed.
Delaware Art Museum, Gift of Frank Eaton True, 2005.

goods. Corseted but vigorous, independent but endearing, Gibson's New Woman comprised a constellation of sometimes contradictory qualities that appealed to both men and women—and made Gibson famous and wealthy.

The West

Americans also looked back nostalgically at the Wild West, and its bold, rugged characters championed a generation earlier by Remington (Figure 18.5). Scenes such as Pyle student Allen Tupper True's confrontation between rogue cowboys and a sheriff reinforced the enduring mythology of the West (Figure 18.15).

Escapism: Travel and Romance

Fiction set in faraway locales or with romantic themes offered readers escape from the workaday world and entertained those for whom travel was impractical or unaffordable. "One Night in Venice" by Dean Cornwell (American, 1892–1960) captures the exotic mystery of Venice through his buttery oil painting style illustrating a short story about a love affair (Figure 18.16). In striking contrast to the shadowy scene at the piano and the warm light of the stone wall, Cornwell's restrained palette highlights the couple's faces and hands, lending an air of mystery and emotional tension.

Shakespeare

References to Shakespeare were not limited to literary periodicals like *Harper's Monthly*. The April 1927 cover for the popular *Liberty Magazine* (Figure 18.17) shows serialized fictional characters Sandy Jenkins and Lil Morse illustrated by Leslie Thrasher (American, 1889–1936) as they prepare for a costume party, dressed as the Shakespearean lovers Antony and Cleopatra. "Lil and Sandy" were so popular that they later became characters in a radio soap opera and in the movie *For the Love o' Lil* (1930)—early examples of transmedia storytelling.

Women's Magazines and Women Illustrators

For over half a century, the women's suffrage movement coexisted with what cultural arbiters defined as the "woman's sphere": a world restricted to home, marriage and motherhood, or spinsterhood. While in general print culture reflected America back to the viewers, it also posited visual fictions manifesting the way Americans wanted their lives to be, or assumed they *ought* to be. Such idealism was especially pronounced in women's magazines that stereotyped gender roles and consigned women to narrow social roles with "feminine" identities accepted by a preponderance of readers as preordained.

Godey's Lady's Book

Philadelphia publisher Louis A. Godey (American, 1804–1878) founded *Godey's Lady's Book* in 1830 and enjoyed modest success until 1837 when he hired Boston editor Sarah Josepha Hale (1788–1879) to upgrade the magazine's content. It was Hale's vision that guided *Godey's Lady's Book* to its position as the "Queen of the Monthlies," and set the tone for all subsequent women's periodicals.

Figure 18.16
Dean Cornwell, "'And when you have gone away and are a prince once more, it will be just as a man that I shall think of you in my solitude. . .'" in "One Night in Venice" by F. Britten Austin, *Hearst's International Magazine*, vol. 41, 1922.
In telling body language, the woman at the piano gazes upward and away from her contemplative companion, as if anticipating her solitude.
Courtesy of Heritage Auctions. The Kelly Collection of American Illustration Art.

Figure 18.17
Leslie Thrasher, "'I'm Dyin', Egypt, Dyin,'" cover for *Liberty* Magazine, April 23, 1927. Oil on canvas, 19 ³/₄ × 15 ³/₄".
Sandy satirically quotes Shakespearean drama with an American pronunciation of one of Antony's last lines to Cleopatra.

Delaware Art Museum, Gift of Mrs. Audrey Thrasher de Russow, 1973.© Liberty Library Corporation.

In an era when women's educational opportunities were limited and housework was punishing, Sarah Hale steered *Godey's Lady's Book* away from political issues and provided her readers with information to make their homes and themselves more beautiful and interesting. Her magazine included articles on housekeeping and cooking, fashion drawings, sewing patterns, piano music, and fiction by prominent authors including Nathaniel Hawthorne, Ralph

Waldo Emerson, Edgar Allan Poe, Henry Wadsworth Longfellow, and Harriet Beecher Stowe. Under Hale's guidance, *Godey's Lady's Book* had 150,000 subscribers and an estimated readership of more than a million by 1860 (Figure 18.18).

Ladies' Home Journal

Founded in 1883, the *Ladies' Home Journal* was the result of a partnership between husband Cyrus H. K. Curtis (American, 1850–1933) and wife Louisa Knapp Curtis (American, 1851–1910), with the latter acting as editor. In five years, with the *Ladies' Home Journal* achieving an unprecedented circulation of 440,000, Louisa Knapp Curtis retired as editor, citing a growing family as her reason. New editor Edward Bok (1863–1930) built on the publication's success, adding informative articles and features aimed at encouraging middle-class women to nurture their potential.

Following the tradition established by Hale, Bok solicited esteemed writers like Bret Harte, Mark Twain, and Arthur Conan Doyle to contribute to the magazine. To augment their work, he hired the most distinguished illustrators of the day. Although Bok rarely hired female artists, a desire to publish features that would appeal to children led him to illustrator Kate Greenaway (English, 1846–1901), whose books were very popular in the United States (*see Chapter 16*). Her nostalgic watercolor drawings of children conjured up an innocent world that appealed to readers of all ages.

The Red Rose Girls

While it was uncommon for female artists to illustrate fiction and news, there was no such prejudice in the magazine's advertising department where illustrators Jessie Willcox Smith (American, 1863–1935) and Elizabeth Shippen Green (American, 1871–1954) created product illustrations. In an effort to improve their prospects, the two young women enrolled in Howard Pyle's Saturday illustration class at the Drexel Institute in 1894. There they met Violet Oakley (American, 1874–1961). The trio was dubbed The Red Rose Girls after a house they leased together.

Figure 18.18
"Window Frost" and "Godey's Fashions for February 1873," *Godey's Lady's Book*, February 1873.
Godey's frequently juxtaposed high-class hand-colored gatefold fashion plates with engravings of an idealized domestic sphere (home and motherhood), thus flattering both elite and working classes. When Hale retired in 1877, she penned a good-bye that exemplifies the presumed righteousness of the gender divide: "And now, having reached my ninetieth year, I must bid farewell to my countrywomen, with the hope that this work of half a century may be blessed to the furtherance of their happiness and usefulness in their Divinely-appointed sphere." *Godey's Lady's Book* was soon after surpassed by the *Ladies' Home Journal*.

St. Louis Public Library.

Green, widely acclaimed for her illustration of children's books, won an exclusive contract with *Harper's Monthly* in 1901. Violet Oakley's professional life also flourished: in addition to magazine illustrations, in 1902 she accepted a $20,000 commission to paint eighteen murals for the new Pennsylvania State Capitol. With the majority of the capitol's mural decorations allocated to renowned illustrator Edwin Austin Abbey (American, 1852–1911), known for Shakespearian and other high-brow subjects, Oakley's share was the most significant assignment ever offered a female American artist. Jessie Willcox Smith became the most prominent female magazine illustrator of the early twentieth century, painting every cover of the immensely popular *Good Housekeeping* magazine from 1918 through 1933 (see Figure 18.19).

The proliferation of women's magazines combined with the Red Rose Girls' unprecedented success improved prospects for many female illustrators. By the early twentieth century, seven periodicals vied for the attention of the American woman: *Delineator, McCall's, Ladies' Home Journal, Woman's Home Companion, Modern Priscilla, Good Housekeeping,* and *Pictorial Review.* These magazines provided a showcase for illustrators, and editors increasingly hired women as well as men.

St. Nicholas, an Illustrated Children's Periodical

Scribner's began publishing the children's magazine *St. Nicholas* in 1873 with short story author and novelist Mary Mapes Dodge (American, 1831–1905) as its founding editor. Designed to be entertaining and morally uplifting, the magazine also aimed to offer illustrations that would give young people an appreciation of art. *St. Nicholas Magazine* published many successful illustrators such as Charles Dana Gibson, Arthur Rackham, and later, Norman Rockwell.

Howard Pyle's Arthurian narratives were first serialized in *St. Nicholas* with freely adapted plots favoring egalitarian values over royal ones, to better emphasize desirable behavior for the American boys who were the target audience. For example, King Arthur disguises himself as a gardener and then reveals his identity, demonstrating that chivalry is a matter of character, not social class (Figure 18.20).

St. Nicholas also featured the work of many women illustrators, at least partly because women were considered especially adept at depicting children and the domestic realm in general—Katharine Pyle (American, 1863–1938), Jessie McDermott Walcott (American, 1857–1907), Clara M. Burd

Figure 18.19
Jessie Willcox Smith, cover for *Good Housekeeping,* October 1928. Watercolor and charcoal on paper, 16 ¹/₄ × 15 ⁷/₈".
Willcox Smith's paintings of idealized children reflected a flawless, self-contained world imagined by middle- and upper-class white Americans, who were the target audience of book and magazine publishers. Advertisements (which she also illustrated) linked her idealized world to a plethora of consumer goods that defined middle-class life.
Delaware Art Museum, Louisa du Pont Copeland Memorial Fund, 1971. © Artist or artist's estate.

Figure 18.20
Howard Pyle, "The Gardener Lad Takes off His Cap," in "The Story of King Arthur and His Knights" by Howard Pyle, *St. Nicholas,* May 1903. Ink on illustration board, 11 ³/₄ × 8 ¹/₄".
Pyle's illustrations, influenced by the Arts and Crafts movement (*Chapter 15*), refer to Gothic illuminated manuscripts and woodcuts with their balance of positive and negative space and use of decorated capitals and blackletter.
Delaware Art Museum, Museum Purchase, 1912.

(American, 1873–1933), and Fanny Young Cory (American,1877–1972) among them (*see Chapter 16, Theme Box 35, "Women in Illustration"*).

Magazine Posters and Covers

In the last decade of the nineteenth century, publishers gave illustrators much creative latitude to promote periodicals with posters. Quite in contrast to the prevailing taste for realism in the mid-1890s, Edward Penfield (American, 1866–1925) and William H. "Will" Bradley (American, 1868–1962) adopted the flat aesthetics of European posters and Japanese prints, setting off a new trend in American poster design (*see Chapter 15*).

The 1896 poster competition for *The Century* sparked the careers of J. C. Leyendecker (German, American, 1874–1951) and Maxfield Parrish (American, 1870–1966), each known for a style that updated traditional academic narrative realism. Parrish's award-winning poster (Figure 18.21) featured a nude in profile against a spatially flattened but complex screen of foliage. He went on to create both magazine covers and advertising posters for *The Century*, *Scribner's Magazine*, and *Lippincott's* in a style that counterpointed naturalistic rendering with idealized or symmetrical forms.

The illustrated magazine covers introduced around 1900 did not always relate to the textual contents but rather promoted the magazine in general. Cover art ideas were mainly conceived by the illustrator and pitched to the art editor. Because covers allowed the illustrator a great deal of self-expression, a prominent signature, and exposure in color, they were prestigious assignments. Publishers competed to retain the best talent in order to enhance the magazine's prestige and brand identity. The regular appearance of an illustrator's work carried the expectation—sometimes unspoken, sometimes by contract—that this illustrator would not work for competitors.

Covers stimulated purchase and were often saved and framed. The *Saturday Evening Post* art editor Kenneth Stuart wrote in 1951, "As a rule, *Post* covers deal with some tangible and homey phase of American life. . .The aim is to depict a situation which can be taken in at a glance. . .Unlike the illustration with its caption and text, the cover painting is a complete unit in a creative sense. It requires no text to amplify its story."

Beginning in the late 1890s with the Gibson Girl craze and the popularity of Art Nouveau with its pervasive decorative motifs of women (*see Chapter 15*), one of the most ubiquitous of cover art genres to arise was that of the **pretty-girl**—images of idealized feminine beauty created as aspirational models for a growing female target audience, and certainly attractive to male readers as well (Figure 18.22). Harrison Fisher (American, 1877–1934) gave *Cosmopolitan* a distinct

Figure 18.21
Maxfield Parrish, poster, *The Century*, August 1897.
Parrish's image paradoxically implies the transmission of light through the trees, without directly creating highlights or shadows on the figure.
Delaware Art Museum, Gift of Mrs. J. Marshall Cole, 1973.

Figure 18.22
Harrison Fisher, cover for *Woman's Home Companion*, February, 1911.
Like the Gibson Girl, the Fisher Girl was meant to represent an ideal of American young womanhood. Fisher was unusual in that he provided covers for competing magazines—likely possible because of his immense celebrity status.
Courtesy of Norman I. Platnick/Enchantment Ink.

identity by providing pretty-girl heads for almost every issue from 1913 to 1934. Fisher also issued expensive books, art prints, and postcards of his famous Fisher Girls.

Alice Barber Stephens (American, 1858–1932) was both a product of and a contributor to the advancement of women illustrators that occurred in the late-nineteenth century. She began her career as a wood engraver and in 1876 enrolled in the Pennsylvania Academy of Fine Arts. There, she and other women artists were hampered by exclusion from drawing the nude model. They petitioned to gain admission to the life drawing classes and were eventually granted gender-separated classes (*see Theme Box 39, "Education"*).

Barber Stephens's 1905 cover for the *Ladies' Home Journal* centers on feminine dress, a recurring interest of the magazine in the early twentieth century (Figure 18.23). With a subtle, restrained palette, she depicts an upper-class woman in finely detailed dress and cape, shaded by a graceful ribboned hat.

Numerous covers celebrated rural America in the form of landscapes, outdoor sports such as fishing or skating, wildlife, and nostalgic farm scenes. Sentimentalized characters such as Maxfield Parrish's sympathetic hobo on *Collier's* (1905) (Figure 18.24) became touchstones for broad segments of the American population, as many struggled to find a place in the turbulent economic shifts of a country moving from an agrarian to a more urban society.

Canadian Illustrators

Dwarfed by the thriving United States, Canadian publishing was meager and conservative. From 1880 onward, thousands of writers and illustrators left Canada for better-paying and more exciting assignments in the United States. Expatriates were often resented by Canadians, who felt that the exodus of talent was harming Canada's economic and artistic prospects.

Jay Hambidge (Canadian, 1867–1924) was an expatriate whose work appeared in *The Century*, *McClure's*, *Collier's*, and *Harper's* (Figure 18.25). From his study of ancient Greek art and geometric equations, he developed a theory of art called **dynamic symmetry**. It was based on the spiral-producing Golden Ratio (*phi*) of 1:1.618, observed in the natural growth patterns of plants

Figure 18.23
Alice Barber Stephens, cover for the *Ladies' Home Journal*, February 1905. Gouache and charcoal on illustration board, 27 9/16 × 21 5/8."
At leisure in a park-like setting, the subject is modeling an eighteenth-century dress with a decidedly modern air. Not obviously a mother or wife but a woman apparently on her own, such confidence marks her attitude as that of the New Woman despite her antiquarian garb.
Delaware Art Museum, Louisa du Pont Copeland Memorial Fund, 1975.

Figure 18.24
Maxfield Parrish, "Tramp's Thanksgiving," cover for *Collier's*, November 18, 1905. Oil and charcoal on paper mounted to cardboard, 20 1/2 × 15 1/2".
Despite his down-and-out economic status, Parrish's handsome hobo projects an almost dreamy optimism. The image would have created empathy for those less fortunate, rather than implying a critique.
Delaware Art Museum, Samuel and Mary R. Bancroft Memorial, 1935.

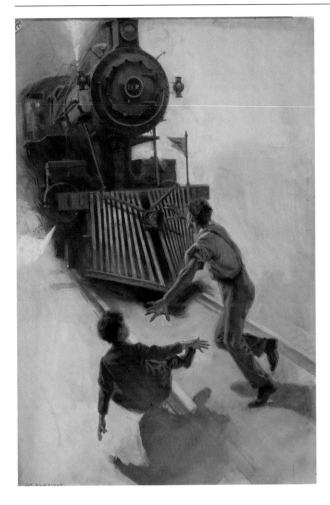

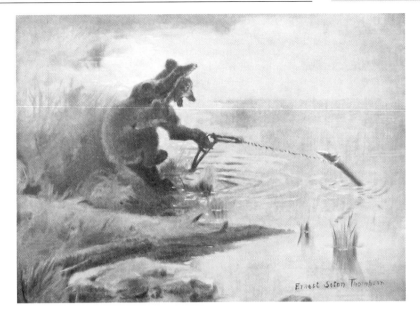

Figure 18.26
Ernest Thompson Seton, "Wahb yelled and jerked back," in *The Biography of a Grizzly*, published by The Century Co., 1900.
Seton often gave animals human-like expression, and argued that animals ought to be accorded rights. Here, he depicts a young bear reacting to a beaver trap.
The Osborne Collection of Early Children's Books, University of Toronto.

Figure 18.25
Jay Hambidge, "McTamany Jumped in Front of the Locomotive," in "Heroes of the Railway Service: II: General View" by Gustav Kobbé, *The Century*, March 1899. Oil on board.
Hambidge, known for his theories on dynamic symmetry, became a prominent art historian at Yale.
Courtesy of Norman Rockwell Museum NRACT. 1976.161.

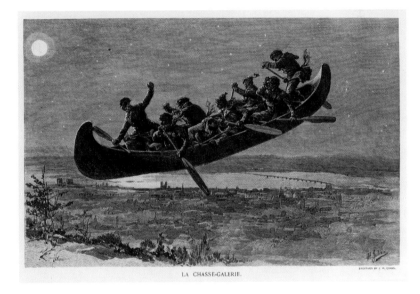

LA CHASSE-GALERIE.

Figure 18.27
Henri Julien, illustration for *La chasse-galerie*, written by Honoré Beaugrand from oral tradition.
The *Century Illustrated Monthly Magazine*, August, 1892.
Julien shows the *coureurs des bois* in their flying canoe above Montreal.
D. B. Dowd Modern Graphic History Library at Washington University in St. Louis.

and Classical proportions of the human body. Robert Henri, Maxfield Parrish, and many others used dynamic symmetry to plan compositions.

Illustrator and writer Ernest Thompson Seton (1860–1946), one of the founders of the Boy Scout movement and a self-taught naturalist, illustrated stories of his own told from animals' points of view. In *The Biography of a Grizzly* (Figure 18.26), Seton portrays Wahb, a bear, experiencing surprise and pain as his paw is caught in a trap, which he eventually figures out how to release.

Because it was popularly thought only humans had reason and emotions, Seton's anthropomorphic animals were controversial. Seton's work contributed to the study of animal psychology and to environmental conservation, animal rights, and the popularity of wildlife art. He was also instrumental in inspiring appreciation (and appropriation) of Native American arts and culture.

Henri Julien (1852–1908), who did not leave Canada, was a visual journalist for *Canadian Illustrated News* and the *Montreal Star*. In 1891, Julien illustrated *La chasse-galerie* (Figure 18.27), a traditional fable in which drunk *coureurs des bois* (lumberjacks) make a deal with the devil to be magically flown in a canoe to the city—in

Julien's picture, Montreal—on New Year's Eve. They will be safe only if they can return by morning, and refrain from invoking God or touching the church steeple's cross during their perilous trip. The image expresses the centrality of the Catholic faith and nostalgia for the disappearing traditional Quebecois life.

American magazines vastly outnumbered Canadian ones by the 1920s, and publishers, writers, and artists adopted a policy of **cultural nationalism** in which Canadian subject matter was patriotically developed in order to stave off assimilation with the United States.

Stylistically, however, Canadian illustration was mostly indistinguishable from American.

Cultural nationalists valorized the **Group of Seven**, young illustrators who mainly left their day jobs to instead paint modernist Canadian landscapes and to teach. John Edward Hervey MacDonald (Canadian, 1873–1932), who did not give up his commercial work, was the most accomplished letterer and designer among them. He and the others were also members of the Toronto Arts and Letters Club established in 1908, the social hub of arts professionals (including illustrators) and their patrons, the executive of which he commemorated in an illuminated display piece (Figure 18.28).

Another member of the Club, the superb draftsman Charles W. Jefferys (British, Canadian, 1869–1951),

started his career as a visual journalist in the United States and later illustrated nearly every schoolbook on Canadian history. In a book Jefferys wrote himself, Montreal's first governor, Paul de Chomedey de Maisonneuve, shoots a Mohawk man who brandishes a tomahawk (Figure 18.29). Jefferys draws details of clothing and weaponry accurately, but he heroizes settlers and leaves the reasons for indigenous peoples' resistance unexplained, making them seem, as Jefferys himself says, "savage."

As the century progressed, Canadian illustrators continued to be pulled in different directions, choosing among American, nationalist, Quebecois, and European models.

Conclusion

By the 1920s, illustration in its myriad uses both reflected and helped define American culture in a vast array of print media that included literary and general-interest magazines and illustrated weekly newspapers. Many of the mass-market magazines were tailored to women, whom publishers regarded as the primary buyers of advertised goods. The marketplace also expanded to include specialty periodicals in fields such as science, sports, religion, specialized fiction, trade journals, and farming.

With the burgeoning capabilities of automated printing presses and full color, narrative realism was at the peak of its popularity in the early decades of the twentieth century. Illustrators were in demand for not just magazines and books, but calendars, postcards, advertising, posters, sheet music, paper dolls, fashion plates, dress patterns, mail-order catalogs, billboards, wallpaper designs, and art prints. As narrative realism continued throughout the twentieth century, it was increasingly challenged by a growing predilection for photography to capture the "real." Inevitably, new approaches favoring stylization, abstraction, and more theory-driven approaches to visual communication would infiltrate from the realms of fine art and design, and split the field of illustration along fault lines of naturalistic depiction versus modernist art sensibilities.

FURTHER READING

Bogart, Michele H., *Artists, Advertising and the Borders of Art* (Chicago: University of Chicago, 1995).

Coyle, Heather Campbell (Ed.), *Howard Pyle: American Master Rediscovered* (Wilmington: Delaware Art Museum, 2011).

Elzea, Rowland, and Elizabeth H. Hawkes (Eds.), *A Small School of Art: The Students of Howard Pyle* (Wilmington: Delaware Art Museum, 1980).

Grunwald Center for the Graphic Arts, *The American Personality: The Artist-Illustrator of Life in the United States, 1860–1930*, with Introduction by Maurice E. Bloch (Los Angeles: University of California, 1976).

Kirschke, Amy Helen, *Art in Crisis: W. E. B. Du Bois and the Struggle for African American Identity and Memory* (Bloomington: Indiana University Press, 2007).

Figure 18.28
J. E. H. MacDonald, Toronto Arts and Letters Club Executive List, 1921. Watercolor, ink, gouache, and gold paint on paper.
The patriotic influence of British Arts and Crafts design and Gothic illuminated manuscripts is evident in this decorative memorial. The solemnity of St. George—patron saint of England—is relieved by tongue-in-cheek coats of arms, reflecting the lively nature of the Club as an instrumental site of Canadian arts development.
Courtesy of The Toronto Arts and Letters Club.

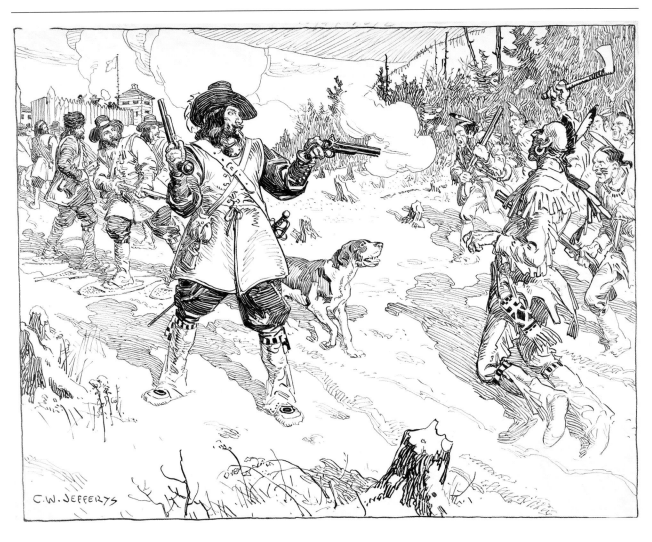

Figure 18.29
Charles W. Jefferys, "Maisonneuve's Fight with the Indians, 1644." *Dramatic Episodes in Canada's Story*, self-published, 1930, p. 21. Standing authoritatively with feet planted firmly on slightly higher ground, signifying his presumed superiority, Maisonneuve holds off Mohawk attackers single-handedly. Maisonneuve had built a fort on their land and was competing with them for the fur trade.

Library and Archives Canada, Acc. No. 1972–26–592.

Kitch, Carolyn, *The Girl on the Magazine Cover: The Origins of Visual Stereotypes in American Mass Media* (Chapel Hill: University of North Carolina Press, 2001).

Larson, Judy L., *American Illustration 1890–1925: Romance, Adventure and Suspense* (Calgary: Glenbow Museum, 1986).

Lupack, Alan, and Barbara Tepa Lupack, *King Arthur in America*, Arthurian Studies 41 (Cambridge: D. S. Brewer, 1999).

May, Jill P., and Robert E. May, *Howard Pyle: Imagining an American School of Art* (Urbana: University of Illinois Press, 2011).

Meyer, Susan E., *America's Great Illustrators* (New York: Excalibur Books; Galahad Books, 1987, c1978).

Mott, Frank Luther, *A History of American Magazines* (Cambridge, MA: Harvard University Press, 1968).

Reed, Walt, *The Illustrator in American, 1860–2000* (New York: The Society of Illustrators, Inc., 2001).

Stuart, Kenneth, "Foreword," In Ashley Halsey, Jr., *Illustrating for The Saturday Evening Post* (Boston: Arlington House, The Writer, Inc., 1951).

KEY TERMS

Académie Julian	leggotype
Art Students League	mass media
Ashcan School	narrative realism
Brandywine School	photoxylography
bullpen	Phrygian cap
continuous tone	pretty-girl
cultural nationalism	Realism
dynamic symmetry	rotogravure
Gibson Girl	showcard
Golden Age	stereoscope
Group of Seven	tailpiece
halftone	

19

Avant-Garde
Illustration, 1900–1950
Jaleen Grove

In the late nineteenth and early twentieth centuries, art underwent enormous changes in Europe, emerging with new purposes and new looks. This chapter surveys movements in modern art and illustration, and introduces issues concerning the function of illustration, the status of "fine art" objects, and the effect that the rise of modern and avant-garde art had on the production and reception of illustration. As will be seen, many modernist movements started from the Arts and Crafts ethos of fine craftsmanship ideally benefiting all levels of society. Some evolved into rarefied art experiments for a privileged few, while others became as utilitarian and democratic as possible, newly identified as "design" more than "art." Illustration was an important component in the growth of both branches, but art and design came to be thought of as different than, and even in opposition to, illustration.

The Emergence of Modernism

The nineteenth and early twentieth centuries brought a reordering of priorities and the questioning of and alteration of traditional social hierarchies, gender roles, presumptions of God and spirituality, and the conduct of daily life. Feelings about "modern times" were simultaneously pessimistic and optimistic: many feared the inevitable disruption of values and practices, whereas others, more disgruntled about the disparity between rich and poor; or health, housing, and education; or national stature, welcomed the chance to change society for the better—even if it took violence.

With the diminishment of traditions came also a questioning of what was true and real—and hence, how to represent reality. Was reality only what one could see? For that matter, what was seeing? In art, prior assumptions of how to depict the world, the purpose of art, the role of the artist or designer, and what constituted good taste were challenged by intellectuals and creators. This change began in late-nineteenth-century France with the **Realists**, who wanted to show the brutal truth of life rather than beautiful ideals; the **Impressionists**, who painted according to the way light and color were perceived; the **Post-Impressionists**, some of whom looked to non-European art for inspiration, with their jarring colors, flattened space, and abandonment of naturalism; and the **Symbolists**, who like the Romantics some seventy years before, were concerned with imagination, horror, awe, spirituality, and metaphor. A complete break with representation based on fidelity to nature as it appeared to the eye came with **Cubism** in the early twentieth century. This movement rejected linear perspective for the concept of showing subjects from multiple angles at once and reduced objects to their most basic forms. A great many more "isms" sprang up after these; only some chief ones and their impact on illustration are addressed here.

Generally, people who felt art's primary purpose was to be beautiful did not appreciate experiments in form, did not want to see differently, and were not receptive to modernists' attempts to reform society. Even though

his own work was considered avant-garde in the United States, John Sloan—a painter of the Ashcan School and known for his unromanticized urban scenes (*see Chapter 20*)—summed up these sentiments in a cartoon belittling Cubism following the 1913 International Exhibition of Modern Art (popularly called the Armory Show) that exposed abstract art to the American public in New York, Chicago, and Boston for the first time (Figure 19.1).

Nonetheless, the desire to break from the past and to keep on exploring new ways to insightfully represent actual life, inner life, or a future life spread quickly, with each generation of counterculture artists and designers striving to experiment with ideas and techniques. Generally referred to as the **avant-garde**, a military term for soldiers sent out to prepare the way in advance of a main attack on an enemy force, the goal of such artists

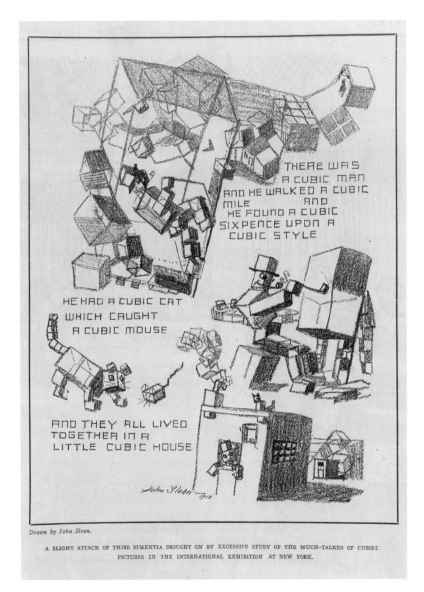

Figure 19.1
John Sloan, "A slight attack of third dimentia [sic] brought on by excessive study of the much-talked of Cubist pictures in the International Exhibition at New York," *The Masses*, February 19, 1913, p. 12. Sloan suggests that Cubism is a gimmick to sell art commodities to people whom he feels mistake novelty for sincere artistic effort. The Armory Show was arranged by a group of painters and sculptors, some of whom were established cartoonists and illustrators: Walt Kuhn (American, 1877–1949), George Luks (American, 1867–1933), and William J. Glackens (American, 1870–1938). Sloan himself exhibited paintings there, using modern, but not abstract, approaches.
Beinecke Rare Book and Manuscript Library, Yale University.

and designers was to aggressively modify culture on the assumption that, having changed the system, regular society would soon follow their lead. Indeed, avant-garde experiments were often met with ridicule, only to be integrated into mainstream culture shortly after. But whether actual social change occurred, as opposed to just the borrowing and commodification of fashionable avant-garde looks, is a matter for debate.

Livres d'Artistes

Illustration was a very important aspect of avant-garde artists' careers, because it was through prints, book illustration, magazines, tracts, and posters that their work could reach the largest number of other artists and the public. But because they were exploring new ways to relate to the world, their illustration took different forms and performed different roles than was customary. No longer was illustration just to decorate a book or show what the text described—illustration was now to stimulate thought. Of course, illustration had never so simplistically decorated or described texts—but modernists had a vested interest in believing this had been so, which contributed to the rise of the over-used phrase "mere illustration" to dismiss traditional narrative and descriptive art forms.

Nineteenth-century French writers and critics such as Symbolist poet Stéphane Mallarmé (1842–1898) disparaged popular illustration, disliking the illustrator's power to bend the author's meaning or to outshine him or her in the public eye, and fearing that illustration would displace the readers' ability to use their own imagination. Mallarmé and other bibliophiles (connoisseurs of fine books) therefore gave illustrated books a new form: the *livre de peintre* or **livre d'artiste** (painter's, or artist's, book). Unlike mass-produced books, these books were finely printed in limited editions embellished with hand-pulled etchings, engravings, or lithographs by modern painters rather than illustrators. Modern artists, who were at this time still very much on the fringes of acceptability, could not overshadow the author in popularity—and their work, being less literal than that of a regular illustrator, would not displace the author's meaning. Rather, they would complement the story or poem as a "sister art." Like William Morris's private press works (*see Chapter 15*), producers of *livres d'artiste* aimed to reform taste and showcase craftsmanship, and these books were expensive. But where Morris and his Arts and Crafts followers wished to revive the values of the past, the French avant-garde wanted to respond to the present moment in all its uncertainty, ephemerality, and variety of expressions.

Edouard Manet (French, 1832–1883) (*see Chapter 14*) was a friend of Mallarmé's, and an associate of the impressionists. Manet's illustration for Mallarmé's translation of Edgar Allen Poe's *The Raven* (1875) (Figure 19.2) centers on a man mourning his deceased lover. Manet's autographic, painterly hand was preserved because he executed his drawings with brush and ink on special **transfer paper** that could offset each drawing to a lithography stone for printing. The seemingly carelessly drawn chair and absence of visual description sharply differ from the precisely delineated engravings of work by popular contemporaries such as Gustave Doré (*see Chapters 14, 15, 16, and 22*). The empty chair and its humanoid cast shadow suggest the lost soul of the grieving protagonist, referred to in the last stanza. The ominous scribbled shape—the raven's shadow—is nearly abstract, allowing the viewer to read into it as she or he would the poem—a key aspect of avant-garde illustration, which was intended to empower and challenge the reader to think, rather than to simply be amused.

Many people thought the illustrations laughable and confusing, and the edition did not sell well. Interest in fine illustrated books grew, however, and they became a major area of French connoisseurship by 1900 that flourished until World War II. Although most *livres d'artiste* favored more conservative illustration than Manet's *The Raven*, art dealer and publisher Ambroise Vollard produced exquisite **éditions de luxe** (deluxe editions) illustrated by rising modernists such as Cézanne, Picasso, Gauguin, and Van Gogh. For Vollard, Pierre Bonnard (French, 1867–1947) illustrated *Parallèlement*, with nine wood engravings and 109 lithographed **croquis** (casual sketches) (Figure 19.3). The looseness of these drawings and the fine binding in Moroccan leather with special wrappers signaled "art" rather than "illustration" to his audience.

Modernists muddied and broadened the definition of illustration not just by introducing new ways of seeing and depicting things, but by also blurring the difference between self-directed work and commissioned work.

Figure 19.2
Edouard Manet, illustration in *The Raven*, by Edward Allen Poe, translated by Stéphane Mallarmé, 1875.
The scene illustrates the lines, "Lamp-light o'er him streaming throws (the Raven's) shadow on the floor;/ And my soul from out that shadow that lies floating on the floor/ Shall be lifted—nevermore!" Manet impressionistically evokes the *feeling*, rather than a detailed scene, of the psychologically dark poem.
University of Waterloo Library, Special Collections & Archives, G7772.

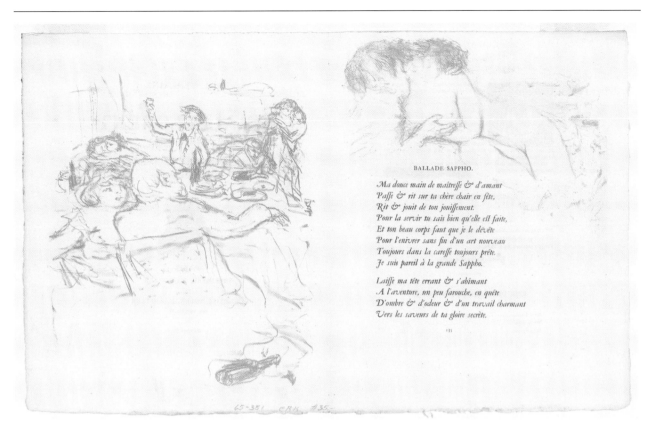

Figure 19.3
Pierre Bonnard, illustration in *Parallèlement*, by Paul Verlaine, published by Ambroise Vollard, 1900. *Parallèlement*'s scandalous lesbian content reflects the avant-garde impulse to explore taboos, while Bonnard's nudes floating in generous white space evoke a sense of intimacy with the subject as if he were sketching the scenes from life—a voyeuristic feeling the book then transmits to the privileged reader.

Yale University Art Gallery. © 2018 Artists Rights Society (ARS), New York / ADAGP, Paris.

Picasso's illustration of Miss Léonie for the first Cubist *livre d'artiste* (Figure 19.4) was commissioned with minimal art direction and issued as a hand-pulled print in a limited edition book. It can stand as a personal artistic expression unconcerned with "illustrative" functions of literal description or storytelling, although symbolic representations of the character's personality can be discerned in it.

Bibliophiles drew a sharp distinction between mass-produced illustrated books and *livres d'artiste*, eschewing commercial styles (especially Art Nouveau, which in posters and advertising was crowding public space and looking dated by 1905), unimaginative portrayal of the text, ostentation, or attempts to fake watercolor or oil painting with printmaking techniques. In what soon became a major point of contention, purist bibliophiles demanded that the illustration be subordinate to the overall layout and typography, while Vollard and others protested that the artist should be allowed complete freedom to break the rules.

Parallèlement was controversial because the softly drawn images flow through the type and are printed in textured pink, rather than in crisp black lines like the type. Painterly treatments like this characterized French books; in some, the images resemble (or are) plates of gallery art rather than illustrations of the text. In England, where William Morris's and Walter Crane's influence was stronger, connoisseurs esteemed the artisanal "architecture" of the whole book and felt that wood engraving and woodcut were the most suitable techniques for making image and text integrate, since they were printed together and shared boldness of line. One of the foremost illustrators of the interwar period, Eric Gill (English, 1882–1940), was also an accomplished engraver, typographer, and designer who operated his

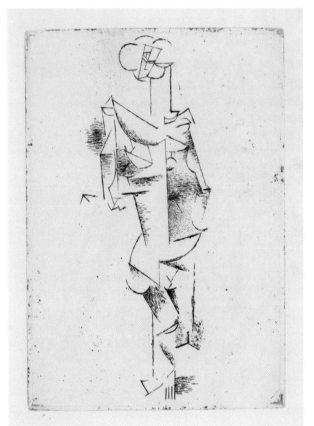

Figure 19.4
Pablo Picasso, illustration in *Saint Matorel* by Max Jacob, August 1910, published 1911. Etching, 7 $^{13}/_{16}$ × 5 $^{9}/_{16}$" (plate).
Picasso's Cubist illustration of Mademoiselle Léonie conveys the dynamism of a figure turning in space around a central axis and represents body parts with geometric forms. In delivering such an idiosyncratic and radical departure from academic drawing, Picasso broke with prior illustrators, who used widely understood, conventional techniques to communicate subject matter as unambiguously as possible.
Beinecke Rare Book and Manuscript Library, Yale University. © 2018 Estate of Pablo Picasso / Artists Rights Society (ARS), New York.

own publishing house, Golden Cockerel Press. His *The Four Gospels* of 1931, printed in an edition of twelve on vellum, derives from Gothic books and blends image and letterform together, using the font Golden Cockerel, which he designed (Figure 19.5).

But *livres d'artiste* were available only to the wealthy. Bibliophiles could seem snobbish, and books like Gill's were decidedly orthodox. For avant-garde artists who wished to confront social ills and to level the differences between bourgeois and working class, the mass media rejected by connoisseurs represented a more promising vehicle for provoking change.

Expressionism

In the early years of the twentieth century, radical German artists and writers had begun the movement called **Expressionism**, characterized by an alienation

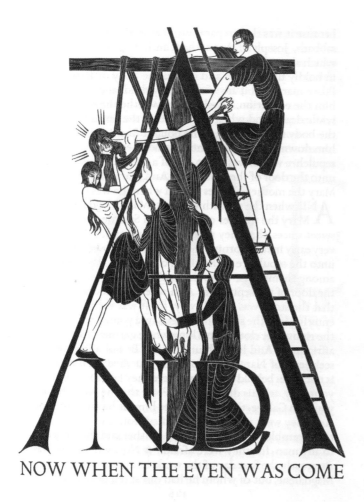

NOW WHEN THE EVEN WAS COME

Figure 19.5
Eric Gill, illustration and book design, *The Four Gospels of the Lord Jesus Christ According to the Authorized Version of King James I*, 1931. Golden Cockerel Press.
Bibliophiles' elevation of "the art of the book" over "industrial book production" contributed to the neglect of illustration for magazines, pulps, children's books, and other media in exhibitions, scholarship, and collections for several decades. Illustration for industrial mass production, however, absorbed influences from *livres d'artiste* and designer-illustrators like Eric Gill, as art directors and book designers became more sensitive to how illustration complemented typography, layout, paper, and other formal aspects.
Beinecke Rare Book and Manuscript Library, Yale University.

from bourgeois values. Adherents portrayed extremes of emotional experience in dystopic and exuberantly charged manners that represented an inner psychological state rather than a familiar outer appearance. The Expressionists believed art should be shared with all classes; therefore, the elitist distinction between art and illustration such as French bibliophiles upheld was not so apparent in their works. Nevertheless, many issued *livres d'artiste* and portfolio editions of their prints for collectors anyway. The wordless novels that Frans Masereel (Flemish, French, 1889–1972) began issuing in 1918 are art-object-like yet illustrative, where image replaces text and invokes the spoken word instead, leaving it up to the reader to invent and narrate the story in his or her imagination or out loud (*see Chapter 23*). The Expressionists were largely painters, but they often inserted hand-pulled prints into their journals, made posters, and published illustrated books, favoring woodcuts because they were quick to make. Frequently crude-looking, woodcuts also related to the folk prints of the working classes, whom they romanticized, while standing apart from the genteel Beaux-arts and Arts and Crafts aesthetics that dominated the "tasteful" publishing of the middle and upper classes. Text was often carved directly into the block, forcing a bold, unambiguous relationship between word and image.

Not unlike the Romantics (*see Chapter 12*), Expressionist Oskar Kokoschka (Austrian, English, 1886–1980) believed that vivid imagination, which he described as "having visions," had the power to modify the artist's consciousness and soul, turning the artist into a specially gifted seer and interpreter of the observable, material world. He quickly became notorious for brutally drawn images that offended polite society. For a poster advertising the magazine *Der Sturm (The Storm)*, he drew a self-portrait showing his head shaved like a criminal's, and fingering a wounded chest like Jesus Christ, the "man of sorrows" (Figure 19.6). Intended to chastise his critics, this image captures how persecuted he felt about the condemnation his work provoked. The crudely outlined figure with his deeply furrowed brow, creases under the eyes, and hint of emaciation relates to the exaggerated depictions of tortured Christ in German Gothic painting, vernacular woodcut, and sculpture. Kokoschka thus connects himself to a native folk tradition, suggesting that Expressionism is a nationalistic and therefore legitimate art form.

Futurism

In Italy, **Futurism**, according to the 1909 and 1910 manifestoes written by poet Filippo Tommaso Marinetti (Italian, 1876–1944), was devoted to the ideological destruction of government, schools, museums, and academic art through confrontation and even war, which the Futurists welcomed as an aesthetic experience. In Europe, modern artists experimented in all media and blurred visual art with sound, music, theater, design, and architecture, often with the aim of

creating a **gesamtkunstwerk**—meaning "total work of art," something precursors to the Expressionists such as composer Wilhelm Richard Wagner (German, 1813–1883) had developed in giant, multimedia theater experiences—that would combine multiple arts into one unified project. The Futurists spread their message through an aggressive publicity campaign in drama, music, poetry, print, painting, sculpture, industrial design, film, gastronomy, and more. Highly anti-sentimental, they celebrated dynamism, speed, and machinery, juxtaposing memory with immediacy, and space with time. The combination of several of these elements in one creative work was called **simultaneity**—the sensory overload of which reflected modern life and was supposed to disrupt complacency.

"Serpentine Dance"—originally titled "Sea = Dancer"—by Gino Severini (Italian, 1883–1966) (Figure 19.7) is an example of the Futurist form of poetry invented by Marinetti called ***parole in libertà*** (words in freedom), where conventions of illustration, writing, and typography are thrown away. Here, the typefaces and freeform placement of the words and shapes visually express the movement, sound, feeling, and colors of a dancer and sea. Severini also blends in references to a propeller, a gunshot, and rays of light—reflecting the Futurists' interest in violence, technology, speed, and the nature of illumination (meaning lighting, making visible, enlightening, and illustrating). Marinetti eventually aligned the Futurists' ultra-nationalist vision of Italy as a mechanized superpower with Italian Fascist politics. In Russia, another group of Futurists—who produced many illustrated books—aligned themselves with Communism.

Inspired by Futurism and Cubism, Sonia Delaunay (Russian, French, 1885–1979) in 1913 devised a ground-breaking *livre d'artiste* for a poem by Blaise Cendrars that addresses the experience of Paris and the madness of contemporary life by describing a dreamlike journey by train through Siberia. Titled *Prose of the Trans-Siberian and of Little Jehanne of France*, the book defies bibliophile notions of the purity of traditional book design with its concertina-fold format, the jumbling of a dozen typefaces printed in various colors plus a naively hand-lettered title on the cover, and the fusion of text and visual matter (a variation of Futurist simultaneity) with a mainly abstract

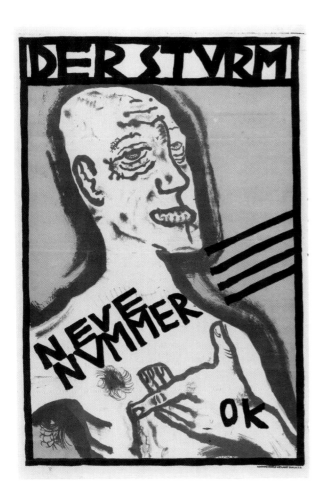

Figure 19.6
Oskar Kokoschka, poster advertising "New Number" of *Der Sturm (The Storm)*, printed by Kunstanstalt Arnold Weylandt, Berlin, March 3, 1910. Color lithograph, 26 3/4 × 18".
This poster publicized the launch of a new and highly influential little magazine titled *Der Sturm*, which concentrated on Expressionist art, literature, and criticism.

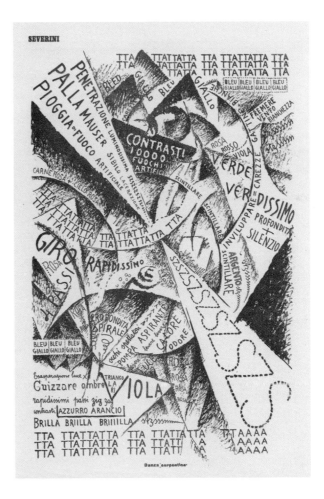

Figure 19.7
Gino Severini, "Danza Serpentina" ("Serpentine Dance"), *Lacerba*, vol. 2, no. 13, July 1, 1914, p. 202.
The poem and its illustration become one and the same in this composition, describing an impression of a dancer and the sea. Colors are written down, rather than painted in. The poem was printed in *Lacerba*, a little magazine devoted to provoking debates in avant-garde literature and art.

design of deliberately clashing hues flowing alongside the tinted stanzas. The artist and the writer Cendrars regarded their combination of image and word as a kind of anti-illustration, where *contrast* (between visual and verbal, between typefaces, between colors), rather than compatibility or mimicry, produced meaning. The book is printed by color letterpress and *pochoir* (*see Chapter 17*). Delaunay also applied similar designs to paintings and costumes (Figure 19.8).

Dada

World War I (1914–1918) was the most technologically advanced and the most horrific war anyone had ever seen. The widespread use of mustard gas, airplanes, machine guns, tanks, the abuse of gentlemanly rules of engagement, and the sheer scale of atrocities and number of countries involved seemed apocalyptic. Feeling that the world had descended into complete madness and debasement, Communist and anarchist artists moving between Zurich, Paris, Berlin, and New York (avoiding conscription) adopted a countercultural strategy of

purposeful creative "nonsense" through the simultaneous presentation of theatrics, sound, poetry, and visual culture. They sought some fundamental core in creativity that would balance the stupidity of war and restore humanity. Dubbing their efforts **Dada**, these men and women, like the Futurists, used propaganda techniques such as theatrical spectacles and small, cheaply printed journals to disseminate their subversive ideas.

In one journal, Francis Picabia (French, 1879–1953) illustrated the artistic precedents of and potential effect of Dada in a diagram (Figure 19.9), borrowing the language of technical illustration to indicate an evolution from earlier French art at the bottom that reverberates up to Dada at the top. Wiring connects a black dynamite-like bar and a clock bearing Dada artists' names, like a time bomb. The importance of publishing to the avant-garde is indicated by a box with a switch, labeled "391"—the title of a radical little magazine that Picabia founded—which electrically powers the ticking apparatus. This image faces a stream-of-consciousness text by one of Dada's main theorists, Tristan Tzara (Romanian, French, 1896–1963), that refers to the beginnings of Dada and an "explosion" in the polite art world.

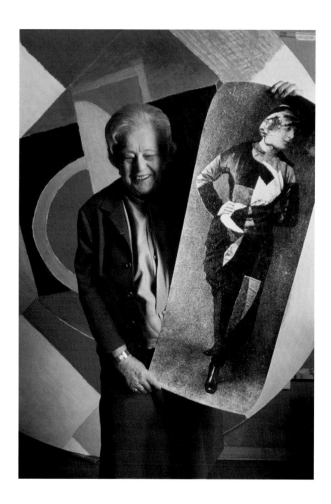

Figure 19.8
Sonia Delaunay, Painter; ca. 1967.
Delaunay holds an image of one of her early fashion designs in front of a painting that has similar coloring. In the early twentieth century, her fabrics and colors would have seemed violent by the standards of the day—with Cubist and Futurist abstraction that styled modern women as bold and independent.
Photo by Jean-Philipp Charbonnier. Gamma-Rapho/Getty Images.

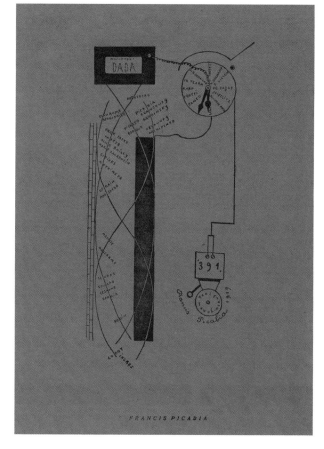

Figure 19.9
Francis Picabia, "Mouvement Dada," *Dada* 5, May 15, 1919, p. 4.
In Dada publications, text is set unconventionally, and illustrations are often stand-alone artworks that have only a passing relationship to the writing or none at all. Picabia, who caricatured people and human relationships as machines, here diagrams Dada's explosive genesis (obliquely described in the facing text "Chronique Zurich," not pictured here) in a composition that also resembles a man's profile.
Beinecke Rare Book and Manuscript Library, Yale University. © 2018 Artists Rights Society (ARS), New York.

Suprematism

The Russian Revolution ushered in the Bolshevik Party (1917) and the First World War yielded the Weimar Republic in Germany (1919), stimulating Communist and Socialist artists' feeling that they had a duty to reform society and thought. To many, the untried new governments represented a chance to make the utopian society so many dreamed of; while to other artists, the new regimes evoked dismay and protest. Some artists, however, like the **Aesthetes** and **Decadents** before them, believed in art for art's sake (*see Chapter 15*): that the artwork need not have a utilitarian purpose, nor be political; that expressing the artist's personal vision or conducting visual experiments in form were perhaps the most positive contributions to life an artist could make. During the war period, Russian **Suprematism** took this stance to extremes, flatly rejecting any naturalistic representation at all in favor of complete abstraction, in what they termed "non-objectivity." Over the next forty years, as social experiments failed to live up to expectations, proponents of art for art's sake became more preoccupied with "formal" elements like composition, color, rhythm, media, and daring, than with message, symbolism, story, and social responsibility. This difference in opinion about what art should do drove gallery art and illustration further apart.

One attempt to reconcile formal experimentation with utility is *About Two Squares*, a children's book by El Lissitzky (born Lazar Markovich Lissitzky; Russian, German, 1890–1941) (Figure 19.10). This didactic story is a metaphor for the establishment of a new (Communist) society, told with elemental Suprematist shapes that were supposed to be understood by anybody, thereby transcending barriers of class and literacy. The first page of this book instructs children to copy the components drawn here with folded paper, colored rods, and wooden blocks, in order to act out the story of destruction of "the black chaos" and rebuilding of order by the heroic red square, which symbolizes Communism.

Primitivism

An overpowering motif of the era was destruction and reconstruction. Ernst Ludwig Kirchner (German, 1880–1938) both illustrated and designed *Umbra Vitae* (*Shadow of Life*), a book of Expressionist poetry in which the title poem describes a dreamlike apocalyptic scene, the inevitable pain of human life and death, with but a faint hope of salvation (Figure 19.11). Kirchner, a member of the early Expressionist group Die Brücke (The Bridge), was influenced by the forceful color and **primitivism** (borrowing from African, Asian, and Polynesian art) of Post-Impressionists such as Henri Matisse (French, 1869–1954), Paul Gauguin (French, 1848–1903), and Vincent Van Gogh (Dutch, 1853–1890); and of Cubists. The use of symmetry, short arms and legs, the elongated, mask-like face of the primary figure with his arms bent at the elbows, and the bent knees of the red figure are reminiscent of Fang, Ambete, and other African sculpture.

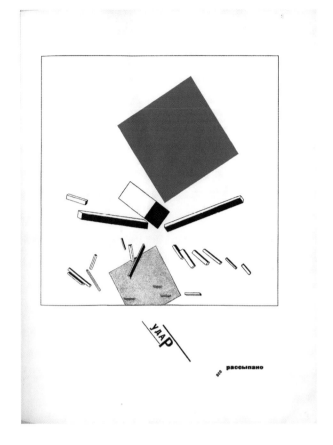

Figure 19.10
El Lissitzky (born Lazar Markovich Lissitzky), "Crash—all scattered," illustration in *About Two Squares*, 1922.
In this children's book first published in 1920, the concepts of "crash" and "scatter" that the red square is doing to the black, white, and gray shapes are echoed in the text, where the lettering is angled and given bars to suggest movement, and one letter is bold to indicate a loud sound. The word *scatter* is shoved off to the right, like the shapes.
Avery Library, Columbia University.

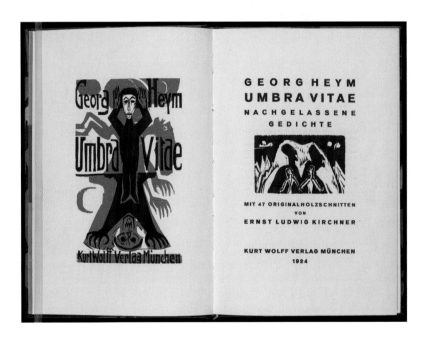

Figure 19.11
Ernst Ludwig Kirchner, frontispiece, *Umbra vitae*, 1923. Woodcut.
Kirchner pioneered a color woodcut technique in which the color blocks were not simply coloring within the lines of a black key block, but instead contributing autonomous forms equivalent to those in black—seen here in the blood-red figure under the man and his skull-faced shadow.
Beinecke Rare Book and Manuscript Library, Yale University.

Surrealism

The stuff of dreams, the unconscious, and non-European cultures that were supposedly closer to nature represented a return to a "real" human state hidden under a false veneer of civilization that the war had torn away. According to the recent psychoanalytic theories of Sigmund Freud and Carl Jung, the unconscious ruled behavior. Poets and artists who established **Surrealism**, some of whom had been part of the Dada movement, sought to connect with the unconscious using **automatism**: spontaneous, intuitive writing or mark-making that circumvented censorious rational thought, sometimes while in altered states of trance, hypnosis, madness, or intoxication; or by embracing chance and accident in the artistic process. In illustrating the poetry book *Simulacre* (Figure 19.12), André Masson (French, American, 1896–1987) made automatic drawings (done as lithographs) side by side with the poet as he wrote the book, so that their productions would be connected and so that Masson's contributions would not be subordinate to the writer's. Masson's personal intuitive responses to the poems illustrate by counterpoint (complementary contrast), rather than by portraying the poems' elusive, shape-shifting contents.

Figure 19.12
André Masson, illustration for poem in *Simulacre* by Michel Leiris, 1925. Lithograph.
The nonsensical juxtaposition of unrelated objects in Surrealist works is one of the movement's most recognizable features. Masson's automatic drawing of birds, architecture, and male and female figures in a dreamlike composition is an expression of the artist's inner psychology.
Beinecke Rare Book and Manuscript Library, Yale University. © 2018 Artists Rights Society (ARS), New York / ADAGP, Paris.

Constructivism

A Russian movement that concentrated on applied art, and that opposed the "uselessness" of art for art's sake and the nonobjective art of Suprematism, was known as **Constructivism**. Working in painting and sculpture as a form of research for architecture, film, and industrial design, its artists welcomed industrial production as a means of bringing art to the masses. Many constructivists embraced **photomontage**: a combination of photographs, text, and pictures cut out of magazines, newspapers, advertising, and ephemera that was popular with Dadaists and Surrealists too (the movements in Germany and Russia were closely related). Poster designers and brothers Georgy Stenberg (Russian, 1900–1933) and Vladimir Stenberg (1899–1982) adopted the photomontage aesthetic, but actually drew from photos rather than pasting in existing ones, achieving a more integrated image (Figure 19.13). The Futurists' interest in skyscrapers, movement, space, and time and the Suprematists' interest in simple shapes and primary colors have influenced the type set in circles and the buildings' simplified, geometric shapes.

Bauhaus and International Style

In 1919, a radical new German art school, the Staatliches Bauhaus, was established. With artists reeling from the upsets of World War I, art for art's sake was rejected in favor of art for the common good, and the aim of Bauhaus was to build an orderly, enlightened way of living by unifying fine art and craft under the rubric of architecture. The new class-leveling order was to be expressed through geometric **pure form** (simple shapes) such as Cubism and Suprematism valued. Guided by the tenet **form follows function**— the principle that the construction and appearance of something should be derived from its most basic intended purpose—Bauhaus proponents embraced the functionality of advertising and the economy of photomechanical production so that their publications could be printed in greater numbers and distributed as widely as possible. Manifesting a preference for typography and design over image, and the dictum **less is more**—the idea that the reduction of elements would amplify and clarify the message—their books are characterized by sans-serif type, untraditional but logically planned layouts, activation of white space as a compositional element rather than simply a neutral background, geometric shapes, and grid layouts to rationalize and standardize visual communication. Photography made the most suitable kind of illustration because it is an industrial technology, matching photomechanical printing and automated typesetting. Like the Dadaists, Futurists, and Constructivists, Bauhaus designers also exploited photomontage.

In 1927, Bauhaus professor László Maholy-Nagy (Hungarian, 1895–1946) wrote a very influential book,

Malerei, Fotografie, Film (*Painting, Photography, Film*), in which he argued that photography and cinema were the media of the future and held more creative promise than painting. The interconnectedness of art, technology, and design; the practicality of attention-getting advertising graphics; and the socially progressive aims associated with photomontage come together in a cover for the magazine *Die Neue Linie* (*The New Line*) (Figure 19.14). Such application in a slick ladies' magazine signals the taming of this once-radical visual experimentation, portending modernism's acceptance by and eventual identification with the same wealthy classes that photomontage originally opposed.

When the Nazi Party forced the closure of the Bauhaus in 1933, its students and faculty dispersed and shared their design sense internationally. After brief stints in The Netherlands and England, Moholy-Nagy moved to Chicago in 1937, passing his ideas to American students and clients. In Switzerland, the

Bauhaus approach, combined with the strict **New Typography** using formulaic grid-based layouts and sans-serif fonts espoused by esteemed modernist typographer Jan Tschichold (German, Swiss, 1902–1974), soon became systematized as "Swiss Style," or **International Style**. Emphasizing the unity of the whole design, in which imagery was decidedly secondary, it became the foundation of what was by the 1950s renamed and ennobled as "graphic design" rather than "commercial art." For Tschichold and many other graphic designers, illustration remained a secondary consideration rather than an equal partner in a publication's look. Photography was preferred over drawings and paintings, and images were nearly

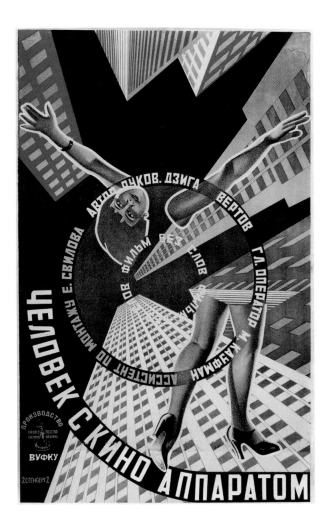

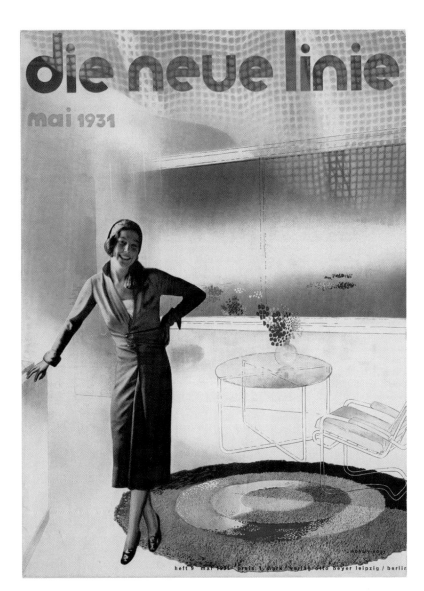

Figure 19.13
Georgy Stenberg and Vladimir Stenberg, poster for film *The Man with the Movie Camera*, directed by Dziga Vertov, 1929. Lithograph, 41¼ × 26".
Instead of showing a scene from *Man with the Movie Camera*'s plot, this poster evokes the sense of being taken into an alternate reality by cinema. Photomontage echoes the splicing/editing techniques of filmmaking, while the spiraling typography and radical perspective illustrate the movie camera's penetration of space and also of the female figure, who is dismembered by the "man with the camera."
Public domain.

Figure 19.14
László Maholy-Nagy, cover for *Die Neue Linie* (*The New Line*), May 1931.
The machine aesthetic that Bauhaus artists (like the Futurists) felt was appropriate to modern times is here expressed in the geometric shapes, patterns, and textures of the curtain and carpet, and the mass-produced furniture. The combination of photography and painting indicates the merging of art and technology, while the model's optimistic smile in her uncluttered space and unembellished dress suggest the utopian happiness that an everyday life infused with modern design was supposed to bring.

interchangeable—slotted into pre-assigned spots on a page. "Unnecessary" ornamentation such as head and tailpieces, borders, and decorated initials was eliminated.

A similar economy characterizes the woodcuts and linoleum cuts of Gerd Arntz (German, Dutch, 1900–1988). Arntz preferred simplified shapes that would be legible and approachable for all people, not just artworld cognoscenti. A Communist, his scenes juxtapose the most privileged lifestyles with the most poverty-stricken to make a point about inequality and injustice (Figure 19.15). In 1928, their economy of line led to his designing the first **infographics**, the easily understood, codified figures seen on public signage and statistical graphs, with social scientist Otto Neurath (German, Austria, 1882–1945) and Marie Reidemeister (later, Neurath) (German, 1898–1986) for their organization International System of Typographic Picture Education (ISOTYPE).

Political Satire

An affiliate of Dada, George Grosz (German, American, 1893–1959) retained a life-long suspicion of art for art's sake and formalism, saying in 1934, "Great art must be discernible to everyone." Grosz had begun

school as an academic artist, but he quickly found that the outrageous materials of circus and sideshow, penny dreadfuls, and cartooning were more exciting, and his earliest published works were caricatures. For him, art was most valid as a political tool, "a gun and a sword" in the fight for freedom. Grosz castigated German society in satirical drawings for numerous books and left-leaning political magazines, and re-issued series of them in lithographed portfolios. The portfolios were printed in three editions of differing quality from plain to *de luxe*, and the most popular sold in tens of thousands, thus bringing avant-garde ideas to a wide audience. One such portfolio titled *Ecce Homo* (Behold the Man—a reference to Jesus), of eighty-four lithographs in black and white and sixteen full-color offset lithographs of paintings, portrays the most corrupt and immoral aspects of postwar urban Germany. "Vor Sonnenaufgang" ("Before Sunrise") depicts a man consorting with prostitutes on a city street, the women's clothes fading away to show their naked bodies (Figure 19.16).

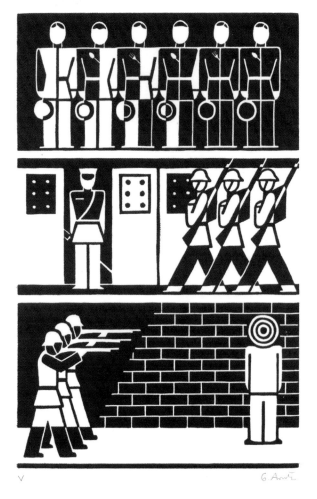

Figure 19.15
Gerd Arntz, *The Barracks*, woodcut, 1927.
The one-color simplified figures in Arntz's personal work published in little magazines, which often criticized German society, led directly to his designing the first infographics for visual communication in public space. Their clean lines complemented International Style typography.

Gerd Arntz Archive, Gemeentemuseum Den Haag. Courtesy of Foundation Gerd Arntz Estate. © 2018 Artists Rights Society (ARS), New York / c/o Pictoright Amsterdam.

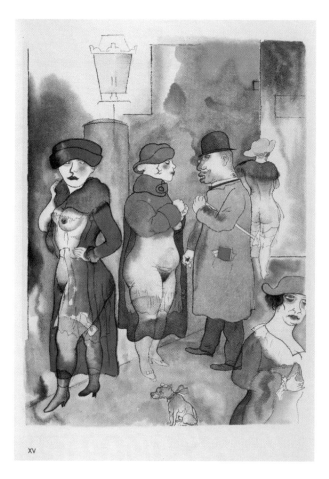

Figure 19.16
George Grosz, "Before Sunrise." No. 15 from the series *Ecce Homo*, 1922 (published in 1923). Offset lithograph.
This portfolio of drawings, which included images of violent sex crimes, was quickly banned, and Grosz was charged with obscenity. In court, he defended his right to depict sordid subjects, saying that because the drawings condemned what they portrayed, they sent moral rather than corrupting messages. Grosz lost and was fined, and had to withdraw sixteen of the most offending pictures from the edition.

Beinecke Rare Book and Manuscript Library, Yale University. Art © Estate of George Grosz/Licensed by VAGA, New York, NY.

Theme Box 40: Greenberg: Avant-Garde and Kitsch
by Jaleen Grove

Those who felt art should reflect traditional ideas of beauty and taste perceived modern art and design as a threat. Those who felt tradition was problematic welcomed modern art and design as a way to change society for the better. These two upper-class competing constituencies, however, did agree on one thing: that sentimental, cheaply made, factory-produced knick-knacks, prints, and reproductions of art that so many people decorated their homes with—dubbed **kitsch**—were products of exploitive, shoddy industrial production and a detriment to good taste and, therefore, were an impediment to the achievement of an enlightened society.

In 1939, a young Marxist intellectual in New York named Clement Greenberg wrote an essay titled "Avant-Garde and Kitsch" for *The Partisan Review*, a **little magazine** (the term for small-run alternative press periodicals, typically literary and left-leaning). In it, Greenberg calls the avant-garde "the only living culture" and claims that it is the only way for society to be renewed and made more equitable. The true avant-garde produces "non-objective" artworks that do not rely on recognizable subject matter or purpose because those would make them commodities and thus fall back into perpetuating the capitalist status quo (*see Chapter 15, Theme Box 33, "Marx: Modes of Production"*). Instead, he says avant-garde artworks are concerned with a "pure preoccupation with the invention and arrangement of spaces, surfaces, shapes, colors,

etc. . . . expression mattering more than what is being expressed." Unsurprisingly, Greenberg went on to become the leading critic and advocate of abstract painting in New York from the 1940s to the 1970s. His emphasis on the basic building blocks of form over depiction is known as **formalism**.

Unfortunately, experimental formalist exploration (Greenberg worried) was not being duly appreciated by elite classes whom he (paradoxically) felt ought to patronize it. The problem, he asserted, is that people's engagement with truly creative art was being disrupted by distracting, profitable kitsch: "popular, commercial art and literature with their chromeotypes, magazine covers, illustrations, ads, slick and pulp fiction, comics, Tin Pan Alley music, tap dancing, Hollywood movies, etc., etc." Kitsch displaces refined artforms because kitsch steals elements from these more sophisticated, handmade and difficult forms that require education, practice, and development of taste to make and appreciate. Kitsch also displaces and appropriates folk and indigenous cultural expression: "Today the native of China, no less than the South American Indian, the Hindu, no less than the Polynesian, have come to prefer to the products of their native art, magazine covers, rotogravure sections and calendar girls," Greenberg mourns. The resulting "debased and academicized simulacra of genuine culture . . . mechanical . . . formulaic . . . faked . . . is the epitome of all that is spurious in the life of our times. . .

demand[ing] nothing of its customers except their money," he charges. Even a smart magazine like the *New Yorker* Greenberg dismisses as "high-class kitsch for the luxury trade." Worst of all, kitsch deters the masses from pursuing the privileged education that elites enjoy, while becoming a vehicle of government propaganda and fascist oppression, thus preserving inequality.

Concerns Greenberg raised about the commercialization of previously noncommercial forms and the loss of folk arts remain pressing, while the value of artistic independence versus service to society and the role of patronage continue to be debated. On the other hand, the essay "Avant-Garde and Kitsch" has been widely criticized by theorists of popular culture for being hypocritical, snobbish, and dismissive; even Greenberg himself in later years acknowledged that it was too sweeping and neglected to criticize middlebrow art. Despite its flaws, it was widely read, and the concept that "high" elite art and "low" popular culture were polar opposites and that the latter was not worthy of notice came to characterize the attitude of the fine art establishment. The belief that illustration could not be considered "art" at all was perpetuated, and few museums, archives, art historians, or art collectors included popular illustration in their purviews.

Further Reading
Greenberg, Clement, "Avant-Garde and Kitsch," *Partisan Review*, 6 (Fall 1939): 34–49.

The rise of the Nazis reinvigorated some avant-garde artists' political engagement. During World War I, John Heartfield (German, 1891–1968; originally known as Helmut Herzfeld) and Dada artists had begun to use photomontage to express visual and social disruption. Over time, Heartfield moved from formalist combinations of materials to a more illustrative tactic, exploiting photography's sense of realism to satirize Adolf Hitler by giving him ridiculous appendages or pasting him into ludicrous scenes. In "Adolf the Superman" (Figure 19.17), Heartfield combines a photo of Hitler with an x-ray, showing that Hitler has swallowed the money of capitalists who stood to profit from National Socialism (Nazi Party). The caption tells us that Hitler spouts (or vomits) tin—meaning, he falsely proclaims Socialist values while hiding greedy inner motives.

The Avant-Garde and Advertising

The Futurist Fortunato Depero (Italian, 1892–1960) distanced himself from the movement when it became associated with Fascist politics, but he carried its progressive, radical impetus and visual language into design. In a 1932 manifesto titled "Futurism and Advertising," Depero argued that art of the past was largely advertising, from the glorification of warriors and saints, to the exaltation of architecture and objects. Advertising art was not just unavoidable and necessary, it was a "living art" seen everywhere by everyone. As a highly mechanized and innovative multimedia phenomenon, he felt advertising was the "purist, truest, and most modern art" for industrialized modern life. Depero's belief in the Futurist qualities of dynamism, boldness, and optimism is found in a composition depicting Campari-soda-drinking men in a café (Figure 19.18).

Global Repercussions

Avant-garde art and thought have had lasting effects on fine art and applied art worldwide, with the visual languages of abstraction and the unconscious quickly being absorbed by foreign artists who visited Europe or who saw works in print. For instance, the interest in fine book arts that surged in France and elsewhere in the 1920s and 1930s also captivated Canadians, especially in Quebec. There, artists often illustrated traditional French-Canadian subjects in small book editions and collectible prints. Then, in the turbulent 1930s some Quebeckers turned away from traditional themes to embrace social activism and modernism. In 1948, a circle of artists known as Les Automatistes (inspired by the French Surrealists) made abstract art a movement in Canada for the first time. The cover and interior of their anarchistic, atheistic manifesto *Le Réfus global* (*Total Refusal*) is embellished with abstract designs in watercolor by Jean-Paul Riopelle (Canadian, 1923–2002) that express a break with oppressive church and government institutions and social customs (Figure 19.19). *Le Réfus global* caused an enormous scandal and became a major contributor to the Quiet Revolution of the 1960s, when Quebeckers sought independence from Canada. Throughout the twentieth century, however, what was shocking in art quickly found general acceptance even in quite conservative publications. Riopelle's work was already becoming the status quo, as Jackson Pollock (American, 1912–1956) was concurrently experimenting with Abstract Expressionism in New York.

Conclusion

As we have seen, one key aspect of the interwar period was that many modernists wanted to reserve art as a sacred space of philosophical research and experimentation, while others wished it to perform a radical political intervention. These aims were often incompatible with everyday application in average publishing, design, and industry. Furthermore, when avant-garde art was successfully applied to books, magazines, goods, or advertising, it seemed to result in *more* distance between rich and poor, not less, as many had wished.

Theorists of art and culture complained that illustration seduced a naïve public into wanting things they didn't really need, and provided entertainment rather than a thoughtful, socially responsible visual culture.

Paradoxically, however, even the most controversial art-for-art's-sake paintings and sculptures were arguably being turned into entertaining commodities, avidly collected by the bourgeoisie. Avant-garde artists who wished to survive by their art alone had to cultivate

Figure 19.17 John Heartfield, "Adolf Der Übermensch: Schluckt Gold und redet Blech" ("Adolf The Superman: Swallows Gold and Spouts Tin"), *AIZ* vol. 11, no. 29, July 17, 1932, p. 675. Copper-plate photogravure. Heartfield's satirical photomontages appeared on the covers and interiors of leftist magazines. This one was also produced as a poster in the weeks before the election that brought Hitler to power in 1932. The Nazis attempted to assassinate Heartfield in 1933, but he escaped to Czechoslovakia, where he continued to make political photomontages. Beinecke Rare Book and Manuscript Library, Yale University. © 2018 Artists Rights Society (ARS), New York / VG Bild-Kunst, Bonn.

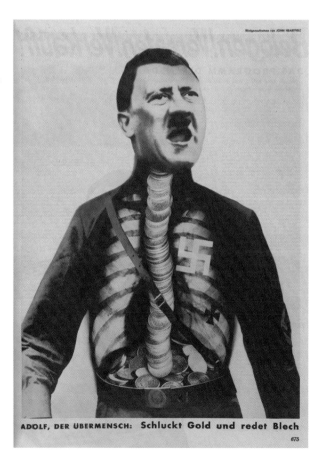

ADOLF, DER ÜBERMENSCH: Schluckt Gold und redet Blech

art dealers and collectors, throwing their supposedly "non-commercial" freedom into question. Despite this resemblance to illustrators' relationships with art directors, and the frequent blurring of personal and commissioned work for publications discussed here, the rhetoric of the modern art world increasingly insisted on drawing a sharp distinction between "fine art" and "commercial art." As people began to distinguish between "high art" (art for art's sake) and "low art" (popular art, such as mainstream illustration, comics, and calendar art), the illustrations by avant-garde artists for *livres d'artiste*, posters, and journals were approached as art objects more than as illustration. Historians and dealers gradually diminished the history of how integral illustration and publishing had once been to avant-garde art, to the point that fine artists' illustration careers began to be eliminated from biographies, or framed as a side interest or necessary evil to fund the artist's "real" work. The supposed isolation of avant-garde art (and indeed museums) from market influences and privilege was not widely critiqued by art theorists until the late twentieth century; it is still hotly debated. Meanwhile, the cultural importance of illustration *as art* has only begun to flourish among art scholars in the twenty-first century.

FURTHER READING

Arnar, Anna Sigrídur, *The Book as Instrument: Stéphane Mallarmé, the Artist's Book, and the Transformation of Print Culture* (Chicago: University of Chicago Press, 2011).

Bury, Stephen, *Breaking the Rules: The Printed Face of the European Avant Garde 1900–1937* (London: British Library, 2008).

Compton, Susan P., *World Backwards: Russian Futurist Books 1912–16* (London: British Library, 1978).

Drucker, Johanna, *The Century of Artists' Books* (New York: Granary Books, 1995).

Lewis, John, *The Twentieth Century Book: Its Illustration and Design* (New York: Van Nostrand Reinhold, 1984).

Melot, Michel, *Art of Illustration* (New York: Rizzoli, 1984).

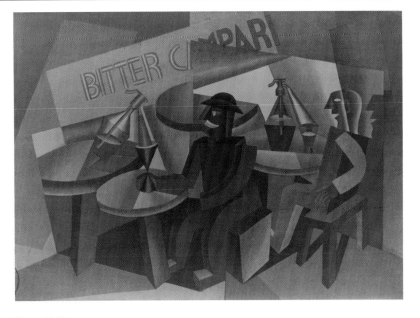

Figure 19.18
Fortunato Depero, *Bitter Campari, 1926.* Photostat, 24 × 34".
Depero created many advertising designs for Italian beverage company Campari. He then resided in New York City from 1928 to 1930, stimulating interest in Futurism there, producing advertising, magazine covers for *Vanity Fair*, and theater sets, as well as exhibiting Futurist paintings and tapestries.

Gift of Davide Campari, Milan. Acc. n.: 190.1968. The Museum of Modern Art, New York. © 2018 Artists Rights Society (ARS), New York / SIAE, Rome.

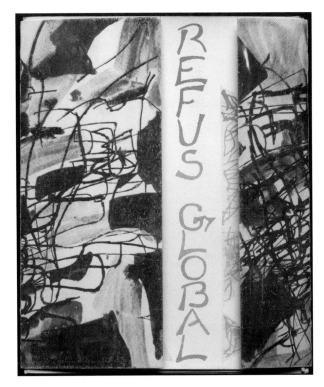

Figure 19.19
Jean-Paul Riopelle and Claude Gauvreau, cover for *Le Réfus global*, by Paul-Émile Borduas (Saint-Hilaire, Quebec, 1905–Paris 1960), published by Mithra-Mythe Éditeur, 1948, 8 1/3 × 7 1/3". Riopelle, a Québecois painter and sculptor, follows the example of French avant-garde artists' books in using fine art painting to illustrate the influential revolutionary sentiments expressed in this manifesto, issued as a pamphlet in four hundred copies.

Archives, The Montreal Museum of Fine Arts. Photo MMFA, Christine Guest. © 2018 Artists Rights Society (ARS), New York / SODRAC, Montreal.

KEY TERMS	
Aesthetes	International Style
automatism	kitsch
avant-garde	less is more
Constructivism	little magazine
croquis	*livre d'artiste*
Cubism	New Typography
Dada	*parole in libertà*
Decadents	photomontage
éditions de luxe	primitivism
Expressionism	pure form
form follows function	simultaneity
formalism	Suprematism
Futurism	Surrealism
gesamtkunstwerk	transfer paper
infographics	

20

Diverse American Illustration Trends, 1915–1940

Roger Reed

with contributions
by Jaleen Grove

In the late nineteenth century, illustrators shifted from being often-anonymous tradesmen to celebrities enjoying unprecedented commercial success. This era, which had seen illustration become a leading form of art and of visual communication, has been dubbed the Golden Age. But between 1909 and 1911, the deaths of three American artists considered star illustrators—Frederick Remington, Howard Pyle, and Edwin Austin Abbey—signaled that this special period had passed.

The following decades experienced financial boom and bust, Prohibition, socialism, universal suffrage, fascism, new feats of technology, the assembly line, Freudian psychology, the cinema, and the changing status of African Americans that occurred with the Harlem Renaissance's cultural, social, and artistic growth. Americans became familiar with more foreign cultures and avant-garde art, while a notable shift in sexual mores paralleled an increase in women's rights. Illustration art reflected these developments immediately and minutely. As a 1929 *Life* cover by Russell Patterson (American, 1896–1977) shows (Figure 20.1), images of youth, beauty, and sex appeal were frequent themes in the burgeoning mass media.

Already by the 1910s, however, photography and cinema had begun to compete with illustration. Even as illustrators became celebrities, tensions between the autonomy of personal expression and the demands of corporate messaging (often discussed in terms of Art versus Craft, or Art versus Industry) were causing illustration to slip in status within critical circles.

In this chapter, we will look at American illustration that departed from mainstream narrative realism; the proliferation and fragmenting of audiences who were both mirrored and molded by a shifting array of magazines, books, and calendars; the exploitation of those audiences by publishers and their advertisers through "lifestyle" advertising images; and the increasingly sexualized depiction of women.

Illustrator as Star

Most magazine and advertising illustrators were typically doing work-for-hire or were paid for the job upon completion or publication, in which ownership of the original art and the rights to it passed to the publisher-client. Prior to 1920, it was unusual for an illustrator to be allowed to sign his or her own advertising work; not even J. C. Leyendecker (German, American, 1874–1951) could sign the famed Arrow Collar illustrations that set the fashion standard for modern young men (Figure 20.2).

The stage was set for the illustrator to become a powerful celebrity when in 1902 Charles Dana Gibson (*Chapter 17*) famously signed a contract for $100,000 for one hundred black-and-white drawings, to be completed exclusively for *Collier's* magazine over a four-year period. Gibson eventually became owner of *Life* magazine—certainly a position far above the relatively low-class tradesmen that most illustrators had been considered in the 1890s. Leyendecker too was commanding top dollar: $1,000 for his clothing advertisements ca. 1910. By 1920, dozens of illustrators had become wealthy, and thousands more entered the middle class, meaning they were considered professionals, could marry women of social standing, and could join prestigious artists' clubs.

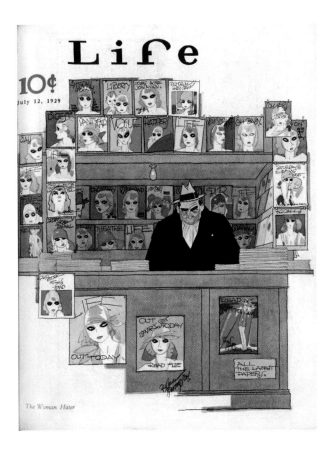

Figure 20.1
Russell Patterson, cover, "The Woman-Hater," *Life*, July 12, 1929.
This magazine cover spoofs the popularity of cover girls that had emerged around 1900, and signals the entrance of women into the public sphere, their emancipation and their objectification, and the importance of young women (called flappers) as a new class of consumer.
The Kelly Collection of American Illustration.

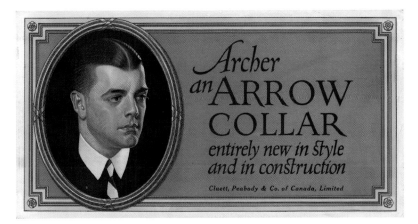

Figure 20.2
Joseph Christian Leyendecker, streetcar card advertisement for Arrow Collars (digitally restored), ca. 1910–1925.
One of the most famous advertising icons of the day, the fictional Arrow Collar Man received fan mail from love-struck women. Leyendecker, who is thought to have been gay, sometimes used his partner Charles Beach as a model.
D. B. Dowd Modern Graphic History Library, Washington University.

Key to illustrators' success was the New York Society of Illustrators, founded in 1901 with the purpose of building friendships among illustrators and formulating business standards for the profession. In its first two years, members included Howard Pyle, Charles Dana Gibson, W. J. Glackens, Edwin Austin Abbey, Harrison Fisher, Arthur Keller, and other prominent men. A few accomplished women were allowed to join as Associate Members in the third and fourth years: Elizabeth Shippen Green, Florence Scovel Shinn, Violet Oakley, May Wilson Preston, and Jessie Willcox Smith. They and twenty other women were allowed to become full members in 1922.

Gibson served as President of the Society in 1904 and from 1909 to 1921. During his tenure, the Society began giving an annual revue (held until the mid-1960s) as a fundraiser for members in need. The show featured comical skits written and produced by members and their spouses, and performed by members and models. These events, attended only by men (their wives could see the dress rehearsal), were remarkable for risqué acts with sexy themes featuring models clad only in G-strings. A version of the show titled *Artists and Models* that debuted in 1923 was the first Broadway spectacle to feature topless actresses in motion, resulting in the public perception that illustrators were a scandalous lot. The royalties of the Broadway production contributed to the society's establishment of a clubhouse in 1934 and then to the purchase of its present headquarters. Today, this also houses its Museum of American Illustration, which had its origins in the permanent collection started in the 1930s.

With a permanent home, the New York Society of Illustrators flourished. Members produced exhibitions, held costume dances, volunteered to design war posters (*see Chapter 21*), trained injured veterans in commercial art, lobbied for fair taxation, awarded scholarships, and drew portraits at charity events. The activities of illustrators often made good press, and their (presumably) discerning eyes made them sought-after tastemakers. Illustrators known for pretty-girl illustration—among them, Howard Chandler Christy, Russell Patterson, Arthur William Brown, John LaGatta, Bradshaw Crandell, and James Montgomery Flagg (the latter five were also producing the Society's annual shows)—were routinely asked to judge beauty pageants until the 1950s, again reinforcing the idea that the profession of illustration was highly sexualized. Such high-profile activity garnered illustrators much publicity. Being closely linked to the entertainment industry through models (who were often aspiring actresses), these men were regularly photographed in the company of famous actors and consulted as experts on fashion and women.

Another factor that enhanced illustrators' fame was their increasing specialization. In the nineteenth century, Kemble became known for cartoons of African Americans while Remington was synonymous with the American West (*see Chapter 18*); such niche expertise became more widespread between the world wars. In this period, Paul Bransom (American, 1885–1979) received steady commissions by focusing exclusively on images of animals (Figure 20.3)—a genre previously illustrated by jack-of-all-trades artists.

Women Illustrators

The one area of illustration where women dominated was in children's subjects (*see Chapter 16, Theme Box 35, "Women in Illustration"*), while many others did skilled but mundane work such as catalogue product renderings, fashion, and **spot illustrations** (small, inexpensive black-and-white images that enliven text-heavy pages). Women found illustration industry jobs desirable (even those that were relatively low status by male standards) because they were among the few professional occupations available to them. Exceptional was Neysa McMein (American, 1888–1949), who grew independently wealthy and socially prominent as a freelancer. McMein specialized in pretty-girl subjects, and unlike the coy and cute girls painted by many of her male peers, her women often appear authoritative (Figure 20.4).

Stylistic Diversity and Specialty Magazine Markets

Between 1915 and 1940, numerous technological, social, and artistic trends resulted in a diversification of stylistic approaches and tastes. Photo-mechanical printing

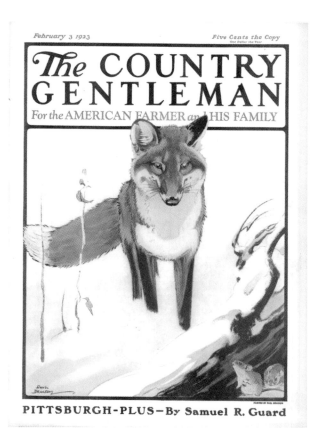

Figure 20.3
Paul Bransom, cover, *The Country Gentleman*, February 3, 1923.
A dedicated specialist, Bransom regularly visited the Bronx Zoo (New York) to hone the anatomical accuracy of his drawing. In this cover, he heightens the drama by placing the viewer in the path of a predator at the eye level of a prey animal; we grasp that this is the moment before the pounce by the fox's hungry eyes and alert stance.
Courtesy of staff, TriUniversity Guelph University Library.

processes and the perfecting of full-color printing permitted nearly any kind of art to be reproduced. The avant-garde movements in Europe began filtering in and support for "art for art's sake" led to greater experimentation (*see Chapter 19*), enabling illustrators to develop more individualistic styles that would give them a unique identity. The cheaper rate of postage in the United States for periodicals was compounded by inexpensive pulp paper, helping crowd out foreign competition and making the early twentieth century a good time to start an American magazine. These factors allowed magazines to enhance their brand identities by using specialized and celebrity illustrators to attract specific readerships, thus giving subcultures their own platforms and visual identities.

Besides the proliferation of pulp magazines, which served to economically test the market for new specialties (*see Chapter 22*), there were higher-production-value **slick magazines** devoted to theater (*Theatre Magazine, Green Book Magazine*), domicile (*House and Garden, Country Life*), cinema (*Shadowland, Silver Screen, Photoplay, Modern Screen, Romantic Movie*), athletics (*Physical Culture*), sophistication (*Town & Country, Mayfair*), and many more niches. Some magazines aimed at "mass"—as many people as possible of different ages and backgrounds—whereas others aimed at "class"— the wealthy elite, or a particular special-interest group. The mass-appeal *Saturday Evening Post* measured its circulation in the millions, whereas the class-oriented *Asia* had a circulation of only 60,000 in 1925.

The Reportorial Sketch and the Ashcan School

Robert Henri's teaching (*see Chapter 18, Theme Box 39, "Education"*) was indirectly influential on illustration of the 1920s. One of his prominent students, John Sloan (American, 1871–1951), like many of his generation, developed a rapid, sketch-like style as a visual journalist (*see Chapter 14*). He was among the most politically radical, volunteering his talents to the fledgling socialist magazine *The Masses* (1911–1917), for which he soon became unpaid art director. Being his own boss, Sloan was free to illustrate according to his conscience. In an illustration of the Ludlow Massacre of April 1914 at which young women and children were asphyxiated, Sloan conveys the desperation and gore of a battle between striking miners and the Colorado National Guard (Figure 20.5). He thus revived the kind of visceral political statement that had rarely been seen since Paul Revere's dramatization of the Boston Massacre, 140 years earlier. This sort of political art was dubbed **Social Realism**—a documentary approach intended to bring critical attention to class inequity by presenting actual events without censorship.

Harlem Renaissance

The mass migration of African Americans to New York City following World War I led to the social movement known as the **Harlem Renaissance**, named after the northern Manhattan neighborhood. This district was a new site of culture and business directed by African

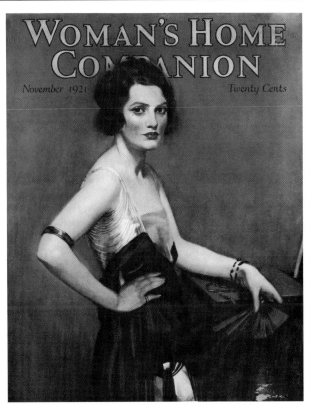

Figure 20.4
Neysa McMein, cover, *Woman's Home Companion*, November 1921.
In her always-open studio, Neysa McMein hosted a continuous stream of artists, writers, critics, and theater people associated with the prominent clique known as the Algonquin Circle. Many of them sat for the pastel portraits at which she excelled, and a few were featured on the numerous magazine covers she executed. McMein broke away from prior pretty-girl illustrators who strove only for an ideal, and instead gave portraits of women who are confident, relaxed, and self-possessed, inviting the viewer to take each seriously.

Courtesy of Norman I. Platnick, Enchantment Ink.

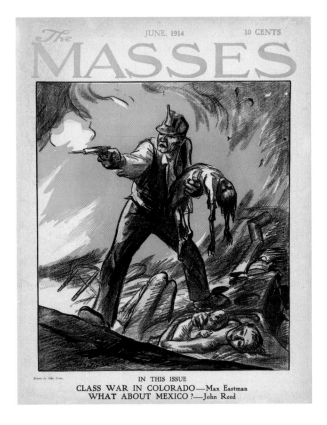

Figure 20.5:
John Sloan, cover, *The Masses*, June 1914.
Newsstand sales of mainstream magazines at this time were driven by politically inert artwork frequently featuring "pretty-girls." In contrast, Sloan's loose crayon drawing of the Ludlow Massacre is reminiscent of Honoré Daumier's political work a century earlier.

D. B. Dowd Modern Graphic History Library, Washington University.

Americans that included jazz and theater venues explored by interested Caucasian Americans. This movement (which became national) gave rise to the "New Negro," the general name given to the type of African American who was gaining affluence, education, and a political voice. The close-knit community of Harlem artists had intimate knowledge of each other's work, which meant that images and texts were particularly well integrated in the books and periodicals they produced.

One prominent illustrator was Aaron Douglas (American, 1898–1979), who held a Bachelor of Fine Arts from the University of Nebraska. Douglas combined modern art and African art to give a distinct identity to African American publications. For the serious, politically progressive journal *Opportunity*, Douglas made a powerful composition of faceted silhouettes with radiating auras, and a sophisticated thicket of interlocking, fractured forms of force that shift between figure and ground (Figure 20.6).

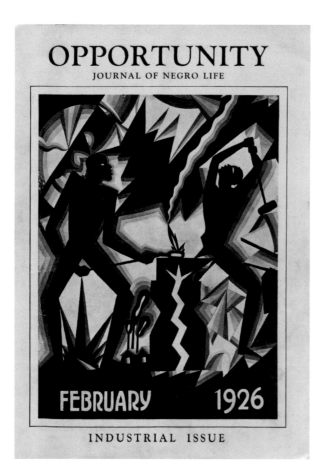

Figure 20.6
Aaron Douglas, cover, *Opportunity*, February 1926.
Douglas's stylized heads often show exaggerated lips. Rather than adopting prevailing racial stereotypes, however, Douglas's imagery emerges from a close study of Egyptian and African art, especially masks made by the Baule and Yaure people from Cote d'Ivoire that he was able to see in the mid-1920s. In referencing ancient African art, this cover would have reminded viewers that people of African descent had a long, noble, and artistic history. Visually, it also related to Cubism and Futurism (*Chapter 19*), thus aligning the Harlem Renaissance with the avant-garde as well.
Special Collections Research Center, University of Chicago Library.

Smart Magazines

Nineteenth-century humor magazines such as *Life* and *Puck* that aimed for a wide audience found new competition from upstart magazines catering to either high or low culture. *Capt. Billy's Whiz Bang* (debuted in 1919) was a bawdy, midwestern ex-serviceman's magazine that carried jokes everyone could grasp; for a while its subtitle was "an explosion of pedigreed bunk [nonsense]." Contrarily, the *New Yorker* (debuted in 1925) was, in its own words, "not edited for the old lady in Dubuque [Iowa]" and claimed "It will hate bunk." This widened the split between urban and rural audiences, and the relative sophistication, or "smartness," that urban life implied. **Smart magazines** such as the *New Yorker*, *Vanity Fair*, *Smart Set*, *Esquire*, and *College Humor* provided a mix of timely, snarky, topical, naughty, clever, and middle-brow content.

Wallace Morgan's (American, 1875–1948) *New Yorker* gag cartoon, "Poor little girl—to think you've never had anyone to protect you," epitomizes the informal, energetic, newspaper-reportorial style of the Gruger School (*see Chapter 14*) (Figure 20.7). The looseness of the technique captured the speed of modernity and was therefore frequently used to depict "café society"—fashionable thrill-seekers ready to throw off Victorian primness for sensual twentieth-century liberty, who were often the subject of and buyers of smart magazines. The caption spoofs Victorian sentimentalism toward the vulnerability and supposed innocence of orphaned children. At this time, New York nightlife was associated with so-called gold-diggers, young working-class women who used their looks to attract wealthy men. Ironically set in a nightclub, the "poor, unprotected girl" is a vampy gold-digger, scantily clothed in the highest style. She acts the part of a waif by ducking her head modestly away from her companion, who seems less likely to protect her than to consume her, but her gesture can be interpreted as seductive coyness. It is not clear who has seduced whom, or who needs protection more.

Clear-line

During and shortly after World War I, a great many British, Canadian, American, and Australian young men experienced European culture first hand. The artists among them, such as Russell Patterson (Figure 20.1), brought back the precise, even-weighted **clear-line** (or *ligne claire*) drawing style that originated in Japanese woodblock prints and had been used in poster design (*see Chapters 6 and 15*) and French fashion publications (*see Chapter 17*). Patterson and his peer John Held Jr. (American, 1889–1958) married this sophisticated European approach to the cruder outlines of the comic images they also drew. This new sleek and simplified line style contrasted with the exuberant crosshatch of Gibson's generation and became associated with modernity.

John Held Jr.'s work appeared in most of the smart magazines (Figure 20.8). A great humorist, he was known for clever captions and his ability to capture the

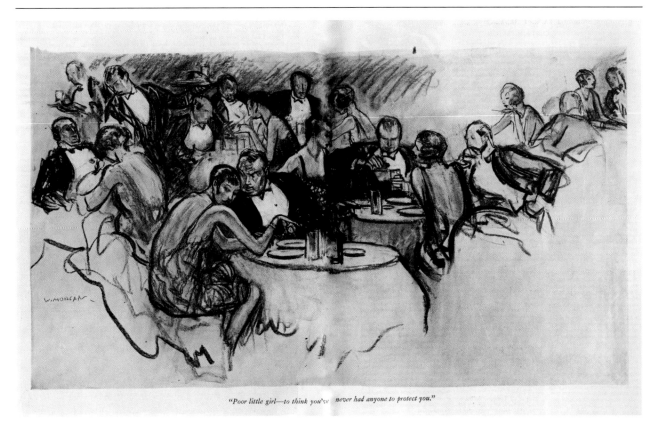

"Poor little girl—to think you've never had anyone to protect you."

Figure 20.7
Wallace Morgan, "Poor little girl—to think you've never had anyone to protect you," *New Yorker*, October 9, 1926.
Though there are approximately twenty figures in this drawing, Morgan cleverly turns a lot of individuals into a crowd, partly by massing together light areas and dark areas into larger shapes, partly by clarifying who is speaking by making background characters less distinct. The loose drawing and wandering diagonals add an appropriate impression of drunkenness to the scene.

© Condé Nast.

language, voice, and character of "flaming youth"— young people who were transgressively participating in speakeasies and cabarets.

Art Deco

Clear-line was also characteristic of **Art Deco**, a design style named after the *Exposition internationale des arts décoratifs et industriels modernes* held in Paris, 1925, where many objects exhibited clean, geometric lines with an emphasis on patterns derived from non-European art forms. Art Deco was also inspired by ancient Egyptian motifs found in King Tutankhamen's tomb (opened in 1922), but the interest in the exotic had been building for some time, starting with the English translation of *Rubáiyát of Omar Khayyam* in the mid-nineteenth century, and bolstered by the popularity of the Middle Eastern–inspired dances and costumes of the Ballets Russes. In 1921, the heart-throb actor Rudolph Valentino starred in the torrid movie *The Sheik*, which offered Westerners a Hollywood version of splendidly decorated Arabian interiors. The inevitable distortion of Asian cultures in popular culture is sometimes critiqued as **orientalism** (*see Chapter 4, Theme Box 10, "Orientalism"*).

The popular vogue in America for Arabian, Japanese, Indonesian, and other "foreign" aesthetics during the 1910s, 1920s, and 1930s coincided with economic and political interest in the "East." The high-culture magazine *Asia* frequently featured the artwork of Frank H. McIntosh (American, 1901–1985),

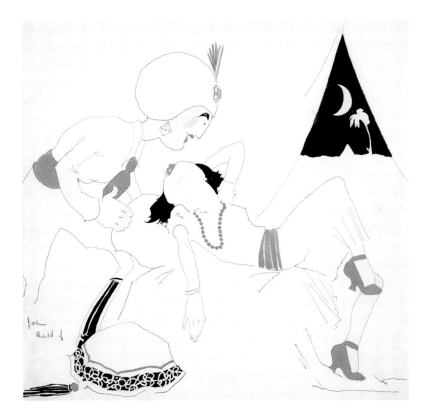

Figure 20.8
John Held Jr., untitled, india ink and gouache, 8 × 8", ca. 1921.
The spare construction of clear-line makes every line meaningful, even precious. It demands some work by the audience to re-create forms that are only suggested. In this case, the entire bed is shown by only a few wrinkles in the sheet. It is a perfect style for caricature by omission; here, Held implies that the only thing important about the woman's face is her lips.

Copyright of the John Held Jr. estate, courtesy of Illustration House.

who used Art Deco and clear-line to depict exoticized Asian themes (Figure 20.9), appealing to an audience of respected politicians, businesspeople, and intellectuals who studied or had careers in areas stretching from the Mediterranean to Oceania.

Moderne

Closely related to Art Deco was the global fascination with the **Streamline** industrial design movement, which applied sleek, curvaceous forms to machines, and the related American avant-garde painting movement called **Precisionism** that portrayed machine, industrial, and factory forms stripped of unnecessary decoration and reduced to geometric elements. Streamline and Precisionism shared roots with the political avant-garde associated with Futurism and Constructivism, and the Bauhaus school's effort to merge art and industry (*see Chapter 19*), but in advertising and magazine cover art, it emerged as a new style largely disconnected from its ideological origins. This new style has been called **Moderne**.

Figure 20.9
Frank H. McIntosh, cover, *Asia*, June 1931.
McIntosh's portrayals of Asians in traditional garb looked "exotic" to Europeans and Americans. The emphases on color, pattern, and geometric composition are characteristic of Art Deco and signify the chic quality of this fashionable and expensive magazine.
Courtesy of the Fleet Library at Rhode Island School of Design, Special Collections, Providence, Rhode Island.

One of the important art directors responsible for bringing the new look into magazines was *Fortune* magazine's Thomas M. Cleland (American, 1880–1964). He quickly gathered a stable of like-minded artists whose designs made *Fortune* (and American business by association) appear like an efficient mechanism emblematic of mass production. Moderne emphasized dynamic page design, diagonal compositions, new typefaces, and **page bleeds** (images over-running the edges of pages). Borrowing from Cubism, which by the 1930s was broadly familiar to the public, the illustrators put emphasis on simplified and abstracted forms not merely to mimic new streamlined industrial design, but to extract the essence of their subjects. To emphasize the additional symbolic function of these visual elements, illustrators did not depict objects in traditional three-dimensional space.

For example, on a cover of *Fortune* magazine (October 1937) Paolo Garretto (Italian, 1903–1989) presents the transformation of pulpwood logs into newsprint with symbolic brevity, using a formal expression rather than an accurate rendering of the manufacturing of pulp. Logs project energetically and give the composition a vanishing point, but the flat forest-green background and machine part in the upper right confound a consistent perspective system. The largest log transforms into a spinning roll of paper; its leading edge then spirals into a newspaper bearing a headline about the soaring demand for pulp. The entire composition is framed in a monumental three-dimensional window—a standard graphic device on *Fortune* covers for many years that provided a consistent brand identity no matter how widely the always-diverse cover illustrations varied.

Garretto was an Italian advertising artist and caricaturist who had been early influenced by Futurism (*see Chapter 19*) and who was living in the United States due to political issues in Fascist Italy. Many such designers and illustrators arrived in North America because of political oppression at this time, bringing European sensibility into mainstream American visual culture.

Moderne imagery remained popular into and after World War II, when it was employed by artists speculating on space travel and anything futuristic (curiously, however, it is missing from science-fiction pulps). Other notable contributors to this movement were Alexander Leydenfrost (Hungarian-American 1888–1961), André Durenceau (Franco-American 1904–1985), Boris Artzybasheff (Ukrainian-American, 1899–1965) (*see Chapter 24*), and Pierre Fix-Masseau (French, 1905–1994). Some of these artists, influenced by **Surrealism**, also utilized juxtapositions of symbolic objects and figures to convey abstract concepts and emotions, prefiguring the turn to **conceptual illustration** ca. 1960 (*see Chapter 24*). Among them, A. M. Cassandre (French, born Ukraine, 1901–1968) stands out for his numerous cover designs for the high-fashion magazine *Harper's Bazaar* (Figure 20.10). The association of apparel with avant-garde art equated fashion with progressive thought and the leading edge of visual culture.

Caricature

In the interwar period, caricature enjoyed a new vogue in association with the acerbic wit of the smart magazines. As in the eighteenth century, sophisticates relished both good-humored and critical portrayals of well-known figures. A *Vanity Fair* caricature by Miguel Covarrubias (Mexican, American, 1904–1957) comments humorously on the extremes of popular and avant-garde cultures (Figure 20.11). The fan-dancing Sally Rand, coy and curvy, improbably shares the stage with Martha Graham, the doyenne of the abruptly modern. Covarrubias uses completely different graphic vocabularies for each to show their incompatibility. But his very pairing bridges their differences: both dancers were in top form that year and represented different states of American dance. The artist's friend, muralist Diego Rivera, remarked that his "caustic but implacably good-humored drawings" were "all irony untainted with malice." Indeed Covarrubias's ability to capture both dancers' essence encourages his audience toward empathy rather than ridicule. "Must we take sides?" he seems to ask.

The Calligraphic Line

Once the clear-line had run its course, the calligraphic line came into prominence. Another deceptively simple-looking drawing manner, it too had its origins in Japanese art—brush calligraphy, rather than woodcut. Casually freehanded in a manner reminiscent of Toulouse-Lautrec (*see Chapter 15*), calligraphic draftsmanship was incorporated into illustration by fashion artist Carl Erickson (American, 1891–1958), who signed his work "Eric"; Ludwig Bemelmans (Austro-Hungarian, American, 1898–1962), author and illustrator of the beloved Madeline stories (*see Chapter 25*); and Jaro Fabry (American, 1912–1953). Fabry was a Hollywood insider whose ink-and-gouache drawings straddled the blurry edge between illustration and cartooning (Figure 20.12). Omitting all but the essentials, the elegant calligraphic line paired refined taste with the high-wire act of ***alla prima*** painting (literally, "first touch" of the brush) to convey breezy sophistication. The style characterized upscale magazines such as *Town and Country* and *Vogue*.

Figure 20.10
A. M. Cassandre, cover, *Harper's Bazaar*, June 1939.
European-trained Cassandre shows the influence of Surrealism in this disembodied figure and the psychologically charged giant shells floating in outer space, loosely evoking beaches that readers would anticipate visiting in coming months.
Courtesy of the D. B. Dowd Modern Graphic History Library, Washington University. Published by *Harper's Bazaar* magazine, June 1939. Reprinted with permission of Hearst Communications, Inc.

Figure 20.11
Miguel Covarrubias, interior illustration, *Vanity Fair*, December 1934, p. 40.
Covarrubias was an expatriate Mexican who eventually returned to Mexico to become Minister of Culture there. His numerous visual juxtapositions of public figures done for *Vanity Fair* seem to conclude that American culture is pluralistic, rather than the legendary "melting pot" that reduces individuality.
© Condé Nast.

Figure 20.12
Jaro Fabry, cover art, *Cinema Arts*, 1937. Gouache.
A high-production-value magazine that lasted for only three issues, *Cinema Arts* sought a more sophisticated niche than the dozens of other movie-fan magazines characterized by slavish renderings from publicity head shots. This face is little more than a handful of lines but is unmistakably the likeness of actress Katharine Hepburn. Even though the costume and setting are intentionally dashed-off, we gather that she is wearing dazzling haute couture while coolly waving a gloved hand to her fans.
Cabinet of American Illustration, Library of Congress.

Reaction to Modernism: Regionalism

The trendiness of exoticized non-European culture, growth of subcultures, avant-garde art, and influx of immigrants led to a backlash, as Americans sought validity in a trend termed the *American Scene*, which expressively documented gritty and everyday American life. An offshoot called **Regionalism**, in parallel with a corresponding literary genre of the same name, both documented and romanticized rural agricultural communities associated with the Midwestern states and the average citizens who toiled there, with the genre taking on conservative and patriotic overtones. A great many talented American artists were emerging from states previously thought to be culturally bereft, and the works of Midwestern Regionalist painters, primarily John Steuart Curry (1897–1946), Thomas Hart Benton (1889–1975), and Grant Wood (1891–1942), gained credence among critics as authentically American. American illustrators such as John Falter (1910–1982), Norman Rockwell (1894–1978), John Clymer (1907–1989), Dale Nichols (1904–1985), and Rockwell Kent (1882–1971) were all producing work consistent with Regionalist ideals for mass periodicals (*see Chapter 23*).

Murals and Prints: Art or Illustration?

Regionalism fit well with numerous artistic ideals, practices, and organizations in Depression America. In particular, there was a strong feeling that art should be available to everyone in terms of physical and conceptual accessibility and price. Although critical opinion was turning against commercial illustration by the late 1930s, many Regionalists and muralists who identified as fine artists borrowed communicative strategies common to illustrators.

Murals were an excellent way to put art into the public eye and to employ artists during the Depression, so under **New Deal** policy (the government's effort to support the unemployed by commissioning new public infrastructure), urban and rural public buildings were decorated with narrative murals featuring historical and archetypal scenes of industry and progress. Commissioned by the Kansas State Legislature, a mural along these lines by John Steuart Curry depicts a historical figure, abolitionist John Brown, in a symbolic manner (Figure 20.13). The mural became highly controversial, with Curry upset that citizens of Kansas disapproved of the subject and his treatment of it. The conflict points to the difficulty of reconciling the fine artist's demand for freedom of expression and

Figure 20.13
John Steuart Curry, *Tragic Prelude*, 1938–1940. Installed in the Kansas State Legislature, Curry's mural was controversial due to the heroic figure of abolitionist Kansan John Brown, who scorned the law to oppose slavery, for which he was eventually hanged. Brown is depicted larger-than-life, his outstretched arms echoing the shape of the looming tornado in the background. The figures around him and at his feet represent the warring sides and the victims of the American Civil War (1861–1865) that came on the heels of Brown's activity.

Kansas State Historical Society.

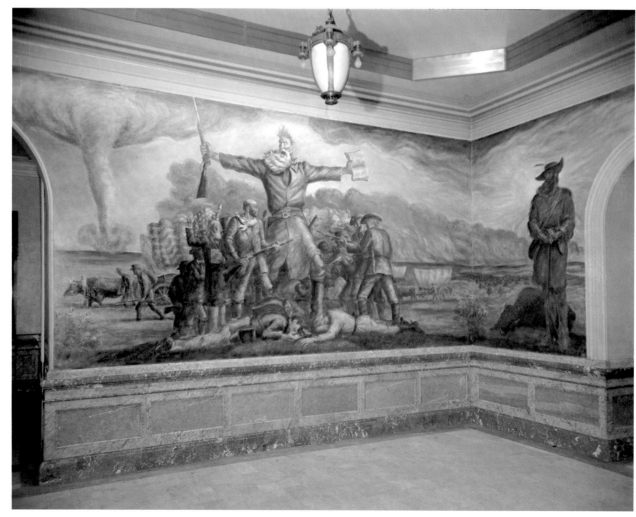

the illustrator's assumed indebtedness to the patron and audience—a key issue of the period that resulted in further divergence between fine art and illustration practice, with the latter being more often denigrated as "*mere* illustration." This act of belittling failed to address a parallel but unacknowledged indebtedness on the part of the fine artist who wished to sell.

Another way to disseminate art was to make prints, but this too exacerbated the controversy around what constituted illustration and what debased fine art. The Associated American Artists was established in 1934 to market putatively fine art etchings of Regionalist and related painters at an affordable price, but the imagery, promotional activities, and business strategy resembled that of a commercial calendar publisher; in fact, about half of the AAA's roster of artists were simultaneously doing illustration in the tradition of narrative realism. Meanwhile, many illustrations appearing in advertising began to resemble **American Scene** painting (descriptive realist works that showed typical American life) that might be seen in a gallery. Both Regionalism and American Scene easel paintings were soon criticized for being "mere illustration" by more avant-garde artists and critics (*see Chapter 19, Theme Box 40, "Greenberg: Avant-Garde and Kitsch"*).

Advertising

By the late nineteenth and early twentieth centuries, buyers of magazines had ceased to pay for the true cost of the magazine's production. Instead, companies supported magazines by paying to advertise in them, and the resulting low cover price meant even more people could afford to pick up a copy. This arrangement put editors in a potential conflict of interest: on one hand, they had to provide the readers with quality, unbiased content. On the other, they had to keep advertisers happy with careful placement of their ads next to related articles. Both readers and advertisers had expectations about content, which in some cases led to a restrictive climate that set limits on illustrators' freedom. *The Saturday Evening Post*, for example, would not allow depictions of alcoholic beverages, women smoking, violence, death, semi-nudity, or African Americans (except in servile roles). Conversely, the specialty magazine such as *Ballyhoo* reveled in salacious imagery, with advertising drawn by its own editorial illustrators to suit.

The advertising industry grew in lavishness and sophistication in tandem with the popularity of psychology, and the science of visual persuasion was born. Advertisers were helped by the specialization of magazines because they could be sure their goods were being pitched to the people most likely to buy them. Highly effective **lifestyle advertising** featuring admirable people enjoying the good life while using the product (rather than simply picturing the product alone) had developed in nineteenth-century French posters and American clothing advertisements. J. C. Leyendecker's 1929 advertising illustration for Kuppenheimer Clothing is a twentieth-century example. Here, Leyendecker combines lifestyle with overt fantasy by placing a mermaid and a galleon among male models in natty Kuppenheimer suits (Figure 20.14). Besides clothes,

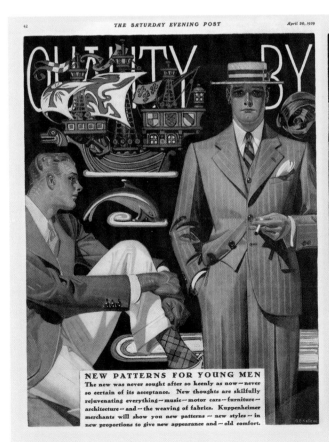
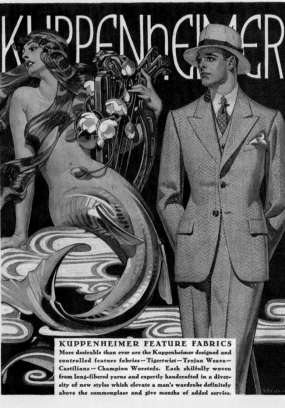

Figure 20.14
Joseph Christian Leyendecker, magazine advertisement, Kuppenheimer Clothing, 1929. Leyendecker's Kuppenheimer advertising art blurred the difference between magazine advertising and magazine covers, which he also illustrated. This double-page spread (a format Leyendecker excelled at) brings to mind the architectural grandeur of a Classical frieze, uniting the enviable worlds of high society and total fantasy.

Courtesy of Thomas Haller Buchanan.

Leyendecker is also effectively selling the newly fashionable Florida resorts as a way of life, but without the inconvenience of sand, swamp, heat, humidity, and sweat. The men's well-rendered garb, of which we can feel the fabric's weight, and the dreamlike mermaid, dolphins, and ship are given a cool, impersonal manner that invites viewers to freely associate the clothing with adventure and elegance, rather than telling them so in a literal narrative.

Would people find advertising illustration more credible if the pictured model did not oversell the proffered goods? A refinement of lifestyle advertising was merely to *imply* the product's presence, rather than show it in use, a strategy found in Charles E. Chambers's (American, 1883–1941) illustration for a cigarette brand (Figure 20.15). Numerous visual cues distinguish the woman in this ad as enviably wealthy and sophisticated, imbuing the brand with a desirable identity by association: her makeup is understated, and her garb includes a ladylike hat and gloves and the latest variant on the "little black dress," which was an established fashion statement synonymous with elegance. We cannot see the flavor of the tobacco, but we can see "taste" in her appearance, where "good taste" stands in for the actual smoke. Her aristocratic bearing and the profile view show

that she has no need to solicit attention; we understand that others come to *her*. What she does need, evidently, is a cigarette: note how her left hand is poised for one to be nestled between her fingers. Such subtlety aids the subliminal acceptance of the product by the viewer. In the case of cigarettes, omission had the added benefit of not breaking conservative magazines' rules and social censure against lady smokers.

Marketers determined that women were the deciding force behind men's purchasing decisions, and so the sales pitch of even masculine products was sometimes addressed to women. They also assumed that women were susceptible to buying something based more on looks than function, so marketing often emphasized style. As sales of automobiles weakened in the 1930s due to market saturation and the Depression, manufacturers such as General Motors turned to designers to give cars more personality and the appearance of technological progress (which was actually minimal) via new shapes, colors, and accessories each year. In a long-running campaign for Fisher Body, which made car bodies for General Motors, pretty-girl illustrator McClelland Barclay (American, 1891–1943) supplied elegant women with fashionable figures to substitute for the car in advertisements (Figure 20.16). The catchline "Body by Fisher" conflated vehicles with sex appeal for the men, while the svelte female figure conveyed upper-class properties for the women, sending the message that Fisher was all about fashion and status.

Calendars

Advertising calendars emerged in the United States around 1870. Many calendars had only one image, with the calendar pages printed on a pad of paper (torn off as months passed) stapled below it. Calendar art, made possible with **rotogravure**, a high-speed intaglio cylinder press, with metal plates using as many as fourteen color separations, dominated the American illustration market by the 1930s. Businesses gave away promotional calendars with their names printed on them, and people also purchased their own as households typically had more than one. Over 150 U.S. calendar companies (which often produced playing cards, jigsaw puzzles, and "art prints" for framing too) such as E.H. Osborne, Brown and Bigelow, and the Gerlach-Barklow Company proliferated by 1950, and their production dwarfed that of magazine subscriptions.

Despite calendar art being considered lower status than magazine illustration, many illustrators' reputations rested largely on their calendar work—Zoë Mozert, Rolf Armstrong, and Henry (Hy) Hintermeister among them. Maxfield Parrish, who first established his career with posters and illustrations, soon became synonymous with calendars and art prints after his designs advertising Edison Mazda Lamps became bestsellers, with the most popular being printed in runs as high as 1,500,000 (Figure 20.17).

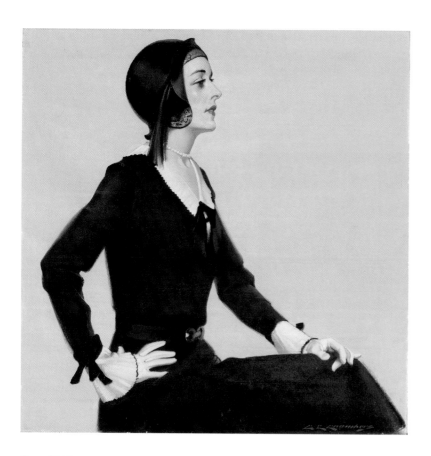

Figure 20.15
Charles E. Chambers, advertising art, "In dress it's distinction . . . in a cigarette it's taste," 1930. Oil on canvas, 21 × 21".
This advertising image is a subtle ploy to stimulate desire and to persuade women to indulge in smoking (considered low class for females) by identifying with this understated, aristocratic model whose left fingers are positioned as if holding a missing cigarette.
Illustration House.

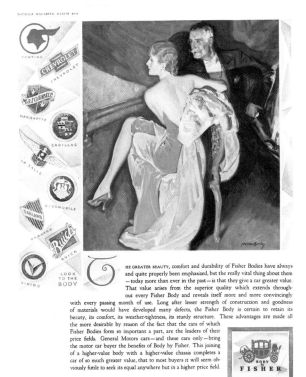

Figure 20.16
McClelland Barclay, advertisement, Fisher Body, *McCall's*, March 1930.
Barclay was famous enough to be permitted to sign his illustrations of fashionable, desirable women for auto body manufacturer Fisher Body. The substitution of the woman's body for the product marketed to both men and women, while turning the female figure into an object of sexual and social-class desire.

Courtesy of Norman I. Platnick, Enchantment Ink.

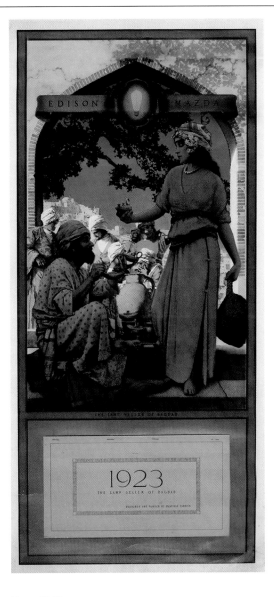

Figure 20.17
Maxfield Parrish, advertising calendar, *The Lamp Seller of Baghdad*, General Electric Company, 1923.
From 1918 to 1934, Parrish portrayed variations on the theme of light for General Electric, often using Classical figures, to promote the adoption of electric lamps. Parrish was paid $2,000 for the first image, and $10,000 each for the last several, for which he also retained the copyright so that he could re-issue them as art prints.

Image courtesy of Heritage Auctions.

Often the calendar image was the only art hanging in the home or workplace, especially in rural America, where a large population still resided. Whereas a poster had explanatory text or a brand name, and a magazine cover included a title and subliminally identified an editorial viewpoint, a calendar usually had to communicate entirely through the strength of the image (although a cute caption was sometimes provided in small print). In seeking to appeal to the largest possible audience, calendar companies relentlessly plumbed the common denominator in art and taste, resulting in pictures that were rural, cheerful, cozy, earnest, unpretentious, self-contained, and retrospective (or timeless) in era—essentially, "comfort food" for the eyes. Common subject matter, always idealized and academically rendered, included landscapes and pin-ups (the most popular subjects), and animals, flowers, bucolic pastoral scenes, and patriotic historical subjects. Norman Rockwell's annual

Boy Scout calendars rivaled both landscapes and pin-ups in popularity.

A common element of calendar art is fantasy—even seemingly realistic scenes are carefully constructed to be as ideal as possible. Parrish, for instance, would paint from scale models made in his machine shop and combine landscape elements from different regions.

Another fantasy staple of calendar art from about 1905 to 1945 was the "Indian Maiden," a rather European-looking young woman posing at water's edge, usually by moonlight, showing off shaved legs

Theme Box 41: Women Consumers of Pin-Ups
by Maria Elena Buszek

Contrary to common assumptions that the pin-up genre was enjoyed by an exclusively male audience, from its inception pin-ups have had female fans. In the World War II era, illustrators like George Petty (American, 1894–1975), Alberto Vargas (Peruvian, American, 1896–1982) and Al Buell (American, 1910–1996) were commissioned specifically to create pin-up-style recruitment posters aimed at women. In the same *Esquire* issue where the "Varga Girl" by Vargas first appeared, a reader-poll indicated nearly three-quarters of the "gentlemen's magazine" subscriptions were in fact read by women, for whom the magazine's illustrations were the number-one attraction. The magazine's letters section frequently published women's letters, and reportedly one-fourth of Vargas's fan mail was from women—who wrote not just in support of his work, or for advice on how they could emulate the Varga Girls' style, but asking how they could get into a career as pin-up illustrators themselves.

As film critic and theorist André Bazin (French, 1918–1958) would write after the war's end, the pin-up was a peculiar, modern creation, not to be confused with "the pornographic or erotic imagery that dates from the dark backward and abysm of time," but a comparatively tame product of post-industrial popular culture. Bazin was drawn to pin-ups because their evolution and popularity emerged from the film history he studied. But while Bazin sought to critique what he felt was the prudishness and hypocrisy of the pin-up's teasing sexuality, many women saw in the genre a form of sexual masquerade and control that they found appealing, and even feminist. As such, the pin-up is a worthy case study for the kind of analysis promoted by scholar John Fiske (American, b. 1939), in which seemingly unlikely audiences read and redefine pop culture in ways that defy common preconceptions of their tastes.

Pin-ups evolved from imagery of the "New Woman," an aggressively modern sexual ideal, with roots in the suffrage movement, which had emerged between 1890 and 1920. This model was appealing to not just women audiences, but also women artists, as seen in depictions by sisters Laurette Patten and Irene Patten (details unknown) and Anita Parkhurst Willcox (American, 1892–1984) of the lively, independent, and sexually alluring women that the burgeoning feminist movement produced—and whose rebelliousness was part of their appeal. The New Woman also provided the country's rapidly growing movie industry with a convenient "type" for the transgressive, modern female characters on which its fortunes would be built. Pin-up illustrations such as Rolf Armstrong's and Enoch Bolles's (American, 1883–1976) fanzine covers in the years following the suffrage movement give us a clear sense of how the turn-of-the-century New Woman evolved through construction, reception, and emulation in a film culture invested in feminist culture (Figure TB41.1). Whether in the form of serial daredevils, adventurous heiresses, or the effervescent flapper, in the 1910s and '20s, Hollywood recognized that women whose behavior pushed boundaries of traditional femininity guaranteed a box-office blitz. The film "fanzine," primarily aimed at young women, was born to promote cinema and the modern culture that films championed, and utilized pin-up illustrations as idealized icons of not just the era's popular actresses, but also the female fans who looked up to them.

The founding of men's fashion magazine *Esquire* in 1933 furthered the rise of the illustrated pin-up girl. *Esquire* published edgy essays and fiction, and also featured "girlie" cartoons of women in various states of undress and in often humorous, modern sexual situations. The most famous early cartoonist was George Petty;

the modern pin-up format was effectively born when his "Petty Girls" moved to a foldout centerfold in December 1939. The year following the birth of the *Esquire* centerfold, Alberto Vargas began working for the magazine. The confident, self-aware Varga Girl debuted in 1940. Acknowledging both the real women who inspired him and the women readers of the magazine, between 1942 and 1945, Vargas's pin-ups addressed the war and women's culture in captions, poems, insignia, or garb, and became a patriotic ideal for American womanhood, iconic of the sweeping changes in gender roles and sexual mores that developed when 60 percent of the female population found themselves working outside the home during World War II. Such pin-ups presented the American public with a heretofore unheard of combination of conventional beauty, blatant sexuality, professional independence, and wholesome patriotism. Zoë Mozert's illustrations for Brown and Bigelow calendars from the period similarly reflected the contradictory cocktail of attributes cultivated by young women— drawing her own figure, she herself was a part of this generation that reveled in new personal and professional freedoms.

During these years, the genre provided a dramatic template through which contemporary women on the home front could construct themselves in life, as well as in pin-up-style self-portraits sent to soldiers overseas, at once both conventionally feminine, and transgressively aware of her own power for a sexual agency that often developed in tandem with this generation's professional experience. As fantasy hybrids, pin-up illustrations suggested new ideals of feminine beauty and behavior, but being largely fictional icons of female allure, they also often modeled unrealistic standards. In this way, the pin-up reflects both problematic and

positive effects on the representation of women's sexuality.

Alas, at the war's end, the nation that had rallied for women to question their traditional roles in society during the war soon stated that it was now their patriotic duty to return to their homes—and alleged pre-war contentment there. Images of women in popular culture followed suit, largely reflecting the postwar American interest in idealizing a less assertive, thoroughly nostalgic construction of the contemporary woman. Even in the often-regressive postwar atmosphere, however, Gil Elvgren's campy and theatrical yet always capable and wholesome calendar girls for Brown and Bigelow continued threads of the WWII pin-up's feminist attitude. In fact, the pin-up's explosive popularity with women during the war encouraged more women pin-up illustrators in the postwar era, such as Elvgren's protégé Joyce Ballantyne (1918–2006), who, like fellow female pin-up artist Zoë Mozert, used herself as her own best model.

Indeed, with the pin-up's increasing absorption for analysis by the burgeoning civil-rights and feminist movements, as well as in the art world avant-garde of the postwar era, the political meanings of the pin-up so covert in previous generations were both acknowledged and amplified in sites from *Ebony* magazine to Pop Art exhibitions. This imbued the pin-up with newer meanings that fit what would become the 1960s' defining, heady climate of political, cultural, and sexual revolution.

Further Reading

Bazin, Andre, "Entomology of the Pin-Up Girl," In *What Is Cinema?* Vol. II (Berkeley: University of California, 1971): 158. First published in *Ecran Français*, December 17, 1946.

Buszek, Maria Elena, *Pin-Up Grrrls: Feminism, Sexuality, Popular Culture* (Durham, NC: Duke University Press, 2006).

Fiske, John, *Reading the Popular* (London: Routledge, 2010).

Knaff, Donna B., *Beyond Rosie the Riveter: Women of World War II in American Popular Graphic Art* (Lawrence: University of Kansas Press, 2013).

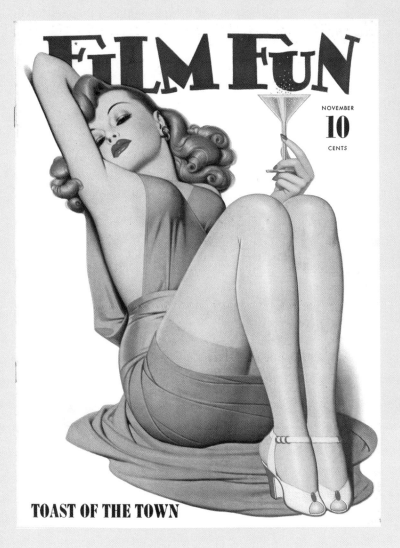

Figure TB41
Enoch Bolles, "Toast of the Town," cover, *Film Fun*, November 1941. Film fanzines were aimed at female audiences and focused on the unconventional femininity of movie actresses, both on- and off-screen. Fanzine illustrators like Bolles created fantasy composites of these thoroughly modern women in provocative covers that suggested their self-awareness and desirability.

Courtesy of Jack Raglin

and wearing highly inaccurate ceremonial garb. Adelaide Hiebel (American, 1885–1965) created endless variations on this theme, all of which adhered to the same popular formula, thereby codifying and perpetuating a number of racial, sexual, and pictorial stereotypes (Figure 20.18).

With numerous calendar publishers pushing out limited variations on such a narrow set of sales-oriented American themes and with no concern for modern art, a hegemonic monoculture emerged that gave calendar art a bad name among the art-educated public. The repetition of traditional, sentimental, and stereotyped images in the millions reminded some critics of Fascist attempts to control media that were simultaneously ongoing in Europe during the 1930s.

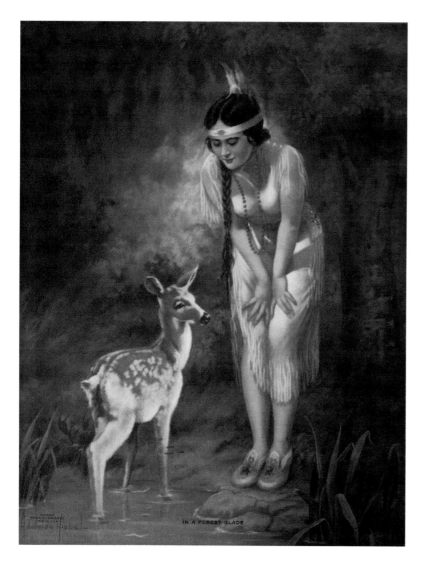

Figure 20.18
Adelaide Hiebel, *In a Forest Glade*, Gerlach-Barklow Calendar Company, 1941.
Hiebel was an artist working exclusively in the studios of the Gerlach-Barklow Calendar Company of Joliet, Illinois. She was required to master the style of a retiring senior artist, Zula Kenyon, although she eventually made a name for herself for hugely popular pastels of the stereotyped Indian Maiden and of children. When she wished to keep her artwork, she had to purchase it from the company.
Courtesy of Tim and Michelle Smith, Shhboom Illustration Gallery.

Pin-ups

Hiebel's Indian Maiden also belongs to the class of calendar and art prints depicting sexually charged representations of a lone female figure in various states of undress known as the **pin-up**. The term comes from the temporary manner in which images were tacked to surfaces for exhibition in public or semi-public spaces, particularly those inhabited by men, such as workshops, auto garages, or military barracks.

Pin-up "types," with facial and bodily features attractive by the standards of each era, exist in fine art precedents ranging from Greek Late Classical sculpture to the academic paintings of William-Adolphe Bouguereau (French, 1825–1905). Like academic art, pin-ups differed from explicitly pornographic imagery by strategic covering of the genital area and by artful posing according to the tenets of academic painting. However, the pin-up did away with the allegorical pretenses (such as the "noble savage" idea that underlies Hiebel's image, or Biblical stories such as Susannah being secretly watched by male Elders as she bathed) that traditionally justified the model's state of nudity or arousal.

Although women enjoyed pin-up imagery (*see Theme Box 41, "Women Consumers of Pin-Ups"*), manufacturers catered to heterosexual male audiences; and illustrators such as Rolf Armstrong (American, 1889–1960), Zoë Mozert (American, born Alice Adelaide Moser, 1907–1993), and Gil Elvgren (American, 1914–1980) offered young, idealized specimens of the wholesome but saucy girl-next-door, or of fantasy mistresses in scanty clothes (Figure 20.19).

Mozert began as an illustrator of romance pulps and film fanzines, and her pretty-girl heads and pin-ups soon became best-selling calendar images from the late 1930s to the early 1950s. Her work was also produced as risqué **Mutoscope cards**, small cardboard pictures purchased from vending machines operated by the International Mutoscope Reel Company, found in amusement parks or arcades (Figure 20.20).

Conclusion

The prewar and interwar period saw illustrators reach new heights of celebrity, but paradoxically, as avant-garde art and criticism of advertising and media became more pronounced, the period also saw illustration's status and market begin to deteriorate. New media forms such as photography and film gained in popularity, but because color photography was still difficult to reproduce faithfully, and because the public appreciated the idealism and stylistic expression of drawn and painted imagery, illustrators still flourished. Many artists, illustrators, and critics began questioning illustrators' roles and the nature and value of artistic freedom. Some found creative expression through print media, whereas others concluded that only exhibition or gallery art afforded true expression. A great many embraced both.

Advances in printing, distribution, and socioeconomic class opportunities allowed illustrators to specialize even more than they had in the nineteenth century. Subcultures centered on youth, race, hobbies, and professional interests now enjoyed a wide range of magazines catering to their interests. These magazines and the illustrations in them both mirrored and shaped their readerships' identities. Women in particular were addressed as consumers and as objects to be emulated or fantasized about.

With targeted magazines came targeted advertising, which sold to specific types of people by reflecting their actual or desired lifestyles, and utilized newly discovered theories of psychology to seduce the consumer. Efficient, high-quality printing made magazines and advertising more colorful than ever before, enhancing their persuasiveness and providing unparalleled creative opportunities for illustrators. Markets for calendars and art prints also grew exponentially. By 1940, with World War II underway, the consumption and enjoyment of illustration and the penetration of advertising had never been more widespread in the United States.

FURTHER READING

Bogart, Michele H., *Artists, Advertising, and the Borders of Art* (Chicago: University of Chicago Press, 1995).

Douglas, George H., *The Smart Magazines: 50 Years of Literary Revelry and High Jinks at Vanity Fair, The New Yorker, Life, Esquire, and the Smart Set* (Hamden, CT: Archon Books, 1991).

Goeser, Caroline, *Picturing the New Negro: Harlem Renaissance Print Culture and Modern Black Identity* (Lawrence, KS: Culture America, 2007).

Robinson, Michael, and Rosalind Ormiston, *Art Deco: The Golden Age of Graphic Art & Illustration* (London: Flame Tree Publishing, 2008).

Sivulka, Juliann, *Soap, Sex, and Cigarettes: A Cultural History of American Advertising*, 2nd ed. (Boston MA: Wadsworth, Cengage Learning, 2012).

Smith, Tim, and Michelle Smith, *Joliet's Gerlach Barklow Calendar Co.* (Charleston, SC: Arcadia Publishing, 2009).

Zurier, Rebecca, Leslie Fishbein, Elise K. Kenney, and Earl Davis, *Art for the Masses: A Radical Magazine and Its Graphics, 1911–1917* (Philadelphia: Temple University Press, 1988).

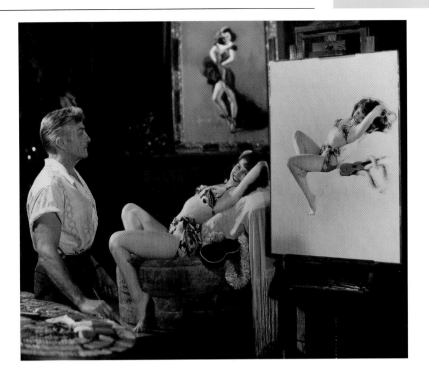

Figure 20.19
Rolf Armstrong in the studio with Olga Bogach. Photograph.
Armstrong also worked as a pretty-girl illustrator, completing many covers for *College Humor*. He became a leading pin-up artist for calendar company Brown and Bigelow.
Courtesy of Grapefruit Moon.

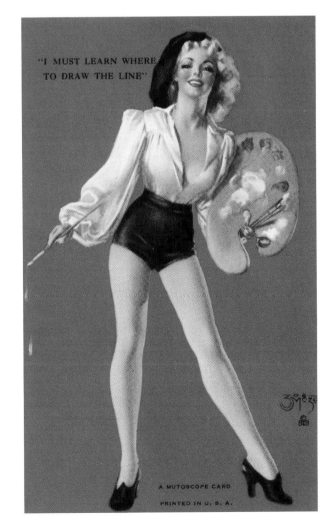

"I MUST LEARN WHERE TO DRAW THE LINE"

A MUTOSCOPE CARD

PRINTED IN U. S. A.

Figure 20.20
Zoë Mozert, *I Must Learn Where to Draw the Line*, Mutoscope card, ca. 1942.
Like many pretty-girl and pin-up illustrators, Mozert used pastels to achieve lush skin tones and dramatic lighting effects. She often used her own figure as her model.
Courtesy of Norman I. Platnick, Enchantment Ink.

KEY TERMS

alla prima	page bleed
American Scene	pin-up
Art Deco	Precisionism
clear-line or *ligne clair*	Regionalism
conceptual illustration	rotogravure
Harlem Renaissance	slick magazines
lifestyle advertising	smart magazines
Moderne	Social Realism
Mutoscope cards	spot illustration
New Deal	Streamline
Orientalism	Surrealism

21

**Wartime Imagery
and Propaganda,
1890–1950**

Thomas La Padula

This chapter looks at illustrations related to war made between 1890 and 1950 that fall into three broad categories: reportage, propaganda, and dissent. **Reportage** illustration is a visual record of events made as an eyewitness account commissioned by a publication or government. **Propaganda** in this chapter includes government-sponsored or officially sanctioned text and imagery designed to influence the public in support of certain endeavors or ideologies. Finally, **dissent** is imagery that is critical of war or its proponents, whether privately made or in its published form. Like reportage, dissent might serve propagandistic goals if recontextualized.

Reportage and War Artists

Objectivity and Bias

Despite the growing efficiency of cameras in the nineteenth century, photography on the battlefield was difficult because of necessarily long exposures and cumbersome equipment. Illustrator-reporters were thus engaged to provide visual records of events that photography could not capture, such as sudden or rapid movement, and occurrences obscured by dark lighting or inclement weather.

Even when photography improved in the twentieth century, governments continued to support illustrator-reporters in major conflicts because the camera was limited in its depth of field and scope. Artists were able to prioritize elements in chaotic situations to create a comprehensible pictorial hierarchy by assembling records of events happening simultaneously or in quick succession into a unified, compelling composition.

Reportage therefore inherently involves human judgment, and even accurately transcribed examples raise questions of objectivity, editorial influence, or bias (*see Theme Box 43, "Adorno: Subjectivity, Objectivity, and the Culture Industries"*). On some level, the same can be said of photography because the framing of the photographic "subject" always excludes something else, while the point of view from which the image is shot can enhance or diminish drama or stature. In all cases, the reporter, illustrator, or photographer must decide what is important, and cultural background, political and social pressures, and practicality affect such judgments.

The line between reportage and propaganda is frequently blurred, as is shown in the ***sensō-e*** (war prints) created during the Sino-Japanese War of 1894–1895 and the Russo-Japanese War of 1904–1905. Both occurred amid Japan's Meiji Restoration (1868–1912), a period of nationalism and rapid modernization. The demand for popular imagery and reportage among Japanese urban populations extended to images of battle. A few artists and photographers actually accompanied journalists to the battlefront, but most images were colorful woodblock illustrations fabricated from secondhand reports. Some were even created in anticipation of "news" yet to come. *Our Forces' Great Victory in the Battle of the Yellow Sea* (Figure 21.1) highlights Japan's modern technology and firepower in a **triptych** (three part) format typical of the over three thousand *sensō-e* created during the Russo-Japanese conflict. Although such prints documented events, they were hyperbolic images that expressed Japan's growing sense of nationalism and emphasized bravery, patriotism, self-sacrifice, and glorious death, thus providing solace for the families of the fallen. *Our Forces' Great Victory* is read from right (title at top) to left, and unlike earlier prints, shows an embrace of chiaroscuro created through tonal blocks, rather than the traditional woodblock approach that relied on outlines filled with flat color (*see Chapter 6*).

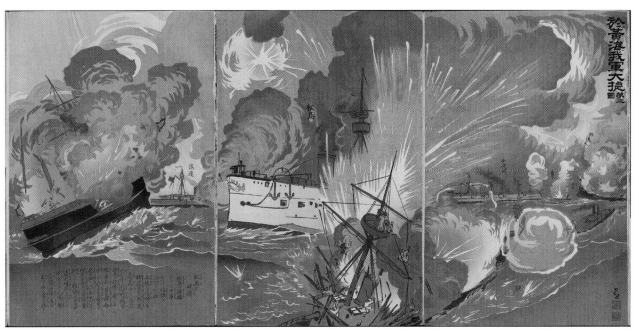

Figure 21.1 Kobayashi Kiyochika, *Our Forces' Great Victory in the Battle of the Yellow Sea*, Japan, ca. 1905. Woodblock print triptych, 14 × 28 $^{7}/_{16}$". Kiyochika's image depicts the Russian Baltic Fleet, exploding and sinking at the Battle of Tsushima (1905). The sense of danger is heightened by red bursts from guns, the random angles of ships, and dynamic cropping—all touches of a new realism in woodblock printing.

Scharf Collection, Museum of Fine Arts, Boston, Jean S. and Frederic A. Sharf Collection.

In contrast a seemingly neutral example of reportage is Ernest-Auguste Bouard's (French, d. 1938) grisaille work depicting an incident in The Boer Wars (1880–1902)—a series of conflicts in which the British Empire fought farmers of Dutch and Afrikaaner descent for control of territories in South Africa. Bouard's academic draftsmanship and life-like detail convey events on the battlefield with a sense of unsentimental accuracy. This acts as a form of visual rhetoric that persuades the viewer that the image is an account free from personal bias (Figure 21.2).

The Art of World War I

Begun in 1914 as a conflict between the Austro-Hungarian Empire and Serbia, tangled treaties fueled a global war involving European nations and their colonies, as well as nations in Asia, the Pacific Islands, and eventually, the United States. Many European governments commissioned fine artists and illustrators to accompany soldiers into battle to document the conflict. Most used traditional drawing and painting approaches to produce artworks intended for gallery display, with no official distinction made between "art" and "illustration." Although ostensibly factual, pieces were at times used as propaganda.

Alfred Theodore Joseph Bastien's (Belgian, 1873–1955) *Canadian Gunners in the Mud* depicts a dramatic landscape with soldiers struggling to free a piece of artillery that is sinking in the mud. Rather than showing active fighting, Bastien's painterly image communicates a universal narrative conflict of "man against nature" within the context of battlefield danger (Figure 21.3).

Like most reportage painters, Paul Nash (British, 1889–1946) made sketches in the field and later developed them into easel paintings. Nash enjoyed a long and distinguished artistic career after serving as an official war artist in both world wars. In his sardonically titled *We Are Making a New World* (1918) (Figure 21.4), Nash's eerie landscape at dawn depicts unprecedented scarring of the earth in the aftermath of heavy bombings at the Western Front. The painting was a rallying call for peace, and hints at the Surrealist approach that would continue in Nash's later works.

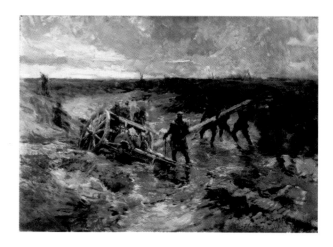

Figure 21.3
Alfred Theodore Joseph Bastien, *Canadian Gunners in the Mud, Passchendaele*, 1917. Oil on canvas, 24 × 34".
Bastien documented the conditions on the Western Front. Reproductions of his paintings appeared regularly in the *Illustrated War News*, a British war-time publication.

Beaverbrook Collection of War Art, Canadian War Museum.

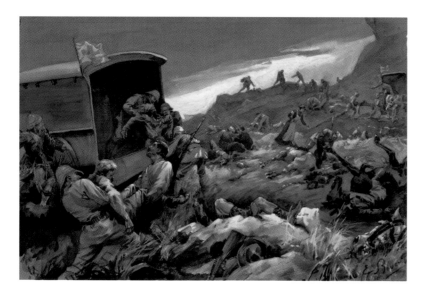

Figure 21.2
Ernest-Auguste Bouard, *Collecting Wounded*, 1900. Grisaille, 21 ⁴/₅ × 14 ¹/₅".
Bouard uses **grisaille**, a monochromatic technique in which shades of gray, black, and white achieve a three-dimensional effect. Having originated in the Renaissance, grisaille was fashionable among print illustrators in the late nineteenth and early twentieth centuries, taking advantage of the new tonal capabilities of halftone printing.

Anne S. K. Brown Military Collection, Brown University Library.

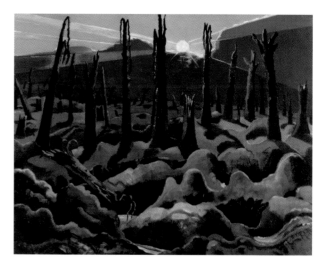

Figure 21.4
Paul Nash, *We Are Making A New World*, 1918. Oil on board, 28 × 36".
Nash depicted the landscape as evidence of man-made destruction. In a letter to his wife on November 16, 1917, Nash shared his concerns: "I am no longer an artist interested and curious, I am a messenger who will bring back word from the men who are fighting to those who want the war to go on forever. Feeble, inarticulate, will be my message, but it will have a bitter truth, and may it burn their lousy souls."
Imperial War Museum.

Theme Box 42: Yellow Journalism
by Thomas La Padula

As events unfolded that would lead to the Spanish–American War of 1898, a battle of a different sort waged between two giants of the American newspaper industry, the *New York Journal*, under William Randolph Hearst, and the *New York World*, owned by publisher Joseph Pulitzer. The papers increasingly relied on sensationalized headlines, speculative commentary, exaggerated stories, and illustrations to bolster circulation—tactics that came to be called **yellow journalism**. Hearst famously spent large sums sending reporters and illustrators out on location to "scoop" the news.

As the political situation in Cuba worsened, the *New York Journal* published hyperbolized accounts of rebel heroes, executions, and starving, mistreated women and children in order to excite sympathies and, of course, to sell papers. Frederic Remington (1861–1909), known for his illustrations of the American West, was sent to Cuba to capture the ongoing conflict between Spain and her colony. He submitted a shocking illustration of an anonymous woman being strip-searched by lecherous Spanish officials. The nudity was offensive or "yellow" enough by itself, but the newspaper descended into further

disrepute when it was discovered that Remington's illustration was untruthful: the woman was actually the sister of an insurgent and had been searched in private by a matron.

In another example of yellow journalism, when the battleship *Maine* mysteriously sank in Havana harbor in February of 1898, Hearst's *World* blamed the incident on the Spanish despite a lack of evidence. Inflamed, the public opinion outcry for revenge is thought to have influenced the U.S. declaration of war in April of 1898.

Why YELLOW Journalism?
The two newspapers famously squabbled over a popular comic featured in the *New York World* called *Hogan's Alley*, whose central character, the Yellow Kid, was invented by Richard Felton Outcault (Figure TB42.1) (*see Chapter 23*). Hearst lured the author-illustrator to the *New York Journal* at a higher salary to create a version of the strip retitled *McFadden's Row of Flats*, still featuring the Yellow Kid. Meanwhile, the *New York World* continued the original strip, now drawn by a new artist (George Luks). Both competitive strips were referred to as "the yellow kids" with the sensationalist journalistic style of

the two papers becoming known as "yellow journalism" by association (Figure TB42.2). The color yellow was already identified with other lowbrow fiction and sometimes scandalous periodicals such as the Arts and Crafts *Yellow Book* (*see Chapter 15*) and yellow-backs—cheaply reprinted fiction and other entertaining and sometimes tawdry reading in nineteenth-century Britain. The logical expansion of "yellow" to include sensationalistic journalism may have been a smear campaign against Pulitzer and Hearst by rival publishers competing for circulation numbers.

Further Reading
Baker, Nicholson, and Margaret Brentano, *The World on Sunday: Graphic Art in Joseph Pulitzer's Newspaper (1898–1911)* (New York: Bulfinch Press, 2005).

Brown, Joshua, *Beyond the Lines: Pictorial Reporting, Everyday Life, and the Crisis of Gilded Age America* (Berkeley: University of California Press, 2006).

Sloan, Bill, *I Watched a Wild Hog Eat My Baby: A Colourful History of Tabloids And Their Cultural Impact* (New York: Prometheus, 2001).

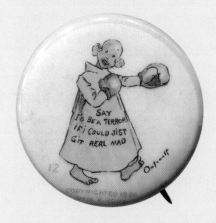

Figure TB42.1
Richard Felton Outcault, promotional button pin featuring comic strip character the Yellow Kid, 1896. 1 1/2 × 1 1/2".
Collection of George Hagenauer.

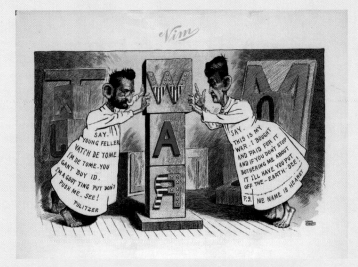

Figure TB42.2
Leon Barritt, "The big type war of the yellow kids," *Vim*, vol. 1, #2.
Library of Congress Prints and Photographs Division, Illus in. AP101.V55 1898 (Case X).

After the United States entered the war in April 1917, the War Department called on the Division of Pictorial Publicity (DPP) to stimulate support for the Allied cause on the home front. The president of the Society of Illustrators, Charles Dana Gibson, acted as art director for the effort and oversaw the DPP's creation of more than 700 poster designs and 1,400 other articles of propaganda.

Gibson handpicked eight illustrators to accompany and document the American Expeditionary Forces (AEF) to the front. Nicknamed "The Eight," the group included American illustrators J. André Smith (1880–1959), Walter Jack Duncan (1881–1941), George Matthews Harding (1882–1959) (Figure 21.5), William J. Aylward

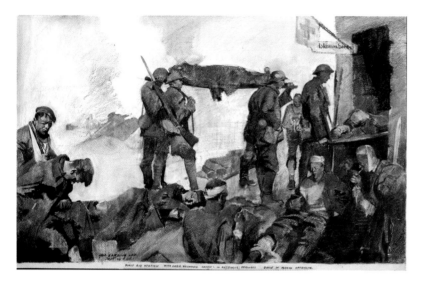

Figure 21.5
George Matthews Harding, *First Aid Station*, 1918. Mixed media, 18 ¼ × 29 ⅛".
Harding's image depicts the transport of battle casualties by German POWs forced to carry the wounded, thus allowing American troops to continue fighting.
Armed Forces History Division, National Museum of American History, Smithsonian Institution.

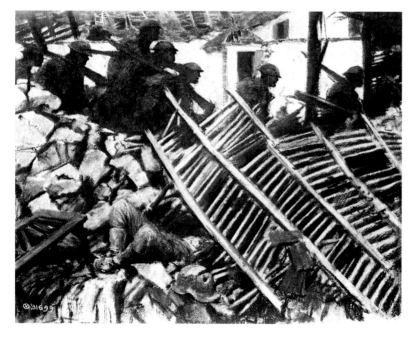

Figure 21.6
Harvey Dunn, *Among the Wreckage—Troops Going Forward at Night*, 1918. Oil, 26 × 33".
Harvey Dunn later described his artist-correspondent role as trying to show the "shock and loss and bitterness and blood of it all." He explained, "The pictures which I am delivering are of no specific place or organization, and while consequently may be lacking in fact, are not however barren of truth insofar as I have succeeded in expressing in them the character of the struggle and the men engaged."
Armed Forces History Division, National Museum of American History, Smithsonian Institution.

(1875–1956), Wallace Morgan (1875–1948), Ernest Piexotto (1869–1940), Harry Townsend (1879–1941) and Harvey Dunn (1884–1952) (Figure 21.6). Together, the AEF artists created over five hundred reportage drawings. With artists working as volunteers, the entire DPP art program economically cost the government just over 13,000 U.S. dollars.

While commissioned to create historic documentation of the U.S. Army's role in the war, the artists were first stationed in the rear, far from the fighting. They submitted bland artwork of little value as news or propaganda, so Harvey Dunn urged Army command to let his contingent go to the frontlines. There, artists filled sketchbooks with rapid, uncensored drawings portraying the gruesome side of combat with piles of casualties and utterly devastated landscapes. Because the physical reality of battle prevented the use of easels and canvas, finished works were painted later. Harry Townsend recalled, "What terrible things I saw and how sick of war I became and yet how fascinated. What subjects for pictures when we really got the opportunity later to do what we felt we could."

Reportage in World War II

World War II was the deadliest war of all time, with a death toll estimated at some fifty to eighty million lives, including battle casualties, postwar disease, and famine. It began with Germany's invasion of Poland in 1939 and soon expanded into a pan-Eurasian conflict that devastated much of Europe, Asia, and North Africa by its end in 1945.

American War Artists

With the Japanese bombing of the U.S. naval base at Pearl Harbor, Hawaii, in 1941, the United States joined the Allies against the Axis Powers. Inspired by the success of the DPP during WWI, the U.S. military again supported artists on all fronts in Europe, Asia, and the Pacific. The artists were commissioned and trained like any soldier, and like their predecessors, created finished paintings in the rear, away from the fighting. They were encouraged to capture everything: the dead and dying and the daily lives of soldiers, from the most devastating to the most mundane. Realism was not requisite; rather, artists were asked to bring back a record in whatever form inspired them. By the end of the war, over two thousand works were created—all the property of the U.S. Government.

Nongovernment Sponsors of War Art in the United States

Life magazine, an American weekly publication, began covering war preparations in 1941. In 1943, the military art program lost its Congressional funding and deactivated the war art unit. *Life*, known for its photojournalism, seized the opportunity to engage many of the sidelined civilian artists to travel with the U.S. Armed Forces to capture combat and military life on behalf of the magazine.

Compassion for soldiers was nearly universal in war art, and apparent in *Life* artist Tom Lea's (American,

1907–2001) *The Two Thousand Yard Stare* (Figure 21.7) in which a battle-fatigued soldier is seemingly numb to the explosive air battle going on in the distance. On the ground behind him, another soldier slumps in front of the wheels of a tank—exhausted or injured.

Abbott Laboratories provided pharmaceutical and medical supplies to the branches of the U.S. Armed Forces in WWII. The company sponsored artist-correspondent Kerr Eby (Canadian, American, 1890–1946) to accompany U.S. Marines in the Pacific. Eby, a pacifist, served as an enlisted man in WWI and later created some of the most stirring artwork of WWII. His *Ebb Tide* (Figure 21.8), for instance, manages to communicate an overall sense of foreboding before the viewer comprehends the dark masses are figures motionless in the surf. Eby's persistent factual documentation of the cruelty of war honored the soldiers in work he considered both reportage *and* dissent.

U.S. Military Publications

In June of 1942, the first issue of *Yank, the Army Weekly* was published. Completely staffed by enlisted men, *Yank* went through twenty-one overseas editions in seventeen countries, eventually reaching a circulation of 2,600,000. The main edition, priced at five cents, consisted of twenty-four pages and included news from the war and home fronts, letters to the editor, "girlie" pin-ups, and cartoon strips.

Howard Brodie (American, 1915–2010) was a newspaper illustrator for the *San Francisco Chronicle*

who enlisted in the army and covered the war for *Yank* in both the Pacific and Europe. In *Battlefield Execution* (Figure 21.9), Brody captures the weight of the executed soldier slumping forward as blood flows from his mouth. After the war, Brody became a courtroom artist before returning to combat art in Korea, Indochina, and Vietnam.

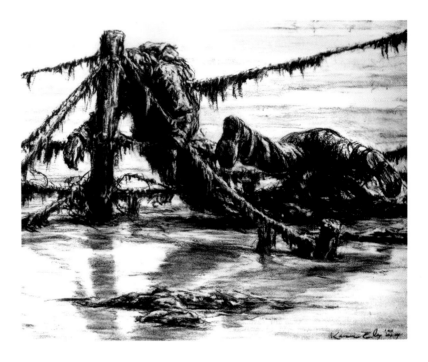

Figure 21.8
Kerr Eby, *Ebb Tide*, 1943. Charcoal on paper, 21 1/$_2$ × 29 1/$_2$".
Eby's dense charcoal drawing camouflages the figures caught on the barbed wire in contrast with the smooth tones of their placid, watery grave.

Navy Art Collection, Naval History Heritage Command.

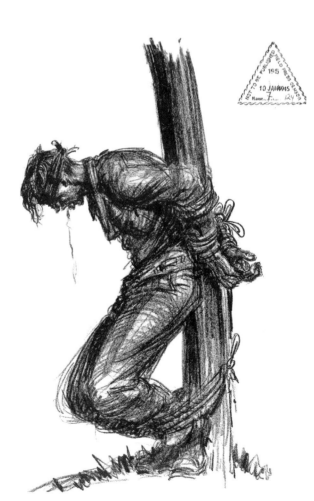

Figure 21.9
Howard Brodie, *Battlefield Execution*, 1945. Pencil on paper, size unknown. Brodie's rendering of one of the three German soldiers he witnessed being executed as spies was later censored by the US Office of Censorship, which was established to control information concerning Allied troops. Brodie said, "To see these three young men calculatingly reduced to quivering corpses before my eyes really burned into my being." A triangular censor's stamp is shown in the upper-right corner.

U.S. Army Center of Military History.

Figure 21.7
Tom Lea, *The Two Thousand Yard Stare*, 1944. Oil on canvas, 36 1/$_2$ × 28 1/$_2$".
Realistically rendered, the saucer-eyed marine's expression reveals the exhaustion and fear of combat. The "thousand yard stare" was a mid-century term for battle fatigue, now considered an early sign of post-traumatic stress.
U.S. Army Center of Military History, Fort Belvoir, Virginia. Image courtesy of the Tom Lea Institute.

The Army newspaper *Stars and Stripes* was under the command of the Army Signal Corps during World War II. The publication ranged from four to eight pages, and circulated in several theaters of military operation. In addition to war and home front news, human-interest stories, and sports, the paper featured cartoons by the American cartoonist Bill Mauldin (American, 1921–2003). His characters Willie and Joe showed the "average combat soldier" with bittersweet black humor that was popular with the soldiers and good for army morale. *Willie and Joe* earned Mauldin a Pulitzer Prize (Figure 21.10).

War Art of the British Commonwealth

Art historian and director of the National Gallery Kenneth Clark (English, 1903–1983) devised the British War Artists Advisory Scheme, administered by the War Artist's Advisory Committee (WAAC) under the auspices of the Ministry of Information. The British government emphasized that recording the war was not just documentation, but interpretation.

Like Great Britain, the Australian and New Zealand governments handpicked and distributed artists among their forces in all theaters of war. Canada also sent thirty-one war artists to record life on the home front and battlefield, and they created nearly five thousand works. Canadian Molly Lamb Bobak (1922–2014), a rare female war artist, enlisted in the Canadian Women's Army Corps (CWAC) in 1942 and maintained a detailed illustrated journal of her military service from life in the barracks to her many travels, literally across the country.

Bobak was also the lone woman among a group of male war artists sent overseas to London and the Netherlands in 1945 to record the aftermath of the war.

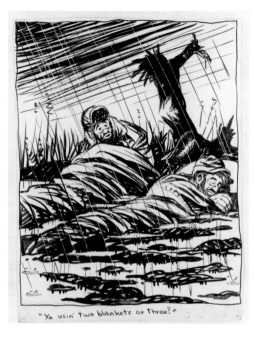

Figure 21.10
Bill Mauldin, "Ya usin' two blankets or three?" *Stars and Stripes*, ca. 1943–1945. Pen and ink, 26 × 19".
Willie and Joe are always shown tattered, fatigued, mud-soaked, and grousing about their dislike of the Army.

Copyright by Bill Mauldin (1945). Courtesy of Bill Mauldin Estate LLC. Photo: Library of Congress.

Rather than recording with academic realism, Bobak's painting invites interpretation through a style somewhat reminiscent of Post-Impressionism (Figure 21.11).

Official War Art of Nazi Germany

Axis artists also chronicled combat in WWII. Starting in 1941, German reportage artist-soldiers along with journalists and photographers were assigned to the staffs of all military units. Referred to as Propaganda Kompanie (Propaganda Company) each "PK" crew included a *Kreigsmaler* (war painter) or a *Presszeichner* (press draftsman). Impressed by their work, Hitler centralized the program in 1942 into a division called the *Staffel der bildenden Künstler* (Squadron of Visual Artists) under the guidance of Captain Luitpold Adam (German, 1888–1950), a WWI veteran and third-generation war artist. German artists were not required to depict combat, and were given a great deal of freedom to memorialize the war with imagery characterizing places, buildings, and people as a form of cultural documentation.

Artists created sketches during rest periods in the field, and superiors reviewed these sketches at the end of each assignment. The artists returned to studios to develop the select compositions into completed paintings. Given the general Nazi preference for traditional realism, most works were competent but not particularly innovative. Pieces were displayed in military headquarters in Germany as well as in occupied foreign cities, and some were published in periodicals or printed as postcards and book illustrations.

In 1942–1943, German publisher Carl Werner issued two albums of Hans Liska's (Austrian, 1907–1983)

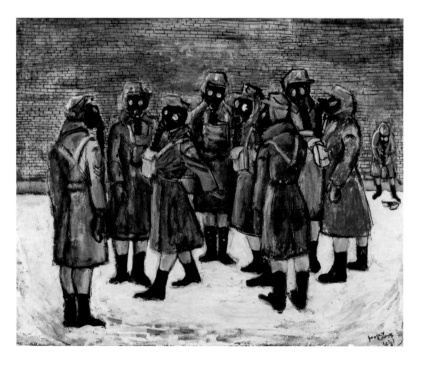

Figure 21.11
Molly Lamb Bobak, *Gas Mask Drill*, 1944. Oil on canvas, 27 × 34".
Bobak's work gives a rare glimpse into the lives of the CWAC. Here, she captures the awkwardness of a group of conscripts testing out their gas masks in frigid weather.

Beaverbrook Collection of War Art, Canadian War Museum.

sketchbook drawings depicting the drama of war. In *Der Tiger* (Figure 21.12), Liska captures the movement of a massive tank maneuvering through urban rubble. The specificity of the architectural ruins in silhouette, the details of the vehicle, the uniforms, and even the posture of the soldiers give the image an air of veracity.

Japanese Reportage

Japanese WWII documentary painting (*senso sakusen kirokuga*) continued much of the tradition of exaltation found in turn-of-the-century woodblock (*senso-e*) prints. However, images were painted in oils depicting volumetric forms with believable light, shadow, and perspective depth. The content was heavily controlled by the state, which propagandistically positioned the adversity of war as momentous heroism (Figure 21.13).

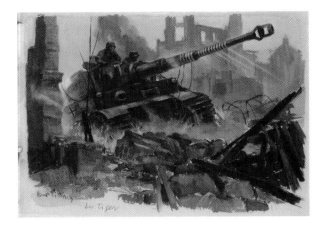

Figure 21.12
Hans Liska, *Der Tiger*, from his sketchbook, 1942.
Liska's *Der Tiger* convincingly conveys the gravitas of the moment as a tank moves through a devastated cityscape.

Deutsches Historiches Museum, Berlin. © 2018 Artists Rights Society (ARS), New York / VG Bild-Kunst, Bonn, Image: Library of Congress.

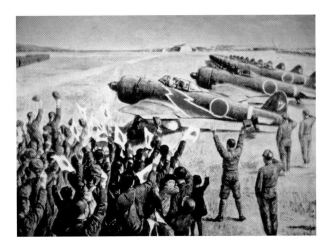

Figure 21.13
Ihara Usaburo, *The 89th Suicide Unit Takes Off from Nakaminato Base*, 1943. Lithograph made from original oil painting.
Japanese war art glorifies the exploits and victories of the Imperial Army and Navy as in this image celebrating *kamikaze* (suicide mission) planes departing, as flag-waving crowds cheer.

Private collection. Peter Newark Military Pictures, Bridgeman Images.

Propaganda

While reportage may have emotional impact, its intention is to record events. Propaganda, on the other hand, is inherently published to shape events by encouraging viewers to believe and perhaps act on the rhetoric communicated.

WWI Propaganda in the United States, Britain, and France

While photography became increasing popular in the early twentieth century, the illustrated poster, with its bold, colorful imagery and lettering, continued to be a popular form of mass communication. Propaganda posters often involved an element of urgency communicated through "direct appeal" from compelling persons, such as an official, a victim, or a widow. Narrative realism dominated WWI posters created by Allied artists. Major topics were the promotion of enlistment, the purchase of bonds to fund the war effort, and the conservation of staples like sugar, rubber, and gasoline.

The poster *I Want You For U.S. Army* (1917) by James Montgomery Flagg echoed a similarly confrontational British design from 1914 that featured Lord Kitchener, Secretary of State of War, in the same pose. By the war's end, Flagg's illustration had been reproduced four million times and is still in use as a recruiting tool today (Figure 21.14).

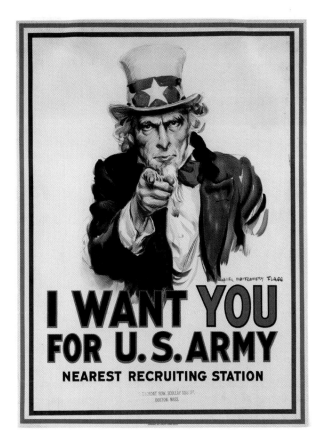

Figure 21.14
James Montgomery Flagg, *I Want You For U.S. Army*, ca. 1917. Lithograph, 39 1/2 × 29 1/4".
Flagg's iconic image, based on a self-portrait, originally appeared as a cover illustration for *Leslie's Magazine* with the title, "What are you doing for Preparedness?"

Library of Congress.

Theme Box 43: Adorno: Subjectivity, Objectivity, and the Culture Industries
by Sheena Calvert

Theodor W. Adorno (German, 1903–1969) was a member of the Institute for Social Research at the University of Frankfurt, nick-named the **Frankfurt School**, a group of philosophers and Marxist socialists who critically analyzed European and American society before, during, and after World War II. Adorno's interdisciplinary work scrutinizes aesthetics, politics, social theory, and the culture industry (loosely understood as the mass media), drawing critical attention to how modernity was having a negative impact on human life. He is known as a radical thinker, especially within the area of **epistemology**: the theory of knowledge and how it is formed.

In their influential treatise *The Dialectic of Enlightenment* (1947), Adorno and collaborator Max Horkheimer (German, 1895–1973) challenge unexamined rationality and regard faith in the existence of objective knowledge as a dangerous legacy of the Early Modern (or, Enlightenment) period. Insistence on objective truth is *not* rational (ironically) because the war, social injustice, and ignorance that reason was supposed to end still prevail in society. In fact, objectivity, which negates personal emotional response, is (arguably) allowing these terrible things to occur. Adorno wishes instead to resurrect subjectivity as the origin of ethical conduct.

Subjectivity and Objectivity
Subjectivity has actually always been entangled in supposedly objective study. What is a fact? How do we establish what counts as an objective fact, or truth—untainted by personal bias, prejudice, opinion, hearsay, taboo? One of the aims of medical, technical, and courtroom illustrators is to bring together information from multiple perspectives to distill a form that is as objective as possible. But there are always subjective (personal and cultural) dimensions affecting perception and the choices made about what to include and exclude. Because we are historically constituted beings shifting with changing attitudes that impact what counts as knowledge at any given time, Adorno reminds us that: "The distinction between subject and object is both real and illusory." Our objectivity can never be 100 percent because we can never completely escape our own subjectivity, our own world view.

The very act of illustrating something establishes a semblance of truth by stabilizing and objectifying verbal and visual ideas into concrete pieces of knowledge. Publishing may bestow a kind of "factualness"—Adorno's word—on words and images, even fantastical ones. The choices of how to represent and what to represent are necessarily editorial. How the author balances his or her objectivity (ability to set aside personal idiosyncrasy) and subjectivity (ability to express things from a personal point of view) becomes very important. Unfortunately, Adorno proposes, the individual's ability to make and consume cultural products such as books and pictures with purposeful, conscientious attention to negotiating objectivity and subjectivity has been injured by the *culture industry*.

The Culture Industry
Adorno critiques late capitalism and its dumbing-down of all areas of social, political, and cultural life, hoping to effect a total transformation of society, to keep it from falling into fascism—a concern quite personal to him since National Socialism (Hitler and the Nazi Party) had forced Adorno and his colleagues into exile.

Adorno theorized that capitalism takes all forms of creative output and reduces them to mere commodities, regardless of what other values they may have. Observing that "Everything has value only in so far as it can be exchanged, not in so far as it is something in itself," in *The Dialectic of Enlightenment*, Adorno points out how mass culture sells itself out very quickly to the "hyper-commercialization" of late capitalism. This means that illustration work becomes subject to the conditions of clients, publishers, distributors, and marketers; losing its ability to mount a meaningful critique of the society that produces it. Illustrations become objects within the marketplace: things to be bought and sold, rather than cultural agents that have another (or additional) purpose within society.

The effect of capitalism on creativity is to sort and package a wide range of expression into convenient, simplified genres that have lost touch with their cultural origins and richness of experience. An example of this would be the way in which street art and graffiti have been taken up by mainstream companies and used to promote products such as sportswear. Such companies exploit the specific urban context from which the designs emerged, recontextualizing them according to a generalized identity they have devised to fit large-scale production and merchandising over vast geographic areas. The result, Adorno would argue, is that these once-radical acts of culture become nothing but another aspect of the mainstream marketplace.

According to Adorno, culture industry products cater to an easy sort of mindless consumption that distracts consumers from real engagement with pressing matters and that erode people's self-knowledge and ability to reflect and engage meaningfully with life. Graffiti becomes a fashion statement, a "look," rather than a call to action or a personal expression. Such erosion of subjectivity in mass culture, for Adorno, explained why the German public acquiesced to fascism and the consequent horrors of World War II.

Adorno's thought has been hugely influential among critics of commercial and popular culture and mass media. Defenders of popular culture and those who study **audience reception** (how consumers and audiences actually use and interpret media), however, argue that the concept of "mass" is totalizing and snobbish, pointing out that popular culture forms frequently

provide agency for users, and that individuals engage with them in highly varied and selective ways to build unique identities. Some have also looked optimistically to social media, where, despite control of the Internet as a mass communication medium by hegemonic corporations and legal and illegal authorities, subjectivity is valued as a way to build unique identities

and provide agency for marginalized individuals and collectives.

Further Reading
Adorno, T. W., *Dialectic of Enlightenment* (Stanford: Stanford University Press, 2007).

Adorno, T. W., "Subject and Object," reprinted in Arato and Gebhardt,

eds., *The Essential Frankfurt School Reader* (New York: Urizen Books, 1978): 497–511.

Adorno, T. W., and M. Horkheimer, translated by Anson G. Rabinbach, "The Culture Industry Reconsidered," *New German Critique,* vol. 6, Fall 1975: 12–19.

Indirect appeals were also effective, as in Savile Lumley's (British, 1876–1960) *Daddy, what did YOU do in the Great War?* (Figure 21.15) in which a daughter's question shames her father, while the son exhibits "appropriate" instincts by playing with toy soldiers. The image invites men to imagine looking back at their avoidance of service with self-reproach.

The dynamic design of *On les aura* (*We'll get them!*), by Jules-Abel Faivre (French, 1867–1945), relies on expert

modeling of the diagonal figure—evidence of Faivre's academic training at the École des Beaux-Arts, Lyon; while the lettering appears to be a handwritten message from the soldier to his countrymen (Figure 21.16).

Fear mongering was also a common tactic in propaganda, and depictions of a dehumanized foe made the enemy easier to fear and hate. *Destroy This Mad Brute* by H. R. Hopps (American, 1869–1937) portrays a German soldier as a fanged gorilla coming ashore in

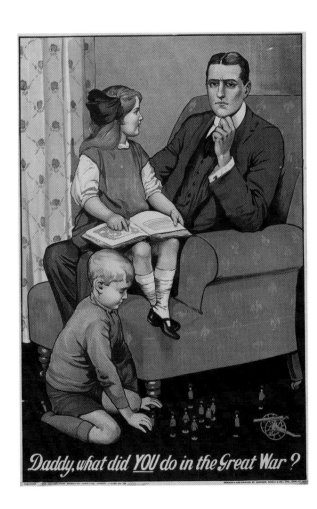

Figure 21.15
Savile Lumley, *Daddy, what did YOU do in the Great War?* 1915. Lithograph, 30 × 19 ¹/₂".
This indirect approach uses shame as motivation for enlistment. The message, that nonparticipation would haunt the intimate areas of domestic life, is presented with a nostalgic feel reminiscent of picture book illustration of the time.
© IWM.

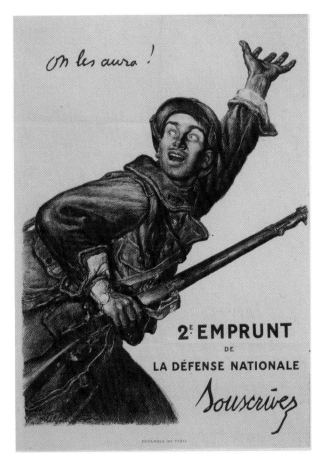

Figure 21.16
Jules-Abel Faivre, *On les aura! 2e Emprunt de la Défense Nationale. Souscrivez. (We'll get them! The 2nd National Defense Loan, Subscribe)*, 1916. Lithograph, 45 × 31 ¹/₂".
The sure draftsmanship of this poster shows Faivre's academic training and is quite unlike his caricatures of the bourgeois and professional classes drawn for periodicals. The hand-lettered plea implies a personal message or perhaps correspondence with a family member in the service.
Library of Congress.

America, with a distressed, half-naked woman in his arms (Figure 21.17).

The equally provocative *That Liberty Shall Not Perish* by Joseph Pennell (American, 1857–1926) envisions the Statue of Liberty and New York harbor in flames, presumably for having been vulnerable due to lack of funds for defense. Celebrated for his pen-and-ink illustrations, Pennell was also well known as a printmaker, having produced over 1,500 etchings and lithographs. He wrote several books on drawing and lived in Europe, returning to the United States just prior to the country's entry into WWI (Figure 21.18).

Government-controlled posters often included personifications of the state. The British had John Bull

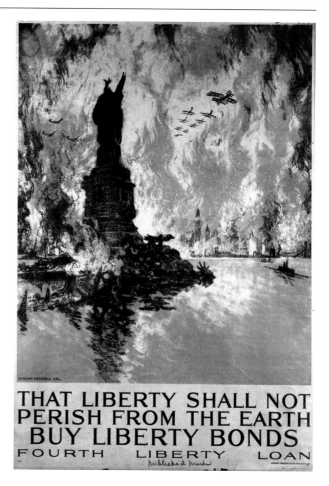

Figure 21.18
Joseph Pennell, *That Liberty Shall Not Perish From The Earth—Buy Liberty Bonds Fourth Liberty Loan*, 1918. Lithograph, 41 × 30".
The message was a foreboding appeal to contribute financially to America's efforts in the war overseas, lest the destruction make its way to the United States.
Library of Congress.

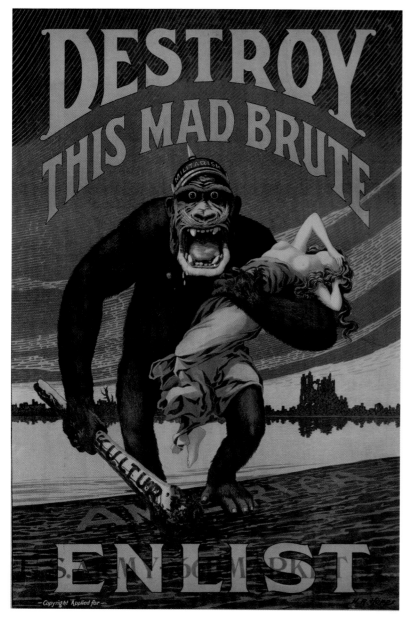

Figure 21.17
Harry R. Hopps, *Destroy This Mad Brute: Enlist*, ca. 1917. Lithograph, 42 × 28".
The intense color and hearty delineation of shapes make this a powerful image even from a distance. Gradations of shading in the sky are made with patterns of parallel lines in flat color, a stylistic technique originating in wood and metal engraving. U.S. Army 660 Market St. is printed over the word ENLIST and refers to the San Francisco recruiting station.
Library of Congress.

and Britannia; Marianne was the symbolic female embodiment of France; and American symbols included Uncle Sam, Columbia, and Liberty. The latter appears armed with a shield, reaching for an oversized sword reverently offered by a Boy Scout, in J. C. Leyendecker's (American, 1874–1951) Third Liberty Loan poster (Figure 21.19). The image equates buying bonds with equipping "Liberty" for battle.

Plakatstil

First credited to Lucian Bernhard (German, 1883–1972) in 1906, **Plakatstil** (Poster style) utilized flat, simplified shapes on plain colored backgrounds. *Plakatstil* designs were printed using lithography, usually with minimal but aesthetically considered lettering. Popular in advertising, the bold technique read easily and quickly from a distance, and was often used in German propaganda. Ludwig Hohlwein's (German, 1874–1949) *Ludendorff-Spende fur Kreigsbeschadigte* (*The Ludendorff Appeal for the War Disabled*) exemplifies *Plakatstil* with simplified forms and restricted palette (Figure 21.20).

Russian Poster Art: The Interwar Period

During WWI, Russia's internal divisions erupted in a revolution that began in 1917 and continued until 1922. Bolshevik forces promoted communist ideology through posters, oratory, theater, film, and traveling exhibits approved by the Agitation and Propaganda Section of the Central Committee of the Communist Party (later referred to as **agitprop**). Images played an important part in Bolshevik communication due to high rates of illiteracy among the populace.

During the revolution, a group of writers and artists referred to as the **ROSTA Windows** collective spread political messages through posters that were hung in kiosks, railway stations, and empty windows. Named after the Russian Telegraph Agency, the group mass-produced designs using cardboard stencils. The folk-art inspired posters combined bold, graphic images with simple prose or slang to communicate with a largely illiterate audience (Figure 21.21).

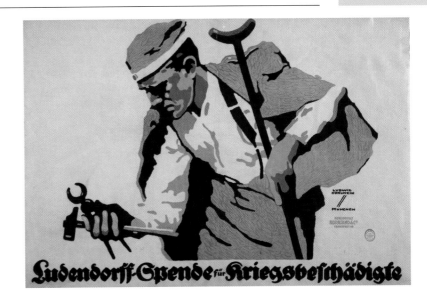

Figure 21.20
Ludwig Hohlwein, *Ludendorff-Spende fur Kriegsbeschadigte (The Ludendorff Appeal for the War Disabled)*, 1917. Lithograph, 24 × 35".
The soldier's graceful posture elicits empathy while the dignified neutral palette gives weight to the difficult circumstances he faces.

Library of Congress.

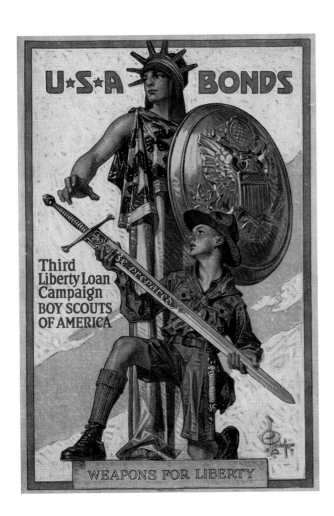

Figure 21.19
J. C. Leyendecker, *U.S.A. Bonds, Third Liberty Loan Campaign, Boy Scouts of America*, 1917. Lithograph, 30 × 20".
Leyendecker's academic training at the Académie Julian in Paris informs this depiction of Liberty accepting the sword of battle.

Library of Congress.

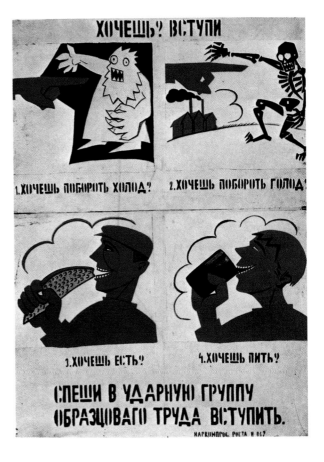

Figure 21.21
Vladimir Mayakovsky, *If You Want Something, Join Us*, ROSTA Window no. 867, 1920. Stencil, size unknown.
This ROSTA propaganda urges anyone cold or hungry (top) to join a strike group so that they can eat and drink (bottom). Over time, standardized symbols and color-coding of the figures made it easy for viewers to distinguish the worker from the power class or from foreign military figures. The posters varied in size from 35" to 86" in height, and 27" to 87" in width.

Collection of the Russian State Library, Moscow, Getty Images.

Early revolutionary posters were also influenced by avant-garde experimentation that featured dynamic asymmetrical compositions, bold typography, and abstract, eye-catching imagery (*see Chapter 19*). When Stalin came to power in 1924, posters emphasized rapid industrialization and proclaimed the Soviet Union a self-sufficient world power. Valorizing the struggle of nation building, machinery came to symbolize the advantages of mechanization and progress made possible by united leadership—an important issue because of the divisive power struggles within the early Union of Soviet Socialist Republics (USSR) (Figure 21.22).

Mid-twentieth-century communist posters often depicted subjects in a style referred to as **Socialist realism**, which idealized political figures and showed the common man as a noble comrade. Vera Sergeyevna Korableva's (1881–1950) poster (Figure 21.23) depicts

farm workers as happy, well fed, and suntanned despite the forced consolidation of peasant lands into state-owned farms in a policy of **collectivization**.

Nazi Propaganda

The 1919 Treaty of Versailles that ended WWI required disarmament, reparations, and territorial concessions from the newly formed German Weimar Republic. Worsening conditions during the Great Depression and divisions within the parliamentary democracy gave rise to the National Socialist German Workers' Party (Nazi Party). Led by Adolph Hitler, the Nazis' anti-Communist stance appealed to the conservative elite, while their anti-Semitic propaganda blamed Germany's postwar degradation on Jews by aligning them with Germany's enemies as part of the anti-Jewish ideology that ultimately led to genocide (Figure 21.24).

The Nazis controlled the media and spread their ideology through film, music, news, radio, and visual propaganda. Labeling avant-garde art "degenerate," Hitler mandated that art of the Third Reich adopt traditional approaches. Designs often employed traditional Germanic **blackletter** fonts or referred stylistically to folk art to cultivate a sense of nationalism.

Hitler was fascinated with "faultless, sports trained bodies," a concept first articulated in his book *Mein Kampf* (1924). Nazi propaganda later sought to inculcate

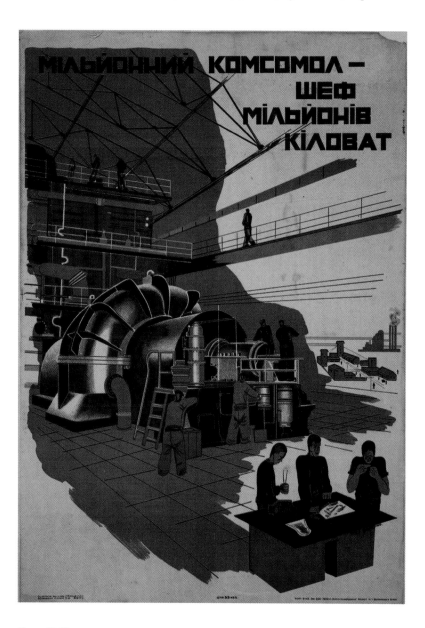

Figure 21.22
G. Gritsenko, *One Million Komsomoltsy—Master of One Million Kilowatts*, 1931. Lithograph, 29 × 20".
This poster celebrates the modernization efforts of the Bolsheviks. The luster of the new metal equipment contrasts the otherwise flat application of color throughout the illustration. Due to innovations by ROSTA Windows, red was strongly associated first with the soldier/worker and then with communism, making red ubiquitous in Russian poster designs.
Dr. Harry Bakwin and Dr. Ruth Morris Bakwin Soviet Posters Collection, Special Collections Research Center, The University of Chicago Library.

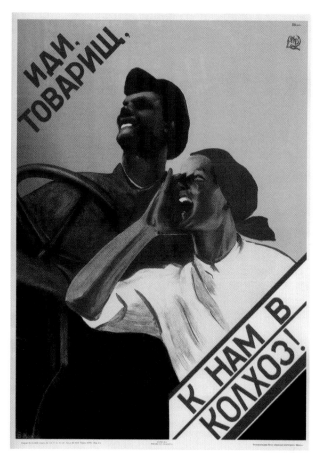

Figure 21.23
Vera Sergeyevna Korableva, *ИДИ ТОВАРИЩ К НАМ В КОЛХОЗЕ! (Come Comrade, Join Us in the Collective Farm!)*, 1930.
An example of Socialist realism, this poster implies happiness and gender equality among farm workers in Soviet Russia, posed here with modern farm equipment.
Heritage Images/Getty Images.

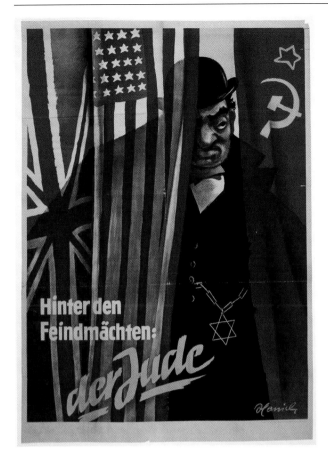

Figure 21.24
Bruno Hanich, *Hinter den Feindmächten: der Jude (Behind the Enemy Powers: The Jew)*, 1943. Lithograph, 33 × 23 ¹/₄".
This defamatory propaganda image implies Jews are behind the actions of the Allied powers.
U.S. Holocaust Memorial Museum.

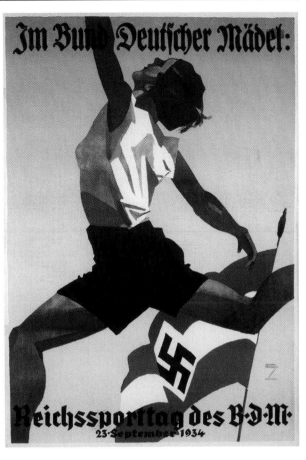

Figure 21.25
Ludwig Hohlwein, *Reichssporttag des B.D.M. (Reich Sports Day of the Association of German Girls)*, September 23, 1934. Lithograph. The paradoxical pairing of the simplified *Plakatstil* illustration with the older blackletter font signaled that modern Germany would honor traditional German values.

Library of Congress.

a sense of nationalism by promoting Germans as the "master race"—superior, pure, and healthy. The health of women, as prospective mothers of this race, became a matter of state concern. The illustration *Reich Sports Day of the Association of German Girls* (1934), created by Ludwig Hohlwein, shows an athletic young woman leaping in front of a waving flag—her arms extended and head thrown back in an exuberant gesture. Images such as this appeared in prominently displayed posters as well as in women's magazines such as *Frauen Warte* (*Women Wait*), the Nazi Party's biweekly magazine (1935–1945) that had a circulation of 1.9 million in 1939 (Figure 21.25).

WWII War Propaganda

Posters from the British Commonwealth

The pressures of World War II revealed internal fault lines within the British Empire. India, already pushing for home rule, was assailed by anti-British propaganda from the Japanese and Germans; and Australia, which had joined Britain immediately in the war against Germany, was forced to divert its forces back to the Pacific to fight Japan. The poster *Together* promoted unity under the British flag by projecting a unified Empire seemingly free from internal fissures (Figure 21.26).

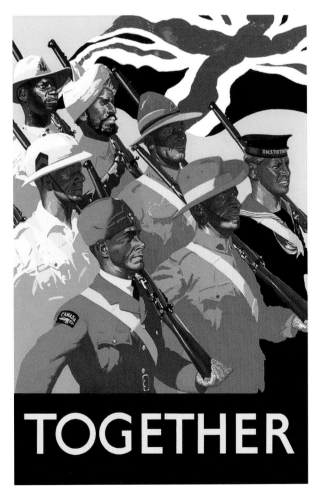

Figure 21.26
Anonymous, *Together*, ca. 1939. Lithograph, 29 ⁷/₈ × 20". With members of various Commonwealth military forces marching together, this poster promotes the unity of the British Empire as implied by the compact diagonal composition. Front row, left to right, are a Canadian airman, an Australian soldier, and a Royal Navy sailor. The second row includes a soldier each from South Africa and New Zealand, followed by soldiers from India and East Africa.

Ministry of Information, © IWM.

Figure 21.27
Harold Forster
(attributed), *Keep
Mum She's Not
So Dumb*, 1942.
Lithograph,
30 × 20".
Keeping secrets
safe from spies was
a common WWII
poster subject. This
design admonished
commissioned
ranks to be vigilant
when their guard
was most likely
down. The cen-
tral female figure
connects with the
viewer as she looks
out from the poster
knowingly.
© IWM.

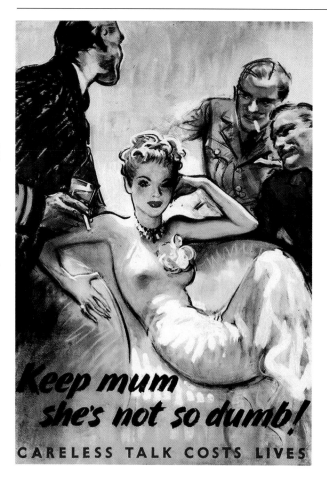

Much Allied propaganda warned against "harmless chat," "loose lips," and the danger of being overheard discussing wartime activities in casual conversation. An unusual example of British propaganda is *Keep Mum She's Not So Dumb* (1942), which shows officers from the three branches of British military service at a social event with a beautiful woman, who is potentially a nefarious spy (Figure 21.27). The press dubbed the blond in this poster "Olga Polovsky" after a popular tune, "Olga Pulloffski, The Beautiful Spy" (1935). The rendering is loose and dramatically lit, a style more common in magazine fiction than propaganda of the era.

Posters promoted public service, urged conservation, and encouraged individual resourcefulness. Abram Games's (British, 1914–1996) *Grow Your Own Food* utilizes a clever synthesis of form to associate growing food with eating it in an illustration that focuses on a solution rather than the problem of food shortages (Figure 21.28).

Games also created some of the more controversial posters of the war, including *This Child Found a Blind* (Figure 21.29), a disturbing composition showing a central red coffin with a cutaway to reveal a child inside. While each element is highly rendered, they remain disconnected because of their unique styles and unnatural coloration. The bottom edge of the casket transforms into an arrow pointing to the unexploded ordnance (called a "blind" in contemporary parlance), as an explosion takes place on the horizon.

Figure 21.28
Abram Games,
*Grow Your Own
Food*, 1942.
Lithograph,
30 × 19".
Games was an
innovative poster
designer who said
of himself and his
work, "I wind the
spring and the
public, in looking at
the poster, will have
that spring released
in its mind." His
influence as a
designer continued
in postwar Britain.
© IWM.

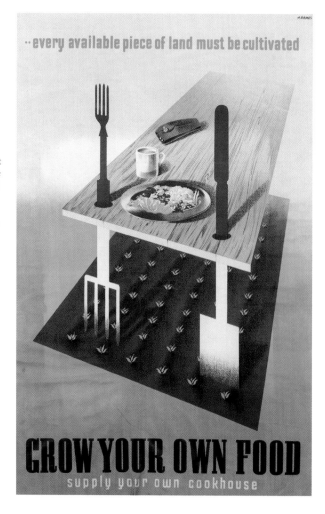

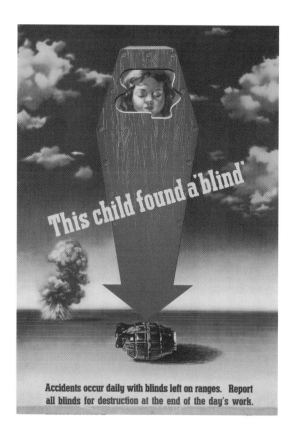

Figure 21.29
Abram Games, *This Child Found a 'Blind,'* ca. 1943. Lithograph, 29 × 19".
This design uses cautionary colors and combines carefully rendered
forms in a sinister dreamscape communicating the dangers of handling
unexploded ordnance.
© IWM.

Wartime Propaganda in the United States

When it became apparent the United States was going to enter the war, the acceleration of industrial production became necessary. Designers and illustrators working under the auspices of government agencies and private corporations promoted industrial growth in answer to the challenge, as seen in the 1942 poster by Jean Carlu (French, 1900–1997) (Figure 21.30). The design favors a dynamic and conceptual integration of text with image over traditional compositional approaches that typically separated headlines from image and explanatory text.

In contrast to more modernist approaches, Norman Rockwell, known for his *Saturday Evening Post* covers (*see Chapter 24*), painted four narrative images that proved highly successful in promoting government bonds. Inspired by President Franklin D. Roosevelt's 1941 address that articulated American values—Freedom of Speech, Freedom of Worship, Freedom From Fear and Freedom From Want—Rockwell's paintings expressed harmony, humility, and middle-class prosperity. Initially refused by the Army, the four paintings were first published by the *Saturday Evening Post* in 1943 and proved so popular that the Treasury Department, with the support of the *Post*, sent them and a selection of other *Post* originals on a traveling exhibition to promote the sale of war bonds. Four million sets of Rockwell's prints were made—many distributed as premiums for bond purchases in a program that raised over 130 million dollars (Figure 21.31).

The expansion of defense manufacturing during WWII concurrent with the deployment of males to military service created a deficit of production workers in the United States. From 1940 to 1945, women joined the American workforce in unprecedented numbers with an increase in the percentage of females in the workforce from a prewar estimate of 25 percent to over 35 percent. One of the most enduring images of the era is *We Can*

Do It by J. Howard Miller (American, 1918–2004) (Figure 21.32), a poster issued in 1943 for display in Westinghouse Company factories. Its purpose was not to recruit women, but rather to encourage the female labor force to work harder at war production.

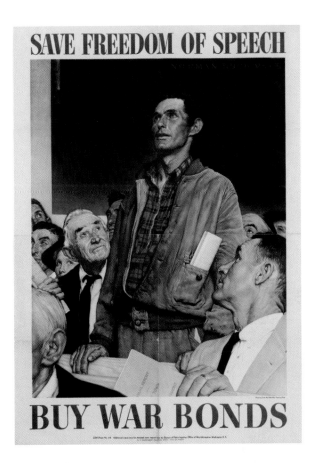

Figure 21.31
Norman Rockwell, "Save Freedom of Speech" from poster series *The Four Freedoms*, 1943.
The Four Freedoms—Freedom of Speech, Freedom of Religion, Freedom From Fear, and Freedom From Want as articulated by President Franklin Roosevelt in his 1941 address, became potent visual icons when interpreted by Rockwell.

The Norman Rockwell Museum.

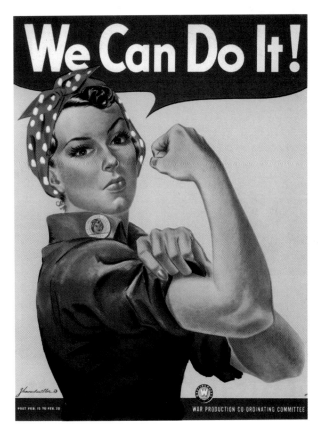

Figure 21.32
J. Howard Miller, *We Can Do It!*, ca. 1943. Lithograph, 22 × 17". Although this poster encouraged female factory workers, most lost their positions when veterans returned home. Rediscovered in the 1980s, the image became a symbol for the feminist movement. The character was dubbed "Rosie the Riveter" after a popular song of the 1940s.

Smithsonian Institute.

Figure 21.30
Jean Carlu, *America's Answer! Production*, 1942. Offset lithograph, 30 × 40". Carlu's award-winning poster shows the influence of European avant-garde precedents. The intersection of headline and gloved-hand illustration cleverly incorporates the turn of the wrench on a nut head with the letter *O* of the key word *Production*.

Smithsonian Institute.

WWII Propaganda Aimed at Children

Propaganda for children was created on both sides of the WWII conflict. The Soviet Union, for instance, published many picture books for children that promoted the ideology of the state. Early Soviet children's books were

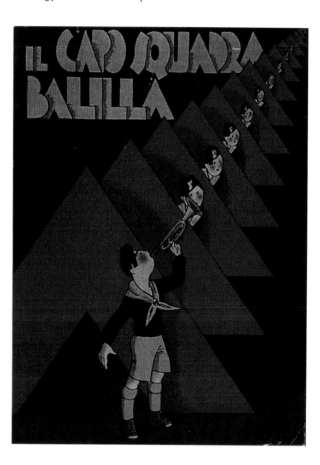

Figure 21.33
Raul Verdini, cover art, *Il Capo-squadra Balilla*, 1934. Lithograph, 7 ³/₈ × 5 ¹/₂".
This cover exhibits Futurist (*Chapter 19*) influences, as the step-repeat design implies time, space, and sound.

Edizione a cura della Presidenza Centrale dell'Opera Balilla, Rome, publisher. The Wolfsonian–Florida International University, Miami Beach, Florida, The Mitchell Wolfson, Jr. Collection, 83.2.551. Photo: Lynton Gardiner.

brightly colored with highly abstracted forms influenced by Constructivism (*see Chapter 19*); later illustrations reflected the general evolution toward realism in Soviet art.

The Third Reich indoctrinated children through organizations like Hitler Jugend (Hitler Youth) and Bund Deütscher Mädel (League of German Girls), while Italy's Benito Mussolini promoted fascist ideology to children through compulsory education and a paramilitaristic youth organization, Opera Nazionale Balilla (National Organization of Balilla), named after a legendary eighteenth-century boy–hero credited with starting a populist uprising against foreign occupiers. The organization's illustrated periodical *Il Capo-squadra Balilla* (literally, "the Leader of the Balilla Squadron") glorified Mussolini and the Fascist Party and offered instruction on saluting, drills, exercise, and hygiene, along with illustrated entertainment for children (Figure 21.33).

The Art of Dissent: Otto Dix, Li Hua, and Rockwell Kent

Amid the official government subsidized propaganda, individuals and groups reacting against war, hegemony, or fascism created self-expressive, documentary, and public-service works to convey trauma, raise awareness, and foment opposition. This work blurred the line between fine art and illustration.

Having volunteered for the German army in WWI, Otto Dix (German, 1891–1969) became a machine-gunner at the Western Front in 1916. After the war, he studied art in Dresden and Dusseldorf (*see Chapter 19*). In 1924, Dix created a cycle of fifty-one haunting intaglio prints, known as *Der Krieg* (*The War*), that were consciously modeled after Goya's *Los Desastres de la Guerra* (*The Disasters of War*) (*see Chapter 12*). Horrified and mesmerized by his experience of war, Dix believed art should expose the factual and emotional depths of life and death. In *Zerschossene* (*Shot to Pieces*) (Figure 21.34), Dix's frenetic line and heavy mottled aquatint nearly merge the mangled figure into the abstracted space—just as casualties in real life had been swallowed into the battlefield.

Departing from the historic traditions of Chinese woodblock printing (*see Chapter 5*) in the 1930s, a group of young Chinese artists with revolutionary Communist leanings published innovative woodcuts. These unsanctioned prints challenged the nationalist government, which the artists considered repressive for being exploitive of the masses and taking weak a stance against Japanese aggressions. Principal among the woodcut artists was Li Hua (Chinese, 1907–1994) who was influenced by Western drawing approaches and who used dense oil-based inks. This unfamiliar aesthetic was not appealing to the rural Chinese audience, and so many of the dissident printmakers returned to traditional methods or folk art styles to communicate with the rural population. Li Hua continued making political prints for decades, and became an influential teacher and central

Figure 21.34
Otto Dix, *Zerschossene (Shot to Pieces)*, from the portfolio *Der Krieg (The War)*, 1923–1924. Etching, drypoint, and aquatint on paper, 8 ¹¹/₁₆ × 9 ¹/₁₆" (plate size).
Associated with Expressionism, Dix nonetheless considered himself a realist, and dismissed the notion that his work was rooted in pacifism. His nightmarish series of etchings nevertheless constitutes a cautionary statement against war.
Georgianna Sayles Aldrich Fund, RISD Museum, Providence. © 2018 Artists Rights Society (ARS), New York / VG Bild-Kunst, Bonn.

figure in Shanghai's and Beijing's modern Chinese woodcut movement (Figure 21.35).

As a printmaker, illustrator, painter, and socialist, Rockwell Kent (American, 1882–1971) had a long and sometimes controversial career. Known for his masterful 1930 illustrations for Herman Melville's *Moby Dick or, The Whale*, Kent illustrated many books, including several self-authored volumes about his travels to remote territories in Greenland, Alaska, and Tierra del Fuego. In 1937, as part of the **Works Progress Administration** (WPA), a federal program intended to alleviate unemployment during the Great Depression, Kent was contracted to create two murals—*Mail Service in the Tropics* (Figure 21.36), and *Mail Service in the Arctic*—for a new U.S. Post Office Department building in Washington, DC. The murals were supposed to celebrate the availability of mail delivery in the territories of Alaska and Puerto Rico. However, native peoples of Alaska were rapidly losing their traditional ways of life, and Puerto Ricans had recently been killed while holding a demonstration for national independence in the 1937 Ponce Massacre. Kent undermined the U.S. government's propagandistic message by slipping in an unauthorized political statement. In the *Tropics* mural, one of the Puerto Rican figures holds a letter written in Native Alaskan that reads: "To the people of Puerto Rico, our friends! Let us change chiefs. That alone can make us equal and free!"

Art in Captivity

Prisoners of war have been known to create stirring records of their captivity under the direst of circumstances. At the turn of the nineteenth century, Boer War prisoners held in British camps created folk art with anything available, not only as a form

of expression and distraction, but also as items they could sell and barter for other goods. During WWII, internment camps kept the Japanese population in the United States in stark conditions, resulting in drawings and objects called *gaman*, a word that means to bear the seemingly unbearable with patience and dignity. Similarly, the works that survive the brutal conditions of the Nazi concentration camps serve as a testament to the emotional fortitude of the inmates who drew them.

The British artist Ronald Searle (1920–2011) began his long illustration career as a British prisoner of war (POW) in a Japanese prison camp in 1941. Risking

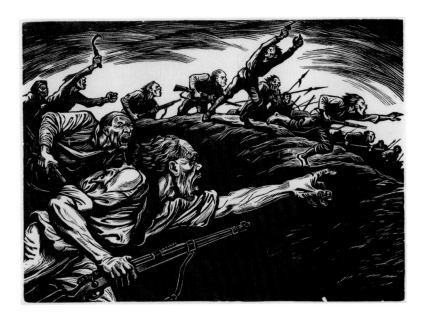

Figure 21.35
Li Hua, "Arise Suffering Slaves," from the series *Tide of Anger*, 1947. Woodcut, oil-based ink on paper, 7 ³/₄ × 10 ³/₄".
Printed in stark black and white with dynamic marks that emphasize the direction of action, Li Hua hoped to inspire resistance against the nationalist government led by Chang Kai-shek.
National Museum of China, Bridgeman Images.

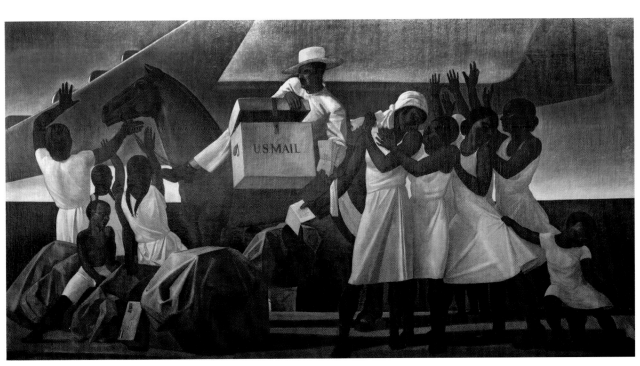

Figure 21.36
Rockwell Kent, *Mail Service in the Tropics* for the Ariel Rios Federal Building, ca. 1937. Oil on canvas, 84 × 162". Rockwell Kent's mural celebrating the first airmail delivery to Puerto Rico immediately caused a stir by including a political statement in the letter held by the central figure. It promoted independence for both Puerto Ricans and Native Alaskans.
Library of Congress.

execution, Searle recorded notes and images depicting the brutal camp conditions on scraps of paper, and hid his drawings under the mattresses of prisoners dying of cholera. He provided pictorial evidence of Japanese mistreatment of POWs, as in the emaciated figure and slack-jaw likeness of a dying man (Figure 21.37). Having learned to draw quickly and furtively, at the conclusion of the war Searle worked as a courtroom artist at the Nuremberg Trials. In the following decades, he produced over seventy books, including numerous works of graphic satire and a collection of wartime sketches titled *To the Kwai and Back: 1939–1945* (1986).

The illustrated memoirs of Eufrosinia Antonovna Kersnovskaya (Russian, 1908–1994) record her twelve years in exile and imprisonment at a mining camp in the Gulag. Accompanied by 680 pictures, Kersnovskaya's memoirs were written in twelve notebooks and, after years of being censored, were partially published in *Ogonyok* magazine in 1990. They were released in six volumes in Russia as *What's a Human Being Worth*, in 2000 (Figure 21.38).

Conclusion

From the late nineteenth century through the mid-twentieth, the world saw large-scale conflicts that were recorded in a variety of illustrative art. Reportage, that is, images made by eyewitnesses, captured first hand the physical and emotional aspects of hostilities. Officially sanctioned propaganda promoted government ideologies in order to garner support for war in general, as well as the social and economic programs that directly or indirectly helped to wage it. Posters,

the commercial use of which soared at the turn of the twentieth century, became a popular vehicle for wartime propaganda.

During this era, we also see both reportage and propagandistic modes redirected or reconsidered for the express purpose of condemning war. Independent artists like Otto Dix and Li Hua illustrated war in ways that inflamed passions as intense as those provoked by pro-war propaganda, while the documentation of suffering by Searle and Kersnovskaya was a prison-side counterpoint to the reportage of official war artists. Rockwell Kent cleverly subverted the propagandistic intentions of his government patron, thus repositioning his commissioned work as dissent.

By the end of WWII, governments reduced poster production in Europe and North America as radio and later television became more effective tools of mass communication. After WWII, the illustrated poster was mainly relegated to the entertainment industries and other commercial venues. However, less industrialized countries, such as in Eastern Europe, continued to rely on poster design for political, social, and artistic expression, while China continued to produce propaganda posters on a large scale during the Cultural Revolution between 1966 and 1976.

The tradition of reportage continues to this day, in war and in situations that disallow photography such as courtrooms and hospitals, as well as in interview journalism or travel journalism where the perceptions of the artist enrich the verbal account (*see Chapter 27, Theme Box 51, "Illustrator as Witness: Contemporary Visual Journalism"*).

FURTHER READING

Chennowith, H. Avery, *Art of War: Eyewitness U.S. Combat Art from the Revolution through the Twentieth Century* (New York: Friedman/Fairfax, 2002).

Eskilson, Stephen, *Graphic Design: A New History*, 2nd ed. (New Haven: Yale University Press, 2012).

Jowett, Garth S., and Victoria O'Donnell, *Propaganda & Persuasion*, 6th ed. (Thousand Oaks, CA: Sage Publications LTD., 2014).

King, David, *Russian Revolutionary Posters: From Civil War to Socialist Realism, From Bolshevism to the End of Stalinism* (London: Tate Publishing, 2012).

Meggs, Philip B., and Alston Century Purvis, *Meggs' History of Graphic Design* (Hoboken, NJ: John Wiley and Sons, Inc., 2012).

Figure 21.37
Ronald Searle, *Man Dying of Cholera*, 1943. Ink on paper, 8 ³/₄ × 6 ⁵/₈".
Risking execution, Searle secretly documented the inhumane conditions in a Japanese POW camp in case he did not survive. To avoid being detected, he learned to sketch quickly.

©1943. Reproduced with kind permission of The Ronald Searle Cultural Trust and The Sayle Literary Agency, image Imperial War Museum.

KEY TERMS	
agitprop	propaganda
audience reception	reportage
blackletter	ROSTA Windows
collectivization	*sensō-e*
dissent	Socialist realism
epistemology	triptych
Frankfurt School	Works Progress
grisaille	Administration
Plakatstil	yellow journalism

где нам дали по одной шайке горячей воды и по горсти песка, вместо мыла.

164 Из бани нас погнали — голых — через всё здание и нам пришлось дефилировать, нагишом, перед целых взводом глазеющих солдат. Среди нас были ещё совсем молоденькие девушки — ещё не заморенные, не утратившие женского обаяния. Под взглядами солдат, девчата извивались, как от прикосновения раскалённым железом и я удивлялась женщинам-"демуркам", которое не сочли нужным избавить

Солдаты гоготали: "Ишь, богородицы!" Напротив! Они ужасались, когда солдаты говорили: "— Богородицы! Ишь-то, смотрите: богородицы стыдливые!" нас от этой "муки стыдом".

Figure 21.38 Eufrosinia Antonovna Kersnovskaya, *The Soldiers Were Guffawing, Holy Virgins, Bah!* 1964–1968. Mixed media on paper, 6 3/5 × 7 9/10". Kersnovskaya documented daily life in the Gulag, including the humiliation of female prisoners. She wrote, "The young girls writhed with shame as they to go naked [sic] before the soldiers who mock them and make obscene gestures."

From the E. Kersnovskaya Collection © I. Chapkovskiy.

22

Alternate Realities in Pulps and Popular Fiction, 1490–Early 2000s

Nicholas Egon Jainschigg

with contributions by R.W. Lovejoy

Pulp magazines, which reached the height of their popularity between the two World Wars, featured sensational fiction churned out by emerging and hack writers and eye-catching, often lurid covers. What put the "pulp" in **pulp fiction** was the cheap, rough paper on which they were printed, as opposed to the higher-quality, more expensive **slicks**, or mainstream magazines printed on smooth, shiny paper. Many writers and illustrators honed their craft in pulps, later graduating to the slicks—sometimes by modulating their melodramatic works to suit the higher production media. This chapter traces the evolution of the pulps and related print media from the nineteenth to the twenty-first century, surveying the genres of horror, fantasy, and science fiction within them.

Nineteenth-Century Precedents and Themes

Titles such as *Spicy Detective Stories* and *The Shadow* have their roots in nineteenth-century Gothic literature, which itself can be traced to ancient texts. For example, in *The Odyssey*, Ulysses' battle with the Cyclops and escape from Calypso's wiles clearly foreshadows the hard-boiled detective outwitting mobsters while tempted by femme fatales.

Fantasy and horror are also historical staples of literature and visual art. By the 1400s, prints pictured a range of chimeric beasts, human-like creatures, imagined cities, and dancing skeletons (*see Chapter 2*) (Figure 22.1). In the nineteenth century, the accelerating rate of invention and technological progress became a subject in itself, giving rise to a third popular and speculative genre, science fiction. Science fiction's cross-pollination with fantasy and horror, and the shared fan culture they gave birth to, linked these three genres inextricably as the twentieth century progressed.

Romanticism

Themes now associated with sci-fi, fantasy, and horror emerged in Romantic-era literature as well (*see Chapter 12*). *Frankenstein, or, The Modern Prometheus*, written by Mary Shelley in 1818, combines elements of medieval romance, action, and terror, placing it firmly in the Gothic novel genre. But its anti-hero Victor Frankenstein is a scientist, not a magician; and his attempts to animate assembled corpses are inspired by contemporary scientific experiments using electricity. *Frankenstein* is thus often cited as the first sci-fi novel. The first illustrated edition was published in 1831 (Figure 22.2). The tale was very much of its time in its critique of technology and hubris, echoing Romantic concerns about the Industrial Revolution, the mechanization of labor, and the power of nature.

Penny Bloods and Penny Dreadfuls

Penny bloods were the pulps' predecessors. These mass-produced periodicals beginning in the 1830s offered frequently violent or outlandish serials of adventure, romance, gothic horror, and crime. They were written quickly by writers paid a penny a line and were affordable to all at a penny per issue. The startling wood engravings

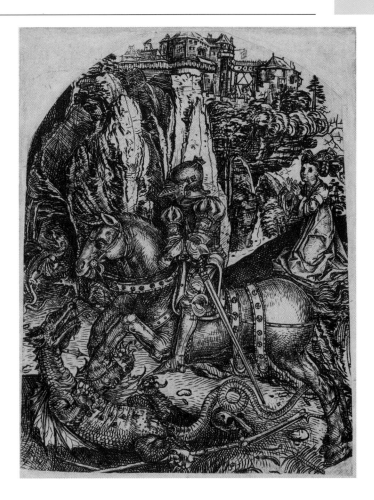

Figure 22.1
Master L.Cz (attributed), *St George and Dragon*, ca. 1491–1499. Engraving, 4 × 3 ⅘".
St. George is depicted as a contemporary knight, riding down the dragon he has already impaled. The dragon is a composite creature, with characteristics mostly of a crocodile, but with frills resembling the medieval depiction of demon wings.
Wikimedia, Europeana Collection.

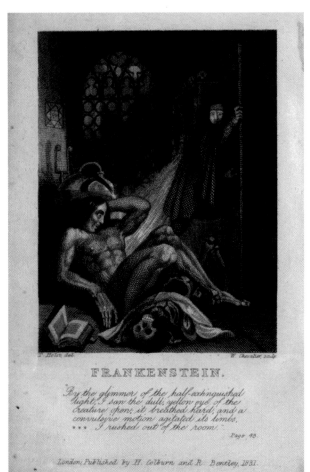

Figure 22.2
Theodor von Holst, *Frankenstein, or, The Modern Prometheus*, by Mary Shelley, third edition, published by Henry Colburn and Richard Bentley, London, 1831. Engraving, 6 ¾ × 3" (page). Holst depicts Victor Frankenstein's human-like creation, Adam, as he is brought to life. The vague "scientific" apparatus in the background gives an aura of authenticity. Frankenstein's alarm and Adam's experience in perceiving himself are consistent with Romantic precepts of horror and awe leading to a more profound understanding of existence.
University of Toronto, Archive.org.

(called chromoxylography when printed in color) of heroes and villains such as Robin Hood, highwayman Dick Turpin, Varney the Vampire, and the notorious Spring-heeled Jack were far more detailed than earlier woodcuts on broadsides (Figure 22.3). Disparaged as tasteless, but hugely popular, penny bloods soon outsold other types of literature. However, by the 1860s, their adult audience had dwindled, and penny bloods were supplanted by the **penny dreadfuls** aimed at the juvenile market.

Literary Illustration

A notable illustrator of fantastic themes was Gustave Doré (French, 1832–1883) (*see Chapters 14 and 16*). In works such as *The Divine Comedy*, Doré places the action within an expansive, richly detailed space and exploits the new tonalities of wood engraving to dramatically spotlight the focal point. His style influenced fellow illustrators and, later, cinematographers (Figure 22.4).

The Romantic reaction against rationalism and industrial order in the arts had an enormous influence in Britain. Notably, nostalgia for the golden age of chivalry in the tales of King Arthur, Christianity, and magic inspired the works of the Pre-Raphaelite Brotherhood, William Morris, and the Arts and Crafts movement (*see Chapter 15*). These artists imbued fantasy subjects with a medieval flavor that still characterizes fantasy book illustration today. In Morris's tale *The Story of the Glittering Plain*, the protagonist Hallblithe travels to a utopian land of immortals to rescue his kidnapped beloved. The illustrated work emulates medieval illuminated manuscripts, with Gothic-inspired fonts, ornate borders, and densely detailed illustrations that enhance the sense of age and romance (Figure 22.5).

Throughout the nineteenth century, there were intermittent literary experiments with subjects we would today consider science fiction, such as future technology and alien life forms. Two early writers strongly identified with these subjects are H. G. Wells (English, 1866–1946) and Jules Verne (French, 1828–1905). A number of illustrators worked on their books, most notably the children's book illustrator Warwick Goble (English, 1862–1943), whose illustrations for Wells's *The War of The Worlds* (1898) are still frequently reprinted (Figure 22.6). His relatively loose watercolor illustrations echo contemporary war reportage, while the abrupt cropping emulates then-nascent documentary photography, giving the work a feeling of immediacy.

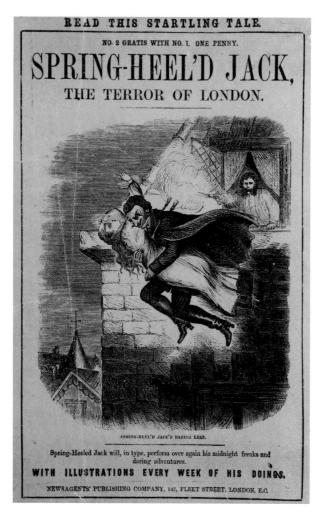

Figure 22.3
Anonymous, cover for *Spring-heeled Jack*, no. 2, 1867. *Spring-heeled Jack: The Terror of London* was based on the exploits of a costumed criminal said to possess horns, claws, glowing eyes, and the ability to leap over fourteen-foot walls with ease. Sales of Spring-heeled Jack's activities would continue in the popular press until 1904.

Wikimedia Commons.

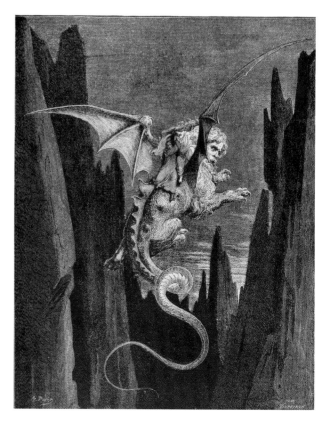

Figure 22.4
Gustave Doré, "Geryon: Canto XVII," *The Divine Comedy* by Dante Alighieri, 1861. Wood engraving.
Virgil straddles the monster's wing, looking down at Dante on the creature's back. Doré skillfully combines the disparate parts of the chimeric monster Geryon into a compositionally and emotionally moving figure. He did not cut his own engravings but maintained a stable of highly skilled engravers.
Courtesy of the Fleet Library, at Rhode Island School of Design, Special Collections, Providence.

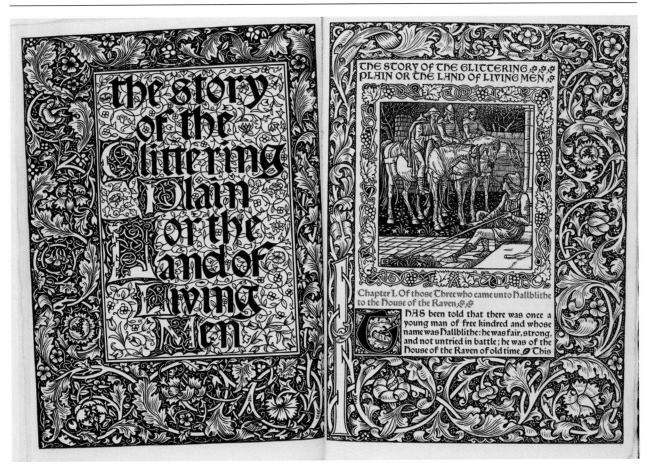

Figure 22.5
William Morris and Walter Crane, title page, *The Story of the Glittering Plain*, Kelmscott Press, 1894. 11 ¹/₂ × 8 ⁵/₁₆" (page, approximate). The highly ornate and labor-intensive borders and pictures in this homage to illuminated manuscripts reflect the story's medieval setting, while obliquely complementing its philosophical inquiry into the purpose of life and work.

Beinecke Rare Book and Manuscript Library, Yale University.

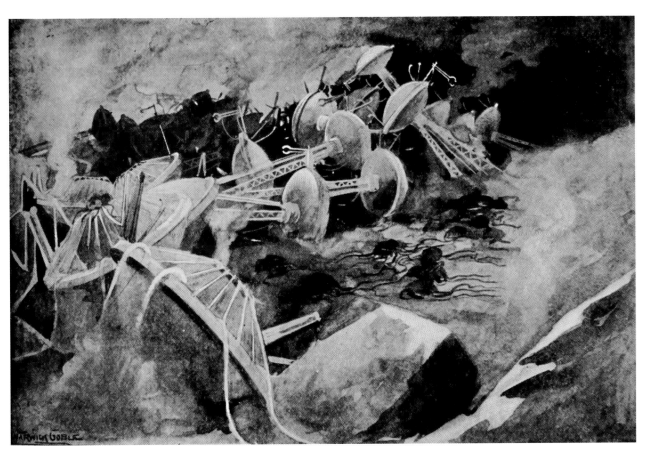

Figure 22.6
Warwick Goble, "Nearly fifty together in that great gulf," illustration for "War of the Worlds," *Pearson's Magazine*, 1897. This plate depicts ruined extraterrestrial tripods, their tentacled alien drivers defeated by Earth's diseases. As a vision of apocalyptic ruin, the image owes a debt to Doré's depictions of the Biblical flood, but the mass of machinery makes the event contemporary with 1897.

Providence Athenaeum.

Relatively few authors followed the lead of Verne and Wells: while many illustrators embraced fantastic subjects, they mostly approached them through the framework of other genres, such as the Gothic, children's books, or fine art. An exception was Albert Robida (French, 1848–1926), an author, illustrator, and caricaturist who illustrated work by Jonathan Swift, Jules Verne, and others. Robida produced a series of illustrated novels dealing with life in the future, including *Le Vingtième Siècle* (*The Twentieth Century*, 1882) (Figure 22.7). These novels depicted a plausibly developed advanced technology with an awareness of how it affected social norms. Robida's work predicted many later developments, such as the telephone and even modern total warfare.

Dime Novels and Story Papers

Story papers, also called comic papers or funny papers, were published in both the United States and Britain. These illustrated eight-page tabloids, with their sequential graphic narratives and cartoons, were an early form of comic book. Mass-produced, thick **dime novels** (so-called because of their price) with pictorial covers were the American version of penny dreadfuls. The concurrent improvements in roads, railways, and the mail enabled wide distribution of both these publications. In 1860, brothers Erastus and Irwin Beadle and their partner Robert Adams successfully sold over 300,000 copies of

their first release, *Beadle's Dime Novels No. 1: Maleska, the Indian Wife of the White Hunter* (a reprint of Ann S. Stephens's magazine serial of the same name). After this, dime novels and story papers flourished, with appealing fast-paced, thrilling tales, often set in exotic locales (Figure 22.8).

In 1896, publisher Frank Munsey lowered the production costs of his failing juvenile fiction magazine, *Golden Argosy*, by switching to cheap pulp paper and eliminating illustrated covers. The now retitled *Argosy* magazine offered some 192 pages for a mere dime, and its success soon permitted the return of cover art. Other publishers soon entered the pulp field, chief among them Street & Smith, publishers of *The Popular Magazine* from 1903, and later *Astounding Stories*; and Popular Publications, with its slightly higher-end (fifteen cents) mystery anthologies *Black Mask* and *Dime Mystery Magazine*.

Twentieth-Century Pulps

Dime novels were supplanted around 1905 by yet another format that offered readers even *more* stories and far more exciting illustrations on the cover: pulps. Sold for a dime, when many slicks cost twenty-five cents, pulp magazines were typically 7 × 10", and featured black-and-white interior line art created by **drybrush**

Figure 22.7
Albert Robida, "A Trip to the Opera in the Year 2000," ca. 1902. Lithograph. Executed in a loose ink-and-wash style reminiscent of contemporaneous fashion illustration, Robida depicts a chic crowd embarking in various flying cars, the women dressed in the shocking new bicycling attire of the 1890s.

Library of Congress.

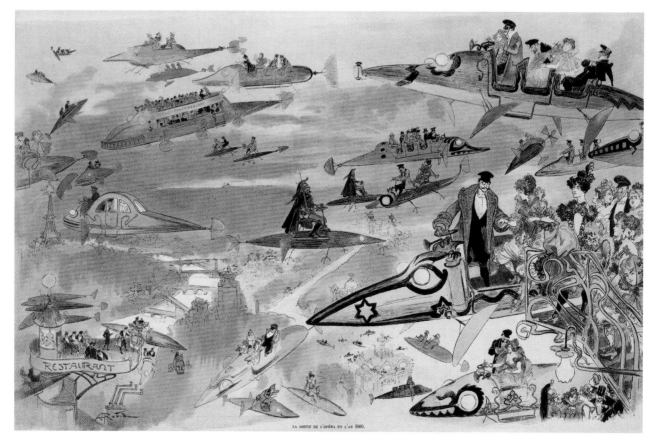

and pen-and-ink techniques that could be reproduced more cheaply than grayscale washes or paintings, which required halftone engravings. By 1915, covers were full color, and typically characterized by extreme action, dramatic lighting, dark shadows, and solid, saturated backgrounds (Figures 22.9, 22.10).

Early pulps included different types of stories to appeal to all audiences, but it proved more profitable to focus on particular genres, leading to titles such as *Weird Tales, Dime Detective, Flying Aces, Oriental Stories, Horror Stories, Love Story, Western Story,* and *Planet Tales.* Cover illustration rarely related to content, although stories were occasionally inspired by the covers.

The best-selling subject matter of many pulps was gory, despite objections from guardians of public mores. Covers, which have to tell a story in a single dramatic image, commonly included beautiful women threatened by maniacs, heroes caught in sadistic traps, and horrors

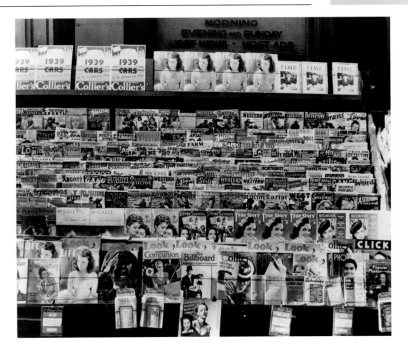

Figure 22.9
Newsstand, 1938.
Pulps used sensational cover art to compete with other magazines in capturing the eye of the potential buyer.
Library of Congress.

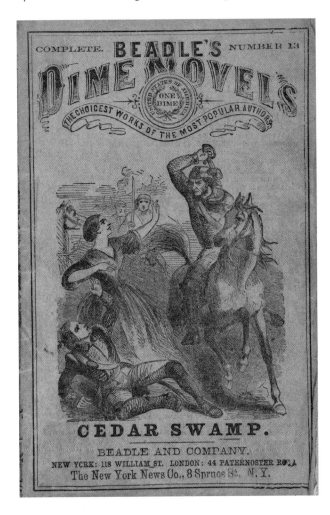

Figure 22.8
Cedar Swamp, Beadle's Dime Novels #13, 1864. Letterpress, approximately 6 ⁵/₈ × 4 ¹/₂" (page).
The first *Dime Novels* did not have illustrated covers. But as the series progressed, many of the early novels were later re-issued with illustrated covers—as in this example of *Dime Novel #13, Cedar Swamp,* originally published in 1860. Images were printed only in black ink on Beadle's signature orange paper covers.
Courtesy of American Antiquarian Society.

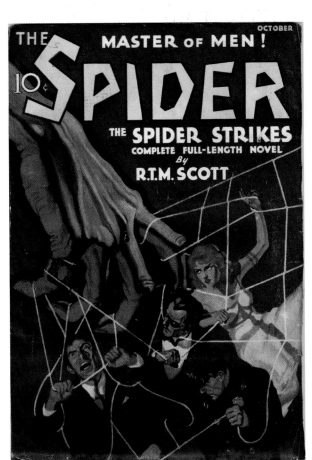

Figure 22.10
Walter Baumhofer, *The Spider,* vol. 1, no. 1, October 1933. The first issue of the magazine featured *The Spider Strikes* by R. T. M. Scott.

THE SPIDER magazine cover image reproduced in this volume by arrangement with Argosy Communications, Inc. © 2016 Argosy Communications, Inc. All rights reserved. *THE SPIDER* is a trademark owned by Argosy Communications, Inc.

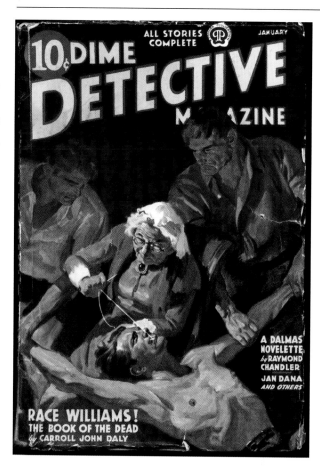

Figure 22.11
Walter Baumhofer, *Dime Detective*, Popular Publications, vol. 26, #2, January 1938. *Dime Detective* publisher Henry Steeger believed the magazine's cover was its most important sales feature. Particular color schemes indicated a specific audience: red, yellow, black for men's magazines; blue and green for women's.
Steeger Properties.

committed by grotesque villains (Figure 22.11). Spicy pulps, at twenty-five cents, were sold from behind the counter rather than on the magazine rack. Their titillating cover art featured scantily clad women and the promise of sexual content. Publishers added "spice" to other genres to raise sales, resulting in *Spicy Adventure Stories*, *Spicy Detective Stories*, and so on (Figure 22.12). Editors of *Spicy Detective* magazine in 1935 advised potential contributors, "This subject [of sex] should be handled delicately and a great deal can be done by implication and suggestion." In 1942, Mayor Fiorello Laguardia forced New York City newsstands to remove the provocative covers from the "spicy" pulps prior to displaying the magazines for sale.

In contrast, romance pulps, aimed at a female audience, depicted more chaste (albeit still provocative) heroines. The "Western Romance" pulps were one of the most popular genres of pulp magazines, where stories combined romance and adventure in a Wild West that had little basis in reality (Figure 22.13). Titles in the Western Romance genre include *Rangeland Romances* (1935–1953), *Rodeo Romances* (1942–1952), *Rangeland Love* (1924–1934), and the most durable and popular of all the pulps, *Ranch Romances* (1924–1971).

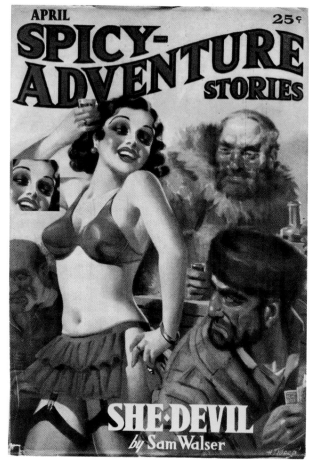

Figure 22.12
H. T. Ward, cover, *Spicy-Adventure Stories*, vol. 4, no. 1, April 1936. "Spicy" pulps promised more explicit stories than the typical pulp.
Wikimedia Commons.

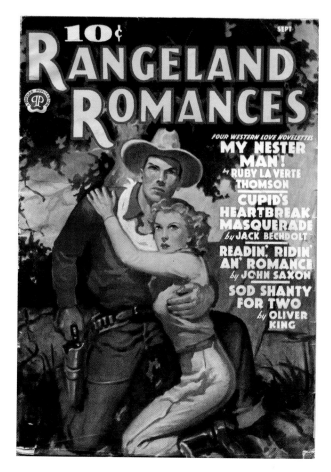

Figure 22.13
Emery Clarke, cover, *Rangeland Romances*, September 1938. One of Popular Publications' longest running titles, *Rangeland Romances* debuted in 1935 and did not cease publication until 1953.
Steeger Properties.

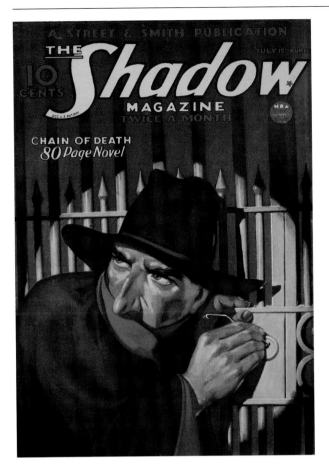

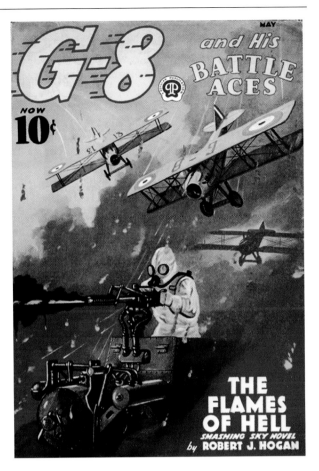

Figure 22.15
Frederick Blakeslee, *G-8 and His Battle Aces*, Popular Publications, vol. 14, no. 4, May 1938. Blakeslee's airplanes were based on first-hand knowledge of the subject, since he had worked for the Curtiss Aeroplane Factory during World War I.

G-8 AND HIS BATTLE ACES magazine cover is reproduced in this volume by arrange-ment with Argosy Communications, Inc.,© 2016 Argosy Communications, Inc. All rights reserved. *G-8 AND HIS BATTLE ACES* ® is a trademark owned by Argosy Communications, Inc. Courtesy of Phil Stephensen-Payne, Galactic Central Publications.

Figure 22.14
George Rozen, *The Shadow*, Street & Smith, vol. 10, no. 4, July 1934. Rozen applies dramatic color and light to focus attention on the character's mysterious identity.

Perhaps the most lasting aspect of the pulps was the popularization of single characters such as Buffalo Bill or writer Dashiell Hammett's detective, The Continental Op. In the 1930s, publishers began to dedicate entire magazines to heroes like The Shadow, who had the power to cloud men's minds (Figure 22.14); or Doc Savage, who used his scientific prowess and physical strength to overcome all obstacles. Comic book superheroes such as Superman can be traced to these precedents.

Because pulps paid as little as one-tenth of what slicks did, pulp illustrators made ends meet by becoming tremendously fast, some reportedly creating seven covers a week. Many were deeply ashamed of their work because of the often-tawdry subjects. Nevertheless, just as the pulps published the work of many notable writers, they also featured outstanding artists, including Norman Saunders (American, 1907–1989), Rafael DeSoto (American, 1904–1992), Jerome and George Rozen (American, 1895–1987, 1895–1973, respectively) and Walter Baumhofer (American, 1904–1987). Some had particular expertise in their subjects: Frederick Blakeslee's (American, 1898–1973) art for wartime aviation pulps combined his masterful knowledge of airplanes with a talent for inventing menacing imaginary weaponry (Figure 22.15).

In the 1950s, television undermined the market for short fiction, and many slicks and pulps ceased publication. Few contemporary art connoisseurs or historians were interested in pulp art, and few of the artists considered their originals to be of any value. Consequently, most of the cover paintings were lost or destroyed; only an estimated 1 percent of the artwork has survived. As the pulps declined, the artists transitioned into other publications—paperbacks and so-called "men's adventure" magazines. Some, including Americans Tom Lovell (1909–1997) and Frank McCarthy (1924–2002), used the pulps as a springboard to careers in advertising, movie posters, and "Western" art.

Twentieth-Century Fantasy and Horror

Books, Advertising, and Periodicals

During the early part of the twentieth century, only the most successful stories were upgraded from pulps to hardcover books. Decorated dust jackets were adopted around 1920 in lieu of the traditional embossed and

printed covers, creating a new venue for illustration—
and making popular books resemble pulps. Edgar Rice
Burroughs's Mars adventure series, with dust jackets
illustrated by J. Allen St. John (American, 1875–1957),
are a superb example (Figure 22.16).

Edgar Allan Poe (American, 1809–1849) was one
of the most innovative writers in the fields of suspense
and the macabre, and a favorite for fine illustrated
books. Harry Clarke's (Irish, 1889–1931) work for
Tales of Mystery and Imagination (1919) is especially
memorable (Figure 22.17). Strongly influenced by
the Arts and Crafts movement and Aubrey Beardsley
(*see Chapter 15*), Clarke brought his own emphasis on
pattern and two-dimensional design, perhaps shaped
by his work in stained glass. His mastery of flowing line
and a visceral appreciation for the ghoulish render his
art simultaneously graceful and gruesome.

Fantasy also featured in advertising illustration
because it encouraged the reader to imagine the product's
invisible but desirable qualities. Franklin Booth's
(American, 1874–1948) advertisement for Estey Organ
weaves fantasy elements into the ordinary: pipes float in
the cavernous space as nudes swathed in drapery evoke
clouds of sound. The "real world" is represented by two

glamorous women seated on an elaborate banquette,
watching the organist play the simple, domestic-sized
organ from which the fantasy originates (Figure 22.18).
Booth's intricate pen-and-ink drawings, influenced by
wood engraving, remained in demand long after color
reproduction had become commonplace. His work was
esteemed for dreamlike scenes of exotic cities and for the
mythical and epic qualities he brought to even the most
mundane subjects.

The first horror and fantasy fiction specialty
magazine was the German *Der Orchideengarten* (*The
Orchid Garden*) (1919–1921). Largely a digest, its
illustrations were generally reprinted from ancient
and modern sources, but it also carried original work
by a number of contemporary German illustrators,
notably Otto Muck (1892–1956), Alfred Kubin (1877–
1959), and Heinrich Kley (1863–1945) (*see Chapter 23*).
Appearing during the turbulent post–World War I years
of avant-garde art, *Der Orchideengarten* embraced a
wide range of influences, including cartoon, Symbolism,
Aestheticism, and Expressionism (*see Chapters 15
and 19*). Its subject matter frequently involved the
uncanny, with covers in bold, flat, three-color printing
(Figure 22.19).

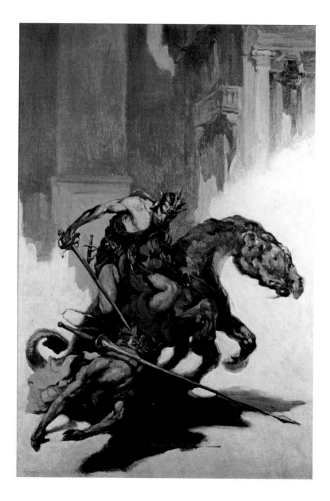

Figure 22.16
J. Allen St. John, dust jacket, *The Chessmen of Mars* by Edgar Rice
Burroughs, AC McClurg & Co, 1922.
Set on Mars, Burroughs's fantastical stories and St. John's art were highly
influential on later comics and fantasy illustrators like Frank Frazetta.
Courtesy of LW Currey Inc.

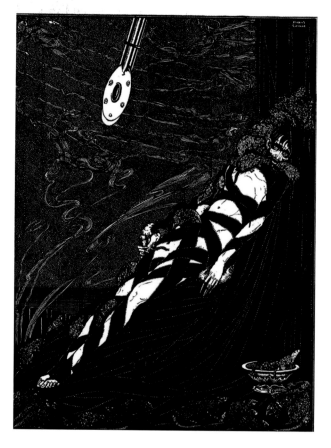

Figure 22.17
Harry Clarke, illustration in "The Pit and The Pendulum," in *Tales of Mystery
and Imagination* by Edgar Allan Poe, George G. Harrap & Co., Ltd., 1923.
Bound to a board, with a slowly descending blade swinging above him, a
prisoner must persuade rats to gnaw him free. Clarke draws attention to the
key elements by defining them in black and white, while the surrounding
area and other details are in shades of gray.
Author's collection.

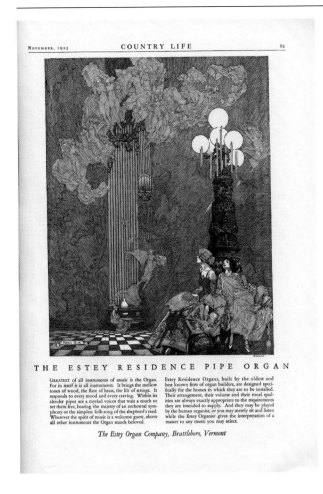

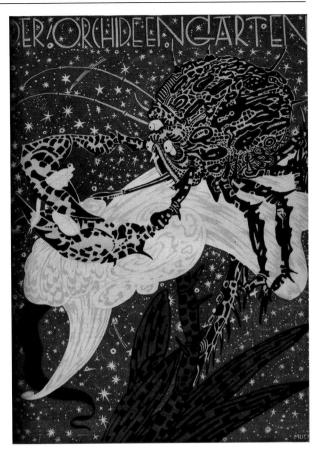

Figure 22.19
Otto Muck, cover, *Der Orchideengarten*, ca. 1920.
This cover displays a monster menacing a naked woman—a cliché of fantasy, science fiction, and horror imagery. The flattened design with rich patterning is reminiscent of illustrator Aubrey Beardsley.

Courtesy of Will Schofield.

Figure 22.18
Franklin Booth, advertising art for Estey Organ, *Country Life*, November 1923.
In this advertisement, the lush floating nudes evoke classical statuary, the painted ceilings of European palaces, and pictorial allegories of the Arts. But cynicism about such fantasies grew during the 1920s, and advertisers turned to more "realistic" lures to promote their products.

Collection of Jaleen Grove.

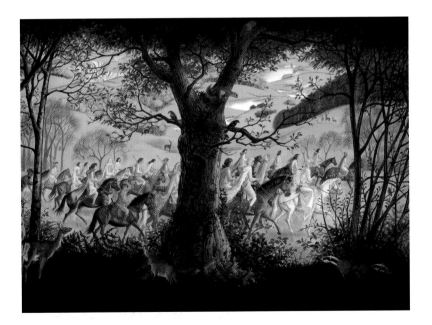

Figure 22.20
Pauline Baynes, *Bilbo's Last Song* by J. R. R Tolkien, 1974.
Illustrated in jewel-like tones, *Bilbo's Last Song* narrates Bilbo Baggins's last journey as he leaves Middle Earth—an episode that falls chronologically at the end of *The Lord of the Rings*. It was published as a standalone volume after Tolkien's death.

Courtesy of Williams College Libraries.

While some European pulp magazines were notable, they were never as popular or diverse as in the United States, and they lacked the defining influence that the pulps had on American sci-fi, fantasy, and horror. The primary influence on European (and later, global) fantasy writing was the **Inklings**. A loosely organized English literary society connected to Oxford University in the 1930s and 1940s, the Inklings included C. S. Lewis (English, b. in Ireland, 1898–1963), J. R. R. Tolkien (English, b. in South Africa, 1892–1973), Charles Williams (English, 1886–1945), and Roger Lancelyn Green (English, 1918–1987). Like the Pre-Raphaelites (*see Chapter 15*), they were unified by an interest in writing, mythology, and Christianity; and their academically informed version of fantasy would heavily influence mainstream fantasy literature, cinema, and gaming. Tolkien's own illustrations for *The Hobbit* (1937) created a world that was foundational to the genre now called **heroic fantasy**: a genre in which heroes act according to noble motives and expectations. More associated with the Narnia stories of C. S. Lewis, Pauline Baynes (English, 1922–2008) was also one of Tolkien's many illustrators (Figure 22.20). Her influences, like those of C. S. Lewis and J. R. R. Tolkien, range from Scandinavian folk art and relics to medieval tapestries and illuminations with their richness of detail in visualizing narratives.

Theme Box 44: Barthes: Mythologies and Death of the Author
by Sheena Calvert

Roland Barthes (French, 1915–1980) was a literary critic, critical theorist, and semiotician who explored how visual and verbal signs deliver meaning (see Chapter 2, Theme Box 7, "Saussure and Peirce: Semiotics"). In *Elements of Semiology* (1964), Barthes extends Saussure's structuralist (systematic, rule-bound) ideas to include analyses of popular culture, proposing that "images, gestures, musical sounds, objects, and the complex associations of all of these, which form the content of ritual, convention or public entertainment: these constitute, if not languages, at least systems of signification."

In his book *Image, Music, Text* (1977), Barthes shows how cultural products can be semiotically decoded to reveal the "ideological worldview" that underlies them—for instance, how advertising and news stories encode attitudes toward social aspirations or gender roles. For Barthes, images perform rhetorically: any kind of reproduction of reality, as in printed or screen-based media, constructs reality and contextualizes signs in a highly manipulative way that intentionally enforces a certain reading and serves specific agendas.

In *Mythologies* (1957), Barthes argues that "myth is, in its most basic form, a special type of speech"—one of the dominant ways in which human beings understand the world they inhabit. Myths are ways of expressing what cannot be directly explained. They are another aspect of semiotic signs where, rather than simply denoting or connoting, they instead embody shared acceptance of certain assumptions in such a way that they are no longer questioned. Myths therefore appear common-sense, natural, familiar.

An example Barthes gives is the spectacle of the professional wrestling match, in which mythological conceptions of good versus evil are played out. In another example, a photo of a young black man saluting France on the cover of *Paris Match* presents the myth of nationalism, serving an agenda that assumes all "sons" of the Empire serve their country. Rhetorically, it suggests that discrimination does not exist in patriotism, when in fact this is historically far from true. Such mythical images distort realities.

Death of the Author
In the traditional view of authorship, meaning lies within the text, placed there by an author whose identity and experiences determine that meaning. In his 1967 essay "The Death of the Author," Barthes questions the assumption that creators thus control meaning, pointing out that the reader (or viewer, in the case of images) cannot and does not simply decode and passively receive a message that has been deposited there by the author alone. Rather than the product of one original individual experience, Barthes says "The text is a tissue of quotations," a collection of fragments drawn from "innumerable centers of culture." Similarly, the essential meaning of a work depends on the impressions of the reader informed by all of his or her own experiences.

By suggesting that it is not the author, but we, the socialized readers of texts, who create meaning and that each person's interpretation is as valid as anyone else's, Barthes also suggests that every time we read a text, we read a different meaning into it, such that there is no single meaning to be found. Thus, Barthes reasons, "the true locus of writing is reading . . . the birth of the reader comes at the expense of the death of the Author."

Further Reading
Barthes, Roland, "The Death of the Author," in *Art and Interpretation: An Anthology of Readings in Aesthetics and the Philosophy of Art*. Ed. Eric Dayton (Peterborough, Ont.: Broadview, 1998): 383–386.

Barthes, Roland, *Elements of Semiology* (London: Atlantic Books, 1997).

Barthes, Roland, *Image, Music, Text* (New York: Hill and Wang, 1977).

Barthes, Roland, *Mythologies* (New York: Hill and Wang, 2013).

Weird Tales: A Horror and Fantasy Pulp

The first American horror and fantasy pulp magazine, *Weird Tales*, was issued in 1923 and continued until 1954 (Figure 22.21). Publishing accomplished authors such as H. P. Lovecraft (American, 1890–1937) and Robert E. Howard (American, 1906–1936), it was tremendously influential on other pulps and on the wider field of imaginative fiction in the United States.

Among the most notable illustrators of *Weird Tales* was Virgil Finlay (American, 1914–1971), who mastered a lively, meticulous stipple technique along with **scratchboard** for his illustrations in sci-fi pulps. Scratchboard, in which sharp tools are used to scratch a black surface to reveal a white ground, allows for precise line work with effects similar to fine wood engraving. The resultant halftone-like shading could be printed in pure black as high-contrast line art that reproduced more clearly on the rough pulp paper than actual halftones.

While Finlay occasionally produced color covers, it was his lower-paying black-and-white work that delighted editors and fans (Figure 22.22). Thus, although he created over 2,800 illustrations during his career, he died in relative poverty.

Many fantasy covers suggested sexual themes, as in Margaret Brundage's (American, 1900–1976) pastel work that often showed nude or nearly nude women. While occasionally appearing empowered and lauded as forerunners of female superheroes in comics, Brundage's subjects more typically fall victim to infatuation or molestation (Figure 22.23).

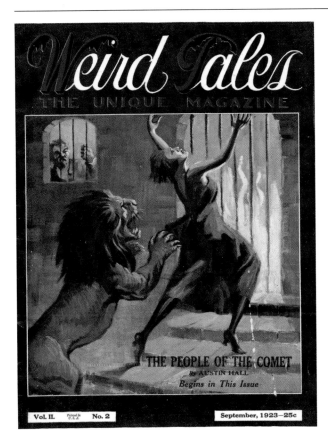

Figure 22.21
Anonymous, cover, *Weird Tales*, September 1923.
In its earlier days, *Weird Tales* covered featured themes of torture and the bizarre as well as more supernatural or science fiction subjects. Here, a woman flees from a lion toward an enormous fire, but is restrained by the bars of her prison while a man watches helplessly.
Courtesy of Heritage Auctions.

Twentieth-Century Science Fiction and Fan Culture

Origins and Fans

The person most responsible for advancing the contemporary fields of sci-fi, fantasy, and horror is publisher Hugo Gernsback (American, b. in Germany, 1884–1967). He founded several magazines, including *Modern Electrics* (1908) and *Electrical Experimenter* (1913; renamed *Science and Invention* in 1920) (Figure 22.24). Gernsback also nurtured fan culture ("fan" is short for fanatics). When the letters column in *Modern Electrics* became tremendously popular and readers began to communicate with one another directly, Gernsback founded the Wireless Association of America, a fan club that attracted over 10,000 members in its first year. Gernsback's readers were devoted to amateur radio and electronics, built their own broadcasters and receivers, and in addition to communicating with one another, perpetrated pranks similar to phone and computer network hackers of later years.

Looking for inexpensive content for his magazines, Gernsback realized that his largely teenage audience would respond well to reprints of stories by Jules Verne and H. G. Wells. These being limited, Gernsback soon wrote his own fiction, commissioned new stories from established pulp writers, and accepted readers' submissions.

Fans used the letters columns to set up regional groups dedicated to reading and creating their own "scientifiction," as Gernsback initially called it. These were the precursors of conventions such as San Diego Comic Con and Dragon Con. Through fan clubs, **fanzines** (informal, cheaply produced publications), and letter columns, science fiction fans were uniquely influential with the editors, writers, and artists who comprised the profession (Figure 22.25).

Science fiction was in essence a joint project. The fanzines and clubs served as incubators for artists, writers, and editors, many of whom continued to contribute to and participate in fan events even after "turning pro."

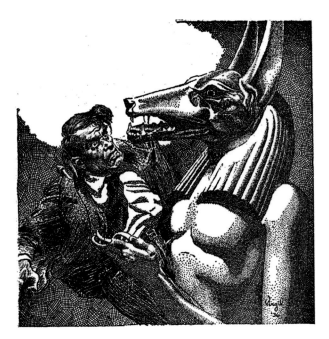

Figure 22.22
Virgil Finlay, illustration in *Opener of the Way* by Robert Bloch, *Weird Tales*, vol. 28, October, 1936.
Finlay stitched together disparate elements with textural effects using delicate line or stipple work with ink in combination with scratchboard. The range of values and textures recalls the finest of the wood engravers of the previous century.
Wikimedia.

Figure 22.23
Margaret Brundage, illustration in "The Altar of Melek," *Weird Tales*, September 1932.
Brundage often showed women in risqué poses or in designs influenced by modern dance and Art Deco. She signed with only her first initial, which masked her female identity.
Courtesy of Heritage Auctions.

While the overwhelmingly male populations of these clubs were somewhat self-reinforcing for the first few decades of fandom (the 1939 convention was officially attended by only one woman, American fanzine editor Myrtle R. "Morojo" Douglas, 1904–1964), the field included influential women from early on—the most notable being Leigh Brackett (American, 1915–1978), who later co-wrote *The Empire Strikes Back*; and C. L. Moore (American, 1911–1987), who met her future husband and collaborator, Henry Kuttner (1915–1958), when he wrote her a fan letter under the assumption that she was male.

Science Fiction Pulps

Gernsback's favorite illustrator, and the man whose work most characterizes the heyday of pulp science fiction, was Frank R. Paul (American, b. in Austria, 1884–1963). Paul studied architectural and mechanical drafting in Vienna and Paris before emigrating to the United States. Originally illustrating for *The Electrical Experimenter*, Paul soon developed a style characterized by gigantic architectural and technological conceptions rendered with intricate details, in bright, primary colors with people reduced to rather stiff, heroic stereotypes (Figure 22.26). His futuristic cities, spaceships, and robots echoed the shapes and surfaces of then-current technology, which lent an air of verisimilitude to the fantastic scenes—often reinforced by exploded or cutaway views that explained the technology.

Figure 22.24
Thomas Wrenn, cover, *Modern Electrics*, March 1912.
A scene reminiscent of Shelley's 1818 *Frankenstein* speculates about the potential of electrical apparatus. Contemporary publications such as *Popular Science* also featured exciting if formulaic covers of fantastical new air, military, or medical technology.
Wikimedia.

Figure 22.25
Joe Shuster (illustrator) and Jerry Siegel (writer), "The Reign of the Super-Man," from the fanzine *Science Fiction: The Advance Guard of Future Civilization* #3, 1933. Mimeograph.
The future creators of Superman began by designing a superhero in Siegel's sci-fi fanzine.
Courtesy of Heritage Auctions.

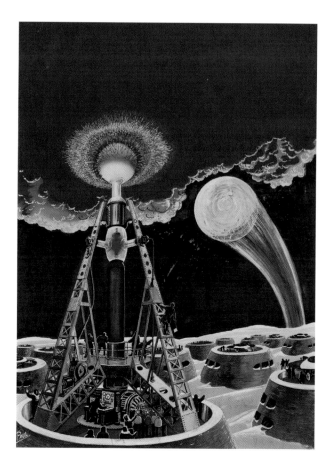

Figure 22.26
Frank R. Paul, "The 35th Millennium," cover of *Wonder Stories*, August 1931.
Despite the dire implications of a meteor hurtling toward earth and a futuristic tower, the prismatic colors of this illustration make it seem more fantastic than terrifying.
Courtesy of Heritage Auctions.

Between 1900 and 1925, almost all of the technologies that shaped the twentieth century were either invented or already deployed: electrification, telephone, zippers, automobiles, heavier-than-air flight, plastics, and radio. Career, lifestyle, and entertainment possibilities burgeoned. Paul's optimistic artwork, with its outsize, panoramic environments, perfectly envisioned the positive side of an expanding future.

In 1926, Gernsback finally published the first magazine devoted entirely to science fiction: *Amazing Stories*. Its immediate popularity prompted a proliferation of sci-fi pulps such as *Science Wonder Stories*, *Startling Stories*, *Astounding Stories*, and more. Paul's work appeared on every issue of *Amazing Stories* for its first three years, establishing the look of the sci-fi genre for years to come.

Over the course of the 1930s, '40s, and early '50s, the pulp aesthetic—flashy, colorful, and sensational—left its stamp on sci-fi illustration and established many of the clichés that have continued to dog the field: bug-eyed monsters, bubble-helmeted space suits, ray guns, metal lingerie, and tube-limbed mechanical men. Alternately reviled and embraced, these subjects in myriad combinations served to grab attention for the magazines and to clearly advertise the types and themes of the stories within (Figure 22.27).

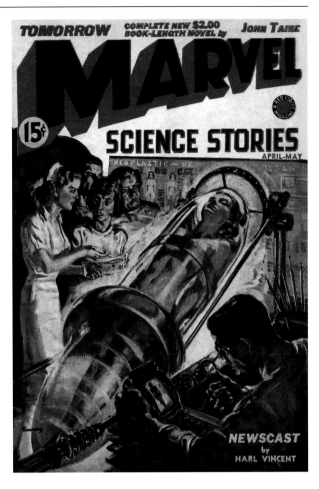

Figure 22.27
Norman Saunders, *Marvel Science Stories*, April–May, 1939.
The gaudy coloration and titillating glimpses of a nude female encased in a phallic capsule are typical of the sensationalist pseudo-science sci-fi was aligned with. Saunders studied with Brandywine artist Harvey Dunn (*Chapter 21*) and produced over one hundred covers a year in many genres other than sci-fi.

Wikimedia. Restoration by Adam Cuerden.

New Directions in Sci-Fi and Fantasy from the 1950s to the 1970s

The rising popularity of *Weird Tales* and similar pulps coincided with the decline of fantasy imagery in general circulation magazines—possibly due to the perception of pulps as tasteless sensationalism. Many other genres, including Western and detective fiction, were also tainted by association with the pulps. With relatively few exceptions, by the 1930s, pulp genres were marginalized—an estrangement that would last for much of the century. Nevertheless, pulp genres remained popular in comics, books, movies, and later, television. The 1950s saw an explosion in the already popular field of comic books, which as descendants of the pulps, were printed on the same cheap paper and fit into the same newsstand racks.

Science fiction subjects also appeared in early films such as director Georges Méliès's 1902 *Le Voyage dans la Lune*, inspired by Jules Verne. As special effects improved, film became both a threat to and a new market for pulps' talent, as in John W. Campbell Jr.'s (American, 1910–1971) popular 1938 thriller *Who Goes There* illustrated by Hannes Bok (American, b. Wayne Francis Woodard, 1914–1964). Having first been published in *Astounding Science-Fiction* (1938), then as a novella, Campbell's story was adapted into the 1951 film *The Thing from Another Planet*, and remade in two versions as *The Thing* (1982 and 2011) (Figure 22.28).

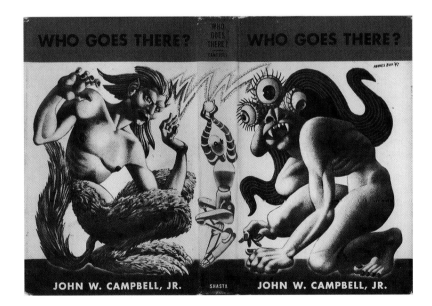

Figure 22.28
Hannes Bok, cover, *Who Goes There* by John Campbell, 1947, 1948.
Bok's career was inextricably tied to fandom in the creative marketplace. Ray Bradbury (not yet a successful author) brought Bok's portfolio to editors at the first World Science Fiction Convention in New York City in 1939. Bok's work was published in *Weird Tales* that same year, and in many other titles thereafter until the mid-1950s. His luminous images were achieved through layers of transparent oil paint.

Merril Collection of Science Fiction, Speculation and Fantasy, Toronto Public Library.

Many sci-fi illustrators have worked in the film industry. Chesley Bonestell's (American, 1888–1986) knowledge of architectural rendering and astronomy made him uniquely suited to working as a consultant on several of the great science fiction films of the 1940s, '50s, and '60s. He also created **matte paintings**—the convincing backgrounds used in special effects when filming on location was impossible. Beyond the realm of entertainment, Bonestell's near-photographic illustrations of space themes (Figure 22.29) helped a panel of rocket scientists led by Dr. Wernher von Braun to raise awareness of and interest in the possibility of spaceflight in a *Collier's* magazine series called "Man Will Conquer Space Soon" (1952–1954).

Paperback Books

By 1950, a number of publishers were experimenting with paperback formats. While continuing many of the pulp genres, paperbacks were more conducive to long-form fiction, conveniently compact, and cheap—and would eventually supersede the pulps. As "one-offs," paperbacks were not part of month-to-month series titles, so each cover had to serve as a lasting sales lure and inform the reader of the book's subject and genre. Their radically reduced size and larger title text area favored simpler images than the pulps, prompting illustrators to adopt a range of shorthand visual symbols—spaceships, stars, robots, and so on that gradually evolved into a markedly different cover style.

Many of the prominent science fiction and fantasy artists of the 1950s and 1960s, including Richard M. Powers (American, 1921–1996) in sci-fi and Frank

Frazetta (American, 1928–2010) in fantasy, made their name in paperbacks. Their distinct, powerful, personal visions radically reshaped cover art.

Powers was influenced by Surrealism (*see Chapter 19*), particularly the work of Yves Tanguy (French, 1900–1955). Originally a pulps illustrator, Powers transitioned to paperbacks as the 1960s' booming paperback market offered both higher pay and more artistic freedom. Powers's work was strongly informed by current intellectual trends, and created a new vocabulary for sci-fi illustration that reflected the genre's return to its more dignified speculative roots. His design for *Wine of the Dreamers* (Figure 22.30) exemplifies his mature style with strong atmospheric and background coloring, and his signature rounded, silvery forms reminiscent of cellular structure and advanced machinery. Exploiting elements of Surrealism and abstraction, Powers developed a moody style that evoked mysterious processes and motivations. As such, it was a perfect complement to **New Wave** science fiction of the period, which embraced more literary and self-consciously artistic treatment of form and subjects.

Frank Frazetta, a seminal figure in late-twentieth-century fantasy illustration, emerged from comic book culture, having worked for both EC Comics and Al Capp's strip *Li'l Abner*. In the early 1960s, he, along with fantasy and history illustrator Roy Krenkel (American, 1918–1983), worked on illustrations for reissues of Edgar Rice Burroughs's early pulp novels. However, it was in 1966,

Figure 22.29
Chesley Bonestell, *The Magazine of Fantasy and Science Fiction*, October 1961.
From illustrations commissioned by teams of scientists to more entertaining platforms like this digest-sized fiction periodical, Bonestell's images were believable in terms of form and materiality, which brought a new respectability to illustrations of future space discovery.
Courtesy of Nick Jainschigg.

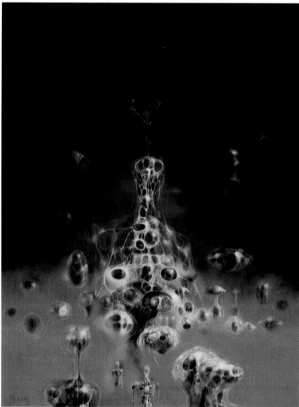

Figure 22.30
Richard M. Powers, cover art for *Wine of the Dreamers* by John D. MacDonald, 1971. Acrylic on wood panel, 40 × 30".
Powers implies enormous scale, with small, barely recognizable humans-cum-aliens among the forms. Powers also adopted collage and other modern art techniques that prefigured and influenced the work of many of today's digital artists.
© The Estate of Richard Powers.

with the revival of the pulp character Conan the Barbarian, that Frazetta developed the style that would establish the look of contemporary heroic fantasy. With technical skills more akin to predecessors Howard Pyle and N. C. Wyeth (*see Chapter 18*) than to most of his contemporaries, Frazetta depicts extremes of power, sexuality, and violence in a way that suited the anti-heroic tenor of the times and attracted new audiences to fantasy literature.

Frazetta's facility for depicting flesh and textures allows him to convincingly depict the sensuality of exaggerated male and female anatomy, highlighting subjects in dramatic chiaroscuro while secondary elements are gesturally brushed in near-monochrome underpainting (Figure 22.31).

European Influences

The 1948 introduction of the 33⅓ rpm LP (long playing) record ushered in a new, larger format of pictorial album covers, which became a significant market area for illustrators. Artist and designer Roger Dean's (English, b. 1944) otherworldly fantasy landscapes appeared as album covers and posters advertising progressive rock bands such as Yes, Asia, and Uriah Heep (Figure 22.32). Dean also designed typefaces, logos, furniture, stage sets, and architecture with an articulation of form and space inspired by his research into psychology and architectural form. His images sometimes echo the flowing patterns of Art Nouveau and medieval architecture, often as impossible environments, such as in his series depicting weightlessly floating structures of rock.

Omni magazine, launched in October 1978, was the first mainstream sci-fi and fantasy magazine that rejected the pulp influence completely in favor of high-art elegance. *Omni* provided the first major U.S. exposure for European artists like De Es Schwertberger (Austrian, b. 1942), H. R. Giger (Swiss, 1940–2014), Jacek Yerka (Polish, b. 1952), Zdzisław Beksiński (Polish, 1929–2005), and Ernst Fuchs (Austrian, 1930–2015)— an artist and founder of the postwar Vienna School of **Fantastic Realism**. Almost all were fine artists rather than commercial illustrators. Often demonstrating strong surrealist or religious influences, many of them worked in deliberately archaic mediums such as egg tempera and oil **glazes**—paint applied in thin transparent layers to achieve a rich, optical mix of color. Their work was nevertheless enthusiastically embraced by American illustrators looking for a way to escape the hackneyed modalities of pulp imagery. Their influence has only grown stronger with the advent of digital image making, including in game and media design (Figure 22.33).

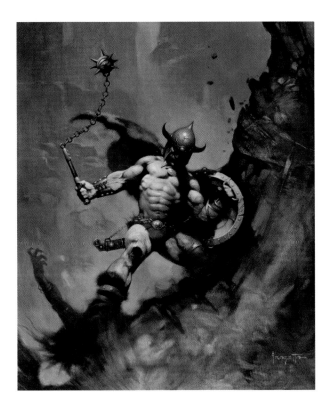

Figure 22.32
Roger Dean, *Pathways*, cover art for LP album *Yessongs* by Yes, Atlantic Records, 1973.
Dean's fantastical approach to space combines organic and manmade elements. People are nonexistent or dwarfed, as in this image where the human presence is suggested only by the spiral walkway. Dean's work influenced the design of later computer-generated film and animation worlds.
© 2016 Roger Dean.

Figure 22.31
Frank Frazetta, "Warrior with Ball and Chain," cover art, *Flashing Swords* no. 1, 1973. Oil on board, 23 × 19".
Shown from low angle, the hyper-muscular warrior is imposing and fully rendered while the vanquished foe is barely discernable in the thinly painted background.
Courtesy of Heritage Auctions.

Figure 22.33
De Es Schwertberger, *The Old One*, "Stoneman" series, 1973. Oil on board, 65 × 49 ¼".
"Stoneman" images appeared in *Omni* in the mid-1970s and were published later as "Philosopher's Stone" in a book and a card deck. The images explore man's struggle to be reunited with light as a source of all matter and thus transcend the limitations of the physical.
Courtesy of De Es Schwertberger.

Mati Klarwein (German, 1932–2002), who briefly trained with Fuchs, was best known for record album graphics and promotional materials of the 1960s and 1970s. Klarwein drew from many ethnic art traditions and celebrated the sensual, often in a chaotic juxtaposition of textural and landscape references that predated the "psychedelic era" by several years (*see Chapter 26*) (Figure 22.34). Brought into sci-fi and fantasy contexts through reprint rights, Fuchs's, Schwertberger's, and Klarwein's art confirmed relationships between speculative fiction and historical art and culture traditions.

Fantasy Illustration in Analog Gaming

In 1974, Gary Gygax (American, 1938–2008) and Dave Arneson (American, 1947–2009) of Tactical Studies Rules, Inc. (TSR) created *Dungeons & Dragons*, the seminal **role-playing game** in which players operate as predefined characters bound by game rules and probability (dice).

Inspired by their shared interest in Tolkien's *The Lord of the Rings* and military strategy games, Gygax and Arneson's premise was that each player was assigned a range of fantasy character **avatars** (personae enacted by the players) whose capabilities could change over the course of play. Gygax and Arneson published a set of rulebooks illustrated with black-and-white drawings by David A. Trampier (American, 1954–2014). Subsequent versions involved full-color imagery and

more sophisticated graphic design by Clyde Caldwell (American, b. 1948) and others (Figure 22.35). *Dungeons & Dragons* spawned the entire role-playing game field and influenced all subsequent fantasy game-related art in analog and later digital forms (*see Chapter 29*).

In 1997, Wizards of the Coast, developers of a game based on illustrated cards called *Magic: The Gathering*, purchased TSR. *Magic* incorporates many of the play elements and aesthetics of *Dungeons & Dragons*. Richard Garfield (American, b. 1963) designed and first published the game in 1993. Since that time, legions of artists have created images for their cards. Freed from the constraint of integrating text, but needing to be effective at small scale, card art has developed into its own specialty field, merging illustration with concept art (Figure 22.36).

1990s to the Present

From the 1990s onward, improved digital-imaging technologies provided new crossover opportunities for fantasy illustrators. Illustration, long a part of **storyboarding** (creating series of images used to design sequences in animation, movies, or motion graphics), now became essential in inventing and depicting fictional

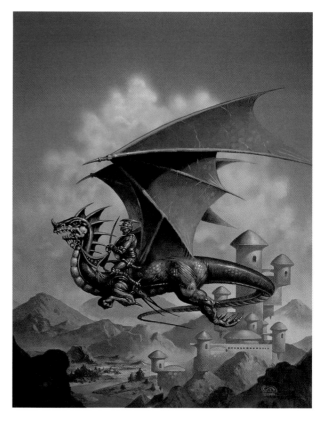

Figure 22.35
Clyde Caldwell, cover, *Dragon Magazine*, issue #71, 1982. Acrylic, 19 × 25".
Visually alluring, *Dungeons & Dragons* artwork helped players imagine the world their characters inhabited. This image is representative of TSR's predominant style, referencing medieval and folkloric characters.
©1982, 2016 Clyde Caldwell. All rights reserved.

Figure 22.34
Mati Klarwein, *Annunciation*, 1961. Oil on canvas, 50 × 34 ⁹/₁₆".
This vividly colorful and sexualized interpretation of the Bible passage proved controversial when used on the cover of Santana's 1970 *Abraxas* album.

otherworlds in **concept art**: the design of characters, props, and backgrounds for computer games and for popular fantasy and sci-fi films.

After being tremendously popular but critically marginalized for nearly a century, by the 1990s science fiction, fantasy, and horror art achieved unprecedented levels of critical acceptance both within and outside the field of illustration. While many illustrators work exclusively within one or another of these genres, it has become much more common for mainstream illustrators to embrace sci-fi, fantasy, and horror themes, and for genre illustrations to win recognition in more mainstream publications. Perhaps fueled by transmedia trends, the greater presence and acceptance of genre themes in the culture at large have led to an equalization of pay scales across genres.

Publications such as the *Spectrum* Annual and a series of well-attended museum and gallery shows throughout the 1990s and early 2000s in the United States heightened the profile and status of fantasy, horror, and sci-fi illustration. It is no longer unusual to see such work winning medals at major venues and used in high-profile publications and campaigns.

Conclusion

Science fiction, fantasy, and horror together represent humankind's greatest fears and greatest aspirations embodied historically in images and texts. From the Romantic movement onward, the themes of wonder, fear, and awe were repeatedly rediscovered, even as they were fading as respectable subjects for "serious" art.

Inexpensive publications, some eventually aligned with radio and television entertainment, created new networks of people concerned with fiction inspired by fantastical notions. As communications technology grew in power, so did the fan culture associated with the genres. By the beginning of the twenty-first century, fan culture had transcended subculture status. Currently, the largest entertainment industries—games and film—are now dominated by science fiction, fantasy, or horror themes in both output and revenues.

Figure 22.36
Terese Nielsen, "Basandra, Battle Seraph," game card for *Magic: The Gathering*, 2011. Echoing stylistic precedents of Art Nouveau, Nielsen's mixed media approach counterpoints patterned graphic areas with more dimensional forms implied through chiaroscuro and texture. *Magic: The Gathering* images must be designed to read clearly at the small size of the printed cards, as well as at larger sizes.

© 2011 Wizards of the Coast.

KEY TERMS

avatar	matte painting
concept art	New Wave
dime novel	penny blood
drybrush	penny dreadful
Fantastic Realism	pulp fiction
fanzine	role-playing game
glaze	scratchboard
heroic fantasy	slicks
Inkling	story paper
line art	storyboarding

FURTHER READING

Bell, Karl, *The Legend of Spring-heeled Jack: Victorian Urban Folklore and Popular Cultures* (Woodbridge, UK: Boydell Press, 2012).

Bold, Christine, *The Oxford History of Popular Print Culture: Volume Six: US Popular Print Culture 1860–1920* (Oxford; New York: Oxford University Press, 2011).

Carpenter, Kevin, *Penny Dreadful and Comics* (London: Victoria and Albert Museum, 1983).

Deforest, Tim, *Storytelling in the Pulps, Comics, and Radio: How Technology Changed Popular Fiction in America* (Jefferson NC: McFarland, 2004).

Ellis, Douglas, and Weinberg, Robert (editors), *The Art of the Pulps: An Illustrated History* (San Diego, CA: IDW Publishing, 2017).

Haining, Peter, *The Classic Era of American Pulp Magazines* (Chicago: Chicago Review Press, 2001).

James, Louis, *Fiction and the Working Man: 1830–1850* (London: Oxford University Press, 1973).

———, *Print and the People: 1819–1851* (London: Allen Lane, 1976).

Lesser, Robert, *Pulp Art: Original Cover Paintings for the Great American Pulp Magazines* (New York: Gramercy Books, 1997).

Robinson, Frank M., and Lawrence Davidson, *Pulp Culture: The Art of Fiction Magazines* (Portland, OR: Collectors Press, 2001).

23

Overview of Comics and Graphic Narratives, 1830–2012

Brian M. Kane

with contributions by Loren Goodman, Michelle Nolan, Gary Tyrrell, and Brittany Tullis, and acknowledgment to the following comics specialists: Brian Walker, James Steranko, Roger Stern, Rick Magyar, Klaus Janson, Denis Kitchen, Cory Sedlmeier, Greg Horn, Tom Brevoort, Randy Duncan, Matthew J. Smith, and Paul Levitz

Comic strips, comic books, and graphic novels are illustrated narratives that use multiple static images called panels, placed consecutively to convey information or tell a story in a technique called **sequential art**. Each panel may contain complementary text, juxtaposed text, parallel text, or no text at all. This chapter covers developments in comics production primarily in the United States that had a lasting impact on this medium. Comics are primarily a "diverse hands" art form, so with few exceptions, what appears in print is usually the work of multiple artists. Sadly, inkers, letterers, and colorists along with background artists are sometimes overlooked, but they are still extremely vital to the creation of graphic narratives.

A Visual Storytelling Art Form Is Born: The Industrial Age of Comics, 1831–1896

Telling stories through the use of pictures has been part of our cultural heritage since our ancestors painted images on cave walls. It is as if our species' highly developed affinity for pictorial narratives is part of our DNA. We not only make images, but we also appreciate them and share them; and current research suggests approximately 65 percent of people are visual learners.

Modern era cartoons are closely descended from a long line of politically motivated and satirical caricatures in the nineteenth century that effectively challenged rulers and politicians through images that transmitted ideas to semi-literate or illiterate viewers. This period is sometimes referred to as the **Industrial Age of comics**. The nineteenth-century publication *Le Charivari* (French, meaning hullabaloo) (*see Chapter 11*) was copied by the British magazine *Punch* (*see Chapter 14*), which inspired other publications such as Charles Wirgman's (British, 1832–1891) magazine *The Japan Punch*. Contemporaneous to the publication *Le Charivari*, Bostonian Charles Ellms (American, 1805–1851) published *The American Comic Almanac* (1831–1846), which was the first U.S. pamphlet containing cartoons and other "whims, scraps, and oddities."

However, the first comic book published in the United States did not originate there; rather, it was the creation of Rodolphe Töpffer (Swiss, 1799–1846), long considered the "Father of the Comic Strip." Töpffer began creating "picture stories" as early as 1827, leading to his first publication of *L'Histoire de Monsieur Jabot* in May 1833. In 1842, Töpffer's drawings for *M. Vieux Bois* were translated and illegally published in pamphlet format in the American newspaper *Brother Jonathan* as *The Adventures of Obadiah Oldbuck*—making it the first U.S. comic book (Figure 23.1). Töpffer was the progenitor of a long line of prolific Franco-Belgian creators that includes writer Jacqueline Rivière (French, 1851–1920) and artist Émile-Joseph Pinchon (French, 1871–1953), whose comic strip *Bécassine* (1905) featured the medium's first female protagonist with a socially driven message; and Hergé, creator of popular character *Tintin* (1929) (Figure 23.7).

The Early Newspaper Comic Strips 1896–1945

"The Yellow Kid and His New Phonograph," published in 1896 by Richard Felton Outcault (American, 1863–1928), is considered the first fully formed comic strip. The main character Mickey Dugan, a.k.a. the Yellow Kid, initially appeared in a black-and-white, single-panel cartoon in the June 2, 1894, edition of *Truth* magazine, but it was in the January 5, 1896, edition of *New York World* that the Kid's nightshirt changed to a brilliant yellow (Figure 23.2). With his mass-market appeal, the Yellow

Figure 23.1
Rodolphe Töpffer, *The Adventures of Obadiah Oldbuck*, Wilson & Co. (publisher), Egbert, Hovey & King (printer), 1841.
Written and illustrated by Töpffer, *The Adventures of Obadiah Oldbuck* is considered the first American comic book, despite being a purloined Swiss import.
Courtesy of Dartmouth College Library, Rauner Rare Book Library.

Figure 23.2
Richard Felton Outcault, "Around the World with the Yellow Kid" by Rudolph Block, *New York Journal*, November 8, 1896. *The Yellow Kid* became the first newspaper comic character with a large fan base, and consequently an early example of the importance of copyright in mass media and trans-media commerce.
Collection of The Ohio State University Billy Ireland Cartoon Library & Museum.

Figure 23.3

Winsor McCay, *Little Nemo in Slumberland, New York Herald*, December 20, 1908.
Written and illustrated by McCay, *Little Nemo* was one of the most influential cartoons of all time.
McCay's groundbreaking page design departed from a standard grid format by varying panel size
and pacing according to the needs of the story. McCay's detailed drawings, experimental use of color,
imaginative architecture, and improbable spaces also set the strip apart from other comic pages.

Collection of The Ohio State University Billy Ireland Cartoon Library & Museum.

Kid was the first comic strip character that stimulated newspaper sales (*see Chapter 21, Theme Box 42, "Yellow Journalism"*). Lacking copyright protection, Mickey Dugan's likeness appeared on unauthorized products such as songbooks, buttons, chocolate figurines, and ladies' fans, which led to unwinnable legal battles.

The twentieth century began with an array of innovative strips that took full advantage of the medium with few limitations on what was "appropriate" for this new art form. Rudolph Dirks' (German, American, 1877–1968) *The Katzenjammer Kids* (1897) featured prankish protagonists Hans and Fritz incessantly thwarting adult authority, and Winsor McCay's (American, ca. 1867/71–1934) impeccably rendered *Little Nemo in Slumberland* (1905) delved into the dream-fears made popular by Sigmund Freud's recently published *Die Traumdeutung* (*The Interpretation of Dr*eams, 1899) (Figure 23.3). Emblematic of the Jazz era was George Herriman's (American, 1880–1944) idiosyncratic, surreal *Krazy Kat* (1913) with its vernacular language play. Socially astute strips like George McManus's (American, 1884–1954) *Bringing Up Father* (1913), and Harold Gray's (American, 1894–1968) *Little Orphan Annie* (1924) entertained readers with relatable characters; while the memorable convoluted machinations of Professor Lucifer Gorgonzola Butts, conceived by Reuben "Rube" Goldberg (American, 1883–1970), delighted and mystified readers with hilariously overdesigned "solutions" to simple everyday tasks (Figure 23.4).

During these early years, several prominent female creators emerged: Fanny Young Cory (American, 1877–1972); Frances Edwina Dumm (American, 1893–1990), the nation's first full-time female editorial cartoonist; and Nell Brinkley (American, ca. 1886/88–1944), whose "Brinkley Girl" (1908) (Figure 23.5) replaced the "Gibson Girl," which in turn gave way to the flapper-themed cartoons of Ethel Hays (American, 1892–1989).

A notable influence on American practitioners was political and social commentator Heinrich Kley (German, 1863–1945), whose illustrations often include

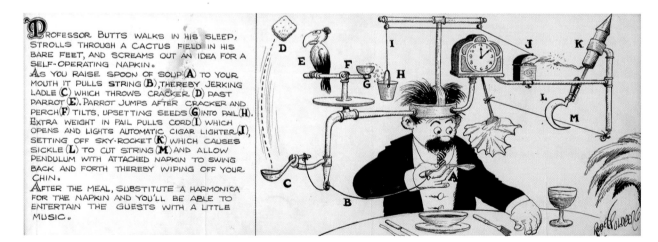

Figure 23.4

Rube Goldberg, "The Self-Operating Napkin," The Inventions of Professor Lucifer G. Butts, A.K., *Collier's*, September 26, 1931.
Goldberg's fantastic "machines" satirized Western society and its embrace of over-designed contraptions to complete even the simplest of tasks. *A Rube Goldberg machine* persists in the lexicon as the definition of any absurdly convoluted solution. The board game *Mouse Trap* is an example of a functional Rube Goldberg machine.

Courtesy of Heritage Auctions.

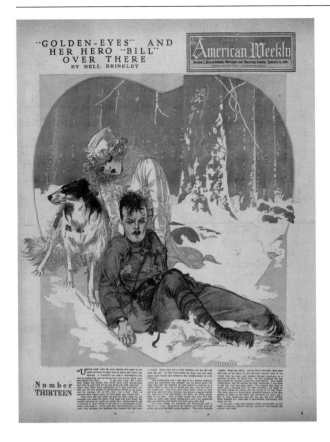

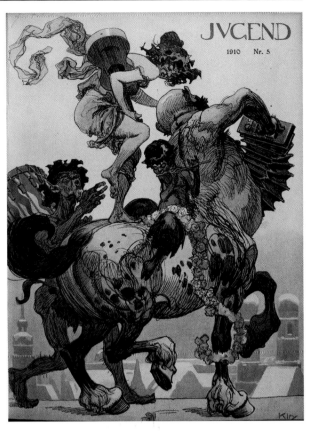

Figure 23.6
Heinrich Kley, cover, *Jugend*, vol. 5, 1910. Kley's lively, sketchy line creates both texture and form on the figures. Spatial depth is achieved through the use of atmospheric perspective, in which color-blocked buildings in the background are made lighter. Walt Disney collected dozens of Kley's drawings and sketchbooks, which proved inspirational to his artists.

Universität Heidelberg Bibliothek. Creative Commons License 3.

Figure 23.5
Nell Brinkley, *"Golden-Eyes" and Her Hero "Bill" Over There*, cover, *American Weekly*, January 19, 1919.
In the early twentieth century, the Brinkley Girl, an alternative to Charles Dana Gibson's aloof Gibson Girl, personified the new American woman as a young, independent, everyday working girl who was both feminine and somewhat feminist.

Collection of The Ohio State University Billy Ireland Cartoon Library & Museum.

anthropomorphic animals and fantastical hybrid creatures (Figure 23.6). His virtuosity with gesture and ink line imbued his characterizations with weight and believability, which had a lasting impact on creators such as Walt Disney (American, 1901–1966). Another important European cartoonist of the twentieth century was Georges Prosper Remi (Belgian, 1907–1983), more popularly known by his pen name, Hergé, the author/illustrator of *Tintin* (Figure 23.7). First appearing in 1929 in Brussels as a weekly cartoon strip in *Le Petit Vingtième*, *Tintin* went on to appear in twenty-three books published between 1929 and 1976, becoming one of the most popular European comics of all time. Hergé's **ligne claire** or clear-line technique, marked by uniform line weight and flat in-filled color, influenced comic and fine artists alike.

Syndicated Licensing

With **syndicated licensing**, the distribution of copyrighted material across geographic markets, comic strips moved away from regional social and political topics of the 1920s and 1930s. This gave rise to family-oriented comic strips containing generalized humor appealing to a broader readership, such as *Blondie* by Murat Bernard "Chic" Young (American, 1901–1973).

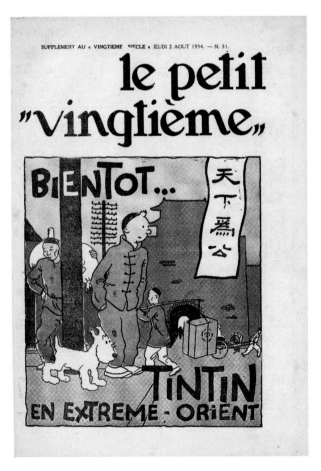

Figure 23.7
Hergé, cover, *Le Petit Vingtième (The Little Twentieth)*, August 2, 1934.
First appearing in 1929, Hergé's character Tintin was an ageless journalist whose boyish curiosity continually propelled him on investigative adventures, confronting cunning or dangerous adversaries—often in foreign countries. His "clear-line" style of drawing and visually dynamic color palettes were influential on future generations of artists.

© Hergé/Moulinsart 2016.

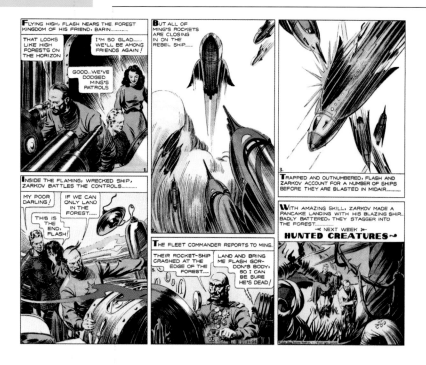

Figure 23.8
Alex Raymond, *Flash Gordon*, King Features, May 31, 1936.
Space travel to distant worlds had been a staple of science fiction for seventy years by the time *Flash Gordon* premiered, but it was Raymond's gracefully fluid brush lines, attention to detail, and ability to imbue Flash with the charisma of a leading movie actor that elevated this strip.
© King Features Syndicate, World Rights Reserved.

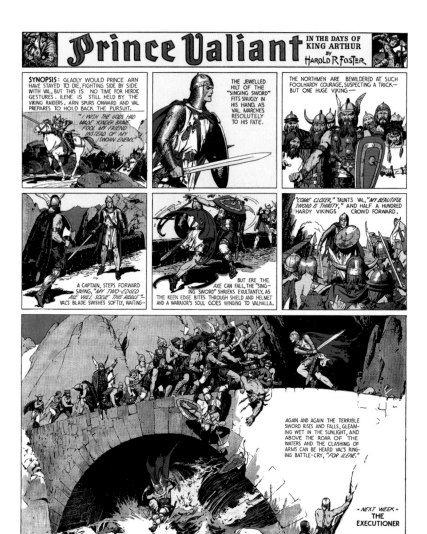

In 1931, George Horace Gallup (American, 1901–1984) conducted his first poll designed to ascertain what people read in their newspapers. Gallup's newspaper poll revealed that while only 4.5 percent of readers complained when the news section of their paper was missing, 88 percent protested when the comics section was absent. Gallup scientifically proved the comics section was being read more than any other section. Realizing the importance of the report, the comic strip magazine supplement *Comics Weekly* immediately expanded its page count to include comic-strip-styled advertisements in addition to their regular comics.

Tarzan (1928) and *Buck Rogers* (1929) were among the first syndicated adventure strips with adult male protagonists, but Gallup's poll changed that. Soon adventure strips like *Flash Gordon* (1934) (Figure 23.8) and *Prince Valiant* (1937) (Figure 23.9) became de rigueur. Typically, these were fantastical tales and mysteries, featuring heroic men, beautiful women, wizened mentors, inept but well-meaning sidekicks, femme fatales, and devious, unstoppable villains—all entangled in life-or-death struggles to save the village/kingdom/city/world/universe.

Before Heroes Were Super: The Platinum Age of Comic Books, 1897–1938

The Yellow Kid in McFadden's Flats (1897) was a 196-page, black-and-white square-bound book containing reprints of the classic strip. Though not a pamphlet, it is considered the first **Platinum Age** comic book, since the term "Comic Book" appeared on its back cover. Similar reprint volumes followed, such as *Buster Brown* (1902) and *Barney Google* (1923).

In 1929, Dell Publishing began producing *The Funnies*, a short-lived twenty-four-page, four-color newsprint weekly. Its tabloid-size made it look like a newspaper insert despite having to be purchased separately. The prototype for all pamphlet-style comic books came in 1933 with *Funnies on Parade*, a promotional giveaway that reprinted Sunday cartoons in a 7 ½ × 10 ½", thirty-two-page format with a higher-quality paper cover. *Funnies on Parade* was followed by *Famous Funnies: A Carnival of Comics*, and by *Famous Funnies, Series 1* (1934). That summer the first ongoing comic book, *Famous Funnies #1*, began; it remained in circulation for twenty-one years.

Figure 23.9
Harold R. "Hal" Foster, *Prince Valiant*, page #71, King Features, June 19, 1938.
During the mid-twentieth century, Hal Foster, Alex Raymond, and Milton Caniff were the top three realist illustrators in comics. A preponderance of comic strip, comic books, and graphic narrative illustrators can trace their stylistic lineage back to these three artists. Foster owned, wrote, and illustrated *Prince Valiant* for thirty-four years. Considered the most realistic of all the strip artists, Foster's originals were illustrated at 36" high by 24" wide.
© King Features Syndicate, World Rights Reserved.

The first publisher to issue comic books using all new material was Major Malcolm Wheeler-Nicholson (American, 1890–1965) who founded National Allied Publications in 1934. The company's first title, *New Fun* (1935), was magazine-sized (10 × 15") and featured "all original" adventure and humor strips. Financial difficulties forced Wheeler-Nicholson into a partnership with printers Harry Donenfeld and Jack Liebowitz, who foreclosed on him in 1937. National Allied was then assumed by the company that would later become DC Comics.

The Foundations of Mythic Icons: The Golden Age of Comic Books, 1938–1956

Realistically drawn adult protagonists in comic strips such as *Tarzan*, *Flash Gordon*, *Prince Valiant*, and the like led the way for "original" adventure heroes in comic books. The first appearance of Superman in *Action Comics* #1 (1938) (Figure 23.10) initiated the **Golden Age of comic books**. Created by writer Jerome "Jerry" Siegel (American, 1914–1996) and cartoonist Joseph "Joe" Shuster (Canadian, American, 1914–1992), Superman has become one of most recognizable characters of all time. *Superman*, along with *Batman* (1939) by Bob Kane (American, 1915–1998) and Milton "Bill" Finger (American, 1914–1974), and *Wonder Woman* (1941) by William Moulton Marston (American, 1893–1947), laid the foundation for comic book superheroes.

From their inception, major comic book companies owned the characters they published because **intellectual property rights**, the laws established to protect writers and artists from publishers exploiting their creations, did not exist (*see Chapter 29, Theme Box 56, "Copyright: An Abbreviated History"*). Publishers bought characters from creators and then paid artists a standard page rate in a **work-for-hire** arrangement, in which publishers owned not only the original artwork, but also all of its future applications. Siegel and Shuster, for example, sold their rights to Superman for $65 each, never imagining its circulation would reach 1,250,000 copies per issue, grossing $950,000 a month by 1940.

Sales of superhero comic books dropped off after World War II, as a variety of crime, Western, romance, horror, sports, science fiction, and humor comic books filled the stands. During the 1950s, Dell Comics became the leading publisher of comic books with many non-superhero titles, including Walt Disney's *Donald Duck* and *Uncle Scrooge* (Figure 23.11), written and illustrated by Carl Barks (American, 1901–2000); and Edgar Rice Burroughs's *Tarzan*, with art by Jesse Marsh (American, 1907–1966).

The Modern Comic Strips, 1945–2001

While ownership of comic strips by original creators was the exception, it became an important bargaining chip in contracts between publishers and creators after

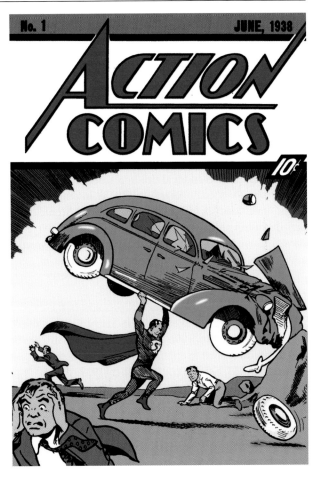

Figure 23.10
Joe Shuster, cover, *Action Comics* #1, June 1938. The foundational aspects of Superman's mythology are evident in his debut appearance in *Action Comics* #1, which began what is known as the Golden Age of comic books.

Action Comics, Batman, Sandman, Swamp Thing, The Dark Knight, and all related characters and elements are trademarks of and © DC Comics.

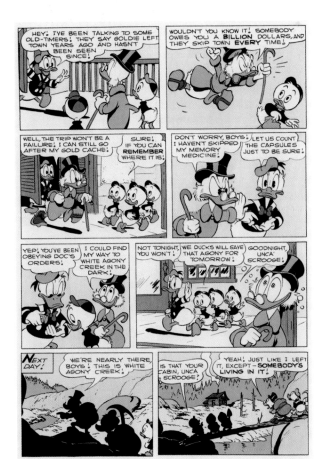

Figure 23.11
Carl Barks, Walt Disney's Uncle Scrooge in "Back to the Klondike," page #16, *Four Color Comics* #456, 1953. An inaugural inductee of the Will Eisner Comic Book Hall of Fame, Barks developed his clean line style from his eight years as an animator at Disney Studios. Barks penciled his Donald Duck and Uncle Scrooge stories and also scripted, inked, and lettered them.

© Disney, All rights reserved, Uncle Scrooge. Image courtesy of Fantagraphics.

World War II. For instance, when American soldiers began returning from the war, comic strip *Steve Canyon*, (1946), created and owned by Milton Caniff (American, 1907–1988), mirrored their lives. Another aspect of Post–WWII comic strips was their reflection of shifting social norms. Although set in medieval times, *Prince Valiant* (1937) by Hal Foster (Canadian, American, 1892–1982) depicted women as strong, self-reliant, and with newborns—resonating with the increase of women working outside the home during the war years. The strip also portrayed the first multicultural couple who married and had children, just as they did in the popular TV sitcom *I Love Lucy* (1953). In other strips, Dalia "Dale" Messick (American, 1906–2005) chronicled the adventures and romances of a female reporter in *Brenda Starr* (1940), and later Walt Kelly's *Pogo* captivated adults and children by satirizing human foibles, social mores, and politics through the activities of his witty anthropomorphized characters (Figure 23.12).

A few persons of color made their mark in the predominantly white male comics industry. Elmer Simms Campbell (American, 1906–1971) was the first African American cartoonist to appear in *Esquire* magazine starting in 1933, before creating *Cuties* (1939–1970) for King Features Syndicate. Jackie Ormes (American, 1911–1985) was the first African American female cartoonist and creator of *Torchy Brown in "Dixie to Harlem"* (1937–1938); and later, *Torchy in Heartbeats* (1950–1954), which narrated the romantic and/or dangerous adventures of a woman fighting social and environmental issues, and racial inequality.

Female Audiences and Creators

From the introduction of *Young Romance* (1947) and *Young Love* (1949) by Joe Simon and Jack Kirby (creators of *Captain America* in 1941), much of the best sequential art appeared in the commercially successful genre of romance comics. In the first half of 1950, nearly 150 romance titles were printed, consisting of more than 500 issues from over two dozen publishers. Dubbed "The Love Glut," a fourth of the newsstand comics were devoted to romance. Virtually all these titles were sold to pubescent girls or young women who enjoyed love stories in an era when few romantic paperback books existed. Many of the finest American comic artists worked in the 1950s romance field, including Frank Frazetta (1928–2010) (*see Chapter 22*), Wallace "Wally" Wood (1927–1981), Alexander "Alex" Toth (1928–2006), and Bob Powell (1916–1967). In all, about 3,750 different romance titles were published over the three decades through 1977.

The most renowned romance artist was Clarence Matthew "Matt" Baker (American, 1921–1959), who was also one of the first African Americans to succeed in comics. Baker's work is identified with the "good girl" art movement that depicted positive female characters as young, attractive, and provocative; and Baker illustrated most of the forty-five issues of *Teen-Age Romances* published from 1949 to 1955 (Figure 23.13). In an era when so many cartoonists exaggerated various aspects of idealized females and males, Baker was famed for his perfect anatomy and impeccable sense of fashion.

Figure 23.12
Walt Kelly, Earth Day, *Pogo*, Post-Hall Syndicate, February 22, 1971. As a former Disney animator, Kelly combined wit and slapstick to create a controversial daily comic that brilliantly exposed corruption in all forms of politics as seen through the eyes of his innocent protagonist, Pogo. Kelly's thought-provoking strip influenced not only political cartoonists such as Jules Feiffer of the *Village Voice*, but also the development of Jim Henson's Muppet characters, Bill Watterson's *Calvin and Hobbes*, and Jeff Smith's *Bone*.

© Okefenokee Glee & Perloo, Inc. Used by permission.

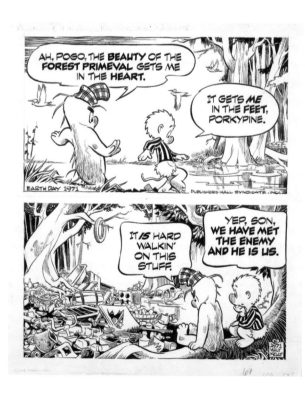

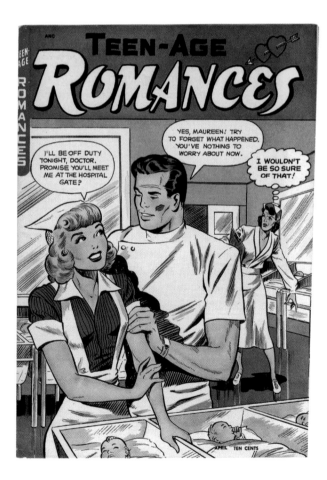

Figure 23.13
Matt Baker, *Teen-Age Romances #2*, St. John Publishing, 1949.
Baker began working in comics on "Good Girls" titles such as *Sheena, Queen of the Jungle* and *Phantom Lady*, eventually becoming one of the most prolific romance comics artists. He was also the illustrator of the first modern graphic novel, *It Rhymes with Lust* (Figure 23.29).
Courtesy of Heritage Auctions.

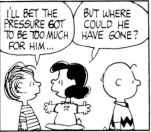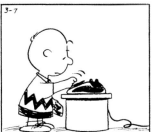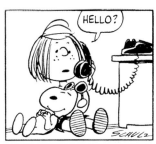

Figure 23.14
Charles M. Schulz, *Peanuts*, United Feature Syndicate, March 7, 1970. Schulz's simple line work never detracted from the intelligence, humor, pathos, and humanity of the story, which was told through the interaction of multiple characters with unique personalities and voices. *Peanuts* became the most popular comic strip of all time.

©Universal Uclick, a division of Andrews McMeel Universal.

Although romance comics as a genre has faded since the 1970s, the overall field of comics by and for women has since significantly expanded. Contemporary female cartoonists such as Cathy Guisewite's (American, b. 1950) *Cathy* (1976–2010) provided a humorous look at the foibles and day-to day quandaries of a modern-day single woman (until her fictional marriage in 2005). Maitena Burundarena's (Argentinian, b. 1962) graphic novels *Mujeres Alteradas* (*Women on the Edge*), *Las Superadas* (*The Overtaken*), and *Curvas Peligrosas* (*Dangerous Curves*) explicitly explore upper-middle-class female subjectivity in all of its postmodern complexity. Maitena's books have pushed against very real boundaries in the comics world, opening doors for other female comics creators in the process, including

female Latin American sequential artists such as Sol Díaz (Chilean, b. 1986), Paola "Power Paola" Gaviria (Ecuadorian raised in Colombia, b. 1977), and Marcela Trujillo (Chilean, b. 1969).

Peanuts

In 1951, a little round-headed kid named Charlie Brown and his dog Snoopy inauspiciously appeared in thirty-five newspapers, and later became global cultural phenomena in the most enduring comic strip of all time. *Peanuts* by Charles M. Schulz (American, 1922–2000) (Figure 23.14) investigates human interaction with a remarkable range of emotion achieved via a technique that theorist Scott McCloud (American, b. 1960) refers to as "amplification through simplification." Schulz, arguably the most influential cartoonist of his generation, paved the way for William "Bill" Griffith (American, b. 1944), Franklin Christenson "Chris" Ware (American, b. 1967), and all the "kid and his dog" comics that followed, including *Calvin and Hobbes* by William Boyd "Bill" Watterson (American, b. 1958).

The Comics Code Authority and Censorship in America

In the 1950s, a conservative, anti-Communist movement known as *McCarthyism* bred rampant fear-mongering, which targeted comic books as the scapegoat for antisocial teen rebellion, leading to an implosion of the industry. Entertaining Comics (or EC Comics), under the guidance of William Maxwell "Bill" Gaines, became a target of the controversy because it produced a profitable line of crime, horror, and science fiction titles, the very books "experts" had linked to juvenile delinquency (Figure 23.15). Gaines, along with editors Harvey Kurtzman (American, 1924–1993) and Al Feldstein (American, 1925–2014), employed the best artists in the industry, including Frazetta, Wood, Toth, Alfonso "Al" Williamson (American, 1931–2010), Bernard "Bernie" Krigstein (American, 1919–1990), Jack Davis (American, 1924–2016), and Marie Severin (American, b. 1929) to illustrate their books.

Key to the anti-comics movement was Fredric Wertham, M.D., who popularized the notion of "mental hygiene" in his book *Seduction of the Innocent* (1954), which condemned comic books as a root cause of society's problems. Despite dissension, after *Seduction of the Innocent*, Wertham was considered the leading expert in his field, and comic books that

Figure 23.15
Johnny Craig, cover, *Crime SuspenStories* #22, EC Comics, April/May 1954. Covers such as this one were considered a contributing factor to juvenile delinquency, and led to an industrywide censorship of all comic books.

Crime SuspenStories and the EC Logo are trademarks and the displayed artwork is copyrighted material owned by William M. Gaines, Agent, Inc. All rights reserved. Scan provided by John Morrow, TwoMorrows Publishing.

sensationalized sex, violence, and horror came under heavy governmental scrutiny.

Fearing government action, in an effort to save the industry, comic book publishers banded together in 1954 to form the Comics Magazine Association of America (CMAA). Judge Charles F. Murphy was appointed administrator to ensure comic books conformed to a set of moral standards. Murphy hired an all-female staff who were not "steeped in the habits and traditions of comic book stories" to review each comic book before it could be published. CMAA also created the Comics Code Authority (CCA) "seal of approval," to be printed on the cover after an issue passed inspection. The once-popular genres of crime and horror comics, which made up a large percentage of the industry's sales, were banned. Many creators left the gutted comic book industry as work and income vanished.

EC also published the humor comic book *MAD*, which was to contemporary American audiences what *Le Charivari* and *Punch* were in the nineteenth century—a mockery of hypocrisy in entertainment, advertising, and consumerism through subversive political and cultural parodies. Written predominantly by Kurtzman and illustrated by many EC Comics artists, *MAD* was a sensation—later influencing the style of illustrated satire in the United States and the underground comix movement of the 1960s (*see Chapter 26*). In a rare example of protest, EC reformatted *MAD* (Figure 23.16) from a comic book

to a magazine in July 1955, rather than submit to censorship. Outside of CCA's purview, *MAD* magazine was able to continue uncensored under the guidance of Kurtzman and was EC Comics' only title to survive the "sanitization" of the industry.

Rebirth of an Industry: The Silver Age of Comic Books, 1956–1973

The **Silver Age of comic books** began with DC Comics' re-introduction of *The Flash* in *Showcase* #4 (1956) and the debut of *Justice League of America* in *The Brave and the Bold* #28 (1960). Seeing the success of DC Comics' new superhero titles, Marvel Comics' publisher Martin Goodman ordered editor and writer Stan Lee (American, b. 1922) to create a competitive superhero comic book. Working with veteran artist Jack Kirby, the two created *The Fantastic Four* (1961) (Figure 23.17). Kirby's comparatively grittier style was visually jarring but effective. The rougher images were in sync with each

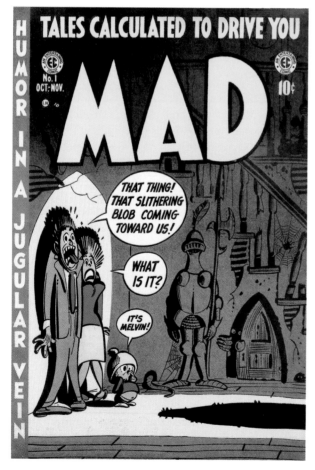

Figure 23.16
Harvey Kurtzman, cover, *MAD* #1, EC Comics, October/November 1952. Although it began as a comic book, *MAD* later changed to a magazine format in order to circumvent censorship by the Comics Code Authority.

Scan provided by John Morrow, TwoMorrows Publishing. MAD™ and © E.C. Publications, Inc.

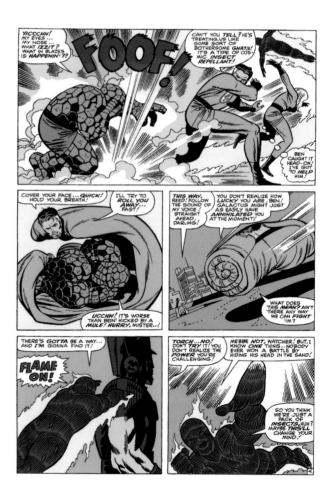

Figure 23.17
Stan Lee (writer), Jack Kirby (penciler), and Joe Sinnott (inker), *The Fantastic Four* #49, page 4, Marvel Comics, April 1966.
Marvel Comics reached out to a younger readership by grounding their superheroes in socially relevant situations. Jack Kirby imbued every panel with kinetic energy.
© Marvel Comics. All rights reserved.

character's human flaws, and their "real" problems made them sympathetic, creating the archetype for future Marvel superheroes.

While Stephen J. "Steve" Ditko (American, b. 1927) worked on Spider-Man and Dr. Strange, and Wood developed Daredevil, Kirby created or co-created The Hulk, Iron Man, Ant-Man, Thor, The Avengers, The X-Men, Nick Fury: Agent of S.H.I.E.L.D., resurrected Captain America, and established an array of villains. In 1971, Kirby moved to DC Comics where he conceived of a plethora of all-new superheroes.

The biggest impact on Silver Age comic book artists came in 1966 with the size change of standard art boards. Art boards, referred to as "twice up" because they were twice the size of final page reproduction, were reduced from approximately 12 ½ × 18" to 10 × 15" because the smaller size saved time and reduced printing costs. For dynamic artists like Kirby, the constraints of the smaller size inhibited the long, natural sweep of their penciled line drawings, whereas others like Neal Adams (American, b. 1941) found that the reduced size made it easier to design whole pages rather than individual panels. No one took advantage of this change more than Jim Steranko (American, b. 1938), whose unique cinematic and advertising-based design sense helped him develop new approaches to page dynamics (Figure 23.18).

The mid-1960s to the mid-1970s was a time of tremendous change and growth for comic books, with an increase in socially relevant stories. In 1971, the U.S. Department of Health, Education, and Welfare asked Marvel Comics to produce a comic book about the dangers of drug use. Editor-in-Chief Stan Lee agreed, but because *Amazing Spider-Man* #96–98 (1971) contained a character addicted to drugs, the CCA denied their seal of approval. In the first confrontation between a major comic book publisher and the CCA since its inception, Marvel ran the story. The positive publicity led the CCA to change the Comics Code to allow negative portrayals of drug addiction, which eventually led to the repeal of some constraints.

As constraints by the Comic Code Authority on horror genre comic books loosened, titles such as *Swamp Thing* became more prevalent. Horror magazine anthologies *Creepy* (1964), *Eerie* (1966), and *Vampirella* (1969) introduced readers to Latino artists such as Esteban Maroto (Spanish, b. 1942), Pablo Marcos (Peruvian, b. 1937), and Alfredo Alcala (Filipino, 1925–2000). Contemporaneously, artists such as Joe Kubert (Polish, American, 1926–2012) and Neal Adams, who worked in a realistic style, redefined the look of heroes and superheroes by heightening the machismo and making them "sexy." Younger artists such as Bernie Wrightson (American, 1948–2017), Barry Windsor-Smith (British, b. 1949) on *Conan the Barbarian*, Michael Wm. Kaluta (American, b. 1947) on *The Shadow*; and Jeffery Catherine Jones (American, 1944–2011) on *Idyl* were characterized by individualized artistic approaches as opposed to a slavish devotion to house styles (Figure 23.19).

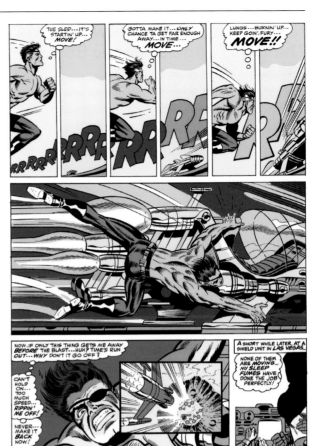

Figure 23.18
Jim Steranko (writer/illustrator), and Joe Sinnott (inker), *Nick Fury Agent of S.H.I.E.L.D.* #1, page 11, Marvel Comics, June 1968. Envisioning the whole page as a dynamic unit, the graphic rhythm of the panels at the top are connected by the "sound effect," and the horizontal movement of both the figure and the jet thrusters take advantage of the center panel's full width. The use of an inserted panel in the bottom register denotes simultaneous events.

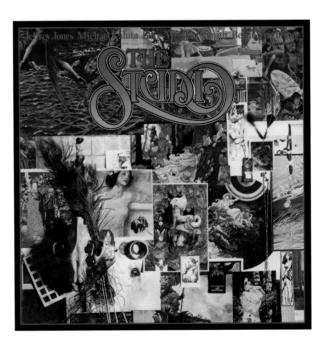

Figure 23.19
Bernie Wrightson, Barry Windsor-Smith, Michael Wm. Kaluta, Jeffery Catherine Jones, *The Studio*, 1979.
Wrightson, Windsor-Smith, Kaluta, and Jones collaborated in a studio in New York's Chelsea District, and created work that was collected into a 160-page book titled *The Studio*, published by Dragon's Dream.

New Ideologies and New Markets: The Bronze Age of Comic Books, 1973–1986

Bronze Age comics witnessed a move toward bleaker, more cynical stories that can be traced to *The Amazing Spider-Man* #121 (1973) (Figure 23.20) in which Peter Parker's/Spider-Man's girlfriend Gwen Stacy was killed. While murder of innocent characters had previously served as foundational plot devices, as in the slaying of Bruce Wayne's/Batman's parents, the slaying of much-loved Gwen Stacy can be considered an **epistemological rupture**, the breaking of an (often unconscious) fundamental archetype, initiating a radical and immediate philosophical dismantling of a belief system. As a result, comic book storytelling conventions were shattered, epitomized by the inability of the hero to "save the day," and the increasing perversion of some heroes toward psychologically darker narratives. The story incited fierce animosity from readers and hostile threats toward writer Gerard F. "Gerry" Conway (American, b. 1952).

Important Changes in Comic Book Marketing and Sales

Since their inception, comic books were predominantly sold through traditional retail outlets that returned unsold copies to publishers for credit when new issues came out. In 1973, Phil Seuling (American, 1934–1984) established a comic book mail-order service that warehoused and sold back issues that were no longer available at the regular retail stores. Seuling approached the major comic book publishers, offering to purchase books on a nonreturnable basis if they gave him a 50 percent discount. Seuling's **direct market** mail-order

and subscription services reached readers outside of mainstream distribution channels and soon fostered artistic growth by expanding offerings to include offbeat or smaller creator-owned comics. Starting in the mid-1970s, several **underground comix** artists (*see Chapter 26*) also infiltrated the mainstream, and soon independent publishers like Fantagraphics (1976) appeared, bypassing both the Comics Code–restricted and the work-for-hire corporate giants.

Direct marketing led to the increase in comic book specialty stores and access to international material. Some of the more notable offerings were *Asterix the Gaul* by René Goscinny (French, 1926–1977) and Albert Uderzo (French, b. 1927); reissues of *The Adventures of Tintin* by Hergé; *Métal Hurlant* (known as *Heavy Metal* in the United States) with art by Jean Giraud, a.k.a. Mœbius, a.k.a. Gir (French, 1938–2012) (Figure 23.21); and *2000 AD* artists such as Brian Bolland (British, b. 1951) (Figure 23.22). Giraud created many popular characters and stories including *Arzach*, *The Airtight Garage of Jerry Cornelius*, and his American Old West cowboy, *Blueberry*. Giraud's wordless, nonlinear surrealist fantasies required the reader to draw meaning from the decaying, unearthly industrial landscapes and elaborately costumed figures. Created decades before others in print and film envisioned a similarly dystopic future, his colorful images (with elegant gradients in ink and watercolor, and later, digital media) influenced not only comics artists, but also the visual language of films such as *Blade Runner*, *Alien*, *Tron*, and *The Fifth Element*.

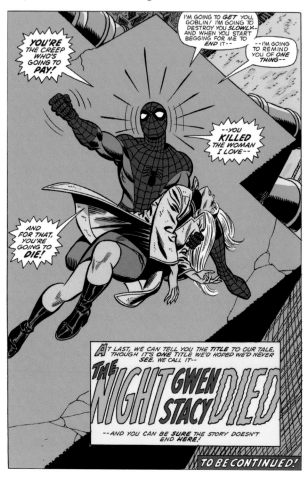

Figure 23.21
Jean Giraud (a.k.a. Mœbius, a.k.a. Gir), *Mœbius Comics* #1, Caliber Comics, reprint, 1996.
As one of the founders of the magazine *Métal Hurlant* (known as *Heavy Metal* in the United States), Giraud is considered one of the most influential European comics artists since Hergé.
Mœbius Comics # 1 cover provided by Gary Reed, Publisher, Caliber Comics. ©The estate of Jean Giraud.

Figure 23.22
Brian Bolland, cover, *Bolland Strips*, Knockabout Comics, 2008.
Bolland co-created the dystopian antihero *Judge Dredd* in 1977, with writer
John Wagner (American, British, b. 1949) and artist Carlos Ezquerra
(Spanish, b. 1947), and illustrated the critically acclaimed graphic novel
Batman: The Killing Joke (1988) for DC Comics. *Bolland Strips* is a collection
of character-driven strips including The Bishop and The Actress, nostalgi-
cally garbed figures (above). Working in Adobe Photoshop, Bolland used a
limited number of brushes for "inking" with lightly modulated fills of color.

©Brian Bolland, image courtesy of the artist.

Possibly the most successful independent comic of
the era was Peter Laird's (American, b. 1954) and Kevin
Eastman's (American, b. 1962) *Teenage Mutant Ninja
Turtles* (*TMNT*, 1984) an anthropomorphic parody of the
superhero trope containing clever, irreverent humor and
rugged aesthetics that set their art apart from corporate
comic books. The initial print run of 3,000 copies was sold
out of the back of a van and was printed in black and white.
Despite Laird's and Eastman's limitations, the characters

developed quickly from their first outline ink cover concept
drawing to the densely modeled pages that enhanced the
grittiness of the characters. *TMNT* was at the vanguard of
the inexpensive black-and-white comic books produced
during the "Black & White Boom" of the 1980s. *TMNT* was
rebranded in 1987 for younger audiences and it crossed over
into animation and film.

Little more than a decade later, the market was
flooded, and the industry collapsed in the mid-1990s.
Yet the growing acceptance of black-and-white comics
in North American markets made way for an influx of
Japanese comics, called **manga**. The stories were translated
and reformatted for English-speaking readers, distributed
by publishers Dark Horse, Marvel, and Viz Comics.

The Language of Manga

Some scholars assert that reading manga is akin to reading
Japanese itself because it draws attention to the poetically
rich ideographic nature of the Japanese language—one
whose very symbols contain direct visual representations of
the objects and concepts they convey. Manga has a unique
visual grammar. Its semiotic system can be described as being
made up of a variety of motives (dealing with motion) and
codified emotive symbols (like exaggerated "Bambi" eyes)
within fantastic narratives achieved through cinematographic
techniques of multiple perspectives, innovative framing and
montage, and stories that often address deeply human issues
through depiction and metaphor.

Osamu Tezuka

Considered the father of contemporary manga, Osamu
Tezuka (Japanese, 1928–1989) composed and penned
150,000 pages for 600 titles, including *Astro Boy*, *Princess
Knight*, and *Phoenix* (Figure 23.23). His characters'
oversized eyes are reminiscent of Western cartoons
and animation, but Tezuka also claimed to have been
influenced by the accentuated, spotlight-reflective eyes
of the Takarazuka Revue, an all-female theater group he
watched as a youth.

Manga has evolved into a socially powerful and
culturally diverse medium that includes scores of talented
creators like Katsuhiro Otomo (Japanese, b. 1954), whose

Figure 23.23
Osamu Tezuka,
Cast of Characters.
In this carnival-like
procession are
some of the many
characters created
by Tezuka. Simba
leads the pack with
Astro Boy at the
center, Phoenix
at the apex, and
Princess Knight
just right of center.
Tezuka includes
himself in a beret
with his left hand
to his face in the
upper right.

© Tezuka Productions.
Image courtesy of
Tezuka Productions.

Theme Box 45: Mitchell: Word and Image
by Carey Gibbons

W. J. T. Mitchell (American, b. 1942) explores a central concern of his work—the relationship between word and image—in great detail in his books *Iconology: Image, Text, Ideology* (1986) and *Picture Theory* (1994). In *Iconology*, he argues that word and image take on different functions during different periods of history and engage in a continual "dialectical struggle" in which image or word compete for supremacy in how they are valued for conveying truth and meaning. Rather than acknowledging the dominance of either word or image, however, Mitchell asserts the greater importance of investigating the interests that are served by this struggle for dominance. Mitchell examines various theories of image-text difference in relation to their respective contexts, asking what sorts of historical pressures or events gave rise to them. For example, in his discussion of the German Enlightenment–era theorist G. E. Lessing, Mitchell explains that Lessing's insistence on borders between the realms of painting and poetry arises from his greater concern with the need to establish and preserve rules between countries in order to ensure the stability of international relations.

Picture Theory, the sequel and companion to *Iconology*, is predominantly an examination of the disparate combinations of meaning that occur when words and images are combined or play off one another. Mitchell describes the relation between words and images as interactive and intermingled, arguing that "the interaction of pictures and texts is constitutive of representation as such: all media are mixed media, and all representations are heterogeneous; there are no 'purely' visual or verbal arts." Mitchell's aim is not to produce a theory of pictures, but to picture theory as an important activity in the formation of representations.

In analyzing the ideology of the image, Mitchell offers two key concepts: **metapicture** and **image-text**. Metapictures are self-referential and self-analytic pictures that reflect on the practices of representation, such as Saul Steinberg's *The Spiral* (1964), a drawing featured in the *New Yorker* that includes a man standing in the center of a spiral he has drawn, with the outer ring elaborated to include a landscape scene. The world depicted is not simply a picture but is brought into existence by picture making, suggesting a world inundated with images where nothing exists outside of pictures.

Mitchell's other concept, image-text, designates composite works or concepts that combine image and text and assume their interwovenness. Examples of imagetext include textual pictures, such as William Blake's works that collapse the distinction between writing and drawing, and pictorial texts that refer to the entrance of language into the visual, such as abstract painting, which is inseparable from the theoretical discourse around it.

Mitchell, who surveys paintings, public art, comics, posters, television, films, and more, argues that a concern with the visual known as the **pictorial turn** is emerging in contemporary culture and scholarly discourse. Like the "linguistic turn" in the 1960s, which called attention to the role of language in culture and theory, the pictorial turn—which led to the establishment of the fields of Visual Culture and Visual Studies in the 1980s—now recognizes the realm of the visual as an important and worthy subject of intense scrutiny. Although Mitchell's emphasis on the mutually dependent, intermingling aspect of image and text might seem to undermine the basis for the pictorial turn, Mitchell explains that literary studies and, ultimately, the entire concept of culture undergoes an enormous change when it discovers the significance of the visual. He emphasizes that although there is a pictorial turn, it has become essential to examine representation in terms of exchanges or relationships, and as a multidimensional, heterogenous process or activity rather than a static thing.

Further Reading
Mitchell, W. J. T., *Iconology: Image, Text, Ideology* (Chicago: University of Chicago Press, 1987).

Mitchell, W. J. T., *Picture Theory: Essays on Visual and Verbal Representation* (Chicago and London: University of Chicago Press, 1994).

Mitchell, W. J. T., *What Do Pictures Want? The Lives and Loves of Images* (Chicago: University of Chicago Press, 2006).

six-volume *Akira* (1982–1990) set in postapocalyptic Japan was one of the first manga translated fully into English; and Eichiro Oda (Japanese, b. 1975), the creator of *One Piece* (1997), a narrative that is the best-selling manga series to date. Pioneering female **mangaka** (manga artist) Machiko Satonaka (Japanese, b. 1948) published *Portrait of Pia* (1964) in the magazine *Shōjo Friend*, paving the way for later artists such as Riyoko Ikeda (*The Rose of Versailles*, 1972), and Naoko Takeuchi (*Sailor Moon*, 1991).

Manga formats and subjects have expanded to incorporate borderless panels, bleeds, and free-flowing memory and dream narratives (Figures 23.24 and 23.25).

Educational manga proliferates with topics as diverse as Shotaro Ishinomori's *Introduction to Japanese Economics* and Tochi Ueyama's *Cooking Papa*, which communicates recipes through everyday stories. The national curriculum even requires some manga textbooks in the Japanese classroom, and sex education in Japan is often conducted via manga.

Manga is continually growing, borrowing, shifting, and adding to its "vocabulary." It has proven itself a fruitful medium for global cross-pollination between manga and Western comics artists, as in Frank Miller's *Ronin* (1983), as well as in Jiro Taniguchi's joint projects

Figure 23.24
Junko Mizuno, cover, *Pure Trance*, 2005.
Typical of Mizuno, this cover illustration is disarmingly cute, with its doe-eyed protagonists, floating doves, and Teddy bears, until one notices the gooey disembodied brains and fetuses in artificial wombs resembling blenders near the bottom of the page. *Pure Trance* depicts life in a post-apocalyptic underworld. Those who have made it underground survive on colorful nutritional food capsules known as Pure Trance (hence the title).

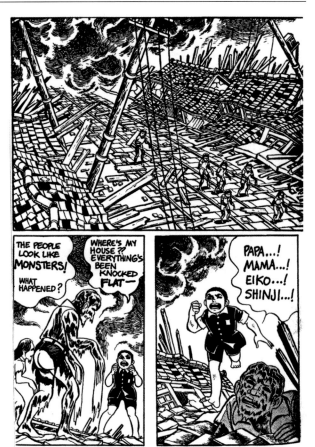

Figure 23.25
Keiji Nakazawa, interior page, *Barefoot Gen*, 1973. Mangaka Keiji Nakazawa, a survivor of the atomic holocaust, bears witness to the 1945 U.S. dropping of nuclear bombs on Japan. Density and texture in the image are inherent in the gritty manga subgenre **gekiga** (dramatic pictures). Such alternative manga that employ strong subjects and topics are aimed at an older audience.

with French comic artist Mœbius, and in Ryoichi Ikegami's (Japanese, b. 1944) *Mai, the Psychic Girl*, an homage to the mutant superhero genre. From the manga-inspired fashions of Jean-Paul Gaultier, to the *Lone Wolf and Cub* imitated swordplay in the *Kill Bill* films, to the Leiji Matsumoto-animated Daft Punk music video *Interstella 5555*, manga's influence is evident across many creative disciplines.

The Maturing of a Medium: The Modern Age of Comic Books, 1986–2001

The **Modern Age of comics**, sometimes referred to as the "Dark Age" of comics, is delineated by two key comic books: Frank Miller's (American, b. 1957) *The Dark Knight Returns* (1986) (Figure 23.26), and *Watchmen* (1986–1987) by writer Alan Moore (British, b. 1953), artist David Chester "Dave" Gibbons (British, b. 1949), and colorist John Higgins (British, b. 1949). Both books envisioned dystopian worlds on the brink of annihilation, but with very different narrative strategies. Miller portrayed Batman as a bludgeon, a destructive force of nature pummeling his way through the entire storyline; while Moore's *Watchmen* deconstructed the concept of terribly flawed costumed heroes living in the real world, attempting to solve a murder mystery.

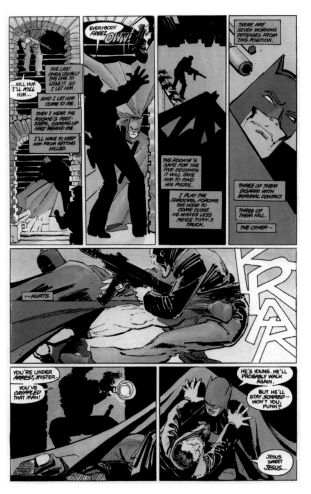

Figure 23.26
Frank Miller (writer/penciler), Klaus Janson (inker), and Lynn Varley (colorist), *The Dark Knight Returns*, Issue #1, page 30, DC Comics, 1986. Originally only a subgenre, grittier dystopian themes later became the prevailing narrative for U.S. comic books. Here, the images evoke movement and foreboding with the dynamic tension between positive and negative shapes as figures are shown at unpredictable angles and sizes, graphically silhouetted and cropped.

Using a structured three-tiered, nine-panel grid format, Gibbons deftly weaves parallel narratives of past and present, including recurrent symbols and visual cues that add to Moore's multilayered, nonlinear narrative. Well-received by readers and critics, both series were subsequently collected into graphic novels and became near-templates for many future superhero narratives.

Concurrent with the maturation of the medium, Will Eisner's influential treatise *Comics and Sequential Art* (1985) debuted, explicating theories and communication principles specific to the comics medium. More than a how-to book, *Comics and Sequential Art* convincingly positioned graphic narrative storytelling as a highly sophisticated visual art form, and inspired Scott McCloud's groundbreaking book *Understanding Comics: The Invisible Art* (1993), further elevating the medium both in public perception and academic discourse.

By 1987, adult-oriented antiheroes had become fashionable for mainstream comic books, resulting in a reduction of titles for younger readers in a generally shrinking comic book market. Conversely, the comic strip *Calvin and Hobbes* (1985–1993) by Bill Watterson, which adopted a humorous and light-hearted approach to storytelling, was in its first year of publication when *The Dark Knight Returns* and *Watchmen* premiered and became one of the most popular comic strips of all time.

In 1989, Alan Moore protégé Neil Gaiman (British, b. 1960) inaugurated the groundbreaking comic book *The Sandman* (Figure 23.27). Gaiman's series of fantasy tales were laced with elements of horror and myth illustrated by several interior artists. Dave McKean (British, b. 1963) illustrated the entire series' seventy-five covers. Regularly outselling DC Comics' *Batman* and *Superman* titles, *The Sandman* paved the way for the creation of DC Comics' mature readers imprint, *Vertigo*, in 1993.

The Graphic Novel

In the early twentieth century, wordless novels by artists Frans Masereel (Belgian, 1889–1972), Otto Nückel (German, 1888–1955), and Lynd Ward (American, 1905–1985) appeared in numbered and trade editions (Figure 23.28). Inspired in part by these early prototypes, but evolving out of the sequential art medium, longer, more mature stories—referred to as **graphic novels**—grew. Unlike traditional comic books that broke up stories over multiple issues according to fairly consistent formulae, the graphic novel allowed creators to develop stories more fully, to go deeper into autobiographical and historical themes, and to push experimental artistic and production techniques.

America's first contemporary graphic novel *It Rhymes with Lust* (Figure 23.29), drawn by Clarence Matthew "Matt" Baker, was an adult-oriented drama dealing with greed and political corruption. The first self-referential use of the term *graphic novel* appeared on the back of *Schlomo Raven* (1976) written by Byron Preiss (American, 1953–2005) and illustrated by Tom Sutton (American, 1937–2002). However, it is Will Eisner's critically acclaimed *A Contract with God* (1978) (Figure 23.30) that is remembered as the first commercially

Figure 23.27
Dave McKean, cover, *Sandman* #48, Vertigo/DC Comics, 1993. Conceived as surrealistic, melancholy windows into each story, McKean's strikingly original covers ran the gamut from traditional and digital paintings to three-dimensional collages that incorporated photography and found art.

Vertigo is a trademark of DC Comics. Image: DC Entertainment.

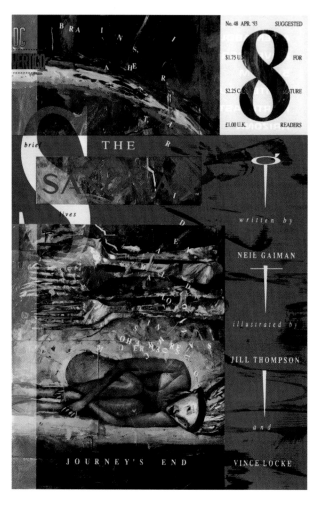

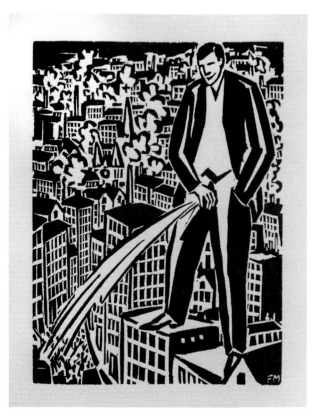

Figure 23.28
Frans Masereel, "Passionate Journey," in *Mon livre d'heures (My Book of Hours)*, 1919. Woodcut.
Influenced by German Expressionism and political opposition to bourgeois society, Masereel's wordless novel was a bestseller—even when the more indecent panels (above) were dropped from some editions.

Courtesy of Special Collections, Clapp Library, Wellesley College. © 2018 Artists Rights Society (ARS), New York.

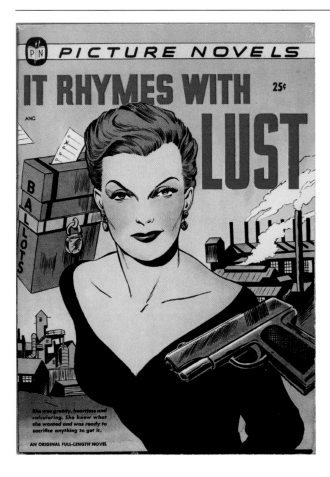

Figure 23.29
Matt Baker and Ray Osrin, cover, *It Rhymes with Lust*, St. John Publications, 1950.
Before the term *graphic novel* caught on, *picture novel* and *picto-fiction* had appeared on paperbacks and magazines in an attempt to distinguish this longer illustrated fiction format from shorter sequential forms.
Image courtesy of Heritage Auctions.

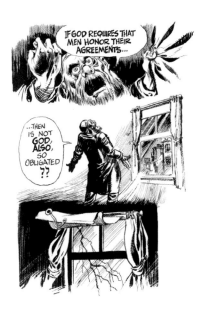

Figure 23.30
Will Eisner, interior spread, *A Contract with God*, Baronet Books, 1978.
Similar in format to the literary short story cycles of Sherwood Anderson's *Winesburg, Ohio* (1919) and Ernest Hemingway's *In Our Time* (1925), *A Contract with God*, set predominately in a 1930s Bronx tenement building, is composed of four distinct semi-autobiographical stories about people's everyday lives. While many comic book creators changed their own names or those of their protagonists to hide their ethnicity, Eisner embraced his Jewish-American heritage in this series.

Image provided by Brian M. Kane. Illustrations from *A Contract with God*. Copyright © 1978, 1985, 1989, 1995, 1996 by Will Eisner. Copyright ©2006 by Will Eisner Studios, Inc., from *The Contract with God Trilogy: Life on Dropsie Avenue* by Will Eisner. Used by permission of W. W. Norton & Company, Inc.

successful modern graphic novel. Technically a collection of semi-autobiographical short stories with an underlying connective theme, *A Contract with God* revolutionized the comics industry by replacing superhero mythologies with more literary scenarios. So, although Eisner did not invent the term *graphic novel*, its use on the cover of *A Contract with God* popularized it.

With critical acceptance of the sequential art medium, graphic novels extended to mainstream mass-market bookstores. Art Spiegelman's (American, b. 1948) groundbreaking postmodern biographical graphic novels, *Maus* and *Maus II* (1986, 1991), won a special Pulitzer Prize in 1992. Both books explore the complicated relationship of a father and grown son through the episodic retelling of the father's WWII experiences as a Jew in Nazi-controlled Poland. Anthropomorphic characters symbolize ethnicity throughout in straightforward black-and-white art that evokes the bleakness of the narrative (Figure 23.31). Memoirs,

Figure 23.31
Art Spiegelman, *Maus II: A Survivor's Tale*, page 25, Pantheon, 1991.
In this page, the Jews are drawn as mice, the gentile Poles are pigs, and the Nazis are cats. Major forms are heavily outlined with simple, finer lines as cross-hatch. Solid areas of black counterpoint and provide graphic weight to the compositions.

Graphic novel excerpt from *Maus II: A Survivor's Tale: And Here My Troubles Began* by Art Spiegelman, copyright ©1986, 1989, 1990, 1991 by Art Spiegelman. Used by permission of Pantheon Books, an imprint of the Knopf Doubleday Publishing Group, a division of Penguin Random House LLC. All rights reserved. Copyright © 1980, 1981, 1982, 1983, 1984, 1985, 1986 by Art Spiegelman, used by permission of The Wylie Agency LLC. Cartoons on p.25 from MAUS PART II: A SURVIVOR'S TALE: AND HERE MY TROUBLES BEGAN by Art Spiegelman (Penguin Books, 1992) copyright © Art Spiegelman, 1986, 1989, 1990, 1991.

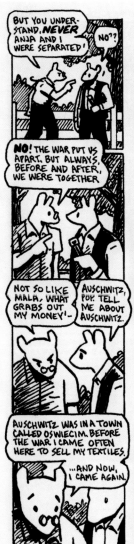
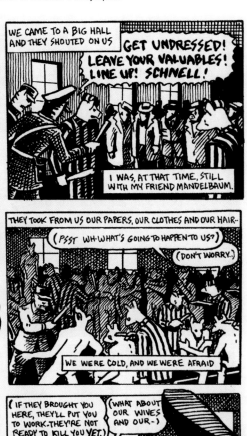
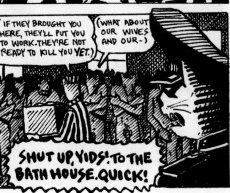

biographies, and pseudo-biographies have since flourished in graphic novels. Marjane Satrapi's (Iranian, French, b. 1969) *Persepolis* (2003) chronicles the life of a young girl growing up under a repressive regime in Tehran; Alison Bechdel's (American, b. 1960) *Fun Home* (2006) (Figure 23.32) centers on issues of sexual orientation and gender roles; *Feynman* (2011) by writer Jim

Ottaviani (American, b. 1963) and artist Leland Myrick (American, b. 1961) is a titillating profile of the brilliant quantum physicist who participated in developing the atom bomb; and Derf Backderf's (American, b. 1959) *My Friend Dahmer* (2012) recounts the formative years of a mass murderer. Graphic novels with a broader conceptual scope include Shaun Tan's (Australian, b. 1974) *The Arrival* (2007) (Figure 23.33), which re-creates the immigrant experience in a wordless picture book tinctured with fantasy elements, while Joe Sacco (Maltese, American, b. 1960) tackles politically charged situations in *Palestine* (2001) (Figure 23.34)—an account of his first-hand experiences in the occupied territories in the West Bank and Gaza Strip.

Creator-copyrighted publications reached much broader readership as mass-market bookstores carried titles like *Bone* (1991) (Figure 23.35) by Jeff Smith (American, b. 1960) and *The Walking Dead* (2003) by writer Robert Kirkman (American, b. 1978) and artist Tony Moore (American, b. 1978).

Longer forms of the graphic novel provide an opportunity for the illustrator and author to create a reading experience in which the representational style

Figure 23.32
Allison Bechdel, *Fun Home: A Family Tragicomic*, page 204, Houghton Mifflin, 2006.
Bechdel's graphic memoir took seven years to complete in a process that involved using photographs of herself for reference for each character. Bechdel's use of simple line work and a one-color wash create a semblance of calm in an emotionally dramatic story.

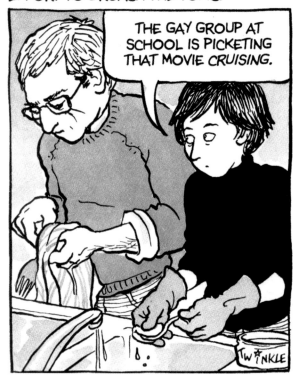

Figure 23.33
Shaun Tan, *The Arrival*, interior page, Hodder's Children's Books, 2006.
The Arrival is a wordless novel that visually interprets an immigrant's journey. Through fantasy architecture, alien-looking yet friendly creatures, and indecipherable symbols, Tan depicts a world that is familiar but strange, to evoke the uncertainty immigrant people might experience in traveling to new lands. Tan's careful, detailed compositions in softly modulated graphite are both dreamy and convincing.

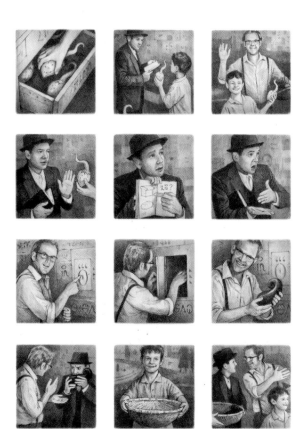

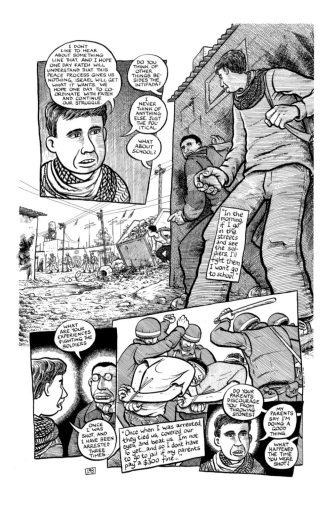

Figure 23.34
Joe Sacco, interior page, *Palestine*, 1996.
Palestine is a collection of stories based on Sacco's travels through the Middle East during the Gulf War. As a participant rather than an observer, Sacco tells stories that exemplify a graphic journalistic approach equivalent to the literary New Journalism style created by Tom Wolfe, Truman Capote, Hunter S. Thompson, and Norman Mailer. Sacco's other graphic journalistic novels include *Safe Area Goražde: The War in Eastern Bosnia 1994–95* and *Footnotes in Gaza* about the Suez Crisis of 1956.

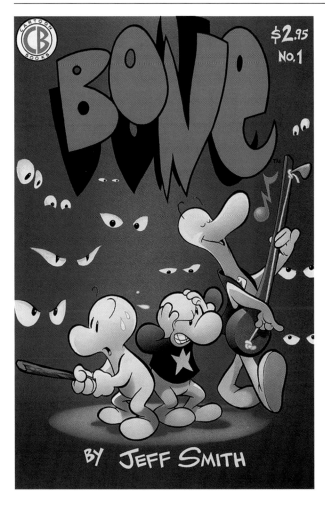

Figure 23.35
Jeff Smith, cover, *Bone*, self-published by Cartoon Books, 1991–2004.
This award-winning graphic novel written and illustrated by Smith is one
of a handful of comic books produced during the Modern Age of comics
that deliberately avoids the dystopian/adult-oriented trend and focuses on
an all-ages readership. Smith's visual references to both Walt Kelly (*Pogo*) in
characters and Mœbius in coloration are evident.

Image courtesy of the artist. *Bone*® is © Jeff Smith, 2016.

and the relationship of images and words is customized
in page design formats that enhance meaning. Their
proliferation in the latter half of the twentieth century
helped practitioners shed assumptions about how
comics should look. Notable innovators are David
Mazzucchelli (American, b. 1960), whose *Asterios Polyp*
shifts drawing styles and color palettes throughout to
demonstrate emotional states of characters and situations
(Figure 23.36); and Brian Selznick (American, b. 1966),
creator of *The Invention of Hugo Cabret* (Figure 23.37),
which features over five hundred pages of tonal graphite
images with decorative black-and-white section breaks
reminiscent of early silent films.

The Digital Age of Comics, 2001–Present

The **Digital Age of comics** began in the 1980s, with digital
media added to the slick, futuristic tech-worlds of many
comics story plots, encouraged partly by fans' fascination
with computers. In 1985, writer Peter B. Gillis (American,
b. 1952) and artist Mike Saenz (American, b. 1959) created
Shatter, the first comic book drawn on a computer (but

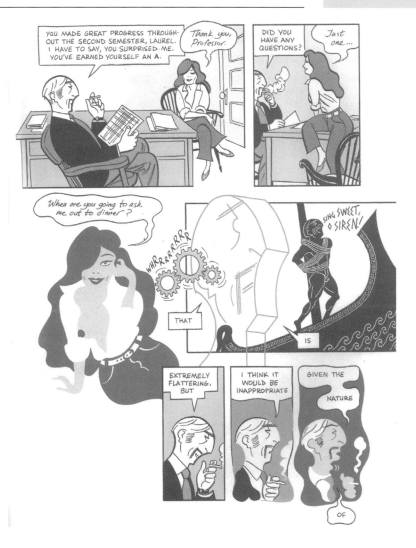

Figure 23.36
David Mazzucchelli, interior page, *Asterios Polyp*, Pantheon, 2009.
Limited to cyan, magenta, and yellow, Mazzucchelli's mannered approach to drawing differentiates
characters and emotional timbre. The protagonist Asterios, an egotistical architect, begins as a highly
stylized character but evolves into a more dimensional human through his odyssey-like journey.
In this image, we see Asterios imagining himself as the Classical hero Odysseus resisting a siren, in
the guise of his voluptuous student.

© David Mazzucchelli. Image by permission of David Mazzucchelli.

Figure 23.37
Brian Selznick, interior spread, *The Invention of Hugo Cabret*, Scholastic
Press, 2007.
Inspired by the life of early filmmaker Georges Méliès, Selznick's illustrated
pages are placed in groups with textual pages interspersed in an effect
reminiscent of the intermittent display of text in early silent films. Readers
project on or decode the meaning of the visuals depending on the preceding
or following text.

From *The Invention of Hugo Cabret* by Brian Selznick. Scholastic Inc./Scholastic Press,
Copyright © 2007 by Brian Selznick, Used by permission.

colored traditionally). This was followed in 1990 by *Batman: Digital Justice* the first fully computer-illustrated graphic novel by writer Doug Murray (American, b. 1947), and illustrators Pepe Moreno (Spanish, b. 1959) and Bob Fingerman (American, b. 1964) (Figure 23.38).

In 1997, comic book veteran Brian Bolland began creating his comics as digital illustrations using Adobe Photoshop in conjunction with a **Wacom tablet**, a flat device connected to a computer and activated by a stylus that allows one to draw with pixels that then appear on the screen. Although digitally illustrating and coloring comics began in the 1980s, it was not until 2001 that all mainstream comics books were being printed entirely from digital files rather than physical plates. Today "penciled" pages can be scanned and transmitted via the Internet to an inker who digitally inks, and then uploads them for the colorist. Or pages may be inked in the traditional manner with pens, brushes, and ink, and then scanned and colored digitally. While digital processing expedites the creative process and eliminates postage costs, it has also eliminated the creation of a unique physical "original" page of *finished* art, often an additional source of income for artists. Working in this manner was the last major hurdle for print production, and it coincided with a greater acceptance on the part of editors toward digital art being considered as the "original." The first half of the decade also saw *CrossGen Comics* become the first company to sell comic books on DVDs and to experiment with motion comics.

Webcomics

Webcomics are any type of digitally produced comic that is accessed online. Webcomics' pre-digital equivalents were cheap independent comics sold directly from artist to customer in person or through **'zine** (short for maga*zine*) networks by mail (*see Chapter 26*). Without regard for location, scarcity, or copyright, online special-interest communities could share webcomics far easier than the 'zine and alternative press networks, and could archive materials indefinitely. In the mid-1990s, webcomics became an alternative to syndication but were initially ridiculed by those who believed syndication was the only proof of quality. Soon syndicated comics appeared both in print and online, rendering the distinction on quality meaningless. Nevertheless, the term refers mainly to digital creator-owned comics offered directly to an audience with or without editorial involvement (Figure 23.39). Without artistic constraints, creators gained opportunities to explore a wider variety of personal experiences relating to gender roles, sexual orientation, national origin, ethnic identity, and political and economic status. Online publishing allowed creators to communicate directly with their audience and to garner support through merchandise sales, subscriptions, or donations. Some webcomics creators have also expanded into prose, children's books, animation, short films, feature films, theater, sketch comedy, games, and apps.

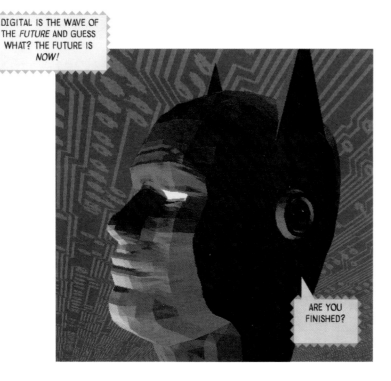

Figure 23.38
Pepe Moreno, interior page, *Batman: Digital Justice*, DC Comics, 1990.
Using 3-D modeling vector and CAD programs and image-editing software like Adobe Photoshop on a 16-bit color Mac II, Moreno and Fingerman created the first graphic novel fully rendered on a computer. With early digital art, the inherent visual aspects of pixelation were brought to the forefront to clarify this new medium to the viewer.
Image provided by Brian M. Kane. *Action Comics, Batman, Sandman, Swamp Thing, The Dark Knight*, and all related characters and elements are trademarks of and © DC Comics.

Figure 23.39
Jesse Reklaw (illustrator) and Lauren Schmidt (story), "Slow Wave," *Carrot Romance*, 2004.
In his webcomic, Reklaw, a computer programmer, designer, illustrator, and cartoonist, illustrated dreams sent to him by the public. The strip ran online from 1995 to 2012, as well as in the alternative press.
Courtesy of the artist. ©2004–2016 Jesse Reklaw, from a dream by Lauren Schmidt.

Conclusion

Unlike purely literary formats, sequential art has always been a "show-don't-tell" medium that acutely stimulates the visual learning centers of our brains. Comic strips began as inexpensive mass entertainment in newspapers, providing refreshing oases of color in the black-and-white world of early twentieth-century newsprint. Those early forms evolved into comic books rife with super-heroic mythic worlds still found in contemporary graphic novels and blockbuster films today.

Prompted by a growing appreciation for sequential narratives since the late 1990s, there has been a dramatic surge of critical interest in comic books, graphic novels, and comic strip compilations. Academic attention by sociologists, historians, literary theorists, and scholars of gender and visual culture studies has resulted in postsecondary degree programs in colleges and universities that now consider comics an art form worthy of study. While part of this newly found acceptance may be attributed to the increase in the quality of the material and the shift toward more adult-themed stories, it may also be due in part to librarians, editors, educators, and media critics of today who grew up well after Wertham's great comic book scourge of the 1950s. In fact, the Comics Code Authority that once censored the industry with an iron fist ceased operation in 2011. As publishing evolves in the digital age, future readers may never own a physical comic book, but the once-maligned sequential art narrative will continue to be entertaining as well as culturally influential.

FURTHER READING

Bramlett, Frank, Roy T. Cook, and Aaron Meskin (Eds.), *The Routledge Companion to Comics* (Oxford: Routledge, 2016).

Eisner, W., *Comics and Sequential Art* (New York: W. W. Norton & Company, 1985).

Gravett, Paul, *Manga: Sixty Years of Japanese Comics* (New York: Harper Design, 2004).

Kunzle, D. *History of the Comic Strip* (Berkeley: University of California Press, 1973).

McCloud, Scott, *Understanding Comics: The Invisible Art* (New York: Harper, 1993).

KEY TERMS

	mangaka
	metapicture
Bronze Age of comic books	**Modern Age of comic books**
Digital Age of comics	pictorial turn
direct market	**Platinum Age of comic books**
epistemological rupture	
gekiga	sequential art
Golden Age of comic books	**Silver Age of comic books**
graphic novel	syndicated licensing
imagetext	underground comix
Industrial Age of comics	Wacom tablet
intellectual property rights	webcomics
	work-for-hire
ligne claire	'zine
manga	

24

The Shifting Postwar
Marketplace:
Illustration in the
United States and
Canada, 1940–1970

Stephanie Haboush Plunkett
with contributions by Jaleen Grove

In the first half of the twentieth century, general-interest magazines like the *Saturday Evening Post* and *Collier's*, and popular women's magazines such as *Ladies' Home Journal*, *Good Housekeeping*, and *McCall's*, had built vast, loyal followings. Emerging from a long period of political and economic transformation following the Great Depression (1929–1939) and World War II (1939–1945), Americans began to re-imagine themselves and the new lives that they hoped to lead. Production, finely tuned by wartime necessity, enabled a booming peacetime economy with a plethora of new products and modern, time-saving conveniences. Directly linked to commerce and to selling the "American Dream" of affluence for everyone, the magazines' aspirational images depicting desirable, ideal high standards of living reflected and shaped twentieth-century visual culture, public perceptions, and consumption. Top publications boasted subscriptions of two to nine million during the 1940s and 1950s, and copies were shared among family and friends, bringing the readership even higher.

Yet by 1970, many of these magazines had disappeared as American popular media evolved, transforming the field of illustration. This chapter explores the illustration of mid-century mass magazines, the postwar shift in publishing and visual culture, and illustrators' responses to it.

Influence of Film and Photography

In magazines, images were encountered at a pace and sequence controlled by the reader, who studied each illustration one at a time and who ascribed significance to each picture according to his or her participatory, personalized interpretation. Film was autonomous by comparison, presenting dynamic content in a gripping medium in a way that was not as dependent on viewer participation. Because one had to see film in a theater, the medium did not immediately threaten illustrated magazines, but it did have an impact on illustration in that viewers became relatively more passive in their media consumption.

From film's earliest days in the 1890s until the 1990s, illustrations appeared on movie posters far more frequently than photographs. Many featured a scene or montage of scenes from a film, whereas others emphasized the likenesses of major stars (Figure 24.1). As audiences became used to seeing close-ups of actors' heads on screen, 1930s magazine covers zoomed in on cover girls' faces too—a format made popular by Jon Whitcomb (American, 1906–1988), a leading illustrator of glamour and celebrities who had begun his career painting movie, theater, and travel posters in his native Ohio. His 1930s story illustrations featuring melodramatic close-ups against a plain background set off a new trend in illustration, nicknamed **big head illustration** (Figure 24.1). This style of composition eventually dominated fiction illustration in women's magazines of the 1950s.

Even before mid-century, photography had begun to replace narrative illustration in magazines. Photographs conveyed a sense of immediacy and placed viewers in the moment, recording events more directly and with presumed accuracy. These qualities felt contemporary and representative of the increasing pace of a changing society (*see Chapter 17, Theme Box 36, "The Camera"*). Though photography ultimately posed a challenge by usurping illustration's dominant role, it was also essential for those who sought to capture countless details, from the subtleties of facial expression to the folds of a model's dress. For many practitioners, reference photography all but eliminated repeat modeling sessions with high professional fees—an advantage in a deadline-driven field.

Artists have used cameras and projection devices for centuries, sometimes surreptitiously if they wished to conceal technical intervention in their process. For many years, fine artists and some illustrators lambasted drawings made with the aid of photographs. They perceived photography as artificial support, which

Figure 24.1
Jon Whitcomb, movie poster, *The Glass Slipper*, 1955.
In this movie poster featuring Leslie Caron in a film adaptation of Cinderella, Whitcomb creates an idealized portrait that subtly alters the actress's proportions, exaggerating her large eyes and pouty lower lip. Unlike studio photography, illustration allowed for the seamless introduction of fantasy elements like the twinkling stars and magic "pixie dust" around her head.
Norman Rockwell Museum Collection.

to them seemed antithetical to the notion of the artist's creative synthesis and skill. Nonetheless, many mid-century illustrators used photographs and projection devices as an integral part of their process (Figure 24.2).

Narrative Realism, Nationalism, and American Values at Mid-Century

As discussed in *Chapter 18,* illustrators in the United States and Canada and their audiences enjoyed a long tradition of narrative realism—visual storytelling derived from academic painting. Advertising, political rhetoric, and textbooks of the nineteenth and twentieth centuries projected presumptive morals and spirits of the people through narrative realism, which often celebrated ideals of family life, democracy, and prosperity—the tenets of

the so-called American Dream. Until the 1960s, social injustice, class divisions, and the persistent economic hardships that many faced were generally ignored in images that reflected a pared-down, small-town existence and promoted as commonplace a material standard that was more aspirational than attainable for many readers.

The American Dream was just as seductive for Europeans and Asians, whose advertising art resembled American examples by the 1920s. Canadians, exposed to far more American media than their own, adopted American values despite the misgivings of cultural nationalists who feared an erosion of Canadian identity. Toronto-based Rex Woods (British, Canadian, 1903–1987) even joined the New York Society of Illustrators and mimicked the advertising art and calendar art techniques of J. C. Leyendecker, Rolf Armstrong (*see Chapter 20*), and Haddon "Sunny" Sundblom (see the section "Sundblom Studios" later). Woods designed pretty-girl covers for almost every *Canadian Home Journal* from 1930 to 1947 (Figure 24.3).

Depictions of African Americans

The unwritten but established policy of the *Saturday Evening Post* was that African Americans were to be

Figure 24.2
Louie Lamone (American, 1918–2007), reference photographs for *New Kids in the Neighborhood* (top row). Norman Rockwell (1894–1978, American), *New Kids in the Neighborhood*, illustration for "Negro in the Suburbs" by Jack Star, *Look*, June 16, 1967 (bottom row). Oil on canvas.
Following his preliminary sketches, Norman Rockwell went to elaborate lengths to create photographs that portrayed his concepts exactly by scouting models and locations, researching costumes and props, and staging scenarios for the camera. Photographs were then transferred, in whole or in part, to his final substrate with the aid of a balopticon projector.
Norman Rockwell Museum Collection. Printed by permission of the Norman Rockwell Family Agency. Copyright © 1967 the Norman Rockwell Family Entities.

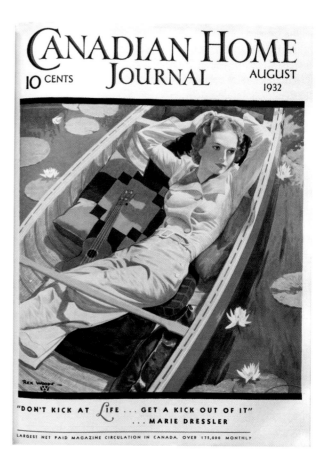

Figure 24.3
Rex Woods, cover, *Canadian Home Journal*, August, 1932.
Canadian magazines had a difficult time competing against better-financed American ones, and frequently resorted to mimicking American titles. This cover aptly documents the convergence of American and Canadian cultures: the young woman wears trousers and has a ukulele, like liberated New York City flappers, but reclines in a canoe—long a symbol of Canadian identity.
Image courtesy of Thomas Fisher Rare Books Library, University of Toronto. By permission of the Rex Woods Estate. Used with permission of Rogers Media Inc. All rights reserved.

portrayed almost exclusively in service roles—evidence of the racial prejudices that sparked the civil rights movement of the 1950s and 1960s. Other marginalized populations were largely ignored unless pointedly the subject of a text. A soft approach to racial inequity characterizes *Boy in a Dining Car* (1946), a *Post* cover (Figure 24.4) by Norman Rockwell (American, 1894–1978) that sympathetically portrays an African American man, but in a service role as a kindly dining car waiter. Until the 1960s, Pullman porters and waiters were exclusively African American. While the profession contributed to the development of the black middle class in America, ubiquitous portrayals of African Americans in service roles perpetuated racial prejudice.

A masterful visual communicator, Rockwell was America's best-known twentieth-century illustrator, whose extensive body of work over a six-decade career became a defining national influence. A *Time* reporter in 1943 said, "He constantly achieves that compromise between a love of realism and the tendency to idealize, which is one of the most deeply ingrained characteristics of the American people."

Less conservative than the *Post*, *Look*, published from 1937 to 1971, was a popular general-interest magazine that emphasized current events and photography. The magazine sometimes commissioned artworks by noted illustrators like Bernie Fuchs (American, 1932–2009) to capture emotionally charged events relating to the civil rights movement and other contemporary themes, as in his 1965 portrait of American Baptist minister and activist Martin Luther King, Jr. (1929–1968) (Figure 24.5). Circulation of this pictorial biweekly peaked in 1969 at 7.75 million readers.

Illustrators Harvey Dinnerstein and Burton Silverman (both American, b. 1928) created compelling depictions of African Americans in reportorial drawings that revived the historical tradition of the artist as visual journalist. Published in newspapers and magazines, their works documented the arrest of Rosa Parks on December 1, 1955, for refusing to give up her seat on a bus to a white passenger, as well as the event's aftermath. This reportorial series of works, including *Church Meeting, Montgomery* by Silverman (Figure 24.6), and *Henrietta Brenson* [sic], *1956*, by Dinnerstein, capture

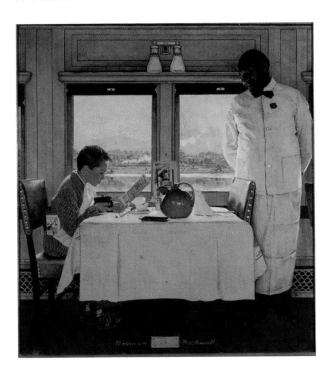

Figure 24.4
Norman Rockwell, *Boy in a Dining Car*, cover art, *The Saturday Evening Post*, December 7, 1946. Oil on canvas, 38 × 36".
Rockwell mirrored a moment in his son's life that he thought would touch a common chord. Inspired by H. K. Browne's illustration of a similar scene in Charles Dickens's *David Copperfield*, Rockwell's painting describes a young boy's first experience of calculating a waiter's tip.
Norman Rockwell Museum Collection. Printed by permission of the Norman Rockwell Family Agency. Copyright © 1946 the Norman Rockwell Family Entities.

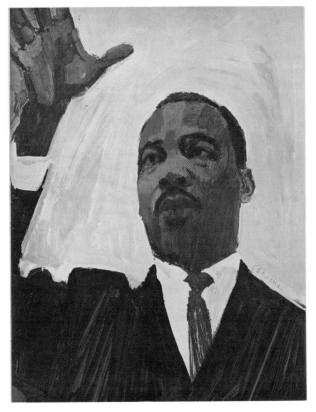

Figure 24.5
Bernie Fuchs, Portrait of Martin Luther King, Jr., in *Look*, March 23, 1965. Bernie Fuchs's portrait captures the energy of civil rights leader Martin Luther King, Jr., who led thousands of nonviolent demonstrators to Montgomery, Alabama, after a five-day march from Selma to Montgomery, in which African American residents joined with the Student Nonviolent Coordinating Committee (SNCC) and the Southern Christian Leadership Conference (SCLC) to campaign for voting rights.
Courtesy of The Fuchs Family. © Estate of Bernie Fuchs.

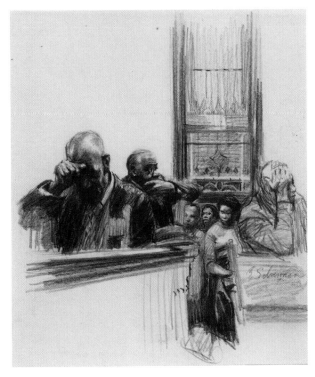

Figure 24.6
Burton Silverman, *Church Meeting, Montgomery*, 1956. Pencil on paper, 12 1/8 × 11". Drawing in graphite on paper directly from life in bus stations, courtrooms, and churches, Silverman sought to capture universal human emotions and to "remain distant enough to make an effective piece of art without losing contact with the intense feelings being generated at the moment of creation."
Courtesy of The Parrish Art Museum, Water Mill, NY, Littlejohn Collection 1961.3.188. © Burton Silverman. 1994 © Burton Philip Silverman/ Licensed by VAGA, New York, NY.

the spectrum of emotions that marked the moment as a turning point in the struggle for civil rights (Figure 24.7).

Depictions of Middle-Class Families and Women

Alfred Charles "Al" Parker (American, 1906–1985) inherited the tradition of narrative realism but updated it in both content and form for mid-century audiences. Parker invented an idealistic mother and daughter who dressed alike and graced covers for *Ladies' Home Journal* from February 1939 until May 1952 (Figure 24.8). The popular duo celebrated holiday traditions, shared a love of sport, and played their part supporting the war effort during World War II. Their ideal family was reunited in July 1945 when their returning soldier was welcomed home, and in keeping with the postwar "baby boom," a son was soon born to Parker's ideal American family in 1946. Parker's last mother-daughter cover portrayed an officer's return to his still-beautiful wife and growing family during the Korean War conflict. Thereafter, *Ladies' Home Journal's* covers were solely photographic.

Expected to manage households and raise children, many middle-class women did not have the means to achieve the beauty standards set by their magazines. Opportunities for education and other accomplishments were limited, and professional employment for married women was not often a subject of serious consideration.

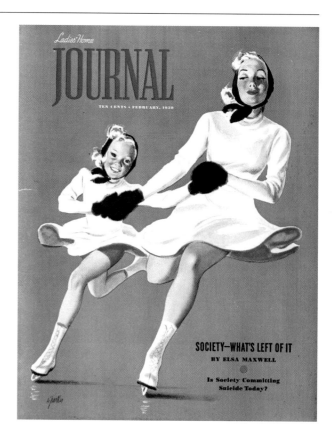

Figure 24.8
Alfred Charles "Al" Parker, cover, *Ladies' Home Journal*, February, 1939. This mother-daughter cover illustration was the first of a popular series featuring an idealized American family that continued until 1952. Parker's cover was designed with a Poster Style aesthetic, emphasizing strong silhouettes against a flat background. The graceful mother and daughter gliding across the suggested ice in perfect unison, and in matching outfits, sparked a fashion trend.
Norman Rockwell Museum Collection. Originally published in *Ladies' Home Journal* magazine, February 1939.

Figure 24.7
Harvey Dinnerstein, *Henrietta Brenson* [sic], *Montgomery, 1956*, 1956. Graphite and chalk on gray laid paper, 14 ³/₁₆ × 9 ¹/₄" (composition). Dinnerstein captures Brinson's resilience and determination, registered in her defiantly folded arms and furrowed brow. Henrietta Brinson was a participant in the Civil Rights Movement.
Delaware Art Museum, F. V. du Pont Acquisition Fund, 1993. © Harvey Dinnerstein, Delaware Art Museum, F. V. du Pont Acquisition Fund, 1993.

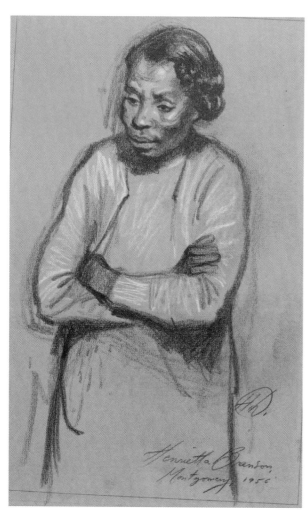

From their inception, *Ladies' Home Journal, Good Housekeeping, McCall's*, and others encouraged the belief that, as charismatic purveyors of taste and culture, women were most instrumental when helping their families achieve success. The suburban home, replete with late-model cars, new appliances, and well-scrubbed children, became synonymous with postwar affluence.

A cover illustration by Stevan Dohanos (American, 1907–1994) exposes the challenges faced by American women who shouldered much of the responsibility for family enjoyment without the opportunity to fully participate in the experience. A woman's husband and children enjoy a relaxing holiday at the beach while she is relegated to the kitchen and endless chores (Figure 24.9).

Teaching the Narrative Tradition: The Famous Artists School

In the late 1940s, the executives of the Society of Illustrators sought to share the traditions, skills, and professionalism of established artists through a correspondence school that would impart their knowledge and help support the Society. The idea was not original—during the late nineteenth century, illustrator Charles Hope Provost founded the Correspondence

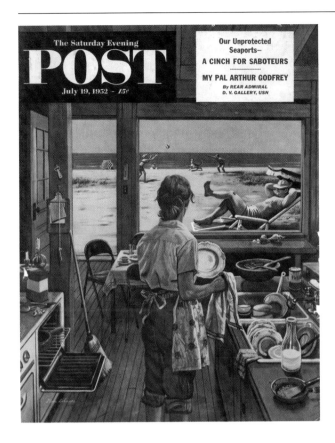

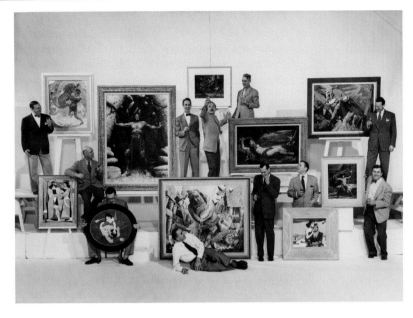

Figure 24.10
Unidentified photographer, publicity photograph of the Founding Famous Artists School Illustration faculty with paintings. Created for Cecil B. DeMille's film, *Samson and Delilah*, 1949. Left to right: Harold von Schmidt, John Atherton, Al Parker, Al Dorne (white shirt, on the ground), Norman Rockwell, Ben Stahl, Peter Helck, Stevan Dohanos, Jon Whitcomb, Austin Briggs (rear, far right), and Robert Fawcett (front, far right). Fred Ludekens is not pictured here.

Figure 24.9
Stevan Dohanos, cover, *Saturday Evening Post*, July 19, 1952.
Stevan Dohanos created many covers for the *Saturday Evening Post* and other publications that focused on people in their environs. He frequently portrayed elements found near his home in Westport, Connecticut, an active community of illustrators during the twentieth century.

School of Illustrating, which offered "home instruction in drawing for newspapers and magazines by successful illustrators," and the Federal Schools of Commercial Designing in Minneapolis began selling correspondence lessons in 1919 (*see Chapter 18, Theme Box 39, "Education"*). But the Society had the advantage of putting some of the biggest names and greatest talents in the business into their plans.

Begun in 1948 in Westport, Connecticut—an artist's colony since the 1920s—the **Famous Artists School** became America's most popular art correspondence school. Due to the Society's nonprofit status, it ended up being operated independently for profit with ex-Society president Albert Dorne (American, 1906–1965) at its head. The initial course offered in-depth how-to instruction in the working methods of eleven "famous artists," including Norman Rockwell, Al Parker, Stevan Dohanos, Robert Fawcett, Jon Whitcomb, Harold von Schmidt, John Atherton, Ben Stahl, Peter Helck, Austin Briggs, and Fred Ludekens (Figures 24.10 and 24.11). Selected lessons were eventually combined in four-volume sets focused on the visual narrative, from idea to finished illustration. Revised annually, the course was updated with new lessons and artists. Salesman sold Famous Artists School courses door-to-door throughout North America and eventually internationally, with Famous Cartoonists and Famous Writers courses soon added to the mix.

Figure 24.11
Al Dorne, *Head Study*, 1949. Pencil on paper, 14 × 18".
Al Dorne's style hovered perfectly between caricature and illustration. Although a Famous Artists School book about his techniques was never published, as director of the School, he contributed many drawings to the career course, such as this sequential series on the development of a head.

The courses attracted more than 60,000 students in the 1940s and 1950s. Students completed assignments from the comfort of home and then sent them to Westport to be corrected by in-house illustrators trained in the methods of the founding faculty. The school's popularity illuminates the historic influence of correspondence education during the postwar era. The G.I. Bill, officially known as the Servicemen's Readjustment Act of 1944, was created to help veterans of World War II by granting tuition stipends for college or trade schools. From 1944 to 1949, nearly nine million veterans received $4 billion under this program—a boon to the Famous Artists School. Women displaced from wartime jobs by returning veterans also sought training in illustration.

Impact of Television

When television was introduced in the late 1940s, few could disguise their fascination with the swiftly passing images of "the home screen." Many saw their first telecasts in bars, which won and retained customers by installing

TV sets that were often tuned to professional wrestling, an early filler of the schedule. Of the 102,000 TV sets in the United States in early 1948, two-thirds were in the New York area, where most stations operated. Those living more than seventy-five miles from such urban centers as New York, Chicago, St. Louis, Boston, or Los Angeles could do little more than read about television as many rural regions did not gain viewing access until 1955 (Figure 24.12).

Television became both a symptom and a cause of accelerating cultural change in America during the 1950s, marking shifts in family life, gender roles, politics, leisure, consumerism, and communications. The new medium especially posed a challenge for illustration. In many respects, television shows such as *Leave It to Beaver* (1957–1963), *Father Knows Best* (1954–1960), and *The Donna Reed Show* (1958–1966) appropriated the tradition of narrative realism of magazine fiction—and in turn, influenced illustration of the era. Amos Sewell (American, 1901–1983), who created fifty-seven *Saturday Evening Post* covers, captures the impact of television in an amusing but pointed portrayal of a hospital visit that is not going well from the patient's point of view (Figure 24.13). An ignored magazine on the desk pales by comparison to the engrossing television set. As people began watching TV instead of reading, corporations shifted their advertising budgets away from print to television, reducing revenues for many illustration-rich magazines.

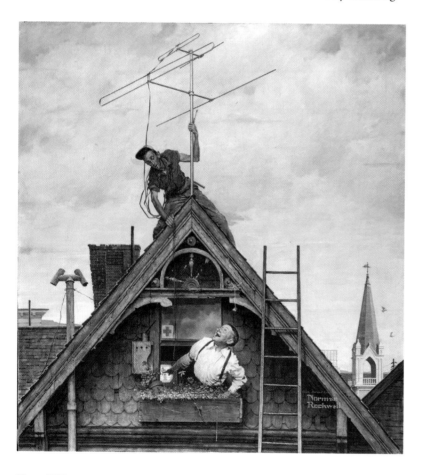

Figure 24.12
Norman Rockwell, *New Television Antenna*, cover art, *The Saturday Evening Post*, November 5, 1949. Oil on canvas, 46 ¹/₂ × 43".
New Television Antenna was painted in the midst of the television bonanza, when public interest in the new medium was on the rise. A workman balancing on the steep rooftop of a time-worn Victorian home installs the latest technology while the home's owner points enthusiastically to a shadowy picture on his television screen. In the 1950s, many older urban buildings were razed in favor of more modern structures. Rockwell thus measures the promise of new technology against the historical past, and invites our consideration of whether television may become the "religion" of the future, as suggested by the church steeple.

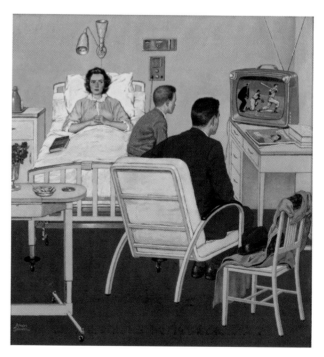

Figure 24.13
Amos Sewell, *Hospital Visit*, cover art, *The Saturday Evening Post*, April 29, 1961. Oil on board, 26 ¹/₄ × 24 ¹/₂".
Sewell sets the scene by showing what is seemingly becoming passé—books and magazines. Oblivious to the patient, this woman's husband and son are absorbed in a television program while she endures their insensitivity. Presumably, guests would never have begun rudely reading the magazine on the desk during their visit—evidence of the cultural shift that the new medium brought.

Theme Box 46: McLuhan: Media Theory
by Sheena Calvert

In the following passage, Marshall McLuhan (Canadian, 1911–1980), an important thinker in media theory, foresaw the form and import of technological developments such as the Internet:

> A computer as a research and communication instrument could enhance retrieval, obsolesce mass library organization, retrieve the individual's encyclopedic function and flip into a private line to speedily tailored data of a saleable kind. (from *The Gutenberg Galaxy: The Making of Typographic Man*, 1962)

He theorized that such ways of producing knowledge and accessing information were the logical extension of new forms of "electronic interdependence" taking shape through the proliferation of television and other electronic media forms of the mid-twentieth century.

In *Understanding Media: The Extensions of Man* (1964), McLuhan distinguishes between "hot" and "cool" media. Hot (high-definition) media are sensually engaging and immersive and require less active attention. Movies and radio, for instance, are linear in form and require little decoding. Cool (low-definition) media are more detached and require more active audience engagement to decode meaning. Cool media would include books and, today, computer games. A lecture is hot, while a seminar is cool, and so on. Forms of illustration that require focused attention and thoughtful contemplation might be described as cool—graphic novels, for example.

In *The Gutenberg Galaxy: The Making of Typographic Man* (1962), McLuhan argues that from 1453 onward (the date of Gutenberg's introduction of moveable type in Europe), human understanding has been influenced by what McLuhan calls the "linearization of print," in which we habitually think in straight lines, left to right and front to back (as in a book). This, in turn, forms our understanding of the world as primarily linear and becomes a habit of thought. It also isolates us from one another, through silent reading: "Printing, a ditto device, confirmed and extended the new visual stress. It created the portable book, which men could read in privacy and in isolation from others," he wrote. *The Gutenberg Galaxy* throws a particularly astute light on the historical and technological as they interface and criticizes the move from oral to visual forms of understanding that print culture promotes: "[T]he world of visual perspective is one of unified and homogeneous space. Such a world is alien to the resonating diversity of spoken words."

For McLuhan, the convergence of technologies and mass media held great potential to reverse the fragmentation of society: the growth of electronic media would return modern society back to a preliterate, oral (non-print-based) culture and social organization, making the world into a **global village** where "'Time' has ceased, and 'space' has vanished." Such media would retribalize and reunify human beings in ways that would address what he saw as the problematic separation of people that had taken place within print culture.

We can see how such ideas are now enacted within social media, where groups form and individuals are linked globally without being affected by distance. It's interesting to consider how the growth of social media has both performed this reunification to a degree, while also reinforcing it. We have access to more information and more social connections than ever, and technology has prompted great social change in ways McLuhan predicted. Yet there is still an inherent separation and loneliness in the specter of people behind individual screens, lacking face-to-face interaction with other human beings. As McLuhan himself warns in *The Gutenberg Galaxy*: "There can only be disaster arising from unawareness of the causalities and effects inherent in our technologies."

In *Understanding Media*, McLuhan also interrogated the relationship between the medium in which something appears and the effects of that medium on the message being conveyed, a concept he famously summarized with the catchphrase "The medium is the message." For illustrators, the question of medium versus message is of great significance. If an image is hand-drawn rather than computer-generated, how does this affect the ideas within the work? McLuhan suggests that all media have intrinsic properties that deeply influence the communication of meaning, where human beings are "massaged" (manipulated) by various media forms that each affect the human sensorium differently. If we think about how digital media shape our perceptions of the world and our modes of work and make us increasingly screen-based, we can see the truth in one of McLuhan's key statements: "We shape our tools and they in turn shape us." This greatly debated theory that our tools and our media deeply and irrevocably change society, often in unpredictable and uncontrollable ways, is called **technological determinism**.

McLuhan's thought was summarized and given visual form in a highly influential milestone in illustration, a book titled *The Medium is the Massage*, in collaboration with the eminent graphic designer Quentin Fiore (American, b. 1920) and publisher Jerome Agel (American, 1930–2007). Exploiting phototypesetting and montage to present integrated image-and-text messages in the format of the mass-produced pulp paperback book, this example of the very electronic media and new communication consumption that McLuhan wrote about was also the heir to earlier experiments and theories introduced by the Dadaists (*Chapter 19*) and Walter Benjamin (*see Chapter 13, Theme Box 27, "Benjamin: Aura, Mass Reproduction, and Translation"*).

Further Reading

McLuhan, Marshall, *The Gutenberg Galaxy: The Making of Typographic Man* (Toronto: University of Toronto Press; 1962).

McLuhan, Marshall, *The Mechanical Bride: Folklore of Industrial Man* (New York: Vanguard Press, 1951).

McLuhan, Marshall, *Understanding Media: The Extensions of Man* (Corte Madera, CA: Gingko Press, 2003).

McLuhan, Marshall, Quentin Fiore, and Jerome Agel, *The Medium is the Massage: An Inventory of Effects* (Corte Madera, CA: Gingko Press, 2001).

The postwar trend toward suburban living also reduced newsstand sales, while rising production and circulation costs lowered profit margins. To combat this problem, publishers experimented with a range of creative marketing techniques, such as geographically specialized **split-run editions**, which allowed publishers and corporations to target segmented markets (such as Canada) by tailoring a portion of the print run with different advertising, editorial content, or covers designed especially for them. Striking graphics, product samples, and foldouts engaged audiences but could not stem the tide. Between 1950 and 1970, illustration-friendly publications like the *Woman's Home Companion*, *Collier's*, and even the *Saturday Evening Post*, disappeared. Produced as a weekly from 1897 to 1963, and later as a biweekly, the *Post* ceased publication in 1969. Since 1970, it has appeared in a variety of formats that do not reflect its original design as a richly illustrated, general-interest magazine.

Influence of Modern Art

As film, photography, and television were changing the media landscape, modernist sensibilities favoring abstraction, avant-garde art, and the Swiss International Style in design also relegated narrative realism to a lesser status (*see Chapter 19*). As in the art world, conceptual approaches began to emerge in the work of illustrators who investigated abstraction and visual metaphor over literal representation. Young postwar illustrators and graphic designers began integrating elements of Post-Impressionism, Cubism, Futurism, Dada, and Surrealism in an effort to bring applied art into greater alignment with fine art. One such illustrator, Boris Artzybasheff (Ukrainian, American, 1899–1965), created striking, socially conscious Surrealist designs for many major magazines, including *Life* and *Fortune*. He also illustrated more than two hundred covers for *Time* between 1941 and 1965, including one featuring an anthropomorphized computer that cheerfully assists businesspeople with their data—an optimistic vision of the future that registers none of the complexity of the digital revolution predicted by Marshall McLuhan (*see Theme Box 46, "McLuhan: Media Theory"* in this chapter) (Figure 24.14).

Illustrators began to abandon the realism and compositional approaches of academic painting. Al Parker's innovative compositions, for instance, used informal poses, high-key palettes, and unique, eye-stopping layouts that emphasized design over detail. American illustrators Tom Lovell (1909–1997), Jon Whitcomb (1906–1988), John Gannam (1907–1965), and Edwin Georgi (1896–1964) also contemporized traditional narrative formats with similar innovations. In one **boy/girl illustration**, a genre that depicts a man and a woman together and captures the spirit of their relationship, M. Coburn "Coby" Whitmore's (American, 1913–1988) lush brushwork and high-key color palette

are reminiscent of **Post-Impressionism** (ca. 1886–1905), the French art movement characterized by flattened, light-filled spaces and asymmetrical compositions (Figure 24.15). Despite its somewhat abstracted quality, Whitmore's image remains tied to the romantic idiom that was prevalent in women's magazines at the time.

Stylistic investigation became the norm in advertisements, movie posters, paperback book jackets, and children's books of the era, which continued to feature illustration. Record album covers such as those by Tom Allen (American, 1928–2004) became a new showcase for illustrators (Figure 24.16). Born in the music production center of Nashville, Tennessee, Allen developed an expressive style that was inspired by the forceful art of his contemporary, figurative painter Leon Golub (American, 1922–2004). Allen and fellow illustrators Robert Weaver (American, 1924–1994) and Robert Andrew Parker (American, b. 1927) favored an approach that exploited composition, juxtaposition, and color in a departure from portraiture's customary realism.

As in the United States, Canadian art directors followed developments in European graphic design, and a number of illustrators in Canada also began to introduce a wider visual vocabulary than previously seen there. The most successful was Oscar Cahén (German, Canadian, 1916–1956), who had come to Canada as a

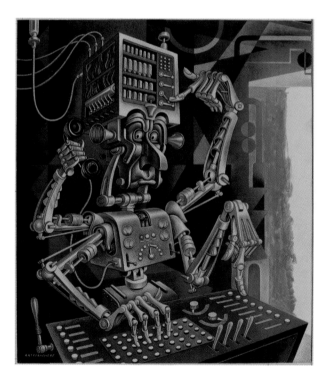

Figure 24.14
Boris Artzybasheff, *Executive of the Future*, cover art, *Esquire*, April 1952. Gouache on illustration board. 13 ¹/₂ × 12".
Boris Artzybasheff's image implies that an anthropomorphic computer interacts via telecommunications with humans in the nascent digital age. Artzybasheff was also known for his striking magazine portraits of noted figures.
Courtesy of the Syracuse University Art Collection. Copyright: Previously published in the April 1952 issue of *Esquire* magazine, a publication of Hearst Communications, Inc.

Figure 24.15
M. Coburn "Coby" Whitmore, *Sleeping Woman*, illustration art, *McCall's*, ca. 1960. 13 ¹/₂ × 15 ¹/₄".
Coby Whitmore's richly painted illustration emphasizes color, shape, and an ambiguous spatial composition, indicating his interest in modern art forms that depart from the traditions of narrative realism.

Collection of the Tinkelman Family, Estate of Carol and Murray Tinkelman. Originally published in *McCall's*® magazine.

refugee in 1940. Cahén's fiction illustration showcases his strengths at skillfully blending European modernism with American narrative realism (Figure 24.17).

The mid-century debate about the relative merits of abstraction and realism placed illustration generally, and Norman Rockwell particularly, in the crossfire. In postwar America, the primacy of abstraction in avant-garde curatorial circles was clearly established, and by the 1950s, abstract art had many collectors. Although much of the general public continued to prefer narrative realism, influential critics such as Clement Greenberg championed **Abstract Expressionism** and disparaged traditional figurative art as kitsch (*see Chapter 19, Theme Box 40, "Greenberg: Avant-Garde and Kitsch"*). By 1961, the popular press had covered Abstract Expressionism for over a decade, beginning with a *Life* magazine story of August 8, 1949, that provocatively asked whether Abstract Expressionist artist Jackson Pollock (American, 1912–1956) was the "greatest living painter" in the United States. Rockwell, it should be noted, was the most *famous* American painter at this

Figure 24.16
Tom Allen, *Little Jimmy Rushing and the Big Brass Label*, album cover art, Columbia Records, 1958.
Widely known for his striking album covers for country and jazz musicians, Tom Allen became friends with many of his subjects and insisted on being present at recording sessions to inspire artwork that he felt was authentic. American jazz and blues singer Jimmy Rushing is sensitively portrayed in this art for his album cover in which furniture and music stands are placed asymmetrically to counterbalance the figure.

Courtesy of Donna L. Thompson, © Estate of Tom Allen/Donna L. Thompson.

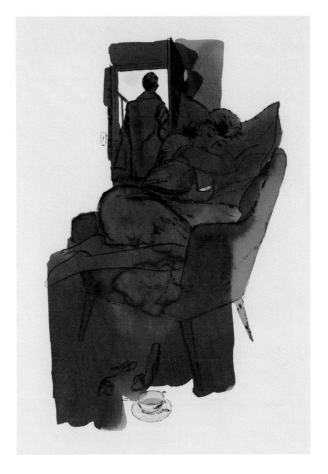

Figure 24.17
Oscar Cahén, illustration art, "The Man With a Coat" by Morley Callaghan, *Maclean's*, April 16, 1955. Ink, pencil, 20 × 27 ¹/₄" (board).
Before coming to Canada, Cahén trained in several European countries and worked as an advertising artist in Prague, where he first encountered and deployed American styles. Like many Canadian illustrators, he also developed an abstract painting career.

Courtesy of The Cahén Archives. © The Cahén Archives.

time. Rockwell's *The Connoisseur* shows the clash between the two modalities (Figure 24.18). His depiction of a well-heeled gallery visitor cleverly aligns the man with tradition, while the abstract painting—modeled after Pollock's infamous "drip" canvases—is a rebellious riot of color. Rockwell's personal opinion of abstraction is ambiguous. However, after completing this illustration, he anonymously submitted sections of one of his studies for *The Connoisseur* to exhibitions, where they took first prize and honorable mention. Rockwell ultimately found he could stay most relevant by applying his narrative painting skills as a catalyst for change.

In the 1960s, particularly following the assassination of President John F. Kennedy in 1963 and the intensification of American military activity in Vietnam, long-held beliefs and cultural norms shifted dramatically in America. Attitudes about race, sexuality, and gender roles were examined as diverse social groups united to fight for civil rights and to protest the Vietnam War. After resigning his forty-seven-year tenure with the *Saturday Evening Post* in 1963, Rockwell embraced the challenge of creating imagery that addressed the nation's pressing concerns in a pared-down, reportorial style. *The Problem We All Live With* for *Look* magazine is based on an actual event, when six-year-old Ruby Bridges was escorted by U.S. Marshals to her first day at an all-white school (Figure 24.19). While the neutral title of the image invites interpretation, Rockwell's depiction of the vulnerable but dignified girl clearly condemns the actions of those who attacked her.

The Studio System

In the postwar age of consumerism, illustration and design studios (first established in the nineteenth century) throughout the nation linked artists with clients to satisfy the rising demand for editorial and advertising imagery. Studio employees included managers, salesmen, art directors, photographers, retouchers, letterers, and illustrators; the studio's clientele were businesses, publishers, and advertising agencies. Aspiring artists often began as apprentices, organizing supplies and matting artworks for presentation to clients—moving into the **bullpen** (the group workspace filled with drafting tables), as salaried illustrators once they had developed their skills and knowledge of production. The studio system continued until approximately 1970.

Sundblom Studios

The artist Haddon "Sunny" Sundblom (American, 1899–1976) opened his successful agency, originally called Stevens, Sundblom & Henry, in 1925 in Chicago, then the capital of the advertising industry. The studio landed prestigious accounts such as Quaker Oats, Cream of Wheat, and Packard autos, which attracted skilled artists seeking employment. By the 1960s, the firm—now called simply Sundblom Studios—had "graduated" some three hundred artist assistants and completed advertising campaigns for Coca-Cola, Maxwell House, American Tobacco Company, Palmolive, Nabisco, Goodyear, Procter & Gamble, Frigidaire, Westinghouse, and other leading corporations.

Sundblom and his staff invented the pleasant, reassuring faces of the Quaker Oats man and Aunt Jemima, and updated the jolly Santa Claus familiar to American audiences from Thomas Nast's nineteenth-century images. The "sunny glow" of Sundblom's art can be attributed to an emphasis on smiling expressions on handsome people, care-free **alla prima** ("at the first

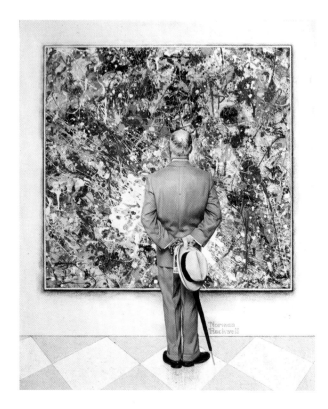

Figure 24.18
Norman Rockwell, *The Connoisseur*, 1961, cover art, *The Saturday Evening Post*, January 13, 1962. Oil on canvas, 37 3/4 × 31 1/2".
Addressing notions of the "high" and "low" in art, Rockwell inspires our consideration of what the gentleman's reaction to the abstract painting might be. The convincing "quotation" of Pollock's technique gave Rockwell the opportunity to utilize abstraction while remaining inside his comfort zone.

Private collection. Printed by permission of the Norman Rockwell Family Agency. Copyright © 1961 the Norman Rockwell Family Entities.

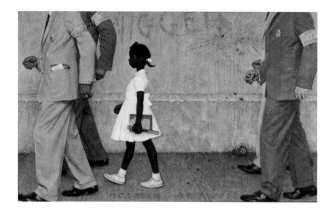

Figure 24.19
Norman Rockwell, *The Problem We All Live With*, 1963, illustration art, *Look*, January 1964. Oil on canvas, 36 × 58".
On its tenth anniversary, Rockwell's painting humanizes enforcement of the 1954 *Brown vs. Board of Education* ruling, which mandated desegregation of American schools. Rockwell heightens attention on the subject by painting the girl in a pristine white dress, symbolizing her innocence.

Norman Rockwell Museum Collection. Printed by permission of the Norman Rockwell Family Agency. Copyright © 1963 the Norman Rockwell Family Entities.

touch") brushstrokes rendering volume directly onto the canvas wet-into-wet, and his use of a rich, warm palette. The Sundblom look—often adopted by artists outside the studio—led to its being equated with privileged American commercialism (Figure 24.20).

Charles E. Cooper Studios

Founded in 1935 and situated at fashionable 57th Street and Lexington Avenue in New York City for three decades, Charles E. Cooper Studios was a renowned agency specializing in glamour illustration for advertising and women's magazines (Figure 24.21). The illustrators received 50 percent of each advertising commission secured by the company's account executives. Often, employment in a studio meant the firm owned all work done by its staff, even if the illustrator had brought the job in him- or herself (as was typical for editorial work). But because their popularity as editorial story illustrators attracted more lucrative advertising contracts, Cooper Studios generously allowed its illustrators to keep 100 percent of such payments. American illustrators Joe

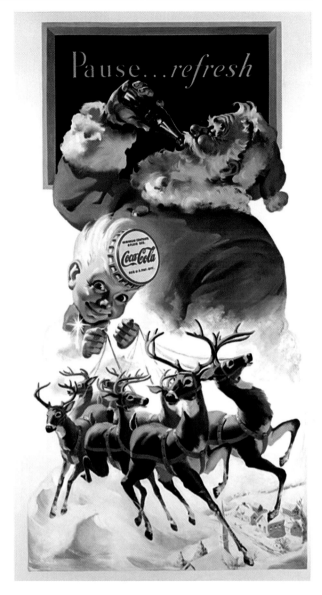

Figure 24.20
Haddon "Sunny" Sundblom, *Travel Refreshed*, Coca-Cola Company, 1949.
The boyish "sprite" character accompanying Santa Claus was introduced in 1949 as Coca-Cola's personification of effervescence. Sundblom's contribution to advertising was primarily that of a stylist—the lush, glowing style of his oil on canvas paintings was highly influential.
© The Coca-Cola Company.

Figure 24.21
Joe De Mers, interior illustration, "The Green Scarf" by Jean Todd Freeman, *Ladies' Home Journal*, February 1956.
Considered too sensual for the covers of the *Saturday Evening Post*, Joe De Mers's distinctive artworks featuring dramatic close-ups and unexpected perspectives often focused on glamourous debutantes and up-and-coming career women in pursuit of romance. The *Saturday Evening Post*, *Ladies' Home Journal*, *McCall's*, *Esquire*, and other magazines published his eye-catching art in conjunction with popular fiction and serialized stories, which were the soap operas of print media. In this double-page spread, De Mers epitomizes the glamour and the convincing naturalistic poses and expressions of the "big head" style that several Cooper Studios illustrators were well known for.

Tearsheet, Norman Rockwell Museum Collection. Originally published in *Ladies' Home Journal*® magazine, February 1956.

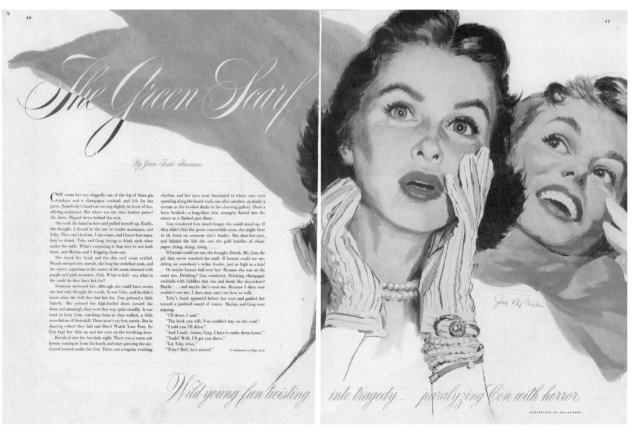

Bowler (b. 1928), Bernard D'Andrea (b. 1923), Lorraine Fox (1922–1976), Bob Levering (1919–2011), Murray Tinkelman (1933–2016), William H. Whittingham (b. 1932), Coby Whitmore, and Jon Whitcomb were among the noted illustrators who worked at Cooper Studios.

Lorraine Fox was one of the most prominent women in the field and the first female inductee into the Society of Illustrators Hall of Fame, albeit posthumously in 1979. Working at the Charles E. Cooper Studios and as a freelance artist, she created stylized, decorative illustrations for magazines, advertisements, and book covers (Figure 24.22). *Good Housekeeping, Redbook, Woman's Day, McCall's*, and *Cosmopolitan* were among her many clients, and she taught at Parsons School of Design and the Famous Artists School.

As the field of illustration shifted emphasis to concepts and experimentation over technical prowess, Cooper Studios recognized the need to attract younger talent interested in visual problem solving and symbolism rather than a traditional painterly approach (Figure 24.23).

Push Pin Studios

Push Pin Studios was formed in New York City in 1954 by Cooper Union graduates Milton Glaser (American, b. 1929), Seymour Chwast (American, b. 1931), Reynold Ruffins (American, b. 1930), and Edward Sorel (American, b. 1929) as a hybrid graphic design and illustration studio. Push Pin was recognized for its eclectic sophistication. As early proponents of what would be dubbed **Postmodernism** (*see Chapter 27*), its members found inspiration in a variety of visual approaches ranging from the Italian Renaissance, Art Nouveau, Art Deco, and Constructivism to comic strips, early American painting, and nineteenth-century woodcuts and engravings. Like Dada artists (*see Chapter 19*), they playfully and ironically combined anachronistic elements with contemporary imagery. Forgotten typographic styles, flourishes, and decorative borders of the nineteenth and early twentieth century were also revived in their work (Figure 24.24).

Push Pin artists rejected the prevailing Swiss (or International Typographic) Style notion that illustration and design were discrete practices, and sought an integration of typography and illustration that pushed against such approaches to visual communication. Inspired by the 1957 *Self-Portrait in Profile* by Dada artist Marcel Duchamp (French, American, 1887–1968), Milton Glaser's poster design (Figure 24.25) of musician Bob Dylan employs a vernacular font consisting of stylized, geometric shapes associated with Art Deco of the 1920s (*see Chapter 20*). Created in New York, the design also resonates with the work of San Francisco poster artists of the 1960s and 1970s (*see Chapter 26*).

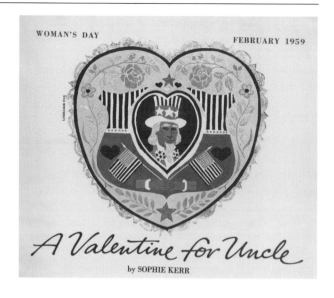

Figure 24.22
Lorraine Fox, "A Valentine for Uncle" by Sophie Kerr, *Woman's Day*, February 1959.
In this piece, Fox has combined actual bits of lace, ink, and dyes with stenciling techniques on paper reminiscent of Victorian decorative crafts with an interpretive portrait of Uncle Sam and other American iconography.
Estate of Lorraine Fox, courtesy of Bernard D'Andrea.

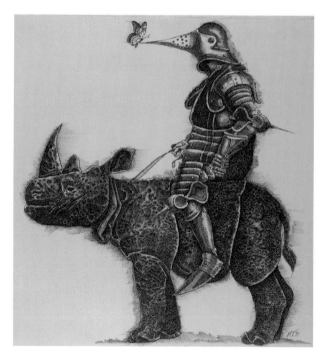

Figure 24.23
Murray Tinkelman, *Knight on Rhinoceros*, cover art, *The Illustrations of Murray Tinkelman*, 1980. Ink on illustration board. 24 7/16 × 23 1/16".
At Cooper Studios, Murray Tinkelman represented a new generation of illustrators who were interested in self-generated projects as much as the commercial assignments. This ink-on-paper piece grew out of Tinkelman's personal explorations as he sharpened his focus on making more conceptually driven images; it ultimately won a Society of Illustrators Gold Medal. This direction attracted a series of compelling assignments that lent themselves to conceptually driven treatment.
Collection of the Tinkelman Family, Estate of Carol and Murray Tinkelman.

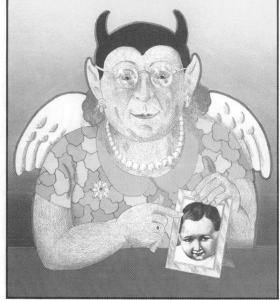

Figure 24.24
Seymour Chwast, "Mothers," cover, *Push Pin Graphic*, December 1976.
Push Pin Graphic, a publication art directed by Seymour Chwast, was first created for Push Pin Studios' friends and clients in 1957, but became a promotional device and an important reference for contemporary illustration and design. It was produced as a thirty-two-page bimonthly magazine from 1976 to 1980 and featured illustrations by Chwast and other artists represented by the studio. Imagery often integrated historical art and design forms, such as the calligraphic flourishes seen in the masthead.

© Seymour Chwast, Pushpin Graphics.

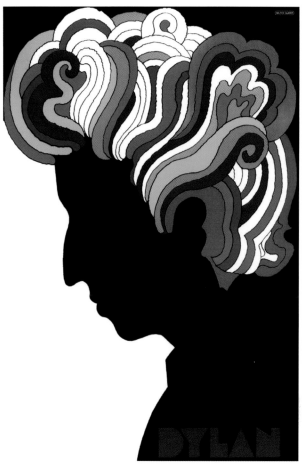
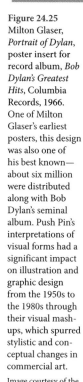

Figure 24.25
Milton Glaser, *Portrait of Dylan*, poster insert for record album, *Bob Dylan's Greatest Hits*, Columbia Records, 1966. One of Milton Glaser's earliest posters, this design was also one of his best known—about six million were distributed along with Bob Dylan's seminal album. Push Pin's interpretations of visual forms had a significant impact on illustration and graphic design from the 1950s to the 1980s through their visual mash-ups, which spurred stylistic and conceptual changes in commercial art.

Image courtesy of the artist. ©Milton Glaser Inc.

End of the Studios

In the 1960s and '70s, as illustration work dwindled in the face of competition from television and photography, the large studios began to close. Many illustrators who freelanced while holding studio jobs gradually became entirely self-employed. One area of illustration that continued to thrive, however, was paperback covers. Will Davies (Canadian, b. 1924), who excelled at chic, glamorous boy-girl subjects in the vein of some of the Cooper Studios illustrators, found a steady client in Harlequin, a Canadian publisher of romance and other popular fiction. Over four decades, he completed more than five hundred covers for their paperbacks (Figure 24.26).

Many Canadian illustrators sought work in New York, but improved communication and delivery systems from the 1960s onward meant artists could stay in Canada. James Hill (1930–2004) was known mainly for editorial and paperback book cover illustration. In the 1960s, he developed a kaleidoscopic painterliness

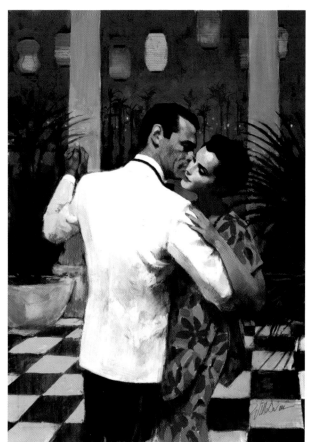

Figure 24.26
Will Davies, cover art, *Neptune's Daughter*, Harlequin, 1987. Canadian illustrator Davies sometimes brought models from New York to Toronto to pose for photo shoots and sketching. His final work was often executed in gouache in a manner similar to Americans such as Al Parker and Jon Whitcomb. He also illustrated fashion, automotive advertising, historical subjects, and portraits for editorial commissions.

Image courtesy of Leif and Simon Peng, *The Art of Will Davies*. © Estate of Will Davies.

Figure 24.27
James Hill, frontispiece, *The Short Stories of Oscar Wilde*, Limited Editions Club, 1968. Using collage with real feathers to achieve an original composition with rich metaphorical content, Hill bridges traditional narrative realism and conceptual illustration and captures the aesthetics of the psychedelic era.

Image courtesy of Jaleen Grove. © Estate of James Hill. Reproduction rights held by the Estate of James Hill.

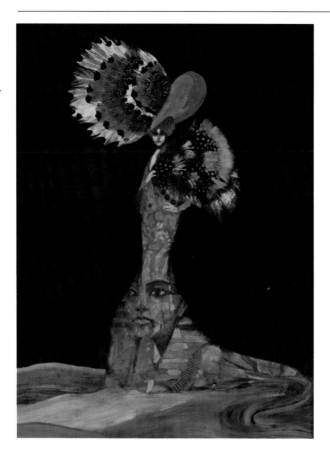

Figure 24.28
R. O. Blechman, "Cantalbert Was Unhappy. He Wanted His Juggling to Reform the World," cover illustration, *The Juggler of Our Lady: A Medieval Legend*, 1953.
Issued soon after World War II, *The Juggler* has an underlying message of social justice, but for Blechman the project also brought together his love of comics and movies. In 1954, *The Juggler* was also made into a short animated film.

Courtesy of R. O. Blechman.

that won him a prestigious commission from the Limited Editions Club, which produced signed editions for collectors (Figure 24.27).

The Conceptual Shift in Editorial Illustration

While many magazines survived the 1950s and 1960s, the number of illustrations used was reduced or replaced by photography. *Sports Illustrated*, *Fortune*, and *Playboy*, however, built distinctive brand identities by featuring more innovative artwork. In this new business environment, individualistic illustrators found favor. One artist with an identifiable autographic style is R. O. Blechman (American, b. 1930), a celebrated illustrator, animator, children's book author, graphic novelist, and editorial cartoonist, whose 1967 animated Alka-Seltzer commercial featuring his characteristically nervous, wavy line is considered seminal. For Blechman, images are often in response to written ideas or concepts, as in his book *The Juggler of Our Lady* (1953), a satirical retelling of a classic medieval Christmas tale in a graphic novel format (Figure 24.28).

The trend toward individualism meant that established mainstream illustrators such as Al Parker had to reinvent themselves. In 1964, *Sports Illustrated* sent Parker, instead of a photojournalist, to capture the excitement of premier auto racing at the Monaco Grand Prix—a highlight of his career (Figure 24.29). Parker painted and photographed on location with little

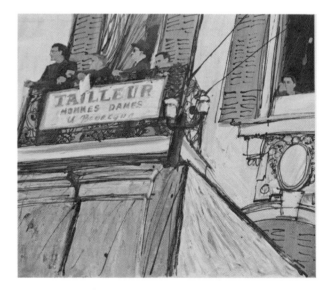

Figure 24.29
Alfred Charles (Al) Parker, interior illustration, "As if at a Parade, Monagasques see the Race from a Strategic Balcony on Boulevard Albert 1 Near the Harbor, Monaco Grand Prix," *Sports Illustrated*, May 1964.
Experiential and documentary, Parker's visual essay uses a dramatic perspective to generate an intimate glimpse of the events unfolding around him.

Al Parker Collection, D. B. Dowd Modern Graphic History Library, Washington University Libraries, Washington University in St. Louis. © Estate of Al Parker.

editorial oversight. The outcome was an expressive suite of autographic illustrations that spread across eight pages that manifested the value of the illustrator's intellect and interpretive abilities.

From the mid-1950s through the 1980s, photography and television provided direct access to world events and left illustration to capture abstract meaning and phenomena not easily described by literal representations. **Conceptual illustration**, which drew some inspiration from Dada and Surrealism (*see Chapter 19*), allowed for the visualization of complex social and psychological issues through metaphor, suggestion, visual puns, and complex word-and-image play. Developments in fine art and cultural criticism also contributed to interest in less literal and more conceptual approaches to illustration. Robert Weaver (American, 1924–1994), a leader of this new direction in illustration in the 1950s, characterized the possibility of the illustrator's role as a cultural agent by saying, "I see no reason why an illustrator should not think of himself as a serious contemporary painter. . . That he has not realized [his artistic opportunities] is borne out by the low opinion in which the illustrator is held in the general art world. Many illustrators of today are too little concerned with the actualities of their time."

From the 1950s through the 1970s, Weaver produced illustrations for *Esquire, Fortune, Sports Illustrated, Life, Look,* the *New York Times,* and Columbia Records, all of whom supported more expressive work (Figure 24.30). Inspired to find new approaches to visual storytelling that were reflective of the growing interest in psychological or ideological content, Weaver ruptured the picture plane and combined discontinuous actions or seemingly unrelated ideas on one page to invite interpretation. His innovative, collage-like approach to painting, as reflected in his 1968 *Lincoln Park,* was quickly imitated by others (Figure 24.31).

In the 1960s, the marketing trend known as **The Big Idea** emerged, in which designers and writers identified a key attribute of an idea or product and then constructed its social meaning through a confluence of experimental design and semiotics—a process sometimes referred to as *visual thinking*. Art directors worked collaboratively with illustrators to develop all aspects of conceptual illustration from layout to allusion and metaphor. Artworks commented on and enhanced the interpretation of text rather than echoing specific passages, and invited reader participation in decoding meaning. For instance, in Saul Steinberg's (Romanian, American, 1914–1999)

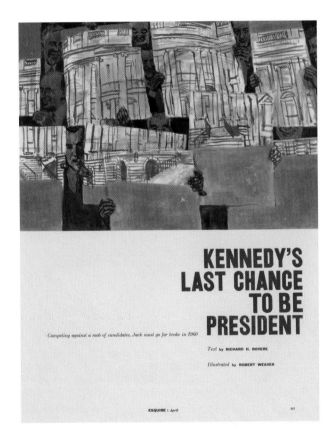

Figure 24.30
Robert Weaver, illustration, "Kennedy's Last Chance to Be President" by Richard Rovere, *Esquire*, April 1959.
Robert Weaver's multilayered composition alludes to shifting powers in government symbolized by individuals holding parts of a fragmented drawing of the White House.
Al Parker Collection, D. B. Dowd Modern Graphic History Library, Washington University in St. Louis. Previously published in the April 1959 issue of *Esquire* magazine, a publication of Hearst Communications, Inc.

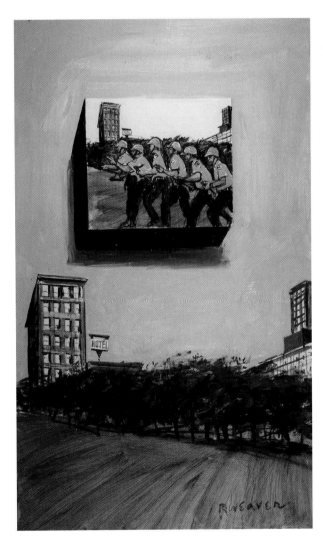

Figure 24.31
Robert Weaver, *Lincoln Park,* ca. 1968. Acrylic on board, 28 1/8 × 17 1/4".
Robert Weaver's split image provides alternate views of Lincoln Park, Chicago, the site of protests during the 1968 Democratic National Convention. Each night, the park was cleared of people—sometimes by force—as inferred by the inset featuring Chicago police armed with nightsticks. Weaver conceived of this approach to convey the passage of time and shifting events in a single image. The snapshot of police in riot gear hangs heavily over the eerily still scene.
Norman Rockwell Museum Collection, Gift of Magdalen and Robert Livesey / Famous Artists School Collection.

ironically titled *Utopia* (Figure 24.32), Long Island is an other-worldly wasteland rising up behind a happy couple who appear plucked from an advertisement, ready to stake their claim. Steinberg's drawing accompanied a 1974 article in the *New Yorker* about the vast influence of urban planner Robert Moses, who favored highways over public transit, and whose controversial policies helped create the modern car-dependent suburbs of Long Island and the rest of the nation. Best known for his incisive and witty *New Yorker* drawings, Steinberg moved across disciplines, creating art for all manner of things—from wallpapers and fabrics to public murals, stage sets, and advertisements.

Conclusion

During the postwar era when magazines still retained vast readerships, narrative imagery for covers, fiction articles, and advertisements remained popular. With the increased use of television and photography to convey visual narratives, mainstream publications foundered. This prompted shifts in magazine content as new attitudes about the creation and consumption of imagery emerged. Although narrative realism was not fully rejected, illustrators moved toward more autographic and conceptual approaches. Many recognized the importance of being active commentators in an ongoing visual dialogue and in conveying a personal voice in their art.

FURTHER READING

Heller, Steven, and Seymour Chwast, *Illustration: A Visual History* (New York: Harry N. Abrams, Inc. 2008).

Hennessey, Maureen Hart, and Ann Knutson, *Norman Rockwell: Pictures for the American People* (New York: Harry N. Abrams, Inc., in association with the High Museum of Art and Norman Rockwell Museum, 1999).

Schick, Ron and Stephanie Haboush Plunkett, *Norman Rockwell: Behind the Camera* (Boston, MA: Little, Brown and Company, 2009).

Pero, Linda Szekely, *American Chronicles: The Art of Norman Rockwell* (Stockbridge, MA: Norman Rockwell Museum, 2009).

Plunkett, Stephanie Haboush, *Ephemeral Beauty: Al Parker and the American Women's Magazine, 1940–1960* (Stockbridge, MA: Norman Rockwell Museum, 2007).

Walker, Nancy A., *Shaping Our Mothers' World: American Women's Magazines* (Jackson, MS: University Press of Mississippi, 2000).

KEY TERMS

Abstract Expressionism	conceptual illustration
alla prima	Famous Artists School
big head illustration	global village
The Big Idea	Post-Impressionism
boy/girl illustration	split-run edition
bullpen	technological determinism

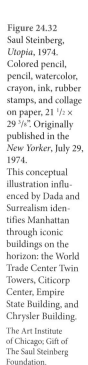

Figure 24.32
Saul Steinberg, *Utopia*, 1974. Colored pencil, pencil, watercolor, crayon, ink, rubber stamps, and collage on paper, 21 ¹/₂ × 29 ³/₈". Originally published in the *New Yorker*, July 29, 1974. This conceptual illustration influenced by Dada and Surrealism identifies Manhattan through iconic buildings on the horizon: the World Trade Center Twin Towers, Citicorp Center, Empire State Building, and Chrysler Building.

The Art Institute of Chicago; Gift of The Saul Steinberg Foundation.

25

Children's Book Illustration, 1920–2000

H. Nichols B. Clark

with contributions by
Whitney Sherman

During the period from 1920 to 2000, accelerated industrialization and the resulting shift away from agrarian economies prompted optimism as well as nostalgia for the past. Shifting cultural perspectives caused artistic creators to look forward as well as back for inspiration, prompting extraordinary changes in children's book illustration and the publishing industry that supported it. Two world wars and periods of economic prosperity and depression impacted the availability of materials used in publishing. Technological advances ushered in printing techniques that distinguished books through processes such as die-cuts, interactive parts, variability of scale, and affordable color. Television entertainment affected how the public related to picture books and the characters within them. The politics of the day—conservatism and liberalism, as well as social inequities challenged by movements such as Civil Rights and Women's Rights—caused the publishing industry to examine their audiences and to address issues of who was and was not served by their books. Additional influences came from federal literacy programs with increased awareness of reading's impact on a child's development and the value of imagination. Modernist and postmodernist cultural movements affected the content and perspectives of picture book illustration, fostering alternative ways to read a page, as well as the forms children's books took. The following thematic discussions highlight some pivotal works published during this dynamic period.

Regionalism, Identity, and Adversity

Children's books from the earliest part of the twentieth century visually document society's shift from the country to the city, from the farm to the factory. The connection between illustrated children's stories and the works created by American Regionalist painters who favored realist depictions of rural life (*see Chapter 20*) is palpable. Wanda Gág's (American, 1893–1946) *Millions of Cats* (1928), for example, is set in an idealized bucolic countryside of rolling, rhythmic hills and expansive space (Figure 25.1). The folk aesthetic of her images reinforces a nostalgic perspective.

The Little Engine That Could (1930), with its heroic engine that rescues a broken-down train with a cargo of toys, signaled optimism in the face of the 1930s' Great Depression. The book's theme of gritty determination offers readers hope through the engine's onomatopoeic mantra: "I think I can, I think I can, I think I can." The illustrations for the first edition were done by a then relatively unknown Lois Lenski (American, 1893–1974), who went on to write and illustrate over one hundred books. The expansive areas of white bring out Lenski's expressive black lines that define shapes of flat color, an aesthetic by-product of the hand-separation of color during print production.

Also written during the Great Depression was Laura Ingalls Wilder's (American, 1867–1957) *Little House on the Prairie* (1932), the first in a series of nine books dedicated to a family's homesteading journey in the American Midwest. A story of overcoming hardship, it shared a sense of nostalgia and yearning for pre-industrial America. The original illustrations by Helen Sewell (American, 1896–1957) reflect the same decorative, bold aesthetic of Gág's work; Sewell's illustrations were replaced in 1953 by those of Garth Williams (British, 1912–1996) whose softly modeled drawings create a warmer feel.

Innovations introduced into Western picture books by Gág, where spreads whimsically integrate image and organically shaped blocks of text, are continued in books by writer-illustrator Virginia Lee Burton (American, 1909–1968). She too provides an elegy to the pastoral tradition in *The Little House* (1942), in which a diminutive dwelling is swallowed up by urban sprawl (Figure 25.2). Burton's *Mike Mulligan and His Steam Shovel* (1939)—a tale in which more efficient diesel models replace the protagonist's steam shovel—addressed issues of technological change, obsolescence,

Figure 25.1
Wanda Gág, interior spread, *Millions of Cats*, 1928.

Gág's most significant contribution to children's book illustration is considered to be her integration of image and text on a spread, often with the image designed to cross the gutter and to break free of a grid—a departure from traditional page layouts in Western book design. This book is the oldest U.S. picture book still in print.

redundancy, and lifestyle values. Burton's contemporary Hardie Gramatky (American, 1907–1979) created *Little Toot* (1939), a best-selling coming-of-age story about an anthropomorphic young tugboat, Toot, who matures just in time to save an ocean liner.

Themes that addressed challenges brought about by modernity and championed the underdog met with a powerful reception during the Depression and war years, and echoed theories of noted educator Lucy Sprague Mitchell (American, 1878–1967), who espoused learning through the "here and now," rather than from the romantic perspectives of fairy tales and myths.

Underdogs and the agrarian ideal also inform author E. B. White's (American, 1899–1985) book *Charlotte's Web*, illustrated by Garth Williams, which considers salvation and death through the compelling story of a spider that saves a pig from slaughter while succumbing to her own life cycle (Figure 25.3). Celebrating family harmony, domesticity, and determination, *Make Way for Ducklings* (1941), written and illustrated by Robert McCloskey (American, 1914–2003), echoes the home-town well-being embraced by Norman Rockwell (*see Chapter 24*) and by much of the editorial and advertising illustration of its day. Because color printing was too expensive during the war years, McCloskey relied on the expressiveness of his charcoal drawings printed in inviting sepia tones (Figure 25.4). Like Robert Lawson's (American, 1892–1957) 1936 illustrations for *The Story of Ferdinand* (Figure 25.18), *Make Way for Ducklings* may be stronger for its monochrome images.

Figure 25.3
Garth Williams, interior illustration, *Charlotte's Web*, Harper & Brothers, 1952.
Garth Williams's insightfully humorous and crisply rendered ink drawings complement E. B. White's forthright yet elegant prose. Williams had previously illustrated another of White's books, *Stuart Little*, in 1945.

Figure 25.2
Virginia Lee Burton, interior illustration, *The Little House*, 1942.
Burton uses the page layout to propel the story: the bright little house maintains its steadfast position in the center of the right half of each spread, and every page turn reveals the further encroachment of the city on the little house until it eventually fills the entire spread. The tale ends with the little house's relocation to the country.

Figure 25.4
Robert McCloskey, interior spread, *Make Way for Ducklings*, 1941.
Through carefully controlled line and tone, McCloskey's naturalistically modeled representation reads well in one-color printing. The Caldecott committee recognized *Make Way for Ducklings* as the outstanding picture book of 1941.

Benefitting from the rising popularity of comics during the 1940s, H. A. (Hans Augusto) Rey's (German, American, 1898–1977) and Margret Rey's (German, American, 1906–1996) book *Curious George*, with its energetic line drawings and saturated color shapes, was eagerly embraced by children for George's ability to create chaos (Figure 25.5). The story, inspired by the Rey's own pet monkeys, engages the reader in a playful narrative driven by the consequences of George's irrepressible curiosity and mischief. George's captor, the Man with the Yellow Hat, facilitates George's adventures and behaves much like a father figure while rescuing George from situations in the nick of time.

Determination and mischief are not qualities reserved for animals in children's books of this period, and strong-willed, charismatic, even naughty characters emerged. *Madeline* (1939), created by Ludwig Bemelmans (Austrian, American, 1898–1962), engages young audiences through image and text that parallel one another (Figure 25.6). Throughout the book, Bemelmans adroitly "rhymes" his pictures as he rhymes his words. On four consecutive pages, Miss Clavel heads up "twelve little girls in two straight lines"—her position changes only slightly relative to the rhyming of the words and visually identical compositions.

Eloise (1955) is a story of a rambunctious heroine written by Kay Thompson (American, 1909–1998) and illustrated by Hilary Knight (American, b. 1926). The illustrations convey a snakes-and-snails subversion with sugar-and-spice sweetness. Knight's perky rendition of Eloise and masterful line work give tangible definition to the text and convey the energy of Thompson's character (Figure 25.7).

Eloise's rebellious antics were topped only by those of the protagonist Max in Maurice Sendak's (American, 1928–2012) *Where the Wild Things Are* (1963) (Figure 25.8).

Figure 25.6
Ludwig Bemelmans, interior illustration, *Madeline*, 1939.
Madeline illustrations shift from bright black-and-yellow images to hauntingly dark, full-color scenes, visually reflecting the protagonist's complex personality.

This now-iconic title elicited adult concern at the time it was published because of issues of defiance, lack of control, and an unstinting use of what were perceived as very scary images. Critics and adults were proved wrong as children flocked to the book, perhaps imagining, like Max, that they were in control.

This extraordinary narrative of only 338 carefully crafted words includes a groundbreaking sequence of wordless spreads. Sendak also uses page layout to advance the narrative by beginning with small, contained illustrations that increase in size until Max's imaginative world exceeds the page trim.

Bedtime and Journeys of the Imagination

Bedtime is one of the treasured times for reading to children; and beyond inducing sleep, the custom promotes lasting affection for books and has been shown to improve literacy. Young children constitute a very special audience who vote with the words "Read it again!" Popular demand has certainly been the case for Margaret Wise Brown's (American, 1910–1952) *Goodnight Moon* (1947), illustrated by Clement Hurd (American, 1908–1988). At a time when Art Deco and even more radical modernist sensibilities impacted contemporary art and design (*see Chapters 19 and 20*), Brown's avant-garde sensibilities informed her daring

I have my own room

It has a coat rack which is as large as me

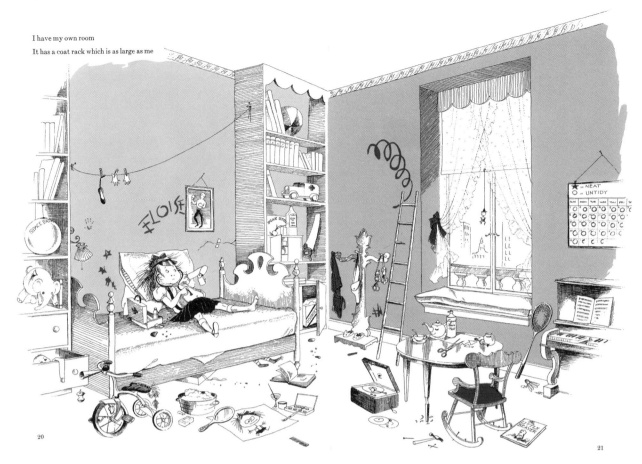

20

21

Figure 25.7
Hilary Knight, interior spread, *Eloise*, by Kay Thompson, 1955.
Knight captures his heroine as a contrary youth who has clearly resisted all entreaties to straighten up her room. His fluidly energetic line work helps define the environmental chaos while the use of intense pink signals Eloise's gender without making her seem too girly.

Reprinted with the permission of Simon & Schuster Books for Young Readers, an imprint of Simon & Schuster Children's Publishing Division, from *Eloise* by Kay Thompson & illustrated by Hilary Knight. Copyright © 1955 by Kay Thompson; copyright renewed © 1983 by Kay Thompson. All rights reserved.

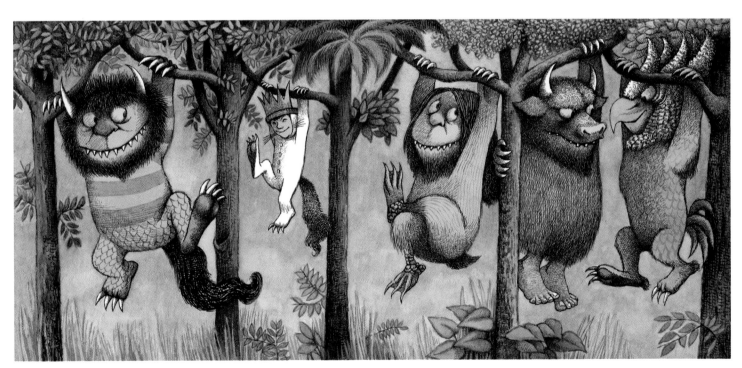

Figure 25.8
Maurice Sendak, interior spread, *Where the Wild Things Are*, 1963.
Sendak's visual references are legion, ranging from the Northern Renaissance and German Romanticism to French naïve painting, and even the film *King Kong* (1933). The "Things" are rendered to capture from memory physical characteristics of Sendak's relatives as seen with a child's unforgiving eye. Despite the controversy surrounding this supposedly subversive and scary book, the Caldecott committee awarded *Where the Wild Things Are* the Caldecott Medal in 1964. To many in the United States and abroad, Sendak may be the most important creator of children's books in the twentieth century.

art direction for Hurd. She encouraged him to use bold colors and naïve draftsmanship, which may themselves have been influenced by his tutelage under modernist painter Ferdinand Léger (French, 1881–1955) (Figure 25.9).

Whereas the goal of *Goodnight Moon* is to be a visual lullaby, Crockett Johnson's (American, 1906–1975) *Harold and the Purple Crayon* (1955) enchants the reader with a world of adventures being created page after page as Harold draws it (Figure 25.10). Johnson's approach was literally a stroke of genius, since he allowed Harold to create a world as a child would, using bold outlines, simple shapes, and a memorable color. Despite the ever-changing places Harold draws, the book ends on an appropriately quiet note when he draws the bed into which he climbs, falling asleep as his purple crayon falls from his hand.

Readers are invited on wordless journeys through cultural and historic realms in Mitsumasa Anno's (Japanese, b. 1926) series *Anno's Journey* (1977), *Anno's Italy*

(1979), *Anno's Britain* (1982), and *Anno's U.S.A.* (1983). Anno, who grew up imagining "people of different cultures living [together] inside a ball," produced crisply drawn images with extraordinary detail toned in muted colors and often embedding characters from the featured culture (Figure 25.11). His illustrations evoke Japanese *ukiyo-e* prints (*see Chapter 6*), and invite the reader to observe characters and use their imaginations to create a story.

During a period when full-color printing was becoming less expensive and more pervasive, Chris Van Allsburg (American, b. 1949) defied the trend by creating one black-and-white title after another. His debut, *The Garden of Abdul Gasazi* (1979), features topiary, formal gardens, and grand architectural elements that create bizarre and mysterious settings for the story (Figure 25.12). *Jumanji* (1981), Van Allsburg's deeply imaginative and psychologically disturbing follow-up effort, reaffirms children's enjoyment of narratives that some consider unsettling.

Figure 25.9
Clement Hurd, interior spread, *Goodnight Moon.* Hurd's full-color spreads alternate with simple black-and-white spot illustrations, while the single room in which the story unfolds grows continually darker inside as the moon grows continually brighter outside, until we say goodnight at the book's end.

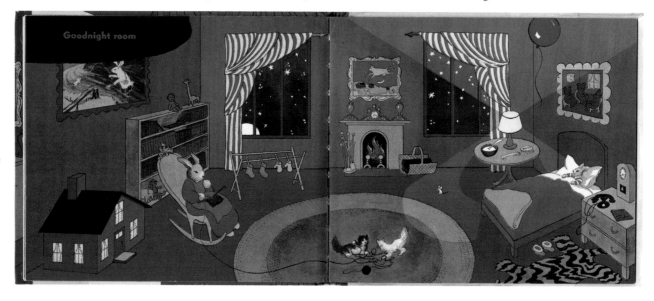

Figure 25.10
Crockett Johnson, interior spread, *Harold and the Purple Crayon,* 1955. Harold's evolving visual narrative moves across the page from left to right where, on each spread, the intentional use of white space teases readers into imagining how the story might unfold.

He made lots of buildings full of windows.

He made a whole city full of windows.

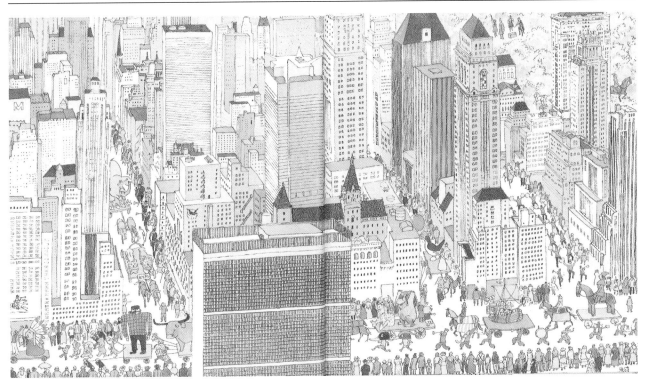

Continuing this visual tradition is David Wiesner (American, b. 1956) whose books *Tuesday* (1991) and *June 29, 1999* (1992) combine a sense of malaise with comic relief, probing the far side of reality with stories of mutant flora and fauna. In *Tuesday*, squadrons of frogs on magic-carpet lily pads pass through "Somewhere U.S.A.," leaving a wake of puzzlement and not a little paranoia (Figure 25.13). Perhaps most remarkable in page composition is Wiesner's early work, *Freefall* (1988), a wordless picture book whose protagonist embarks on a sleep-induced adventure through the pages of a book he was reading as he fell asleep. *Freefall* literally unfolds into a single, continuous narrative scene that extends from one spread onto the next; if laid out flat, the entire story would read as a scroll or an accordion book.

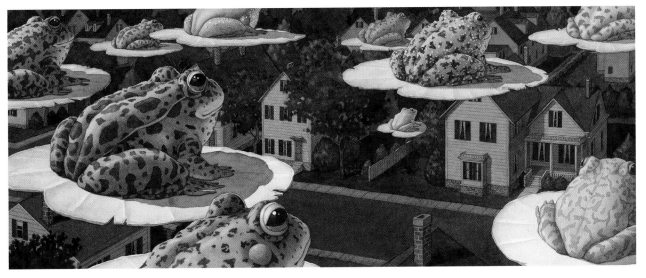

Figure 25.13
David Wiesner, interior spread, *Tuesday*, 1991.
The cool palette and hyper-real clarity of the scenes add to the compelling and eerie visual experience of this wordless book. Wiesner also used an unconventionally wide format to assist in telling the story.

Reaching the Masses

Recognizing the need for families to have home libraries to educate and entertain their children, Illinois native and Smith College graduate, Olive Beaupré Miller (American, 1883–1968), compiled, edited, published, and distributed *My Book House*. Published in Chicago as a six-volume set in 1921, it quickly grew to a twelve-volume set by 1932. The series comprised graded readings focused on folk- and fairytales, poetry, songs, biographies, and retellings of classics including Shakespeare.

Maud Petersham (American, 1890–1971) and Miska Petersham (Hungarian-born American, 1888–1960) contributed heavily to the series, their decorative folk-art-like illustrations often reinterpreting famous masterpieces. The *My Book House* series was only sold door-to-door and only by sales*women*—a progressive business tactic that inspired the homemaker-customer with trust for the saleswoman (perceived as a potential "mother herself"). Book sets remained in print until 1954, reaching thousands of readers during their thirty-three-year run.

Little Golden Books, introduced by Simon & Schuster in 1942, began as a bold venture committed to publishing attractive, colored books at affordable prices (Figure 25.14). The initial offering was *The Color Kittens* (1942) by Alice Provensen (American, b. 1918) and Martin Provensen (American, 1916–1987). The duo came from the field of animation and went on to create many remarkable books for children, including *A Visit to William Blake's Inn* (1981). The work of the Provensens, great admirers of folk art, combined visual clarity with the sequence and pacing of animation.

The eighth Golden Book—one of the best-selling children's books of all time with over fifteen million copies sold—was *The Poky Little Puppy* (1942). Part of its appeal is the winning pictures by the European gift-book

But when they looked down at the grassy place near the bottom of the hill, there he was, running round and round, his nose to the ground.

Figure 25.14
Gustaf Tenggren, interior spread, *The Poky Little Puppy* by Janette Sebring Lowrey, 1942. Little Golden Books were a new, affordable format distributed through supermarkets, pharmacies, and department stores where customers could buy them on impulse.

(*see Chapter 16*) illustrator Gustaf Tenggren (Swedish, American, 1896–1970), who had come to the United States to design for the innovative Walt Disney Studios. Other publishers quickly followed suit, producing equally well-crafted titles that were readily accessible and affordable, making mass-market publishing a permanent aspect of today's children's book industry. During the Cold War period, Little Golden Books were banned in the Soviet Union for being too "capitalist." *The Poky Little Puppy*, for instance, was perceived to have no interest in joining his peers in their collective pursuits, displaying instead a streak of subversive individualism.

Early Reading and Pictures

The educational impact of the "Dick and Jane" readers ("Janet and John" readers in the United Kingdom) in the mid-twentieth century is incalculable. Eighty percent of first-graders in the 1950s learned to read using these early reader books. Their wholesome yet banal illustrations, attributed to Eleanor Campbell (American, 1894–1986) and Keith Ward (American, 1906–2000), projected unfettered optimism. A 1954 article in *Life* magazine that lamented the mind-numbing content of these readers and their deleterious effects on student motivation prompted the editorial cartoonist Theodore Geisel (American, 1904–1991), a.k.a. Dr. Seuss, to produce *The Cat in the Hat* in 1957—an early reader that defied boredom with 236 distinct words, of which 221 are monosyllabic. The book revolutionized reading for young children. Geisel's wonky characters and surreal landscapes grace the pages of over thirty subsequent titles, including *One Fish, Two Fish, Red Fish, Blue Fish* (1960). *The Cat in the Hat* spawned an industry of early readers, dubbed "easy readers" because of their short chapters, few words, and many pictures. Many more followed from various publishers including Syd Hoff's (American, 1912–2004) *Danny the Dinosaur* (1958), and Arnold Lobel's (American, 1933–1987) *Frog and Toad Are Friends* (1970) (Figure 25.15).

Early reader books also convey educational concepts tangibly, such as Dorothy Kunhardt's (American, 1901–1979) *Pat the Bunny* (1940), which uses tactile surfaces like fur or sandpaper to extend the reading experience. Inspired by tenets of the Bank Street College of Education, a progressive early-learning research body in New York, Kunhardt's experiential book provides interactivity and stimulates the senses. Because of production challenges, many publishers rejected the prototype until Simon & Schuster, the adventurous house of Little Golden Books fame, took it on; after more than seventy years, *Pat the Bunny* remains in print and has sold over six million copies.

Inspired by punching holes into a stack of papers, Eric Carle (American, b. 1929) created *The Very Hungry Caterpillar* (1969) to tell of a caterpillar's eventual metamorphosis into a butterfly (Figure 25.16). As the caterpillar eats its way through the book, it encounters opportunities for learning numbers, days of the week, and different kinds of fruit along the way. The book was initially printed in Japan because the die-cut pages and punched holes presented challenges for U.S. printers.

Controversy in Children's Publishing

Certain picture books published to date have become controversial over time, while others garnered opprobrium immediately. Jean de Brunhoff's (French, 1899–1937) *L'Histoire de Babar* (*The Story of Babar*, 1931) was an early success, but critics later challenged the book's propriety in the context of French colonization of Africa, and charged it with perpetrating racial stereotypes that promote a white Eurocentric worldview. Offending images have been replaced or removed in later editions. In contrast, William Pène du Bois's (American, 1916–1993) *Giant Otto* has been left unaltered since 1936. The story features a large yellow otterhound who, being too large for his small French town, is enlisted by the French Foreign Legion to use his size and strength to subdue "Arabs" in Africa (Figure 25.17). The story is also sympathetic to the French colonization of Africa, and although much beloved, it may be viewed, like *The Story of Babar*, as Eurocentric. *Giant Otto* has been described as a literary predecessor to Norman Bridwell's (American, 1928–2014) character Clifford (Scholastic Books, 1963), another oversized dog, although Clifford is quite uncontroversial.

Figure 25.15
Arnold Lobel, interior illustration, *Frog and Toad Are Friends*, 1970. Created as a series of four books, Lobel's story relied on only two main characters, Frog and Toad, rendered in soft graphite drawings. The regular, intimate placement of the pair in the near foreground complements the story of warm kinship, motivating young readers to learn to read in order to share in their friendship.

Illustration copyright © 1970 Arnold Lobel.

Figure 25.16
Eric Carle, interior spread, *The Very Hungry Caterpillar*, 1969. Reflecting his training in graphic design, Carle's signature paper collage technique makes a bold, colorful, and immediately engaging visual statement.

From *The Very Hungry Caterpillar* by Eric Carle, copyright © 1969, 1987 by Eric Carle. Used by permission of Philomel, an imprint of Penguin Young Readers Group, a division of Penguin Random House LLC.

Figure 25.17
William Pène du Bois, cover (front and back), *Giant Otto*, 1936. Pène du Bois uses clear lines and broad washes of color that give the images a charming style. The compositions use scale to emphasize Otto's unusual size.

Image courtesy of The Eric Carle Museum.

Other children's books have become embroiled in political issues. Robert Lawson's *The Story of Ferdinand* (1936) recounts a young bull—a bullied outsider—that would rather smell flowers than fight in the bullring. Published before the outbreak of the Spanish Civil War, it became a political flashpoint, detested by authoritarian regimes for its apparent message of pacifism (Figure 25.18). Banned in Spain by dictator Francisco Franco and by the Nazi Party, influential political and literary luminaries such as Franklin Delano Roosevelt, Thomas Mann, and H. G. Wells immediately came to its defense.

As the American Civil Rights movement was gaining momentum in the United States, Garth Williams's *The Rabbits' Wedding* (1958), a picture book aimed at children three to seven years old, quickly drew ire in Alabama where the book was politicized for its purported themes of racial integration and interracial marriage. In response, Williams asserted that he had used black and white rabbits merely for "picturesque" purposes.

Also in 1964, Shel Silverstein (American, 1930–1999) wrote and illustrated *The Giving Tree*, the fictional recounting of a little boy's life through his friendship with a female apple tree that was subsequently posited as exploitation. Illustrated in spare, elegant line drawings that harmoniously accompany Silverstein's poetry, the book has stimulated wide interpretation from Biblical charity and parent-child nurturing, to misogyny and sexism. Silverstein's professional activity as a cartoonist for *Playboy* and his adult-oriented satirical alphabet *Uncle Shelby's ABZ Book* (1961) generated consternation about his suitability as an author-illustrator for children. He defied the skeptics and created a series of books

beloved by generations of readers young and old. Similarly, illustrator Tomi Ungerer (French, b. 1931) was forced to retreat from children's book publishing in the United States in 1974 because of the erotic adult titles he contemporaneously published. His popular *Mellops* series first appeared in 1957, with *The Mellops Strike Oil* (1958) considered too dangerous for children when Mrs. Mellops nearly burns to death in an oil fire.

The Caldecott committee, whose judges change annually, often selects books destined for controversy such as Sendak's *In the Night Kitchen* (1970), a visually complex story of a child's surreal, nocturnal adventure (Figure 25.19). The book's bold approach has earned it constant inclusion on lists of most-challenged books; nevertheless, the American Library Association committee awarded it a Caldecott Honor in 1971. Sendak and Ungerer both worked with visionary editor Ursula Nordstrom. Friends with Ungerer as well as colleagues, Sendak considered Ungerer's courage and audacity an inspiration, especially for his book *Where the Wild Things Are*.

William Steig (American, 1907–2003) ruffled feathers based on presumed allusions to current events. In the story *Sylvester and the Magic Pebble* (1969), Sylvester the donkey-protagonist wishes to be turned into a stone to escape a predatory lion (Figure 25.20). His distraught parents go to the police, who Steig depicted as pigs. In another era, this might have been innocuous anthropomorphism, but in 1969, following divisive anti-Vietnam protests and police brutality at the 1968 Democratic National Convention, the label "pigs" became disparaging slang for police. Steig claimed not to have cast his porcine police as critique but exulted that the controversy significantly augmented sales.

He is very happy.

Figure 25.18
Robert Lawson, interior illustration, *The Story of Ferdinand* by Munro Leaf, 1936.
Lawson's elegant black-and-white line art balances bold shapes and selected details against carefully designed white spaces that are suggestive of the protagonist's size and nature.

Figure 25.19
Maurice Sendak, interior illustration, *In the Night Kitchen*, 1970.
An homage to Winsor McCay's *Little Nemo in Slumberland* (see Chapter 23), Sendak's *In the Night Kitchen* drew controversy because the main character is nude in about five panels of the story.

They went to the police. The police could not find their child.

Figure 25.20
William Steig, interior illustration, *Sylvester and the Magic Pebble*, 1969.
In this story of interspecies struggle, Steig did not consciously align characters with contemporary groups, but audiences nevertheless interpreted the pigs as a political statement alluding to police violence.

Figure 25.21
Gerald McDermott, interior illustration, *Arrow to the Sun*, 1974.
Considered an expert on mythology, McDermott drew on this knowledge and his experience in filmmaking to create dramatic page spreads using bold color palettes. His writing and illustrations relied on retelling tales and myths from Brazil, the Congo, Egypt, Ghana, India, Ireland, Japan, Mexico, and the Pacific Northwest.

Towards Inclusivity in U.S. Publishing

Racial insensitivity and stereotyping in children's books have been long established with examples like Joel Chandler Harris's (American, 1848–1908) *Uncle Remus* stories (1870–1910); Helen Bannerman's (Scottish, 1862–1946) *The Story of Little Black Sambo* (1899); and Jean de Brunhoff's *The Story of Babar* (1931). The self-conscious quest for more culturally diverse books in the United States harkens back to the 1920s when Holling C. Holling's (American, 1900–1973) *Little Big Bye and Bye* (1926) sparked interest in Native American cultures.

Gerald McDermott (American, 1941–2012) also championed the development of culturally diverse children's books throughout his life (Figure 25.21). Yet notwithstanding his extensive research and respect for the cultures about which he wrote, McDermott's Native-American–themed book met with controversy when residents of reservations throughout the Southwest questioned the authenticity of his retelling and his right to publish on a specific part of their culture at all (*see Chapter 8, Theme Box 15, "Cultural Appropriation"*).

A concerted effort to improve the visibility of underrepresented peoples continued with Ezra Jack Keats's (American, 1916–1983) *The Snowy Day* (1962), which depicts a young African American named Peter who shares the universal enchantment with the magic of snow (Figure 25.22). The book was revolutionary in the respectful depiction of its protagonist, yet Keats, who was white, came under fire for illustrating what he ostensibly did not know. Significantly, many members of the African American community came to his defense.

The success of *The Snowy Day* marked the emergence of an engaged African American readership and signaled to the publishing industry a need to expand its literary repertoire. In response to the emotionally charged controversy surrounding Keats's efforts, an important young voice emerged from within the African American community: John Steptoe (American, 1950–1989), who published *Stevie* (1969) when he was only nineteen. Set in his New York City neighborhood of Bedford-Stuyvesant,

Figure 25.22
Ezra Jack Keats, interior spread, *The Snowy Day*, 1962.
The Snowy Day coincided with the unfolding Civil Rights movement, predating the Civil Rights Act by two years. Keats had illustrated more than thirty books by other authors before he both wrote and illustrated it.

the story presents an urban experience through poignant imagery and dialect that provided urban African American children with a story about their neighborhoods told in their own terms. The 1970s also ushered in a growing interest in African and African American folklore. A pioneer was Ashley Bryan (American, b. 1923), whose *The Ox of Wonderful Horns and Other African Folktales* (1971) extrapolated sources from South Africa to Angola (Figure 25.23).

Much of Jerry Pinkney's (American, b. 1939) work is focused on African American themes, often created in conjunction with his wife, Gloria Jean Pinkney (American,

b. 1941), or Julius Lester (American, b. 1939). Controversial books like *Uncle Remus* were revisited in the 1980s and 1990s by Pinkney and Lester, presented in more sensitive and accessible language (Figure 25.24). These two also revived Helen Bannerman's notorious 1899 *The Story of Little Black Sambo*, retold as *Sam and the Tigers* (1996).

Although most collaborations were that of author and illustrator working separately, the husband and wife team of Leo Dillon (American, 1933–2012) and Diane Dillon (American, b. 1933) worked together on the same images. Their airbrush and watercolor illustrations range from stylized realism to more flat works that, like Bryan's illustrations, evoke African textile design and sculpture (Figure 25.25). Tom Feelings (American, 1933–2003), the first African American to win the Caldecott Honor Award, introduced young audiences to Swahili numbers and

Figure 25.23
Ashley Bryan, interior page, *The Ox of Wonderful Horns and Other African Folktales*, 1971. Resounding with the palette of African rock painting and textiles as well as the crisp planarity of African sculpture, Bryan uses a limited, earthy palette to create a powerfully expressive image.

Courtesy of The Ashley Bryan Center, © 2016, The Ashley Bryan Center.

Figure 25.24
Jerry Pinkney, interior page, *Uncle Remus and Tar Baby*, 1987.
In reinterpreting *Uncle Remus*, Pinkney pays homage to the superb illustrations by A. B. Frost for the 1895 edition, as he echoes the poses of the tar baby and Br'er Rabbit.

From *The Tales of Uncle Remus* by Julius Lester, illustrated by Jerry Pinkney. Illustrations copyright © 1987 by Jerry Pinkney. Used by permission of Dial Books for Young Readers, an imprint of Penguin Young Readers Group, a division of Penguin Random House LLC.

Figure 25.25
Leo and Diane Dillon, cover (front and back), *Why Mosquitoes Buzz in People's Ears*, 1975.
As a creative team, the Dillons considered themselves as one artist. Efforts by the Dillons, John Steptoe, Tom Feelings, and other trailblazers allowed a talented second generation of writers and illustrators specializing in African American topics to emerge in the late 1970s.

From *Why Mosquitoes Buzz in People's Ears* by Verna Aardema, pictures by Leo and Diane Dillon. Pictures copyright © 1975 by Leo and Diane Dillon. Used by permission of Dial Books for Young Readers, an imprint of Penguin Young Readers Group, a division of Penguin Random House LLC.

letters in *Moja Means One: Swahili Counting Book* (1971) and *Jambo Means Hello: Swahili Alphabet Book* (1974). Unquestionably, Feelings's most powerful and unsettling book was *The Middle Passage: White Ships/Black Cargo* (1995), which visualized the brutal, inhumane treatment of captured African peoples during their transport to America to become slaves (Figure 25.26).

Stories involving immigration to the United States are plentiful and varied. Allen Say (Japanese-born American, b. 1937) came to the United States at the age of sixteen after World War II, an experience he recounts in the book *The Boy of the Three-Year Nap* (1988). Illustrated in watercolor, it explores Say's multicultural heritage, having been born to

a Japanese-American mother and a Korean father who had been adopted by British parents and raised in Shanghai. His best-known book, *Grandfather's Journey*, recalls his grandfather's immigration and mirrors some of Say's own migrations (Figure 25.27).

In contrast, Ed Young (Chinese-born American, b. 1931) illustrated *Lon Po Po: A Red Riding Hood Story from China* (1989), a Chinese version of the original French tale, through the lens of his Chinese heritage. In this version, a mother leaves her three daughters for the night to visit their grandmother. Initially duped by a crafty wolf into thinking he is their grandmother, the three girls find a way to eventually kill the wolf (Figure 25.28).

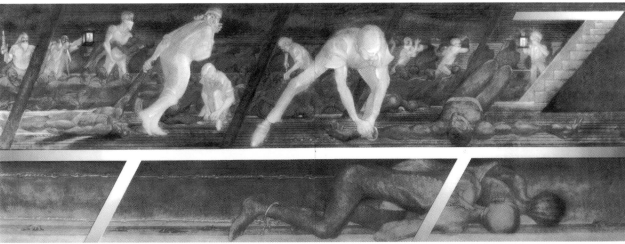

Figure 25.26
Tom Feelings, interior spread, *The Middle Passage: White Ships/Black Cargo*, 1995. The grayscale tempera and ink paintings of Feelings's powerful opus are stark reminders of this dreadful episode in history. Feelings imbues this scene with a claustrophobic compression and desperation that accentuates the grim brutality of the slave trade.

From The Middle Passage: White Ships Black Cargo by Tom Feelings, copyright © 1995 by Tom Feelings. Used by permission of Dial Books for Young Readers, an imprint of Penguin Young Readers Group, a division of Penguin Random House LLC, and by permission of The Tom Feelings Collection, LLC.

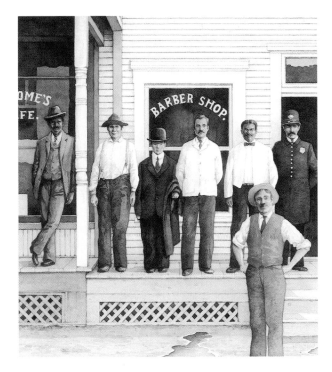

Figure 25.27
Allen Say, interior illustration, *Grandfather's Journey*, 1993.
In spare text and compositionally quiet watercolor images, Say recounts his grandfather's cyclical wanderlust and yearning for home throughout a life journey that takes him from Japan to North America and back again, a longing Say later experiences as an immigrant living in California.

Illustration from Grandfather's Journey by Allen Say, Copyright © 1993 by Allen Say. Reprinted by permission of Houghton Mifflin Harcourt Publishing Company. All rights reserved.

Figure 25.28
Ed Young, interior page, *Lon Po Po: A Red Riding Hood Story from China*, 1989. Young's bold, lucid page designs convey a clarity and harmony of arrangement through cut-paper collage, loose vaporous washes, and chalky pastels that recall the asymmetry and open spaces found in Chinese screen painting.

From Lon Po Po by Ed Young, copyright © 1989 by Ed Young. Used by permission of Philomel, an imprint of Penguin Young Readers Group, a division of Penguin Random House LLC.

Hispano-centric themes were treated as early as the 1930s and 1940s with Leo Politi's (American, 1908–1996) *Little Pancho* (1938), *Pedro, the Angel of Olivera Street* (1946), and *Song of the Swallows* (1950), but few illustrated books of merit appeared in the subsequent decades. Latino culture began to attract more attention from the publishing industry in the 1980s and 1990s with narratives by Lulu Delacre (American, b. 1957) and Raúl Colón (American, b. 1952). Delacre grew up in San Juan, Puerto Rico, and trained at the École supérieure d'arts graphiques in Paris. In 1989, she published *Arroz con Leche: Popular Songs and Rhymes from Latin America*, which was the first of her several bilingual books, including the award-winning *The Bossy Gallito El Gallo de Bodas: A Traditional Cuban Folktale* (1994, Figure 25.29). Colón also grew up in (Caguas) Puerto Rico, but his early efforts did not reflect Latino culture until he illustrated Pat Mora's (American, b. 1942) *Tomás and the Library Lady* (1997), which is based on the real-life success story of Tomás Rivera, the son of a migrant worker who becomes Chancellor of the University of California at Riverside (Figure 25.30).

In addition to culturally diverse subjects in the 1980s, previously taboo subjects such as sexual orientation gained visibility. Despite often meeting resistance, gay-themed novels were prevalent by the time Diana Souza's (American), *Heather Has Two Mommies* (originally self-published in 1989) appeared. Her black-and-white interior illustrations are innocuous; nonetheless, libraries banned it and protesters pilfered it from public libraries because it portrayed same-sex parenting positively. Michael Willhoite's (American, b. 1946) *Daddy's Roommate* (1991) likewise met with vigorous opposition.

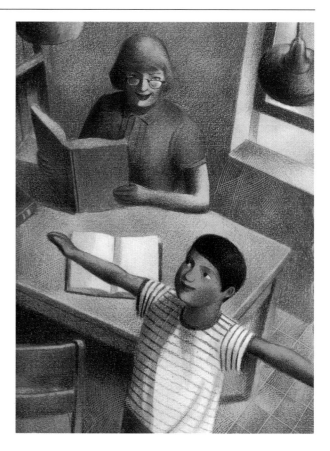

Figure 25.30
Raúl Colón, interior page, *Tomás and the Library Lady*, 1997. Colón's wonderfully soft-focus renderings are redolent of Mexican muralists Alfred Ramos Martinez (1871–1946) or Diego Rivera (1886–1957) (*see Chapter 7*). His images are noted for the use of an etching tool to create parallel line textures in the colored pencil tones.

Figure 25.29
Lulu Delacre, interior spread, *The Bossy Gallito El Gallo de Bodas: A Traditional Cuban Folktale*, 1994. Delacre infuses her illustrations with bold colors and rich detail that capture the vitality of an open-air market. The book contains a glossary of Spanish words and information on the birds in the story.

Transcending Suppression

Farshid Mesghali (Iranian, b. 1943), who began his career as an animator, graphic designer, and illustrator, worked throughout most of the 1970s in Iran under the patronage of Tehran's Center for the Intellectual Development of Children and Young Adults (CIDCYA), where he created films, posters, and children's books. Using layered relief prints, he illustrated *The Little Black Fish* (1968), a story about sacrifice and the yearning for freedom written by Samad Behrangi, a leftist Iranian author who died the year the book was published. Subsequently, the book was used to propel leftist ideals in a struggle against the country's reigning dictatorship. Mesghali left Tehran for Paris in 1980 soon after the Islamic Revolution of 1979, when religious fundamentalists took power. Mesghali's bold, playful block print images create a visual connection to folkloric and mythical narratives that embodied coded messages during the politically repressive 1970s. The book was translated into English in 1971.

In Eastern Europe, Jirí Trnka (Czech, 1912–1969) worked as a puppet-maker and puppeteer for animated films, earning the moniker of "Walt Disney of the East." Many of his children's books have been published in English, including *Brouči* (*Fireflies*, 1970), a now-classic Czech tale from the early 1870s. Like Mesghali, Trnka

too worked under authoritarian rule. From 1948 onward, when the Soviet Communist Party governed Czechoslovakia, folk tales were tolerated as long as they didn't disrupt the "party line." Using collage-like watercolors reminiscent of Odilon Redon's (French, 1840–1916) Symbolist pastel works of the previous century, Trnka's dream-like illustrated fairytales were found acceptable, and his subtle "messages" passed unnoticed by the Communist Party censors. This continued until the "Prague Spring" in 1968 when political liberalization in the country made room for broader forms of artistic and literary work to be created.

Postmodernist Influences and Experiential Books

In the later twentieth century, Postmodernism was making its presence felt in children's publishing as it was in fine art. Nonlinear or ambiguous approaches to the form of the book, and the construct of the viewer/book relationship were explored. Many scholars count Pat Hutchins's (British, b. 1942) *Rosie's Walk* (1968) among the earliest examples of a postmodern picture book, in which unorthodox placement of image and text makes it difficult to determine who the real protagonist is, challenging the norms of a linear, controlled reading. The layout of David Macaulay's (British-born American, b. 1946) *Black and White* (1990) also allows the images to be read and reread in a discontinuous manner, assuring that the book will be experienced differently every time (Figure 25.31).

Another book challenging convention is Jon Scieszka's (American, b. 1954) *The Stinky Cheese Man and Other Fairly Stupid Tales* (1992), illustrated by Lane

Smith (American, b. 1959). Visually, the book is a riot of distortion and cascading mismatched typefaces that reinforce the equally ludicrous text, keeping the reader off balance (Figure 25.32). Although the critical reviews were decidedly mixed, it still garnered a Caldecott Honor—a Committee choice that anticipated the book's success as a seminal model that shattered the status quo.

Figure 25.31
David Macaulay, interior spread, *Black and White*, 1990.
This book is an example of postmodern sensibility in that its illustrations may be read in any order, leaving the meaning of the book up to the reader.

Figure 25.32
Lane Smith, interior spread, *The Stinky Cheese Man and Other Fairly Stupid Tales*, 1992.
The book's innovative design by Molly Leach, Smith's wife, provides an unconventional framework for text and illustration that reflects the subversive impulse of Dada montages, as well as punk zines, television graphics, and alternative comics circulating in late-twentieth-century popular culture.

Theme Box 47: Diversifying Recognition within Picture Book Illustration

by Whitney Sherman and Ashley Benham Yazdani

Highly respected awards honoring artistic quality and subject matter in children's illustration are conferred in a range of countries. In recent years, lack of diversity among award winners has attracted criticism, but the cause of this imbalance is difficult to pin down. The history of Caldecott medalists is particularly controversial. Excluding Caldecott Honor winners, over 60 percent of Caldecott medalists are male despite the fact that the children's illustration industry has a historically high percentage of female practitioners. By contrast, the gender balance of Newbery Award–winning authors historically skews in the opposite direction of the Caldecott, with over 60 percent of winners being female. However, the racial breakdown remains consistent between the two awards, with white authors and illustrators making up over 90 percent of all award winners.

Imbalances of gender, class, or race have potentially long-lasting implications in that some publishers, reviewers, librarians, readers, and educators may subconsciously favor the sort of illustrators who most commonly win awards. If this happens, the already dominant groups will create more books, further limiting diverse representation among picture book illustrators and the subject matter they depict.

The significance of receiving any of these awards cannot be overstated, with benefits to illustrators that include not just direct monetary gains but also numerous incidental benefits such as boosts in sales, greater exposure for their past works, the promise of future work, and increased demand for speaking engagements and school visits. The honor of these awards truly solidifies the recipient's place in the industry.

Selected awards are presented here chronologically according to their date of origin and grouped within similar award goals:

In the United States, the Association for Library Service to Children (ALSC), a branch of the American Library Association (ALA), operates as the governing body behind many celebrated awards for American children's illustration and literature. The longest-running award for excellence in children's literature, the **John Newbery Medal** (1922), has only been awarded to a picture book twice in its history.

The highest honor given specifically for American children's illustration is the **Caldecott Medal** (1938), named for nineteenth-century illustrator Randolph Caldecott. The Caldecott Medal is bestowed upon the most distinguished American children's picture book of the year. Since its inception, the Caldecott committee has also annually acknowledged a small selection of **Caldecott Honor Books**.

The Children's Book Council of Australia has developed the **Picture Book of the Year Awards** (1946), given for literary and artistic excellence in books for children eighteen years and under. The CBC also grants awards in Early Childhood, Young Readers, and Older Readers.

Additional awards were developed as interest in children's literature grew with the baby boom following World War II. Beginning in 1952, the International Board on Books for Young People (IBBY) has celebrated exceptional children's authors and illustrators through a biennial **IBBY Honour List**. Although Austria, Germany, the Netherlands, Norway, Sweden, and Switzerland participated from the outset, the inclusion of more member countries did not happen for several decades. Currently, each participating country contributes between one and three of its best children's publications.

While the aforementioned awards recognized new and upcoming work, the **Laura Ingalls Wilder Medal** (1954) began honoring individuals who made significant contributions to the field of children's literature over a period of years. This award's creation marked an important step in acknowledging artists' commitment to the field. Initially given out every five years, the Wilder Medal is now presented annually.

In 1955 in the United Kingdom, the Chartered Institute of Library and Information Professionals (CILIP) established the **Kate Greenaway Medal**. Its recipient is given the chance to donate £500 worth of books to a library of his or her choice. In recent years, CILIP has also been given the **Colin Mears Award**, a financial award funded by the bequest of Mears, a children's book collector.

In response to widespread social changes in the United States during the 1960s, new awards were established to cultivate diversity. Earliest of these is the **Coretta Scott King Award** (1969), given annually to African American writers and illustrators who demonstrate appreciation for African American heritage and cultural values, and celebrate our common humanity. **The Stonewall Book Award** (1971) is the first award given in recognition of books relating to the LGBTQ community, honoring both adult and youth literature. The most recent of awards to promote equity is the **Schneider Family Book Award** (2003), given annually to an author or illustrator for creating excellent youth and children's work that addresses disability.

The **Batchelder Award** (1968), promoting authors and illustrators of children's books originating in countries outside the United States, is named for former librarian and ALSC executive director Mildred Batchelder, who wished "to eliminate barriers to understanding between people of different cultures, races, nations, and languages." In Canada, the Children's Book Centre (CCBC) oversees awards spanning several genres of children's literature: the **Marilyn Baillie Picture Book Award** is presented to the most distinguished English-language picture book first published in Canada for children ages three to eight; and the Canadian Library Association's **Amelia Frances Howard-Gibbon Illustrator's Award** (1971), named

for a nineteenth-century Canadian teacher, is annually presented to the most distinguished illustrated book in the Canadian children's publishing industry. In the United Kingdom, children's books published within the UK market or created by illustrators living in the UK may receive the **Victoria & Albert Illustration Award** (1972), under the Book Illustration category.

With its close ties to the American children's publishing industry, the Society of Children's Book Writers and Illustrators (SCBWI) oversees the annual **Golden Kite Awards** (1973), with a category for Picture Book Illustration. The Golden Kite Award honors excellence in the field of English-language children's literature and is, significantly, the only children's literary award to be selected by a jury of peers.

During the 1980s, Canadian illustrators in particular saw a marked increase in awards for their work. The **Elizabeth Mrazik-Cleaver Canadian Picture Book Award** (1985), named in memory of the eponymous Canadian illustrator, is overseen annually by a small committee from the Canadian branch of IBBY, and is given for artistic merit in Canadian picture books. In 1987, the **Governor General's Literary Awards**, overseen by the Canada Council for the Arts, began recognizing the best English- and French-language books in seven categories. Administered by the Canadian Booksellers Association, and honoring literary works in thirteen categories, including Children's Picture Book of the Year, the highly regarded **Libris Award** is annually awarded to the greatest works of Canadian literature.

Few awards are specifically for illustration students, but in the United Kingdom, the **Macmillan Prize for Illustration** (1985) offers both a financial reward and the chance of being discovered. Illustrators just embarking on their published careers may be eligible for several awards. To support new African American voices in children's literature, the ALA established

the **John Steptoe New Talent Award** in 1995. This annual award goes to an African American author or illustrator who has been published fewer than three times (the recipient may win the award only once). For all illustrators just beginning their careers, the **Ezra Jack Keats Book Award** added a New Illustrator Award (2001) and began recognizing Honor Books in 2012. The **New Illustrator Award** is open to all illustrators who have been published fewer than three times.

As the twentieth century was closing, recognition of Latino voices within the children's book industry opened up. The **Pura Belpré Award** has honored outstanding Latino/Latina writers and illustrators since 1996. Named for the first Latina librarian at the New York Public Library, this award is cosponsored by the ALSC and REFORMA, the National Association to Promote Library and Information Services to Latinos and the Spanish-Speaking (also a division of the ALA). Several Honor Books are recognized, and two Pura Belpré awards are given annually to work that best portrays and celebrates Latino cultural experiences.

To further recognize nonfiction contributions to children's literature in English, the ALSC established the **Robert F. Sibert Informational Book Medal** in 2001, awarded annually for the best nonfiction informational book in the United States.

Established by the Swedish government in 2002 and administered by the Swedish Arts Council in the name of their country's most beloved children's author, the **Astrid Lindgren Memorial Award** bestows a gift of five million Swedish krona on the recipient. The award can go to an author or illustrator, literary critic, scholar, or librarian. A quick scan of the winners shows the committee has historically recognized individuals and groups around the globe, with balanced distribution to genders. In contrast, two awards focusing on works produced in the United States have to date awarded to more white men than any other group working

in the field: the New York **Society of Illustrators Lifetime Achievement Award** (2005), which grants two awards annually, one posthumously and one to a living illustrator; and the **Geisel Award** (2006), named in memory of Theodore Geisel, a.k.a. Dr. Seuss, which is presented annually to the most distinguished early reader book.

Among the many awards the ALA has established, it also oversees the aforementioned Coretta Scott King award and the **Virginia Hamilton Award for Lifetime Achievement** (2010). Conferred annually, this award alternately honors an African American author, illustrator, or author-illustrator for lifetime contributions to the field of children's literature, or recognizes an African American individual for significant youth involvement through reading programs and community engagement utilizing celebrated African American children's literature.

The **On-The-Verge Emerging Voices Awards** (2012) are given to two unpublished recipients (either writers or illustrators) from "traditionally underrepresented ethnic and/or cultural backgrounds in children's literature in America" that help to launch the recipient into the picture book field by providing him or her with industry exposure, professional manuscript consultation, and publicity.

Until recently, authors and illustrators had mainly been recognized for commercially printed books. The ability to print on demand created need for a new category of awards recognizing individuals who self-publish. A bevy of new awards includes the **Spark Award** (2013) for outstanding nontraditionally published works; the **Purple Dragonfly Awards** (2010) specifically for children's literature; the **Royal Dragonfly Awards** (2011) recognizing self-published work in several genres; and the **Independent Publisher Book Awards** (IPPY) (1996) for university, small-press, and self-publishers in several categories, including children's literature.

Quite distinct from David Macaulay's postmodernist book design for *Black and White* are his architectural titles that delve into the mechanics of his subject matter with great visual detail. Beginning with *Cathedral* (1973) (Figure 25.33) through *Pyramid* (1975) and *Castle* (1977) to *Mosque* (2003), Macaulay's writing and complex line images demystify the world of architecture for the young and not-so-young reader. *The Way Things Work* (1988) and *The Way We Work* (2008) reflect a fascination with explaining technical processes, whether mechanical or human. In the latter effort, Macaulay explores the human body through the metaphor of architecture, describing body parts and systems from mechanical and organic perspectives.

Conclusion

Despite the economic and political changes during the period of 1920 to 2000, the picture books covered in this chapter have stood the test of time, due in great measure to their adaptation to and anticipation of changing mores and perspectives, their exceptional beauty, and the enduring relevance of their subject matter. Innovative formats such as Eric Carle's *The Very Hungry Caterpillar* or Dorothy Kunhardt's *Pat the Bunny* pushed contemporary production limits, while others such as Robert McCloskey's *Make Way for Ducklings* succeeded despite limited printing resources. Classic tales originally containing racial biases were revised, such as Jerry Pinkney's version of *Uncle Remus*; while others such as Ed Young's book *Lon Po Po: A Red Riding Hood Story from China* were updated through the illustrator's cultural lens. Importantly, in a period of great social change and shifting demographics, previously marginalized segments of society were finally better represented in mainstream publishing with titles such as Holling C. Holling's *Little Big Bye and Bye*, John Steptoe's *Stevie*, and Lulu Delacre's, *The Bossy Gallito El Gallo de Bodas: A Traditional Cuban Folktale*. Further, postmodern aesthetics of picture books such as David Macaulay's *Black and White* or Lane Smith's illustrations for *The Stinky Cheese Man and Other Fairly Stupid Tales* defy the status quo. As a result, the field of children's picture books enjoys greater breadth of expression and attention as a robust and meaningful area of contemporary publishing.

FURTHER READING

Bader, Barbara, *American Picturebooks from Noah's Ark to the Beast Within* (New York: Macmillan Publishing Co., 1976).

Baines, Phil, *Puffin by Design: 70 Years of Imagination* (London: Allen Lane, 2010).

Cummins, Julie (Ed.), *Children's Book Illustration and Design* (New York: Library of Applied Design, 1992).

———, *Children's Book Illustration and Design*, vol. 2 (New York: Library of Applied Design, 1992).

Evans, Dilys, *Show and Tell: Exploring the Fine Art of Children's Book Illustration* (San Francisco: Chronicle Books, 2008).

Hearn, Michael Patrick et al., *Myth, Magic, and Mystery: One Hundred Years of American Children's Book Illustration* (Boulder, CO: Roberts Rinehart Publishers, 1996).

Heller, Steven, and Marshall Arisman (Eds.), *The Education of an Illustrator* (New York: Allworth Press, 2000).

Kirk, Connie Ann, *Companion to American Children's Picture Books* (Westport, CT: Greenwood Press, 2005).

Klemin, Diane, *The Illustrated Book: Its Art and Craft* (New York: Clarkson N. Potter, 1970).

Marantz, Kenneth, and Sylvia Marantz (Eds.), *The Art of Children's Picture Books: A Selective Reference Guide* (Florence, KY: Taylor and Francis, 1988).

———, *Creating Picture Books: Interviews with Editors, Art Directors, Reviewers, Professors, Librarians, and Showcasers* (Jefferson, NC: McFarland & Co., Inc., 1998).

———, *Multicultural Picture Books: Art for Illuminating Our World*, 2nd ed. (Lanham, MD: Scarecrow Press, 2005).

Marcus, Leonard S., *Ways of Telling: Conversations on the Art of the Picture Book* (New York: Dutton Children's Books, 2002).

Nikolajeva, Maria, and Carole Scott, *How Picturebooks Work* (London: Routledge, 2000).

Nodelman, Perry, *Words About Pictures: The Narrative Art of Children's Picture Books* (Athens, GA: University of Georgia Press, 1990).

Salisbury, Martin, and Morag Styles, *Children's Picturebooks: The Art of Visual Storytelling* (London: Laurence King Publishing Ltd., 2012).

Shulevitz, Uri, *Writing with Pictures: How to Write and Illustrate Children's Books* (New York: Watson-Guptill Publications, 1985).

Sipe, Lawrence R., and Sylvia Pantaleo, *Postmodern Picturebooks: Play, Parody, and Self-Referentiality* (Florence, KY: Taylor & Francis, 2008).

Spaulding, Amy E., *The Page as a Stage Set: Storyboard Picture Books* (Lanham, MD: Scarecrow Press, 1995).

Whalley, Joyce I., and Tessa R. Chester, *A History of Children's Book Illustration* (London: John Murray, Ltd., 1997).

Figure 25.33 David Macaulay, interior page, *Cathedral*, 1973. Macaulay's informative illustrations engage young audiences with dramatic vantage points skillfully rendered in extreme detail.

26

**Countercultures:
Underground
Comix, Rock Posters,
and Protest Art,
1960–1990**

R.W. Lovejoy

The 1960s witnessed cultural and political events that fundamentally changed American life: the August 1963 March on Washington and resulting Civil Rights Act of 1964; the Black Power movement and the Voting Rights Act of 1965; and the assassinations of President John F. Kennedy and Dr. Martin Luther King, Jr., which rocked previously held assumptions of social constructs and stirred repressed hatred in the nation. The 1963 publication of Betty Friedan's revolutionary feminist book *The Feminine Mystique* questioned the primacy of motherhood over career, while the introduction of "The Pill" offered women unprecedented contraceptive control, a key to changing women's economic role. Dissent over the Vietnam War prompted sit-ins and peaceful demonstrations all over the country—some violently attacked by police.

It was the heyday of experimentation, bringing **Pop Art** (which turned popular culture themes and products of mass culture into ironic gallery art objects while satirizing commercial art) (Figure 26.1); new wave film and psychedelic music; and the emergence of **underground comix** (independent comic strips and books that originated with the alternative press), a movement that redefined the comics medium. Filled with events both devastating and progressive, this period shook political and cultural foundations in the United States and elsewhere, inspiring the search for an alternative culture founded upon egalitarian values, civil rights, and peace.

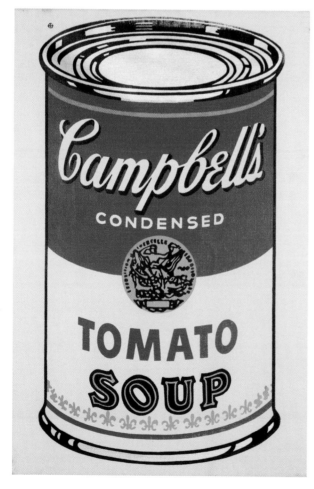

Figure 26.1
Andy Warhol, *Campbell's Soup Can (Tomato)*, 1965. Synthetic polymer paint and silkscreen ink on canvas, 36 × 24". Warhol, who won many awards throughout the 1950s for his illustration, typically used printmaking techniques to picture products in multiples. He then used this strategy of repeating images to critique mass production and consumerism in what was soon dubbed Pop Art. Here, his hand-made screenprint of the iconic soup can resembles billboard or poster advertising art—but it was intended for gallery display instead.

Image and artwork © 2018 Andy Warhol Foundation for the Visual Arts, Inc. Licensed by Artists Rights Society.

Alternative Press

The "hippie" culture, most associated today with the political and social movements of the 1960s, was an outgrowth of the subculture of politically left-leaning poets, writers, jazz musicians, and other nonconformists that formed the Beat Generation, stereotypically called "beatniks." The political roots of countercultures are also located in the Civil Rights movement and anti–Cold War protests of the 1950s that later coalesced around the peace movements of the 1960s and '70s in protest of the U.S. military presence in Vietnam. These movements were connected and fueled by the **alternative press**—independent publishers who sought to provide journalism and information neglected by large media corporations. The accessibility of print technologies—offset printing, automated typesetting machines, and rub-down transfer display lettering such as **Letraset** used in paste-up mechanicals (camera-ready art and text assembled on a white board in preparation for photographic transfer to a printing matrix)—combined with the relatively cheap cost of newsprint and postage meant that for a few hundred dollars, anyone could become a publisher. These resources, relatively easy for untrained individuals to learn, allowed novice publishers to experiment with the visual style of their publications. Distribution networks were arranged through music stores and drug paraphernalia shops, called "head shops," that catered to a young audience and helped the counterculture networks collectively called "the underground" to flourish.

As increasing numbers of people became politically active, the alternative press reports on politics became vital lines of communication and engaged readers who empathized with counterculture activities, even if they were not activists themselves. Soon many major cities had thriving underground newspapers. Although readership was small compared to mainstream newspapers, the alternative press gained a devoted audience, often supported by sales and by advertisers seeking to reach the growing youth audience. The *Berkeley Barb* had a circulation of approximately 20,000 in 1967, and the *Los Angeles Free Press*, at its height, had a readership of 95,000. Smaller alternative papers' circulations ranged between 1,000 and 10,000. However small the numbers appeared, these newspapers were often kept and shared, thus reaching an audience much larger than the circulation figures.

Initially, alternative newspapers focused on local stories and community events and were largely published in isolation from one another. In 1966, one of *The East Village Other (EVO)*'s founders, Walter Bowart (American, 1939–2007), along with Alan Katzman and John Wilcox, brought together twenty-five underground papers in the Underground Press Syndicate (UPS). In 1967, other leftist news and feature distributors such as the Liberation News Service (LNS) emerged. These alternative news agencies enabled publishers to share news stories, columns, comics, photographs, and other resources, thus economically printing more and better content and cultivating larger audiences. The newspapers were disseminated through record shops, independent bookstores, head shops, and by

local street vendors. Communities found their experience and interests reflected in the art and articles, creating a shared sense of cultural identity that linked local expression to national movements (Figure 26.2).

Psychedelic Posters

Blues, folk, and jazz formed the basis for the emerging musical forms of rock 'n roll and bebop, respectively—the new choice for young audiences of the 1950s. Typical early blues or jazz concert posters were dominated by the names of the musicians in plain text with headshots and decorative elements such as musical notes or stars, designs that rarely reflected the emotions of the music. This trend changed in the 1960s with psychedelic rock concerts and the emergence of San Francisco as its epicenter. Posters became less explicit in their message and more conceptual in their approach, embracing experimental graphics that visualized the immersive experience of hallucinogenic drugs.

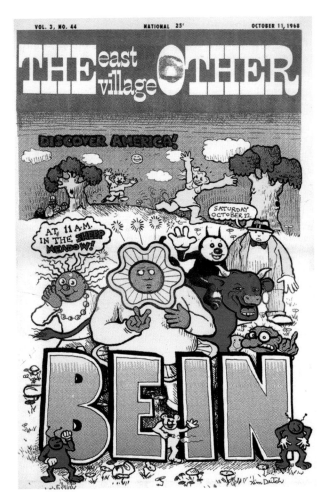

Figure 26.2
Kim Deitch, cover, *East Village Other*, October 11, 1968.
Counterculture newspapers like *The East Village Other* (*EVO*) published the early work of many underground cartoonists, including Robert Crumb, Kim Deitch, and Trina Robbins. Underground newspaper designs ranged from visually elaborate to plain text. Experimentation with layout and gradient color techniques sometimes made the stories illegible, but this freedom of design and lack of professional polish signified the noncommercial values of the counterculture. This cover by *EVO* staff artist Kim Deitch includes his signature characters Sunshine Girl and Waldo the Cat.

Image: Fantagraphics, © Kim Deitch. Courtesy of Fantagraphics (fantagraphics.com).

Music, drugs, long hair, flamboyant dress, light shows, and dance were combined for the first time at The Charlatans' 1965 concert, and promoted with a poster known as "The Seed," created by band members George Hunter (American, birth year unknown) and Michael Ferguson (American, 1942–1979). The poster is densely packed with loosely drawn portraits of the band members and hand-lettered band name and event information. The poster style influenced the creation of even more sophisticated use of hand-lettering and drawn images in visually stimulating yet increasingly complex compositions.

Soon experimental hand-drawn and photographically manipulated lettering, images, and color dominated poster designs. The performers' names and the venue became secondary to visual coding of the concert experience. "The posters looked like what we were playing," recalled Grateful Dead drummer Mickey Hart. "They were an open call to come and have fun . . . they didn't just announce the concert, they resonated with the style of the times." The trend toward a more conceptual approach to illustration was seen not just in music posters, but also in protest posters and later in underground comix.

Key among San Francisco psychedelic poster artists were **The Big Five**: Americans Victor Moscoso (b. 1936), Rick Griffin (1944–1991), Alton Kelley (1940–2008), Stanley Mouse (b. 1940), and Robert Wesley "Wes" Wilson (b. 1937). Moscoso studied at both Cooper Union and Yale and was one of the few formally trained San Francisco poster artists. He found that he had to rethink the function of his illustrations in order to produce effective psychedelic posters, stating, "[B]y reversing everything that I had learned . . . I got with the trip. Lettering should not be legible. A poster should not transmit its message easily

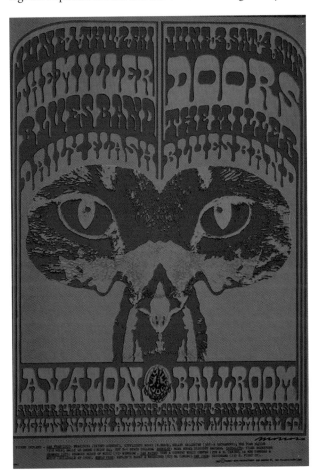

Figure 26.3
Victor Moscoso, poster, *The Doors, Steve Miller Blues Band, Avalon Ballroom*, 1967. By the mid-1960s, standard photographic portraits and naturalistic illustrations of rock musicians had been replaced by a more conceptual approach to promoting shows. The overlaying of photographic images, Victorian-era lettering, and vibrating color combinations reflected the musical experience.

and simply . . . Once I figured it out, then I was able to bring my schooling into it, and my vibrating colors. I could out-vibrate anyone" (Figure 26.3).

In another pioneering example by Wes Wilson, the title of *The Sound* dominates the poster and is linked to a sensuous female nude in the center through shared coloration (Figure 26.4). In the background, Wilson's swirling letterforms melt into sinuous shapes and are printed in optically vibrating color combinations that make legibility difficult.

While also functioning as advertisements, psychedelic posters were meant to be contemplated for their own sake—as a complement to the music and to capture the mind-expanding experience of LSD and marijuana, prevalent recreational drugs. The relative accessibility of screenprinting and general affordability of offset lithography provided poster illustrators and designers with the means to publish and promote themselves. Communities outside of California soon established their own clubs and ballrooms and hired local artists to create original posters in the psychedelic style as well. Typically distributed by hand to venues where tickets were sold, remaining posters were tacked up in neighborhoods where young music lovers might see them.

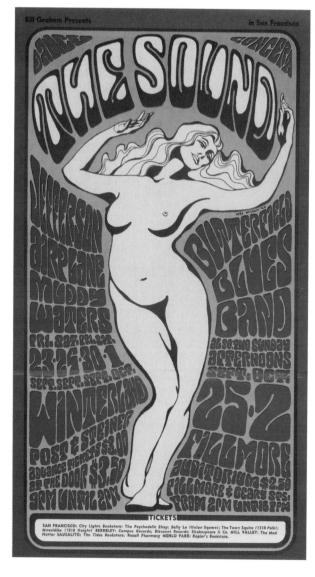

Figure 26.4
Robert Wesley "Wes" Wilson, poster, *The Sound*, published by Bill Graham Presents, San Francisco, 1966. Lithograph, 24 ¹/₂ × 13 ¹/₂". Barely legible lettering, expressive color, and imagery based on Art Nouveau precedents (*see Chapter 15*) convey the rapturous, hallucinogenic, mind-altering state of psychedelic concert audiences.

© 1966 Wes Wilson, Digital image ©2017 The Museum of Modern Art, New York/Scala, Florence.

Appropriation of Art Sources

The appropriation of images from fine and popular art sources was an important aspect of psychedelic poster art of the 1960s. Wes Wilson's radically experimental lettering was inspired by the work of Alfred Roller (Austrian, 1864–1935), a painter, designer, and poster artist associated with the **Vienna Secession** (an influential Austrian art and design group that was an offshoot of the Arts and Crafts movement). Likewise, Alton Kelley's and Stanley Mouse's design for the Grateful Dead's 1966 concert poster *Skull and Roses* appropriated a 1913 painting by illustrator Edmund J. Sullivan (English, 1869–1933), a look that eventually became synonymous with the band's visual aesthetic (Figure 26.5). Outside the psychedelic scene, contemporary Pop Art figures such as Andy Warhol, Roy Lichtenstein, and New York illustrators/designers associated with Push Pin Studios (*see Chapter 24*) also reinterpreted motifs from popular culture, comic books, or Art Nouveau designs.

By 1967, the innovations of psychedelic art had been incorporated into mainstream culture. Wes Wilson discovered to his chagrin that his groundbreaking work was little known in New York art circles, where illustrators such as Peter Max (American, b. 1937) adapted the style of The Big Five for mainstream advertising designed to appeal to the youth market.

Print and the Black Panther Party

The most influential radical African American artist of the counterculture was Emory Douglas (American, b. 1943), who worked for the alternative newspaper the *Black Panther Community News Service*, published by the Black Panther Party (BPP). Formed in 1966 by Bobby Seale and Huey Newton in Oakland, California, the BPP was a militant activist group that advocated black community resistance against repressive racist government tactics and sought equality for all ethnic minorities through concerted activism. In 1967, Emory Douglas became the Party's "Revolutionary Artist and Minister of Culture." Douglas shortened the Party newspaper's title to the *Black Panther* and emblazoned it with his distinctive panther logo.

Douglas moved production from mimeograph to offset press, giving the underground newspaper a professional look with two-color illustrations—usually simplified drawings with bold outlines and flat areas of color drawn with markers. Douglas also produced a full-page political cartoon for the back cover of each issue illustrating an aspect of the Panthers' ten-point program advocating community activism and armed resistance. One-third of the papers were sold in the Bay Area with an additional 10,000 to 20,000 printed and pasted-up as posters throughout Oakland; the rest were distributed throughout the United States.

Douglas's focus on empowered, militant black activists was revolutionary because it suggested violence and retribution to come (Figure 26.6), in contrast with media images of civil rights protests usually portraying peaceful demonstrators being victimized.

While the BPP's violent rhetoric brought publicity and some limited boosts in membership, it ultimately aggravated relations with police and the government, and was largely rejected by the community. By 1970, the BPP shifted its emphasis to community work such as clothing drives, free lunch programs, and medical services. Douglas's illustrations mirrored this change with posters featuring more modeled, expressive drawings in ink and graphite pencil (Figure 26.7).

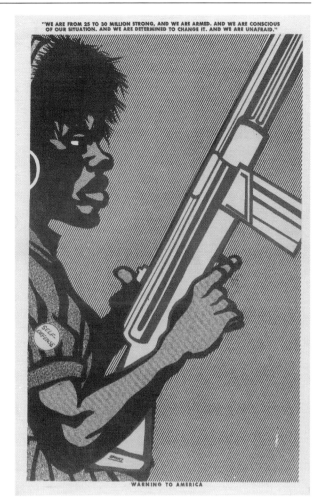

Figure 26.6
Emory Douglas, "Warning to America," the *Black Panther*, June 27, 1970.
Douglas's dynamically composed illustrations emphasized the active role of women as community leaders and fighters for justice, prepared to resist oppression.

© 2018 Emory Douglas/Artists Rights Society (ARS), New York.

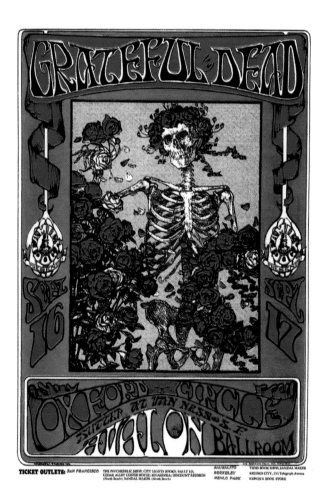

Figure 26.5
Alton Kelley and Stanley Mouse, poster, *Skull and Roses/Grateful Dead, Oxford Circle, Avalon Ballroom, San Francisco*, 1966.
Psychedelic poster artists found vintage illustrations offered powerful material from which to build representations of the new music and cultural scene. Kelley and Mouse appropriated a 1913 illustration and made it the central image of their Grateful Dead concert poster.

Artwork by Stanley Mouse and Alton Kelley. ©1966, 1984, 1994 Rhino Entertainment Company. Used with permission. All rights reserved.

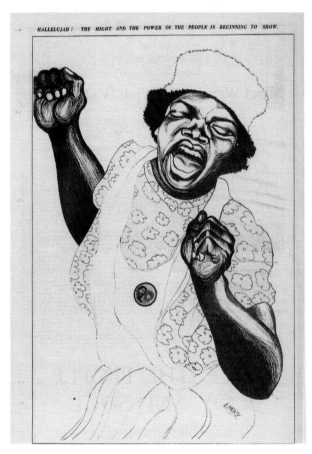

Figure 26.7
Emory Douglas, "Hallelujah—The Might and Power of the People is Beginning to Show," the *Black Panther*, May 29, 1971.
Finding that support for aggressive policies was weak, the Black Panther Party refocused its efforts on community social development. Posters were an important method of rallying collective action when infighting and pressure from government authorities threatened solidarity.

© 2018 Emory Douglas/Artists Rights Society (ARS), New York.

Theme Box 48: Butler: Gender and Queer Studies
by Pernille Holm

Looking at prescribed themes and stereotypes, in the 1970s art historians Griselda Pollock (b. 1949) and John Berger (1926–2017) (*see Chapter 9, Theme Box 17, "Ways of Seeing"*) began to shift the debate about gender from a focus on the identity of the artist to the gender biases and power structures embedded in visual communication and art. They showed how visual language implies, embodies, and reinforces assumptions about masculinity and femininity. As Berger argues, in visual culture, "Men act, women appear. Men look at women. Women watch themselves being looked at." Film theorist Laura Mulvey (English, b. 1941) elaborated on Berger's argument in the context of traditional cinema. She argued that in typical Hollywood films, men are the bearers of the look, whereas women are the spectacle. The male hero is typically active and instrumental in moving the story forward while the female character, cast as an object of desire, is often passive or disrupts the narrative flow as a distracting object. Furthermore, from the point of view of the camera lens, implicitly a heterosexual male's view, the actress is regarded in highly gendered and sexualized ways. Thereby, Mulvey argues, Hollywood cinema reflects and reinforces the ways in which pleasure in looking and the *power to look* have been assigned to what she calls the **male gaze** in patriarchal society. Many scholars since have analyzed other media such as pin-ups and medical imaging in terms of the male gaze.

The question of gender informs much feminist discourse on visual communication: how masculinity and femininity are conveyed, what power structures are embedded in visuals, and the significance of the practitioner's gender. Much debate has focused on female,

queer, and cross-gender identities, not to promote them above the male heterosexual identity, but to address areas of culture that have been systematically devalued so that heterosexual men could have an advantage. Feminist and queer discourses aim to redress the balance while unmasking the roots of sexism and challenging the reasons for discrimination.

Many artists and illustrators have challenged gender assumptions and explored the very question of what gender is, from widely varying points of view. In the 1970s, some entertained the idea that there are essential differences between men and women to be celebrated on equal terms. Such views were realized through an engagement with and articulation of women's identities and unique, often personal, female experiences. Hence, the possibility of specifically female visual language (in terms of subject matter and materials) was explored and in some cases adopted. Strands of female traditional culture were retrieved and reevaluated, and time-honored female craft materials were given a new consideration and status. Faith Ringgold's (American, b. 1930) use of quilts to illustrate African American stories stems from this recuperation (Figure TB48.1).

In the 1980s and '90s, women artists and art historians began to question the idea of an innate femininity and the notion that there are essential differences between men and women, partly because the claim that women are naturally and essentially different to men can easily backfire, rendering women "other" to the norm instead of equal.

American philosopher and gender theorist Judith Butler (b. 1956) greatly influenced some of these ideas. In her books *Gender Trouble* and *Bodies That Matter*, she argued that gender

is not an expression of a biologically determined sex but rather culturally and socially constructed through a set of stylized bodily acts that are repeated over time to the point that they seem "natural"—which makes them self-perpetuating and hard to challenge.

In effect, we perform "femininity" or "masculinity," and this performance is what itself creates gender. Butler does not perceive gender performance as a voluntary choice. On the contrary, she argues we are limited and regulated through various social pressures embedded in speech and manners, which predetermine what gendered identities are permitted and what stylized actions we may perform (for example, women's sports uniforms are more revealing than men's, and we are conditioned to accept a man who speaks assertively more than we are a woman). Coerced to perform these stylized acts, we give the impression of having a coherent and stable gendered identity while in fact we are only exhibiting the norms and conventions produced by social expectations. The key myths this perpetuates are that females are opposite to and lesser than males, and that heterosexuality is preferred.

Rather than trying to define "women" and "men" as fundamental binary opposites, Butler believes we should examine how power shapes our understanding of gender; and furthermore, that we should "free" gender and let it be flexible and multifaceted. Her ideas of identity as elastic, variable, and unbound are key principles in queer theory, the philosophical discourse that challenges the assumption that sexual orientation and gender are fixed.

Fine artists of the 1980s and '90s critically reexamined past and present images of women. In particular, the female body was

problematized: it was either removed from art altogether, stripped of its erotic connotations, or used in an accusatory or ironic manner. "Femininity" was rejected, exposed as an ideological construct designed to suppress women.

Meanwhile, third wave feminism began to challenge the didactic, cool, and unemotional art associated with this period. Instead of making critical works about the representation of women in patriarchal culture, they celebrated, enjoyed, and played with notions of femininity, cross-gender, and the sexed body in all its diversity. While artists recognized femininity as a cultural construct, they took it as one they could explore and play with in order to seduce both men and women. Irony and parody became key strategic devices. There was also an increased emphasis on personal and individual identity rather than on shared identity. Alternative views of gender are presented in *Girls Will Be Boys Will Be Girls: A Coloring Book* (2004). The authors chose this medium because they felt that humorous pictures were the most approachable way to communicate the issues.

For illustrators interested in putting gender on the agenda, there is a rich history on which to draw. Most importantly, there are no "innocent" ways of examining or representing gender. Whichever strategy is adopted, certain values and views will be expressed. The trick is to do it knowingly and with a mind open to the nuances at play.

Further Reading

Berger, John, *Ways of Seeing* (London: Penguin Books, 1972).

Butler, Judith, *Gender Trouble: Feminism and the Subversion of Identity* (New York: Routledge, 2015).

Butler, Judith, *Bodies That Matter: On the Discursive Limits of "Sex"* (New York: Routledge, 2011).

Mulvey, Laura, "Visual Pleasure and Narrative Cinema," *Screen*, vol. 16, no. 3, Autumn 1975: 6–18.

Pollock, Griselda, "Women, Art, and Art History: Gender and Feminist Analyses—Art History—Oxford Bibliographies—Obo." http://www.oxfordbibliographies.com/view/document/obo-9780199920105/obo-9780199920105-0034.xml.

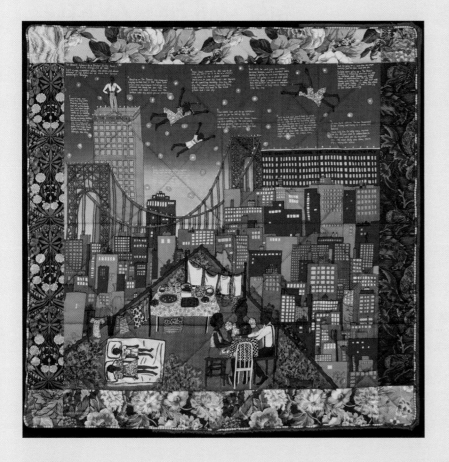

Figure TB48.1
Faith Ringgold, *Tar Beach 2*, Quilt, 1990. Multicolored screenprint on silk plain weave, printed cotton plain weave, black and green synthetic moire, 66 × 67".
The narrative of living in New York City that the quilt documents was developed into the Caldecott-honor-winning children's book *Tar Beach*.

Purchased with funds contributed by W. B. Dixon Stroud, 1992, Philadelphia Museum of Art, Object Number 1992–100–1. © 1990 Faith Ringgold.

Underground Comix

Comic books for adults was a contradiction in terms in the early 1960s. Newspaper comic strips might appeal to adult readers, but comic books were strictly kids' stuff and had been since the imposition of the Comics Code in 1954. By the 1960s, comic art in America was stagnating under its restrictions (*see Chapter 23*). It was therefore radical when underground comix, independent comic strips, and books that dealt with adult themes in a comic book format emerged with seeming disregard for the Comics Code or the popular marketplace. As independent, noncorporate publications, underground comix avoided the regulatory environment of standard distribution channels, and liberally dealt with topics like sex, violence, drugs, race, politics, mental health, and religion. Outrageous or taboo topics and adult themes within were signaled to readers by the spelling of *comics* with an *x* on covers (*comix*), to indicate the more adult, "X-rated" content.

Many underground cartoonists had been avid comics readers as children and enjoyed pre–Comics Code horror and science fiction titles, as well as Harvey Kurtzman's pioneering satirical periodical *MAD* (*see Chapter 23*). Early newspaper comic strips were another major influence, particularly Chester Gould's (American, 1900–1985) *Dick Tracy*, Harold Gray's (American, 1894–1968) *Little Orphan Annie*, and George Herriman's (American, 1880–1944) *Krazy Kat*. Several comix took root in fanzine and small press publications that paid little or no money because they offered freedom from censorship, which attracted many artists. "Hurricane" Nancy Kalish (American, b. 1941), Kim Deitch (American, b. 1944), and Manuel "Spain" Rodriguez (American, 1940–2012) were among the artists submitting comix to underground papers like *The East Village Other*. With *EVO* and other publications paying for comix, the work was profitable enough to help support the artists. However, it was the ability to explore adult themes in stand-alone comix books and the public's interest in reading in this format that fully established underground comix as a movement.

Creative Variety in Comix

The difference between underground and mainstream cartoonists was as much a matter of aesthetic sensibility as it was of subject matter. Underground cartoonist and comic historian Trina Robbins recalled, "Plot was not considered important . . . The underground artist, more concerned with design than content, simply put felt-tipped pen to paper and let it flow, man." Yet for some, political and social content remained paramount.

Underground comix flourished at a time when mainstream comic book plots were generic and publishers forced the creator to adopt a common "house style" and to specialize as writer, penciller, inker, letterer, or colorist. Underground cartoonists, by contrast, typically wrote, lettered, and illustrated their own stories with total editorial control. They embraced a wide range of formal aesthetics and ideologies with little stylistic or narrative similarity in underground comix as a whole.

The first wave of undergrounds included a wide range of subjects from Gilbert Shelton's (American, b. 1940) *Wonder Warthog*, a violent satire of superhero tropes; to ex-soldier Vaughn Bodé's (American, 1941–1975) *Das Kampf* (1963), a satire of the military; to Allen "A. Jay" J. Shapiro's (American, 1932–1987) *Harry Chess* (1966) (Figure 26.8), a comic that addressed homosexuality. Drawn in an appealing bold line, this lighthearted, pun-filled parody of the spy genre carried real political weight at a time when homosexuality was illegal and frequently prosecuted. Other taboo themes, including religious satires such as Frank Stack's (American, b. 1937) *The Adventures of Jesus* (1964) and Jack Jackson's (American, 1941–2006) *God Nose* (1964) appeared; as did Joel Beck's (American, 1943–1999) *Lenny of Laredo* (1965), a comic inspired by the life of controversial comedian Lenny Bruce. Many of these

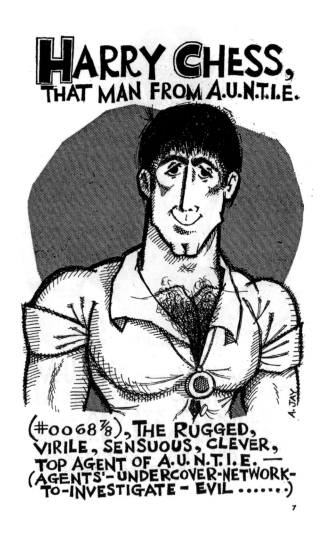

Figure 26.8

Allen "A. Jay" J. Shapiro, *Harry Chess: That Man from A.U.N.T.I.E.*, 1966. One of the first comics to feature a gay lead character, *Harry Chess* was initially published as a comic strip for the Philadelphia-based gay newspaper *Drum*. The comic parodied the popular television series *The Man from U.N.C.L.E.* (1964–1968). The strips were issued in a collected edition in 1966 just as the first wave of underground comix was being published.

artists were soon drawn to San Francisco's poster and music scene, where they helped establish that city as a center of underground publishing.

Before moving to San Francisco, Robert Crumb (American, b. 1943), a former illustrator for the American Greetings card company, had published cartoons in magazines and counterculture newspapers (Figure 26.9). Drawn with distinctive cross-hatching, using a **rapidograph** (a drafting pen that produces a uniform line thickness), Crumb's drawings stylistically recalled early American newspaper comic strips and animation of the 1920s and '30s. The exuberant familiarity of Crumb's style, however, was in startling contrast to his subject matter, which included satire, explicit sex and violence, and LSD-inspired visions. The 1967 publication of Robert Crumb's *Zap* signaled the maturation of the underground comix form and led to an avalanche of underground comix that included a stand-alone comix tabloid titled *Gothic Blimp Works* published in 1969 by the *EVO*.

Crumb's characters were based on types of people commonly found within the counterculture: the hip but hypocritical Fritz the Cat, the con man turned spiritual guru Mr. Natural, and hippie-turned-feminist Honeybunch Kominsky. Racial issues were addressed head on, as in the character of statuesque African Angelfood McSpade, a personification of female racial and sexual stereotypes; and Whiteman, the embodiment of white male repression and suppressed violence. Featured in *Zap's* first issue, Whiteman, a businessman confronted by the stresses of everyday life, struggles to maintain his upright façade, but anxiety reveals his sexual and violent fantasies (Figure 26.10).

The first two issues of *Zap* were solo efforts by Robert Crumb. By its third issue, Crumb transitioned *Zap* into an anthology owned collectively by the contributors who thereafter voted to invite additional cartoonists. Contributors included S. Clay Wilson (American, b. 1941), a pen-and-ink artist whose violent sex-fueled fantasies pushed the boundaries of acceptability, in a style redolent of Art Nouveau illustrator and author Aubrey Beardsley (*see Chapter 15*). Thereafter, perhaps inspired by Wilson's approach, Crumb's own style became

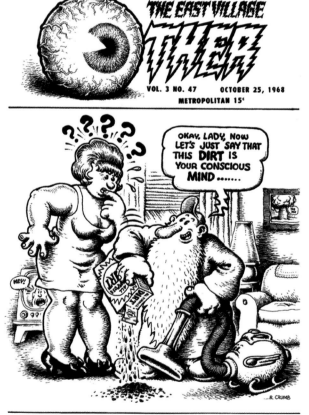

Figure 26.9
Robert Crumb, *East Village Other*, October 25, 1968.
Robert Crumb's Mr. Natural, part con man and part spiritual guru, uses commercial products to demonstrate a spiritual lesson. The underground paper the *East Village Other* was one of the first alternative papers to publish the cartoons of the first wave of underground cartoonists.
Copyright © Robert Crumb 1967, 1968, 1969. Collection of the author.

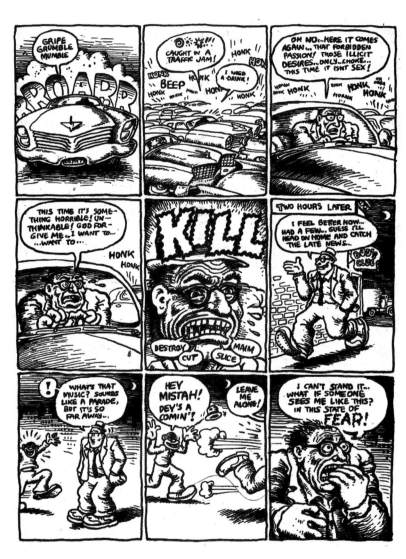

Figure 26.10
Robert Crumb, "Whiteman," *Zap* #1, 1967.
In his business suit and dark-rimmed glasses, Whiteman resembles mild-mannered Clark Kent, Superman's everyman persona. Whereas Clark Kent hides the hero within the everyday person, Crumb's average man reveals the suppressed feelings of lust and rage triggered by the workaday routine. Crumb's drawing style changes as Whiteman becomes increasingly grotesque, fighting "hidden desires" only through supreme effort of will or by drinking at the local bar.
Collection of the author. Copyright © Robert Crumb 1967, 1968, 1969.

darker and included stories that featured explicit violence (including the murder of Fritz the Cat) and sexual assaults on his female characters (Figure 26.11).

Chicago was the Midwestern headquarters of '60s counterculture. There, Jay Lynch (American, 1945–2017) and fellow cartoonist Skip Williamson (American, 1944–2017), inspired by Robert Crumb's *Zap*, started

their own anthology *Bijou Funnies* featuring, along with their own stories, the work of cartoonists Gilbert Shelton (American, b. 1940) and Art Spiegelman (American, b. 1948) (Figure 26.12).

Spiegelman embraced formal experimentation. For him, each story was a new challenge that required a different visual technique and style appropriate to

Figure 26.11
Robert Crumb, "Don't Touch Me!" *Snatch* #3, 1969. Influenced by the often-violent themes of underground cartoonist S. Clay Wilson, Robert Crumb's work began to explore darker subjects. Crumb uses sequential panels to create dramatic tension by zooming in on the rendered detail of the maniacal attacker in this example.

Collection of the author. Copyright © Robert Crumb 1967, 1968, 1969.

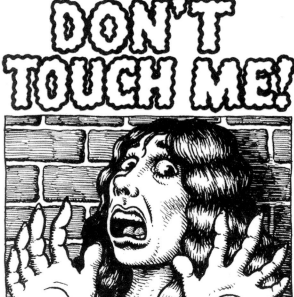

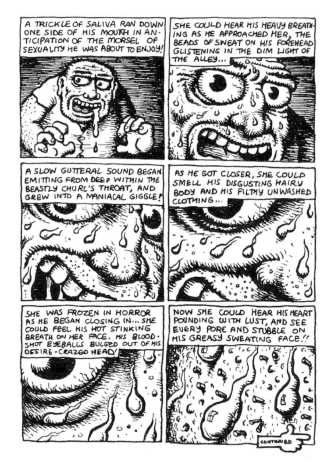

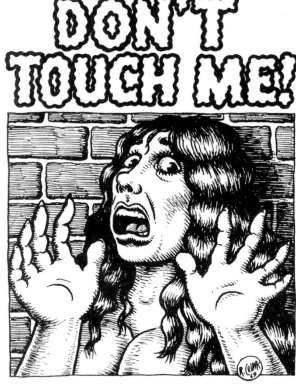

Figure 26.12
Jay Lynch, *The Best of Bijou Funnies*, 1975. The interaction between comic duo Nard—a bald-headed conservative human—and his hip, black, bohemian cat Pat resembled classic comedy duos like Mutt and Jeff, or Laurel and Hardy, albeit with plenty of sex and nudity to underscore its underground credentials.

Courtesy of Jay Lynch. © Jay Lynch.

its narrative: one story would call for scratchboard tools and brush, whereas another was better expressed with a rapidograph. In "Ace Hole, Midget Detective" (Figure 26.13), Spiegelman combines stylistic references to popular art, comics, film noir, pulp fiction art, and fine-art movements like Expressionism and Cubism, in a detective story that investigates the very nature of visual narrative.

Shelton's technique was more traditional. His pen-and-ink work was polished and expressively cartoonish, in stories with witty plots and punch lines that had both political impact and humor (Figure 26.14). Over time, his signature characters, The Fabulous Furry Freak Brothers, satirized and critiqued a range of different cultural trends from hippiedom and Punk Rock to religious fundamentalism, international terrorism, and globalization.

In 1969, Shelton, Jack Jackson, Fred Todd, and Dave Moriarty founded Rip Off Press, one of the most successful underground publishing groups to emerge from San Francisco—and eventually established the Rip Off Syndicate to distribute comic strips to college newspapers and alternative publications. Other major publishers of underground comix included Don and Alice Schenker's

the Print Mint, Ron Turner's Last Gasp, and Denis Kitchen's Milwaukee-based Krupp (later Kitchen Sink).

As many looked to Eastern religions and altered states as paths to enlightenment, some underground cartoonists turned to the power of visual narrative to explore spiritual themes. Barbara "Willy" Mendes' (American, b. 1948) comic narrative "Realm of Karma Comix" (Figure 26.15) depicts two anthropomorphic horses strategizing on how to achieve cosmic consciousness. In her work, Mendes symbolizes subjective reality and a hierarchy of spiritual forces as intricate designs that framed the more naturalistic elements of her stories. The splash page is partitioned by a series of arcs contained within a heavy decorative border whose circular oculi contain symmetrical medallions. The central image is a frontal example of **horror vacui**, a design space entirely filled with artistic detail; and is reminiscent of **metal cuts**, an engraving on metal, with its light-on-dark approach; while the lower narrative panels use linear perspective to spatially describe narratives. Although clothed in mystical ornamentation, the story is grounded in humor, with the animal protagonists concluding, "That karma is heavy stuff!"

Figure 26.14
Gilbert Shelton, *The Fabulous Furry Freak Brothers*, 1971.
Shelton's most famous characters, The Fabulous Furry Freak Brothers, were a burlesque of hippie culture whose adventures revolved around the eternal quest for drugs. Here, Shelton parodizes contemporary documentaries commonly shown to youth in schools that used scare tactics to dissuade drug use.
Collection of the author. Copyright ©1968, 2014 by Gilbert Shelton, used by permission.

Figure 26.13
Art Spiegelman, "Ace Hole, Midget Detective," *Short Order Comix* #1, 1974.
For this narrative, Spiegelman renders each character using a different tool to replicate styles related to each: a crowquill pen for the Picasso woman, rapidograph for Mr. Potato Head, and brush for Ace Hole (in the style of pulp art).

Collection of the author. Graphic Novel Excerpt from *Breakdowns: Portrait of the Artist as a Young %@&*!* by Art Spiegelman, copyright © 1972, 1973, 1974, 1975, 1976, 1977, 2005, 2006, 2007, and 2008 by Art Spiegelman. Used by permission of Pantheon Books, an imprint of the Knopf Doubleday Publishing Group, a division of Penguin Random House LLC. All rights reserved. Portrait of the Artist as a Young %@&*! by Art Spiegelman (Pantheon, 2008). Copyright © 1972, 1973, 1974, 1975, 1976, 1977, 2005, 2006, 2007 and 2008 by Art Spiegelman, used by permission of The Wylie Agency LLC.

Figure 26.15
Barbara "Willy" Mendes, "Realm of Karma Comix," *All Girl Thrills*, 1971.
Willy Mendes' comix explore the spiritual through illustrations influenced by her study of Eastern philosophy and Latin American art.
Collection of the author. © Barbara Mendes.

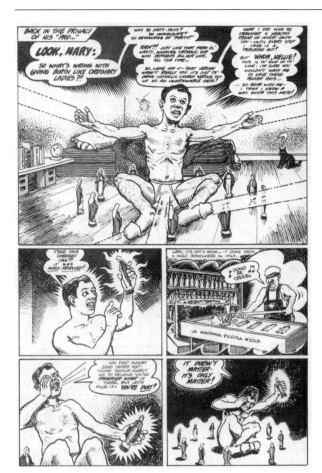

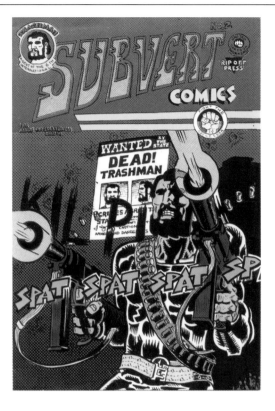

Figure 26.17
Manuel "Spain" Rodriguez, *Subvert Comics* #2, 1972.
Spain's revolutionary hero Trashman, who first appeared in 1968 in *The East Village Other*, engages in dynamic action sequences that show the influence of mainstream comic book artist Jack Kirby.

Image: Fantagraphics (fantagraphics.com). Copyright © Spain Rodriguez.

In the autobiographical *Binky Brown Meets the Holy Virgin Mary* (Figure 26.16), Justin Green (American, b. 1945) depicts a young protagonist's spiritual struggle to reconcile his sexual awakening with his religious beliefs. Green's bold line-drawing style with broad passages of dark and light, stream of consciousness narrative, and bawdy humor take us through Binky's fanatical attempts to remain pure of mind and body.

Manuel "Spain" Rodriguez was a working-class artist interested in socialist and revolutionary politics. Informed by his experience in a motorcycle gang, Spain's work often centered on the clash of violent forces. His long-running science fiction adventure series *Trashman: Agent of the 6th International* tells the story of a world ruled by vast corporations and the revolutionaries who fight them for liberty. Drawn in an aggressive bold line style similar to mainstream comics, Trashman was a decidedly blue-collar protagonist: a former auto mechanic turned armed and dangerous hero (Figure 26.17).

Kim Deitch, like Rodriguez, entered the underground through his illustrations for the *EVO*. By 1967, the two artists were earning $40 a week producing illustrations as well as paste-up and **layout** (arranging typeset words, images, lettering, line art, and so on,

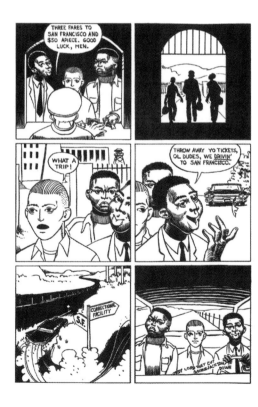

Figure 26.18
Guy Colwell, *Inner City Romances* #1, 1972.
Colwell trained as a realist painter and did not have a background in comics before publishing *Inner City Romances*. He combines black-and-white contour drawings with heavy hatching, using small sable brushes. Realistic narratives focusing on African Americans were so rare in American comics that it was often mistakenly assumed that Colwell himself was black.

Collection of the author. © Guy Colwell.

in a design) work for *EVO*—a meager living at a time when mainstream comic book artists were paid $40 to $60 per page. The drawing style and narratives of Kim Deitch, the son of cartoonist and animator Gene Deitch (American, b. 1924), refer to historical animation and magazine art. This can be seen in his character Waldo, a mischievous blue cat with the large round eyes and white gloves reminiscent of early animated characters such as Oswald the Rabbit (1927) and Felix the Cat (1923). Deitch's dense use of texture enlivens compositions jam-packed with smaller background figures and animated objects moving across the page (Figure 26.2).

Cartoonists and comics dealing with the experiences of marginalized social groups were nearly nonexistent. Among the exceptions was Guy Colwell's (American, b. 1945) (Figure 26.18) *Inner City Romances*, an underground comix that presented narratives about prison life (where Caldwell had spent two years for refusing to comply with the draft), urban culture, and revolutionary politics. Colwell tells a story of three ex-convicts (two black, one white) who must decide whether to return to drugs and crime or to become political activists once they leave prison.

Feminist Perspectives

Most of the first wave of underground cartoonists were white males. Nonwhite characters were generally stereotyped, and female characters were typically nude at some point in the story, regardless of the plot. Feminism interested the majority of male underground cartoonists only to the extent that it could be satirized, and for the most part, male cartoonists seemed unsympathetic to the movement. Little was published from a female perspective until the 1970s.

It Ain't Me Babe (1970) was the first all-women's underground comix in the United States. Trina Robbins (b. 1938), a regular contributor to *EVO* and numerous other underground papers, along with Mendes, produced the one-shot comic book featuring narratives with active female protagonists and feminist points of view. The cover by Robbins depicts classic female cartoon characters such as Little Lulu and Wonder Woman marching together as activists (Figure 26.19).

In 1972, Robbins and nine other female artists formed the Wimmen's Comix Collective. They published an eponymous anthology that was equally owned by the artists with rotating editorship to ensure that no one vision dominated the series. Their groundbreaking stories dealt with controversial social issues of particular importance to women, including "A Teenage Abortion" by Lora Fountain (issue #1); and other topics untouched by male cartoonists, such as menstruation, masturbation, lesbians, and feminists. "So, Ya Wanna Be an Artist" (from issue #2) by Lee Marrs offered practical advice to novice artists (Figure 26.20).

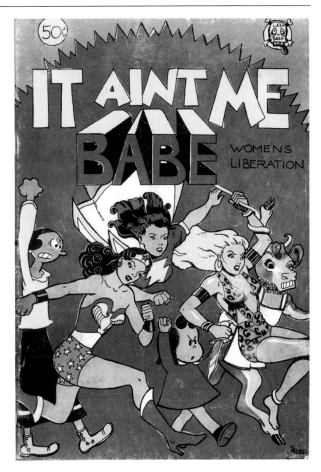

Figure 26.19
Trina Robbins, *It Ain't Me Babe*, 1970. Although female cartoonists had been published in underground newspapers as early as 1965, underground comix publishers, for all their progressive ideals, were reluctant to print the work of female artists. *It Ain't Me Babe* was the first all-female underground comix ever published. The cover features classic cartoon characters including Olive Oyl, Wonder Woman, and Little Lulu marching for women's liberation.

Collection of the author. © Trina Robbins.

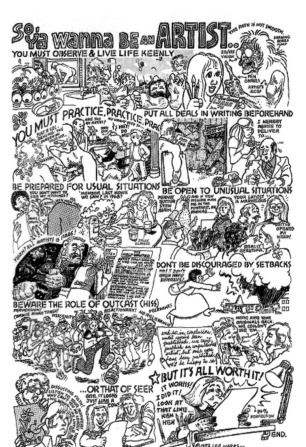

Figure 26.20
Lee Marrs, "So, Ya Wanna Be an Artist," *Wimmen's Comix* #2, 1973. Marrs had worked for mainstream publisher DC Comics and others, along with working in underground comix. Her didactic montage layout utilizes curving, tightly packed all-caps lettering to guide the reader through the realities of a woman becoming an artist.

Collection of the author. © Lee Marrs.

Like the *Wimmen's Comix* anthologies, *Tit's 'n' Clits*, a collection of stories by women edited by Joyce Farmer (American, b. 1938) and Lyn Chevely (who also worked under the pseudonyms "Chin Lyvely" and "Lyn Chevli") (American, 1931–2016) candidly explored neglected areas of women's experience, including birth control, sexuality, women's rights, and dialogue between the sexes and among women themselves. The title purposely challenged the sex-laden and often misogynist underground comix produced by S. Clay Wilson, Robert Crumb, and other male illustrators. Farmer and Chevely also produced the groundbreaking *Abortion Eve* (1973), a story informed by their work as counselors at a women's free clinic following *Roe v. Wade*, the landmark Supreme Court decision legalizing abortion in the United States.

An anti-abortion organization, Right to Life, also published a response to the court decision in comic form: a religious tract titled *Who Killed Junior?* (1973). The fact that both prochoice and prolife groups chose comics as a medium for debate indicates how far comics storytelling had progressed since 1965—from cheap thrills and titillation to subject matter that included current events and serious social debates.

Gay and Lesbian Comix

Gay and lesbian characters and themes had appeared sporadically in underground comix since the publication of *Harry Chess* in the mid-1960s. Beginning in 1967, the *Advocate* briefly published single-panel cartoons by Joe Johnson (*Miss Thing, Big Dick*). The first comix about a lesbian was Trina Robbins's "Sandy Comes Out," published by the Wimmen's Comix Collective (Figure 26.21).

Mary Wings (American, b. 1949) then published her own *Come Out Comix* (1973), the first exclusively lesbian comic book, in response to Robbins's "Sandy Comes Out," because she felt the earlier story lacked the "emotional and spiritual side to coming out" (Figure 26.22). Wings's expressive art gave voice to a story that, in the true underground comix manner, was both universal and, as the cover declared, "One Person's Experience!" The following year cartoonist Roberta Gregory (American, b. 1953) came out as a lesbian cartoonist through her stories in *Wimmen's Comix*, and in 1976, she self-published *Dynamite Damsels*, also in response to Robbins's "Sandy Comes Out." Between 1976 and 1981, Larry Fuller (American, birth year unknown), one of the few African Americans working in underground comix, produced three issues of a gay male romance anthology titled *Gay Heartthrobs*, modeled on the mainstream romance comic *Heart Throbs*.

Denis Kitchen (American, b. 1946), a cartoonist and publisher under the label Kitchen Sink, saw the potential for a new publication exploring lesbian, gay, bisexual, transgender, and queer/questioning (LGBTQ) life. He asked comix veteran Howard Cruse (American, b. 1944), one of the few openly gay underground cartoonists, to be

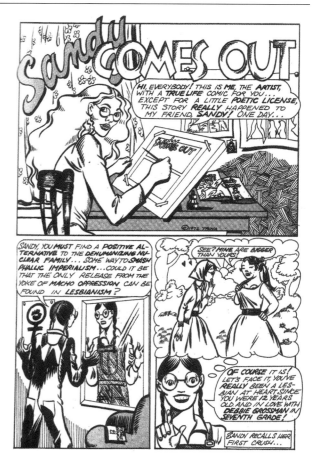

Figure 26.21
Trina Robbins, "Sandy Comes Out," *Wimmen's Comix*, 1972.
The Wimmen's Comix Collective offered a venue for female cartoonists to explore a variety of subjects. The versatile Trina Robbins drew both humorous and adventure-themed underground comix. Her "Sandy Comes Out" was the first lesbian comix story, inspired by Sandy Crumb, sister of artist Robert Crumb, who was Robbins's roommate at the time.
Collection of the author. © Trina Robbins.

its editor. Cruse accepted, despite fearing the potential loss of his income as a mainstream illustrator once his sexual orientation became public. In 1980, they published the first issue of *Gay Comix*, an annual anthology that would run for twenty-five issues with contributions from established underground artists that included Roberta Gregory, Lee Marrs (American, b. 1945), and Rand Holmes (Canadian, 1942–2002).

Cruse's "Billy Goes Out" from the first issue displays the insight and emotional authenticity that Cruse asked of his contributors. The story takes the reader into the gay singles scene by following Billy as he copes with the loss of a partner and eases his depression, at least temporarily, by finding "sex and/or love." Cruse innovatively combines words and illustrations in **thought balloons**, a graphic device used in comics to indicate that the words included in the form were being thought rather than spoken, as Billy moves through the more naturalistically drawn central narrative. His thoughts become a surreal montage of memories, satirical commentary on the gay singles scene, and reflections on Billy's own actions (Figure 26.23).

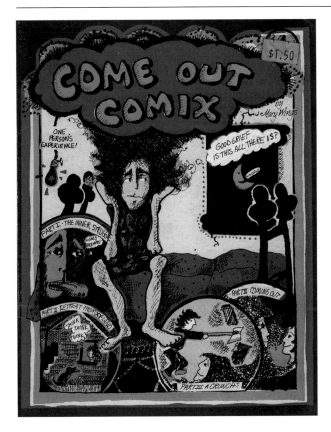

Figure 26.22
Mary Wings, *Come Out Comix*, 1973.
Prior to Wings's and Robbins's work, few underground comix existed with gay and lesbian characters that were not burlesques in the mode of *Harry Chess*. Wings would later self-publish a second comix, *Dyke Shorts* (1978), and contribute stories to the anthology *Gay Comix*.
Collection of the author. © Mary Wings.

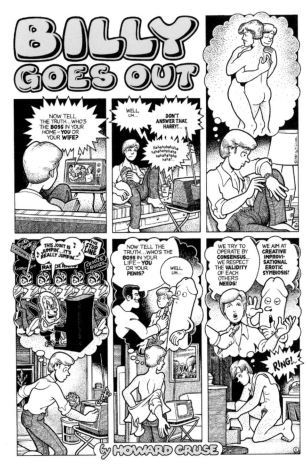

Figure 26.23
Howard Cruse, "Billy Goes Out," *Gay Comix #1*, 1980.
Throughout the story, Cruse juxtaposes Billy's night out as he adjusts to the death of his partner Brad with images roaming through his mind, shown in the thought balloons. This device illustrates Billy's character, history, and emotional states triggered by the night's journey.
Courtesy of the artist. ©1980 by Howard Cruse.

Censorship and Decline of Comix

In the 1970 legal case *People v. Kirkpatrick*, Robert Crumb's *Zap* #4 (Figure 26.24) became the first comic book to be found legally obscene in the United States because it included several sexually explicit stories. Despite the artists having previously published far more taboo material for other titles, the court found Crumb's "Joe Blow" the most offensive. A satire on suburban middle-class family values, Crumb's story exposed the degeneracy beneath a seemingly normal façade, revealing a family that solved its problems through pills ("A simple pill called 'Compoz' . . . And I'm a new man!") and happily engaged in incestuous relations.

Then in 1973 the underground comix community was affected as the court ruled that local community standards determined if publications were pornographic under the law. These events resulted in increased police raids on head shops and music stores that carried underground comix. Since it was illegal to send pornography through the U.S. Postal Service, and few bookshops yet specialized in comic books, no alternative system existed to distribute comix once vendors grew reluctant to offer risqué titles. Meanwhile, the market itself witnessed a general downturn in sales due to an oversaturation of low-to-mixed-quality

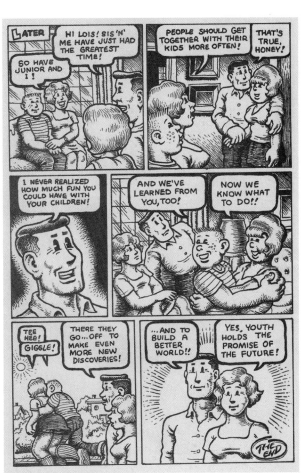

Figure 26.24
Robert Crumb, "Joe Blow," *Zap* #4, 1969.
Drawings of cartoon characters having sex was one of the major taboos of the Comics Code, and anathema to anti-comics crusaders. With incest as a theme, "Joe Blow" pushed the limits of acceptability even within the counterculture.
Collection of the author. © Robert Crumb 1967, 1968, 1969.

Theme Box 49: Freedom of Speech and Censorship in Cartoons
by Jaleen Grove

On January 7, 2015, in Paris, two men assassinated the editor and cartoonists of the satirical periodical *Charlie Hebdo* (many others were also killed or injured in this attack and its aftermath, including the gunmen). It is understood that the perpetrators, who were aligned with the militant group Al Qaeda, took exception to the magazine's deliberately offensive depiction of the Prophet Muhammad. In previous years, threats had been made against other cartoonists about the portrayal of the Prophet in Danish newspapers. These events are a divisive issue among illustrators and cartoonists, with some decrying depictions that knowingly offend, and others defending them. The following two polemic essays present opposing views on the matter that have been voiced in actual published articles, roundtables, and Internet discussions. The reader is encouraged not to adopt one or the other position but rather to reflect on what contingencies would render portions of each argument acceptable or unacceptable, and to consider what is not addressed by either the pro or con sides presented here.

An Argument for Unfettered Freedom of Speech

It is an artist's prerogative and a cartoonist's responsibility to raise issues and make people think. They perform a service to society. Accordingly, even the most controversial expression should be protected.

Nothing should be too sacred for satire, because shock value is a useful, effective tool to raise awareness. Some cartoons are therefore designed to offend, and naturally, use imagery objectionable to some. In France, these cartoons are called **gouaille** and are considered a venerable tradition. Such images need to be seen in context and cannot be properly understood without their captions or other supporting text—which often demonstrate the intent of the cartoon. Typically cartoonists *must* use well-known tropes to visually communicate a character's identity, and doing so is not automatically bad. Using a feather headdress to indicate a Native American, for example, is not racist if the gag is sympathetically arguing a Native American point of view.

Since there is no rule in the Quran against depicting Prophet Muhammad, a cartoon that does so is not a *religious* case for offense. Even if it were, one person's belief should not constitute a limit on someone else's, because each individual must decide for themselves what is right. Furthermore, blasphemy and racism are not the same thing; just because a cartoon insults a specific religious leader does not mean the cartoon is racist—it is dangerous rhetoric to conflate a person with an entire body of people.

If the artist's intent was not to be racist, then the work is only racist according to subjective interpretation—one that misunderstands the artist's goal. To identify a real racist

intent, a pattern must be established; a cartoonist or magazine that equally lampoons *all* groups is being even-handed and ought not to be condemned over one cartoon.

Catering to people's sensitivities by caving in to censorship demands actually reinforces notions of weakness and victimhood, and panders to the idea that there is no other option besides taking violent offense. People who feel insulted could demonstrate their strength through critical argument, by rising above what offends them, or making their own cartoons.

Freedom of speech is the most important right of all: without it you cannot defend other rights. Nobody should ever be able to dictate what other people can or can't look at, because it is impossible to fairly decide what should be censored—and any attempt to do so gives too much power to the deciders. Even degrees of restriction (as for certain kinds of pornography) are tantamount to censorship. A true democracy is free, and anything less than total freedom of speech is fascism.

If everyone else enjoys freedom of speech, so should cartoonists. It's just a cartoon—and cartoons don't kill (terrorists do). Social change on difficult matters will never occur without offending somebody or challenging laws. To imply that cartoonists who offend cause their own assassinations is victim-blaming and lets the assassins off the hook. When cartoonists and other artists suffer because of what they depict, the blame needs to be put right on

the shoulders of the perpetrators—not the messengers of what are often just uncomfortable truths.

Defending total freedom of speech in democratic countries is therefore an important role model for the rest of the world. If citizens give up their freedoms, fascists, dictators, and special interest groups who do not represent the majority win. Artists need to speak and create without having to worry about whether the targets of their jokes and others not even directly involved will get offended.

An Argument for Restrictions on Freedom of Speech

An offensive cartoon is never "just" a cartoon—they hurt and they have bad effects.

It is simply arrogant for a handful of artists to decide for everyone else what is appropriate to mock. Unlimited freedom of speech risks perpetuating hate and inequity.

Cartoonists who oversimplify complex social conflicts and employ gratuitous shock effects discourage people from looking at issues seriously or fairly. Such inflammatory creations prevent sides from learning tolerance and respect. If a given artwork does not make things better and may make society worse, perhaps it shouldn't be published at all.

If an artist does not belong to a given cultural or religious group, he or she has no right to dictate what is or is not appropriate in reference to them. Worse, when artists take on issues that are not their own, they may usurp the voice of the very

groups they believe they are helping. It is understandable (although not excusable) that some citizens feel violence is their only option, when their own perspectives are repeatedly insulted or shut out.

Offensive cartooning like *gouaille* cannot be defended on "traditional" grounds when current national makeups are multicultural. Much of what has caused controversy and murder is just plain bad art: *good* cartoonists can make their point without frustrating others; they need not fall back on cheap shock tactics and easy antiquated tropes. Cartoons that use old racial stereotypes such as feathers on Native Americans are still racist, even if the context or intent is non- or anti-racist. This is because images communicate apart from words whether we want them to or not, and a symbol that has been widely used with racist intent in the past (feathers connoting "savages") will continue to evoke that racism no matter what. This is especially true online where images are frequently passed around and repurposed minus the original caption or context, or when there's a language barrier.

Audiences make their own interpretations—and just because an artist may be unaware of how their work signifies in various places does not mean the work is inoffensive. Nor is mocking all groups equally any proof of fairness because that leaves existing inequalities intact and unexamined. Thus, even when a given artist is not personally racist, the effect of their work may uphold

systemic racism (inequality perpetuated by established customs and institutions).

When a given image is displayed in public and impels the antagonism of one segment of a community towards another, the disadvantaged group cannot simply ignore it. In fact, American law states that everybody has freedom of speech and press (with two exceptions: violating local standards and aiding terrorism). As well, according to law, those exercising their freedom must also "suffer the consequences"—artists, editors, publishers, and distributors can and should be held to account for intended and unintended consequences.

Taking a hands-off approach to censorship means dominant groups will bully the less powerful. Restricting damaging images acknowledges the fact that certain groups are just not as privileged as others; that some need accommodation and protection in order to get a fair chance at equality. Restrictions against what can or can't be seen (and when or where) would enhance social cohesion and are a reasonable alternative to all-out censorship.

A true democracy is ruled by the people through elected representatives, where interests and policy are determined by consensus. Restrictions or even censorship decided by such a government process are therefore exemplary of a good democracy.

publications. Concurrently, paper costs rose, increasing production expenses and resulting in losses for underground publishers and distributors, who cut staff and discontinued titles in an attempt to keep publishing. The counterculture dreams that had begun nearly a decade before were over, and it seemed that the underground comix would be one more relic of the psychedelic era.

Comix in the '80s and Beyond

After a lull in the late 1970s, the social values and DIY (do-it-yourself) sensibility of the underground would continue in the democratic punk culture, where the important thing was not how well you drew or wrote, or how polished your publication looked, but how well you expressed yourself. The proliferation of affordable photocopy machines gave rise to the **'zine**, an abbreviation of the word "magazine"; and **mini-comic**, a small comic format arising in the 1980s that is self-published. The rudimentary handmade quality of the publications further underscored the importance of bringing unbridled personality and obsessions to the crafted object.

One of the longest-practicing mini-comics cartoonists is Colin Upton (Canadian, b. 1960). Since 1984, he has drawn stories about his personal life and struggle with diabetes, a variety of pet interests such as military history and tea, the punk scene, the vagaries of the fine-art world, and the social strata of his hometown of Vancouver, Canada (Figure 26.25).

After a hiatus from publishing in the late 1970s, Robert Crumb made a strong return in the 1980s. In 1981, he founded *Weirdo*, establishing a venue for alternative cartoonists including Dori Seda (American,

1951–1988) (*Lonely Nights, Dori Stories*), Peter Bagge (American, b. 1957) (*Hate*), and Daniel Clowes (American, b. 1961) (*Eightball, Ghost World*), as well as old colleagues such as Spain Rodriguez, and Crumb's wife, Aline Kominsky-Crumb (American, b. 1948), all of whom carried on in the underground comix tradition or were informed by them. *Weirdo* focused on raw expressiveness rather than artistic polish. After a seven-year break, *Wimmen's Comix* was revived in 1984. The issue featured stories by the first wave of underground cartoonists and work by up-and-coming illustrators like Phoebe Gloeckner (American, b. 1960) and Caryn Leschen (American, b. 1966). Using the same rotating editorship and collectivist spirit upon which it had been founded, *Wimmen's Comix* continued publication into the 1990s (Figure 26.26). "By the time we finally ended in 1992, there were more women in comics than ever before," recalled Trina Robbins in a *Comics Journal* interview; "We really did open the door for women to do comics."

Françoise Mouly's (French, b. 1955) and husband Art Spiegelman's ground-breaking periodical *RAW* (1980–1991) featured avant-garde alternative cartoonists such as Mark Newgarden (American, b. 1959), Richard McGuire (American, b. 1957), Charles Burns (American, b. 1955), and Gary Panter (American, b. 1950), and offered reprints

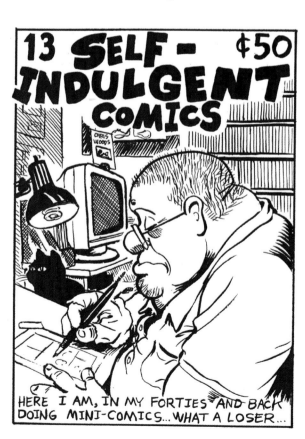

Figure 26.25
Colin Upton, *Self-Indulgent Comics* #13, 2001.
In the tradition of autobiographical comix, Upton gives an unvarnished account of his personal life. In this example, he self-reflexively analyzes his obsession with making mini-comics, concluding that he makes them because "Drawing comics makes me feel less useless. If you don't like it, shut up and go to hell!"
Courtesy of the artist. © Colin Upton.

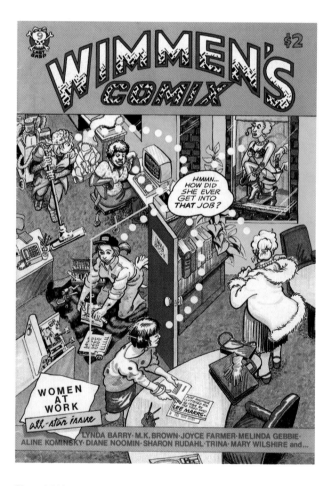

Figure 26.26
Lee Marrs, *Wimmen's Comix* #9, 1984.
Marrs's cover for the "Women at Work" issue presents women of different races and occupations all united by the same question: "Hmmn . . . How did she ever get into *that* job?" In the 1980s, under a rotating editorship, *Wimmen's Comix* provided an entryway for a new generation of female alternative artists.
Collection of the author. © Lee Marrs.

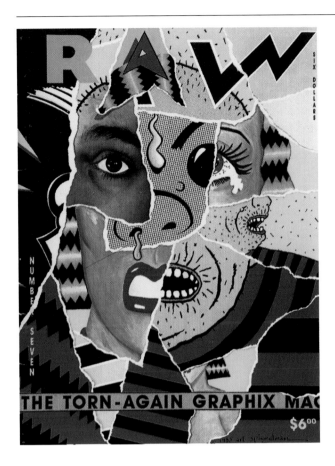

Figure 26.27
Art Spiegelman, *Raw* #7, 1985.
Raw, like *Weirdo*, was an anthology showcasing alternative comix. Spiegelman's cover simulates a collage constructed from pieces of artwork by that issue's contributors. Spiegelman and co-editor Françoise Mouly tore off the top corner of each magazine; they then taped the torn piece to the inside cover of a different copy of the same issue.

of classic comic strips such as Winsor McCay's *Little Nemo in Slumberland* (*see Chapter 23*) (Figure 26.27).

Spiegelman's most publicized success is *Maus*, a full-length autobiographical Holocaust story (*see Chapter 23*) that was serialized in *Raw*, having been expanded from an original short story published in the underground comix *Funny Aminals* (sic) in 1972. Substituting mice for Jews and cats for Nazis, *Maus* tells the story of his parents' experiences during World War II as Jewish prisoners in a German concentration camp. The tale is interwoven with a present-day narrative of Spiegelman's relationship with his disapproving father. Typical of Spiegelman's interest in metanarratives, the author comments throughout on the story itself. Influenced by Frans Masereel (Flemish, 1889–1972; *see Chapter 23*), *Maus* is drawn in a simplified style reminiscent of woodcut, with innovative page layouts. The 1992 collected edition became the first graphic novel to be awarded a Pulitzer Prize.

Conclusion

During the social upheavals of the 1960s, alternative comics grew out of a transgressive underground sensibility. Comix (with an *x* for adult content) expanded

the narrative possibilities of the comic medium, which had become, for the most part, enfeebled by corporate publishers constrained by the Comics Code. Along with the short-term gains of groundbreaking topics and stylistic freedom, underground publishing of the 1960s–1980s established a system for sales and distribution of alternative publications in the United States. Stores specializing in comic books, zines, mini-comics, and other narrative formats continue to flourish. The liberating effect was felt in mainstream comics as well, with artists at DC and Marvel Comics demanding more artistic freedom and part ownership of their characters—prerogatives unheard of in the 1960s.

Psychedelic posters, underground graphics, and comix were more than short-lived phenomena borne of an era of "sex, drugs, and rock-n-roll," and should more rightfully be considered as artistically challenging work instrumental in breaking the hegemony of mainstream postwar American visual culture (*see Chapter 24*). Furthermore, the freedom that emerged in the underground press of the psychedelic era has slowly become part of the practices of mainstream comics publishing, perhaps making the triumph of personal expression over compliance the legacy of the counterculture era.

FURTHER READING

Durant, Sam, *Black Panther: The Revolutionary Art of Emory Douglas* (New York: Rizzoli International Publications, Inc., 2007).

Estren, Mark James, *A History of Underground Comics* (Berkeley, CA: Ronin Publishing, 1993).

Hall, Justin (Ed.), *No Straight Lines: Four Decades of Queer Comics* (Seattle: Fantagraphics, 2013).

Hatfield, Charles, *Alternative Comics* (Jackson: University Press of Mississippi, 2005).

Hodler, Timothy, and Dan Nadel (Eds.), *The Comics Journal* (1970 to present) http://www.tcj.com/category/tcj-archive/.

Owen, Ted, *High Art: A History of the Psychedelic Poster* (London: Sanctuary Publishing, 1999).

Robbins, Trina, *Pretty in Ink: North American Women Cartoonists 1896–2013*, (Seattle, WA: Fantagraphics Book, 2013).

Rosenkranz, Patrick, *Rebel Visions: The Underground Comix Revolution: 1963–1975* (Seattle, WA: Fantagraphics Books, 2002).

KEY TERMS	
alternative press	paste-up mechanical
The Big Five	Pop Art
gouaille	rapidograph
horror vacui	systemic racism
layout	thought balloon
Letraset	underground comix
male gaze	Vienna Secession
metal cut	'zine
mini-comic	

27

Print Illustration in the Postmodern World, 1970–Early 2000s
Whitney Sherman

With the changing cultural and technological environments of the late twentieth and early twenty-first centuries, the nature of print illustration shifted. The relationship of illustration to design and to gallery-specific works, the evolution of "conceptual" illustration's continuing complex negotiations of meaning, and the influence of "lowbrow" aesthetics in shaping visual sensibilities all had deep-rooted instinctual and intellectual effects on illustration practice. This chapter considers these effects alongside the confluence of media and culture, and the use of emerging digital tools as agents of change inside and outside the industry.

Operating in Separate Spheres

As previous chapters have shown, illustration, lettering, and page layout were often performed by the same individual, who was alternately referred to as a *graphic artist* or *commercial artist*. Just prior to and after World War II, many graphic artists were influenced by modernist design ideas within the International Typographic (or Swiss) Style that emphasized the unity and simplicity of page design. These advocates of modernism, for the most part, preferred sans-serif typography and photography, avoiding ornamentation and narrative illustration. Such graphic arts professionals started to view their activities as distinct from that of illustrators, and "*graphic designers*" (a term first coined in 1922 that gained acceptance in the 1950s) began to operate in a separate sphere. This evolution can be seen in the history of the American Institute of Graphic Arts (AIGA), a professional and industry organization established to serve individuals working within practices identified as "graphic arts" (including illustration). During the 1950s, this group shifted its mission away from the concerns of printers and illustrators toward modernist design practitioners. Tellingly, in 2005, the AIGA officially changed its name to *AIGA, the professional association for design*.

Critical Reconsideration of Illustration in the Postmodern Era

While contemporary practitioners may not formally concern themselves with art theory as they make or discuss their work, they are nonetheless affected by the discourse of art critics, philosophers, and scholars, as well as by discussions about politics, film, science, music, and other topics that make audiences think differently about images.

In the 1960s, widespread social change—the Civil Rights Movement, feminism, gay rights, anti-war student-led protests in France and the United States, and the emerging independence of formerly colonized countries—was caused by and resulted in widespread questioning of hegemonic values and beliefs. Late-twentieth-century thought particularly challenged the assumptions of the goodness of "progress" that underpins high modernism. Theorists debated the validity of European superiority, the value of technological change, the ability of language to capture truth, and categories such as gender and race. In media and art theory, analysts and critics skeptical of modernist ideals embraced inquiry through methods derived from psychoanalysis, semiotics, feminism, and literary and cultural theory to expose the hidden power structures that influence culture—including the making and consumption of visual art and texts. Such applications of critical theory are colloquially referred to as **deconstruction** (although properly, the term means a specific kind of literary criticism; *see Theme Box 50, "Derrida: Deconstruction and Floating Signifiers"*). This profound alteration in mindset led the new era to be referred to as the **Postmodern**.

Postmodernism led to new concepts as well as new forms. At mid-century, much illustration was derided in modern art discourse, which privileged abstraction and an elitist avant-garde. Many illustrators in turn questioned modernism's assumptions, and instead affirmed the importance of craftsmanship, narrative, and archetypal structures in art. In the Postmodern era, however, illustrators around the world began creating diverse kinds of images using multiple visual languages from all varieties of art, informed by the principles of deconstruction.

Stylistic Diversification after 1970

The social changes of the 1960s contributed to a variety of expressions and perspectives in illustration. Working within mainstream mass media, American illustrators Bernie Fuchs (1932–2009), Robert M. Cunningham (1924–2010), Robert Heindel (1938–2005), and Bob Peak (1927–1992) reinvigorated the look and feel of magazine illustration by embracing stylistic innovation, as Robert Weaver (American, 1924–1994) had (*see Chapter 24*). Because they were less focused on detail than many of their predecessors had been, much of their imagery appeared sympathetic to the abstraction prevalent in fine art of the 1950s and 1960s, though subject matter remained loosely recognizable.

In the 1970s, Peak and others established a new market for figurative illustration that competed with photography. Peak experimented with montaged compositions and textural effects, and favored strong color palettes in what evolved over time into his seminal movie poster style (Figure 27.1). Also working with bolder coloration was

Figure 27.1
Bob Peak, movie poster illustration for *Apocalypse Now*, United Artists/Omni Zoetrope, 1979. Produced only four years after the end of the Vietnam War, the *Apocalypse Now* poster art shows a quietly demonic head of the film's antagonist, Colonel Walter E. Kurtz played by Marlon Brando. Central to the anti-war storyline was Kurtz's unfettered and savage insanity in the darkness of war. Peak evokes these themes rather than showing any particular moment in detail. Brando's dripping head is bathed in dramatic light, floating above a watery scene with explosive flashes illuminating an inky sky.
© Bob Peak.

Theme Box 50: Derrida: Deconstruction and Floating Signifiers
by Sheena Calvert and JoAnn Purcell

Jacques Derrida (French, 1930–2004) was a philosopher whose extensive written output covers diverse subjects such as phenomenology, existentialism, ethics, and structuralism; but his name is primarily associated with the concept of *deconstruction*. Meaning "of construction" in French, deconstruction is not simply about taking apart language and meaning. Rather, it is the critical analysis of signs (images, texts, sounds, and so on) to see how language and meaning are assembled, how they match, and how they clash. In this sense, deconstruction is creative, generating new meanings and insights.

Derrida's work concerns semiotics (see *Chapter 2, Theme Box 7, "Saussure and Peirce: Semiotics"*), the study of how signs stand for ideas and things. Remember, Ferdinand de Saussure posited that a sign is made up of a "signifier" (an illustration) and a "signified" (what it stands for); and he identified a system of rules related to social behavior ("structures") that determined how such signs would be used and decoded. His school of thought is known as **structuralism**. Derrida's ideas advanced these concepts and contributed to the school of thought known as **post-structuralism**, because he disputed the notion that communication and meaning are exactingly determined.

Challenging the structuralist contention that signs denote specific meanings, Derrida theorized that signifiers "float," or convey meaning only fleetingly. A *floating signifier* is independent of any one signified, and is not intended to point toward any specific meaning. It is in "free play" and is involved in an "indefinite referral of signifier to signified," as Derrida put it. Consider that when an illustration is made, it always has

a context because it has a client and an intended audience. But the context floats for the actual viewers every time they view it because, although people are participants in social structures, each person has a unique state of mind, distractions, personal experience, and past associations through which he or she interprets the signifier.

For Saussure, signs differ from one another, and our ability to see the differences between signs is what allows us to know what they mean. For Derrida, the difference between signs is never so certain, and determining meaning (the signified) is never-ending because the signified and the signifier are like wandering chameleons, changing appearances according to nuances of contexts that people see around them. The other originator of semiotic theory, Charles Sanders Peirce, also believed that meaning was constantly in flux, and gave the name *semiosis* to the process of attempting to fix meaning only to have it slip away again.

Signification is central to illustration. To play with constructing/deconstructing meaning is to create new worlds with the "language" of images. An example of a place where the signifier and the signified have been disconnected is a work by the Surrealist René Magritte (French, 1898–1967), whose famous 1936 painting *The Treachery of Images* (Figure 3 in the Introduction) tries to break the links between the image, the words describing it, and the signified. Magritte paints a tobacco pipe but captions it in French with "This is not a pipe" (*Ceci n'est pas une pipe*), reminding us that the painting itself (signifier) is not a pipe (signified). This painting affirms the ability of artists and illustrators to deconstruct and construct

meaning according to their own playful interpretation of images and text—a fundamental component of conceptual illustration.

That meaning is never stable is an important concept underpinning Postmodern theories and the interpretation of images—a principle most ambitiously demonstrated by Luigi Serafini's (Italian, b. 1949) opus *Codex Seraphinianus* (1981). Despite resembling a scientific text of utmost clarity, the *Codex* confounds illustration's basic purpose of illuminating (in the sense of clarifying meaning) by using an indecipherable script and ambiguous image relationships. A key point for the illustrator is that signification is contingent upon context, audience, and juxtaposition more than it is on authorial intent.

Further Reading

Derrida, Jacques, *Dissemination* (Chicago: University of Chicago Press, 1981).

Derrida, Jacques, *Margins of Philosophy* (Chicago: University of Chicago Press, 1982).

Derrida, Jacques, *Of Grammatology* (Paris: Minuit, 1967).

Derrida, Jacques, *Speech and Phenomena and Other Essays on Husserl's Theory of Signs* (Evanston: Northwestern University Press, 1973).

Derrida, Jacques, *Writing and Difference* (Paris: Seuil, 1967).

Serafini, Luigi, *Codex Seraphinianus* (Milano: Franco Maria Ricci, 1981).

*Quoted material attributable to subject

Robert M. Cunningham, who offered fresh perspectives on familiar scenes by employing brilliant color within strong, flattened compositions inspired by the sweeping horizon of the Bahamas, which he visited frequently (Figure 27.2); and by the art of color field painters Mark Rothko (Latvian, American, 1903–1970) and Richard Diebenkorn (American, 1922–1993).

An important periodical in the development of new illustration techniques in the late 1960s and '70s was *Lithopinion*, published by Local One of the trade union Amalgamated Lithographers of America. Filled with thoughtful essays on diverse topics and views, the glossy, superbly printed magazine solicited the most innovative illustration from leading illustrators, who were allowed freedom to experiment. It was for an assignment documenting British pubs that Bernie Fuchs developed the technique that made him famous: lush color fields loosely painted using layers of oil glaze (he had previously used acrylics). Fuchs's images were inspired by cinematic devices such as a flattened depth of field or dynamic cropping (Figure 27.3). He enjoyed a long career of illustrating for sports and lifestyle magazines, and was a founder of the Illustrators Workshop, a preeminent commercial art program that he taught with Alan E. Cober (American, 1935–1998), Fred Otnes (American, 1925–2015), Mark English (American, b. 1933), Robert Heindel, and Bob Peak.

Equally dynamic is the work of Robert Heindel, whose artistic direction took a turn after he saw ballet legends Margot Fonteyn and Rudolph Nureyev dancing *Paradise Lost*. From the late 1980s through the 1990s, Heindel, acting on invitation by prestigious dance companies, collaborated with them to produce and exhibit bodies of work. As with Cunningham and Peak, powerful composition and color were at the heart of Heindel's work (Figure 27.4).

Open investigation of expressive painterly approaches can also be seen in the work of R. Gregory Christie (American, b. 1971), who illustrates fiction and nonfiction stories on black lives. Initially working as an editorial illustrator for major national magazines before moving into children's literature, Christie—a three-time Coretta Scott King award winner—combines flat abstract shapes and tonally rendered areas, creating distorted yet recognizable faces that communicate the individual's personality or emotions. Christie's book jacket and interior images cover

Figure 27.3
Bernie Fuchs, illustration in the book *Ride Like the Wind* by the artist, Blue Sky Press, 2004. Though showing a limited amount of his famous rubbed-out technique, this image for a children's book set in the early days of the Pony Express still shows Fuchs's signature style, characterized by wiped-out areas of thinned oil paint on canvas, asymmetrical composition, dynamic complementary colors, and expressive brush strokes. He once told an interviewer that the hardest part of his job was getting the idea: "my aim is . . . to make illustrations that will contribute to, and perhaps heighten, the meaning, drama, and emotion of the words."
Private collection.

Figure 27.2
Robert M. Cunningham, *Olympic Runner*, U.S. Postal Service stamp, 1980. Cunningham's planar approach uses dramatic light and shadow to propel this runner forward as he breaks free of the color field behind him. Cunningham photographed his subjects and their surroundings extensively, and like many artists of the era, projected and manipulated images to establish a final composition that was painted in acrylics on canvas.
Collection of the Norman Rockwell Museum.

Figure 27.4
Robert Heindel, *The White Skirt*, 1996. Oil on board, 36 × 48". Heindel's long-term relationship with dance companies gave him extraordinary access to his subjects, which informed his expressive body of work. His canvases are liberally covered with paint that is then scribed and scraped to create the effects of movement or to freeze the action.
Private collection. Further information about Robert Heindel is available at www.thereddotgallery.com.

topics like gender equality and tell the stories of notable figures such as Harriet Tubman, Dr. Martin Luther King, Jr., Muhammad Ali, and Richard Wright. His music CD covers used similar techniques (Figure 27.5).

Factors endemic to the postmodern era such as feminism, the surging independence of illustrators, and the recouping of archetypal themes and antiquarian styles come together in the work of Heather Cooper (Canadian, b. 1945). Having cofounded design company Burns and Cooper in 1970, Cooper created advertising and editorial illustration that drew heavily on illustration history. Like others of this period, she strove to bridge personal expression with commercial obligation in assignments such as the Roots clothing company's iconic beaver logo and the book cover for *Bluebeard's Egg* (Figure 27.6). The latter painting was simultaneously issued as a poster and as a limited edition print.

Editorial Illustration after 1970

Principally created with traditional media until very late in the century, mainstream editorial illustration as well as illustration for niche and enthusiast markets continued to appear in print in national American magazines such as *The Progressive, The Atlantic, The New Yorker, Rolling Stone, Boston Globe, Washington Post,* and the *New York Times,* to name a few. Regional markets also grew their own crop of prominent publications, such as *Texas Monthly,* the *Washingtonian,* the *Plain Dealer,* and *Detroit Free Press.* The work seen in each of these publications has varied greatly, with art directors developing their own cadre of regulars whose work has come to singularly define each publication.

Conceptual illustration, which relies on the illustrator's point of view communicated through visual metaphors and other nonliteral approaches, works well for political and socially critical material; for illustrations concerning medical or psychological topics; and for business concepts in which a didactic or realistic approach might be off-putting or uninteresting. Alan E. Cober (American, 1935–1998) believed that art had the power to influence and inform public opinion, and he documented with compassion the experiences of society's hidden populations—the incarcerated, the mentally ill, and the elderly—in expressive, symbolic drawings published in books, magazines, and newspapers. Throughout his life, Cober filled hundreds of sketchbooks

Figure 27.7
Alan E. Cober, sketchbook drawing of electric chair, Sing-Sing Correctional Facility, 1971. 8 ³/₄ × 10".
Cober's unwavering documentary ink-on-paper drawings captured elements of the death row chamber at the notorious Sing-Sing Correctional Facility in Ossining, New York, near where he lived. He also documented the inhumane treatment of patients at the Willowbrook State School for the mentally challenged in Staten Island, New York.
Collection of Ellen Cober.

Figure 27.8
Marshall Arisman, *The Curse of Violent Crime*, cover art for *Time*, 1981. Oil on ragboard, 23 × 29".
Although much of his work has been made to be exhibited in a gallery, Arisman in 2005 expressed his undifferentiated view of applied and fine art, saying, "The difference between the illustration stuff and my personal work or fine art work is really time."

Smithsonian Institute.

Figure 27.9
Brad Holland, illustration in "Straight to the Vein," Op-Ed page, *New York Times*, 1971.
Employing a visual metaphor, Holland connects a spoon (used to prepare heroin for injection) with the concept of spoon-feeding or overindulging the many mouths on the arm in this pen-and-ink drawing. His subject's stare describes an intense "hunger." Holland created this image without an assigned editorial context, and art director JC Suares only later picked it up for use in an article on addiction, poverty, race, and the failures of the prison system.

© 1970, Brad Holland.

with everything from simple notations to fully developed paintings, often integrating textual inscriptions within his art (Figure 27.7). He described his style as a kind of "magic realism," characterized by a searching pen line and the distortion of form in the tradition of Ben Shahn (Lithuanian, American, 1898–1969) and George Grosz (*see Chapter 19*).

Marshall Arisman (American, b. 1937) has tackled strong editorial subjects throughout his illustration career. His image for the Violent Crime issue of *Time* magazine was conceptually based on his belief (stated in a September 2005 interview for the blog *Tastes Like Chicken*) "that when you put a gun in your hand it is not you with a gun—you are actually violence itself. . .;" adding that "the attempt on the *Time* cover was to simply make the face and the gun the same phenomenon" (Figure 27.8). Violence has been an ongoing theme in Arisman's work beginning with his 1973 publication *Frozen Images: Drawings by Marshall Arisman*, a compilation that focused on media-driven violence. The black-and-white images are marked by writhing figures, ink spatter, and grisly expressions that reflect deep emotional anger and horror. Influences such as Francisco Goya (*Chapter 12*) and Francis Bacon (Irish, 1909–1992) can readily be seen in Arisman's editorial paintings. His primary interests are in creating an emotional response and in storytelling. He uses his hands to paint rather than a brush, to express his emotions more directly during the process.

The Op-Ed Page and Op-Art

Particularly influential after 1970 was the *New York Times* **Op-Ed** page (opposite editorial) where writers, other than the editors, expressed their opinions—paired with some of the most provocative illustration of the era. While the editorial page had previously existed in the *Times* and other papers, it wasn't until then, under art director Jean-Claude "JC" Suares (Egyptian, American, 1942–2013), that the Op-Ed page adopted an illustrated format. Utilizing conceptual illustration often influenced by Surrealism (*see Chapter 19*), Suares initiated a new visual era for magazine and news editorial pages. He introduced numerous Eastern European illustrators to the U.S. market, and fostered the editorial careers of many including Eugène Mihaesco (Romanian, b. 1937), Anita Siegel (American, 1939–2011), Ralph Steadman (British, b. 1936), and Brad Holland (American, b. 1943), to name a few. Considered a pioneer of conceptual illustration, Holland often defied the art direction status quo by insisting that he not reiterate the text literally (Figure 27.9).

By the beginning of 1980s, the Op-Ed page had begun to reach its high point of commissioning myriad domestic and international illustration talent. Following the successful tenure of Suares, Jerelle Kraus (American) directed the Op-Ed page in two discontinuous stages: 1979–1989 and 1993–1996. Kraus continued the tradition of hiring Eastern European illustrators active in the Polish social movement *Solidarność* (Independent

Self-governing Labor Union "Solidarity") and known for their graphic subversion and conceptual acuity.

Kraus also commissioned French illustrator Roland Topor (1938–1997), whose ink drawings projected brutal force and the macabre, profoundly influencing the direction of the Op-Ed page as well as many fellow editorial illustrators in the late 1970s. He stated that an illustrator's duty is "to put your deepest soul on paper, to communicate directly from your nakedness. Anything less is unforgivable."

Senior editors sometimes rejected the more controversial art, forcing Suares and Kraus to advocate passionately for creative freedom. In 1997, the Op-Ed page came under the art direction of Nicholas Blechman (American, b. 1967), himself an illustrator (and son of R. O. Blechman, *Chapter 24*), who began to offer more stand-alone images such as photography, informational charts, and drawings under the banner title of **Op-Art**. Illustrator Lauren Redniss's (American) Op-Art pages combine on-the-street interviews with her journalistic drawing in full-page graphic compositions clamoring to be read in dynamic image-and-text relationships (Figure 27.10). Today, both the Op-Art and the Op-Ed page remain desirable commissions for illustrators despite current tighter editorial controls and emphasis on political correctness.

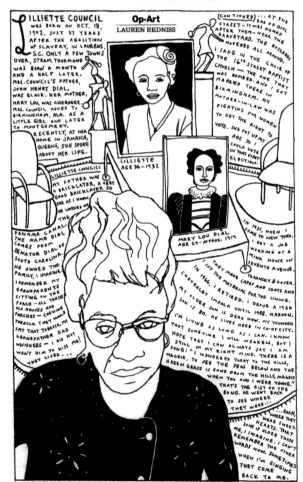

Figure 27.10
Lauren Redniss, "Lilliette Council," Op-Art page, *New York Times*, January 2, 2005. Ink on paper.
Pulitzer Prize nominee Lauren Redniss embeds Lilliette Council's oral history within her on location drawing to fill the entire tabloid-sized page. As if in a sketchbook, Redniss surrounds the images with Council's personal account of being born into slavery.
© 2005, Lauren Redniss.

The Progressive

Under the art direction of Patrick J. B. Flynn (American, b. 1952) from 1981 to 1999, *The Progressive* (formerly *La Follette's Weekly*, 1909)—a monthly magazine of investigative reporting, political commentary, cultural coverage, activism, interviews, poetry, and humor—became a haven for expressive editorial illustrators in the 1980s. Having formerly worked at the *New York Times* under JC Suarez, Flynn believed that the art would be remembered long after the writing if the right illustrator was selected for each project and given creative freedom. Frances Jetter (American, b. 1951), for example, responded to news of senseless violence in Kosovo and Columbine with an image showing a foreground planet heavily scarred as bullets continue to hit its surface. A figure slumps partially into a crater—a disembodied hand and foot scattered on the surface nearby (Figure 27.11).

The New Yorker

Since 1925, *New Yorker* covers have represented a particular urbane perspective of New Yorkers' day-to-day lives, while providing content with a broader cultural resonance. In the 1990s, subjects like Art Spiegelman's Valentine's Day cover of an orthodox Jewish man kissing a woman of color (sometimes referred to as *The Kiss*) sparked national conversations. That cover was assigned by then-editor Tina Brown, who found in Spiegelman a voice for developing some of her more controversial themes.

Figure 27.11
Frances Jetter, "Kosovo, Columbine, etc.," art for *The Progressive*, 1999. Linocut.
As the granddaughter of an active union worker, Frances Jetter was drawn to *The Progressive* for political reasons. She is influenced by German political artists George Grosz and Käthe Kollwitz (*Chapter 19*), along with the comic strip commentary in *MAD* magazine (*Chapter 23*).
Frances Jetter, ©1999.

Soon after, she hired covers art director Françoise Mouly, who, with her husband Spiegelman, had already ruffled the status quo with their edgy comics anthology *RAW* (1980–1991) (*see Chapter 26*). Particularly for politically charged themes, Mouly chose cover artists for their ability to convey a message rather than for purely stylistic reasons. This practice continued into the 2000s with Barry Blitt (Canadian, American, b. 1958) creating controversial covers such as the infamous "Obama fist bump" image (Figure 27.12). Inspired by the racist scare tactics used by political opponents of then-Senator Barack Obama, who was campaigning to win the 2008 presidential election, the satirical picture caused a firestorm of commentary.

Rolling Stone

Rolling Stone magazine cultivated its use of illustration during Fred Woodward's tenure as art director from 1987 to 2001. The magazine typically commissioned cover portraits of prominent or rising figures in entertainment, as well as images for music reviews and political coverage. Diverse in style, *Rolling Stone* caricatures rarely relied on stereotypes and were frequently concept-driven illustrations that conveyed aspects of the subject's personality, such as Ralph Steadman's (British, b. 1936) portrait of Hunter S. Thompson (Figure 27.13).

Other venerable *RS* illustrators include Anita Kunz (Canadian, b. 1956) (Figure 27.14), Philip Burke (American, b. 1956), Robert Grossman (American, b. 1940), and Robert Risko (American, b. 1956). In the twenty-first century, talents such as Sam Weber (American, b. 1981), Rick Sealock (Canadian, b. 1975), Yuko Shimizu (Japanese, American, b. 1970), Victor Melamed (Russian, b. 1977), and Edward Kinsella (American, b. 1983) have contributed to upwards of twenty-seven international editions.

Figure 27.12
Barry Blitt, "The Politics of Fear," cover art, *The New Yorker*, July 21, 2008. Watercolor on paper.
Oppositional political commentary of the time suggested that Obama was Muslim and thus not "American," politically or nationalistically. The absurdity of the comment led Blitt to parody the situation by going "over-the-top" with cultural markers: Michelle and Barack Obama are in an oval office (referring to the White House's center of presidential activity), wearing garb to suggest she is an Angela Davis–style radical and he is a follower of al Qaeda leader Osama bin Laden (seen in the portrait over the fireplace). Blitt finishes his concoction with a celebratory fist bump while an American flag burns in the fireplace. The satirical image was, nonetheless, taken literally by many.
Collection of the artist.

Figure 27.13
Ralph Steadman, Vintage Dr. Gonzo from "Fear and Loathing in Las Vegas," *Rolling Stone*, 1971. Hunter S. Thompson's now infamous book was serialized in the magazine. Steadman was commissioned after attempts at using photography failed; his work was already known at *RS* for its savage political and social commentary. Using varying ink lines and splotches, and a blending of mechanical and freehand cross-hatching, he evokes precision and chaos. Steadman was sent the book's manuscript and several days later shipped all of the drawings back. None were rejected.

Figure 27.14
Anita Kunz, portrait of Chuck Berry, *Rolling Stone*, 1988. Kunz's mixed media illustrations are tightly rendered caricatures capturing the nature of the subject while commenting on their situation. Here, she imagines the moment when musician Chuck Berry "discovers" his famous Duck Walk. The slanting angles in the background and the figure's pose give the piece movement without extreme exaggeration.
Collection of Jann Wenner.

Crucial Marketplace Changes, 1975–1990

The Fax and the Courier

During the 1980s and before, illustration for editorial and advertising markets was typically commissioned from local talents who could bring portfolios to an art director's office, making it imperative for most illustrators to be in or near a city center in order to acquire high-profile projects. Sketches and finished works were mailed or hand-delivered to the client, and the job was discussed in person or by phone.

With the introduction of Exxon's Qwip **fax machine** (abbreviation of facsimile) in the mid- to late-1970s, black-and-white text and imagery could be sent using telephone lines to anyone who had a similar machine, anywhere in the world. At first, the machines were somewhat clunky in design and lengthy in processing time, but improved machines enjoyed widespread use in the 1980s. The fax machine broke down the barriers between a distant market and an illustrator. Receipt of a manuscript or sketch approval could occur within a day, accelerating the creative and business process.

The second important change for editorial illustration was the establishment of courier company Federal Express (FedEx) in 1971. Deadlines for editorial assignments are notoriously tight, and FedEx provided a method for rapid delivery of final art. By the early to mid-1980s, FedEx was vital to the day-to-day mechanics of *all markets* within the field, with the cost routinely covered by the client. In the 1990s, the process of sending tangible finished illustrations by courier began to be replaced by transmission of scanned images by email as both desktop scanner and Internet use increased.

The Annual

Long an established social and professional club, the New York Society of Illustrators (established 1901, *Chapter 20*) produced its first annual in 1959. Initially, pages were printed in black and white, then in color in 2005. The Society's Annual has chronicled much of the best illustration work being produced nationally and internationally.

In 1981, Edward Booth-Clibborn (British, b. 1932), editor of the curated annual *European Illustration* (1973), became critical of much of the more traditional work being celebrated in American illustration annuals. In New York, he met with Robert Priest (British American, b. 1946), then–art director of *Esquire*; illustrators Julian Allen (British, 1942–1998) and Marshall Arisman (American, b. 1937); and Steven Heller (American, b. 1950), then–art director of the *New York Times Book Review*. In April 1981, Priest, Allen, Arisman, and Heller agreed that the United States was ready for an alternative vehicle with which to celebrate a new wave

of expressionistic, illustration brut (see below), and conceptual approaches. The *American Illustration Annual* was born, giving the selected works ample space on each page to create a forum in which the illustrations served as commentary in their own right. Over the years, the cover of the annual *American Illustration* has included images by some of the most influential illustrators in the United States, including Kinuko Craft (Japanese, American, b. 1940) for Annual #3; Peter Sis (Czechoslovakian, American, b. 1949) for Annual #5; Jack Unruh (American, 1935–2016) for Annual #8; Istvan Banyai (Hungarian, American, b. 1949) for Annual #18; Christoph Niemann (German, American, b. 1970) for Annual #23; and You Jung Byun (Korean, American, b. 1981) for the special Annual #32 (Figure 27.15).

Another significant annual of the time was the *Print Regional Design Annual* in which illustrations were selected and displayed by regions of the United States in an attempt to be more inclusive than most competitive annuals. Along with the aforementioned communication technologies, annuals stimulated stylistic innovation and opened a broader base of markets for illustrators.

Figure 27.15
You Jung Byun, cover, *American Illustration* #32 (Live Cover Project), 2013. Marker on book cloth cover, 9 ⁵/₈ × 10 ³/₄".
Normally commissioned from one artist, in 2013 *American Illustration* director Mark Heflin created an event out of the cover art commission by inviting forty illustrators to create ten hand-painted/drawn covers each—such as this one by Byun. The 400 unique covers were sent randomly to buyers. The other covers were all white with only the black typography on them.

© 2013, You Jung Byun. Image courtesy of American Photography/American Illustration.

Theme Box 51: Illustrator as Witness: Contemporary Visual Journalism
by Victor Juhasz and Whitney Sherman

Dominant use of photography and video in news documentation and reporting may lead one to the impression that visual journalism, the act of recording events in real time using some form of drawing, has all but disappeared. However, we see a rise in its uses as a way to record daily life and environments around us, and as a complement to contemporary photojournalism. Visual journalism continues to occupy a distinct role in the world of illustration and to be invaluable to our understanding of many events in ways that a photograph may not capture.

Photojournalism's great advantage and undeniable power are in catching the split-second occurrence and freezing that moment in its details. Unlike drawn visual journalism, photography does not linger, contemplate, edit, interpret, or prioritize information of an observed experience. The very act of drawing is slower, and in the case of visual journalism, the process relies on the illustrator's absorption of the scene, resultant responses, and choices concerning how information is recorded. However objective the intent, during the drawing process, subjective editorial choices are made about what the illustrator considers important—and how it is brought to the viewer's attention. The viewer can follow and digest the creative process, identifying with the illustrator's experience.

War art figures significantly in visual journalism (see Chapters 14 and 21). Artist/Illustrators in or embedded with the military can express a humanistic sensibility and a subtler totality of the experience; the physical and psychological wounds feel personal (see Figure TB51.1). The best courtroom artists bring psychological acuity and drama to their subject matter, capturing likenesses and gestures in places where cameras are forbidden.

Their images communicate the often long daily proceedings and the varied, sometimes fleeting body language that occurs in courtroom environments. They may record and express the passage of time in one image, or compose disparate elements into one persuasive composition. Visual journalists also create powerfully unique records of news events such as protests, political debates, and environmental disasters. Although not as imbued with drama, interview and travel journalism are prevalent, as seen in the increasing number of socially and culturally driven urban sketching groups that record an ever-changing public scene. Each is an energetic practice that draws the viewer into the intimate act of observation, an act that has adapted and changed since the advent of printing.

Coming out of the war years, Howard Brodie (American, 1915–2010) sketched during World War II in the South Pacific and Europe.

Later, as CBS-TV's premier courtroom artist, he covered, among others, Jack Ruby's trial for killing Lee Harvey Oswald. And Kerr Eby (Canadian, 1890–1946) covered both world wars, leaving a vast historical record of combat in the twentieth century (see Chapter 21).

Notable postwar practitioners include Robert Weaver, whose striking on-location drawings appeared in Sports Illustrated, Life, and Esquire; Franklin McMahon (American, 1921–2012), the "artist-reporter" who covered the news from spacecraft landings to the trial of the killers of Emmett Till, a catalyst for the civil-rights movement; and Alan E. Cober who crafted a frightening beauty in his drawings of inmates, the institutionalized, and the elderly. Most recently, reportage and courtroom artist Janet Hamlin, along with her editorial and picture book work, has covered the tribunals in Guantanamo Bay, Cuba, as the most active courtroom artist from 2006 to present.

Figure TB51.1
Victor Juhasz, on-location sketch, published in *GQ* online, July 2012. Ink on paper. Medics tend to a man wounded by an improvised explosive device (IED), Kandahar Province, Afghanistan, August, 2011.

Courtesy of Victor Juhasz

Stylistic Diversity in the Contemporary Context

From the 1960s to the 1980s, Postmodernist artists began reviving and repurposing visual styles of the past and borrowing from subcultures, and illustrators were doing much of the same. Associated with the California art scene, artists working in **Lowbrow** or **Pop Surrealism** appropriated local popular culture forms and influenced commissioned illustration art, eventually redefining what was acceptable in illustration in the 2000s and after.

Lowbrow, Pop Surrealism, and Illustration Brut

All three of these labels share certain characteristics, yet represent vastly different imagery. Opinions differ on whether the terms *Lowbrow* and *Pop Surrealism* are interchangeable. *Lowbrow*, which contrasts with *highbrow* or elite culture, is a term originating in 1979 when artist Robert Williams (American, b. 1943) titled his book *The Lowbrow Art of Robert Williams* in reaction to established highbrow art venues that would not accept his work. Lowbrow includes any expression of popular culture widely considered taboo, tasteless, offensive, or even illegal by polite mainstream standards, with cultural roots often originating in popular illustration, underground comix, punk music, erotica, kitsch, surfer, and hot-rod subcultures (*see Chapter 19, Theme Box 40, "Greenberg: Avant-Garde and Kitsch"*). Lowbrow developed concurrently with Northern California street art and early aspects of the **DIY** (do-it-yourself) movement.

The term *Pop Surrealism* was coined by the Aldrich Contemporary Art Museum for its 1998 eponymous exhibit. Steven Henry Madoff in *Artforum International*, October 1998, described this genre as the "marriage of Surrealism's dream-laden fetish for the body eroticized and grotesque, and Pop Art's celebration of the shallower, corrosively bright world." Pop Surrealist imagery uses similar sources to Lowbrow, yet the result is quite different, with Pop Surrealists relying more on the subconscious (Figure 27.16).

Another and vastly different example of Pop Surrealism influence and an artist borrowing from past visual culture is Camille Rose Garcia (American, b. 1970), who in her gallery art uses nostalgic iconography that appropriates cartoon references from Walt Disney (American, 1901–1966) and Max Fleischer (Polish, 1883–1972) (Figure 27.17). She subsequently moved into illustrating children's literature for a decidedly adult audience—a market that later expanded in the twenty-first century.

Among the new aesthetic approaches of the late 1990s was an influx of naïve art and **Illustration Brut**—derived from "art brut," a moniker applied to fine art created outside the aesthetic and social boundaries of polite culture. These works reflected reverse standards of beauty, were visually and culturally influenced by visionary artists, and were sympathetic to the emerging DIY or "maker" movement with its interest in self-expression, authenticity, and related self-publishing efforts of the 1980s and '90s such as alternative comics and 'zines (*see Chapters 26 and 29*).

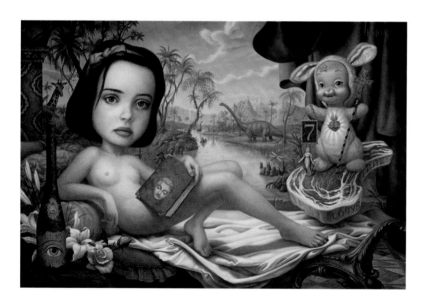

Figure 27.16
Mark Ryden, *Snow White*, 1997. Oil on canvas, 48 × 72".
This image appeared in Ryden's debut exhibition *Meat Show* at the Mendenhall Gallery in California. Influential in illustration, Ryden's finely rendered paintings bring his subjects to life, as in this example in which Snow White is provocatively surrounded by ancient, mystical, and kitsch objects, with a distant landscape that includes a giraffe and dinosaurs. While his references to classical art are clear, Ryden's ever-present cuts of meat and references to religious iconography and scripture add to the mystery. For instance, the inclusion of the number seven, referenced frequently in the Bible, is also the number of dwarves in the fairy tale.

Courtesy of the artist.

Figure 27.17
Camille Rose Garcia, *The Magic Bottle*, book cover, 2006. Acrylic on wood panel with oil-based top coat.
Garcia's self-authored graphic novel is a story about the loss of the natural world due to ecological mistakes. Her images materially reference the visual surface of cel animations, with dripping backdrops. The figures are drawn with a heavy use of black that gives the image weight. Garcia's later work uses a brighter, almost saccharine color palette and an even greater intensity of detail.

© Camille Rose Garcia.

Characterized by appropriation of mainstream advertising and cultural ephemera, the output of artists active in the 1990s, known as the Beautiful Losers, developed from their passion for making art as a lifestyle rather than as a profession. Certain artists of the group manipulated principles of rhetoric and design, ironically referencing familiar icons to address social issues such as consumerism, homelessness, youth despair, and urban decay.

Margaret Kilgallen (American, 1967–2001) was among the most recognizable and beloved members of the Beautiful Losers. The emotional honesty and the self-taught aspects of her work—inspired by street vernacular, folk art, and signage—had a deep influence on illustration. Ten years after her untimely death, a detail of her image of a woman in profile wearing a bathing cap with a number 10 within a star was used on a *Juxtapoz* cover as a companion issue to the first major institutional retrospective of street art, Art in the Streets, at the Museum of Contemporary Art, Los Angeles in 2011. Other notable Losers include Geoff McFetridge (Canadian, b. 1971) and Barry McGee (American, b. 1966), Kilgallen's husband.

Certain artists identified as Losers found popular success through the high visibility of their political street art and were paradoxically hired by design firms and agencies to create advertising, posters, and apparel. As an artistic force, the Beautiful Losers' acceptance into the halls of mainstream commercial imagery allowed illustrators less interested in traditional aesthetic directions to get published. Many emerging practitioners emulated these self-trained artists, who were eventually epitomized in the 2008 documentary film *Beautiful Losers Contemporary Art and Street Culture* (and later book). Overall, their aesthetic and social attitudes helped change the public's perception of artists as social/political agents, and illustrators' sense of creating meaning.

In other examples of stylistic diversity, Christian Northeast (British, Canadian, b. 1967) appropriates and deconstructs ephemera from the nineteenth to mid-twentieth centuries as fodder for his elaborate collages, while Sara Fanelli (Italian, British, b. 1969) utilizes vintage ephemera, textures, and lettering that carry strong narrative potential (Figure 27.18). Fanelli simultaneously reveals and obscures the origins of the elements she uses in compositions that celebrate the beauty of found materials.

Figure 27.18
Sara Fanelli, Children's Books issue of the *New York Times Book Review*, cover, 2001. Fanelli's imaginary worlds involve a collaged combination of raw and vintage materials (some scanned and enlarged) and hand work. Fanelli simultaneously reveals and obscures the origins of the elements she uses in compositions that celebrate the beauty of found ephemera.

© 2001 Collection of the artist.

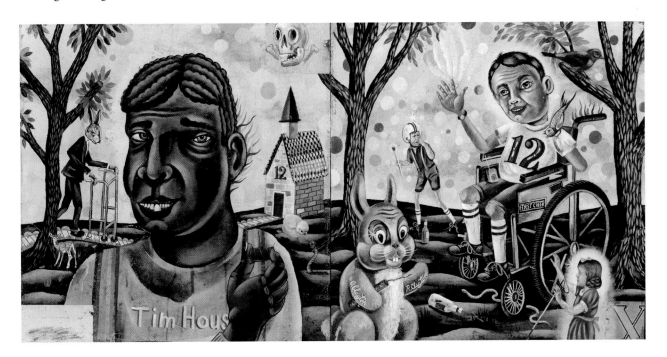

Figure 27.19
Clayton Brothers, *A Wonderful Place to Live (In Green Pastures)*, cover art, *Blab 12*, Fantagraphics, 2001. Mixed media acrylic on wood panel, 16 × 32", 2001. This Clayton Brothers painting appeared in the exhibition *Green Pastures* at La Luz de Jesus Gallery and on the cover of *Blab*, the cutting-edge annual edited by Monte Beauchamp that began in 1986. The image, wrapping the front and back cover, shows a bucolic scene filled with disturbing and awkward vignettes that mash up scale, mood, and iconography, evoking Surrealist sensibilities. The painting collages tonally rendered figures against a background with flattened perspective.

Collection of John Purlia.

Gallery Trends and Illustration

Made specifically for display, images illustrating alternative and subcultural themes permeated galleries such as La Luz de Jesus in Los Angeles; while the magazine *Juxtapoz* (1994), edited by Robert Williams, helped direct and grow the California gallery movement. *Juxtapoz* and the galleries provided a forum for illustrators seeking more personal expression in their commissioned work. Some artists associated with the gallery or the magazine resisted the label of "illustrator" despite accepting commissions, whereas others in the illustration field found these environments to be inspirational to creative work that departed from narrative realism. The codes and messages they shared— sometimes random, sometimes personal—sought to reject the intellectual elitism associated with modernism as well as the sometimes heavy-handedness of art direction. The diversity of subjects and resistance to codified avenues of expression, especially work previously deemed aesthetically beautiful or appealing, defined the interests of many artists working at this time. The Clayton Brothers exemplify this trend (Figure 27.19).

Figure 27.20
Barbara Nessim, *The Gift*, 1984. Digital print, 24 × 30".
Nessim was one of the first illustrators to integrate digital tools into her commercial assignments. Such work—created on an NEC PC 100 and printed on a JetGraphic 3000—was highly experimental. Though crude by today's digital tool standards, it shows vibrancy in color and line, and in its day appeared revolutionary and fascinating, as the digital frontier was just opening up. Commissions using Nessim's digital approach came later as art directors warmed up to the change.
Courtesy of Barbara Nessim.

Digital Revolution

In the 1990s and 2000s, illustration expanded beyond print to include digital tools and environments, and Postmodernist thinking encouraged the crossing of social and technological boundaries to create new forms in which experimentation trumped representation. A significant outcome was that the pro-photography outlook that had dominated art direction of the 1970s and '80s gave way to a new pro-illustration era in the '90s, one that favored comingling traditional, digital, and web-based media (*see Chapter 29*). This gave makers greater license to move beyond traditionally created illustration as it was understood at the time.

The opportunity to connect, reconnect, or disconnect applied art practices such as apparel or toy making with illustration expanded experimentation and redefined what it meant to be an illustrator. No longer were illustrators kept to the domain of the page or to the parameters of commissions as the impetus for illustrating. This change aided in reconfiguring the traditional client-artist-user workflow, putting authorship into the hands of the illustrator. Practitioners could rethink where and how their work could be published, and consider how dimension, movement, and scale could be used.

As prior chapters indicate, each new technology has had its own unique impact on art production; the impact of the desktop computer and peripherals has been likened to that of moveable type (*see Chapter 24, Theme Box 46, "McLuhan: Media Theory"*). As the first commercially viable computer with a user-friendly graphical user interface (GUI) and a mouse, the **Apple Macintosh** introduced in 1984 preceded other visually oriented platforms such as the **Commodore Amiga** and **Microsoft Windows 1.0** (both in 1985). The Apple Macintosh sparked a change in the design field by making page layout and desktop publishing possible with bundled software: **MacDraw**, a vector-based drawing application, and **MacPaint**, a bitmap-based graphics painting program. The computer hardware and software applications had a direct effect on the image-making process of illustration, yet it wasn't until the launch of **Adobe Illustrator** (1986) and **Adobe Photoshop** (1988) that digital applications entered the "toolbox" of many illustrators. These applications offered the ability to digitally create an image; to augment one created with traditional materials; or to prepare one for transmission over the web, accelerating the delivery of a commissioned piece. Misperceptions concerning the quality of work that would come from these new tools as well as arguments about whether computers would cause the end of traditional illustration persisted, with many insisting that no one would draw again if these machines were allowed into the studio or classroom. Despite the general acceptance of digital tools in design practice, traditional media illustrators remained ambivalent or felt threatened.

Barbara Nessim (American, b. 1939) is a pioneer in using computers to generate drawings and collages as illustrations. In 1982, Nessim was invited to be artist-in-residence at Time Inc.'s Video Information Services

division (TVIS), where she was able to experiment with their computers freely (TVIS closed in 1984). The years 1986–1996 are considered **The Paint Box Era** (or Phase Two) of digital art history because drawing software that did not require programming was readily available. Nessim's first digital illustration commission was for *BYTE* magazine (vol. 9, no. 10) in September 1984 (Figure 27.20). The strong graphic qualities of early digital tools suited Nessim's dominant linework and flat color sensibility while providing an exciting medium with which she could expand her artistic repertoire.

Braid Media Arts (1975; currently Braid Art Labs), a studio collective originally composed of Rick Berry (American, b. 1953), Darrel Anderson (American, b. 1953), and Phil Hale (American, b. 1963), became one of the most influential groups in science fiction and fantasy illustration (*see Chapter 22*). Within the genre of fantasy illustration, Rick Berry is known for making the first digitally "painted" book cover for author William Gibson's (American, Canadian, b. 1948) seminal 1985 cyberpunk novel *Neuromancer*. At that time, there was no commercially available software, so unlike Nessim, who drew solely with digital tools, Berry started with a physical painting and collaborated with programmers at Massachusetts Institute of Technology's Machine Architectural Group to digitally enhance it. In keeping with the dark mood of the narrative, the digital effects Berry attained by working with engineers at MIT were indeed otherworldly for viewers in 1985.

While pursuing disparate aesthetic approaches and subject matter, members of Braid Media Arts frequently collaborated, working over and with each other's creations and making use of emerging digital technology as well as traditional oil paints and inks. Braid's cofounder Darrel Anderson became a 3-D digital art pioneer who created many of his own software tools, including the program GroBoTo, an application used by digital artists who seek a user-friendly way to accelerate the **3-D modeling** process. As the collective "Braid," and as individuals, Berry, Hale, and Anderson developed and hybridized forms of digital art practice that continue to powerfully influence illustration, concept art, and digital design.

Conclusion

Through the last decades of the twentieth century, illustrators gained a hitherto unknown position of authorship over their creative work. The opening up and cross-pollination of traditional markets and dissolution of discipline boundaries liberated practitioners to explore new directions in their editorial art, picture books, self-published 'zines, surface design, and concept art for films and gallery-specific works. As a result, market hybridization became inevitable. The development of conceptual editorial work, the influences of Lowbrow on notions of beauty, and the introduction of digital tools into the field had enormous impact on how illustrators make and how audiences perceive illustration.

The general availability of digital tools and development of supporting digital environments accelerated illustrators' timelines and delivery of projects. New digital tools also challenged traditionalists' thoughts about what skills were appropriate and offered experimental avenues for those willing to explore them. Entering the twenty-first century, questions concerning the effects of digital technology, evolving aesthetics, and social concerns would appear, including use of the web and social media, which would take illustration practice into uncharted territories and create exciting possibilities within the field.

KEY TERMS	
3-D modeling	MacDraw
Adobe Illustrator	MacPaint
Adobe Photoshop	Microsoft Windows 1.0
Apple Macintosh	Op-Art
Commodore Amiga	Op-Ed
conceptual illustration	The Paint Box Era
deconstruction	Pop Surrealism
DIY	Postmodern
fax machine	poststructuralism
Illustration Brut	structuralism
Lowbrow	

28

Medical Illustration after Gray's *Anatomy*: 1859– Early 2000s

David M. Mazierski

Gray's *Anatomy* (1858) (*see Chapter 10*) initiated a new phase in the cultural position and professional practice of medical illustration. Advances in medicine and the life sciences, geopolitical events, and revolutions in culture, education, and communication technologies have further altered and expanded the audiences, venues, media, purposes, and conventions of this branch of illustration.

The European Tradition in Anatomical Illustration after Henry Gray

In the late nineteenth and early twentieth centuries, human anatomy texts created in Germany and Austria were the most important reference books of their kind. Germanic universities were home to many new scientific discoveries and innovative research programs during this period. Advances in the reproduction of halftone illustrations also contributed to the success of these works, with artwork rendered almost entirely in black watercolor wash. Unlike previous anatomy texts, in which illustrations supported extensive textual descriptions, these anatomical **atlases** relied on images as their primary mode of communication. They presented anatomy in systemic fashion—that is, organized by organ systems, beginning with the skeleton, then proceeding to the joints and ligaments, muscles, viscera, and circulatory and nervous systems.

Handatlas der Anatomie des Menschen was authored by Dr. Werner Spalteholz (German, 1861–1940) at the University of Leipzig (Figure 28.1). The principal illustrator was Bruno Héroux (German, 1868–1944), a fine artist known for his etchings and bookplates. He prepared between six hundred and seven hundred halftone anatomical illustrations, and many anatomists referred to the publication as the best illustrated atlas of its day. Sadly, the original illustrations and printing plates were destroyed in the wartime bombing of Leipzig on December 4, 1943. Later editions of the atlas contain images reproduced from pre-war printed halftones and do not reflect the freshness and detail of the original art.

Another textbook was written by Dr. Johannes Sobotta (German, 1869–1945) at Würzburg. *Atlas der deskriptiven Anatomie des Menschen* also featured black-and-white halftones, some with color added to identify important structures. The principal illustrator was Karl Hajek, about whom little is known. Subsequent editions included color watercolor paintings by Erich Lepier. The atlas is still in print in a number of languages (Figure 28.2).

The high point of the European anatomical tradition was the four-volume, seven-book series *Topographische Anatomie* by Dr. Eduard Pernkopf (Austrian, 1888–1955) produced at the University of Vienna from 1928–1945 and 1948 to 1955. The rich, painstakingly detailed watercolor illustrations were the work of a team of four principal artists: Erich Lepier (Austrian, 1898–1974), Ludwig Schrott (Austrian, 1906–1970), Karl Endtresser (Austrian, 1903–1978), and Franz Batke (Austrian, 1903–1983).

Lepier and Schrott were informally trained technical artists, while Endtresser and Batke had studied at the Vienna Academy of Fine Arts. During the twenty-seven years of production, other illustrators contributed to the over eight hundred figures, including Batke's wife Josefine Batke-Köller (Austrian, 1897–1967) and Schrott's father. Pernkopf died in 1955 and colleagues Werner Platzer (Austrian, b. 1929) and Alexander Pickler compiled the last two books. In 1963, the publisher, Urban & Schwarzenberg, removed the text and published the work as a two-volume set of labeled artworks. While comprised of some of the most beautiful medical illustration ever created, the work is marred by Pernkopf's association with the Nazi Party as well as the inclusion of the *hakenkreuz* (swastika) in some of the artists' signatures (removed in later editions), and the uncertain provenance of cadavers dissected at the Anatomy Institute of the University of Vienna during the war. Due to ethical concerns regarding its controversial origin, the books are now out of print, and their publisher no longer licenses the use of the images. Postwar illustrations by Lepier appear in later editions of the Sobotta atlas and

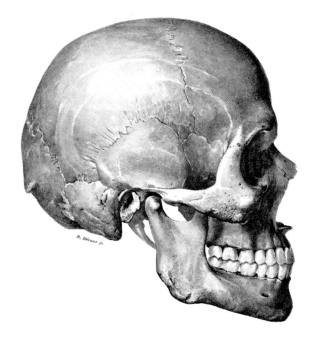

Figure 28.1
Bruno Héroux, lateral view of the human skull, *Handatlas der Anatomie des Menschen* by Werner Spalteholz, 1890. Black watercolor wash. Subtle anatomical details are visible through use of the full tonal range. In the preface to the first English edition, Spalteholz emphasized that mechanical halftones were used because they reproduce the original drawings more accurately than woodcut.
Hirzel Verlag.

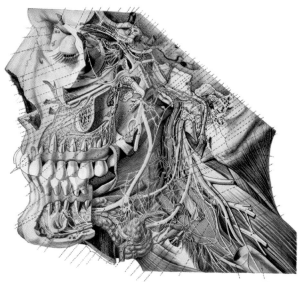

Figure 28.2
Karl Hajek, cranial portion of the autonomic nervous system, *Atlas der deskriptiven Anatomie des Menschen* by Johannes Sobotta, 1904. Black watercolor wash with mechanical color overlay. The many leader lines visible in this illustration indicate the extensive labeling, characteristic of atlases in this period.
Elsevier.

Anatomy: A Regional Atlas of the Human Body by Dr. Carmine Clemente (American, b. 1928) (Figure 28.3).

The European atlases were the most widely used and respected anatomical references in the early twentieth century. However, their systemic approach was not applicable to the process of dissecting the body, which proceeds from superficial to deep structures on one region at a time. Furthermore, the multivolume format made buying the books a prohibitive expense for medical students, and forced anatomists to flip through multiple books during dissection.

Medical Illustration in North America: Formal Training and Professionalization

Before 1911, there were no formal training programs for medical or scientific illustrators anywhere in the world. Most medical illustrators were artists with a profound scientific interest or a working relationship with a scientist, such as the anatomist Govard Bidloo (Dutch, 1649–1713) and the illustrator Gerard de Lairesse (Dutch, 1641–1711) (*see Chapter 10*). Occasionally, the author/scientist was the illustrator, such as Ernst Haeckel (German, 1834–1919) (*see Chapter 9*). Some scientists, who were the first witnesses to the phenomena they observed, had to visually document their research—microscopist Robert Hooke (English, 1635–1703) (*see Chapter 9*) is one. Rarely, an illustrator shared equal knowledge and authority with the author, as did anatomist Henry Gray and the anatomist/illustrator Henry Vandyke Carter (English, 1831–1897)

(*see Chapter 10*). In all cases, it was critical that the illustrator thoroughly understood the subject being depicted because simple observational drawing was not sufficient to produce accurate, didactic figures.

This philosophy guided Max Brödel (German, 1870–1941), the "father" of modern medical illustration, who founded the first academic program for medical illustrators and raised the practice to a profession in its own right.

Brödel trained for six years at the Academy of Fine Art in Leipzig and created illustrations for physiologist Carl Ludwig and anatomists Wilhelm His and Werner Spalteholz. Brödel's meticulous work caught the attention of Drs. William Welch and Franklin Mall, physicians from Johns Hopkins University who were working in Ludwig's lab. They brought Brödel to Baltimore in 1894 to work for them. At Hopkins, Brödel perfected his signature techniques: carbon dust (carbon pencil drawing on textured chalk or calcium-coated board, with midtones blended with soft flat brushes dipped into carbon dust produced by sharpening pencils on sandpaper) and pen and ink (with linework reflecting his early training as an engraver) (Figures 28.4 and 28.5).

In 1911, Brödel became the first Director of Art as Applied to Medicine at Johns Hopkins University, the world's first formal medical illustration program. Ten years later, Tom Jones (American, 1885–1961) established a second program at the University of Illinois (Figure 28.6). Jones studied fine art before collaborating with anatomists at the University of Illinois College of Medicine. He illustrated Albert C. Eycleshymer and Daniel M. Schoemaker's *A Cross-Section Anatomy* (1911),

Figure 28.3
Erich Lepier, Figure 573: anterior dissection of the mid-thoracic vertebral column, spinal cord and prevertebral structures, in *Anatomy, A Regional Atlas of the Human Body* by Carmine Clemente, ca. 1950. Reproduced in Urban & Schwarzenberg, 1987. Color watercolor on hot press board. Lepier's painting demonstrates the high level of technical expertise and detail achieved by German and Austrian anatomical illustrators in the mid-twentieth century.

Elsevier.

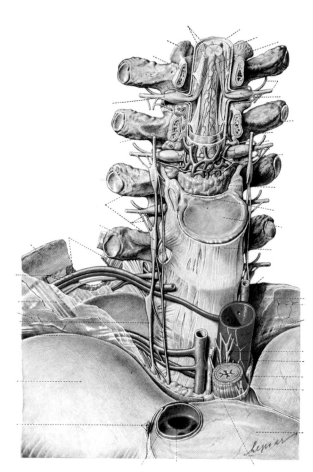

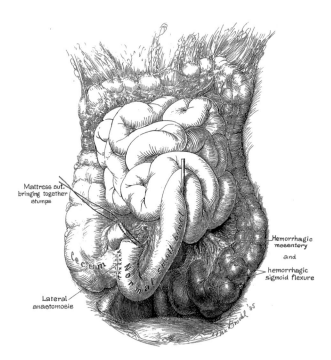

Figure 28.4
Max Brödel, general view of the abdominal viscera after operation, in "Intestinal Obstruction Due to a Hole in the Mesentery of the Ascending Colon," *Journal of the American Medical Association*, no. 106, pp. 895–898, 1914. Reproduced in T. S. Cullen, 1936. Pen and ink on Ross smooth scratchboard.
Brödel's fluid and descriptive linework demonstrate his expertise in engraving techniques.
Collection of the Max Brödel Archives, in the Department of Art as Applied to Medicine, The Johns Hopkins University School of Medicine.

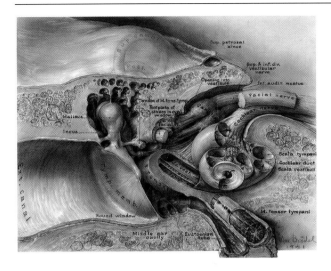

Figure 28.5
Max Brödel, anatomy of the middle and inner ear, 1941; published in *Three Unpublished Drawings of the Anatomy of the Human Ear* by Max Brödel, 1946. Carbon pencil and dust on Ross stipple board.
Nuances of texture, volume, and spatial relationship are critical in anatomical depictions of this type.

Collection of the Max Brödel Archives, in the Department of Art as Applied to Medicine, The Johns Hopkins University School of Medicine.

coauthored and illustrated Eycleshymer's *Hand-Atlas of Clinical Anatomy* (1925), and coauthored *A Manual of Surgical Anatomy* (1942) with fellow illustrator Willard C. Shepard (American, 1886–1975). His delicate black watercolor wash renderings and pen-and-ink drawings are looser in style than Brödel's (Figure 28.7). Most North American medical illustrators can trace their artistic lineage back to either Brödel or Jones. A number of Brödel's graduates went on to found medical art programs: Muriel McLatchie Miller (Boston, 1941), Lewis Waters (Dallas, 1945), Maria Wishart (Toronto, 1945), Mary Maciel (Cincinnati, 1947), Jack Wilson (Augusta, 1948), Natt Jacobs (Rochester, NY, 1948), and Ralph Sweet (San Francisco, 1952) (Figure 28.8), which points to the rapid growth of the profession and the rising importance of images for education and advertising in the medical market after World War II.

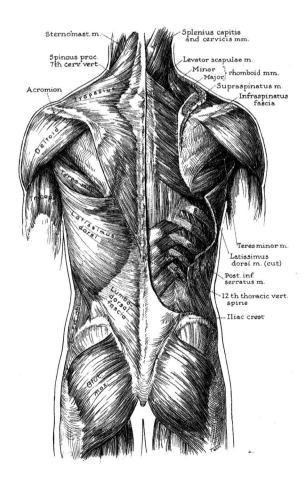

Figure 28.6
Tom Jones, muscles of the trunk, posterior view, ca. 1942; published in *A Manual of Surgical Anatomy* by Tom Jones and Willard C. Shepard, p. 38, 1945. Pen and ink.
Jones is called the "father" of *modern* biomedical communications for his embrace of multimedia, such as exhibits, motion pictures, transparencies, models, audiotapes, and television.

Elsevier.

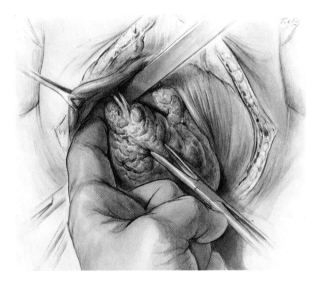

Figure 28.7
Tom Jones, illustration in "Technique of Thyroidectomy" by Arthur E. Hertzler, M.D., *American Journal of Surgery*, vol. 42, issue 2, p. 468, November 1938. Black watercolor wash on illustration board.
Jones's loose, luminous wash drawings provide a tonal counterpoint to the carbon dust illustrations of Brödel and his students.

Image courtesy of the University of Illinois at Chicago.

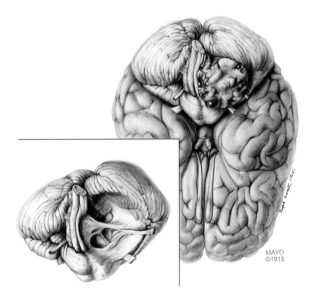

Figure 28.8
Ralph Sweet, ventral view of the brain demonstrating a cerebellar tumor, and the post-surgical view after the tumor is removed, 1915. Carbon dust on calcium-coated board.
In this illustration, we see the convention of adding an inset to provide supplementary visual information.

Image courtesy of the Mayo Clinic.

Founding of the Association of Medical Illustrators

In 1944, a group of medical illustrators led by Jones and Muriel McLatchie Miller (Canadian, 1900–1965) decided to form a professional organization. Their inaugural meeting in Chicago the following year attracted thirty delegates, including Elizabeth Brödel, Max's daughter—a Hopkins graduate. As of 2016, the Association of Medical Illustrators (AMI) has over five hundred members from around the world.

Another AMI founder and Hopkins graduate was Ralph Sweet (American, 1892–1961), who worked at the Mayo Clinic and later at the University of California, Berkeley. Noted for his inventive, lively pen-and-ink illustrations, he was talented in tonal and color media as well.

Dorcas Hager Padget (American, 1906–1973), not unlike Brödel, was a medical illustrator who, without any formal training in scientific research, was recognized for making significant contributions to medicine. She is best known for carbon dust illustrations created for neurosurgeon Dr. Walter E. Dandy, and her research into the development of the intracranial arterial system and neuropathology (Figure 28.9). She authored or coauthored twelve peer-reviewed papers in neuroscience and embryology, a remarkable achievement for a woman without formal medical training in what was then the male-dominated world of scientific research. Her success

may be attributed to her exceptional deep knowledge, acute observational skills, and critical attention to detail as a medical illustrator.

Medical Illustration in Canada: *Grant's Atlas* and a Conceptual Re-framing of the Anatomy Atlas

German anatomy books were not available to North American medical schools during World War II. The opportunity to fill this void was seized by anatomist John Charles Boileau Grant (Scottish, 1886–1973). Grant moved to Canada after World War I and taught anatomy at the Universities of Manitoba and Toronto. He envisioned an atlas that would present human anatomy organized by body region in one volume. The key innovations of *An Atlas of Anatomy* (known in later editions simply as *Grant's Atlas*) sprang from the need for it to function as an aid to dissection (Figure 28.10).

Whereas European atlases were organized by organ system (e.g., skeletal, circulatory), Grant's book was organized by region (e.g., thorax, abdomen); and the illustrations depicted anatomy from superficial to deep structures, consistent with cadaver dissection. In addition, European atlases depicted "typical" anatomy synthesized from observations of numerous specimens, while Grant's artists illustrated individual specimens, including atypical or unusual features, to better prepare students for encountering anomalies in the dissecting room or operating theater. The original dissections are available for study in the University of Toronto's Faculty of Medicine. Students can juxtapose the illustrations directly with their source material, reducing the confusion caused by comparing "messy" cadaver dissection with the synthetic, idealized anatomy presented in other contemporary atlases.

Grant's principal artist was Dorothy Foster Chubb (Canadian, 1908–2002), who worked primarily in carbon dust. Rather than draw on the calcium-coated papers used by Brödel, Chubb drew on a more durable and forgiving (but slightly coarser) cold-press illustration board, which worked well with her loose, textured drawing style (Figure 28.11). Chubb was one of a number of Canadian women—including Eleanor Sweezey (1915–2007), Eila Hopper Ross (1913–2000), Maria Wishart (1893–1983), Nancy Grahame Joy (1920–2013), and Elizabeth Blackstock (1911–2009)—who shaped the history of medical illustration in Canada.

Postwar Medical Illustration

Frank Netter (American, 1906–1991) became synonymous with late twentieth-century medical illustration in North America. He studied commercial art at the National Academy of Design and the Art Students League of New York, but family pressure convinced him to study medicine; he completed his degree at New York University just as the Great Depression began. Unable to make a living running a private clinic, Netter turned to freelance illustration to supplement his income, and soon gave up medicine

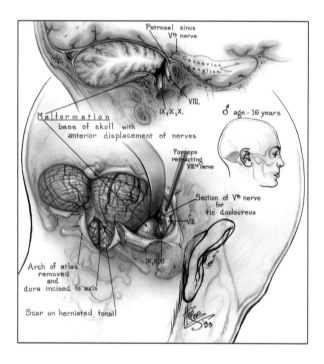

Figure 28.9
Dorcas Hager Padget, congenital deformation at the base of the skull, altering position of the trigeminal nerve in a young patient, in "Concerning the Cause of Trigeminal Neuralgia" by Walter E. Dandy, *American Journal of Surgery*, vol. XXIV, no. 2, p. 453, ca. 1934. Carbon pencil on paper.
Padget uses transparency to communicate crucial anatomical relationships. The innermost structures—the cranial nerves and brain tissue—are fully rendered; the skull is "ghosted in"; and external anatomy, necessary for orientation, is shown using simple but beautifully weighted linework.

Original illustration # III-14-6 in Dandy/Padget Collection of the Max Brödel Archives, in the Department of Art as Applied to Medicine, The Johns Hopkins University School of Medicine.

altogether after receiving several lucrative commissions from pharmaceutical clients. In 1936, he began a lifelong career association with the CIBA Pharmaceutical Company. The fresh, vivid watercolor and gouache illustrations he created for the company's Clinical Symposia publications became so popular with physicians that they

were compiled into thirteen books published between 1948 and 1988, and an anatomy atlas targeted to allied health students in 1989 (Figure 28.12). Netter was incredibly prolific, creating almost four thousand illustrations during his fifty-year career, or approximately one researched and rendered illustration every three business days.

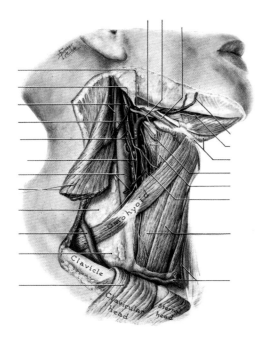

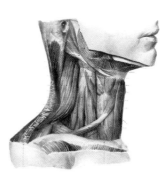
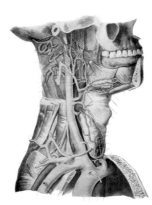
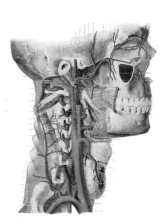

Figure 28.10a–e
Dorothy Foster Chubb, illustration in *An Atlas of Anatomy* by John Charles Boileau Grant, 1943 (a); and Bruno Héroux, illustrations in *Handatlas der Anatomie des Menschen*, 1890 (b–e).
Chubb's illustration (a) demonstrates J. C. B. Grant's approach to regional anatomy. A student performing a neck dissection would have to refer to four separate illustrations in the Spalteholz atlas (b–e) versus the one *Grant's Atlas* figure based on actual dissection (a).

a: Wolters Kluwer; b–e Hirzel Verlag.

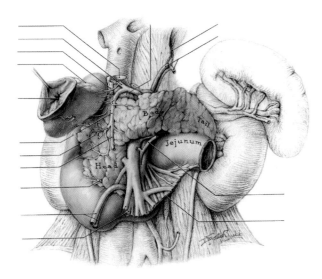
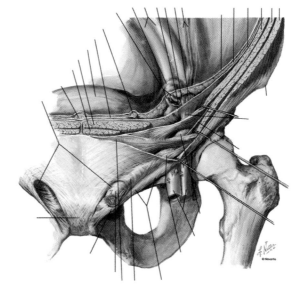

Figure 28.11
Dorothy Foster Chubb, pancreas and duodenum *in situ*, in *An Atlas of Anatomy* by John Charles Boileau Grant, 1943. Carbon dust and white gouache on cold-press illustration board.
Organs at the focal point of this illustration are fully rendered in continuous tone; surrounding structures, executed in lower-contrast linework, provide context without competing for attention.

Wolters Kluwer.

Figure 28.12
Frank Netter, Plate 245, inguinal canal and spermatic cord, in *Atlas of Human Anatomy* by Frank Netter, 1989. Color watercolor, gouache, and airbrush.
The complex architecture of this region is explained visually by use of saturated, clearly differentiated colors (including conventional blue veins and red arteries) and a physical separation of the layers forming the inguinal canal.

Elsevier.

Other medical artists found markets in the rapid mid-century growth of pharmaceutical research, branding, and advertising. Pharmaceutical and medical-device manufacturers sought to engage physicians and associate themselves with scientific research and education; accurate medical illustrations with superb production values were a means to achieve this. One notable genre of promotional publication between 1940 and 1960 was the "anatomical transparency"—layered sequences of illustrations, printed on transparent sheets, that enabled the viewer to visualize successive anatomical layers with each page turn. Gladys McHugh (American, 1895–1979), a Hopkins graduate, produced beautiful examples of such illustrations in *The Eye in Anatomical Transparencies*, published by Bausch & Lomb in 1943 (Figure 28.13). It contains thirty-two separate plates that layer together to form two detailed, sequential dissections of the eye and orbit.

Gerald P. Hodge (American, 1920–2012) was a fine artist and a 1949 graduate of Johns Hopkins. After fifteen years of illustrative work, he chaired a graduate program in scientific and medical illustration at the University of Michigan at Ann Arbor, which ran from 1964 to 1999. Hodge was known for surgical illustration in pen and ink and carbon dust, and for his color paintings of the retina (Figure 28.14); he was also a member of the Guild of Natural Science Illustrators (GNSI) and conducted workshops at AMI and GNSI meetings up until his death. Hodge's passion and mentorship were notable: five of the six accredited medical illustration programs were directed by his former students.

Peter George Cull (British, 1927–2012) was a prominent medical artist in the United Kingdom. He trained as a commercial artist and then apprenticed in medical art at Guy's Hospital in London. Cull illustrated gorilla pathology, forensic evidence, human anatomy (Figure 28.15), and surgery, using a variety of mixed media that reflected his wide-ranging interests, talents, and experiences. He was awarded for his contributions to medical art and education in Great Britain, and appointed

Figure 28.13
Gladys McHugh, successive layers of the anterior view of the eye, in *The Human Eye in Anatomical Transparencies* by Peter C. Kronfeld and Gladys McHugh, Bausch & Lomb Press, 1943. Gouache.
Layered, transparent pages allow the viewer to visualize "virtual dissections," anticipating digital virtual anatomy tools by over half a century.

Image courtesy Bausch & Lomb.

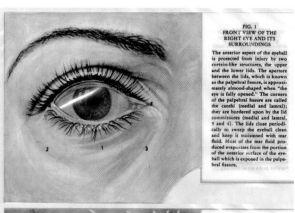
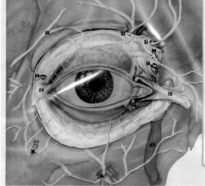
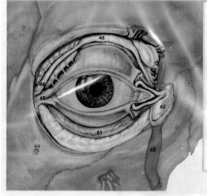
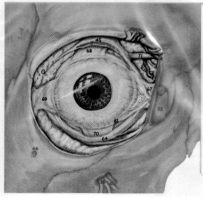

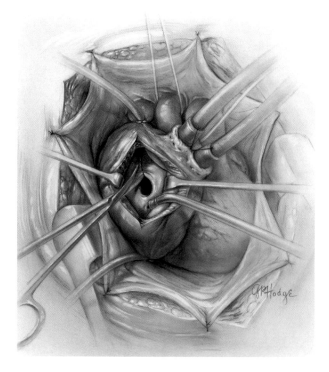

Figure 28.14
Gerald Hodge, surgical repair of septal defect, 1961. Carbon dust on clay-coated paper.
Illustration is crucial in communicating surgical procedures because it clarifies the relationships between structures of similar color and texture, removes visual "noise" created by blood and nonessential tools, and narrows focus. Here, salient features are depicted with increased contrast and detail.
Biomedical Communications, University of Toronto.

professor of medical art at London University (the only chair in medical art in Europe). Cull was instrumental in forming the Institute of Medical and Biological Illustrators (currently the Institute of Medical Illustrators) in the UK in 1967.

Bill Andrews (American, b. 1956) continues to influence the style of contemporary medical illustration in North America. Andrews received his MA in Biomedical Communications from the University of Texas Health Science Center at Dallas, and has worked

at the Texas Heart Institute and the University of Texas M.D. Anderson Cancer Center, where he collaborated with world-renowned cardiac surgeon Denton A. Cooley (American, 1920–2016). During this time, Andrews developed his economical, loose line art style (Figure 28.16) as applied to hundreds of surgical illustrations, as well as his signature technique: color pencil and alkyd paint on Canson paper (Figure 28.17). Andrews became a faculty member of the Georgia Regents University Medical Illustration program in 1999.

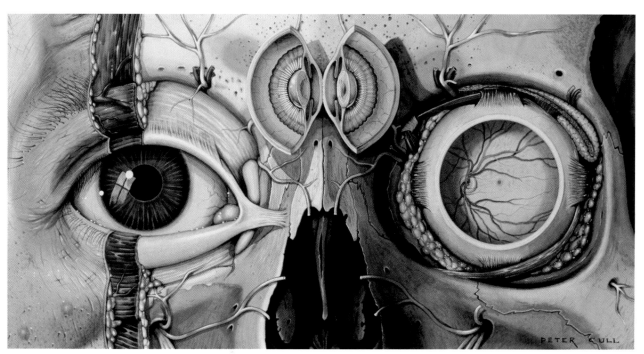

Figure 28.15
Peter Cull, dissection of the face, before 1973. Watercolor.
Cull's commercial training is evident in this striking depiction. The sequential layers of dissection demonstrate anatomical relationships around the orbit and create visual drama where the red line of the muscle layer intersects the iris. The bisected anterior portion of the left eyeball is placed on the bridge of the nose, reinforcing the near-symmetry of the composition and its powerful grid-like organization.
Peter Cull, Science Photo Library.

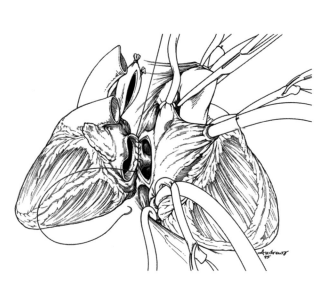

Figure 28.16
Bill Andrews, cardiac surgery, 1995. Pen and ink.
The high volume and rapid turnaround time of medical illustrations in institutional environments provided stimulus for the development of Andrews's economical linework style.
Courtesy of Bill Andrews.

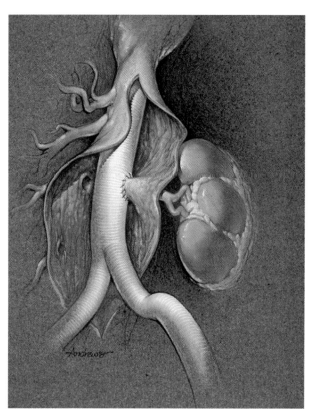

Figure 28.17
Bill Andrews, abdominal aortic graft. Prismacolor and alkyd paint on Canson Mi-Tientes paper.
Andrews's use of colored paper for the midtones of his illustration and loose handling of colored pencil and paint echo classical portrait techniques.
Courtesy of Bill Andrews.

Thieme and the Modern Anatomy Atlas

In 2005, the publisher Thieme (Leipzig) released the first book of its series, *Atlas of Anatomy*, a completely new body of work containing over three thousand figures. The illustrations, created using Adobe® Photoshop®, are the work of two prodigious artists: Karl H. Wesker (German, b. 1953) and Markus Emanuel Maria Voll (German, b. 1961). Prior to 1978, Wesker was a fine artist and exhibit designer, until he took on freelance work creating graphics for the Steglitz Clinic in Berlin, which led to further medical and scientific commissions. Since the mid-1990s he has worked for Thieme, creating thousands of full-color medical illustrations (Figure 28.18).

Voll, with training in graphic design, created computer graphics for medical and scientific publications before beginning to work with Wesker in 1992. He later returned to the university to study medicine—a not unheard-of career route for medical artists, immersed as they are, in the culture of scientific discovery and medical practice as they create their illustrations (Figure 28.19).

Medical Art in Popular Culture

Up to this point, we have examined images created primarily for recording and disseminating information by and among professionals, such as anatomists, scientists, and surgeons, or for use in education. Even anatomical illustrations commissioned by the pharmaceutical industry, while used for promotion, were framed as resources for physicians. In the twentieth century, the domain of the medical illustrator extended widely into commercial and popular realms as well. With new audiences, venues, and purposes, the range of visual languages embraced by medical artists expanded greatly.

One of the greatest modern popularizers of anatomy and physiology was Fritz Kahn (German, 1888–1968), a gynecologist, surgeon, and science writer. Kahn's passion was to make science broadly accessible, in part as a vehicle of public health promotion. To this end, he made groundbreaking use of visual metaphor to explain the workings of the human body for the layperson in books, including his five-volume *Das Leben des Menschen* (*Human Life*, 1922–1931; Figure 28.20), later updated as *Der Mensch gesund und krank* (1939, translated as *Man in Structure and Function*, 1943). Not an illustrator himself, Kahn worked closely with artists and designers to develop his concepts; some of his artists are known, whereas others remain anonymous. His vision is profoundly modern. It reflects contemporary art styles (e.g., Art Nouveau, Figure 28.20; New Objectivity, Figure 28.21) and commercial advertising; and draws heavily on metaphors from industry and technology, as in the now-iconic poster *Der Mensch als Industriepalast* (*Man as Industrial Palace*, 1926) (Figure 28.21), created under Kahn's direction by Fritz Schüler. Kahn's work introduced the metaphor of the body as industrial technology to the visual lexicon of medical illustration. When the National Socialist party came to power in 1933, Kahn was expelled from Germany and his books were burned, but his images

Figure 28.18
Karl Wesker, gluteal region and ischio-anal fossa, in *Atlas of Anatomy*, edited by A. M. Gilroy, B. R. MacPherson, and L. M. Ross, 2010. Adobe Photoshop. The contents of the Thieme atlas are organized by regions of the body, then cover the region system by system, and finally describe dissection from superficial to deep, bringing together the purely anatomical and surgical methods of teaching gross anatomy.
Thieme.

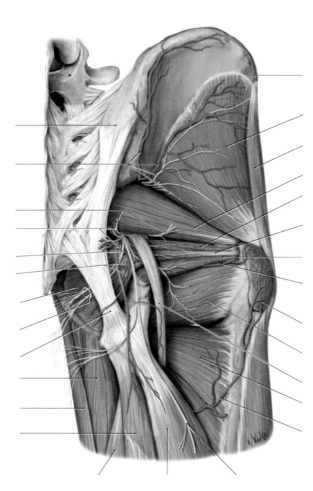

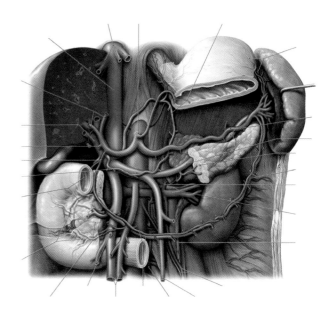

Figure 28.19
Markus Voll, portal vein: pancreas and spleen, in *Atlas of Anatomy*, edited by A. M. Gilroy, B. R. MacPherson, and L. M. Ross, 2010. Adobe Photoshop. Wesker and Voll's clean, synthetic anatomical illustrations represent a modern return to the German and Austrian traditions established in the early twentieth century.
Thieme.

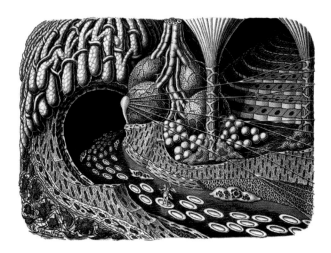

Figure 28.20
Fritz Kahn (concept), Arthur Schmitson (illustrator), "Fairytale journey along the bloodstream: Entering a gland cave with ideal cell landscape," *Das Leben des Menschen*, vol. 2, Franckh/Kosmos, 1924.
A now-widespread visual convention associated with Kahn is that of the "cell landscape": the body's microscopic structure conceived of as a three-dimensional geography within which an observer might travel.
© Kosmos/Westfälisches Schulmuseum, Dortmund.

were appropriated for use in Nazi-endorsed propaganda. He marked his work "fk©" during this time, which facilitated his efforts to re-assert ownership of his work after the war. Since the 1930s, there have been numerous remakes and interpretations of Kahn's images in all fields of illustration, reflecting the wide international, intergenerational, and interdisciplinary reception of his ideas and his ongoing influence on contemporary visualization.

A number of nonmedical artists and commercial illustrators also found themselves receiving commissions that brought them into the realm of medical illustration. Arthur Lidov (American, 1917–1990), a self-trained artist, is significant for medically themed conceptual paintings for pharmaceutical companies and popular culture magazines such as *Life*, *Time*, *Fortune*, and *The Saturday Evening Post*. Lidov moved to New York City in 1946, inspired by illustration in the realist tradition being done there. His work bridged commercial and fine art: in addition to magazine work, his paintings were exhibited at the National Academy of Art and the Museum of Modern Art. Often surreal in their figurative depictions, Lidov's strikingly original and influential illustrations were inspired by his fascination with the workings of the body, especially the brain, and were created in oil, egg tempera, gouache, resin, and mixed media (Figure 28.22).

Frank Armitage (Australian, American, 1926–2016) began his career as a mural artist. In 1952, he joined Walt Disney Studios, creating backgrounds for many of the studio's classic films, such as *Sleeping Beauty* (1959), *Mary Poppins* (1964), and *The Jungle Book* (1967), as well as designs for Disney theme parks. Although he was not a trained medical illustrator, his interest in medicine led him to audit classes at the UCLA Medical School and sketch in the Anatomy Department. He created

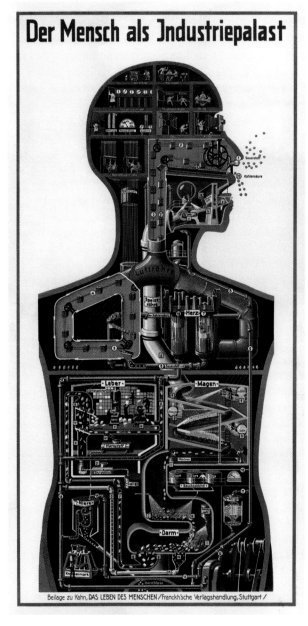

Figure 28.22
Arthur Lidov, the lungs, *Life*, December 7, 1962. Mixed media.
Lidov's elaborate visual analogies to describe the workings of the human body reference Fritz Kahn, but take the concept in a more organic, less technological direction.
Collection of the Albert Einstein College of Medicine.

Figure 28.21
Fritz Kahn (concept) and Fritz Schüler (illustrator), *Der Mensch als Industriepalast (Man as Industrial Palace)*, Franckh/Kosmos, 1926.
This chromo-lithograph poster, designed and promoted as a "splendid wall decoration for home and school," was first distributed as a supplement with the subscription edition of *Das Leben des Menschen*, vol. 3.

Wall chart, Franckh/Der praktische Schulmann, Stuttgart, © Kosmos/Westfälisches Schulmuseum, Dortmund.

production illustrations and set designs for the science fiction film *Fantastic Voyage* (1966), which received an Academy Award for Best Art Direction. Armitage went on to produce unique, atmospheric paintings of medical subjects (Figure 28.23) on sheets of acetate sandwiched between spaced glass panes for *Life* magazine, and made significant contributions to the Wonders of Life Pavilion at Epcot, the Walt Disney theme park in Florida that celebrates modern technology and international culture.

Robert Demarest (American, b. 1932) trained under Muriel McLatchie Miller (a Brödel graduate) at the Massachusetts General Hospital program from 1948 to 1951. Demarest's four-decade professional career was spent at Columbia. At the time of his retirement in 1993, he was directing a multimillion-dollar Audiovisual Center in Columbia University's Medical School with a staff of thirty, a fact pointing to the importance of visual media in medical education in the late twentieth century. He was twice president of the AMI (1967–1968 and 1988–1989); won numerous professional awards; and illustrated dozens of textbooks, research papers, and popular magazine articles for *Time, Life, Newsweek, Reader's Digest,* and *National Geographic*. In 2015, Columbia University honored his contributions by acquiring his body of work for its Health Science Library Permanent Archives. Demarest's beautifully crafted and detailed watercolor and airbrush illustrations are delicate, sensitive, and full of humanity (Figure 28.24).

From Pencils to Pixels

The advent of digital painting tools (especially Adobe Photoshop) and developments in 3-D computer graphics had a strong influence on the production and style of

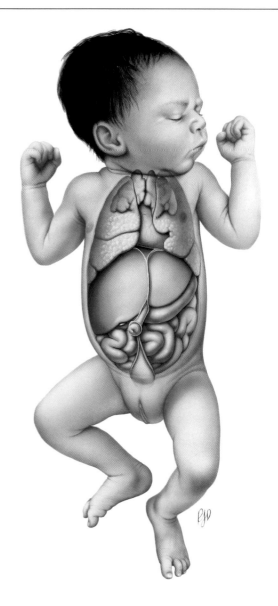

Figure 28.24
Robert Demarest, newborn female infant anatomy, ca. 1980. Color watercolor and airbrush.
This figure demonstrates considerations taken in depicting anatomy for a lay audience. In contrast to anatomical atlases, which depict the body opened to reveal its structures, the internal organs are ghosted into the form of a living, sleeping infant. The entire child is shown, rather than isolated anatomy, which further softens and humanizes the image.
Image courtesy of the artist.

Figure 28.23
Frank Armitage, bronchioles, ca. 1960. Acrylic on acetate, 26 × 26".
Atmospheric perspective and lack of recognizable scale give Armitage's paintings an otherworldly feel in this image for a pharmaceutical client.
Image courtesy of the artist's estate.

medical illustrations. Driven by pharmaceutical clients and their desire to look contemporary or "futuristic," medical illustrators turned in their watercolors and airbrushes for computer graphics software, and in some instances deliberately emulated the look of images created with radiographic and advanced **electron microscope** technologies (*see Theme Box 53, "The Electron Microscope"*). As computer graphics technology continues to evolve, animation plays an increasingly important role in medical and scientific visualization. For many medical illustrators, animation has become if not their primary medium, then an important tool in their creative repertoire.

Kirk Moldoff's (American, b. 1954) layered acrylic sculptures and later airbrush renderings draw on his background in three-dimensional reconstruction of neurological structures and a keen interest in the visual

Theme Box 52: The Visible Human Project
by David M. Mazierski

The Visible Human Project is an initiative funded by the United States National Library of Medicine to create a database of human anatomy derived from complete, sectioned male and female cadavers. Two individuals who donated their bodies to the project were frozen, scanned via MRI, and thin sectioned. The sections were photographed as they were made. The combined MRI scans and photographs can be reassembled using various software packages to re-image the entire body or specific areas of interest. The database of images is freely available through an application to the NLM. For more information, visit https://www.nlm.nih.gov/research/visible/visible_human.html.

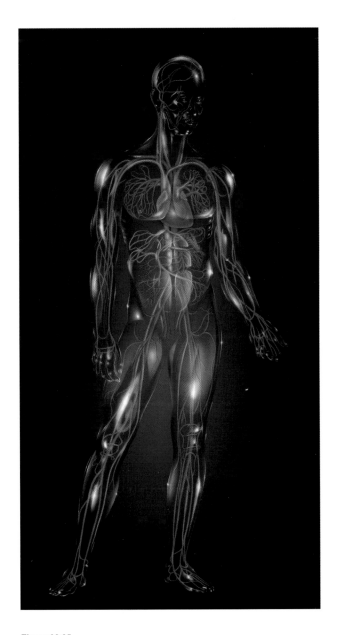

Figure 28.25
Kirk Moldoff, circulatory system, in *The Incredible Machine*, p. 118, National Geographic Books, 1985. Airbrushed acrylic on layered acetate and hot press board.
Moldoff's inspiration for the transparent man came from his experience with sculpting acrylic models.
Image courtesy of the artist.

depiction of transparency. His "Glassman" series of transparent human anatomical studies (Figure 28.25) and panoramic molecular "Macroscapes" for the National Geographic book *The Incredible Machine* brought his work to a wider audience. Moldoff has been a creative director at several New York medical animation studios, and the Society of Illustrators has exhibited his medical and pharmaceutical work.

Before the discovery of **Roentgen rays** (X-rays) in 1895, the human body was opaque, its interior made visible only by physically opening it through dissection or surgery. X-rays revealed the interior of the *living* body and allowed conceptualization of the body as a transparent organism. As a result, medical illustrators soon developed conventions to depict this transparency (Figure 28.9). Moldoff's "Glassman" epitomizes a key conceptual shift between early anatomical illustration and that of the modern era. His innovative representation of the body inspired many illustrators, and it has become a common visual trope in contemporary medical illustration.

Keith Kasnot (American, b. 1955) epitomizes the rapid evolution of medical illustration. He successfully moved from airbrush to digital painting (Figure 28.26) to

Figure 28.26
Keith Kasnot, retinal artery pathology, 1998. Adobe Photoshop and Autodesk Maya.
Selective lighting and narrow depth of field draw attention to the region of interest. This image references the intimate lighting of an endoscopic probe in a small anatomical space.
© Keith Kasnot.

3-D animation while maintaining a consistent style and expanding his professional practice. Kasnot trained at a number of art schools and graduated from the medical illustration program at the University of Texas Southwestern Medical Center, Dallas (1983). He cites the Vienna School of Fantastic Realism (*see Chapter 22*) and the background paintings of Disney animated films as important influences. His award-winning illustrations appear in *National Geographic* and have been exhibited with the Society of Illustrators in New York and Los Angeles.

David Bolinsky (American, b. 1952) and Jane Hurd (American, b. 1946) also moved from traditional media to digital production and 3-D computer graphics. However, their careers characterize the expanding role of medical illustrator into that of art director and creative director. Bolinsky (Figure 28.27) was the first medical illustrator to make the (expensive) leap into 3-D computer animation production in 1984 when he founded Advanced Imaging. In 2001, he cofounded XVIVO Scientific Animation, a medical and scientific digital imaging company. XVIVO worked with the Department of Molecular and Cellular Biology at Harvard University for over a year to produce *The Inner Life of the Cell* (2006), an animation depicting complex biomolecular interactions. Hurd (Figure 28.28) began her career at the Georgetown University Medical and Dental School before starting her own business in 1979, with clients that include *National Geographic* and the National Institutes of Health. In 1992, Hurd joined the Medical News Network as Director of Graphics, with

Figure 28.28
Jane Hurd, normal bacteria of the colon, in "Bacteria: Teaching Old Bugs New Tricks" by T. Y. Canby, *National Geographic*, p. 50, August 1993. Airbrush on illustration board.
Hurd's captivating illustrations led to her employment by Time Life to design their patient education media under the direction of former Surgeon General of the United States Dr. C. Everett Koop.

T.Y. Canby National Geographic.

Figure 28.27
David Bolinsky, ultrastructure of the cell, 2016. NewTek LightWave 3D and Adobe After Effects®. Bolinsky's exacting digital models summarize his career as a pioneer in the digital representation of cellular visualization.

© e.mersion studios, LLC, David Bolinsky.

Theme Box 53: The Electron Microscope
by David M. Mazierski

Light microscopy has a physical limitation: objects smaller than half a micron (0.5×10^{-6}) are beyond the resolving power of even the best instruments. This is a physics problem: no lens design can overcome the fact that objects smaller than the wavelengths of light used to observe them cannot be seen. A breakthrough was achieved in the 1930s with the electron microscope.

Instead of light, a beam of electrons is either passed through an incredibly thin-sectioned specimen (transmission electron microscopy) or bounced off the subject, which is coated in a precious metal (scanning electron microscopy, or SEM). Electron speed affects wavelength, so the faster the electrons travel, the smaller the wavelength and object that can be observed. The speed of the electron beam is controlled by passing it through a series of magnets, which function as "lenses." Transmission electron microscopy revolutionized the study of cellular ultrastructure in life sciences and helped create the twentieth-century discipline of cell biology, which combined the study of cell structure (cytology) and function (biochemistry).

responsibility for creating complex medical animation for broadcast television. From 1998 to 2004, her company Hurd Studios produced award-winning educational solutions for the pharmaceutical industry.

Electron Microscopy and Cellular Illustration

The first modern illustrations of cell ultrastructure were interpretations of **transmission electron micrographs** (Figure 28.29). Later, individual cells and small objects like insects and virus particles were frozen and covered with a thin layer of metal, such as gold, which would reflect the electron beam to form a **scanning electron micrograph** (Figure 28.29). Tiny pieces of frozen tissue could be fractured to reveal the three-dimensional structure of the cell interior and its components.

An innovator in the creation of interpretive microscopic illustrations is Radivoj Krstic (pronounced "KRAH-stitch") (Yugoslav, b. 1935). A medical school graduate, Krstic worked with electron microscopes and joined the Institute of Histology and Embryology, Faculty of Medicine in Lausanne, Switzerland, in 1969, also serving as a Senior Lecturer of Scientific Illustration in the School of Arts in Lausanne. He has written and illustrated four major reference books and dozens of scientific papers. *Ultrastructure of the Mammalian Cell: An Atlas* (1979) and *Human Microscopic Anatomy* (1991), illustrated with pen-and-ink figures, convey the complex architecture of cells and tissues, and many medical illustrators consider them essential references (Figure 28.30).

While aesthetically pleasing, Krstic's images serve as records of his research and as reference for scientists. Jack J. Kunz (Swiss, 1919–2009) created illustrations of cells for a more general audience (Figure 28.31). Kunz operated a graphic design studio in Zurich before moving to New York City in 1947, and then over the next twenty years, he created colorful, photorealistic paintings of cellular structures and organisms for the *Life* Nature

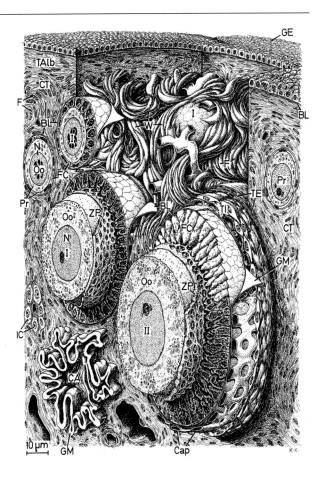

Figure 28.30
Radivoj Krstic, Plate 187, cortex of the ovary, in *Human Microscopic Anatomy*, 1991. Ink drawing.
Diverse and complex levels of section convey structure and relationships among components within a dense block of microscopic tissue. In conveying tissue architecture, this illustration resembles a technical drawing more than something a layperson might associate with biological science.

Springer Verlag.

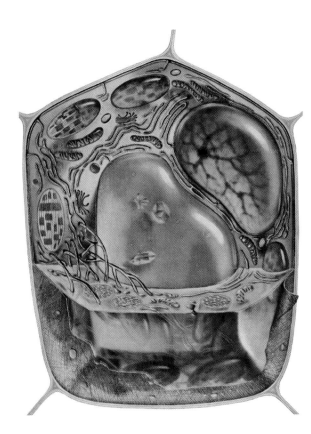

Figure 28.31
Jack Kunz, plant cell, in *The Plants* edited by F. W. Went, p. 44, 1963. Gouache.
Kunz's realistic renderings for Time Life publications brought the discoveries of cell biologists into millions of American homes.
©1963 Time Inc.

a b

Figure 28.29a, b
Louisa Howard, red blood cell (*) in a capillary, pancreatic tissue (a), Dartmouth College, 2006 or earlier, transmission (thin section) electron micrograph. Bruce Wetzel (photographer) and Harry Schaefer (photographer), red blood cell (*) (b), National Cancer Institute, 1982, scanning electron micrograph.
Electron microscopy images like these are important reference material for medical illustrators seeking to accurately depict the functions of the body at the cellular level.

Wikimedia.

Library and *Life* Science Library books, as well as for a book on forestry. He blended his medical and scientific illustration career with commercial design, working with publisher Walter Herdeg (Swiss, 1908–1995) on projects at his influential magazine *Graphis*.

Illustrations such as Kunz's depict cell ultrastructure with imagined color and lighting effects that do not exist at this scale. Reference images from electron microscopy influence how medical subjects are illustrated, from the standpoint of the richness of new information and the aesthetic of the image. Some illustrators emulate the appearance of scanning electron micrographs with a unidirectional front "light" source, matte surface finish, and incredible depth of field. Many 3-D software packages incorporate virtual materials and environments that can render scenes almost indistinguishable from actual SEM images.

Edmond Alexander (American, b. 1944) and Cynthia Turner (American, b. 1957) are studio partners, each with unique styles and specialities. Alexander's focus is **histology** (Figure 28.32), while Turner focuses on **pathophysiology** and **mechanisms of action** for pharmaceutical and biotechnology research (Figure 28.33). Alexander has a BSc in Oceanography and Art, and has taught animation and film graphics at the University of Texas Southwestern Medical School in Dallas. Turner has an MA in Biomedical Illustration. In 1984, they formed their own company and have gone on to create award-winning cinematic, richly colorful works with groundbreaking use of digital imaging technology that demonstrates exemplary understanding and depiction of complex contemporary topics. Turner also promotes illustrators' rights through her work on the Founding Board of the Illustrators' Partnership of America (IPA, 2000) and as a cofounder and cochair of the American Society of Illustrators Partnership (ASIP, 2007) along with illustrator Brad Holland (American, b. 1943).

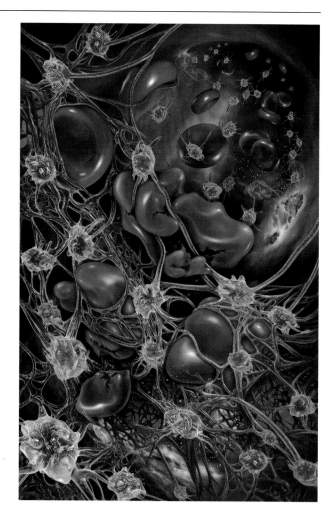

Figure 28.33
Cynthia Turner, activated platelets in atypical hemolytic uremic syndrome (aHUS), 2010. Digital media.
Turner provides a view inside a capillary, depicting atypical hemolytic uremic syndrome, an uncontrolled, fatal immune response of continuously activated platelets and endothelial cells. This image was commissioned for print and collateral use in investor prospectus and trade publications.

Image courtesy of the artist. © 2011 Alexion Pharmaceuticals.

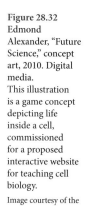

Figure 28.32
Edmond Alexander, "Future Science," concept art, 2010. Digital media.
This illustration is a game concept depicting life inside a cell, commissioned for a proposed interactive website for teaching cell biology.

Image courtesy of the artist © 2010 Edmond Alexander.

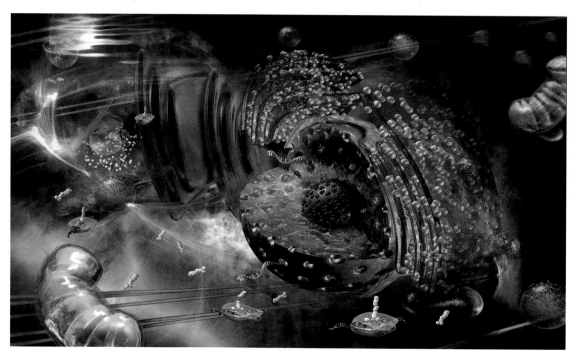

Molecular Visualization

The late twentieth century witnessed the emergence of **structural biology**, the study of the structure of important large biological molecules such as proteins. Understanding molecular structure and function is central to medicine and the life sciences, and, accordingly, medical illustrators increasingly depict mechanisms and concepts in molecular biology and biochemistry.

It has been said that medical illustrators visualize the invisible—for example, revealing organs within a body via transparency. In the case of molecular visualizations, illustrators depict objects that can *never* be seen: atoms and molecules are smaller than the wavelength of visible light. For this reason, all molecular visualization is necessarily metaphorical, and a variety of representational conventions have evolved to capture different aspects of structure and function (Figure 28.34). *Bond diagrams* use lines to represent the bonds between atoms within a molecule; this convention has its roots in mid-nineteenth-century chemistry. *Space-filling diagrams*, developed by scientist Linus Pauling (American, 1901–1994), depict each atom as a sphere, which represents the atom's electron cloud. *Ribbon diagrams*, also known as *Richardson diagrams*, codified by biochemist Jane S. Richardson (American, b. 1941), provide schematic representation of secondary molecular structures using arrows and coiled ribbons. Each convention organizes information about a different feature of the molecule and highlights different structural relationships. In fact, molecular visualization is frequently not only a means of depicting and communicating what is known, but is a vital part of the research process itself because in a visual representation, properties may emerge from the data that were not perceptible before. For example, molecular models may reveal "shape complementarity" between different molecules—sites where two molecules may fit together to trigger a reaction.

While diagrammatic representations of atoms and molecules have existed since the early nineteenth century, the "father" of contemporary molecular illustration is Irving Geis (American, 1908–1997). Trained in architecture and fine art, Geis was a regular contributor to *Scientific American* from 1948 to 1983. In 1961, Geis created what has become an iconic image in the canon of molecular illustration: a painting of the atomic structure of myoglobin, solved by biochemist John Kendrew (English, 1917–1997) using **X-ray crystallography** in 1958 (Figure 28.35). This was the first complete protein structure ever solved, and it marked a milestone in the emerging field of structural biology. Geis took six months to complete his watercolor illustration, working from photographs of the physical model constructed by Kendrew. It is the first example of a molecular illustration intended for a lay audience. Geis also coauthored and illustrated three books on biochemistry and molecular biology with Richard E. Dickerson (American, b. 1931).

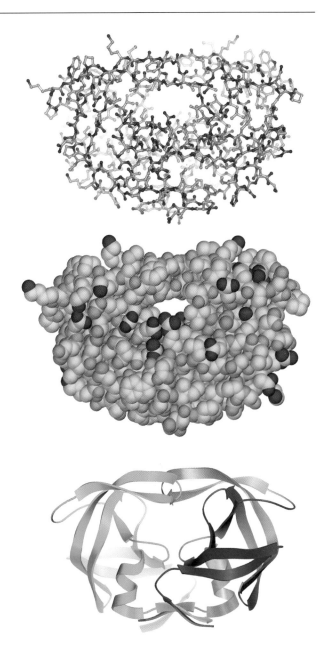

Figure 28.34
David Goodsell, HIV protease, in *Structure* by David Goodsell, vol. 13, pp. 347–354, 2005. Coordinates come from PDB entry 7hvp at the Protein Data Bank (http://www.pdb.org) and are illustrated using the Python Molecular Viewer (Sanner, 1999).
Goodsell shows three visual metaphors for comparing molecular structure. From top to bottom, bond, space-filling, and ribbon diagrams each depict the HIV protease molecule at the same scale.

© 2005 Elsevier Ltd. Image courtesy of the artist.

It is astonishing to consider the labor involved in the illustrations Geis created by hand, given that contemporary molecular visualization relies on 3-D digital modeling technology using structural data. This data is freely available from the **Protein Data Bank**, an online repository for experimentally derived data about the structure of proteins and other biological molecules. Even with such advanced resources and graphic tools, illustrators must still make informed critical decisions about what to represent and how to represent it to

Theme Box 54: Haraway: Crossing the Boundaries: Some Thoughts about Cyborgs
by Peta S. Cook

"I would rather be a cyborg than a goddess."

This statement ends Donna Haraway's (b. 1944) famous and influential 1985 article, "A Manifesto for Cyborgs: Science, Technology, and Socialist Feminism in the 1980s," in which Haraway reconceptualizes what it means to be human in contemporary society. For her, technologies are a way to reimagine feminism and to challenge and break down binary thinking based on differentiation and othering (for instance, that male and female are clear categories and opposites, with the female considered deviant from and inferior to the male "norm"). This provides food for thought for contemporary illustration by questioning how the world is represented and explained, while also providing a way to engage with pressing social and technological changes that alter the definition and meaning of being human, animal, natural, artificial, self, and other.

Haraway argues that *we have never been human*—at least, not in the way that humanness is typically conceptualized. She demonstrates this through the breakdown of boundaries between animal/human, organism (human-animal)/technology, and physical/nonphysical that create the **cyborg**, which Haraway defines as "a cybernetic organism, a hybrid of machine and organism, a creature of social reality as well as a creature of fiction." (Haraway, 1985, p. 65).

The first boundary breakdown is animal/human. Haraway shows there is a strong affinity and connectedness between humans and animals (as shown by the animal rights movement) resulting in the difficulty of isolating one species from the other. During agility trials with her own dogs, particularly Ms. Cayenne Pepper, both Prof. Haraway and Ms. Pepper must know, anticipate, and respond to each other: it is not a one-way power relationship of human over animal. Rather, she argues we are companion species.

This argument connects to Haraway's second boundary crossing: the fusion of organism/technology, which challenges distinctions between self/other. The OncoMouse, a transgenic creature created through genetic engineering and the first patented animal, carries a human oncogene that predisposes it to developing breast cancer. Haraway notes that while we need to account for the inequitable and exploitive use of these animals, they should not be thought of as "simply test systems, tools, means to brainier mammals' ends, and commodities" (Haraway, 1997, p. 82) because their embodied being and use mean they are kin, "both us and not-us." Such crossings are examined in the drawings, sculptures, and installation works of Patricia Piccinini (Australian, b. 1965), whose gallery art explores how bio-, genetic, and digital technologies are challenging self/other and human/animal. Her imagery provokes empathy in the viewer due to the human-like qualities of the creatures she creates, as well as how life-like they appear to be. Such disintegrations of animal/human (and human/other) are not unfamiliar to illustrators of children's books, who often enter an anthropomorphic world. An example is Norman Lindsay's (Australian, 1879–1969) iconic children's book *The Magic Pudding* (1918), featuring a talking koala, penguin, and pudding (which also blurs life/death and beginning/end, as the pudding reforms after being eaten). The animal (other)/human hybrid is thus both fantasy and reality.

Similarly, xenotransplantation (animal-to-human transplantation) involves transplanting living animal cells, tissues, or whole organs into the human body to perform functions that it cannot otherwise. This transpecies fusion provokes a variety of social responses and consequences, ranging from acceptance to "yuck." What is relevant here for illustration is not thinking about where the human ends and the animal starts, but rather that the interspecies boundary has been thoroughly breached—both historically and contemporarily—through technology and medicine. For example, records and depictions of blood transfusions from sheep to humans date back to the seventeenth century. The aim of these transfusions was to transfer the animal's qualities into the human recipient, such as a calm disposition.

The third collapse—and the one that is the least defined by Haraway—is that of physical/nonphysical. For example, the self/other fusion of the OncoMouse cannot be seen in its outward appearance, but it nonetheless exists at a genetic level that has radically changed this animal. Likewise, modern communication technologies such as the Internet, WiFi, Bluetooth, and email, work in ways that are invisible yet make contemporary interpersonal relationships (be they professional or personal) in the developed world possible. These invisible technologies fuse people together, regardless of time or place, across the world.

For Haraway, these three boundary crossings—animal/human, organism/technology, and physical/nonphysical—enable the questioning of other dualisms. Significantly for feminists, the cyborg metaphor thereby questions the limited oppositional structure of gender (man/woman) and sexual (heterosexual/homosexual) identities and highlights how these have been constructed by society broadly. A perfect example of this is Norrie, who lives in Sydney, Australia. Norrie was born male, underwent gender reassignment surgery to become female in 1989, but subsequently stopped taking female hormones. Norrie is therefore neither male nor female, and has successfully fought for hir* gender neutrality to be correctly recorded and recognized. Should Norrie choose to get married, however,

*Some transgendered people have chosen *hir* as their preferred pronoun.

this is likely to pose legal problems because, at the time of writing, only men and women can get married in Australia (thus legalizing and normalizing heterosexual coupling, and marginalizing other gender or sexual identities). Norrie is neither male nor female, so can Norrie be legally married or not?

What these tensions illustrate are the privileges and power associated with asserting and maintaining boundaries (including through legislation), and the contradictions that are evident therein. While a post-gender reality sounds attractive to some, gender remains an important feature of identity, as well as a political issue and a way of socially maintaining difference. The hierarchical, gendered structure of our society continues. Therefore, while the cyborg exists, we cannot forget that binary thought still structures the way human society works and functions. For instance, many human-technology cyborgs in popular culture are dystopic and violent—such as the militaristic cyborg—or highly gendered. For example, large and super strong masculine cyborgs contrast greatly with slim and highly sexualized feminine cyborgs, which replicates patriarchal control over technology and its function.

Illustrators can push beyond these traditional notions of gender and sexuality as "fixed" by critiquing the continuing social tensions and problems caused by narrow categorizations of man/woman and heterosexual/homosexual. Residing in both reality and the imaginary, and being real and *not real* at the same time, the cyborg can be a tool to "think with," to imagine how things *could be*, as in Alessandro Sicioldr's (Italian, b. 1990) biomorphic drawings that abstractly blend differing natural and organic forms (Figure TB54.1). While we are cyborgs and cyborgs surround us, the postgendered cyborg reality is yet to come, a tantalizing opportunity to transcend the confining binary and socially constructed story of division and difference.

Further Reading

Bibby, Paul, and Dan Harrison, Neither man nor woman: Norrie wins gender appeal, *The Sydney Morning Herald*, April 2, 2014, http://www.smh.com.au/nsw/neither-man-nor-woman-norrie-wins-gender-appeal-20140401-35xgt.html (accessed August 13, 2015).

Cook, Peta S., "Modernistic Posthuman Prophecy of Donna Haraway," In D. Cabrera, C. Bailey, and L. Buys (Eds.), *Social Change in the 21st Century 2004 Conference Proceedings* (Centre for Social Change Research, School of Humanities and Human Services, Queensland University of Technology, Brisbane, Australia, October 29, 2004).

Cook, Peta S., "The Social Aspects of Xenotransplantation," *Sociology Compass*, vol. 7, no. 3, 2013: 237–254.

Haraway, Donna, "A Manifesto for Cyborgs: Science, Technology, and Socialist Feminism in the 1980s," *Socialist Review*, vol. 15, no. 2, 1985: 65–107.

Haraway, Donna, *Modest_Witness@Second.Millennium.FemaleMan©_Meets_OncoMouse™: Feminism and Technoscience* (New York: Routledge, 1997).

Haraway, Donna, *Simians, Cyborgs, and Women: The Reinvention of Nature* (London: Free Association Books, 1991).

Haraway, Donna, *When Species Meet* (Minneapolis: University of Minnesota, 2008).

* Quoted material attributable to subject

Figure TB54.1
Alessandro Sicioldr, *Small Equestrian Structure*, 2014, 7 7/8 × 11 13/16", Graphite.
Courtesy of Alessandro Sicioldr.

Figure 28.36
David Goodsell, *Escherichia coli*, 1999. Watercolor.
Goodsell creates watercolor paintings based on his research in molecular biology to convey the intense "busyness" at the molecular level in an accurate and aesthetically beautiful way. In 2016, Goodsell's illustration of the Ebola virus received the Wellcome Image Award, given by the Wellcome Trust for outstanding achievement in biomedical imaging.

© David S. Goodsell 1999. Courtesy of the artist.

Figure 28.35
Irving Geis, myoglobin, in "The Three-Dimensional Structure of a Protein Molecule" by J. C. Kendrow, *Scientific American*, vol. 205, no. 6, December 1961. Watercolor.
Geis's stunning use of color and atmospheric perspective to describe complex three-dimensional form guide the eye to salient features in a dense cluster of visual information.

Irving Geis Collection, Howard Hughes Medical Institute.

produce an image that communicates clearly the most relevant information about the molecular structure or process in question.

David S. Goodsell (American, b. 1961) is an artist and professor of molecular biology at The Scripps Research Institute in La Jolla, California. His detailed ink and watercolor paintings of the "mesoscale"—the dense landscape of molecules within a cell—follow from meticulous research and structural data. Goodsell notes that this creative process organizes and triggers insights into available data. He authored *The Machinery of Life* (1993; 2nd edition, 2009), a richly illustrated introduction to biochemistry, and is deeply involved in using art for science outreach (Figures 28.36 and 28.37).

Data-driven molecular visualization is largely in the realm of digital modeling and animation, allowing users to see or interact with molecular models in virtual 3-D space. Although beyond the scope of this book, pioneering 3-D molecular animations by scientific animators can readily be found online.

Figure 28.37
David Goodsell, phototropin, "Molecule of the Month," March 2015.
Goodsell's "Molecule of the Month" contributions for the Protein Data Bank website introduce different biological molecules using digital molecular models rendered to resemble the aesthetic of his hand-rendered art.

Computer 3-D rendering of molecular data courtesy of the artist.

Conclusion

At the beginning of the twentieth century, medical illustration was defined as the practice of rendering anatomical or surgical art for reproduction in print. Advances in printing technology made books affordable for students, and for the first time accurate, halftone depictions of anatomy and surgery were widely available. The second and third generations of medical illustrators graduating from programs founded by Brödel, Jones, and their students began their careers coincident with incredible technical developments, as photography, microphotography, television, and advances in graphic arts transformed visual information. Storytelling via television carried over to textbooks, and the explosion of information necessitated more visuals and shorter turnaround times for the artist. New graphic arts materials like mylar, lettering systems, and adhesive pattern films helped create simpler images as well as charts and graphs (part of the domain of medical illustrators employed by hospitals and educational institutions). In the early 1980s, artists like Bill Andrews introduced a fresh direction in line and color art. This trend brought a more abbreviated look to renderings. Although using fewer lines and less tone, these illustrations maintained sufficient visual cues for clarity and teaching value, reflecting the importance of economy in both creation and reproduction of contemporary medical art.

The current domain of medical illustrators has expanded rapidly and profoundly in recent decades, as these interdisciplinary professionals embraced emerging technologies from film and video to 3-D computer graphics and interactive media. Advances in scientific and medical research and the revolution in information technology have created new categories of visual information to be interpreted, and have radically altered our ability to collect, organize, and visualize medical and scientific data. Most practicing medical illustrators have received graduate level training and some attain a PhD in related disciplines, ensuring a pool of suitably trained and accredited educators to maintain the profession. Medical illustrators are often collaborators with the scientists whose work they visualize and in some cases are scientists themselves. Their expertise in communication theory and design, media production, and high-level science has led some to roles as art directors and managers of medical multimedia companies. The computing power now available to scientists and illustrators in the form of sophisticated 3-D modeling and animation programs affects how people conduct research, communicate, and learn, and how health care and education are delivered. Medical and scientific illustration still serve their traditional audiences—anatomists, researchers, and students—but they now play an increasing role in patient education, consumer health information, advertising, and public health—further expanding the role and definition of the discipline.

FURTHER READING

Crosby, Ranice W., and John Cody, *Max Brödel: The Man Who Put Art Into Medicine* (New York: Springer-Verlag, 1991).

Herdig, Walter (Ed.), *The Artist in the Service of Science* (Zürich: The Graphis Press, 1973).

Roberts, Kenneth B., and John D. W. Tomlinson, *The Fabric of the Body: European Traditions of Anatomical Illustration* (Oxford: Clarendon Press, 1993).

KEY TERMS

atlas	Roentgen rays
cyborg	scanning electron
electron microscope	micrograph (SEM)
histology	transmission electron
mechanisms of action	micrograph
pathophysiology	X-ray crystallography
Protein Data Bank	

29

Digital Forms

Nanette Hoogslag and
Whitney Sherman
with contributions by Brian M. Kane

Since the 1990s, digital technologies have developed rapidly, placing the computer in all its forms at the center of daily communication. These continuously developing technologies affect the appearance and reproduction of illustration to a great extent. Not only do they make distribution of images possible on a large scale and give individual illustrators direct access to global audiences, but the aesthetics and technical structures of new media also have given rise to radically new forms of digitally based illustration. These moving, interactive, and programmed images (experienced on the web, in apps, and in game environments) are shaped and influenced by the abilities of the computer, but they also shape and influence *how we understand* technology in return.

This chapter investigates what is new in new media illustration through examples that document a wide range of creative expression and digital resources. It also explores how digital technologies have stimulated new commercial relationships that have revitalized artisanship and thus shaped current illustration practices.

New Media

The term **new media** describes computer-based media in which the computer is used for both distribution and presentation. This means that the expressive capabilities of these media are set by the limits and capabilities of the computer. But beyond its technological nature, new media should be understood for its transformative impact on culture and communication, just as the way we read has been defined by print technology over the last five hundred years (*see Chapter 24, Theme Box 46, "McLuhan: Media Theory"*). Illustrations reproduced in books or in other printed publications did not move, change, or make sounds—they were fundamentally contemplative or decorative visual experiences often considered in close relationship with written texts. New media illustration continues many of the inherent qualities of print-based illustration, such as the aesthetic experience, but it has also gradually adopted the expressive possibilities of digital technology. The language of illustration is undergoing **remediation**: converging with other media traditions and technologies, adjusting or discontinuing existing practices, and transforming into new hybrid forms. This adaptation is shifting the ways we use illustration as a communication tool and changing the way we comprehend its role and its qualities.

An example is the tablet-magazine *Adam*, which adheres to the printed periodical tradition with its magazine-like structure based on a series of articles. But these articles are presented in a wide variety of multimedia, navigated by swiping, pinching, and tapping. Furthermore, the cover, designed by Fefè Projects and creative director Luigi Vernieri, consists of an interactive illustration in which the user can mix and match image components. This cover does not present a single fixed image, but rather the experience of more than 2,500 possible combinations (Figure 29.1). It invites readers to playfully create new combinations of images in a way that constantly alters the gist of the illustration.

Figure 29.1
Fefè Projects and Luigi Vernieri, cover variations, *Adam*, "Alphabet-Digital-Art-Magazine," 2012. The changeable image presents traditional and new media qualities of illustration, where user interaction, movement, and play make individualized, expressive meanings.

Screenshots by Nanette Hoogslag.

The Structure of New Media

A new media illustration such as the magazine cover for *Adam* comes from an understanding and implementation of the capabilities and processes founded on digitization, multimedia, and computer networks. These elements are the fundamental building blocks of new media communication as first described by media theorist Lev Manovich (b. Russia, 1960), who defined the fundamental interrelationship for new media communication (*see Theme Box 55, "Manovich: The Language of New Media"*). Beyond the static visuals of print illustration, new media illustration is expressed through movement, audio, and tactile experiences put together with the capabilities of interaction, automation, and a networked connection. This makes way for very different kinds of communication and narration and extends the notion of illustration, as explored in this chapter.

Movement

Animation, or the use of sequential drawings to create an illusion of movement, is best known for its use in time-based visual narratives. But animation can also be used to enhance particular aspects of the image by providing minor movements within an otherwise nonmoving context. The illustration "No Country for Slow Broadband" by Stephan Vuillemin (France, b. 1986) (Figure 29.2) appears as a fixed image, but it has elements showing continual subtle movements. The flapping of Superman's cape, the vapor rising gently from the coffee, and the lazy typing of the man slouched on the sofa effectively extend the moment of engagement. They enhance and define a *present tense*, with each motion suggesting a different nuance in the meaning of the illustration.

The illustration created by Vuillemin is referred to as an **animated GIF** (Graphics Interchange Format), which consists of a single image file that encodes multiple frames that allow for animated movement to appear. GIFs have been part of network media since 1987 and have become popular due to their small file size, software compatibility across multiple platforms, and ease of creation. In the beginning, they were often used to create fast-loading logos, buttons, and banners, but over the years the animated GIF has become a popular form of expression in its own right.

Interaction and Multimedia

Pull-down menus, clickable icons, buttons, and hypertext links are just some of the possibilities for interaction that deepen the media experience. Ubiquitous in the navigation of websites and apps, interactive options help direct a user's behavior and provide ways of navigating and organizing information, to make the total sum of the available information more manageable. But for illustration, interaction (often in combination with multimedia) can be an effective tool for nonlinear storytelling because it can engage through multiple senses and offer prolonged engagement through play. Interaction allows the presence of multiple storytelling options and moments of surprise.

One of the earlier multimedia and software platforms used for creating such interactive applications was Adobe Flash (formerly Macromedia Flash), which became popular in the early 2000s. Flash was attractive to nonprogrammers because it combined vector drawing, animation, and interaction within a software package that did not require high-end coding skills. Illustrator and animator Han Hoogerbrugge (Dutch, b. 1963) is one of the early pioneers of **Flash animation**, which he explores for its expressive possibilities of interaction and as a meaningful component of illustration. In *Modern Living* (1998–2001), a series of offbeat existentialist sketches, Hoogerbrugge invites the user to play with the elements of the illustration (Figure 29.3).

Figure 29.2
Stephan Vuillemin, "No Country for Slow Broadband," *New York Times*, 2013. Animated GIF.
Animated GIFs have found a place as illustrations within online editorial publications such as the *New York Times* and the *New Yorker*.

Courtesy of Stephan Vuillemin.

Figure 29.3
Han Hoogerbrugge, *Modern Living*, 1998–2001. Flash animation.
Hoogerbrugge uses approximately one hundred Flash-based images to present various kinds of interaction, animation, and sound effects that invite the user to play with the elements of the illustration. It is through play that the narrative is revealed. These interactive images were first published online at the end of the last century. Due to the limits of broadband connection speed, the images had to be small and in the lowest possible resolution in order to be viewed properly. The original images were no more than 500 pixels wide with a resolution of 72 dpi.

Screenshot by Nanette Hoogslag.

Theme Box 55: Manovich: The Language of New Media
by Nanette Hoogslag

In the book *The Language of New Media* (2001), Lev Manovich defines "new media" as capabilities and processes founded on digitization, multimedia, and computer networks. The first systematic and rigorous theorization of the topic, Manovich's book analyzes new media's major forms, conventions, and design patterns.

Digitization means that whatever is represented through a computer is built from tiny interchangeable units: digits. Based on the available information, these units can be programmed to create expression through any medium available within a computer network. The computer network does not only refer to the screen, scanner, and audio speakers integrated or directly connected to a computer; it refers also to the entire global network of (mobile) computers, connected through the Internet, with access to all their available information.

Manovich presents new media as the coming together of three older media cultures—print, cinema, and information technology—in a human-computer interface, a system in which human understanding and computer logic meet. These "older" media cultures can still be recognized in the way text, images, and video are presented. But it is in their synthesis and the continued influence and acceptance of new ways of interacting with information that new digitally native forms are generated. Two of these digitally native forms are of particular significance: **hypertext**—text (or other kinds of content, such as images) that is linked to other information in nonhierarchical and associative ways; and the **database**—an archive of digitized information that can be accessed by search queries.

Manovich identifies five fundamental principles of how new media objects—for instance, a digital image or a text file—are structured:

1. *Numerical*: A new media object is numerical and can be described mathematically. This means it can be programmed.

2. *Modular*: A new media object is built from small discrete parts: pixels, vowels, characters, or bits of script. When these parts are assembled into larger recognizable media objects, each basic module keeps its discrete identity. This mean that the smallest components (such as pixels) not only can be modified without disturbing the whole media object but also can be stored independently in databases.

3. *Automated*: The numeric nature and modular structure together allow the principle of automation: the execution of computer programs without human intervention.

4. *Varied*: The computer can create many variations based on the same original data files.

5. *Transcoded*: A new media object has two interrelated aspects that Manovich calls the "cultural layer" and the "machine-readable layer." The cultural layer is the experience that makes sense to us humans—for instance, the text and images we can see on the screen. The machine-readable layer is the part of the computer file that only the computer can read, the code that instructs and interacts with other computer files. **Transcoding** is the term for translating one layer into the other.

The invisible interactions of the machine-readable layer influence how we create and what we create, and are fundamental in shaping the resulting message. However, the relationship between human and computer is a two-way street because the machine and the code it interacts with are the result of human invention. It is this logic of interrelation between computer and human that defines the "language" of new media.

Although there is an ongoing discourse on whether Manovich's influential vision is complete in the light of ongoing developments, key concepts such as fundamental programmability and transcoding are still relevant for understanding the material construction and functionality of new media objects, including digital illustration.

Further Reading
Manovich, Lev, *The Language of New Media* (Cambridge, MA: MIT Press, 2001).

*Quoted material attributable to subject

He choreographs the user's behavior by careful design of particular triggers that suggest potential interaction, and through the use of imagery, sound effects, repetition, and surprise. Only if the user acts in a certain way does the illustration reveal its full narrative plot.

Hoogerbrugge explored these mechanisms more extensively in one of the earliest interactive online graphic novels, *Hotel* (produced by Submarine Channel, 2004). It presents a surrealistic ten-part story that is part animation, part game, and part graphic novel that takes place in continually changing and responsive settings.

This key work showcases numerous effective applications of digital technologies to create not just multiple parallel storylines and engaging aesthetics, but also meaningful interactive and sound-based experiences. Hoogerbrugge carefully considers the

particular properties of digital media, such as multimedia, automation, dynamic navigation, and direct response, but does so alongside traditional visual and narrative methods.

A next step in visual and audio experiences, and importantly, the extension of direct interaction through touch, came with the introduction of the **tablet** computer, particularly the **Apple iPad** (2010). In the development of the tablet, more priority was given to the overall sensation as part of the user experience. The enhanced screen resolution and color saturation, the full-screen experience of an application, and in particular, the ability to directly touch the screen's triggers made for a far more immersive interactive experience. The software application (or **app**) *Numby* (2012) is an example of a programmed image that benefitted from this type of intense interaction. *Numby* is a musical counting game for children (Figure 29.4a–c) that fuses sound, spoken and written text, image, touch, automation, and interaction into a total experience. Numbers automatically relate to sounds and colors; touch can trigger a tune, a voice, or short animated sequences. For children, for whom fingers are primary tools of investigation, there seems to be no need to explain how *Numby* works. Direct touch comes naturally, and children intuitively engage with an illustrated robot that can respond to their actions.

Networked Connections

The Internet, the global network connecting computers (*see Theme Box 57, "Information Sharing: An Online Community Grows"*), has made publishing and information easily available for large numbers of people worldwide, leading to new ways of communicating through and with images. Stimulated by the easy and plentiful options with which to (re)distribute images and

the availability of image manipulation tools, as well as portable computer devices such as mobile smartphones, individual creators can instantly reach a global audience with their new work. Using social media, they can publish to selected groups or to everybody on the Net (short for Internet)—from sending a temporary image on Snapchat (a device-to-device sharing program in which the content

b

Figure 29.4a-c
Amit Pitaru and James Paterson, *Numby*, 2013. Flash animation. *Numby* is a counting app for children. This interactive narrative presents a visual experience first and foremost; game and play only come into existence through interaction.

Screenshots by Nanette Hoogslag.

a

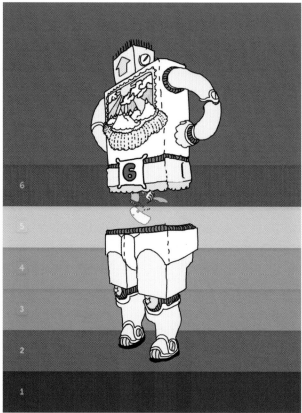

c

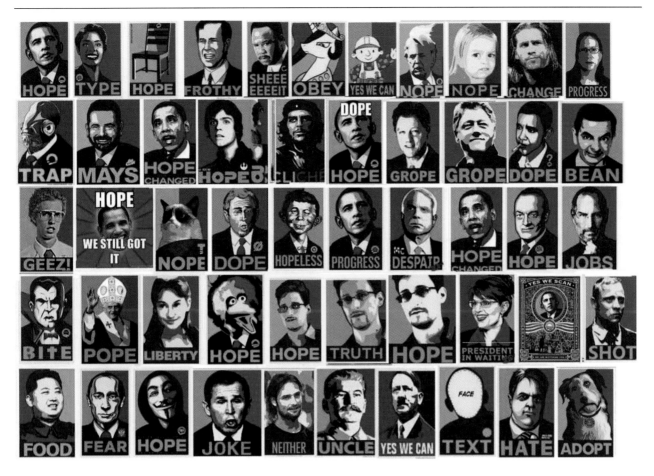

Figure 29.5
A variety of *Obama Hope* memes, 2008–2016. This collation shows only a fraction of the various memes within this strand that are present online. The top-left image is the original one created for the election campaign for U.S. President Barack Obama in 2008, by Shepard Fairey, based on a photograph by Mannie Garcia for the Associated Press. Note the image in the top right is the image of the author, created through meme-generator Obama-me.com, which automatically transforms an image into the language of the "Obama-Hope" image. Fairey joined his "own" ongoing meme with an image created on behalf of adoptapet .com, positioned at the bottom right.
Screenshot by Nanette Hoogslag.

becomes unavailable after a short amount of time) to posting entire collections of work on huge, indexed repositories of personal and public information such as YouTube or Facebook.

Posting and reposting images have become normal practice. Other than as part of official media productions, illustrations can now be published and circulated as independent popular offerings and responses. For instance, through postings on the social media platform Twitter, illustrators have the option to direct their work at selected communities through regular **tweeting** (a tweet is a single Twitter posting) that connects them to communities far beyond their own countries.

While the Internet has given illustrators greater professional independence, it equally has created insecurity around professional practice and authorship, and fostered global competition, including from nonprofessional makers. Copyright is very hard to maintain within this open environment (*see Theme Box 56, "Copyright: An Abbreviated History"*).

Memes

Internet memes—viral images, movie or sound clips, GIF animations, and texts that are circulated around social media platforms—have a special place in image-based network communication. Typical memes are blatant parodic mutations of an original source, created by anonymous makers. In this way, each meme becomes part of a family of related images. These related images all use the elements of the original image to create responses that often mock the original source, while referring equally to new events and to other memes in the same strand.

One well-known Internet meme is the collection of images based on *Obama Hope*, the unofficial election poster created for the presidential election campaign of Barack Obama in 2008 by Shepard Fairey (American, b. 1970), based on a photograph by Mannie Garcia for the Associated Press (the right to use the photo was later contested in court) (Figure 29.5). The effectiveness of the poster image and the proliferation of this image both offline and online sparked visual responses in social media almost instantly. These responses use the basic visual grammar of the blue and red central portrait and text banner and then alter a few core components. Although the content of the messages within the *Obama Hope* meme has changed over time, many express some kind of political commentary or engagement. Brought together, these memes create an expanded public discussion around (American) politics, Obama as president, leadership, and world events. What is interesting is that *Obama Hope* iterations are found in print as well as online, and in mainstream editorial channels as well in social media, with each iteration sparking new lines of discussion many years after the first image.

New Forms

Picture Book Apps

Since 2005 the markets for **e-books** (books and magazines in digital formats) have been rapidly expanding with the introduction of e-readers and tablets, small portable computers with touchscreen displays. Specifically designed for media consumption, tablets allow the user to carry hundreds of searchable books and other media productions on their person. The development of these devices gave rise to new forms of interactive storytelling

Theme Box 56: Copyright: An Abbreviated History
by Linda Joy Kattwinkel

Artists have always copied each other's works. Until relatively recently in human history, artists were trained in their craft through apprenticeships that involved slavish copies of their mentor's works and styles. Many early engravings were copies of paintings. Legal theories of copyright did not arise until the fifteenth century, after Gutenberg's movable type printing press made mechanical reproduction of books possible on a mass economically viable scale. As the new printing industry developed, legal systems had to determine who was entitled to profit from it—the authors who created the literary value or the publishers who invested time and resources into publishing it? Two different theories of copyright emerged: the *inherent rights theory* in mainland Europe and the *economic incentive theory* in England.

In mainland Europe, artists and authors were thought to enjoy inherent "natural rights" to own the fruits of their labor as soon as they created their works. Printers had to pay authors to publish their texts.

In England, in contrast, authors initially had no publishing rights: the crown (and its favored publishers) controlled and benefited from the printing industry. This changed when the British Parliament passed the Statute of Anne in 1710, which granted reproduction rights for two fourteen-year terms, but only to authors of literary works, and only if they registered their writings. In 1735, the Hogarth Act extended this limited copyright to engravings. Instead of inherent natural rights, in Great Britain the rationale for copyright became to promote progress of the arts for the public's benefit by providing an economic incentive to authors to create new works, in the form of a limited monopoly on reproduction rights.

As a young country, the United States adopted Great Britain's economic incentive approach. The first federal copyright act, in 1790, mirrored the Statute of Anne. It granted limited terms of copyright to authors of maps, charts, and books. Subsequent amendments added protection for other types of works, including engravings in 1802; photographs in 1865; and finally, paintings, drawings, and statuary in 1870. To ensure the widest possible reproduction and dissemination of works, U.S. law made it particularly difficult to obtain copyright protection. Authors had to comply with a rigid copyright registration system and other formalities, such as prescribed forms of copyright notice. If formalities were not met, the works were considered public domain. Initially, works by foreign authors received no protection at all. The formalities system successfully met Congress's goal of making works widely available. In the first ten years, of over 13,000 titles published in the United States, only 556 were registered for copyright protection.

Various amendments to the federal copyright law extended the term and the scope of copyright protection as new types of works and exploitation developed. U.S. and foreign "authors" (now defined as anyone who creates works entitled to copyright, including visual artists) could control not only mechanical reproduction of their works, but also public displays and performances, substantially similar copies made by hand, and adaptations for "derivative works" (for example, motion pictures based on books). In accordance with the First Amendment's guarantee of uncensored public debate, courts developed a robust "fair use" doctrine, providing exemptions from infringement when works were used for commentary, criticism, or educational purposes.

Meanwhile, European nations were developing their own copyright laws. Reflecting the inherent natural rights philosophy, copyright protection was automatic upon creation of a work. Additional "moral rights" were codified to protect the integrity of artworks and authors' rights of accreditation, even if they no longer owned the copyright. International treaties were also developed. The Berne Convention, enacted in 1886 (after intense lobbying by writer Victor Hugo), required member countries to protect copyrights of foreign authors the same as their own authors, set minimum copyright terms, and forbade member countries from imposing formalities.

In the United States, Congress continued to revise copyright law. In 1976, a major overhaul extended copyright protection to unpublished works and codified much copyright doctrine that had been developing in the courts, including the fair use doctrine. Formalities were still required, but the copyright term was changed to life of the author plus fifty years. It took another twelve years for the United States to accept the European view of inherent copyright. In 1988, the United States passed the Berne Convention Implementation Act. U.S. copyright law was revised to comply with the treaty, establishing U.S. copyright protection upon creation of a work. Mandatory formalities were eliminated (although U.S. citizens must still obtain a registration before bringing an infringement lawsuit). Moral rights were adopted, but only for certain one-of-a-kind works of visual arts (not reproductions like printed illustrations or digital files). Subsequent amendments in 1994 restored copyright for certain foreign works and in 1998 extended the copyright term to life plus seventy years (to match the current standard term in Europe).

As new technologies develop, Congress and U.S. courts continue to adjust copyright law. Digital and online copying present significant challenges. The ease of digital copying, the pervasive online culture of social media sharing, and website models that encourage and monetize the posting and sharing of other people's content have created expectations that content found online should be free for the taking. The "copyleft" movement and Creative Commons licensing systems support a culture of free sharing of content. Advocates want copyright terms reduced and formalities restored. Under increasing pressure from both nonprofit archival institutions and for-profit corporate interests, the U.S. Copyright Office is pushing for **orphan works** legislation. While the intent is to safeguard those who use old and apparently abandoned works, the proposal would allow unlicensed use of works whenever the copyright owner cannot be located, even if such works are not likely to be "orphaned."

Allowing unfettered use of difficult-to-trace material is of particular concern to visual artists because copies of their works often do not contain accreditation and are not easily searchable in word-based systems. The perceived value of illustration is already diminishing in today's online environment. Social media sites impose terms and conditions on their users that allow such sites unfettered free use of their content. Online stock imagery and design sites, especially those based on bidding, are driving down fees, creating expectations among consumers that images are fungible cheap commodities. Contests for art services are prevalent, in which the only "award" is public recognition and "exposure" (even, ironically, by the 2012 Obama campaign for posters promoting his job creation program). All of these pressures make it increasingly difficult for authors to earn a livelihood from their works.

The Digital Millennium Copyright Act of 1998 attempted to address rampant copying online, including a new "DMCA take-down procedure" to facilitate removal of infringing content by website hosts. In the courts, decisions are trending toward allowing extensive digital copying for applications perceived as beneficial to consumers. The fair use concept of "transformative" works has been stretched to include reproduction of low-resolution images in search engine results, and to allow Google to scan entire libraries without paying or getting permission from authors. The situation with social media is murkier. Whether copying from online social posting sites will be considered infringement depends on the wording of the site's terms and conditions. In 2013, Haitian photo-journalist Daniel Morel won his infringement claims against news agencies who copied his photos of the 2010 Haiti earthquake from his TwitPic account and sold them to other agencies and stock services. When Morel complained, the agencies filed suit against him. The court held that Twitter's particular terms, while allowing Twitter itself and Twitter users to freely copy Morel's photos, did not allow the agencies to do so. The news agencies' decision to aggressively litigate their alleged entitlement to such free use, however, is troubling for artists—as is the court's inherent ruling that social media user terms are enforceable contracts (including provisions that allow social media sites to monetize user content themselves and allow others to do so).

Unauthorized copying that violates contractual terms or does not fit fair use parameters remains infringement, but as a practical matter, is difficult to stop in an environment where online copies can go viral instantly—outpacing enforcement efforts. If copiers ignore take-down requests, litigation is the only recourse, but the expense of bringing suit makes that option unavailable to most artists (Morel, for example, was supported by pro bono and contingency counsel). National limits of copyright law add to the dilemma. Artists who post their portfolios online can expect to see their images reproduced not just on blogs and social media, but also in books and on merchandise, through foreign websites where U.S. laws, including DMCA take-down notices, have no effect.

The inherent rights and economic incentive theories of copyright law share a basic premise that artists must be able to earn revenues, if not a livelihood, from their works. Whether copyright law can overcome the culture of free online content is uncertain. In the United States, the Copyright Office has recommended that Congress create a copyright small claims court to make it easier for authors to prosecute infringement, and, as of this writing, two bills have been introduced to do so. The U.S. Department of Commerce has formed working groups of academics, lawyers, artists, and content users to envision solutions that will preserve authors' economic interests but also support industries that enable widespread public access to copyrighted works. There is no consensus, but most participants agree that in addition to legal remedies, we need new technologies, such as image marking and tracking, and automated licensing and billing processes to effectively protect our copyrights online. International cooperation for handling online infringement, perhaps even new treaties, may also be necessary.

and, with it, the creation of **book apps**, computer applications installed on the tablet or device, available via download from protected shopping portals such as iTunes.

Moonbot Studios, founded by illustrator, animator, and children's book author William Joyce (American, b. 1957), was one of the first large studios dedicated to creating book apps. The studio's first production, *The Fantastic Flying Books of Mr. Morris Lessmore*, is an example of how expressive book apps can be. Released in 2011, it is based on an animated film and uses a mixture of 3-D modeling and stop-motion animation to translate short storylines as well as nonmoving scenes for digital delivery (Figure 29.6). With its synthesis of written and spoken text, interaction, and touch navigation, the production brings together aspects of books, animation, and playing. Each "page" presents a static setting and animated story fragments, and solicits interactive exploration of central elements. For example, a swiping movement can activate the wind, and a virtual piano keyboard invites the reader to play a tune (Figure 29.7).

More recently, Joyce took the tablet experience a step further by creating an augmented reality edition of *Morris Lessmore* that combines a physically printed book with a screen-based experience (Figure 29.8). The **augmented reality** consists of a live recording of the physical book made through the camera lens of a mobile device. The user views the book on the screen of the device. Cues on each page of the physical book trigger the responsive software of the book app, which automatically maps virtual imagery onto the live recording. The imagery matches the dimensions of the real book and the space around it, taking the distortions of the camera angle into account. Augmented reality blends the physical world and computer information, blurring boundaries between real and virtual, enabling a new kind of imaginative visualization in storytelling.

An **e-textbook** is another type of electronic publication that is growing in use, particularly in the areas of science and education. For instance, e-textbooks can present 3-D rendered models created by medical illustrators, offering virtual instruction in 360 degrees on objects and processes such as complicated surgical procedures or new medical techniques (*see Chapter 28*). These e-textbooks are designed to interact in complex and varied ways that combine the hybridity of graphic narratives with text and (moving) images online. They are particularly effective in teaching the approximately 65 percent of people deemed to be visual learners.

But the production costs of a book app or an e-textbook can be prohibitive because of the integration of additional animation, video, and programming. Further complications arise because not all applications and devices are mutually compatible, while the rapid

Figure 29.7
Moonbot Studios, *The Fantastic Flying Books of Mr. Morris Lessmore*, 2011. The virtual keyboard invites readers either to play the score or to create their own tune.

Screenshot by Nanette Hoogslag.

Figure 29.6
Moonbot Studios, *The Fantastic Flying Books of Mr. Morris Lessmore*, 2011. The arrows encourage readers to swipe the screen; this action creates a sensation of blowing wind.

Screenshot by Nanette Hoogslag.

Figure 29.8
Moonbot Studios, *The Fantastic Flying Books of Mr. Morris Lessmore*, augmented reality edition, 2012.
The sensation of augmented reality is created when the tablet is held in proximity to the printed book, where on the screen of the tablet visual content is added to the live-recorded image of the book in real time.

Courtesy of Moonbot Studios.

rate at which hardware and software changes requires continuous updating. Particularly in the commercial publishing market, this has slowed uptake for high-end visual productions—but near continual drops in the price of hardware and software and the expanding growth of tablet use, particularly in educational environments, could permit for expansion of the e-book market.

Illustration for Games

Illustration is indispensable in the domain of computer games, particularly adventure games set in simulated worlds with narrative plots. Until 1980, such games were text-only. *Mystery House* (Figure 29.9), designed and illustrated by Roberta Williams and programmed by her husband, Ken Williams, for Apple II, was the first graphic adventure game. Based on the classic structure of Agatha Christie's murder mysteries, seventy vector drawings conjured up an old Victorian mansion and its various rooms. Although necessarily crude due to technological limitations, these simple line drawings made visual communication an essential part of the game experience by locating the written game instructions in virtual space, leading the player through the game narrative, and engaging him or her more immersively than ever before.

Many adventure games and role-playing games are characterized by open-ended, user-defined plots, avatars with moral makeups and talents, and multiplayer collaborative game play. Users have come to expect rich aesthetic and narrative experiences in sophisticated character movements, actions, and plots. Game and 3-D design software applications such as Maya, ZBrush, and Unity satisfy such expectations with highly naturalistic rendering with dynamic lighting and interactivity. Popular combat, driving, or action adventure games such as *Call of Duty*, *Grand Theft Auto*, or *Rise of the Tomb Raider* (Figure 29.10), for example, emulate a cinematic realism from a first- or third-person perspective that places the player within the action.

Though this new form of narrative realism may seem to be dominating the immersive game genres, more experimental games using alternative visual languages have made significant contributions to the industry as well. For instance, *Sir Benfro's Brilliant Balloon* (2013) by Tim Fishlock (British, b. 1963) is a narrative game that requires the player to keep the protagonist moving along a twisting narrow course strewn with various obstacles, often in the shape of wriggling magical creatures (Figure 29.11). The rising difficulty of the pathway may create the gaming "hook," but it is the visual narrative's particular aesthetic quality that carries the game. The scenery and characters are whimsical and created in multiple drawing styles that incorporate historical illustration and ephemera. To emphasize the narrative component, the game app includes backstories of all the individual creatures, making it both game and picture book.

Figure 29.10
Rise of the Tomb Raider, video game, 2015.
A high level of realism contributes to the immersive quality of video games such as *Rise of the Tomb Raider*, an action-adventure game in which players control the heroine, who must survive the dangers of extreme environments while tracking clues and avoiding attacks by assailants.
Image courtesy of Crystal Dynamics.

Figure 29.11
Tim Fishlock, *Sir Benfro's Brilliant Balloon*, video game, 2013.
With a timeless quality, *Sir Benfro* draws on a playful visual quality reminiscent of Push Pin Studio's use of Victorian engravings in the 1950s and '60s.
Courtesy of Tim Fishlock.

Figure 29.9
Roberta Williams, *Mystery House*, video game, On-Line Systems (later known as Sierra On-line), 1980.
Mystery House was the first adventure game using computer graphics. The color white was created by combining green and purple light in RGB colorspace. The bleeding of the two colors shows on the edges and vertical lines.
Screenshot of the game running on Apple II, courtesy of Laine Nooney.

Another, more complex, narrative game is *Sword & Sworcery EP* (2011), designed and developed by Superbrothers and produced by Capybara Games (both Canadian, 2003) (Figure 29.12). *Sword & Sworcery EP* has the player join the quest of a mysterious warrior journeying through various landscapes. Game clues are hidden in the landscapes, and interaction encompasses various actions, including written dialogue. The player can trigger changes such as switching between "dream" and "real" worlds, while other actions are driven by real time-based events such as the position of the moon.

With a visual language emulating the pixelation and jagged movements of early console games like *SuperMario* (Nintendo, 1985), *Sword & Sworcery EP* refers to the history of computer graphics as an established cultural environment, with its own traditions. In both *Sword & Sworcery EP* and *Sir Benfro*, the overtly stylized visual languages are important narrative components that constitute an alternative understanding of what game experience can be, in contrast to the drive toward immersive hyperreality found in the majority of narrative games.

Figure 29.12
Superbrothers and Capybara Games Inc., *Sword & Sworcery EP*, 2011.
This game deliberately uses pixelation as its aesthetic experience, referring to the already rich history of visual styles of computer graphics.

Screenshot by Nanette Hoogslag.

Games as Illustration

In the preceding examples, illustration is an essential part of game design. Conversely, game design and game experience themselves can be used to illustrate something, where virtual experiences delivered in a game-like format clarify instructions, explore complex problems, or give insight into sociopolitical ideas. One such game is *The Best Amendment* (referring to the American constitutional right to bear arms) by Molleindustria (Paolo Pedercini, Italian, b. 1981). Created soon after the 2012 mass killing at Sandy Hook Elementary School (Newtown, Connecticut), *The Best Amendment* is a satirical "shoot 'em up" game that, akin to a political cartoon, presents critical commentary on the proliferation of gun use and the staunch defense of gun ownership by the American National Rifle Association (Figure 29.13a–e). At first, the game action and cartoon

a b c

Figure 29.13a-e
Paolo Pedercini for Molleindustria, *The Best Amendment*, 2013.
The download screen on the website Molleindustria explains and contextualizes the game (a). The opening screen of the game then quotes the 2013 executive vice president of the National Rifle Association, USA (b). The opening sequence of the game continues (c). Further into the game, more adversaries carry larger guns (d). The final screen shows the player's score and points out negative behavior that actually caused the demise of the player (e).

Screenshots by Nanette Hoogslag.

d e

aesthetic invite the player to think of shooting as just a bit of fun, but then the player gradually realizes, in the process of playing, that this trigger-happy attitude is actually the source of the unwinnable arms race unleashed in the game. *The Best Amendment* can be played on the website Games for Change, a nonprofit organization that facilitates the creation and distribution of social impact games as critical tools to stimulate sociopolitical awareness.

New Media in the Evolving Marketplace: The Illustrator as Author and Entrepreneur

Digitization: On-demand Printing and Online Publishing

Digital resources for creation and distribution via the web have profoundly enlarged illustrators' purview and impacted the relationships between illustrators and their clients. Illustrators today can make images and products using on-demand print services that provide the artists with high levels of creative control and that allow them to get directly in touch with their audience. The impetus for making and the ability to sell are therefore often driven by the creator's own urges rather than by client commission.

Digitization has not meant the disappearance of the printed artifact, as has been often predicted. On the contrary, it has enabled new printing processes that have made the production of small editions or even one or many copies possible and affordable, as well as enabled the automatic adaptation of a print design to allow for bespoke printed objects. **Print-on-demand** (PoD) is a technology and business process using fast laser or inkjet printers to quickly fulfill consumer orders of one or many copies of a publication (Figure 29.14a–b). It has democratized the publishing of picture books, portfolios, and magazines by empowering creators to determine their publications' aesthetics and editions; and within given parameters, to set their own price points and royalties too. Besides saving printing and shipping costs and reducing paper waste, there is no risk of having unsold copies returned. Participating PoD vendors can also print and ship projects locally.

Initially, PoD books were looked upon with skepticism because they lacked the endorsement of established publishers. Over time, this attitude has changed as the print quality and the prevalence of well-designed publications have increased. Many established traditional publishers now embrace e-publications, and institutions such as the National Gallery in London and the Rijksmuseum in The Netherlands use

a

b

Figure 29.14a, b
Maria Torres, online art magazine cover, *FORGE*, no. 8, distributed by www.issuu.com, 2015 (a); Matthew James-Wilson (Editor-in-Chief), Kendra Yi (illustrator), and Kira Aszman (illustrator), interior page collaboration for "*Sin-cere*," *FORGE*, 2015 (b).
Print-on-demand platforms enable self-publishers to update a publication, track usage through analytics, customize the user experience, and promote their publications through linked social media.
Screenshots by Susan Doyle.

Theme Box 57: Information Sharing: An Online Community Grows
by Whitney Sherman

While the Internet was introduced for public use in the late 1980s in the form of chat rooms and electronic mail, it was not until about 1993 that websites began to be widely established and consulted. Venues for illustrators to show or sell original art directly to the public were initially limited by slow bandwidth and other technical restrictions. By the late 1990s, email accounts could transmit substantial image data, and global promotion became possible through portfolio websites and web portals. Marketing online soon followed with a website owner's ability to add preprogrammed payment systems known as **widgets** to sites. Then **blogs** (a term coined from *web log* in 1999 by programmer Peter Merholz) gave an easy way to post new content and to speak directly to the public daily about one's work and thoughts (Figure TB57.1).

The transition to a digital world had significant impact on how editorial and corporate information was delivered to the public, and on how illustrators were hired and paid. Direct access to production outlets such as web publishing gave the illustrator greater autonomy over authorship and production. Among the benefits of web-based resources was the ability for isolated freelance illustrators to seek each other out to address shared concerns.

An online community grew from basic websites with message boards to ones permitting marketing and other interactions between illustrators, clients, and the public. Over time, websites such as The iSpot (Gerald & Cullen Rapp artists' representative); Drawger (Bug Logic); Illustration Friday (Penelope Dullaghan); Today's Inspiration (Leif Peng); Illustration Art (David Apatoff); Drawn! (John Martz), 100 Years of Illustration (Paul Giambarba); Illustration Daily (Pawel Pokutycki and Babette Wagenvoort); Illustration Mundo (Nate Williams); The Comics Journal (Timothy Hodler and Dan Nadel); Escape from Illustration Island (Thomas James); and BibliOdyssey

(Paul "peacay") came into being, each with its own constituency, objectives, and identity giving insight into the makers and the context for which their work was made.

Importantly, online groups could discuss industry issues that emerged or were exacerbated by the Internet. These included gauging fees in the uncharted web environment and protecting one's work from unwarranted usage, including appropriation under the guise of the orphan works designation (where authorship is uncredited and deemed impossible to trace); and exploitation by digitally based stock houses (businesses set up to manage and sell previously created illustration for resale to new customers), which undercut the valuation

illustrators placed on their own stock or "reuse" sales.

The proliferation of business models that encourage image rights violations and devaluations prompted the foundation of the Illustrator's Partnership of America (IPA) by Brad Holland, Cynthia Turner, Ken Dubrowski, Brian Leister, and David Lesh. The IPA fought for intellectual property rights (*see Theme Box 56, "Copyright: An Abbreviated History"*) and founded the first Illustrators' Conference (ICON) in collaboration with numerous sympathetic individuals and related businesses, to bring illustrators together to discuss, among other things, important topics relating to the business of illustration that had been affected by the Internet.

James Gurney

This daily weblog by Dinotopia creator James Gurney is for illustrators, plein-air painters, sketchers, comic artists, animators, art students, and writers. You'll find practical studio tips, insights into the making of the Dinotopia books, and first-hand reports from art schools and museums.

Complete DVD Set

8 hours of demos. Great gift idea. Save $50.

Blog Index

Academic Painters (334)
Animals (238)
Animation (87)
Architecture (29)
Art By Committee (43)
Art Schools (93)
Audio (30)
Book reviews (46)
Casein Painting (61)
Catskill Mountains (11)

WEDNESDAY, JULY 25, 2007

The Road Tour

I should explain about what I hope to accomplish this blog. It's called Gurney Journey because it will be a simple record of people and places that my wife Jeanette and I encounter on the road tour for the new Dinotopia book. The new book officially launches October 1.

I'm trying to do the same thing Arthur Denison did on his travels and record what he saw, heard, and thought during his journey. I want to use this blog to let you follow the ups and downs as we travel around to meet Dinotopia readers.

I'll include pages from my sketchbook whenever possible, along with a few photos to take you behind the scenes.

Posted by James Gurney at Wednesday, July 25, 2007
M □ ⧓ ⨍ ⑨ G+1 Recommend this on Google
Labels: Journey to Chandara , road tour

1 comment:

 Steven said...
It's extremely nice for your fans to be able to read what you've been up to, Mr. Gurney, and as always it is a fascinating glimpse. Thank you for sharing. :)
July 30, 2007 at 1:21 AM

Post a Comment

Figure TB57.1
James Gurney's blog *Gurney Journey*, photo of Gurney sketching by Douglas Baz, July 25, 2007. Illustrators such as James Gurney (American, b. 1958) have taken advantage of the weblog format as a public forum through which to communicate directly with an online audience.
Screenshot by Jaleen Grove.

print-on-demand to provide materials for museum visitors. At the Dutch theme park De Efteling (which opened in 1952), guests can create their own customized fairytale book through Efteling's web application, using images by illustrator Job van Gelder (Dutch, b. 1971) (Figure 29.15).

Digital Art and Art Objects

Some see digitization processes as threatening the sense of agency of the maker in the creation of a unique and original physical art object. Meanwhile, archivists in libraries and museums are grappling with what it means to make an "original" digital illustration. Because electronic devices and presentation software change rapidly and can quickly become obsolete, questions about how digital forms can be preserved and conserved have arisen.

In what may be interpreted as a reaction to the ubiquitous presence of digital media, renewed appreciation of things handmade emerged in the DIY (do-it-yourself) or **maker movement**—and with it came a resurgence of traditional media such as oil, acrylic, gouache, and ink; and time-honored methods such as hand painting and collage. Woodcut, linoleum block, and letterpress printing have also rebounded in popularity. The **giclée** print, a high-quality inkjet print made as an art print in often limited editions, is a hybrid of old and new media that somewhat satisfies the desire for a tangible and durable object from a digital file.

All these changes in creative methods and media have had an impact on the illustrator's professional identity, whereby individual entrepreneurship has at times become more aligned with fine-art practice. New marketplaces, online web shops, pop-ups, and brick-and-mortar galleries focus on the emergence of illustration as art and artifact. Galleries celebrate the object and create environments that encourage production of illustration outside the mandate of a commission. Sometimes responding to countercultural aesthetics or made at physical scales far larger than the printed page, illustration in this context fuses conventions of high and low art (*see "Lowbrow and Pop Surrealism" in Chapter 27*), and often challenges the traditionalist values and methods descended from the narrative realism of the "Golden Age"—long the benchmark of twentieth-century American illustration (*see Chapter 18*).

Illustrator as Entrepreneur

Illustrators have established cottage industries with on-demand printing, applying their design and illustration skills to products such as apparel, stickers, tote bags, postage stamps, and fabrics produced in limited quantities (Figure 29.16).

Many creators cross-market items sold both in online shops (B2C: business-to-consumer) and at craft fairs, which allows consumers to look and touch first, then buy later from home. The fairs bring together an audience of like-minded consumers looking for unique, artisanal work, while the online shops bypass

Figure 29.15
Job van Gelder, covers, *Hansel and Gretel, The Emperor's New Clothes, The Six Servants,* and *Sleeping Beauty,* 2015. Customizable personalized books are available to visitors of the Dutch theme park Efteling in collaboration with the Dutch publisher Rubenstein.

Screenshots by Job van Gelder composed by Whitney Sherman. Illustrations Job van Gelder, ©Rubenstein, publisher.

Figure 29.16
Oliver Lake/ Iota illustration, custom-designed tote bags made of digitally printed canvas, 2015. Specialized tote bags and other custom items such as 3-D printed ceramics, scarves, or custom graphics on apparel are easily created and sold through online marketplaces like Etsy, which promotes artisan goods. Several manufacturing vendors also provide marketplaces on their sites for makers.

Screenshot of Etsy online shop page by Whitney Sherman.

Theme Box 58: Why Does Critical Theory Matter for Illustration?
by Sheena Calvert and Jaleen Grove

"The best way to predict the future is to design it."—Buckminster Fuller

To be an illustrator is not simply a question of learning aesthetic styles and technical skills. To participate in the shaping of the discipline and of culture, as more than a passive witness, it is essential to critically reflect on what we do and to build the necessary confidence and thinking skills to take an active role in both the development of the field and of society. The need is pressing because of rapid technological changes and diversifying audiences, which each demand shrewd and sensitive handling in order to speak effectively, minimize harm, and remain socially relevant and economically viable. In what ways do technology and complex social systems require new modes of illustration?

Responding to Technology

Technology is transforming how work is produced and disseminated; moving image, sound-based work, and hybrid forms now coexist alongside traditional modes of practice. Work that is relational and social and which happens in space and time, rather than simply in two dimensions, is becoming more frequent, and so closer collaboration between the previously separated disciplines of art, design, and computer science is required. Challenges and opportunities abound—if we can foresee them. Predictions such as those of Marshall McLuhan (*see Chapter 24, Theme Box 46, "McLuhan: Media Theory"*) based on what happened after the invention of moveable type can help us anticipate the impact of these new media.

As Henry Jenkins reminds us, a key trait of the new digital environment is its propensity for collaboration and audience feedback (*Chapter 16, Theme Box 34, "Jenkins: Media Convergence"*). In the writings of Roland Barthes (*Chapter 22, Theme Box 44, "Barthes: Mythologies and Death of the Author"*) and Karl Marx (*Chapter 15, Theme Box 33, "Marx: Modes of Production"*), authorship and production come under scrutiny. Who is the author of a work that has many contributors? Is the originator the person who supplies a work's final meaning or the viewer? Marx's and Theodor Adorno's ideas (*Chapter 21, Theme Box 43, "Adorno: Subjectivity, Objectivity, and the Culture Industries"*) continue to have relevance, since they ask us to reflect on the politics of production, the (arguably) lost sense of ownership we have over mass-reproduced works, and the general commodification of our practice when we create works for commercial rather than social purposes. Analyses by the likes of McLuhan and Jenkins help us understand the advantages and pitfalls of contemporary corporate control, and remind us that social and commercial priorities are not so easily separated.

Forming Representation

Various chapters in this book show how illustrations of the past were usually made for a specific audience, and when purportedly made for a North American or European "mass," they still had a specific audience implicitly in mind: in general, white and socioeconomically well-off. Critical theory helps us identify how images are rhetorical and carry underlying messages and meanings. People such as Benedict Anderson (*Chapter 3, Theme Box 8, "Nationalism"*), Edward Said (*Chapter 4, Theme Box 10, "Orientalism"*), Stuart Hall (*Chapter 7, Theme Box 13, "Hall: Encoding, Decoding, Transcoding"*), Judith Butler (*Chapter 26, Theme Box 48, "Judith Butler: Gender and Queer Studies"*), and Donna Haraway (*Chapter 28, Theme Box 54, "Haraway: Crossing Boundaries"*) help us rethink how conventional depictions concerning identity, race, gender, and species operate— tropes that were once thought unproblematic. We would think very carefully nowadays about illustrations that use the kinds of stereotypical images once commonly accepted. A complication that critical theory might help us address is: how does one give visibility to a group without stereotyping?

In previous theme boxes, we have seen how the status of images is always in question. From Plato (*Chapter 1, Theme Box 2, "Plato: Allegory of the Cave"*) onward, thinkers have challenged pictures because their claims to represent "truth" are problematic. Theorists such as Hall, Michel Foucault (*Chapter 10, Theme Box 19, "Discourse and Power"*), Roland Barthes (*Chapter 22, Theme Box 44, "Barthes: Mythologies and Death of the Author"*), and Jacques Derrida (*Chapter 27, Theme Box 50, "Derrida: Deconstruction and Floating Signifiers"*) show us how hidden narratives of culture and society embedded in illustration reinforce power structures, but also how the ambiguity of meaning can be subverted to suggest other messages.

The large body of critical inquiry provides a rich trove of ideas for illustration practice, allowing us to reflect on narrative, imagination, and the act of depicting more generally. What is the role of self-expression versus work that has a public and practical function? Illustrators have been making work for thousands of years that addresses specific practical and functional needs, and that work has been part of a broader search for meaning, for human expression, and part of the compulsion to "picture" the world as well. Is this a lesser position with respect to fine art?

Critics such as Clement Greenberg (*Chapter 19, Theme Box 40, "Greenberg: Avant-Garde and Kitsch"*), William Morris (*see "William Morris, Edward Burne-Jones, and the Kelmscott Press" in Chapter 15*), and Walter Benjamin (*Chapter 13, Theme Box 27, "Benjamin: Aura, Mass Reproduction, and Translation"*) have each had an impact on art and media production

with the force of their theories relating to this and similar questions.

The Practical Intellectual
Critical theory gives practitioners a way to reflect on their own conditions of creation and consumption. It allows us to cope with rapid changes and to be more than just "pairs of hands." Illustrators of the future need to be "practical intellectuals," fully grappling with the key questions of our time while flexing our "making" muscles, by understanding the histories of the subject, and maintaining a deep curiosity about all the possibilities that new technologies, cultures, and intellectual ideas bring to the practice of illustration.

Critical theory is not a negative form of criticality, but one that is productive and analytical in nature, asking us to place our work in a broader context: the history of ideas. Any form of creative practice automatically brings us into contact with history, politics, philosophy, sociology, ethnography, anthropology, new and old technologies, and more. To undertake critical theory is to acknowledge that what we do as illustrators is as intellectual as it is technical; that practice needs to respond to the particular moment in history in which it is made; and to exploit its place at the intersection between other forms of knowledge.
Finally, illustration is participatory. We illustrate *with*, not *for*. A

traditional model that has been challenged is the idea that illustrators simply interpret on behalf of others, a concept that renders invisible their own authorship, which reinforces the erroneous fine-art elevation of the sole practitioner. A different model is to see audiences as co-participants in a process: they shape, co-create, and feed back, which illustrators facilitate through thoughtful visual problem solving. Illustration and society; social responsibility, ethics, and sustainability come to the fore in this process—illustration is not just a question of aesthetics and form created by individual illustrators, but of understanding the importance of strategies, systems, and global networks.

the middle-man—retail "brick-and-mortar" shops—to reach consumers directly. Online shopping sites such as the popular site Etsy are built to streamline the process of setting up a storefront with visually attractive pages, providing a dedicated search engine, a guaranteed payment system, and links to networks and communities. Entrepreneurial artist websites or social media pages such as Tumblr and personal blogs have become important for marketing products and for self-promotion. For example, the Chinese microblog Weibo ("microblog/ing" in Mandarin, launched 2009) has also served as a platform for illustrators' product sales.

Beyond relatively small artisan production and sales, illustrators and other makers seek new ways of financing more ambitious projects outside the support of traditional funding models. Peer-to-peer financing systems, so-called **crowdfunding** systems, can connect creative project developers with non-institutional funders through specifically designed web environments such as Kickstarter (launched 2009). Sites like these can help capitalize ventures by raising relatively small monetary contributions from a large number of people.

Directly and indirectly, these online delivery systems can be considered as part of *prosumerism*, a term coined by futurologist Alvin Toffler in 1980 to describe the involvement of individuals in designing or improving the goods and services of the marketplace. "Prosumers" take part in the production process by specifying or

influencing design, similar to the way affluent clients have collaborated with architects or dressmakers.

The highly communicative and applied nature of illustration, as well as its close links with decorative arts, made it a natural step for many illustrators to explore the creation and sale of artisan and decorated products. Critics have questioned whether this trend is a legitimate part of illustration, dismissing it as an opportunistic, trendy scramble for income that once came from important editorial commissions that often engaged with serious issues. But artisanal illustrated products may also lead to thought-provoking social commentary, taking illustration away from the page into a wider world and extending the power of the illustration in new directions.

Conclusion

While illustrators and audiences continue to value the physical artifact and the agency of the individual maker, computer technologies have fundamentally changed the creation, distribution, and reception of images. Digitization has offered new ways of engaging with traditions while generating wholly new creative outlets. New media illustration and all the possibilities that have opened up through digital technologies are just the latest steps to extend long-existing methods and media of illustration. Increasingly, online communication networks

along with new media are pivotal to the illustration of ideas, stories, and experience of play.

New media technology questions the permanency of traditional methods and values, while we as makers and consumers in turn question the value of technological developments. New media brings full circle a discussion—held through practice and critical dialogue—of what we actually wish to regard as illustration. If illustrations can be both physical and intangible and can take the form of periodicals, books, apps, animation, and games, how do we qualify its methods? If illustration includes independent artifacts sold through web shops or placed without context on a social media site, then what, if anything, does it illustrate? If everyone can instantly create and upload a picture, meaningful within its milieu, what is the added value of a professionally made illustration? How can we speak of creative authorship or copyrights if an image is easy to appropriate by anyone, once it is available online?

With these questions open for debate, it is worth going back to a principle of illustration that does not seem to have been affected by all these changes: Illustration is pictorial communication that is designed to give insight, clarification, commentary, and reflection on ideas, information, and narratives. Illustration can be made using any method or medium, and is vital in helping us make sense of the world through meaningful images that engage with individuals and groups within the context of a larger cultural dialogue.

KEY TERMS

animated GIF	hypertext
app	Internet meme
augmented reality	maker movement
blog	new media
book app	orphan works
crowdfunding	print-on-demand
database	remediation
e-book	tablet
e-textbook	transcoding
Flash animation	tweet
giclée	widget

About the Contributors

Ashbrook

Susan Ashbrook is Associate Professor, College of Art and Design, Lesley University (BA University of Wisconsin/Madison, PhD Boston University). Her interest in illustration stems in part from a childhood love of the books illustrated by Beatrix Potter, Arthur Rackham and A.A. Milne. Investigations into the legacy of the Pre-Raphaelite illustrators in Arts & Crafts book design led to her doctoral dissertation, "The British Private Press Movement, 1890 to 1914." She finds the intersection of the ideologies of craft and social justice advocated by theorists and practitioners of the Arts & Crafts Movement compelling. Ashbrook is now pursuing the next chapter of wood-engraved illustration in the 20th Century, focusing especially on Anglo-American artist/writer Clare Leighton, as well as keepsake book decorations by women artists at the turn of the 19th/20th centuries. At Lesley University she enjoys teaching courses in 19th and 20th century European and American art.

Bravo

Monica Bravo (Ph.D., Brown University, 2016) is a Lecturer in the History of Art Department and Program in Ethnicity, Race, and Migration at Yale University. She specializes in the history of photography and the modern art of the Americas. Her dissertation and current book project examines exchanges between US modernist photographers and modern Mexican artists working in painting, poetry, music, and photography, resulting in the development of a Greater American modernism in the interwar period. Her research has been supported by fellowships from the Center for Advanced Study in the Visual Arts (CASVA), the Center for Creative Photography, the Georgia O'Keeffe Research Center, and the Huntington Library and Art Collections.

Brinkerhoff

Robert Brinkerhoff is a Professor of Illustration at Rhode Island School of Design, where, after nine years as Illustration Department Head, he became Dean of Fine Arts in 2017. His teaching explores the intersection of illustration, design, writing, semiotics, social justice and narrative theory, and his client list includes major corporations and institutions of higher learning such as MIT, Brown University and Brandeis University, and regional and national magazines. Since 2011 he has been the illustrator for *VUE*, published quarterly by the Annenberg Institute for School Reform at Brown University. From 2007–2009 he served as Chief Critic for RISD's European Honors Program in Rome and was a Faculty Mentor for the Salama Foundation's Emerging Artists Fellowship in the UAE. In service to the illustration profession he was Education Chair for ICON7: The Illustration Conference, and ICON8's Vice-President from 2010–2014. In 2015 RISD hosted the Illustration Research Symposium: Illustrator as Public Intellectual under his co-leadership and organization.

Buszek

Maria Elena Buszek is a scholar, critic, curator, and Associate Professor of Art History at the University of Colorado Denver, where she teaches courses on modern and contemporary art. Her recent publications include the books *Pin-Up Grrrls: Feminism, Sexuality, Popular Culture* (Duke University Press Books, 2006) and *Extra/Ordinary: Craft and Contemporary Art* (Duke, 2011). She has also contributed writing to numerous international anthologies, exhibition catalogues and scholarly journals: most recently, essays in *Dorothy Iannone: Censorship and the Irrepressible Drive Toward Divinity; Mark Mothersbaugh: Myopia*; and *In Wonderland: The Surrealist Adventures of Women Artists in Mexico and the United States.*

Calvert

Dr. Sheena Calvert is an artist/designer/writer. She has an active interest in the intersections between a wide range of disciplines, including illustration, graphic design and fine art, and is particularly concerned with exploring the implications of technology and philosophy on their practice. As a typographer and book designer she questions the materiality of language (text/speech) and its implications for how we form knowledge. Her theory and practice-based research entitled "materialanguage" explores these concerns. She ran a design studio, Parlour, in New York, working for a range of non-profit and cultural sector clients; and now works in London under the name .918 press. Teaching at both the Royal College of Art and the University of the Arts, London (Camberwell College of Art and Central St. Martins), Calvert is concerned with how to bring theory and practice into closer alignment and promotes cross-disciplinary thinking through interrogating certain "primary" questions such as "what is an image?" "what is language?" and "what is color?"

Campbell

Bolaji Campbell is Professor of the Arts of Africa and the African Diaspora in the Department of History of Art and Visual Culture at RISD. Campbell holds a PhD in Art History from the University of Wisconsin-Madison as well as a MFA in Painting and a BA in Fine Arts from the Obafemi Awolowo University (formerly University of Ife), Nigeria. He has published numerous essays in learned journals and as chapters in books; his most recent work is entitled *Painting for the Gods: Art and Aesthetics of Yoruba Religious Murals* (Africa World Press, 2008).

Carter

Alice A. Carter is co-founder of San Jose State University's Animation/Illustration program, former Co-Director of Education at the Walt Disney Family Museum, and currently President of the Board of Trustees at the Norman Rockwell Museum. She earned her BFA at the University of the Arts and her Master's Degree at Stanford University. Honors include San Jose State's Outstanding Professor Award, a Fulbright Fellowship in Cairo, Egypt, the New York Society of Illustrators Distinguished Educator in the Arts award, and the Umhoefer Prize for Achievement in the Humanities. Carter's illustrations have been exhibited widely, and her clients have included LucasFilm Ltd., *Rolling Stone* magazine, *The New York Times*, and ABC Television. Carter is the author of *The Art of National Geographic: One Hundred Years of Illustration; The Red Rose Girls: An Uncommon Story of Art and Love; The Essential Thomas Eakins*; and *Cecilia Beaux: A Modern Painter in The Gilded Age.*

Clark

H. Nichols B. Clark is the Founding Director and Chief Curator Emeritus of The Eric Carle Museum of Picture Book Art and currently Founding Director of The Ashley Bryan Center. Previously, he was Chair of Education at the High Museum of Art in Atlanta. After holding posts at the National Gallery of Art and Phillips Exeter Academy, he served as Curator of American Art at the Chrysler Museum of Art in Norfolk, Virginia. While at the Chrysler, he was co-curator of *Myth, Magic, and Mystery: One Hundred Years of American Children's Book Illustration* which resulted in the book of the same title. His other publications include two books on American art and sculpture, and numerous catalog essays and articles. Clark received his BA cum laude from Harvard University and his MA (1975) and PhD (1982) in Art History from the University of Delaware.

Cook

Dr. Peta Cook is a Senior Lecturer in Sociology at the University of Tasmania, Australia. Her research investigates meaning-making and the lived experiences of aging, health and illness, and medical science and technology. This has included examining what counts as knowledge, truth and fact, and why. Cook is internationally known for her social research on xenotransplantation (animal-to-human transplants), and has presented this research at the World Health Organization (Geneva, Switzerland). Most recently, Cook has been analyzing the issues that face older people in contemporary Australian society, spanning from how cancer in older people is treated to how aging is perceived and experienced by older people.

Desai

Binita Desai is currently a Professor at the Dhirubhai Ambani Institute of Information and Communication Technology, Gandhinagar, Gujarat. She is a practicing professional in the areas of Graphic Design and Animation and has been teaching students of design and information technology since 2002. She graduated from the Maharaja Sayajirao University, Faculty of Fine Arts, Baroda, Gujarat, in 1985. She subsequently received her animation training at the National Institute of Design from 1980–85. She has worked as a design professional and taught at the National Institute of Design until 1997.

Dowd

Douglas B. Dowd is a professor of art and American culture studies at Washington University in St. Louis. He serves as the faculty director of the Modern Graphic History Library (MGHL) at the university, which was endowed and renamed in his honor in 2016. The D. B. Dowd MGHL is devoted primarily to the culture of the illustrated periodical. He has curated exhibitions in the history of illustration for the Museum of the City of New York, the Norman Rockwell Museum, and the Kemper Museum of Art. He co-edited *Strips, Toons and Bluesies* with Todd Hignite for Princeton Architectural Press in 2006. An illustrator and essayist, he publishes the illustrated journal *Spartan Holiday*. His fine books and prints are in the permanent collections of the National Gallery of Art, the Fogg Museum at Harvard, and the New York Public Library. He blogs on graphic culture at his site, dbdowd.com.

Doyle

Associate Professor at Rhode Island School of Design, Susan Doyle is the chairman of the Illustration Department and a former critic in the RISD European Honors Program in Rome, Italy. Doyle has an MFA in Painting and Printmaking and a BFA in Illustration, and spent the first decade of her career as an award-winning art director and a creative director before focusing her energy on teaching and a studio practice in painting and lithography. She has been engrossed in the study of illustration history since 2007 and teaches a survey course on the subject at RISD.

Ferrara

Kev Ferrara is an illustrator, author, and commercial artist living in upstate New York. His research concerns the parallel histories of aesthetic philosophy and artistic composition and the relationship between 19th century developments in Romantic Symbolism and the Golden Age of American Illustration—in particular, Howard Pyle's Brandywine tradition of image making. His recent graphic novel *The Dead Rider: Crown of Souls*, published through Dark Horse Comics and Random House Books, was selected for inclusion in Spectrum 22 for the year's best science fiction and fantasy.

Gibbons

Carey Gibbons recently completed a PhD from the Courtauld Institute of Art in London. Her dissertation focuses on the illustrations of Arthur Hughes and Frederick Sandys, two artists associated with the Pre-Raphaelites. She discusses their illustrations together in order to explore different approaches to identity, subjectivity, and bodily representation from 1860–1910. Her approach crosses disciplines, engaging with

illustrations in relation to their accompanying texts and Victorian science, religion, and gender constructions. She is now continuing her research on Victorian illustration but is also expanding her focus beyond the 19th century, examining the lithographs of Prentiss Taylor and Art Deco fashion illustration.

Goodman

Loren Goodman, PhD, is the author of *Famous Americans*, selected by W.S. Merwin for the 2002 Yale Series of Younger Poets; *Suppository Writing* (2008); and *New Products* (2010). He is an Associate Professor of Creative Writing and English Literature at Yonsei University/Underwood International College in Seoul, Korea, where he teaches courses on manga and illuminated text, and serves as the UIC Creative Writing Director. He continues to study and write about the influence of Tetsuya Chiba's and Ikki Kashiwara's manga *Ashita no Joe* (1968) on the world of contemporary Japanese boxing.

Grove

Jaleen Grove has published monographs on the illustrators Oscar Cahén (2015) and Walter Haskell Hinton (2010), as well as several scholarly articles on aspects of popular visual culture and communication. As Postdoctoral Fellow in Popular Print at Washington University in St. Louis, Grove is conducting research on 19th and 20th century illustrators' networks and communities. After completing a BFA (Emily Carr, 1999), and an MA thesis in Communication and Culture (Ryerson, 2006) that examined the status of illustrators within the art world, Grove completed a PhD dissertation (Stony Brook, 2014) on the impact of Canadian illustrators on American and Canadian national identity. She has taught at OCAD University, Wilfrid Laurier University, Stony Brook University, and Parsons School of Design; and she serves as an Associate Editor of the *Journal of Illustration*. A full-time artist and graphic designer before embarking upon her academic career, Grove maintains a studio practice alongside her research and writing.

Holahan

Mary F. Holahan is the Curator of Illustration and Curator of the Outlooks Exhibition Series at the Delaware Art Museum in Wilmington, Delaware. She received her PhD in Art History from the University of Delaware; her dissertation was on Irish illustrator and book-cover designer Althea Gyles. Dr. Holahan has worked in the museum field since 1978, as Registrar, Special Assistant to the Director, and Curator of Collections and Exhibitions at the Delaware Art Museum. In 2010, she assumed the Museum's newly-designed position of Curator of Illustration and oversees its historic illustration collection, on view in six galleries. She has written for various Delaware Art Museum publications. Most recently, she curated and wrote the principal catalogue essay "'So Beautifully Illustrated': Katharine Richardson Wireman and the Art of Illustration" (2012).

Holm

Dr. Pernille Holm is a Danish visual artist and educator based in London and Kent, United Kingdom. She graduated in 1994 from Goldsmiths College with a BA in Fine Art and Art History. Subsequently, she completed an MA degree in Visual Culture at Middlesex University and an MA degree in Printmaking at Wimbledon School of Art. In 2006, she finished a practice-based PhD in Fine Art at Goldsmiths College. Dedicated to art education, she has devoted a large part of her career to lecturing in art and design. As a professional artist, she has exhibited widely across Britain and in Europe.

Hoogslag

Nanette Hoogslag is an internationally practicing illustrator, designer, academic researcher and course leader of the BA (Hons) course Illustration and Animation at the Anglia Ruskin University in Cambridge, UK. Her work and approach come from a deep understanding of communication and visual media practices, investigating these traditions in the light of current digital transformation and digital cultures. This approach translates into fundamental research considering the nature and quality of illustration and practice-based research exploring the relation between real-time data and visual narrative. Next to her ongoing illustration practice, Hoogslag initiates and curates public projects and has published papers for various established illustration and design publications and journals. She studied graphic design at the Gerrit Rietveld Academie in Amsterdam, and completed her MA and PhD in Illustration at the Royal College of Art in London.

Hudson

Graham Hudson is secretary and a founding member of the Ephemera Society (UK) and a member of the Ephemera Society of America. Before retirement he was a member of the Chartered Society of Designers and a senior lecturer teaching graphic design at the Kent Institute of Art & Design. Published works on aspects of ephemeral printing include *The Design and Printing of Ephemera in Britain and America, 1720–1920* (British Library and Oak Knoll Press, 2008) and contributions to the *Journal of the Printing Historical Society, Art Libraries Journal, Journal of the Writing Equipment Society*, and *Industrial Archaeology*, as well as numerous articles in *The Ephemerist*.

Jainschigg

Nicholas Jainschigg has been a science fiction, fantasy and horror illustrator since the early 1980s, and has illustrated over 200 book and magazine covers. His scientific illustrations and animations have been exhibited in the US and Europe. He is an associate professor at the Rhode Island School of Design.

Juhasz

Since 1974 Victor Juhasz's award winning images have appeared in major magazines, newspapers, advertisements, and books, both national and international. His

work is included in the permanent collection of the USAF Art Program, and he has documented soldiers and Marines in the United States, Kuwait, Iraq and Afghanistan. In collaboration with the Joe Bonham Project, he has drawn the wounded at Walter Reed and McGuire Hospitals. Juhasz also illustrates children's books and serves on the Executive Board of the Society of Illustrators in NY. He has been awarded its highest honors, including the prestigious Hamilton King award for his work as an embedded artist.

Kane

Brian M. Kane has an MA in History of Art and a PhD in Arts Administration, Education and Policy from The Ohio State University. Kane was a comic book inker for Marvel Comics and Dark Horse Comics, and an art instructor. He is the author of *James Bama: American Realist* and the IPPY Award-winning, Eisner-nominated biography *Hal Foster: Prince of Illustrators*. Currently, Kane is an editor for Fantagraphics Books where his projects include the New York Times Best-Selling *Prince Valiant* reprint volumes, and Fantagraphics Studio Edition of Hal Foster's *Prince Valiant*.

Kattwinkel

Linda Joy Kattwinkel received her BFA in Communication Arts from Virginia Commonwealth University, where she attended Phil Meggs' first class on the history of graphic design. After a 13-year career as an illustrator and graphic artist, and extensive exploration of personal artwork at The Woman's Building in Los Angeles, she decided to become an attorney. As a member of Owen, Wickersham & Erickson in San Francisco, Kattwinkel's law practice focuses on copyright, trademark and arts law on behalf of designers and visual artists. She continues to create personal artwork.

Kelley

Sonja Kelley is an Assistant Professor in the Department of Art History, Theory and Criticism at the Maryland Institute College of Art (MICA) in Baltimore, MD, where she teaches classes on Asian art history. Her research focuses on Chinese art of the twentieth century. She holds a PhD in Art and Archaeology from Princeton University, and her dissertation explored the work of government-supported printmakers in Sichuan Province in the People's Republic of China from 1949 to 1966. She is also interested in the creation of "peasant prints" in China in the late 20th century and the work of women artists in China's contemporary art scene.

Knox

Page Knox is an adjunct professor in the Art History Department of Columbia University, where she received her PhD in 2012 with a focus in American Art. Her dissertation, "*Scribner's Monthly* 1870–1881: Illustrating a New American Art World," explored the significant expansion of illustration in print media during the 1870s, using *Scribner's Monthly* as a lens to examine how the medium changed the general aesthetic in American art in the late nineteenth century. A Contractual Lecturer for the Education Department at the Metropolitan Museum of Art, Page participates in adult gallery programs and lectures in special exhibitions, and also teaches membership classes that engage with the museum's collections.

La Padula

Thomas La Padula graduated from the Parsons School of Design with a BFA, and earned his MFA from Syracuse University. For over thirty-eight years, La Padula has illustrated for national and international magazines, advertising agencies and publishing houses. He is on the faculty at Pratt Institute, where he is the illustration coordinator, teaching classes in both reflective and digital illustration.

Lambrecht

Winnie Lambrecht received her PhD in anthropology from the University of California, Berkeley, with a specialty in sub-Saharan African and non-Western arts and architecture, with a focus on visual anthropology. Her ongoing interests lie at the intersection of visual and literary arts (visual literacy), and the African diaspora. Lambrecht is a documentary filmmaker and has produced films in the US, Armenia, Tanzania and Mexico. She served as the director of the Folk/Traditional & Community Arts Program at the RI State Council on the Arts; and has curated special exhibitions and cultural projects (including for the Smithsonian Institute) and served as the director for a number of international cultural exchange projects in France, Mexico and Québec. Lambrecht is a contributing editor to *Parabola Magazine* and teaches at the Rhode Island School of Design. She continues to produce documentary films and play music.

Lobban

Dr. Richard A. Lobban Jr. earned his PhD at Northwestern and is Professor Emeritus of Anthropology and African Studies at Rhode Island College. Having taught at many national and international universities, he is now Adjunct Professor of African Studies, Naval War College. He serves as the Executive Director of the Sudan Studies Association and as a Subject Matter Expert (SME); as well as an Expert Witness in asylum cases for African refugees. As an archeologist he is excavating a Meroitic era temple in the eastern Sudan; and is an active beekeeper and a devoted collector of historical maps of Africa.

Lovejoy

R. W. Lovejoy is an instructor in graphic design at American University and has taught history of illustration and history of political art and persuasive imagery for Ringling College of Art and Design. He has an MA in Art History from the University of South Florida and a PhD in History from the University of Manchester, UK.

Martin, Jr

Francis Martin, Jr. received his PhD in Art History from UCLA, where he was awarded a Rockefeller Grant for his studies. He is currently a lecturer at the University of Central Florida. Dr. Martin has written numerous articles and catalog essays, including for *Facing History: The Black Image in American Art 1710–1940*, which accompanied a traveling exhibition organized by The Corcoran Gallery of Art (Washington, D.C.); a book review of Hugh Honour's *The Image of the Black in Western Art* for the Winterthur Portfolio (Summer/Autumn 1990); and "E.W. Kemble: To Ignore is to Deny" in the *Journal of Popular Culture* (2004), for which he received the prestigious Russel B. Nye award. He continues to write and publish.

Mazierski

David M. Mazierski is a medical illustrator and Associate Professor in the Biomedical Communications graduate program at the University of Toronto. He credits his early interest in medical art to the anatomical transparency pages seen in 1960s encyclopedias, the film *Fantastic Voyage*, and his father's first aid manuals. A high school art teacher guided him towards the combination of science and illustration, which led to a BSc in Art as Applied to Medicine from the University of Toronto in 1982. His first job was to illustrate an atlas of camel anatomy produced at the Ben-Gurion University of the Negev, Israel. In 2008 he completed a Master's Degree in Ecology and Evolutionary Biology. He currently teaches courses in anatomical illustration, digital media production, and the history of scientific and medical illustration.

Morgan

Wayne Morgan is an art curator interested in popular and democratic forms, who initially studied fine art to improve his chances at a design school pursuing illustration. He was captured by fine art and curation, but retains his interest in visual narrative. Curating over 200 exhibitions for the Dunlop Art Gallery and others, he has investigated the edges of folk art, comics, illustration, pinball, and democratic access efforts. A fan of The Eight, the artist/illustrators from Philadelphia, Morgan is the recognized expert on Palmer Cox, as well as the illustrators associated with "Northerns", novels of the early twentieth century featuring the Royal Canadian Mounted Police.

Nishimura

Margot McIlwain Nishimura is the Deputy Director for Collections, Programs and Public Engagement at the Newport Restoration Foundation, in Newport, Rhode Island. She has a PhD in Medieval Art from the Institute of Fine Arts at New York University and spent many years teaching the history of illuminated manuscripts—at the University of Cape Town, Smith College, Mount Holyoke, Brown University, and the Rhode Island School of Design. Her research and publications have focused on English Gothic Psalters, marginalia in all medieval media, a 10th-century Frankish Gospel Book, and the Grey Collection of illuminated manuscripts in the National Library of South Africa. She is the author of *Images in the Margins* in the J. Paul Getty Museum's "Medieval Imagination" Series (Los Angeles: Getty Publications, 2009).

Parmal

Pamela Parmal began work at the Museum of Fine Arts, Boston, in 1999 and was appointed Chair of the David and Roberta Logie Department of Textile and Fashion Arts in 2014. She has curated a number of exhibitions including *Fashion Show: Paris Collections 2006* in November 2006–March 2007; *The Embroideries of Colonial Boston* in 2012; and she co-curated *#techstyle*, March–July 2016. She is now collaborating on an exhibition on 18th century art told through the vehicle of Casanova's memoirs, for which she has written an essay on Casanova and dress. Parmal received a Master's Degree from the Fashion Institute of Technology in New York City. The University of Wisconsin granted her BAs in Art History and French. Before taking her position at the MFA/Boston, she was Associate Curator for the Museum of Art, Rhode Island School of Design.

Plunkett

Stephanie Haboush Plunkett is the Deputy Director and Chief Curator of the Norman Rockwell Museum in Stockbridge, MA where her many curatorial projects include: *Rockwell and Realism in an Abstract World; The Unknown Hopper: Edward Hopper as Illustrator; Ice Age to the Digital Age: The 3D Animation Art of Blue Sky Studios; Witness: The Art of Jerry Pinkney; Ephemeral Beauty: Al Parker and the American Women's Magazine: 1940–1960; Building Books: The Art of David Macaulay,* and *The Art of The New Yorker: Eighty Years in the Vanguard.* She is author of two American Library Association Notable children's books and *Learning from the Masters: The Famous Artists School* (2017). She has an MFA from the School of Visual Arts and has taught at the Maryland Institute College of Art (MICA). Plunkett previously held curatorial positions at the Brooklyn Museum, the Brooklyn Children's Museum, and the Heckscher Museum of Art.

Purcell

JoAnn Purcell is the Program Coordinator of the Illustration Diploma at Seneca College, Toronto, where she also teaches drawing, painting, color theory, and art and illustration history. She was instrumental in the creation of the award winning Animation Arts Centre and was the Program Coordinator in the early years. She has years of hands-on experience as a visual artist, animator and VFX artist. JoAnn graduated from the Ontario College of Art and Design and holds an MA in Art History from York University, Toronto. She is currently pursuing her PhD in Critical Disability Studies there using comics as her medium of inquiry.

Reed

Roger Reed began working at his father Walt Reed's gallery Illustration House in 1981 and is now the President. He

has worked in every phase of the business, and remains involved in sales, research and writing, database design, valuation modeling, and authentication. Reed moved the gallery from Connecticut to New York City in 1987, and expanded it into an auction house in 1989. In the fall of 1997, he curated the first major museum retrospective of illustrator J. C. Leyendecker's work at the Norman Rockwell Museum. Reed has edited or contributed to several books, articles, and documentaries relating to illustration history, including *The Illustrator in America* by Walt Reed, and he is on the Permanent Collection Committee of the Society of Illustrators in New York. He lives in Westport, Connecticut.

Rosenzweig

Daphne Lange Rosenzweig, PhD, is a specialist in Asian art, consultant to American and Canadian museums, conference lecturer, and professional journal book reviewer. A Certified Appraiser of Personal Property with the International Society of Appraisers (ISA CAPP), she is President of Rosenzweig Associates, Inc., a private appraisal firm. With degrees from Mount Holyoke College and Columbia University, she was a Fulbright Fellow at the National Palace Museum in Taiwan. Her publications focus on Japanese prints, Chinese jades, Buddhist art, and Chinese and Korean painting. She is a full-time art historian at the Ringling College of Art and Design, teaching courses in Japanese prints, Chinese, Japanese, Buddhist, and Islamic art and culture, as well as in modern architecture.

Sabnani

Nina Sabnani is an artist and storyteller who uses film, illustration and writing to tell her stories. Graduating from the Faculty of Fine Arts, Vadodara she received an MA in film from Syracuse University, NY, which she pursued as a Fulbright Fellow. Her doctoral work led her to explore the dynamics between words and images in storytelling. Sabnani's work in film and illustrated books seeks to bring together animation and ethnography. She is currently Professor at the Industrial Design Centre, IIT Bombay. Her award winning films *Mukand and Riaz, Tanko Bole Chhe* (*The Stitches Speak*), and *Hum Chitra Banate Hain* (*We Make Images*) have been made into illustrated books and translated in several Indian languages.

Saska

Hope Saska is Curator of Collections and Exhibitions at the CU Art Museum, University of Colorado Boulder. A specialist in works on paper, Saska holds a PhD in History of Art and Architecture from Brown University with a dissertation on graphic satire and caricature from 18th century England. After completion of her dissertation she served as Andrew W. Mellon Curatorial Fellow at the Detroit Institute of Art in Prints, Drawings and Photographs. As Samuel H. Kress Curatorial Fellow at The Lewis Walpole Library and while a graduate student at Brown, she contributed to digital humanities projects exploring 18th Century art and culture.

Schick

İrvin Cemil Schick holds a PhD from the Massachusetts Institute of Technology and has taught at Harvard University, MIT, and İstanbul Şehir University. He is the author of *The Erotic Margin: Sexuality and Spatiality in Alteritist Discourse; The Fair Circassian: Adventures of an Orientalist Motif* (in Turkish); and *Writing the Body, Society, and the Universe: On Islam, Gender, and Culture* (in Turkish). He is the editor of *The M. Uğur Derman 65th Birthday Festschrift*; and *European Female Captives and their Muslim Masters: Narratives of Captivity in 'Turkish' Lands* (in Turkish); and is a co-editor of *Turkey in Transition: New Perspectives; Women in the Ottoman Balkans: Gender, Culture and History; Calligraphy and Architecture in the Muslim World*; and *The Principal Figures of Turkish Architecture* (in Turkish). His research interests include the arts of the book; gender, sexuality, spatiality, and the body; and animals and the environment, all in the context of Islam and particularly Turkey.

Schiller

Researcher and art historian Joyce K. Schiller was the first curator at the Rockwell Center for American Visual Studies and is credited with helping to establish its curatorial base. Her exhibits include "Witness: The Art of Jerry Pinkney," "R.O. Blechman: The Inquiring Line," and "It's a Dog's Life: Norman Rockwell Paints Man's Best Friend." Schiller held a PhD from Washington University in St. Louis and served as a museum curator, lecturer, and educator at the St. Louis Art Museum, Reynolda House Museum of American Art, and Delaware Art Museum before joining the Rockwell Center. She also taught the Critical Seminar for the MFA in Illustration Practice at MICA. Schiller passed away in 2014, during the development of the *History of Illustration* textbook.

Sherman

Founding Director of the MFA in Illustration Practice, and co-founder of the MA in Illustration at MICA the Maryland Institute College of Art (MICA), Whitney Sherman examines illustration through education, exhibition and her studio practice of print illustration, and surface design for Pbody Dsign. She is also Co-Director of Dolphin Press & Print at MICA, where she received the Excellence in Teaching award. A former creative director, art director and designer, her illustration work is recognized by *American Illustration*, Society of Illustrators NY, *Communication Arts* and *Print Regional Design* annuals. She created the central artwork for the USPS Breast Cancer Research stamp, the first US semi-postal issue; and authored *Playing with Sketches*, to date translated into four languages. Sherman has given workshops and lectures in China, Mexico and the US. She served as the President of ICON5, and has exhibited internationally. Her work can be seen at whitneysherman.com, pbodyd sign.com, and on the Norman Rockwell Museum site illustrationhistory.org.

Stanfield-Mazzi

Maya Stanfield-Mazzi received her PhD from the University of California, Los Angeles and is Associate Professor of Art History at the University of Florida. She specializes in art of Pre-Columbian and colonial Latin America. Her book *Object and Apparition: Envisioning the Christian Divine in the Colonial Andes* (University of Arizona Press, 2013) addresses the ways in which images of Christ and the Virgin Mary helped Christianity take root in the Andes. She shows that ex-voto paintings, which illustrate miracles associated with important local statues of Christ and Mary, were key to fostering Christian devotion.

Syme

Alison Syme received her PhD in Art History from Harvard University in 2005 and is currently Associate Professor of Modern Art at the University of Toronto. Her work focuses primarily on art and visual culture of the later 19th and earlier 20th Centuries in Britain, France, and the United States, though she also occasionally publishes on contemporary art. Her first book, *A Touch of Blossom: John Singer Sargent and the Queer Flora of Fin-de-Siècle Art* (Penn State University Press, 2010), was shortlisted for the Modernist Studies Association Book Prize in 2011. She is currently writing a book on the Victorian painter Edward Burne-Jones, the research for which is funded by the Social Sciences and Humanities Research Council of Canada.

Wall

Shelley Wall AOCAD MSc, BMC, PhD, is a medical illustrator and an Assistant Professor in the Biomedical Communications graduate program (BMC), Institute of Medical Science, Faculty of Medicine, University of Toronto; and in the Department of Biology, University of Toronto Mississauga. Before joining the BMC faculty, she worked as a biomedical multimedia developer at the Hospital for Sick Children (Toronto), creating illustrations and animations for pediatric patient education. Her areas of research and teaching include visual narrative strategies, the history of medical and bioscientific illustration, and the socio-cultural dimensions of medical visualization.

Wood

Frances Wood was a curator of the British Library's Chinese collections for more than 30 years. From the 1980s onward, she embraced collaborative work with Chinese and Japanese scholars that ultimately led to the founding of the International Dunhuang Project—a groundbreaking initiative to digitize and share images of manuscripts, paintings and other artifacts originally from archaeological sites in Dunhuang and elsewhere along the Silk Road. A graduate of Cambridge University, Wood's many titles include *Chinese Illustration* (British Library, 1985); *The Silk Road: Two Thousand Years in the Heart of Asia* (University of California Press, 2002); *China's First Emperor and His Terracotta Warriors* (St. Martin's Press, 2008); and *The Diamond Sutra: The Story of the World's Earliest Dated Printed Book* (with Mark Barnard) (British Library, 2010).

Yazdani

Ashley Yazdani is an illustrator and educator. She received her MFA in Illustration Practice from the Maryland Institute College of Art (MICA), and her BFA in Illustration from California College of the Arts. Her artwork often explores themes of environmentalism, and addresses the relationship between humans and nature. She has taught illustration at both MICA and Towson University, and is working on her first picture book, slated for publication in 2019.

Bibliography

Chapter 2

Bechtel, Edwin, *Jacques Callot* (New York: George Braziller, 1955).

Bever, Edward, "Witchcraft Prosecutions and the Decline of Magic," *Journal of Interdisciplinary History*, vol. 40, no. 2, *The Crisis of the Seventeenth Century: Interdisciplinary Perspectives* (Autumn, 2009), p. 263, http://www.jstor.org/stable/40263656.

Boorsch, Suzanne, and Nadine M. Orenstein, "The Print in the North: The Age of Albrecht Dürer and Lucas van Leyden," *The Metropolitan Museum of Art Bulletin Publication New Series*, vol. 54, no. 4, Spring 1997, doi: 10.2307/3269145.

Booton, Diane E., "Hand-Me-Downs: The (re)use of Relief Metalcuts by Brothers Étienne Larcher at Nantes and Jean Du Pré at Paris," *Bulletin du bibliophile*, 2011, 238–266. Accessed through Academia.edu: https://www.academia.edu/365553/Hand_Me_Downs_The_Re_use_of_Relief_Metalcuts_by_Brothers_Étienne_Larcher_at_Nantes_and_Jean_Du_Pré_at_Paris.

Cameron, Euan, *The European Reformation* (Oxford: Oxford University Press, 1991).

Carrieri, Maria Patrizia, and Diego Serraino, "Longevity of Popes and Artists between the 13th and the 19th century," *International Journal of Epidemiology*, vol. 34, no. 6, December 2005, 1435-1436, doi: 10.1093/ije/dyi211.

Colonna, Francesco, *Hypnerotomachia Poliphili: The Strife of Love in a Dream*. Translated by Jocelyn Godwin. (New York: Thames & Hudson, 1999).

Doorly, Patrick, "Dürer's 'Melencolia I': Plato's Abandoned Search for the Beautiful," *The Art Bulletin*, vol. 86, no. 2, June 2004, 255–276, doi: 10.2307/3177417.

Goldstein, Carl, *Print Culture in Early Modern France, Abraham Bosse and the Purposes of Print* (New York: Cambridge University Press, 2012).

Goodrich, L. Carrington, "Movable Type Printing: Two Notes," *Journal of the American Oriental Society*, vol. 94, no. 4, 1974, 476–477, http://www.jstor.org/stable/600591.

Grieken, Joris van, Ger Luiten, and Jan Van der Stock, *Hieronymus Cock, The Renaissance in Print* (New Haven and London: Yale University Press, 2013).

Griffiths, Antony, *Prints and Printmaking, An Introduction To The History And Techniques* (Los Angeles: University of California Press, Berkeley in conjunction with British Museum Press, 1996).

Grossinger, Christa, *Humour and Folly in Secular and Profane Prints of Northern Europe 1430–1540* (London: Harvey Miller Publishers, 2002).

Hadavas, Kosta (Ed.), *In Nuremberg Chronicle*. Beloit College, Morse Library, Online Edition: http://www.beloit.edu/nuremberg/inside/about/tour.htm 2007.

Hoffmann, Detlef, *The Playing Card, An Illustrated History* (Greenwich: New York Graphic Society, 1973).

Houston, Robert A., "Literacy, European History Online (EGO)," published by the Institute of European History (IEG), (2011), 11–28, http://ieg-ego.eu/en/threads/backgrounds/literacy/robert-a-houston-literacy#LanguageandLiteracy

Jacobsen, Michael A., "The Meaning of Mantegna's Battle of Sea Monsters," *The Art Bulletin*, vol. 64, no. 4, December 1982, 623–629, doi: 10.2307/3050273.

Kohanski, Tamarah, and C. David Benson (Trans. and eds.), "Introduction," In *The Book of John Mandeville* (2007, Online edition), http://d.lib.rochester.edu/teams/text/kohanski-and-benson-the-book-of-john-mandeville-introduction.

Landau, David, and Peter Parshall, *The Renaissance Print 1470–1550*. (New Haven and London: Yale University Press, 1994).

Lefbvre, Lucien, and Henri-Jean Martin, *The Coming of the Book, the Impact of Printing 1450–1800*. (London and New York: Verso, 2010).

McPhee, Constance, and Nadine M. Orenstein, *Infinite Jest, Caricature and Satire from Leonardo to Levine* (New York: Metropolitan Museum of Art, 2011).

Monteyne, Joseph, *The Printed Image in Early Modern London, Urban Space, Visual Representation and Social Exchange* (Hampshire and Burlington: Ashgate, 2007).

Müller, Christian, Stephen Kemperdick, and Maryan W. Ainsworth, *Hans Holbein the Younger, The Basel Years 1515–1532* (Munich, London, New York: Prestel, 2006).

Needham, Paul, "Prints in the Early Printing Shops," in *The Woodcut in Fifteenth-Century Europe*, edited by Peter Parshall, 17–37. (Washington, DC: National Gallery of Art, 2009).

Nevins, Teresa K., "Oedipus in the Sion Textile," in *The Woodcut in Fifteenth-Century Europe*, edited by Peter Parshall, 17–37 (Washington, DC: National Gallery of Art, 2009).

Pon, Lisa, "Print and Privileges: Regulating the Image in 16th Century Italy," *Harvard University Art Museum's bulletin*, vol. 6, no. 2, Autumn 1998, 41–64.

Robison, Andrew, and Klaus Albrecht Schröder et al., *Albrecht Dürer, Master Drawings and Prints from the Albertina* (Washington, DC: National Gallery of Art, 2013).

Schmidt, Peter, "The Early Print and the Origins of the Picture Postcard," in *The Woodcut in Fifteenth-Century*

Europe, edited by Peter Parshall, 239–257 (Washington, DC: National Gallery of Art. 2009).

Shiner, Larry, *The Invention of Art, A Cultural History*. (Chicago and New York: University of Chicago Press, 2001).

Talvacchia, Bette, *Taking Positions, On the Erotic in Renaissance Culture* (Princeton: Princeton University Press, 1999).

Weekes, Ursula, "Convents as Patrons and Producers of Woodcuts in the Low Countries around 1500," in *The Woodcut in Fifteenth-Century Europe*, edited by Peter Parshall, 259–275 (Washington, DC: National Gallery of Art, 2009).

Chapter 3

Mukherji, Parul Dave, *The Citrasutra of the Vishnudharmottara-Purana* (New Delhi, IGNCA, 2001).

Subramanyan, K. G., *Moving Focus: Essays on Indian Art* (New Delhi: Lalit Kala Akademi, 1978).

Symes, M. *An Account of an Embassy to the Kingdom of Ava, Sent by the Governor-General of India, in the Year 1795* (London: Bulmer and Co., 1800).

Chapter 5

Chia, Lucille, *Printing for Profit: The Commercial Publishers of Jianyang, Fujian (11th–17th Centuries)* (Cambridge, MA: Harvard University Press, 2002).

Ebrey, Thomas, "The Editions, Superstates and States of the Ten Bamboo Studio Collection of Calligraphy and Painting," *East Asian Library Journal*, vol. 14, no. 1, Spring 2010, 1–119.

Fan Jinshi, *The Art of Mogao Grottoes in Dunhuang: A Journey into China's Buddhist Shrine* (Paramus, NJ: Homa & Sekey Books, 2009).

Harper, Donald J., *Early Chinese Medical Literature: The Mawangdui Medical Manuscripts* (London and New York: Kegan Paul International, 1998).

He Yuming, *Home and the World: Editing the "Glorious Ming" in Woodblock-printed Books of the Sixteenth and Seventeenth Centuries* (Cambridge, MA: Harvard University Asia Center, 2013).

Kinney, Anne Behnke, *Exemplary Women of Early China: The Lienü Zhuan of Liu Xiang* (New York: Columbia University Press, 2017).

Liu, Cary Y., et al., *Recarving China's Past: Art, Archaeology, and Architecture of the "Wu Family Shrines"* (New Haven & London: Yale University Press, 2005).

McCausland, Shane, *Gu Kaizhi and the Admonitions Scroll* (London: British Museum Press, 2003).

Murray, Julia K. "Buddhism and Early Narrative Illustration in China," *Archives of Asian Art*, vol. 48, 1995, 17–31. Accessed February 10, 2015. http://www.jstor.org /stable/20111252.

——, "Changing the Frame: Prefaces and Colophons in the Chinese Illustrated Book *Dijian tushuo* (The Emperor's Mirror, illustrated and discussed)," *East Asian Library Journal*, vol. 12, no. 1, Spring 2006, 20–67.

——, "Didactic Illustrations in Printed Books," in *Studies on China: Printing and Book Culture in Late Imperial China*, edited by Cynthia J. Brokaw and Kai-Wing Chow, 417–450 (Berkeley: University of California Press, 2005).

——, "The 'Ladies' Classic of Filial Piety' and Sung Textual Illustration: Problems of Reconstruction and Artistic Context," *Ars Orientalis*, vol. 18, 1988, 95–129. Accessed February 26, 2015. http://www.jstor.org/stable/4629372.

——, *Mirror of Morality: Chinese Narrative Illustration and Confucian Ideology* (Honolulu: University of Hawai'i Press, 2007).

——, "What Is 'Chinese Narrative Illustration'?" *The Art Bulletin*, vol. 80, no. 4, 1998, 602–615. Accessed February 10, 2015. http://www.jstor.org/stable/3051315.

Nylan, Michael, *The Five "Confucian" Classics* (New Haven: Yale University Press: 2001). Accessed April 23, 2015. http://yalepress.yale.edu/YupBooks/pdf /0300081855.pdf?winOpen=true.

Reed, Christopher A., *Gutenberg in Shanghai: Chinese Print Capitalism 1876–1937* (Vancouver: University of British Columbia Press, 2004).

Sung Ying-Hsing, *Chinese Technology in the Seventeenth Century: T'ien-kung k'ai-wu*, Translated and annotated by E-tu Zen Sun and Shiou-Chuan Sun (State College, PA: Pennsylvania State University, 1966. Reprint, Mineola, NY: Dover Publications, 1997).

Tsien, Tsuen-hsuin, "Paper and Printing," in Joseph Needham, *Science and Civilisation in China*, vol. 5, part 1 (Cambridge: Cambridge University Press, 1985).

Twitchett, Denis, *Printing and Publishing in Medieval China* (London: Wynken de Worde Society, 1983).

Wood, Frances, *Chinese Illustration* (London: British Library, 1985).

Wood, Frances, and Mark Barnard, *The Diamond Sutra: The Story of the World's Earliest Dated Printed Book* (London: British Library, 2010).

Wu Hung, *The Wu Liang Shrine: The Ideology of Early Chinese Pictorial Art* (Stanford: Stanford University Press, 1989).

Ye Xiaoqing, *The Dianshizhai Pictorial: Shanghai Urban Life, 1884–1898* (Ann Arbor: University of Michigan Press, 2003).

Chapter 6

47 Ronin Multimedia, http://www.47ronin.com.

Asano, Shugo, and Timothy Clark, *The Passionate Art of Kitagawa Utamaro* (London: British Museum Press, 1995).

Bank of Japan, Currency Museum, http://www.imes.boj.or .jp/cm/english/history/.

Bickford, Lawrence, *Sumo and the Woodblock Print Masters* (New York: Kodansha America, Inc., 1994.)

Bouquillard, Jocelyn, and Christophe Marquet, *Hokusai: First Manga Master* (New York: Abrams, 2007).

Breuer, Karin, *Japanesque: The Japanese Print in the Era of Impressionism* (San Francisco: The Fine Arts Museums of San Francisco, in conjunction with Prestel Publishing, 2010).

Brown, Kendall H., et al., *Light in Darkness: Women in Japanese Prints of Early Showa* (Los Angeles: Fisher Gallery, University of Southern California, 1996).

Bru, Ricard, *Erotic Japonisme: The Influence of Japanese Sexual Imagery on Western Art* (Amsterdam: Hotei Publishing, 2013).

Chiappa, J. Noel, and Jason M. Levine. "Tsukioka Yoshitoshi (1839–1892) Catalogue Raisonné," August 29, 2013. http://www.yoshitoshi.net/.

Chibbett, David G., *The History of Japanese Printing and Book Illustration* (New York: Kodansha International, 1977).

Clark, Timothy, et al., *The Actor's Image: Print Makers of the Katsukawa School* (Chicago: The Art Institute of Chicago, 1994).

———, *The Dawn of the Floating World, 1650–1765: Early Ukiyo-e Treasures from the Museum of Fine Arts, Boston* (London: Royal Academy of Arts, 2001).

———, *Shunga: Sex and Pleasure in Japanese Art* (London: British Museum, 2014).

Dalby, Lisa, *Geisha* (Berkley: University of the California Press, 1999, reprint).

Franklin, Colin, *Exploring Japanese Books and Scrolls* (Delaware: Oak Knoll Press; London: British Library, 2005).

Gerstle, C. Andrew, *Kabuki, Heroes on the Osaka Stage, 1780–1830* (London: The British Museum Press, 2005).

Guth, Christine M. E., Alicia Volk, Emiko Yamanishi, et al., *Japan and Paris: Impressionism, Postimpressionism and the Modern Era* (Honolulu: Honolulu Academy of the Arts, 2004).

———, *Hokusai's Great Wave: Biography of a Global Icon* (Honolulu: University of Hawaii Press, 2015).

Haft, Alfred, *Aesthetic Strategies of the Floating World* (Leiden: Brill Publisher, 2013).

Hayashi, Yoshikazu, and Richard Lane, Teihon, *Ukiyo-e Shunga Meihin Shusei (The Complete Ukiyo-e Shunga)* (Tokyo: 1995–2000).

Hillier, Jack, *The Art of the Japanese Book* (London: Published for Sotheby's New York: Philip Wilson Publishers, 1987).

Irvine, Gregory, *Japonisme and the Rise of the Modern Art Movement: The Arts of the Meiji Period* (London: Thames & Hudson Publishers, 2013).

KABUKI. http://www.kabuki21.com.

Kanada, Margaret Miller, *Color Woodblock Printmaking: The Traditional Method of Ukiyo-e* (Tokyo: Shufurotomo Co., Ltd., 1989).

Keene, Donald, Ann Nishimura Morse, and A. Frederic Sharf, *Japan at the Dawn of the Modern Age: Woodblock Prints from the Meiji Era, 1868–1912. Selections from the Jean S. and Frederic A. Sharf Collection at the Museum of Fine Arts, Boston* (Boston: Museum of Fine Arts, 2001).

Kita, Sandy, et al., *The Floating World of Ukiyo-e: Shadows, Dreams, and Substance* (New York: Harry N. Abrams, Inc., in association with the Library of Congress, 2001).

Marks, Andreas, *Japanese Woodblock Prints: Artists, Publishers and Masterworks, 1680–1900* (North Clarendon, VT: Tuttle Publishing, 2010).

Meech, Julia, and Gabriel P. Weisberg, *Japonisme Comes to America: The Japanese Impact on the Graphic Arts 1876–1925* (New York: Harry N. Abrams, Inc., in conjunction with the Jane Voorhees Zimmerli Art Museum, Rutgers, 1990).

Meech-Pekarik, Julia, *The World of the Meiji Print* (New York: Weatherhill, 1986).

Merritt, Helen, and Nanako Yamada, *Woodblock Kuchi-e Prints: Reflections of Meiji Culture* (Honolulu: University of Hawaii Press, 2000).

Mirviss, Joan B., et al., *The Frank Lloyd Wright Collection of Surimono* (New York: Weatherhill, Inc., in conjunction with the Phoenix Art Museum, 1995).

Morse, Anne Nishimura, ed., *Drama and Desire: Japanese Paintings from the Floating World, 1690–1850* (Boston: Museum of Fine Arts, 2007).

OsakaPrints.com, http://www.osakaprints.com.

Reigle, Amy Newland, ed., *The Commercial and Cultural Climate of Japanese Printmaking* (Amsterdam: Hotei Publishing, 2004).

Rodner, William S., *Edwardian London through Japanese Eyes: The Art and Writings of Yoshio Markino, 1897–1915* (Leiden: Brill Publisher, 2012).

Rosenzweig, Daphne Lange, "Musha-e: Japanese Warrior Prints," *Journal of Advanced Appraisal Practices*, 2014, 1–14.

Salter, Rebecca, *Japanese Woodblock Printing* (Honolulu: University of Hawaii Press, 2002).

Screech, Timon, *Sex and the Floating World: Erotic Images in Japan, 1700–1820* (Honolulu: University of Hawaii Press, 1999).

Seigle, Cecilia Segawa, et al., *A Courtesan's Day: Hour by Hour* (Amsterdam: Hotei Publishing, 2004).

Thompson, Sarah E., and H. D. Harootunian, *Under Currents in the Floating World: Censorship and Japanese Prints* (New York: The Asia Society Galleries, 1991).

Toda, Kenji, *Japanese and Chinese Illustrated Books in the Ryerson Library of the Art Institute of Chicago* (Mansfield Centre, CT: Martino Publishing, 2004).

Uspensky, Mikhail, *Hiroshige: One Hundred Views of Edo* (Bournemouth, England: Parkstone, 1997).

Weinberg, David R., *Kuniyoshi: The Faithful Samurai* (Leiden: Hotei Publishing, 2000).

Chapter 7

Ades, Dawn, *Art in Latin America: The Modern Era, 1820–1980* (New Haven: Yale University Press, 1989).

Adorno, Rolena, *Guaman Poma Writing and Resistance in Colonial Peru* (Austin: University of Texas Press/Institute of Latin American Studies, 2000).

Alva, Walter, and Christopher B. Donnan, *Royal Tombs of Sipán* (Los Angeles: University of California, 1993).

Baird, Ellen, "Sahagún's *Primeros Memoriales* and *Codex Florentino*: European Elements in the Illustrations," in *Smoke and Mist: Middle American Studies in Memory of Thelma Sullivan*, edited by Karen Dakin and J. Kathryn Josserand, Part I (Oxford: BAR, 1988): 15–40.

Bleichmar, Daniela, *Visible Empire: Botanical Expeditions and Visual Culture in the Hispanic Enlightenment* (Chicago; London: University of Chicago Press, 2012).

Boone, Elizabeth Hill, *Stories in Red and Black: Pictorial Histories of the Aztecs and Mixtecs* (Austin: University of Texas Press, 2000).

Brading, David A., Ramón Mujica Pinilla, and Scarlett O'Phelan Godoy, *Visión y símbolos: del virreinato criollo a la república peruana* (Lima: Banco de Crédito, 2006).

Brunk, Samuel, *The Posthumous Career of Emiliano Zapata: Myth, Memory, and Mexico's Twentieth Century* (Austin: University of Texas Press, 2010).

Burger, Richard L., *Chavín and the Origins of Andean Civilization* (London and New York: Thames & Hudson, 1995).

Carrera, Magali Marie, *Imagining Identity in New Spain: Race, Lineage, and the Colonial Body in Portraiture and Casta Paintings* (Austin: University of Texas Press, 2003).

Casillas, Mercurio, *Posada: Illustrator of Chapbooks* (Mexico City: Editorial RM, 2007).

Coe, Michael D., *Breaking the Maya Code* (New York: Thames and Hudson, 1992).

Coffey, Mary K., *How a Revolutionary Art Became Official Culture: Murals, Museums, and the Mexican State* (Durham, NC: Duke University Press, 2012).

Craven, David, *Art and Revolution in Latin America, 1910–1990* (New Haven: Yale University Press, 2002).

Dean, Carolyn, "Copied Carts: Spanish Prints and Colonial Peruvian Paintings," *Art Bulletin*, vol. 78, no. 1, 1996, 98–110.

———, *Inka Bodies and the Body of Christ: Corpus Christi in Colonial Cuzco, Peru* (Durham, NC: Duke University Press, 1999).

Diener, Pablo, "Traveling Artists in America: Visions and Views," *Culture and History*, vol. 1, no. 2, 2012, 1–13.

Durand, Jorge, and Douglas S. Massey, *Miracles on the Border: Retablos of Mexican Migrants to the United States* (Tucson: University of Arizona Press, 1995).

Frank, Patrick, *Posada's Broadsheets: Mexican Popular Imagery, 1890–1910* (Albuquerque: University of New Mexico Press, 1998).

Frame, Mary, "Blood, Fertility, and Transformation: Interwoven Themes in the Paracas Necropolis Embroideries," in *Ritual Sacrifice in Ancient Peru*, edited by Elizabeth P. Benson and Anita G. Cook (Austin: University of Texas Press, 2001): 55–92.

Goldman, Shifra, "Six Women Artists of Mexico," *Woman's Art Journal*, vol. 3, no. 2, Autumn-Winter, 1982–1983, 1–9.

Herren, Angela Marie, "Portraying the Aztec Past in the Codex Azcatitlan: Colonial Strategies," *Athanor*, vol. 22, 2004, 7–13.

Jackson, Margaret A., *Moche Art and Visual Culture in Ancient Peru* (Albuquerque: University of New Mexico Press, 2008).

Katzew, Ilona, *Casta Painting: Images of Race in Eighteenth-Century Mexico* (New Haven: Yale University Press, 2004).

Klein, Cecelia F., "Woven Heaven, Tangled Earth: A Weaver's Paradigm of the Mesoamerican Cosmos," *NYAS Annals of the New York Academy of Sciences*, vol. 385, no. 1, 1982, 1–35.

Landes, Joan B., *Visualizing the Nation: Gender, Representation, and Revolution in Eighteenth-Century France* (Ithaca, NY: Cornell University Press, 2001).

Leibsohn, Dana, and Barbara Mundy, "Map of Guaxtepec," in *Painting a New World: Mexican Art and Life, 1521–1821*, edited by Donna Pierce, Rogelio Ruiz Gomar, and Clara Bargellini (Denver: Frederick and Jan Mayer Center for Pre-Columbian and Spanish Colonial Art, Denver Art Museum, 2004): 116–118.

McNamara, Patrick J., *Sons of the Sierra: Juárez, Díaz, and the People of Ixtlán, Oaxaca, 1855–1920* (Chapel Hill: The University of North Carolina Press, 2007).

Milbrath, Susan, *Heaven and Earth in Ancient Mexico: Astronomy and Seasonal Cycles in the Codex Borgia* (Austin: University of Texas Press, 2013).

Mundy, Barbara E., *The Mapping of New Spain: Indigenous Cartography and the Maps of the* Relaciones Geográficas (Chicago: University of Chicago Press, 1996).

Orozco, José Clemente, *An Autobiography* (New York: Dover Publications, 2001).

Pierce, Donna, Rogelio Ruiz Gomar, and Clara Bargellini (Eds.), *Painting a New World Mexican Art and Life 1521–1821* (Denver: Frederick and Jan Mayer Center for Pre-Columbian and Spanish Colonial Art, Denver Art Museum, 2004).

Quilter, Jeffrey, "The Narrative Approach to Moche Iconography," *Latin American Antiquity*, vol. 8, no. 2, 1997, 113–133.

Reents Budet, Dorie, Joseph W. Ball, Michael P. Mezzatesta, and Linda Schele, *Painting the Maya Universe: Royal Ceramics of the Classic Period* (Durham: Duke University Press, in association with Duke University Museum of Art, 1994).

Restall, Matthew, *Seven Myths of the Spanish Conquest* (New York: Oxford University Press, 2003).

Rick, John W., "The Evolution of Authority and Power at Chavín de Huántar, Peru," *Archeological Papers of the*

American Anthropological Association, vol. 14, no. 1, January 2004, 71–89.

Roe, Peter G., and Alana Cordy-Collins, *Chavin Art* (Greeley, CO: University of Northern Colorado, Museum of Anthropology, 1983).

Stanfield-Mazzi, Maya, "In the Aftermath of Crisis: The Painted Ex-Voto in Colonial Peru." Toronto, Latin American Studies Association Annual Conference, 2010.

———, *Object and Apparition: Envisioning the Christian Divine in the Colonial Andes* (Tucson, AZ: University of Arizona Press, 2013).

Stone, Rebecca R., *Art of the Andes from Chavín to Inca*, 3rd ed. (London: Thames and Hudson, 2012).

Stone-Miller, Rebecca, *To Weave for the Sun: Ancient Andean Textiles in the Museum of Fine Arts, Boston* (Boston: Museum of Fine Arts, 1992).

Taube, Karl, "Lightning Celts and Corn Fetishes: The Formative Olmec and the Development of Maize Symbolism in Mesoamerica and the American Southwest," in *Olmec Art and Archaeology*, edited by John Clark and Mary Pye (Washington, DC: National Gallery of Art, 2000): 296–337.

———, "The Olmec Maize God: The Face of Corn in Formative Mesoamerica," *Res*, vol. 29/30, 1996, 39–81.

Tedlock, Dennis (Ed.), *Popol Vuh: The Definitive Edition of the Mayan Book of the Dawn of Life and the Glories of Gods and Kings* (New York: Simon & Schuster, 1996).

Van de Guchte, Maarten, "Invention and Assimilation: European Engravings as Models for the Drawings of Felipe Guaman Poma de Ayala," in *Guaman Poma de Ayala: The Colonial Art of an Andean Author*, edited by Rolena Adorno (New York: Americas Society, 1992): 92–109.

Widdifield, Stacie G., "Dispossession, Assimilation, and the Image of the Indian in Late-Nineteenth-Century Mexican Painting," *The Art Journal*, 1990, 125–132.

Zarur, Elizabeth Netto Calil, and Charles M. Lovell, *Art and Faith in Mexico: The Nineteenth-Century* Retablo *Tradition* (Albuquerque: University of New Mexico Press, 2001).

Chapter 8

Abiodun, Rowland, *Yoruba Art and Language: Seeking the African in African Art* (New York: Cambridge University Press, 2014).

Abiodun, Rowland, John Pemberton, and Ulli Beier, *Cloth Only Wears to Shreds, Textiles and Photographs from the Ulli Beier Collection* (Amherst, MA: Mead Art Museum, 2004).

Adandé, Joseph, *Appliquéd Cloth or Hangings*, Historical Museum of Abomey, Université Nationale du Bénin, 1999–2011. Accessed April, 3 2013, http://www.epa-prema.net/abomeyGB/resources/hangings.htm

Akinola, G. A., "The Origin of the Eweka Dynasty of Benin—A Study in the Use and Abuse of Oral Traditions," in *Journal of Historical Society of Nigeria*, vol. VIII, no. 3, 1976, 21–36.

Apley, Alice, "Igbo–Ukwu (ca. 9th century)," *Heilbrunn Timeline of Art History*, Metropolitan Museum of Art, 2001. Accessed December 15, 2014, http://www.metmuseum.org/toah/hd/igbo/hd_igbo.htm.

Areo, Margaret Olugbemisola, and Razaq Olatunde Rom Kalilu, "Origin of and Visual Semiotics in Yoruba Textile of Adire," *Arts and Design Studies*, vol. 12, 2013, www.iiste.org.

Campbell, Bolaji, *Painting for the Gods: Art and Aesthetics of Yoruba Religious Murals* (Trenton, NJ: African World Press, 2008).

Drewal, Henry, and John Pemberton with Rowland Abiodun, *Yoruba: Nine Centuries of African Art and Thought* (New York: Center for African Art, in association with Harry N. Abrams, Inc., 1989).

Ezra, Kate, *Royal Art of Benin from the Pearls Collection* (New York: The Metropolitan Museum of Art, 1992).

Gumpert, Lynn (Ed.), *The Poetics of Cloth: African Textiles, Recent Art* (New York: Grey Art Gallery, New York University, 2008).

Johnson, Samuel, *The History of the Yorubas, from the Earliest Times to the Beginning of the British Protectorate* (Lagos, Nigeria: CSS Bookshops Ltd, 1921 and 2006).

Kirkham, Pat, and Susan Weber, *History of Design: Decorative Arts and Material Culture, 1400–2000 (Bard Graduate Center for Studies in the Decorative Arts, Design & Culture)* (New Haven: Yale University Press, 2013).

Kreamer, Christine Mullen, et al., *Inscribing Meaning: Writing and Graphic Systems in African Art* (Washington, DC: Smithsonian, National Museum of African Art, 2007).

Lawal, Babatunde, "Aworan: Representing the Self and Its Metaphysical Other in Yoruba Art," *Art Bulletin*, vol. 83, no. 3, 2001.

Liberato, Carlos F., *Money, Cloth-Currency, Monopoly, and Slave Trade in the Rivers of Guiné and the Cape Verde Islands 1755–1777*. Accessed April 4, 2015, https://www.academia.edu/5019257/Liberato_Money-Cloth-Monopoly-Slave-Trade-in-Guine-and-Cape-Verde_1755-1777.

Loder, Robert, Lisa Muncke, John Picton, Brunei Gallery Edinburgh College of Art, et al., *Image and Form: Prints, Drawings, and Sculpture from Southern Africa and Nigeria* (London: School of Oriental and African Studies, University of London, 1997).

Meurant, Georges, and Robert Farris Thompson, *Mbuti Design: Paintings by Pygmy Women of the Ituri Forest* (New York: Thames and Hudson, 1996).

Okediji, Moyo, *African Renaissance: Old Forms New Images in Yoruba Art* (Boulder, CO: University Press of Colorado, 2002).

Ola, Yomi, *Satires of Power in Yoruba Visual Culture* (Durham, NC: Carolina Academic Press, 2013).

Oloidi, Ola, "Art and Nationalism in Colonial Nigeria," in *Seven Stories about Modern Art in Africa*, edited by Clementine Deliss (London: Whitechapel, 1995).

Omu, Fred I. A., "The Iwe Irohin, 1859–1867," in *Journal of Historical Society of Nigeria*, vol. IV, no. 1, December 1967, 35–44.

Ross, Doran, et al., *Wrapped in Pride, Ghanaian Kente and African American Identity* (Los Angeles: UCLA Fowler Museum of Cultural History, 1998).

Schoen, Brian, *The Fragile Fabric of Union: Cotton, Federal Politics, and the Global Origins of the Civil War* (Baltimore, MD: Johns Hopkins University Press, 2009).

Spencer, Anne M., *In Praise of Heroes: Contemporary African Commemorative Cloth: An Exhibition at the Newark Museum*, September 14, 1982–February 27, 1983. Newark, NJ: Newark Museum, ca. 1982.

Spring, Christopher, *African Textiles Today* (London: The British Museum Press, and Washington, DC: Smithsonian Books, in association with British Museum Press, 2012).

Thompson, Robert Farris, *Flash of the Spirit: African and Afro-American Art and Philosophy* (New York: Vintage Books, 1984).

Vaughan, Olufemi, *Nigerian Chiefs: Traditional Power in Modern Politics, 1890s–1990s* (Rochester, NY: University of Rochester Press, 2000).

Ventura, Carol, *The Twenty-first Century Voices of the Ashanti Adinkra and Kente Cloths of Ghana*, Reprinted from Textile Society of America, 13th Biennial Symposium, Washington, DC, 2012. Accessed March 25, 2015. http://digitalcommons.unl.edu/cgi/viewcontent.cgi?article=1750&context=tsaconf.

Visona, Monica Blackmun, Robin Poynor, and Herbert M. Cole, *A History of Art in Africa* (Upper Saddle River, NJ: Pearson-Prentice Hall, 2001 and 2008).

Chapter 10

Barnett, Richard, *The Sick Rose or Disease and the Art of Medical Illustration* (London: Thames & Hudson, 2014).

Caldwell, Janis McLarren, "The Strange Death of the Animated Cadaver: Changing Conventions in Nineteenth-Century British Anatomical Illustration," *Literature and Medicine*, vol. 25, no. 2, 2006, 325–357.

Carlino, Andrea, *Paper Bodies: A Catalogue of Anatomical Fugitive Sheets 1538–1687* (London: Wellcome Institute for the History of Medicine, 1999).

Cazort, Mimi, "The Theatre of the Body," in *The Ingenious Machine of Nature: Four Centuries of Art and Anatomy* (Ottawa: National Gallery of Canada, 1996): 11–42.

Choulant, L., *History and Bibliography of Anatomic Illustration* (New York, London: Hafner, 1945).

Clayton, Martin, and Ron Philo, *Leonardo Da Vinci: Anatomist* (London: Royal Collection Trust, 2012).

Defelipe, Javier, *Cajal's Butterflies of the Soul: Science and Art* (Oxford: Oxford University Press, 2010).

Duffin, Jacalyn, *History of Medicine: A Scandalously Short Introduction*, 2nd ed. (Toronto: University of Toronto Press, 2010).

Elkins, James, "Two Conceptions of the Human Form: Bernard Siegfried Albinus and Andreas Vesalius," *Artibus et Historiae*, vol. 7, no. 14, 1986, 91–106.

Findlen, Paula, "Anatomy Theaters, Botanical Gardens, and Natural History Collections," in *The Cambridge History of Science*, edited by Katharine and Lorraine Daston Park (Cambridge: Cambridge University Press, 2006): 272–289.

Haeger, Knut, *The Illustrated History of Surgery*, 2nd ed. (London: Harold Starke Publishers, 2000).

Hanigan, William C., William Ragen, and Reginald Foster, "Dryander of Marburg and the First Textbook of Neuroanatomy," *Neurosurgery*, vol. 26, no. 3, 1990, 489–498.

Hildebrand, Reinhard, "Attic Perfection in Anatomy: Bernhard Siegfried Albinus (1697–1770) and Samuel Thomas Soemmerring (1755–1830)," *Annals of Anatomy*, vol. 187, no. 5, 2005, 555–573.

Huisman, Tim, "Squares and Diopters: The Drawing System of a Famous Anatomical Atlas," *Tractrix*, vol. 4, 1992, 1–11.

Kemp, Martin, "'The Mark of Truth': Looking and Learning in Some Anatomical Illustrations From the Renaissance and Eighteenth Century," in *Medicine and the Five Senses*, edited by W. F. and Roy Porter Bynum (Cambridge: Cambridge University Press, 1993): 85–121.

———, "Style and Non-Style in Anatomical Illustration: From Renaissance Humanism to Henry Gray," *Journal of Anatomy*, vol. 216, 2010, 192–208.

Le Minor, Jean-Marie, and Henri Sick (Eds.), *J. M. Bourgery & N. H. Jacob: Atlas of Human Anatomy and Surgery: Selection of the Most Important Coloured Plates* (New York: Barnes & Noble, n.d.).

Linden, David E. J., "Five Hundred Years of Brain Images," *Archives of Neurology*, vol. 59, 2002, 308–313.

Lupacchini, Rossella, and Annarita Angelini (Eds.), *The Art of Science: From Perspective Drawing to Quantum Randomness* (Cham, Switzerland: Springer International Publishing, 2014)

Magner, Lois N., *A History of the Life Sciences*, 3rd ed., rev. and expanded (New York: Marcel Dekker, 2002).

Massey, Lyle, "Pregnancy and Pathology: Picturing Childbirth in Eighteenth-Century Obstetric Atlases," *The Art Bulletin*, vol. 87, no. 1, 2005, 73–92.

Murray, T. J., "Robert Carswell: The First Illustrator of Ms," *The International MS Journal*, vol. 16, 2009, 98–101.

Neher, Allister, "The Truth About Our Bones: William Cheselden's *Osteographia*," *Medical History*, vol. 54, 2010, 517–528.

Oldfield, Philip, *Vesalius at 500: An Exhibition Commemorating the Five-Hundredth Anniversary of the Birth of*

Andreas Vesalius (Toronto: Thomas Fisher Rare Book Library, University of Toronto, 2014).

Patrizio, Andrew, and Dawn Kemp (Eds.), *Anatomy Acts: How We Come to Know Ourselves* (Edinburgh: Berlinn, 2006).

Porter, Roy, *The Greatest Benefit to Mankind: A Medical History of Humanity* (New York: W.W. Norton & Company, 1997).

Richardson, Ruth, *The Making of Mr. Gray's Anatomy: Bodies, Books, Fortune, Fame* (Oxford: Oxford University Press, 2008).

Roberts, K. B., "The Contexts of Anatomical Illustration," in *The Ingenious Machine of Nature: Four Centuries of Art and Anatomy*, edited by Mimi Cazort, Monique Kornell, and K. B. Roberts (Ottawa: National Gallery of Canada, 1996): 71–103.

Roberts, K. B., and J. D. W. Tomlinson, *The Fabric of the Body: European Traditions of Anatomical Illustration* (Oxford: Oxford University Press, 1992).

Rosse, Cornelius, "Anatomy Atlases," *Clinical Anatomy*, vol. 12, 1999, 293–299.

Sappol, Michael, *Dream Anatomy* (Bethesda, MD: U.S. Department of Health and Human Services, National Institutes of Health, National Library of Medicine, 2006).

Saunders, J. B. deCusance, and Charles D. O'Malley, *The Illustrations from the Works of Andreas Vesalius of Brussels* (New York: The World Publishing Company, 1950).

Schiebinger, Londa, "Skeletons in the Closet: The First Illustrations of the Female Skeleton in Eighteenth-Century Anatomy," *Representations*, vol. 14, 1986, 42–82.

——, *Nature's Body: Gender in the Making of Modern Science* (Boston: Beacon Press, 1993).

Schmidt, Suzanne Karr, with Kimberly Nichols, *Altered and Adorned: Using Renaissance Prints in Daily Life* (Chicago: The Art Institute of Chicago, 2011).

Thornton, John L., and Carole Reeves, *Medical Book Illustration: A Short History* (Cambridge: The Oleander Press, 1983).

Thornton, John L., *Jan Van Rymsdyk: Medical Artist of the Eighteenth Century* (New York: Oleander Press, 1982).

Whittington, Karl. "The Cruciform Womb: Process, Symbol and Salvation in Bodleian Library Ms. Ashmole 399," *Different Visions: A Journal of New Perspectives on Medieval Art*, vol. 1, 2008, 1–24.

Chapter 11

Manuscripts

Brooks, Charles William Shirley, 1964 Diary, Houghton Library.

Silver, Henry, Diary, *Punch* Archive.

Books and Articles

Adrian, Arthur A., *Mark Lemon: First Editor of Punch* (London: Oxford University Press, 1966).

Altick, Richard D., *Punch: The Lively Youth of a British Institution, 1841–1851* (Columbus: Ohio State University Press, 1997).

——, *The English Common Reader* (Chicago: University of Chicago Press, 1967).

——, *Victorian People and Ideas* (New York: W. W. Norton & Company, 1973).

Anderson, Patricia, *The Printed Image and the Transformation of Popular Culture: 1790–1860* (Oxford: Clarendon Press, 1991).

Ashbee, Charles Robert, *Caricature* (London: Chapman and Hall, 1928).

Barker, Hannah, *Newspapers, Politics and English Society 1695–1855* (Essex: Longman, 2000).

Bechtel, Edwin De T., *Freedom of the Press and L'Association Mensuelle: Charles Versus Louis-Philippe* (New York: The Grolier Club, 1952).

Bindman, David, *Hogarth and His Times* (Berkeley and Los Angeles: University of California Press, 1997).

Bird, Kenneth, *The Good-Tempered Pencil* (London: Max Reinhardt, 1956).

Boime, Albert, *Art in an Age of Counterrevolution, 1815–1848* (Chicago: University of Chicago Press, 2004).

Briggs, Susan, and Asa Briggs, *Cap and Bell: Punch's Chronicle of English History in the Making 1841–1861* (London: MacDonald and Co., 1972).

Bryant, Mark, and Simon Heneage, *Dictionary of British Cartoonists and Caricaturists: 1730–1980* (London: Scholar Press, 1994).

Carpenter, Kevin, *Penny Dreadfuls and Comics* (London: Victorian and Albert Museum, 1983).

Charters, Erica Michiko, Eve Rosenhaft, and Hannah Smith, *Civilians and War in Europe, 1618–1815* (Liverpool: Liverpool University Press, 2012).

Childs, Elizabeth C., "Big Trouble: Daumier, Gargantua, and the Censorship of Political Caricature," *Art Journal*, vol. 51, no. 1, Uneasy Pieces (Spring 1992), 26–37.

Curtis, L. Perry, *Apes and Angels: The Irishman in Victorian Caricature* (London and Washington, DC: Smithsonian Institution Press, 1997).

Dolmetsch, Joan D., *Rebellion and Reconciliation* (Williamsburg, VA: Colonial Williamsburg Foundation, 1979).

Donald, Diana, *The Age of Caricature: Satirical Prints in the Reign of George III* (New Haven and London: Yale University Press, 1996).

du Maurier, Daphne (Ed.). *The Young George du Maurier: A Selection of His Letters, 1860–67* (London: Peter Davies, 1951).

Everitt, Graham, *English Caricaturists and Graphic Humorists of the Nineteenth Century* (London: Swan Sonnenschein & Co., 1893).

Fielding, Henry, *Joseph Andrews* (New York: Penguin Books, 1999).

Fisher, Leona W., "Mark Lemon's Farces on the Woman Question," *Studies in English Literature, 1500–1900*, vol. 28, no. 4, Autumn 1988, 649–670.

Fort, Bernadette, and Angela Rosenthal (Eds.), *The Other Hogarth* (Princeton and Oxford: Princeton University Press, 2001).

Fox, Celina, *Graphic Journalism in England During the 1830s and 1840s* (New York and London: Garland, 1988).

Frith, W. P., *John Leech: His Life and Work* (London: R. Bentley, 1891).

Gatrell, Vic, *City of Laughter: Sex and Satire in Eighteenth-Century London* (New York: Walker and Company, 2006).

George, M. Dorothy, *Catalogue of Prints and Drawings in the British Museum* (London: British Museum, 1935–1954).

———, *English Political Caricature* (Oxford: Clarendon Press, 1959).

———, *Hogarth to Cruikshank: Social Change in Graphic Satire* (New York: Walker and Company, 1967).

Gertz, Stephen J., "A Grand Rip-Off of Grandville's Metamorphoses Du Jour," *Booktryst*, September 5, 2013. Web. http://www.booktryst.com/2013/09/a-grand-rip-off-of-grandvilles.html

Gifford, Denis, *The British Comic Catalogue: 1874–1974* (Westport: Greenwood Press, 1975).

———, *Victorian Comics* (London: George Allen & Unwin Ltd., 1976).

Gilmartin, Kevin, *Print Politics: The Press and Radical Opposition in Early Nineteenth-Century England* (Cambridge: Cambridge University Press, 1996).

Godfrey, Richard, *English Caricature: 1610 to the Present* (London: Victoria and Albert Museum, 1984).

———, *James Gillray: The Art of Caricature* (London: Tate Gallery Publishing, Ltd., 2001).

Goldstein, Robert Justin, *Censorship of Political Caricature in Nineteenth Century France* (London: Kent State University Press, 1989).

Gombrich, E. H., *Meditations on a Hobby Horse* (London: Phaidon, 1994).

Greene, Roland, Stephen Cushman, Clare Cavanagh, et al. (Eds.), *The Princeton Encyclopedia of Poetry and Poetics* (Princeton: Princeton University Press, 2012).

Harris, Tim (Ed.), *Popular Culture in England c. 1500–1850* (London: MacMillan, 1995).

Harvey, R. C., *The Art of the Funnies* (Jackson: The University Press of Mississippi, 1996).

———, "Table Talk and the Birth of Modern Magazine Cartooning," *The Comics Journal*, no. 249, December 2002, 119–121.

Heard, Kate, *High Spirits: The Comic Art of Thomas Rowlandson* (London: Royal Collections Trust, 2013).

Hill, Draper (Ed.) *The Satirical Etchings of James Gillray* (New York: Dover Publications, Inc., 1976).

Hillier, Bevis, *Cartoons and Caricatures* (London: Studio Vista Ltd., 1970).

Houfe, Simon, *The Dictionary of British Book Illustrators and Caricaturists 1800–1914* (Woodbridge: Antique Collector's Club, 1996).

———, *John Leech and the Victorian Scene* (Woodbridge: Antique Collector's Club, 1984).

Hults, Linda C., *The Print in the Western World* (Madison: University of Wisconsin Press, 1996).

Jackson, Mason, *The Pictorial Press: Its Origins and Progress* (London: Hurst & Blackett, 1885).

James, Louis, *Fiction and the Working Man: 1830–1850* (London: Oxford University Press, 1973).

———, *Print and the People: 1819–1851* (London: Allen Lane, 1976).

Kemnitz, Tom, "Matt Morgan of Tomahawk and English Cartooning, 1867–1870," *Victorian Studies*, vol. 18, 1975, 5–34.

Kerr, David, *Caricature and French Political Culture 1830–1848: Charles Philipon and the Illustrated Press* (New York: Oxford University Press, 2000).

Kunzle, David, *The Early Comic Strip* (Berkeley: University of California Press, 1973).

———, *The History of the Comic Strip: The Nineteenth Century* (Berkeley: University of California Press, 1990).

Lambourne, Lionel, *Caricature* (London: Stemmer House, 1983).

Lauterbach, Edward S., *Fun and Its Contributors: The Literary History of a Victorian Humor Magazine* (Unpublished Ph.D. Dissertation: University of Illinois, 1961).

Leary, Patrick, *The Punch Brotherhood* (London: British Library, 2010).

Leech, John, *John Leech's Pictures of Life and Characters* (London: Bradbury Agnew and Co., 1886).

Lynch, Bohun, *A History of Caricature* (Boston: Little, Brown and Company, 1927).

Mayhew, Athol, *A Jorum of Punch* (London: Downey & Co., 1895).

Mayor, A. Hayatt, *Prints and People* (New York: Metropolitan Museum of Art; distributed by New York Graphic Society, 1971).

McFee, Constance C., and Nadine M. Orenstein, *Infinite Jest: Caricature and Satire from Leonardo to Levine* (New York: The Metropolitan Museum of Art, 2011).

Melot, Michel, and Neil McWilliam, "Daumier and Art History: Aesthetic Judgment/Political Judgment," *Oxford Art Journal*, vol. 11, no. 1, 1988, 3–24.

Moran, James, *Printing Presses: History and Development from the Fifteenth Century to Modern Times* (London: Faber, 1973).

Patten, Robert L., "Conventions of Georgian Caricature," *Art Journal*, vol. 43, no. 4, The Issue of Caricature, Winter, 1983, 331–338.

————, *George Cruickshank's Life, Times, and Art* (London: The Lutterworth Press, 1996).

Paulson, Ronald, *The Fictions of Satire* (Baltimore: Johns Hopkins Press, 1967).

————, *Rowlandson: A New Interpretation* (London: Studio Vista, 1972).

Payne, Matthew, and Payne James, *Regarding Thomas Rowlandson 1757–1827* (London: Hogarth Arts, 2010).

Popkin, Jeremy D., *Press, Revolution, and Social Identities in France, 1830–1835* (University Park: Penn State University Press, 2001).

Prager, Arthur, *The Mahogany Tree* (New York: Hawthorn Books, 1979).

Price, Richard, *A History of Punch* (London: Collins, 1957).

Rauser, Amelia Faye, *Caricature Unmasked: Irony, Authenticity, and Individualism in Eighteenth Century Prints* (Newark: University of Delaware Press, 2008).

Sabin, Roger, *Comics, Comix and Graphic Novels* (London: Phaidon Press Ltd., 1996).

Scully, Richard, "The Cartoon Emperor: The Impact of Louis Napoleon Bonaparte on European Comic Art, 1848–1870," *European Comic Art*, vol. 4, no. 2, 2011, 69–90.

Slater, Michael, *Douglas Jerrold* (London: Duckworth, 2002).

Spielmann, M. H., *The History of Punch* (London: Cassell and Company, Ltd., 1895).

Tenniel, Sir John, *Cartoons by Sir John Tenniel, Selected from the pages of "Punch."* (London: "Punch" Office, 1901).

Thackeray, W. M. "George Cruikshank," *Westminster Review* (June 1840), reprinted in *The Works of William Makepeace Thackeray*, vol. XIII (London: Smith, Elder, and Co., 1902).

————, "Half-a-Crown's Worth of Cheap Knowledge," *Fraser's Magazine* XVII, 1838, 279–290.

————, "John Leech's Pictures of Life and Character," *Quarterly Review* (December 1854), reprinted in *The Works of William Makepeace Thackeray*, vol. XIII (London: Smith, Elder, and Co., 1902).

Tunsler, John, J. Hogarth, and John Nichols, *The Works of William Hogarth: In a Series of Engravings with Descriptions, and a Comment on Their Moral Tendency* (London: Jones and Co., 1833).

Uglow, Jenny, *Hogarth: A Life and a World* (New York: Farrar, Straus and Giroux, 1997).

Wardroper, John, *The Caricatures of George Cruikshank* (London: Gordon Fraser Gallery, 1977).

Wood, Marcus, *Folly and Vice: The Art of Satire and Social Criticism* (London: South Bank Centre, 1989).

————, *Radical Satire and Print Culture, 1790–1822* (Oxford: Clarendon Press, 1994).

Yousif, Keri, *Balzac, Grandville, and the Rise of Book Illustration* (Surrey: Ashgate Publishing Limited, 2012).

Chapter 15

Arwas, Victor, *Berthon & Grasset* (London: Academy Editions, 1978).

Beardsley, Aubrey, "The Art of Hoarding," *New Review*, vol. 11, July 1894, 53–55.

Carter, Karen L., "The Spectatorship of the *Affiche Illustrée* and the Modern City of Paris, 1880–1900," *Journal of Design History*, vol. 25, no. 1, 2012, 11–31.

Chéret, Jules, "The Art of the Hoarding," *The New Review*, vol. 11, no. 62, July 1894, 47–55.

Collins, Bradford R., "The Poster as Art: Jules Chéret and the Struggle for the Equality of the Arts in Late Nineteenth-Century France," *Design Issues*, vol. 2, no. 1, Spring 1985, 41–50.

Dowling, Linda, "Aestheticism," *Encyclopedia of Aesthetics. Oxford Art Online*, Oxford University Press, accessed October 2, 2016, http://www.oxfordartonline.com .myaccess.library.utoronto.ca/subscriber/article/opr /t234/e0009.

————, "Letterpress and Picture in the Literary Periodicals of the 1890s," *Yearbook of English Studies*, vol. 16, 1986, 117–131.

Elzea, Betty, *Frederick Sandys, 1829–1904: A Catalogue Raisonné* (London: Antique Collectors Club, 2001).

Frankel, Nicholas, *Oscar Wilde's Decorated Books* (Ann Arbor: University of Michigan Press, 2000).

Hiatt, Charles, *Picture Posters: A Short History of the Illustrated Placard, with many reproductions of the most artistic examples in all countries* (London: George Bell and Sons, 1895).

Jackson, Holbrook, *The Eighteen Nineties: A Review of Art and Ideas at the Close of the Nineteenth Century* (London: Grant Richards, 1913; reprinted Brighton: Harvester Press, 1976).

Kooistra, Lorraine Janzen, *Poetry, Pictures and Popular Publishing: The Illustrated Gift Book and Victorian Popular Culture, 1855–1870* (Athens: Ohio University Press, 2011).

Ledger, Sally, "Wilde Women and the Yellow Book: The Sexual Politics of Aestheticism and Decadence," *English Literature in Transition 1880–1920*, vol. 50, no. 1, Winter 2007, 5–26.

Leng, Andrew, "The Ideology of 'Eternal Truth': William Holman Hunt and *The Lady of Shalott* 1850–1905," *Word and Image*, vol. 7, no. 4, October 1991, 314–328.

Maindron, Ernest, *L'Affiche illustrée* (Paris: G. Boudet, 1896).

Margolin, Victor, *American Poster Renaissance* (New York: Watson-Guptill, 1975).

Morris, William, "Preface," in John Ruskin, *The Nature of Gothic* (London: Kelmscott Press, 1892).

Peterson, William S., *The Beautiful Poster Lady: A Life of Ethel Reed* (New Castle, DE: Oak Knoll Press, 2013).

——, *The Kelmscott Press: A History of William Morris's Typographical Adventure* (Berkeley, CA: University of California Press, 1991).

Reade, Brian, *Beardsley* (London: Studio Vista, 1967).

Snodgrass, Chris, *Aubrey Beardsley, Dandy of the Grotesque* (New York: Oxford University Press, 1995).

Thompson, Susan Otis, *American Book Design and William Morris* (New Castle, DE: Oak Knoll Press, 1996).

White, Gleeson, *English Illustration: The Sixties, 1855–70* (London: Constable, 1897; Reprint Bath: Kingsmead, 1970).

Whiteley, Jon, "The Art of the Eragny Press," in *Lucien Pissarro in England: the Eragny Press 1895–1914* (Oxford: Ashmolean Museum, 2011).

Zatlin, Linda Gertner, *Beardsley, Japonisme, and the Perversion of the Victorian Ideal* (Cambridge: Cambridge University Press, 1997).

Ludwig, Coy, *Maxfield Parrish*, 2nd ed. (Atglen, PA: Schiffer Publishing Co., 1993).

Minnesota Calendars, collections.mnhs.org/MNHistory Magazine/articles/58/v58i07p353–365.pdf.

Rockwell, Norman, *My Adventures as an Illustrator* (Garden City, NY: Doubleday, 1960).

Smith, Tim, and Michelle Smith, *Joliet's Gerlach Barklow Calendar Company* (Charleston, SC: Arcadia Publishing Co., 2009).

Stavitsky, Gail, *Precisionism in America, 1915–1941: Reordering Reality* (New York: Abrams, 1994)

Steiner, Raymond J., *The Art Students League of New York: A History* (Saugerties, NY: CSS Publications, Inc., 1999).

Wood, Grant, *Revolt Against the City* (Iowa City: Clio Press, 1935).

Zurier, Rebecca, *Art for The Masses: A Radical Magazine and Its Graphics 1911–1917* (Philadelphia: Temple University Press, 1988).

Chapter 20

Balmer, Edwin, *The Science of Advertising: The Force of Advertising as a Business Influence* (New York: Duffield & Company, 1910).

Bogart, Michele H., *Artists, Advertising, and the Borders of Art* (Chicago: University of Chicago Press, 1995).

Bransom, Paul, *All Unplanned: Memoirs of the Golden Age of Illustration* (Johnstown, NY: Baronet Litho, Inc., 1983).

Corn, Wanda M., *The Great American Thing: Modern Art and National Identity* (Berkeley, CA: University of California Press, 1999).

Covarrubias; Mexican Genius in the United States (Washington, DC: Cultural Institute of Mexico, 2006).

Dunn, Harvey, *An Evening in the Classroom* (New York: privately printed/Mario Cooper, 1933).

Gopnik, Adam, "High and Low: Caricature, Primitivism, and the Cubist Portrait," *Art Journal*, vol. 43, no. 4, Winter 1983), 371–376.

Gruger, Frederic R., "Illustration," *Encyclopedia Brittannica*, 14th edition, 1929.

Heller, Steven, "Paolo Garretto: A Reconsideration," Available at www.hellerbooks.com/pdfs/print_garretto.pdf.

Heller, Steven, and Louise Fili, *Streamline: American Art Deco Graphic Design* (San Francisco: Chronicle Books, 1995).

Kery, Pat, *Art Deco Graphics* (New York: Thames and Hudson, 2002).

Kirschke, Amy Helene, *Aaron Douglas: Art, Race, and the Harlem Renaissance* (Jackson: University Press of Mississippi, 1995).

Laing, Ellen Johnston, *Selling Happiness: Calendar Posters and Visual Culture in Early Twentieth-century Shanghai* (Honolulu: University of Hawaii Press, 2004).

Chapter 22

Duane, Patrick A., "Penny Dreadfuls: Late Nineteenth-Century Boys' Literature and Crime," *Victorian Studies*, vol. 22, no. 2, Winter 1979.

De La Ree, Gerry (Ed.), *Virgil Finlay Remembered* (Upper Saddle River, NJ: De La Ree, Gerry Publisher, 1981).

Frank, Jane, *Richard Powers* (London: Paper Tiger, 2001).

Gunnison, John P., *Walter Baumhofer: Pulp Art Masters* (Silver Spring, MD: Adventure House, 2007).

Haining, Peter, *Terror: A History of Illustrations from the Pulp Magazines* (New York: A & W Visual Library Publications, 1976).

Jones, Gerald, *Men of Tomorrow: Geeks, Gangsters, and the Birth of the Comic Book* (New York: Basic Books, 2004).

Kaenel, Philippe (Ed.), *Gustave Doré: Master of Imagination* (Paris; Ottawa: Musee d'Orsay/Flammarion/National Gallery of Canada, 2014).

Levin, Gail, *Edward Hopper as Illustrator* (New York: The Whitney Museum of American Art, 1979).

Miller, Ron, and Frederick C. Durant, III, *The Art of Chesley Bonestell* (London: Paper Tiger, 2001).

The Pacific Printer: The Leading Trade Journal in the West, XVI (San Francisco, July 1916).

Pulp Fiction Art: Cheap Thrills and Painted Nightmares, DVD, Directed by Jamie McDonald (Forked River, NJ: Kultur International Films, 2007).

Chapter 23

Abel, Jessica, and Matt Madden, *Drawing Words & Writing Pictures: Making Comics, Manga, Graphic Novels, and Beyond* (New York: First Second, 2008).

Adams, Neal (2012). Personal communication.

Arnold, Andrew D., "No Bones About It," *Time*, September 17, 2004. Retrieved on June 3, 2015, from http://content.time.com/time/arts/article/0,8599,698456,00.html.

Bettelheim, Bruno, "Book Review: Seduction of the Innocent by Fredric Wertham," *The Library Quarterly*, vol. 25, no. 1, 1955, 129–130.

Breevort, Tom (2014). Personal communication.

Campanelli, John, "'Calvin and Hobbes' Fans Still Pine 15 Years After Its Exit," *Plain Dealer*, February 1, 2010. Retrieved on September 12, 2014, from http://www.cleveland.com/living/index.ssf/2010/02/fans_still_pine_for_calvin_and.html.

Campbell, W. Joseph, *Yellow Journalism: Puncturing the Myths, Defining the Legacies* (Westport, CT: Praeger, 2001).

Caputo, Tony, and Jim Steranko, *Visual Storytelling: The Art and Technique* (New York: Watson-Guptill, 2002).

Childs, E. C., "Big Trouble: Daumier, Gargantua, and the Censorship of Political Caricature," *Art Journal*, vol. 51, no. 1, Uneasy Pieces, Spring 1992, 26–37.

Claywood, Carolyn, "Seduction of the Innocent," *School Library Journal*, July 1994, 48.

Coville, Jamie, "The Platinum Age 1897–1938," 2014. Retrieved on September 12, 2014, from https://web.archive.org/web/20030415153354/www.collectortimes.com/~comichistory/Platinum.html.

Dean, Michael, "Fine Young Cannibals: How Phil Seuling and a Generation of Teenage Entrepreneurs Created the Direct Market and Changed the Face of Comics," *Comics Journal*, July 2006, 49–59.

De Sá, Leonardo, *Rodolphe Töpffer*, 2003–2006. Retrieved on August 29, 2014, from http://leonardodesa.interdinamica.net/comics/lds/vb/VieuxBoisSynopsis.asp.

Dooley, Michael, and Steven Heller (Eds.), *The Education of a Comics Artist: Visual Narrative in Cartoons, Graphic Novels, and Beyond* (New York: Allworth Press, 2005).

Duin, Steve, and Mike Richardson, *Comics: Between the Panels* (Milwaukie, OR: Dark Horse Comics, 1998).

Duncan, Randy, Matthew J. Smith, and Paul Levitz, *The Power of Comics: History, Form and Culture,* 2nd ed. (Unpublished manuscript, 2014).

Ellms, Charles, *The American Comic Almanac* (Boston: Ellms, 1831).

Eisner, Will, *Comics and Sequential Art* (New York: W. W. Norton & Company, 1985).

———, *Graphic Storytelling and Visual Narrative* (New York: W. W. Norton & Company, 1996).

———, *P*S Magazine: The Best of The Preventive Maintenance Monthly* (New York: Abrams ComicArts, 2011).

———, Transcript of Will Eisner's keynote address at the "'Will Eisner Symposium:' The 2002 University of Florida Conference on Comics and Graphic Novels," 2002. Retrieved on August 25, 2014, from http://www.english.ufl.edu/imagetext/archives/v1_1/eisner/.

Fingeroth, Danny, *The Rough Guide to Graphic Novels* (New York: Rough Guides, 2008).

Fortess, Karl E., "Comics as Non-Art." *The Funnies: An American Idiom* (London: Collier-Macmillan, Ltd., 1963).

Fry, Philip, and Ted Poulos, *Steranko: Graphic Narrative: Story-Telling in the Comics and the Visual Novel* (Winnipeg: Winnipeg Art Gallery, 1978).

Fuchs, Wolfgang J., and Reinhold Reitberger, *Comics: Anatomy of a Mass Medium* (Boston: Little, Brown, 1972).

Gardner, Jared, *Projections: Comics and the History of Twenty-First-Century Storytelling* (Stanford, CA: Stanford University Press).

Gifford, Dennis, *The International Book of Comics* (New York: Crescent Books, 1984).

Gordon, Ian, *Comic Strips and Consumer Culture, 1890–1945* (Washington, DC: Smithsonian Institution Press, 1998).

Goulart, Ron (Ed.), *Comic Book Culture: An Illustrated History* (Portland, OR: Collectors Press, 2007).

———, *The Encyclopedia of American Comics from 1897 to the Present* (New York: Facts on File, 1990).

———, "The Funnies," in *Comic Book Encyclopedia* (New York: Harper Entertainment, 1991).

———, *Over 50 Years of American Comic Books* (Lincolnwood, IL: Mallard Press, 1991).

———, *Ron Goulart's Great History of Comic Books* (Chicago: Contemporary Books, 1986).

Gravett, Paul, *Manga: Sixty Years of Japanese Comics* (New York: Harper Design, 2004).

Grossman, Lev, and Richard Lacayo, "The 100 Best English-Language Novels from 1923 to the Present," *Time*, October 16, 2005.

Harvey, Robert C., *Children of the Yellow Kid: The Evolution of the American Comic Strip* (Seattle: Frye Art Museum, in association with the University of Washington Press, 1998).

———, *The Life and Art of Murphy Anderson* (Raleigh, NC: TwoMorrows Publishing, 2003).

Heimer, Mel, *Famous Artists & Writers of King Features Syndicate* (New York: King Features Syndicate, 1949).

Hoad, Phil, "Neil Gaiman and Dave McKean: How We Made The Sandman." October 22, 2013. Retrieved on May 25, 2015, from http://www.theguardian.com/culture/2013/oct/22/how-we-made-sandman-gaiman.

Horn, Greg (2014). Personal communication.

Hughes, Virginia, "Were the First Artists Mostly Women?", *National Geographic*, October 8, 2013.

Isabella, Tony, *1000 Comic Books You Must Read* (Iola, WI: Krause Publications, 2009).

Janson, Klaus (2014). Personal communication.

Johnson, Dan, "Gerry Conway and John Romita, Sr. Discuss The Green Goblin's Last Stand," *Back Issue*, no. 18, October 2006, 56–60.

Jones, Gerard, *Men of Tomorrow: Geeks, Gangsters, and the Birth of the Comic Book* (New York: Basic Books, 2004).

Kane, Brian M., *Hal Foster: Prince of Illustrators—Father of the Adventure Strip* (Lebanon, NJ: Vanguard Productions, 2001).

Kannenberg, Gene, Jr., *500 Essential Graphic Novels: The Ultimate Guide* (New York: Collins Design, 2008).

Kantor, Deborah (Ed.), *Graphic Artists Guild Handbook: Pricing & Ethical Guidelines*, 13th ed. (New York: Graphic Artists Guild, 2010).

Kitchen, Dennis (December 28, 2010–March 13, 2012). Personal communication.

Koster, T. (2014). Personal communication.

Kurtzman, Harvey, and Michael Barrier, *From Aargh! to Zap!: Harvey Kurtzman's Visual History of the Comics* (New York: Prentice Hall Press, 1991).

Kunzle, David, *History of the Comic Strip* (Berkeley: University of California Press, 1973).

Legman, Gershon, "The First Comic Books in America: Revisions and Reflections," *American Notes & Queries*, V, January 1946, 148–151.

Levitz, Paul, "The Dark Age 1984–1998," in *75 Years of DC Comics: The Art of Modern Mythmaking* (Köln: Taschen, 2010).

———, *Will Eisner: Champion of the Graphic Novel* (New York: Abrams Comicarts, 2015).

Magyar, Rick (2014). Personal communication.

Marchand, Roland, *Advertising the American Dream: Making Way for Modernity, 1920–1940* (Berkeley: University of California Press, 1985).

McCloud, Scott, *Making Comics: Storytelling Secrets of Comics, Manga and Graphic Novels* (New York: Harper, 2006).

———, *Reinventing Comics: How Imagination and Technology Are Revolutionizing an Art Form* (New York: Harper, 2000).

———, *Understanding Comics: The Invisible Art* (New York: Harper, 1993).

McGrath, Charles, "Not Funnies," *New York Times Magazine*, July 11, 2004.

Medrano, Sherard, *Digital Comics: The New Trend Towards Digital Media* (Master of Science in Publishing thesis paper, New York: Pace University, Dyson College of Arts & Sciences, 2009).

Mishler, Anita L., "Book Review: Seduction of the Innocent by Frederic Wertham," *Public Opinion Quarterly*, vol. 19, no. 1, Spring 1955, 115–117.

Moore, Alan, *Alan Moore's Writing for Comics* (Rantoul, IL: Avatar Press, 2003).

Mullaney, Dean, Bruce Canwell, Paul Tumey, and Brian Walker (Eds.), *King of the Comics: 100 Years of King Features* (San Diego: IDW Publishing, 2015).

Murray, Christopher J., *Encyclopedia of the Romantic Era, 1760–1850* (New York: Fitzroy Dearborn/Routledge, 2004).

Murrell, William, *A History of American Graphic Humor* (New York: Whitney Museum of Art, 1933–1938).

Norris, James D., *Advertising and the Transformation of American Society, 1865–1920* (New York: Greenwood Press, 1990).

Olson, Richard D., "R. F. Outcault, The Father of the American Sunday Comics, and the Truth About the Creation of the Yellow Kid," 2014. Retrieved on September 14, 2014, from http://www.neponset.com/yellowkid/history.htm.

Reitberger, Reinhold, and Wolfgang Fuchs, *Comics: Anatomy of a Mass Medium* (Boston: Little, Brown and Company, 1971).

Sacks, Jason, *American Comic Book Chronicles: The 1970s, 1970–1979* (Raleigh, NC: TwoMorrows Publishing, 2014).

Saffel, Steve, "Mutant Menace," in *Spider-Man the Icon: The Life and Times of a Pop Culture Phenomenon* (New York: Titan Books, 2007).

Schelly, Bill, *American Comic Book Chronicles: The 1950s, 1950–1959* (Raleigh, NC: TwoMorrows Publishing, 2013).

Schodt, Frederik, *Dreamland Japan: Writings on Modern Manga* (Berkeley: Stone Bridge Press, 1996).

Screech, Matthew, "A Challenge to Convention: Jean Giraud/Gir/Moebius," in *Masters of the Ninth Art: Bandes Dessinées and Franco-Belgian Identity* (Liverpool: Liverpool University Press, 2005): Chapter 4.

Sedlmeier, Cory, (2014). Personal communication.

Smolderen, Thierry, *The Origins of Comics: From William Hogarth to Winsor McCay* (Jackson, MI: University Press of Mississippi, 2014).

Steranko, Jim, *The Steranko History of Comics*, vol. 1 (Reading, PA: Supergraphics, 1970).

———, *The Steranko History of Comics*, vol. 2 (Reading, PA: Supergraphics, 1972).

———, (2014). Personal communication.

Talon, Durwin, *Comics Above Ground: How Sequential Art Affects Mainstream Media* (Raleigh, NC: TwoMorrows Publishing, 2004).

———, *Panel Discussions: Design in Sequential Art Storytelling* (Raleigh, NC: TwoMorrows Publishing, 2002).

Taylor, Chris, *How Star Wars Conquered the Universe: The Past, Present, and Future of a Multibillion Dollar Franchise* (New York: Basic Books, 2014).

Thompson, Harry, *Tintin: Hergé and His Creation* (London: Hodder and Stoughton, 1991).

Tilley, Carol L., "Seducing the Innocent: Fredric Wertham and the Falsifications That Helped Condemn Comics," *Information & Culture*, vol. 47, no. 4, pp. 383–413, 2012.

Vakos, Patricia, "Why the Blank Stare? Strategies for Visual Learners," Pearson Prentice Hall eTeach, 2013. Retrieved on September 12, 2014, from http://www.phschool.com/eteach/social_studies/2003_05/essay.html.

Walker, Brian, *The Comics Before 1945* (New York: H. N. Abrams, 2004).

———, *The Comics Since 1945* (New York: H. N. Abrams, 2002).

———, (2014). Personal communication.

The Warren Ellis Forum, 2002. Retrieved on August 8, 2014, from http://forums.delphiforums.com/n/main.asp?webtag =ellis&nav=start&prettyurl=%2Fellis&gid=2003802586.

Weiner, Robert G. (Ed.), *Graphic Novels and Comics in Libraries and Archives: Essays on Readers, Research, History and Cataloging* (Jefferson, NC: McFarland & Company, Inc., 2010).

Weiner, Stephen, *Faster Than a Speeding Bullet: The Rise of the Graphic Novel* (New York: NBM, 2003).

———, *The 101 Best Graphic Novels* (New York: NBM, 2005).

Wells, John, *American Comic Book Chronicles: The 1960s, 1965–1969* (Raleigh, NC: TwoMorrows Publishing, 2014).

Wertham, Fredric, *Seduction of the Innocent* (New York: Rinehart, 1954).

White, David M., and Robert H. Abel (Eds.), *The Funnies: An American Idiom* (London: Collier-Macmillan, Ltd., 1963).

Wiese, Ellen, *Enter: The Comics, Rodolphe Töpffer's Essay on Physiognomy and The True Story of Monsieur Crépin* (Lincoln: University of Nebraska Press, 1965).

Wright, Bradford W., *Comic Book Nation: The Transformation of Youth Culture in America* (Baltimore: Johns Hopkins University Press, 2003).

Wright, Nicky, *The Classic Era of American Comics* (Lincolnwood, IL: Contemporary Books, 2000).

Annotated Bibliography for Comic Strips, Comic Books and Graphic Novels

Brian M. Kane

Early Graphic Narratives

A History of American Graphic Humor, Vol. 1: 1747–1865 (1933), and *A History of American Graphic Humor, Vol. 2: 1865–1938* (1938).

Completed before the first appearance of Superman, these two volumes represent an amazingly thoughtful history of the medium in America. The last few pages of the final chapter mention the early animations of Winsor McCay's Gertie, Louis Glackens and "Bud" Fisher's Mutt and Jeff, and Walt Disney's Mickey Mouse. It concludes that the field of animation "is widening, and sooner or later we may expect something more significant in animated cartoon satire" (Murrell, 1938, p. 259).

The Origins of Comics: From William Hogarth to Winsor McCay (2014).

International in its scope, this is a well-researched history of the early comics.

Comic Strips

The Comics: An Illustrated History of Comic Strip Art (1974), and *The Comics: An Illustrated History of Comic Strip Art, 1895–2010* (2011).

Jerry Robinson's history of comic strips received a lavish upgrade in 2011. At almost four hundred pages and filled with hundreds of illustrations, this is a first-person accounting by one of the founding artists of the comic book medium. The 2011 edition is the preferred volume.

The Smithsonian Collection of Newspaper Comics (1977, 1981).

Edited by Bill Blackbeard and Martin Williams, this indispensable coffee-table book produced by the Smithsonian Institution was one of the first retrospectives to help legitimize the scholarly study of comic strips. The text is sparse but insightful, and the examples are plentiful.

R. F. Outcault's The Yellow Kid: A Centennial Celebration of the Kid Who Started the Comics (1995).

Bill Blackbeard's definitive history of America's first comic strip and the origins of Yellow Journalism. This volume also contains a wealth of black-and-white and color reproductions of the Yellow Kid strip.

The Comic Strip Century: Celebrating 100 Years of an American Art Form, Vol. 1 (1995), and *The Comic Strip Century: Celebrating 100 Years of an American Art Form, Vol. 2* (1995).

Edited by Bill Blackbeard and Dale Crain, this two-volume set contains stunning examples from Blackbeard's San Francisco Academy of Comic Art collection. Volume 1 begins with an overview of the history of comic strips and a collection from 1895 to the 1930s, while volume 2 has no text but completes the collection from the 1930s to 1995.

100 Years of American Newspaper Comics: An Illustrated Encyclopedia (1996).

Maurice Horn's encyclopedia contains listings for comic strips only. Biographical information on artists can only be found within the listing(s) for the strip(s) they illustrated.

Children of the Yellow Kid: The Evolution of the American Comic Strip (1998).

Robert C. Harvey's overview of how the comic strip industry evolved after the Yellow Kid's run.

The Comics Since 1945 (2002), *The Comics Before 1945* (2004), and *The Comics: The Complete Collection* (2014).

The third volume is a compilation of the earlier two volumes. These books written by comics historian Brian Walker is the most complete overall examination of the history of comic strips available.

King of the Comics: 100 Years of King Features Syndicate (2015).

A comprehensive history of King Features Syndicate spanning its one hundred years in producing comic strips. Entries for strips are concise, but the hundreds of images make this volume indispensable.

Comic Strips and Comic Books

The World Encyclopedia of Comics (1976).

Edited by Maurice Horn, this 790-page illustrated encyclopedia was the first compilation to look at comics in all its forms from an international perspective. Although it is nearly forty years out of date, and written when there were only seven comic book publishers, it contains one of

the first year-by-year chronologies, an analytical analysis of the art form, over 1,200 entries, and a 10,000 name index.

Ron Goulart's Great History of Comic Books (1986), *The Great Comic Book Artists* (1986), *The Great Comic Book Artists, Vol. 2* (1989), *The Encyclopedia of American Comics* (1990) *Over 50 Years of American Comic Books* (1991), *The Funnies: 100 Years of American Comic Strips* (1995), and *Comic Book Culture* (2007).

Ron Goulart has provided insightful accountings of the comics medium for almost thirty years. Earlier volumes are out of date but are useful as reference material.

Masters of American Comics (2005).

This volume does not cover many of the masters of the comics medium. There is a redundancy among the writers regarding some artists, and a complete oversight of others who should be included.

Comics Between the Panels (1998).

Written by Steve Duin and Mike Richardson, this five-hundred-page encyclopedia of comics contains engaging entries as well as additional interesting sidebars that are usually not covered in other collections.

Comics, a Global History, 1968 to the Present (2014).

By Dan Mazur and Alexander Danner, this book traces five decades of global comic work in Europe, Asia, and North America.

Comic Books—Chronologically Based

The Steranko History of Comics, Vol. 1 (1970), and *The Steranko History of Comics, Vol. 2* (1972).

Intended as a detailed, behind-the-scenes, multivolume series about the history of American comic books, these two impressive volumes were the only ones Jim Steranko was able to produce. The first volume covers the influence of adventure comic strips and pulp magazines on the creation of the earliest superheroes, and the second volume concludes at the end of World War II.

From Aargh! To Zap!: Harvey Kurtzman's Visual History of the Comics (1991).

This volume covers comic books from 1930 to 1990, and was cowritten by one of the foremost proponents of the comics art form, Harvey Kurtzman, and J. Michael Barrier. Although it is actually an annotated gallery, as opposed to a historical treatise, it is worth reading for Kurtzman's insights regarding the medium.

Marvel: Five Fabulous Decades of the World's Greatest Comics (1991), *DC Comics: Sixty Years of the World's Favorite Comic Book Heroes* (1995), *DC Comics Year by Year: A Visual Chronicle Hardcover* (2010), *75 Years of DC Comics: The Art of Modern Mythmaking* (2013), and *The Golden Age of DC Comics: 1935–1956* (2013).

All of these are beautifully produced coffee-table color volumes that are profusely illustrated with important and sometimes rare art. They each contain the basic histories of their respective companies.

Men of Tomorrow: Geeks, Gangsters, and the Birth of the Comic Book (2004) by Gerald Jones, and *Marvel Comics: The Untold Story* (2012) by Sean Howe.

Both of these books are well-researched, behind-the-scenes, text-only histories of, respectively, DC Comics and Marvel Comics. The text is engaging, and though the focus is not on art, as most of the other books here are, it is important for art students to understand that the publishing of comic books is a business.

A Complete History of American Comic Books (2008), and *Comic Books: How the Industry Works* (2008).

Author Shirrel Rhoades was the Executive Vice President of Marvel Entertainment and Publisher of Marvel Comics from 1996 to 1999, so some of the information presented in these two volumes is autobiographical. However, they are heavily footnoted from Wikipedia and other online sources, so the information may not be completely reliable. Other sections, such as Rhoades's early history of DC Comics that quotes greatly from Gerald Jones's book *Men of Tomorrow,* heavily reference secondary rather than primary sources.

1000 Comic Books You Must Read (2009).

Comic book writer Tony Isabella presents a chronological review of the industry by selecting key books from each period and gives a brief synopsis for each. It is more of a reference book than a historical one.

The Power of Comics: History, Form and Culture (2009, 2014 unpublished revised manuscript).

Randy Duncan, Matthew J. Smith, and Paul Levitz present one of the better comprehensive overviews about the comic book industry and its impact on culture. Intended as a textbook for teaching a course on the medium, it includes questions and activities at the end of each chapter. A revised edition is awaiting publication.

The American Comic Book Chronicles: The 1950s, 1950–59 (2013), *The American Comic Book Chronicles: The 1960s, 1956–64* (2012), *The American Comic Book Chronicles: The 1960s, 1965–69* (2014), *The American Comic Book Chronicles: The 1970s, 1970–79* (2014), *The American Comic Book Chronicles: The 1980s, 1980–89* (2013).

This series from TwoMorrows Publishing is the first year-by-year examination of the entire comic book industry. Each year includes a timeline of events important to the comics industry, world history, and popular culture. Profusely illustrated, this series offers a wealth of information about comic books, their creators, and the business of making comic books.

Comic Books—Genre/Theme Based

The Funnies: An American Idiom (1963).

Edited by David Manning White and Robert H. Abel, this book is a thorough analysis of the comics medium both as an art form and a business circa 1963. Various authors contribute chapters ranging from "The American Image Abroad," "Mental Health Attitudes of Youth," "Who Reads the Funnies—And Why?," "Male and Female Relations in the American Comic Strip," and "The Researchers Report: The World of Sunday Comics."

The Great Comic Book Heroes (1965 and 2003).

Over twenty years before he won a Pulitzer Prize for his editorial cartoons in the Village Voice, Jules Feiffer authored the first insider-based history of comic books. In 1945, at the age of sixteen, Feiffer started assisting Will Eisner on The Spirit, and began drawing his own comics section by the time he was eighteen. The 9 × 12" 1965 edition was edited by E. L. Doctorow, and two-thirds of it is dedicated to color reprints of all the major superheroes Feiffer covers. The affordable 2003 reprint contains all the text and some black-and-white panels, but not the color pages.

Comix: A History of Comic Books in America (1971).

Les Daniels's first history of comic books contains insights into the various genres/waves within the comic book industry, including The Birth of Comic Books, Dumb Animals, EC Comics and the Comics Code, Marvel Comics, and the beginning of underground comix.

The International Book of Comics (1984).

Denis Gifford presents an eclectic collection of early comic strips and comic books and their counterparts in other countries.

The Classic Era of American Comics (2000).

Primarily genre based, Nicky Wright's book follows a loosely chronological history of comic books from the 1930s up to 1950.

The Silver Age of Comic Book Art (2003).

Written and designed by Arlen Schumer, this volume exclusively focuses on the careers of eight artists whose work shaped the Silver Age of Comics. These artists are Carmine Infantino, Steve Ditko, Jack Kirby, Gil Kane, Joe Kubert, Gene Colan, Jim Steranko, and Neal Adams.

Comix: The Underground Revolution (2004).

This volume by Dez Skinn is a thorough examination of how the "X" got into "Comix." It also contains a checklist of all the major American and United Kingdom underground comix titles and the key artist(s) for each book.

Comics, Comix & Graphic Novels: A History of Comic Art (2008).

Roger Sabin presents one of the few histories that focuses more on underground and alternative comix works rather than mainstream publications. It also contains some very rare Industrial Age and Platinum Age pieces.

A History of Underground Comics: 20ᵗʰ Anniversary Addition (2012).

Mark James Estren's history of adult-oriented comix is a comprehensive analysis of this medium.

Graphic Novels

Graphic Novels: Everything You Need to Know (2005).

Though not a history of the art form, Paul Gravett's volume is a thematically based overview of important graphic narratives in print at the time of its publication.

The Rough Guide to Graphic Novels (2008).

Authored by former Marvel Comics editor and writer Danny Fingeroth, this book contains a short history of the medium and individual reviews of the existing graphic novel "canon."

Faster Than a Speeding Bullet: The Rise of the Graphic Novel (2012).

Stephen Weiner presents a very succinct history of the graphic novel covering many of the major books in the industry, but little more.

Understanding How the Medium Works

Comics and Sequential Art (1985) by Will Eisner, and *Understanding Comics: The Invisible Art* (1993) by Scott McCloud.

These are the two seminal volumes when it comes to understanding how the comics medium works. Complementary volumes by both authors/artists exist, but these two groundbreaking volumes remain their most important examinations of the art form.

Autobiographies and Biographies

Carl Barks	*Carl Barks and the Art of the Comic Book* (1981) by Michael Barrier.
Milton Caniff	*Caniff: A Visual Biography* (2011) by Dean Mullaney.
	Meanwhile: A Biography of Milton Caniff, Creator of Terry and the Pirates *and* Steve Canyon (2007) by Robert C. Harvey.
Jack Cole	*Jack Cole and Plastic Man: Forms Stretched to Their Limits* (2001) by Art Spiegelman and Chip Kidd.
Percy Crosby	*Skippy and Percy Crosby* (1978) by Jerry Robinson.
Jack Davis	*Jack Davis: Drawing American Pop Culture: A Career Retrospective* (2011) by Jack Davis.
Steve Ditko	*Strange and Stranger: The World of Steve Ditko* (2008) by Blake Bell.
Will Eisner	*Will Eisner: A Dreamer's Life in Comics* (2010) by Michael Schumacher.
	Will Eisner: A Spirited Life (2005) by Bob Andelman.
Will Elder	*Will Elder: The Mad Playboy of Art* (2004) by Will Elder.
Al Feldstein	*Feldstein: The Mad Life and Fantastic Art of Al Feldstein!* (2013) by Grant Geissman.
Harold R. Foster	*Hal Foster: Prince of Illustrators, Father of the Adventure Strip* (2001, 2010) by Brian M. Kane.
Hergé	*Hergé: The Man Who Created Tintin* (2009) by Pierre Assouline and Charles Ruas.
George Herriman	*Krazy Kat: The Comic Art of George Herriman* (1999) by Patrick McDonnell,

Karen O'Connell, and Georgia Riley De Havenon.

Carmine Infantino *The Amazing World of Carmine Infantino* (2001) by Carmine Infantino and J. David Spurlock.

Walt Kelly *Walt Kelly: The Life and Art of the Creator of Pogo* (2012) by Thomas Andrae and Carsten Laqua.

Jack Kirby *Kirby: King of Comics* (2008) by Mark Evanier.

Bernard Krigstein *B. Krigstein, Volume 1* (2003) by Greg Sadowski.

Joe Kubert *Man of Rock: A Biography of Joe Kubert* (2008) by Bill Schelly.

Harvey Kurtzman *The Art of Harvey Kurtzman: The Mad Genius of Comics* (2009) by Denis Kitchen and Paul Buhle.

Winsor McCay *Winsor McCay: His Life and Art* (1987, 2005) by John Canemaker.

Alex Raymond *Alex Raymond: His Life and Art* (2007) by Tom Roberts.

Charles M. Schulz *My Life with Charlie Brown* (2010) by Charles M. Schulz.

Peanuts: A Biography (2008) by David Michaelis.

Sparky: The Life and Art of Charles Schulz (2010) by Beverly Gherman.

Joe Simon *Joe Simon, My Life in Comics: The Illustrated Autobiography of Joe Simon* (2011) by Joe Simon.

Curt Swan *Curt Swan A Life in Comics* (2002) by Eddy Zeno.

Alex Toth *Genius, Isolated: The Life and Art of Alex Toth* (2011) by Bruce Canwell and Dean Mullaney.

Genius, Illustrated: The Life and Art of Alex Toth (2013) by Bruce Canwell and Dean Mullaney.

Genius, Animated: The Cartoon Art of Alex Toth (2014) by Bruce Canwell and Dean Mullaney.

Wallace Wood *Against The Grain: Mad Artist Wallace Wood* (2003) by Bhob Stewart.

Wally's World: The Brilliant Life and Tragic Death of Wally Wood, The World's Second-Best Comic Book Artist (2006) by Steve Starger and J. David Spurlock.

Chapter 26

Auther, Elissa, and Adam Lerner (Eds.), *West of Center: Art and the Counterculture Experiment in America, 1965–1977* (Minneapolis: University of Minnesota Press, 2013).

Barrier, Mike, "Notes on the Underground," *Funnyworld* #12, Summer 1970.

Chaters, Ann (Ed.), *The Portable Sixties Reader* (New York: Penguin Books, 2002).

Christenson, Eric, "San Francisco and the 1960s Psychedelic Art Explosion," in *Juxtapoz*, vol. 21, no. 3, March 2014.

Crumb, Robert, *The Complete Crumb* (vols. 1 to 15), (Seattle, WA: Fantagraphics Books, 2005).

Daniels, Les, *Comix: A History of Comic Books in America* (New York: Outerbridge and Dienstfrey, 1971).

Doss, Erika, "Revolutionary Art Is a Tool for Liberation": Emory Douglas and Protest Aesthetics at the Black Panther," in Kathleen Cleaver and George Katsiaficas (Eds.), *Liberation Imagination and the Black Panther Party: A New Look at the Black Panther* (pp. 175–187) (New York: Routledge/Taylor & Francis Group, 2001)

Dowers, Michael (Ed.), *The New Wave: The Underground Mini Comix of the 1980s* (Seattle, WA: Fantagraphics, 2010).

Dueben, Alex, "An Oral History of Wimmen's Comix," *The Comics Journal*, Fantagraphics, March 31 and April 6, 2016. Available at http://www.tcj.com/an-oral-history-of-wimmens-comix-part-2/.

Duncombe, Stephen, *Notes from the Underground: Zines and the Politics of Alternative Culture* (Bloomington, IN: Microcosm Publishing, 2008).

Durant, Sam, *Black Panther: The Revolutionary Art of Emory Douglas* (New York: Rizzoli International Publications, Inc., 2007).

Eskilson, Stephen, *Graphic Design: A New History* (New Haven, CT: Yale University Press, 2012).

Estren, Mark James, *A History of Underground Comics* (Berkeley, CA: Ronin Publishing, 1993).

Freedom du Lac, J., "Stanley Mouse Talks Grateful Dead, Zig-Zags, Hot Rods, Hippies and What Journey Took from Jimi," *Washington Post*, April 10, 2009.

Gair, Christopher, *The American Counterculture* (Edinburgh, Scotland: Edinburgh University Press, 2007).

Glessing, Robert J., *The Underground Press in America* (Bloomington and London: Indiana University Press, 1972).

Groth, Gary, and Robert Fiore (Eds.), *The New Comics* (New York: Berkley Books, 1988).

Grushkin, Paul, *The Art of Classic Rock: Rock Memorabilia, Tour Posters, and Merchandise* (New York: HarperCollins, 2010).

———, *The Art of Rock* (New York: Abbeville Press, 1987).

Guffey, Elizabeth E., *Retro: The Culture of Revival* (London: Reaktion Books, 2006)

Hall, Justin (Ed.), *No Straight Lines: Four Decades of Queer Comics* (Seattle, WA: Fantagraphics, 2013).

Hatfield, Charles, *Alternative Comics* (Jackson: University Press of Mississippi, 2005).

Harvey, Robert C., *The Art of the Comic Book* (Jackson: University Press of Mississippi, 1996).

Hendra, Tony, *Going Too Far* (New York: Doubleday, 1987).

Holm, D. K. (Ed.), *R. Crumb: Conversations* (Jackson: University Press of Mississippi, 2004).

Jeffery, Scott, "Tales from the Sphinx: An Interview with John Thompson," *Nth Mind*, August 14, 2012. Available at https://nthmind.wordpress.com/2012/08/14/tales-from-the-sphinx-an-interview-with-john-thompson/.

Kaplan, Geoff, *Power to the People: The Graphic Design of the Radical Press and the Rise of the Counter-Culture, 1964–1974* (Chicago: University of Chicago Press, 2013).

Kitchen, Denis, *The Oddly Compelling Art of Denis Kitchen* (Milwaukie, OR: Dark Horse Books, 2010).

Lampert, Nicolas, *A People's Art History of the United States: 250 Years of Activist Art and Artists Working in Social Justice Movements* (New York and London: New Press, 2013).

Lopes, Paul, *Demanding Respect: The Evolution of the American Comic Book* (Philadelphia, PA: Temple University Press, 2009).

Mad Peck, *Mad Peck Studios: A Twenty Year Retrospective* (New York: Doubleday, 1987).

Meggs, Philip B., and Alston W. Purvis, *Meggs' History of Graphic Design* (Hoboken, NJ: Wiley and Sons, 2012).

McMillan, John, *Smoking Typewriters: The Sixties Underground Press and the Rise of Alternative Media in America* (London: Oxford University Press, 2011).

Owen, Ted, *High Art: A History of the Psychedelic Poster* (London: Sanctuary Publishing, 1999).

Robbins, Trina, *A Century of Women Cartoonists* (Northampton, MA: Kitchen Sink, 1993).

——, *From Girls to Grrlz: A History of Women's Comics from Teens to Zines* (San Francisco, CA: Chronicle Books, 1999).

——, *Pretty in Ink: North American Women Cartoonists 1896–2013*, (Seattle, WA: Fantagraphics Book, 2013).

Rodriguez, Spain, *Trashman Lives!* (Seattle, WA: Fantagraphics Books, 1989).

Rosenkranz, Patrick, *Rand Holmes: The Artist Himself* (Seattle, WA: Fantagraphics Books, 2010).

——, *Rebel Visions: The Underground Comix Revolution: 1963–1975* (Seattle, WA: Fantagraphics Books, 2002).

——, *You Call This Art? A Greg Irons Retrospective* (Seattle, WA: Fantagraphics Books, 2008).

Sabin, Roger, *Adult Comics: An Introduction* (New York: Routledge, 1993).

——, *Comics, Comix & Graphic Novels: A History of Comic Art* (London: Phaidon, 1996).

Santa Cruz, Nicole, "Expressing Judaism with a Paintbrush," *Los Angeles Times*, November 30, 2009. Available at http://articles.latimes.com/2009/nov/30/local/la-me-beliefs-artist30-2009nov30.

Stewart, Sean (Ed.), *On the Ground: An Illustrated Anecdotal History of the Sixties Underground* (Oakland, CA: PM Press, 2011).

Witek, Joseph (Ed.). *Conversations: Art Spiegelman* (Jackson: University Press of Mississippi, 2007).

Witek, Joseph, "Imagetext, or, Why Art Spiegelman Doesn't Draw Comics," *ImageTexT: Interdisciplinary Comics Studies*. 1.1, 2004, Department of English, University of Florida. Available at http://www.english.ufl.edu/imagetext/archives/v1_1/witek/index.shtml.

Chapter 28

Anonymous, "In Memoriam: Ralph Sweet," *University of California San Francisco Medical Center Campus Newsletter*, vol. 13, no. 1, 1961, 2.

Campbell, Iain D., "Timeline: The March of Structural Biology," *Nature Reviews Molecular Cell Biology*, vol. 3, no. 5, 2002, 377–381.

Crosby, Ranice. W., and John Cody, *Max Brödel: The Man Who Put Art into Medicine* (New York: Springer-Verlag, 1991).

von Debschitz, Ute, and Thilo von Debschitz, *Fritz Kahn* (Cologne: Taschen, 2013).

Demarest, Robert J. (Ed.), *The History of the Association of Medical Illustrators 1945–1995* (Atlanta: The Association of Medical Illustrators, 1995).

Dickerson, Richard E., "Obituary: Irving Geis, Molecular Artist, 1908–1997," *Protein Science*, vol. 6, no. 11, 1997, 2483–2484.

"Gallery: Frank Armitage," *Journal of Biocommunication*, vol. 24, no. 2, 1997, 12–15.

Goodsell, David S., "Illustrating Molecules," in *The Guild Handbook of Scientific Illustration*, 2nd edition, edited by E. R. S. Hodges (Hoboken, NJ: Wiley, 2003), 267–270.

——, "Visual Methods from Atoms to Cells: Minireview," *Structure*, vol. 13, 2005, 347–354.

——, "Visualization of Macromolecular Structures," *Nature Methods Supplement*, vol. 7, no. 3s, 2010, S42–S55.

——, "Putting Proteins in Context," *BioEssays*, vol. 34, no. 9, 2012, 718–720.

Hubbard, Christopher J., "Eduard Pernkopf's *Atlas of Topographical and Applied Human Anatomy*: The Continuing Ethical Controversy," *The Anatomical Record*, vol. 265, 2001, 207–211.

Krstic, Radivoj V., *Human Microscopic Anatomy: An Atlas for Students of Medicine and Biology* (Berlin: Springer-Verlag, 1991).

Perkins, James A., "A History of Molecular Representation Part One: 1800 to the 1960s," *Journal of Biocommunication*, vol. 31, no. 1, 2005, 13.

——, "A History of Molecular Representation Part Two: The 1960s–Present," *Journal of Biocommunication*, vol. 31, no. 2, 2005, 14.

Rasmussen, Nicholas, "Mitochondrial Structure and the Practice of Cell Biology in the 1950s," *Journal of the History of Biology*, vol. 28, no. 3, 1995, 381–429.

Richards, Sabrina, "Painting the Protein Atomic, 1961," *Scientist*, vol. 26, no. 8, 2012, 76.

Roberts, Kenneth B., and John D. W. Tomlinson, *The Fabric of the Body: European Traditions of Anatomical Illustration* (Oxford: Clarendon Press, 1993).

Rosse, Cornelius, "Anatomy Atlases," *Clinical Anatomy*, vol. 12, 1999, 293–299.

Sanner, Michel F., "Python: A Programming Language for Software Integration and Development," *Journal of Molecular Graphics and Modelling*, vol. 17, no. 1, 1999, 57–61.

Thornton, John L., and Carole Reeves, *Medical Book Illustration: A Short History* (Cambridge: The Oleander Press, 1983).

Wall, Shelley, "Mid-Twentieth-Century Anatomical Transparencies and the Depiction of Three-Dimensional Form," *Clinical Anatomy*, vol. 23, 2010, 915–921.

Williams, David. J., "The History of Werner Spalteholz's *Handatlas Der Anatomie Des Menschen*," *Journal of Audiovisual Media in Medicine*, vol. 22, no. 4, 1999, 164–170.

——, "The History of Eduard Pernkopf's *Topographische Anatomie Des Menschen*," *Journal of Biocommunication*, vol. 15, no. 2, 1988, 2–12.

Wilson-Pauwels, Linda, *The Development of Academic Programs in Medical Illustration in North America from 1911 to 1991* (dissertation, Ontario Institute for Studies in Education, University of Toronto, Toronto, Canada, 1992).

Chapter 29

Anonymous, *Exclusive Interview with William Joyce on "The Fantastic Flying Books of Mr. Morris Lessmore,"* Amazon Books [online], 2012. Available from https://www.youtube.com/watch?v=3FacOqWgd3o&feature=youtube_gdata_player.

BBC, "School Shooting: How It Happened." *BBC* [online], December 18, 2012. Available from http://www.bbc.co.uk/news/world-us-canada-20738998.

Beiguelman, Giselle, "For an Aesthetics of Transmission," *First Monday*, 2006.

Bennett, Richard, "No Country for Slow Broadband," *New York Times* [online], June 15, 2013. Available from http://www.nytimes.com/2013/06/16/opinion/sunday/no-country-for-slow-broadband.html.

Bolter, Jay David, and Richard. Grusin, *Remediation: Understanding New Media*, 1st ed. (Cambridge, MA: The MIT Press, 2000).

Capybara Games and Superbrothers, *Sword & Sworcery* [online], 2011. Available from http://www.swordandsworcery.com/.

Cashmore, Pete, *Why 2013 Is the Year of Responsive Web Design* [online], 2012. Available from http://mashable.com/2012/12/11/responsive-web-design/.

Crow, D, *Visible Signs: An Introduction to Semiotics in the Visual Arts*, 2nd ed. (Lausanne; Worthing: AVA Publishing, 2010).

Deloumeau-Prigent, Kaelig, "Mobile-First Responsive Web Design and IE8," *Guardian* [online], October 14, 2013. Available from http://www.theguardian.com/info/developer-blog/2013/oct/14/mobile-first-responsive-ie8.

Donahoo, Daniel, *The Fantastic Flying Books of Mr. Morris Lessmore Is a Game-Changing eBook App, GeekDad*, Wired.com, May 31, 2011.

Fishlock, Tim, *Sir Benfro's Brilliant Balloon* [online], 2013. Available from http://sirbenfro.com/.

Fuller, Matthew., *Software Studies: A Lexicon*) Cambridge: MIT Press, 2008).

Galloway, Alexander R., *The Interface Effect* (Cambridge: Polity Press, 2012).

Gitelman, Lisa, *Always Already New: Media, History, and the Data of Culture* (Cambridge: MIT Press, 2008).

Hayles, N. Katherine, *My Mother Was a Computer: Digital Subjects and Literary Texts*, new ed. (Chicago: University of Chicago Press, 2005).

Hoogslag, Nanette. *On the Persistence of a Modest Medium* (Ph.D. diss., Royal College of Art, London, in press).

Infinity Ward, *Call of Duty* [online], Infinity Ward, 2003. Available from http://www.callofduty.com/uk/en/.

Joyce, William E., *The Fantastic Flying Books of Mr. Morris Lessmore* (London: Simon & Schuster Children's Books, 2012).

Kittler, Friedrich, *Gramophone, Film, Typewriter*, Translation by G. Winthrop-Young and Michael Wutz (Stanford: Stanford University Press, 1999).

Kress, Gunter, and Theo van Leeuwen, *Multimodal Discourse: The Modes and Media of Contemporary Communication* (London: Arnold Publishers, 2001).

——, *Reading Images: The Grammar of Visual Design*, 2nd ed. (Florence, KY: Routledge, 2006).

Male, Allan, *Illustration: A Theoretical and Contextual Perspective.* (London and New York: AVA Publishing, 2007).

Manovich, Lev, *The Language of New Media.* (Cambridge: MIT Press, 2002).

——, *Software Takes Command* (London: Bloomsbury Academic, 2008).

Molleindustria, *The Best Amendment* [online], 2013. Available from http://www.molleindustria.org/the-best-amendment/.

Pitaru, Amit, and James Paterson, *Numby* [online], 2012. Available from https://itunes.apple.com/gb/app/numby/id499958256?mt=8.

Rockstar Games, *Grand Theft Auto IV* [online], 2013. Available from http://www.rockstargames.com/IV/.

Salen, Katie, and Eric Zimmerman, *Rules of Play: Game Design Fundamentals* [online], 2004. MIT Press e-book. Available from https://mitpress.mit.edu/rules

Segel, Edward, and Jeffrey Heer, "Narrative Visualization: Telling Stories with Data," *Visualization and Computer Graphics, IEEE Transactions*, vol. 16, no. 6, 2010, 1139–1148.

Thatgamecompany, *Journey* [online], 2012. Available from http://thatgamecompany.com/games/journey/.

Ustwo, *Monument Valley* [online], 2014. Available from http://monumentvalleygame.com.

Vlaanderen, Remco, *Interview with Han Hoogerbrugge*, 2009.

Wark, McKenzie, *Gamer Theory* (Cambridge: Harvard University Press, 2007).

Glossary

3-D modeling Process of developing a mathematical representation of any three-dimensional animate or inanimate object using specialized software.

Abstract Expressionism American fine-art movement emerging in the 1940s, in which artists intuitively painted large, abstract canvases. Jackson Pollock was a leading figure.

abuna-e *Ukiyo-e* prints capturing glimpses of partial nudity, usually by depicting females engaged in private moments. Not explicitly erotic, these prints were not censored by the government.

academic Reflecting the technical and thematic conventions mandated by official art academies that aimed to represent noble ideals set by Classical and Old Master precedents by use of linear perspective, canons of proportion of the human figure, and other rules.

Académie Julian Famous Paris atelier where many American artists studied academic drawing and painting. After 1900, it also had classes in design and illustration.

Adobe Illustrator Vector-based (using mathematical coordinates) software program developed in 1986 by the Adobe Corporation. It creates infinitely scalable imagery and letterforms, and enables a variety of distortions while keeping file sizes small.

Adobe Photoshop Raster-based (using pixels) software program developed in 1988 by the Adobe Corporation for image editing and image generation. Highly sophisticated tools, effects, and filters enable mimicry of various traditional media such as oil paint glazing, screen printing, and dry media textures.

Aestheticism Late nineteenth-century British movement valuing beauty and quality in the fine and decorative arts, partly inspired by Japanese art, and valuing design over narrative qualities. Its affiliates were called Aesthetes. Over time, it became increasingly associated with art for art's sake and stylistic eclecticism.

affect The aspect of visual and verbal texts that is registered nonverbally, emotionally, physically, and intuitively.

affiche illustrée French for illustrated poster (as opposed to text-only, or typographical poster).

agitprop Contraction of agitation and propaganda. Its early associations with Bolshevism have given way to broader usage to describe cultural output with an explicit political message.

alienation The Marxist concept that modern industrial capitalist production reduces craftsmanship and occupation to robot-like labor, leading to workers' dissociation from the products they make, and resulting in their loss of identity, deep dissatisfaction, and social ills.

alla prima Italian art term meaning "at the first touch" referring to a style of painting in which the brush confidently captures the subject in calligraphic gestures that have not been worked over, corrected, or polished; usually implies wet into wet paint application.

allegory Literary or visual art strategy in which a concept is presented in the guise of a metaphorical story or person.

alternative press Independent publishers who seek to provide journalism, imagery, and information neglected by large media corporations.

American Regionalism Modern art movement in the Midwest United States from the 1920s to 1950s that favored Realist yet heroic depictions of rural life and labor.

American Scene Documentary depictions of gritty and everyday American life, often urban, associated with painting between 1900 and 1950.

amphora Large, long-necked, two-handled storage jar with an oval body, usually tapering to a point at the base. Its pair of handles extends from immediately below the lip to the shoulder.

Ancien Régime Literally "the old regime," meaning the ruling elite who were displaced by the French Revolution.

animated GIF Graphics Interchange Format. The GIF is an early type of image file that can make both animated and still images, is widely adaptable to different platforms, and is compressed in such a way as to be "lossless" or nondegraded in a small file size.

annuals Compendia of stories and articles that over time became larger and more illustrated and were often marketed in advance of holidays as "gift books" in the nineteenth and early twentieth centuries.

anthropomorphism The attribution of human semblances, behaviors, or intentions to nonhuman entities. Aesop's fables (ca. 620–560 BCE), in which animals act like people, are early examples.

aobon Literally "blue books" in Japanese. Popular illustrated fiction named for the color of their covers, generally made for a younger or less literate audience than the *kibyoshi* (yellow books).

app An abbreviated form of the word *application*, or small software program. The word *app* is often used to indicate a mobile application for phones and pads, and designed in particular to match the demands, capabilities, and constraints of these devices.

Apple Macintosh First introduced in 1984, this personal computer preceded other visually oriented platforms, opening the way for widespread use of digital hardware. Limited to black and white until 1987, it utilized a graphical user interface (GUI) that enabled fewer keystroke commands and point-and-click access to functions on the machine.

apsaras In Hindu mythology, celestial maidens akin to angels.

aquatint In etching, a method of achieving subtle shades of gray that resemble a grainy watercolor wash.

arabesque Sinuous ornamental line or motif associated with floral patterns in Middle Eastern art.

architectonic Of or relating to the principles of architecture.

Art Deco Design style named after the *Exposition internationale des arts décoratifs et industriels modernes* held in Paris, 1925, where many objects exhibited clean, geometric lines with an emphasis on repetition, planarity and symmetry.

art for art's sake Modernist theory emerging in the late nineteenth century that art should be concerned exclusively with aesthetics rather than practical, political, narrative, or moral functions.

Art Nouveau European movement in the 1890s characterized by sinuous, organic forms and an aesthetic mixture of Rococo, Japanese, Celtic, and Arts and Crafts influences, often featuring women and flowers.

Art Students League An art school where pupils hire the instructors and attend classes as they wish, self-directing their training. The New York ASL was especially important for illustrators.

Arts and Crafts movement Art movement flourishing in Britain between 1880 and 1920 that spread internationally in reaction to the artistic and social degradation brought about by industrialization. With roots in the design reform of the 1850s, the movement sought to reform all of society by restoring workers' dignity and pleasure in making objects by traditional handcraft methods. It was made up of numerous societies, workshops, and guilds, the most famous of which, the Arts and Crafts Exhibition Society founded in 1887, gave the movement its name.

Ashcan School Moniker given by a critic to Realist painters who, inspired by Robert Henri, depicted the immigrant and working-class inhabitants of the city (mostly New York) in a manner informed by their work as newspaper graphic journalists and cartoonists. Prominent affiliates include John Sloan, George Luks, William Glackens, Edward Hopper, and Everett Shinn.

atlas Book containing a collection of maps, tables, or other images. In medicine, an atlas of anatomy is composed primarily of images of body structures, arranged either by system (bones, muscles, nerves, etc.) or region (head, upper limb, chest, etc.).

attributes Symbols and props used to identify saints in images and sculptures.

audience reception Field of study in which researchers document and analyze how individuals and groups use and interpret communication media and art.

augmented reality A live direct or indirect view of a physical, real-world environment whose elements are enhanced by computer-generated sensory input such as sound, video, graphics, or GPS data.

aura The physical and spiritual impact of a unique artwork, evoking a sense of unbridgeable distance and awe that can only be experienced in person in the presence of the work itself. Concept originated by Walter Benjamin.

automatism Spontaneous, intuitive writing or mark-making explored by Surrealist artists that circumvented censorious rational thought, sometimes while in altered states of trance, hypnosis, madness, or intoxication.

avant-garde Military term for soldiers sent out to prepare the way in advance of a main attack. Used in art to refer to those whose methods are experimental or ground-breaking, usually in modern or contemporary art.

avatar Character in a game controlled by the player, who may also represent the player.

ballad sheet Cheap song sheet of the Early Modern period printed on one side only.

banderole Scroll-like form in early prints that indicates that speech is going on between characters within an image; an early form of the speech balloon.

baren A bamboo pad used to rub the back of printing paper to transfer the printer's ink from a woodblock to paper.

bas-reliefs Low relief sculptures in which elements appear to be shallow projections from a recessed background.

Baxter process Color printing in which color blocks are overprinted on to an intaglio-printed base image.

ben-day tints Transparent sheets with tonal patterns of dots, lines, or other textures that were positioned as overlays to artwork before it was photographically reproduced for commercial printing. Named for inventor Benjamin Day and patented in 1878.

bibliophile A lover or collector of books.

The Big Five Key San Francisco psychedelic poster artists Victor Moscoso, Rick Griffin, Alton Kelley, Stanley Mouse, and Robert Wesley "Wes" Wilson.

big head illustration A nickname sometimes used derisively to describe fiction illustration from the 1930s to the 1960s in which the characters' faces fill the whole page, similar to a close-up shot in a movie.

The Big Idea A marketing strategy that gained popularity in the 1960s in which a key attribute of a product is imbued with rich, memorable social meaning, often through startling symbolic associations and conceptually integrated text and image.

bijin-ga Ukiyo-e prints of beautiful women.

binomial nomenclature The identification of an organism by its genus and species (e.g., *Homo sapiens*).

Birmingham School Nickname of the Centre for Contemporary Cultural Studies, a Marxist-oriented research center at the University of Birmingham established in 1964 and closed in 2002, that was influential on the field of Cultural Studies.

blackletter Popular Western European script from the twelfth century until the seventeenth century, typical of early letterforms adapted for use in movable type. Blackletter is characterized by heavy vertical strokes and a generally condensed, angular quality. It was used strategically in Nazi propaganda to lay claim to and create pride in German traditions.

blockbook Book printed using a single woodblock per page, where both text and image were carved into the block together.

blog Website usually concerned with a particular topic, updated regularly. Term coined in 1999 by programmer Peter Merholz from *web log*.

bodhisattva In Buddhism, a being intent on enlightenment who remains on earth to help people. Refers to the historical Buddha before his enlightenment as well as others.

book app Interactive visual storytelling application especially created for tablets and other mobile devices. See also *app*.

book of hours Popular and variable compendium of prayers for the lay population in which the structure of the text allowed the reader to mimic monastic ritual.

boy/girl illustration Illustration for romance stories in women's magazines that hints at the couple's relationship and personalities. Also referred to as *he/she illustration*.

Brandywine School General moniker for illustrators who were trained by or heavily influenced by Howard Pyle, who taught courses in the vicinity of the Brandywine River, Delaware. Associated illustrators include Pyle, N. C. Wyeth, Harvey Dunn, Frank Schoonover, Jessie Willcox Smith, Violet Oakley, and dozens more.

broadsheet A large, single sheet popular print common before the advent of the popular press. Sometimes folded, early broadsheets were often in ballad or poem form with unsophisticated woodcut illustrations, often used for news and propaganda.

broadside Single-sided unfolded print, usually created to post in public spaces. Early broadsides were typically printed from woodblocks and used for proclamations or to communicate ephemeral or popular subject matter.

Bronze Age of comics An era in comics publishing ca. 1973–1986.

bullpen The large workroom of an engraving house, commercial art service, or design studio, where drawing boards are clustered near large windows and workers are paid a wage or salary. Also used to describe copywriting/art direction teams in advertising agencies.

bunraku Traditional Japanese puppet theater.

burin Tool for cutting lines into engraving plates.

cabinet of curiosity Popular in Europe in the seventeenth and eighteenth centuries, a collection of rare or exotic objects including scientific specimens and art objects—ranging from portraits to artforms of non-European cultures. From the German *Wunderkammer*, cabinets of curiosity are considered forerunners of the modern museum.

caksani "Illustrator" in Sanskrit; an illuminator who explains with images and/or texts.

calavera Mexican illustration of skulls and skeletons, often satirical or darkly humorous.

camera obscura Literally a "dark room." A forerunner of the camera that projected a scene through a pinhole onto a flat surface for tracing.

caricature or *caricatura* Exaggerated or charged image, typically a comic human portrait.

cartouche Decorative shape with plain or elaborate border framing a name, title, writing, or image, affixed to an object or featured in a design (such as a map, title page, or book cover).

casta **painting** Painting genre originating in Mexico that illustrates racial mixing by depicting inter-racial couples with their children, ranked according to their racial backgrounds.

celt Polished stone in the shape of an axe head, treasured as a valuable in Mesoamerica and often incised with imagery.

Charana Chitta Indian vertical scrolls presenting a story in pictures.

chiaroscuro Renaissance innovation in painting in which dramatic shading and highlights, often using a darkened background, describes three-dimensional forms rather than relying on outlines.

chiroxylograph Print or book with hand-drawn calligraphy, and small woodcut prints glued in.

chitra-nirupan "Illustration" in Sanskrit; an explanation using a picture as an example.

chitrakar Sanskrit for artist.

Chitrasutra Indian guide to the traditional depiction of Indian gods.

chromolithography Color lithographs, also called chromos, widely used in the nineteenth century to print advertising, caricature, maps, scientific illustrations, and reproductions of paintings.

chromoxylography Nineteenth-century process of printing color images from wood engraving blocks.

chronophotography Single photograph that captures successive moments in time with multiple exposures.

clear-line or *ligne claire* Drawing style that originated in Japanese woodblock prints, characterized by precise, even-weighted lines, widely used in early twentieth-century fashion illustration and European comics.

codex Book format in which pages are individual sheets, stacked and held together by stitching rather than in a roll (scroll format), enabling quicker reference and slowing wear.

collectivization Policy of forced collective agriculture that reallocated peasant lands into collective (group) farms, mandated by and subservient to the Soviet state in the 1920s and 1930s.

comic juxtaposition Placing humorously incongruous objects or figures close together to highlight their differences.

Comics Code Authority Body established in 1954 by comics publishers to set strict moral standards for American comic books in response to concerns that sex, violence, and racial stereotypes in comics were corrupting youth.

commedia dell'arte Popular open-air theatrical performance that originated in sixteenth-century Northern Italy, in which actors improvise lines while playing stock characters following traditional plots, lacing their acts with pertinent timely social and political commentary and jokes.

Commodore Amiga Developed in 1985, the Commodore Amiga was a personal computer offering advanced graphic, animation, audio, and multitasking capabilities in color. It was a significant upgrade from 8-bit computers previously available.

Company Painting Hybrid form of art in India that combined traditional Indian forms with European ones, often depicting everyday life and marketed mainly to the English associated with the East India Company.

concept art Illustration created to design backgrounds, machinery, characters, and other elements of film or games.

conceptual illustration Illustration that does not replicate the text verbatim but instead establishes meaning through metaphor, word play, visual pun, free association, and other strategies that require the viewer to problem-solve.

concertina fold or **style** Paper printed on one side only and folded zig-zag fashion. Also referred to as *accordion fold*.

Constructivism Russian art movement opposed to art for art's sake that aimed to bring useful art forms to the masses in multiple media types, including photomontage.

continuous tone Gradients of gray or color in photographs or paintings that cannot be printed by letterpress or photomechanical means without being first converted into halftones.

correspondent Soldier/artist or official artist who traveled on behalf of a newspaper, sometimes with a military unit, to record events based on firsthand observation, possibly participating in combat as well. Also called a "special artist."

corrido Broadsheet that combines the lyrics of a narrative folk song with illustration.

costumbrismo Mode of illustration popular in nineteenth-century Latin America, in which artists depicted local customs and costumes.

counterpoint The interaction of word and image together to create more meanings than word or image do alone; also the interaction of contrasting elements within a picture.

couture High-quality, made-to-measure, or otherwise customized clothing based on a collection of new designs that are introduced annually by a fashion atelier; pioneered by Charles Worth, in 1858.

crewel Worsted yarn for embroidery and edging.

croquis In fashion illustration, a figure template over which concept drawings are made; more generally, a sketch.

crowdfunding Online appeal to the general public to pay certain costs of a project or initiative.

Cubism Art movement originating in Paris ca. 1905 that broke with representation based on fidelity to nature as it appeared to the eye by rejecting linear perspective and instead showing subjects from multiple angles at once.

cultural appropriation Unauthorized, exploitive use of one social group's art, religious symbols, customs, and other cultural expression by another, usually more powerful group.

cultural capital Concept theorized by Pierre Bourdieu, in which a combination of symbolic values, specialized knowledge, taste, and feeling of belonging empower an individual to invest successfully in the production and consumption of culture to promote their social status.

cultural hybridity The nonexploitive evolution of new cultural forms that occurs when cultures mix.

cultural nationalism Patriotic policy of protecting and supporting a country's customs, arts, languages, and industries through patronage, legislation, tax breaks, and rhetoric, for the purposes of defining the citizenship, territory, and rights of select people.

cut Abbreviation of *woodcut* that became standard for any reproduced image in print from engravings to halftones to line blocks.

cyborg Life form theorized by Donna Haraway that is socially and physically a hybrid of species, of organism and machine, or of physical and nonphysical entities.

cylinder die Equipment used in siderography for transferring an intaglio image from one steel plate to another.

Dada European movement circa World War I that sought to be a kind of anti-art by exploring nonsense, combinations of media, intentionally offensive subjects, and juxtapositions of imagery critical of society. Surrealism was an offshoot.

daguerreotype Early form of photograph perfected by Louis Daguerre in 1839 that uses no negative but rather exposes a metal plate directly.

database Archive of digitized information that can be accessed by search queries.

Decadents Artists and art connoisseurs stemming from the Aesthetic movement, who admired art for art's sake and privileged the sensual aspects of art marked by opulence, decoration, beauty, and perverse and erotic subject matter, with little regard for conventional morality or usefulness.

Deccan Art General term for art made from 1500 to 1900 of the Deccan Peninsula of Southern India, characterized by influences from the Ottoman Empire, China, and Europe, featuring richly detailed landscapes with elongated figures and gold leaf.

decode In communication theory, the process of determining meaning from a given piece of media, such as an advertisement, book cover, or mural.

deconstruction Philosophy and critical analysis method indebted to Jacques Derrida that asserts that objects, words, hierarchies, and their meanings are not stable because of their dependence on arbitrary signifiers in language, or "constructs." Colloquially, the act of unmasking how words, images, relationships, and identities work.

Digital Age of comics An era in comics publishing ca. 2001–present.

dime novel Inexpensive, sensational fiction printed in a thick, small booklet and sold in the United States between 1860 and 1915.

Dionysian Mysteries Rituals of ancient Greece and Rome that used intoxicants and other trance-inducing techniques (like dance and music) to remove inhibitions and social constraints, liberating the individual to achieve a new state of awareness.

direct market Mail-order and subscription services that reach readers outside the mainstream distribution channels.

discourse Texts, images, speech, customs—anything that represents a set of ideas, as well as the professional and popular debates surrounding them.

dissent Political opposition to reigning governance and policy, sometimes involving civil disobedience.

DIY (Do-it-yourself) movement Popular culture movement rejecting commercially produced objects for ones created by individuals, usually in their own home; and entrepreneurial activity often related to a political desire to be more individualistic and less dependent on large corporations and environmentally damaging mass production. DIY objects take advantage of common materials used or reused (upcycled) in inventive ways.

douban Relief printing method in which each block is irregularly shaped and only large enough to cover the area needed for its assigned color.

double elephant Large standard page size measuring 39.5 × 26.5", used for lavishly illustrated informational books in science, maps, architecture, and other grand topics.

drybrush Technique of painting with very little water or oil, in which the bristles of the brush deposit scratchy marks. Can be used to create line art for reproduction.

drypoint Intaglio printmaking technique in which a metal plate is incised with a sharp tool that leaves a furry-looking line.

dynamic symmetry Influential system of composing artworks derived from ancient Greek art and geometry, developed by Jay Hambidge and first published in a book by the same name in 1920.

e-book Electronic book; a text delivered online and read on-screen through electronic devices.

e-textbook Electronic textbook that can deliver advanced interactive content, such as 3-D renderings, animations, and virtual instruction online.

échoppe Tool used in etching to create a swelling line that enhances description of three-dimensional volume and mimics the style of linework made by an engraver.

écorché Images of flayed human figures posed as if to demonstrate their own musculature.

éditions de luxe Luxury books produced for collectors that often use stand-alone artwork by gallery-oriented artists for their illustrations.

electron microscope Microscope that uses a beam of electrons instead of light as its source of illumination. The beam of electrons is focused by electromagnets, instead

of glass lenses. It is capable of resolving objects thousands of times smaller than can be seen under a light microscope.

electrotype Method of casting and electroplating an engraving and/or text in metal to make a printing matrix capable of withstanding a great many impressions in the press, first developed in the 1830s to create duplicates of page layouts (or parts of them) as an alternative to stereotypes. By the 1880s, the technology was updated with a photo-based process to produce hard copper printing plates that could reproduce line art perfectly. The technology was still in use as late as the 1980s in modern letterpress.

emaki Japanese hand scrolls in a horizontal format.

embroidery Technique of applying stitches of colored threads onto a woven fabric ground to create figures or patterns.

encode In communication theory, the authoring of a given piece of media, such as an advertisement, book cover, or mural, usually using commonly shared signs so that the audience will be able to understand the intended meaning.

engraving Intaglio printmaking technique in which a copper or steel plate is incised with a burin that makes crisp lines (not to be confused with wood engraving, a relief printing process).

epistemological rupture The breaking of an (often unconscious) fundamental model.

etching Intaglio printmaking technique in which a drawing is incised into a wax or varnish ground (a coating) applied to a metal plate. The plate is submerged in a series of acid baths, and the acid etches (eats away) the exposed portion of the plate. The ground is removed and an impression is printed from the resulting recessed lines.

Expressionism Twentieth-century art movement in which natural forms are distorted to create a psychologically and politically charged subjective or symbolic image rather than to present familiar outer appearance.

extra-illustration Imagery added to a text by a reader, often by cutting and pasting prints and illustrations from elsewhere. Also known as *grangerization*.

ex-voto "After the vow"—a work of art created to give thanks for divine assistance.

Famous Artists School Westport, Connecticut business headed by illustrator Al Dorne that produced and sold mail-order illustration lessons written by famous illustrators to the public. Completed lessons were mailed back to the school and marked by professional illustrators.

Fantastic Realism Fine-art movement originating in Vienna in 1948 that used academic techniques to render traditional subjects blended with imaginary and Surrealist ones, following the Symbolists of the nineteenth century.

fanzine Informal periodical, or "fan magazine," produced by and for aficionados of a subcultural interest such as science fiction, using inexpensive media such as mimeographs or photocopiers.

fax machine Abbreviation of *facsimile*. An information transmission device initially called a Qwip by Exxon, which popularized it in the mid- to late-1970s, that could send text or imagery using telephone lines to anyone anywhere in the world who had a similar machine.

field of cultural production A network of interested individuals and institutions that constitute a professional discipline, theorized by Pierre Bourdieu as a site of competition for power and status.

filial piety Obedience and service to one's progenitors.

flâneur Man of leisure; a literary archetype associated with the nineteenth-century French poet Charles Baudelaire in his "The Painter of Modern Life" (1863); an urbanite absorbing the experience of the modern city by strolling in the streets, looking for inspiration.

Flash animation Animation created in Flash, a popular authoring software developed by Macromedia, now owned by Adobe. Flash animations are in a resizable file format that is small enough to stream across an Internet connection. They often use vector graphics or contain simple interactivity.

florilegium Literally "flower book" in Latin, a collection of botanical illustrations, often cataloguing the plants in a single collection or location.

flying stationer Hawker of broadsides characterized by the speed with which he scurried from one location to the next.

form follows function The modernist principle that the construction and appearance of something should be derived from its most basic intended purpose.

formalism Art and art criticism with an aesthetic emphasis on the basic building blocks of form (line, shape, color, medium, etc.) rather than depiction or narrative.

forme Arrangement of illustration blocks and composed typography for letterpress printing. They are held together in a metal frame called a chase.

formschneider "Woodcutter" in German; the specialist responsible for actually incising the wood blocks that were often designed or transferred onto the block by an artist.

foul biting In etching, when the acid gets past the ground and eats away more of the printing plate than it should, marring the surface or eroding the clarity of lines.

Frankfurt School Nickname of a mid-twentieth-century group of Marxist thinkers at the Institute for Social Research, University of Frankfurt, who critically analyzed the effects of mass communications and modernity on European and American society.

fresco Technique of painting on a moist plaster surface with colors ground up in water or a limewater mixture.

fukeiga "Pictures of landscape"—in Japanese art, landscapes that depict particular places, usually with some temporal specificity and often using a more European approach to perspective.

Futurism European art movement beginning before World War I that combined sound, poetry, advertising, drama, movement, and painting into startling spectacles and forms for the purposes of critiquing society. Some proponents advocated violence and became associated with Italian fascism.

gafu Japanese printed picture books created as models for artists, in which paintings by masters are translated into woodblock images. The practice began in China.

gauffrage "Blind" embossing, that is, creating a dimensional impression on paper without the use of ink or color; used in Japanese woodblock prints.

gekiga Dramatic pictures, a subgenre, or alternative manga, that depict serious subjects and topics aimed at an older audience.

genius Concept arising during the Romantic period (1775–1850) in which the artist is considered to be a special individual who has great insight because of his imagination and talent and his remoteness from ordinary life, resulting in works of great originality and passion.

genre scene Depiction of everyday life.

gesaku Literally "playful compositions" in Japanese, applied to the category of popular reading, as distinguished from more serious academic or classical literature.

gesamtkunstwerk Literally "total work of art" in German, referring to productions that combine all the arts (music, visual art, poetry, literature, dance, architecture) into one all-encompassing spectacle. Originated in the Romantic period.

Gibson Girl Not a specific person but an ideal model of modern American beauty that emerged in the 1890s, this "New Woman" type exercised more rights and enjoyed more personal liberty than her female forebears. Named for their creator, Charles Dana Gibson, upper-class Gibson Girls were often attended by a host of love-struck suitors.

giclée A term for a high-quality inkjet print, usually made as a fine-art object from an original painting or digital art. True giclée prints are made with pigment-based inks, rather than dye-based inks.

gift book Lavishly decorated, nineteenth-century book of collected essays, short fiction, and poetry primarily published in time for the holiday season and intended to be given as a gift. Later, gift books were often fine productions of color-illustrated literature, fairy tales, or short stories.

gillotage Invented in the mid-nineteenth century, this etching process rendered a relief printing plate by dissolving the area that did not print in acid, while protecting the raised lines that were to be printed. Credited to Charles Gillot, the process enabled photomechanical transference of the image to be etched onto the printing plate, and was an improvement of an earlier method (nonphotomechanical) by his father Firmin Gillot.

glaze Renaissance technique of layering thin, transparent oil paints to achieve luminosity and the illusion of spatial depth.

global village Term coined by Marshall McLuhan to describe the social unity across time and space that he predicted would result from networked electronic communication.

go Japanese word for the professional pseudonyms taken by artists, often incorporating parts of former mentors' names.

gokan Illustrated serial popular fiction, usually published in sets.

Golden Age While dates are in dispute, this term typically refers to the heyday of illustration circa 1900 after photomechanical means had supplanted the need for wood engravers to translate original art onto relief blocks and before photography came to dominate print media. It also coincided with a peak in the importance, variety, and quantity of illustrated books and magazines.

Golden Age of comic books An era in comic book publishing ca. 1938–1956.

gouaille "Cheeky humor" in French, referring to cartoons that deliberately offend taste for the purpose of productive banter.

Grand Tour Customary tour of famous ancient Classical cities and sites in mainly Italy and Greece. Lasting weeks to years, these were often undertaken by younger adults of the upper classes from Northern Europe and the Americas to complete their education and to refine their taste.

graphic novel Sequential art format combining words and images, usually delivering a complete story rather than just one episode as regular comic books do. Subject matter is often more literary or autobiographical, and production techniques may be experimental and/or higher quality.

gravidae Images of pregnant figures, usually with cutaways to show reproductive aspects of anatomy.

grisaille Painting that uses modulated monochrome to approximate a sculptural look in two-dimensional imagery; or a black-and-white study in preparation for more finished color work; or a finished illustration for reproduction in black and white.

grotesque Comically distorted figures, creatures, or images that range from the absurd to the horrific.

grotto Natural or artificial cave used as decorative or devotional space.

Group of Seven Collective of Toronto-based illustrators who in the 1910s and 1920s turned to modernist landscape painting in an attempt to define a unique nationalistic art form that would express Canada's independence from Great Britain and the United States.

hadith Extensive corpus consisting of sayings and doings attributed to the Prophet Muhammad.

hagiography Collection of embellished biographical accounts of saints.

halftone Photograph or artwork that has been photomechanically rendered as a series of tiny dots that approximate gray tones for the purpose of being printed. Smaller dot sizes create more nuanced tones (high-resolution images) and larger dots are used in low-resolution images such as in newspapers.

hanashibon Japanese collection of short stories.

Harlem Renaissance Social movement named after the New York City neighborhood that became a vibrant site of culture and business directed by African Americans in the early twentieth century and that supported and celebrated their heritage, community development, and political equality.

hatayi Stylized floral cross-section motifs thought to have been imported by Timurid court artists from western China.

headpiece Decorative illustrated element placed as a divider at the beginning of a chapter, usually in the blank space above the title. Commonly employing architectural, floral, or zoomorphic motifs.

hegemony Perpetuation of society's status quo by institutional control coupled with the acquiescence of citizens.

heroic fantasy Fiction descended from Arthurian literary traditions and associated with author J. R. R. Tolkien, in which heroes act according to noble motives and expectations.

hieroglyph Pictographic script, particularly that of the ancient Egyptians, in which many of the symbols are conventionalized yet recognizable pictures of the things represented.

histology Microscopic structure of plant or animal tissues.

historiated initial Large letters marking a section of an illuminated manuscript that contain identifiable scenes or figures related to adjacent text.

history painting Most prestigious category of academic art, depicting heroic Classical and Biblical scenes according to established rules and symbols, and intended to uplift the viewer into a higher moral state while instructing on historical subjects.

Horn book A primer, usually concerning the alphabet or religious matter, typically covered with a transparent sheet of horn (or mica) and fitted with a handle. Originated in England ca. 1450.

horror vacui "Fear of empty space" in Latin, describing a design or an area of a design that is entirely filled with artistic detail.

hypertext Software system that allows the user to create and link fields of information, text, or graphic material enabling extensive cross-referencing between related sections in a nonsequential way.

iconography In art history, a term that refers to the depicted subject matter and symbols, and the study of their denotative (literal) and connotative (hinted at) meanings.

iconophobia or **iconoclasm** Aversion to and repudiation of images, often because they are considered tantamount to idolatry.

Illustration Brut Term derived from Jean Dubuffet's term *art brut* and applied to illustration that embodies similar attributes, such as being created outside the aesthetic boundaries of the accepted standards of beauty or culture.

imagetext Concept introduced by W. J. T. Mitchell that proposes there is always a verbal component to the visual and a visual component to the verbal. Some forms exhibit this very obviously, such as calligrams.

Impressionism Nineteenth-century art movement originating in France that tried to capture fleeting moments often painted on scene, emphasizing light, color, and indistinct shapes very differently from the formulaic, carefully rendered paintings seen in the academic salons.

incunabula Books printed before 1501, as opposed to manuscripts.

indexicality The quality of a photograph to act as a semiotic "index"—as evidence of having been present at the scene that is recorded—thereby implying that what is recorded is a reliable, true document of the actual time, place, and subject matter.

Industrial Age of comics An era in comics publishing ca. 1831–1896.

infographics Visual communication of quantitative information using symbols, charts, and easily understood icons.

Inklings English literary group that included J. R. R. Tolkien and C. S. Lewis, who popularized heroic fantasy.

intaglio Printmaking in which the matrix consists of recessed lines that are then filled with ink and printed with a rolling press.

intellectual property rights Rights established by law to protect writers and artists from publishers and others exploiting their ideas and creations.

International Style Formulaic grid-based layouts using sans-serif fonts and emphasizing unity of design, widely adopted by modern graphic designers worldwide.

Internet meme Activity, concept, image, or movie clip that spreads, often as parody, from person to person via social media.

Jaina style Art form of the followers of Jainism in India, known for flat, stylized figures with a protruding eye; also known as *Western Indian painting*.

Japonisme French term for the incorporation of Japanese aesthetic influences in Western art, which became highly fashionable in the latter half of the nineteenth century after the West reestablished trade with Japan.

jinns Supernatural beings. One of the three categories of sentient beings along with humans and angels in Arabic and Islamic mythology and theology; Anglicized as *genie*.

juan Chapter or volume in a Chinese manuscript or book.

kaavad Portable wooden shrine of the Rajasthani people of India, with many doors and surfaces painted with images that are manipulated by a storyteller as he relates a narrative.

kabuki Stylized popular drama in Japan developed in the seventeenth century, involving elaborate costumes, music, and dancing.

kacho-e or **kacho-ga** Traditional *ukiyo-e* prints dealing with natural subjects other than humans; sometimes referred to as "bird and flower" prints.

Kalighat style Prints made in Bengal characterized by bright colors, strong lines, simplified forms, and rhythmic compositions that illustrate historical and religious subjects, morals, and satire.

kathputli Wooden puppets of the Rajasthani people of India.

kibyoshi "Yellow or yellowed covers" in Japanese. Illustrated, entertaining, often satirical novels set in contemporary Japan, usually for adult audiences. Some consider kibyoshi to be antecedents of modern-day manga.

kitsch Derisive German word for sentimental, cheaply made, factory-produced knick-knacks, prints, and reproductions of art.

kokkei-bon Japanese comic novels.

kuchi-e Frontispieces in Japanese romance novels in the late nineteenth and early twentieth centuries.

kyokabon Illustrated poetry books usually featuring short verse with *ukiyo-e* images.

large cut Double-page feature illustration in nineteenth-century newspapers, created from multiple woodblocks, often simultaneously engraved in the same style by different engravers to save time and then bolted together to form the final image.

Late Period 664–332 BCE in ancient Egypt, ending with the conquest by Alexander the Great and establishment of the Ptolemaic Kingdom.

layout Arrangement of typeset words, images, lettering, line art, and so on adhered to a mechanical board prior to photomechanically processing for offset printing.

leggotype First halftone printing process. Invented by William Leggo in 1869.

less is more Modernist maxim that the reduction of elements will amplify and clarify a message.

Letraset Brand name of rub-down, transferred lettering used in making paste-ups for photomechanical printing.

letterpress Relief printing using moveable type and image "cuts" (type-high woodblocks or mounted image plates ready for printing).

lifestyle advertising Advertising featuring appealing people enjoying the product being sold in a context conveying

a specific social class, values, and taste that the targeted audience would wish to identify with by purchasing the product.

ligne claire or **clear-line** Illustration technique characterized by uniform line weight and flat in-filled color.

line art Black-and-white illustration with stippling, hatching, dry brush, and other pen-and-ink techniques that approximate the look of gray tones, sometimes by use of prefabricated ben-day patterns laid down over a line drawing. Such techniques were an alternative to halftones, which did not reproduce well on pulp paper and cost more to produce.

line block Photomechanically produced matrix or "cut" produced by photographically transferring the artist's drawing onto a photo-sensitive metal plate. The nonprinting areas are etched away, resulting in a relief that is mounted on wood type-high, to be set with type for letterpress.

linear perspective Illusion of camera-like, realistic three-dimensional space in drawing or painting, perfected in the late fifteenth century by Renaissance artists. Also called *mathematical perspective* due to its adherence to rules of geometry.

literary news illustrators Newspaper illustrators who drew imagined pictures from verbal reports transmitted via telegraph.

literati In imperial China, amateur scholar-artists rather than academic professionals.

lithography Printing technology invented in the final years of the eighteenth century in which the artist draws on a prepared flat stone matrix with a greasy crayon or liquid, which is then treated chemically to fix it. The absorbent stone is dampened, and when ink is applied, it adheres only to the greasy drawing and not to the moist, bare areas of stone, allowing a print to be pulled from the drawing. Since no engraver was necessary, lithographs allowed the illustrator's personal autographic style to be reproduced without translation.

little magazine Small-run alternative press periodicals, typically literary and left-leaning.

livre d'artiste "Artist's book" in French, referring to collectible books produced by artists themselves, or by a publisher who commissions artists to supply pictures to accompany a text. Sometimes the pictures are not illustrations per se, but autonomous artworks. Also called a *livre de peinture* or painter's book.

logocentrism Emphasis on the cultural value of the written word over imagery, with the assumption that verbal communication is more true, accurate, and valuable than other ways of communicating.

lost-wax process Process in which an original sculpture is made or cast in wax, from which a mold is made, followed by the wax being burned out and replaced with metal.

Lowbrow Art movement originating in California, contrasted to highbrow or elite culture. Includes any expression of popular culture widely considered taboo, tasteless, offensive, or even illegal by polite mainstream standards, with cultural roots in popular illustration, underground comix, punk music, erotica, kitsch, surfer and hot-rod subculture. Also written as *low brow, lobrow,* or *low-brow,* and sometimes considered synonymous with Pop Surrealism.

MacDraw Vector-based drawing application created for use on the Apple Macintosh, and one of the first WYSIWYG (acronym for "what you see is what you get") drawing programs. This software program allowed the user to create technical drawings and floor plans.

MacPaint A bitmap-based graphics painting program created for use on the Apple Macintosh.

Mahabharata An ancient epic Indian history with devotional components.

Maker movement Artistic and artisanal movement using innovative economic models including self-publishing efforts, alternative comics, and 'zines. See also *DIY (Do-it-yourself) movement.*

male gaze Laura Mulvey's 1975 theory that most cinematography is structured to reinforce a heterosexual man's view of women as sexualized, gendered, and passive. The term also refers to an imbalance—noted by John Berger in 1972—that in art, media, and advertising, women are depicted (and thereby are encouraged to regard and present themselves) according to patriarchal concepts of them as objects of desire, good mothers, passive servants, and other tropes that buttress male supremacy.

manga "Informal pictures" in Japanese, referring to cartoons, sketches, or comics; but outside of Japan generally referring to comics originating in Japan or that are stylistically related.

mangaka Japanese for manga artist.

mankha Itinerant professional bards in India who tell stories of the Buddha's life using picture boards.

marchande des modes A milliner, especially one whose role is to create the latest fashion in headwear.

marginalia Images in the margins, or at the edges of manuscript pages, that usually have little immediately recognizable relevance to the text or illustrations on the same page.

mass media Communication technology controlled by large corporations that is designed to reach as many people as possible, resulting in the same message being seen by millions at approximately the same time. Newspapers, "slick" magazines, radio, and television are examples.

matrix Anything from which multiple identical prints are made, such as a woodblock, film negative, or lithographic plate. A matrix is also the mold from which letterform are cast.

matte painting Large, photographic-looking painted backdrops used in cinematic special effects to substitute for an actual location.

mechanisms of action In pharmacology, the mechanisms of action (MoA) refer to the specific biochemical reaction that a drug produces through the interaction of the molecules of the drug and its target in the living cell. For example, the molecules in aspirin suppress the production of hormones that are responsible for pain and inflammation.

media convergence The coordinated development of entertainment industry products across multiple media forms at once, created and controlled by the same or closely related corporations.

memento mori Images that serve as a reminder of death.

mercer Shopkeeper, especially a purveyor of textiles.

metal cut An engraving on metal used for printing. An early example of a metal cut is the fifteenth-century technique

called *dotted manner* (*manière criblée*), referring to the dots that form the image.

metapicture A picture that, according to W. J. T. Mitchell, reflects on the nature of pictures and picturing; that exhibits—often by way of a joke—an awareness that pictures are fabrications that both enforce and question the nature of representation; and that reminds us that pictures have an innate agency that animates human interaction with them.

mezzotint An intaglio process in which the image is created dark-to-light by first laboriously riddling the plate with ink-holding texture and subsequently lightening it by selectively burnishing away that tone.

Micrograph (SEM) Image made by a device used for viewing objects smaller than half a micron, in which a beam of electrons is either passed through an incredibly thin-sectioned specimen (transmission electron microscopy) or bounced off the subject—which has been coated in a precious metal (scanning electron microscopy, or SEM).

microscopists Those who use microscopes for scientific study.

Microsoft Windows 1.0 Developed in 1985, Microsoft Windows 1.0, a graphical user interface operating system, was the first version of the Windows line. Bill Gates, who had worked at Apple on the Macintosh project, leased certain aspects of the user interface from Apple when creating Microsoft.

Middle Kingdom 2040–1786 BCE in ancient Egypt, comprising the eleventh to thirteenth dynasties.

mie Dramatic pose struck by a Kabuki actor to cause a pause in the action during a kabuki drama. Certain *mie* became emblematic of particular emotions and were "stock" poses.

mimesis Imitation or representation of nature.

mini-comic Small comic format arising in the 1980s that is self-published using a photocopier and mainly distributed by postal service and at comic conventions.

miniature A painted or hand-drawn scene within the body of a manuscript that is set off on its own and not framed by an initial letter. Miniatures can occupy whole pages in an illuminated manuscript. Also, a vastly smaller-than-life-sized image such as a miniature portrait, usually commissioned to carry in one's pocket.

mitate-e Literally "comparison" or "analogy" in Japanese, in which *ukiyo-e* prints transpose anachronistic props, costumes, and characters in contemporary performances or make literary allusions through symbols. These ironic and sophisticated prints require interpretation by a cultured audience in order to understand the layered meaning.

mnemonic device Picture or object with key events briefly indicated in a symbolic or narrative manner, used to aid the memory of a storyteller in relating a long narrative.

Modern Age of comics An era in comics and comic book publishing ca. 1986–2001.

Moderne Style of illustration derived from Streamline, Precisionism, and avant-garde art, characterized by dynamic composition and simplified form.

mon Customized crests worn by actors, passed down between generations of family members in the acting trade.

monogatari Epic Japanese literary form that includes romantic and historic tales.

Mutoscope card Small cardboard picture of a pin-up purchased from vending machines operated by the International Mutoscope Reel Company, found in amusement parks or arcades.

narrative realism Narrative depictions characterized by individualized and naturalistically depicted characters, explicit settings modeled through light and shadow and linear perspective, with convincing life-like details.

Natya Shastra An ancient Indian text describing how all matter and events, seen and unseeable, are to be represented in art.

negotiated meaning According to Stuart Hall, this is meaning that a viewer gives an image or text that is derived from what the originator intended but that is modified according to the needs of the viewer.

Neoclassicism Art movement of the later eighteenth century closely tied to the values and training of the art academies that celebrated rationalism and Classical art and history. Intended to edify and to cultivate social responsibility and personal restraint, stylistically, it is more simplified and stiff than the sensual and entertaining but more "degenerate" Rococo style that directly preceded it.

neuroaesthetics Scientific study of aesthetic reception in the brain.

New Deal Policy of U.S. president Franklin D. Roosevelt's Democratic government during the 1930s to support the unemployed by commissioning new public infrastructure. Under this policy, many artists decorated urban and rural public buildings with murals.

New Kingdom 1580–1085 BCE in ancient Egypt, comprising the eighteenth to twentieth dynasties, characterized by the predominance of Thebes.

new media Media forms and capabilities of media that are set by computing and computers (which also distribute and exhibit new media features) and that have a transforming impact on culture and the way we communicate.

New Typography Influential twentieth-century approach to typography ruled by minimalist aesthetics, logic, and clarity, espoused by typographer Jan Tschichold.

New Wave Literary science fiction movement circa 1970.

New Woman Late nineteenth-century feminist, independent woman in Europe and the United States who advocated for women's political and educational rights.

nishiki-e Literally "brocade prints" in Japanese; polychrome prints made at the height of the stylistic development of *ukiyo-e*.

nō Classical masked theater traditionally favored by Japanese upper classes.

oban Paper size of roughly 10 × 15", a popular *ukiyo-e* format.

octavo Common and convenient size of book in use since the advent of printed books. Each full sheet of paper is folded three times and sewn or stapled along one seam; then it is trimmed to create eight leaves (sixteen pages). At the printing stage, the printer sets up eight page layouts on a single "forme," each in the proper orientation (a second forme is made for the other eight sides of the pages).

offset lithography High-speed process of commercial lithography in which the plate transfers ink to a rubber roller that subsequently transfers the ink to the paper, popularized after 1900.

okubi-e "Big head" prints featuring close-ups, rather than full figures; sometimes of beauties or actors in *ukiyo-e*.

Old Kingdom 2780–2280 BCE in ancient Egypt, comprising the third to sixth dynasties, characterized by the predominance of Memphis.

oleograph Multicolor lithograph printed on canvas to imitate oil painting.

onnagata In Japan, male kabuki actors in female roles.

Op-Art page Page in the *New York Times* opinion section that features artworks that range from charts to drawings to photographic imagery. Appearing occasionally, in contrast to the long-running illustrated Op-Ed page, its images reflect more than opinions—they also bring relevant information on the topic at hand in a way that text cannot.

Op-Ed page Abbreviation of "opposite the editorial page" in the *New York Times,* because it presents opinions written by persons other than the editors. In the 1970s, this page became famous for its often controversial, witty, or philosophical illustration. "Op-Ed" has come to be used to refer to other editorial illustration that is characteristically similar in approach.

oppositional meaning Meaning that a viewer gives an image or text that is opposite to, divergent from, or otherwise hostile to what the creator intended.

oriental A now discredited way of referencing Middle Eastern and Asian cultures.

orientalism Term used critically by Edward W. Said to indicate stereotypical European colonialist conceptions of and attitudes toward cultures from the Mediterranean to Japan (the "Orient" was contrasted to the "Occident"—Europe) that perpetuate inequity and misunderstanding.

orphan works Publishing designation in which authorship is deemed impossible to trace, or an author's rights are considered to have been dispatched by conditions of prior publication.

page bleed Full-page image that overruns the edges of the page rather than being contained within its margins.

The Paint Box Era (1986–1996) Phase 2 in the evolution of digital media art, when users no longer needed to know programming to create images, because paint software programs and devices such as affordable personal scanners became available. The Paint Box Era was preceded by Phase 1: The Pioneers (1956–1986) and succeeded by Phase 3: The Multimedia Era (1996–2006).

panopticon Literally "all-seeing eye" in Greek, specifically referring to a tall tower discussed by Michel Foucault that was used for watching prisoners in nineteenth-century jails, but referring more generally to systems of surveillance that coerce those surveilled to police themselves.

parietal From *paries*, meaning "wall" in Latin; describing art that is affixed directly on the wall of a building or cave.

parody Work that imitates and exaggerates or mutates the style of an author, artist, or work for comic effect.

parole in libertà Literally "words in freedom" in Italian, a tenet of Futurist word-pictures that expressed sound and emotion by the use of untraditional typesetting and lettering.

participatory culture Concept proposed by media theorist Henry Jenkins that suggests consumers expect and maintain some control over corporate culture industry production through fan groups, social media, and their own creation of content.

paste-up mechanicals The application of typeset text, special lettering, halftones, and line art in black assembled together using wax or adhesive on a white board that is then photographically transferred to a printing matrix.

pata Illustrated scrolls used in India for the live narration of a story by a professional storyteller.

pathophysiology Combination of pathology (disease) and physiology (function): the study of functional change that accompanies disease.

peintre-graveur Literally "painter-engraver" in French, a term art historians use to distinguish early printmakers who engraved their own designs rather than working from the designs of others or copying extant artwork.

penny bloods Cheap, sensational fiction and quasi-reportage marketed to a general working-class readership, noted for particularly violent subjects.

penny dreadfuls Cheap, sensational fiction of the nineteenth century marketed to male youth.

phad Illustrated horizontal cloth scroll used by storytellers among the Rajasthani people.

photo-trichromatic printing Technique in which an original color illustration was photographed through special filters to separate the primary colors (red, yellow, and blue) to approximate the image in a color print.

photogram Photograph made by exposing an object laid directly on a photosensitive plate, negative, or paper rather than by using a camera.

photomontage Combination of photographs, text, and pictures cut out of magazines, newspapers, advertising, and ephemera to create images or designs. Photomontage was popular with Dadaists and Surrealists in the early twentieth century.

photoxylography Photomechanical means of exposing an image onto a woodblock so that a reproductive engraver could then use the image as a guide for carving the design without having to redraw it first.

phrenology Nineteenth-century pseudo-science in which practitioners divined the personality, morality, talents, and other traits of individuals by examining the shape of their heads and facial features. Textbooks of phrenology upheld long-standing race-, class-, and gender-based prejudices.

Phrygian cap Soft conical hat with a rounded tip that curls forward. First worn in the ancient country of Phrygia and recorded in Greek art, a similar cap worn during the Roman empire came to symbolize freedom because it was worn by emancipated slaves. Later, during the French Revolution (ca. 1789), it reappeared, as a red cap worn by revolutionaries as a symbol of liberty.

pictorial turn Coined by W. J. T. Mitchell, a movement in academic study when many scholars began theorizing images and visuality, leading to the establishment of the fields of Visual Culture and Visual Studies.

picturesque English art trend of the Romantic period in which paintings, gardens, and architecture were composed following rules of composition and staged subject matter that evoked sentimental aesthetic contemplation.

pin-up Lone female figure in provocative clothing or seminude, often displayed in posters and calendars on walls

in primarily masculine environments such as military barracks and mechanics' garages.

Plakatstil "Poster style" in German. Credited to designer/illustrator Lucian Bernhard (German, 1883–1972), this reductive method of illustration originated in the first decade of the 1900s and is characterized by simplified, flat, colored shapes rather than outlines, placed on a plain background with a bold title of one to three words.

planography Printmaking technologies such as lithography that use a flat matrix and rely on the difference between an ink-attracting image layer (oil-based crayon, for instance) on a hydrophilic base (protected from ink by water).

Platinum Age of comic books An era in comic book publishing ca. 1897–1938.

pochoir Fine stencil technique in which colors are brushed onto paper through metal stencils. Used in creating fine and limited editions.

polychrome Decorated or executed in many colors, referring to a statue, vase, mural, or print.

Pop Art Movement in which illustrator Andy Warhol became a leader among fine artists who turned popular culture themes and products of mass culture into ironic gallery art objects while satirizing commercial art.

Pop Surrealism Term coined by The Aldrich Contemporary Art Museum for its 1998 exhibit of the same name, in reference to artwork that drew from pop culture and surrealist ideas. Closely related to Lowbrow.

Post-Impressionism Painting movement originating in France between 1886 and 1905 that favored intense colors, flattened space, broad brushstrokes, abandonment of naturalism, and compositional designs atypical of the Impressionists who preceded them.

Poster Movement Late nineteenth-century craze for artistically designed posters in Europe and North America, strongly associated with Art Nouveau.

Postmodern Era in which various movements react against Modernism's emphasis on "progress" and related concepts, marked by ironic self-reference and absurdity; and radical reexamination of culture, nature, identity, history, and language. Stylistically, Postmodernist aesthetics often borrow traditional materials and forms or combine them with contemporary and futuristic ones in jarring ways.

poststructuralism Postmodern approach to interpreting texts that generally considers textual meaning and knowledge to be unfixed and indebted more to the reader—who is influenced by institutions, social groups, networks, and systems of power—than to the text's authorial intent.

pothi Palm leaf manuscript found in the Bihar, Orissa, Tamil Nadu, and Gujarat regions of India.

Pre-Raphaelite Brotherhood (PRB) Small group formed in 1848 by rebellious young artists including Dante Gabriel Rossetti, John Everett Millais, and William Holman Hunt, who were profoundly influenced by the theories of critic John Ruskin. The PRB were inspired by Gothic paintings, architecture, and illuminations of the Northern Renaissance rather than the Classical modes favored by the Southern Renaissance. Many of their highly detailed, intensely colored paintings—and elegantly pared-down illustrations—explored the morality and status of women, history and mythology, and social commentary.

Precisionism American avant-garde painting movement of the 1930s that portrayed machine, industrial, and factory forms stripped of unnecessary decoration and reduced to geometric elements.

preferred meaning The meaning intended by the creator of a text or artwork.

pretty girl Genre of illustration arising in the late nineteenth century that eventually led to the photographed cover girls of today's magazines. Artists portrayed beauties according to the taste of the day but also established new standards. Many pretty girls were envisioned as an ideal American woman "type"—wealthy, wholesome, vigorous, and independent without violating propriety.

primitivism Controversial effort among modern European and American artists to imitate the aesthetics of non-European art forms, in an attempt to imbue their works with a sense of natural and essential expression and meaning.

print capitalism Concept theorized by Benedict Anderson in which the idea of nationhood and the construction of colonial states is indebted to the production and circulation of printed matter serving administrative, business, and scientific interests.

print-on-demand Publishing of books and art prints in which the consumer pays to obtain hard-copy reproductions, usually made in limited edition by laser or inkjet technology.

private press Independently owned and operated publishing, with the goal of producing small editions without considerations of commercial profitability overriding creative intent. Freedom of expression (artistic, literary, political, or sexual) is at the heart of the enterprise.

propaganda Biased presentation of ideas, images, or facts with the intent to sway opinions to help or damage a political, ideological, or social cause.

Protein Data Bank Online database of digital files that describe the three-dimensional structure of thousands of large-scale biological molecules. The files are free to download, and the molecular structures can be visualized with a number of open-source applications.

psalter Book containing the "Book of Psalms" from the Old Testament, usually bound along with other devotional material for private use.

pulp fiction or **pulps** Inexpensive magazines and books printed in black line art on cheap paper containing high pulpwood content. With brightly colored sensational covers, popular mid-twentieth century pulps featured generic fiction such as Westerns, romance, sci-fi, crime, and adventure.

Puranas Traditional narratives told in India to impart the wisdom of the Vedas; frequently illustrated.

pure form Simple geometric shapes such as cubes, spheres, and pyramids that Cubism and Suprematism valued; considered to express the essential truth of matter.

Ramayana Famous ancient Indian epic considered sacred by Hindus, telling the history of the divine hero, Rama.

rapidograph Drafting pen, or technical pen, that produces a uniform line thickness ranging from bold to exceptionally fine weights.

rasa A sentiment or feeling that an image in Indian art intends to provoke.

rasik "Connoisseur" in Sanskrit.

re-appropriation Social action on the part of marginalized groups to gain control over or subvert symbols and

hegemonic narratives that have been appropriated from their culture by other groups or corporations.

readymade An actual object presented as a work of art or part of one. Originated by Marcel Duchamp, who in 1917 entered a urinal he dubbed *Fountain* to the Armory Show art exhibition.

Realism Nineteenth- and early twentieth-century art that depicted life as it actually was rather than as idealized. Subject matter frequently documented the unglamorous but real living conditions and culture of the poorer classes and came to be associated with socialist political views.

reducing/enlarging machine Nineteenth-century apparatus using latex rubber to reduce or enlarge intricate imagery for lithography.

Regency 1811–1820, a period in British history when King George III was unable to rule due to mental illness and his son (the later George IV) was the acting monarch (Regent) in his stead.

Regionalism Patriotic American painting movement of the 1930s that, in parallel with a corresponding literary genre of the same name, documented and romanticized rural agricultural communities associated with the Midwest states and the average citizens who toiled there.

register Any clearly delineated section within a composition, often demarcated by lines or some other graphic divider and used to sort and separate different groups of characters, places, or events. This device has been used since ancient times.

registration The precise placement of different impressions onto the same print, such as when two or more colors must line up in an exact position on the paper. When they don't line up, the result is referred to as *off-register*.

relics The remains or partial remains of a deceased person, usually a saint or other holy entity.

relief etching Developed by William Blake, this technique allowed an artist to use a brush or nib to draw directly on the plate with stop-out varnish. The etching acid removed the negative spaces around the varnish, leaving the drawing as raised marks that were then rolled with ink.

relief Referring in general to a difference in the depths of parts, as in a sculpted panel in which carved figures stand out from a flat background. In printing, relief refers to any technique in which the (inked) printing surface is higher than the supporting block or plate. Xylography, linoleum block printing, wood engraving, and letterpress are relief processes.

remediation When new media absorbs older media and brings about new forms. For example, when software renders analog technical illustration as vector graphics and combines it with animation and interactivity delivered online.

reportage Written or drawn account of news or events based on direct observation.

retablo "Altarpiece" in Spanish; a small devotional painting meant for a home altar.

Roadside Art Commercially oriented art that developed in urban areas of Africa after World War II. Roadside Art is typically made by self-taught artists and used to advertise local enterprises.

Rococo Ornate eighteenth-century style characterized by light colors, curvy forms, and sensuous subject matter, associated with *ancien regime* aristocracy.

Roentgen rays X-rays, as they were first named by their discoverer, Wilhelm Röntgen, in 1895.

role-playing game Digital or analog game in which players operate through imaginary but lifelike characters according to a combination of player-defined action, probability using dice, and game rules. *Dungeons and Dragons* was a progenitor.

rollout drawing or **photograph** Two-dimensional visual record made by researchers that captures figurative, narrative, or other imagery that is wrapped around a three-dimensional shape, such as a ceramic vessel, so that its components may all be seen at once.

Romanesque Noting or pertaining to the style of architecture prevailing in western or southern Europe from the ninth through the twelfth centuries, characterized by heavy masonry construction with narrow openings, and features such as the round arch, groin vault, and barrel vault, and the introduction or development of the vaulting rib, vaulting shaft, and central and western towers for churches.

Romanticism Art movement of the late eighteenth and early nineteenth centuries that emphasized the special role of the insightful, artistic "genius," imagination, the humbleness of mankind before nature, the power of the senses, and heroic individualism.

rōnin In Japanese history, a samurai who is no longer in service of a feudal lord or *daimyo*.

ROSTA Windows Stencil-replicated propaganda posters, usually designed in sequential panels or "windows," which gave them their name. They relied on the Russian folk art and print traditions.

roto section Newspaper insert or weekend magazine printed by rotogravure on newsprint paper, often in brown ink or with extra colors, featuring many photographs and illustrations.

rotogravure High-speed intaglio printing used for image-heavy quality publications and weekend newspaper inserts, capable of fine detail and rich blacks and colors.

royal octavo Standard page size used in books, measuring approximately 6 ¼ × 10".

The Royal Society Prestigious group of British "natural philosophers" interested in promoting knowledge of the natural world though observation and experiments. They met regularly in London beginning in the 1640s to discuss and promote science and received a royal charter in 1663.

Saga-bon Small press books printed in Saga, near Kyoto, around the turn of the seventeenth century by Koetsu and Sōan.

sansui-e Japanese landscape images springing from a painting tradition, sometimes employing a variety of vantage points.

satire Irony, ridicule, invective, exaggeration, or humor used to criticize people or ideas and expose vice, folly, and ignorance.

scanning electron microscopy or micrograph [SEM] Technique utilizing an electron microscope that generates an image by focusing a stream of electrons onto the surface of the subject being studied. The reflected energy signal is captured, and the resulting grayscale image shows the surface topography of the subject.

scholasticism Discourse embraced by medieval scholars in order to legitimize points of Catholic dogma through logical debate, thus aligning it with classical philosophy and knowledge.

School of Gruger Originating with Philadelphia newspapers in the 1890s, a style influenced by Frederic R. Gruger, practiced by Wallace Morgan, Henry Raleigh, Arthur William Brown, Charles D. Mitchell, and others. Partly inspired by the painter and teacher Robert Henri, they developed a rapid, loose reportorial sketch technique using pencil, wash, or ink. Used extensively in the 1920s in illustrating fiction and social commentary, the style has also been referred to as the *Philadelphia School.*

scratchboard Illustration board coated with black pigment over a layer of white clay that can be scratched into to make fine white lines reminiscent of wood engraving.

Second Style Manner of fresco painting in ancient Pompeii that dominated the first century BCE, where walls were illusionistically decorated with architectural features, *trompe l'oeil*, and the use of relative perspective.

Semiotics Study of signs, representation, and meaning-making pioneered by Ferdinand de Saussure and Charles Sanders Peirce. Also known as *semiology.*

senso-e Japanese word for "war prints," especially referring to woodcuts that illustrated battles of the Sino-Japanese and Russo-Japanese Wars. While *senso-e* fulfilled a journalistic function, they were also highly propagandistic.

sensorium Sensory and intellectual apparatus of the entire body.

sequential art Illustrated narratives (comic strips, comic books, and graphic novels) that use multiple static images called panels, placed consecutively—sometimes containing complementary text, juxtaposed text, parallel text, or no text at all—to convey information or tell a story.

set pieces More formal or stylized compositions meant to encapsulate or idealize plots rather than capture a single moment in a narrative.

setsuwa Japanese folktales, fairy tales, myths, and legends.

shibai-e *Ukiyo-e* prints depicting the stage or stage performances.

Shin Hanga Literally "New Woodblock (print)," an early twentieth-century art movement in Japan (ca. 1915–1942) to revitalize woodblock printing after *ukiyo-e*'s decline in the Meiji era.

showcard Small- or medium-sized hand-lettered and embellished advertising sign placed in shop windows or on shop counters or walls.

shunga Literally "springtime pictures" in Japanese, referring to erotic *ukiyo-e* prints.

siderography Method for making duplicates of engraved steel plates, usually used in the production of banknotes and stock certificates.

signature Sheaf of pages folded and sewn through the centerfold in bookbinding.

Silver Age of comic books An era in comic book publishing ca. 1956–1973.

simultaneity Futurist concept of juxtaposing or combining several disparate or conflicting formal elements in one creative work to imply sensory overload or to disrupt conventional interpretation.

the Sixties Considered a highpoint in Victorian wood-engraved illustration (ca. 1855–1870), artists of the Pre-Raphaelite Brotherhood and critic John Ruskin were influential in this era.

siyar Biography of the Prophet Muhammad.

slick magazines or **slicks** Higher-priced magazines printed on glossy paper that allows for higher-quality images; usually contrasted to cheap pulp magazines printed on rough, highly acidic paper that yellows faster. *The Saturday Evening Post* was the largest circulation slick magazine.

slurry Wet mixture of fibers from which paper is made.

smart magazine Magazine with witty writing, acerbic social commentary, edgy contemporary literature, and high fashion. Several titles emerged in the 1920s, and include the *New Yorker*, *Vanity Fair*, and *Smart Set.*

social realism Documentary illustration intended to bring critical attention to class inequity by presenting actual events without censorship.

Socialist realism Upbeat academic and narrative realism styles of illustration used to promote Communist ideals and the excellence of leaders in Communist countries.

special artist Illustrator sent by newspapers to report on wars and other events; also referred to as a *special, correspondent, visual reporter,* or *graphic journalist.*

speech scroll Ribbon-like graphic element used in both Mesoamerican and European art to suggest speech, song, or other types of sound; precursor to speech bubbles in comics; also known as a *banderole* in Medieval manuscripts and Early Modern prints.

split-run edition Alternative version of a mass magazine that is specially produced for a specific geographic region and that contains advertising and editorial content for that region alone.

spot illustration Small, inexpensive image that enlivens text-heavy pages.

staffage Incidental figures included to populate and give scale to a landscape or street scene.

Stamp Tax Government fee levied on publishing or for the filing of legal documents.

stelae Stone slabs positioned to stand upright, usually as a marker; some are decorated.

stereoscope Optical device resembling goggles, used for viewing two nearly identical photographs mounted side-by-side so that the stereoscope causes the photographed scene to appear three-dimensional.

stereotype Method for casting a single, large printing plate from a finalized page layout of letterpress type and engravings, thereby allowing the type to be immediately reused on another job while printing occurred. A stereotype also constituted a permanent copy of the typeset publication for later reprints. Colloquially, the word is borrowed to refer to a customary symbol for a kind of person or thing. This strictly codified representation communicates a body of inherited associations, beliefs, and values regarding the person or thing it stands for. Because they are convenient, commonly understood signs, stereotypes are passed down unaltered for years, through different media forms, narratives, and belief systems. *Cliché* can refer to either a stereotype or an electrotype (see above), and in the same way, refers to something predictable and lacking nuance. See also *stock cut.*

stipple Chiefly used in intaglio printmaking and pen-and-ink drawing, this technique builds up tone through tiny

dots or flecks. Dispersion and size of the dots can be carefully controlled to simulate different grays.

stock cut Stereotype or electrotype of common, general-purpose imagery kept on hand at a printing house for quick and cheap insertion into a text; forerunner of clip art and stock art. Also the origin of the term *stock* when referring to a common character type or other predictable thing. See also *stereotype*.

story papers Heavily illustrated tabloid-sized periodicals aimed at male youth of the late nineteenth century; forerunners of comic books.

storyboard Sequential narrative resembling a comic book page annotated with arrows, visualizing the story, sets, action, and camera angles of a film or animation.

Streamline Industrial design movement that applied sleek, curvaceous forms to machines to make them sell better and, in a few cases of trains, cars, planes, and boats, to make them move more efficiently through air or water.

structural biology Branch of molecular biology that seeks to understand the structure and function of biological macro-molecules like proteins and nucleic acids. This knowledge is important in understanding cellular function and the potential treatment of disease at the molecular level.

structuralism The theory that language is based on underlying social, psychological, and linguistic rules (structures) that determine a text's meaning.

sublime Quality of aesthetic appreciation associated with the Romantic period in European art characterized by a sense of awe tinged with fear, often in the presence of nature.

sumptuary laws Laws decreeing what materials, garments, and ornaments people were allowed to wear, based on class, vocation, wealth, and ethnic background.

Suprematism Russian art movement that emerged during the 1917 Revolution, characterized by geometric, minimalist abstract forms and championing the artist's personal vision and visual experimentation as a research ground for radically reinventing society.

surimono Literally "printed things," *surimonos* were custom-illustrated prints privately published by poetry associations in Edo, Japan (Tokyo).

Surrealism European art movement stemming from Dada after World War I that explored the unconscious.

sutra In Buddhism, a doctrinal sermon or expository text.

Symbolism Late nineteenth-century art movement originating in France, concerned with imagination, horror, awe, spirituality, and metaphor.

symposium In ancient Greece and Rome, a convivial meeting, usually following a dinner, for drinking and intellectual conversation.

synesthesia Literally "union of the senses" in Greek. A physiological condition in some people's brains in which sensory stimuli (such as a sound) consistently trigger another sense (such as seeing a color in the mind's eye).

syndicated licensing Distribution of copyrighted material across geographic markets, used to place the same comic strip in various different newspapers, for example.

systemic racism Racial inequality perpetuated by established customs and institutions, often reinforced by visual tropes.

tablet Originally, an electronic drawing pad attached to a computer and using a stylus to create artwork in a software program. Also an electronic device using apps to deliver multimedia content, such as games, movies, databases, or e-books.

tailpiece Decorative embellishment printed at the end of a book chapter or magazine article.

tasvirkhana Court studio during the reign of the Mughal Empire in which artisans worked under the guidance of Persian masters to create luxurious books.

taxonomy System and process of classification, usually referring to the scientific identification of species, and their placement into larger groups based on their degree of relationship.

technological determinism Concept in media theory that suggests communication technologies irrevocably and uncontrollably change society and individuals by altering behavior and patterns of thought.

Thanjavar style Painting style of Southern India that incorporates gold and precious stones.

thought bubble or balloon Graphic device used in comics to indicate that the words included in the form are being thought rather than spoken.

transcoding (1) Interrelation within a computer between information that can be translated into experiences that make sense to us humans (for instance, multimedia images or readable texts) and information that is only machine-readable (the code, or instructions, and interaction with other computers).

transcoding (2) Theorist Stuart Hall's word for appropriating common tropes and subverting them to effect social change.

transfer paper Special paper used to offset a drawing to a lithography stone for printing.

transmedia storytelling Production of interrelated narratives across several media platforms at once.

transmission electron micrograph or microscopy Technique utilizing an electron microscope that generates an image by focusing a stream of electrons through an ultrathin-sectioned specimen.

triptych Any three-part composition; or a painting or altarpiece with three panels.

trompe l'oeil Literally "deceive the eye" in French, referring to a painting technique in which the subject is rendered realistically in such a way as to look three-dimensional, emphasizing the illusion of tactile and spatial qualities.

trope Commonly repeated idea or image (or other sign) with a particular set of widely understood associations that imbue it with an ideological function. Similar to *stereotype*, without being as specific in its prescription of how a person, object, narrative or event is to be represented.

tusche Greasy suspension of carbon pigment in liquid, used to create hand-drawn washes in lithography.

tweet Short message sent via the social media platform Twitter.

tympanum Often decorated, arched recessed space above the horizontal top of a door or window.

type high Height of cast type and prepared wood and engraving blocks used in letterpress printing; 0.918 inches (23.3 mm).

typology Old Testament figure or story interpreted as symbolically prefiguring events or characters in the New Testament. In art, this includes the strategic repeated compositions or use of visual symbolism that encouraged viewers to relate symbolic "types" to each other in

order to create theological associations to inspire deeper understanding.

ukiyo-e Literally "pictures of the floating world," in Japanese. Refers to woodcut prints made during Japan's Edo period (1615–1868), many of which depicted life and diversions in the pleasure quarters of the city.

underground comics or **comix** Independent comic strips and books that historically originated with the alternative press or that have been self-published. Spelling of the word with an *x* originally signified mature content but now designates comics on various subjects not produced by large corporations such as Marvel or DC.

Upper Paleolithic Of, relating to, or characteristic of the cultures of the Stone Age, which appeared first in Africa and are marked by the steady development of stone tools and later antler and bone artifacts, engravings on bone and stone, sculpted figures, and paintings and engravings on the walls of caves and rock shelters.

vanitas Painting or other image in which depicted objects symbolize the transience of earthly pleasures, or of life itself. Vanitas paintings flourished in the seventeenth century in Northern Europe, particularly in the Netherlands.

Vedas Ancient oral and recorded texts in the Hindu tradition that provide the spiritual and philosophical parameters of life and culture.

Vienna Secession Artistic group formed in 1897 whose graphic language *(Sezessionstil)* is characterized by flat, two-dimensional shapes and geometric designs. Influenced by Symbolist painting, French Art Nouveau and the Glasgow School, they published an innovative journal *Ver Sacrum*, or Sacred Spring, from 1898 to 1903.

vignette Traditionally in books, a small sketch in the margin or at the end of a chapter that captures a fleeting moment or depicts a character in a simple, informal manner, without a frame or extensive background filled in. Also an image in which the edge fades out softly.

visual culture Aspects of a culture that are seen, such as art, fashion, design, performance, display, or illustration, and the practices, attitudes, and ways of looking and understanding that they engender.

visual literacy Ability to critically apprehend or interpret pictures or other visual communication.

visual music Genre of art originating in the nineteenth century that gives visual form to music and sound.

wabi-sabi Japanese aesthetic related to Zen Buddhism that values the imperfect, broken, and transient.

Wacom tablet Pressure sensitive digital input device configured as a tablet, which is drawn on with a proprietary stylus produced by Japanese firm Wacom Co. Ltd.

webcomics Any type of comic that is primarily produced for, published, and accessed online (as opposed to syndication for print first).

widget Preprogrammed digital action that can be quickly and relatively easily implemented into a website.

wood engraving Relief printing from blocks made of extremely hard wood such as boxwood to withstand thousands of impressions, where the design is engraved on the robust end grain of the wood to enable minute detail. One of the most common types of printing from 1835 to 1885, when it began to be replaced by photomechanical methods using line art and halftones.

work for hire Arrangement in which the creator is paid by a publisher or other company to create original work that is then owned by them. The publisher is entitled to exploit the artwork along with all of its future applications, with no further remuneration to the artist.

Works Progress Administration (WPA) A federal program (1935–1943, renamed the Work Projects Administration in 1939) in the United States developed to alleviate high unemployment during the Great Depression by employing people in government-funded projects, including construction of roads, bridges, schools, and post offices. The program employed millions and also provided funding for writers, musicians, theater, and the visual arts.

X-ray crystallography Technique that can demonstrate the molecular structure of a crystal by using X-rays, which bounce off the atoms of the crystal in different directions. When the angles of the reflected X-ray beams are measured and compared, a three-dimensional picture of the crystal can be generated.

xylography Relief printing process in which raised designs are created by cutting away the nonprinting areas of a wooden block. The raised design is then surface rolled (or brushed) with ink, which is transferred to the printing paper or fabric by rubbing the back of the sheet. See also *relief processes* and *ukiyo-e*.

yakusha-e Ukiyo-e prints of actors.

yellow journalism Sensationalized news reporting that uses overstated or misleading headlines, spurious facts, and eye-catching imagery to increase readership.

yellow-backs Cheap, amusing, and sometimes tawdry fiction published during the nineteenth century and sold at railway stations and newsstands.

Yokohama-e Ukiyo-e woodblock prints depicting the influx of foreigners and the changing way of life in the Japanese port city of Yokohama after it was opened to trade.

'zine Abbreviation of the word *magazine* or *fanzine*, referring to a small folded or stapled booklet or pamphlet; self-published, usually using a photocopier or desktop printing and mainly distributed by postal service or at comics conventions.

Index